CHARDIN

1699-1779

*A special exhibition organized by the Réunion des Musées Nationaux, Paris,
The Cleveland Museum of Art, and Museum of Fine Arts, Boston*

*Grand Palais, Paris: January 29 through April 30, 1979
The Cleveland Museum of Art: June 6 through August 12, 1979
Museum of Fine Arts, Boston: September 11 through November 19, 1979*

The United States exhibition supervised by William S. Talbot

*Catalog translated by Emilie P. Kadish and Ursula Korneitchouk
Edited by Sally W. Goodfellow*

Pierre Rosenberg

CHARDIN

1699-1779

Published by The Cleveland Museum of Art
in cooperation with Indiana University Press

Curators in Charge

William S. Talbot, Associate Curator of Paintings
The Cleveland Museum of Art

John Walsh, Jr., Baker Curator of Paintings
Museum of Fine Arts, Boston

Pierre Rosenberg, Curator, Department of Paintings
Musée du Louvre, Paris

The exhibition in the United States was made possible by a grant from the National Endowment for the Arts, a federal agency, and by a federal indemnity from the Federal Council on the Arts and the Humanities.

Cover illustration: Detail of *Basket of Wild Strawberries* [115].

French edition published in 1979 by Editions de la Réunion des musées nationaux, 10 rue de l'Abbaye, 75006 Paris.

Second Printing 1980
English translation © 1979 by The Cleveland Museum of Art,
11150 East Boulevard, Cleveland, Ohio 44106.

Typesetting by Abetter Typesetter, Cleveland, Ohio 44118.
Printing by Great Lakes Lithograph Company, Cleveland, Ohio 44109.
Format adapted from the French edition designed by Jean-Pierre Rosier.

Library of Congress Cataloging in Publication Data is on page 425.
ISBN: 0-910-386-48-x cloth
ISBN: 0-910-386-49-8 paper

Contents

Foreword

When Pierre Rosenberg suggested organizing a Chardin exhibition more than five years ago, we responded enthusiastically. The possibility of collaborating on such a worthwhile contribution to both knowledge and delight was one to be grasped immediately and developed carefully. After many vicissitudes the project became reality, but those who see the exhibition cannot possibly imagine the labors attendant upon its birth and delivery—this being the first comprehensive exhibition of Chardin's works in this century as well as the first serious art-historical assemblage of the artist's works ever held. Although Pierre Rosenberg discusses this neglect of Chardin, a few American words may be in order.

Chardin was and is a great master, but recognition has not always come easily. His sobriety and realism make full love difficult, because in his pictures activities are limited and subjects are common. Indeed, Chardin was an alchemist, transmuting a severely restricted range of middle-class subjects into precious material sought by royalty and aristocracy, to say nothing of the middle class itself. He is never abstract; neither is his realism simple. Painters adore him for his ability to maintain in an extraordinary way outward appearance, underlying meaning, and design.

The 200th anniversary of the artist's death occurs at a time when abstraction is under question and various forms of neo-realism flourish. Chardin's art tests all pretenders to either persuasion, for it preserves corporeality while ennobling it by what can only be described as a magical transubstantiation. Thus, his art is truly relevant to a contemporary understanding of the visual arts.

The exhibition in Paris numbered 142 pictures, of which we show 90. The reasons for the reduced number shown in Cleveland and Boston involve problems of fragile condition, policy restrictions, and personal judgment (it is hard for owners to live without a Chardin for more than four months, let alone eleven). Since pastel is the most fragile of all pictorial media, the pastels shown in Paris could not travel here; likewise, the Chicago pastel seen here was not sent to Paris. Both sides are losers. This catalog, however, includes all of the works in the Paris exhibition so that the author's arguments may be documented in full. It was agreed that the biography of Chardin should be left in the original French, since it is comprised largely of comtemporary documents, precious in their original wording. This volume, then, is not only an introduction to the art of Chardin but a fundamental research tool as well.

Most foreign loans to the American exhibition have been insured under the provisions of the Arts and Artifacts Indemnity Act passed by Congress in 1975 and implemented through the Federal Council on the Arts and Humanities. We are most grateful for this indemnification, for without it the insurance costs would be prohibitive.

The costs of packing, shipping, installation, and educational activities are major expenses in mounting such an exhibition; here the National Endowment for the Arts made a most generous grant to both the Cleveland and Boston museums. Without such enlightened federal support the exhibition would have been difficult (if not impossible) to achieve and to interpret fully.

An overwhelming debt is owed to French museums for their cooperation in lending the thirty-four works from their collections. To Michel Laclotte, Chief Curator of the Department of Paintings at the Louvre, go special thanks for the loan of no less than thirteen Chardins. The Jacquemart-André Museum, administered by the Institut de France, and the privately directed Musée de la Chasse et de la Nature were particularly unselfish in their major contributions. Private collectors were especially helpful, most notably the descendants who hold the remarkable nineteenth-century legacy of the Marcille family—the greatest collectors of Chardin. We are also grateful to Phillipe de Rothschild, who parted with his Chardin masterpiece so that it could be seen in America.

Many museums of Europe also kindly cooperated. We particularly note our thanks to The Hermitage of Leningrad and the Staatliche Museen Preussischer Kulturbesitz, representing Schloss Charlottenburg and the Gemäldegalerie at Berlin-Dahlem. The Nationalmuseum in Stockholm, despite its forthcoming rococo exhibition this fall, kindly lent several Chardins, collected by Count Tessin in the eighteenth century.

American museums were no less forthcoming. Without the vital assistance of the National Gallery, The Metropolitan Museum of Art, the Museum of Fine Arts in Springfield, and the Norton Simon Foundation, among others, the exhibition would have been sadly deficient. To all the lenders we offer thanks for their patience, forbearance, and generosity.

Our colleagues in France have been both sympathetic and intelligent in their cooperation. Hubert Landais, Director of the Musées de France, was a constant support; without his backing the American exhibition might well have failed. Irène Bizot, Deputy Administrator of the Réunion des Musées Nationaux, was her usual friendly, efficient, and tireless self, and with Marguerite Rebois of the Exhibitions Office, made all technical problems fade away. Designer Jean-Pierre Rosier was notably helpful in the complexities involved in the design and production of the catalog.

In this country, highest praise and thanks are due William S. Talbot, Associate Curator of Paintings at Cleveland, and John Walsh, Jr., Curator of Paintings at Boston, for their tireless and painstaking labors in connection with all facets of the exhibition. Logistics of transportation were ably handled by Delbert Gutridge and

Linda Thomas, Registrars at Cleveland and Boston. The installation in Cleveland was under the supervision of William E. Ward, and in Boston, Tom Wong. In Cleveland, Ursula Korneitchouk, Assistant to the Director, and Linda Jackson, Secretary to the Paintings Department, contributed heavily to the success of the entire project.

The American catalog was the responsibility of the Cleveland Museum and Merald E. Wrolstad, Editor of Publications, but the enormous task of editing the translations fell to Assistant Editor for Catalogs Sally W. Goodfellow, whose success deserves the thanks of every reader. Helpful assistance in preparation of the catalog was kindly provided by Jack Perry Brown, Janet Leonard, Amy Levine, Bernice Spink, Georgina Toth, Joy Walworth, Jo Zuppan, and especially Shirley Hyatt. The principal work of translation, carried out by Emilie P. Kadish and Ursula Korneitchouk, was difficult and subtle, but, with a cooperative effort tolerated and guided by Pierre Rosenberg, was successfully completed in a relatively short time. Additional thanks go to William Talbot and David Ditner who provided help with translating.

Finally, we must pay tribute to Pierre Rosenberg. He would say, "Pay tribute to Chardin"—and, of course, he is right. Nevertheless, he has made a major contribution to our knowledge of Chardin in this catalog and an even more important contribution to the appreciation of this great master in his selection of works and patient exposition of their history and virtues. He has made it possible for us to salute Chardin and to delight in his work on this, the 200th anniversary of his death.

Sherman E. Lee, Director Jan Fontein, Director
The Cleveland Museum of Art Museum of Fine Arts, Boston

Index of Owners

Preface

Strange as it may seem, there has never been an exhaustive Chardin exhibition. The exhibitions held in 1860, 1907, 1926, 1929, and 1959 focused mainly on works from private collections. The bicentennial of Chardin's death, however, offers a fitting occasion to reappraise a painter who, already famous during his lifetime and then rediscovered in the mid-nineteenth century, is at present better known for his still lifes than for his genre scenes, while the reverse was true at the beginning of our century. The aim of this exhibition was simply to bring the best of his works together—a difficult task, considering that his paintings are scattered around the world, many of them in museums and private collections that are not readily accessible.

The ninety works shown in Cleveland and Boston come from museums and private collections in North America and Europe. Twelve pictures are on loan from provincial French museums, nine from Parisian museums, thirteen from the Louvre. Nineteen works have generously been made available from French private collections, including certain key paintings [27, 28, 72, 115, 126, 127] without which the exhibition would have fallen short of its goal. Our decision not to borrow paintings that are currently on the market only slightly affects the exhibition's image of Chardin, although it does deprive us of several important compositions. Legal restrictions prevented some museums from lending us several essential works (*Lady with a Bird Organ* and *Still Life with Plums* in The Frick Collection, New York; a *Cat Coveting Oysters* and a *Kitchen Table* in the Burrell Collection, Glasgow; a pastel said to be the portrait of Bachelier in the Fogg Art Museum, Cambridge; three still lifes in the Reinhart Collection at Winterthur). Also missing are numerous works from the Henry de Rothschild collection which were destroyed during World War II, among them several genre scenes of which no other version is known to exist.

Of the loans refused to the United States, *The Scullery Maid* and *A Lady Taking Tea* from Glasgow are the most serious losses (along with *The Tavern-Keeper Boy*, which could not be loaned to either Paris or the United States). Hardly less regrettable are the absences of *The Schoolmistress* and *The House of Cards* from London's National Gallery, as well as *Bouquet of Carnations,...* from Edinburgh. Unfortunately, the beautiful still life from Karlsruhe, *Partridge, Bowl of Plums, and Basket of Pears,* could not be sent, nor *Still Life with a Bust of Mercury* from Moscow

(also not sent to Paris). The inability of Ottawa to loan their *Return from Market* prevents a juxtaposition with the Louvre version [81], and the absence of *The White Tablecloth* is only tempered by its availability to the American public at The Art Institute of Chicago.

These shortcomings notwithstanding, our project was most favorably received by private lenders and museums alike, and we express our sincere gratitude to all who made its realization possible. We are most indebted to our colleagues in Berlin, Stockholm, New York (The Metropolitan Museum of Art), Washington (National Gallery of Art), and Paris (Musée Jacquemart-André and Musée de la Chasse et de la Nature), who in each case generously agreed to lend a number of Chardins. We keenly appreciate what must have been difficult decisions.

We have attempted, above all, to define the various phases of the painter's career, to trace the evolution of his style, and to stress the diversity of his art — thereby correcting the prevailing tendency to view it as all of a piece. We also found it useful to show two versions of certain still-life or genre compositions side by side so as to throw some light on the working methods of the artist. Chardin labored with painstaking slowness; each of his compositions was the result of thorough deliberation and, once worked out, could be done again in several versions. Occasionally changing a detail here or there, Chardin enjoyed repeating his compositions, probably at his patron's request. Therefore, juxtaposing two versions of the same composition will challenge the viewer to compare their quality and to ponder Chardin's reasons for such repetitions.

Chardin's fame is by now firmly established. His life and work have been researched by many — from Hédouin to the Goncourt brothers; Bocher, Guiffrey, Pascal and Gaucheron to G. Wildenstein; from Furst, Goldschmidt, and G. de Lastic to D. Carritt. Yet the researchers seldom went back to the sources. We felt it indispensable to fill this gap. We therefore reexamined all archival documents known to relate to Chardin, his life and work, his environment, and his supporters. We re-read the reviews of the Salons in which Chardin regularly participated. Above all, we systematically scanned sales catalogs of the eighteenth and nineteenth centuries, which enabled us to retrace the history of most of Chardin's paintings from the dates of their execution to their present whereabouts. Certainly the catalog reflects this long and tedious labor, which could not have been accomplished without the unfailing help of Mmes Nicole Munich and Sylvie Savina.

In an effort to make each catalog entry as complete as possible, particular attention was given to the provenance of each painting and to related works. Information on provenance is especially important in the case of Chardin, whose paintings were soon imitated and copied. Under the heading *Related Works,* principal Chardin compositions that are missing from the exhibition (but not in dealers' hands) are reproduced in small reference photographs, and we have compiled as complete a list as possible of the various other known versions — autograph or not — of the genre and still-life compositions included in the catalog. As we shall explain in the Introduction, our research has established that Chardin was far less productive than had generally been assumed.

The chronological arrangement of the catalog is especially important. The entries are grouped into eight sections; each group represents a major period in Chardin's career and is preceded by a short essay describing the stylistic characteristics:

Chardin's Beginnings
First Still Lifes: "Skilled in Animals and Fruits"
First Commissions
Utensils and Household Objects
Genre Scenes
Chardin's Return to Still-Life Painting
Large Decorative Compositions and Trompe l'Oeil in Grisaille
Chardin's Pastels

Whenever possible, we have adhered to the titles given to Chardin's paintings in the eighteenth century; these titles appear in quotation marks.

In addition to the Bibliography and List of Exhibitions, both of them compiled with the assistance of Mlle Marie-Paule Durand, the catalog includes a Chardin Biography, for which we are indebted to Mme Sylvie Savina. This biography, based on archival documents and many other sources, yields a wealth of information on the artist's eventful, if unromantic, life. And the Critical Evaluation of Chardin reflects each new generation's opinion of Chardin and an appreciation of his art in keeping with its own concept of painting, particular tastes, and preoccupations.

Two items in the catalog deserve explanation. The first is a "glossary" of the objects most frequently represented in Chardin's oeuvre — objects chosen for their form and beauty rather than for their significance. Many of them were among Chardin's personal belongings and are mentioned in the various inventories drawn up in the course of his career. We found it useful to illustrate them separately and designate them by their correct eighteenth-century names.

The second item is a list — though not entirely complete — of the principal collectors of Chardin paintings from the eighteenth century to the present. Genuine Chardin admirers or rich benefactors, "discoverers" of the painter, or artists who found inspiration in his works, these collectors were essential in preserving and transmitting Chardin's canvases; they also prove that the lesson taught by Chardin, today more appreciated than ever, had never ceased to be understood.

It is my great pleasure to thank the Permanent Secretary of the French Academy; Madam President of the Foundation for La Maison de la Chasse et de la Nature; and Their Honors, the Mayors of Amiens, Angers, Bordeaux, Carcassonne, Chartres, Cherbourg, Douai, Paris, and Rennes.

In addition, I especially want to thank Mmes E. Andersson, K. de Beaumont, G. Bentzen, N. Blondel, J. Bran-Ricci, G. Bresc, T. Burrolet, V. Cabanel, A. Caubet, P. A. Chevrier, M. C. Chaudonneret, I. Compin, M. David-Weill, D. Didier, S. Douce de la Salle, L. Faillant, M. P. Foissy, S. Folds McCullagh, P. de Forges, M. Fournier, T. Gaehtgens, E. de Ganay, M. Gallet, G. Génisson, F. Guéroult, H. Guicharnaud, S. Guillot, A. Hallé, M. Hours, V. Huchard, I. Kouznietsova, M. A. Le Bayon, J. Durfort de Civrac de Lorge, L. Schneider, M. Lyon, L. de Margerie, L. Meysonnier, M.

M. Misserey, A. M. Moniot, de Mouchy, I. Nemilova, M. Pelletier, Ph. Pascal, M. Pinault, A. Pingeot, Ch. de Quiqueran, M. Rambaud, H. Robels, M. Roland-Michel, M. C. Sahut, C. Samoyault, A. Sérullaz, K. Simons, M. Skira, M. Stuffmann, C. Viazzoli, E. Vieillard, J. Wrightsman, A. Zwollo; and Messrs. D. Alcouffe, H. Baderou, F. Baratte, F. Bergot, P. Bjurström, A. Blunt, de Boissieu, H. Börsch-Supan, G. Bourligueux, F. Bouvet, A. Brejon de Lavergnée, H. Brigstocke, C. Brown, F. Cummings, J. P. Cuzin, B. Dahlbäck, R. Descadeillas, C. Donat de Chapeaurouge, M. Faré, J. Foucart, J. Foucart Sr., H. P. Fourest, J. R. Gaborit, T. Gaehtgens, E. de Ganay, M. Gallet, S. Grandjean, P. Grate, Ph. Grunchec, F. Haskell, C. van Hasselt, J. Heidner, de Hohenzollern, M. Hopkinson, M. Laclotte, M. Laskin, G. de Lastic, S. E. Lee, M. Levey, J. Leymarie, Lions, G. Lundberg, G. Mabille, J. F. Malle, H. P. McIlhenny, A. Meyer, A. Moatti, P. Monart, D. Mosby, J. Müller Hofstede, R. Mühlberger, E. Munhall, P. Nathan, S. Nikitine, D. Ojalvo, H. N. Opperman, E. Picard, T. Pignatti, C. Piper, M. Ratouis de Limay, A. Rosenbaum, J. Rishel, Ph. de Rothschild, M. Roullet, D. Rust, J. P. Samoyault, P. Sandblom, E. Schleier, A. Schnapper, M. Sérullaz, R. E. Spear, M. Stein, Ch. Sterling, S. Takashima, W. Talbot, Ph. Thiébaut, H. Thierry, C. Thompson, G. Turpin, P. Vaisse, J. L. Vannier, J. Vilain, C. A. Wachtmeister, A. G. Wahlberg, J. Walsh, G. Weisberg, J. White, J. Wilhelm, M. Wilson, E. Zafran, and Y. Zolotov.

Special thanks go to Mr. David Carritt for generously sharing with us the wealth of information, some of it unpublished, which he has been able to gather on Chardin. Mlle Elizabeth Walter contributed valuable biographical and bibliographical data; Mme Nicole Munich combed the archival documents with exemplary zeal; Mlle Marie-Paule Durand did extensive library research and helped considerably with the painstaking process of compiling the bibliography. Finally, it was my good fortune to obtain the concerned and untiring cooperation of Mme Sylvie Savina, to whom I am much indebted.

Pierre Rosenberg

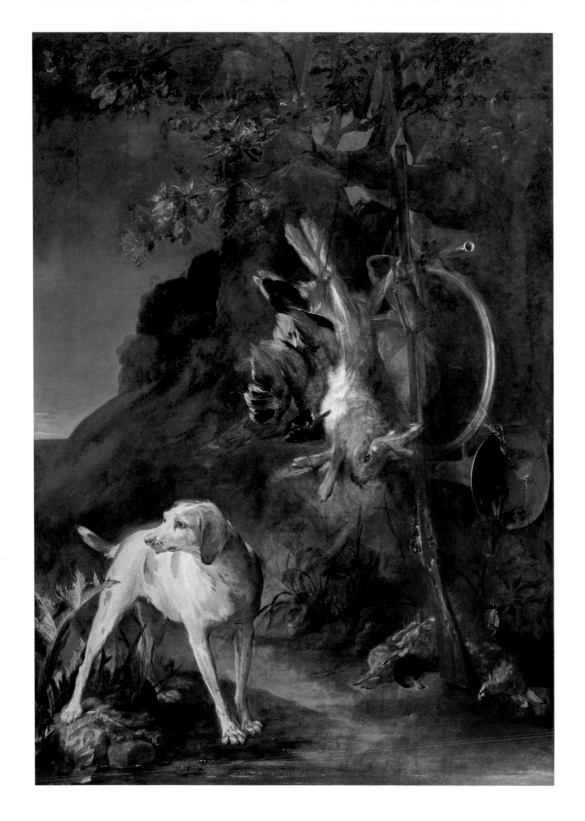

Color Plate I. *The Hound,* 192.5 × 139 cm. Pasadena, Norton Simon Museum. [6]

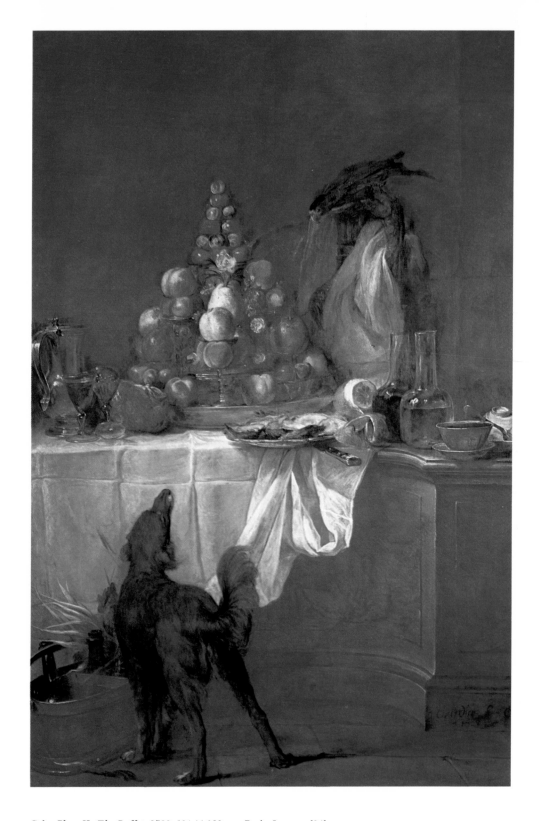

Color Plate II. *The Buffet*, 1728, 194 × 129 cm. Paris, Louvre. [14]

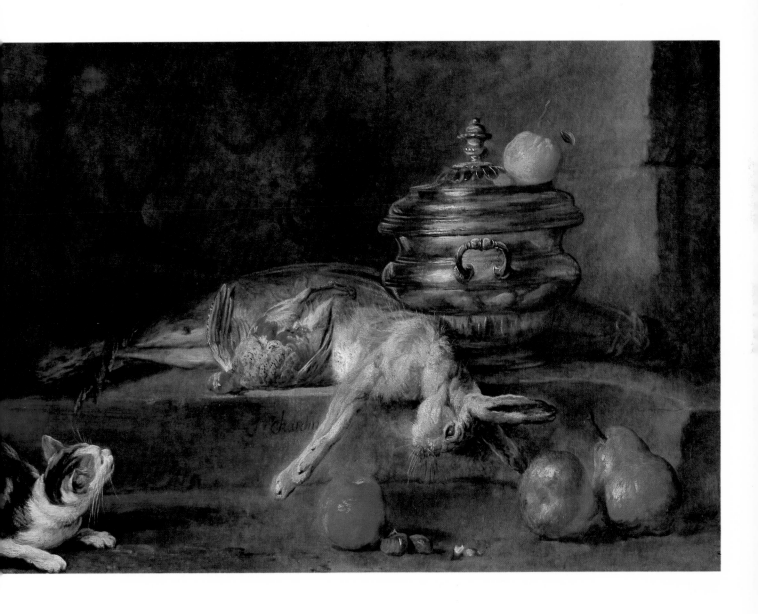

Color Plate III. *Cat Stalking a Partridge and a Hare Left Near a Soup Tureen*, 73.5 × 105 cm. New York, The Metropolitan Museum of Art. [20]

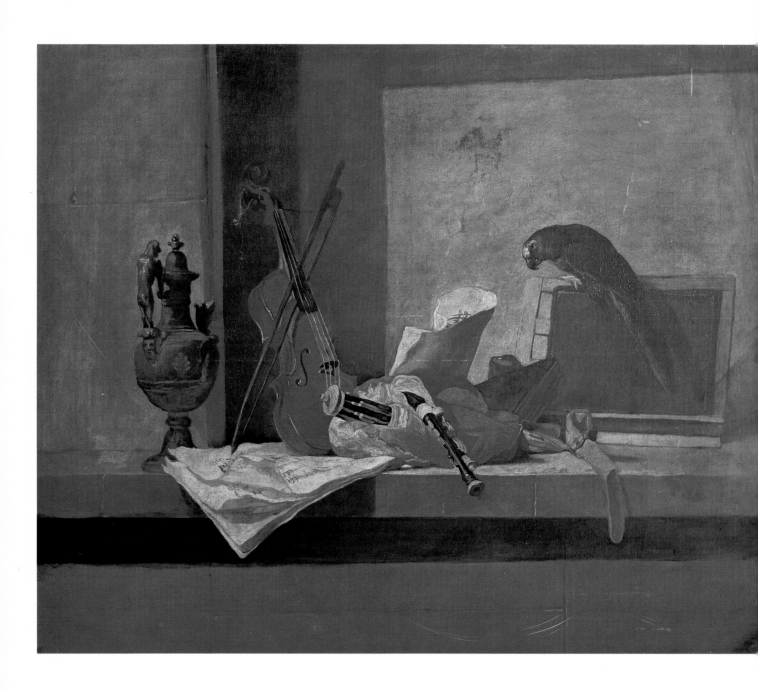

Color Plate IV. *Musical Instruments and Parrot*, 117.5 × 143.5 cm. Paris, Private Collection. [27]

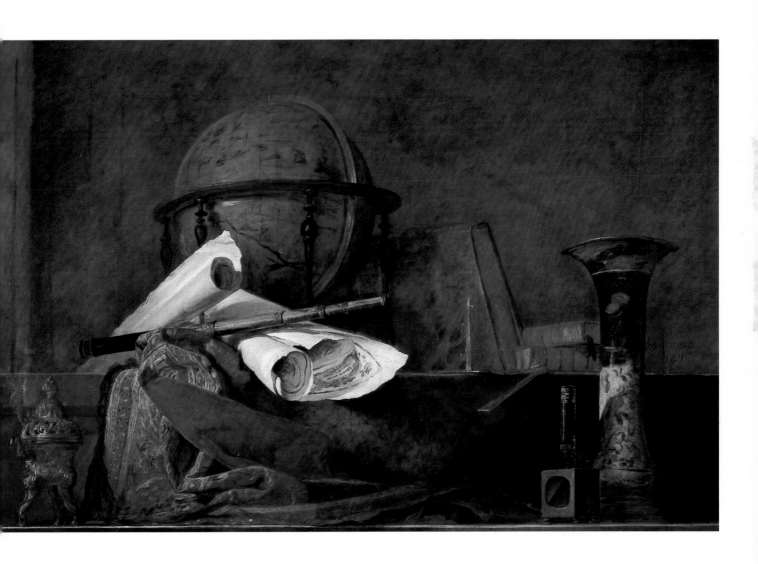

Color Plate V. *Attributes of the Sciences*, 1731, 141 × 219.5 cm. Paris, Musée Jacquemart-André. [29]

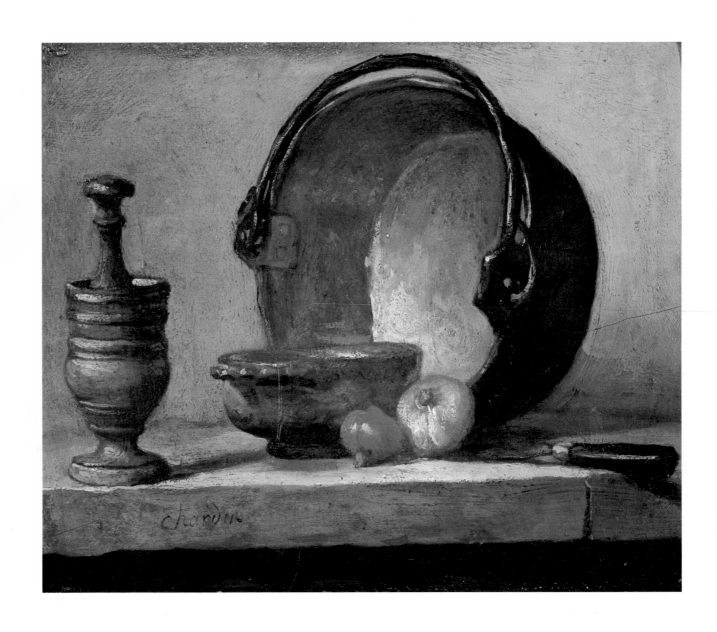

Color Plate VI. *Mortar and Pestle, Bowl, Two Onions, Copper Pot, and Knife,* 17 × 20.5 cm. Paris, Musée Cognacq-Jay. [52]

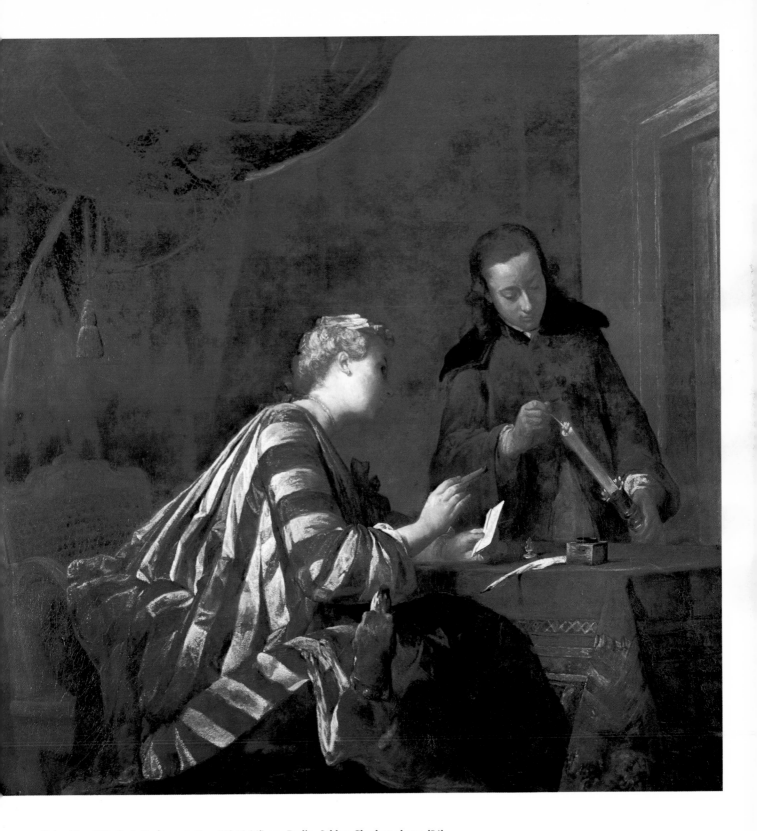

Color Plate VII. *Lady Sealing a Letter,* 146 × 147 cm. Berlin, Schloss Charlottenburg. [54]

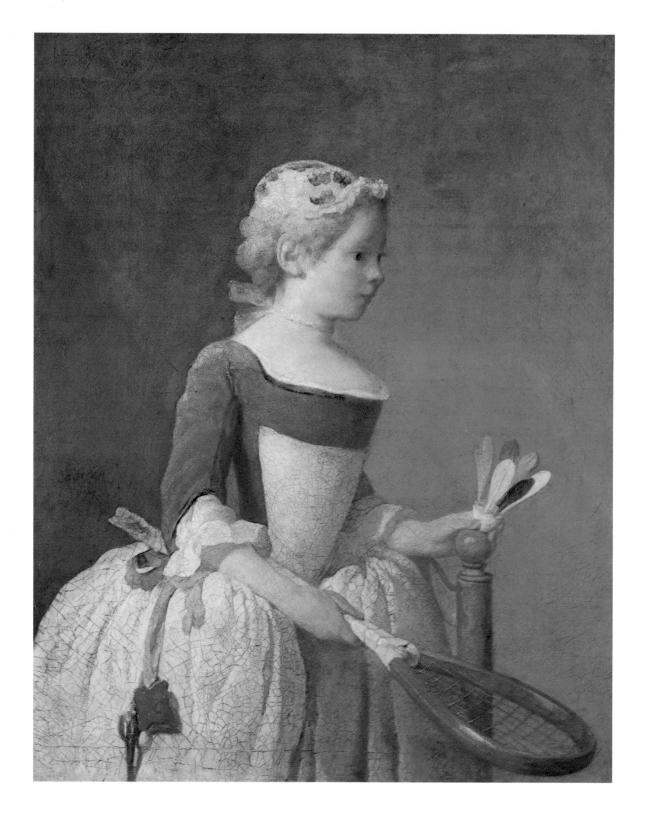

Color Plate VIII. *Little Girl with Shuttlecock,* 1737, 81 × 65 cm. Paris, Private Collection. [72]

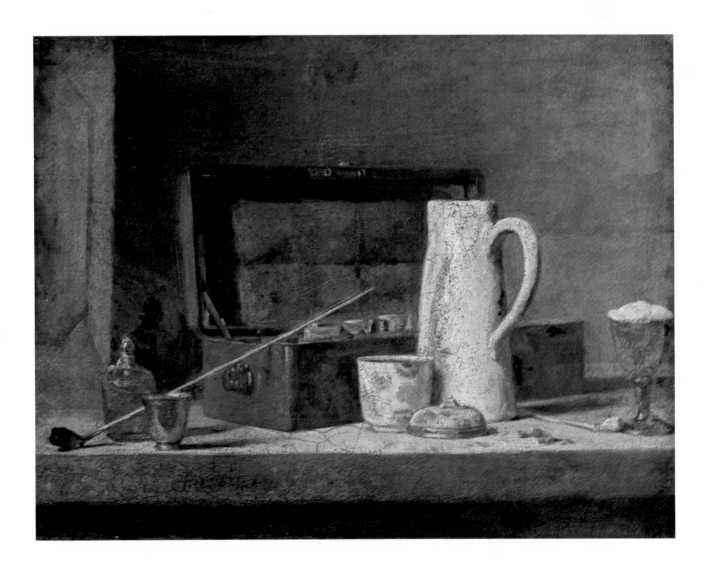

Color Plate IX. *The Smoker's Kit*, 32.5 × 40 cm. Paris, Louvre. [74]

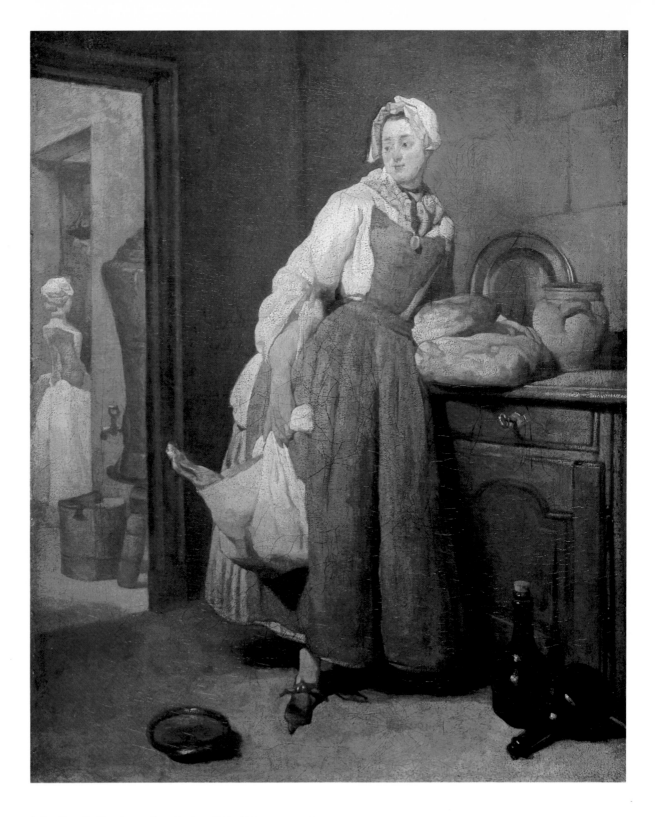

Color Plate X. *The Return from Market,* 1739, 47 × 38 cm. Paris, Louvre. [81]

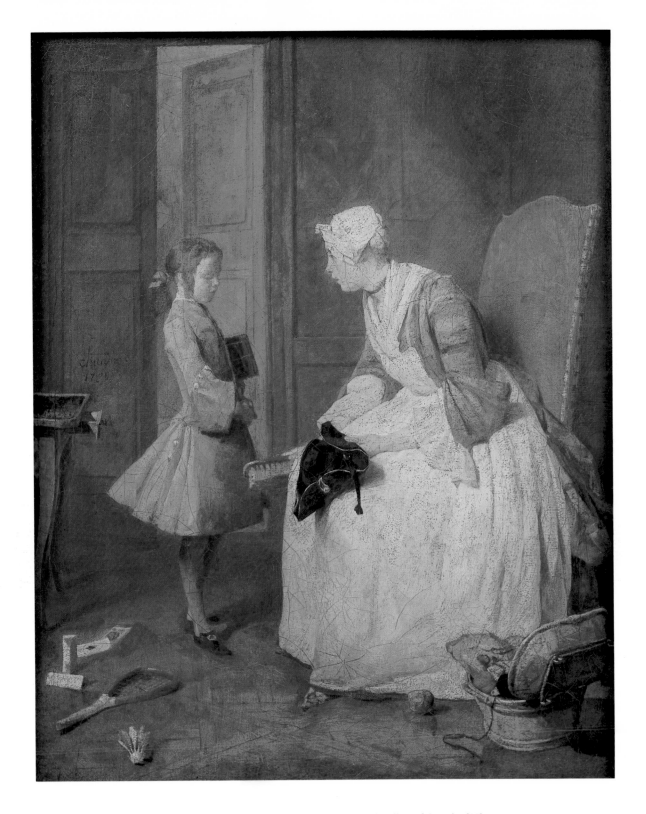

Color Plate XI. *The Governess,* 1738, 46.5 × 37.5 cm. Ottawa, The National Gallery of Canada. [83]

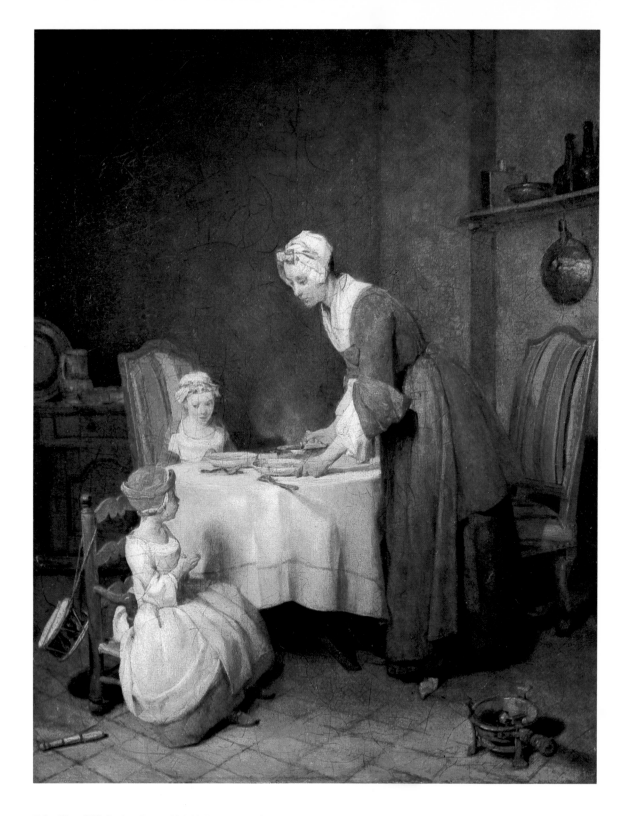

Color Plate XII. *Saying Grace,* 49.5 × 38.5 cm. Paris, Louvre. [86]

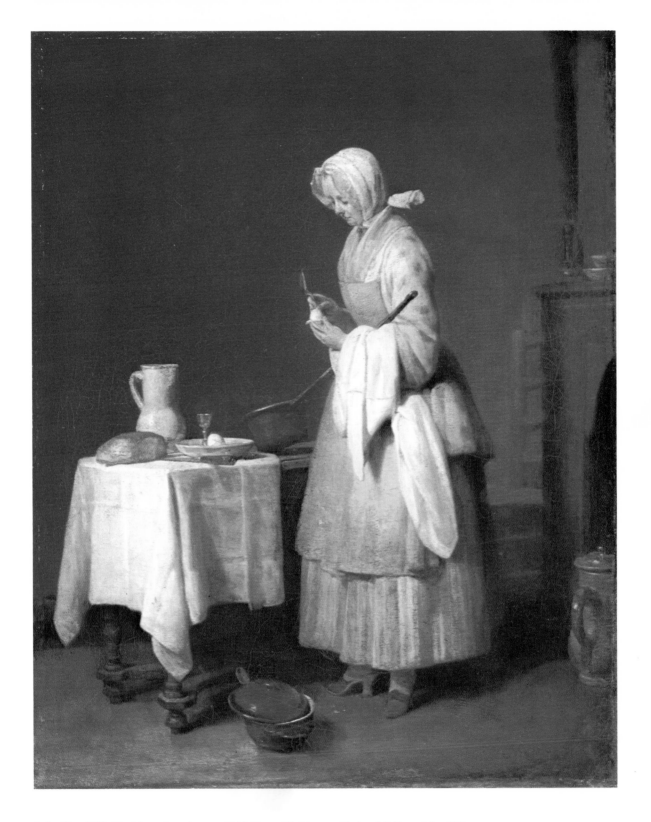

Color Plate XIII. *Meal for a Convalescent,* 46 × 37 cm. Washington, National Gallery of Art. [92]

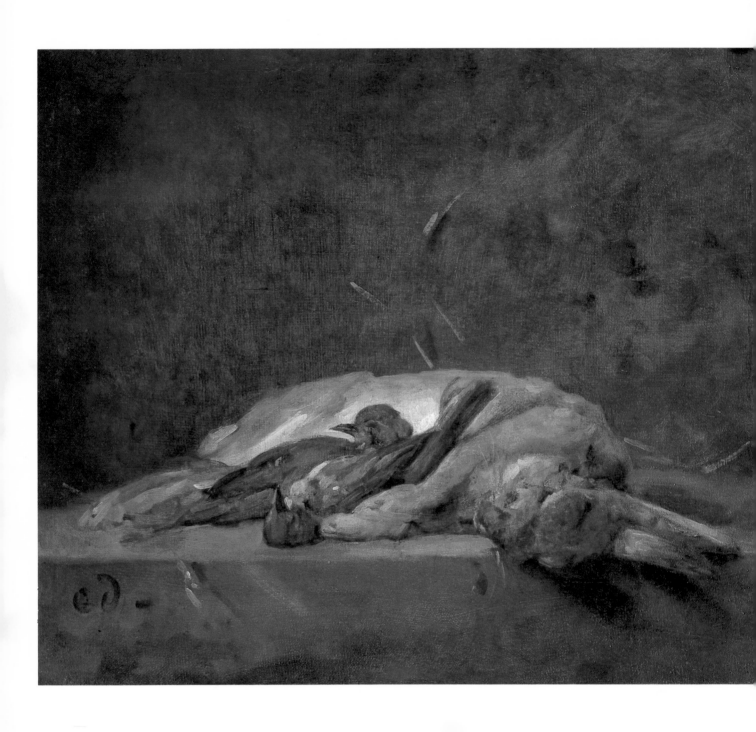

Color Plate XIV. *A Rabbit, Two Thrushes, and Some Straw on a Stone Ledge*, 38.5 × 45 cm. Paris, Musée de la Chasse et de la Nature. [98]

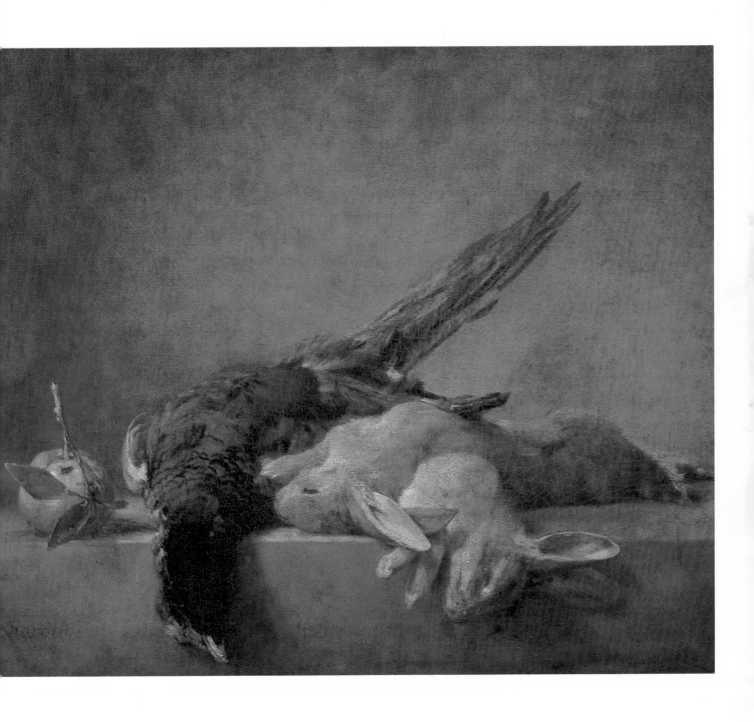

Color Plate XV. *Two Rabbits, a Pheasant, and Seville Orange on a Stone Ledge*, 49.5 × 59.5 cm. Washington, National Gallery of Art. [99]

Color Plate XVI. *Jar of Apricots*, 1758, 57 × 51 cm. Toronto, Art Gallery of Ontario. [110]

Color Plate XVII. *The Cut Melon*, 1760, 57 × 52 cm. Paris, Private Collection. [111]

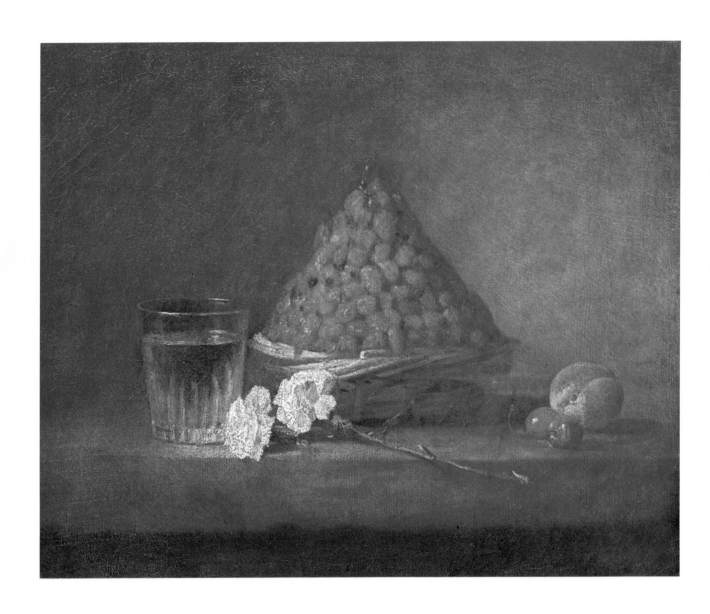

Color Plate XVIII. *Basket of Wild Strawberries*, 38 × 46 cm. Paris, Private Collection. [115]

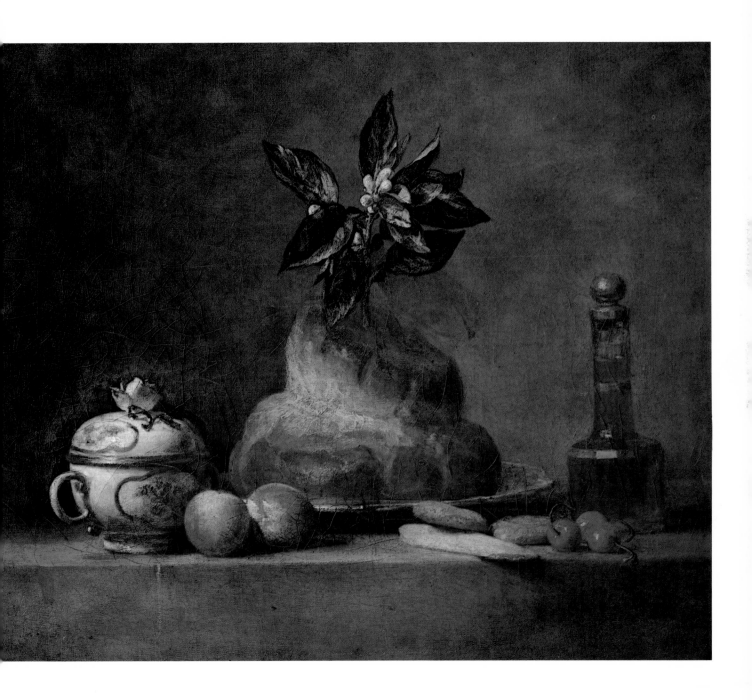

Color Plate XIX. *The Brioche,* 1763, 47 × 56 cm. Paris, Louvre. [118]

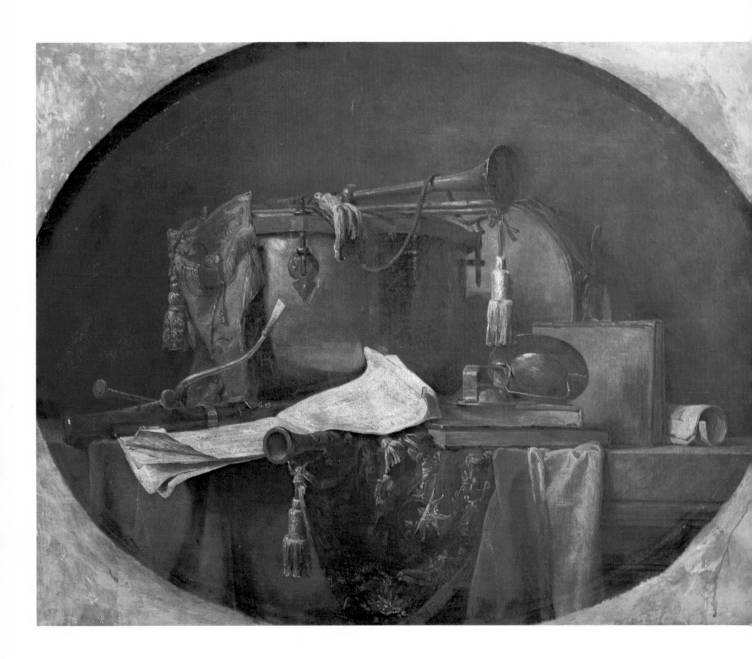

Color Plate XX. *Attributes of Military Music,* 1767, 112 × 144.5 cm. Paris, Private Collection. [127]

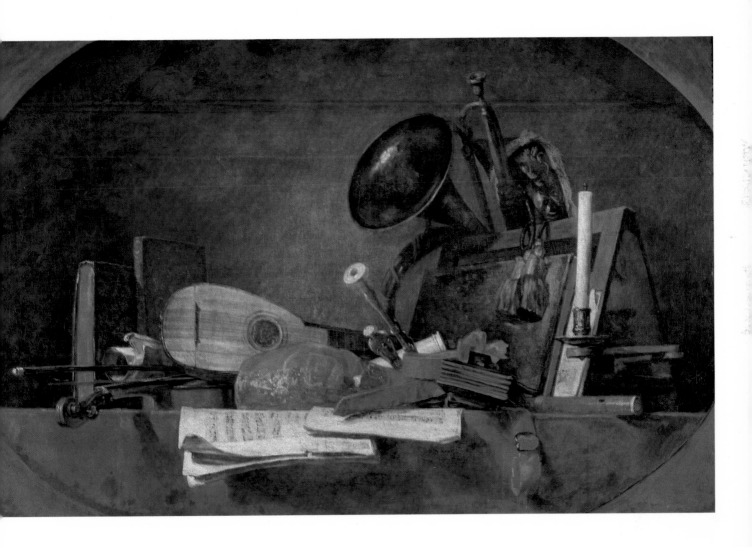

Color Plate XXI. *Attributes of Music,* 1765, 91 × 145 cm. Paris, Louvre. [124]

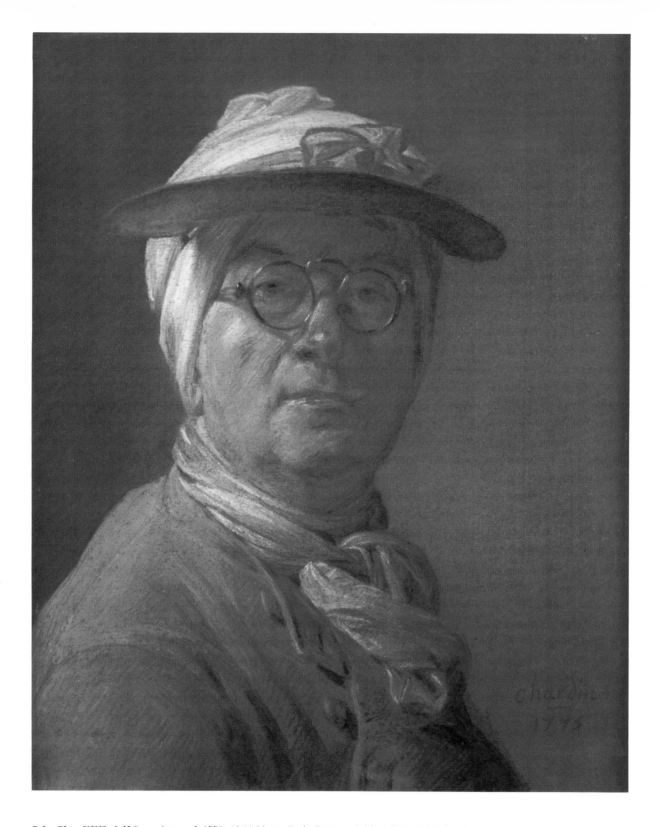

Color Plate XXII. *Self-Portrait*, pastel, 1775, 46 × 38 cm. Paris, Louvre, Cabinet des Dessins. [136]·

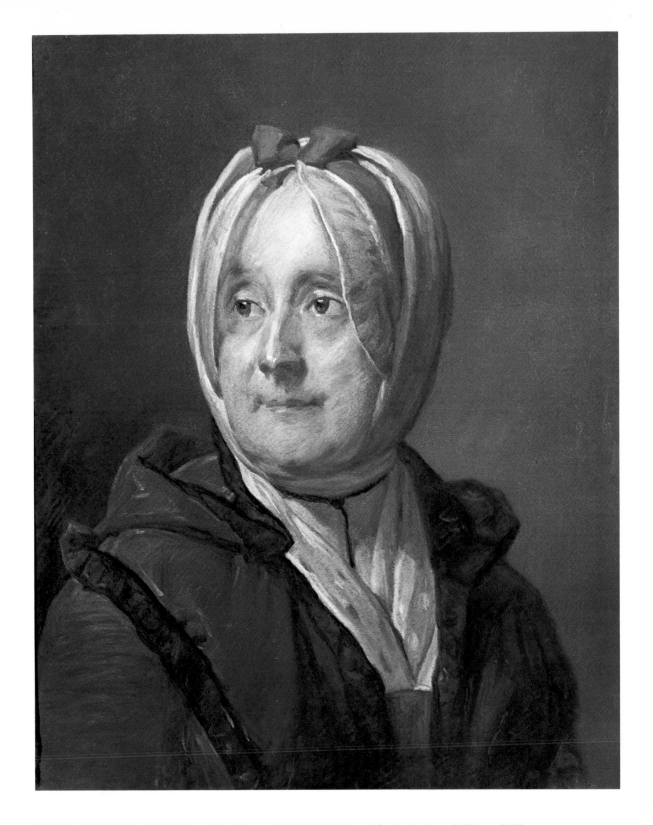

Color Plate XXIII. *Portrait of Madame Chardin*, pastel, 1776, 46 × 38 cm. The Art Institute of Chicago. [137]

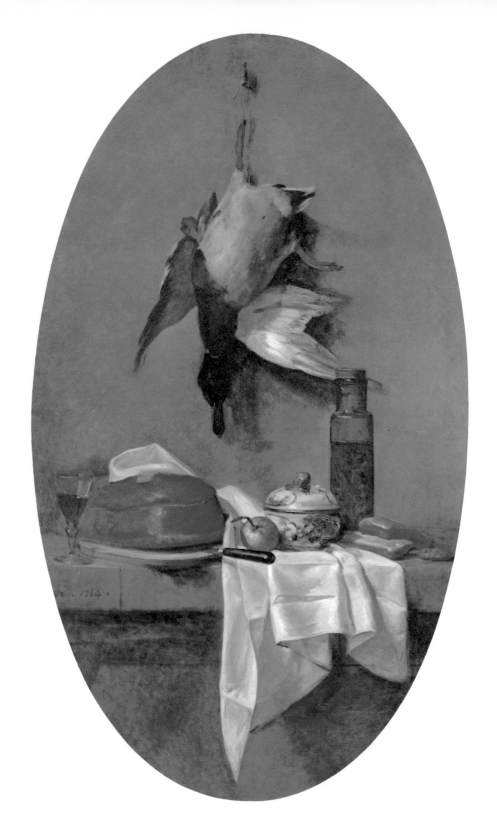

Color Plate XXIV. *Duck Hung by One Leg, Pâté, Bowl, and Jar of Olives,* 1764, 152.5 × 96.5 cm. Springfield, Museum of Fine Arts. [122]

Introduction

To the painters who are constantly reproaching writers for not being able to talk sense about pictures, and for the bland way they attribute to painters intentions they never had, I would add that if painters really do what I described, or, to be categorical, if Chardin had done all that I described, he never intended it, and it is even highly probable that he was never aware of it. Perhaps he would have been greatly astonished to learn that he had put so much fervour into conveying the animation of what we believe to be still life, had supped delight from iridescent oyster-shell cups and from cool seawater, sympathised in a tablecloth's affection for a table, in shadow's affection for light.

Marcel Proust On Art and Literature, 1896-1919

Chardin is today a famous painter. His still lifes, genre scenes, and pastels are among the most popular works of the entire eighteenth century. There is no history book without a reproduction of *Saying Grace* or *The Diligent Mother*. Few art-history books fail to include an illustration of *The Ray-Fish* or one of Chardin's self-portraits. Nothing is simpler, it would seem, nothing more "eighteenth-century," than his paintings; nothing else appears more accessible, more direct. To read commentators, who repeat the same praises and make use of the same adjectives, from the Goncourts on, there is nothing more reassuring than the world of Chardin.

But this account calls for some revision. How is one to reconcile the official painter of the Academy and the autodidact, to admire in Chardin both the perfect expression of the French spirit and an artist whose paintings could be taken by Nicolas de Largillierre for Flemish works? How is one to see in the artist both a "calculcating constructor of space" and the painter of modesty, tenderness, and human warmth? André Gide, focusing on Chardin's still lifes, was bent on "admiring only the painting." It is Chardin's genre scenes, however, that are held to be the finest images we have of the industrious and upright bourgeoisie of the artist's time.

Upon closer analysis, one feels Chardin's work has always perplexed those who admired and liked it. "This magic," Diderot admitted early on, "is

beyond comprehension." Might not Chardin be the painter of contradictions par excellence?

The first contradiction is more apparent than real. As is well known, Chardin did not receive his training from the Academy. A little hastily perhaps, some have decided he was self-taught; but this is to forget the lessons given him by Pierre-Jacques Cazes and Noël-Nicolas Coypel and the role of the Academy of Saint Luke in his formation. Nonetheless, it is true that he did not follow the customary *cursus* of the painters of his time. It is but one step from there to seeing Chardin as isolated and misunderstood, an independent — even a rebel. The step has often been taken, but one who does so underestimates the importance of Chardin's admission into the Academy in 1728. He forgets that Chardin attended Academy meetings with exemplary regularity, that he was a conscientious exhibitor at the Salons. He fails to take into consideration the fact that Chardin was the scrupulous treasurer of the Academy. And he fails to remember how flattered the painter was at having obtained living quarters in the Louvre in 1757, or that this recipient of a royal pension was appreciative of a series of "benefits" granted him by the king. Even though Chardin did not receive the traditional instruction, and even though his workmanship took his contemporaries — who could not compare it with that of any painter of the preceding generation — by surprise, the artist was indeed, in his life as in his ambitions, one of the most disciplined creators of his age.

A Fragonard ceasing to exhibit at the Salon after 1767 in order to devote himself to his personal clientele, openly turning his back on the official art world, or a Greuze hoping with his *Caracalla* (1769) to be accepted as a history painter and refusing, when he failed, any compromise with the Academy, could more justifiably be considered opponents of the artistic establishment of their time. Chardin, on the other hand, believed in the Academy. He believed in the value of its educational role (for proof, one has only to remember that he wanted to make a history painter of his son), in the social status and the financial ease it obtained for its members, and which it had procured for him. Nothing in his life — in what we know of his ideas or in his work — prefigures the Revolution. Wanting to belong to his own age, Chardin seems to have succeeded perfectly in doing so.

Detail of [27].

Detail of [126].

39

Detail of [4]

Detail of [11]

40

Detail of [20].

Detail of [99].

Was Chardin a painter in the Northern tradition, or did the French spirit find in him its perfect expression? This contradiction, raised above, was expressed even in the writings of his contemporaries. Like Greuze and Watteau, Chardin was often thought of in the eighteenth century as the "French Teniers," sometimes as his inferior (Mariette) and sometimes as his superior (*Mercure de France,* November 1753). Chardin's *Philosopher* evoked the name of Rembrandt, whom Chardin copied in one of his last works: the pastel in the Besançon museum.

But these are not the names brought up today as we seek a stylistic origin for Chardin's paintings. Those which come more spontaneously to mind are Pieter Boel and Jan Fyt for the early still lifes and Willem Kalf for the still lifes depicting kitchen utensils. And this applies as much to execution as to composition and choice of subject. There is nothing surprising about the fact that these artists, popular in the eighteenth century and well represented at the time, in Paris, inspired Chardin.

The origin of the genre scenes is also to be found among the Northern painters. As Snoep-Reitsma (1973) has shown, almost without exception the themes of Chardin's paintings have Dutch precedents which the artist could have known well, thanks to the engravings then circulating in great abundance in Paris. Although Chardin seems to have retained in his paintings the symbolic significance assigned them by Dutch painters, he reinvented compositions very different from those of his predecessors. The Northern influence is especially noticeable in his execution; it is even more palpable in the late genre scenes with their smooth, porcelain-like finish.

Is it possible to find a French source for the art of Chardin? Mariette proposes, not without some condescension, the name of the Le Nains: "I shall content myself with remarking that, rightly speaking, Chardin's talent is only a repetition of the talent of the Le Nain brothers. Like them, he chooses the simplest, most ingenuous subjects, and, to tell the truth, his choices are even better." This same Mariette, as we shall see later, introduces the names of Claude-François Desportes and Jean-Baptiste Oudry. There were in Chardin's collection two copies of the works of the former and also "a small sketch of Vateaux, painted on wood, representing a battle scene." As for Oudry, his elder by thirteen years, Chardin appears to have taken great pains to avoid him. Only two critics — Abbé Raynal in 1750 and Abbé Garrigues de Froment in 1753 — compared the talents of the two painters, without granting

preference to either one. Just the opposite, however, was expressed by the author of the entry for "illusion" in the *Encyclopédie méthodique* (1787, I, 443): "Chardin's painting was as superior to that of Oudry, as Oudry's itself was to the mediocre." The "antagonism" between the two artists mentioned by Wildenstein (1963, p. 32) is purely imaginary. There was, to be sure, friction between Chardin and Oudry in 1761 regarding the place Chardin assigned to Oudry's paintings at the Salon, but the quarrel involved Jacques-Charles Oudry, the untalented son of the great Oudry who had died in 1755.

Distrusting his contemporaries and turning prudently toward his predecessors, Chardin reinvented a style for his own use: "I have to forget all that I have seen, even the very way in which these objects have been treated by others," Cochin has Chardin saying as he stands before the first rabbit he undertakes to paint. Is it not paradoxical that this style should have become the symbol of eighteenth-century French art?

Chardin, born in Paris, virtually never left his native city: a glittering, bustling city, self-assured, the leader in every fashion. How was Chardin, a rapt, meditative painter, able to isolate himself and create in silence the least "Parisian" paintings of the entire century? This is one of the mysteries connected with this artist. One would like to imagine Chardin a solitary individual, a provincial. Nothing, however, would be farther from the truth. Chardin had friends, especially artist friends, and was aware of all that was going on at the time in Paris in the field of painting. And he could not have been ignorant of the great works of the past — more abundant in his time than they are today.

Chardin wanted to be a part of his own time, as we have said, and he truly was: he has the elegance, grace, and refinement of his century. He disguises suffering for fear of disturbing his viewer with an unbridled display. His art, conceived as a source of pleasure for the eye, avoids unpleasant spectacles of an unappetizing, everyday way of life, not out of prudishness — far from it — but out of respect for good manners. The surprising thing is that Chardin does not allow himself to be imprisoned within this framework; at the same time, however, he reveals himself the least of any artist in all the history of art. He hides his painstaking effort under the appearance of ease.

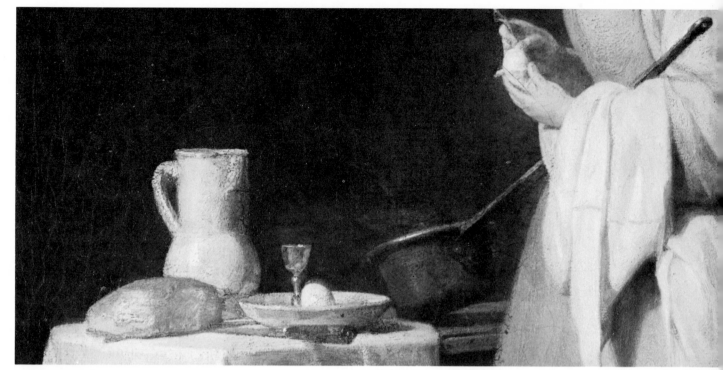

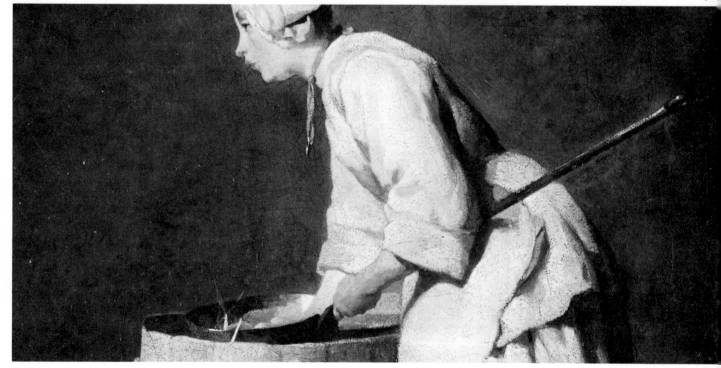

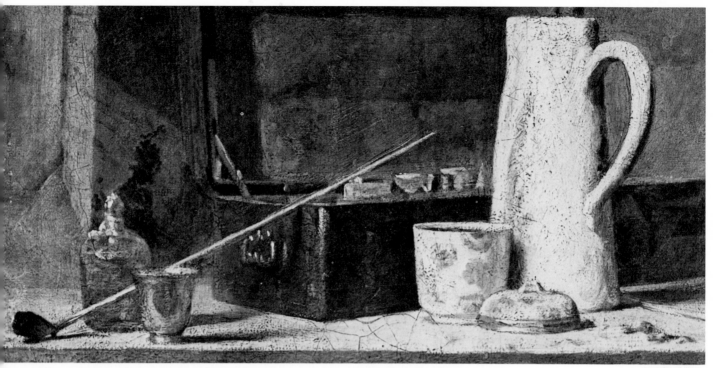

Detail of [74].

Detail of [70].

45

Chardin's contemporaries were more sensitive than we are today to a second contradiction—one that was apparent to them in Chardin's work. The importance of the hierarchy of genres in the eighteenth century, which classified painters according to the subjects they treated, is well known. This hierarchy rested on the simple and then-universally-accepted idea that the representation of *man,* above all, merited the attention of the painter, whose principal endowment was imagination. But Chardin painted what he saw. Even his genre scenes—as Mariette (1749) reminds us—were painted from life. It would appear, therefore, that he lacked the qualities so highly esteemed by his age.

Yet Chardin's contemporaries, even very early in his career, admired his still lifes as well as his genre scenes. And even though their technical virtuosity was admired most of all, the best critics of the time understood that Chardin's works were also the fruit of long study and intelligent reflection. They were hindered, however, in their admiration by the subjects Chardin took on. They recognized the artist as "superior," but uniquely in his "genre": "His paintings often create an illusion; even though this is not the greatest of all merits in painting, it is nevertheless very great" (Mathon de la Cour, 1765). Even Diderot accepted this hierarchy; one has only to reread his famous lines on the Salon of 1767: "I am not unaware that the models of Chardin, those inanimate entities which he imitates, change neither place, nor color, nor shape.... Chardin's kind of painting is the easiest." This attitude brings out the full import of the letter which Jean-Baptiste Marie Pierre, the new First Painter to the King, wrote to Chardin in 1778: "You must agree that even though you work as hard, your sketches have never involved expenditures as costly or losses of time as considerable as those of your colleagues who have pursued the Great Genres." This remark was all the more cruel for Chardin since he was the first to accept the hierarchy of genres and regretted not having the education which would have allowed him to paint "nobler" subjects. Leaving aside the fact that he had wanted to make a history painter of his son, let us recall that by taking up genre painting the artist had attempted to scale one rung of this hierarchy, and that by presenting his first portraits to the Salon he had ventured even farther, if unsuccessfully.

There is more to it than that, however. As René Demoris (1969) has justly pointed out—and the observation is important—Chardin took on the still life

as a history painter. Of course, he painted what he saw; but the objects depicted were chosen for their shapes or colors and were arranged to suit the artist. He reorganized what nature offered him, recreated it, reconstructed it, imposed on it his personal vision. This attitude is much more discernible in his work than in the majority of painters of still lifes who had preceded him. Although he accepted the hierarchy of genres, he tried to adapt its rules to humbler subjects: "Chardin's humility implies less a submission to his model than a secret destruction of it for the benefit of his painting" (Malraux, 1951). Chardin gave objects their due, conferring on the still life its title to nobility. All who emulated him — from Cézanne to Matisse, from Braque to Morandi — understood this and did likewise, in their turn.

This attitude is even more apparent in Chardin's genre scenes: "Not one woman of the Third Estate," wrote a visitor to the Salon of 1741, "goes there [to the Salon] who does not think she sees an image of her features, her family life, her straightforward manners, her bearing, her daily occupations, her moral code, the moods of her children, her furniture, her wardrobe." But is that really what Chardin was after? Nothing could be less certain. In fact, the artist constantly avoided anecdote, picturesque detail, and the historical sidelight, which those who made up legends for the engravings popularizing his works (together with certain of Chardin's *pasticheurs* in the second half of the nineteenth century), were determined to find in his compositions. Taking the course opposite that of his Flemish predecessors, Chardin selected the most banal of scenes, those which lent themselves with the greatest difficulty to narration and interpretation, and removed from them every specific reference to any contemporary event or fashion. His approach contrasts sharply with that of Greuze, the other artist greatly admired by Diderot, who sought an emotional response by choosing the most dramatic moment to paint, the one conveying the greatest tension. Chardin avoided such outbursts: by situating his scenes outside time, he invested them with an enduring value.

Chardin shows us the child at play or the adult involved in his most uninspiring, most routine, most repetitive occupation. The faces of his figures are devoid both of individuality and of expression. No movement disturbs his arrangements or intrudes upon his peaceful scenes. The world that Chardin imposes on his figures is a closed world, a stopped world (but without

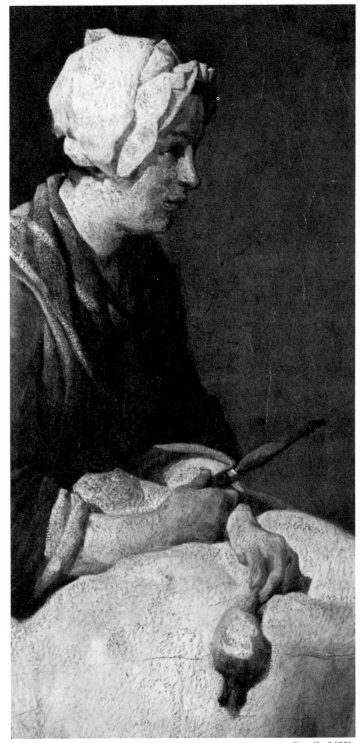

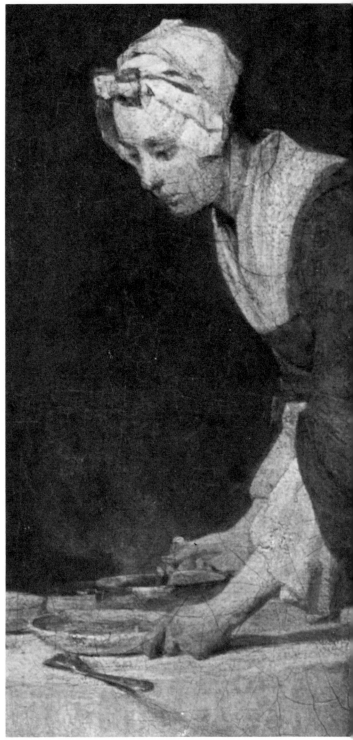

Detail of [82].

Detail of [86].

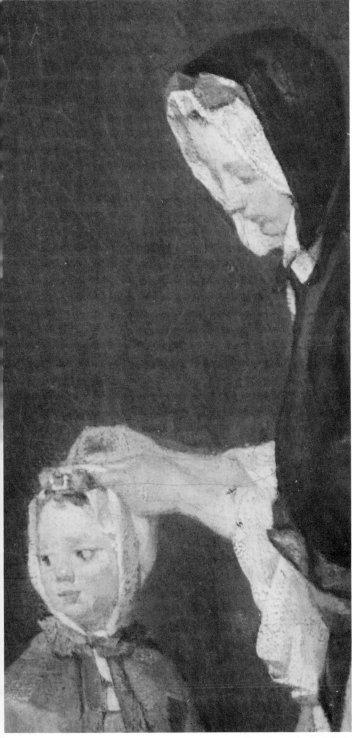

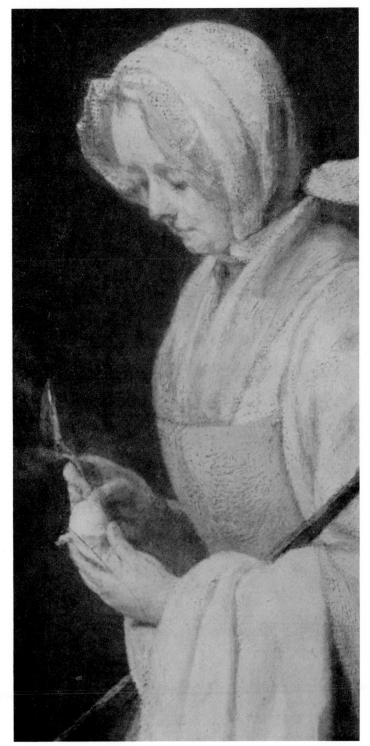

Detail of [88].

Detail of [92].

surprise), a world at rest, a world of "indefinite duration." Yet it is anything but an abstract world. The artist conveys a message through the faithful observation of attitudes—the position of a hand at rest, of an arm carrying something, of a neck made tense by effort. This hand is the hand of an adolescent, this arm the arm of a servant girl, this neck the neck of a mother already worn by life or of a draftsman bent over his work.

By choosing what seemed most banal in the world around him, by retaining whatever summed it up and characterized it, Chardin reduced what he saw to its essence. And he did this in a way that permitted his understanding, his compassion, and his sympathy for the world of childhood—whose greatest poet he may have been—to show through. Just as, when painting still lifes, Chardin had avoided simply making still lifes by giving greater importance to composition and the utilization of space, so in his scenes of family life the artist clearly departed from the laws governing genre painting.

Is Chardin a painter of still lifes or of genre scenes? After some initial groping, the artist devoted his attention first of all to the representation of game and fruit, then of kitchen utensils. A few large-size pictures mark his beginnings: the pieces done by him at his reception into the Academy—*The Ray-Fish* and *The Buffet*—and some overdoors whose function was primarily decorative. From 1733 on, or perhaps slightly earlier, and for more than twenty years, he turned to the representation of the human figure, without, however, completely abandoning still life. He showed scenes from everyday life inspired by the bourgeois or lower-class world around him. He concentrated once again on the still life before obtaining, late in his life, a commission to paint the overdoors for the châteaus of Choisy and Bellevue. A series of admirable pastels brought his career to a close.

It was a curious career, whose development is not immediately comprehensible. A remark by Mariette referring to the abrupt change in Chardin's manner and to his conversion to genre painting provides some enlightenment: "He feared, and perhaps justifiably, that if he painted only inanimate and uninteresting objects the public would soon weary of his work and that if he tried to paint living animals, he would end up much too far behind the Messrs. Desportes and Oudry, two formidable rivals who had already gone into that field and whose reputations were well established." This remark—and there are other contemporary observations to support it—reveals that Chardin was uneasy and concerned about critics. Not satisfied with a single for-

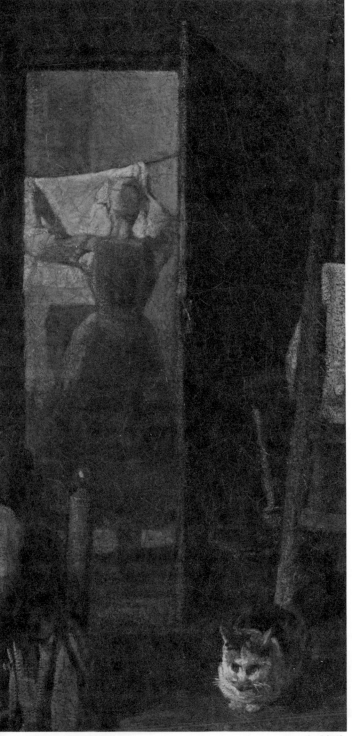

Detail of [56].

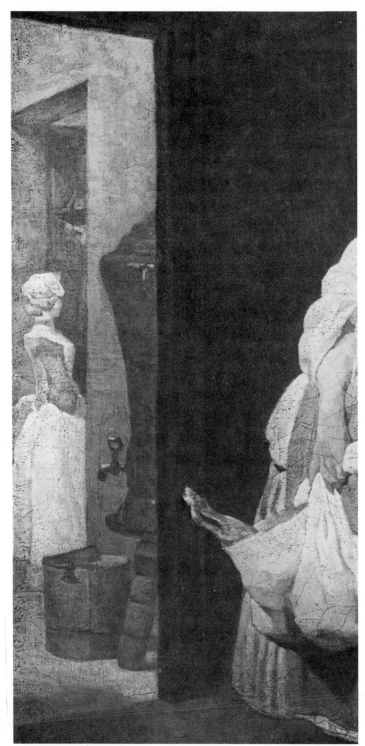

Detail of [81].

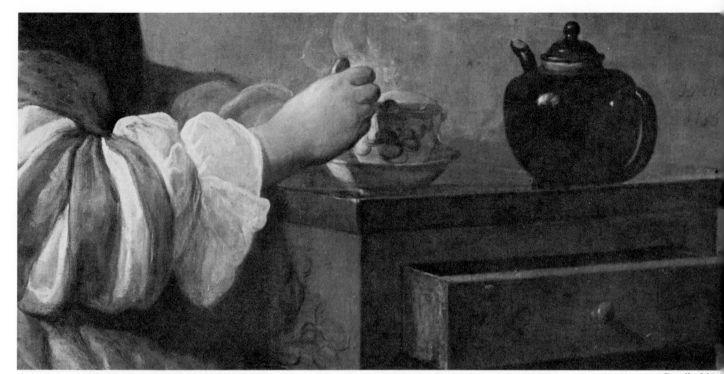

Detail of [64

Detail of [104]

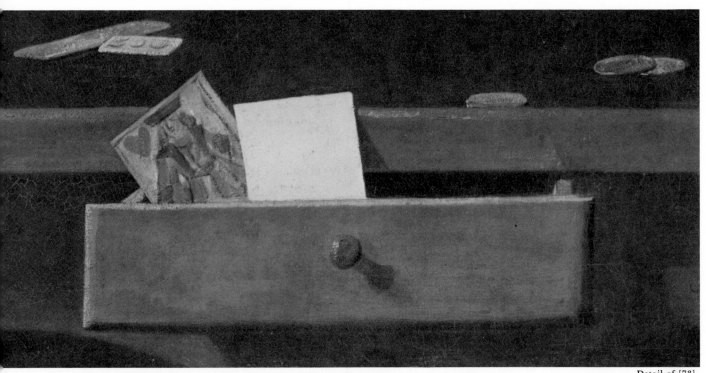

Detail of [73].

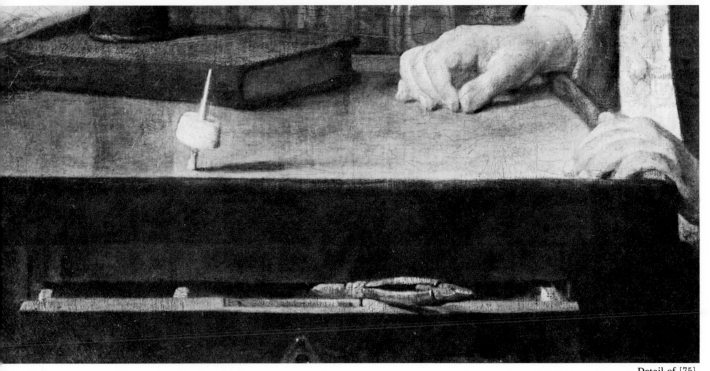

Detail of [75].

mula worked out once and for all, he unceasingly desired to explore new directions. If he never imitated his contemporaries, it was in order not to enter into competition with them, as much out of fear as out of pride; it left him free to create or invent, in the genres he did take up, a new kind of painting.

Very likely Chardin's ambition has, up to now, been underestimated. How is one to reconcile this ambition with another characteristic of Chardin's work — the artist's replicas? It is a well-known fact that throughout his entire career Chardin repeated himself. There exist numerous versions of the still lifes, especially those (sometimes half a dozen versions) depicting household utensils, as well as the most popular genre scenes. To be sure, Chardin was copied during his lifetime with his consent. But it is clear that he was fond of repeating his compositions (or that he was obliged to do so), sometimes introducing a "change" in later ones and sometimes remaining faithful to his original version.

There are two reasons for this often-troubling phenomenon. The first is quite simply a "commercial order." Replicas were commissioned from him by collectors who were not satisfied with the numerous engravings made after his genre scenes; these commissions constituted for Chardin a not inconsiderable source of income. Thus, in 1759, a friend of Chardin proposed to the Margravine of Baden, one of Chardin's numerous foreign admirers, that he could get for her, at a good price, replicas of two still lifes which the artist had just delivered to Abbé Trublet. Chardin had taken back his pictures and would copy them. The deal did not go through, but it is enlightening, nonetheless.

Another reason for multiple versions of paintings — which a visit to this exhibition will show are not always of equal quality — goes back to the fact that the enlightened public of the eighteenth century believed imagination to be the principal virtue of the painter. Chardin was not content just to copy what he saw; he organized and arranged it with great care. Therefore, the invention of new compositions "cost him dearly." Only after he had spent a long time with his arrangement did he begin to paint. It is understandable, then, that Chardin, an artist not overly endowed with imagination, saw himself constrained to repeat what he did.

Whether it be in his still lifes or in his genre scenes, Chardin depicts a very limited number of objects or figures. There are no landscapes, few living animals (Mariette has told us why), no butterflies, few birds, few flowers, and only a limited number of vegetables chosen for their forms and colors. For his figural paintings Chardin prefers women to men, adolescents and children to adults. The greatness of the painter lies in his ability to avoid monotony with this voluntarily restricted vocabulary of objects and figures.

Formerly, not enough stress has been placed on the considerable evolution of Chardin's style, on the modifications of coloring, execution, and composition that he made during the fifty-five years of his artistic career. These transformations make it possible today to construct a coherent chronology of Chardin's work which bears out his need for self-renewal, his concern and his will to find new solutions for the problems involved in the construction of space and in color harmony.

Chardin had a predilection throughout his career for certain colors—the warm browns, for example—against which nearly all his compositions stand out. But the early scumbled backgrounds, formed by nuances and gradations which evoke more than they actually describe niches or walls of stone, were followed by backgrounds that are unified, abstract, and divided sometimes by a diagonal ray of light. From the very beginning, Chardin's colors, rarely used in undiluted form, blended with one another. But with time, Chardin was to accord increasing importance to the light bathing his composition, to the reflections cast by the objects on one another. The rough and rugged touch was to be replaced by a smoother execution in which the brushstroke was to disappear in favor of a "recipe" unique for his time and which even contemporaries admired: "He repainted [his pictures] until he developed this fracturing of tones which creates greater distance from the object and establishes interrelationships with everything that surrounds it; finally he obtained this magical harmony by which he distinguished himself as a superior master....His principle...was that all shadows are one, and that somehow, the same tone must be used to break them up."

Chardin's composition was to change in the course of time in an equally apparent manner. The first paintings exhibit a precarious balance in which the laws of perspective have not yet been perfectly mastered. But then come the solid exercises in virtuosity, the variations on the theme of kitchen tools produced in the 1730s. The evolution was to continue more and more markedly

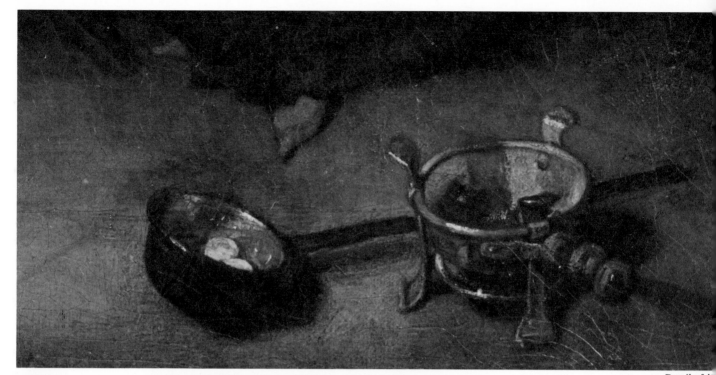

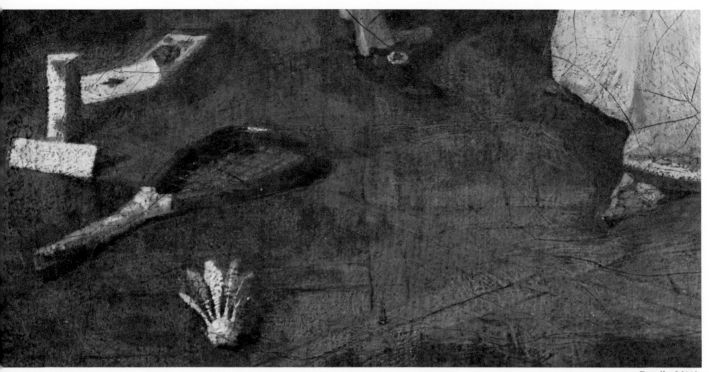

Detail of [83].

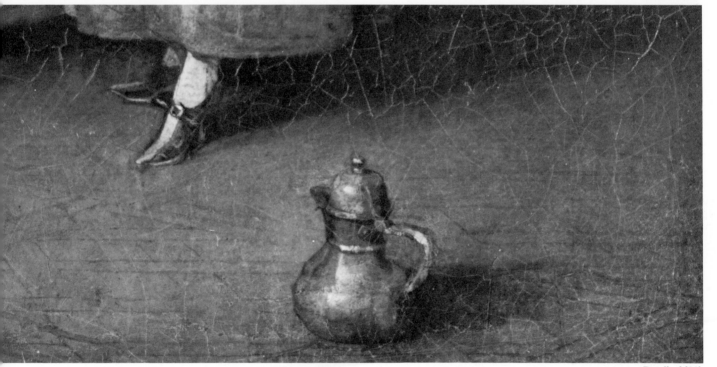

Detail of [88].

in favor of increasingly complex arrangements with an increasingly refined counterpoint.

It is in the utilization of space, however, that Chardin's evolution was to be particularly apparent. As time went on, Chardin was to reduce the scale of the game, fruit, utensils, and figures he represented and to give growing importance (might one say significance?) to the void which dominates his composition. He was to move farther and farther away from what he depicted, as if to enable us to grasp at a single glance both composition and harmony.

This slow and progressive evolution, as palpable in the still lifes as in the genre scenes, is the product of reflection renewed by Chardin each time he began another picture. It witnesses as much to a deepening of his art as to the artist's constant search for perfection. In this search, Chardin placed stringent demands on himself; he worked slowly and painstakingly in granting a privileged placed to composition and construction. Unlike a Cézanne, in whose work the search shows, everything in Chardin seems to fall naturally into place. This "gently imperious simplifier" disguises his discoveries, refuses to let any of his findings show through. Soothing and a delight to the eye, his art appears simple. But let us not be deceived.

Granted, Chardin was not a theoretician or a man of doctrine, even though he "possessed an unusually forceful means of expression to communicate his ideas and make them understood, even in those aspects of art least amenable to explanation, such as the magic of color and the various causes of the effects of light." In his *Salon* for 1765, Diderot has Chardin speaking at length (the essence of this text is referred to in the Critical Evaluation of Chardin); but nothing in this celebrated page enables one to define Chardin's general conception of painting, although it demonstrates Chardin's glibness, his good sense, conscientiousness, and humility ("he who has not experienced the difficulty of art makes nothing worthwhile"). Even though he speaks of the difficult craft of the painter, and sometimes of his art, Chardin does not seem to have been a man of ideas. One is struck, as has been said, however, when looking more closely at his works and studying them more carefully, by the will and the ambition, the desire for renewal on which they rest.

Yet that is not all. In 1753 Abbé Le Blanc observed: "He knows how to capture what would escape anyone else." Indeed. From *The Ray-Fish* [7] to the *Jar of Olives* [114], from the Rothenbourg *Musical Instruments* [27, 28] to those he painted nearly forty years later for Bellevue [126, 127], or again,

from *The Scullery Maid* [79] to *Meal for a Convalescent* [92], how far he has come!

To better attain genuine fidelity to an object or a body, to arrive at its truth, Chardin moved farther and farther away from its detailed representation or appearance. Increasingly, he was to violate the reality, the faithful image — with full knowledge, we believe — in order to better reveal the beauty of the objects and the bodies around us. His peerless eye was not to be the victim of his talents. Slowly, as in everything he undertook, step by step and willingly, Chardin learned how to place his technical ability at the service of a demand that is the very essence of painting. Compare, for proof, the first and the last *Silver Goblets,* or the loaves of bread in *The Return from Market* and the loaf, painted ten years afterward, in *Meal for a Convalescent.* It is no longer a particular goblet or loaf of bread which Chardin shows us, but goblets and loaves of bread in their enduring truth. Chardin was never to push this search for a reconciliation between resemblance and stylization further than in his last self-portraits in pastel.

In a little-known text whose title, "Some Reflections on the Renunciation of the Subject in the Plastic Arts" (*Verve,* I, December 1937, pp. 7-10), is more relevant than ever, André Gide wrote: "Likewise, it was still lifes by Chardin or Cézanne that I first studied most willingly. There at least I was quite sure I was admiring only the painting.... The kind of ecstacy into which contemplation of these paintings plunged me remained pure, as pure as my rapture upon hearing a concerto or a trio by Mozart. I thought, and am still close to thinking, that emotion must spring immediately from masses, colors, and forms in painting, and from harmony, rhythm, and melodic line in music, without any appeal to the intellect which enters here only as an intruder...." He added farther on: "I find in a *Basket of Strawberries* by Chardin, for example, the contemplation of a spiritual concern as grave as in his *Saying Grace.*"

One has the feeling the writer is experiencing some difficulty. Is Chardin a dispassionate arranger of space or a painter who grants primacy to emotion? In him there is always this ambiguity that many writers and painters have sensed: "The Chardin genre has, in my opinion, the expression which characterizes simplicity and goodness," wrote Vincent Van Gogh to his brother Théo in 1885. And André Malraux remarked, *"The Return from Market* is an inspired Braque, but clothed just enough to fool the spectator."

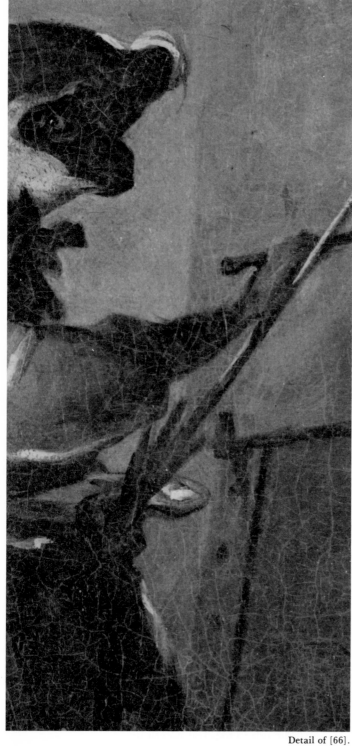

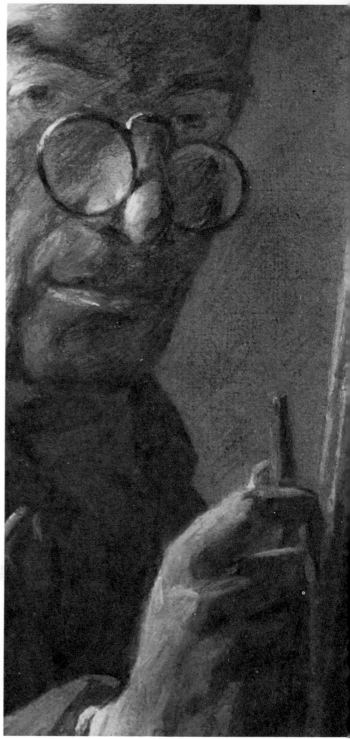

Detail of [66].

Detail of [139]

Now a precursor of the cubists, painter of modernity, and now the painter of tenderness and restrained feeling, symbol of the eighteenth century, Chardin cannot be pigeonholed. Each age has seen him with its own sensitivity, has retained those eighteenth-century texts which suited it, and has loved him in its own fashion.

Let us cite two more quotations, the first taken from André Gide's book on Poussin (1945, introduction unpaginated): "And, without doubt, what succeeds in moving me as much as the most expressive figure is a 'still life' by Chardin, a *dish of plums* or a *copper water urn*. The substantial gravity in one of these paintings and the attention lavished on the object are as contemplative as the spiritual concern of a meditation by Descartes." The second quotation is taken from Chardin himself, as reported by his faithful friend Charles-Nicolas Cochin (1780): "One uses colors, but one paints with feeling." One can find in these two quotations an explanation for the confusion of critics before the works of Chardin when they no longer wish to be descriptive and literary.

Chardin's work lends itself poorly to analysis through language: "The first glance generally tells the spectator all he has to know and still gives him the sense of a complexity which calls for analysis." But all he can analyze are the technical means—not the complexity or the richness of the work. Still more resistant to analysis are the voluptuousness, the sensuality, the lingering emotion, the tenderness, and the gravity which set Chardin apart and place him in the ranks of the great painters.

Before undertaking preparation of this catalog, even though I was aware of Chardin's genius, I wondered whether his universe was not a little narrow. I wondered whether a body of work which appeared so repetitive would not produce an impression of monotony. I am convinced today of the contrary. Because he varies imperceptibly his subtlest discoveries, Chardin asks that one give him time, that one look at his paintings slowly. That, too, is my hope—that the viewer will savor them one by one. The world of Chardin— silent and discreet, patiently constructed—is not discovered in an instant. And that is the way Chardin wanted it to be.

Some Important Dates

The following is a brief chronological survey of the significant events in the life and work of Chardin. The numbers in brackets indicate catalog numbers of works in the present exhibition. Published in French at the back of this catalog is a more detailed biography which includes references to original archival documents, other published sources, or new works still in manuscript.

1699

2 November: Birth in Paris of Jean Siméon Chardin, son of Jean Chardin (died 1731) and of Jeanne Françoise David (died 1743). His father was a master cabinetmaker specializing in billiard tables.

3 November: Baptism in the parish of Saint-Sulpice (both during his life and after his death, many writers wrongly called him Jean-Baptiste Siméon). His godfather, Siméon Simonet, was a cabinetmaker and his godmother, Anne Bourgine, the wife of a cabinetmaker. By his first wife, Agnès Dargonne (died 1693), Chardin's father had five children, and by his second wife, four: the artist; Juste (1702-1794); Noël Sébastien (1697-?); and Marie Claude (1704-?). Before 1720 the Chardin family was living at 21 rue de Four, at the corner of the rue Princesse in Paris.

1720

One of the witnesses at the wedding of Chardin's younger sister, Marie Claude, is the painter Noël-Nicolas Coypel (1690-1734).

1723

6 May: First marriage contract between Jean Siméon Chardin and Marguerite Saintard (1709-1735) who has a large dowry of 3000 *livres;* the painter himself has 2000 *livres,* from which he has to pay his admission fee to the Academy of Saint Luke as a master painter. Witnesses for the two parties come from quite different backgrounds: Chardin's relatives are cabinetmakers, racquetmakers, musicians, and merchants; his fiancée's relatives are lawyers and parliament officers, and her friends include a cardinal's secretary and a lieutenant colonel in the army.

1724

3 February: Is received as master painter in the Academy of Saint Luke, the venerable Paris guild of painters whose rival is the more powerful Royal Academy of Painting and Sculpture. Although nothing is known of his early training, Chardin undoubtedly spent time in the studios of Pierre-Jacques Cazes (1676-1754) and of Noël-Nicolas Coypel.

1726

This date appears in the 1743 print by Pierre Louis Surugue *fils* (1716-1772) after Chardin's *The Monkey as Painter* (see [66]).

1728

June: Exhibits *The Ray-Fish* [7] at the Place Dauphine.

25 September: Is admitted to the Royal Academy and is accepted the same day as a "painter skilled in animals and fruits." He offers to the Academy his *Ray-Fish* [7] and *The Buffet* [14].

1729

5 February: Resigns his mastership in the old Academy of Saint Luke.

5 December: A fireworks display is held at Versailles to celebrate the birth of the Dauphin, son of Louis XV. Following (with others) the designs of J. A. Meissonnier (1675-1750), Chardin worked twenty-eight days decorating the scenery — for which he received 250 *livres,* 10 *sols.*

1730

15 February: Receives six *livres* from Count Conrad-Alexandre de Rothenbourg for the fruit used in painting dining-room overdoors.

31 October: Receives 360 *livres* for three overdoors representing *Music* and *Instruments.*

1731

17 January: Chardin and Marguerite Saintard dissolve the marriage contract of 1723, his fiancée having had financial reversals.

26 January: Second marriage contract in which Marguerite Saintard's dowry is only 1000 *livres;* Chardin now brings 2500 *livres.*

1 February: Marriage of Chardin and Marguerite Saintard at Saint-Sulpice. Chardin is 31 years of age, his wife 22.

2 April: Death of Jean Chardin, father of the painter.

8 August: Receives 300 *livres* from Count Rothenbourg for two pictures "representing the arts displayed on the cabinets of his Excellency's library...."

18 November: Baptism of Jean Pierre Chardin, son of the painter.

This year Chardin participates with others in restoring the frescos in the François I gallery at Fontainebleau, under the direction of Jean Baptiste Vanloo (1684-1745).

1732

June: Exhibits at the Exposition de la Jeunesse, Place Dauphine [27, 28, 33].

1733

3 August: Baptism of Marguerite Agnès, daughter of the painter.

This year Chardin probably paints his first pictures with figures [54, 55].

1734

June: Exhibits sixteen pictures at the Place Dauphine, including [54].

During 1734 Conrad-Alexandre de Rothenbourg paid Chardin 480 *livres* for six pictures painted earlier.

1735

13 April: Death of Marguerite Saintard, wife of the painter.

3 October: Chardin takes back from the heirs of Conrad-Alexandre de Rothenbourg his *Philosopher* [62], probably for lack of payment.

1736/1737

Death of Marguerite Agnès, daughter of the painter.

1737

August: Exhibits eight figural pictures, including [55, 56, 62, 72, 73], at the Salon du Louvre (it had not been held since 1704, except for 1725).

18 November: Estate inventory of Chardin's wife detailing the furniture and objects that are found in many of his pictures.

1738

May: First advertisement for a print after a Chardin painting [54] in the *Mercure de France* (p. 955).

August-September: Exhibits nine pictures at the Salon, including [54, 68, 69, 75, 76]. See also [79].

Andrew Hay sale in London — to our knowledge, first public sale (with catalog) that includes a Chardin painting *(A Girl with Cherries)*.

1739

August: Exhibits six pictures at the Salon, including [64, 83]. See also [59, 80, 82].

1740

August: Exhibits five pictures at the Salon, including *Saying Grace* [86] and *The Diligent Mother* [84].

27 November: Is presented to Louis XV at Versailles and offers him *Saying Grace* and *The Diligent Mother* (today in the Louvre).

J. Faber (1684-1756), an English printmaker, publishes in London a mezzotint after *The Young Draftsman* [76] exhibited in the Salon of 1738 (no. 117).

1741

August: Exhibits *The Morning Toilet* [88] and *The House of Cards* [71] at the Salon.

December: The *Mercure de France* (p. 2697) announces the sale of a print by Le Bas (1707-1783) after *The Morning Toilet.*

1742

January to June: Chardin is ill. He shows nothing at the Salon.

1743

January: Two color prints by Jacques Fabien Gauthier-Dagoty (1716-1785) after *The Embroiderer* [68] and *Young Student Drawing* [69] advertised in the *Mercure de France* (p. 149).

August: Exhibits three works at the Salon.

28 September: Is elected to the position of Counsellor to the Royal Academy of Painting and Sculpture.

7 November: Death of Jeanne François David, mother of the artist.

1744

26 November: Marriage of Chardin and Françoise Marguerite Pouget (1707-1791) at Saint-Sulpice. A wealthy widow with no children by her first husband, Charles de Malnoé, she is 37 years old. Juste Chardin, cabinetmaker and the painter's brother, and Jacques-André-Joseph Aved (1702-1766), the portrait painter, were witnesses for Chardin.

1745

6 October: Letter from Tessin (1695-1770) in Paris to Scheffer (1715-1786) of Stockholm indicates that the royal princess, Luise Ulrike of Sweden, very much wanted two Chardins of the same size as those painted for Tessin on the subjects of *Éducation douce* and *Éducation sévère.* Subsequent correspondence reveals that: Chardin wanted more than a year to do the pictures, his painstaking slowness was well known, and he worked on only one painting at a time.

21 October: Birth and baptism of Angélique Françoise, daughter of the painter; she dies at an early age.

During the year, Chardin's pictures appear at public sale in France for the first time, in the estate of Antoine de La Roque (1672-1744), and include [55, 56, 68, 69, 83]. See also [80].

1746

August: Exhibits two portraits and two other pictures at the Salon, including [90]. See also [89].

From 1746-1748 there is much correspondence between Tessin and Scheffer about Chardin (and Boucher) pictures for the new gallery at Drottningholm Palace.

1747

Chardin now lives at 13 rue Princesse, in a house belonging to his second wife.

August: Exhibits only one picture at the Salon [60].

1748

August: Again exhibits only one picture at the Salon [94].

1751

August: Exhibits *The Bird-Song Organ* [93] at the Salon.

1752

3 February: The king pays Chardin 1500 *livres* for *The Bird-Song Organ* (see [93]).

September: The painter receives his first royal pension of 500 *livres*.

1753

August: Exhibits nine pictures, four of which are still lifes, at the Salon; included are [22, 62]. See also [94, 95].

1754

6 April: Jean Pierre, son of the painter, is admitted to competition for the Grand Prix.

31 August: Jean Pierre wins the Academy's First Prize for Painting.

1755

22 March: Is unanimously elected treasurer of the Academy; he begins his duties in May.

In August he is put in charge of the hanging of the Salon, where he shows two pictures (see [33]).

24 December: Jean Pierre receives an award of 75 *livres* as *élève royal protégé.*

Chardin's pension is still 500 *livres.*

1756

12 January, 3 May, 2 July, 12 October: Jean Pierre is awarded 75 *livres* each date.

Chardin's pension is increased 500 *livres.*

1757

27 May: The king grants Chardin living quarters in the Louvre. Here he exhibits six paintings at the Salon, including [102, 103]. See also [79].

17 July: Carle Vanloo, Director of the Royal School for Sponsored Students, proposes Jean Pierre Chardin for a pension to the French Academy in Rome, which he receives 13 September.

A terrible quarrel breaks out between Chardin and his son over the inheritance from Marguerite Saintard. Originally heir to his mother's and young sister's estates, Jean Pierre charges that his father misled him into renouncing his inheritance.

1759

March: A silver goblet is stolen from Chardin's quarters in the Louvre and is sold on the Pont Neuf for 30 *livres.*

August: Exhibits nine pictures, seven of which are still lifes, at the Salon; included are [106, 108, 109].

1761

13 July: Is officially made responsible for the hanging of the Salon. This is a delicate responsibility, and a quarrel erupts between Chardin and Oudry *fils* over the installations. Diderot, in his Salon criticisms, emphasizes the prankishness with which his friend Chardin carried out his duties.

August: Exhibits eight pictures, including [110, 111, 115].

11 November: Natoire, Director of the French Academy in Rome, complains to Marigny about the slowness and lack of ability of Jean Pierre Chardin.

1762

January: Lépicié's engraving of Chardin's *House of Cards* [71] is reproduced in *British Magazine* (p. 32) with interpretive text. This print was to be given to each of the magazine's subscribers.

21 July: Jean Pierre is kidnapped by pirates during his return voyage to France.

1763

May: Receives 250-*livre* increase in pension for taking charge of hanging the Salons.

August: Exhibits six pictures, including [114, 117, 119].

1764

28 October: Receives the commission for three overdoors for the Château de Choisy [123, 124], through the request of his friend Cochin.

1765

30 January: Is unanimously received as an honorary associate of the Academy of Sciences, Literature, and Arts of Rouen.

August: Exhibits the Choisy overdoors [123, 124] at the Salon, along with several other paintings, including [120, 121, 122].

1766

5 July: Cochin proposes to Marigny that Chardin paint two overdoors for the Château de Bellevue.

Catherine II (1729-1796), Empress of Russia, commissions *Attributes of the Arts* [125] for the Academy of Fine Arts in St. Petersburg.

1767

26 June: Jean Pierre Chardin arrives in Venice; this is the last sure date concerning his whereabouts. He is believed to have committed suicide sometime between 1767 and 1769.

August: Exhibits the two Bellevue overdoors [126, 127] at the Salon.

1768

March: Receives 300-*livre* increase in pension.

July: Payment for both Bellevue overdoors is approved at 1600 *livres;* the three for Choisy, at 2400 *livres.*

1769

August: Exhibits nine pictures at the Salon, including [130, 131, 132].

September, October: Despite illness, Chardin attends regular meetings of the Academy.

1770

July: The king increases Chardin's pension by 400 *livres.*

Jean-Baptiste Marie Pierre becomes director of the Academy. The influence of Cochin *fils,* close friend of Chardin, declines.

1771

July: Receives payment for the Choisy and Bellevue pictures, 460 *livres* in cash and 3340 *livres* from customs' duties and salt taxes.

August: Exhibits four pictures, three of which are pastels, at the Salon; included are [133, 134].

1772

February: Ill with kidney stones.

1773

August: Exhibits two pictures, one a pastel, at the Salon (see [55]).

The Chardins sell their house at 13 rue Princesse.

1774

30 July: Resigns as treasurer of the Academy and thus is no longer in charge of hanging at the Salon.

1775

August: Exhibits three pastels at the Salon, including [135, 136].

1777

March: Tries unsuccessfully to intervene with d'Angiviller, director of royal construction, on behalf of his faithful friend Cochin, in order to save him from complete disgrace.

August: Exhibits one painting [138] and three pastels at the Salon.

1778

30 May: Presents the Academy with a collection of prints after his works bound as a volume.

This year Chardin receives a pension of 1400 *livres.*

1779

August: Exhibits several pastels at the Salon. He offers one of them to Madame Victoire, daughter of Louis XV; she makes him a return gift of a gold snuff box.

2 October: Chardin is too ill to go to the meeting of the Academy.

6 November: Chardin is dangerously ill.

16 November: The edema in his legs spreads to other parts of his body.

6 December: Chardin dies at nine o'clock in the morning in his quarters in the Louvre, at 80 years of age. He is buried the next day at Saint-Germain L'Auxerrois.

18 December: Estate inventory of Chardin.

1780

4 March: Deposition stating that Chardin's correct name is Jean Siméon.

6 March: Chardin estate sale, Hotel d'Aligre. His widow moves to a cousin's home on the rue Renard-Saint-Saveur, where she dies in 1791.

Objects from Chardin's Household

Jean Siméon Chardin lived all his life in Paris, seldom venturing far from the city. His travel to Fontainebleau in 1731 to take part in the restoration of the frescos in the gallery of François I can hardly be called a journey. Furthermore, nothing indicates that he ever went to Rouen, where the Academy admitted him to membership in 1765, or even that he visited his friend the draftsman Desfriches in Orléans.

He was born on the rue de Seine and raised in his parents' house. In 1720, or a little before, the Chardin family moved to a large house at 21 rue du Four, at the corner of the rue Princesse. More than twenty years later (1744), when Chardin had married for the second time, he lived not far away in a house belonging to his wife, at 13 rue Princesse. It was not until 1757 that he left the district of his birth, Saint-Germain-des Prés, to occupy, alongside the greatest painters of his time, an apartment in the Louvre. It faced the church of Saint-Thomas (now destroyed), and opened onto the rue des Orties. There Chardin was to die twenty-two years later. His wife would then move to a cousin's house on the rue du Renard-Saint-Sauveur (near the rue Greneta in the second arrondissement) taking her furniture, some pictures, and mementos of her husband.

We have glimpses into Chardin's private life, thanks to several important inventories which allow us to study his growing prosperity. Four archival documents in particular deserve mention: (1) Chardin's second marriage contract with Marguerite Saintard of 26 January 1731 [Archives Nationales, Minutier Central, étude CXVII, liasse 377]; (2) the estate inventory of Marguerite Saintard, who died in 1735, dated 18 November 1737 [Archives Nationales, Minutier Central, étude CXVII, liasse 417] — by far the most complete of the four; (3) the artist's estate inventory dated 18 December 1779 [Archives Nationales, Minutier Central, étude LVI, liasse 246]; and (4) the estate inventory of Chardin's second wife, Françoise Marguerite Pouget, 6 June 1791 [Archives Nationales, Minutier Central, étude XCIX, liasse 730, unpublished]. These inventories list pictures, furniture, objects, plates and dishes, silver, household linen, various papers, rent contracts, etc. For our purposes here, we have selected only the objects and furniture adequately described in the inventories. It was interesting to try to recognize these objects and items of furniture in the Chardin paintings in this exhibition! Each item is followed by the catalog numbers of the pictures in which it can be found; the boldface number refers to the picture whose detail is illustrated.

The objects can be divided into three types. First, there are valuable and unusual objects which appear only once in Chardin's work: the silver soup tureen [20], the Chinese incense burner [29], the silver centerpiece [14]; and things which appear only a very few times, such as the bronze ewer [27, 123, 125]. Since these items do not appear in the inventories—Chardin probably having borrowed them for the occasion—we will not discuss them here, nor the glassware which was the subject of an article in 1959 by James Barrelet.

Second, there are the very common objects (pots, casseroles, mortars, etc.), obviously too minor to be precisely identified in the inventories.

The third category of objects is more difficult to define: occasionally represented by Chardin, but continually described in the inventories, these are the corner cupboards of rosewood, the clock with its marquetry case, the silver goblets, the copper water urn, and so on.

We do not want to suggest Chardin's way of life, nor to study it by means of his pictures (this was the subject of a 1959 article by Georges Wildenstein). Neither do we seek to draw up a catalog of all the objects that appear in the painter's work. Rather, we have chosen simply to illustrate some of the things mentioned in the inventories. Our choice is therefore imperfect and at times arbitrary, but we believe that the visual comparison of certain objects and furniture appearing in the painter's pictures—associated with dated inventories, even though conjectural in some instances—might enable the viewer to enter into greater intimacy with the artist.

Kitchen Utensils

Copper Urn. "A copper water urn provided with a lid, and rings also of copper holding two buckets of water with its faucet of *potin*" (alloy of copper) "resting on a base of *bois de chine*, valued at twenty-five *livres*" (1737). This household water reservoir is mentioned in the inventories of 1731 and 1737. [53, 55, **57,** 80, 81]

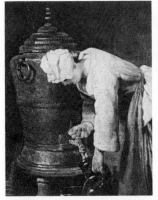

Pot. "Two medium [pots] and one small pot" (1779). Probably in the inventories of 1731 and 1737 as well. There are three types: brass, copper, and tinned copper. [7, 34, 35, 36, 37, **38,** 39, 40, 42, 43, 44, 45, 47, 48, 49, 50, 51, 52, 55, 57, 78, 79, 82, 102, 105]

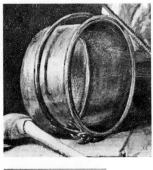

Skimmer. "Three skimmers" (1737). This utensil is also mentioned in the inventory of 1779. [7, 34, 35, 37, 38, 39, 42, **43,** 45, 46, 79, 102]

Water Pitcher. Lead-glazed earthenware; could be part of the "household utensils" in the inventories of 1731, 1737, 1779. [7, 36, 43, 46, **47,** 48, 49, 50, 51, 102, 105]

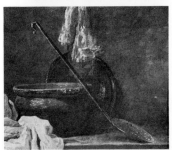

Small Casserole. Lead-glazed earthenware with glazed interior; could be part of the "household utensils" in the inventories of 1731, 1737, 1779. [40, 47, 50, **51,** 79, 102]

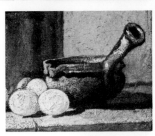
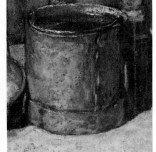

Bucket. Could be part of the "household utensils" in the inventories of 1731 and 1737, or could be the "iron-bound bucket" in the inventory of 1779. [**53,** 55, 57, 80, 81]

Mortar and Pestle. This object, which seems to be of wood, was used to grind salt or spices; it appears frequently in the artist's work. In the inventory of 1779 only a "stone mortar" or a "little mortar of white marble" is mentioned. [7, 36, 37, 39, 40, **52,** 53, 102]

Wooden Spice Box. Found in many of Chardin's pictures, this object is not mentioned in the inventories — perhaps because it is so small and common. [7, 12, 38, 43, 46, 48, 49, 50, **51,** 102, 105]

Large Water Bowl. This very common household object does not appear in the inventories. [56, 58, **82**]

Brazier. Coals placed in the opening allowed a pan resting on lugs to continue cooking. This very common object does not appear in the inventories. [37, 41, 55, **57**]

Furniture

Small Serving Table. Done in "vernis Martin" to imitate Oriental lacquer, this table had a marble top. "A little serving table in reddish wood" (1731). It is also found in the inventory of 1737. [64, 103, **104**]

Corner Cupboard. "Two rosewood corner cupboards with two doors, each decorated with inlays, bronze mounts, and rose marble tops..." (1737). These two pieces belonged to Chardin from 1731; they are probably the same as those in the inventory of 1791. [**90**]

Gaming Table. "A *table à cadrille* covered in green cloth" or "a gaming table of beechwood, covered in green cloth" (1791). This square table, accommodating four persons, contained a drawer in the center of each side. It is found in the inventories from 1737 on. [71, **73**, 83]

Chair Covered in Siamoise. *(Siamoise* was an inexpensive fabric of linen and cotton, striped in bold colors and manufactured in Rouen.) Could be among the numerous *capucine* chairs covered in fabric (often blue serge) mentioned in various inventories. [**86,** 87, 89]

Chair. *"Capucine*-style chair in walnut" (1737). We find chairs or armchairs of this type in all the inventories as *"à la capucine"* (i.e., in unpainted, turned wood) or in wood with "varnished cane seat." [56, 64, 68, 72, **82,** 84, 91, 94, 95]

Child's Armchair. This child's chair is not found in any inventory; yet it was represented by Chardin numerous times—as an armchair [85, 86, 87, **89**], or as a side chair [56, 58].

Carpet. Two large "Turkish carpets" served as coverings for oak tables in Chardin's studio in 1737. [**29**, 54]

Various Objects

Clock. In 1731 Marguerite Saintard brought to the joint estate "a clock in its marquetry case." In her estate inventory of 1737 there is "a clock with enameled dial in its marquetry case, ornamented in bronze, made in Paris by Fiacre Clément." In the 1779 and 1791 inventories the same object by "Fiacre Clément and Jacques" (about whom we know nothing) is mentioned again. [**88**]

Sconces. "Two fireplace sconces with two sockets each, in bronze with leaves of the same metal" (1737). Mention of these sconces is made in the 1779 and 1791 inventories. [**84**]

Silver Goblet. "Two goblets also footed...entirely of coin silver" (1737). These goblets are mentioned again in the 1779 and 1791 inventories. [8, 9, **10**, 11, 12, 13, 74, 128]

Spirit Brazier. "A spirit-brazier of silver plate" (1779). This brazier with alcohol burner was sometimes accompanied by a little pan. Chardin also represented it in copper. [86, 87, 89, 103, **104**]

Cruet Stand. "A cruet stand and covered cruets" (1779). The cruet stand, usually in silver, held two glass bottles with silver mountings. [103, **104**]

Coffeepot. "Coffeepot...entirely of silver" (1791). This pear-shaped pot could have been silver or pewter. [**88**]

Water Jug and Bowl. This water jug (with vermeil mounts?) was most certainly one of the numerous "covered water jug[s]... and bowl" (1737) mentioned up to 1791. [**111**, 117]

Teacup. This piece was probably part of the "ten-piece set of mantelpiece ornaments...four saucers, four cups..." (1737). [14, **64**, 84, 95]

Meissen Covered Bowl. This bowl could belong to the "various porcelains" of the 1779 inventory. [114, **122**]

Covered Bowl. This object could be part of the table service "in common earthenware" (1779) on Madame Chardin's buffet in the hallway of the Chardin's quarters in the Louvre. [**103**, 104]

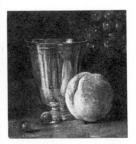

Principal Collectors of Chardin

This short list makes no attempt to name every Chardin collector from the eighteenth century to the present. Its purpose, above all, is to evoke the personalities of certain owners of Chardin's paintings, but it excludes art dealers—an admittedly arbitrary decision, however, since their importance should by no means be underestimated.

Some of these collectors played an essential part in Chardin's rise to fame and in the rediscovery of his art around 1840 to 1850, at a time when art historians had not yet understood the originality and greatness of French eighteenth-century painting. Some of them are well-known figures, others have been neglected until now (Rothenbourg, Pigalle, Louis-Joseph Le Lorrain, Barroilhet, Rouillard, et al.).

The most striking aspect of this list is the large number of eighteenth- and nineteenth-century artists who owned works by Chardin. Many of them were major painters (Aved, de Troy, Jean-Baptiste Vanloo, Louis-Joseph Le Lorrain, Dandré-Bardon—see [21], Peters—see [102], Largillierre, Delacroix, Ingres, Picasso, Alexis Vollon, Philippe Rousseau, François Flameng, Sébastien Rouillard, Nélie Jacquemart, and Gounod); some were amateur artists (La Caze, the Baroness Nathaniel de Rothschild); others were draftsmen (Desfriches, Sylvestre) or engravers (Le Bas, Wille, Burty, Denon, Jules de Goncourt), architects (Boscry, Trouard, Lemoyne), goldsmiths or jewellers (Roettiers—see [110 and 111], Godefroy, Lempereur), and above all, sculptors (Bouchardon, Lemoyne, Pigalle, Robert Le Lorrain, and Philippe Caffiéri).

We must admit, however, that we know very little about many of the eighteenth-century collectors such as Abbé Pommyer or the Chardin-lovers in England (to whom David Carritt is soon to devote an article), and that a detailed account of Chardin's rediscovery in the nineteenth century still remains to be written, notwithstanding the remarkable publications by McCoubrey (1964) and Haskell (1976). Who, for instance, was Dugléré, the "former manager of the Café Anglais," owner of some beautiful Chardin still lifes (see [36])? Why had M. Bruzard thought of "erecting a monument to those artists who contributed most to the honor of the French school," as stated in the foreword to the catalog for the sale of his collection after his death in 1839? And what prompted Bruzard, at a time when no one was any longer interested in Chardin, to add a third Chardin pastel to the two portraits he had already acquired at the Gounod auction?

Clearly, the history of taste, like the history of art is only in its infancy.

Eighteenth Century

AVED, Joseph (1702-1766). The painter Aved was one of Chardin's oldest friends. The two knew each other from at least 1730, when both of them painted for Rothenbourg. It was Aved who prompted Chardin to devote himself to painting genre scenes. Chardin portrayed him in 1734 [62]. In 1761 Aved sold two Chardin still lifes to the Margravine of Baden, Karoline Luise. At the time of his death, Aved had no less than nine Chardin paintings in his possession [see estate inventory and sale catalog, 24 November 1766; also Wildenstein, 1922]. All nine were still lifes; five of them are in this exhibition: [6, 8, 17, 22, 100].

BOSCRY, Pierre (died 1781). Pierre Boscry, an architect, who in 1743 lived at the rue Cassette, was the lender of the *Portrait of the Painter Joseph Aved* [62] to the Salon of 1753. He owned ten Chardins when he died: six genre scenes (of which three are in this exhibition [59, 60, 62]) and four still lifes (sale of 19 March 1781). The inventory after his death on 1 March 1781 [Archives Nationales Y 13973] yields no detailed information on what must have been an important collection. [On Boscry *père* and *fils* and their activities as architect and contractor, see Gallet, 1972, p. 145.]

BOUCHARDON, Edme (1698-1762). This sculptor seems to have owned only one of Chardin's still lifes [34]; on the other hand, his sculptures repeatedly—albeit after his death—inspired paintings by Chardin [123, 133, 138].

CAFFIERI, Philippe (1714-1774). Five Chardin paintings (including [23]) were in the estate sale of this renowned metal caster and chiseler. [On Philippe and his brother Jean-Jacques Caffiéri, see J.J. Guiffrey, 1877.]

CATHERINE II OF RUSSIA (1729-1796) owned five Chardins, all of which are exhibited here: [58, 72, 73, 89, 125]. Diderot played an important part in the purchase of some of them. One came from the Louis-Antoine Crozat collection; the *Attributes of the Arts* [125] was directly commissioned for the Academy of Fine Arts in St. Petersburg in 1766.

DENON, Baron Vivant (1747-1825). Denon was general director of the Musée Napoléon and owned a *Bird-Song Organ* (see [93]), as well as the version of *Saying Grace* which entered the Louvre as part of the La Caze collection [87].

DESFRICHES, Thomas-Aignan (1715-1800). This draftsman from Orléans and long-time friend of the painter owned many of Chardin's works, including a *Vase of Flowers* (see [100]) and *The House of Cards* (see [65]). Portions of his inventories (as well as his letters to Chardin) were published by Ratouis de Limay in 1907 and in 1916; we have examined new documents that prove Desfriches continued to acquire paintings by his friend after Chardin's death (see [112, 113]).

DIDOT. The editor of the catalog for the first Didot sale on 27-28 December 1819, which included four Chardins, specified with regard to the *Bird-Song Organ* that "This and the three following pictures belonged ...to Madame Geoffrin." Three paintings in this exhibition—[57, 93, 101]—figured in this sale, but detailed information is lacking.

FREDERICK THE GREAT OF PRUSSIA (1712-1786). As early as 1752 (in *Reflexions artistiques sur les différentes écoles de peinture*) the Marquis d'Argens wrote of Frederick: "The superb buildings he has had constructed, worthy of the greatness of the Romans, are filled with the works of our Boulogne, our Caze, our Coypel, our de Troie, our Chardin, our Rignaud, our Largillière, our Watteau, and our Vanloo." However, we do not know how and through whom Frederick (or his brother Henry) purchased the three Chardins in this exhibition [54, 77, 80]. Friedrich Rudolf of Rothenburg (1710-1751), cousin of Conrad-Alexandre, seems to have been instrumental [on F. R. Rothenburg, see Börsch Supan, 1968], but we were unable to find the pertinent documents—incompletely published by Seidel in 1900 and supposedly still conserved somewhere in East Germany.

GEMINIANI, Francesco (ca. 1680-1762). Known mainly as Francesco Corelli's most important pupil, this violinist and composer was also a passionate collector and amateur dealer. *The Young Draftsman*, now at the Louvre [76], passed through his hands in 1741 and again in 1743. David Carritt is in the process of preparing a paper on the relationship of Geminiani—who lived in London but visited Paris between 1749 and 1755—to French art of the eighteenth century.

GODEFROY, Charles (died 1748) and two of his sons, Charles-Théodose (1718-1796) and Auguste-Gabriel (1728-1813). Chardin seems to have had close ties to this family, which also included the painter Joseph-Ferdinand Godefroy. Charles was a banker and jeweller; two of his children were portrayed by Chardin (see [63, 75]). Upon Charles's death, two Chardin still lifes were sold at auction.

GOUNOD—see Sylvestre.

HUNTER, William (1718-1783). This great physician and collector bequeathed to the University of Glasgow his very diversified collection, which included three Chardins. We know that he bought *A Lady Taking Tea* [64] at the sale of the Prince of Carignan's collection in London, in 1765; but we still do not know how and when he acquired *The Kitchen Boy* and *The Scullery Maid* [79]. [Cf. Russell, 1957, and exh. cat. London, 1973.]

KAROLINE LUISE, Margravine of Baden (1723-1783), spouse of Karl Friedrich of Baden-Durlach. The margravine acquired five Chardins, four of which are still at Karlsruhe (for the fifth, see [54]). Only one could be lent to this exhibition—[18]. Two Chardins were acquired in 1759 through the agency of the dealer François Joullain; two still lifes were bought in 1761 which had been in the Aved collection. In 1759 the margravine had wanted to obtain replicas of the still lifes which Chardin had just completed for Abbé Trublet [108, 109]. [The margravine's fascinating and little-known correspondence was published by G. Kircher in 1933.]

LA LIVE DE JULLY, Laurent de (1725-1779). "Introducer of Ambassadors" and lover of contemporary French painting, La Live published in 1764 the catalog of his collection, which he sold in 1770. He owned several Chardins [102, 103] (see also [94, 95]), but it appears doubtful that Chardin painted for him the *Saying Grace* exhibited at the Salon of 1746 (cf. [89]). [On La Live, see Courajod, 1873; Clément de Ris, 1877; and more recently, Scott 1973.]

LA ROQUE, Chevalier Antoine de (1672-1744). La Roque was not only one of the principal collectors of Chardin's works (when his estate was liquidated, ten Chardins came up for sale in May 1745, among them [55, 56, 68, 69] (see also [50]), but he also contributed to Chardin's rise to fame by regularly publishing highly favorable articles on the painter in *Mercure de France* [see Clément de Ris, 1877; Deville, 1910; and Zmijewska, 1970]. The catalog for the La Roque sale is the earliest French catalog that mentions pictures by Chardin.

LE BAS, Jacques-Philippe (1707-1783). This artist, who made engraved copies of four Chardin compositions, was probably owner of the *Cat Stalking a Partridge and a Hare Left Near a Soup Tureen,* now at the Metropolitan Museum in New York [20], and of the early *Surgeon's Signboard,* which he unsuccessfully tried to sell in Sweden in 1745 (see [1].

LE LORRAIN, Robert (1666-1743); Louis-Joseph (1715-1759). Robert Lorrain, a sculptor, and Louis-Joseph, a painter, are unrelated. After the former's death, the estate inventory—which Cazes had helped to draft and which was the earliest to mention Chardin's name [Sainte-Beuve, 1929, p. 144]—included "two small pictures painted on canvas" by Chardin. When the latter sold his collection in 1758, prior to his departure for Russia [see Rosenberg, 1978], four important Chardin still lifes were sold at auction (see [25, 57 ?]).

LEMOYNE, Jean-Baptiste (1704-1778). This sculptor had at least eight Chardin paintings in his possession, four of which are exhibited here: [66, 67, 98, 101]. A considerable number of paintings from his collection appeared again in 1828 when the collection of his son, the architect Pierre-Hippolyte Lemoyne, came up for sale.

LE NOIR, Jean-Jacques. Very little is known about Le Noir family, although they must have belonged to Chardin's closest circle of friends. Several family members sat for Chardin as his models, but we do not know which of Chardin's paintings were in their possession (see [70, 71]).

LIECHTENSTEIN, Prince Joseph Wenzel of (1696-1772). This Austrian prince, whose portrait of 1741 by Rigaud is still part of the Liechtenstein collection, bought three paintings during his ambassadorship to Paris (1737 to 1741): *The Governess* [83], *Woman Scraping Vegetables* (see [82]), and *The Return from Market* (see [80]). *Meal for a Convalescent* [92] was probably commissioned only a few years later. [On Liechtenstein, see Falke, 1882.]

LIVOIS, Pierre-Louis Eveillard, Marquis de (1736-1790). According to the catalog by P. Sentout [Angers, 1791], the Marquis de Livois owned ten of Chardin's works—among them, three pastels. Three of these works are now at the museum in Angers [120] and two are among the finest still lifes now at the Louvre [117, 118]. [On Livois, see Planchenault, 1933 and 1934.]

LOUIS XV (1710-1774). Chardin offered *The Diligent Mother* [84] and *Saying Grace* [86] to the king in 1740. The king commissioned *The Bird-Song Organ* (see [93]) in 1751, three overdoors for the Château de Choisy [123, 124] in 1765, and two years later, two new overdoors for Bellevue [126, 127].

LUISE ULRIKE OF SWEDEN (1720-1782). Sister of Frederick the Great and wife of Adolf Fredrik, king of Sweden as of 1751, Luise Ulrike assembled an exceptional collection of Chardin paintings at Drottningholm Castle. She acquired some of them from Count Tessin [78, 88], others either from the La Roque collection [55, 56, 68, 69] or directly from the artist [90] (see also [94, 95]). Valuable information on Chardin's working methods, his deliberate slowness, and his international reputation can be found in Luise Ulrike's letters to her mother, published by Arnheim in 1909/10, as well as in the largely unpublished correspondence of Tessin and Scheffer, the two consecutive Swedish ambassadors to Paris.

MARIGNY, Abel Poisson, Marquis de Ménars and Marquis de Vandières (1727-1781). Royal Buildings Superintendent under Louis XV, Marigny owned *The Bird-Song Organ* [93] that had been commissioned for the king; he also inherited a *Kitchen Maid* and a *Kitchen Boy* at the death of his sister, Madame de Pompadour, in 1764.

PIGALLE, Jean-Baptiste (1714-1785). A total of six Chardin paintings are listed in the inventory of Pigalle's estate after his death (29 August 1785) [Archives Nationales, minutier central, étude LVII, liasse 574]. Chardin repeatedly represented Pigalle's statue of *Mercury* in his paintings [94, 125].

ROTHENBOURG, Conrad-Alexandre, Comte de (1683/84-1735). This personage of sumptuous tastes—French ambassador to Madrid at the time of his death—has at times been confused with his cousin Friedrich Rudolf, whose role under Frederick the Great, especially with regard to the Prussian king's paintings collection, is well known. Conrad-Alexandre's own collection has been completely ignored until now. It comprised six Chardins, of which five are shown in this exhibition: the two overdoors of the Musée Jacquemart-André [29, 30], two overdoors representing musical instruments [27, 28], and the *Portrait of the Painter Joseph Aved* [62]. Rothenbourg was Chardin's first important patron.

SPARRE, Count Gustaf Adolf (1746-1794). He owned two Chardin still lifes, as well as *The Drawing Lesson* [94] and *The Right Education* [95]. We do not know whether he got them from the Swedish queen, Luise Ulrike, or from La Live de Jully's collection. [On Sparre, see Hasselgren, 1974.]

SYLVESTRE, Jacques-Augustin de (1719-1809). Sylvestre, an engraver known as "drawing master to the royal children of France," seems to have been one of Chardin's most fervent admirers. He regularly loaned his own Chardin paintings to the various Salons (1759, 1761, 1763, 1773). Some of them—for instance, the two pastels at the Louvre [134, 135]—reappeared on the market when the collection of the painter François-Louis Gounod (1758-1823), father of the composer, was sold in 1824 (see also [9, 106]).

TESSIN, Count Carl Gustaf (1695-1770). We are today fairly well informed on Count Tessin, his career, and the role he played in assembling Luise Ulrike's collection as well as his own [see Bjurström's catalog introductions for the exhibitions of the Stockholm drawings, 1970-71]. During his third stay in Paris (1739 to 1742) he bought the only drawings (recently discovered) which can be attributed firmly to Chardin [1, 2, 4], as well as one of Chardin's most beautiful still lifes [78]. He subsequently commissioned *The Morning Toilet*, another masterpiece, and also seems to have owned two "domestic subjects" which appeared in a Stockholm sale in 1786.

TROY, Jean-François de (1679-1752). Four Chardin paintings (including [24, 53]) figured in the sale of this painter's collection twelve years after his death, but it is uncertain whether he had owned them or whether the expert Rémy had put them in this sale.

TROUARD, Louis-François (1729-1794). Trouard, an architect, was the lender of two hunting still lifes by Chardin to the Salon of 1759. Seven Chardin paintings appeared in the sale of his collection in 1779, including *Soap Bubbles* [61], now at the Metropolitan Museum. [On Trouard, see Gallet, 1976.]

VANLOO, Jean-Baptiste (1684-1745). The grisaille done after a bas-relief by Dusquesnoy and exhibited by Chardin at the Exposition de la Jeunesse of 1732 was purchased by Vanloo at a heavy price. It was put up for sale in 1772 after the death of his son, the painter Louis-Michel Vanloo.

Nineteenth and Twentieth Centuries

ANDRE, Edouard (1835-1894) and Nélie (or Nelly) JACQUE-MART (1841-1912) bought three superb Chardins [29, 30, 39] for the museum which today bears their name. [For the most recent information on these collectors, see Fl. Gétreau-Abondance's introduction to the catalog of French paintings at the Musée Jacquemart-André, 1976.]

BARROILHET, Paul (1810-1871). Many works by Chardin (see [9, 36, 37, 51]) went through the hands of this famous Parisian opera singer who was also a passionate collector of paintings and who, according to the *Grand Larouse* [1867, pp. 267-68], "several times assembled and sold some rather curious collections." In the catalog preface for the sale on 12 March 1855, which included one Chardin painting, Ch. Blanc wrote: "Here is an eye-opener for Monsieur La Caze who has the monopoly on beautiful Chardins." [See also Th. Gautier's catalog preface for the sale of 10 March 1856.] The *Portrait of Barroilhet* by Couture is now at the Fogg Art Museum in Cambridge, Massachusetts.

BEURNONVILLE, Baron E. de. "Baron de Beurnonville is a collector whose sales are becoming regular events. Constantly seized by the desire to acquire, he periodically has to rid himself of his surplus. He is a distinguished amateur but altogether too fervent" [Eudel, 1884, p. 333; see also 1882, pp. 148-56, and 1886, pp. 195-99]. At one time or another, he owned [13, 20, 21, 85, 102].

BORTHON, Edmond (1825-1889). This collector from Dijon had a fine group of Chardins in his possession. Three of them are in this exhibition: [13, 85, 100]. [On Borthon, see H. C[habeuf]'s introduction to the catalog of his collection, 1890.]

BURAT, Jules (1807-1885). Information on this collector, a professor at the Ecole des Arts et Métiers, can be found in the catalog preface by Mantz for the sale held after Burat's death in 1885, as well as in Eudel's listings [1886, pp. 365-68], which include the purchase and sales prices of the paintings from the Burat collection. The latter admirably documents the rapid increase in value of eighteenth-century French paintings at a time of great monetary stability. Thus, a second version of the Louvre's *Three Lady-Apples, Two Chestnuts, Bowl, and Silver Goblet* [128], destroyed during World War II with other works from the Henry de Rothschild collection, had been acquired for 400 francs at the Marcille sale of 1857 and was resold for 4,500 francs; the painting in this exhibtion [46], purchased for 355 francs, was sold to Laurent-Richard for 2,800 francs.

BURTY, Philippe (1830-1890). Etcher and art critic, Burty organized the first comprehensive Chardin exhibition at the Galerie Martinet in 1860 and prepared the catalog of engravings by Jules Goncourt. Himself a collector, he owned *Glass of Water and Coffeepot*, now at Pittsburgh [116]. [On Burty, see Tourneux, 1907.]

CYPIERRE, Casimir Perrin, Marquis de (1784-1844). Cypierre was one of the first rediscoverers of Chardin in the nineteenth century. When he died, the sale of his collection on 10 March 1845 (for which Thoré had written the catalog) caused a sensation. It included a version of *Child with a Top* (see [75]), now in Sao Paulo, and the replica in Washington of *The Schoolmistress* (see [70]). Clément de Ris [1848, p. 194] wrote: "Although Chardin had been forgotten until now, his *Spinning Top* and his *Card Game*, both included in the sale of the Cypierre collection, attracted the attention of collectors, and the trend has continued since then." [On Cypierre, see *Bulletin de l'Alliance des Arts*, 25 December 1844, pp. 179-80, and 10 February 1845, pp. 212-13; also see Girod de l'Ain, 1977.]

DAVID-WEILL, David (1871-1952). President of the National Museum Council, David-Weill built an important collection of French paintings, for which Henriot wrote a catalog in 1926. He owned five of the Chardins in this exhibition: [48, 49, 61, 99, 100]. Some of his pictures appear in his portrait by Vuillard (Paris, Private Collection).

DOUCET, Jacques (1853-1929). A great fashion designer and lively member of Parisian society in the first quarter of this century, Doucet sold his collection of eighteenth-century works of art in 1912 in order to concentrate on modern art. He owned three of the Chardin paintings in this exhibition [12, 61, 122] — among them, the superb *Duck* now at Springfield.

FLAMENG, François (1856-1923). Many artists of the eighteenth and nineteenth century bought works by Chardin, and the tradition still continues (see the catalog of the Picasso collection, Paris, 1978). Among nineteenth-century painters who owned (or believed that they owned) Chardin paintings were not only Delacroix and Ingres, but also Alexis Vollon, Philippe Rousseau, Sébastien Rouillard, and Daniel Saint (see [87]). Flameng, a very popular painter and engraver in his lifetime, once owned *Attributes of the Painter and the Draftsman* [31] and *Attributes of the Architects* [32]; they were sold by him in 1919.

GONCOURT, Jules (1830-1870) and Edmond de (1822-1896). While Jules made engravings after Chardin paintings, Edmond contributed greatly to Chardin's fame by writing about him. They owned several drawings by Chardin (?), including *Curiosity* [140] and *Man in a Three-Cornered Hat* [142]. [On the Goncourt brothers, see, most recently Bouillon, 1967.]

LA CAZE, Louis (1798-1869). La Caze, physician and amateur painter, was one of the greatest collectors of his century and probably the most generous benefactor in the entire history of the Louvre. However, there is not much specific information on the provenance of his acquisitions [see *Annuarie des Artistes et des Amateurs*, 1861, II, p. 119; the articles by Mantz, 1870, and by Chennevières, 1888-1889; and more recently, Sylvie Béguin, 1969]. He owned eleven Chardin paintings (now at the Louvre) in this exhibition: [8, 51, 53, 65, 87, 104, 114, 117, 118, 128, 129].

LAPERLIER, Laurent (1805-1878). Laperlier, an official of the colonial military administration, is one of the most intriguing figures among the art collectors of the nineteenth century and was one of the heaviest lenders to the first comprehensive Chardin exhibition in 1860 at the Galerie Martinet. We know his personality reasonably well from the letters that he wrote from Algiers—where he had retired—to Couture [Compiègne] and to the Goncourt brothers [Bibliothèque Nationale] and in a letter that the painter Bonvin [see also Moreau-Nélaton, 1927] sent to the art critic Philippe Burty, who shared his unwavering admiration for Chardin [published by Burty in *L'Art*, 1879]. Laperlier sold part of his collection in 1867; a second sale took place after his death in 1879. Numbers [1, 13, 20, 21, 29, 30, 59, 74, 81, 130] (see also [139]) were all once in his possession. The Louvre acquired *The Smoker's Kit*, *The Return from Market*, and *Basket of Peaches...* at the 1867 sale.

LAURENT-RICHARD, Vincent-Claude (1811-1886). A tailor by profession, proprietor of Eau de Botot, and the physician Charcot's father-in-law, Laurent-Richard counts among the knowledgeable (and numerous) art collectors in the second half of the nineteenth century who were interested both in Northern art and in eighteenth-century French painting. Works by Chardin appeared in each of his three sales: 1873, 1878, and 1886 (see [13, 46]). [On Laurent-Richard, see Ménard, 1873, and Eudel, 1887, pp. 431-32.]

LAVALARD, Ernst (1818-1894) and Olympe (1813-1887). The collection of the Lavalard brothers, which included four Chardin still lifes (three of which are in this exhibition [41, 43, 101]) came to the museum at Amiens by bequest in 1890. [See, most recently, Foucart *Père*, 1977.]

MARCILLE, Francois-Martial (1790-1856) and his two sons Eudoxe (1814-1890) and Camille (1816-1875) were the greatest Chardin collectors of all time. Most of the paintings, such as the overdoor from Bellevue, were bought by François-Martial. When he died, a part of the collection was sold at two sales, and the portion inherited by Camille—who played an important role in the formation of the museum at Chartres (in 1968 Chartres organized an exhibition in his honor)—was dispersed in 1876. The portion in-herited and further augmented by Eudoxe has remained intact. Twenty-two paintings in this exhibition [5, 10, 11, 24, 27, 28, 33, 39, 57, 85, 91, 97, 100, 106, 107, 110, 111, 115, 121, 126, 127, 138] come from these Marcille collections. Some letters addressed to the Goncourt brothers, preserved at the Bibliothèque Nationale, and various articles (*Annuaire des Artistes et des Amateurs*, 1862, III; Duplessis, 1876; Chennevières, 1890; Ratouis de Limay, 1938; Huisman, 1959) yield information on the three art-loving members of the Marcille family.

MICHEL-LEVY, Léon (1846-1925). Fourteen Chardins from his collection came up for sale when he died in 1925. Four of them are in this exhibition: [21, 42, 51, 139].

ROTHSCHILD, Baroness Nathaniel de (1825-1899) and her grandson Henry (1872-1946). Herself a painter noted for her water colors, and a student of Nelly Jacquemart, the baroness collected many of Chardin's paintings. Her collection was considerably expanded by her grandson Henry who, along with his son Philippe, organized a Chardin exhibition in 1929 at the Galerie Pigalle and also wrote an excellent Chardin monograph (1931) under the pseudonym André Pascal, in collaboration with Roger Gaucheron. The collection, however, was largely destroyed in England during World War II (excellent photographs of the works collected by Henry can be seen in a volume of plates edited by Quintin in 1929). Henry de Rothschild once owned eight of the paintings in this exhibition: [9, 15, 20, 36, 72, 110, 111, 139].

ROUILLARD, Sébastien (1789-1852). Little is known about this painter [see exh. cat. Florence, 1977, p. 207]. Following Rouillard's death, several important Chardin works from his collection, including two sketches (see [91]) and the overdoors from Bellevue [126, 127], came up for sale on 21 February 1853.

ROUSSEAU, Philippe (1816-1887). Rousseau, along with his colleagues Bonvin, Decamps, and several other realist painters of the nineteenth century, was a great admirer of Chardin. He owned two major Chardin still lifes [13, 39]. Shortly before his death, he told Eudel that he considered Chardin his "true teacher" [1888, p. 370].

THORE, Théophile (Bürger) (1807-1869). In 1860 the renowned art critic wrote several very important pages on Chardin, wherein he reported that, in 1840, he had "acquired for ten francs, at Vendôme" both the *Meat-Day Meal* [38] and the *Fast-Day Meal* [37], now at the Louvre. [On Thoré, see, most recently, Haskell, 1976.]

VOLLON, Alexis (1865-1945). Son of the painter Antoine Vollon and a painter himself, Alexis Vollon owned several still lifes, two of which are shown in this exhibition: [44, 48].

Critical Evaluation of Chardin

Chardin's Contemporaries

Much was written about Chardin during his lifetime—on the whole, highly favorable. Most of these texts, which fall into several categories, have been published many times (Bocher, 1876; Guiffrey, 1908; Wildenstein, 1933); some of them have become famous—particularly those by Diderot [*Salons,* Seznec and Adhémar, 4 vols., 1957 to 1967].

Chardin exhibited regularly at the Salons from 1737, the year they were reestablished. Each of his entries received very favorable criticism in countless journals and reviews [see Zmijewska, 1970] from more or less famous art critics of the time, occasionally under witty pen names. Most of them are contained in the fifty-six volumes of the Deloynes Archives at the Cabinet des Estampes, Bibliothèque Nationale, Paris [see Duplessis, 1881]. Almost without exception, their admiring vocabulary used to describe Chardin's pictures is so repetitive that it makes for tedious reading, but in this catalog we have excerpted only those comments that seem pertinent to the individual works under discussion. Wherever possible, the quotations are taken directly from the original texts rather than from the clippings collected or recopied by Deloynes.

Diderot's accounts of the *Salons* (beginning with the Salon of 1759) are, of course, vastly superior in their literary quality. Diderot did not attempt to derive a theory of aesthetics from the Chardin paintings he admired. More critic than historian, Diderot's interest and appreciation concentrated mainly on the painter's technique and on the poetry in his works, and he expressed admirably his impressions of these paintings.

The regular appearance of prints after Chardin's paintings offered the critics a new opportunity to comment on the painter's compositions. Thus, the *Mercure de France*—until 1744 under the direction of Antoine de La Roque—applauded each new engraving that appeared on the market.

The second and most important group of texts consists of those written after Chardin's death in 1779. Largely unpublished in the eighteenth century but repeatedly published in the nineteenth, they still constitute an invaluable source of information on Chardin. Most important among them are the writings of Charles-Nicolas Cochin (1715-1790), an engraver's son and Chardin's lifelong friend. They are the main source consulted by Haillet de Couronne, Secretary of the Academy of Rouen, in preparing his eulogy of Chardin, read before the Academy to which Chardin had belonged since 1765. The obituary penned by the painter Antoine Renou (1731-1806)

also bears mentioning, as do the obituaries published in the *Journal de Littérature, des Sciences et des Arts* of 1780 [I, pp. 59-64] and in the *Nécrologe* [X, 1780, p. 177-91].

An article by Pierre-Jean Mariette deserves special mention. Written in 1749 and published in 1853, it expresses some reservations about the art of Chardin; and in its sincerity and acuity of observation, it contrasts with the usual Salon reviews.

Outside France, published eighteenth-century texts on Chardin are rare; however, a systematic record of them has not yet been compiled. *British Magazine* once published an article accompanying an engraving of Chardin's *The House of Cards* [71]; prints of the engraving were distributed as gifts to the subscribers of the magazine [see also Whitley, 1928, p. 31].

To reprint the bulk of contemporary texts on Chardin would in itself take up the entire catalog; we therefore have chosen to republish (with modern spelling) a selection of the most famous of these and to include both famous and unknown commentaries that, having escaped the notice of those who investigated Chardin earlier, are no less interesting.

Passages in poetry have been left in the original French; the prose selections have been translated for the English edition.

"His painting style is unique: there are no finished outlines, no mellow blending of colors; it is, on the contrary, very rough and rugged. His brushstrokes seem heavy, and yet his figures are strikingly true to life; his singular treatment only makes them more natural, with more soul."

Chevalier de Neufville de Brunaubois-Montador (1707-1770?), *Description raisonnée des tableaux exposés au Louvre; lettre à Madame la Marquise de S.P.R.*, 1738.

Vers d'un professeur du collège du Plessis,
à M. Chardin, peintre de l'Académie R[oya]le de Peintre,
sur les deux Tableaux qu'il a faits pour le Roy.

Sage rival de la nature,
Par quel heureux talent sais-tu plaire à nos yeux?
Chardin, tout vit dans ta peinture,
Tout est riant, ingénieux.
D'un nouveau goût, inventeur et modèle,
Tu montres la carrière et remportes le prix.
Que j'aime ton dessin et ce pinceau fidèle,
Qui sait avec tant d'art placer le coloris.
Oui, c'est la nature, c'est elle!
A sa simplicité je reconnais ses traits;
Mes yeux la trouveraient moins belle
Si tu l'ornais de plus d'attraits.
D'une *mère laborieuse*
Quel pinceau délicat pourrait comme le tien
Tracer l'air imposant et l'austère maintien?
Un enfant hypocrite écoute la grondeuse;
Les yeux de cet enfant sont ravis, enchantés;
C'est à peindre cet âge, orné de l'innocence,
Que tu fais éclater tes plus vives beautés;
Chardin, c'est à l'aimable enfance
Que tu dois de ton art les traits les plus vantés.

Près d'une sage *gouvernante*
Ici la toile me présente
Deux enfants dont l'air seul annonce la candeur.
Le dîner les attend; mais il faut au Seigneur
Un petit mot préliminaire.
Le frère joint les mains, et, d'un ton bégayant,
Prononçant la courte prière,
Jette sur le potage un oeil impatient.
D'un air modeste et fin sa soeur le considère.
Quelle naïveté dans ces tendres objets!
Le connaisseur que ton ouvrage attire,
Chardin, n'est jamais las d'en contempler les traits,
Empressé, curieux, il regarde, il admire;
Sourit à ces enfants, et se laissant charmer,
Sent encore bien plus qu'il ne peut exprimer.
Mais pourquoi m'étonnner que tes heureux ouvrages.
Du public éclairé remportent les suffrages?
Ton pinceau travaillait pour ce séjour pompeux
Où le goût rassembla de ces maîtres fameux,
Des Le Brun, des Mignard, les savantes merveilles.
Pour prix de tes charmantes veilles,
Parmi tous ces grands noms, le tien sera compté:
Tel auprès des auteurs d'*Andromaque* et d'*Horace*,
La Fontaine est assis au sommet du Parnasse,
Et jouit avec eux de l'immortalité.

Mercure de France, December 1740, p. 2710.

"His [Marivaux's] comedies are no comedies; they are novels which now cause laughter, now tears. His style is unique, or rather, his style is not a style: to write as he does, he has to be utterly himself. He writes as *Chardin* paints; it's a special genre, much admired, but beyond anyone else's reach: imitators can only produce monstrosities."

Thomas L'Affichard (1698-1753),
Caprices romanesques, Amsterdam, 1745, p. 63.

Among the painters who have originality and an eye for composition, I should have mentioned Chardin. He is admired for his talent in rendering with his singularly artless truthfulness certain moments from everyday life which in themselves are of no interest and deserve no attention. Some are unworthy of the author's choice or of the beauty with which he invests them; yet they earn him a reputation that has even spread abroad. He paints only for his own diversion and consequently produces very little; but the public, eager for his works, compensates by eagerly snatching up the engraved copies of his paintings. The two life-size portraits exhibited at the Salon are the first I have seen done in his manner. Although they are very good and promise to be even better if he makes portraiture his occupation, the public would be greatly disappointed if, for convenience's sake, he abandoned or even neglected his gift for originality and inventiveness in favor of a genre that has become too commonplace and for which there is no need."

La Font de Saint-Yenne, *Réflexions sur quelques causes de l'État présent de la Peinture en France (avec un examen des principaux ouvrages exposés au Louvre le mois d'août 1746)*, 1747, pp. 109-10.

A. M. Chardin, de l'Académie Royale de peinture.
Envoi.
Partisan éclairé de la simple nature,
Tu l'embellis sans la farder
Et tu prouves dans ta peinture,
Qu'avec l'art le plus fin elle peut s'accorder.
La fable te doit son hommage,
Ton heureux talent est l'image
De ce que La Fontaine a laissé dan le sien.
Que ne puis-je approcher d'un pinceau si fidèle!
Que ne puis-je, en ces vers, me guider sur le tien!
Mais tu serviras de modèle,
Et je serai toujours fort au-dessous du mien.

Charles-Etienne Pesselier (1711/12-1763), *Fables Nouvelles*, livre II, fable XVI, 1748, p. 68.

"The prints engraved after Monsieur Chardin's paintings are faring very well indeed; they have become as fashionable as those after Teniers, Wouwerman, and Lancret and have supplanted the serious prints of Le Brun, Poussin, Le Sueur, and even Coypel. The public at large takes pleasure in these representations of familiar scenes from daily life and prefers them unhesitatingly to more lofty subjects which require a certain amount of study in order to be appreciated. I do not wish to examine whether that is detrimental to good taste. Suffice it to note that at bottom, Chardin's talent is only a renewal of the art of the Le Nain brothers. Like them, he chooses the simplest, most naive subjects—to be honest, his choice is even better than theirs. He knows how to capture attitudes and characters, and his paintings are not devoid of expression. It is this, in my opinion, that makes his paintings so popular and that has earned him a place beside Teniers and the other Flemish painters who specialized in roughly the same genre, whatever the distance between their work and his. There is no denying that Chardin's paintings smack too much of effort and labor. His touch is heavy and never varied. There is no ease in his brushstrokes; everything is expressed in the same manner and with a certain indecision—all of which makes his works seem cold. Even his colors are not sufficiently true, though they generally harmonize. Lacking in draftsmanship and unable to execute preparatory studies on paper, he is obliged to keep constantly before his eyes the object he intends to paint, from the first sketch to the last finishing touch. That is a lengthy procedure and would discourage any other artist; naturally, he always claims that his work costs him an infinite effort—and if he tried to hide it, his paintings would betray it nonetheless."

Pierre-Jean Mariette, *Abécédario*, 1749, published by Chennevières and Montaiglon, 1853, I, pp. 359-60.

"Monsieur Chardin has the same talents as Monsieur Oudry, except in landscape painting. He excels at simple little subjects in the Flemish taste. His composition and drawing are good; his coloring is sometimes a bit gray. His method of painting is singular. He applies his colors one by one, almost without blending them, so that his pictures look somewhat like mosaics, or like pieces built of many parts, like needlepoint tapestry done in cross-stitch."

Abbé Guillaume-Thomas-François Raynal (1713-1796), *Correspondance littéraire*, 1750; 1877 edition, I, p. 464 (attributed to Bachaumont in the postface of the *Journal* by Wille, 1857 edition, II, p. 403).

"There are works which need no label to indicate their master. Such are the works by Chardin, the painter who renders nature with the greatest accuracy and truth. My plan will not allow discussion of all the pictures which deserve attention, so I shall single out his picture of a girl saying her gospel lesson. What Monsieur de Fontenelle has said about a philosopher applies exactly to Monsieur Chardin: *He catches nature in the act.* He has the gift of capturing what would escape any other painter; the painting, which shows only two figures, is astonishingly full of life and action. The head of the girl is so expressive that one can almost hear her talk; one can read in her face the sorrow she feels for not knowing her lesson well. The figures are bathed in light and have that knowing, spiritual touch that is unmistakably Chardin's. Chardin does not emulate any other master; he has developed a manner of his own which it would be dangerous to imitate. His paintings are true to life in color, exact in drawing, and most spiritual in their imitations of nature; he renders the minutest details with a patience worthy of the Flemish painters, but his brushstroke is as forceful as that of the great Italian masters."

Abbé Jean-Bernard Le Blanc (1707-1782), *Observations sur les ouvrages de MM. de l'Académie...*, Paris, 1753, pp. 23-25.

"Answer me, illustrious Chardin! When will jealous Painting overcome your philosophy and your indifference toward your all too assured success? When will it stir you again to take up your brushes and to create at leisure most of these images of nature, so sincere, so affectionate and full of simplicity? What magic is it, what art unknown to all but you, that can cast such a spell? Everything is pleasing in the decorative scheme of your pictures, their subject as well as their execution. The searching eye, deceived by the apparent ease and lightness of your art, would try in vain to pierce the secret of your paintings by scrutinizing them attentively. It is engulfed, it loses itself in the magic of your touch. Tired of the effort, yet avid for more of the pleasure, it wanders off and then draws close again. It cannot get enough of what it sees, and when it leaves at last, it vows to return."

Louis-Guillaume Baillet de Saint-Julien (1715-?), *Caractères des Peintres français actuellement vivants*, in *La Peinture*, Amsterdam, 1755, p.5.

"Monsieur Chardin's merit is universally recognized. His paintings at the Salon are worthy of the reputation he earned in this genre which is so true to life, and in which he has excelled for so long. There is no collection in all of Europe where his paintings are not placed among the ranks of the greatest masters. Dutch patience never has copied nature more faithfully, no Italian genius has ever rendered it more rigorously; the combination must astonish anyone who cares to think about it. Of twenty painters who express nature faithfully, each will do it in a manner unlike that of all the others. To the person who has learned to know and appreciate these mysteries of art, painting is one of the sources of highest pleasure."

Mercure de France, October 1761, p. 156.

"Remember what Chardin has told us at the Salon: 'Gentlemen, gentlemen, have a heart. Among all the pictures here, seek out the worst and know that two thousand hapless artists broke their brushes between their teeth, despairing to paint anything as bad. Parrocel, whom you call a dauber and who in fact is, if you compare him to Vernet, this same Parrocel is nevertheless a rare talent compared to the multitude of others who started their careers like him and then abandoned them. Le Moine said that it takes thirty years of practice to know how to preserve a sketch, and Le Moine was no fool. If you listen to me, you will perhaps learn to be forebearing.' To preserve one's sketch means to transform a rough draft into a finished picture. Let it be said—without wanting to interrupt Monsieur Chardin and his reporter—that it is one thing to execute a beautiful sketch; but to turn it into a fine picture is quite another.

"Chardin seemed to doubt that there could be any education longer and more painful than that of a painter, not even that of a physician, lawyer, or professor at the Sorbonne. 'At age seven or eight,' he said, 'they put the crayon in our hand. We begin to draw, after engravings, eyes, mouths, noses and ears, then feet and hands. Our back has been bent over the sketchbook for a very long time when we finally come face to face with a statue of Hercules or with the [Belvedere] torso, and little do you know of the tears shed on account of some satyr or gladiator, of the Medici Venus or the Antinoüs. Rest assured that the Greek masterpieces would no longer elicit the envy of the art teachers if the latter were exposed to their pupils' scorn. After having wilted for days on end and spent nights by lamplight in front of some inanimate still-life objects, we are confronted with living nature. Suddenly all the effort of the preceding years seems to have been for naught, for we feel more at a loss than the first time we picked up the chalk. The eye must be taught to see nature; many have never perceived it and never will! Such is the torture of our lives. After five to six years in front of the model, we are left to our own genius, if we have any. But talent does not declare itself at a moment's notice, and one can rarely face up to one's own ineptitude after the first attempt. How many trials it takes, how many errors!... The person who has not felt the suffering of art produces nothing of value; the one who, like my son, has suffered them too soon produces nothing at all.

"You come in time, Chardin, to comfort my eyes which your colleague Challes has so cruelly hurt. Welcome back, great magician, with your mute compositions! How eloquently they speak to the artist! How much they tell him about the representation of nature, the science of color and harmony! How freely the air flows around these objects! The light of the sun never has better redeemed the incongruity of the creatures on which it shines. Among artists, Chardin is the one who hardly acknowledges friendly and hostile colors...."

Denis Diderot, *Salon de 1765*, Seznec and Adhémar, 1960, II, pp. 57-59, 111.

"Nature was his first teacher. He had an innate understanding of chiaroscuro and strove very early to perfect this rare talent. He was convinced that it is color that makes imitation charming and that gives to the imitated object a value it seldom has in reality. It was probably this concern for accuracy that prevented Chardin from ascending to the category of history painting which requires vaster knowledge and imagination, more effort and genius, and a greater amount of detail than the other types of painting — or rather: which reunites them all. Chardin limited himself to a single genre, preferring to be the best painter in a lesser category rather than to join the crowd of mediocre painters in a higher one. He surely will always be considered one of the greatest colorists of the French School."

"Eloge historique de M. Chardin," *Le Nécrologe des Hommes illustres,* XV, 1780, pp. 178-79.

"His canvases cost him much time, for he was not content with an approximate imitation of nature; he strove for the greatest truth in tones and effects. This is why he painted them over and over again, until he developed this fracturing of tones which creates greater distance from the object and establishes interrelationships with everything that surrounds it; finally he obtained this magic harmony by which he distinguished himself as a superior master.

"Through long practice, profound reflections and his efforts to meet his own exacting standards, he had gained a wealth of theoretical knowledge that made his advice infinitely useful to those who consulted him. Several times, without touching the work of artists who had confidence in him, he showed how they could bring harmony into paintings that seemed discordant. He gave them — pardon the expression — the recipe for a kind of sauce that would enhance their dish and impart an excellent taste. His principle in this respect was that all shadows are one, and that somehow, the same tone must be used to break them up. Few colorist painters are aware of this theory.

"In consequence, very few paintings by other artists could hold their own next to those by Chardin, despite the fact that his brushwork was generally too rugged to be entirely pleasing. It was said of him, as of M. Restout the Elder, that he was a dangerous neighbor.

"His paintings possess yet another rare quality: they show truth and simplicity in attitudes and in composition. Nothing seems deliberately introduced for the sake of effect or grouping; yet all requirements are met with a skill that is the more admirable for being so inconspicuous. Quite apart from the truth and strength of the coloring, his paintings beguiled everybody by their natural simplicity. In general, the public is not very responsive to so-called picturesque devices and to ingenious efforts to bring off special effects. These actually can have some merit, but too often they stray from the reality of nature and thus miss their purpose. At bottom, most people hope to find truth and naturalness in art; Monsieur Chardin therefore met with the greatest success at all exhibitions...

"Chardin was a short man, but strong and muscular. He was witty and, above all, possessed both a great deal of common sense and excellent judgment. He expressed himself forcefully to get his ideas across, even where they concerned problems which usually resist explanation, such as the magic of color and the various causes of light effects. His repartee was frequently quick and unexpected. One day an artist expounded at great length on the methods he followed in order to purify and perfect his use of color. Growing impatient at so much chatter on the part of a man whom he knew only for the slick and cold execution of his pictures, Chardin said: 'Since when does one paint with color?' 'With what else?' came the astonished reply. 'You should *use* color, but *paint* with your feelings,' explained Chardin."

Charles-Nicholas Cochin, *Essai sur la vie de M. Chardin,* 1780, published by Ch. de Beaurepaire in 1875/76, pp. 426-28, 434.

Neglect

After his death, Chardin was rapidly forgotten. Texts on his life and work are extremely rare between the years 1780 and 1846, and those which do exist must be read with caution. Even his date of birth had been mistaken by Pahin de la Blancherie in 1783 (p. 235), and again in 1791 by the author of a Chardin biography published in the *Encyclopédie méthodique*, II, p. 137, who acknowledged at least that "One could say Chardin was an important painter in an unimportant genre," and that "Nobody was more skilled in the art of painting than he, although he practiced it in a singular fashion." In 1844 in his book on the museums of Russia and Germany (p.453), Louis Viardot mentioned Chardin (along with the Le Nain brothers) as belonging to "the crowd...of dead people...who are no longer talked about, and perhaps never were."

From this unfortunate period for the posthumous fame of Chardin and for French eighteenth-century art in general, we have selected four texts of varying opinion. It is to the authors' credit that they even mentioned the name of Chardin and recognized certain qualities in his work at a time when only a few collectors indifferent to the trends of fashion prevented either destruction or disappearance of his paintings.

"Chardin painted portraits, scenes with few figures, the attributes of the arts, still lifes of food and drink, fruits, animals, and even foolish subjects with the drunken abandon of a superior talent.

"His brushwork is so masculine and energetic, his use of color so accurate and true, his manner of execution so imbued with the prestigious power of illusion that the smallest details exude the breath of a creative genius. All attacks against this friend, or rather against this artist who held nature's secrets in trust, were in vain; the competition only made him appear more marvellous, to the ridicule of his rivals...."

P.M. Gault de Saint-Germain, *Trois siècles de la peinture en France*, 1808, p. 248-50.

"Chardin's works demonstrate that, as he himself aptly put it, 'one can define the shape of every object in nature by showing the precise color tones of everything that surrounds it.' When he once saw paintings with harsh outlines and crude coloring, he exclaimed heatedly that 'nature was not to be rendered with the colors one buys from a merchant, but by accurately imitating its own *local* colors, its colors in relation to space and to the light that illuminates it.' When he was sought out for consultation — which happened often — he wasted no time in long discussions but reached for his palette or his pastels, which was what he called an irresistible argument."

R.N. [Robin] in Michaud's *Bibliographie Universelle ancienne et moderne*, 1813, VIII, p. 75; second edition, 1844, p. 507.

"The painter Chardin was notoriously outspoken and firm of character. He could not stand it when people of note betrayed their ignorance of his art, of which he had a high opinion. The impertinence of foolish questions annoyed him and once caused him to give a stinging lesson to a lady of rank: 'Monseux, monseux,' asked the lady in whose house he was painting, 'is it difficult to do what you are doing?' 'To whistle and keep one's fingers busy is all it takes, Madam,' replied the artist. 'You see,' said she, 'my butler has been manipulating the brush for the past eight days; he's already three-quarters done with his training. A few more lessons and he should be able to do a painting, don't you think?' 'Upon my word, Madam, he can, if you please, complete my painting, for I am leaving.'"

Dusaulchoy, *Mosaïque historique, politique et littérature*, 1818, II, pp. 156-57.

"Chardin, as I have said before, also painted portraits that were remarkably true to life, and private scenes from daily life, composed of few figures; a single figure often made for a very interesting painting. He painted the attributes of the arts and still lifes of meals, fruits, vegetables, and animals with the vigor of a superior artist. His brush had an expressive touch, his coloring was accurate and perfectly suited to the objects he painted. His manner of execution is difficult to define; it had the magic of illusion and showed creativity even in the handling of the smallest detail....

"One might propose that a Chardin painting be hung in every studio as an example of the mastery of color and harmony, perhaps even as a complete dictionary of the principles involved in the use of color and of chiaroscuro for visual effect."

C. Le Carpentier, *Galerie des Peintres Célèbres*, 1821, II, pp. 236-37.

Rediscovery

From Hédouin (1846) to the Goncourt Brothers (1863-1864)

Chardin's rediscovery was sudden. It can be accurately traced to 1845/46. We previously mentioned that the sale of the Marquis de Cypierre's collection on 10 March 1845 had created a sensation. The sale catalog's preface, apparently written by Théophile Thoré and republished in the *Bulletin de l'Alliance des Arts,* was a sort of manifesto of this abrupt turnabout, as can be seen from the excerpt in this chapter.

When the Louvre, which had been closed for six months, reopened shortly after the sale, it exhibited *The Diligent Mother* and *Saying Grace,* described by Champfleury as "two small, but utterly charming Chardins...Chardin has not been fashionable in our time, but his works will some day be more coveted than those by Greuze" *(L'Artiste,* 15 July 1845, p. 8).

Even more decisive — though little known today and missing from the bibliography of the various Chardin monographs by Wildenstein — was the appearance of two articles by Pierre Hédouin in the *Bulletin des Arts* (10 November and 10 December 1846; republished in book form with variations in 1856). The first of these articles is biographical; the second includes a chronological catalog of Chardin's paintings, listing 102 of them and constituting the first catalog raisonné of his work.

From then on, exhibitions, critical accounts and articles followed in rapid succession; the number of Chardin collectors increased, and so did the prices for his paintings. The Louvre bought four of them (perhaps, in fact, only three) in 1852. The weakest Chardin paintings from the François-Martial Marcille collection were sold in 1857. In 1860 Philippe Burty (see Principal Collectors of Chardin) organized the first comprehensive exhibition of eighteenth-century French art at François Petit's Galerie Martinet, 26 Boulevard des Italiens, where he initially showed twenty-two Chardin canvases, all from private collections. Another nineteen were added later, of which eleven came from the collection of Laurent Laperlier, the occasionally more fortunate rival of Dr. Louis La Caze. In 1849 the Minister of the Interior had commissioned from Camille Demesmay (1815-1890) a bust of Chardin in marble; it was exhibited at the Salon of 1850, and is now in the Amiens museum.

The rehabilitation of Chardin was swift and without noteworthy reservations. It was brought about by writers, art critics, and such journals as *Magasin Pittoresque, L'Artiste,* or *L'Illustration,* which reproduced Chardin's most popular compositions from the eighteenth-century engravings of his genre scenes.

It is obviously impossible to compile a complete list of the critics who were instrumental in the "rediscovery" of Chardin. McCoubrey (1964) and Haskell (1976) have already approached this question. Since this is neither the place for a complete survey nor an "honors list," we should like to mention — besides Burty and Thoré (who also collected Chardin's paintings) — Charles Blanc (1813-1882), Champfleury (on Champfleury, see G. and J. Lacambre, 1973), Philippe de Chennevières (1820-1899) [see Lugt, 1921] and his son Henry, L. Clément de Ris (1820-1882) [see Chennevières, 1873], Théophile Gautier (1811-1872), the painter Edmond Héd-

ouin's father Pierre (1789-1868), the art expert and picture-restorer Simon Horsin-Déon (1812-1882), Arsène Houssaye (1815-1896), and Sainte-Beuve (1804-1869) [see his article on the Le Nain brothers, first published in 1863]. Each of our texts by most of these authors was chosen for the particular light it throws on Chardin's oeuvre.

Balzac, the greatest French writer of his time, mentioned Chardin's name only once. In *Le Cousin Pons,* written in 1846-1847 [ed. La Pléiade, VI, 1960, p. 779], a "magnificent portrait by Sebastiano del Piombo, painted on marble in 1546" in the collector's inheritance was replaced by "a portrait of a lady, signed Chardin!"

Not the last to discover Chardin were the painters themselves. In the eighteenth century, they were, as we have mentioned, among the most assiduous collectors of Chardin's still lifes. In the nineteenth century they were directly inspired by Chardin's canvases, often to the point of executing pastiches. It would be impossible to mention them all. For some of them, Chardin became a cult. But the greatest nineteenth-century artists — in particular, Manet — found inspiration in Chardin's work without lapsing into servile imitation. Among them were Philippe Rousseau (1816-1887); Laperlier's friend François Bonvin (1817-1887) who, in an unpublished letter, told about his embarrassment when Ingres proudly showed him his "Chardin" (now at the museum of Montauban); Antoine Vollon (1833-1900); Alexandre-Gabriel Decamps (1803-1860) [see Mosby, 1977]; Théodule Ribot (1823-1891); and Eugène Boudin (1824-1898) in his still lifes. Finally, Jean Pezous (1815-1885), whom we plan to treat in a separate study, was to become Chardin's unwitting first "forger."

A charming but almost unnoticed exhibition, organized at Laren in 1962 ("Vier franse meesters"), focused on some of these artists; more information on them can be found in the remarkable articles by Gabriel Weisberg (1970, 1972, etc.) who justly insists upon the influence of Chardin. Finally, we would like to refer the reader to our catalog entry for the Louvre's *Saying Grace* [86], where we quote extensively from an article on this painting, published in the May 1848 issue of the *Magasin Pittoresque.* It neatly sums up the nineteenth-century's perception of Chardin. Painter of an "honest" and virtuous class of people, reflecting "the true history of the nation," Chardin was seen as *the* French painter par excellence, equally indifferent to the seductions of Italy and to the Northern painters contemptuously dismissed by Louis XIV as *magots.* This concept prevailed among the next generation of critics, although it was made more subtle by Thoré in 1860.

"It is peculiar that France is the country where the paintings of the French school are least appreciated. While the English and the Italians grant our national painters a place of honor in their galleries, Paris has scarcely a single special collection of works of the French school. The Louvre has no Boucher, no Chardin, no Nattier, no Fragonard, no François Lemoine. It owns only one magnificent sketch by Watteau and two small works by Carle Vanloo; there are no other Vanloos, nothing from the school of Watteau, nothing by Lancret or Pater. Only with the opening of galleries along the river can one find two Bouchers, one Lemoine, and a few Chardins of little interest. There is nothing else to represent the charming school of eighteenth-century French painting, the most original and inspired period in the history of our art. It is true, of course, that the Louvre is rich in works by Poussin, Claude, and Lesueur, and that it has been stuffed with the insipid productions of the Empire period for the past thirty years. But in the meantime, Guérin, Guillemot, Meynier, Menjaud, Cocherau, and the rest of them are quite forgotten, whereas Watteau, Boucher, and the coquettish pleiade of painters from the time of Louis XV have reconquered the esteem of the true lovers of good painting."

Preface (by Thoré) to the catalog for the Marquis de Cypierre sale, 10 March 1845 (also published in *Bulletin de l'Alliance des Arts,* 10 February 1845, pp. 242-43).

"Chardin is one of a number of distinguished artists whom the fickleness and deplorable prejudice of our nation have long plunged into oblivion. It may be painful to admit, but that is how we are; the proverb, 'A prophet is without honor in his own country,' is an incontestable truth that applies to us in particular. Had the author of *Saying Grace* and *The Diligent Mother* been born in Belgium or Holland, we would praise him to high heaven in our good kingdom of France, where all that is foreign is always received with the greatest favor. We would compare him to the many other masters of the Low Countries and say: 'This one here, the one who paints nature as if caught in the act, is never trivial. He is as good a colorist as he is a draftsman; in one word, he combines all that it takes to be a true genre painter.' But alas, Chardin is French. And that, in the eyes of his compatriots, is a flaw his eminent qualities cannot erase. . . .

"Let us add that he painted as much as possible directly on the canvas with the loaded brush. The roughness of the paint and the accidents of light were his primary means to achieve illusion. He used them so well that no other artist ever matched his perfect imitation of nature! This is our opportunity to defend Chardin against the disdain which certain persons who busy themselves with art criticism have poured on his talent and his works. We consider it a mission of justice as well as a useful deed, so that Chardin may at last occupy his due place among the best painters of our school."

Pierre Hédouin, "Chardin," *Bulletin des Arts,* 10 November 1846, pp. 185, 189.

"Diderot, the pioneering French critic of the visual arts, was a great admirer of Chardin. And he was right—although, true to character, he showed perhaps a more sensitive judgment in his choice of subjects than in his appraisal of Chardin's merits as a painter. Chardin probably appealed to the author of the *Père de Famille* because he painted the intimacy of family life and the candid unpretentiousness of the bourgeoisie, and because he treated these domestic subjects with an almost Dutch refinement. But the greatness of Chardin's talent lies mainly in his broad and simple understanding of nature, his emphasis on local color, his robust use of paint. These are the qualities for which even the least of his sketches today are passionately sought after. His still life known as *The Silver Goblet* in Monsieur Barroilhet's collection is a marvel of composition and color; the Flemish and Dutch masters never produced anything more real, more sincere and more skillfully executed."

Théophile Gautier, preface to the catalog for the Barroilhet sale on 10 March 1856.

"Aalbert Cuijp, Adriaan Brouwer, Nicholaas Maes, and Jan Fyt—these are the only great practitioners with whom the talent of Chardin can be compared in certain respects.

"Moreover, Chardin had that originality which defied the prevailing fashion, brave man! Little did he care if the followers of Watteau turned out sweet little expressionless women devoid of reality and boudoir scenes to go with easy virtue, or if Boucher undressed his marquesses to look like nymphs, or disguised courtiers as shepherds in the midst of a scene from the Opera. He, Chardin, did not titillate frivolous tastes nor cater to favorite mistresses, grand lords, and little abbots. He was so unaffected by contemporary attitudes and styles that artists like Largillière at first mistook his paintings for the works of a foreigner, imported from Flanders. For who in France could, at that time, have painted the magnificent still life of *Fruits,* of bowls and vases [97] which the author gave to the Academy as his reception piece? It is not surprising that Largillière was reminded of Antwerp when he saw it, and thought immediately of Snyders. That was in 1728. Chardin was twenty-nine at the time, and he was fortunate enough to have more than a half-century of work yet before him."

W. Bürger (Thoré), "Exposition de tableaux de l'Ecole française ancienne tirés des collections d'amateurs," *Gazette des Beaux-Arts,* 1860, VII, p. 334.

"Le Nain never had the charm of Chardin; he never tried for it. Chardin was a cunning, sunny fellow who showed only the friendly sides of life; he brought a certain elegance to the domestic scene. His watchful mothers and contrite children are presented most engagingly. His children seldom cry, for his mothers chide only tongue-in-cheek. Life seems gay in his bright rooms."

Champfleury, "Nouvelles recherches sur la vie et l'oeuvre des frères Le Nain," *Gazette des Beaux-Arts,* 1860, VIII, p. 185.

"Diderot was a Chardin enthusiast but liked Greuze equally well for different reasons. The one appealed to his artistic tastes and the other to his philosophical system. In the first, he saw only imitation of nature, frankness of color, and masterful execution. In the second he saw the poetry of bourgeois living as he himself expressed it in his dramas. Though not insensitive to purely pictorial qualities, Diderot shared with most people of literary bent a great preoccupation with the subject of a painting. He looked first for a moral message, for intended pathos, for an instructive theme to be developed. When he saw a canvas he first analyzed its composition with the marvelous instinct of a stage manager; if he disapproved, he altered the grouping of figures, redistributing them in a more logical manner and relegating to the second plane whichever figure he found unduly prominent in the foreground; he refocused the lighting, glossed over or sacrificed details which he considered disproportionately ambitious, modified the expressions, adjusted the gestures, corrected the costumes, and in his tumultuous, ardent, colorful style, remade the whole picture from top to bottom with results that were often superior to the painter's creation. The canvas paled beside the written page. Diderot, however, in spite of his wit, fire, eloquence, and imagination, misunderstood the true aim of painting. He did not acknowledge its autonomy and, as many persons still do today, he confused philosophy with art, although the two are completely different. Neither painting nor poetry or music is meant to demonstrate any kind of philosophical system or to confirm a moral truth; for if such were the case, Hogarth would be a greater master than Michelangelo and Raphael, and the *Inconveniences of Intemperance* would rate higher than the Farnesina frescoes which contain no lesson. The arts teach and moralize by their beauty alone, not by translating a philosophical or social formula. For the truly artistic person, painting has only itself as its purpose, which is quite enough."

Théophile Gautier, "Chardin et Greuze," *L'Artiste,* 15 October 1861, p. 174.

"The bourgeoisie of the eighteenth century, this "third estate" which was still nothing but soon was to become all-powerful, found in Chardin its painter — I almost said its historian. The industrious bourgeoisie, still uncorrupted in its morals and orderly in its lifestyle, provided the subjects for Chardin's compositions. The Dutch masters gladly take us into their taverns where the taciturn and melancholy locals smoke their pipes while beer-drunk sailors from the Zuider Zee scuffle. Chardin fused to this Northern truth the refinement of a French temperament. He discreetly guides us into the workroom where a mother reprimands her lazy little girl for bungling a piece of embroidery, or into the dining room where she carefully ladles out soup for her children and into the study where the governess vainly admonishes her young charge not to tarry on his way to school. If sometimes Chardin wanders from the front rooms to the backstairs, or from a bourgeois home to an artisan's shop, his brush ennobles the humblest chores with an undefinable, simple grace and distinction that one would seek in vain in the Netherlandish masters....

"Chardin's great qualities are his composition and his touch....I have seen many of Chardin's paintings and have always noticed the extreme sobriety in his handling of the accessories. His backgrounds are airy and transparent, but there is nothing to distract one's attention. Where a Flemish painter would inevitably show an accumulation of details, the French artist abbreviates, simplifies, or eliminates them. Take, for example, one of the always delightful versions of *Saying Grace*: a Mieris, a Metsu, or even the inspired Teniers himself would certainly have seized the occasion to fill the background of the painting with a rich array of dishes on a sideboard, an elegant ewer, a half-peeled lemon, and many glasses of Bohemian crystal. Chardin shows better judgment, and where he paints a scene with human figures, he takes great care not to complicate the picture needlessly, to be sparing with accessories, and not to tell everything, so that the viewer may add something of his own and complete the painter's thought."

Charles Blanc, "Chardin," *Histoire des Peintres,* 1862, pp. 5-6, 8-9.

Consecration

From the Goncourts (1863-64) to Wildenstein (1933)

The seventy years which separate the writings of the Goncourt brothers from Wildenstein's work were marked by a triple phenomenon: multiplication of scholarly research, "internationalization" of Chardin's fame, and more or less successful attempts to compare Chardin's paintings to those by past and present great masters.

The appearance—first in two installments in the *Gazette des Beaux-Arts,* 1863 and 1864, then in an 1864 fascicule—of an important Chardin study by the Goncourt brothers [see Bouillon, 1967] made history. This work, illustrated by Jules de Goncourt's engravings, was the result of twenty years of scholarly research and work on Chardin rather than the point of departure for his rediscovery, as had long been believed. It finally made Chardin known to the general public. In 1875 the Goncourts published their *Notules* (we have used an edition of 1880 in this catalog), adding much useful and precise information on the provenance and location of many of Chardin's paintings. As a chapter in the often-republished book, *L'Art du XVIIIe Siècle,* the Chardin monograph by the Goncourts was for a long time the standard reference work on the painter.

From then on, monographs multiplied. The first, by Emmanuel Bocher (1876) was far more than a catalog raisonné of Chardin prints; it was, in fact, the second catalog raisonné of Chardin's entire oeuvre. Next came the monographs by Charles Normand (1901) and Gaston Schéfer (1904), one by Armand Dayot and Léandre Vaillat (1907), published in connection with an exhibition at the Galerie Georges Petit; and above all, a monograph by Jean Guiffrey (not dated, appeared in 1907) with a preceding study by Armand Dayot. Republished separately in 1908, Guiffrey's exemplary and still rather useful work constitutes the third catalog raisonné of Chardin's paintings and drawings. Then followed a work by Edmond Pilon (1909); an English monograph by Herbert Ernest Augustus Furst (1911), extremely unusual but not without merit; others by Tristan Klingsor (1924), André Pascal (see Principal Collectors, under Rothschild), Roger Gaucheron (1931), and finally, André Ridder (1932). Some authors of articles which appeared during this period also deserve mention: Henry de Chennevières (1888 to 1890); Paul Leprieur, who wrote in 1909 on the *Child with Violin* and *Child with a Top* that had just been acquired by the Louvre (remember that the La Caze collection had entered the Louvre in 1869 and that two years earlier the museum had acquired three Chardins at the Laperlier sale); Emile Dacier; and Pierre Cornu.

The internationalization of Chardin's fame can be gathered from an increase in Chardin acquisitions by foreign museums and in foreign exhibitions dedicated to Chardin, either partially (Berlin, 1883 and 1910; London, 1907 and 1932; Amsterdam, 1926; Stockholm, 1926; etc.) or exclusively (New York, 1926; Chicago, 1927) and by the growing number of books (Furst, 1911) and articles on this artist, mainly in German and English (Dilke, Grautoff, Pinder, Benesch, Hildebrandt, Ganz, R. Fry, et al.). Chardin paintings preserved since the eighteenth century in Berlin,

Russia, and Stockholm were published by Clément de Ris (1874 and 1880), Sander (1872-76), Mantz (1883), Dohme (1883), and others. In short, enough comprehensive information on the various aspects of Chardin's life and work was gradually accumulated to allow a more accurate and complete understanding of his importance and influence.

Finally, the interest in Chardin which the Goncourt brothers had triggered became a veritable craze among writers and painters alike, as witnessed by some of our following quotations. Two names in particular began to crop up very early in the frequent comparisons of Chardin to other artists: those of the Le Nain brothers (as already observed by Mariette in 1749!) and of Vermeer. Those of Corot (whose opinion of Chardin remains unknown) and of Cézanne were added soon. By pure coincidence — instructive for the art historian and fortunate for the amateur — both the Le Nain brothers and Cézanne have recently been celebrated in the very galleries at the Grand Palais which housed this Chardin exhibition in Paris.

"Awareness and science — these sum up the methods, the secret and the talent of Chardin. His admirable technique is rooted in the most profound theoretical insights gained in long and solitary meditation. His gift of painting stemmed from his gift of seeing, a gift from which Diderot derived the best and surest part of his artistic education. This extraordinary visual awareness enabled Chardin to discern at first glance whether a painting lacked harmony and, if so, how the discordant elements could be brought together. He was, in short, a great practitioner with the mind of a great theoretician, which accounts for his unique painting method. Why should he bother with the simplistic guidelines followed by the colorists of his time, with the rainbow theory which assigned a fixed place to all the conventional colors of light to be parcelled out over the canvas? He had no use for convention and prescribed arrangements; nor did he accept the prevailing prejudice of friendly and hostile colors. Like Nature, herself, he dared use the most contradictory colors. Furthermore, he neither mixed nor blended them, but applied them side by side in frank opposition. Instead of blending, he interrelated them, grouped them, corrected and caressed them in a systematic interplay of reflections which, while preserving the frank character of each color, unified the picture and seemed to imbue every object with the light and hue of its surroundings. On each object painted in a given color, he always bestows some note, some brightness from the tones of the objects around it. A close look reveals some red in this glass of water, red also in this blue apron, blue in this white linen. From these reminders, these continuous echoes, arise at a distance the unique harmony in everything he painted — not the petty, miserably contrived harmony of blended colors, but a sonorous, noble harmony which flows only from the hand of the masters."

Edmond and Jules de Goncourt, "Chardin," *Gazette des Beaux-Arts,* 1864, XVI, pp. 166-67.

"Chardin was the sober mind of those demented times. An honest spirit! The great soul of a child! He put a bottle, a knife, a silver goblet and some cherries on a table, and the sight of it moved him to copy its colors, shapes, and reflections with knowing naivete. These paintings of 'still-lifes' are marvels. We never tire of studying the excellent examples Eudoxe Marcille and Burty have lent to this exhibition. They would provide a perfect occasion for Félibien to aggravate Pymandre even more: if only 'ignorant' people can like the peasant pictures by Lenain, how much more must the person be out of his wits who cares to look at a poor rabbit hung by its paws! For our part, we look at it with extreme pleasure. But we gladly forgive Chardin when he adds a bit of living nature to his still lifes. We think *The Water Urn* from the Marcille collection, illustrated here with an engraving, is a masterpiece in every respect. It is at once the work of an assured draftsman and of a sensitive but robust colorist. Chardin is definitely not enough appreciated yet. But to think that fifty years ago, in the sad period that produced *Endymions* and *Bélisaires,* his exquisite works hardly fetched two *louis*! Oh Style, what crimes have been committed in your name!"

Paul Mantz, "Exposition en faveur des Alsaciens et Lorrains," *Gazette des Beaux-Arts,* August 1874, X, p. 114.

"But Chardin!

"When it comes to Chardin, I have often wished I knew something about the man. (Watteau was exactly as I imagined him.) Bourgeois, Corot's kind and as good-natured, but more care-worn, more setbacks in his life.

"The Goncourts' book is magnificent. La Tour, witty, Voltairian.

"Pastel painting is a technique I would like to know. One day, I'll try it — later. If one knows how to paint a head in oil, one should be able to learn how to do it in pastel in a matter of hours.

"I liked what he said of Chardin. I am more and more convinced that true painters don't 'finish' their pictures, in the sense in which 'finish' is too often understood; in other words, so carefully worked out that you have to rub your nose on it to see it. From very close, the best paintings, precisely those that are the most complete from the technical point of view, are made up of color touches posed side by side; they show to best effect from a certain distance. Rembrandt staunchly persisted in this, no matter how they made him suffer for it (the good burghers actually found Van der Helst much better, because you could view his paintings from very close). In this respect, Chardin is as good as Rembrandt."

Vincent Van Gogh, Letter to his brother Théo, November 1885, *Correspondance*, II, 1960, p. 499.

"But Chardin was also the painter of contemporary family life. His intimate subjects are unique pearls of story-telling. They are unequalled in their simplicity, their ingenuousness of concept and expression. He extracts from a subject the essence particularly and uniquely suited to painting and avoids the pitfalls so common in French genre painting, namely the pursuit of the spiritual, ostentation, witticism, histrionics. These preoccupations of the public do not matter to the true artist; what matters is his talent, his genius, and to be himself. Incidentally, Chardin's technical qualities are always the same, whether in still lifes or in domestic scenes. His draftsmanship is assured, simple, true to nature, and devoid of provocative additions: it exemplifies French rational concentration. He is a master with an innate pragmatic taste of distinction, the very real distinction of the honest *petite bourgeoisie*. Where did he get his beguiling, fluid, luminous color, so delicate and yet so vigorous? Second only to Van der Meer of Delft, he is indeed the inventor of this fine French *gray*, in happy contrast to the 'Flemish sauces' and the bituminous hues of misty lands. In our eyes, he makes Flemish paintings look as though they were cooked in beer. Instead of their dark interiors, Chardin likes to play up the ruby glow of French wine reflected in a decanter or in a glass, and he sees all things in the clarity of this congenial wine. In sum, he is one of those masters who, in the field of painting, knows best how to make us love the true and wholesome genius of France."

Henry de Chennevières, "Chardin au musée du Louvre," *Gazette des Beaux-Arts*, July 1888, XXXVIII, p. 56.

"If I knew that young man, I would not deter him from visiting the Louvre, I would be more inclined to go with him. But leading him into the La Caze Room and the Room of the eighteenth-century French School, or the Rubens Room, or some other room of the French School, I would halt him before the Chardins. And when he stood amazed by this sumptuous painting of what he had called commonplace, this appetizing painting of a way of life he had considered vapid, this greatness achieved in a kind of art he had supposed paltry, I would say to him, You're happy, aren't you? But really you have seen nothing more than a well-to-do tradesman's wife pointing out to her daughter where she had made mistakes in her wool-work *(The Diligent Mother)*, a woman with an armful of loaves *(The Return from Market)*, a kitchen where a live cat walks across a heap of oysters while a dead skate hangs against the wall, a half-cleared sideboard with knives still lying about on the cloth, *(Fruits and Animals)*, and even worse, table and kitchen ware, not just Dresden chocolate pots and pretty things of that sort *(Various Utensils)*, but such as you consider ugliest, a shiny saucepan lid, crocks of all sorts and sizes (a salt jar, a skimmer), sights you shudder at, like raw fish lying about on a table, and sights that turn your stomach, like half-drained tumblers and a plethora of tumblers filled to the brim *(Fruits and Animals)*. "If all this now strikes you as beautiful to the eye, it is because Chardin found it beautiful to paint; and he found it beautiful to paint because he thought it beautiful to the eye."

Marcel Proust, "Chardin et Rembrandt," written in 1895 and first published in *Le Figaro Littéraire*, 27 March 1954 (ed. *Le Pléiade, Contre Sainte-Beuve*, 1971, p. 373; English trans. by Sylvia T. Warner, *Marcel Proust on Art and Literature, 1896-1919*, New York: Meridian, 1958).

"The characteristic aspect of Cézanne's paintings stems from this juxtaposition, this mosaic of separate but slightly overlapping tones. 'Painting,' he said, 'is to record one's color sensations.' So demanding was his eye that he had to resort to this technical refinement in order to preserve the quality and flavor of his sensations, and to satisfy his craving for harmony. Cézanne's fruits or his unfinished figures are the best examples for this working method, which is perhaps a renewal of Chardin's method: some square touches can indicate a round shape, thanks to the soft tints that surround it; the outline comes last, like a violent stab at the essence, enhancing and isolating a form already rendered perceptible in the graduations of color."

Maurice Denis, "Cézanne," *L'Occident*, No. 70, September 1907, p. 131.

"All the splendor derives exclusively from a voluptuous painterliness which no other painter, probably with the exception of Vermeer of Delft, ever possessed to such high degree. Our good Chardin performs his task with love, like a good cabinetmaker, bricklayer, screwcutter, or any good craftsman who ends up loving the material in which he works and the tool which lifts him out of uniform boredom, bestowing on him the dignity of a man who knows his means. He painted with equal love the bare arm protruding from a scalloped sleeve, the napkin it holds, and the leg of lamb in the napkin which weighs heavily in the rosy, pudgy hand. He lavished the same attention on the little girl intent on saying grace correctly to speed up the serving of her soup, as on the mother who, with an amused look, is going to serve her, and on the bourgeois amenities that surround them, the aprons, the woolen dresses, the blue stripe running across the tablecloth, the soup tureen, the furniture of polished oak, the shifting, caressing shadows. He knows that all this is in agreement, that the life of the objects depends on the moral life of human beings, that the moral life of human beings receives the reflections of these objects. He pays his tender respect to all that exists. He and Watteau are, in France, the only pious painters of an impious century."

Elie Faure, *Histoire de l'Art, Art Moderne*, IV, 1921, pp. 226-27.

"Indeed, anyone who has experienced the elation and despair which come from the attempt to express their feelings about vision in oil paint will know that it is impossible for him to speak with complete judicial impartiality about Chardin. Amongst all the gods of the artist's Pantheon who seem to change before his wondering gaze — now grown to unheard-of dimensions, and now shrinking to a minor place — Chardin remains unchangingly the same. His shrine may not be the most richly adorned, but the little lamp that burns there never goes out. There are days of lowered vitality when one may wander disconsolately in a gallery like the Louvre, in despair at one's incapacity to respond to the appeal of the great masters, whom one had thought to be one's friends, but who suddenly seem to speak an alien tongue. At such times Chardin is certain to bring relief; no painter can fail to respond the moment he catches sight of that miraculous substance, that magic paste which Chardin could control with his caressing touch. And then there is his colour which glows so radiantly, so seductively and enchantingly and which is all the same so elusive, so shy and retiring. For Chardin seems almost afraid to say what his incredibly penetrating vision discerns in the crockery and vegetables that lie on the kitchen table with the gray light of a narrow Paris street filtering in through the window. He is afraid you will think he is exaggerating. He takes infinite pains to modify and correct his statements. He sees a kind of blueness in that white pot, just where the angle is right to get a colder light than the rest, but to say blue outright would be an exaggeration; blue, yes, if you like, but ever so much modified and diminished by other colours. And yet, with all these modifications, the colour is never dirty or confused; that would be the worst lie of all. And so, with his infinite simplicity, Chardin gains our confidence, we will trust him anywhere; we know he will not try to impress us, that he will never embellish his account in any way, and we are ready to take his slightest hints at their full value. We need discount nothing."

Roger Fry, *Characteristics of French Art*, London, 1932, pp. 61-62.

Chardin Today

From the Wildenstein Monograph (1933) to the Present

Georges Wildenstein's monograph (1933) still remains the principal work on Chardin. It comprises a biography, reprints of earlier biographies, an iconography of the painter, a monograph by his son Jean-Pierre, but above all, a catalog of 1,237 entries resulting from systematic inspection of old sales, Salon, and museum catalogs. The profusely illustrated Wildenstein work classifies Chardin's oeuvre in thematic groupings; large captions in italics are used only for authentic works. Thirty years later, Wildenstein published a revised edition which differs from the earlier work in two important respects: works of uncertain attribution are no longer listed (but lost paintings mentioned during Chardin's lifetime are included) and the total of 406 authentic Chardin paintings are cataloged in *chronological* order. In 1969 a "revised and complete" English edition was published by Daniel Wildenstein, incorporating numerous corrections and including a biography and an "appendix" compiling all mentions of works attributed to Chardin in sales catalogs and other publications. It should be noted that a certain number of Chardin paintings shown in the present exhibition (from museums in Bordeaux, Chartres, Douai, Frankfurt, Oxford, Princeton, Rennes, the Carnavalet and the Musée de la Chasse in Paris, et al.) are missing from one or the other of the Wildenstein editions.

Publications on Chardin which have appeared since 1933 can be divided into several categories:

There are, first of all, the monographs written in foreign languages. The best of these, by the painter and art critic Ernst Goldschmidt (1879-1959), was first published in Swedish (1945), then in Danish, his mother language (1947). Others are in Hungarian by Klára Garas (1963); in Russian by I. Nemilova (1961), Zolotov (1962), and Lazarev (1947 and 1974; a monograph in German by the same author, published in East Germany, appeared in 1966); in German, edited by Mittelstädt (1963 and 1968); in Italian by Franceso Valcanover (in the popular series *I Maestri del Colore*, 1966, no. 124; also published in French, 1967 and 1978); and in Japanese by Mitsuhiko Kuroe (1975). Monographs by Francis Jourdain (1949) and Bernard Denvir (1950) appeared in several languages; Rosenberg's (1963) has been translated into German and English.

The second category comprises scholarly articles dedicated to in-depth study of individual paintings (David Carritt, J. Cailleux, Carol Clark, M. Kemp, Serge Ernst, Kurt Martin, P. Rosenberg, Th. Rousseau, J. Wilhelm, et al.) and exhibition catalogs *(La Nature Morte,* Paris, 1952, under Charles Sterling; *Hommage à Chardin,* Paris, 1959, under Georges de Lastic, et al.), as well as certain museum catalogs (Ch. Sterling, M. Davies, J. G. von Hohenzollern, J. Rishel, G. Monnier, P. Bjürstrom, Colin Eisler, et al.).

A third category deals with Chardin in connection with specialized interests: music (A. P. de Mirimonde), glassware (J. Barrelet), "accessories of living" (G. Wildenstein, 1959), drawing (J. Mathey and A. Ananoff), nineteenth-century Chardin "revival"

(F. Watson, 1960 and 1970; McCoubrey and F. Haskell), Chardin and England (F. Watson and D. Carritt), Northern influence (H. Gerson, 1942, and J. Cailleux), the *Salons* (Zmijewska), Chardin and Diderot (J. Seznec and J. Adhémar and the bulk of literature on Diderot's art criticism), Chardin and Marcel Proust (Gita May, 1957), and so on.

The approach from aesthetic, iconological, or sociological points of view is of more recent date. Though sometimes unconvincing (the analysis by Bataille of *The Ray-Fish*, published in the August/September issue 1973 of *Critique*, or the writings by Arnold Hauser), this type of Chardin study should not be dismissed summarily. The recent works by Ella Snoep-Reitsma (1973), who sees Chardin as a "full-blooded moralist"; by Donat Carlos de Chapeaurouge (1972; the same author also defended an unpublished thesis on Chardin at the University of Bonn in 1953); by R. Paulson (1975); or by Michael Fried (1975-76, on the problem of absorption in Chardin's work; and, in particular, by René Demoris (1969), add a new dimension and deepen our understanding of Chardin's oeuvre.

Our catalog, however limited, is the result of all this research. Devoted to one of the greatest painters of the eighteenth century, it is intended above all to serve Chardin.

"Born into the working class, not particularly industrious, yet highly conscientious, he used his admirable natural gifts like a diligent and serious artisan. A 'painter' from the very beginning, having learned the technique of paints and brushes, he somehow locked himself up in his medium. In painting alone did he strive to find the means to express whatever his genius saw all around him and what he wanted to record: the play of light and of textures and even those impressions of paint usually associated with the sense of touch.

"His subordination to the dictates of technique and materials enabled him to attain the highest achievements in art and assures him today of a steady and appreciative following among our most progressive painters who are no longer bound by tradition and conventions."

Georges Wildenstein, *Chardin*, Paris, 1933, p. 29.

"Certain masters, however, seem really to have been mastered by the thing seen, and even claimed that this submission contributed to their talent. Such artists often belong to a special human type, that of Chardin and Corot; and they are the least romantic men imaginable. Should we say 'bourgeois'? I doubt if humility is a bourgeois virtue and that shy, good-hearted artist, Corot, seems more like Fra Angelico than like Ingres. Whereas Chardin's seeming humility involved not so much subservience to the model as its destruction in the interests of his picture. He used to say that 'one paints with emotions, not with colors,' but with his emotions he painted—peaches! The boy in *The Sketcher* [*The Young Draftsman*] is no more emotive than the still life with a pitcher and that marvelous blue of the carpet on which he is playing owes but little to the real. Chardin's *Housewife* [*The Return from Market*] might be a first-class Braque, dressed up just enough to take in the spectator. For Chardin is no eighteenth-century *petit-maître*, more sensitive than his coevals; he is, like Corot, a *simplifier*, discreet but unflinching. His quietly convincing mastery ended for ever the still lifes of the Dutch school, made his contemporaries look like decorators, and in France, from Watteau's death down to the Revolution, there was nothing that we can set up against his art."

André Malraux, *The Voices of Silence*, trans. by Stuart Gilbert, Garden City, NY: Doubleday, 1953, pp. 295-96.

"At the close of his life, Chardin finally braved the one subject he always seemed to have avoided: the human face. He tackled it with dazzling skill, re-composing colors and volumes built of opposing touches of pastel. His vision was sharply analytical; his warm humanity brings these rare portraits intensely alive, endowing them with an extraordinary presence. If the trite realities of daily life appear to have constituted his only source of inspiration until 1771, their spiritual content would, if such were necessary, reveal itself in his latest works.

"On first analysis, Chardin may appear isolated, opposed to the grandiose options of the painters of his time. But as soon as one judges his works strictly by their visual qualities, one begins to see his link to the brilliant art of the court and to understand why he gained acceptance. To be sure, many of his contemporaries could see in him only a flair for decor and anecdote, as borne out by the success of the engravings, made after his paintings, which permitted the public to appreciate his works but stripped them of their pictorial magic and reduced them to the level of tender illustrations."

Albert Chatelet, in Thuillier and Châtelet, *De Le Nain à Fragonard*, 1964, p. 206.

"Chardin does not withdraw to the lofty world of gods and heroes of classical mythology or religious lore.

"When the ancient mythologies have lost their meaning, *felix culpa!*, we begin to feel awed by the realities of daily life.

"I believe that more and more recognition will be given to those artists who, simply by their silence and by abstaining from the themes imposed by the ideology of the period, have kept in touch with the non-artists of their time; for at bottom, they lived in better agreement with the temper of their time and its actual outlook — regardless of the prevailing ideological superstructure.

"If one takes the down-to-earth as point of departure and neither makes nor wastes any effort in trying to rise to an exalted or splendid level, every effort, every contribution of the artistic genius goes into transfiguring the manner of execution, changing the language, and helping the spirit to take a new step, thus constituting magnificent *progress*.

"Rameau is a case in point. So is Chardin, for instance, with his 'sense of the void' around *Child with a Top* and around the player at *The Game of Knucklebones*, or with his 'dream light' in *The Monkey as Antiquarian*.

"Endeavor to treat the most common subject in the most ordinary fashion, and your genius will come forth."

Francis Ponge, "De la Nature Morte et de Chardin," *Nouveau Recueil*, Paris, 1967, pp. 171-72.

"Chardin never tries to hide his overriding concern with carefully planned arrangements: he makes no secret of it in the way he slips a leg of mutton through the handle of a jug or balances a skimmer on a kettle. He was known to spend considerable time in properly displaying the subjects he intended to paint. The Dutch masters, too, were concerned with composition, but it rarely became such a central issue as it was for Chardin. Dutch still lifes often catch the depicted objects by surprise, still lying about as their users left them. In sum, Dutch still lifes tend to conjure up a genre scene from which the human figure is temporarily absent. In a still life by Claesz, for instance, a faint reflection of the potential consumer is discernible on the polished surface of a silver ewer. Dutch still lifes can often be linked to a certain time of day, for instance, lunch time. Moreover, the Dutch frequently render the exact atmosphere proper to their subject; they particularize certain background elements and rely on perspective for a feeling of space; their arrangements of objects relate to specific events. By contrast, the order which Chardin imposes upon his objects — even when he paints the leftovers from a meal — can never be mistaken for natural clutter or for the result of recent activity. His objects look as though the painter had come by and, without seeking any other justification, had given them the central place they occupy in his canvas. The human presence, latent in Dutch still lifes, has been resolutely expelled from those by Chardin (which also explains why Chardin was to rid himself so quickly of the dog and the cat that had introduced an extraneous element of anecdote).

"The rejection of incident, the central placement of objects, the marked change of planes between object and background, and an indifference to wealth — these are traits which bring to mind a group of paintings described as 'Vanities' that were particularly current in the seventeenth century....

"History painting presupposed a well-educated viewer and appealed to his active intellect. The decoding of a painting increased the viewer's enjoyment. In a Chardin painting, the eye, once it has deciphered the simplicity of basic shapes, is left to roam with an uncertainty that mobilizes attention, and the viewer's mind is led to a sort of restful *contemplation*. There is much to see but nothing to guess or to deduce. The only movement, infinitesimal and illusory, is that of colored atoms. Chardin's art is an art of *fascination*.

"Though the figures are clearly represented in action, there is no *movement*. They are caught at a timeless moment of their action, which puts them at *rest*. At mealtime, it is the moment of *Saying Grace;* when it is time for a walk, it is the moment when the governess takes a last glance at the child. Similarly, the servant girl is shown *immobile*, bent over, while her jug fills with water from the urn. Better still, the *Kitchen Boy* and *Kitchen Maid* are shown at the precise moment where they interrupt their busy scrubbing of kettle or barrel and lift their heads to look at something beyond the painted scene. In *The Return from Market* the woman has already placed the bread on the buffet but has her purse still in hand and is just pausing to catch her breath. This moment of suspense is singled out even more sharply in the painting of children who are

building houses of cards where they dare not move and are holding their breath to prevent the house's collapse, or in the case of the boy fascinated by a spinning top.

"For the sometimes-brief lapse of time recorded in the canvas, the human figure is, in fact, motionless. It is caught at a precise instant, free from activity, in a moment of leisure, no matter how fugitive. Sometimes, as in *Lady Taking Tea,* the action itself denotes leisure; there is no pressing sense of time. Servants are shown not in a moment of exertion but in a moment of relaxation which follows or interrupts their exertion—even at a moment which allows for a bit of distraction, as in the case of *The Washerwoman* or the *Kitchen Boy.* In scenes with mothers and governesses, the women watch the children attentively but without specific expression: the viewer is free to interpret the look on the face of the National Gallery's *Young Governess,* or of the mother in *Saying Grace,* as he pleases. These seem to be fleeting moments where the child does not require undivided attention; the adult's eyes rest on the youngster with a slight detachment and for no particular purpose — and perhaps this aimless watchfulness is peculiarly apt to express affection. It is a lost moment where time stands still, and the human being, center of activity, is seen for what it is, beyond the grasp of any practical exigency. This still moment of uninhabited time (for we do not know what has caused the servant to look up, and the expression on the mother's face eludes us) transcends the time taken up by the activity depicted: there is a sense of infinity about these human figures which are shown caught in action and yet detached from it."

René Demoris, "La nature morte chez Chardin," *Revue d'Esthétique,* 1969, 4, pp. 369, 377-78, 383-84.

NOTES

In the catalog entries, an asterisk following the name of the lender or lending institution indicates that the picture was exhibited only in Paris.

Numbers appearing in brackets throughout the catalog refer to works in this exhibition.

In some instances, the French title given beneath the English title of a catalog entry is set within quotation marks; this reflects the title exactly as it was given in eighteenth-century sale catalogs.

Throughout the catalog, French eighteenth-century currency is noted in *livres.* The approximate value of the *livre* expressed in 1979 dollars and sterling is given here for years of significant variation:

1723	$1.37	67	pence
1724	$1.29	63.5	p
1725	$1.99	98	p
1726	$1.79	88	p
1727	$1.54	75	p
1729	$1.49	73	p
1731	$1.39	68	p
1732-1775	$1.31-1.42	64-70	p

Also throughout the catalog, French eighteenth-century measures are given in *pieds, pouces,* or *lignes.* Approximate equivalents in centimeters and inches are as follows:

1 *pied* = 12 *pouces;* 1 *pouce* = 12 *lignes*

1 *pied*	= 32.48 cm.	= 12.79 inches
1 *pouce*	= 2.71 cm.	= 1.07 inches
1 *ligne*	= .226 cm.	= .089 inches

Catalog

I *Chardin's Beginnings*

Chardin's formation as an artist remains a mystery. One essential fact, however, would weigh heavily in the painter's career: among the foremost artists of his generation, he is the only one who did not receive the thorough training offered by the Academy.

Jean-Siméon Chardin was born in 1699, one year after Bouchardon, the same year as Subleyras and Jeaurat. Natoire and Dandré-Bardon were born in 1700, Dumont le Romain and Frontier in 1701, Aved—one of Chardin's closest friends—in 1702, and Tremolières and Boucher in 1703. Carle Vanloo, the most famous painter of his time, was born in 1705, as was Blanchet. Chardin kept more or less closely in touch with all these artists, all of whom were well known then, some of whom are now forgotten. Yet Chardin is the only one whose artistic education almost totally eludes us.

Thanks to his earliest biographies, we know at least that his father, a maker of billiard tables, allowed him to study under Pierre-Jacques Cazes (1676-1754), from whom he learned "to draw." His real ambition, however, was to emulate his teacher, who specialized in large religious canvases and "to succeed in history painting" [Mariette, 1749]. We must keep in mind that during the eighteenth century painters were "classified" (and paid) according to their subjects. Still-life, landscape, and genre painters were at the bottom of a "hierarchy of categories" in which religious and mythological subjects ranked highest, and these were precisely what Cazes painted. We may find it difficult today to understand this hierarchy of categories and to acknowledge its importance, but we must realize that its theory was accepted by all the painters of that period and that it was based on the fairly simple premise that the essential quality for an artist was the imagination used in representing the human image: "The history painter alone is the painter of the soul; the others paint merely for the eye!" wrote La Font de Saint-Yenne in 1747.

It is therefore not surprising that Chardin should have wanted to become a history painter. But, according to Mariette, he did not succeed, "howevermuch he desired it." It was probably this failure that prompted him to turn to the great Academy's lowly, undistinguished rival, the Académie de Saint-Luc, which opened its doors to him in 1724.

The few works in this exhibition which antedate his first still lifes are but vestiges of the artist's earliest attempts, most of them now lost. The major work of his youth, a large signboard for a surgeon's shop (reminiscent of Watteau's beginnings) had disappeared, and the sketch for it was destroyed when the Hotel de Ville burned in 1871. An engraving by Jules de Goncourt, however, enables us to confirm that a drawing at the Stockholm museum [1] is a preparatory study for the youthful work. A second drawing, also at Stockholm [2], was done in preparation for the small *Game of Billiards* [3], a painting acquired in Paris by Count Tessin during Chardin's lifetime; it recently entered the collection of the Musée Carnavalet, Paris.

We cannot by any means claim to reconstruct the young Chardin's artistic debuts from such scanty evidence, particularly since these works give us no hint of the direction Chardin's art was to take either in subject matter or technique. Nevertheless, they confirm what had already been learned from old biographical texts: Not only did the billiard-table business of the father inspire one of his son's first pictures, but the verso of the first of the Stockholm drawings [1] also reveals a *Figure Study of a Male Nude,* attesting to the obvious influence of Cazes.

These earliest works are drawings, of which only a very few can definitely be attributed to Chardin. They are marked by a great variety of influences derived from the best-known French artists of the time, such as Restout, Lemoine, La Fosse, even Pieter Boel (see [4])—a first indication of Chardin's enduring interest in Northern painting. Yet nothing in them points toward an artist of genius. Charles-Nicolas Cochin (1715-1790), one of Chardin's most faithful friends, was right when he wrote following Chardin's death that "M. Chardin had made little progress by the time he left the school of M. Cazes," to which he added, alluding to his friend's training outside the Academy, that Chardin "often regretted not having had the benefit of a first-rate education." We shall see how he strove to compensate for it throughout his entire career.

1

1 *The Vinegar-Barrow*

(La vinaigrette)

Charcoal with white highlights on gray-beige paper, 287 × 406 mm. On the verso, by Chardin: a half-length study of a male nude, the right arm raised to the face; black charcoal with highlights in chalk. At the lower right, in pen, in Tessin's hand: *Chardin;* numbers *2854* (Sparre), *106* (Tessin) [the last digit was changed to *8*], and *2960* (Nationalmuseum).
Stockholm, Nationalmuseum, Drawings Collection, 2960/1863*

Provenance. Collection of Count Carl Gustaf Tessin (1695-1770). Acquired in Paris between 1739 and 1741 (on p.69 of list of works sent to Stockholm by Tessin in 1741, see *Un brouhétier* [bath-chair man]). Manuscript cat. 1749, no. 106, *Un brouhétier. Equisse au charbon.* Royal Library of Stockholm (manuscript cat. edited in 1790 by F. Sparre, no. 2854). Royal Museums of Stockholm (Lugt 1921, I, no. 1638).

Exhibitions. 1922, Stockholm, no. 42; 1932, London, no. 764 (no. 642 in commemorative cat.); 1933, Stockholm, no. 73; 1935, Copenhagen, no. 333; 1935, Paris, no. 56; 1937, Paris, no. 520; 1950, Paris, no. 77A; 1950, Vienna, no. 75, pl. V; 1952, London, no.18; 1958, Munich, no. 2763; 1963, Leningrad; 1969, New York, Boston, Chicago, no. 103 (pl.).

Bibliography. Dilke, 1899, p. 390 (ill.); Schönbrunner and Meder, 1895-1908, no. 914 (ill.); Guiffrey, 1908, p. 94, no. 247; Furst, 1911, p. 137 and pl. 42; Gauffin, 1915, p. 146 (ill.); Benesch, 1924, p. 167 (ill.); Mathey, 1933, p. 83; Robiquet, 1938, pp. 130-32 (with pl.); Goldschmidt, 1945, p. 62 and pl. 13; Goldschmidt, 1947, pl. 15; Lavallée, 1948, p. 73; Sutton, 1949, p. 41 and pl. 49; Boucher and Jaccottet, 1952, p. 1874 and pl. 44; Mathey, 1964, pp. 17-20, 27, and fig. 2 on p. 19; Valcanover, 1966, fig. 3; Ananoff, 1967, p. 61, fig. 2 (color); Pignatti, 1968, p. 53, fig. 10; Bjurström, 1969, pp. 58-60 and fig. 2 on p. 59; Wilhelm, 1969, p. 10 (ill.); Benesch, 1970, p. 75 and fig. 40.

Related Works. A weaker sanguine version of the "strapper" and of the "vinegar-barrow" is in a private collection in New York.

Chardin(?), New York, Private Collection.

It will come as a surprise that the *Chardin* catalog opens with a drawing, for Chardin is said to have dispensed with drawing. However, the Stockholm page is the painter's earliest-known work. It shows a bath-chair or hand-chaise—a kind of litter put on two wheels but without carrying shafts in the back, nicknamed "vinegar-barrow" because it resembled the tank-carts dragged through the streets by vinegar peddlers [see Robiquet, 1938, where such a model from the Musée de la Voiture at Compiègne is illustrated]. This type of carriage, much like an eighteenth-century taxicab and boasting a suspension mechanism said to have been invented by Pascal, used to be drawn by a "strapper" and pushed by a "panter."

In 1969, confirming the intuition of E. Goldschmidt, the eminent Danish Chardin expert, both P. Bjurström and J. Wilhelm were able to establish independently that the Stockholm drawing was made in preparation for a figure group which appeared at the extreme right of a surgeon's signboard—one of Chardin's earliest works. Charles-Nicolas Cochin (1715-1790) has left us an excellent Chardin biography, written after the painter's death. The manuscript that we cite here, now at the Bibliothèque Municipale in Rouen, was subsequently taken over—without much change, except perhaps in form—by Haillet de Couronne (of whose two existing manuscripts the original is at Rouen, the other at the Ecole des Beaux-Arts):

"Around that time, when he was in his early youth, a surgeon friend of his father's asked the young man to paint him a signboard to hang above his shop. He wanted it to show the tools of his trade, such as lancets, trepans, and the like. Yet this was not what young Chardin had in mind. Unbeknownst to the surgeon, he painted a crowded figure composition. His subject was a man injured in a duel and taken to the shop of a surgeon who examines his wound to dress it. The police officer, the watchman, a group of women, and other figures people the scene that was composed with much verve and action. The painting was hastily done, yet with much taste and an exciting effect. Early one morning when everyone was still asleep in the surgeon's house, he [Chardin] had it hung in place. Upon waking, the surgeon was surprised to see passers-by stop at his door; he went out and saw the new signboard. Although tempted to fly into anger that his idea had not been executed, when he heard so much praise from all quarters he felt ashamed of his poor taste and no longer dared to complain—except very faintly. This picture made the young Chardin's talents known to the entire Academy, for it caused such a stir that nobody neglected to go and see it."

This signboard, measuring about 4.4 meters in length and belonging in 1745 to Jacques-Philippe Le Bas (1707-1783; see [20]), was sold after the death of this engraver and has since disappeared. But Chardin kept its painted sketch until his death

(it is listed in the inventory of his estate). The Musée Carnvalet acquired it at auction from Laperlier in 1867. Unfortunately, it was burned in the Hôtel de Ville fire in 1871. Happily, however, Jules de Goncourt (1830-1870) had made an engraved copy [Burty, 1876, no. 57]—thanks to which it has now been firmly proven that the still-disputed Stockholm drawing is indeed a preparatory study for the lost painting.

Jules de Goncourt, engraving after an oil sketch of *The Surgeon's Signboard*, now lost.

The attribution can be confirmed on two other grounds as well. Firstly, Count Tessin—one of Chardin's earliest admirers to whom this catalog will refer on numerous occasions—unhesitatingly accepted this attribution as of 1741, at which date he mentioned the drawing (at an estimated value of one *livre!*) along with the two others still owned by the Stockholm Nationalmuseum in a list of works which he sent to Sweden. When and how Tessin acquired the three drawings remains unknown.

If this were not proof enough, the attribution is supported by a second argument which has the advantage of confirming the date of the Stockholm drawing that had been somewhat rashly assigned. The verso of the sheet represents a half-length male nude (never before published) which all the experts consider not to be by Chardin. Wrongly so, in our opinion. For it not only shows all the technical characteristics of the *The Vinegar-Barrow* but also is close in style to the nude studies (five at the Ecole des Beaux-Arts and a very fine group in a French private collection) by Chardin's first teacher, Pierre-Jacques Cazes (1676-1754). The pertinent passage in Cochin's biography reads:

"He studied history painting under Cazes, and the results were only of the most ordinary kind. Monsieur Caze's school was hardly suited to shape pupils; instead of painting from nature, the students had to content themselves with copying their master's paintings and doing some drawing at the Academy in the evenings. Cazes could not afford to hire models. He turned out his best pictures merely on the strength of long practice, with the aid of a small number of studies he had made in his youth and of some figure drawing he pursued at the Academy. To do him justice, he was in many respects a superior draftsman; nonetheless, his style was a little too mannered."

In fact, the verso of the Stockholm drawing remains to this day the only evidence of Caze's influence.

The recto drawing is executed with a brutal vigor similar to drawings by such artists as Lemoine or Restout. In subject matter it is close to—but can hardly have been antedated by—Claude Gillot's *Scene with Two Carriages* in the Louvre. Because the Stockholm page reveals a certain clumsiness, the name of Pietro Longhi has been suggested [Pignatti, 1968]. But the painted sketch had already prompted the Goncourts [1863, p. 518] to speak of "the freedom of brush and inspiration of the last great Venetian masters," and even of Guardi! What makes the drawing remarkable is its quick execution, its sureness in placing the figures, and the observation of a street scene as if done from life.

2 Manservant Pouring a Drink for a Player

(Serveur versant à boire à un joueur)

Sanguine, charcoal, and white highlights on grayish-brown paper, totally fastened with adhesive, 248 × 367 mm. (right corner cut). At the lower right, in pen, in Tessin's hand: *Chardin;* numbers *2855* (Sparre) and *107* [changed to *109*] (Tessin). Stockholm, Nationalmuseum, Drawings Collection, 2962/1863*

Provenance. Collection of Count Carl Gustaf Tessin (1695-1770). Acquired in Paris between 1739 and 1741 (on p. 69 of list of works sent to Stockholm by Tessin in 1741, see *Un garçon qui verse à boire* ["Servant who pours a drink"]). Manuscript cat. 1749, no. 107, *Garçon qui verse à boire à un homme, au crayon rouge* (Servant who pours a drink for a man, in red chalk"). Royal Library of Stockholm (manuscript cat. edited in 1790 by F. Sparre, no. 2855). Royal Museums of Stockholm (Lugt, 1921, I, no. 1638).

Exhibitions. 1922, Stockholm, no. 43; 1932, London, no. 770 (no. 663 in commemorative cat.); 1933, Stockholm, no. 72; 1935, Paris, no. 58; 1958, Stockholm, no. 228, pl. 51; 1968, London, no. 146, fig. 200: 1970-71, Paris, Brussels, Amsterdam, no. 55 (with pl.).

Bibliography. Dilke, 1899, p. 341 (ill.); Schönbrunner and Meder, 1895-1908, no. 1008 (ill.); Guiffrey, 1908, p. 94, no. 246; Gauffin, 1915, p. 146 (ill.); Ridder, 1932, pl. 93; Mathey, 1933, p. 83; Goldschmidt, 1945, p. 65, pl. 15; Goldschmidt, 1947, pl. 17; Sutton, 1949, pl. 50; Mathey, 1964, pp. 17-20, 27, and fig. 3 on p. 19; Ananoff, 1967, p. 60, fig. 1 (color pl.); Hulton, 1968, p. 163 and fig. 3, p. 164 ("Etienne Jeaurat"); Bjurström, 1969, p. 58; Rosenberg, 1969, p. 99; Wilhelm, 1969, pp. 7-12 (ill. p. 10).

This is a preparatory drawing for a figure group at the left of *The Game of Billliards* [3]. Its provenance (cf. [1]) leaves no doubt about its attribution. Both the drawing and the oil sketch in the Musée Carnavalet must belong among Chardin's earliest works—in our opinion, prior to 1724.

Although at first glance this drawing and *The Vinegar-Barrow* appear to differ widely in technique as well as execution—in *Manservant...* the three-color technique brings to mind drawings by La Fosse and even Watteau, and the execution is less abrupt, the strokes better rounded than in *The Vinegar-Barrow*—the two drawings have certain striking points in common: both are done

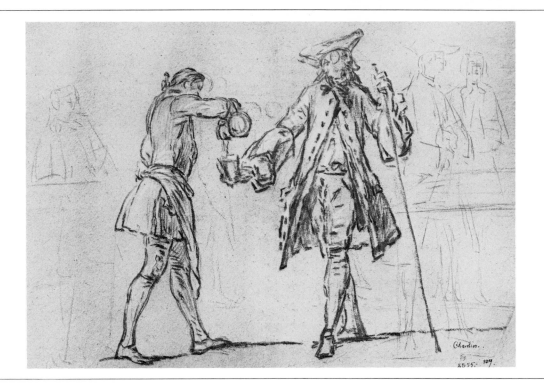

in large scale, particularly in the way figures are firmly placed and the way in which their gestures and attitudes are captured.

In any event, the two Stockholm drawings permit us to raise certain questions. Did the artist do much drawing? It has always been thought he did not. No doubt his graphic work consisted of more than just the five drawings exhibited here—and surely he must have produced numerous preparatory studies for such paintings as his *Surgeon's Signboard* or *The Game of Billiards*—but it is significant that not a single drawing by Chardin appeared in his estate sale, although that sale catalog listed numerous drawings by his contemporaries.

Only three instances can be found of Chardin drawings offered for sale during his lifetime. The first instance has been brought to our attention by David Carritt: Sir John Eyles's sale of 1741 in London included twelve Chardin drawings, but unfortunately the titles were not detailed.

Second, there was the sale held by the painter Louis-Joseph Le Lorrain (1715-1759) at the time of his departure for Russia on 20 March 1758: lot 89 from among his private collection consisted of 600 drawings, and Chardin's name appeared next to that of Boucher.

Third, there was the Dezallier d'Argenville sale of 18 January 1779. The sales list mentioned no. 482, *Une femme debout tenant un panier à son bras* ("Standing woman with basket on her arm"),

and no. 483, *Une figure d'académie et sept études dont plusieures compositions par Chardin* ("Nude figure and seven studies, including several compositions by Chardin").

Shortly after Chardin's death, drawings by him appeared at two other sales: On 19 November 1783, no. 125, *Intérieur de cuisine* ("Kitchen interior"), and on 1[6] February 1786 at Monsieur St. M[aurice]'s sale, nos. 598 and 681. [See also [140], *Provenance.*]

It is important to note that the drawings found up to now all date from the painter's youth. Did he later abandon drawing? We believe so, and the writings of Pierre-Jean Mariette (1694-1775) confirm it: after voicing some reservations about Chardin's work as a painter, he writes, "Lacking in drawing skill. . . (and unable to do his studies and preparations on paper [he added later]), Monsieur Chardin has to keep the object he proposes to imitate [at first he had written 'model' rather than 'object'] continuously before his eyes, from the very first sketch to the last stroke of the brush." Therefore, it seems likely that for his earliest paintings Chardin wanted to make preparatory studies just as he had seen others do. It seems equally likely that when he abandoned this genre of painting he also abandoned this method of preparation and henceforth painted directly the dead animals and diverse objects displayed before him, developing in the process his own original technique which even his contemporaries admired.

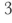

3

3 *The Game of Billiards*

(La partie de billard)

Canvas, 55 × 82.5 cm.
Paris, Musée Carnavalet

Provenance. In Paris since 1964. Acquired in London, Heim Gallery, 1968.

Exhibition. 1968, London (Heim), no. 13 with pl. ("Etienne Jeaurat").

Bibliography. Mathey, 1964, p. 28, fig. 15 ("English school; in the spirit of Gravelot"); Hulton, 1968, p. 163 and fig. 2, p. 164 ("Jeaurat"); Bjurström, 1969, pp. 58-60 and fig. 1 ("Copy after Chardin?"), Rosenberg, 1969, p. 99 (attribution doubted, but see Wilhelm, 1969, p. 12, note 9); Wilhelm, 1969, pp. 7-12; *Bulletin du musée Carnavalet*, 1973, no. 1-2, p. 21 (attributed to Chardin); *Apollo*, April 1975, p. 311 ("attributed to Chardin").

Related Works. See [2] for the preparatory drawing in Stockholm's Nationalmuseum. A recently identified copy [Rosenberg, 1969, p. 99, fig. 3] is in the Pushkin Museum, Moscow (no. 27005; former attribution: French School, 18th c., 38 × 64 cm.; formerly in the collection of the Princes Viazemsky at their Ostaffievo estate near Moscow; entered the Pushkin Museum in 1930. [We are most grateful to Miss Irene Kouznetsova, curator at the Pushkin Museum, for furnishing this and other useful information.]) Except for the omission of the man who enters at left with a three-cornered hat in hand and greets a seated spectator—as well as of some minor figures, the plate, and wine glass on the bench—the copy differs only slightly from the painting in Paris.

This painting, which the Musée Carnavalet acquired in 1968, is still not unanimously accepted as a Chardin (it is not included in the Wildenstein catalog of 1969). It once was attributed to an English artist close to Gravelot, then to the painter Etienne Jeaurat, who was born in the same year as Chardin and outlived

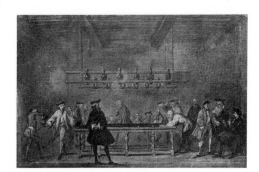

After Chardin, Moscow, Pushkin Museum.

him by ten years; finally, it was published as the copy of a lost, early Chardin—a signboard to which the upper half was thought to have been added later.

However, Jacques Wilhelm (1969) clearly sorted out the various reasons which lead to the belief that the Carnavalet painting is an

original entirely by Chardin's hand. Let us restate them one by one: First, none of the other suggested names is convincing. Further, the quality of execution and the freedom of the brushstrokes—particularly striking if one compares this painting with the copy in Moscow (see *Related Works*)—show clearly that we are in the presence of an original. Nor is there anything to confirm the ingenious hypothesis that the painting was enlarged by a later addition of the upper portion—a hypothesis in support of the argument that the painting is actually the sketch for a signboard. To the contrary, an examination of the picture by the laboratory at the Louvre has determined that the painting has not been enlarged.

Above all, however, the attribution of the painting is based on its connection with the preparatory drawing [2] for the group at the left of the painting, showing a man in the act of pouring a drink for one of the billiard players. This exhibition offers the first opportunity to compare the drawing with the painting. The drawing in turn, had been attributed to Chardin as early as the mid-eighteenth century by the Swedish patron, Tessin, and the catalog entry states our reasons for considering the attribution irrefutable. But there is complementary evidence to confirm it: the painting shows two players at a billiard table surrounded by a crowd of spectators. The room is in "one of those public establishments with billiard halls that were quite numerous then in Paris," writes J. Wilhelm. "To the beams of the hall are fixed wooden frames for tin-plate reflectors which illuminated the billiard table." Wilhelm also mentions "a wall poster with illegible inscription, probably a listing of police regulations to be observed in public places." These bits of information would tell us little if it were not for the fact that Chardin's father (born around 1670/75, died April 2, 1731) was a carpenter and maker of billiard tables and, as of 1701, was the official supplier to the royal inventory and the Menus-Plaisirs, in which function he was succeeded by his younger son Juste (who died at the age of 91—24 Thermidor Year II—and whose name was often associated with that of his brother, Jean Siméon). Is it too rash to see a connection between the painting at the Musée Carnavalet and the profession of both Chardin's father and his brother? We do not think so. Moreover, it should be remembered that one of Chardin's first commissions—the surgeon's signboard—was a similar type of painting. Jules de Goncourt's engraved copy makes it possible to establish that the composition of the lost signboard painting and the placement of the figures—small-scale but full-length—perhaps relates it to the Carnavalet picture.

In our opinion, the bulk of the evidence is conclusive. Only the date of the Carnavalet painting remains to be established. Wildenstein [1963-69, nos. 3 and 4] holds that the signboard and its sketch were painted between 1720 and 1726. Wilhelm, who takes his cue from the dress fashions of the time, places the Carnavalet painting "near 1725, or perhaps even three to four years earlier"—a suggestion which we readily accept.

A concluding remark is in order: It is well known that Chardin established his reputation with still-life paintings of game and everyday objects and that he seems to have devoted himself exclusively to this category over a long period, until around 1733. Yet the available evidence indicates that his earliest attempts at painting were of a very different kind and that he first embarked on genre painting with ambition: never again, in fact, was he to tackle subjects that called for so many figures. Thereafter, he would carefully limit his narratives and rarely would he again paint groups of more than three figures (we know of only one example, the later version "with changes" of his *Saying Grace*, exhibited at the Salon of 1761). It will be noted, however, that he continued to place his figures against the same brown walls and to organize his compositions with the same severity, often insisting on the perspective of flagstone pavements and showing a preference for openings toward an exterior—to add space to the compostion and to reveal a new scene. In this respect, *The Game of Billiards* already foreshadows *Woman Drawing Water from a Water Urn* [55], or *The Governess* [83], and *The Return from Market* [80].

4 Head of a Wild Boar

(Hure de sanglier)

Charcoal, sanguine, and traces of white chalk, totally fastened with adhesive, 264 × 406 mm. At the lower right, in pen, in Tessin's hand: *Chardin;* numbers *2856* (Sparre) and [erased] *79* (Tessin). Stockholm, Nationlmuseum, Drawings Collection, 2963/1863*

Provenance. Collection of Count Carl Gustaf Tessin (1695-1770). Acquired in Paris between 1793 and 1741 (on p. 69 of list of works sent to Stockholm by Tessin in 1741, see *Une tête de sanglier* ["Head of a wild boar"]). Manuscript cat. 1749, p. 120, no. 83, *Une hure de sanglier aux trois crayons, paper gris* ("Head of a wild boar done in three colors on gray paper"). Royal Library of Stockholm (manuscript cat. edited in 1790 by F. Sparre, no. 2856). Royal Museums of Stockholm (Lugt, 1921, I, no. 1638).

Exhibitions. 1922, Stockholm, no. 44; 1933, Stockholm, no. 74; 1935, Paris, no. 57; 1958, Stockholm, no. 229; 1968, London, no. 148, fig. 183; 1970-71, Paris, Brussels, and Amsterdam, no. 56 (with pl.).

Bibliography. Guiffrey, 1908, p. 94, no. 248; Ridder, 1932, pl. 94; Mathey, 1933, p. 83; Wildenstein, 1933, p. 247 cited under no. 1201; Lavallée, 1948, p. 73; Mathey, 1964, pp. 17-20, 27, and fig. 1 on p. 18; Anaoff, 1967, p. 61, fig. 4 (color pl.); Seznec and Adhémar, 1967, p. 24; Hulton, 1968, p. 163; Bjurström, 1969, p. 58.

The provenance of the third Stockholm drawing, also large in format, is the same as that of the other two; it must therefore date from before 1741. On his list of 1741, Tessin estimated its value at three *livres*, whereas he had valued the two preceding drawings at only one *livre* each. In the catalog of 1749 it is listed with the same attribution but is associated—probably because of a copying error—with a *Hare Suspended by Its Legs*, a magnificent sheet by

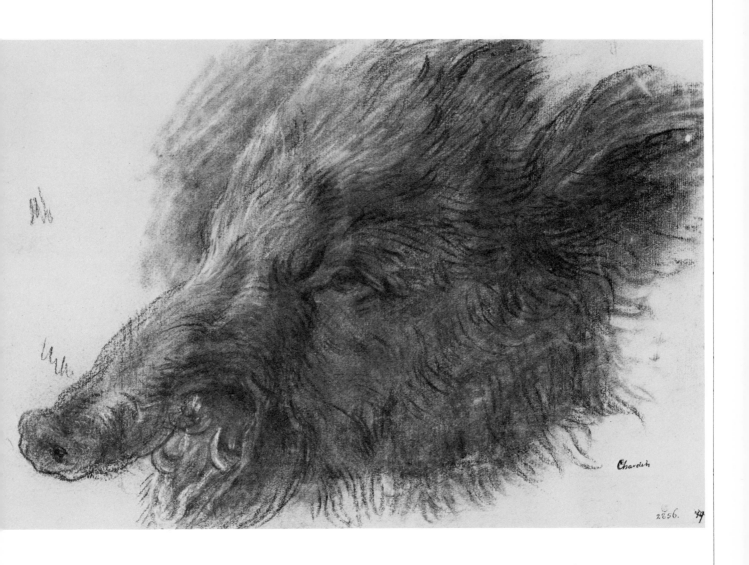

Chardin

2856.

François-Jérôme Chantereau [Bjurström, 1971, p.83, fig. 15] which indeed is not unrelated to Chardin's pictures of the same subject.

If *The Vinegar-Barrow* brought to mind the names of Restout and Lemoine (and, of course, that of Cazes with respect to the verso), and if the *Manservant Pouring a Drink for a Player* reminded us of the three-color drawings by La Fosse, this *Head of a Wild Boar,* in turn, clearly evokes the drawings by Desportes and those

Chantereau, Stockholm.

by Pieter Boel—an artist from Antwerp who was active in France between 1668 and 1674.

This Stockholm drawing has often been related to a painting of the same subject which Chardin exhibited at the Salon of 1769, no. 33: "Head of a wild boar," measuring 3 *pieds* wide by 2 *pieds* 6 *pouces* high, "in the collection of the Lord Chancellor" (who no doubt was Charles-Augustin de Maupeou, who succeeded his father in the Chancellery in 1768). The painting is now lost, but a drawing by Gabriel de Saint-Aubin (1724-1780), jotted on the margin of his copy of the Salon catalog [now at the Bibliothèque

Saint-Aubin, detail of a sketch
on a page of the 1769 Salon catalog.

Nationale; Dacier, 1909, II, p. 75] makes it possible to confirm the similarity in composition. In the painting, however, the head of the animal is turned to the right and its mouth is not as widely open. While one may wonder whether the Salon painting of 1769, so harshly criticized by Diderot [Seznec and Adhémar, 1967, p. 84: "heavy-handed... neither the ease nor the verve I would have liked to see"], could perhaps have been done long before the date of its exhibition, it should also be said that there is nothing to prove that the Stockholm drawing is indeed a preparatory study for the lost painting.

Head of a Wild Boar is the only firmly attributed Chardin drawing of a hunting subject. [With caution—for we know it only from reproduction—we may add a *Hare* from the collections of Chennevières, Biron, and Tuffier; Mathey, 1964, p. 23, no. 7, with ill., recently exhibited in Tokyo, 1977, no. 5.] Though a date cannot be advanced for the drawing, it can perhaps be viewed—along with the other two Stockholm drawings—as one of the painter's earliest works, while he was still finding his way. In this case, and given the obviously clumsy execution, the lack of assurance, and the patent reference to the animal painters of the seventeenth century, one could easily understand why Chardin quickly abandoned this type of drawing and, dispensing with preparatory studies, turned to painting directly the game he saw before him.

II *First Still Lifes:*
"Skilled in Animals and Fruits"

Why did Chardin devote himself to still-life painting? Once again, his early biographies provide insight. Though the texts of Mariette and Cochin differ in detail, they agree in substance, reporting that Noël-Nicolas Coypel—who, incidentally, was only nine years older than Chardin and was a witness at the wedding of Chardin's sister in 1720—once asked Chardin to paint "a gun in the portrait of a man dressed as a hunter." Significantly, Cochin added: "At that time, M. Chardin was convinced that a painter must extract everything from his head and would need to look at nature only if he was lacking in genius [i.e., Chardin believed that only history painting called upon the imagination]. He realized then that it was difficult to achieve truth in rendering the color and the effects of light present in nature, and this attempt led him to certain reflections which made him into what we have seen ever since."

The rest of the story is known and is mentioned in the discussion of [17]: When Chardin prepared to paint a hare (according to Mariette, but of a rabbit according to Cochin) he had received as a gift, he said: "I must forget everything I have seen and even the manner in which such objects have been painted by others.... I must place it at a distance where I no longer see the details. Above all, I must strive for proper and utterly faithful imitation of the general masses, the color tones, the roundness of shape, and the effects of light and shadows." His success with the rabbit earned him a commission for a duck (see [17]).

Two main events signalled the beginning of Chardin's official career and have often been retold. Painters had notoriously little occasion to make themselves known; one of the few opportunities was an annual open-air exhibition, the Exposition de la Jeunesse (youth fair) held at the Place Dauphine on the day of Corpus Christi. In 1728 Chardin showed ten or twelve paintings, including *The Ray-Fish* [7], and promptly attracted attention. Less than four months later—probably owing to his success at the Exposition—he was approved by and on the same day received into the Royal Academy of Painting through the intervention of Largillierre, himself a still-life painter, and by Louis de Boullongne, director of the Academy. He offered his *Ray-Fish* and *The Buffet* [14] as reception pieces. The following year he relinquished his position at the Académie de Saint-Luc.

Which are Chardin's early still lifes and how can they be identified? It should be noted here that as much for chronology as for convenience we will deal later in separate groupings with Chardin's decorative compositions and paintings of household utensils. It must also be added that our only knowledge of a Chardin painting presumably dating from 1727, which shows a dog, a cat, and a monkey, is based on a rather poor photograph. The painting might conceivably be the one described as "a dog, a monkey, and a cat painted from life" at the Salon of 1753 and which then belonged to M. de Bombarde. *The Ray-Fish* [7] obviously also dates from before 1728, when it entered the collection of the Academy.

Chardin frequently signed but seldom dated his works. Only three paintings that bear the date of 1728 are known: *The Buffet* [14], *Two Dead Rabbits* at Karlsruhe, and *The Lucky Thief* in the Edmond de Rothschild collection in Switzerland. There is only one dated work from the year 1730: *The Water Spaniel* of the Wildenstein collection, New York. Also included in the short list should be the hunting subjects in Dublin [25] and Douai [26], which appear to be dated from 1731 and 1732 respectively.

How can we, from such precious few firm points of reference, reconstruct the beginnings of Chardin's early career, which occurred at a time when the official Salons had not yet been re-established and when written comments on his works were very few?

The first point is that although Chardin was received into the Academy despite his lack of Academy training, he was admitted only into the most humble of categories: a painter "skilled in animals and fruits." Indeed, animals were the basic repertory of the young artist: hares, rabbits, ducks, pheasants, partridges, an occasional lapwing or a woodcock — in short, dead game. Live animals were significant exceptions. They generally appear in his dated pictures — for instance, cats (in *The Ray-Fish* [7] and *Cat Stalking a Partridge and a Hare Left Near a Soup Tureen* [20]) or dogs (in *The Hound* [6] or *The Buffet* [14]). All his biographers dwell on the reason for this rarity: Chardin painted from the model, slowly, constantly returning to his canvases until "at last he obtained that magic harmony which distinguished him as such a superior artist." Can this practice be reconciled with representing living creatures? His long career clearly shows that he was not a painter of movement.

A second, seldom-given, reason seems just as important. Two of his contemporaries, Oudry and Desportes, had already made the painting of live animals their specialty and were therefore "two powerful competitors who surpassed him and whose reputations were established." Did Chardin fear, as Mariette suggested, that he might be judged inferior to his predecessors "in painting live animals?"

Various kinds of fruit play almost as big a role in his early still lifes: plums, peaches, pears, apricots, grapes, figs, and Seville oranges sometimes accompany a glass, sometimes a bottle, often the silver goblet that Chardin was so fond of painting throughout his career, occasionally a tureen [20] or a water pitcher [19].

The Ray-Fish and *The Buffet* occupy a place of their own, as much by their size as by the choice of the objects and animals represented. They proclaimed the artist's

ambition and caused a sensation. As late as 1763 Diderot was advising every aspiring young painter to refine his skill by copying *The Ray-Fish.*

What characterizes the roughly twenty works in this section, executed over a period of hardly more than seven or eight years? Without elaborating upon our reasons for adopting the chronological order proposed in this catalog, and without going into the details covered in the discussions of each individual painting, it should be stressed that the group shares the same originality and the same novelty of composition, execution, and sense of color. Chardin's characteristic style, even from his earliest still lifes, is to reconcile a great freedom of treatment and a vigorous and bold touch, with an unerring accuracy of rendition, a keen observation, and a carefully planned composition that gives the appearance of utter simplicity. Each object, each animal seems to have its natural place, resulting from Chardin's meticulous care in striving for perfect balance, albeit somewhat precarious.

Right from the start, Chardin did not wish to be a painter who merely represented nature as faithfully as possible; instead, he sought — through careful reflection — to re-create it for us. "He was not satisfied with a close imitation of reality": his paintings were "the fruit of profound study."

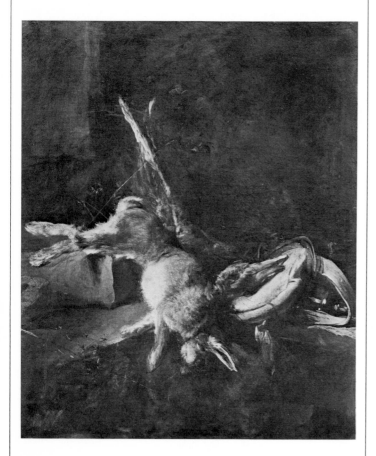

5

5 *Two Rabbits with Game Bag and Powder Flask*

(Deux lapins mort avec gibecière et poire à poudre)

Canvas, 73 × 60 cm.
Paris, Private Collection

Provenance. Collection of Count d'Houdetot; acquired at the d'Houdetot sale, 12-14 December 1859, no. 24 (600 francs), by Eudoxe Marcille (1814-1890), and is still in his family's collection. Perhaps the painting described as *Un tableau représentant des lapins mort, haut de deux pieds 4 pouces sur un pied 10 pouces de large* ("A picture of two dead rabbits, measuring 2 *pieds* 4 *pouces* by 1 *pied* 10 *pouces*") [75.5 × 59.5 cm.], no. 37 in the sale, 20 March 1758, of the painter Louis-Joseph Le Lorrain (1715-1759).

Exhibitions. 1874, Paris, no. 57; 1878, Paris, no. 35; 1883-84, Paris, no. 22; 1935, Brussels, no. 919.

Bibliography. Horsin-Déon, 1862, p. 137; Bocher, 1876, p. 101; Goncourt, 1880, p. 130; Chennevières, 1888, p. 60; Schéfer, 1904, p. 109 (with pl.); Guiffrey, 1908, p. 79, no. 139; Goncourt, 1909, p. 191; Pilon, 1909, p. 167; Furst, 1911, p. 125; Wildenstein, 1933, no. 707, fig. 86; Wildenstein, 1963-69, no. 11, fig. 6.

The painting was paired with *Wild Rabbit with Game Bag...* [24] in the mid-nineteenth century and has been presented as its companion piece ever since. Wrongly, in our opinion. The two paintings differ both in execution and compositional layout — so assured in *Wild Rabbit with Game Bag...*, yet of an extremely precarious stability in *Two Rabbits with Game Bag and Powder Flask*. Let us point out at once the important changes visible to the naked eye which Chardin brought to the latter composition. The nose of a rabbit at the lower right edge of the canvas is as clearly discernible as the alterations in the position of its paws and ears. It seems obvious — and has been confirmed by laboratory examination — that Chardin modified his picture and may even have painted over an earlier composition, which now reappears from underneath. This would explain the confusion in certain portions of the canvas, for instance, in the body of the second rabbit or around the game bag, as well as the compositional instability which gives the impression that the rabbits are about to slide onto the floor.

"Monsieur Marcille attributes that indefinable crumbly quality in the rendering of fine hair to the manipulation of dry pigment which, in the hand of the master, became a substance that created coarse little reliefs," reported H. de Chennevières (1888) with respect to this painting, which we are inclined to place among Chardin's earliest experiments, closely resembling a hare which "had been given to him as a present" and which "he ventured to paint." According to Mariette [1854, p. 356], this hare determined the direction of the artist's career.

6 *The Hound*

(Le chien courant)

Canvas, 192.5 × 139 cm.
Pasadena, Norton Simon Museum

Provenance. Collection of Count du Luc (1720-1775) in 1759 (?) [see discussion below].

Collection of Joseph Aved (1702-1766), painter and friend of Chardin, in Aved sale of 24 November 1766, no. 132, *Un tableau peint grassement sur toile de six pieds et demi de haut sur 4 pieds 5 pouces de large; il représente un lièvre, un canard, une gibecière, une boîte à poudre, un cor-de-chasse; le tout groupé ensemble et attaché à un arbre; un fusil, deux lapereaux, un faisan mort et un chien* ("A thickly painted canvas, 6½ *pieds* high by 4 *pieds* 5 *pouces* long [211 × 143.5 cm.], representing a hare, a duck, a game bag, a powder flask, and a hunting horn grouped together and tied to a tree; a rifle, two young rabbits, a dead pheasant, and a dog"). In the inventory of Aved's estate after his death on 16 June 1766, the painting is difficult to identify [see Archives Nationales, Minutier Central, étude CII, liasse 434; also see Wildenstein, 1922: three lots of this inventory, nos. 78, 104, and 116, each at an estimated value of seventy-two *livres*, could refer either to *The Hound* or to *The Water Spaniel*]. A second Aved sale of 1770, mentioned by the Goncourt brothers [1909, p. 186] and several subsequent authors, seems never to have taken place. Probably there was a confusion with the sale of 1766 [Wildenstein, 1922, I, p. 140].

Sale, P[assalaqua], *Amateur distingué d'une des capitales de L'Allemagne* ("distinguished art-lover from a German capitol") 18-19 March 1853, no. 111, *Nature morte. Attirail de chasse gardé par un chien dans un paysage* ("Still life: Hunting paraphernalia guarded by a dog, with landscape").

Collection of Prince Gagarine of Russia and at Saint-Cloud in 1910 (letter in a French private collection).

Collection of Enrique Santa-Marina, then Ramon J. Santa-Marina, Buenos Aires.

Acquired by Norton Simon in Paris, 1972.

Exhibitions. 1759, Salon, no. 35(?); 1974, San Francisco, no. 4 (with color pl.).

Bibliography. Wildenstein, 1933, no. 676, fig. 69; Lazarev, 1947, pl. 5; Adhémar, 1960, p. 455; Wildenstein, 1963-69, no. 69, fig. 33; Lazarev, 1966, pl. 5; Lazarev, 1974, pl. 182; Mirimonde, 1977, p. 16.

Wildenstein [1969, p. 56] theorized that the Norton Simon painting might have been exhibited at the Exposition de la Jeunesse of 1734. There is no proof, although it is known that Chardin's largest work in this exhibition, *Lady Sealing a Letter* [54], measured only 146 by 147 cm., and thus is smaller than *The Hound.*

Perhaps we might suggest that the "Return from the Hunt" at the Salon of 1759, no. 35 [see Wildenstein, 1963-69, no. 72, now lost], which measured "about 7 *pieds* high by 4 *pieds* wide" [227 × 130 cm.] and belonged to the Count du Luc (probably Jean-Baptiste Félix Hubert, Marquis de Vintimille, 1720-1775, husband of Countess de Mailly, Louis XV's mistress), could be the Norton Simon picture (or *The Water Spaniel* in the Wildenstein collection, although it is somewhat smaller). Our hypothesis, however, is fragile. Yet the existing ties between Chardin, Count du Luc, and the painter Aved (who exhibited a portrait of the

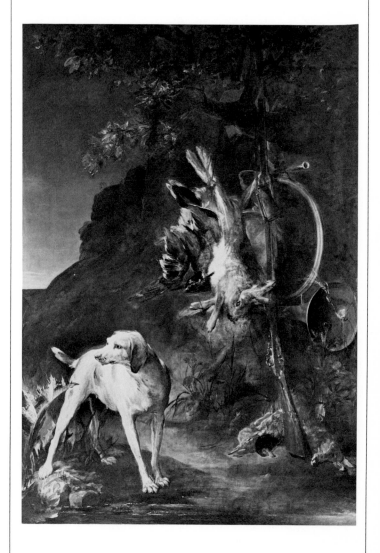

6

See Color Plate I.

count at the Salon of 1753) are well known. And it is equally well known that Chardin habitually exhibited paintings at the Salon which had been executed several years earlier.

This painting has often been viewed as a pendant to *The Water Spaniel* in the Wildenstein collection, New York, which is signed and dated 1730. The same date has therefore been suggested for this canvas. The suggestion lacks support, however, except for the fact that both paintings came up for sale in 1766, after the death of Chardin's painter-friend, Aved. At the time, the measurements of the two paintings differed noticeably: *The Hound* measured approximately 211 by 143 cm., whereas *The Water Spaniel* was only 192 by 108 cm. The P[assalaqua] sale catalog of 1853 gives no dimensions. By 1910 the two paintings had already been converted into a pair; at that time they both belonged to Prince Gagarine, and we have a letter from Gagarine—written at Saint-Cloud on 18 April 1910 and apparently addressed to Leprieur, curator at the Louvre—in which he gives the dimensions of both paintings as 195 by 138 cm. These measurements correspond closely to the present size of the Norton Simon canvas. The Wildenstein painting, on the other hand, which in 1933 still measured 192 by 139 cm. [no. 677, fig. 68], was reduced to its original size of 192 by 108 cm. at some point prior to 1963 [Wildenstein, 1963-69, no. 68, fig. 32].

Although these changes of size reduce the height of the Norton Simon canvas by almost 20 cm. and slightly distort its original format, they would hardly matter if they did not permit us to challenge its traditionally assigned date of 1730—an unsatisfactory date for stylistic reasons as well, for the painting is done in an un-Chardin-like technique, quick and fluid and without the crumbly impasto effects so admired by his critics from the eighteenth century.

The repertory of the return-from-the-hunt pictures is already characeristic of Chardin: hare, duck, rabbits, pheasant—these were to reappear in many of his canvases. The gun also reappears, but the large hunting horn, its bell brightened by a blooming poppy, recurs only in *The Water Spaniel* of 1730. And the emphasis on nature and plant life is exceptional, although the objects represented still lack the weight and firmness that Chardin was to give to everything he painted. *The Hound,* a magnificent pointer, is a brilliant homage to Desportes and brings to mind Deportes' *Dog Watching Over Game Beside a Rose Bush* of 1724, now at the Louvre. Over a generation older than Chardin, François Desportes (born 1661) was received into the Academy in the year of Chardin's birth, and his reputation was at its peak in the early 1720s. Therefore, it is not surprising that Chardin should initally have taken him as an example (as borne out by the inventory on 18 November 1737 of Chardin's deceased first wife, Marguerite Saintard, which included "two copies of animals after Desportes, painted on canvas"). But it is understandable that he soon stopped imitating Desportes' royal hunting themes; it is equally understandable that we can detect little, if any, mutual influence between Chardin and Oudry (born in 1686 and thirteen years Chardin's senior), for the two artists managed to avoid each other throughout their careers instead of trying to compete with one another.

7 The Ray-Fish (also called *Kitchen Interior*)

(la Raie, dit aussi Intérieur de cuisine)

Canvas, 114.5 × 146 cm.
Paris, Musée du Louvre, Inv. 3197*

Provenance. Admission piece, submitted by Chardin when he was received into the Academy on 25 September 1728 [see Minutes, ed. 1883, V. pp. 47-48]; at the Academy until the French Revolution [see Fontaine, 1910]; seized during the Revolution. This canvas, *Saying Grace,* and *The Diligent Mother* are the only works by Chardin continuously exhibited at the Louvre since June 1796 [see cat. of Year VII, no. 23]. "Cleaned" by Citizen Michaud upon request of the Conseil du musée central des Arts [Minutes, Archives of the Louvre, I BB3], decision of 25 Germinal, Year VI.

Exhibitions. 1728, Paris, Exposition de la Jeunesse, no cat. (cf. Guiffrey, 1908, pp. 5-6, and Dorbec, 1905);1946, Paris, no. 93; 1958, Munich, no. 35, fig. 58; 1966, Vienna, no. 7, pl. 32.

Bibliography. Le Carpentier, 1821, p. 236 and note 2; Champfleury, 1845, p. 8; Hédouin, 1846, pp. 186, 222, 227, no. 93; Clément de Ris, 1848, p. 111; Museum cat. (Villot), 1855, no. 96; Hédouin, 1856, pp. 176, 187, 200, no. 93; Blanc, 1862, p. 15; Goncourt, 1863 pp. 518-20; Bocher, 1876, p. 83, no. 96; Goncourt, 1880, p. 129; Chennevières, 1888, p. 57; Fourcaud, 1899, pp. 393, 394, 417, and pl. 387; Dilke, 1899, p. 180; Dilke, 1899 (2), p. 113; Fourcaud, 1900, p. 5 (with ill.), 11, 12, 35; Merson, 1900, pp. 302-03; Normand, 1901, pp. 10, 26, 30, 31, 96, and 106; Dorbec, 1904, pp. 342, 348; Schéfer, 1904, pp. 13 (with ill.), 37-39, 52; Dorbec, 1905, pp. 460-61 and pl. on p. 461; Dayot and Vaillat, 1907, pl. 22, p. V; Guiffrey, 1908, p. 69, no. 76; Goncourt, 1909, pp. 101-3, 120, 189; Pilon, 1909, pl. between pp. 24 and 25, pp. 25-26, 165; Fontaine, 1910, VIII, 56, 88, 114, 194 (also ed. 1903); Furst, 1911, p. 121, no. 89 and pl. 4; Raffaelli, 1913, pp. 52-53; Museum cat. (Brière), 1924, no. 89; Hildenbrandt, 1924, p. 166, fig. 213; Klingsor, 1924, pl. on p. 21; Réau, 1925, pl. 34; Schneider, 1926, fig. 79; Gillet, 1929, pp. 59, 60, 68, pl. 70 (repr.); Pascal and Gaucheron, 1931, pp. 7, 28, 59-60; Ridder, 1932, pp. 6, 30, 49, 54, pl. 1; Wildenstein, 1933, no. 678, fig. 74; Grappe, 1938, pl. on p. 27; Brinckmann, 1940, pl. 384; Pilon, 1941, fig. on p. 28; Goldschmidt, 1945, fig. 11; Hautecoeur, 1945, p. 50; Goldschmidt, 1947, fig. 13; Florisoone, 1948, pp. 61, 63; Jourdain, 1949, fig. 55; Denvir, 1950, p. 7 and color pl. II; Sterling, 1952, p. 100; Proust, 1954, p. 42 (with pl.); Francastel, 1955, p. 128 and pl. on p. 129; Golzio, 1955, p. 913 (pl.); Fussiner, 1956, pp. 305, 307, 308 (with pl.); Seznec and Adhémar, 1957, p. 223 and fig. 78; Eisler, 1960, pl. on p. 205; M.G., 1960, p. 29; Schönberger and Soehner, 1960, pp. 89, 357, figs. 254-55 (details), 259; Schwarz, 1961, pl. on p. 134; Bazin, 1962, pp. 226-27 (with color ill.); Faré, 1962, p. 162; Zolotov, 1962, pl. 1; Garas, 1963, pl. 1; Rosenberg, 1963, pp. 6, 8, 23, 25, 26, 60, 88, 89, 99 (color pl.), 100, 103 (details); Mittelstädt (ed.), 1963, p. 16, pl. on p. 17; Wildenstein, 1963-69, no. 46, pl. 4 (color); McCoubrey, 1964, p. 52 and fig. 6; Thuillier and Châtelet, 1964, pp. 200, 201 (color

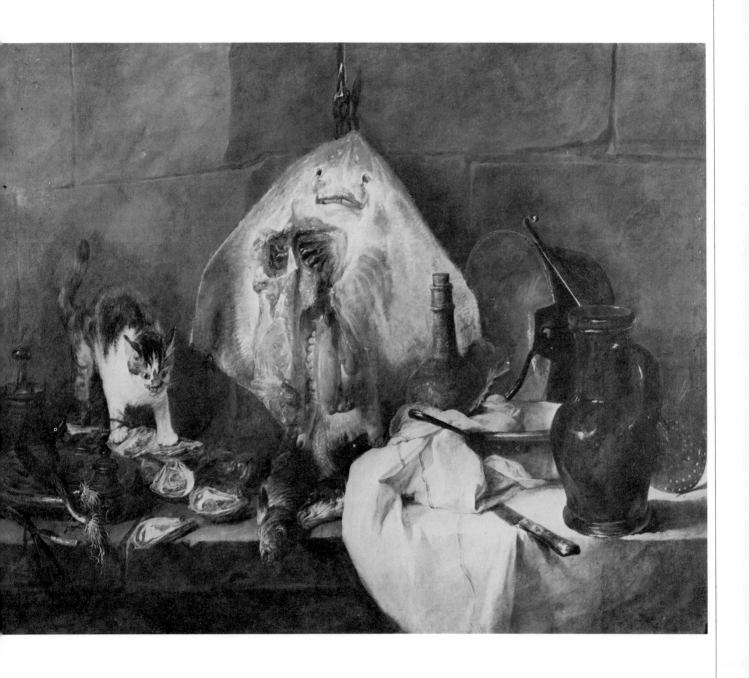

pl.), 202; Huyghe, 1965, pl. on p. 6; Lazarev, 1966, pl. 2; Valcanover, 1966, pl. 3 (also in French ed. Valcanover and Martin, 1967); Seznec, 1967, pp. 139, 140 (with fig.); Demoris, 1969, pl. between pp. 368 and 369; Proust, 1971, pp. 375-76; Stuffman, 1971, p. 371; Levey, 1972, pl. 142; Bois, Bonne, Bonnefoi, Damisch, and Lebenszteyn, 1973, pp. 681-90 (with pl.); Lacambre, 1973, p. 46; Rosenberg, Reynaud, Compin, 1974, no. 122 (with fig.); Kuroe, 1975, pl. 3 (color); Paulson, 1975, p. 105, fig. 58; *Dictionnaire Robert*, 1975, I, p. 487 (ill.); Faré, 1976, pl. 234 (color); Banks, 1977, p. 69; Faré, 1977, fig. 119 (color); *Chefs-d'oeuvre de l'Art. Grands Peintres*, 1978, pl. 3 (color).

Related Works. A copy of this painting appeared in the Bouhier de l'Ecluse sale of 23-25 May 1870, no. 48. Could this copy be the same work of which the Courtauld Institute of London owns a photograph (Collection of R. H. Ward, Paris, 1938) and which was sold at Drouot, room 11, on 20 December 1974, no. 27 (reproduced) — a work now in a private collection in Paris?

An "original study of the cat" for *The Ray-Fish* appeared at the d'Orlemont sale of 9 February 1833, no. 34 [Wildenstein, 1933, no. 1194].

A copy by Charles Deshayes is at the museum in Le Mans (missing in the catalog of 1932), where it had been placed by the state in 1895.

Cézanne's drawing after the jug and the right portion of this picture has often been reproduced. It is generally dated 1887 to 1891 [Venturi, 1936, no. 1385; Chapuis, no. 958; Berthold, *Cézanne und die alten Meister*, 1958, no. 234, pl. 24; McCoubrey, 1964, fig. 18; and exh. cat. *Water Colour and Pencil Drawings by Cézanne*, London, 1973, p. 167, no. 79] and is at present at the museum in Basel. On the back, it will be recalled, Cézanne copied one of the naiads from Rubens' *Disembarkment of Marie de Médicis*.

Matisse, in turn, copied *The Ray-Fish* in June 1896 [Archives of the Louvre, Register of Copyists, LL 31; see exh. cat. *Matisse*, Paris, 1970, no. 39, p. 131 ill.]. This copy, now in the Matisse Museum at Cateau-Cambrésis, had remained at the Louvre until 1921 when the administration decided on November 7 and 8 to sell its "abandoned" copies. "A few days before the sale" Matisse withdrew his *Dead Christ* after Philippe de Champagne and his *Ray-Fish* [*Le Cousin Pons*, 1 December 1921, pp. 660-61].

Matisse's admiration for Chardin is documented in H. Matisse, *Ecrits et propos sur l'art* (Paris, 1972), pp. 51, 54: "Yes, I go often to the Louvre. I mainly study the work of Chardin there. I go to the Louvre to study his technique [1913]." Also see pp. 55, 77, 81, 82 (where he comments on *The Ray-Fish*), and 91; on pp. 130 and 163 P. Courthion remarks: "Your copy of *The Ray-Fish* is the first work where you reveal yourself completely. It clearly is a Chardin seen through the eyes of Matisse [1931]."

Among other noteworthy copies are one by Tal Coat, 1927 [exh. cat. *Tal Coat*, Paris, 1976, no. 5], one by René Levrel, 1927 [exh. cat. *René Levrel*, Nantes, 1976, no. 5], as well as pastiches by Boudin [Musée Eugène Boudin, Honfleur; see *La Revue du Louvre*, 1964, p. 284, fig. 19 on p. 290, and 1968, p. 380, fig. 2] and by Soutine [exh. cat. *Soutine*, Paris, 1973, no. 33].

At this point, it may be useful to cite pertinent passages from eighteenth-century manuscripts or from their first publication — passages where *The Ray-Fish* is under discussion and where the circumstances leading to the creation of this masterpiece are being questioned in some respects. First of all, there are the Minutes of the Academy [ed. 1883, V, pp. 47-48: "On the same day (25 September 1728) Jean Simeon Chardin, a painter skilled in animals and fruits, submitted several such paintings with which

the Academy was so pleased that, having taken a vote, his application was accepted and the Academy received him at the same time as an Academician, selecting two of his paintings — a *Buffet* and a *Cuisine* — which he is to frame. He further was granted a reduction of 100 *livres* in his initiation fee"]. Scarcely twenty years later, in 1749, P.J. Mariette wrote [manuscript at the Cabinet des Estampes, Bibliothèque Nationale, Ya2 4 fol.]:

"But soon, his friends... urged him to be among the candidates and promised that his efforts would not be in vain. They were right. No sooner had Chardin submitted several of his paintings to the Academy than he had all their votes in his favor, and in 1724 he was received [and]... accepted simply on the strength of — which is very rare — two admission pieces that the Academy selected from the paintings he had submitted, including a *Ray-Fish which he had painted several years before* [italics ours], at a time when he certainly could never have imagined that this work would some day earn him the honors he now received."

We must also quote what Haillet de Couronne wrote immediately after Chardin's death (two manuscripts exist — one at the Ecole des Beaux-Arts, published in 1854, and one, used here, at the Bibliothèque Municipale, Rouen), based directly on information supplied by Chardin's lifelong friend, Charles Nicolas Cochin (1715-1790):

"Encouraged by the praise he received from various artists, he thought of presenting himself to the Royal Academy; but he first wished to gauge the opinions held by the leading officers of that body, wherefore he resorted to an innocent ruse. As if by accident, he left his paintings in the first room while he himself waited in the second. Arrives Monsieur de Largillierre, an excellent painter, foremost among the colorists and one of the most knowledgeable theorists concerning effects of light. Struck by these paintings, he stops to examine them before proceeding to the second Academy room where the candidate was waiting. While going through the door, he said: 'You've got some very good paintings there; surely they are by some good Flemish painter; and when it comes to color, the Flemish school is an excellent one. Now let's take a look at your works....' 'Monsieur, you have just seen them....' 'Oh!' said M. de Largillierre, 'introduce yourself, my friend, introduce yourself.'

"Caught in the same little ruse, Chardin's old teacher Cazes also had high praise for the pictures without knowing that they were done by his pupil. It is said that the prank vexed him a little but that he promptly forgave Chardin, encouraging him and sponsoring his presentation. Chardin thus received general applause. But that was not all. When Louis de Boullongne, director of the Academy and first painter to the king, entered the assembly, Chardin pointed out to him that the *ten or twelve* exhibited paintings were all done by him and that the Academy was free to do as it pleased with whatever paintings it wished to select. 'He has not even been accepted yet,' said M. de Boullongne, 'and already he speaks of having been received! By the way, he added, thou didst well to tell me.'

"It was he, in fact, who reported the proposition: it was accepted with pleasure. The academy took two of the paintings, a *Buffet* loaded with fruit and silverware, and the beautiful picture of a *Ray-Fish* with kitchen utensils, which still arouses the admiration of all artists, so bold is its color, so wonderful its execution and effect."

Finally there is the text of the *Nécrologe* of 1779 [XV, Paris, 1780, p. 178]:

"According to custom, Corpus Christi is the day when painters who do not belong to the Academy can exhibit their work at the Place Dauphine. It was there that in 1728 Chardin exhibited some of his works. Academy members who came along either by chance or because they were curious were struck by the paintings of this artist. One in particular, representing a disemboweled ray-fish, truly astonished them. They went to Chardin, encouraged him to present himself before the Academy, and he was unanimously accepted and at once received, with highest praise. He was allowed to submit as his admission piece that same *Ray-Fish* which continues to be as admired as ever."

These texts, similar in tenor, seem more to the point in the general impression they jointly convey than in their details, which warrant some further remarks: For instance, no matter how plausible it sounds that Chardin should have exhibited his *Ray-Fish* at the Exposition de la Jeunesse of 1728, the only existing reference to it comes from the pen of an obituary writer. We know, however, that Chardin, along with many other young artists of his generation, exhibited several of his works at the Place Dauphine in 1732 and 1734.

Before regular Salon exhibitions were instituted in 1737, artists had little occasion to show their work to the public. The Exposition de la Jeunesse "was held in Paris once a year, in the northern corner of the Place Dauphine and on the Pont Neuf, along the route of the St. Batholomew procession. It depended on the weather; when it was held it lasted from six in the morning until noon. The art objects were fastened to the wall hangings and tapestries which, by order of the police, lined the path of the Procession of the Holy Sacrament. If it rained on the day of Corpus Christi, the exhibition was postponed until one week later (i.e., from *Fête-Dieu* to *petite Fête-Dieu*), and if it then rained again, it was adjourned to the following year." [Bellier de la Chavignerie, 1864, p.39]

In 1728 Chardin was admitted and made a full member of the Academy on the same day, along with his contemporaries, the painters Bonaventure de Bar and Dumont le Romain. He was only twenty-nine years old. Desportes had been received at age thirty-eight, Oudry at thirty-three. As "skilled in animals and fruits," the Academy placed Chardin at the lowest level of the hierarchy of genres then unanimously accepted: still life. But it is no accident that Cochin and Haillet de Couronne mentioned three names in connection with his admission — that of Chardin's teacher Cazes, who was a good history painter; Louis de Boullongne, first painter to the king; and finally, Largillierre, who

untiringly produced vigorous still lifes that are among the most spirited and most freely executed in the history of French painting and who himself owned a Chardin painting, *Young Woman at Her Toilet*, unfortunately a work now difficult to identify.

This brilliant reception at the Academy did not bring Chardin fame and fortune overnight. In 1729 he still collaborated modestly in the staging of festivals and fireworks celebrating the birth of the dauphin; in 1731 he participated no less modestly in the restoration of the François I gallery at Fontainebleau. It was to good purpose that Cochin and Haillet de Couronne pointed out how Chardin, by beginning his career immediately after the death of Watteau (1721), became the continuator of the Flemish-oriented Northern tradition at a moment when the battle between "*rubénistes*" and "*poussinistes*" had already been decided in favor of the former and was about to end, assuring, as Largillierre would put it, the triumph of color over design. It would seem that in accepting the two paintings from among a whole dozen offered by Chardin (a list that would be interesting to know), the Academy made a careful choice: desiring to indicate a new direction, it selected *The Ray-Fish*; but in order to counterbalance the perhaps too expressionistic use of color in this painting, it also selected the more classical and "French" *Buffet*.

Lastly, it is important to note that, according to Mariette, *The Ray-Fish* had been "painted several years before" 1728 and not just "slightly before," as Wildenstein said. This thinly painted work, so different from *The Buffet*, gives the impression of having been done at a noticeably earlier date than *The Buffet*, which is thickly painted and dated 1728. It is a brilliant painting, one of the artist's most frequently reproduced works, dashingly executed ["It was finished within one day," wrote Michaud in his *Biographie Universelle* (1844, VII, p. 501). Michaud added that "this fish, still fresh, was eaten on the following day."]

The Ray-Fish has aroused unanimous admiration from the eighteenth century onward. We shall quote only two of the numerous passages in literature — some more, some less fortunate in inspiration — which focus on this painting, each in its turn elaborating upon the contrast between the cat, the single living element in the canvas, and the hideous "face" of the ray-fish, or on the ambitious pyramidal composition, or on the bright light on the slaughtered fish. Diderot (1763) was particularly fascinated by the realism of this work:

"After my child would have copied and re-copied this piece [Chardin's *Jar of Olives* [114] at the Louvre], I should keep him busy on the disemboweled *Ray-Fish* by the same master. The subject is disgusting, but it is truly the fish's very flesh, skin, and blood; it affects us as though we saw the thing itself. Monsieur Pierre, look well at this piece when you go to the Academy and learn, if you can, the secret of redeeming through skill the disgusting aspect of certain things."

Rather than to quote from the hermetic *Critique* essay of 1973 (which discusses the separation of animal and vegetable motifs on the left from the inanimate objects on the right of the composi-

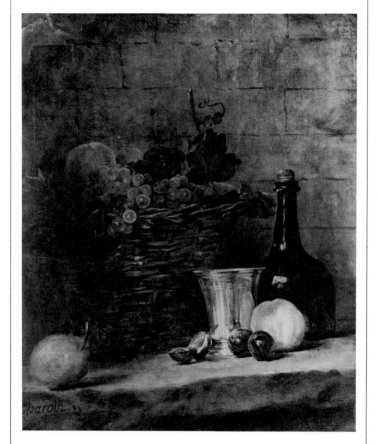

8

tion), we may be excused for preferring to choose as our second example a passage from a text by Marcel Proust, written around 1895 but published for the first time in 1954 in *Figaro Littéraire* [ed. 1971, pp. 375-76; English text from *Marcel Proust on Art and Literature, 1896-1919* (New York: Meridian, 1958)]:

"Now come into the kitchen, where the entrance is strictly guarded by a feudality of crocks of all sizes, faithful, hardworking servants, a handsome industrious race. Knives, brisk plain-dealers, lie on the table in a menacing idleness that intends no harm. But a strange monster hangs above your head, a skate, still fresh as the sea it rippled in; and the sight of it mixes the foreign charm of the sea, the calms, the tempests it matched and outrode, with the cravings of gluttony, as though a recollection of the Museum of Natural History traversed the delicious smell of food in a restaurant. It has been gutted, and you can admire the beauty of its delicate immense structural design, painted with red blood, azure nerves, and white sinews like the nave of a polychrome cathedral. Nearby are other fish, prostrate as their death agony left them, contorted in a stiff despairing curve, their eyes bulging out. Then there are oysters again, and a cat, counterpointing this fishy creation with the covert vitality of its subtler contours and with its glittering eyes fixed on the skate, picks its velvet-footed way in unhurried haste among the opened shells, and discloses at once the prudence of its character, the lust of its palate, and the daring of its enterprise. An eye practised in trafficking with the other senses, and in reconstituting by means of a few strokes of colour not merely a whole past, but a whole future, can already feel the freshness of the oysters that will dabble the cat's paws, and hear their tiny splintering exclamations and the thunder of their fall, as the precarious heap of frail splintered shells gives way under the cat's weight."

8 *Basket of White and Red Grapes with Silver Goblet, Bottle, Peaches, Plums, and a Pear*

(Panier de raisins blancs et noirs, avec un gobelet d'argent et une bouteille, des pêches, des prunes, et une poire)

Canvas, 69 × 58 cm. (frequently referred to—but wrongly—as being painted on paper pasted to canvas). Signed at the lower left: *Chardin.* This is probably painting no. 129 which brought twenty-nine *livres* at the Aved sale of 24 November (not October) 1766: Sébastien [sic] Chardin. *Des raisins et des pêches dans un panier. Une poire, une pêche, des prunes, un gobelet d'argent et une bouteille. Tableau peint sur une toile 29 pouces de haut sur 23 pouces de large* ("Raisins and peaches in a basket. A pear, a peach, plums, a silver goblet, and a bottle. Picture painted on a canvas 29 *pouces* high by 23 *pouces* wide" [78 × 62 cm.]). [See also G. Wildenstein, 1922, pp. 210-11.] In 1933 Wildenstein cataloged it separately but considered it "probably" identical to the painting in the Louvre. In 1963-69, no. 25, he considered

it, for no apparent reason, to be "possibly another version" of *The Silver Goblet* [9].
Paris, Musée du Louvre, M. I. 1044

Provenance. Bequeathed to the Louvre by Dr. La Caze in 1869. It belonged to La Caze (1798-1869); acquired from the "Rochard Collection of London" (the Rochard brothers were collector/dealers; several Rochard sales took place in Paris, London, and Brussels between 1844 and 1859).

Exhibitions. 1860, Paris, no. 362; 1969, Paris, Exhibition of the La Caze Collection, p. 10 (122); 1977, Paris, no number, p. 77.

Bibliography. La Caze cat., 1871, no. 183; Bocher, 1876, p. 87, no. 183; Goncourt, 1880, p. 129; Chennevières, 1889, p. 130; Normand, 1901, pp. 95, 181; Guiffrey, 1908, p. 71, no. 84; Goncourt, 1909, p. 190; Pilon, 1909, pp. 58, 166; Furst, 1911, p. 122, no. 115; Museum cat. (Brière), 1924, no. 115 (*not* 116); Ridder, 1932, pl. 28; Wildenstein, 1933, no. 864, fig. 132; Jourdain, 1949, pl. 47; Wildenstein, 1959, p. 98 and fig. 1 on p. 97; Wildenstein, 1963-69, no. 22, fig. 10; Rosenberg, Reynaud, Compin, 1974, no. 120 (ill.).

Related Works. Another version of the lower portion of this painting is known to us only through a mediocre photograph at the Courtauld Institute in London; before the war this version was known to have been at Galerie Brunner, Paris.

This Louvre painting poses various problems. First, is it really, as we believe, the canvas from the collection of the painter Aved? The description fits, although the dimensions given in the sale catalog after the death of Chardin's painter friend in 1766 differ noticeably. The canvas does not appear to have been reduced, except perhaps very slightly on the left; but dimensions listed in eighteenth-century sales catalogs are often unprecise.

The second question: Had the Louvre painting been conceived as a companion piece to another canvas, as Chardin liked to do? In the Aved sale, which included no less than nine of Chardin's works, the Louvre painting appeared in a separate lot; but a painting in the following lot (no. 130, now lost)—"Two mackerels attached to the wall, two cucumbers, two scallions, and a large goblet on a table"—had comparable dimensions (30 by 24 *pouces*). Besides, the two canvases were listed together in the inventory of Aved's estate (and estimated at seventy-two *livres!*) [Archives Nationales, Minutier Central, étude C II, liasse 434; see also G. Wildenstein, 1922, either p. 210, no. 78, or p. 211, no. 104]. The hypothesis advanced by Wildenstein (1963-69) that the Stockholm painting of a *Rabbit, Copper Pot, Quince, and Two Chestnuts* [78] could be the pendant to the Louvre painting must, in our opinion, be discarded. It is generally agreed that the Louvre painting dates from before 1728, between 1726 and 1728—perhaps earlier. Certainly neither the shape of the footed goblet which reappears throughout Chardin's career, nor of the bottle which was common during the eighteenth century, can help in confirming the date. However, the still-slightly-shifting quality of the composition—the not-quite-perfect balance of the objects placed on the stone ledge—announces *The Buffet*. And although the background wall of stone is similar to that in *The Ray-Fish*, the glimpse of sky through an opening in the upper left

is exceptional for Chardin, the sedentary Parisian who never tackled the open landscape; it smacks somewhat of the beginner. Yet one cannot but admire the perfect sense of color, the sobriety of the compositional scheme, and the subtle interrelationships which delighted even Henry de Chennevières in 1889.

9 *Preparations for Lunch (also called The Silver Goblet)*

(Les apprêts d'un déjeuner, dit aussi Le gobelet d'argent)

Canvas, 81 × 64.5 cm. Signed on the ledge of the niche, lower left corner: *Chardin*.
Paris, Private Collection

Provenance. In our opinion this cannot be one of the three pictures, different in format, listed as no. 18 in the Sylvestre sale of 28 February-25 March 1811 [Wildenstein, 1933 and 1963-69]; but it could be one of the two paintings of no. 15 in the same sale, *Deux tableaux où sont représentés deux oiseaux morts, un jambon et d'autres objets inanimés posés sur des tablettes, H. 26 pouces 6 lignes; L. 21 pouces 3 lignes* ("Two pictures representing two dead birds, a ham, and other inanimate objects arranged on trays" [71.5 × 57.5 cm.]). One of these two paintings, the now-lost *Lapwings*, belonged to Sylvestre at the time of the Salon of 1761 [no. 44; see Wildenstein, 1933, no. 750, and 1963-69, no. 285]. The other one is also considered lost by Wildenstein [1933, no. 751; 1963-69, no. 286].

One of four Chardins under no. 3, consisting of six paintings (four by Chardin, one by Monnoyer, and a *Lion's Head* study of Oudry) sold in two lots at the Gounod sale of 23 February 1824. (This collection included, as did the Sylvestre collection, the *Self-Portrait* [134] and the *Portrait of Madame Chardin* [135], both in pastel and both at the Louvre.) The title in the Gounod sale was: *Du jambon dans un plat, une bouteille et un grand Gobelet d'Argent: Morc. de 29 pouces 2 lignes de H. sur 23 pouces 2 lignes de L.* ("Ham on a plate, a bottle, and a large silver goblet" [79 × 62.5 cm.]).

Collection of the opera singer Barroilhet; Barroilhet sale of 10 March 1856, no. 18, *Le Gobelet d'argent* (?); Barroilhet sale of 2-3 April 1860, no. 102; Barroilhet sale of 15-16 March 1872, no. 3.

Acquired before 1876 by Baronness Nathaniel de Rothschild.

Collection of Henry de Rothschild, then James de Rothschild.

Anonymous sale of 23 May 1951 at Galerie Charpentier, no. 23, with reproduction.

Acquired by Victor Lyon of Geneva [*Arts*, 27 April 1951, with reproduction; *Annuaire international des ventes*, 1951, no. 939, with reproduction].

Exhibitions. 1860, Paris, no. 360; 1907, Paris, no. 57; 1926, Amsterdam, no. 17; 1929, Paris, no. 42; 1956, Paris no. 21.

Bibliography. Bocher, 1876, p. 103; Goncourt, 1880, p. 130; Dayot and Vaillat, 1907, no. 52 (with pl.); Guiffrey, 1908, p. 88, no. 202; Goncourt, 1909, pp. 191-92; Furst, 1911, p. 129; Quintin, 1929, pl. not numbered; Pascal and Gaucheron, 1931, pp. 139-40; Wildenstein, 1933, no. 1062, fig. 134 (and no. 751?); Barrelet, 1959, p. 308; Wildenstein, 1963-69, no. 24, pl. 2 (color) (and no. 286?).

Related Works. Another version (63 × 57 cm.), cut above and at the sides but without noticeable changes, had been in the collection of the fashion designer Jacques Doucet (1853-1929) as of 1908 [Guiffrey, no. 120]. It was acquired by the Metropolitan Museum in New York at the

Doucet sale on 5 June 1912, no. 140 [Sterling cat., 1955, pp. 127-28, ill.], then sold at Parke-Bernet of New York on 15 February 1973, no. 52 [see *The Metropolitan Museum of Art, Report on Art Transactions 1971-1973*, Appendix II, p. 2], and is today on the English market. G. Wildenstein accepted the attribution in 1933 [no. 1063, fig. 145]; Sterling considered it to be "from Chardin's studio" in 1955. It is not cataloged in Wildenstein, 1963-69.

In the niche of a stone wall are a footed silver goblet filled with red wine, a loaf of bread with a bone-handled knife stuck into it, and a pewter plate with a slice of ham and a long spoon placed before a big, half-full bottle of red wine, which Barrelet (1959) considers, curiously enough, to be of a type that came into use after 1766. Bread crumbs on the ledge in front of the niche accentuate the sense of depth in this composition. Wildenstein places the date of this painting between 1726 and 1728, which we find acceptable. The canvas attests to Chardin's preference for warm browns rich in nuances and for a vibrant light which envelops the objects and links them together. Wasting no time on certain representational details—is it really a slice of ham? a spoon or a fork?—Chardin set about to capture the reflected light on the silver goblet, the bottle, the cork, and the knife handle, and to give not only color but also volume and even weight to these objects that he had placed in relation to one another with consummate skill.

10 *Silver Goblet, Peach, White and Red Grapes, and Apples*

(Gobelet d'argent, pêche, raisin blanc et noir, grains de raisin et pomme)

Canvas, 46 × 56 cm. Signed at the lower right: *J. S. Chardin.*
Paris, Private Collection

Provenance. Collection of Eudoxe Marcille (1814-1890); probably in the possession of the Marcille family since 1863; it may previously have belonged to François Marcille (1790-1856), father of Eudoxe.

Exhibitions. 1959, Paris, no. 2; 1961, Paris, no. 14; 1968, London, no. 140, fig. 184.

Bibliography. Bocher, 1876, p. 101; Goncourt, 1880, p. 130; Chennevières, 1889, p. 128; Schéfer, 1904, p. 64; Guiffrey, 1908, p. 80, no. 147 (*not* 148); Goncourt, 1909, p. 191; Furst, 1911, p. 126; Wildenstein, 1933, no. 875, fig. 136; Wildenstein, 1963-69, no. 290, fig. 139; Rosenberg, 1969, p. 99.

Chardin was to paint this footed goblet many times throughout his entire career, but the manner of execution would change. Here, as in *Preparations for Lunch* [9], *Basket of White and Red Grapes . . .* [8], the painting at the St. Louis Museum [9], or the *Glass Carafe* of Karlsruhe (compare the half-peeled lemon in the Karlsruhe picture to the one in *Glass of Water . . .* [11]), the look of silver has been achieved with impastos—thicknesses of pigment which Chardin abandoned in favor of a smoother, more velvety and

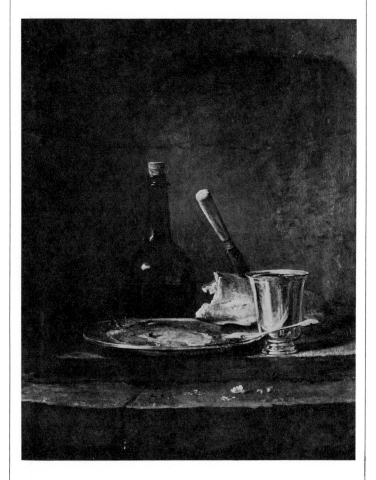

9

10

delicate execution in his *Silver Goblet* at the Louvre [128], dated around 1768, where the effects of the brush are suppressed.

Because his output was slow, Chardin developed a habit of exhibiting works at the Salons which he had done in earlier years. In 1753 he thus presented "two pendant pieces under the same number, showing fruits, from the collection of M. de Chasse." Abbé Garrigues de Froment wrote of them:

"I still must deal with the paintings of fruits and of animals by this artist, no doubt exhibited for a second time, since they date even farther back than *The Philosopher* [62] (that is, *before* 1734). To judge them by themselves, without comparing, I can think only of one reproach, and even this reproach would fall on only one among those of the former type [i.e., fruit], where the background has perhaps darkened. Be this as it may, the background is at present almost as strong in color as the objects which no longer stand out; they hardly produce any effect at all."

The criticism is perhaps excessive, but it applies to some extent to the two Marcille paintings — among the darkest of Chardin's early still lifes. These objects which appear to shimmer in the dim light exude all the more mystery and poetry.

11 *Glass of Water with Pear,*
Half-Peeled Lemon,
Three Walnuts, Two Chestnuts,
and Pieces of Nutshells

(Verre d'eau à demi plein avec poire, citron à demi pelé, trois noix dont une ouverte, deux châtaignes et des débris de coquille de noix)

Canvas, 45.5 × 55 cm. Signed at the lower right: *J. S. Chardin.*
France, Private Collection*

Provenance. See [10]; now separated from its companion piece.

Exhibitions. 1959, Paris no. 3; 1961, Paris, no. 13; 1968, London, no. 141, fig. 185.

Bibliography. Goncourt, 1863, p. 521; Bocher, 1876, p. 101; Goncourt, 1880, p. 130; Chennevières, 1889, p. 128; Guiffrey, 1908, p. 80, no. 148; Goncourt, 1909, pp. 106-7, 191; Furst, 1911, p. 126; Wildenstein, 1933, no. 829, fig. 107; Ver[onesi], 1959, p. 266; Wildenstein, 1963-69, no. 289, fig. 137; Lazarev, 1966, pl. 18; Rosenberg, 1969, p. 99.

"It is a glass of water between two chestnuts and three walnuts; look at it for a little while, then step back a few paces and the glass turns, takes on a shape; it is real glass, real water; it is the

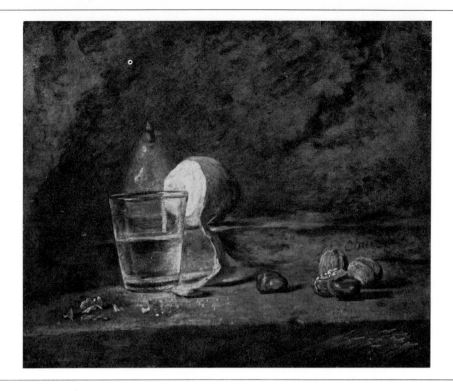

nameless color produced by the double transparencies of the vessel and its contents. At the water's surface and in the bottom of the glass the very daylight plays, trembles, and drowns. The most tender nuances, the subtlest variations of a blue verging on green, an infinite modulation of a certain glaucous gray, crystalline and glassy, everywhere broken brushstrokes, gleams that dart from the shadows, highlights slipping over the rim of the glass like a finger—that is all one sees when you stand close to the canvas. Here, in the corner, there is nothing but a muddy texture, the stroke of a brush being wiped; then suddenly a walnut appears, curled up in its shell, showing all its cartilages, revealing itself with all the details of its form and color."

This passage from the Goncourt brothers' first article on Chardin in 1863 seems clearly to refer to the painting from the Eudoxe Marcille collection, which they certainly knew. (The preceding passage, associated with the pendant in 1959, applies better to [13], at that time in the Laperlier collection.)

Wildenstein (1963-69) dates the pair around 1760. G. de Lastic (exh. cat. 1959) places them "around 1726-1728." We concur with his point of view (1969) by comparing them with the *Basket of White and Red Grapes...* [8]. Seen side by side, the two silver goblets mirroring a peach provide convincing evidence.

12 *Plate of Oysters*

(Le plat d'huîtres)

Canvas, 43 × 53.5 cm. Signed at lower right on edge of table: *Chardin.* London, Private Collection

Provenance. Sale D.B., 11 June 1782, no. 14, *Un déjeuner d'huître avec une bouteille, un verre et une boîte à poivre [18 pouces sur 15]* ("A lunch of oysters with a bottle, a glass and a pepper box" [48.6 × 40.5 cm.]).

Sale X, 29 November 1793, no. 18, *Un déjeuner composé d'un plat d'huîtres, une bouteille de vin et divers accessoires [19 pouces sur 15]* ("A lunch composed of a plate of oysters, a bottle of wine, and various accessories" [51.3 × 40.5 cm.]).

Sale Montmerqué, 17-18 May 1861, no. 6.

Sale J. W. G. D. of London, 25 February 1869, no. 21 (for another painting from this collection see [20]).

Collection of Jacques Doucet; Jacques Doucet sale, 5-8 June 1912, no. 142 (ill.).

Collection of J. D. Rockefeller III, New York.

Exhibitions. Never shown.

Bibliography. Guiffrey, 1908, p. 76, no. 118; Furst, 1911, p. 124; Dacier, 1912, p. 337; Wildenstein, 1933, no. 904, fig. 138; Wildenstein, 1963-69, no. 27, fig. 12; *Sunday Times,* 3 September 1978, p. 29 (color ill.).

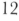

Chardin arranged a pepper box, some oysters on an earthenware plate, a glass filled with red wine, a bottle, an oyster, and a knife on a large stone ledge. The objects stand out against a neutral background. The date of 1726-1728, proposed by Wildenstein for this painting, seems justified, as much by its vigorous, almost brutal, execution as by its somewhat unstable composition. The large crack in the stone ledge reappears in the *Still Life with Two Cucumbers* at The Frick Collection, New York [Wildenstein, 1963-69, no. 271, fig. 126], which must have been painted at approximately the same time.

In the first years of his career Chardin was fond of representing oysters on plates. Other examples in this exhibition are *The Ray-Fish* [7] and *The Buffet* [14]. A *Cat Coveting Oysters* is in a private Swiss collection [Wildenstein, 1963-69, no. 275, fig. 130]; its pendant, however, is dated 1728 rather than 1758. (A similar version is in the Burrell collection, Glasgow.)

The cool harmony of the frieze-like composition, the reflections on the wooden spice box, the glass and the metal, and the straightforward execution are characteristic of these "lunches" in which Chardin specialized at the start of his career as a still-life painter.

13 *Carafe of Wine, Silver Goblet, Five Cherries, Two Peaches, An Apricot, and a Green Apple*

(Carafe à demi pleine de vin, gobelet d'argent, cinq cerises, deux pêches, un abricot et une pomme verte)

Canvas, 43 × 49.5 cm. Signed at the lower right: *Chardin.*
St. Louis, The St. Louis Art Museum

Provenance. Collection of Laurent Laperlier before 1863; Laperlier auction, 11-13 April 1867, no. 16.

First Laurent-Richard sale, 7 April 1873, no. 2; second Laurent-Richard sale, 23-25 May 1878, no. 91.

Collection of E[dmond]Borthon [Dijon cat., 1890, no. 15]: The Borthon sale catalog indicates that the painting had figured in the sales of the Beurnonville, Laperlier, and Laurent-Richard (no. 91) collections and that "the latter had acquired it from Philippe Rousseau," suggesting that Rousseau owned it between Laperlier and Laurent-Richard [see also Ménard, 1873, p. 181; on Chardin and Philippe Rousseau, see [39]]. However, we know of only one Beurnonville sale prior to 1867, held on 15 April 1844, where no. 18 lists *Fruits et autres apprêts de repas—quatre toiles en pendant; H. 39; L. 47* ("Fruits and other dishes prepared for meals" [39 by 47 cm.]). Could the St. Louis painting have been one of these?

Collection of M. d'Hotelans (son-in-law of Borthon) at Château de Novillars near Besançon.

Collection of H. S. Southan, Hamilton, Ontario, Canada.

Acquired by The St. Louis Art Museum in November 1934.

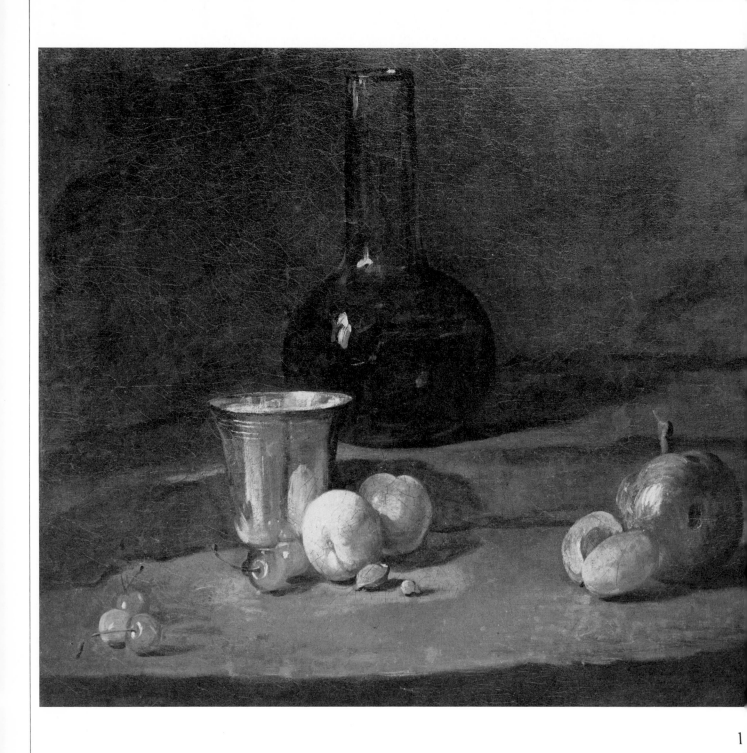

Exhibitions. 1920, New York, no. 3 (or 4?); 1926, New York, no. 15; 1927, Chicago, no. 14; 1933, Springfield, no. 40 (ill.);1936, New York, no. 1;1958, New York, no. 25, ill. on p. 43; 1961, Los Angeles, p. 19; 1965, Columbus, no. 7.

Bibliography. Goncourt, 1863, p. 521 (the engraving by Jules de Goncourt, a detail from this painting, illustrated the article); Burty, 1867, p. V; Ménard, 1873, p. 181; Bocher, 1876, p. 38; Burty, 1876, p. 13; Goncourt, 1880, pp. 126, 128 (wrongly identified with a painting in the Aved sale of 1766); Dijon cat., Borthon Collection, 1890, p. 1, no. 15; Guiffrey, 1908, pp. 42,44,101; Goncourt, 1909, pp. 106, 186 (note 1), 188-89; Wildenstein, 1933, no. 766, fig. 96; R[ogers], 1935, pp. 52-55 (with ill.); Museum cat., 1953, p. 83 (with ill.); *Arts,* November 1958, p. 47 (repr.); Barrelet, 1959, p. 309; Nemilova, 1961, pl. 15; Wildenstein, 1963-69, no. 295, fig. 144; Museum cat., 1975, p. 128 (with ill.).

Prints. A portion of the painting was engraved by Jules de Goncourt (1830-1870). [Cf. Bocher, 1876, p. 38, no. 36; and Burty, 1876, p. 13, no. 58].

Jules de Goncourt,
engraving after Chardin.

At the Salon of 1863 Jules de Goncourt exhibited his engraving of the center part of the picture—then in the Laperlier collection—showing the base of the carafe, the goblet, the peaches, and the cherries [Burty, 1876, no. 58; exh. cat. *Goncourt,* Paris, 1933, no. 153, with ill.]. In the same year the Goncourt brothers described the painting in an article for the *Gazette des Beaux-Arts* (which they illustrated with the engraving):

"A silver goblet with some fruits around it, nothing more, is an admirable picture of his. The shine and sparkle of the goblet is done with a mere few touches of white, scratched on with dry paste. In the shadows there are all kinds of tones and colorations: streaks of an almost-purple blue, drippings of red which are the reflections of the cherries against the goblet, a faded red-brown blurred into pewter shadows, specks of red and yellow playing in touches of Prussian blue—a continuous echo of all the surrounding colors gliding over the polished metal of the goblet."

It has been suggested that this work is the pendant to the *Pewter Pitcher with a Slice of Melon* formerly in the Henry de Rothschild collection [Wildenstein, 1933, no. 780, fig. 93; 1963-69, no. 296, fig. 146]. The height of this painting fragment, destroyed in World War II, was the same as that of the St. Louis painting; moreover, both paintings were once part of the Laperlier collection. Yet the scale of the objects is too different for the two paintings to have been conceived as a pair, and they also had entered the Laperlier collection at separate times. In fact, in 1860 when the Rothschild painting was exhibited at Galerie Martinet (no. 364), the St. Louis painting certainly could not yet have belonged to the illustrious and voracious collector. We do believe, however, that the two works are contemporaneous and date from around 1728. The pewter pitcher reappears in *The Buffet* as well as in one of the Karlsruhe paintings [*Pewter Pitcher and Basket of Peaches,* Wildenstein, 1933, no. 802, fig. 150; 1963-69, no. 48, fig. 20], and the basket in the *Partridge...,* also at Karlsruhe [18]. If the silver goblet was a standard motif in Chardin's oeuvre (see [8]), the simple carafe occurs more rarely. Barrelet (1959) compares it to the one, slightly different in shape, that is seen in the engraving of *The Monkey as Painter* (see [66]), where the date of 1726 is clearly legible on the portfolio in this composition; this would make it one of Chardin's earliest works.

Should one insist on finding a pendant to the St. Louis picture, the *Basket of Plums with Bottle, Glass, and Two Cucumbers* in The Frick Collection, New York, would seem a better choice [Wildenstein, 1933, no. 852, fig. 95; 1963-69, no. 271, fig. 126]. Its format (45 × 50 cm.) is close to that of the St. Louis canvas and, above all, the scale of the objects and the manner of execution are very similar.

New York, The Frick Collection.

14 *The Buffet*

(Le buffet)

Canvas, 194 × 129 cm. Signed and dated at the lower right:
J. Chardin f.c. 1728.
Paris, Musée du Louvre, Inv. 3198

Provenance. Reception piece for the Academy, 25 September
1728 [see Minutes, ed. 1883. V, pp. 47-48; also catalog entry on *The
Ray-Fish]*; at the Academy until the French Revolution [see Fontaine,
1910]; seized during the Revolution and exhibited at the Louvre since
June 1796. The painting was sent to Compiègne shortly after 1821 (ap-
peared in Compiègne catalogs of 1832 and 1837) and was returned to
the Louvre on 22 April 1850 upon intervention by F. Villot [letters of
10 April, 16 April, 28 June, and 8 July 1861; Archives of the Louvre,
série P12. See also Chennevières, 1888, p. 58: "M. de Nieuwerkerke
had it brought in under the pretext that it needed repair, and then he
took it upon himself to keep it"].

Exhibitions. 1728, Paris, Exposition de la Jeunesse, no cat.; 1936,
Paris, no. 17; 1974, Paris, no. 99, and color pl. on p. 125.

Bibliography. (Also see entry on *The Ray-Fish* [7])
Museum cat. (Villot), 1855, no. 97; Bürger (Thoré), 1860, p. 334;
Blanc, 1862, p. 15; Goncourt, 1863, pp. 519-20; Bocher, 1876, pp.
83-84, no. 97; Goncourt, 1880, p. 129; Chennevières, 1888, pp. 57-58;
Fourcaud, 1899, p. 394; Dilke, 1899, p. 180; Dilke, 1899 (2), p. 113;
Fourcaud, 1900, p. 12; Normand, 1901, pp. 31, 106; Schéfer, 1904,
pp. 17 (pl.), 37, 39; Dorbec, 1905, pp. 460-61; Dayot and Guiffrey,
1907, pl. between pp. 88 and 89; Guiffrey, 1908, p. 70, no. 77; Gon-
court, 1909, pp. 101-5, 189; Pilon, 1909, pp. 25-26, 165; Fontaine,
1910, pp. 56, 58, 142; Furst, 1911, p. 121, no. 90, pl. 5; Museum cat.
(Brière), 1924, no. 90; Pascal and Gaucheron, 1931, pp. 7, 60; Ridder,
1932, pp. 6, 30, 54, pl. 2; Wildenstein, 1933, no. 675, fig. 73; Pilon,
1941, pl. on p. 9; Goldschmidt, 1945, fig. 12; Villeboeuf, 1946, p. 108
(ill.); Goldschmidt, 1947, fig. 14; Lazarev, 1947, pl. 4; Florisoone,
1948, p. 63; Jourdain, 1949, fig. 46; Denvir, 1950, pl. 3; Proust, 1954,
p. 42 (with ill.); Barrelet, 1959, pp. 308-9, 311, figs. 7 and 8 (details);
Wildenstein, 1959, p. 98, fig. 2; Adhémar, 1960, p. 455, pl. 240;
Eisler, 1960, pl. on p. 204; Faré, 1962, p. 162; Garas, 1963, pl. 2;
Rosenberg, 1963, pp. 8, 21, 25, 30, 60; Wildenstein, 1963-69, no. 47,
pl. 5 (color); Thuillier and Châtelet, 1964, p. 202; Lazarev, 1966, pl.
4; Proust, 1971, pp. 374-75; Lacambre, 1973, p. 46, note 1;
Rosenberg, Reynaud, Compin, 1974, no. 123 (with pl.); Rosenberg,
1974, p. 459, fig. 3; Kuroe, 1975, pl. 4 (color).

Related Works. The painting was far less admired and copied than
The Ray Fish [7]. There is, however, a copy by Matisse, executed in
April 1896 [Register of Copyists, Archives of the Louvre] and not
"around 1893" [exh. cat. *Matisse*, Paris, 1970, no. 2A, with ill. p. 105;
also see p. 61 where the following is cited from a letter that Matisse
wrote to A. Rouveyre 25 July 1943: "...Chardin and his pyramids of
peaches that I copied at the Louvre when I was young and hairy like
Absalom"].

The painting belonged to the Academy until the French Revolu-
tion and eventually was "relegated" for some time to the Château
de Compiègne. Thanks to Frédéric Villot (1809-1875) — then the
new curator of paintings — it was brought back to the Louvre in
1850, and when the Ministry of Works, responsible for Com-
piègne, reclaimed it, the general director of the museum,
Nieuwerkerke (probably at Villot's request), refused in these

terms: "The painting by Chardin... figures now in too honorable
a manner in the gallery by the riverbank (Grande Galerie) for us
to be deprived of it."

The phrase is revealing. It indicates that Chardin's work was
beginning to return to favor several years before the first writings
by the Goncourt brothers appeared (1863-1864), as can also be
gathered from the admiring lines by Thoré, the "discoverer" of
Vermeer, who wrote in 1860: "Who else in France could then
have painted this magnificent picture?"

The Buffet has been famous ever since, though it was never to
attain the popularity of *The Ray-Fish*. It has been venerated by
many, from Philippe Rousseau who "spent hours of discourage-
ment under the spell of this painting, despairing in advance of the
poor success of his own imitations" [Chennevières, 1888, pp.
57-58] to Matisse, who copied it in 1896.

This canvas, dated 1728, is among Chardin's earliest dated
works. It is, in fact, along with a still life of *Two Rabbits, Game
Bag, Powder Flask, and Seville Orange* at Karlsruhe, his first
firmly dated work still in existence, and consequently provides an
essential clue to the fragile chronology of Chardin's beginnings.
Wildenstein had observed in 1959 that the pewter jug behind the
two fern-ash glasses [see Barrelet, 1959] at the extreme left of the
composition reappears in another Karlsruhe painting, *Pewter Jug
with Basket of Peaches and Plums* [Wildenstein, 1963-69, no. 48,

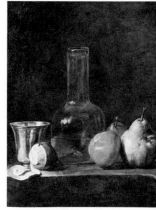

Karlsruhe, Staatliche Kunsthalle.

fig. 20], which regrettably is not in this exhibition, and in a can-
vas from the Henry de Rothschild collection which was destroyed
during World War II (idem., no. 296, fig. 146). By 1963 he had
drawn the conclusion that the first of these two, along with its
pendant, *Carafe, Silver Goblet, Peeled Lemon, Apple, and Pears*
(also at Karlsruhe) must be close in date to the Louvre *Buffet.*
Unaccountably, he abandoned his hypothesis in 1969 and placed
the pair around 1760. In our opinion the revision is untenable, as

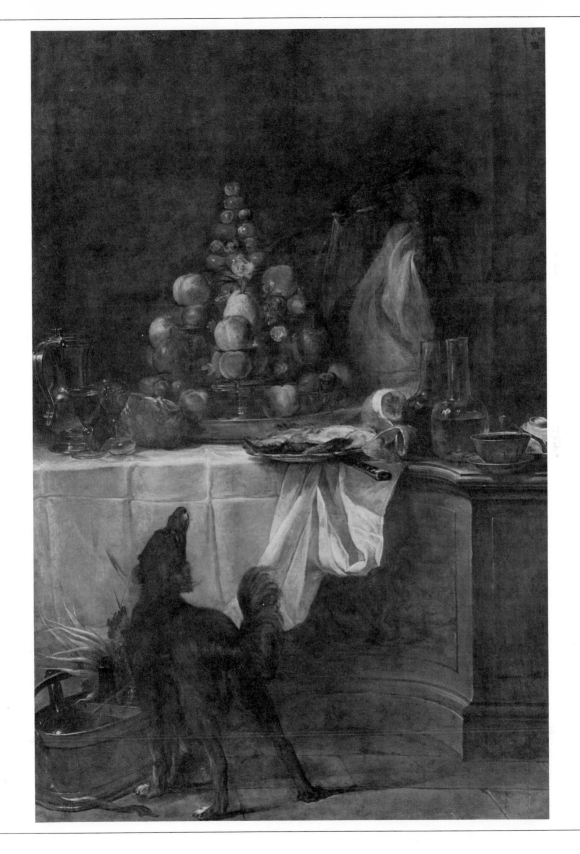

14

See Color Plate II.

the three-quarter-empty, simple carafe in the second painting of the Karlsruhe pair is identical to the two carafes at the right of the Louvre picture.

The Buffet is sumptuous, yet controlled, more in the tradition of buffets à la Desportes than in that of Flemish repasts. We should like to conclude our discussion with a masterful but little-known description of this work written around 1895 by Marcel Proust and published for the first time in 1954 in *Figaro Littéraire* [ed. 1971, pp. 374-75; English text from *Marcel Proust on Art and Literature, 1896-1919* (New York: Meridian, 1958):

"Into these rooms where you see nothing but a representation of other people's limited minds and the reflection of your own boredom, Chardin enters as does the light, giving its colour to everything, conjuring up from the timeless obscurity where they lay entombed all nature's creatures, animate or inanimate, together with the meaning of her design, so brilliant to the eye, so dark to the understanding. As in *The Sleeping Beauty*, they are all brought back to life, resume their colour, begin to talk to you, put on life and duration. On the sideboard everything, from the stiff creases of the turned-back cloth to the knife lying askew and jutting out by the length of its blade, records the hurry of servants, witnesses to the gluttony of guests. The dish of fruit, still as glorious and already as ravaged as an autumnal orchard is crowned with swelling peaches, rosy as cherubs, smiling and inaccessible as the gods on Olympus. A dog with outstretched neck cannot reach up to them, and makes them the more desirable for being desired in vain. He eats them by sight, divining their fragrant flesh from the downy skin that it moistens. Wine-glasses, clear as daylight, enticing as spring-water, are grouped together, those in which a few sips of sweet wine display themselves as though lingering in a gullet standing besides others already almost drained, like emblems of a lively thirst beside emblems of a thirst allayed. One glass has half tipped over, tilted like the bell of a withered flower; the luck of its position discloses the pontil mark at its base, the delicacy of its stem, the purity of its crystal, the elegance of its contours. Freed henceforward by the crack running through it from the claims of a household it will serve no longer, its useless grace has the aristocracy of a Venice glass. Oyster shells, light as cups of mother-of-pearl, cool as the sea-water they offer us, lie about on the cloth like charming fragile symbols on the altar of gluttony, Cold water in a bucket, swirled all to one side by the kick of a hasty passing foot, spills over on to the floor and a knife, token of an appetite that could not wait to begin, quickly tucked away by someone and heaving up the golden rounds of lemon that seem to have been put there by appetite's own hand, these complete the mouth-watering array...."

15 *Rabbit with Red Partridge and Seville Orange*

(Lapin mort avec une perdrix rouge et une bigarade)

Canvas, 68 × 60 cm. (several centimeters of the canvas are folded back on all sides; original measurements were 81 × 65 cm.). Signed at the lower left in brown letters: *Chardin*.
Paris, Musée de la Chasse et de la Nature

Provenance. Collection of the Baroness Nathaniel de Rothschild, from 1876; Baron Henry de Rothschild; Baron James de Rothschild. Preempted 1 December 1966 by the National Museums, no. 115 (color plate), and acquired by the Louvre in association with the Fondation de la Chasse, to be given on indefinite loan to the Musée de la Chasse et de la Nature.

Exhibitions. 1926, Amsterdam, no. 16; 1929, Paris, no. 41; 1949, Paris, no. 8.

Bibliography. Bocher, 1876, p. 103; Goncourt, 1880, p. 130; Nolhac, 1907, p. 46 (ill.); Dayot and Vaillat, 1908, no. 28 (with pl.); Guiffrey, 1908, p.88, no. 200; Goncourt, 1909, p. 192; Pilon, 1909, p. 66, note 1; Furst, 1911, p. 129; Quintin, 1929, pl. not numbered; *Beaux-Arts*, 15 October 1929, no. 10, ill. on p. 27; Ganz, 1930, p. 162 (with ill.); Pascal and Gaucheron, 1931, p. 137; Wildenstein, 1933, no. 713, fig. 77; Wildenstein, 1963-69, no. 39, pl. 3 (color); *Connaissance des Arts*, February 1967, pp. 47, 49 (with ill.); *Gazette de l'Hôtel Drouot*, 2 April 1971, p. 11 (with ill.).

The date of 1727-1728 proposed by Wildenstein for this painting seems convincing. In connection with this picture and others related to it, we quote the famous comment of the Goncourt brothers [1863, p. 520]: "In his paintings of animals, his hares, rabbits, and partridges—those subjects which the eighteenth century would describe as *'retours de chasse'*—what master has equalled him? Even Fyt himself, who was more witty, more lively and entertaining to the eye, more minutely detailed in feather and hair, must yield to him in firmness, breadth of handling, and truth of effect." The brothers further praise "these deep, mixed backgrounds that he knows so well how to scumble, where the coolness as in a forest grotto mingles vaguely with the shadows of a sideboard and one of those tables that is colored in tones of moss and topped with dull marble and which so often bears the artist's signature."

This canvas from the Musée de la Chasse is less monochrome than the other hunt subjects shown here: the orange flash of the Seville orange (a type of bitter orange used in the eighteenth century in pastries), the three leaves garnishing its stem, the red beak and feet of the partridge with its rust and gray breast, are color accents the artist was little accustomed to use. Chardin remains faithful, however, to his diagonal compositions—here given depth by the projection of the head of the rabbit beyond the ledge which supports the dead game. Around the head of the rabbit lies the whole organization and balance of the painting.

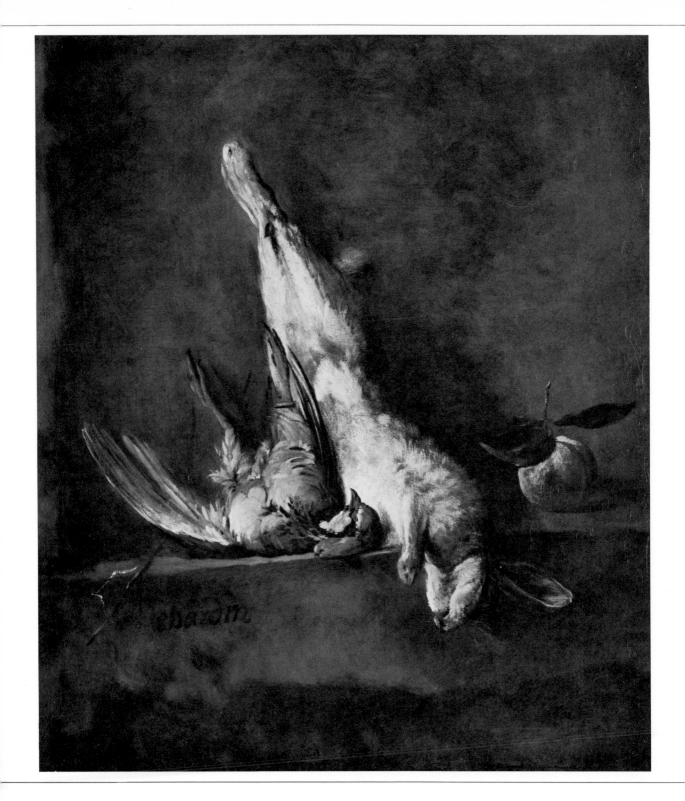

15

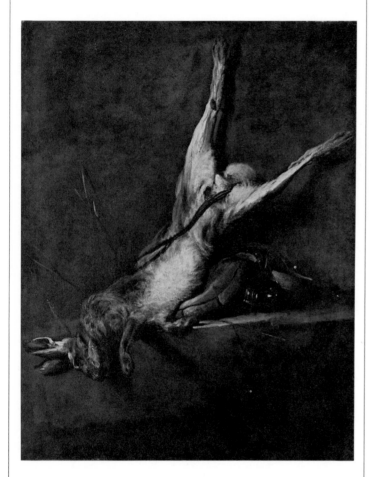

16

16 *Hare with Powder Flask and Game Bag*

(Lièvre mort avec poire à poudre et gibecière)

Canvas, 98 × 76 cm. Signed at the lower right: *Chardin f.*
France, Private Collection

Provenance. Paris art market; private collection in the north of France before World War II. Sometimes identified with the painting in the collection of Charles Germain (sale, 21 June 1858, no. 21; also see [23]; however, this identification cannot be correct unless the dimensions of the present painting were reversed in the catalog of that sale.

Exhibitions. 1926, Amsterdam, no. 15 (with ill.); 1929, Paris, no. 10; 1930, Paris, no. 24; 1931, Paris, no. 780; 1933, London, no. 36; 1945, Paris, no. 7 (with pl.); 1962, Paris, unnumbered ill.

Bibliography. New York Herald Tribune, art supplement, 26 April 1925, p. 12; *The Burlington Magazine,* December 1927, pl. 20; *Le Temps,* 10 October 1929; Fosca, *Candide,* 8 May 1930; Bibesco, *Renaissance,* February 1933, p. 132 (ill.); Wildenstein, 1933, no. 710, fig. 85; Faré, 1962, II, fig. 370; Wildenstein, 1963-69, no. 10, fig. 4; Faré, 1976, p. 150, fig. 229.

It has not been possible to identify this painting among the several "hunt subjects" mentioned in the sales and inventories of the eighteenth century. This, however, is one of Chardin's most daring compositions: a large, red hare is nailed to the wall with its white breast towards the viewer. Its paws, spread wide like the arms of a cross, slash across the canvas from right to left. The forepart of its body rests on a sloping stone ledge upon which have been placed, as is so common in Chardin's works, a powder flask and a game bag whose thong furrows the animal's belly. Several wisps of straw and an ear of wheat animate the composition.

This work can only date from the years 1726 to 1730. During this period Chardin liked to fill his picture space with compositions of calculated simplicity—compositions which remain, however, slightly shifting and unstable. Already in this painting the hare has that sense of weight which was to be the source of admiration among the artist's contemporaries: one can sense that the animal is freshly killed and that the body still retains its suppleness. It was only later in his career (see [98, 101]) that Chardin would isolate his hunting still lifes in a large empty space and depict his animals already stiffened in death, giving his paintings that emotive quality which is so exceptional in French painting of Louis XV's era.

17 *A Green-Neck Duck Hung on the Wall and a Seville Orange*

(Un canard col-vert attaché à la muraille et une bigarade)

Canvas, 80.5 × 64.5 cm. Signed at the lower right: *Chardin.*
Paris, Musée de la Chasse et de la Nature

Provenance. Included in a sale, without catalog, at the Hôtel Drouot in 1957. Acquired on the Paris art market by the Musée de la Chasse et de la Nature in 1963.

Four entries in sales of the eighteenth century can be related to this painting:

1) Sale of the collection of the painter Joseph Aved (1702-1766), 24 November 1766, no. 135, *Un canard attaché à la muraille et un citron sur une table. Tableau peint sur une toile de 29 pouces de haut sur 23 de large* ("A duck fastened to the wall and a lemon on a table. Painting on canvas, 78.5 × 62 cm."). See also the estate inventory following Aved's death 16 June 1766 [Archives Nationales, Minutier Central, étude C II, liasse 434, no. 122, "a painting depicting a duck"; and Wildenstein, 1922, p. 211].

2) Anonymous sale, after 2 December 1768, no. 61, *Un tableau représentant un canard et une bigarade peint par Chardin; sur toile dans sa bordure dorée; il porte deux pieds six pouces de haut sur deux pieds de large* ("A painting depicting a duck and a Seville orange, painted by Chardin; on canvas, with gilt frame; it measures 81 × 65 cm.").

3) Sale, Pierre Le Brun, 18 November 1771, no. 42, *Un tableau représentant un canard peint par Chardin sur toile avec bordure. Hauteur deux pieds six pouces sur deux pieds* ("A painting depicting a duck, painted by Chardin, on canvas with frame, 81 × 65 cm.").

4) Sale (Le Brun), 22 September 1774, no. 112, *Un tableau savant sur toile de 2 pieds 5 pouces de haut, sur 1 pied 10 pouces 6 lignes de large. Il représente un canard sauvage attaché par une patte à la muraille et un citron sur une table* ("A masterly painting on canvas, 78.5 × 61 cm. It depicts a wild duck fastened by one foot to a wall, and a lemon on a table.").

In 1933 Wildenstein grouped these four items under one entry (no. 698). G. de Lastic in 1959 [exh. cat., Paris] considered that only the second and third sales related to this painting, which was at that time still on the market. In his editions of 1963 and 1969, Wildenstein cataloged the painting of the first and fourth sales (no. 14) separately from that of the second and third sales (no. 15). In his judgment this latter painting could not be confused with that of the Musée de la Chasse, which seemed to fall outside the body of Chardin's work. It must be pointed out that the differences in dimensions from one catalog to another are minimal (1 inch, that is, 2.5 cm., in height and 1¹/₂ inches, or 3.75 cm., in width) and that the descriptions are very similar (the first and last sales mention a lemon; only the second catalog gives the correct name of the fruit on the table to the right as a Seville orange). In addition, it is well known that sale catalogs in the eighteenth century were no more accurate than those of our own time. Clearly, nothing excludes the possibility that the same painting—the one now in the Musée de la Chasse—could have appeared in these four sales in a period of less than ten years, before disappearing for almost two centuries.

Exhibitions. 1958, Stockholm, no. 76; 1959, Paris, no. 1, pl. 1.

Bibliography. Ver[onesi], 1959, p. 265 (with fig.); Huyghe, 1965, p. 4 (with ill. in reverse); Faré, 1976, p. 151, fig. 231.

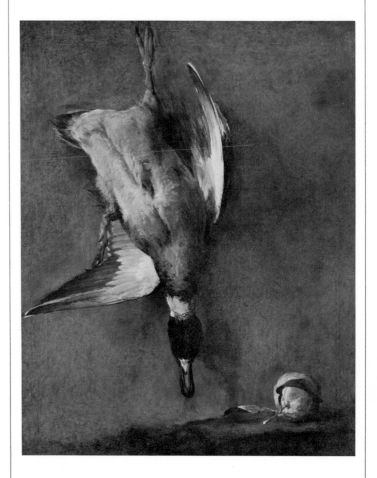

17

The *Green-Neck Duck...* purchased by the Musée de la Chasse in 1963 was associated by G. de Lastic in the catalog of the 1959 Paris exhibition with the well-known passage from Mariette describing Chardin's beginnings as a painter:

"Monsieur Chardin, never hoping to attain — as much as he might have wished it — to the talent of history painting, decided to pursue a specialized field. He trained himself to this end, and was led to embrace the discipline with which we have seen him commencing his artistic career, in the following manner. Someone had made him a gift of a rabbit; he found it beautiful and hazarded an attempt at painting it. Some friends to whom he showed the first product of his brush perceived great promise in it and encouraged him as best they might. The canvas which he had used, one which had chanced to fall into his hands, was not nearly filled by the figure of the rabbit and he was therefore able to add some kitchen utensils, and his painting became a composition. This work lost no time in finding itself an owner, but he took it only on the condition that it should have a companion piece, with a duck as its subject." [P.-J. Mariette, from the manuscript text; see the 1853 edition, p. 356.]

This same passage from Mariette was related by Wildenstein [1959, p. 177] to two paintings, one now in Berlin, the other in Detroit (exhibited here as [112, 113]: "the dryness of handling in them might well argue for an early date. Are these then Chardin's first works? Such an opinion might well be accepted." Wildenstein, however, seems to have rejected this hypothesis in his editions of 1963 and 1969. According to D. Carritt, the *Rabbit, Copper Pot, Quince, and Two Chestnuts* [78] in the Stockholm Museum might well be the pendant described by Mariette.

All the above theories seem rather fragile, especially in view of the fact that the duck from the Musée de la Chasse painting was faithfully reproduced by Chardin in *The Water Spaniel*, now in the Wildenstein collection in New York, which dates from 1730 [Wildenstein, 1963-69, no. 68, fig. 32]. Moreover, the *Green-Neck Duck...* is itself composed of juxtaposed elements from several of Chardin's paintings. Quite apart from the re-use of the duck, caught by one leg on the rim of a vase in the Wildenstein painting, but utterly identical in both works, above and beyond all of this, comparisons will inevitably be drawn with the hare, game bag, and powder flask in the painting exhibited here as [16]. As for the spaniel, it appears again in the curious picture from a Swedish collection, included in this exhibition as [141].

Whatever the case may be, the *Green-Neck Duck...* here, which appears more as a simple study for an important composition than as a finished work, would seem closer in date to the paintings of 1728-1730 than to those canvases done prior to Chardin's admission to the Academy. The four bold patches of orange in the beak and feet of the duck and the granular surface of the Seville orange punctuate the composition, giving it rhythm, and make of this delightful and skillful work a masterpiece of refinement — all in nuances and half-tones. The delicacy of the browns and grays in the bird's breast feathers, the perfect poise and marvelous balance of the design, testify to Chardin's mastery of technique by the age of thirty.

18 *Partridge, Bowl of Plums, and Basket of Pears*

(Perdrix morte, compotier de prunes et panier de poires)

Canvas 92 × 74 cm. Signed (with letters made to appear as if carved in stone) at the lower right: *J. S. chardin.*
Karlsruhe, Staatliche Kunsthalle*

Provenance. Acquired with its pendant by the Margravine of Baden, Karoline Luise, in December 1759, through the agency of the architect La Guêpière, from the art dealer "Jouillain."

Exhibition. 1910, Berlin, no. 13 (no. 300 in the small-size edition of the cat.).

Bibliography. Dussieux, 1856, p. 18: Bürger (Thoré), 1860, p. 307; Parthey, 1863, p. 278, no. 8; Goncourt, 1864, p. 154; Viardot, 1864, pp. 139-40; Bocher, 1876, p. 90, no. 579; Dussieux, 1876, p. 165; Goncourt, 1880, p. 129; Grautoff, 1908, p. 502; Guiffrey, 1908, pp. 57-58, no. 7; Goncourt, 1909, p. 191; Pinder, 1909, p. 43; Meier-Graefe, 1910, pp. 271-72; Furst, 1911, p. 131 and pl. 28 (detail); Ridder, 1932, p. 44, pl. 52; Kircher, 1933, pp. 13-14, 109-11, 197; Wildenstein, 1933, no. 740, fig. 81; Pinder, 1938, p. 24; Burckhardt, ed. K. Martin, 1941, pp. 41, 153; Donat de Chapeaurouge, 1955, p. 8 (with ill.); Wildenstein, 1963-69, no. 45, fig. 19; Museum cat. 1963, no. 28 (with ill.); McCoubrey, 1964, p. 46 and fig. 8; Museum cat. (J. Lauts), 1966, pp. 76-77, no. 498 (pl. on p. 159 of Vol. II); Lauts, 1970, p. 40 (color pl.).

Karlsruhe has four Chardins (of which only the present painting could be loaned for the exhibition), all acquired during the artist's lifetime by the Margravine Karoline Luise (1723-1783) of Baden-Durlach, wife of the Margrave Karl Friedrich. Two other related paintings have also been associated with the Margravine in the past. One, *The Little Orange Tree* [cat. 1966, no. 495], long believed to be by Chardin, was quite properly attributed by G. Kircher in 1928 to Henri-Horace Roland de La Porte (1725-1793) on the basis of evidence from the Margravine's correspondence and the original bill of sale; de La Porte has been one of the principal "victims" of Chardin, to use Diderot's phrase.

Another painting, *Lady Sealing a Letter,* mentioned by a number of nineteenth-century authors, was a gift to the Margravine in 1759 from Georg Wilhelm Fleischmann; it was sold by Karlsruhe in 1853 and may be the painting now owned by the Louvre (MNR 60), on loan to the French embassy at the Vatican (see [54]).

Two of the Chardin still lifes now at Karlsruhe and still on their original canvases, *Basket of Peaches with Pewter Cup* and *Half-Peeled Lemon with Glass Carafe* [cat. 1966, nos. 496 and 497], were acquired by the Margravine in 1761 through the agency of J. H. Eberts from the collection of the painter Aved. This artist's name appears frequently among the early owners of Chardin's works, and he must have been, according to a tradition current in the eighteenth century, as much a collector as a dealer in the works of his friends.

The circumstances of the purchase in 1759 of the present painting and its pendant, *Two Rabbits with Game Bag, Powder Flask, and Orange* [Wildenstein, 1963-69, no. 44, fig. 18], are somewhat

confused. The Margravine wrote Counsellor Fleischmann, then in Paris, on 19 October 1759 [cf. Kircher, 1933, pp. 105-11]: "Since you, sir, are acquainted with the Abbé Troublet [sic], I would appreciate finding out, through you, how much he paid M. Chardin for two paintings, one of which depicts a glass of water, some cherries, and I know not what other fruits as well...." Clearly, this refers to the two paintings exhibited at the Salon of 1759; see [108, 109].

Fleischmann answered on the 27th of October: "As this capable painter has been a friend of mine these ten years past, you may be assured of acquiring from him duplicate versions of these paintings at a cost which would be hardly greater than that which the Abbé paid for his, although that gentleman has asked me to omit mention of the price he gave for them."

In spite of this offer, the Margravine felt "obliged to refuse for a while yet anything which would be very expensive." She adds: "I do not know at all the work of this artist; some have praised him highly to me but have said at the same time that he is dreadfully expensive."

At this point, Fleischmann offered from his own collection the small version of the *Lady Sealing a Letter,* mentioned above, and the Margravine purchased the present painting and its pendant for 200 *livres* (according to the receipt) or 240 *livres* (according to one of the Margravine's letters). The purchase was arranged through the architect Pierre-Louis-Philippe de La Guêpière, who was in Paris at this point and who had been the Margrave's director of construction since 1752. The two paintings had belonged to a "merchant," "a very honest man,", one "Jouillain"; this was undoubtedly the painter, engraver, and dealer François Joullain (1697-1778). The pictures arrived in Karlsruhe on 28 December 1759, along with two by Bachelier.

"The Bacheliers are beautiful, but the Chardins carry the day; they are wonderful," writes the Margravine, who adds in another letter, again by comparison with the other two paintings: "I am

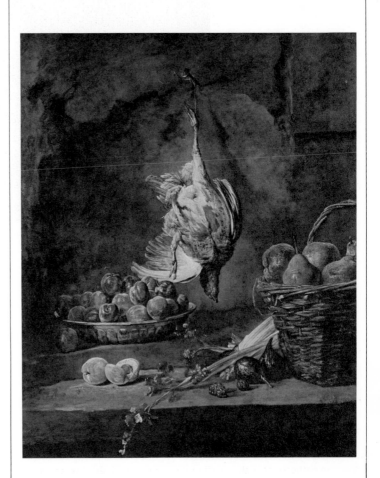

Karlsruhe, Staatliche Kunsthalle.

18

133

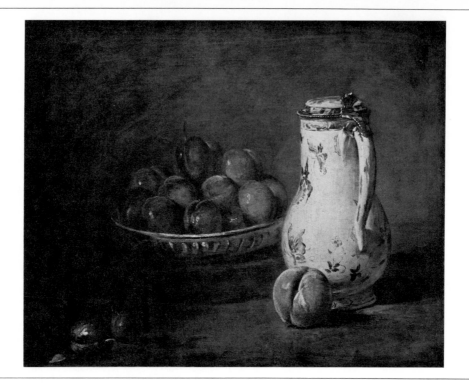

pleased with them [the Bacheliers], but that in no way prevents me from judging the two Chardins much superior."

One of the pair, *Two Rabbits with Game Bag, Powder Flask, and Orange,* is clearly dated 1728 (not 1726), and the present painting has usually been given the same date. However, it is not at all certain that the two paintings were originally conceived as a pair; if they are close to each other in date, it seems best to place the present painting one or two years later than its companion. In any event, these two works should be considered as slightly later than the other two Chardins at Karlsruhe, which Wildenstein [1963, nos. 48 and 49, figs. 20 and 21] has correctly dated "about 1728" and "about 1728-1729"; strangely, the same author dates these same works "about 1760" in his 1969 edition. It will be remembered that the motif of the carafe which appears in one of this pair is faithfully repeated in *The Buffet* from the Louvre [14], also dated 1728.

The partridge hangs in front of a niche in the stone, fastened to the wall by a large nail. A basket of pears (similar to the *Basket of White and Red Grapes...* [8]), a pewter dish full of plums, two peaches (one already cut open), two figs, and some stalks of celery are placed on the stone steps. Chardin's originality in this work appears in the fact that only half of the basket of pears is shown in the foreground of the composition, while the principal subject has been placed in the middle ground. Of special note is the quality of the scumbling, which is at once realistic and abstract, and from which emerges the form of the bird — the red partridge which Chardin painted several times in a similar manner about this same date [Wildenstein, 1969, no. 28, fig. 13]. Admirable, too, is the warm harmony of the colors and the beautiful clear light which bathes the composition.

19 *Bowl of Plums, a Peach, and Water Pitcher*

(Jatte de prunes, une pêche et un pot à eau)

Canvas, 45 × 57 cm. (not 37 × 44 cm.).
Washington, The Phillips Collection

Provenance. Roberts sale in London, 24-28 February 1913, no. 19 (?); the catalog of this sale has not been found; the sale was not held at Sotheby's nor at Christie's. Acquired in 1920 by Duncan Phillips.

Exhibitions. 1941, Washington, no. 12; 1941-44, Kansas City (no cat.); 1977, Omaha, no. 11 (with pl.).

Bibliography. Phillips Cat., 1926, p. 17 and pl. II; Phillips, 1928, p. 25; Phillips, 1931, p. 20 and pl. 3; Wildenstein, 1933, no. 854, fig. 112; Phillips, *The American Magazine of Art,* April 1935, p. 219 (repr.); Phillips Cat., 1952, no. 17 and pl. 7; Adhémar, 1960, p. 457; Wildenstein, 1963-69, no. 257, fig. 121.

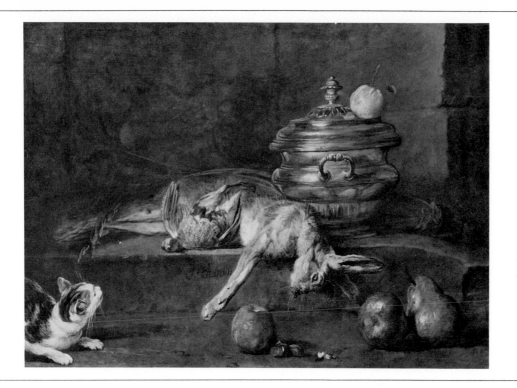

20

See Color Plate III.

This magnificent painting has only rarely been reproduced, yet it is one of the finest Chardin still lifes in the United States. The water pitcher with its silver mounts (whose date and origin are far from clear) is not to be seen in any other painting by the artist; the one that appears in *The Cut Melon* [111] and in *Grapes and Pomegranates* [117] is somewhat different. However, the pewter bowl full of plums seems to be identical with the one in *Partridge, Bowl of Plums, and Basket of Pears* [18]. Both the *Bowl of Plums...* and the *Partridge, Bowl of Plums...*, moreover, are chronologically close, in our opinion, and were painted around 1728 (and not 1756, as Wildenstein proposes for the Washington painting). We find confirmation of this dating in the scumbled background and the relative instability of the composition, which is somewhat out of balance. *Bowl of Plums...* also calls for a companion piece, but it is difficult to identify one among the numerous pairs of Chardin paintings put up for sale in the eighteenth century with a format similar to that of the Washington painting.

20 *Cat Stalking a Partridge and Hare Left Near a Soup Tureen*

(Un chat guettant une perdrix et un lièvre morts jetés près d'un pot à oille)

Canvas, 73.5 × 105 cm. Signed in the center: *S.* [or *J.*] *chardin.*
New York, The Metropolitan Museum of Art

Provenance. For the provenance prior to Laperlier, see the general discussion on this painting (below). Laperlier collection as of 1860; Laperlier sale, 11-13 April 1867, no. 19. J. W. G. D. sale (of London), 25 February 1869, no. 20. Sale of M[aillet] d[u] B[oullay, curator of Rouen's Musée des Antiquités], 8 May 1869, no. 1. Edwards sale, 25 May 1905, no. 5 (with plate). Baron Henry de Rothschild, from 1907. Mme Adrien Thierry, Paris. Purchased by the Metropolitan Museum in 1959 from the Fletcher Fund.

Exhibitions. 1860, Paris, no. 355; 1907, Paris, no. 60; 1929, Paris, no. 40; 1954, Rotterdam, no. 52, pl. 29.

Bibliography. Bürger (Thoré), 1860, p. 235; Burty, 1867, p. V; Burty, 1879, p. 148; Goncourt, 1880, p. 128; Dayot and Vaillat, 1907, pl. 21; Guiffrey, 1908, p. 88, no. 201; Goncourt, 1909, p. 189; Pilon, 1909, p. 66, note 1; Furst, 1911, p. 129; Alexandre, 1929, p. 526 (ill.); Quintin, 1929, pl. not numbered; Pascal and Gaucheron, 1931, p. 139; Wildenstein, 1933, no. 688, fig. 75 (and no. 689?); Wildenstein, 1959, p. 99 (*not* 97); Eisler, 1960, pp. 202-12 (with pl.); *Sele Arte*, 1960, no. 46, fig. 22; *Weltkunst*, 1 April 1960, cover ill.; Wildenstein, 1963-69, no. 33, fig. 14 (and no. 34?); Cailleux, 1971, pp. III and V; Kuroe, 1975, p. 80 (ill.).

Wildenstein and C. Eisler (1960) both date this painting around 1727-1728, a dating we find perfectly justified when we compare its partridge and hare with those in paintings at the Musée de la Chasse [15] and Dublin [25]. Additional, even stronger confirmation is provided by comparing this painting with *The Lucky Thief* [Wildenstein, 1963-69, no. 274, fig. 129], one of the two companion pieces in the Edmond de Rothschild collection, unfortunately

Switzerland, Edmond de Rothschild Collection.

not included in the present exhibition (a replica, with variations, of the *Thief* is on the London market; the companion piece, *Cat Fond of Oysters,* also with variations, is in the Burrell collection in Glasgow; and one of poorer quality is in the Lisbon Museum). The date of the Rothschild painting, which Eisler has connected with the painting in the Metropolitan Museum, is generally read as *1758.* But the third figure, as D. Carritt has kindly demonstrated, is clearly a *2.* The cat in the Rothschild painting, therefore, is the blood brother of the one in the American composition.

Chardin likes to introduce a living animal into his still lifes with game or fish. *The Ray-Fish* and *The Buffet* are the first examples of this, together with *The Water Spaniel* (1730) and *The Hound.* But cats—in the present instance a watchful white and russet cat—occupy an important place (to which certain recent studies have attached the symbolic meanings of lust and evil, which we find risky) in the artist's domestic scenes (see [56, 58]), as well as in his still lifes. The painting's originality, however, resides especially in the soup tureen, the *pot à oille* probably made of silver, unique in Chardin's work and "borrowed from some goldsmith" [Wildenstein, 1959]. Daniel Alcouffe relates it to the creations of Claude II Ballin (1661-1754) [cf. *Les grands orfèvres de Louis XIII à Charles X,* 1965, ill. pp. 49 and 82].

Behind the tureen can be seen a large cardoon, on its sculptured cover an orange, and in the foreground in front of the stone niche, a bright red apple, two chestnuts, and two large pears similar to those seen in the Karlsruhe *Glass Carafe and Half-Peeled Lemon* [Wildenstein, 1963-69, no. 49, fig. 21].

The early provenance of the work poses a problem. The Goncourts [1864, p. 161; see also Blanc, 1883, I, p. 10, and Normand, 1901, pp. 14-16] relate an anecdote deserving of a careful reading: "One day while he was painting a dead hare being eyed by a cat, his friend Le Bas pays him a visit. Le Bas is excited by his hare and lets him know he wants to buy it from him. 'We can make a deal,' Chardin says to him. 'You have a jacket that I like very much.' Le Bas then took off his jacket and carried off the painting."

The Goncourts, faithful to the original text, add the source of the story—a handwritten note in the sale catalog of the Le Bas sale (in reality, a biography of Le Bas by Joullain *fils,* prior to 7 Frimaire Year IV [Bibliothèque Nationale, Cabinet des Estampes, Ee 1 to Ee 5]. There was in the December 1783 estate sale of the celebrated engraver, in lot no. 12, *Un lièvre mort, un chat qui le guette et des fruits sur un rebord de pierre. Hauteur 20 pouces, largeur 38 pouces; toile* ("A dead hare, a cat eyeing him, and some fruit on a stone ledge; 54 by 103 cm.; canvas") [Wildenstein, 1933, no. 689; 1963-69, no. 34]. Its width corresponds closely with that of the New York painting, but the height is appreciably smaller. There may well have been a misprint in the Le Bas sale catalog (20 *pouces* instead of 30, which would equal 71 cm.), all the more so as the proportions of the Le Bas painting as given indicate a piece twice as wide as it is high, something extremely unusual for Chardin. Jacques-Philippe Le Bas (1707-1783), it should be remembered, not only engraved four figure compositions by Chardin *(The Right Education, The Drawing Lesson, The Morning Toilet,* and *The Housekeeper*—all more or less directly related to Sweden) but also owned (no. 11 of his sale) the *Surgeon's Signboard* (see [1]). The latter was an early work of Chardin which Le Bas tried to sell to Count Tessin in 1746 through the intermediary of his pupil, the Swedish engraver and architect, Jean Eric Rehn (1717-1793), lately returned to Sweden at the time [*Archives de l'Art Français,* 1854, V. p. 120].

W. Bürger (Thoré) greatly admired the painting when it was exhibited in 1860 at the Galerie Martinet. "It is stronger in tone than Snyders," wrote the 'discoverer' of Vermeer, "and only in the work of Aalbert Cuijp [sic] would one look for analogies to this vigorous painting." The critic could also have cited the name of Jan Fyt, whose *Dead Hare and Birds* (at the Metropolitan Museum since 1871) was in his possession, as C. Eisler (1960) reminds us.

The droll note produced by the orange perched on the soup tureen, which is reflected in the cover; the idea of the cat poised and ready to steal the partridge; the red splash of the apple placed in the very center of the painting; the gentle curve of the stone niche echoing the line created by the body of the large hare—glassy-eyed but freshly killed—make this painting, as Bürger wrote more than a century ago, "one of the most extraordinary" by Chardin.

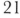

21 *Hare with Game Bag and Powder Flask*

(Lièvre mort avec gibecière et poire à poudre)

Canvas, 62 × 80 cm. Signed at the bottom right: *Chardin.*
Philadelphia, Collection of Henry P. McIlhenny, gift to the
Philadelphia Museum of Art with life interest reserved

Provenance. Appears to have been one of the two paintings by Chardin
at the estate sale of the painter, poet, musician and art-writer, Michel-
François Dandré-Bardon (1700-1783; in fact, many Chardin paintings
belonged to eighteenth-century artists). 23 June 1783, no. 7 *Un lièvre
mort et pendu par une patte. Hauteur 24 pouces, largeur 30 pouces,
toile* ("A dead hare hung by one leg; 65 by 81 cm; canvas"). Collection
of Laperlier, first sale, 11-13 April 1867, no. 22; either withdrawn or
bought back (according to the Goncourts): second sale, 17-18 February
1879 (a letter from Laperlier to Couture, dated 8 March 1873 and
preserved at the Château de Compiègne, alludes to the painting: "I
have only seven Chardins left, one of which is the famous suspended
Hare.") Collection of Baron de Beurnonville, sale of 9-16 May 1881,
no. 20. Collection of Léon Michel-Lévy by 1907; sale of 17-18 February
1925, no. 128, with plate. Purchased by Henry P. McIlhenny in 1934.

Exhibitions. 1860, Paris, no. 106; 1880, Paris, no. 41; 1892, Paris, no.
6; 1907, Paris, no. 18; 1926, New York, no. 9 (with pl.); 1927,
Chicago, no. 9; 1929-31, Cambridge, no. cat.; 1934, Chicago, no. 135;
1935-36, New York, no. 24 (with pl.); 1936-37, Cambridge and
Philadelphia, no cat.; 1949, New York, no. 39; 1949, Philadelphia, no

cat.; 1962, San Francisco, no. 4 (with pl.); 1977, Allentown, pp. 10-11
(with pl.).

Bibliography. Bürger (Thoré), 1860, p. 334; Burty, 1867, p. V;
Bocher, 1876, p. 115; Burty, 1879, p. 148; Goncourt, 1880, p. 128;
Dayot and Vaillat, 1907, pl. 47; Guiffrey, 1907, p. 102; Tourneux,
1907, pp. 95 (with pl.), 97; Guiffrey, 1908, p. 83, no. 166; Goncourt,
1909, p. 189; Pilon, 1909, pp. 66-67, note 1, and p. 167; Furst 1911,
p. 127; *Le Figaro Artistique,* 11 June 1925, p. 522 (with ill.); Wildens-
tein, 1933, no. 706, fig. 82; *Beaux-Arts,* 6 December 1935, p. 1 (with
ill.); Pilon, 1941, p. 35 (ill.); Lazarev, 1947, pl. 11; Robb, 1951, fig.
358; Wildenstein, 1963-69, no. 260, fig. 123; H. G. G., *The
Philadelphia Museum of Art Bulletin,* Autumn/Winter 1965 (with ill.);
Lazarev, 1966, pl. 15.

Print. An engraving by Louis Monziès illustrates the catalog for the se-
cond Laperlier sale (1879).

Since 1860 art historians have believed that this work was painting
no. 36 of the 1757 Salon, described as *Un tableau d'une pièce de
gibier avec une gibecière et une poire à poudre...* ("Painting of a
piece of game with a game bag and a powder flask, from the col-
lection of M. de Damery"). But there is no proof that this is so.
The fact is that none of the commentators on this Salon describes
the painting or speaks of a hare. And the description supplied by
the catalog, which does not give the painting's dimensions, could
just as easily apply to any of a number of other hunting scenes by
Chardin.

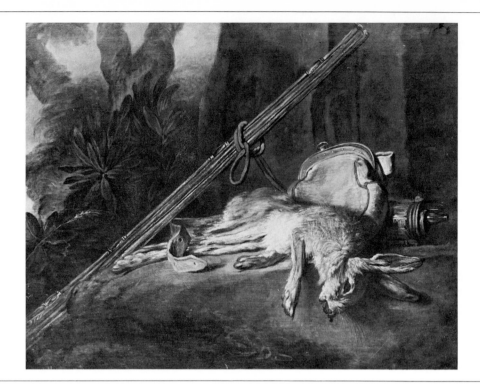

From this hypothetical presence of the McIlhenny *Hare* at the 1757 Salon, it has been deduced that the work dates from 1756-1757. Nothing is less certain. When we ask what might have been the painting at the 1757 Salon belonging to M. Damery (the chevalier Damery, avid collector of engravings and drawings (?), Lugt, 1921, no. 2862), everything leads us to believe it was a much earlier work. A similar case would be the *Hare* from the Aved collection, exhibited at the 1753 Salon but painted around 1730 [22]. The two paintings from the Trouard collection at the Salon of 1759—*Des pièces de gibier avec un fourniment et une gibecière* ("Game scenes with equipment and game bag") which appeared at the 22 February 1779 sale of the architect along with no. 45, *Divers gibiers morts* ("Various still lifes with game") —have a format common among Chardin's early works, that is, approximately 80 × 65 cm.) and would seem most likely to have been painted before 1730. It seems certain, at any rate, that between the years 1750 and 1760 Chardin exhibited some earlier paintings of which he remained rather proud, along with his recent productions. We would place the *Hare* exhibited here shortly before 1730.

Standing out against a scumbled brown background, a large dead hare with its paws spread far apart lies on a game bag. The boldness of the composition and the elimination of all detail in order to focus on the single dead animal, game bag, and powder flask make this painting the most accomplished of Chardin's still lifes with game.

"In his *Dead Hare,*" wrote Thoré [Bürger, 1860, p. 334], "there is something of Jan Fyt in the exquisite quality of the gray tones and the adroit skill of the brushstroke; but he is simpler and more accurate than the Flemish painter." In 1867 Philippe Burty wrote (p. V): "The *Hare* is one of those specimens of painting which defy all comparison with the most-touted masterpieces of the foreign schools because of the simplicity of its execution and the strength of the illusion."

22 *Hare with Gun, Game Bag, and Powder Flask*

(Lièvre mort avec fusil, gibecière et poire à poudre)

Canvas, 75 × 95 cm.
Paris, Musée de la Chasse et de la Nature

Provenance. By 1753 was in the possession of Aved (1702-1766); Aved sale, 24 November 1766, no. 134 (24 *livres*), *Un lièvre, une gibecière, une boîte à poudre et un fusil dans un paysage sur une toile de 30 pouces de haut sur 37 pouces de large, sans bordure* ("A hare, game bag, powder flask, and gun in a landscape, on canvas, 81 by 100 cm."); see also the estate inventory of Aved, dated 6 June 1766, no. 99,

Un lièvre et des attributs de chasse ("Hare and hunting attributes") valued together with three other paintings by Lely, Santerre, and Le Sueur at 72 *livres* [Archives Nationales, Minutier Central, étude C II, liasse 434; see also Wildenstein, 1922, p. 211]. Associated by Wildenstein [1933, under no. 721] with *Un lièvre et attributs de chasse* ("Hare and hunting attributes") at the Ch. Germain sale of 21 June 1858, no. 21 (76 × 98 cm.).

Discovered by the author of the present catalog in 1968 when the work, which came from the south of France, was lacking any attribution; acquired at this time by the Musée de la Chasse.

Exhibition. 1753, Salon, no. 65 ("A painting of game, belonging to M. Aved").

Bibliography. Wildenstein, 1933, no. 721 (whereabouts unknown); Wildenstein, 1963-69, no. 70 (dated around 1730, whereabouts unknown).

According to the catalog, Chardin exhibited nine paintings at the 1753 Salon. (Some of them must have been added while the exhibition was in progress, since the critics speak sometimes of seven and sometimes of eight paintings.) These nine Salon paintings include: replicas of the *Draftsman Copying Pigalle's Mercury* and *Girl Reciting Her Gospel Passage* (no. 59; see [94, 95]); *The Philosopher* (no. 60; see [62]), now in the Louvre; *Blind Man of the Quinze-Vingts* (no. 61); *Dog, Monkey, and Cat* (no. 62), with the preceding painting, from the collection of M. de Bombarde; *Partridge and Fruit* (no. 63); and finally, in addition to the Musée de la Chasse painting (no. 65), two paintings of *Fruits* (no. 64) which were, a critic informs us, "accompanied by vases," at the time the property of M. de Chasse.

The reader will note first of all that critics paid particular attention to the figured paintings, admiring above all *The Philosopher;* in it they "easily recognized the portrait of Monsieur Aved, friend of Chardin," the owner, in 1753, of the painting exhibited here [*Exposition de peintures, sculptures et gravures tirées de l'année littéraire de Fréron*, 1753, Bibliothèque Nationale, collection of Deloynes, XLVII, no. 1240, p. 523]. Although these critics expressed almost unreserved admiration for *The Philosopher*, painted in 1734, they were not at all unanimous in their judgment of the *Draftsman* and the *Girl*. Some of them speak of decline, condemn his change of style, and reproach Chardin for becoming "weak" and "hesitant." Others, at the same time, state that "Chardin is getting better every day."

It would seem, in any event, that Chardin wanted to exhibit works from different periods in his career at the 1753 Salon as well as still lifes and genre scenes. *The Philosopher* dates from 1734, and as Abbé Garrigues de Froment justly remarked, "The paintings of fruits and animals which this same artist has exhibited,...date from earlier than *The Philosopher*" [*Sentiments d'un amateur*, 4 September 1753, pp. 34-37]. Of these paintings of fruits and animals, the only identifiable ones seem to be the *Partridge and Fruit*, now in England [Wildenstein, 1933, nos. 743, 746 and 747; 1963-69, nos. 29 and 231, fig 13] and the *Dog, Monkey, and Cat* (original [?] 80 × 100 cm.; signed and dated from 1727) which is known to us only through a mediocre

photograph at the Courtauld Institute of London [Wildenstein, 1933, nos. 686 and 687, fig. 213; 1963-69, no. 230 (lost)]. These two paintings and the vigorous Musée de la Chasse composition seem to antedate 1730. The latter recalls, in its frank and brutal execution and its blue-green coloration, *The Water Spaniel* of the Wildenstein collection in New York [Wildenstein, 1933, no. 677, fig. 68; 1963-69, no. 68, fig. 32], which is dated from 1730. It also shares with the *Spaniel* the curious and unconvincing bit of landscape on the left of the composition.

In his response to Estève, Joubert [Deloynes, V, no. 61, pp. 10-13 of his *Lettre à un amateur...*], the only Salon critic to our knowledge who gives the painting's exact title, has this to say:

"It also pleased him to pass over in silence two animal paintings by the same artist, one representing a monkey, a dog, and a cat, and the other a dead hare. And yet these are two very fine paintings, not only for the verity of the effect, but also for the bold and daring brushwork; they are handled with great authority."

Abbé Garrigues (*op. cit.*), for his part, concludes: "If one had to compare M. Chardin's way of handling the animal genre with that of M. Oudry, I think I would be right in maintaining that M. Chardin's manner is prouder, more picturesque, and M. Oudry's is looser, but more studied, richer of finish."

By presenting in 1753 paintings executed nearly a quarter of a century earlier, Chardin was unhesitatingly allowing comparison of his first works with those of his celebrated rival and elder who died two years later. He probably also wanted to reply to those who accused him, at Salon after Salon, of always repeating himself, without evolving or changing.

23 *Wild Rabbit with Game Bag and Powder Flask*

(Lapin de garenne mort avec une gibecière et une poire à poudre)

Canvas, 81 × 65 cm. Signed at the lower left: *Chardin.*
Paris, Musée du Louvre, Inv. 3203*

Provenance. Probably from the estate sale of the sculptor Caffieri (1714-1774), 10 October 1775, no. 13, *Un lièvre pendu par les pattes de derrière auprès d'une gibecière et appuyé sur un rebord de pierre... hauteur 2 pieds 6 pouces, largeur 2 pieds* ("A hare suspended by its hind legs near a game bag and resting on a stone ledge; 80 by 65 cm."); then in an anonymous sale, 27 January 1777, no. 13; and finally in the Molini sale, 30 March 1778, no. 34, *Un lapin attaché et groupé avec une gibecière et une poire à poudre. Toile, H. 30 pouces, largeur 24 pouces* ("A rabbit strung up and grouped with a game bag and powder flask; canvas; 81 by 65 cm."). Collection of the painter Jules Boilly (1796-1874). Acquired by the Louvre on 3 May 1852 for 700 francs.

Exhibition. 1969, Tokyo, no. 3 (with pl.).

Bibliography. Museum cat. (Villot), 1855, no. 100; Hédouin, 1856, p. 201, no. 106; Blanc, 1862, p. 15; Goncourt, 1863, p. 520, note 1; Bocher, 1876, p. 84, no. 100; Goncourt, 1880, p. 129; Chennevières,

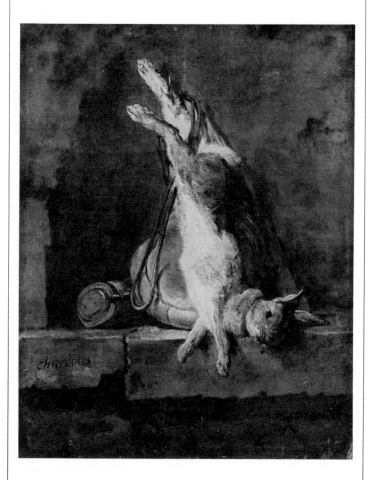

chardin

23

1888, p. 60; Normand, 1901, p. 38; Guiffrey, 1908, p. 69, no. 74; Goncourt, 1909, p. 189; Pilon, 1909, p. 66, notes 1 and 165; Furst, 1911, p. 121, no. 94; Raffaelli, 1913, p. 55; Museum cat. (Brière), 1924, no. 94; Klingsor, 1924, p. 105 (ill.); Ridder, 1932, pl. 16; Bazin, 1932, p. 152, fig. 15; Wildenstein, 1933, no. 705, fig. 79; *Beaux-Arts,* August 1937, p. 14 (ill.); Pilon, 1941, p. 40 (with pl.); Jourdain, 1949, fig. 50; Mras, 959, p. 67, fig. 2; Wildenstein, 1963-69, no. 36, fig. 16; Rouart-Orienti, 1970, p. 96; Rosenberg, Reynaud, Compin, 1974, no. 121 (ill.); Faré, 1976, p. 154, fig. 235.

Related Works. A drawing once in the collections of the Marquis Ph. de Chennevières and the Marquis de Biron, then in the collection of Dr. Tuffier [Mathey, 1964, fig. 7], has frequently been associated with the Louvre painting. The drawing is done in black and red chalk, set off with water colors and pastel, and depicts a dead rabbit hung by its hind legs, with the hind quarters of another rabbit—rapidly sketched—and a soup tureen (?) on the right. It is certainly closely related to Chardin's hunting paintings and early sketches, but we shall reserve final judgment, since we know it only through reproduction.

Prior to 1852 the Louvre owned, besides *The Ray-Fish* [7] and *The Buffet* [14] which it had inherited from the Academy, *Saying Grace* [86] and *The Diligent Mother* [84] acquired by Louis XV, and the three pastels purchased at the Bruzard sale in 1839 [134, 135, 136]. In 1851 Frédéric Villot, the new curator of the imperial museum, exhibited one of the Choisy overdoors [123] which had been confiscated during the Revolution and stored at Fontainebleau. The following year he bought from M. de Laneuville the *Fast-Day Meal* [37] and *Meat-Day Meal* [38], *The Monkey as Antiquarian* (see [67]), and on 3 May, "four days after the Laneuville proposal," as we learn from H. de Chennevières (1888), the painting presently under discussion. All this activity was a sign of the rapidly developing fad for the work of Chardin. (The first catalog of Chardin's work, compiled by Hédouin, had been published in 1846.) But not until 1867 with the Laperlier sale and especially 1869 with the La Caze bequest would Chardin be worthily represented at the Louvre.

Thus, the visitor to the Louvre could admire Chardin, before 1867-1869, in his pastels, his finest genre scenes, and his most ambitiously composed still lifes. But only the *Wild Rabbit,* once in the Jules Boilly collection, represented the painter of sober, realistic still lifes—free, yet fascinating in their craftsmanship. This probably explains why the *Wild Rabbit* was copied by, or at least influenced, several avant-garde artists of the time and why it seems to have been especially popular before the La Caze collection entered the Louvre; thereafter, it was largely forgotten. Achille Emperaire, Cézanne's friend, copied it in 1857 [see Reff, 1964, p. 558; Register of Copyists at the Louvre, dated 11 March]. Manet was directly inspired by it in a painting now in a private collection in Paris [see Bazin, 1932, and Rouart-Orienti, 1970, no. 108, with ill.] and an engraving [see, most recently, exh. cat. *Manet,* Galerie H. Berès, Paris, 1978, no. 56, repr. opp. no. 29], which in turn inspired an engraving by Bracquemond [see exh. cat. *Bracquemond,* Mortagne-Chartres, 1972, no. 30]. Other names we could add to the list include Bonvin, Vollon,

Boudin, and Vuillard [around 1888; see exh. cat. *Vuillard-Roussel*, Paris, 1968, no. 4, with ill.], not to mention the interesting painting at Princeton, under the ambitious name of Delacroix, published in 1959 by Mras.

Wildenstein dated the Louvre painting 1727 after comparing it with the Karlsruhe Museum's *Rabbit, Game Bag, Powder Flask, and Seville Orange.* The Karlsruhe picture is the only presently known still life of a rabbit from Chardin's early career which is dated —1728. We would place the Louvre painting slightly later. Chardin experts have often confused hares and rabbits—in eighteenth-century sales, as well as at the present time. Such is the case here. Not only Wildenstein made this mistake but also the author of the catalog for the Caffieri sale of 1775, if one admits that the painting at this sale is indeed the one now in the Louvre. However, we do not believe one ought to attach too much importance to this confusion, especially since Chardin himself did not insist on the greatest anatomical accuracy.

24 *Wild Rabbit with Game Bag, Powder Flask, Thrush, and Lark*

(Lapin de garenne mort avec gibecière, poire à poudre, une grive et une alouette)

Canvas, 73 × 60 cm.
Paris, Private Collection

Provenance. In the Eudoxe Marcille (1814-1890) collection by 1862 (probably from the collection of his father, François-Martial); has remained in the family since that time. Might be the *Un lapin une gipsicière [sic] et une boîte à poudre... 26 pouces 6 lignes de haut sur 20 pouces 6 lignes de large* ("A rabbit, game bag, and powder flask; 71.5 by 55.5 cm.") at the sale of the painter J.F. de Troy (1679-1752), 9 April 1764, no. 139 [Wildenstein, 1933, no. 720; 1963-69, no. 35]. We also point out painting no. 26 at a sale of 10-11 May 1837 *Un lièvre est accroché par les pattes; sur le devant une grive est étendue* ("A hare is suspended by the legs; a thrush is stretched out in front").

Exhibitions. 1874, Paris, no. 58; 1878, Paris, no. 36; 1935, Brussels, no. 920; 1937, Paris, no. 145; 1961, Paris, no. 11.

Bibliography. Horsin-Déon, 1862, p. 137; Bocher, 1876, p. 100; Goncourt, 1880, p. 130; Guiffrey, 1908, p. 79, no. 140; Goncourt, 1909, p. 191; Furst, 1911, p. 125; Wildenstein, 1933, no. 708, fig. 87 (and 720?); *Beaux-Arts,* August 1937, with ill.; Hourticq, 1939, pl. on p. 91; Wildenstein, 1963-69, no. 12, fig. 7 (and 35?); Pizon, 1972, p. 13 (with ill.).

Art historians have often chosen to see in this painting the companion piece of *Two Rabbits with Game Bag and Powder Flask* [5]. We believe this is in error: not only were the two paintings not brought together before belonging to the Marcille collection, but most importantly, they do not seem to us to be exactly contemporaneous. The composition of the first painting is not well organized, whereas the clumsiness has disappeared in the second. Although the middle ground of the second painting with its

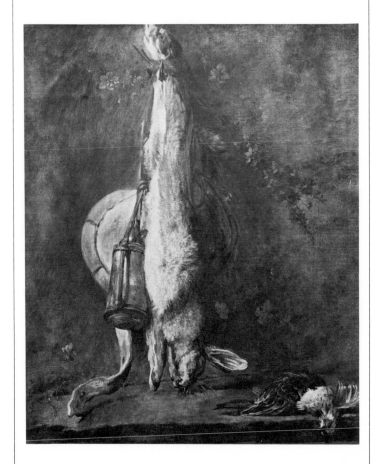

24

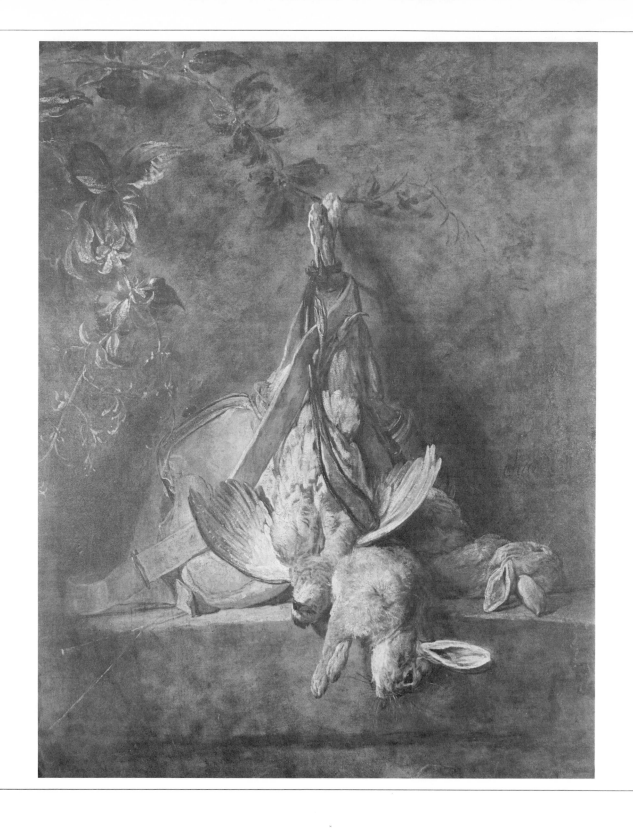

background of stone painted in a warm and vibrant scumbled brown is frequent in all the Chardins completed prior to 1732, the consummately simple composition is masterfully handled and points to a date in the vicinity of 1730. A rabbit with its legs tied hangs from a hook to which are also attached a game bag and powder flask. The blue ribbon of the powder flask is the only note of bright color in the entire composition.

The reader is asked to consider this painting (and the whole series of rabbits and hares done by Chardin early in his career) in connection with the famous text by Cochin (cited here from the original manuscript preserved at the Bibliothèque Municipale, Rouen), written shortly after the death of the artist:

"The first lessons M. Chardin had derived from nature committed him to continue studying it assiduously. One of the first things he did was a rabbit. The object itself seems very insignificant, but the way he wanted to do it made of it a serious study. He wanted to paint it with the utmost verity in every respect — *with discernment, without any trace of slavishness which might have rendered the execution cold and dry* [italics added]. He had not yet attempted to render fur, fully realizing that one should not count the individual hairs nor render it in detail. 'Here,' he said to himself, 'is an object to be rendered. In order to paint it as it is, *I have to forget* all I have seen and even *the way these things have been treated by others.* I have to place it at such a distance that I no longer see its details. I must above all faithfully imitate its general masses, color tones, volume, and the effects of light and shadows.' In this he succeeded; his rabbit reveals the first fruits of that discernment and magical execution which ever since have characterized the gifts that have distinguished him."

The "others," especially the Northern painters — a Fyt and a Weenix, among others — whom Chardin tried to forget, often represented hares and rabbits. Chardin knew their works and did not want to be enslaved by them any more than to a minutely detailed rendering. In order to achieve the "truth" which was not the truth of detail, he had perfected a technique, a "magical execution," which captivated many a nineteenth-century realist, from Bonvin to Manet. The fact that Chardin was also able to impart to his composition, dominated by the elegant harmony of the teal-blue and grayish-brown notes, the quality which Cochin called "discernment" makes his works unique in the painting of his time.

25 Two Rabbits, a Gray Partridge, Game Bag, and Powder Flask

(Deux lapins, une perdrix grise avec une gibecière et une poire à poudre)

Canvas, 82 × 65 cm. Signed and dated at the lower right: *Chardin 173(?)*.
Dublin, The National Gallery of Ireland

Provenance. Possibly the painting at the Lempereur sale, 24 May 1773, no. 97, *Un tableau d'un effet piquant représentant une perdrix, des lapins et une gibecière. Hauteur 29 pouces, largeur 26. Toile* ("A striking painting representing a partridge, some rabbits, and a game bag; 78.5 by 70 cm.; canvas"), although it must have been cut down slightly on two sides. (But it is not to be identified with the *deux lièvres* ["two hares," 62 × 51.5 cm.] at the sale of Mme Lancret, 5 April 1782, no. 158, a painting which is unknown to us [Wildenstein, 1933, no. 727; 1963-69, no. 41]). Formerly in the collection of Sir Hugh Lane. Entered The National Gallery of Ireland with the Lane bequest in 1918.

Exhibitions. 1964, Dublin, no. 154; 1968, London, no. 127, fig. 190.

Bibliography. Brinton, 1916, pp. 68, 70, 73 (with pl.); Dublin Cat., 1918, no. 41, pl. 13; Bodkin, 1925, p. 94; Ridder, 1932, pl. 65; Wildenstein, 1933, no. 712, fig. 84; Wildenstein, 1933 (2), p. 377, fig. 11; Wildenstein, 1963-69, no. 40, fig. 17; Museum cat. (White), 1968, p. 72, pl. XV (color); Museum cat., 1971, p. 20, no. 799; White, 1974, p. 39, pl. VII in color on p. 40.

The reading of the date on this painting is in dispute. The catalog for the 1964 Dublin exhibition gave it as 1761 or 1751. The 1968 London catalog proposed 17(30?) in line with Wildenstein (1963-69) who nevertheless had declared it illegible in his first edition (1933). Wildenstein must consider this date as a later addition, since he places the painting "around 1727-1728." We think that the painting dates from 1731, a year which fits the work perfectly.

The rigid organization, a perfect pyramid whose base — the stone bench Chardin was fond of using in his early works — is broken by the head and forepart of a dead rabbit, dmonstrates the control acquired by the artist. The color scale is very restrained, going from the gray-blue of the partridge with its widely spread wings to the browns of the two rabbits, and from the royal blue of the ribbon binding the feet of the three dead animals to the spot of blood on the neck of one of the victims.

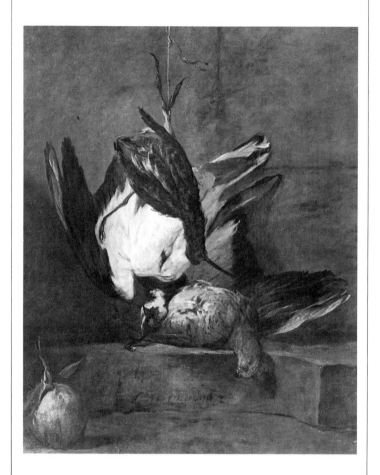

26 Tufted Lapwing, Gray Partridge, Woodcock, and Seville Orange

(Vanneau huppé, perdrix grise, bécasse et bigarade)

Canvas, 58.5 × 49.5 cm. Signed and dated at the bottom center: *J. Chardin 173(2?).*
Douai, Musée de la Chartreuse

Provenance. Sackville Gallery, London, 1924. Lucerne Fine Arts Company in 1927 (according to Wildenstein, 1933). Acquired in England by the Douai Museum in 1964.

Exhibitions. 1966, Vienna, no. 8, pl. 31; 1975, Brussels, no. 88, pl. on p. 132.

Bibliography. Wildenstein, 1933, no. 699 (among the paintings "either of doubtful origin, or forged, or which we have not seen"); Douai cat. guide, 1967, p. 34 (ill.); 1968, p. 31 (ill.).

This painting is the only Chardin to enter a French provincial museum since the beginning of the century; it is also the *only one* to date to have been acquired by purchase. In spite of its absence in recent editions of Wildenstein's work [see, however, 1969, p. 240], its attribution is beyond doubt. More problemtic, however, is its date of execution. It seems that we can read the date at the bottom center of the painting: 1732. Yet that date seems at first to correspond poorly with the style of the work. The composition and technique seem to belong to a later, more developed style. The concave curbstone on which the gray partridge lies and the backdrop formed by large stone blocks painted in scumble—to which a tufted lapwing and long-billed woodcock are tied by the leg—are frequently seen in works painted by Chardin around 1728 or shortly before. The large bright Seville orange in the left foreground [cf. 15, 17] interrupts the monotony of the general coloring; it also enlivens the composition, which is centered on the white splash formed by the lapwing's breast and the body of the woodcock outlined against it.

If the 1732 date is correct—and there is no reason to reject it a priori—we would have to admit that the evolution of Chardin's style is in no way linear and that the artist is quite capable of painting in the same year works as different in technique and spirit as the *Breast of Mutton* at the Musée Jacquemart-André, with its clearly geometrical aspect, and the Douai painting with its supple, harmonious rhythm.

Even though partridges and Seville oranges are common in the work of Chardin, this is the only time, as far as we know, when the painter used a woodcock. As for the lapwing, we know that Chardin made it the subject of a painting exhibited at the 1761 Salon (no. 44, *des Vanneaux*). However, this painting disappeared after the Silvestre sale of 1811.

III *First Commissions*

The two years 1730 and 1731 were decisive in Chardin's life. After a long engagement, he married Marguerite Saintard, who gave birth to Jean Pierre Chardin on 18 November 1731. He also found—probably through the intermediary of Aved—his first benefactor, Conrad-Alexandre de Rothenbourg, the king's ambassador to Madrid, for whom he executed two large overdoors of musical subjects [27] and [28] in 1730 and the *Attributes of the Sciences* [29] and *Attributes of the Arts* [30], now at the Musée Jacquemart-André, in the following year. These large decorative canvases show how well Chardin adapted to the requests of his clientele. Lyrical and warmly felt, they bespeak Chardin's constant urge to expand and renew his art and to branch out into new directions.

At the Exposition de la Jeunesse of 1732 where he presented some of the paintings he had done for Rothenbourg, he also exhibited a trompe l'oeil in grisaille after a low relief by Duquesnoy (no. 33)—yet another proof of his willingness to explore fresh paths. This painting created a sensation and was bought for a very high price by the painter Louis-Michel Vanloo, according to reports in the *Mercure de France,* whose editor—the Chevalier Antoine de la Roque (1672-1744)—was one of the first to collect and defend Chardin's works.

Such reviews, however, tend to hide the more mundane fact that Chardin produced little and worked slowly, thereby achieving recognition with difficulty. In 1729 it was necessary for him to participate in the staging of a fireworks display, and two years later, to collaborate in the restoration of the François I gallery at Fontainebleau.

His first commissions were no doubt more than welcome. In addition to the overdoors, he had painted *The Philosopher* [62] for Rothenbourg, and Rothenbourg's death in 1735 deprived him of an influential patronage. (It does not appear that Chardin received any more new commissions for decorative paintings until 1765.) After 1733, however, and an abrupt shift to genre painting, Chardin managed to renew his style, increase his patronage, and establish his fame.

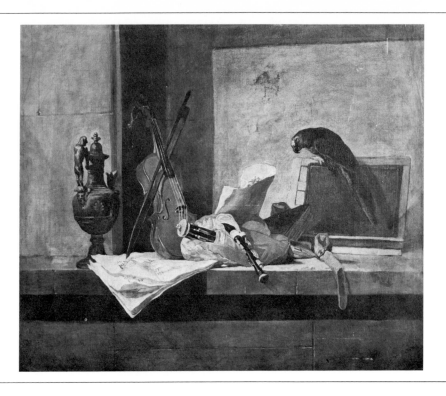

See Color Plat

27 *Musical Instruments and Parrot*

(Instruments de musique et perroquet)

Canvas (originally curved; the corners have been added), 117.5 × 143.5 cm.
Paris, Private Collection

Provenance. Most certainly one of the "two paintings made for Count de Rothenbourg, French ambassador to Madrid, representing different animals, musical instruments, and trophies...." exhibited at the 1732 Exposition de la Jeunesse [*Mercure de France*, July 1732, p. 1611; 734, p. 1405] also see discussion for [28]]. Possibly exhibited a second time with its companion piece at the 1734 Exposition among the sixteen paintings shown by Chardin: *trophées de musique* [*Mercure de France*, June 1734, p. 1405]. Possibly in the collection of François-Martial Marcille; if so, nos. 17 and 22 of the first François Marcille, 12 January 1857, *Instruments de musique*, bought back by his son Eudoxe. Collection of Eudoxe Marcille as of 1862 [Horsin-Déon]; has remained in the family since that time.

Exhibitions. 1732, Exposition de la Jeunesse, no. cat.; 1734, Exposition de la Jeunesse, no. cat.; 1874, Paris, no. 60; 1878, Paris, no. 32; 1880, Paris, no. 33; 1887, Paris, no. 17; 1907, Paris, no. 26; 1935, Brussels, no. 921.

Bibliography. Horsin-Déon, 1862, p. 137; Bocher, 1876, p. 99; Goncourt, 1880, p. 124; Hamel, 1887, p. 254; Chennevières, 1888, p. 59; Chennevières, 1890, p. 303; Normand, 1901, p. 37; Guiffrey, 1907, p. 102; Guiffrey, 1908, p. 79; no. 137; Goncourt, 1909, pp. 183-84; Pilon, 1909, p. 167; Furst, 1911, p. 125; Wildenstein, 1933, no. 1115, fig. 175 (see also nos. 1122, 1122a, 1123); Wildenstein, 1963-69, no. 347, fig. 158 (see also nos. 88, 89, 90); Mirimonde, 1977, p. 15.

Related Works. Camille Marcille, brother of Eudoxe, owned *Un violon, une musette, des cahiers de musique, un pupitre sur lequel est perché un perroquet dont on ne voit que la moitié du corps* ("A violin, a musette, some music books, a music stand on which is perched a parrot, only half of whose body shows"), signed *Chardin* and measuring 62 × 77 cm. It was exhibited in Chartres in 1858, no. 64, and again in 1869, no. 973. Nothing is known of this work since the second Camille Marcille sale in Paris on 8-9 March 1876, no. 2; it may have come from the second François Marcille sale (father of Camille) of 2-3 March 1857, no. 40 [Wildenstein, 1933, no. 1125].

See [28] for discussion.

28 *Musical Instruments and Basket of Fruit*

(Instruments de musique et corbeille de fruits)

Canvas, 117 × 143 cm., originally curved.
Paris, Private Collection

Provenance. Collection of Count de Rothenbourg at the time of their showing at the 1732 Exposition de la Jeunesse (see [27] and discussion below). Collection of Eudoxe Marcille as of 1862 [Horsin-Déon]; has remained in the family since that time.

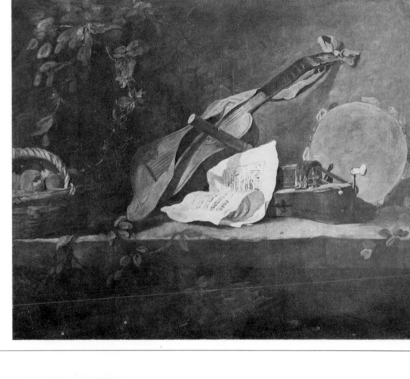

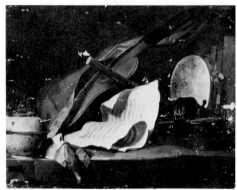

Chardin(?), Paris, Private Collection.

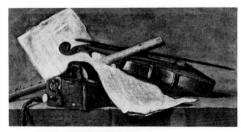

Paris, Private Collection.

Exhibitions. 1732, Exposition de la Jeunesse, no cat.; 1734, Exposition de la Jeunesse, no. cat.; 1874, Paris, no. 61; 1878, Paris, no. 31; 1880, Paris, no. 36; 1887, Paris, no. 18; 1907, Paris, no. 27; 1935, Brussels, no. 922.

Bibliography. Horsin-Déon, 1862, p. 137; Bocher, 1876, pp. 99-100; Goncourt, 1880, p. 124; Hamel, 1887, p. 254; Chennevières, 1888, p. 59; Chennevières, 1890, p. 303; Normand, 1901, p. 37; Schéfer, 1904, p. 105 (ill.); Guiffrey, 1907, p. 102; Guiffrey, 1908, p. 75, no. 138; Goncourt, 1909, p. 184; Pilon, 1909, p. 167; Furst, 1911, p. 125; Wildenstein, 1933, no 1116, fig. 177 (see also nos. 1122, 1122a, 1123); Wildenstein, 1963-69, no. 348, fig. 159 (see also nos. 88, 89, 90); Mirimonde, 1977, p. 15.

Related Works. A version of the central motif of this painting is in a Paris collection (82 × 102 cm.; signed, or rather inscribed, *Chardin* at the lower left). In this painting the basket of fruit on the left is replaced by a Chinese porcelain soup tureen, and the tambourine is noticeably more perpendicular to the wall. These modifications cover a composition which originally was identical to the one exhibited here. It comes from the collections of M. Le N... [cataloged by Horsin-Déon], sale of 27 February 1860, no. 12, "A very bold tone, a great accuracy of color make of this very simple composition a remarkable work" [see Wildenstein, 1933, no. 1124]; then Mame (Tours). A painting of *Musical Instruments* measuring 72 × 90 cm. was at the sale of the Marchioness of Langeac, 2 April 1778, no. 48 [Wildenstein, 1933, no. 1119; 1963-69, no. 350].

 The Goncourts [1880, p. 125, note 1] refer to two paintings of musical instruments put up for sale at the time they were compiling their study. The first of these paintings, which appeared at the Barroilhet sale of 12 March 1855, no. 4, apparently is still in a large Paris

collection [Wildenstein, 1933, no. 1117; 1963-69, no. 349, fig. 160]. It must also date from the 1730s. The second, which appeared at a sale of 1860 and which the Goncourts describe as curved in shape, must be the same as the painting commented on above and described by Horsin-Déon. Lastly, we point out *Un tableau d'instruments de musique par Chardin* ("A painting of musical instruments by Chardin") exhibited at the Toulouse Salon in 1769, no. 9, as a companion piece to *Mathematical Instruments*, no. 10 [cf. Mesuret, 1972, p. 197]. We know nothing about these two works; they have never been mentioned in the literature on Chardin.

Art historians—Georges Wildenstein, in particular—have seen in these two superb paintings "the full flowering of the artist" [Chennevières, 1888] in his later years, around 1767—later, therefore, than the Louvre's *Attributes of the Arts* [123] and *Attributes of Music* [124] which had been painted for Choisy in 1765. Very obviously, they are nothing of the sort. Provenance supports what style, execution, and composition already suggest.

In 1732 Chardin exhibited again at the Exposition de la Jeunesse. In 1728 he had shown there, among other paintings, *The Ray-Fish*, the success of which, according to a contemporary, had much to do with his early entry into the Academy. Before the reopening of regular Salons in 1737, artists had very few opportunities to become known to the public and to collectors. Those artists who did not paint for the Church or for public buildings were at a particular disadvantage. Chardin, who had just become established, therefore owed it to himself to participate in this event. The *Mercure de France* of July 1732 reported: "We have seen with great pleasure especially those [paintings] of M. Chardin of the Royal Academy, painted with care and truth, which leaves nothing to be desired. Two of these paintings, made for the Count of Rothenbourg, French ambassador to Madrid, represent different animals, musical instruments and trophies, and several other small paintings of utensils...." The author of the text then goes on to praise highly a version of *Eight Children Playing with a Goat* [33].

As proof that the paintings exhibited here are those shown at the Exposition de la Jeunesse and belonging to Count de Rothenbourg, a number of documents preserved at the Archives Nationales, Minutier Central [generously communicated to us by Mlle Mireille Rambaud] indicate that Rothenbourg owned no fewer than six Chardins: among these were the two Marcille paintings [27, 28], the two large overdoors now at the Musée Jacquemart-André [29, 30], and the *Portrait of the Painter Joseph Aved* (also called *The Philosopher*) [62]. Count Conrad-Alexandre de Rothenbourg (1683/84-1735), son of a man of gentle birth from Brandenburg who had entered into the service of France, became a colonel in 1709, a brigadier general in 1716, and was sent on several missions to Berlin and Madrid. He brought his brilliant career to a close as French ambassador to Madrid, returning from there for reasons of health in 1734. He died on 4 April 1735. He had gone to great expense to set up the interior of his residence in Paris at 5, rue du Regard. His residuary legatee was his cousin, Count Friedrich-Rudolf von

Rothenburg, who had married a daughter of the Parabère, mistress of the Regent. We will come across his name again on several occasions with regard to the Chardins owned by Frederick the Great of Prussia.

On 31 October 1730 Chardin sent a first bill for 360 *livres* for "original paintings of *three* overdoors for the Count's drawing room, the landing, and for the first apartment, representing *Music* and *Instruments.*" On 8 August 1731 there was another bill for 300 *livres* for "two paintings representing the *Arts* fixed to the cabinets of the library" [étude XXIII, liasse 490]. Also among the papers of the Rothenbourg succession, dated from 3 October 1735 [liasse 488], we find a very interesting document informing us that *The Philosopher* had been commissioned by Rothenbourg and that the painting, which had probably not yet been paid for at the time of the count's death, had been returned to Chardin "to dispose of as he sees fit."

So in actual fact, as of 31 December 1734 [liasse 488], Chardin had delivered to Rothenbourg "four small and two large" paintings—the six compositions which we mentioned. In the estate inventory of Rothenbourg dated 21 April 1735 [liasse 486], we find mentioned under no. 430 only three paintings: *Un philosophe, un Globe, un Buste* ("A philosopher, a globe, a bust"). The overdoors, installed in their places at that time, were probably not listed in the inventory with the furniture.

Only one point remains unclear. As we have said, Chardin exhibited two paintings at the 1732 Exposition de la Jeunesse. However, three paintings were commissioned by Rothenbourg to decorate his drawing room. What became of the third? The three paintings might have been exhibited again in 1734; this hypothesis has little foundation but is not completely out of the question. Among the sixteen paintings shown that year by Chardin were "some music trophies."

The two works cataloged here are very obviously overdoors: under their thick coat of varnish, one can clearly distinguish the pieces added to the four corners.

In the first painting we see lying on a hewn-stone shelf a violin, done in a handsome warm brown, with its bow; a cherry-red musette with silver trim and pipes of ivory and ebony; a music book extending over the edge of the shelf; a sheet of music; and perched on a music stand, a blue and green parrot. The gilded and sculptured ewer will reappear frequently in the work of Chardin; among the paintings exhibited here we can name the two versions of the *Attributes of the Arts* at The Hermitage [125] and the Louvre [123].

The second painting appears more rustic with its fruit-filled wicker basket and the honeysuckle, which we also find in works of the same period, such as the *Two Rabbits, a Brown Partridge...* [25] in Dublin. The ledge, constructed of irregular stone, displays a guitar with its sky-blue strap, a music book, a German flute, a hurdy-gurdy (similar to the one in the *Musical Instruments* formerly in the Barroilhet collection, cited under *Related Works*), and a tambourine with pink bows.

These two paintings, although exhibited in 1732, had already been painted before October 1730—probably during that year. They are earlier than the *Attributes of the Sciences* [29] and *Attributes of the Arts* [30] at the Musée Jacquemart-André which are signed and dated 1731. Their composition is still a little unstable, as in the earliest Chardin paintings, but they also share the considerable spontaneity one finds in those first paintings. By reason of the boldness of their treatment, their spirit, their lyricism, and their charm, these two paintings count incontestably among the masterpieces of the early Chardin.

29 *Attributes of the Sciences*

(Les Attributs des Sciences)

Canvas, 141 × 219.5 cm. Signed and dated on two lines toward the center right: *J. S. Chardin. 1731.*
Paris, Musée Jacquemart-André

Provenance. Commissioned by Count Conrad-Alexandre de Rothenbourg (1683/84-1735) for his residence in Paris. Collection of Laurent Laperlier as of approximately 1858; Laperlier sale, 11-12 April 1867, no. 14; acquired at this sale by Edouard André (1835-1894); Musée Jacquemart-André.

Exhibitions. 1732, Exposition de la Jeunesse (?); 1734, Exposition de la Jeunesse (?); 1860, Paris, no. 349; 1880, Paris, no. 38; 1883-84, Paris, no. 26; 1910, Berlin, no. 55 (or no. 11 of large-size edition of cat.); 1954, Rotterdam, no. 44, pl. 25; 1955-56, New York, no. 33 (with pl.); 1959, Albi, no. 32; 1974, Paris, no. 101; 1978, Moscow and Leningrad, no. 111.

Bibliography. Bürger (Thoré), 1860, pp. 234-35; Burty, 1867, p. VI; Anonymous, *La Chronique des Arts et de la Curiosité,* 1867, p. 122; Bocher, 1876, pp. 94, 115; Burty, 1879, p. 148; Goncourt, 1880, p. 124; Chennevières, 1888, p. 59; Dilke, 1899, p. 190; Dilke, 1899 (2), p. 119; Guiffrey, 1908, pp. 36,40,73, no. 100; Furst, 1911, p. 123; Museum cat. (Gillet), 1913, no. 22; Dacier, 1913, p. 62; Lafenestre, 1914, p. 55; Seymour de Ricci, 1914, p. 21; Moreau-Nélaton, 1927, p. 29; Ridder, 1932, pl. 32; Wildenstein, 1933, no. 1130, fig. 180; Goldschmidt, 1945, fig. 41; Jourdain, 1949, fig. 45; Barrelet, 1959, p. 311; Wildenstein, 1959, p. 100, fig. 4; Adhémar, 1960, p. 455; Nemilova, 1961, pl. 18; Faré, 1962, p. 163; Antonova, 1963, p. 145; Wildenstein, 1963-69, no. 87, pl. 8 (color); Cain, 1967, p. 218; Museum cat. (Gétreau-Abondance), 1976, no. 7.

See [30] for discussion.

30 *Attributes of the Arts*

(Les Attributs des Arts)

Canvas, 140 × 215 cm. Signed and dated on two lines at lower left: *J. S. Chardin 1731.*
Paris, Musée Jacquemart-André

Provenance. See [29], Laperlier sale, no. 13.

Exhibitions. 1732, Exposition de la Jeunesse (?); 1734, Exposition de la Jeunesse (?); 1860, Paris, no. 350; 1880, Paris, no. 37; 1883-84, Paris, no. 26; 1910, Berlin, no. 51 (or no. 10 in large-size edition of cat.); 1954, Rotterdam, no. 43; 1955-56, New York, no. 32 (with pl.); 1957, Besançon, no. 59; 1959, Albi, no. 31; 1974, Paris, no. 100 (with ill.); 1977, Paris, p. 77; 1978, Bordeaux, no. 95 (with ill.).

Bibliography. Bürger, (Thoré), 1860, pp. 234-35; Burty, 1867, p. VI; Anonymous, *La Chronique des Arts et de la Curiosité,* 1867, p. 122; Bocher, 1876, pp. 94, 115; Burty, 1879, p. 148; Goncourt, 1880, p. 124; Chennevières, 1888, p. 59; Dilke, 1899, p. 190; Dilke, 1899 (2), p. 119; Guiffrey, 1908, pp. 36, 40, 73, no. 99; Goncourt, 1909, p. 183; Furst, 1911, p. 123; Museum cat. (Gillet), 1913, no. 21; Dacier, 1913, p. 62; Lafenestre, 1914, p. 55; Seymour de Ricci, 1914, p. 21; Moreau-Nélaton, 1927, p. 29; Ridder, 1932, pl. 33; Wildenstein, 1933, no. 1129, fig. 179; Goldschmidt, 1945, fig. 42; Adhémar, 1960, p. 455; Faré, 1962, p. 163; Wildenstein, 1963-69, no. 86, pl. 9 (color); Schmid, 1966, p. 519; Cain, 1967, p. 218; Cailleux, 1969, p. VI and fig. 10 (detail); Museum cat. (Gétreau-Abondance), 1976, no. 6.

The two canvases of the Musée Jacquemart-André have always been justly famous, but their origin had remained unknown. Nor was it known how they came into the possession of Laurent Laperlier, who owned them in the nineteenth century. Both questions can now be answered.

In our discussion of *Musical Instruments...* from the Marcille collection [27, 28] we mentioned the archival documents providing proof that Count Conrad-Alexandre de Rothenbourg had commissioned six paintings from Chardin, among them "two pictures representing the *Arts,* [to be] placed above the book cabinets of His Excellency's library in the first suite of his Paris townhouse" on the rue de Regard. On 8 August 1731 [Archives Nationales, Minutier Central, étude XXIII, liasse 440] Chardin sent an invoice in the amount of 300 *livres* for the two works. The paintings, which seem to have been removable pictures rather than overdoors in the strict sense of the word, are listed in the inventory of Rothenbourg's estate after his death on 3 October 1735 [liasse 488]: "A globe, a bust." Could Chardin have borrowed them for exhibition at the Expositions de la Jeunesse of 1732 and 1734, in the absence of the ambassador who was in Madrid between 1731 and 1734? We believe so, although we can offer no proof.

Thanks to an unpublished letter by Laurent Laperlier, we now know how that great collector acquired the two works over a century later. On 18 January 1864 Laperlier, official of the military administration who had retired to Algiers in 1860, wrote to the Goncourt brothers from Algiers [Bibliothèque Nationale, Manuscripts, n.a.f. 22467]:

See Color Plate

"As for myself, I know of only one [anecdote] concerning my two large paintings of three meters each *(Attributes of the Sciences* and *Attributes of the Arts)*. These paintings existed in a village near Paris, in a house bought by the local municipality to be converted into a school for children. That was around 1848. The school was never established, and after some ten years the community decided to sell the building along with the rubbish that was rotting inside. From this [heap] came the two beautiful paintings of mine which, all covered with mildew so that it was impossible to decipher what they represented, were sold — one for nine francs and the other for thirty-five. The first went to Tremblay's father who at the time dealt in antiquities at the Court des Fontaines, the other went to a jumble shop at Versailles. The paintings came to Paris on a handcart where they served to cover up old kitchen utensils.

"As the load arrives at the shop, the great merchant Couvreur happens by, smells a good catch, and buys a painting right there in the street for 100 francs. He no sooner has it in hand than he examines it and finds a signature and date in letters the size of a fingernail. He listens around, inquires, and learns that the pendant is at Versailles. He gets Basset to join in the wily hunt; they discover and buy the second piece for 100 or 120 francs. I get wind of it, I come running — one of the pictures is already sold, to M. Dever, a collector...but he lets me have it — in short, I buy the two masterpieces for 3,000 francs."

These two pictures, painted in the year of Chardin's marriage to Marguerite Saintard and of Jean Pierre's birth, were shown in 1860 at the Galerie Martinet, Boulevard des Italiens, in the first exhibition of the nineteenth century that made it possible to assess Chardin's genius in its many diverse aspects. The organizers had assembled twenty Chardin canvases for the inauguration of their exhibit; another nineteen were added later and are listed in a supplement to the rare catalog by Philippe Burty. Of these, "Laurent Laperlier, along with La Caze and Marcille one of the richest Chardin collectors, furnished eleven of his own, including two masterpieces seven feet in length: *Attributes of the Arts* and *Attributes of the Sciences*" [Bürger (Thoré), 1860, pp. 234-35].

In *Attributes of the Sciences* a large globe dominates the upper register where we see contrasted against the customary neutral brown background, some geographical charts, a square, and a sextant in front of some books, of which one could be an atlas, an oriental rug unfolds in the foreground, flanked by an incense burner, a microscope, and a fluted Japanese vase. Each of these motifs finds its counterpart in *Attributes of the Arts*: in the center, against a red curtain with golden tassels (shown also in the *Lady Sealing a Letter* of 1733 [54] and in *The House of Cards* [65], is a large plaster bust (perhaps the Pseudo-Diomedes now at the Bibliothèque Mazarine, according to valuable information obtained from Jean-René Gaborit), surrounded by a square palette full of brushes, rolls of white and blue paper, and a

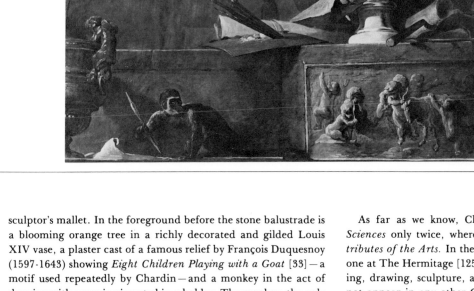

sculptor's mallet. In the foreground before the stone balustrade is a blooming orange tree in a richly decorated and gilded Louis XIV vase, a plaster cast of a famous relief by François Duquesnoy (1597-1643) showing *Eight Children Playing with a Goat* [33] — a motif used repeatedly by Chardin — and a monkey in the act of drawing with sanguine inserted in a holder. The monkey, the only living, mobile element in both compositions, symbolizes the artists' vanity in pretending to compete with the beauty of nature. It corresponds to the oriental incense burner and the fragrant smoke it releases — symbol of evasion, of distant journeys and, no doubt, also of too great a confidence placed in science itself.

Does the painting really represent the attributes of the sciences even though the objects shown allude essentially to the distant Orient — land of fragrances, carpets, and vases — despite the predominance of "geographical" objects? The title traditionally given to this painting since 1860 seems justified in the light of Diderot's description [Seznec & Adhémar, 1960, p. 112] of another painting on the same subject, exhibited at the Salon of 1765 (no. 45) and lost during the early nineteenth century (see [123, 124], which Chardin had executed for the Château de Choisy: "Seen on a table covered with a reddish carpet are, from right to left I think, some books standing on their edges, a microscope, a handbell, a globe half-hidden by a curtain of green taffetas, a thermometer, an upright concave mirror, small field glasses with case, rolled-up maps, and the end of a telescope."

As far as we know, Chardin painted the *Attributes of the Sciences* only twice, whereas he repeatedly represented the *Attributes of the Arts*. In the version at the Louvre [123] and in the one at The Hermitage [125], he not only evoked the arts of painting, drawing, sculpture, and goldsmithing (the gilded vase does not appear in any other Chardin picture) but also included architecture — a subject which he treated again in a separate picture [32].

Among Chardin paintings of the year 1731 there are four which deserve particular attention: *Meat-Day Meal* [38] and *Fast-Day Meal* [37], both at the Louvre, and the two decorative overdoor canvases at the Musée Jacquemart-André. In the Louvre pair, carefully executed on copper and small in size, Chardin depicts the daily world, the familiar objects of a kitchen. In the Jacquemart-André pair, by contrast, he shows us works of art and precious, rare objects evocative of distant worlds. The large format is unusual for Chardin; the execution is rapid, almost brutal, meant to be seen from a distance; the vivid, clashing colors have nothing in common with the cool, elephant-gray harmony of the two little coppers at the Louvre.

How can we reconcile two concepts which apparently differ so greatly? To begin with, it is our impression that Chardin's development was not one of steady, linear evolution. Though he progressively tackled new subjects — here, the representation of rare objects and in the Louvre pair that of the most ordinary kit-

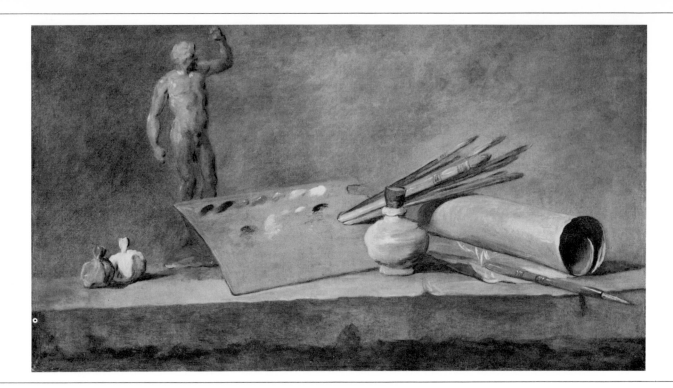

chen utensils—he did not give up his hunting subjects and the formula he had perfected for painting birds and dead rabbits. But above all, one can sense in this apparent diversity the same determination to come to terms with problems of space, to articulate it, and to find new solutions to better control it. In this respect, the sumptuous still lifes at the Musée Jacquemart-André attest to a keen knowledge of trompe l'oeil techniques and laws of perspective behind the disorder of disparate objects apparently strewn at random across the vast stone ledges to purely decorative effect.

31 *Attributes of the Painter and the Draftsman*

(Les Attributs de peintre et du dessinateur)

Canvas, 50 × 86 cm.
Princeton, The Art Museum, Princeton University

Provenance. Sale of 15 May 1879, no. 27 ("Chardin, attributed to. The Painter. 46 × 84 cm.")? Sale X, 19 April 1880, no. 8. Mme X sale, 24 April 1907, no. 13; acquired at this sale by the painter François Flameng (1856-1923), owner of another Chardin still life now in the Museum Boymans-van Beuningen in Rotterdam [not included in the 1963-69 Wildenstein; cf. Wildenstein, 1933, no. 874, fig. 223]. François Flameng sale, 26—27 May 1919, no. 5 (with ill.). Next owned by the expert Féral, along with its companion piece; then in the possession of Joseph Demotte, New York. Given to The Art Museum, Princeton University, by Miss Helen Clay Frick in 1935.

Exhibitions. 1907, Paris, no. 12 (or 13 or 14); 136, New York, no. 2; 947, New York, no. 17; 1948, Montclair, no. 2; 1952, Syracuse, no. 1.

Bibliography. Guiffrey, 1908, p. 76, no. 122; Furst, 1911, p. 124; Wildenstein, 1933, no. 1135, fig. 218 (among "paintings either of doubtful origin, or forged, or which we have not seen"); *Bulletin of the Department of Art and Archaelogy of Princeton University,* 1935, pp. 17-19; Constable, 1955, pp. 23-25, 27, and pl. 2; Morse, 1955, p. 25; *Record of the Art Museum* [Princeton], *1966,* 1969, p. 31 (with pl.); Schmid, 1966, p. 519 (and note 8).

See [32] for discussion.

32 *Attributes of the Architect*

(Les Attributs de l'architecte)

Canvas, 50 × 86 cm.
Princeton, The Art Museum, Princeton University

Provenance. Companion piece of [31]. X sale, 15 May 1879, no. 28 ("Attributed to Chardin. Music. 46 × 84 cm."(X sale, 19 April 1880, no. 9. Mme X sale, 24 April 1907, no. 14; acquired by François Flameng. François Flameng sale, 26-27 May 1919, no. 6. Next owned by Féral; then by Joseph Demotte, New York. Given to The Art Museum, Princeton University, by Miss Helen Clay Frick in 1935.

Exhibitions. 1907, Paris, no. 13 (or 12 or 14); 1936, New York, no. 3; 1947, New York, no. 18; 1948, Montclair, no. 3.

Bibliography. Guiffrey, 1907, p. 76, no. 123; Furst, 1911, p. 124; Wildenstein, 1933, no. 1136; *Bulletin of the Department of Art and Archaelogy of Princeton University,* 1935, pp. 17-19, pl. on p. 18; *Art Digest,* 15 November 1936, pl. on p. 23; Morse, 1955, p. 25; *Record of the Art Museum* [Princeton], *1966,* 1969, p. 31.

These two paintings are not included in the 1963-69 editions of Wildenstein [see, however, 1969, p. 244] and have only rarely been reproduced; in fact, *Attributes of the Architect* seems to have been copied only once. Yet we are convinced that both paintings were done by Chardin and were probably intended for use as overdoors. On one we see the tools of the architect: ruler,

compass, protractor (a goniometer?) lying on a small black box; three books, one of them open to the print of a plan; and a large sheet of paper on which plans for a building have been sketched.

On the other, painting and draftsmanship are symbolized by two bladders containing red and white pigments; a clay statuette of a man with upraised arm (used by academies for drawing lessons); a rectangular palette with brushes; a small stoneware bottle probably containing a binder; a chalk-holder with red chalk; and a roll of blue paper [cf. Constable, 1955, and Schmid, 1966]. These objects, though arranged differently, are also shown in a painting which once belonged to the Jacques Doucet collection and which has turned up several times at recent sales [64 × 81 cm.; Wildenstein, 1933, no. 1134, fig. 174; 1963-69, no. 342, fig. 156; most recently, sale of 2 December 1975, no. 4—a clumsy restoration has revealed on the right of the composition a plaster bust of a child]. It might be that this painting rather than the one of the same subject at Princeton was the work sold on 2 June 1779, no. 208, at a sale of *"Poismenu* and other second-hand dealers."

The dating of these two works, with their somewhat off-balance composition, is a problem. The connections between *Attributes of the Painter and the Draftsman* and certain motifs of *Attributes of the Arts,* which we know to be from 1731, encourage us to place them at the same time: around 1730-1732. This date is contingent, however, upon the more careful examination which this exhibition makes possible.

33 *Eight Children Playing with a Goat*

(Huit Enfants jouant avec une chèvre)

Canvas, 23.5 × 40 cm. On the back, a collection stamp and numerous bits of information handwritten by Eudoxe Marcille; this information does not specify where or when he (or his father, François-Martial) acquired the work.
Paris, Private Collection

Provenance. Collection of the painter Jean-Baptiste Vanloo (1684-1745) in 1732, then of his son Louis-Michel (1707-1771); Louis-Michel Vanloo estate sale, 14 December 1772, no. 80. Sorbet sale, 1 April 1776, no. 48. M[olini] sale, 30 March 1778, no. 35. Ch[ariot] sale, 28 January 1788, no. 49 (specifies that the painting comes from the sale of "M. de Sorbeck"). [These references probably relate to the painting exhibited here, although some doubt still lingers; see discussion below.] Collection of Baron de Thiais (or Thais or Thiers) (?). Prior to 1876 in the collection of Eudoxe Marcille (1814-1890); has remained in the collection of this family.

Exhibitions. 1732, Exposition de la Jeunesse, no. cat. (?); 1849, Paris, no. 7 (*"Un bas relief [grisaille]"*) (?); 1883—84, Paris, not in cat. (We have been unable to verify the accuracy of this information.); 1959, Paris, no. 23, pl. 13.

Bibliography. Bocher, 1876, p. 100; Goncourt, 1880, p. 125; Chennevières, 1890, p. 303; Fourcaud, 1899, p. 393; Fourcaud, 1900, pp. 11, 13; Normand, 1901, p. 83; Schéfer, 1904, pp. 44, 47, 55; Avenel, 1907, p. 577; Guiffrey, 1908, pp. 80-81, no. 151; Goncourt, 1909, pp. 184, 185; Dacier, 1911, pp. 17, 34-35, note 1; Furst, 1911, p. 126; Wildenstein, 1933, no. 1205, fig. 172, no. 1216; Wildenstein, 1963-69, no. 83, fig. 38; Cailleux, 1969, pp. VI, VIII; Faré, 1976, p. 158, fig. 242.

Related Works. For the numerous versions painted by Chardin, see below. We are familiar with two interpretations of the work. One was on the market in Monte Carlo several years ago; the other was put up for sale under the attribution of P.-J. Sauvage (1744-1818), a Belgian expert in trompe l'oeil paintings, on 7 March 1970, at the Palais Galliéra, cat. no. 66 (with repr.), 24.5 × 40.5 cm.

The little trompe l'oeil, of which only one version is known today, is one of the Chardin works posing a great number of problems. The first is the number of autograph copies of it which have existed.

In 1732 Chardin exhibited at the Exposition de la Jeunesse. The author of the review printed in the July 1732 issue of the *Mercure de France* (p. 1611)—Antoine de La Roque, in all probability—praised the paintings made for Count de Rothenbourg. He wrote:

"But the piece which does him the greatest honor is the bas-relief painted after a bronze bas-relief by Francois Flamand, representing children marvelously fashioned by this famous master and imitated so well by the brush of the clever painter that, however, close to it one stands, looking at it one is so charmed one absolutely has to reach out and touch the painting in order to be undeceived. This painting of the first rank may be seen in the collection of M. Van Loo, painter of the Academy."

Charles-Nicolas Cochin (1715-1790) took up the subject again in an anecdote he related: "M. Chardin had exhibited a painting of a bronze bas-relief copied to perfection and painted with all possible taste. M. Van Loo asked him how much he thought the painting

was worth. M. Chardin gave him a price that was rather low but which he doubted he could get anyone to pay, for he had not yet had the good fortune to be well paid. 'It's mine,' M. Van Loo said to him, 'but it's worth more than that price.' So he gave him more for it.

"Nothing is more flattering for an artist," added Cochin, "than such a mark of esteem on the part of a man as famous as M. J.B. Van Loo." The hero of this adventure is, of course, Jean-Baptiste Vanloo, and not his son Louis-Michel, as most commentators write today.

The painting at the 1732 exhibition is certainly the one at the estate sale of Louis-Michel Vanloo and which Gabriel de Saint-Aubin sketched on the margin of his copy of the catalog [preserved in the Cabinet des Estampes, Bibliothèque Nationale; cf. Dacier, 1911]. It is most assuredly the one which then appeared at the 1776 Sorbet sale (sketched once again by Saint-Aubin in a catalog later sold at Christie's, 18 April 1967, no. 45; now in a New York collection) and at the sales of M[olini] and Ch[ariot] in 1778 and 1788, respectively.

In these four sales the height of the work varies between eight and nine *pouces* and the width between fourteen and fifteen (i.e., 22.5 or 25 × 38 or 40 cm.). These dimensions fit the painting exhibited here. One could then accept the identification of this work with the Vanloo painting if in the sales it were not *always* specified that the "bas-relief is painted in bronze and its tone is so perfectly rendered that it produces an illusion..." or again, that the Chardin painting is done in "imitation of the antique bronze." The Marcille painting is clearly a copy of a plaster cast.

In 1737 Chardin presented a bas-relief painted in bronze at the first Salon to be held since 1704. He repeated himself in 1755 (no. 46) with *Des enfants jouant avec une chèvre imitation d'un bas relief en bronze* ("Children playing with a goat, imitation of a bas-relief in bronze"), but not, as has been claimed [cf. Guiffrey, 1908,

Saint-Aubin, sketch on a page of the Sorbet sale catalog (1776).

Saint-Aubin, detail of a sketch on a pag of the L. M. Vanloo sale catalog (1772).

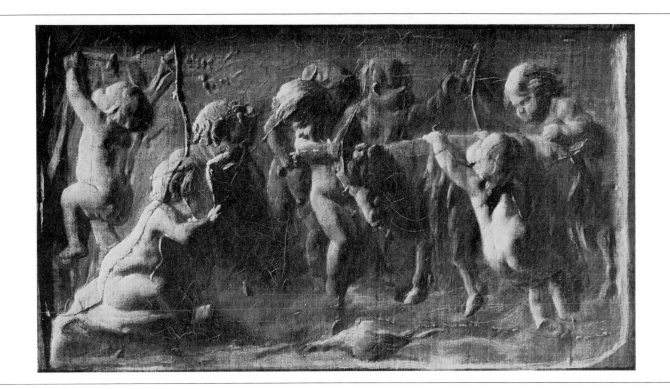

33

and exh. cat. 1969, Paris], in 1771 (no. 38). The work presented at the 1771 Salon was the Moscow painting which copied Bouchardon [133].

Another consideration is that a copy of this Chardin composition on copper, with the same format, was put up for sale on 23 February 1778, no. 33, and then again on 14 February 1785, no. 99 [Wildenstein, 1933, no. 1214; 1963-69, no. 85]. Another version on wood appeared in the sales of 8 April 1777, no. 730 (sale of Prince Conti, who also owned a copy in terra cotta of the original by Duquesnoy); second Conti sale, 15 March 1779, no. 279; 24 April 1783, no. 46; 16 January 1799, no. 17; and 11 May 1828, no. 63 [Wildenstein, 1933, no. 1218; 1963-69, no. 84; this is the painting that was shown at the 1799 Salon de la Correspondance, no. 39, under the unconvincing name of Chardin *fils,* according to Bellier de la Chavignerie, 1864, p. 356]. Finally, a third copy on canvas, measuring only nine *pouces* by eleven (could there be an error on the part of the catalog editor and might we have here the Marcille painting?), has been pointed out in a sale of 31 May 1790, no. 46.

From all these indications, various conclusions can be drawn. First of all, the piece done by François Duquesnoy (1597-1643), called François Flamand in the eighteenth century, seems to have been quite popular in the seventeenth and eighteenth centuries. The marble original is at the Villa Doria Pamphili in Rome. Mariette Fransolet (1942) has listed several copies of it but was unaware of the one in bronze, approximately the same size as the painting exhibited here and belonging to the Dutuit collection at the Petit-Palais, Paris. The work has been copied and incorporated by a great many seventeenth-century Dutch artists in their genre scenes — for example, G. Dou (National Gallery of London) and W. Van Mieris (Ten Bos collection in Almelo). Dou especially seems to have specialized in the reproduction of this bas-relief; there are ten examples between 1653 and 1655 [see the Louvre's *Trumpet Player,* Inv. 1216, exh. cat. Paris, 1970-71, no. 65]. It was also copied in portraits by F. Van Lint [Cailleux, 1969, gif. 14] and G. Netscher (*Portrait of a Woman* in the Glasgow Art Gallery). French artists seem not to have been left behind: Desportes, at least five times [Cailleux, 1969, does not mention the Gien painting], and Boucher (*Attributes of the Painter and Sculptor* in The Frick Collection, New York) both used the Duquesnoy bas-relief in their works, usually in its bronze version.

As for Chardin, he also included it on several occasions in his paintings. The first example is *Attributes of the Arts* [30] now in the Musée Jacquemart-André, in which the plaster bas-relief occupies a place of prominence. We also find it in a Moscow painting, unfortunately not in this exhibition [Wildenstein, 1963-69, no. 237, pl. 38], in which Chardin sketches the Duquesnoy motif on the stone wall serving as background for *Attributes of the Arts with a Bust of Mercury.* Is it not possible that Chardin himself owned a copy of this plaster cast? If so, does the reference to a "bas-relief

valued at 500 *livres*" in the Chardin estate inventory of 18 December 1779 relate to this plaster cast rather than to a work by Chardin, since all the artist's paintings but one are valued at less than 100 *livres*?

Two points remain to be considered: first, the painting's date. Everything leads us to believe it was painted shortly before the 1732 Exposition de la Jeunesse. The fact that the bas-relief appears in the 1731 *Attributes of the Arts* [30] would seem to prove this. In addition, its execution is very different from the one characterizing the grisaille trompe l'oeil which dates from the last years of Chardin's life. All we need do to be convinced of the early date is to compare the Marcille painting with the four late examples brought together here [131, 132, 133, 138].

The second point concerns the symbolic value of Jean-Baptiste Vanloo's purchase of the work. We know that in 1731 Chardin participated in the restoration of the François I gallery at Fontainbleau directed by Vanloo (and in the company of Huillot and others). Was it in order to thank Chardin, whom he knew well, that Vanloo bought his painting at a good price? Did he do it to help the young painter? And did he not want his gesture to be known so that a barely established artist would be assured a certain amount of publicity?

IV *Utensils and Household Objects*

From 1730 on — perhaps slightly earlier, though today we know of no earlier example — Chardin added a new type of painting to his repertory: little pictures of kitchen interiors. Using a limited number of objects chosen as much for their forms as for their commonplace nature, he multiplied his representations of pots, kettles, jugs, and pitchers. Definitely preferring curves and avoiding the rigidity of straight lines, he arranged and rearranged his objects with great care. Chardin made this type of picture his specialty until around 1733 and took pleasure in repeating them. He also liked to turn them out in pairs, so he could play on thematic opposites (e.g. *Fast-Day Meal* [37] and *Meat-Day Meal* [38]) or on counterpoints in lighting and shapes.

These pictures differ from earlier still lifes in a number of distinct characteristics. First of all, they focus on ordinary, common objects: pots and kettles accompanied by cuts of meat, vegetables, chickens and eggs, or fish. Their composition never contains the slightest narrative element or extraneous detail. It is this elimination of the picturesque in favor of the single form of the objects, their substance, and the play of light reflected from their surfaces that endows these works with a peculiar originality all their own. Chardin was to paint these subjects in a lighter and lighter tone and in a progressively broad, less meticulous style, and the space surrounding them was to play an increasingly important role. He would insist on the qualities of copper, on the beauty of materials, but would perfect without fundamental change during the next five or six years the formula devised around 1730. This formula reached its perfection in a set of four small pictures painted on wood, blond in tone, serene in composition, and monumental despite their modest format; they now belong to the Detroit Institute of Arts [50], the Louvre [51, 53], and the Musée Cognacq-Jay [52].

In 1730 Chardin signed paintings as different as *The Water Spaniel, A Leg of Mutton* [34], and *A Loin of Meat* [35]. From 1731 date some works as apparently unrelated as *Fast-Day Meal* [37] and *Meat-Day Meal* [38] (painted on copper, both now at the Louvre), the *Attributes of the Sciences* [29] and the *Attributes of the Arts* [30], and *Two Rabbits, a Brown Partridge, Game Bag, and Powder Flask* [25] in Dublin. *A Quarter of Cutlets on Striped Linen...* [39] and *Tufted Lapwing, Red Partridge, Woodcock, and Seville Orange* [26], so dissimilar, were both done in 1732. The immense difference in style and technique between works of the same date seems baf-

fling. Yet we were convinced that Chardin did not change his formula abruptly. Instead he seems to have painstakingly evolved a new type of composition and exploited it for some years before he abandoned it. This explains the seemingly irreconcilable chronological overlappings which so embarrass art historians and which create problems in dating much of Chardin's work. It also explains the grouping of Chardin's paintings in this catalog. Although his last still lifes of game are contemporary with his first still lifes of household utensils, it seems preferable to separate them by subject and type. The same applies to his genre paintings, the first of which go back to 1733, when he was producing still lifes.

It is easy to see a link between Chardin's still lifes of game and the long Flemish tradition of painting, or to cite such names as Pieter Boel and Jan Fyt in this context. To find exact precedents for Chardin's treatment of household utensils is a more delicate problem, however. Chardin was far from being an innovator, let alone a revolutionary; nothing could be more contrary to his temperament. And he was certainly not the first to paint this type of picture (one has only to think of Willem Kalf). Rather, his greatness lies in the careful insistence with which he chose the objects he wished to paint, in the refined arrangements of his compositions, and in the freshness he could bring to each of his many variations on a theme. His attitude — that of a true creator — would be understood by a Cézanne, a Braque, or later, a Morandi.

34 *A Leg of Mutton*

(Nature morte au gigot)

Canvas, 40 × 32.5 cm. Signed and dated at the lower right: *Chardin 1730*.
France, Private Collection

Provenance. Probably the painting at the Edme Bouchardon sale
"after the death of M. Girard, his nephew" (Edme Bouchardon died in
1762; his nephew was Louis-Bonaventure Girard), 13 September 1808,
no. 33, *Un tableau offrant une table de cuisine sur laquelle sont
différents objets relatifs à la bonne chère et un gigot suspendu, le tout
rendu avec cette vérité égale à la nature. Toile* ("A painting showing a
kitchen table on which lie various objects related to good eating, and a
leg of mutton hanging, all rendered with a truth equal to nature. Can-
vas") [Wildenstein, 1933, no. 976; 1963-69, no. 113, "whereabouts
unknown"; see also p. 242 of 1969 edition]. In an English collection in
1832 at the latest, as an old inscription on the back of the painting
confirms. Collection of Canon Milford in Oxford until about 1963.

Exhibition. 1968, Paris, no. 124.

Bibliography. Bordeaux, exh. cat., 1969-70, Paris, p. 17; [Watson],
1970, p. 538; Bordeaux, exh. cat., 1978, p. 132.

Of the numerous small paintings of household subjects done by
Chardin, this one, along with the one in Bordeaux [35], is the
earliest to have come down to us. There is no known replica of it.
The objects which adorn it—a skimmer, a pot, a glazed clay pit-
cher with its cover, a reed basket, and vegetables (turnip, leeks,
onions, and cabbage)—are placed on a stone ledge above which a
leg of mutton hangs on a hook. Chardin frequently made use of
this same repertory, subtly varying the position of each object. By
means of the light on the left which brightly illumines both the leg
of mutton and the nail and causes the brass pieces to shimmer in
the shadow, Chardin interrupts the perfect symmetry of the com-
position. The execution, characterized by short, quick brush-
strokes that are vibrant and somewhat heavily applied, is very dif-
ferent from that of his first still lifes with game or fruit; it enables
the artist to render perfectly the composition of each object and
its own peculiar quality.

 The work seems to have belonged to Bouchardon (see *Pro-
venance*), although we have been unable to find any mention of it
in the collections of the sculptor (1698-1762) [Guiffrey, 1885, p.
311 ff., and Roserot, 1897]. We know that Chardin put works by
Bouchardon in his paintings on more than one occasion; however,
nothing is known of the relationship between the two artists. It
would not be surprising for Bouchardon to have owned a Char-
din; the number of eighteenth-century painters, sculptors,
engravers, and architects possessing Chardin's paintings was con-
siderable.

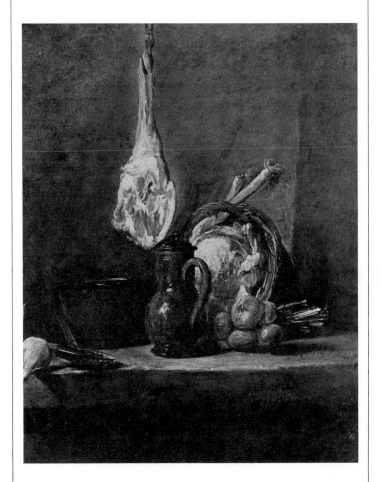

34

35

35 *A Loin of Meat*

(Nature morte au carré de viande)

Canvas, 40.5 × 32.5 cm. Signed and dated at the lower right:
Chardin. 1730.
Bordeaux, Musée des Beaux-Arts

Provenance. The history of this painting is unclear. It has been iden-
tified with a canvas that appeared as no. 14 in an anonymous sale, 4
February 1868. This hypothesis, however, seems unlikely since the
author of the catalog for this sale, the well-known expert Féral, would
not have been likely to omit mention of the signature and date,
especially since he included these details for a companion piece, no.
13. This latter painting was signed and dated 1728, "the year of his
admission to the Academy," Féral adds. The present painting has also
been tentatively identified with a picture listed as no. 20 in the sale of
the collection of Prince Paul Galitzin, 10-11 March 1875. But once
again the signature and date are not mentioned, although the compan-
ion piece, no. 21, is described in the catalog as "signed in full at bot-
tom right and dated 1750." Only one painting, no. 85 of a sale 9-11
April 1822, bearing the date 1730, can be identified as the painting
from Bordeaux. Collection of the painter Auguste Poirson (died in
Paris, 1896); Poirson bequest, 1900, no. 86.

Exhibitions. 1969-70, Paris, no. 2, pl. on p. 16 (with the following
press reviews: *Le Figaro,* 27 September, 25 November, and 11
December 1969; *Connaissance des Arts,* November, p. 19; *L'Amateur
d'Art,* 20 November; *Union,* 26 November; *Les Nouvelles Littéraires,*
27 November, repr.; *Réforme,* 29 November; *Le P.G.,* December; *Le
Parisien Libéré,* 1 December 1969; *Le Monde,* 4 December; *Journal du
Dimanche,* 7 December; *Feuille d'avis de Lausanne,* 12 December,
repr.; *Figaro Littéraire,* 15 December; *Le Peintre—le Guide du Collec-
tionneur,* 15 December, repr.; *Valeurs actuelles,* 22 December, repr.;
Presse Française et Etrangère, 27 December; *Plaisir de France,* January
1970, repr.; *Der Bund,* 1 March; *Sud-Ouest,* 15 March, repr.; *Bulletin
annuel d'information de la Préfecture,* 25 April, p. 25; *Les Muses,* no.
40, 22 June; *Carnet des Arts,* 1970, p. 116, with repr.); 1970-71,
Nagoya, Kamakura, Osaka, Fukoka, no. 28, with color pl. (with works
in the 1971-72 exh., p. 10 and pl. 61); 1978, Bordeaux, no. 94 (with
ill. pp. 128, 133).

Bibliography. [Watson], 1970, p. 538; Martin-Méry, 1972, p. 49; Faré,
1976, p. 154, fig. 236; Martin-Méry, 1976, p. 20; Young, 1978, p.
700.

Related Works. Several versions of this work exist, although they vary
in quality and the certainty of their "pedigree." The present writer has
seen three of these besides the one at Bordeaux: (1) a canvas (40.5 ×
33 cm.) at the Allen Memorial Art Museum in Oberlin, Ohio, signed
and dated 1739, exhibited a number of times but not included in
Wildenstein [see the important article on this work by K. Martin,
1951, pp. 17-23]; (2) a second version (40.5 × 32.5 cm.) of poor
quality, with pendant, at Dumbarton Oaks in Washington, whose date
reads 1743 and whose signature has been interpreted as that of a cer-
tain "Jamin" [see the article by K. Martin, 1957, pp. 238-44, concern-
ing this painting and its pendant; not included in Wildenstein]; and
finally, (3) a work (40 × 31 cm.), also with pendant, in the Norton
Simon collection, Pasadena, California, the only extant version
cataloged by Wildenstein [1933, no. 943 and fig. 128; 1963-69, no. 62,
fig. 30]. Another signed version (known only in a photograph) with a
companion piece appeared as no. 133 in the sale of the Léon Michel-
Lévy collection, 17-18 June 1925 [Wildenstein, 1933, no. 944].

A number of paintings which have appeared in sales in the past might be confused with one or another of the above versions of this work. These are: (1) "poultry with kitchen utensils" (38 × 29.5 cm.; sale, 22 January 1776, no. 24); (2) a painting, with pendant, of "kitchen utensils; a ray-fish, a capon, and cheese can be seen in one [of the pair]" (35 × 24.5 cm.; sale, collection of "M. Prault, the king's printer," 27 November 1780, no. 15) (descriptions of items in sales of 1 March 1781, no. 88, and 13 December 1790, no. 81, are too imprecise to be connected with the Bordeaux painting); (3) a painting, with pendant, in the Norton Simon collection, Pasadena—the author of the 1822 catalog follows Chardin's name with the date 1730 but does not state which of the two paintings is dated (sale, 9-11 April 1822, no. 85)—this painting, the third one cited above under *Provenance,* could be the painting now in Bordeaux; (4) "A kitchen table with vegetables and household utensils. In the background, a piece of beef is hung from the wall. This painting, signed and dated 1740, belonging to me, was sold to M. Clément de Ris." [Hédouin, 1846, p. 227, no. 98; *id.,* 1856, p. 200, no. 98] (sale, collection of Clément de Ris, 1846); (5) a painting which is probably the pendant of the Raleigh painting [36] (38 × 31 cm.; sale, January 31, 1853, no. 12); (6) a painting, the first of those cited above under *Provenance,* that does not seem to be related to the Bordeaux painting (sale, 4 February 1868, no. 14); (7) a painting, the second cited above under *Provenance,* that also seems unrelated to the Bordeaux painting (40 × 32 cm.; sale, 10-11 March 1875, no. 21); and finally, (8) a painting which is almost certainly the one that appeared later in the Léon Michel-Lévy sale (sale, Dugléré collection, 11 June 1884, no. 25). For numerous versions of the companion to the Bordeaux painting, see [36].

Oberlin, Allen Memorial Art Museum.

Pasadena, Norton Simon Museum.

Although many versions of *A Loin of Meat* are known, it is difficult to decide which of the many items in eighteenth- and nineteenth-century sales might relate to this painting (see *Related Works*). Of the versions known today, two bear later dates—1739 and 1743—and both, especially the one at Dumbarton Oaks, are weaker paintings, as is often the case with Chardin's replicas.

A Leg of Mutton [34] is dated the same as the present painting—1730; this fact, as well as the similarity of format, has led to speculation that they may be pendants. This seems highly unlikely, however, since the two works do not complement each other: both compositons are lit from the left and certain of the vegetables (onions and leeks), as well as some of the utensils (earthenware pitcher with cover, copper pot), appear in both. In fact, these two paintings read more like variations on the same theme, perhaps that of the *Meat-Day Meal* [38]. Any search for a pendant to the Bordeaux painting must almost certainly look to one of the versions of the picture now at Raleigh [36]. As early as 1776, within Chardin's own lifetime, these two compositions appeared together in one sale. Such pairs were frequently found in nineteenth-century collections, even as in some cases today (e.g., the Norton Simon collection).

A Loin of Meat was discovered at the time of its exhibition at the Galerie Cailleux in 1969 and has just recently been added to an all-too-brief list of the works of Chardin that can be found in France's provincial museums. It was one of the artist's first attempts at a genre which was then somewhat new to him; the numerous highlights and overly busy brushstrokes distract the eye, tending to impair the viewer's impression of the painting. In spite of this, however, Chardin was still able to give these familiar objects a certain mysterious presence, that "magical" atmosphere admired by so many authors in the eighteenth century.

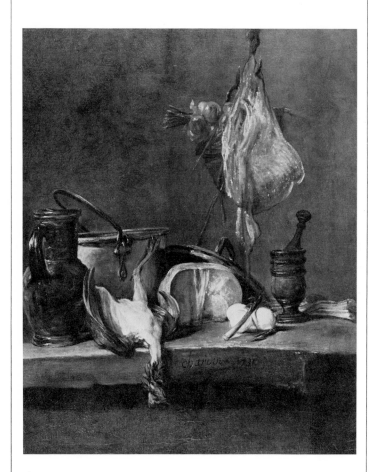

36

36 *Ray-Fish and Basket of Onions*

(Nature morte à la raie et au panier d'oignons)

Canvas, 40 × 32 cm. Signed and dated on the edge: *Chardin, 1731.*
Raleigh, The North Carolina Museum of Art, Museum Purchase Fund

Provenance. Dugléré sale ("former manager of the Café Anglais"), 31
January 1853, no. 11 ("Chardin, dated 1731, still life. Canvas, 38 cm.
high, 31 cm. wide"). By 1860 in the collection of the famous singer Paul
Barroilhet (born in 1805; one of the first nineteenth-century collectors of
Chardin); Barroilhet sale, 15-16 March 1872, no. 5, without indication
of signature or date. Collection of Baroness Nathaniel de Rothschild in
1876; Henry de Rothschild collection. Acquired by The North Carolina
Museum of Art in 1963.

Exhibitions. 1860, Paris, no. 359; 1907, Paris, no. 58; 1929, Paris, no.
30; 1958, Des Moines, cat. unpaginated (ill.); 1963, Winston-Salem, p.
56, pl. on p. 57; 1963, New York, no. 16 (with pl.); 1965, Columbus,
no. 5; 1970, Raleigh, p. 74; 1975, Richmond, no. cat.

Bibliography. Bürger (Thoré) 1860, p. 235; Bocher, 1876, p. 103; Gon-
court, 1880, p. 130; Guiffrey, 1908, p. 89, no. 211; Goncourt, 1909, p.
192; Furst, 1911, p. 125; *L'Art vivant,* 1 November 1929, p. 836 (ill.);
Quintin, 1929, unpaginated (pl.); Pascal and Gaucheron, 1931, p. 137;
Wildenstein, 1933, nos. 909, 916, fig. 131; Faré, 1962, p. 163 and note
577; *Arts,* April 1963, p. 54; *North Carolina Museum of Art Calendar
of Art Events,* November 1963, repr.; Wildenstein, 1963-69, no. 103,

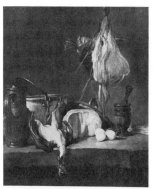

Pasadena, Norton Simon Museum.

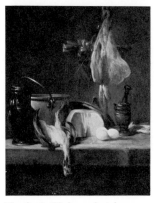

Hartford, Wadsworth Atheneum.

162

fig. 44 ("signed 1736, signature and date doubtful" and placed "around 1732"; see also nos. 98, 99); *The Art Quarterly*, 1963, no. 4, pl. on p. 491; *The Connoisseur*, May 1964, p. 70 (ill.); *La Chronique des Arts*, supplement to *Gazette des Beaux-Arts*, February 1964, p. 59, no. 202 (ill.); *Pantheon*, 1964, 2, p. 120 (ill.); Gerdts and Burke, 1971, p. 198 (ill.).

Related Works. There are even more replicas of this work than of its companion piece, *A Loin of Meat* [35], but their provenance is often obscure. We have seen three of them in addition to the version in Raleigh, and only one of them is dated: (1) at Dumbarton Oaks, Washington (40.5 × 32.5 cm., with companion piece), dated 1743 and allegedly signed *Jamin* [see article by K. Martin, 1957, pp. 238-44; not in Wildenstein]; (2) in the Norton Simon collection, Pasadena, California (40 × 31 cm.). [Wildenstein, 1933, no. 913, fig. 127; 1963-69, no. 63, fig. 29]; and (3) at the Wadsworth Atheneum, Hartford, Connecticut (signed, 41.5 × 32.5 cm.). [According to a May 1970 letter from Daniel Wildenstein to the Hartford museum, this version is no. 104 of the 1963-69 Wildenstein and, consequently, the painting in the Camille Marcille sale of 6-7 March 1876 (no. 20, "companion piece" of the work in the Musée Jacquemart-André, no. 39).]

Through photographs we are familiar with five versions: one with a companion piece (signed) at the Léon Michel-Lévy sale of 17-18 June 1925, no. 132 [Wildenstein, 1933, no. 914]; two at the sales of M.-C. Hoogendijk in Amsterdam, 14 May 1912, no. 13 (said to have been signed and dated 1737), and Doucet (signed), 6 June 1912, no. 143 [Wildenstein, 1933, no. 915; identified as the painting at the Taraval sale of 1786—an hypothesis abandoned in the 1963-69 edition]; one in the Jules Strauss collection (possibly the same as the one at the Hoogendijk sale in Amsterdam), signed and dated 1732, at a sale by Parke Bernet in New York, 14 March 1951, no. 68; and lastly, a signed version belonging to the Drey Gallery in Munich in 1927 (a photograph is at the Courtauld Institute, London). It is, of course, possible that some of these pictures have been confused with one another.

In addition, the following early sales offered versions which might be the same as one or more of the paintings cited above: 22 January 1776, no. 24, with companion piece, 38 × 29.5 cm., "poultry with kitchen utensils"; 27 November 1780, collection of M. Prault, the king's printer, no. 15, with companion piece, 35 × 24.5 cm. ("We see in one a ray-fish, a capon, and a piece of cheese") [descriptions for the sales of 1 March 1781, no. 88, and 13 December 1790, no. 81, are too vague to be connected with the Raleigh picture]; 20 March 1786, Taraval sale, no. 51, single painting, 40 × 32.5 cm. ("A chicken, a piece of cheese, some eggs, a pot, a clay pitcher, mortar,... on a stone ledge") [Wildenstein, 1963-69, no. 102]; 9-11 April 1822, no. 85, with companion piece, one of which—or both—was dated 1730 and might be confused with the Bordeaux work; 31 January 1853, no. 11, with companion piece, collection of Dugléré—probably the Raleigh painting, since the author of the catalog states that the work is dated 1731; 4 February 1868, no. 13, with companion piece—Féral, author of the catalog, specifies that "the picture, which is characterized by magnificent coloration and the most astonishing relief, bears the artist's signature and the date 1728, the year of his admission into the Academy"; 15-16 March 1872, no. 5, collection of Barroilhet (the picture exhibited here); 10-11 March 1875, no. 21, with companion piece, "signed in full at the lower right and dated 1750"; 6-9 March 1876, first Camille Marcille sale, no. 20 (see earlier reference to the version in the Hartford Museum); and 11 June 1884, no. 24, with companion piece, collection of Dugléré (the piece at the Léon Michel-Lévy sale in 1925).

Six dated versions of this composition are known. The Raleigh one is the oldest, if we exclude the one put up for sale on 4 February 1868, (see *Related Works*) and unfortunately lost since then, which the famous expert Féral, author of the sale catalog, declared was signed and dated 1728. This date, if correct, would be very important, for it would indicate that by the time of his admission into the Academy Chardin was devoting himself to small paintings of kitchen utensils and household items.

The Raleigh version is not in perfect condition. The museum conservator, Mrs. Catherine Leach, kindly informs us that the painting has been "considerably retouched" and the signature "reinforced." Even so, of all the versions we have seen, it is the finest in subject matter and execution — "a masterpiece of delicate execution comparable to the interiors of the Dutchman Kalf," as Thoré (Bürger) wrote in 1860.

Attention has been focused more than once on the kitchen items adorning the paintings from this period in Chardin's career — glazed earthenware pitcher, copper pot, mortar, etc. — and connections have been proposed between them and various items listed in the 18 November 1737 estate inventory of Chardin's first wife, Marguerite Saintard. Because these objects were very common in the eighteenth century, there is certainly nothing surprising about their being in the Chardin household. More intriguing is Chardin's unflagging interest in repeating them, moving them from one painting to the next, recomposing a new work each time. One senses what pleasure the artist must have had in arranging each familiar object chosen for its particular shape, volume, material, and color. Only when his carefully worked out composition was achieved did Chardin pick up his brushes and begin to paint.

Did he repeat only those compositions which satisfied him? And can we explain why some are known to us in so many versions while others are unique? We have no answers for these questions.

37 Fast-Day Meal

(Menu de maigre)

Copper, 33 × 41 cm. Signed and dated at the lower right: *Chardin 1731*.
Paris, Musée du Louvre, Inv. 3204*

Provenance. Acquired about 1840 by Théophile Thoré (Bürger) in Vendôme for ten francs. ["Not twenty years ago we paid ten francs in Vendôme for the two paintings, now in the Louvre, signed and dated *Chardin 1731*. In 1845 M. Barroilhet paid 155 francs for them at public sale. In 1852 the museum bought them for 3,500 francs, along with *The Monkey as Antiquarian*, which alone would be worth double that sum today" (Bürger, 1860).] The sale to which Thoré refers is probably the Alliance des Arts sale of 3 May 1845, no. 5, "Chardin, Still life: household utensils." Acquired by Frédéric Villot, curator of paintings at the Louvre, at a private sale from the expert Ferdinand Laneuville with *The Monkey as Antiquarian* (see [67]) in April 1852, for 3,000 francs [letter of 23 April and rough draft of letter to Count de Nieuwekerke; decision made on 30 April; Archives of the Louvre, p. 6].

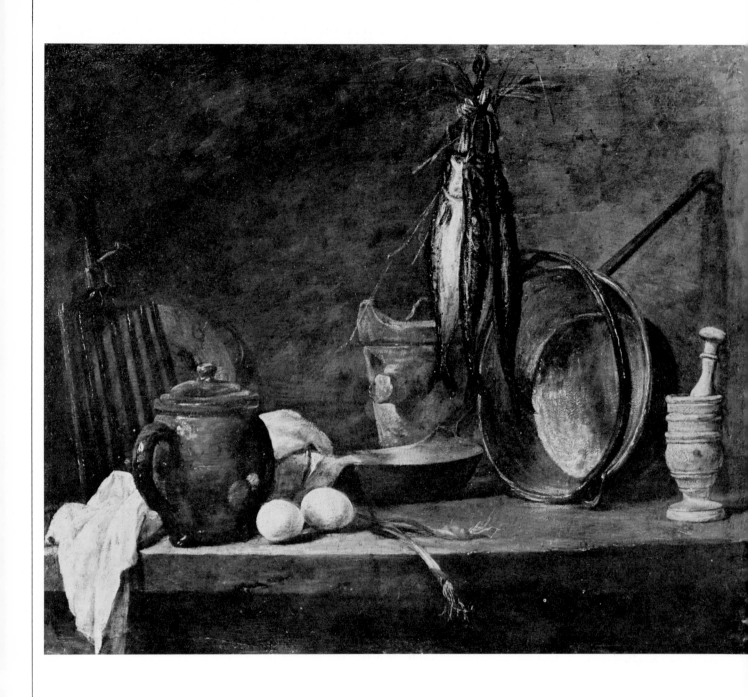

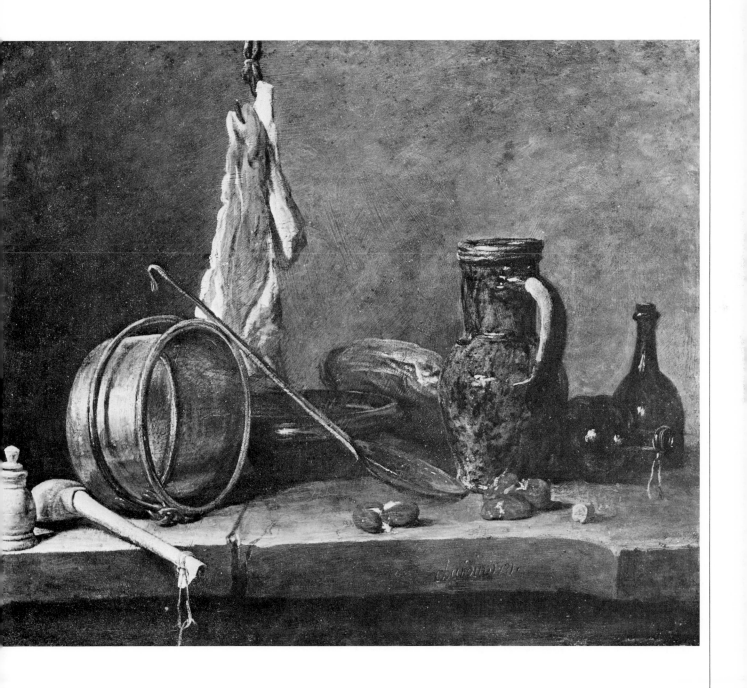

Exhibition. 1960, Paris, no. 563.

Bibliography. Hédouin, 1846, p. 227 (editor's note: "two charming little still lifes, signed and dated, belonging to M. Barroilhet"); Museum cat. (Villot), 1855, no. 101; Hédouin, 1856, p. 201, no. 103; Bürger (Thoré), 1860, p. 333; Goncourt, 1863, p. 520 (note); Bocher, 1876, p. 84, no. 101; Goncourt, 1880, p. 129; Chennevières, 1888, p. 60; Normand, 1901, p. 38; Guiffrey, 1908, p. 70, no. 78; Goncourt, 1909, pp. 189-90; Pilon, 1909, pp. 62, 165; Furst, 1911, p. 121, no. 95; Museum cat. (Brière), 1924, no. 95; Ridder, 1932, pl. 5; Wildenstein, 1933, no. 892, fig. 137; Jourdain, 1949, pl. 7; Wildenstein, 1959, pp. 99-100, fig. 3; Faré, 1962, p. 163 (II, pl. 363); Wildenstein, 1963-69, no. 91, pl. 11 (color); Adhémar, 1960, p. 455; Clark, 1974, p. 312, fig. 5; Rosenberg, Reynaud, Compin, 1974, no. 126 (with ill.); Faré, 1976, p. 156, fig. 239.

Related Works. A fairly recent copy on canvas was sold at the Hôtel Drouot, 20 January 1978, Room 4 (no cat., 18.5 × 24 cm., on the stretcher: "no. 489 Chardin painting from the collection of M. Rouzé-Huet").

See [38] for discussion.

38 *Meat-Day Meal*

(Menu de gras)

Copper, 33 × 41 cm. Signed and dated at the lower right: *Chardin. 1731.*
Paris, Musée du Louvre, Inv. 3205*

Provenance. See [37].

Exhibition. 1960 Paris, no. 564.

Bibliography. Hédouin, 1846, p. 227 (note); Museum cat. (Villot), 1855, no. 102; Hédouin, 1856, p. 201, no. 103; Bürger (Thoré), 1860, p. 333; Goncourt, 1863, p. 520 (note); Bocher, 1876, p. 84, no. 102; Goncourt, 1880, p. 129; Chennevières, 1888, p. 60; Normand, 1901, p. 38; Guiffrey, 1908, p. 70, no. 79; Goncourt, 1909, pp. 189-90; Pilon, 1909, pp. 62, 165; Furst, 1911, p. 121, no. 96; Museum cat. (Brière), 1924, no. 96; Ridder, 1932, pl. 4; Wildenstein, 1933, no. 939, fig. 135; Jourdain, 1949, pl. 6; Maugis, 1958, p. 74 (repr.); Barrelet, 1959, pp. 307-8; Adhémar, 1960, p. 455; Faré, 1962, p. 163 (II, pl. 364); Wildenstein, 1963-69, no. 92, pl. 10 (color); Clark, 1974, p. 313, fig. 6; Rosenberg, Reynaud, Compin, 1974, no. 127 (with ill.); Faré, 1976, p. 156, fig. 128.

The history of these two works summarizes the rapid rediscovery of Chardin around 1850. The compositions were found by Thoré (Bürger) about 1840 in Vendôme and purchased for ten francs. Shortly after that, the singer Barroilhet, one of the first to collect Chardin paintings in the nineteenth century, bought them at a public sale for 155 francs, and in 1852 the Louvre acquired them for 3,000 francs at a private sale, along with *The Monkey as Antiquarian* (see [67]).

The report drawn up by Frédéric Villot—the new curator of paintings at the Louvre at the time—in which he proposes the purchase of the two works to Nieuwerkerke also deserved to be cited: "Chardin paintings on copper are extremely rare; and these in particular, combining as they do a very fine finish and a thick, bold touch, prove that the French school has had artists who were equal to if not better than the most skillful Flemish painters."

Thirty years later the public was enraptured by Chardin. Henry de Chennevières, for example, wrote in his 1888 article on the Chardins in the Louvre: "How very delightful in their paint and satisfying in their arrangement of lines are these miniscule still lifes with such precious detail! Do you know anything as exquisite as the leek of no. 101 [referring to the frequently reissued catalog of Villot] placed there so appropriately to interrupt the line of the table? And the three herrings on the wall! And the repetitions of that untranslatable slate gray!"

These two works, dated the year of the marriage so eagerly anticipated by Chardin, confirm the new direction taken by the artist. He is experimenting with a new support—copper—which he will use very seldom (a small version of *Lady Sealing a Letter,* probably contemporaneous with the large painting exhibited here [54], was executed on copper). No longer was Chardin content with painting dead game or baskets of fruit; he depicts kitchen utensils intended for everyday use. In the one painting, we see lying on a stone ledge from left to right—and this repertory will be used frequently by Chardin—a grill, a pan, a cooking pot on legs, a long-handled frying pan, an earthenware brazier, a brass kettle, and a mortar for salt. In the other, we see a wooden pepper box (or spice box), a wooden spoon, a tinned copper pot, a dish, a skimmer, a green earthenware pitcher, and two bottles of dark glass—one lying on its side. A white napkin, two eggs reflected in the cooking pot, the leeks which Chennevières admired so much, and three herrings hung on the wall—the first in a long series—in one painting, and a cut of meat, a loaf of bread, and some raw kidneys in the other, make it clear that the subject is fast-day and meat-day meals, required observances of the Church.

The execution of both compositions is bold, and the color scale (which recent restoration of the two works has enhanced) gains in refinement; the viewer is aware of a subtle contrast between the cold, metallic hues of the *Fast-Day Meal* and the warm colors—browns, reds, chestnut—of the *Meat-Day Meal.* The real innovation in these works, however, is the scale that Chardin gives to the objects. Previously, the things he painted appeared greater than life, but here they are reduced in size and thereby multiplied—making the delicate problems of construction and composition much more complex for the artist. The viewer senses that the selection and placement of each object is more planned than in the still lifes of the Northern painters.

39 *A Quarter of Cutlets on Striped Linen, a Pitcher, Two Onions, Copper Pot with Skimmer, and Mortar and Pestle*

(Nature morte avec un quartier de côtelettes posé sur une serviette à liteau, une cruche, deux oignons, une écumoire, un chaudron de cuivre et un égrugeoir)

Canvas, 42 × 34 cm. Signed and dated at the lower right on two lines: *J. S. Chardin. 1732.*
Paris, Musée Jacquemart-André

Provenance. Collection of Camille Marcille (1816-1876) before 1863 [Adhémar, 1968]; sale of 6-7 March 1876, no. 19 [see intro. to the sale cat. by Paul de Saint-Victor, p. V]. Collection of the painter Philippe Rousseau (1816-1887); sale of his studio, 26 January 1888, no. 32. Lefèvre-Bougon sale, 1-2 April 1895, no. 8 (with pl.); acquired at this sale by Nelly Jacquemart (1841-1912), widow of Edouard André (1835-1894).

Exhibitions. 1956, New York, no. 31 (with pl.); 1958, Lyon (no cat.; in exchange for a work by Prud'hon lent to the Musée Jacquemart-André by Lyon); 1959, Albi, no. 30 (repr.); 1960, Moscow and Leningrad (no cat.; in exchange for a work by Van Gogh); 1968, London, no. 128, fig. 188; 1968, Atlanta, p. 24 (with ill.); 1978, Bordeaux, no. 96 (with ill.).

Bibliography. Bocher, 1876, pp. 97-98, 116; Saint-Victor, 1876, p. V; Goncourt, 1880, p. 128; Eudel, 1889, p. 50; Guiffrey, 1908, pp. 43, 49; Goncourt, 1909, p. 189; Dacier, 1913, p. 62, pl. on p. 59; Seymour de Ricci, 1914, p. 21 (repr.); Museum cat. (Gillet), 1913, no. 236; Lafenestre, 1914, P. 55; Farrenc, 1928, p. 294; Ridder, 1932, pl. 34; Wildenstein, 1933, no. 940, fig. 129; Goldschmidt, 1945, fig. 44; Faré, 1962, p. 163; Wildenstein, 1963-69, no. 105, pl. 12 (color); McCoubrey, 1964, p. 46 and fig. 7; Cain, 1967, p. 268; Adhémar, 1968, p. 232; Museum cat. (Gétreau-Abondance), 1976, no. 8.

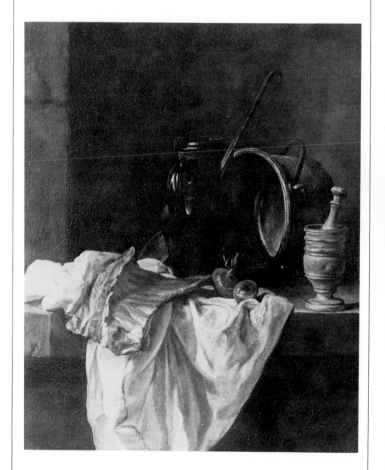

In an undated letter [1863 or 1864; Bibliothèque Nationale, Manuscrits, n.a.f. 22469] to the Goncourts written to congratulate them for their articles in the *Gazette des Beaux-Arts,* Camille Marcille describes this painting and its "companion piece," although he makes it clear that he does not know their provenance. This would seem to indicate that the two works had belonged to his father, François-Martial, who died in 1856. They may have been bought back by Camille at the first of his father's sales (12 January 1857, no. 27, *chaudron et ustensiles de cuisine* ["kettle and kitchen utensils"], and no. 24, *ustensiles de cuisine)* or perhaps at the second Marcille sale of 2-3 March 1857 (nos. 34 and 38, *ustensiles de cuisine).*

The "companion piece," separated from the painting in the Musée Jacquemart-André since the sale of 1876, would seem to be the picture now in the Hartford museum, identical to the painting in Raleigh (see [36] *Related Works).* There is no proof, however, that the two compositions were together in the eighteenth century. In fact, not only were the paintings separated in the sale of 1876 and acquired by two different collectors, but they were judged not to be companion pieces by the expert, Jean Féral.

39

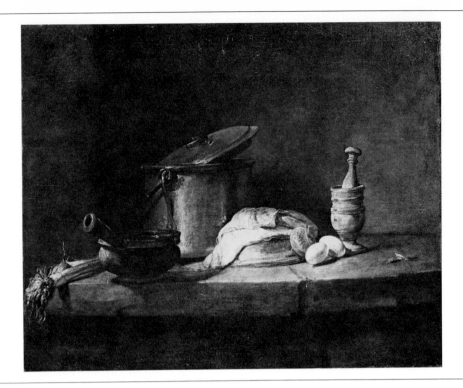

The painting in the Musée Jacquemart-André next belonged to the painter Philippe Rousseau, a great admirer of Chardin and the author of a tribute, *Chardin and His Models.* Shortly before Rousseau's death in 1887 Paul Eudel visited him in his studio, where he noticed a "robust still life by Chardin." Their conversation then turned to the painter. "Ah!" exclaimed Rousseau, "Chardin the great painter, the marvelous artist, the king of the realists! If you want to please me, always speak of Chardin in this way. He is my true master and no one will ever be able to express warmenough praise for this neglected man whom we have known and sincerely admired for such a short time. Chardin is one of the purest glories not only of France but of all Art." [Eudel, 1889, pp. 366, 369-70].

Few works by Chardin dated from 1732 have survived [see, however, the two small still lifes on wood in the Wyndham collection in England; Wildenstein, 1963-69, nos. 95 and 96, fig. 41 and 42]. Yet we must remember that the artist displayed "several other small paintings of utensils" that year at the Exposition de la Jeunesse [*Mercure de France,* July 1732, p. 1611]. Was the painting now in the Musée Jacquemart-André among these works? Was it this painting the Goncourts had in mind in their famous text [1863, p. 521]?:

"Nothing is too humble for his brushes. He dwells on the larder of the common man. He paints the deep kettle, the pepper box, the wooden mortar and pestle, the simplest pieces of furniture. No bit of nature is scorned. After an hour of study he will attack a quarter of mutton chops; and the blood, the fat, and the bones, the pearly surface of the nerves, the meat—his brush will express all that. His impastos exude, as it were, the quintessence of the flesh."

40 Leeks, Casserole, Copper Pot with Cover, Large Slice of Fish, Onion, Two Eggs, and Mortar and Pestle

(Poireaux, poêlon, marmite de cuivre, couvercle et large tranche de poisson, oignon, deux oeufs, égrugeoir avec son pilon)

Canvas, 32.5 × 40.5 cm. Signed at the lower right: *Chardin.*
Paris, Private Collection*

Provenance. Formerly in the Soulzbach collection.

Exhibitions. Never shown.

Bibliography. Unpublished.

Only one other version of this work is known, clearly the equal of this one in quality. Signed and dated 1734, it is preserved at Wanås

Castle in Sweden [Wildenstein, 1933, no. 1003, fig. 164; 1963-69, no. 137, fig. 50]. Count Sparre acquired it in Paris at the end of the eighteenth century [on Gustaf Adolf Sparre, see Hasselgren, 1974, p. 166 with ill.]. Its companion piece, a version of the Amiens painting [43], is also preserved at Wanås. The collection to which the painting presently under discussion belongs also includes a version

Wanås, Private Collection.

of the Indianapolis painting [42], signed and dated 17(32?); these two paintings, at some point after their completion, were paired—in our opinion, artificially.

Leeks, Casserole, Copper Pot with Cover... sums up the artist's intentions and originality. Chardin strongly lights certain objects, while others gleam in a half-light. And he uses short brushstrokes in just the right spots to give wood and copper their proper values, to shape the glazed earthenware pitcher, and to give mass to the two eggs. These small, apparently unambitious paintings—perfect when taken as separate pieces—are stylistic exercises on the same theme, echoing one another, like so many pieces of the same game, all aiming toward one end: absolute equilibrium, perfect construction.

41 *Pot, Earthenware Brazier, Casserole, Tablecloth, Cabbage, Bread, Two Eggs, Leek, and Three Herrings Hanging on a Wall*

(Nature morte avec chaudron, fourneau de terre, poêlon, nappe, chou, pain, deux oeufs, poireau, et trois harengs suspendus à la muraille)

Canvas, 42 × 33 cm. Signed on stone shelf: *J. B. Chardin.*
Amiens, Musée de Picardie

Provenance. In the collection of the brothers Ernest and Olympe Lavalard as of 1862, at which date this collection was installed in Paris. (Horsin-Déon, who described the Lavalard collection, could have advised the two brothers to acquire this painting, perhaps at the Barroilhet

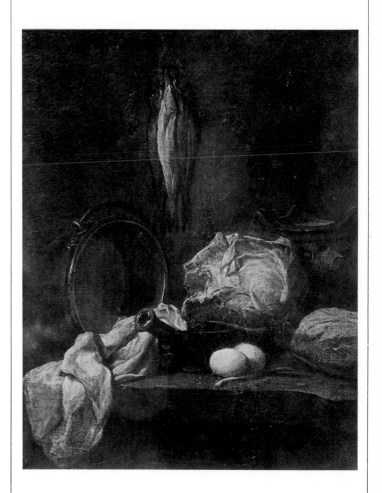

41

auction of 10 March 1859, where no. 12 was listed as "Still life: Herrings. Sketch," or at the first Camille Marcille sale of 12-13 January 1857, no. 18, "Herring and kitchen utensils.") In 1890 the painting was a Lavalard bequest to the museum at Amiens. In 1894 it entered the Musée de Picardie.

Exhibitions. 1949, San Francisco, no. 5 (ill.); 1961-62, Montreal, Quebec, Ottawa, and Toronto, no. 15 (with ill.).

Bibliography. Horsin-Déon, 1862, p. 145; Bocher, 1876, p. 95; Goncourt, 1880, p. 130; Gonse, 1900, p. 15; Guiffrey, 1908, p. 62, no. 34 (measurements reversed); Goncourt, 1909, p. 192; Furst, 1911, p. 119; Museum cat., 1911, p. 138 (error in dimensions); Ridder, 1932, pl. 42; Wildenstein, 1933, no. 894, fig. 148; Vergnet-Ruiz and Laclotte, 1962, pp. 84, 230; Wildenstein, 1963-69, no. 57, fig. 28; Foucart (*père*), 1977, pp. 43, 50.

Related Works. A second, very similar version, also signed but slightly smaller (38 × 30.5 cm.) may have been included, as far as one can guess from the vagueness of old sales catalogs, in the sales of the following collections: Charles Godegroy, 22 April 1748, no. 36; de Troy, 9 April 1764, no. 138; Caffieri, 10 October 1775, no. 15; Pasquier, 1 March 1781, no. 88; Boscry, 19 March 1781, no. 21; Aubert, 2 March 1786, no. 55; Calonne, 21 April 1788, no. 233; Sauvage, 6 — not 16 — December 1808, no. 27; and Barroilhet, 2-3 April 1860, nos. 98 and 101 (for the pendant). This picture seemed to reappear in the

Williamstown (Mass.), Sterling and Francine Clark Art Institute.

Williamstown (Mass.), Sterling and Francine Clark Art Institute.

Swedish collections of Wiens and Hagemann, before coming up for auction at Sotheby's on 19 March, 1975, no. 69. It is now at the Sterling and Francine Clark Art Institute of Williamstown, Massachusetts [Wildenstein, 1933, no. 893, fig. 123 and no. 917; Wildenstein 1963-69, no. 55, fig. 26]. But the Swedish picture could conceivably also be one of the "two domestic subjects" in the Tessin sale of 1786 (no. 3). The second, also now at Williamstown, shows an earthenware brazier, an earthenware casserole, and a kettle on stone table with a crumpled tablecloth and two onions—one of the few Chardin compositions for which there is no example in this exhibition [Wildenstein, 1933, no. 951, fig. 124 and no. 946; 1963-69, no. 54, fig. 25]. No other versions of this work are known to exist.

The work must date from the years 1731-1733: Chardin again used the same kitchen utensils, the same victuals, and rearranged them on the slightly curved stone ledge he often chose. Although the Amiens painting is not in perfect condition, many of its original refinements are still intact. The contrast between the elephant gray of the brazier and the cool gray of the tinned inside of the copper kettle endows the work with a soft and delicate harmony all its own.

42 *Napkin, Pitcher, Turnip, Copper Pot with Skimmer, Two Cucumbers, Cabbage, and a Bunch of Carrots on a Stone Shelf*

(Table de pierre avec une serviette, un pichet, un navet, un chaudron et son écumoire, deux concombres, un chou et une botte de carottes)

Canvas, 31 × 39 cm. Signed at the middle right: *Chardin.*
Indianapolis, Indianapolis Museum of Art

Provenance. Leroux sale (according to Stern cat.). Charles Stern sale, 8-10 June 1899, no. 319. Léon Michel-Lévy collection since 1899; Léon Michel-Lévy sale, 17-18 June 1925, no. 136. Art market, Paris, 1926-1936. In 1936 the painting was a gift of James E. Roberts to the Art Association of Indianapolis.

Exhibitions. 1926, Amsterdam, no. 19; 1929, Paris, no. 11; 1932, Paris, no. 176; 1933, Amsterdam, no. 51, pl. 48; 1934, Paris, no. 23; 1965, Columbus, no. 4.

Bibliography. Guiffrey, 1908, p. 84, no. 176; Pilon, 1909, p. 167; Furst, 1911, p. 127; Wildenstein, 1933, no. 1006 (not ill.); Tompkins, 1936, pp. 36-40, pl. on p. 37; Frankfurter, 1949, p. 93 (ill.); Museum cat., 1951, no. 31 (with ill.); Wildenstein, 1963-69, no. 53, fig. 24; Museum cat., 1970, p. 125 (with ill.).

Related Works. Wildenstein cataloged two other versions of this painting, known to us only in photographs. One of them was formerly in the Eudoxe Marcille collection [Wildenstein, 1933, no. 1005, fig. 140; 1963-69, no. 116, fig. 50], the other, cropped at the top, was formerly in the Henry de Rothschild collection [Wildenstein, 1933, no. 1020, fig. 120; 1963-69, no. 117, fig. 51]. We have found a third, slightly larger than the Indianapolis picture, signed and dated right of center *J. S. Chardin 17(32?)*, now in the same private collection in Paris as [40].

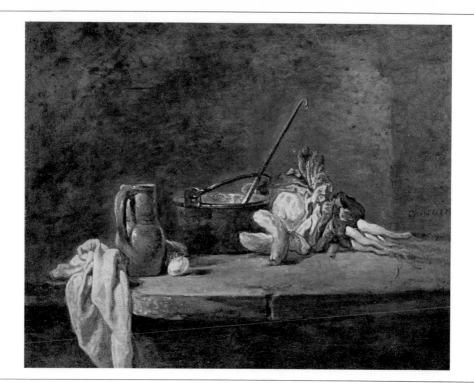

While Wildenstein placed the date between 1728 and 1730, we would suggest around 1732, which seems to be the date on one of the other known versions mentioned above. Moreover, we believe that Chardin began in 1730 to paint kitchen interiors of the most ordinary kind and to reduce the scale of the objects shown. Here he has increased his usual group of objects by two cucumbers. These two cucumbers also appear in a still life at The Frick Collection, New York [Wildenstein, 1963-69, no. 271, fig. 126], which seems to predate the Indianapolis painting by a few years. The Indianapolis painting and others of the same type surfaced only at the close of the nineteenth century. Our research failed to trace the earlier whereabouts of the paintings, mainly because early sales catalogs are too vague and seldom include dimensions in their descriptions. It may be assumed, however, that it was shortly after his marriage that Chardin began to produce this type of picture in increasing numbers for a thriving market of Parisian collectors. A case in point is the 1732 Exposition de la Jeunesse, where the artist showed "several...small paintings of utensils."

Paris, Private Collection.

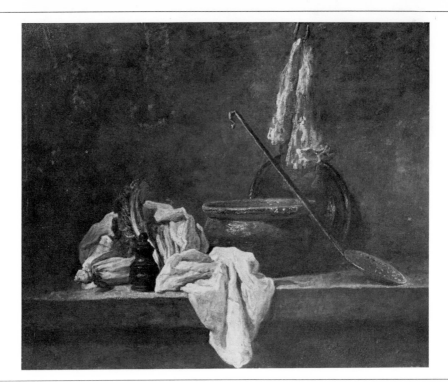

43 Beets, Spice Box, Dishcloth, Pot, Glazed Earthenware Plate, Skimmer, and Meat on a Hook

(Nature morte avec bettes, boîte à épices, torchon, terrine, plat en terre vernissée, écumoire et morceaux de viande pendus à un croc)

Canvas, 33 × 40.5 cm. Monogram at lower right: *c.d.*
Amiens, Mueée de Picardie

Provanance. In the collection of Ernest and Olympe Lavalard as of 1862, at which date this collection was installed in Paris. In 1890 it was a bequest of the Lavalard brothers, natives of Roye, to the Musée de Picardie; it entered the museum collection in 1894.

Exhibitions. 1931, Paris, no. 6; 1954, Sarrebrück and Rouen, no. 79 (with pl.).

Bibliography. Horsin-Déon, 1862, p. 145; Bocher, 1876, p. 95; Gonse, 1900, p. 15; Guiffrey, 1908, p. 62, no. 35 (dimensions reversed); Furst, 1911, p. 119; Museum cat., 1911, no. 139 (with wrong dimensions); Wildenstein, 1933, no. 955 (not ill.); Vergnet-Ruiz and Laclotte, 1962, pp. 84, 230; Wildenstein, 1963-69, no. 118, fig. 52; Foucart (*père*), 1977, pp. 43, 50.

Related Works. There are two other versions, one which came to Sweden in the late eighteenth century and is now at Wanås Castle [Wildenstein, 1933, no. 954; 1963-69, no. 138, fig. 60; for its first Swedish owner, Count Gustaf Adolf Sparre, see Hasselgren, 1774, p. 166, ill.] where it serves as companion piece to another version of [40], signed and dated 1734. The second was formerly in the Henry de Rothschild collection and is now in another private collection in Paris [Wildenstein, 1933, no. 956, fig. 170; 1963-69, no. 107, fig. 46, listed as destroyed during World War II]. Its date, once read as 1721, then as 1727, is impossible to decipher.

Wanås, Private Collection.

One version of this composition is dated 1734; but we should not conclude from this date that all three known examples were painted in the same year, particularly in view of the fact that Chardin repeatedly painted similar compositions—such as *A Loin of Meat* [35] and *Ray-Fish and Basket of Onions* [36]—over a period of more than ten, perhaps even twenty, years.

The Amiens canvas is most skillfully executed. Chardin's highly individual technique of painting with thick layers of crumbly paste which lend weight to each object and catch the light (as well as dust, making it very tricky to clean the paintings) leads here to a particularly satisfying result. Works like the Amiens painting and others of its type were so often repeated by Chardin that one might mistake them for series production. Their originality resides precisely in Chardin's unique technique combined with his great care in constructing their pictorial space.

44 *Pitcher and Cover, Copper Pot, Napkin, Three Eggs, Wicker Basket, Slice of Salmon on a Pot Cover, Leek, and Crock on a Stone Shelf*

(Table de pierre avec un pichet et son couvercle, un chaudron, une serviette, trois oeufs, un panier d'osier, une tranche de saumon posée sur un couvercle, un poireau et une terrine)

Canvas, 40.5 × 32.5 cm. Signed on stone shelf to the right of the napkin: *J. S. Chardin.*
Edinburgh, National Gallery of Scotland*

Provenance. Collection of Alexis Vollon, son of the painter Antoine Vollon (1833-1900), the "Chardin of the nineteenth century." (For another painting belonging to Antoine Vollon, see [48].) Acquired in 1908 from W. B. Paterson, Scottish dealer estalished in London.

Exhibition. 1907, Paris, no. 67 (or 68).

Bibliography. Guiffrey, 1908, p. 90, no. 221; Museum cat., 1920, no. 959; Ridder, 1932, pl. 59; Wildenstein, 1933, no. 952, fig. 147; Denvir, 1950, pl. 39; Museum cat., 1957, p. 46, no. 959; Seznec, 1962, p. 25 (with ill.); Museum cat., illustrations, 1965, p. 16A; Wildenstein, 1963-69, no. 50, fig. 22; Museum cat., 1970, p. 13, no. 959; Wright, 1976, p. 37.

Wildenstein placed the date of this little-known and seldom-exhibited painting between 1728 and 1730. We prefer to suggest 1734, for it has striking similarities to the painting at Wanås (see [40]) dated 1734. The subject matter becomes humbler, the lighting softer, expressed in subtler tonalities and eliminating the shadows. Gone are the thick layers of impasto as Chardin turns toward an art of delicate nuances. His repertory of objects seems to expand: here he has added a tureen and wicker basket. The com-

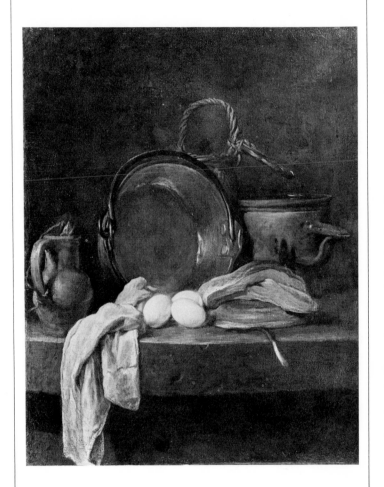

44

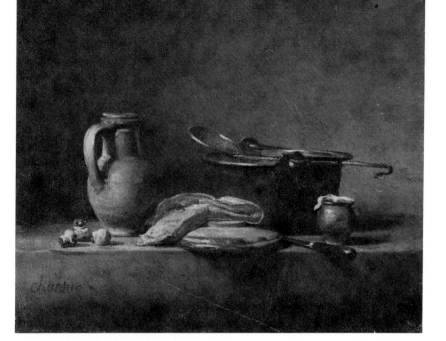

position remains crowded, the objects overlap and are placed in the foreground, very close to the viewer. Only considerably later would Chardin begin to show his objects from a greater distance and give growing importance to the space that surrounds and, above all, dominates them.

45 Three Mushrooms, Pitcher, A Slice of Salmon on an Overturned Earthenware Plate, Copper Pot with Skimmer, Knife, and Small Covered Stoneware Pot

(Un chaudron avec son écumoire, une cruche, une tranche de saumon posée sur une assiette de terre retournée, un couteau, un petit pot de grès bouché et trois champignons de Paris)

Canvas, 32.5 × 40 cm. Signed at the lower left: *Chardin*.
Paris, Musée du Louvre, M.N.R. 716

Provenance. L. Paraf collection, Paris, 1928 (?). Georges Renaud collection; "sold" to the Düsseldorf Museum during World War II (no. 571); returned by Germany after the war. Assigned to the Louvre by the *Office des Biens privés* in 1951.

Exhibitions. 1926, New York, no. 14 (with pl.); 1927, Chicago, no. 13; 1933, Amsterdam, no. 55, pl. 50; 1934, London, no. 25.

Bibliography. Wildenstein, 1933, no. 957, fig. 114; Wildenstein, 1963 ("A.MM. Wildenstein, New York"); Wildenstein, 1969 ("private collection"), no. 114, fig. 48(?); Rosenberg, Reynaud, Compin, 1974, no. 125 (ill.); Faré, 1976, p. 159, fig. 243 ("private collection")(?).

X-radiographs of this work reveal clearly that the pitcher originally stood more to the left, the slice of salmon was placed more vertically, the copper pot rested on its side in a position similar to that seen in the painting at the Musée Cognacq-Jay [52], and finally, the skimmer leaned at an upright slant against the pot. These modifications, visible to the unaided eye, prove beyond doubt that

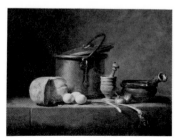

The Hague, Mauritshuis.

the work is indeed from Chardin's hand. It may originally have been intended as a pendant piece to *Corner of a Table* at the museum in The Hague [Wildenstein, 1963-69, no. 143, fig. 62; bequeathed in 1947 by Dr. A. Bredius with a provision that forbids its loan] which has the same dimensions and dates unquestionably from the same period—around 1732, in our opinion.

To identify the Louvre canvas from descriptions in old sales catalogs is difficult, but the following sales are offered cautiously: Vidal, 11 December 1804, no. 8, "two pictures of kitchen utensils, fish, vegetable and fruit, etc..."; Houzé de Grandchamp, 6 July 1809, no. 70, "a picture representing fish" (30 × 40 cm.); Sylvestre, 28 February-25 March 1811, no. 18, summary description of three paintings with "fish"; Gruel, 16-18 April 1811, no. 5, "four other paintings, fish, fruit, vegetable, and household utensils." In none of these sales is there any allusion to the slice of salmon which appears in the Louvre painting as well as in [44, 46, and 47].

At first glance, the small Louvre painting disappoints, but it gains considerably when contemplated at length. Its strength lies in its sober composition, soft gray light, and the lively harmonizing of the green of the overturned plate with the rose of the slice of fish and the velvety quality of the soot on the outside of the copper pot.

46 *Copper Pot with Oil Cruet, Cheese, Kitchen Knife, Pepper Box, Slice of Salmon, Four Mushrooms, Water Pitcher, and Bowl*

(Marmite de cuivre avec une burette d'huile, un fromage entamé, un couteau de cuisine, une poivrière, une tranche de saumon, quatre champignons de Paris, un pot à eau et une écuelle)

Canvas, 27 × 36.5 cm. Signed at the upper right: *Chardin*. Only traces of a date are visible.
Paris, Private Collection

Provenance. Collection of Jules Burat as of 1856 [Eudel, 1886; Burat is said to have acquired it for 355 francs]; sale after Burat's death, 28-29 April 1885, no. 35 (illustrated with an engraving by G. M. Greux). Collection of Laurent-Richard; sale after his death, 28-29 May 1886, no. 5 (with ill.). Acquired by Brenot, Paris. Collection of Thierry de la Noue, Paris. Collection of Norman B. Woolworth, New York. Sale at Parke-Bernet, New York, 31 October 1962, no. 7 (with color ill.).

Exhibition. 1950, Paris, no. 7.

Bibliography. Annuaire des artistes et des amateurs, 1861, p. 130; Bocher, 1876, p. 95; Goncourt, 1880, p. 130; Mantz, 1885, p. IX; Eudel, 1886, pp. 353, 365; Eudel, 1887, p. 433; Guiffrey, 1908, pp.

47-48; Goncourt, 1909, p. 192; Wildenstein, 1933, no. 922, fig. 215; *Connaissance des Arts,* December 1963, no. 142, p. 115 (ill.); *The Connoisseur,* February 1963, no. 612, p. 141, ill. on p. 140; Wildenstein, 1969, p. 242.

Prints. An engraving by Gustave-Marcel Greux (1838-1919) was listed in the 1885 Burat sale catalog. Ch. Normand surely used this same engraving, before any lettering, to illustrate his book on Chardin (1901), p. 28.

Although Wildenstein counted this work among the category of "doubtful or forged works, or those which we have not seen" in 1933 and did not catalog it in the 1963-69 editions, it can be attributed only to Chardin. A frieze-like composition, the use of relatively thin pigment and, above all, a color scheme which, though vivid, seems to bathe everything in the pale, cool light of a winter morning endow these spare works with a character and discreet charm all their own. Chardin, having already undertaken his first figure paintings, seemed to approach his still lifes with an eye more attuned to the importance of light. But he did not long persist in this vein, turning instead to the warm colors and brilliant copper kettles of his most perfect still lifes — his last, we believe, before the final blooming some twenty years later.

47 A Pitcher with Cover, Two Eggs, a Casserole, Three Herrings Hanging on a Wall, a Copper Pot, a Slice of Fish on a Pot Cover, and a Jug on a Stone Ledge

(Table de pierre avec un pichet et son couvercle, deux oeufs, un poêlon, trois harengs pendus à la muraille, un chaudron de cuivre, une tranche de poisson posée sur un couvercle et une cruche)

Canvas, 32 × 39 cm. Signed on the ledge at lower left: *Chardin.* Oxford, Ashmolean Museum

Provenance. Anonymous sale at Christie's on 23 January 1920, no. 14. Collection of Mrs. W. R. R. Weldon. Gift of Mrs. Weldon to the Ashmolean Museum in 1927.

Exhibitions. 1925, Norwich, no. 9; 1954-55, London, no. 185 (two other versions cited in the catalog were confused with the one now in New York; see *Related Works*).

Bibliography. Denvir, 1950, pl. 34; London exh. cat., Whitney collection, 1960, no. 11; Museum cat., 1962, p. 33, no. 91, pl. 37; Wright, 1976, p. 37.

Related Works. Another version, identical but slightly larger, is in the collection of John Hay Whitney, New York. It is signed in the shadow cast by the stone ledge. We know it only by photograph, but it seems weaker than the Ashmolean painting.

New York, Private Collection.

Wildenstein does not catalog this work, and dates the New York version in the Whitney collection around 1731, based upon its similarities to the *Fast-Day Meal* at the Louvre. In our opinion, however, the Oxford version is not only authentic but also is at least as fine in quality as the one in New York. The date suggested by Wildenstein is clearly more convincing than that proposed by Denvir (1762?), though perhaps a little too early. The execution is pastier and less nervous than that of the *Fast-Day Meal* and approaches that of Chardin's first figure paintings.

The objects are placed on a thick, slightly curving stone ledge which casts the darkest shadows in the canvas. The background wall, also faintly curved, echoes the curve of the ledge, although slightly shifted. Such variations allow Chardin to alternate areas of shadow and light. The light comes from the left — as it does in almost all Chardin paintings of this period — and hits the usual, cleverly arranged assortment of pitcher, casserole, pot, and jug, enlivening the darks greens, browns, or golden yellows of copper and glazed earthenware. The brightness of the herring, eggs, and slice of salmon punctuates the harmony of warm and somber tones.

Chardin preferred rounded objects — swelling jugs and pots; the round, but obliquely seen rim of the pot resting on its side, with the half-circle of its handle; the oval shapes of eggs. But a deeper reason behind this preference for cylindrical forms lies in the fact that Chardin was, above all, a constructor who was sensitive to the perfect balance of his works. Desiring to be neither a theoretician nor a cold geometrist, he wanted to give an effortless appearance to even his most studied, most calculated compostions.

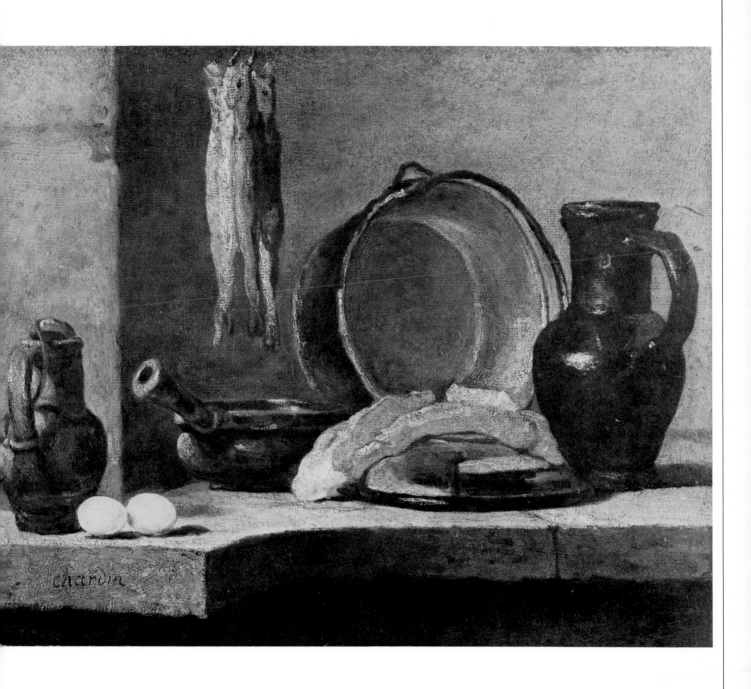

47

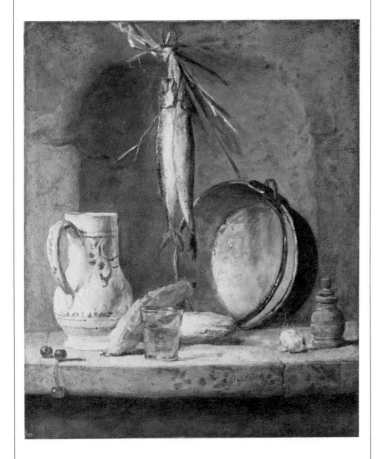

48 *Faience Pitcher, Three Cherries, a Half-Filled Water Glass, Two Cucumbers, a Brass Pot, a Turnip Next to a Pepper Box, and Two Herrings Tied with Straw to a Nail Before a Niche*

(Nature morte avec un pichet de faience, trois cerises, un verre d'eau à demi-plein, deux concombres, un chaudron de cuivre jaune, un navet près d'une poivrière et deux harengs accrochés par de la paille à un clou devant une niche)

Cnavas. 41 × 33.6 cm. Signed at the lower right on edge of stone shelf: *Chardin.*
The Cleveland Museum of Art, Purchase, Leonard C. Hanna Jr. Bequest. 74.1

Provenance. Benoist sale, 30 March 1857, no. 12 (description without dimensions). M.R. sale, 28 April 1860, no. 12 (description without dimensions). Collection of Henri Viollet of Tours, 1873; sale, 22 December 1881 (?; we can only identify this in the sale cat. with no. 134, "Vase of flowers, canvas 41 × 27"). Mame collection, Tours; Mame sale, 26-29 April 1904, no. 7 (ill. p. 22). In the collection of the painter Alexis Vollon (1865-1945) at least between 1904 and 1909. David David-Weill collection, 1925-1947. Sydney J. Lamon collection, New York; sale at Christie's, London, 29 June 1973, no. 21 (ill.). Purchased by The Cleveland Museum of Art in 1974.

Exhibitions. 1873, Tours, no. 501; 1907, Paris, no. 68; 1947, New York, no. 9; 1975, Cleveland, no. 46 (ill.).

Bibliography. Dayot and Vaillat, 1907, pl. 19; Guiffrey, 1907, p. 102; Tourneux, 1907, p. 98; Frantz, 1908, p. 29 (ill.); Grautoff, 1908, p. 498; Guiffrey, 1908, p. 90, no. 220; Pilon, 1909, p. 168; Furst, 1911, pl. 38 (listed as belonging to the National Gallery of Scotland, due to confusion with [44], also once part of the Alexis Vallon collection; Henriot, 1925, p. 2; Henriot, 1926, pp. 35-37 (repr.); Wildenstein, 1933, no. 896, no. 125 (and no. 898); Wildenstein, 1963-69, no. 272, fig. 127 (and no. 56, fig. 27: in the English edition of this work Wildenstein admits confusion of no. 56 with no. 272); *Country Life,* 16 August 1973, p. 434 (ill.); Clark, 1974, pp. 309-14, color cover and figs. 3, 4 (details); *The Bulletin of The Cleveland Museum of Art,* March 1975, pp. 78, 98.

See [49] for discussion.

48

49 *Faience Pitcher, Three Cherries, a Half-Filled Water Glass, Two Cucumbers, a Brass Pot, a Turnip Next to a Pepper Box, and Two Herrings Tied with Straw to a Nail Before a Niche*

(Nature morte avec un pichet de faïence, trois cerises, un verre d'eau à demi-plein, deux concombres, un chaudron de cuivre jaune, un navet près d'une poivrière et deux harengs acccrochés par de la paille à un clou devant une niche)

Canvas, 39 × 35 cm. Signed at the lower right on edge of stone shelf: *Chardin.*
Paris, Private Collection*

Provenance. M.D.M. [Michaux] sale, 11-13 October 1877, no. 59. Collection of Mme Edouard Michel. David David-Weill collection since 1926.

Exhibitions. 1947, New York, no. 10; 1950, Montreal, no. 19.

Bibliography. Henriot, 1925, p. 2, pl. III; Henriot, 1926, pp. 39-40 (repr.); Wildenstein, 1933, no. 897, fig. 126; Furst, 1940, p. 16 (repr.); *Art Digest*, 1 November 1947, p. 12; Wildenstein, 1963-69; no. 273, fig. 128; Clark, 1974, p. 314, note 3.

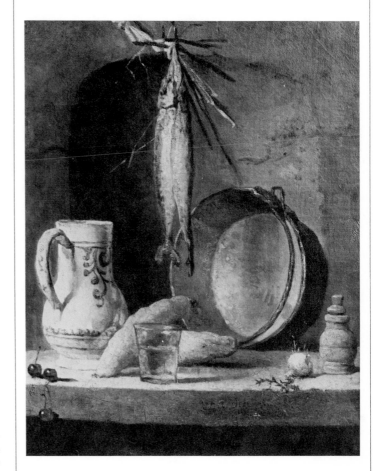

To establish a date for these two handsome still lifes in Cleveland and Paris is a ticklish problem. We need only remember that a confusion by Furst (1911) had once misled Wildenstein (1963) into believing that this composition existed in three very similar versions and that he cataloged the Cleveland canvas under two separate numbers for which he suggested two vastly different dates — one "around 1728?" and the other "close to 1758 (the same date he suggested for the Paris version). We tend to concur with Carol Clark (1974), who places the date of the Cleveland picture around 1738, though we suspect it may be a little earlier (1734 at most?). We see the habitual repertory of shapes arranged with habitual care: the herrings with their silvery bellies and steel-blue backs, the brass pot (the same as in the painting at the Cognacq-Jay Museum), the pepper box. Two cucumbers are added (already familiar from the still life in The Frick Collection), as are three freshly plucked cherries — one of them dangling over the table edge by its stem — and a pitcher of coarse ceramic with blue decorations. The latter object occurs nowhere else in Chardin's oeuvre.

Compared to Chardin's other early still lifes done shortly after 1730, these two pictures surprise by their golden luminosity. The harmonious composition breathes air; light (in the half-filled water glass) and shadows play the primary part. The treatment is more interesting, the impastos more marked. The two works are less grandly austere and exude a spring-like joy that is quite unusual for Chardin.

The Cleveland version differs little from its duplicate in Paris, and both were once part of the David-Weill collection. In the Paris

49

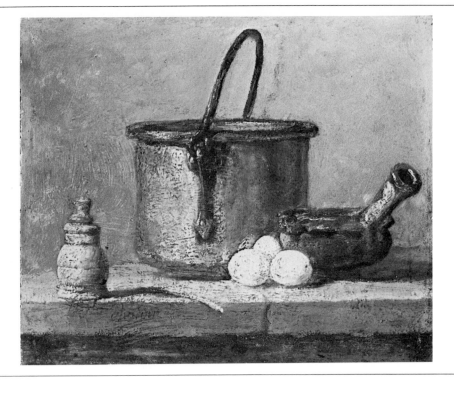

version the signature appears slightly closer to the center, the turnip still has it leaves, and the objects generally seem to appear to the viewer at a somewhat closer range. As with the copper kettle paintings at Detroit and the Louvre, we are eager to exhibit nearly identical versions side by side, hoping to draw the viewer into a fascinating and rewarding confrontation.

In any event, Chardin's frequent repetitions underline one of the characteristics of his still lifes: his abiding concern for compositional structure and for the most perfectly balanced arrangement of objects — chosen as much for their forms as for what they evoke at first glance — combined with his interest in playing voids against solids, in pitching objects against their surrounding space, be it in frieze-like compositions or, as here, in a pyramidal structure. Once he had come to terms with a problems of this nature, Chardin would set about painting his picture and, if he were satisfied (or had been commissioned), would then repeat it.

Inscription on the back of the Detroit picture.

50 *Tinned Copper Pot, Pepper Box, Leek, Three Eggs, and a Casserole on a Table*

(Chaudron de cuivre rouge étamé, poivrière, poireau, trois oeufs et poêlon posés sur une table)

Wood (oak?), 17 × 21 cm. Signed at the lower left on edge of table: *Chardin.*
Detroit, The Detroit Institute of Arts

Provenance. The work could be one of the "three small pictures painted on panel by said Sieur Chardin, representing kitchen objects and framed in gilded wood, estimated at 30 *livres* altogether" which appeared in the 1737 inventory of Marguerite Saintard, Chardin's first wife, who died in 1735. Collection of Antoine de La Roque (?). Sale after La Roque's death, in May 1745, no. 75, describes "two small pictures, 6 *pouces* high by 7½ *pouces* wide, painted by M. Chardin and representing various

kitchen utensils," estimated at 30 *livres*, acquired by 'Delpêche.'" It was certainly the painting with pendant acquired for 36 *livres* by the German-born engraver Jean-Georges Wille (1715-1808); a handwritten inscription in pen on the back reads "In the cabinet of J. G. Wille, engraver to the king." Missing from the Wille sale of 1784. Léon Dru collection [according to Guiffrey, 1908; incidentally, Dru—a civil engineer who died in 1904—bequeathed to the State the monies which permitted the Louvre to acquire Chardin's *Young Man with a Violin* (63) and *Child with a Top* (75)]. Count de Castel (according to the San Francisco catalog of 1934). In the collection of Mme Léon Kleinberger between 1907 and 1934. Acquired by Robert H. Tannahill in 1935. Gift of Robert H. Tannahill to The Detroit Institute of Arts in 1970.

Exhibitions. 1907, Paris, no. 15; 1934, San Francisco, no. 25 (ill.); 1970, Detroit, p. 27 (color pl. on p. 28).

Bibliography. Wille, 1857, I, p. 141 (the passage in Wille's *Journal* is quoted by all early authors—Chennevières, 1888; Dilke, 1899; Normand, 1901; Pilon, 1909—but the Detroit painting is not mentioned); Guiffrey, 1908, pp. 72, 81, no. 157; Furst, 1911, p. 126; Wildenstein, 1933, no. 999 (not ill.); Wildenstein, 1960, p. 2; Wildenstein, 1963-69, no. 119 (not ill.); Cummings-Elam, 1971, p. 117.

See [51] for discussion.

51 *Tinned Copper Pot, Pepper Box, Leek, Three Eggs, and a Casserole on a Table*

(Chaudron de cuivre rouge étamé, poivrière, poireau, trois oeufs et poêlon posés sur une table)

Wood (oak), 17 × 21 cm. Signed at the lower left on edge of table: *Chardin*.
Paris, Musée du Louvre, M. I. 1045*

Provenance. Possibly Marguerite Saintard (1737) and Antoine de La Roque (1745); see [50]. Count d'Houdetot sale of 12-14 December 1859, no. 22, *Un chaudron, un pot, des oeufs, une poivrière* ("A kettle, a pot, some eggs, a pepper box"). Barroilhet sale, 2-3 April 1860, no. 100, *Le petit chaudron de cuivre rouge* ("The small copper pot"). M. Cournerie in 1860 (see *Exhibitions*). Collection of Dr. Louis La Caze (1798-1869); bequest to the Louvre in 1869.

Exhibitions. 1852, Paris, no. 208 ("Ustensile de cuisine" signed "Chardin to M.xxx") (?); 1860, Paris, no. 367; 1960, Paris, Louvre, no. 577; 1969, Paris, La Caze collection, p. 10 (122).

Bibliography. Museum cat. (La Caze), 1871, no. 184; Bocher, 1876, p. 87, no. 184; Goncourt, 1880, p. 129; Chennevières, 1889, p. 129; Normand, 1901, p. 40; Guiffrey, 1908, p. 72, no. 92; Goncourt, 1909, p. 190; Pilon, 1909, p. 166; Furst, 1911, p. 123; Museum cat. (Brière), 1924, no. 116; Ridder, 1932, pl. 30; Wildenstein, 1933, no. 998, fig.

155; Jourdain, 1949, pl. 2; Rosenberg, 1963, pp. 65-66 (color pl.); Wildenstein, 1963-69, no. 139, fig. 61; McCoubrey, 1964, fig. 12; Rosenberg, Reynaud, Compin, 1974, no. 139 (ill.); Paulson, 1975, p. 107, fig. 60.

In his diary entry for 14 August 1760, J. G. Wille wrote: "I have purchased two small paintings by M. Chardin; on one there is an inverted pot, some onions, and various other items; on the other, a pot, a casserole, and other objects, very nicely executed, 36 *livres;* that's cheap, so they let me have them as a favor." [*Journal* published by Duplessis in 1857, I, p. 141]. That one of these paintings is now in Detroit is confirmed by the old inscription on the back of the panel (see [50], *Provenance*). Could *Mortar and Pestle...* in the Musée Cognacq-Jay [52], which appears to have been an isolated example of the theme, be the American painting's companion piece? There is no proof to the contrary. Neither is there any evidence to support this hypothesis which Wildenstein rejected in 1960 but then defended in 1963 and again, even more strongly, in 1969.

The second point is harder to prove. There were two small panels of "kitchen utensils" the size of the paintings now in Detroit [50], the Louvre [51], and the Musée Cognacq-Jay [52] at the May 1745 sale of the Chevalier Antoine de La Roque, one of the first Chardin enthusiasts. An attempt has been made to identify the Louvre painting with one of the works at the La Roque sale. Wille, for his part, is supposed to have bought his paintings directly from Chardin. The text of his diary, however, not only fails to confirm this but also suggests quite the contrary: "so they let me have them as a favor." Could one not propose a different, admittedly fragile, hypothesis? The La Roque paintings sell for 30 *livres* in 1745. They are acquired by a certain "Delpèche" — could it be the banker Despueschs, owner in 1745 of *The Game of Goose* and *The Card Trick* which Surugue had engraved the preceding year, and whose name crops up again in connection with *The Governess* [83]? Fifteen years later, he — whoever he is — resells the paintings for 36 *livres* to Wille.

One might go so far as to propose that the three paintings of the Louvre, Detroit, and Cognacq-Jay museums are the *Attributes of Cooking,* "three small paintings done on wood" which were in Marguerite Saintard's estate inventory of 1737 and valued at 30 *livres.* However, given the present state of our knowledge of Chardin, there is no way to substantiate this.

Laboratory tests have been conducted at Detroit and at the Louvre on the three paintings. The x-radiograph of the piece at the Cognacq-Jay museum reveals some revisions and changes as well as a bold treatment and rapid execution. But the x-radiographs of the Louvre and Detroit paintings are fascinating. Chardin seems to have utilized pieces of a much larger wood panel here, as he also did for *The Copper Water Urn* [53]. Underneath the copper pot of the Louvre one can clearly see, to the left of the pepper box, the bare foot of a child and, in the upper part of the painting, a hand. Acanthus leaves, spheres, and volutes can be discerned beneath the painting in Detroit. Had Chardin made use of the surface of one of his older compositions or that of the work of another artist? It is not possible to say, but by examining other Chardin paintings executed on wood around the same time, one might perhaps be able to "reconstitute" the original painting.

Wildenstein dates the Detroit and Cognacq-Jay paintings about 1732 and the Louvre one "around 1734." This second date seems the most convincing for all three works, since they are the product of an extremely bright palette — something new for Chardin.

The Detroit painting is not well known. Rarely exhibited, it is even more rarely reproduced. (It is not reproduced in the several editions of Wildenstein and seems to have been confused, through some error in the arrangement of the entries, with one of the kitchen still-life paintings of the Amiens type [43]. It has been relatively inaccessible from the beginning of the century, and only since its entry into the Detroit museum in 1970 has it become available for study. Its exhibition alongside the Louvre version, which is very similiar in quality, should bring it the popularity it deserves.

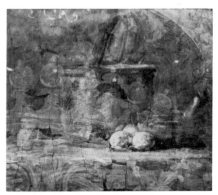

X-radiographs of the paintings at Detroit, the Louvre, and Cognacq-Jay museums.

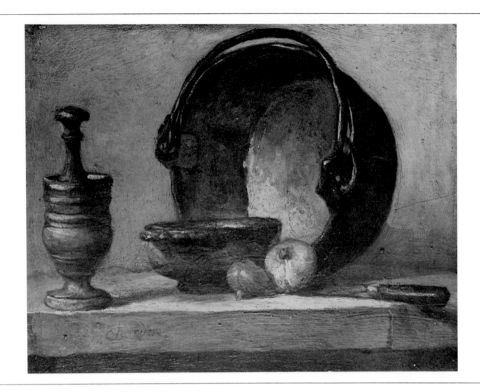

See Color Plate VI.

The Louvre painting, which presents only variations in detail when compared with the Detroit version (the handle of the copper pot seems to have been rendered in a colder, more metallic color), is, of course, much better known. Does it predate the American painting? Comparison of the two works, hopefully, will make it possible to decide.

As usual, Chardin takes up his brushes only when he has completed the arrangement of his painting. With meticulous but unsystematized care he puts each object in its place, skillfully playing on the convex and concave forms, spacing them on the canvas with a consummate sense of rhythm. Lest the table edge appear too flat and monotonous, the artist places a leek on it. The table edge is slightly shaded. The white stem of the leek and its darker shadow stand out against it, while the green portion — the only harsh and acidic note in the entire piece — lies on a luminous table which brightens all the objects. The color scale, from the grayish white of the eggs — reflected on the pot — to the reddish browns of the pot, from the copper color of the wooden pepper box to the elephant gray of the handle and the saucepan — set off against a neutral background — is warm, sensual, like the material, rugged and savory. Neither virtuosity nor coldness infect this formal perfection. And therein lies the greatness of Chardin. The modest, silent world of Chardin — the world of the humblest objects and of familiar scenes — retains its humanity and its warmth.

52 Mortar and Pestle, Bowl, Two Onions, Copper Pot, and Knife

(Egrugeoir avec son pilon, un bol, deux oignons, chaudron de cuivre rouge et couteau)

Wood (oak), 17 × 20.5 cm. Signed at the lower left on edge of table: *Chardin.*
Paris, Musée Cognacq-Jay

Provenance. Possibly Marguerite Saintard (1737), La Roque (1745), and Wille (1760) (see [50], *Provenance*). It is to be noted, however, that unlike the painting in Detroit, the Cognacq-Jay work does not carry any inscription on the back of the panel. In the Léon Michel-Lévy collection as of 1907; Léon Michel-Lévy sale, 17-18 June 1925, no. 135 (ill.). Acquired by Stettiner. Ernest Cognacq collection; given to the city of Paris in 1928.

Exhibitions. 1951, Paris, no. 33 (?); 1954, Rotterdam, no. 51; 1955, Zurich, no. 67; 1959, Paris, no. 18 (cover ill.).

Bibliography. Guiffrey, 1908, p. 84, no. 175; Furst, 1911, p. 127; Museum cat. (Jonas), 1930, p. 13, no. 19; Wildenstein, 1933, no. 1000, fig. 150 (according to 1963-69 ed., no. 1026); Pilon, 1941, p. 63 (ill.); Wildenstein, 1960, p. 2; Barcelo, *Vie des Arts*, 1960, p. 42, no. 21; Garas, 1963, pl. 31; Rosenberg, 1963, pp. 66-67 (color pl.; also the jacket); Wildenstein, 1963-69, no. 101, fig. 43; Lazarev, 1966, pl. 13; Valcanover, 1966, pl. 15 (color); Demoris, 1969, p. 368; Burrolet, 1973, p. 7, fig. on p. 2; *Chefs-d'oeuvre de l'Art. Grands Peintres,* 1978, pl. 15.

With regard to the provenance, x-radiographic analysis, and probable dating (1734-1735?) of this painting, see [50 and 51].

The Cognacq-Jay painting is the companion piece either of the Louvre painting or, more likely, of the one in Detroit. The mortar corresponds to the pepper box, the onions to the eggs, the bowl to the casserole, the knife to the leek. The copper pot is resting on its side (an arrangment which accentuates the sense of depth in the composition) so that its untinned copper interior can be seen. The single cold note in the work is the handle of the knife.

Paintings done on wood are rare for Chardin; *The Water Urn* of Stockholm [55], dated 1733, and a small-scale version of *Lady Sealing a Letter* [54], also dated 1733, seem to indicate that at this point in his career Chardin was considering the use of this new material. Although the objects are those Chardin had been painting since 1730, there is innovation in the richness of the pictorial matter and in the color scale which becomes brighter and warmer. The color scale heralds that of *The Embroiderer* [68] and *Young Student Drawing* [69], small figure paintings that are also on wood but seem to be a little later than the Cognacq-Jay painting.

The usual objects painted by Chardin all refer to the kitchen. The artist arranges them in relationships intended to set them off to best advantage and confers upon them a presence which makes it easy to understand why attempts have sometimes been made to interpret his paintings as so many *vanités* (commentaries on the futility of worldly pleasures). But if it is difficult to give a metaphysical dimension or symbolic meaning to such works, it would be just as wrong to see in them only stylistic exercises, pure plastic constructions. Chardin is able here, as in his other domestic scenes, to bring to bear on ordinary objects a gentle, kindly regard that impels the spectator to contemplation.

53 *The Copper Water Urn*

(La fontaine de cuivre)

Wood (oak) on two boards joined vertically with the grain of the wood, 28.5 × 23 cm. Signed toward the bottom left: *Chardin*.
Paris, Musée du Louvre, M.I. 1037*

Provenance. Possibly one of the "three little paintings done on wood... representing kitchen attributes" from the 1737 estate inventory of Marguerite Saintard, Chardin's first wife. Sale of the painter J. B. [actually J. F.] de Troy (1679-1752), 9 April 1764, no. 137 (39 *livres*); one of the four Chardin works in this sale was "An artistically executed painting, representing a brass water urn on its wooden base, a bucket, a long-handled saucepan, a glazed clay pitcher with handle, on a wooden surface 27.7 × 21.6 cm." Sale of Mme la présidente de Bandeville, 3 December 1787, no. 52 (20 *livres*). M. du C. sale, 30 April-2 May 1791, no. 147. Collection of Dr. Louis La Caze (1798-1869) since 1860; given to the Louvre in 1869.

Exhibitions. 1860, Paris, no. 363; 1960, Paris, no. 567; 1969, Paris, La Caze collection, p. 10 (122).

Bibliography. Mantz, 1870, p. 17; Museum cat. (La Caze), 1871, no. 176; Bocher, 1876, p. 86, no. 176; Chennevières, 1889, p. 127; Normand, 1901, pp. 40, 74, 96; Dorbec, 1904, p. 12; Guiffrey, 1908, p. 69, no. 75 (pl. between pp. 18 and 19); Pilon, 1909, pp. 58, 166; Furst, 1911, p. 122, no. 108; Museum cat. (Brière), 1924, no. 108; Ridder, 1932, pl. 27; Wildenstein, 1933, no. 996, fig. 186; Florisoone, 1938, pl. 7 (color); Pilon, 1941, pl. on p. 4; Goldschmidt, 1945, fig. 18; Goldschmidt, 1947, fig. 21; Lazarev, 1947, fig. 6; Jourdain, 1949, pl. 49; Denvir, 1950, pl. 7; *Arts*, 4 January 1956 (ill.); Wildenstein, 1959, p. 100; *Revue du Louvre et des Musées de France*, 1961, 1 (color pl. between pp. 46 and 47); Zolotov, 1962, pl. 6; Garas, 1963, pl. 8; Rosenberg, 1963, pp 23, 60, 61 (color pl.), 62; Mittelstädt (ed.), 1963, p. 20, pl. on p. 21 (color); Wildenstein, 1963-69, no. 126, pl. 13 (color); Huyghe, 1965, p. 10 (ill.); Lazarev, 1966, pl. 9; Valcanover, 1966, pl. 2 (color); Demoris, 1969, p. 371 (pl. between pp. 368 and 369); Levey, 1972, pl. 143; Lazarev, 1974, fig. 6; Rosenberg, Reynaud, Compin, 1974, no. 140 (ill.); Kuroe, 1975, pl. 5 (color); *Chefs-d'oeuvre de l'Art. Grands Peintres*, 1978, pl. 2 (color).

Related Works. A replica of the same format but dull and muted in color and without any luminosity is preserved at the Barnes Foundation in Merion, Pennsylvania [probably identical with Wildenstein, 1933, no. 997; 1963-69, no. 127, not repr.].

A "water urn study," along with three other paintings by Chardin, appeared under the same number—7—at a sale (M.) held on 18 November 1803.

Wildenstein (1933) notes in a sale [Alexandre] of 27-28 November 1843 that a painting of "kitchen utensils," no. 11 (wood, 21 × 20 cm.), sold as a companion piece to no. 12, "bouquet of flowers," also on wood and of the same format. He supposes that a painting of *Kitchen Utensils* (wood, 16 × 20 cm.) exhibited in Paris in 1843 for the benefit of the inhabitants of Guadeloupe might be the Louvre painting. It has not been possible to check this information.

Finally, D. Carritt has kindly drawn attention to a painting in a London sale on 25-26 March 1765, no. 9, "A piece of still life with a still."

This painting elicited little comment at the 1860 Galerie Martinet exhibition organized by Philippe Burty. (Neither Thoré nor Théophile Gautier speak of it, and the Goncourt brothers do not take note of it even in their *Notules*.) Yet it did get noticed. For it

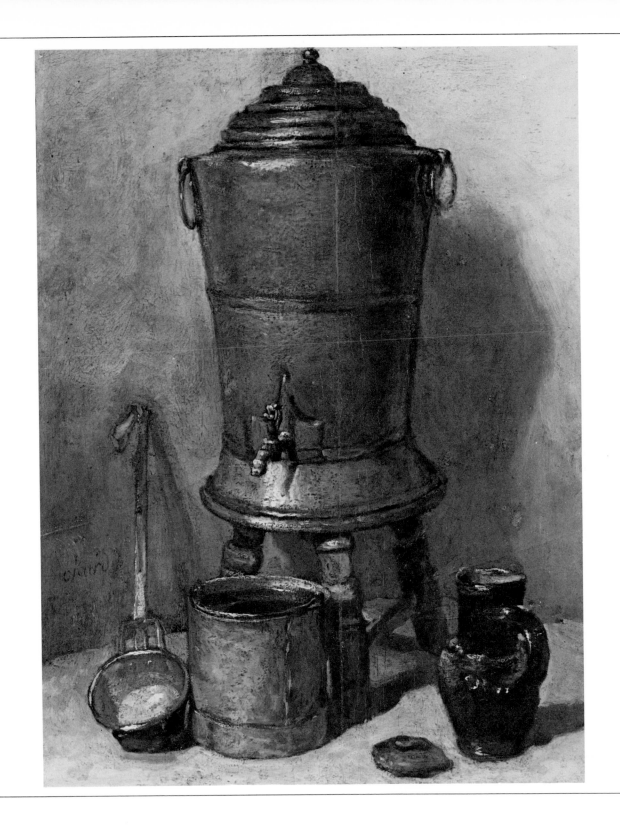

53

was very probably at that exhibition that François Bonvin (1817-1887) saw it and was directly inspired by it in painting his *Copper Water Urn,* dated 1861, which is now in the Louvre [Weisberg, 1970, p. 362, fig. 4]. Only gradually, however, did it become famous. To be sure, Paul Mantz mentions it in his article on the entry of the La Caze collection into the Louvre [1870, p. 17]: "That copper water urn so handsome and so gleaming... which was evidently a family possession.... There is in Chardin much to learn about the successful commingling of colors, the witty rugosity of manner, the perfect freedom of style." But it was only after the Franco-Prussian War that the painting became one of Chardin's most frequently copied works.

"A family possession" is precisely what the *Water Urn* was. Mention is made in the estate inventory of Marguerite Saintard 18 November 1737 (although she died in April 1735) of "a copper water urn equipped with its cover and rings, which are also of copper, containing two water compartments with its faucet of pinchbeck [a copper alloy] resting on wooden legs and valued at 25

X-radiograph of *The Copper Water Urn.*

livres." Chardin used this water urn in two of his best known compositions — first in the *Woman Drawing Water from a Water Urn,* two versions of which are exhibited here [55 and 57], in which it is turned slightly to the right — then in the background of *The Return from Market,* in two versions here [80 and 81], in which it is presented in profile. Can it be said, as one frequently reads today, that the Louvre painting is a study for the *Woman Drawing Water from a Water Urn?* That is extremely doubtful, because the work stands perfectly well by itself and because Chardin, as Mariette pointed out as early as 1749, did not usually prepare for his paintings with sketches or studies. Contrary to the practice of most of his

contemporaries, he painted them directly, after carefully arranging the objects or the persons he was representing.

From the point of view of style, *The Water Urn* is very close to the copper pot paintings of the Louvre, Detroit, and the Cognacq-Jay museums [50, 51, and 52], and must date, like them, from about 1734. Like those three paintings, it is done on wood. The artist used the length of two boards, and the x-radiography of the work makes it possible to distinguish another composition beneath the surface, as is also the case with the copper pot paintings at the Louvre and Detroit. On the right, a child's arm and a hand holding a round object which rest on a book are clearly visible. In the center, underneath the water urn, one can see less clearly the head of a bearded man. (The observations are the results of the examination conducted by Mme Fayant of the Research Laboratory of the Museums of France.) It seems likely that the pieces of wood used here were once part of the composition which has been discovered underneath the Louvre's copper pot painting, confirming, if confirmation is necessary, that they are truly contemporary.

The Water Urn is incontestably one of Chardin's most perfect works. Everything seems to fall into place naturally in this composition, which nevertheless is the fruit of mature consideration. The objects depicted have been chosen for their "humility" and, even more, for their forms and colors. The dark green of the pitcher and the yellow coppers of the saucepan stand out against the magnificent gray wall which closes the composition and deliberately deprives it of its depth. Never before has the relationship between space and objects been as thoroughly mastered. Never before has Chardin given in so little to them.

In the words of René Demoris, "By intervening so decisively, and sometimes so openly, in the arrangement of his models, Chardin regains a part of the *privilege of invention* to the advantage of the humble still life." Rejecting every superfluous detail, every anecdote, Chardin paints the essential, without intending to bestow on his work a symbolic value. Rejecting, too, illusion — the Oudry-style trompe l'oeil — and most especially instantaneity, he aims at the atemporal. It is this lesson above all which Cézanne retained.

V *Genre Scenes*

There is no need to repeat the anecdote relating how Chardin, the still-life painter, decided to devote himself to genre scenes. It seems certain that the decision was, once again, due to Aved's influence. The date of this conversion has often been debated, mainly because Cochin placed it "around 1737," whereas available evidence points to 1733 or perhaps even 1732. In any event, the Berlin painting of a *Lady Sealing a Letter* [54] is dated 1733, and Chardin showed several figure compositions at the Exposition de la Jeunesse of 1734.

In the same year, he painted for Rothenbourg *The Philosopher*, actually a portrait of his friend Aved [62]. In 1735, the year his first wife Marguerite Saintard died, he exhibited at the Academy "four excellent small pieces representing women going about their chores and a young boy playing with cards" [55, 56, 64, 65?], of which the *Mercure de France* wrote: "His knowing touch and the great truthfulness which prevails throughout, together with his uncommon understanding, were much admired." The official Salons, of which Chardin was to become one of the most faithful participants, were re-established in 1737. They allowed Chardin to show his work regularly and to receive critical acclaim year after year.

Between 1737 and 1773 Chardin exhibited forty-six figure compositions. This number calls for certain qualifications. First, Chardin sometimes showed the same painting at exhibitions that were several years apart. Thus his *Portrait of the Painter Joseph Aved* [62] was exhibited in 1737 and 1753; his *Scullery Maid* [79] in 1738 and most probably again in 1769. Furthermore, he showed the same compositions "with changes" at intervals of several years: *Saying Grace* [86, 89] appeared at the Salons of 1740, 1746, and 1761; *The Return from Market (see* [81]) in 1739 and 1769; *The Embroiderer* [68] and *The Young Student Drawing* [69] in 1738 and 1759. Therefore, the fact that a painting was presented at a Salon did not necessarily mean that its date was the same as the year of its exhibition. More and more often, Chardin chose to show his older pictures alongside recent works.

His genre scenes and figure compositions are sometimes signed as well as dated: [54], 1733; [55], 1733?; [62], 1734; [64], 1735; [72], 1737?; [76] and [77], 1737; [79] and [80], 1738; [81] and [83], 1739; and finally, [89], the replica of *Saying Grace* in The Hermitage, dated 1744, (the year of Chardin's second marriage to Françoise-Marguerite Pouget, widow of Charles de Malnoé).

All of this makes it impossible to deduce the date of Chardin's paintings from the date of the Salon exhibitions at which they appeared.

Fortunately, most of his genre paintings exhibited at the Salons were reproduced in engravings (except *Meal for a Convalescent* [92]). These prints were usually done soon after the picture was painted, though no generalization is possible. It was chiefly through such prints, which earned considerable income for the artist, that Chardin's compositions became widely known.

We have endeavored to include in this exhibition as many of the figure compositions shown at the Salons as possible; we have succeeded in assembling thirty-eight of them. Those which could not come — either because the rules of the institution to which they belong prohibit the loan or because the loans were refused — are listed in the Foreword. We have mentioned the fate of the Henry de Rothschild collection, destroyed during World War II, which included a *Scullery Maid* [79], *Girl Toying with Her Lunch*, and a *Child with the Attributes of Childhood* (Salon of 1737), as well as a version of the *Blind Man of Quinze-Vingts* (Salon of 1753). Certain other compositions have deteriorated (e.g., *The Housekeeper* [91]) or are known only through engravings or studio copies, such as the *Game of Goose, Card Trick* (Salon of 1743), *Portrait of Merchant Mahon's Little Daughter Playing with Her Doll* (Salon of 1738), and *Mme Le Noir Holding a Book* (Salon of 1743). With the exception of these works, we are able to include in this catalog one or several versions of each of Chardin's figure compositions. In some instances, several versions of the same subject are presented side by side: *Saying Grace*, [84, 85, 86, 89]; *The Return from Market*, [80, 81]; and *The Young Draftsman*, [76, 77]. This not only provides in most cases a first opportunity for close comparison but also poses the problem of repetition in Chardin's oeuvre — a question already raised by his domestic still lifes.

With respect to genre scenes, this problem becomes particularly acute and touches upon the central aspect of Chardin's creative process. Is the first version always the best? Are all replicas by Chardin's own hand? How did the artist proceed? We know from Mariette [1749] that he dispensed with drawing and painted directly from the model. As for his repetitions of still lifes, there is the rarely quoted testimony of Counsellor Georg Fleischmann (see discussion of [18, 108, 109]). We also know that Chardin invested a tremendous effort in each composition, according to the fascinating unpublished letters which Scheffer, the Swedish ambassador to Paris, wrote to his predecessor, Count Tessin (see [90]). But the reasons for such repetitions are unknown. The difference in quality among several versions of the same composition — a difference made striking in this exhibition — is difficult to explain.

Later in this catalog are reproduced the versos of copies of Chardin's *The Diligent Mother* and *Saying Grace* at Stockholm (see [84, 86]), both dating from 1741. It should be remembered that a "copy partially retouched by Chardin" (see [83]) appeared on the market in 1745 when the La Roque collection was dispersed. These instances prove that a flourishing trade in replicas existed during Chardin's lifetime, approved and encouraged by the artist himself.

It has often been asked who bought Chardin's genre scenes. A great many artists were among the first collectors of his still lifes, but his figure compositions attracted a

Girl Toying with Her Lunch.

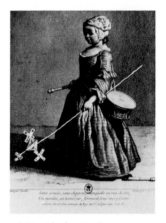

Child with the Attributes of Childhood.

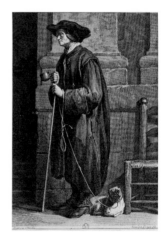

Blind Man of Quinze-Vingts.

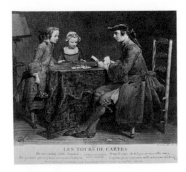

Card Tricks.

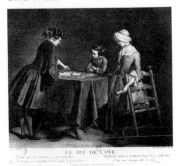

Game of Goose.

Portrait of Merchant Mahon's Little Daughter... .

Mme Le Noir Holding a Book.

different clientele. Except for *Saying Grace* [86] and *The Diligent Mother* [84], which Chardin offered to Louis XV in 1740, most of his figure compositions were bought for or commissioned by the courts of foreign princes: Prince Joseph Wenzel of Liechtenstein, Luise Ulrike of Sweden, Frederick II of Prussia, Catherine II of Russia. England seems to have been particularly early in acquiring Chardin's genre scenes [64, 70, 71, 76, 79, and possibly 70 and 71]. The *Mercure de France* protested in 1747: "It is annoying that M. Chardin's paintings, such as *The Water Urn, The Washerwoman,* and *The Morning Toilet,* disappear into foreign countries and are lost to us." In an unpublished 1746 letter which is quoted later, Chardin wrote in connection with the departure for Sweden of his *Domestic Pleasures* [90] that he hoped the painting would not leave France before an engraving could be made: "one owes something to his nation."

Some general remarks on Chardin's figure compositions are in order here. They are almost always vertical in format (except [94] and [95]); the largest [54], which is also the earliest, measures 146 × 147 cm. The smallest are two ravishing paintings on wood, now in Stockholm, *The Embroiderer* [68] and *Young Student Drawing* [69]; also on panel and in Stockholm is his *Woman Drawing Water from a Water Urn*[55].

One cannot help being struck by the extremely few figures in these compositions. In most cases, there is only one; there are two in eleven of the paintings in this catalog—a maximum of three in eight instances—mostly secondary figures shown from behind and relegated to the middle ground. Chardin's version of *Saying Grace* in the Salon of 1761 (see [86]), which we know from a copy, is the only instance where he shows four people in one picture.

Note also that the figures in most of those compositions are large in scale, busts or half-lengths, almost in profile. Later, Chardin would increase the distance between himself and the scene to be painted, present full-length figures, and diminish their scale. The turning point for this radical departure occurred between 1738 and 1740 and corresponds to a profound change of style. The reason for this break still eludes us.

Another point is that Chardin preferred to paint women rather than men, children and adolescents rather than adults. This obviously deliberate choice is discussed under the individual works.

Much has been said about Chardin's unity of style and inspiration. In our opinion, nothing could be less accurate. No two paintings could be more different in technique, composition, and choice of colors, models, and subject than *The Bird-Song Organ* [93] and *Lady Sealing a Letter* [54] or *The Morning Toilet* [88] and *The Game of Knucklebones* [60] or *Saying Grace* [85] and *The Governess* [83], of hardly two years earlier.

Much has often been made of the stillness of these compositions, the timeless, closed world of which Chardin was poet, or of the figures so absorbed in their daily chores or their play. Yet this apparent unity conceals the quest of a restless, constantly dissatisfied artist who forever modifies his technique and compositions, always bent on deepening their significance. What strikes us is not the unity but the great diver-

sity—from the thick paint, heavy manner, and lack of transparency of his early figures to the carefully refined execution of his genre scenes in the 1750s; from the robust solidity of figures with the same household objects that had inspired the earlier still lifes to the delicate and wistful feminine silhouettes to which he progressed after having lavished affectionate attention on his pictures of children, painted between 1735 and 1740. The bread placed on the buffet by the girl in *The Return from Market* [80] could hardly be more different from the bread on the table in *Meal for a Convalescent* [92]. In the first example it is rendered in great detail, down to the flour on the crust. In the second example, nine years later, Chardin was more concerned with the volume of the loaf, its weight and place in the overall scheme of the composition. And the woman has been transformed from a stout servant interested mainly in material pleasures into a grave and melancholy nurse absorbed in her own thoughts. This evolution, which needs to be examined at greater length, is the achievement of a creative genius rather than of a skilled practitioner who, once he has hit upon a successful formula, exploits it for all its worth.

The Monkey as Antiquarian.

What were the origins of these compositions and the motivations of their author? We get few answers from Chardin's contemporaries, who never tired of comparing him to Teniers and to Rembrandt (often placing him above these predecessors). Yet these names at least indicate Chardin's obvious orientation toward Northern traditions—more Dutch than Flemish, in our opinion. It is well known that such Dutch painters as Van Mieris, Dou, Metsu, Van der Werff, Netscher, and Schalcken became popular in France in the second half of the eighteenth century, influencing Chardin more and more. It is also known that Chardin drew the inspiration for his subjects from certain themes and symbols established in the Netherlands during the seventeenth century; it is clear, however, that he treated them in new and original ways. Thus he managed wisely to use to his advantage the privilege of invention which the history painters claimed exclusively and on which they rested their superiority.

The Monkey as Painter.

Three more points should be made concerning this period of Chardin's career. First, did Chardin continue to paint still lifes during these years? It seems certain that his last still lifes of household utensils were done after 1733; evidently he never totally abandoned this type. But we have been able to single out only two works which belong neither to the group of still lifes done before 1735 nor to those done after 1746: *The Smoker's Kit* [74] and *Rabbit, Copper Pot, Quince, and Two Chestnuts* at Stockholm [78]. The date of the former would clearly seem to be 1737—the same as that of the *Little Girl with Shuttlecock* [72]. The date of the latter, however, is more problematical. We hope that the comparison of this masterpiece with the works in this exhibition dating from before 1740 may lead to a satisfactory solution.

No mention has yet been made of Chardin's *Singeries* (monkey pictures), of which he showed two versions at the Salon of 1740. We have chosen to exhibit *The Monkey as Painter* [66] and *The Monkey as Antiquarian* [67] from the Chartres Museum, for they are the finest as well as the most certainly original among the surviving examples. An engraving by Surugue (executed in 1743), after *The Monkey as Painter*

by Chardin, is dated 1726 on the portfolio. Could Chardin have been painting such monkey pictures ever since 1726? It does not seem possible to resolve this vexing question at present.

Finally, we must mention the problem of Chardin's portraits. Portraiture occupied an enviable place in the famous "hierarchy of categories," more prominent than still-life painting. Chardin's *Portrait of the Painter Joseph Aved* [62], his portraits of the Godefroy children [63, 75], and that of *The Son of M. Le Noir* [71] prove that he ventured into this category. The first is alternately called *The Philosopher* or *The Chemist;* in the second painting one of the Godefroy children holds a violin and the other is watching a top spin; while in the third, Le Noir's son amuses himself by building a house of cards. They are all somewhat outside the bounds of portraiture, strictly defined. We know from engravings, however, that Chardin did indeed try his hand at portraiture — in 1746 (portrait of the surgeon Levret; a second male portrait at the same Salon remains completely unknown) and again in 1757 (portrait of M. Louis, another surgeon). These portraits failed to please, and Chardin, who took things "too much to heart," was probably stung by their cool reception. From 1771 onward he took his revenge with an admirable series of pastels.

Portrait of M. Levret.

Portrait of M. Louis.

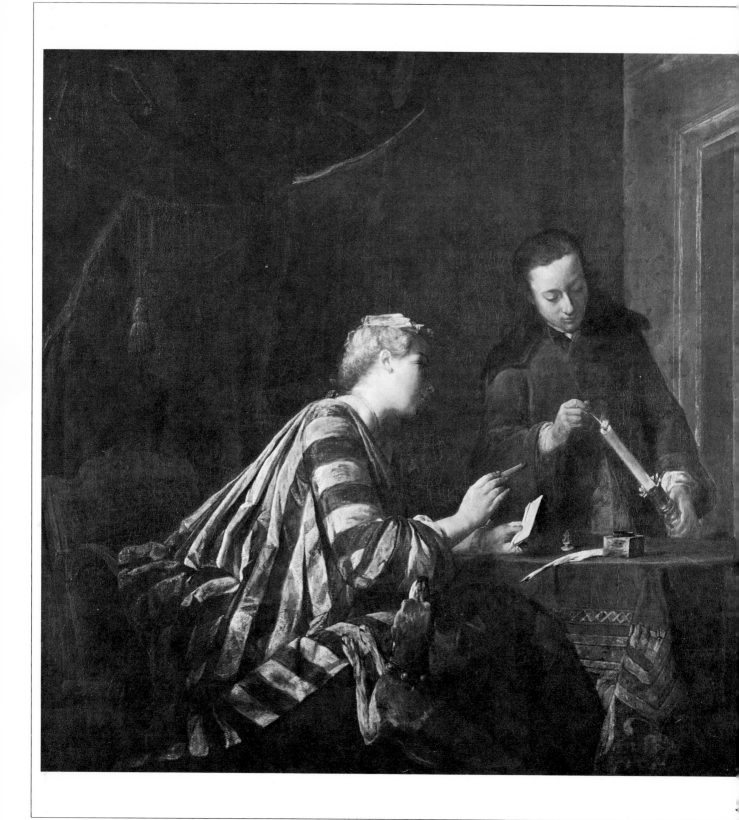

See Color Pla

54 *Lady Sealing a Letter*

(Une femme occupée à cacheter une lettre)

Canvas, 146 × 147 cm. Signed and dated at the lower left on the chair leg, in two lines: *J. S. Chardin f. 173(3?)*
Berlin, Staatliche Museen Preussicher Kulturbesitz, Schloss Charlottenburg

Detail of the signature.

Provenance. Still in Paris in 1738. Collection of Prince Henry of Prussia, brother of Frederick the Great, at the Unter den Linden Palace in Berlin under the title *Le Majordome* in 1779 [Dohme, 1883, claims that the painting could have been acquired by the prince as early as 1738]. In 1864 at the palace in Potsdam, then at the New Palace, and finally, in 1941, at the Charlottenburg Palace in Berlin.

Exhibitions. 1734, Paris, Exposition de la Jeunesse, no. cat.; 1738, Salon, no. 34; 1883, Berlin, no. 120; 1910, Berlin, no. 303 (with ill.; or no. 20 with ill. in large cat. edition); 1930, Berlin, p. 47, no. 185; 1937, Paris, no. 135 (album pl. 53); 1947, Wiesbaden, no. 13; 1951, Wiesbaden, no. 2; 1951-52, Berlin, no. 11; 1962, Berlin, no. 6, pl. 1; 1963, Paris, no. 2 (with pl.).

Bibliography. Nicolai, 1779, II, p. 687; Parthey, 1863, p. 278, no. 1; Dohme, 1883, pp. 254-56 (engraving by G. Eilers between pp. 253 and 254); Ephrussi, 1883, p. 104; Dilke, 1899, pp. 182, 184, 185, 186 (repr. of the engraving p. 179); Dilke, 1899 (2), pp. 116-17; Fourcaud, 1899, pp. 395, 396 (repr. of the engraving), 412; Seidel, 1900, p. 85, no. 21, and pl. on p. 40; Fourcaud, 1900, pp. 13, 19, 30; Merson, 1900, p. 305; Nicolle, 1900, p. 156; Normand, 1901, pp. 86 (repr. of the engraving), 88; Dorbec, 1904, p. 342; Schéfer, 1904, pp. 51-52, 56, 59; Dorbec, 1905, p. 462; Dayot and Vaillat, 1907, pl. 51; Guiffrey, 1908, p. 56, no. 1; Goncourt, 1909, pp. 110, 116, 177-78 (original unknown); Pilon, 1909, pp. 38, 50, 76; Alfassa, 1910, p. 294, pl. on p. 295; Meier Graefe, 1910, pp. 270, 271 (with pl.); Vaudoyer, 1910, repr. on p. 21; Furst, 1911, p. 131 and pl. 6; Bouyer, 1919, p. 433 (with ill.); Foerster, 1923, p. 61; Hildenbrandt, 1924, fig. 214, p. 167; Klingsor, 1924, pl. on 27; Réau, 1924, p. 496 (ill.); Réau, 1925, pl. 35; Boucher, 1928, p. 199; Gillet, 1929, p. 85; Osborn, 1929, p. 188 (ill.); Pascal and Gaucheron, 1931, p. 62; Ridder, 1932, pp. 8, 49, 62, and pl. 49; Wildenstein, 1933, no. 246, fig. 49; *L'Amour de l'Art*, May 1937, p. 23, fig. 45; Goulinat, 1937, p. 248 (ill.); Groos, 1937, p. 182; Hourticq, 1939, p. 102 (ill.); Brinckmann, 1940, fig. 376; Pilon, 1941, pl. on p. 51; Leporini, 1942, p. 68; Goldschmidt, 1945, p. 3; Goldschmidt, 1947, pl. 19; Florisoone, 1948, p. 63; Jourdain, 1949, pl. 28; Museum cat., 1956, p. 13; 1960, p. 20; and 1963, p. 28; Schwarz, 1961, pl. on p. 55; Pognon and Bruand, 1962, p. 31; *Arts*, 1-7 May 1963 (ill.); Garas, 1963, pl. 3; Rosenberg,

1963, pp. 9, 30, 31, 45, and color pl. on p. 27; Mittelstädt (ed.), 1963, p. 18, pl. on p. 19 (color); Wildenstein, 1963-69, no. 121, pl. 16 (color); Thuillier and Châtelet, 1964, p. 204; Huyghe, 1965, p. 12 (repr.); Valcanover, 1966, pl. 1 (color); Leymarie, 1967, pp. 54 (pl.), 55, 58; Snoep-Reitsma, 1973, pp. 174, 219, 222 (fig. 77, engraving); Carritt, 1974, p. 502; Kuroe, 1975, pl. 9 (color); Börsch-Supan, 1975, p. 132 and fig. 16, p. 131; *Dictionnaire Robert*, 1975, p. 408 (ill.); Kemp, 1978, p. 22; *Chefs-d'oeuvre de l'Art. Grands peintres*, 1978, pl. 1 (color).

Prints. An engraving by Etienne Fessard (1714-1777) in 1738 or shortly thereafter bears the following inscription:

> *Make haste then, Frontain: see your young mistress,*
> *Her tender impatience sparkles in her eyes;*
> *Already she can hardly wait for her heart's desire*
> *To receive this message, her tender feeling's pledge.*
> *Ah! Frontain, you act so slowly that it's plain*
> *The God of Love has never touched your heart.*

The caption indicates the engraver's name and "Chardin Pinx. 1732." Bocher [1876, pp. 17-18, no. 12] lists three states of the engraving [see also Pognon and Bruand, 1926, p. 31, no. 13]. The May 1738 *Mercure de France* publicized the engraving in these terms: "There is on sale at Fessard's a print engraved by him which is very piquant and whose subject is simply and naturally depicted. It shows a very charming young woman ready to seal a letter with a lighted candle which a servant is about to give her. This print has been made after an excellent painting by M. Chardin, whose talent is well known."

Bocher, Pognon, and Bruand also call attention to a duplicate copy published in Augsburg with the legend both in German and Latin.

Engraving by G. Eilers [see Dohme, 1883] and etching by Peter Halm [see Seidel, 1900].

A 2.40-f. postage stamp, drawn by Mazeline after this painting, was issued on 8 April 1946 and withdrawn on 11 August 1946.

No copy of Faber's mezzotint (1740), so often mentioned, perhaps through confusion with that of *The Young Draftsman* [77], has come to light.

Related Works. A small version of this work was preserved in the Karlsruhe Museum. Dussieux took note of it in 1856 [p. 18], and it was often mentioned by nineteenth-century authors. It became known long before the original in Berlin; in fact, it had been auctioned off in Karlsruhe on 18 November 1853. This painting had been given to the Margravine of Baden, Karoline Luise, during the winter of 1759 by Georg Wilhelm Fleischmann, a native of Strasbury who was a counsellor at the Hessian court. At the time, Fleischmann was living in Paris and knew Chardin personally. The support of the work is not known, but it measured 24 × 21 cm. [see, in addition to Wildenstein, 1933, no. 246, and 1963-69, no. 125; Kircher, 1933, pp. 41, 107, and 109; Donat de Chapeaurouge, 1955, pp. 6-7; and letter to us from Professor Jan Lauts]. In none of the Margravine's letters is it said that the painting is "a copy made by Chardin" [Wildenstein, 1963 p. 159]. On the contrary, Karoline Luise thanks Fleischmann for the handsome Chardin, "one of the most charming pieces" in her picture gallery.

A small version on wood measuring 24.5 × 24.5 cm. appeared at the Beaujon sale, 23 April 1787, no. 224.

Another version on copper and measuring approximately 25 × 24 cm. appeared at the following sales: Giraud of Versailles, 4 January-8 March 1779, no. 36; Boscry, 19 March 1781, no. 18; Martial Pelletier (or Peltier, according to the Goncourt brothers), 28 April 1870, no. 5 [cf. Goncourt, 1909, pp. 110-11]; and F. Watelin, 17 November 1919, no. 71. The painting in question is probably the very fine piece loaned by the Louvre (M.N.R. 60; 26 × 25.5 cm., copper on wood) to the French embassy at the Vatican.

Although they may be identical with the versions on wood and copper listed above, there are also the following paintings: sale, London, 19-21 April 1764, no. 37, "A lady writing a letter" [mentioned to us by D. Carritt]; from the estate inventory of Robert Soyer dated 15 Brumaire Year XI (study by Bottet of Orléans), "another by the same painter representing a lady sealing a letter" (four Chardin still lifes are in the

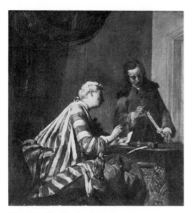

Chardin(?), Paris, Louvre.

same inventory); Hubert Robert sale, 5 April 1809, no. 31, without any indication of dimensions or support but with this remark: "The dress, which resembles that of the late Madame *Joffrin* [*sic*], renders this piece truly curious and original"; Count d'Houdetot sale, 12-14 December 1859, no. 32, "scene" by Chardin, with no indication of size or support; and the Marquis de V... sale, London, Christie's, 5 June 1871, no. 227, probably the Houdetot painting ("Handetol," in the catalog). According to the Goncourts, the Peltier (or Pelletier) painting came from the H. Robert collection and the Houdetot sale. According to Boucher [1928, p. 199], the Watelin painting—exhibited at the Musée Carnavalet in 1928, no. 35—"is clearly identified as coming from the former Beaujon, Hubert Robert, and Houdetot collections. It is one of the scenes of domestic intimacy in which Chardin has put the best of the moving sobriety and the transparent harmony which characterize his talent." Wildenstein [1963-69, nos. 122 to 125] lists, in addition to the Berlin painting, four versions of this work which, in his view, are all lost.

Lady Sealing a Letter enjoyed a revival of interest after 1850 on the basis of the 1738 engraving of Etienne Fessard—the original only became known shortly after 1883, the date of its exhibition in Berlin. Lady Dilke [1899] wrote in this regard: "I have it from M. Silvy that it [the painting] was discovered by himself, together with Messrs. Thibaudeau and Danlos, some years ago, *behind an armoire* in the storeroom of the Old Potsdam."

The work had, however, been noticed in two eighteenth-century exhibitions: the 1734 Exposition de la Jeunesse and the Salon of 1738. With respect to the former, the *Mercure de France* for June (we previously noted that Antoine de La Roque, a collector of Chardin works, had obtained the privilege for the *Mercure* in 1721), commenting on Chardin's entry of sixteen paintings, wrote: "The largest represents a young woman impatiently waiting for someone to give her a lighted candle to seal a letter; the figures are

life-size." The commentaries on the 1738 Salon at which Chardin displayed nine paintings were just as laudatory. "This painter...," wrote the *Mercure de France* [October 1738, p. 2185], "who has acquired a great reputation with the paintings he exhibited in the last Salon, was even more generally appreciated this year."

A frequently cited passage written by the Chevalier de Neufville de Brunaubois-Montador in his "letter to the Marquise de S.P.R." reads as follows: "His taste in painting is unique: there are no finished lines, there is no blending of colors; on the contrary, his work is rough and unpolished. His brushstrokes seem heavy, yet his figures are strikingly true. His singular manner endows them with greater naturalness and feeling." The chevalier concludes by saying "There is all the greater reason to praise him, as he has been received by the Academy as an animal painter."

This last remark is of some importance. Why and when did Chardin decide to devote himself to the representation of the human figure? The very first Chardin paintings—signboards—were genre scenes, but the artist gave these up, rather quickly it seems, in order to paint only still lifes. An answer to the question was provided by Mariette, who wrote in 1749 [manuscript in the Cabinet des Estampes, Bibliothèque Nationale]:

"He was continuing to work on similar compositions (still lifes) when an incident occurred which caused him to advance one more step in painting. M. Aved, a portrait painter, was his friend, as he still is, and they saw one another often. One day a lady had come looking for M. Aved to have him do her portrait; she wanted it to extend as far as the knees and insisted she could give only 400 *livres* for it. She left without having struck a deal, for, although M. Aved was not then as busy as he has been since, her offer seemed to him much too modest; M. Chardin, on the contrary, urged him not to let this opportunity pass, and tried to convince him that 400 *livres* was a good price for someone who was not yet widely known. 'You'd be right,' answered M. Aved, 'if a portrait were as easy to do as a saveloy.' He said that because at the time M. Chardin was painting a work for a firescreen in which he was depicting a saveloy on a dish. [Is this the picture now in Chicago? Wildenstein, 1963-69, no. 73, fig. 34.] Aved's remark impressed Chardin and, taking it as the truth rather than a joke, *he subjected his talent to a serious reexamination,* and the more he examined it, the more he was persuaded that it would never get him very far. He feared, and perhaps rightly so, that if he painted only inanimate and rather uninteresting objects, the public would soon grow weary of his productions and that if he followed through with his desire to paint living animals, he would end up inferior to the Messrs. Desportes and Oudry—two formidable rivals who had already exploited this area with considerable success. At that point he made up his mind to abandon his first talent; he had to choose another...."

It is impossible to insist too much on the importance of this quotation. For fear of boring his public, for fear of being unable to compete with Desportes and Oudry in the living-animal genre, Chardin decided to "abandon his first talent" and "choose another." Exactly when did this episode take place? Mariette cites

as Chardin's first attempt in his new "talent" the "head of a young man blowing soap bubbles" (see [59]). This hypothesis is unverifiable, all the more so as the version of the "conversion" given by Cochin and Haillet de Couronne differs on this point (see [56]). What is certain, at any rate, is that the Berlin painting bears the earliest date and there is nothing to prove that it later than the versions of *Soap Bubbles* included in this exhibition [59 and 61].

The subject of the work does not call for any special commentary. The caption for Fessard's engraving confirms the obvious interpretation: the young servant is not making sufficient haste to suit his mistress to carry her love note to her suitor. There is nothing new in this theme; Snoep-Reitsma (1973) has stressed its relationship with numerous seventeenth-century Dutch canvases, by Terborch, Netscher, and Schalken, among others. The painting duplicates, furthermore, two engravings of F. B. Lépicié (figs. 78 and 79) made in 1732 from two closely related paintings by Charles-Antoine Coypel: *Village Love*, or *Artless Love*, and *City Love*, or *Flirtatious Love*. The Coypel paintings show that the theme was also not unknown in French painting of the time.

In contrast to the Northern painters, Chardin uses a large format, which is unusual for him. Another equally surprising, but not unique element in this work is the atmosphere of luxury in which the scene takes place: the heroine clothed in a luminous dress and accompanied by a greyhound wearing a rich collar; the carpet — possibly the one seen in the 1731 painting of *Attributes of the Sciences;* the heavy red curtain decorated with gold tassels — from *Attributes of the Arts;* the fluted armchair; and the silver candlestick held by the manservant who wears a fur-collared brown suit. All are representative of a world that Chardin quickly abandoned for a simpler, more domestic one. Although one can only admire the way in which Chardin was able to draw attention to the stick of red wax and the white spot of color which constitutes the letter, there are in the painting certain awkward touches which do not stem from the format of the work alone (or its condition, especially in the lower part of the canvas). A certain ponderousness in the execution solidly confirms that this is the work of a beginner in an unfamiliar genre.

55 *Woman Drawing Water from a Water Urn* (also called *The Water Urn* or *The Woman at the Urn*)

(*Une femme tirant de l'eau à une fontaine, dit La Fontaine ou La femme à la fontaine*)

Wood (and not canvas), 38 × 43 cm. Signed on the lower part of the wooden bucket in the center of the painting: *Chardin 173* (*3* rather than *5*).
Stockholm, Nationalmuseum

Provenance. Painted for the Chevalier Antoine de La Roque [see Mariette]. La Roque sale, May 1745, no. 102, with *La Blanchisseuse* (*The Washerwoman*) [56] (the first sale in France at which works by Chardin appeared); acquired at this sale by Count Carl Gustaf Tessin (1695-1770), Swedish ambassador extraordinary to Paris between 1739 and 1742, through the intermediary of the dealer Gersaint (J. Heidner has made available Gersaint's receipt dated 9 July 1745, which was included in a letter of 21 July 1745 from Scheffer to Tessin [3,553 *livres* 15 *sols* had been spent at the La Roque sale]) for the heir to the throne and future king of Sweden, Prince Adolf Frederick (the picture never belonged to Tessin, as P. Grate has made clear). Royal Collection of Sweden at the Chateau de Drottningholm until 1865 (a plan, of about 1790, showing a room at Drottningholm with the Chadin painting in it and drawn up by Fredenheim, the curator of the collections, is reproduced by Nordenfalk in the catalog of the Stockholm museum, 1958, p. XXXI). At the Stockholm Nationalmuseum since 1865.

Exhibitions. 1734, Exposition de la Jeunesse (?); 1735, 2 July, Chardin exhibited at the Academy some "humble women occupied with their housework" (*Mercure de France*, June 1735, p. 1386); 1737, Salon (p. 13, reprint of cat.).

Bibliography. (relating *directly* to the work in Stockholm). Blanc, 1862, p. 16; Clément de Ris, 1874, pp. 497-98; Bocher, 1876, p. 23, no. 21, and p. 93, no. 781; Dussieux, 1876, p. 604; Sander, 1876, p. 164, no. 6; Goncourt, 1880, p. 121; Chennevières, 1889, p. 127; Chennevières, 1890, p. 302; *L'Intermédiaire des Chercheurs et des Curieux*, 10 March 1891, pp. 137-38; Dilke, 1898, p. 334; Dilke, 1899, pp. 333, 335, 341; Dilke, 1899, (2), pp. 116, 120, 121; Leclercq, 1899, p. 128; Merson, 1900, pp. 305-6; Nicolle, 1900, p. 156; Dayot and Vaillat, 1907, pl. 32; Guiffrey, 1908, p. 92, no. 236; Goncourt, 1909, p. 179; Pilon, 1909, p. 43; Furst, 1911, p. 133; Lespinasse, 1911, pp. 117, 316; Gauffin, 1923, pl. 25; Museum cat. (Siren), 1928, p. 184, no. 781; Pascal and Gaucheron, 1931, p. 101; Wildenstein, 1933, no. 23 (and 22); Roux, 1940, pp. 639-40; Goldschmidt, 1945, fig. 19; Davies, 1947, p. 28; Goldschmidt, 1947, fig. 20; Strömborn, 1951, p. 158, no. 63 (*id.* 1949); Museum cat. (Nordenfalk), 1958, p. 41, no. 781; Rosenberg, 1963, p. 82; Wildenstein, 1963-69, no. 128, pl. 14 (in color); Paulson, 1975, p. 107, fig. 61.

Prints. The caption for the engraving by Charles-Nicolas Cochin *père* (1688-1754) entitled *La Fontaine (The Water Urn)*, specifies that it was done after the "original" in the Chevalier de La Roque collection. The Stockholm painting is, therefore, the one which figured in the 1737 Salon and was popularized by the engraving.

Bocher [1876, no. 21; see also Roux, 1940, pp. 639-40] describes three states of this engraving and a reduced version. He also lists the various engravings made in the nineteenth century, either after the Cochin plate or the Marcille painting (cf. [57]) [*L'Illustration*, 1848; Ch. Blanc, 1862; *Gazette des Beaux-Arts*, 1 February 1864 and 1 January 1868, etc.].

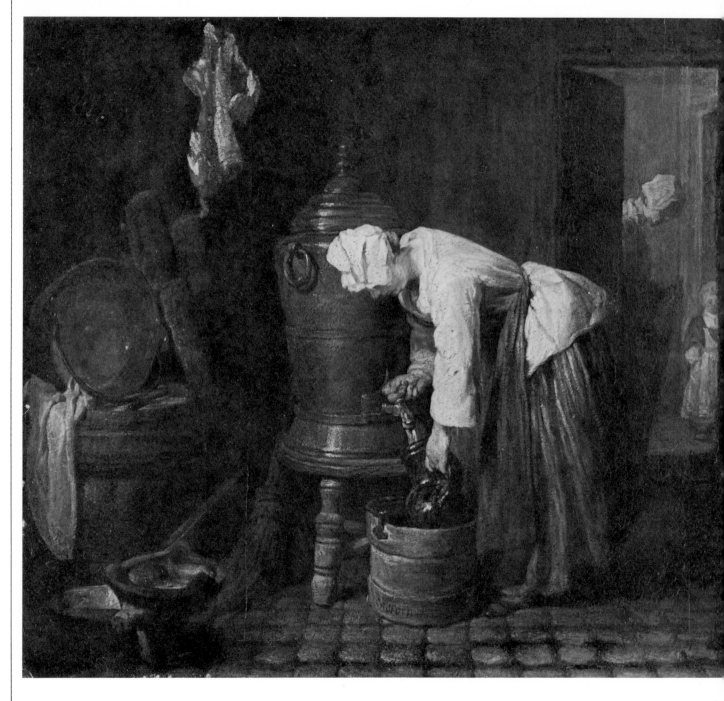

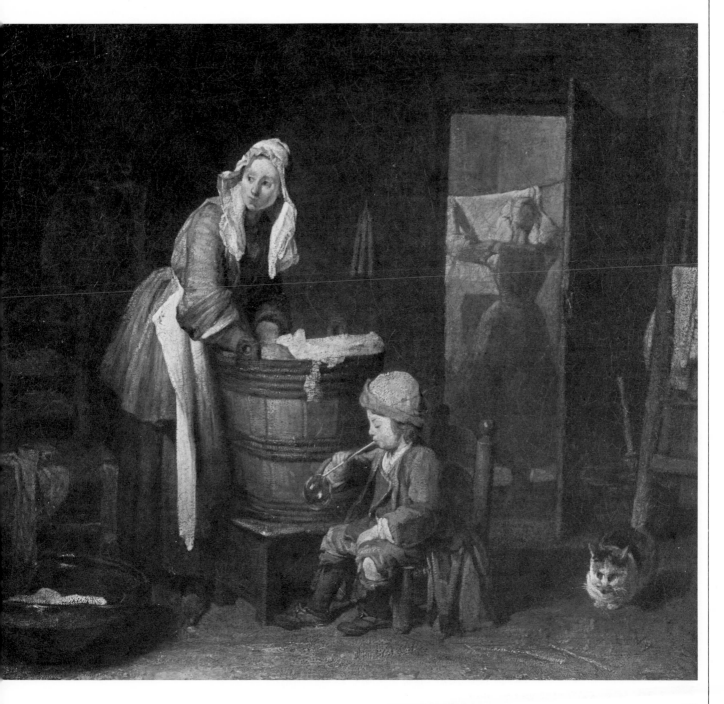

56

The Cochin engraving, which was often duplicated, is cited in the June 1739 *Mercure de France*, p. 136: "Here are two more new prints [the second is, of course, that of *La Blanchisseuse*], very well engraved by Mr. C. N. Cochin at whose shop on the Pont Notre-Dame they are for sale. The prints have been made from two original paintings by M. Chardin belonging to the Chevalier de La Roque that are very successfully organized in the style of Teniers. They are well deserving of such comparison, in the opinion of the enlightened public which saw them exhibited at the last [actually the second last] Salon."

Related Works. Chardin exhibited two *Water Urn* paintings at the Salon. The 1737 Salon vesion, engraved in 1739 and sold by La Roque in 1745, is certainly the painting that is today in Stockholm.

At the Salon of 1773 Chardin exhibited only two paintings: a "study head in pastel" (no. 37) and a *Femme qui tire de l'eau à une fontaine* (Woman drawing water from a water urn") (no. 36), owned at the time by "M. Silvestre, drawing master to the royal children." But the editor of the 12 September 1773 issue of *L'Année littéraire* (V, pp. 113-14) speaks of "some Chardin paintings, *several of which are old,* [that] have been very well received...." The Sylvestre painting, therefore, had been completed well before 1773 and, as was his habit, Chardin was exhibiting a work far from new. This painting is very probably the one at the Sylvestre of 28 February-25 March 1811, no. 12, 36 × 42 cm.

In addition to [55 and 57], there are three other versions supposedly done by Chardin himself. We accept as a Chardin only the work in the National Gallery, London, which M. Davies (1947) considers a "copy" or "an original of inferior quality," 37.5 × 44.5 cm. [Wildenstein, 1963-69, no. 133, fig. 56]. Another is at the Barnes Foundation in Merion, Pennsylvania (formerly in the Cook collection in Richmond, Virginia, with companion piece, wood, 39 × 44 cm. [Wildenstein, 1933, no. 24, fig. 3; rightly rejected today by Wildenstein, 1960, p. 2,

London, National Gallery.

but severely judged by Dilke as early as 1898, p. 334]. The third is in a private collection in Lausanne, 40 × 57 cm. [Wildenstein 1963-69, no. 130, fig. 55; also see Rosenberg, 1969, p. 99, "very mediocre"].

However, in eighteenth-century sales there were a vertical version, 36.5 × 31 cm. (5-10 April 1780, no. 20, and 21-22 February 1799, no. 10), and two horizontal versions (Lempereur sale, 24 May 1773, 36.5 × 40.5, and Brian sale, 12 December 1808, no. 69, 35 × 51.5 cm.) in addition to the La Roque painting and the the painting from the Sylvestre collection sold in 1811.

There were, then, during Chardin's *liftime*, three autograph versions: one in the La Roque sale, now in Stockholm, and the works in the Sylvestre collection and the Lempereur sale, here identified with the paintings in London and in the Marcille collection. After taking into account the addition in the uppper part of the Marcille picture, there is nothing in their dimensions to contradict this identification.

56 *Woman Doing Wash* (also called *The Washerwoman*)

(Une femme s'occupant à savonner, dit La Blanchissuese)

Canvas, 37 × 42.5 cm. Signed on the stool which supports the tub: *Chardin.* (The pins which attach the apron can be read as a monogram, *S. C.*; see Wildenstein.)
Stockholm, Nationalmuseum*

Provenance. See [55].

Exhibitions. 1734, Exposition de la Jeunesse (?); 1735, 2 July, in the halls of the Academy (see [55]); 1737, Salon (p. 13, reprint of cat.).

Bibliography. (relating *directly* to the work in Stockholm). Clément de Ris, 1874, pp. 497-98; Bocher, 1876, p. 13, no. 6, and p. 93, no. 780; Dussieux, 1876, p. 604; Sander, 1876, p. 164, no. 5; Goncourt, 1880, p. 120; Dilke, 1898, p. 334; Dilke, 1899, pp. 333, 335, 336; Dilke, 1899, (2), pp. 116, 120, 121; Leclercq, 1899, p. 128; Merson, 1900, pp. 305, 306; Nicolle, 1900, p. 156; Dayot and Vaillat, 1907, under no. 31; Guiffrey, 1908, pp. 92-93, no. 237; Goncourt, 1909, p. 177; Pilon, 1909, p. 43; Furst, 1911, p. 133; Lespinasse, 1911, pp. 117, 315-16; Gauffin, 1923, pl. 24; Museum cat., 1928, p. 184, no. 78; Pascal and Gaucheron, 1931, p. 127; Wildenstein, 1933, no. 4 (and 4a), fig. 5; Roux, 1940, pp. 638-39; Goldschmidt, 1945, fig. 20; Goldschmidt, 1947, fig. 22; Denvir, 1950, pl. 6; Museum cat. (Nordenfalk), 1958, pl. 41, no. 780; Rosenberg, 1963, pp. 10, 45, 49, 58 (color pl.), 82; Wildenstein, 1963-69, no. 135, pl. 15 (color); Kuroe, 1975, pl. 8 (color).

Prints. See [55], *Prints.* Cochin entitles this print *The Washerwoman.* Bocher (1876) describes two states of it as well as an etched forgery of reduced size. This old forgery is ponderously executed [cf. also Roux, 1940, pp. 638-39]. In June 1850 the *Magasin Pittoresque* (p. 173) printed a small reproduction on wood of this engraving, the first of many illustrating the works of Chardin and dating from the second half of the nineteenth century [for example, see C. Lucien-Huard, *Les Musées chez soi*, n.d., I, p. 357].

Related Works. The single painting on this subject exhibited in the eighteenth century was the Stockholm picture shown at the Salon of 1737, engraved two years later by Cochin and acquired in 1745 at the La Roque sale by the heir to the Swedish throne, Prince Adolf Frederick. The version in The Hermitage [58] comes from the Louis-Antoine Crozat collection (1755) and was purchased by Catherine II of Russia in 1772. Finally, Chardin himself kept a copy of this composition; it appeared in the inventory of his estate dated 18 December 1779 *(une savonneuse* ["one who uses soap"] valued at 36 *livres*) and at the Chardin sale of 6 March 1780, no. 15. It is in all likelihood the same painting that shows up again at the M. X sale (by Le Brun) on 11 December 1780, no. 160, with the same dimensions.

Today only two other versions of the compositions are known: one at the Barnes Foundation in Merion, Pennsylvania (formerly in the Cook collection in Richmond, Virginia) with *The Woman at the Urn* as companion piece, wood, 39 × 44 cm. [Wildenstein, 1933, no. 6; also see [55], *Related Works*], no longer accepted as authentic, and another formerly in the Henry de Rothschild collection, 35 × 41 cm., which was destroyed during World War II [Wildenstein, 1933, no. 7, fig. 2; 1963-69, no. 134, fig. 57]. As far as one can tell from the surviving photographs of it, this second painting might be the one that was in the Chardin sale.

The two Stockholm paintings have a very simple history, beginning with their exhibition at the Salon of 1737. They were in the posses-

sion of Antoine de La Roque, for whom they had probably been painted, when Charles-Nicolas Cochin engraved them two years later. In 1745 they were acquired at La Roque's estate sale by the dealer Gersaint, who was acting for Count Tessin, who, in turn, was acting for the heir to the Swedish throne. Since that time they have never left Sweden, nor have they ever appeared in an exhibition. Their departure from France seems to have caused some disturbance, however. "It is unfortunate," wrote the *Mercure de France* in June 1747, "that the various paintings of M. Chardin such as *The Water Urn*, *The Washerwoman*, and *The Morning Toilet* [88] go to foreign countries and are lost to us."

Comparisons have often been made between the two paintings mentioned in the texts of Mariette and Cochin (mentioned later by Haillet de Couronne), which recount Chardin's beginnings in genre painting. The first part of the Mariette text (from which the others differ very little) has been cited with regard to *Lady Sealing a Letter* [54]. Here is how Cochin described the incident:

"Aved, a portrait painter and friend of Chardin, said to him—in an outburst—'Do you think that [portrait painting] is as easy as painting *langues fourrées* [a kind of cake very popular in the eighteenth century] and saveloys?' M. Chardin was offended by this, but controlled himself and gave no sign of his feelings. The next day, however, he began a figural painting of a maidservant drawing water from a water urn."

Cochin gives 1737 as the date of this episode. Haillet de Couronne, who follows Cochin's account faithfully (and brings it to a close with the personal judgment—"He was entirely successful"), writes more cautiously, "around 1737." Mariette, thirty years earlier identifies *Soap Bubbles* (see [59]) as Chardin's first figure painting and adds, without giving any date, "Some time after, he made for M. le Chevalier de La Roque the two *Cuisines* [kitchen scenes] which M. Cochin has engraved."

It seems plausible to accept the date accompanying the signature on *The Water Urn* (*The Washerwoman* is not dated), which seems to read 1733 rather than 1735. Another factor supports this conclusion. The text of the inscription accompanying the engravings of *The Washerwoman* and *The Water Urn* and their description—"in the style of Teniers"—has been underscored. It should be remembered, however, that Chardin exhibited at the 1734 Exposition de la Jeunesse no fewer than sixteen paintings (of which [33] and perhaps [27 to 30] were among them), with "subjects in the style of Teniers," to use the words of the *Mercure de France*. These compositions also must have been exhibited in 1735, on 2 July, at the Academy. The *Mercure de France* mentions Chardin's entry in these terms: "M. Chardin is exhibiting four excellent little works representing humble women busy with their household chores and a young boy playing with cards. The spectator will be greatly impressed by his masterful touch and the truth which reigns everywhere with uncommon intelligence." Everything indicates that the *Mercure* was referring to *The Water Urn* and *The Washerwoman*, both belonging to La Roque, who was also the editor of the *Mercure de France*.

Were the two pieces conceived as companion pieces? *The Water Urn* is on wood—a medium for which Chardin seems to have had an affection, especially around 1733—while *The Washerwoman* is on canvas. The Stockholm paintings, it must be added, are the only ones paired (except for those owned by the Barnes Foundation), and all the autographed versions mentioned in eighteenth-century sales or contemporary exhibitions are single pieces. It would seem more likely that the compositions are not companion pieces and that Chardin wanted to satisfy La Roque by composing a second painting to accompany the first.

The two works are now in far-from-perfect condition. Very wide cracks have profoundly altered the clarity of certain parts. Even in 1874 Clément de Ris was complaining about a "state of deterioration which is painful to see." And Lady Dilke, comparing the Stockholm paintings with those which today belong to the Barnes Foundation and with *The Water Urn* that the National Gallery in London had just acquired (which she rightly observed "has a far more serious claim as an authentic work of the master"), speaks of "venerable ruins," while at the same time admiring "elements of a surprising truth and extraordinary delicacy."

From the still lifes of these years, we have grown accustomed to Chardin's copper water urn, pot, pitcher, earthenware brazier, long-handled frying pan, and piece of meat hanging from the ceiling; what is new is the intrusion into this familiar world of two large feminine figures. Another innovation is the doors which open onto two brightly lit scenes and punctuate the background wall which encloses the composition. A woman sweeps while a child stands on the threshold of a second door. Another woman is seen hanging up laundry.

The surprise of visitors at the 1737 Salon and of the editor of the *Mercure de France* [September 1737, p. 2020; probably La Roque] is understandable. "M Chardin excelled in painting both live and dead animals in a manner as true as it was unusual, but we did not know that his talent extended further. He has demonstrated a manner that greatly enhances his reputation, and the figures we have seen in all his works have been highly praised by the most demanding connoisseurs."

One might go still further and give his paintings a deeper meaning. E. Snoep-Reitsma [1973, pp. 176-180] saw in *The Washerwoman*, for example, the contrast between good (the two women at work and the religious print in the back of the room) and evil (the cat, a symbol of "voluptuousness" and "carnality," and the child blowing soap bubbles). This hardly seems likely. Nor should we interpret the paintings as works symbolizing the drudgery of the middle classes on the eve of the Revolution.

What seems more obvious is the extreme care taken by Chardin to construct his compositions, static arrangements in which the gestures are arrested and stiff. Also noteworthy is the minimal attention given to the faces, perhaps because it was too difficult to make them truly expressive. No less striking is the contrast between these two works and the *Lady Sealing a Letter* [54], which also dates from 1733. It would seem—and this would not be the first

The painting, exhibited on numerous occasions during the second half of the nineteenth century, often drew comment ("a master painting," according to Mantz in 1874) and had a great deal to do with the rediscovery of Chardin even before the Louvre, with the La Caze collection (1869), could offer the general public a fine ensemble of the master's paintings. Théophile Gautier described the painting in *L'Artiste,* 15 February 1864:

"'Here is something very interesting!' say the lovers of painting and those who take special pleasure in compositions arranged like a tableau in the fifth act of a play. Yes, certainly very interesting! One sees in it what on one else has mentioned: bourgeois family life in the eighteenth century, with no dukes, marchionesses, and ballerinas, as one might expect. Furthermore, what accuracy in [rendering] the motion of the bent figure! Or the ample pleats in her simple garments! Or the copper water urn! The Dutch have done nothing better, and, take my workd for it, Chardin did not spend a month putting on the finishing touches."

Several months earlier the Goncourts commented on the same painting, praising "the whites, so broken and yet so clear, in the bonnet and the blouse of the woman bending over to turn the faucet, the warm coloring of the slight profile all ruddy and full of health, the medley of colors on her petticoat.

"Under [Chardin's] hand, under his gnarled and lifelike drafting, everything takes on an indefinable solidity and fullness. He stuffs the workbag and makes the rounded sides of the pitcher bulge. He gives the armoire a sense of massiveness. He depicts the kettle's ample measure. By means of thickness of contour, breadth of lines, and a kind of coarse strength and natural grandeur, the things in his figural paintings achieve a distinct style."

Comparison of the Stockholm painting on wood and the Marcille canvas shows very few differences between the two works, even in coloring. The only noteworthy difference is the glazed clay dish which Chardin has placed on the floor, to the right.

One of the principal problems concerning Chardin is raised in his very first figure compositions: that of autograph duplicates. The versions shown here—admittedly in very different states of preservation—are indisputably the best. Their comparison, like that of other Chardin compositions *(Saying Grace, The Return from Market,* and *Soap Bubbles)* should prove fascinating, perhaps enabling us to reach a better understanding of what still remains one of the "mysteries" connected with Chardin—identical repetition in his work.

time in his career—that Chardin, once he had decided to "abandon his first talent," wanted to approach in two different ways the genre which would assure his reputation.

57 *Woman Drawing Water from a Water Urn*

(Une femme tirant de l'eau à une fontaine)

Canvas, 50.5 × 43.5 cm. (a strip measuring 11 × 5 cm. has been added to the upper part; the painting is reproduced here *without* that addition). Signed at the bottom left, on the barrel: *Chardin.*
France, Private Collection*

Provenance. Anonymous sale [Didot], 27-28 December 1819, no. 23 (the author of the catalog claims, without proof, that this painting and the three other Chardins in the Didot collection (see [93], [101]) belonged to Mme Geoffrin). Viscount d'Harcourt sale, 31 January-2 February 1842, no. 15. In the collection of Francois Marcille (1790-1856) at least by 1848 [cf. Clément de Ris]. Inherited by his son, Eudoxe Marcille, in 1856; has remained in this family since that time. For the provenance of the painting in the eighteenth century, see [55], *Related Works.*

Exhibitions. 1860, Paris, no. 101; 1874, Paris, no. 59; 1878, Paris, no. 30; 1883-84, Paris, no. 23; 1887, Paris, no. 19; 1934, Paris, no. 17; 1935, Brussels, no. 918; 1955, Paris, no. 8; 1961, Paris, no. 7.

Bibliography. Clément de Ris, 1848, p. 194; Bürger (Thoré), 1860, pp. 234, 334, 338; Blanc, 1862, pp. 8, 16, 9 (engraving by Bocourt and Carbonneau after Marcille's work); Horsin-Déon, 1862, pp. 136-37; Goncourt, 1863, p. 525; Gautier, 1864, p. 75; Mantz, 1874, p. 114 (with engraved repr. of the work); Bocher, 1876, p. 98; Goncourt, 1880, p. 121; Hamel, 1887, pp. 254-55; Chennevières, 1889, p. 127 (with engraved repr. of the work, p. 125); Chennevières, 1890, p. 302; Dilke, 1899, pp. 138, 341; Dilke, 1899 (2), p. 115; Fourcaud, 1899, p. 406 (with repr. of the engraving); Fourcaud, 1900, p. 24 (repr.); Merson, 1900, p. 306 (note); Normand, 1901, p. 42 (repr. of Cochin's engraving); Schéfer, 1904, pp. 25 (repr.), 43, 48, 55; Dayot and Vaillat, 1907, under no. 32; Guiffrey, 1908, p. 78, no. 133; Goncourt, 1909, pp. 113, 175; Pilon, 1909, repr. between pp. 88 and 89; Furst, 1911, p. 125 and pl. 25; Lespinasse, 1911, p. 316; Stockholm cat., 1928, p. 184, no. 781; Wildenstein, 1933, no. 27, fig. 7; Grappe, 1934, p. 479; Ratouis de Limay, 1938, p. 305 (ill.); Furst, 1940, p. 18 (repr.); Davies, 1947, p. 28; Wildenstein, 1960, p. 2; Zolotov, 1962, pl. 2; Wildenstein, 1963-69, no. 129, fig. 54.

This is an autograph replica of the painting in Stockholm [55] (also see [55] for the other known versions). The upper part of the painting has been cleverly enlarged by an additional 11 × 5 cm. Didot, the owner at the time, had wanted to make it the companion piece of the version of *The Bird-Song Organ* [93] which belonged to him. By 1848 the work was in the François Marcille collection. At that time Clément de Ris commented on it favorably, preferring it to Baron Schwiter's version, which was then being shown in the Bonne-Nouvelle Gallery's exhibition (the first in the nineteenth century which included Chardin) and which today is in the National Gallery, London.

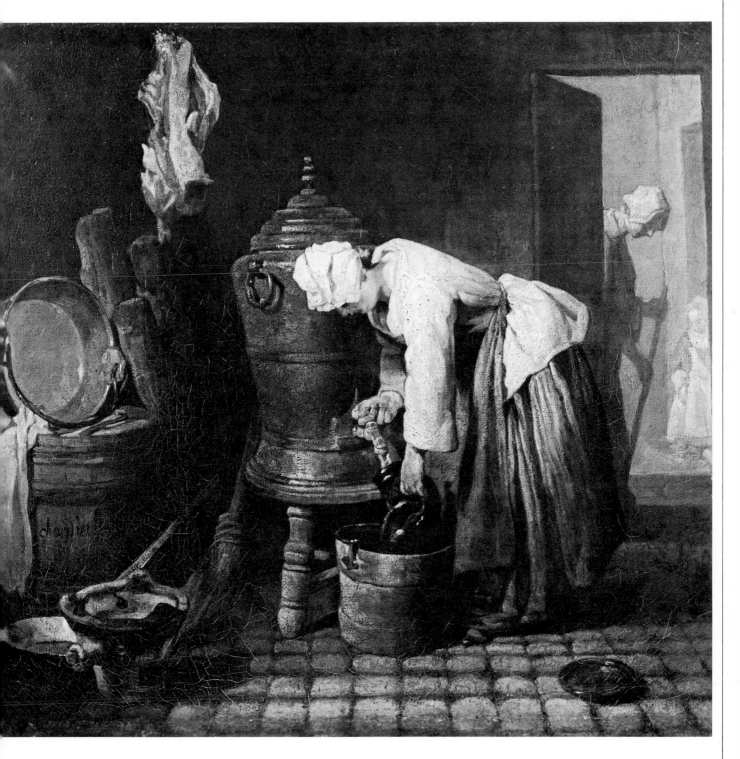

57

58 *The Washerwoman*

(La blanchisseuse)

Canvas, 37.5 × 42.5 cm. Signed at the upper left: *Chardin.*
Leningrad, The Hermitage

Provenance. Collection of Louis-Antoine Crozat, Baron de Thiers
(1699-1770), nephew and heir of Pierre Crozat (1665-1740), and of his
brothers Louis-François (1691-1750) and Joseph-Antoine (1696-1751);
described in the catalog of this collection compiled by J. B. Lacurne de
Saint-Aulaye in 1755 (p. 54) and in numerous eighteenth-century guides
to Paris; inventoried by François Tronchin in 1771 [see Stuffmann,
1968]. Acquired in 1772, upon the advice of Diderot who was then in St.
Petersburg, by Catherine II of Russia (there is a contract signed by
Diderot and the three daughters and two sons-in-law of the Baron de
Thiers); the packing cases containing paintings from the Crozat collec-
tion were delayed for three months on the banks of the Seine "between
the sky and the water" before reaching Russia [see Tronchin, 1895, and
Tourneux, 1898]).

Exhibitions. 1955-56, Moscow, Leningrad, p. 61; 1965, Bordeaux, no.
17; 1965-66, Paris, no. 15 (with ill.); 1967-68, Dresden; 1968, Göteborg,
no. 23.

Bibliography (with reference to the work at The Hermitage). Hermitage
cat., 1774 (reprinted in *Revue Universelle des Arts,* 1861, 14, (p. 219,
no. 1157); Bocher, 1876, p. 92, no. 1514; Dussieux, 1876, p. 578; Clé-
ment de Ris, 1880, p. 270; Goncourt, 1880, p. 120; Mantz, 1883, p.
138; Museum cat., 1887, p. 51, no. 1514; Tourneux, 1898, p. 340, pl.
on p. 341; Normand, 1901, p. 56; Museum cat. (Somov), 1903, p. 21,
no. 1514; Schéfer, 1904, p. 21 (repr.); Guiffrey, 1908, p. 91, no. 234;
Goncourt, 1909, p. 177; Pilon, 1909, pp. 43, 88, 170; Furst, 1911, p.
133, pl. 7; Réau, 1912, p. 396; Museum cat. (Somov), 1916, p. 21, no.
1514; Weiner, 1923, pl. 299; Réau, 1929, p. 180, no. 32; Pascal and
Gaucheron, 1931, p. 127; Ridder, 1932, pl. 75; Wildenstein, 1933, no.
5; Mihan, *Apollo,* April 1944, p. 90 (ill.); Lazarev, 1947, pl. 16; Her-
mitage cat., 1955, p. 107, no. 90 (with ill.); Sterling, 1957, p. 43, pl. 36;
Museum cat. (Levinson-Lessing), 1958, p. 355, no. 1185, pl. 278;
Boudaille, 1961, fol. 29 (repr.); Descargues, 1961, p. 35; Nemilova,
1961, pls. 4, 5 (detail); Zolotov, 1962, pl. 4; Garas, 1963, pls. 10, 11
(detail); Mittelstädt (ed.), 1963, p. 28, pl. on p. 29 (color); Wildenstein,
1963, no. 136, fig. 58; Museum cat. (Levinson-Lessing), 1963 (German
ed.), no. 76 (color pl.); Lazarev, 1966, pl. 35 (color); Stuffmann, 1968,
p. 127, no. 122 (ill.); Charmet, 1970, p. 25; Lazarev, 1974, pl. 182;
Nemilova, 1975, p. 436, fig. 16; Museum cat., 1976, p. 233, no. 1185
(ill.).

See [56] for information concerning the other versions of this com-
position, the Cochin engraving, and dating for the Hermitage
painting.

Wildenstein pointed out (1933) that the Stockholm version has
two pieces of straw on the ground at the lower right; the same seems
to be true, however, for the Russian version, on which a signature
has recently been discovered. These variations in detail can be at-
tributed just as easily to overly vigorous cleanings or clumsy,
misguided restorations. A side-by-side comparison of the two
paintings, never before made, will make it possible not only to
judge the two versions in terms of quality (something which no
photograph, especially in the case of Chardin, can convey) but will
also enable us to investigate the problem of autograph duplicates.

That Chardin worked hard on each of these compositions is cer-
tain. That he lacked imagination — that essential quality which
enabled eighteenth-century painters to "invent" new composi-
tions — has been said by critics again and again. These facts,
however, do not explain the extraordinary relationship between
the two works. The differences are perhaps most notable in the
facial expressions, which seem to have been most difficult for Char-
din. Sometimes, even in the best replicas — as, for example, the
Leningrad painting — these expressions are surprisingy simple and
absent-minded.

In the two pictures, besides the skillful composition, with its
opening into the linen room, Chardin has marvelously depicted
these two women occupied by daily chores and the little boy absorb-
ed in his play. Though separate, they are bound closely to one
another in that subtle intimacy, sympathy, and tendeness that
makes Chardin one of the great poets.

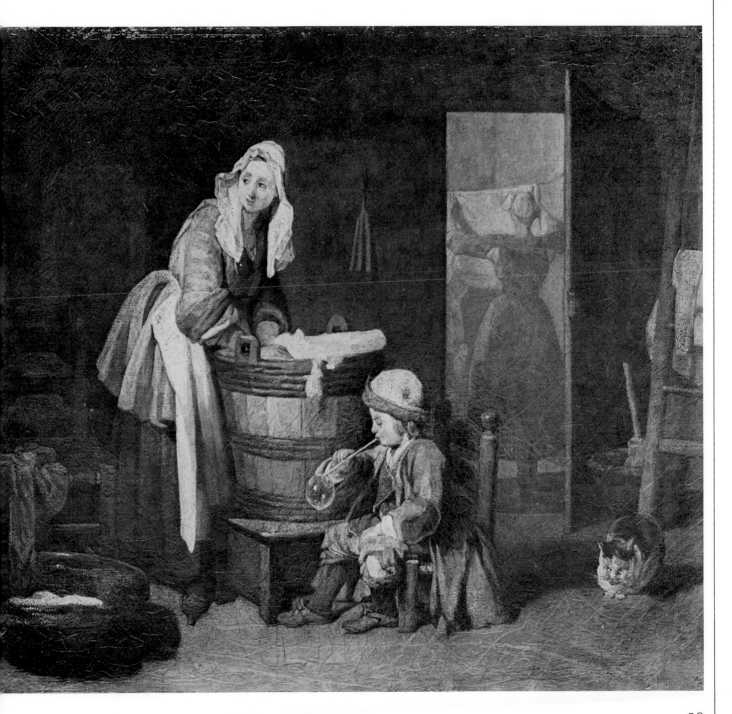

58

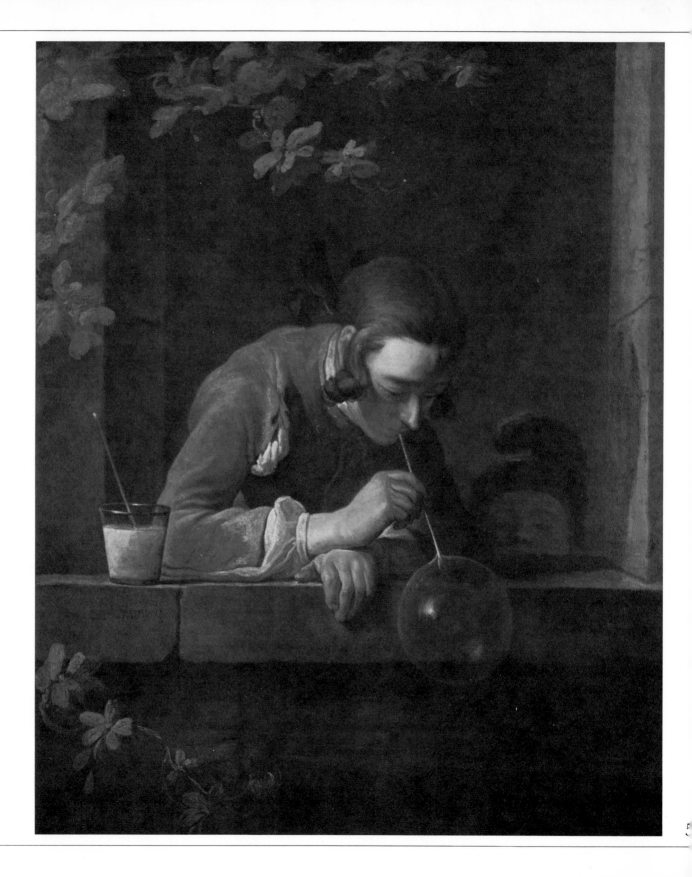

59 Soap Bubbles

("Les bouteilles de savon")

Canvas, 93 × 74.5 cm. Signed on the stone ledge at the left:
J. S. Chardin.
Washington, National Gallery of Art

Provenance. Collection of the architect Pierre Boscry (died 1781);
Boscry estate sale, 19 March 1781, no. 17(?) (see [60], *Provenance*). This
could be the painting anonymously described in one of the first
nineteenth-century texts marking the revival of Chardin [*L'Artiste*, 5
August 1845]:
 "We have just seen one of the most ravishing and best-preserved paint-
ings of Chardin *in the atelier of M. Roehn*" [italics added; Hédouin,
1846 and 1856, informs us that it was the elder Roehn (1780-1867)].
"This signed painting depicts a very simple and charming young boy
dressed in the style of Louis XIV [*sic*], leaning out a window *which is
framed by vines and clusters of ivy leaves*, amusing himself by blowing
soap bubbles. Nothing could be more natural, more graceful, or more
harmonious than this charming composition. It is nature caught in the
act, without dazzling color or the least affectation. You have seen this
young boy twenty times, a hundred times, at a courtyard window or in a
garden; he reminds you nostalgically of the simple games of your own
childhood. The painter did not have to look for him at the Opéra-
Comique or the Variétés Amusantes. The keen pleasure we feel on gaz-
ing on this boy is mingled with fear and regret; our overseas neighbors
have taken away our finest Watteaus; they will certainly not leave us this
delightful Chardin."
 Laurent Laperlier collection in 1860; Laperlier sale, 11-13 April
1867, no. 10. Acquired by "Biesta." In 1889 a reader of the *In-
termédiaire des chercheurs et des curieux* searches for the painting. Sold
for $22,000 in 1905 [Gimpel, 1963] to John W. Simpson, a New York
lawyer. Gift of Mrs. John W. Simpson to the National Gallery of Art in
1942.

Exhibitions. 1739, Salon (p. 13, reprint of the cat.) (?); 1849, Paris, no.
8 ("M. Roehn père"); 1860, Paris, no. 352; 1920, New York, no. 1;
1934, Chicago, no. 134 (repr. pl. 29); 1936, Cleveland, no. 56 (repr. pl.
16); 1939, Boston, no. 2 (repr. p. 19); 1939, New York, no. 38 (repr. pl.
82); 1939, New York (Wildenstein), no. 2.

Bibliography. *L'Artiste* (without author's name), 5 August 1845, p. 72
(?); Hédouin, 1846, p. 224, no. 19 ("à Roehn Père") (considered the
painting of the 1739 Salon) (?); Hédouin, 1856, p. 191, no 19 ("Apparte-
nant à M. Roehn père") (?); Bürger (Thoré), 1860, p. 234; Blanc, 1862,
p. 16; Goncourt, 1863, p. 524; 1864, p. 151; *La Chronique des Arts et
de la Curiosité*, 21 April 1867, p. 122; Burty, 1879, p. 148; Espel, *L'in-
termediaire des chercheurs et des curieux*, 10 May 1889, p. 262; Dilke,
1899, p. 181; Dilke, 1899 (2), p. 115; Dayot and Vaillat, 1907, pl. 12;
Guiffrey, 1908, p. 75 (confuses the Laperlier painting with the one in
the Bocher collection); Goncourt, 1909, pp. 112, 132, 177; Wildenstein,
1933, no. 134, fig. 22; Frankfurter, *Art News*, March 1939, pp. 10, 13
(repr. p. 9); *Art Digest*, June 1942, p. 6 (repr.); Richardson, 1942, pp.
348 (ill.), 349; Denvir, 1950, pl. 17; Einstein, 1956, pp. 19, 22, fig. 17;
Museum cat. (Walker), 1963, p. 317 (ill.); Garas, 1963, pl. 18; Gimpel,
1963, p. 305 (for a water-color copy by Forain, see p. 213); Wildenstein,
1963-69, no. 74, pl. 6 (color); Museum cat., 1965, p. 26, no. 552 (ill.
1968, p. 19); Held and Posner, 1971, p. 317 (repr.); Stuffmann, 1971,
pl. 370; Snoep-Reitsma, 1973, pp. 217-19, fig. 74; Museum cat., 1975,
p. 66 (repr. p. 67); Kuroe, 1975, cover and pl. 7 (color); Walker, 1975,
no. 431, pl. on p. 325 (color); *Antiek*, 1976, p. 146 (ill.).

Prints and *Related Works.* Only the *vertical versions* of this composition
are at issue here (for the horizontal versions, see [61]). An engraving by

Pierre Filloeul (1696-after 1754). already cited by Mariette in 1749, ap-
peared shortly before December 1739 [Bocher, 1876 p. 14, no. 8;
Pognon and Bruand, 1962, p. 193, no. 87]. Advertised in the *Mercure
de France* of December 1739, it is the companion piece to *The Game of
Knucklebones* (see [60] for the text from the *Mercure de France*) and
carries the following legend:
 Consider well, young man,
 These little globes of soap.
 Their movement so variable,
 Their luster so fragile
 Will prompt you to say with reason,
 That many an Iris in this is very like them.
Only one painted version (Paris, private collection), which corresponds
exactly in reverse to this engraving—81 × 65 cm. (painting), the same
dimensions as those of the Baltimore painting [60]—is known to us. It is
unquestionably eighteenth century, but unfortunately its quality is such
that one cannot see it as an original by the hand of Chardin. The
Washington painting differs in a number of ways from the Filloeul
engraving. The question which naturally arises—whether we are con-
fronted with old additions or a new autograph version—will be discussed
later.

We know today of only one vertical autograph version of this most
famous of all Chardin compositions: the painting in Washington.
Thanks to an engraving by Pierre Filloeul published in 1739, it is

Engraving by P. Filloeul.

known that Chardin had painted a vertical composition. The dif-
ferences between this engraving and the Washington painting are
significant: the elimination of the bas-relief in the lower part of the
Washington picture, and in the upper and lower corners, the addi-
tion of honeysuckle and, to the right, a stone wall. The Filloeul
engraving has a companion piece—*The Game of Knucklebones*—
which corresponds faithfully to the painting in Baltimore [60]. The
Baltimore painting comes, in all likelihood (at least the dimensions

are the same), from the sales of the architect Boscry (1781) and Gruel (1811; see *Provenance* above). But because the Washington painting is noticeably larger and differs considerably from the engraving, it cannot be the pendant to the Baltimore painting—or at least until now has not been seen as such. The Washington painting has just been carefully examined and restored, and is the subject of an unpublished report (31 May 1978, National Gallery, by William Leisher, Assistant Conservator, who graciously consented to make his text available to us), whose conclusions are fascinating. To summarize them, the Washington painting has been enlarged on the sides, particularly on the right; the honeysuckle is an addition, and, beneath the repaints and wear, one can distinguish the remains of the bas-relief. Leisher is convinced that the Washington painting is the companion piece to the Baltimore painting which Filloeul engraved in 1739. However, he does not take a position on the reasons for, and the dating of, these modifications.

Leisher's conclusions do not, unfortunately, solve all the problems; for if one accepts them, then one has to admit that the Washington painting probably comes from the Boscry and Gruel sales. One would also have to agree that the painting underwent these changes between 1811 (date of the Gruel sale) and probably 1845, when it was described at length in the atelier of Roehn *père* (the author of the description stresses the frame of honeysuckle, which he takes for "vines and clusters of ivy leaves")—or at the latest, 1860 (when it was in the Laperlier collection and had the same dimensions as the Washington painting). When one remembers the oblivion into which Chardin had by then fallen, such an explanation seems surprising.

If one advances the hypothesis that these modifications were made in the eighteenth century by Chardin or by an artist who knew his work well (the addition of the honeysuckle presupposes knowledge of the other version, the New York painting [61], then the Washington painting cannot be the one in the Boscry (1781) and the Gruel (1811) sales.

Might one go further and attempt to identify the Washington painting with another version of the composition? We have only to remember that in 1739 Chardin exhibited at the Salon "a small painting representing the frivolous play of a young man, blowing soap bubbles." This painting is probably the same one engraved by Filloeul that very year, but we have no proof (why did its companion piece not appear in the Salon?). There is no proof either that the painting in the Salon was a vertical one. Furthermore, in Chardin's estate inventory, prepared on 18 December 1779, there is mention of "a boy making soap bubbles, valued at twenty-four *livres.*" Was the work, which does not appear at the estate sale of 6 March 1780, vertical or horizontal? What has become of it?

In conclusion—with apologies for the complexity of this analysis—it does not seem absolutely certain to us: that the Washington painting is the companion piece of the one in Baltimore; that it is the one engraved by Filloeul; that it is the one which was exhibited in the Salon of 1739; or that it was sold at the Boscry and Gruel sales.

One recalls the account of Mariette (1749; see [54]) relating the sudden "conversion" of Chardin, on Aved's advice (see [62]), to the representation of the human figure:

"He had the opportunity to paint the head of a young man blowing soap bubbles, which exists as a print; he had painted him carefully from life and had tried hard to give him an ingenuous air; he showed it around; people said nice things to him about it. The masters of the art praised the effort he had made to get that far, and the curious [not envious, as the editor of the version printed in 1854 read erroneously], by displaying great interest in this new subject matter, caused him to embrace it."

The Mariette text is essential in any attempt to determine the relationship of these paintings. Rather than contradict the texts of Cochin and Haillet de Couronne, written thirty years later, it introduces important nuances. The two biographers give as the earliest examples of Chardin's "new talent," *The Water Urn* and *The Washerwoman* of Stockholm [55, 56]. But Mariette mentions these paintings only as second attempts. The artist seems, then, to have painted first the version of *Soap Bubbles* which was engraved vertically, rather than one of the horizontal versions. The style of the Washington painting bears out this conclusion: the face of the young man, with its still rather hesitant modelling is not unlike that of the servant in the 1733 *Lady Sealing A Letter* [54]. The Goncourts had noticed this, for they insisted on the "*laborious* aspect of his work" ("His rendering of flesh is usually ponderous; he does not differentiate it enough from the fabrics and accessories"). Because Mariette's account does not mention *The Game of Knucklebones* [60], nothing prevents us from seeing this painting as an appreciably later work executed by Chardin to be a companion piece to the Washington painting (or rather another version of the latter).

The painting has several old titles: the *Bouteilles de savon,* the *Bulles,* or the *Bulles de savon.* Its subject, which was common in seventeenth-century Dutch painting (Mieris, The Hague; Netscher, Boston; Slingeland, Florence; P. de Hooch, N. Maes, et al.) and also in France in the eighteenth century (Lancret, Raoux, Boucher, and Charles-Amédée Vanloo in Washington), needs no comment. Numerous authors have focused on its moral and philosophical significance [Rousseau, 1950; Sterling, 1955; Donat de Chapeaurouge especially, 1969, p. 54; and recently, Snoep-Reitsma, 1973]. If everyone agrees that the soap bubble is a symbol of the fragility of human life—a *vanitas*—does that mean one must interpret the work as an allusion to feminine inconstancy and passing love?

In this painting, Chardin undertakes for the first time the theme of childhood, or more exactly, early adolescence—a theme enjoying a privileged place in paintings depicting large, half-length figures. Although Chardin's subjects are those of seventeenth-century Dutch painting, he handles them in a way that is unique to the eighteenth century. He places his model (sometimes two figures) before an architectural background of stone, framed to isolate the scene. His figures, busy with their games, are sometimes

absorbed in what they are doing, but are always dreamy and melancholy, as if their minds were elsewhere. If, as usual, he emphasizes the composition, Chardin would first convey his tender feeling for, and understanding of, these young people, these boys and girls to whom eighteenth-century society would soon accord increasing importance.

One final note is that Manet's famous *Bulles dè savon,* now in the Gulbenkian Foundation in Lisbon, is generally dated from the end of 1867 or early 1868. The Chardin painting, already exhibited in 1860, had caused a great stir at the Laperlier sale of April 1867; it is entirely possible that Manet saw it there.

60 *The Game of Knucklebones*

("Les osselets")

Canvas, 81.5 × 64.5 cm. (the picture seems to have been made oval in the nineteenth century; originally it was rectangular). Signed at the lower right: *J. S. Chardin.*
Baltimore, The Baltimore Museum of Art, Mary Frick Jacobs Collection

Provenance. Very probably in the collection of the architect Pierre Boscry (see [59]; estate sale of Boscry on 19 March 1781, no. 17, "Two fine paintings done on canvas measuring 81 × 65 cm, representing a young man blowing soap bubbles and a woman playing knucklebones." Very probably Gruel sale, 16-18 April 1811, no. 5, "Young boy making soap bubbles with a pipe, girl playing with knucklebones. Four other paintings, fish, fruits, vegetables, and household utensils." Ernest Cronier collection; Cronier sale, 4-5 December 1905, no. 2 (repr.; for another painting in this sale, see [72]. Acquired by L.-C. Charley (50,000 francs); in his collection in Paris in 1907. Acquired from René Gimpel in 1923 by Mary Frick Jacobs [see Gimpel, 1963]. Given to the Baltimore museum in 1938.

Exibitions: 1907, Paris, no. 2; 1954, Baltimore, no. 83; 1963, Raleigh, no. 69, pl. on p. 97; 1965, Columbus, no. 2; 1968, London, no. 136, fig. 195.

Bibliography. Alexandre, 1905, pp. 4, 6, 8, 10, pl. on p. 11; Dayot and Vaillat, 1907, pl. 43; Guiffrey, 1908, p. 74, no. 105; Furst, 1911, p. 123; Ridder, 1932, pl. 39; Wildenstein, 1933, no. 176, fig. 44; Museum cat., 1938, no. 14 (pl.); Denvir, 1950, pl. 21; H[irsch], 1951, pp. 1-4 (with ill.); *Art Digest,* 15 May 1955, p. 15 (repr.); Museum cat., 1955, p. 31 (repr.); Pognon and Bruand, 1962, p. 192; Gimpel, 1963, p. 239; Wildenstein, 1963-69, no. 164, pl. 21 (color); Huyghe, 1965, p. 13 (repr.); Rosenberg, 1969, p. 99 (said wrongly to be oval at first); Snoep-Reitsma, 1973, p. 218.

Print. An engraving, without significant variations, was executed by Pierre Filloeul (1696-after 1754) [Bocher, 1876, p. 41, no. 39A; Pognon and Bruand, 1972, no. 86]. Its caption reads as follows:
Already grown and full of charm
It ill becomes you, dear Lisette,
To play alone at knucklebones,
From now henceforth you are made
To make a young admirer happy
By deigning to grant him some part in your games.
This print was advertised in the December 1739 *Mercure de France:* "Two small vertical prints, with half-length figures in the style of Girardow [i.e., Gérard Dou], have appeared recently, engraved by Mr.

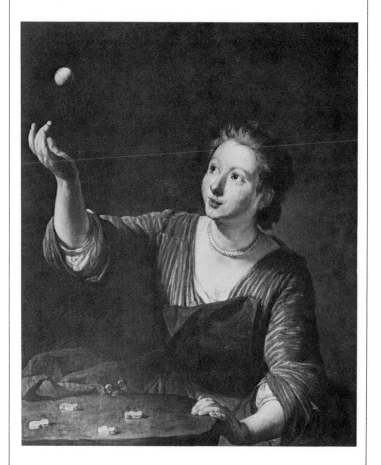

60

Filloeul after M. Chardin. In one there is a young woman playing knucklebones and in the other a young man blowing soap bubbles. These prints can be purchased at the beginning of the rue du Fouasse, near the rue Galande, at the shop of Filloeul."

Wildenstein [1969, no. 164] mentions an engraving of 1742 by Lépicié, but it was not known to Bocher nor to the author of the recent volume listing eighteenth-century French engravings (including Lépicié) at the Bibliothèque Nationale, Paris [Sjöberg, 1977].

Only one version of this composition is known today; everything leads one to believe that it is this painting which Pierre Filloeul engraved in 1739. It is mentioned in the sales of the architect Boscry (1781) and of Gruel (1811), and it reappears in 1905 in the Ernest Cronier collection. In the eighteenth century the painting had as its companion piece a version of *Soap Bubbles* that is today identified (in a not entirely convincing way; see [59]) with the one in the National Gallery, Washington. Whether the Baltimore painting antedates *Soap Bubbles* and what its exact date might be still need to be determined. Its heavy, thick brushstrokes lead one to believe it was painted after the Washington painting, around 1734. Was it intended as a companion piece to the painting in Washington — perhaps at the owner's request? Or did that companion piece — the painting which changed hands at the Boscry and Gruel sales — disappear? Answers to these questions have been offered in the discussion concerning the Washington painting [59].

The painting calls for several remarks on the subject. The model, a very young girl — the only one in the works of Chardin to be shown with her head uncovered [Hirsch, 1951] — is wearing a blue-bibbed apron (with a pair of scissors attached to her waist by a red ribbon) and a pearl necklace and earrings. The implications of the engraving's caption, urging the model to take part in other games at the side of a young admirer, must not, however, be interpreted as reflecting the thought of Chardin. As Snoep-Reitsma (1973) has indicated, the slightly suggestive allusions, in which Filloeul seems to have specialized, are more the contribution of the engraver (probably to the taste of his clientele) than of the painter.

The girl is watching the ball she has just tossed in the air and has her other hand ready to pick up the four knucklebones lying on the kitchen tabletop. The theme is unique for Chardin, despite the fact that he often featured childhood games and made them, in a way, a specialty. The work is exceptional in that Chardin is trying to represent a gesture. Here, the painter of fixed poses ventures into a new domain — movement — with only partial success.

The painting's merit lies elsewhere. When the author of the note in the 1739 *Mercure de France* compared *The Game of Knucklebones* with Gérard Dou (1613-1675) — who was then at the height of fame and whose cold, smooth style and lighting effects are not to be found in Chardin — he was pointing out the school which inspired Chardin. Chardin wanted to take on genre to tell a story, and to represent in all its simplicity a scene from everyday life which was faithfully observed but not mainly anecdotal or picturesque.

A curious detail confirms this point. In the Chardin estate sale of 6 March 1780, mention is made, among the framed prints, of *"Le*

jeu d'osselets d'après le chevalier van der Verf (no. 58) by J. Massard. This print from the collection of M. Choiseul is without lettering." This engraving, which dates from 1771, is certainly later than the Baltimore painting. It evidences once again Chardin's taste for the subjects made fashionable by Northern painters.

61 *Soap Bubbles*

("Les bouteilles de savon")

Canvas, 61 × 63 cm. Signed at the bottom left: *J. Chardin.*
New York, The Metropolitan Museum of Art, Catherine D. Wentworth Fund, 1949

Provenance. Probably in the collection of the architect Louis-François Trouard (1729-1794) [for information on Trouard, see M. Gallet, *Gazette des Beaux-Arts,* February 176, pp. 65-92]; Trouard sale (with six other Chardins), 22 February 1779, no. 44, "Two companion pictures, each representing a young boy seen half-length; one is amusing himself by blowing soap bubbles and the other by building a house on cards; on canvas, 62 × 65 cm." In the Jacques Doucet collection since at least 1899; Doucet sale, 6 June 1912, no. 136 (with ill.; the painting "made" more than 300,000 francs; its companion piece at the time, now in the Reinhart collection, Winterthur, 190,000!). David David-Weill collection, then Fritz Mannheimer, Amsterdam. Confiscated by the Nazis and sent to the museum in Linz during World War II. Acquired by the Metropolitan Museum in 1949.

Exhibitions. 1946, Paris, no. 10; 1950-51, Philadelphia, no. 47 (ill.).

Bibliography. Dilke, 1899, pp. 182, 184; Dilke, 1899, (2), pp. 114-16; Guiffrey, 1908, p. 75, no. 113 (pl. between pp. 36 and 37; Pilon, 1909, p. 168; Furst, 1911, p. 124; Dacier, 1912, p. 337; Henriot, 1926, 1, pp. 25-27 (with pl.); Jamot, 1931, pl. 31a; Wildenstein, 1933, no. 135, pl. 20; Jourdain, 1949, pl. 30; Rousseau, 1950, pp. 221-27 (with ill.); *Art Digest,* 1 June 1949, p. 11 (ill.); *Art News,* October 1950, p. 38 (with color ill.); *Weltkunst,* 15 March 1951, detail on cover and p. 2; Museum cat., 1954, p. 18; Rousseau, 1954, p. 5 and pl. on p. 39; Museum cat. (Sterling), 1955, p. 126 (ill.); Eisler, 1960, pp. 206 (repr.) 207; Rorimer, 1961, p. 124 (repr.); Wildenstein, 1963-69, no. 75, fig. 35; Watson, 1970, p. 537; Snoep-Reitsma, 1973, pp. 217-19; Paulson, 1975, p. 106, fig. 59.

Prints. For the Filloeul engraving (1739), see [59]. Henri Lefort made an engraving of the painting when it was in the Doucet collection [see Dilke, 1899, opp. p. 180].

Related Works. For the vertical versions, see [59], *Related Works.* Also see [59] for the version of the 1739 Salon and the one in the estate inventory of Chardin, which may have been vertical or horizontal.

Sales held in the eighteenth century (to which must be added the references under *Provenance* for this painting and the Washington one, [59]) contain four references, all of them perhaps relating to the same painting (for the companion piece, see [70]).

Sale of Baché, Brilliant, De Cossé, Quéné, et al., 22 April 1776, no. 81, with, as companion piece, *Une jeune fille faisant lire un enfant* ("A girl teaching a child to read").

Sale of Rohan-Chabot, Wâtelet, Breteuil, Billy, Angervilliers, Robert, 23 May 1780, no. 26, with, as pendant, *Une jeune fille qui montre à lire à un enfant* ("A girl showing a child how to read"; 58 × 73 cm.).

Wâtelet sale, 12 June 1786, no. 10; pendant of the same subject; 65 × 81 cm.

Dulac sale, 6 April 1801, no. 19, pendant of the same subject with no dimensions given.

In addition, there was an English sale pointed out by D. Carritt, the Rongent sale, 1755, no. 50, "A boy blowing bubbles," without dimensions.

Several versions of this work are known today: one which was until recently in Kansas City [Wildenstein, 1963-69, no. 76, fig. 36] and which may have been the one in the Emmanuel Bocher collection [Bocher, 1876, pp. 15 and 94; Goncourt, 1909, p. 177], is an old, retouched copy; another of very fine quality, signed *J. S. Chardin* at the left, and today on the market in New York (60 × 73 cm.), is probably the same as the painting in the Philippe de Kerhallet collection in 1912 and sold in Paris on 28 February 1973 (no. 90, "after Chardin"; we have not seen this painting since its recent restoration).

Finally, Clément de Ris [1877, pp. 174-75] mentions a version "which M. Boilly *fils* owned about ten years ago" and which might be one or the other of the paintings listed here.

For the theme of this painting and its moral significance, see the discussion of the Washington picture [59].

An attempt has been made to see in the Metropolitan's *Soap Bubbles* the companion piece of *The House of Cards* in the Reinhart collection, Winterthur [Wildenstein, 1963-69, no. 209, fig. 98; 58 × 63 cm.]. Actually, two paintings on these subjects were involved in the 1779 sale of the architect Trouard. The Reinhart painting and the one now in New York were together in the Jacques Doucet collection in 1899 [Dilke]. We do not know, however, what happened to the two works for more than a century, a hundred and twenty years to be exact. The difference in quality between the two paintings, which the rediscovery of the Nuneham *House of Cards* [D. Carritt, 1974] has made more evident—the Reinhart version being only a partial duplication of this latter—militates against this identification. In addition, replicas of Chardin's works were noted during his lifetime. One finds, for instance, that the catalog of the Count de Sainte-Maure sale, 27 May 1764 (no. 101), mentions "A young man making a house of cards *in the style of* [italics added] M. Chardin. It is painted on canvas, 78.5 × 97.5 cm." (see [65]).

To repeat what was said in the entry for the Washington painting [59], Mariette considered the vertical version of the *Bulles de savon* the first to be painted. The technique of the New York canvas, in our opinion, confirms this point. The faces have lost their polished surfaces; the stroke is becoming broad but has not yet acquired the transparencies and nuances which make the works painted in 1735-1738 his most perfect examples of compositions with large figures.

In any event, comparison of the paintings from New York, Washington, and Baltimore—brought together in this exhibition—with works that are dated *(Lady Sealing a Letter,* 1733; *Portrait of the*

Painter Joseph Aved, 1734; *A Lady Taking Tea,* 1735), and with the Stockholm paintings (which are almost certainly from 1733) and still lifes from 1732, will enable us to attain a better understanding of the evolution and transformations in Chardin's style at this pivotal point in his career.

62 *Portrait of the Painter Joseph Aved (also called The Philosopher)*

(Portrait du peintre Joseph Aved, dit encore "Le souffleur")

Canvas, 138 × 105 cm. Signed and dated at the right center on three lines: *Chardin / ce 4 XIIre / 1734.*
Paris, Musée du Louvre, Louvre, R.F. 2169

Provenance. Painted for Conrad-Alexandre de Rothenbourg (1683/84-1735; on the paintings of Rothenbourg, one of the first collectors of Chardin, see [27] to [30]): On 3 October 1735, Chardin received from the ambassador's estate, in addition to 200 *livres,* "a painting representing a *philosopher,* which the late comte de Rottembourg had commissioned from him and which has been returned to the said Chardin (as he acknowledges) to dispose of it as he sees fit" [Archives Nationales, Minutier Central, étude XXIII, liasse 488; information about this unpublished document was most generously made available by Mlle Mireille Rambaud); the painting is also mentioned in the estate inventory of the count dated 21 April 1735. Owned in 1753 by the architect Pierre Boscry (died 1781) [on Boscry, see M. Gallet, 1972, p. 145]; in 1743 he was living on the rue Cassette, just a few steps away from Chardin. Boscry estate sale, 19 March 1781, no. 16 (and *not* no. 76), "a chemist.... " (For the ten paintings by Chardin in the Boscry collection, see [59] and [60].) Disappeared between 1781 and 1900. Mentioned for the first time after 1781 in the collection of Mme Bureau in 1900, on the occasion of the Exposition Universelle [in 1899 Lady Dilke, p. 340, was still regretting the disappearance of the original]. Listed in the 30 April 1915 will of Pierre Paul Bureau, a lawyer at the Court of Appeals in Paris, who died on 24 May 1915. Given to the Louvre with two paintings by Pierre Bureau (1822-1876), a painter and father of the donor.

Exhibitions. 1737, Salon, unnumbered (p. 11, reprint of the cat.); 1753, Salon, no. 60; 1900, Paris, no. 4561; 1907, Paris, no. 1; 1930, Paris, no. 23; 1957-58, Paris, no. 13; 1959, Munich, no. 36; 1959, Paris, not in cat.; 1960, Paris, no. 565; 1964-65, Rennes, Dijon, Chambéry, Saint-Etienne, Avignon, no. 5.

Bibliography. Fourcaud, 1900 (2) pp. 273, 274, note 1; Lafenestre, 1900, p. 558; Molinier, Marx, Marcou (1900), p. 132; Normand, 1901, p. 70 (painting or engraving?); Dorbec, 1904, pp. 341-43 (repr. of the engraving), 351 (does not seem to know the painting); Schéfer, 1904, pp. 52, 55; Dayot, 1907, pl. on p. 125; Dayot and Vaillat, 1907, pl. 4; Guiffrey, 1907, pp. 101-2; Tourneux, 1907, p. 98; Frantz, 1908, p. 29; Guiffrey, 1908, pp. 73-74, no. 103 (pl. between pp. 84 and 85); Pilon, 1909, pp. 128-31 (repr. between pp. 128 and 129); Furst, 1911, p. 123; Brière, 1918-19, pp. 82-85; Brière, 1919, pl. 25 (text unpaginated); Wildenstein, 1922, pp. 129-31 (with ill.); Museum cat. (Brière), 1924, no. 3034; Gillet, 1929, p. 62, pl. 74 on p. 72; Fosca, *Candide,* 8 May 1930; Pascal and Gaucheron, 1931, p. 85; Ridder, 1932, pp. 9, 11, 34, 45-46; Wildenstein, 1933, no. 451, fig. 59; Pilon, 1941, p. 50 (ill.); Gerson, 1942, p. 93; Goldschmidt, 1945, fig. 48; Goldschmidt, 1947, fig. 8; Benesch, 1948, pp. 297-98, fig. 12; Jourdain, 1949, fig. 29; Denvir, 1950, pl. 25; Barrelet, 1959, p. 311; *Art News,* September, 1960, p. 46

(ill.); Rosenberg, 1963, p. 31; Wildenstein, 1963-69, no. 145, pl. 17 (color); Thuillier and Châtelet, 1964, p. 204; Zolotov, 1968, p. 68 (ill.); Snoep-Reitsma, 1973, pp. 230-31; Carritt, 1974, pp. 502-3; Rosenberg, Reynaud, Compin, 1974, no. 128 (ill.); Cailleux, 1975, p. 293; Fried, 1975-76, pp. 145-46, 148, 168; Sjöberg, 1977, p. 409; Kemp, 1978, p. 22.

Prints. The painting was engraved in 1744 by François-Bernard Lépicié (1698-1755), secretary and historiographer of the Academy, with the title *Le Soufleur [sic].* The engraving was exhibited at the Salon of 1745 [p. 34 of the cat.]. The caption (also by Lépicié) accompanying the engraving, which survives in only one state [Bocher, 1876, p. 51, no. 48; Sjöberg, 1977, p. 409, no. 69], is worth repeating:
 Despite your steady vigils,
 And this vain paraphernalia of chemical science
 You well could find at the bottom of your retorts,
 Misery and despair.
Chardin's signature and the date of the painting can be seen in this engraving which the *Mercure de France* advertised in January 1745.

The three different titles given to this painting in the eighteenth century caused art historians some difficulty until Gaston Brière established its exact provenance in 1918-1919, shortly after it entered the Louvre.

At the Salon of 1737, where Chardin presented no fewer than eight paintings, it was called "a chemist in his laboratory." François-Bernard Lépicié engraved it in 1744 with the title *Le Soufleur [sic].* The *Mercure de France* of January 1745, in announcing the appearance of the print, specified that "the painting... represents a *"soufleur"* in his laboratory attentively reading a book on alchemy." The author of the catalog for the 1753 Salon, where Chardin showed nine paintings, entitled it this time "a philosopher reading." This is also the title it bore when in the possession of Conrad-Alexandre de Rothenbourg, who had commissioned it (as he had many masterworks of Chardin's youth).

According to the *Dictionnaire de l'Academie* [1694 edition, p. 494], *"soufleur* is one who seeks the philosopher's stone by means of chemistry." Clearly, the "intellectualization" of the title of the piece in 1753 is more apparent than real.

It is certain that the painting of the 1753 Salon is the same as the one painted in 1734 and exhibited in 1737. Abbé Garrigues de Froment, one of the commentators on the 1753 Salon, in his *Sentiments d'un amateur sur l'exposition des tableaux au Louvre* [1753, p. 34], compared *The Philosopher* to more recent paintings by Chardin characterized by "an unusual and novel execution." "The new manner," he wrote, "differs from the one we see in the philosopher reading, which the same author painted, or rather, which he painted in 1734." Abbé Garrigues could not have known this date unless he had actually seen the painting.

The identity of the model in the picture as the painter Joseph Aved (1702-1766) is established by another critic of the 1753 Salon. The review of Fréron [*Exposition des peintures, sculptures...,* 1753, coll. Deloynes, Bibliothèque Nationale, Vol. XLVIII, no. 1240, p. 523] concludes with a note on *The Philosopher.* "One recognizes in the painting," Fréron writes, "the portrait of Mon-

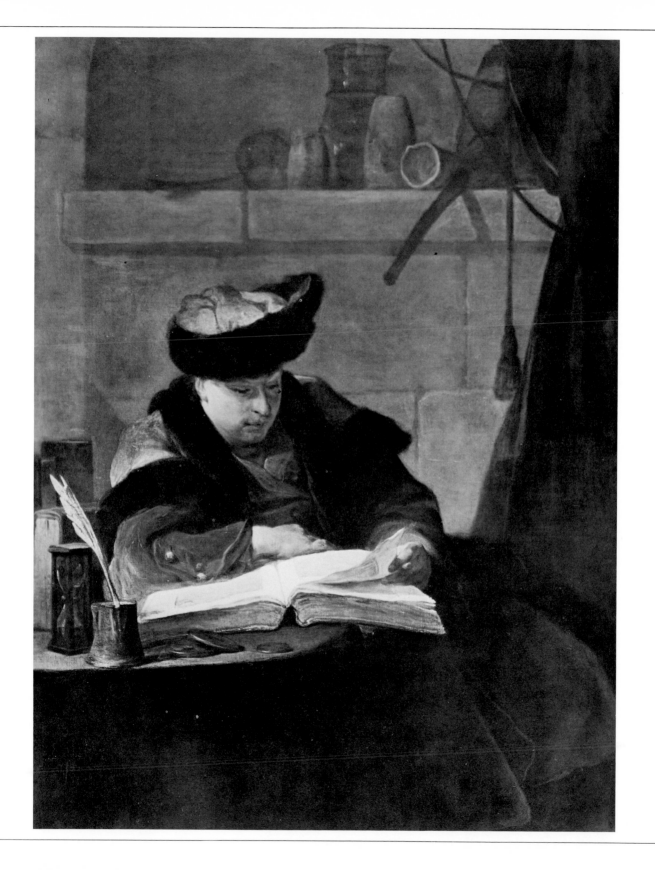

sieur Aved, Chardin's friend." This identification, which the Goncourts proposed when the work was known only by the engraving [1863, p. 522], has not always been accepted. Brière, for instance, expresses some reservations. We think that he is wrong. Certainly the resemblance between the portrait and what is known of the features of Aved [see Wildenstein, 1922, who cites four portraits, pp. 22, 89] is not entirely convincing; remember that, except in his pastels, Chardin was not a portrait painter. That he tried to be one is beyond dispute. That he wanted, by undertaking this new genre, to mount another rung in the rigid hierarchy of genres is also certain. It is just as certain, however, that his endeavors met with little success. This is confirmed by the critics of the Salons of 1746 and 1757, at which Chardin exhibited portraits.

The friendship between Aved and Chardin is well known. The anecdote relating how Aved was instrumental in Chardin's decision to devote himself to genre paintings is mentioned in the entry for *Lady Sealing A Letter* [54]. It is known, too [Dorbec, 1904], that Aved—who also worked for Rothenbourg—helped with the preparation of the estate inventory of Chardin's first wife (1737) and that he witnessed Chardin's second marriage to Françoise-Marguerite Pouget in 1744. It should also be remembered that at the estate sale following Aved's death in 1766, there were no fewer than nine Chardin paintings, the majority of which are included in this exhibition. (When he acquired *The Philosopher* at the Salon of 1753, the architect Boscry himself owned ten paintings by Chardin.) By using Aved as his model, Chardin was certainly honoring a friend, as well as the one from whom he had taken his first lessons in figure painting.

The criticism of the 1737 Salon scarcely mentions *The Philosopher.* On the other hand, in 1753 the work is commented on a great deal. Abbé Garrigues de Froment, who has already been cited, praises its merits in order to better criticize Chardin's recent works: "How well chosen are the masses of shadow and light! How skillfully the action of the figure is characterized! For some years now, M. Chardin has chosen to blend his colors. He overpolishes and overworks his compositions. Are we any better for this change in manner or way of doing things?" This question is not without foundation. In fact, after the 1753 Salon, Chardin abandoned genre scenes and returned to painting still lifes.

The reservations were few. Chardin "has outdone himself," according to the *Mercure* (p.4). Abbé Leblanc [*Observations sur les ouvrages...,* 1753, p. 25] comments rightly on the dimensions of *The Philosopher* "which, contrary to habit, Chardin has painted life size." Abbé Laugier [*Jugement d'un amateur...,* 1753, p. 42] writes, in a very fine text: "We see a truly philosophical reader who is not content just to read, but who meditates and probes and who seems so completely absorbed in his meditation that it appears one would have difficulty in getting his attention."

The name of Rembrandt is mentioned by several critics. "One could take [it] for a Rembrandt," writes Estève [*Lettre à un ami,* 1753]. For Gabriel Huquier *fils* [*Lettres...,* 1753, pp. 27-28], "He can be on an equal footing with Rembrandt, but the exactitude

and finesse of his draftsmanship puts him higher." Grimm reports to Diderot [15 September 1753, *Correspondance philosophique, littéraire et critique,* p. 60]: "This painting seemed to me very fine and worthy of Rembrandt even though little has been said of it." These observations should be compared with the commentary on Mariette's copy of the catalog for the 1737 Salon (Deloynes collection) concerning *The Water Urn* and the *Washerwoman:* "very fine painting... the author has his own manner which is original and which aims at Rembrandt." This comparison, probably inspired by the personality of Aved, "the Batavian," has been frequently noted in recent years [Gerson, 1942; Benesch, 1948; Snoep-Reitsma, 1973; Cailleux, 1975]. It makes less sense today, however, than it did in the eighteenth century when the red costume edged with fur, the yellow hat, the half-light in which the room is bathed, and the air of concentration on the attentive face of the model reminded Salon visitors of the works of the Amsterdam painter which they could see in France.

The painting has often given rise to reservations concerning its size and stiffness. Brière himself, while praising the atmosphere "in which the artist has enveloped the attentive reader bent over his black book of spells and the laboratory equipment in the soft light of a mysterious interior," nevertheless criticizes the technique as "a little ponderous and hesitant, as it were." Such reservations seem excessive. As Abbé Laugier and Gabriel Huquier had already noted in 1753 ("There is in the philosopher's head an attention that is perfectly expressed") and which M. Fried echoed more recently (1975-1976), we must look beyond an ambitious attempt to represent a Rembrandtesque portrait of a friend. Rather Chardin seeks to convey an image of the philosopher who is absorbed in his reading—one "who is not content simply to read, but who meditates and probes... ."

63 *Portrait of Charles Godefroy (1718-1796) (also called Young Man with a Violin)*

(Portrait de Charles Godefroy [1718-1796], dit Le jeune homme au violon)

Canvas, 67.5 × 74.5 cm.
Paris, Musée du Louvre, R.F. 1706*

Provenance. Certainly commissioned by Charles Godefroy, father of the subject. Seems to have passed by inheritance first to his son, then to his surviving brother (in *Child with a Top*), Auguste-Gabriel Godefroy (1728-1813). Bequeathed, on the advice of his cousin, Dr. Charles-Louis Varnier, to Pierre Torras, broker and first cousin to the Godefroy brothers; kept at the farm of La Rosière at Tracy-sur Mer (Calvados) until 1858. To Dr. Boutin at Versailles, 83 bis, boulevard de la Reine, in 1867. Collection of Mme Emile Trépard, great-granddaughter of Torras and daughter of Dr. Boutin, in 1897. Acquired with its companion piece in 1907 from Mme Emile Trépard by the Louvre for 350,000 francs, partly with the remainder of the Léon Dru bequest (committee of 3 June 1907; board of trustees of 10 July); for a painting which had belonged to Dru, who died in 1904, see [50].

Exhibitions. 1867, Versailles, no. 100 ("Portrait de jeune homme etudiant le violon"); 1897, Paris, no. 27 ("A. de Villetaneuse l'enfant au violon"); 1907, Paris, no. 63; 1934, Paris, no. 606; 1946, Paris, no. 352; 1949, San Francisco, no. 6 (ill.); 1951, Geneva, no. 14; 1957, Paris, no. 15; 1969, Bordeaux, no. 80 (pl. 50).

Bibliography. Burty, *La Liberté,* 16 September 1867 (only one painting cited); Michel, 10 May 1897, p. 3; Tourneux, 1897, p. 452; Schéfer, 1904, p. 56 (composition cited); *The Burlington Magazine,* August 1907, p. 335; October 1907, pp. 57-58, pl. 46; Dayot, 1907, p. 129 (pl.); Dayot and Guiffrey, 1907, p. V (ill.); Dayot and Vaillat, 1907, pl. 6; Guiffrey, 1907, pp. 97-100; Michel, 14 June 1907, p. 3; Nolhac, 1907, p. 44 (ill.); *Musées et Monuments de France,* 1907, pp. 88, 121; *L'Illustration,* 15 and 22 June 1907 (ill.); Tourneux, 1907, pp. 94-95; Frantz, 1908, p. 29; Guiffrey, 1908, p. 66, no. 63; Desazars, 1909, pp. 407-16; Le Prieur, 1909, pp. 135-56; Pilon, 1909, pl. between pp. 16 and 17, pp. 51, 93, 165; Furst, 1911, p. 121, no. 62, pl. 13; Champreux, 1913, pp. 33-35; Raffaelli, 1913, p. 52; Museum cat. (Brière), 1924, no. 90B; Gillet, 1929, pp. 66, 74; Ridder, 1932, pp. 9, 34, pl. 9; Wildenstein, 1933, no. 627, fig. 28; Pilon, 1941, p. 17 (ill.); Goldschmidt, 1945, fig. 25; Goldschmidt, 1947, fig. 26; Lazarev, 1947, fig. 29; *Arts News,* October 1949, p. 31 (ill.); Jourdain, 1949, fig. 31; Denvir, 1950, pl. 16; Adhémar, 1960, p. 455; Ponge, 1963, p. 257 (color detail); Wildenstein, 1963-69, no. 167, pl. 22 (color); Lazarev, 1966, pl. 48; Mirimonde, 1966, pp. 145-146, fig. 12 on p. 148; Zolotov, 1968, p. 70 (ill.); Rosenberg, Reynaud, Compin, 1974, no. 132 (ill.); Mirimonde, 1977, p. 54.

Print. An etching by Eugène Décisy (1866-1936) was commissioned in 1922 by the chalcography of the Louvre [*Catalogue de la chalcographie,* 1968, p. 172, no. 6732].

Related Works. There is no eighteenth-century reference to another *Child with a Violin* that we know of. One should note, however, these sales: [Roux du Cantal], 17-18 February 1835 (no. 48); Hébrard, Strasbourg, 25 October 1838 (no. 43); and the Viscountess de Choiseul of 15-16 March 1839 (no. 121).

Young Man with a Violin has always been presented as the companion piece to *Child with a Top* [75]. At first glance, however, there is nothing to indicate that it was intended as such. Unlike *Child with a Top, Young Man with a Violin* is not signed, did not figure at the Salon of 1738, was not engraved in the eighteenth century, and no early replicas of it are known. How, under these circumstances, can one affirm that we really have here the portrait of Charles-Théodose Godefroy (1718-1796), son of the jeweller Charles and elder brother by ten years of Auguste-Gabriel? Frankly, we have no eighteenth-century document to prove it. Yet there are two strong reasons for believing it to be so.

First, there is a very fine drawing by Jean-Baptiste Massé (1687-1767), signed and dated 1736, which depicts the Godefroy children [sale, of 14-15 June 1920, no. 12, reproduced in the cat.; today in the Musée Nissim de Camondo, Paris, 1973 cat., no. 715]. The distinct face of the young man in the foreground, with his large mouth, bright eyes, and wide nostrils, is perfectly recognizable. There is, in addition, confirmation that this drawing well represents Charles Godefroy: the will of Massé, published by Campardon [*J. B. Massé, peintre de Louis XV,* Paris, 1880, p. 149] states that "There will be remitted to M. de Villetaneuse [Charles Godefroy] immediately after my death a drawing made by me from life... of his portrait, that of his brother and of our mutual friend M. Fallavel the Elder." We know that Charles Godefroy, like his father before him, helped Massé publish his engravings after the *Galerie des Glaces* of Le Brun, his life's work.

We come now to our second point: all that is known of the life of Charles Godefroy lends support to the idea that this painting is indeed his portrait. Passionately fond of music, Charles was himself an amateur composer and friend of the opera composer Grétry [see Mirimonde, 1977]. Yet his musical interest did not interfere with his career: in 1750 he was appointed municipal judge of Toulouse.

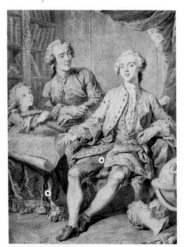

J. B. Massé, *The Godefroy Children.*
Paris, Musée Nissim de Camondo.

This appointment authorized him to be called *Seigneur de Villetaneuse,* the name Cochin used in engraving the portrait in 1780 [see Desazars, 1909].

But is this really the companion piece of the *Child with a Top* [75]? An x-radiograph made by the Louvre laboratory shows that the work has been considerably "arranged." On the left side there seems to be an added strip 6.5 cm. wide. This modification explains the awkward appearance of the caned chair on which Charles Godefroy is (or ought to be) seated. Upon closer examination, one sees that the strip comes from the right side of the painting. The upper part of the violin bow and a book are clearly distinguishable on it. In like manner, a strip measuring 5 or 6 cm. wide has been cut away from the lower part of the painting and attached to the top to provide more "air" around the head of the model, which was considerably altered by Chardin in the course of his painting.

X-radiograph and reconstruction of the original appearance of *Young Man with a Violin.*

In fact, if the two paintings do represent the two brothers, they do not seem to have been conceived as companion pieces. The scale of the figures is very different and the head of the violinist seems to be "brought forward" more than that of his brother. Had Chardin planned a squarer format for his painting, with the model standing? Did Chardin himself make the changes which have been noted and, if so, when? There are still no easy answers for these questions.

One can, however, speculate on whether the two paintings are of the same date. Auguste-Gabriel, the younger boy, was ten years old in 1738, the date of the Salon in which his portrait was shown. That is approximately the age of the model, give or take a year or two. In 1738, therefore, Charles would have been twenty, if the two paintings are contemporaneous. But that seems doubtful since, on the drawing done by Massé and dated 1736, the age difference between the two boys seems much greater. Might one then conclude that the portrait of *Young Man with a Violin* was painted before the one of his younger brother? The style of the piece confirms this conclusion. *Child with a Top* has the transparency, the confident execution, and the self-assured, solid compositin which characterize Chardin's works from 1737 to 1738. In *Young Man with a Violin,* however, the violinist seems awkward: one cannot be sure whether he is seated or standing. More importantly, he is the only model in the surviving oil portraits of Chardin who *is looking at* the spectator. This innovation, which Chardin never repeated (see, however, the *Portrait of Mlle Mahon,* known through the engraving) appears to be once more the work of a "beginner" in a new genre rather than of an artist already sure of himself. By comparison with the *Portrait of the Painter Joseph Aved* [62] and *The Game of Knucklebones* [60], we would suggest dating the work around 1734-1735.

In spite of its modifications, the work has great charm, and its recent restoration has revealed many delightful details: the sleeves with their wide cuffs attached at the elbow by the large suit buttons of the French coat, the elegant violin, the powdered hair tied back at the neck. Also admirable is the refined sense of color harmony, with olive green, dark red, and white. In particular, it is the model's face—open, serious, and faintly smiling—that holds one's attention. For once it seems that Chardin was trying to "paint a likeness." More than to portray an image of an adolescent, he wanted, above all, to successfully portray the musician son of one of his friends.

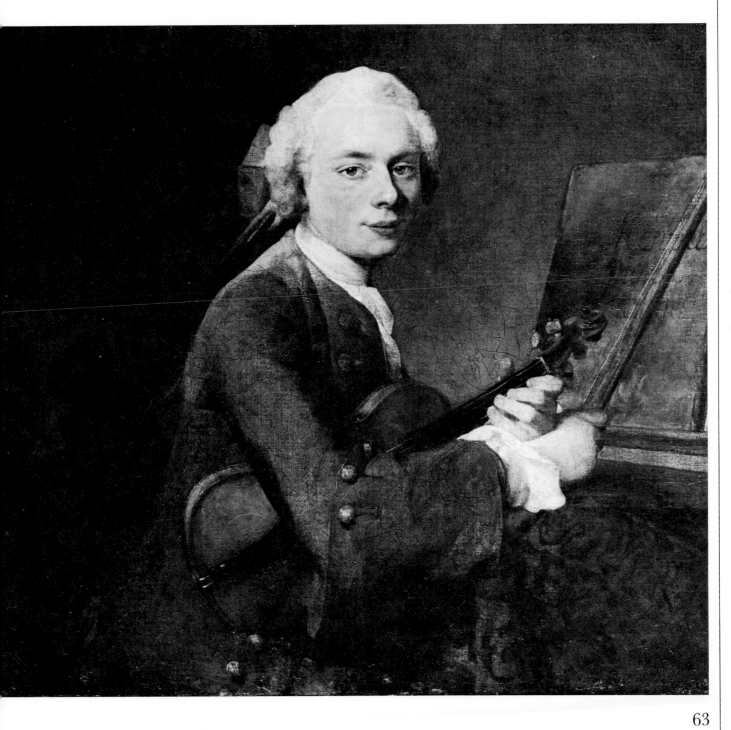

63

64 A Lady Taking Tea

("Une dame qui prend du thé")

Canvas, 80 × 101 cm. Signed and dated at the right, near the teapot, on two lines: *J. S. Chardin / 173*(5?); inscribed on the back on four lines: *ce tableau a été fair en février 1735* [Kemp, 1978, fig. 25]. Glasgow, Hunterian Art Gallery, University of Glasgow*

Inscription on the back of the original canvas.

Provenance. Sale of "the noble collection of Pictures, From the Grand Cabinets of Cardinal Mazarine, and Prince Carignan, Duke d'Valentinois" at Prestage's, London, 26 February 1765: "Lot 36. A Lady Drinking Tea. 2'8" × 3'4" " (Lot 37. "Chardine [*sic*]. A Boy Building a Houpe [*sic*] with Cards" is the Nuneham painting published by Carritt in 1974. The catalog specifies that the two paintings were engraved). Acquired at this sale by Dr. William Hunter (1718-1783) for 8 *livres.* (On the intriguing figure of Hunter, who owned three Chardin paintings — including [79] — a Rembrandt, and a vast collection of medical and scientific pieces, see the catalog of the 1973 London exhibition.) Given by Hunter to the University of Glasgow in 1783.

Exhibitions. 1739, Salon (p. 13, reprint of the cat.); 1907, London, no. 114; 1913, London, no. 39, pl. 23; 1925, Norwich, no. 8; 1926, Amsterdam, no. 9; 1932, London, no. 188; 1952, London, no. 4; 1962, London, no. 101, pl. 26; 1966, The Hague, no. 33 (with ill.); 1966, Paris, no. 33 (with ill.); 1973, London, no. 15 (ill.) (advertisement repr. for this exhibition in *The Burlington Magazine,* October 1973, p. XCVII).

Bibliography. Museum cat. (Laskey), 1813, p. 87, no. 18; *The Burlington Magazine,* October 1907, pp. 47-48, pl. on p. 49; Dayot and Vaillat, 1907, pl. 50; Guiffrey, 1908, p. 61, no. 23; Pilon,, 1909, pp. 38, 76, 169; Furst, p. 132 and pl. 8; Gillet, 1929, p. 63; Ridder, 1932, pl. 55; Cox, 1932, p. 8; Wildenstein, 1933, no. 251, fig. 50; De la Mare, 1948, pl. 5 (color); Museum cat. (MacLaren-Young), 1952, no. 4; Russell, 1957, p. 12 (ill.); Wildenstein, 1959, p. 100; Rosenberg, 1963, pp. 10, 28 (color pl.), 32 (color detail), 45; Wildenstein, 1963-69, no. 148, pl. 18, (color); Lazarev, 1966, pl. 36; Valcanover, 1966, double page in color, pl. 6; Watson, 1970, p. 537; Snoep-Reitsma, 1973, p. 222; Carritt, 1974, pp. 502-7; Kuroe, 1975, pl. 10; Kemp, 1976, pp. 228-31; Conisbee, 1976, p. 417; Wright, 1976, p. 37; Kemp, 1978, pp. 22-25, fig. 26 (and cover); *Chefs-d'oeuvre de l'Art. Grands Peintres,* 1978, pl. 6.

Print. An engraving by Pierre Filloeul (1696-after 1754) [Bocher, 1876, p. 18, no. 13; Pognon and Bruand, 1962, p. 200, no. 127] bore the following caption:

How happy young Damis would be, Climène,
If this boiling liquor
Could warm your heart,
And if sugar had the supreme power
Of sweetening in your mood
The sternness that suitor finds.

The engraving is undated and seems not to have been publicized in the *Mercure de France.*

This work, popular since the beginning of the century (it was included in the 1966 Dutch exhibition, In the Light of Vermeer), has been the object of recent research which has provided more information about its history. Quite recently, Kemp (1978) published the photograph of an inscription on the back of the original painting that was discovered during a relining and restoration. It establishes the date of the work as *February 1735,* thus ending controversy about the reading of the date on the right of the composition, whose last digit — as is so often the case in Chardin's works — is very difficult to read. Several years earlier, David Carritt (1974) carefully studied the *Lady Taking Tea* when Nuneham Castle's *House of Cards* was published (a painting in a poor state of preservation and therefore impossible to include in the present exhibition; for the replica in the Reinhart collection at Winterthur, see [65]). Not only was Carritt able to discover the precise origin of the work but he was also able to prove that the two compositions had been conceived as companion pieces. Carritt published (see *Provenance*) a reference to a 1765 London sale catalog that is useful for two reasons. On the one hand, it enables us to know when Dr. William Hunter, founder of the University of Glasgow's Art Gallery in 1783 (one of the oldest museums in the world) had been able to obtain the painting; on the other hand, it gives us the name of the previous owner: Victor-Amédée, Prince de Carignan, nephew of Cardinal Mazarin, who had died in 1741. His widow lived until 1766. Amédée himself had inherited the famous collection of the Countess de Verrue, his mother-in-law, who had died in 1736. Were these two Chardins possibly among the countess's paintings? Although unlikely, it is not impossible that the prince made the purchase directly from Chardin. He could have been in contact with the artist through Vanloo, who had worked for his family; Jean-Baptiste Vanloo, as noted earlier (see [33]), knew Chardin very well as early as 1731. In addition, as Carritt reminds us, the painter Joseph-Ferdinand, a member of the Godefroy family — great patrons of Chardin (see [63] and [75]) — "was pensioned by the Prince de Carignan" [see the preface of the Godefroy sale cat., 22 April 1748]. Thus the Prince de Carignan takes his place alongside La Roque and Rothenbourg, among the very first collectors of Chardin.

Carritt's second point is that the Glasgow painting and the Nuneham work were conceived by Chardin as companion pieces. The two paintings, brought together again in a sale in 1765, had both been engraved shortly after their completion by Pierre

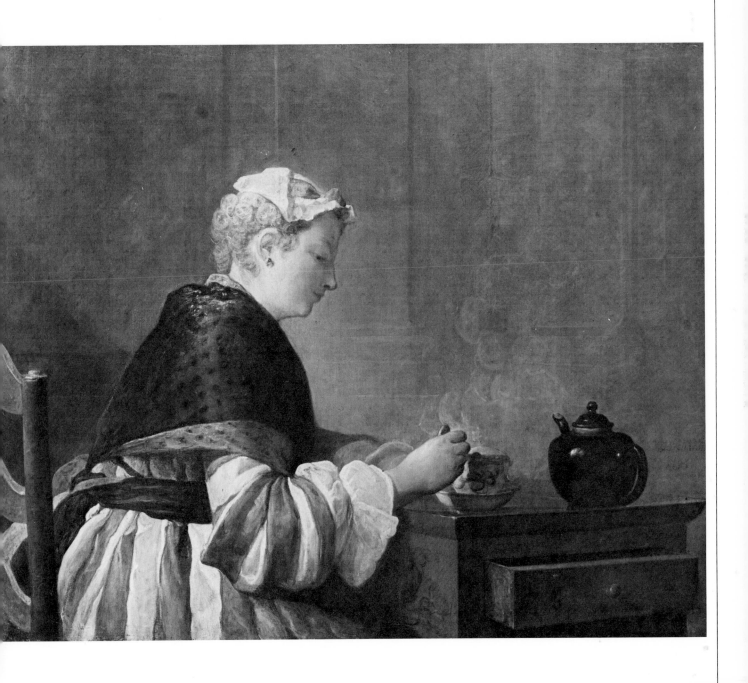

64

Filloeul. They seem really to correspond to one another in both size and subject (both are variations on the theme of vanity).

Finally, Carritt also suggests that *The House of Cards* could very well be the *Young Boy Playing with Cards* exhibited with three other paintings (see [55] and [56]) by Chardin, 2 July 1735, at the Academy on the occasion of an election of officers [*Mercure de France,* June 1735, p. 1386]. Nevertheless, it is still not known why Chardin would have exhibited only this painting to his colleagues when the *Lady Taking Tea* had been finished for some months and why the latter painting was exhibited without its companion piece (and also without great critical notice) at the Salon of 1739.

The resemblance between the model of this painting and that of the *Lady Sealing a Letter* painted two years before has often been noted. Both women are wearing the same dress. Some have thought the model was Marguerite Saintard, Chardin's wife, who died on 13 April 1735, two months after *Lady Taking Tea* had been completed. Is it unreasonable to suggest that Chardin wanted to keep for a while the work which reminded him of his wife? A detail already noted by Wildenstein (1959) supports this hypothesis. In the 1737 estate inventory of Mme Chardin, mention is made of a *tayère en terre de Flandre* which was in Mme Chardin's bedroom, and also a *table de cabaret* (with a little rimmed top for cups) [see Pascal and Gaucheron, 1931, p. 67, note]. Are the glazed clay teapot (with its awkwardly shaped spout) and the lacquered table, which appear elsewhere in the work of Chardin (see [103, 104]), the same ones we see in the Glasgow painting?

Of Chardin's compositions with large figures, *A Lady Taking Tea* is the third he painted, after the paintings in Berlin [54] and the Louvre [62]. It is also the most accomplished. The composition is extremely simple, although some awkwardness is evident in the perspective of the chair and the table. Nevertheless, the harmonization of colors—the gray-green stripes of the dress edged in red and the red of the lacquer on the table, the various blues of the shawl, bonnet, and the powdered hair—is perfectly achieved.

From the somewhat lifeless face, with its vague and dreamy gaze, absorbed in the contemplation of the steam rising from the teacup, a feeling of gentleness and tenderness emerges that in his century only Chardin knew how to capture on canvas.

65 *The House of Cards*

(Le château de cartes)

Canvas, 77 × 68 cm. (originally round); the corners of the painting are formed with pieces taken from the original composition; the canvas texture is the same; for the original dimensions, see *Provenance.* Signed at the bottom left near the elbow (very faint): *S. Chardin* (?).
Paris, Musée du Louvre, M.I. 1032*

Provenance. In our opinion, this is the painting in the sale of the dealers Lebrun, Lerouge, Verrier, and Dubois, 12 March 1782, no. 134: "A young man seen half-length and in profile, his two hands resting on a table, and making a castle of cards. Diameter: thirty *pouces,* Round canvas" (81 cm. in diameter). Acquired by De Vouge[s], a dealer living at the Hôtel de Bullion. Wildenstein [1963-69, no. 162, fig. 73] related to this sale the painting formerly in the Henry de Rothschild collection (see *Related Works*). But even though the subject of the Rothschild painting was set in a bull's-eye, the canvas is, in fact, rectangular. For the Louvre painting to be the very same painting as the one in the De Vouge collection, 2 cm. would have had to be cut off both the top and bottom and approximately 6 cm. from each side. Dr. Louis La Caze collection (1798-1869) at least by 1860; bequeathed with the rest of his collection to the Louvre in 1869.

Exhibitions. 1860, Paris, no. 98; 1954-55, Tokyo, no. 17 (color pl.); 1957, Paris, no. cat.; 1959, Paris, no. 7; 1960, Copenhagen, no. 5 (ill.); 1960, Paris, no. 573; 1963, Paris, no. 404; 1964, traveling exh., no. 28 (ill.); 1967-68, San Diego, San Francisco, Sacramento, Santa Barbara, New Orleans, San Antonio, unnumbered but repr.; 1969, Paris, La Caze collection, p. 10 (122); 1970, Osaka, no. cat.; 1973, Troyes, Nancy, Rouen, no. 5 (ill.).

Bibliography. Bürger (Thoré), 1860, pp. 333, 334, 336; Gautier, 1860, pp. 1261-62; Gautier, 1864, p. 74; Mantz, 1871, p. 17; Museum cat. (La Caze), 1871, no. 171; Bocher, 1876, p. 86, no. 171; Chennevières. 1889, p. 123; Moreau-Vauthier, n.d., but around 1897, pl. on p. 248; Normand, 1901, p. 66; Schéfer, 1904, pp. 29 (repr.), 48, 55; Guiffrey, 1907, p. 97; Guiffrey, 1908, pp. 66-67, no. 65; Pilon, 1909, pp. 43, 95 (note), 100, 104, 160; Lepreuir, 1909, p. 137; Furst, 1911, p. 122, no. 103; Museum cat. (Brière), 1924, no. 103; Bodkin, 1925, pp. 93-94; Pascal and Gaucheron, 1931, p. 125; Ridder, 1932, pl. 7; Wildenstein, 1933, no. 146, fig. 47; Pilon, 1941, pl. on p. 24; Goldschmidt, 1945, fig. 28; Goldschmidt, 1947, fig. 6; Jourdain, 1949, fig. 26; Pigler, 1956, II, p. 526; Wildenstein, 1963-69, no. 163, pl. 20 (color); Rosenberg, 1969, p. 99; Carritt, 1974, p. 505; Rosenberg, Reynaud, Compin, no. 129 (ill.); Kuroe, 1975, p. 89 (black and white fig.); *The Barnes Foundation Journal of the Art Department,* Spring 1976, pl. 14; Kemp, 1978, p. 23.

Print. The painting was engraved by Rodriguez to illustrate the book by Normand [1901, p. 66].

Related Works. An early rectangular replica of good quality is in a Paris collection. A copy by "Dissoubroy" (?) has been placed by the Musée de Beaune in the town hall (catalog of the paintings of Beaune, thesis by Ch. Schaettel, 1971, no. 47). Another copy, of April 1904, by Albert Marquet (1875-1947) is in the Musée Bastien-Lepage at Montmédy (see exh. cat. *Albert Marquet Exhibition,* Paris, 1975-76, no. 13; Marquet had first copied the painting in 1898 [Register of Copyists, Archives of the Louvre]).

The most important work to be related to the Louvre painting is the version formerly in the Henry de Rothschild collection, 82 × 102 cm., inscribed at the bottom right *Chardin 1737* [Wildenstein, 1963-69, no. 162, fig. 73]. The only difference—significant, however,—between the

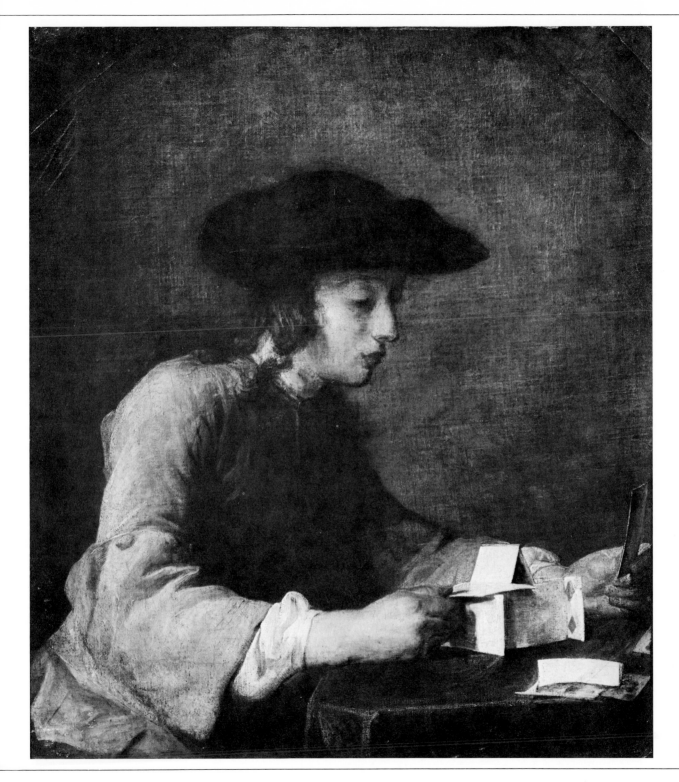

65

Louvre painting and this one, other than the architectural background and the chair on which the model is seated, is that the Rothschild painting is set within a circular stone bull's-eye opening. We agree with those who believe the Rothschild painting to be an early replica that cannot go back to Chardin himself. It is possibly the painting at the sale of the Count de Sainte-Maure, 27 March 1764, no. 101: "A young man making a castle with cards in the style of M. Chardin. Three *pieds* wide by two *pieds* five *pouces* high" (97.5 × 78.5 cm.).

The theme of the house of cards inspired Chardin on numerous occasions. Three times he exhibited paintings on this subject (1735, 1737, and 1741), and three compositions were engraved in the eighteenth century (by Pierre Aveline, 1702?-1760? [73]; Pierre Filloeul; and François-Bernard Lépicié [71]). Besides the versions in the Louvre and the National Galleries of London and Washington [71, 73], we now know of another version—by Chardin, in our opinion: the Nuneham painting which has already been mentioned in reference to its companion piece, *Lady Taking Tea* [64]. A replica of the Nuneham picture is at Winterthur, a pastiche is at the Musée Cognacq-Jay, and an altered copy is at the Musée de Dijon.

Here, in conclusion, is a list of *The House of Cards* paintings which appeared in eighteenth-century sales:

Count de Sainte-Maure, 27 March 1764, no. 101, 97.5 × 78.5 cm., "in the style of M. Chardin" (reference has also been made to this painting in the entry for Glasgow's *Lady Taking Tea* [64] with regard to its companion piece).

The House of Cards. England, Private Collection.

Victor-Amédée, Prince de Carignan, London, 26 February 1765, no. 37. This is the Nuneham painting, companion piece to the Glasgow painting [Carritt, 1974, p. 506].

Sale [Caffieri], 10 October 1775, no. 12, 65 × 54 cm.

Sale [Jombert *père*], 15 April 1776, no. 35, 65 × 54 cm. (probably the same as the preceding painting, apparently lost today).

Anonymous sale by A. Paillet, 15 December 1777, no. 211, 86.5 × 67.5 cm. Wildenstein [1963-69, no. 207, pl. 33] incorrectly identifies the painting in Washington's National Gallery, which was formerly at The Hermitage, with the one mentioned in this sale; the Russian painting's companion piece was *Little Girl With Shuttlecock* [72], which had left France in 1774 [it is included at that date in a Hermitage catalog]).

Trouard sale, 22 February 1779, no. 44, 62 × 85 cm. (this is the painting generally identified with the one in the Reinhart collection, Winterthur, Switzerland [Wildenstein, 1963-69, no. 209, fig. 98]; see the entry for its companion piece at the Doucet sale, the Metropolitan Museum's *Soap Bubbles* [61]).

Sale of the dealers Lebrun, Lerouge, Verrier, and Dubois, 12 March 1782, no. 134, 81 cm. diam. (in our view, the painting in the Louvre).

Fauquier sale, London, 30 January 1789, no. 75 (the Nuneham painting mentioned above [Carritt, 1974, p. 502]).

In an inventory of the paintings in the collection of the painter and friend of Chardin, Aignan-Thomas Desfriches, drawn up around the year 1800 (and which is still in the family of the artist from Orléans), mention is made of a "young man making castles of cards by Chardin" (Desfriches sale, 6-7 May 1834, no. 53).

We mention, for completeness, the sales of 24-27 September 1832 [Langlier], no. 9; 19 February 1848, no. 6 [Gueting]; and 26-29 December 1849 [M. de Saint-Albin], no. 13. None of these sales gives the dimensions of *The House of Cards* paintings, nor do they give sufficiently accurate descriptions to enable identification with this or that composition.

Chardin had a predilection for the theme of the young adolescent building a house of cards. Through close analysis of early texts, sale entries of the eighteenth century, Salon catalogs, and a careful examination of the engravings (see *Related Works*), it is possible to state that he created only four types of compositions on this subject: (1) the horizontal, undated version by Pierre Filloeul, companion piece to *A Lady Taking Tea* in Glasgow [64]; (2) the Louvre painting, round in shape in 1782, and the only one not to be engraved; (3) the vertical, undated Washington painting [73] engraved by Pierre Aveline, companion piece to *Little Girl With Shuttlecock* [72]; (4) the painting [71] in London's National Gallery, the most polished of all, engraved by Lépicié *père* in 1743.

In what order were the four compositions done? We know that Chardin exhibited paintings on this subject three times: in 1735 at the Academy, and in 1737 and 1741 at the Salon. It is generally agreed that the version in the National Gallery, London, is the one exhibited at the 1741 Salon (for the reasons, see [71]). Carritt (1974) demonstrated that the Nuneham painting is the one "made or completed that year" which Chardin submitted to his colleagues at the Academy on 2 July 1735.

Which of the three versions of *The House of Cards* was in the Salon of 1737? It might have been the Nuneham painting, but why exhibit it again only two years after its first public presentation? The fact that the replica of the Louvre's *House of Cards* (formerly in the Henry de Rothschild collection) is dated 1737 could favor this composition as the Salon picture. Two factors, it seems to us, destroy this hypothesis. It was rare that Salon paintings were not also engraved. The Louvre painting was one such case, while the Washington version was popularized by the print of Aveline. More importantly, the *Little Girl With Shuttlecock* [72] appeared at that same 1737 Salon. These two compositions remained together for a long time, or at least they were together in 1774 when Catherine the Great bought them. It seems logical, therefore—though Chardin was often unpredictable—to think that they were together as of the 1737 Salon.

The Louvre painting has suffered much over the years. Not only has it lost its original round form (see *Provenance*) but it is also abraded. In addition, in the course of painting, Chardin changed

the composition considerably. Radiographs show that the young boy was originally hatless. His hair, which has been appreciably modified, was arranged to let his ear show. (Restoration of the painting promises to be so delicate that it was not undertaken for this exhibition.) Any judgment, therefore, on stylistic matters becomes paticularly difficult to make. Yet the painting fits in well between *The House of Cards* from Nuneham and the one in Washington. It lacks both the rich drapery of the Nuneham picture and its ambitious composition, with light falling on the cards through a window opening. Nor does it have the somewhat affected elegance of the Washington painting. The Louvre composition could very well date from 1736. In any event, Chardin hesitated a great deal before giving it its present appearance.

This is not the place to dwell on the significance of *The House of Cards* as a symbol of the vanity of worldly constructions. A comparison is made in the entry for the London painting [71] of the cap-

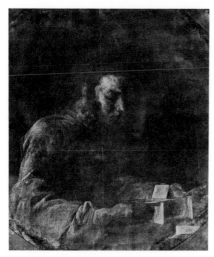

X-radiograph of the Louvre painting.

tions accompanying the three engravings after the various Chardin compositions, and artists treating the same theme are mentioned. We shall see that Chardin, as in his still lifes, recomposed and recreated a work, each time making use of the same elements. It will suffice to cite Thoré, who wrote, when he saw the La Caze painting exhibited in 1860, "To what other master, of any school whatever, can we compare... *The House of Cards?* In these full-size figures he takes after no one: he is unique."

66 *The Monkey as Painter*

(Le Singe peintre)

Canvas, 28.5 × 23.5 cm. (and not 45 × 35 cm., as has often been repeated, especially by Wildenstein, 1933). Signed at the upper left: *Chardin.*
Chartres, Musée des Beaux-Arts

Provenance. Everything suggests that this painting and its companion piece were the two paintings in the collection and estate sale of the sculptor Jean-Baptiste Lemoyne (1704-1778): "Two companion paintings representing monkeys, one dressed like a painter and the other like an antiquarian. Height, eleven *pouces;* width, eight *pouces;* canvas" (29.5 × 21 cm.); they turn up again at the D[e]P[reuil] sale of 25 November 1811, no. 161 (27.1 × 21.6 cm.). Garnier Courtois collection at Chartres between 1858 and 1898. Given to the Chartres museum by Mme Justin Garnier-Courtois in 1898.

Exhibitions. 1858, Chartres, no. 343; 1869, Chartres, no. 79; 1896, Chartres, no. 238; 1975, Brussels, no. 99 (ill. pl. 1145).

Bibliography. Goncourt, 1863, p. 523, note; Goncourt, 1880, p. 119; Dayot and Vaillat, 1907, under no. 40, p. VIII; Guiffrey, 1908, p. 68 under no. 71; Goncourt, 1909, p. 175; Museum cat., 1920, p. 10, no. 33; 1931, p. 6, no. 33; Wildenstein, 1933, no. 1187; Museum cat., 1954, p. 6, no. 18; 1958, p. 7, no. 20; Gobillot, 1957, p. 1 (ill.); Exh. cat., Paris, 1959, under no. 11; Vergnet-Ruiz and Laclotte, 1962, pp. 84, 230.

See [67] for discussion.

67 *The Monkey as Antiquarian*

(Le Singe antiquaire)

Canvas, 28.5 × 23.5 cm. (and not 43 × 32 cm.). Signed at the top near the center: *Chardin.*
Chartres, Musée des Beaux-Arts

Provenance. See [66].

Exhibitions. 1858, Chartres, no. 342; 1869, Chartres, no. 78; 1896, Chartres, no. 237; 1958, Bordeaux, no. 9; 1975, Brussels, no. 100 (ill. p. 145).

Bibliography. Goncourt, 1863, p. 523, note; Goncourt, 1880, p. 119; Dayot and Vaillat, 1907, under no. 40, p. VIII; Guiffrey, 1908, p. 74, no. 108 (confuses it with the *Singe antiquaire* formerly in the Deligand collection and now at the Fine Arts Gallery of San Diego); Goncourt, 1909, p. 175; Museum cat., 1920, p. 10, no. 34; 1931, p. 6, no. 34; Wildenstein, 1933, no. 1173; Denvir, 1950, pl. 4 in color (error in the caption: it is the Louvre painting that is reproduced); Museum cat., 1954, p. 6, no. 19; 1958, p. 7, no. 21; Vergnet-Ruiz and Laclotte, 1962, pp. 84, 230.

Prints. The *Singe de la peintre* and the *Singe antiquaire* were engraved in 1743 by Pierre-Louis Surugue *fils (1716-1772)* [Bocher, 1876, p. 43, no. 42 and p. 8, no. 2] and exhibited at the 1743 Salon (p. 38, reprint of the catalog). Surugue unquestionably engraved the two paintings by Chardin that had been exhibited at the 1740 Salon. Captions for his engravings were written by Charles-Etienne Pesselier (1711/12-1763) [on

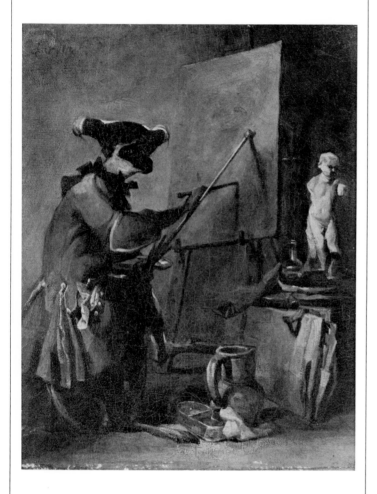

66

this writer friend of Chardin, see *Précis analytique des travaux de l'Académie... de Rouen*, 1817, III, pp. 254-56, and *Mémoires de l'Académie... d'Amiens*, 1900, XLVI, pp. 276-79; see also the *Critical Evaluation of Chardin* in this catalog]:

Le peintre
The monkey, exact imitator or parodist,
Is a very common animal,
And some men on this earth paint the one
Who serves as a model to the other.

L'antiquaire
In the obscure maze of ancient monuments
Why, learned man, do you put yourself to so much trouble?
For truly philosophical eyes, our century
Provides enough to keep one busy.

The portfolio in the foreground of *The Monkey as Painter* bears the date *1726*, which does not appear in any other version. These engravings were frequently reproduced [see Snoep-Reitsma, 1973, figs. 7 and 8, p. 171], although *The Monkey as Painter* was more often duplicated than *The Monkey as Antiquarian* [Normand, p. 100]. The latter, however, was the subject of a woodcut after a drawing by F. Bocourt, who illustrated the life of Chardin in Charles Blanc's *Histoire des Peintres* (1862).

Related Works. Chardin exhibited two paintings on these subjects at the 1740 Salon: no. 58, "a monkey painting," and no. 59, "the monkey of philosophy." Except for the second painting's title ("or rather the monkey coin collector and antiquarian") jotted down in the Salon catalog by its owner (Deloynes coll., Cabinet des Estampes, Bibliothèque Nationale), these paintings drew little comment. No early source gives the dimensions of the two paintings. But at the Chardin estate sale of 6 March 1780, no. 17 comprised "Two paintings representing Monkeys. Height, 27 *pouces;* Width, 21 *pouces.* Canvas. They were engraved by the same man" [*i.e.*, Surugue]. Because the 1740 Salon paintings are most likely those engraved by Surugue three years later, it has been concluded that the Salon paintings measured 73 × 59.5 cm.

The only monkey paintings to be put up for sale in France in Chardin's lifetime were those of the 1778 J. B. Lemoyne sale — very probably (see *Provenance*) the paintings which are now in Chartres. But D. Carritt has called attention to the John Ellys [Sir John Eyles] sale in London on 27-28 February 1760 (no. 40, "Chardin. Two pieces of monkeys") and to the two paintings in the Bullock sale at Christie's, 28 February 1800 (no. 34, "Chardin. The virtuoso and the artist, satyrical"), as well as the sale of the Duke of Hamilton, on 6 June 1819, (no. 7, "Chardin. Two, the Monkey, Painter and the Monkey, Amateur, oval"). There are, finally, the two paintings at the sale of the Destouches collection (21 March 1794, p. 77, no. 295, 62 × 46.5 cm.) which might very well be traced back to Chardin.

Through a photograph, we know the copy of *The Monkey as Painter* (40 × 32 cm.) that was in the Henry de Rothschild collection, destroyed during World War II. We also know the very mediocre one formerly in the Charles-Victor Tillot collection [exh. cat. Paris, 1959, no. 11; cf. Wildenstein, 1960, p. 2] and those: (1) in the Musée de Saint-Quentin (73 × 60 cm.; formerly in the Quentin de La Tour collection), which seems to merit reconsideration; (2) in the Lepke sale in Berlin, 29 November 1932, no. 50 (28.5 × 23 cm.); (3) formerly in the Boer collection in Amsterdam, then in Geneva (size unknown); and (4) at Higgins' in Paris in 1952 (81 × 65 cm.). (The painting in the Kunsthistorisches Museum of Vienna is of a different composition and has nothing to do with Chardin.)

With regard to *The Monkey as Antiquarian*, there are the very mediocre versions at Lille (73 × 55 cm.), the Petit-Palais (29 × 24 cm.), and those: (1) put up for sale at Christie's on 26 February 1926, no. 143; (2) exhibited in Amsterdam in 1926 (no. 14) and sold in Paris

on 8 July 1942, no. 45 (75 × 63 cm.); and (3) of Higgins' in Paris in 1952 (81 × 65 cm.; said to come, with its companion piece, from the Ropiquet sale of 20-21 November 1840, nos. 62 and 63, but no dimensions are available). We must not forget (4) the very fine copy (43 × 33 cm.) which is perhaps the companion piece of the Rothschild painting; it was formerly in the Deligand collection in Paris and is now at the Fine Arts Gallery of San Diego.

We have not mentioned the Louvre's two paintings (Inv. 3206 and M.I. 1033) which have often been presented as companion pieces from the 1740 Salon. Wrongly so, in our opinion. Not only are the dimensions of the two paintings appreciably different (*The Monkey as Painter* measures 73 × 59.5 cm., and *The Monkey as Antiquarian*, 81 × 64.5 cm.); they do not have the same provenance. The first painting comes from the La Caze collection, to which it belonged no later than 1860; the second was bought from Laneuville along with *The Meat-Day Meal* and *The Fast-Day Meal* in 1852. It was part of the singer Barroilhet's collection in 1848. But the most important reason for rejecting this

Paris, Louvre. Chardin(?), Paris, Louvre.

association of the two paintings is that they are very different in style. In 1848, while reviewing an exhibition in which *The Monkey as Antiquarian* figured, Clément de Ris expressed doubts about its attribution (p. 194):

"We shall express no opinion concerning the authenticity of the painting belonging to M. Barroilhet, the *Singe antiquaire;* it has long been attributed to Watteau, to whose manner it relates much more than it does to that of Chardin. After all, and even though this work is in poor condition, it has an undeniable merit which we openly acknowledge."

Twelve years later La Caze lent his *Monkey as Painter* to the Galerie Martinet. Thoré [Bürger, 1860, p. 338] did not find it to be "of very high quality; but at least its authenticity is not in doubt...." We agree with his second point: we do not in any way deny that *The Monkey as Painter* is the painting at the 1740 Saon (and consequently at the Chardin estate sale). As for *The Monkey as Antiquarian*, even when given an extremely early date — 1726, for example, which we read on the portfolio in the engraved version of *The Monkey as Painter* — its attribution is a problem; therefore, we prefer not to consider it a work by Chardin.

Of all the versions of *The Monkey as Painter* and *The Monkey as Antiquarian*, we have chosen to exhibit the paintings from Chartres, which, however, have been omitted from recent editions of Wildenstein's work. They strike us as the finest pair known today of the compositions popularized by the 1743 engravings of Surugue. Their provenance, furthermore, is excellent — confirming, if need be, their authenticity.

67

The first question which arises concerns their dating. Remember that Chardin exhibited at the 1740 Salon two paintings on these subjects; they probably figured at the Chardin estate sale and were much larger than those now in Chartres. *The Monkey as Painter* of the Louvre is probably one of them. But there is nothing to prove that the pictures exhibited had been painted in 1740. The Goncourts have rightly pointed out that 1726 was clearly visible on the portfolio in the foreground of the engraving of *The Monkey as Painter*. Nothing supports the notion that Chardin had taken up this theme at that date, all the more so because none of the painted versions of the painting which are known carry the 1726 date. From the point of view of execution alone, it is possible to propose a date of about 1735-1740 for the Chartres paintings, not much earlier than the 1740 Salon.

The themes of *The Monkey as Painter* and *The Monkey as Antiquarian* are well known. Thoré wrote in 1860, in connection with the paintings in the Louvre [Bürger, p. 338]: "These fantasies of Chardin remind one of the great artist whom France has just lost... of Decamps, who left behind several masterpieces having to do with monkeys—the *Experts*, among others. David Teniers was the first to invent or at least to popularize this kind of transposition of caricature, but, his subtlety and wit notwithstanding, Chardin and Decamps have surpassed him." Another name called to mind by these monkey themes, a name at least as important as Teniers, is, of course, Watteau. We find him mentioned in 1848 by Clément de Ris [p. 194; also cited above under *Related Works*]. Frédéric Villot mentions him in his report preparatory to the acquisition of *The Monkey as Antiquarian* by the Louvre [Archives du Louvre, dated 23 April 1852]. And, most recently, Snoep-Reitsma (1973) stressed the relationship between the composition of Watteau known through the engraving of L. Desplaces (*La Peintre* [a copy is in the Musée des Arts Décoratifs, Paris; cf. Rosenberg-Camesasca, 1970, no. 70]) and the piece by Chardin. It should be noted that at the time of the second marriage contract of Chardin in 1731, there was in the painter's collection "a small sketch of Vateaux [*sic*], painted on wood, representing a battle" (this description is taken from the 1737 estate inventory of Marguerite Saintard). Thus, Chardin was not unaware of Watteau. Far from it!

Before dealing with the significance of the two works, let us consider the damaged plaster sculpture of a *putto* which the monkey painter apparently intends to copy. Except for the position of the legs, that *putto* resembles, to an astonishing degree, the *Amour en plâtre (The Plaster Cupid)* painted by Cézanne, a composition frequently repeated by the artist [Picon-Orienti, 1975, nos. 834 to 838]. We know that Cézanne thought he was copying a plaster cast done by Puget which is still preserved in his atelier at Aix. Herding [1970, no. 125; see also Reff, 1967, p. 282] has proposed for this plaster cast the name of Nicolas Coustou. Rightly so, it appears, judging from the Largillierre canvas which shows the sculptures in his studio. Among the plasters surrounding him is a *putto* seen from the back, which seems to be the one copied by Chardin and Cézanne. The similarity—too close to ignore—constitutes a new link, however accidental, between the two painters.

Several recent studies have dealt with the interpretation of the subjects. One recalls that Dora Panofsky (1952) saw in Watteau's *La Peintre* and in its companion piece *La Sculpture* many self-portraits of the artist. Does the same hold true for the monkey pieces of Chardin? Or ought one rather subscribe to the brilliant thesis of H. W. Janson [1952, pp. 311-312]? According to Janson, the elegantly garbed monkey copying an antique statuette represents the artist turning to works of the past in preference to the direct study of nature, but in doing so, he will succeed only in copying his own monkey image, his simian nature. One notes in the engraving that a monkey, not the antiquity, appears on the canvas. In *The Monkey as Antiquarian*, according to Janson, who finds confirmation for his opinion in Pesselier's captions at the bottom of the Surugue engravings, Chardin was trying to ridicule collectors of ancient coins who would be better advised to encourage modern art. Snoep-Reitsma (1975) goes even further and sees Chardin taking a stand in the two paintings in favor of the "Moderns" in their quarrel with the Academy. The interpretation is a bold one, but it calls for nuances. That there is in *The Monkey as Antiquarian* something more than a simple atelier exercise is proven by the title given the work at the 1740 Salon: *The Monkey of Philosophy*. That the caption for *The Monkey as Antiquarian* engraving (see *Prints* above) is a profession of faith—albeit very trite—in favor of "our century" is clear. But to see in these paintings a lampoon directed against the Academy, to which Chardin owed everything, strikes us as highly improbable and totally contrary to Chardin's way of thinking.

Whatever the case may be, the merit of these two works lies elsewhere. Avoiding the least suggestion of vulgarity and even showing affection for the monkeys he depicts, Chardin describes two interiors. One is that of a painter who has "succeeded." The painter is seated on a stool, wearing a feathered, three-cornered hat and a brown suit trimmed with gold braid. In front of him rests a portfolio, a rag, a pitcher, a tray for cleaning his brushes, a stone for grinding his colors, a flask of oil, a roll of blue paper, and a knife; on the wall are two swords. The antiquarian, clothed in an ample dressing gown, is studying a medal with a magnifying glass. Behind him one sees a cabinet for storing his medals, and at his feet, an antique-looking footstool with a pile of books. A smoking stove sits to the right of him. Why not simply see in these paintings a French answer (with a humorous note seldom found in Chardin) to the Flemish *"singeries"* which were enjoying enormous popularity at the time in Paris?

68 *The Embroiderer*

(L'ouvrière en tapisserie)

Wood (oak), 18 × 15.5 cm. Allegedly signed on the left: *Chardin.*
Stockholm, Nationalmuseum

Provenance. Collection of the Chevalier Antoine de La Roque in 1743
(perhaps even commissioned by him from Chardin). La Roque estate
sale, May 1745, no. 39, "Two other little paintings five *pouces* wide by
seven high (13.5 × 18.9 cm.), painted on wood by M. *Chardin,* one of
which represents a girl embroidering and the other a young draftsman
seen from the back; they are enclosed in frames which are appropriately
sculpted and gilded" (sold for 100 *livres* with its companion piece, accor-
ding to the copy of the catalog in the library of the Louvre, which states
they were bought "by Gersaint for M. le Marquis de Lalvure" [?—the
name is hard to read], for 79 *livres* 19 *sols,* according to the copy at the
Institut Suédois in Paris). Acquired by the dealer E. F. Gersaint (author
of the catalog) through the intermediary of Tessin, for the heir to the
Swedish throne, Prince Adolf Fredrik (1710-1771) (in his estate inven-
tory of 1771 they are valued at 300 *dalers* each [Lespinasse, 1911, p.
318]; arrived in Stockholm August 1745. On the death of Adolf Fredrik,
they were acquired by his son Gustaf III for 375 *dalers* each. Drott-
ningholm Castle until 1865. At the Nationalmuseum since then.

Exhibitions. 1738, Salon, no. 26 (p. 15, reprint of the cat.: "a working
woman selecting wool from her basket"); 1929, Paris, no. 2; 1967,
Bordeaux, no. 17, pl. 15; 1968, London, no. 133, fig. 192.

Bibliograpy. Clément de Ris, 1874, p. 497; Bocher, 1876, p. 92, no.
778; Dussieux, 1876, p. 604; Sander, 1876, p. 164, no. 1; Goncourt,
1880, p. 122; Dilke, 1899, pp. 335, 337 (ill.), 340; Dilke, 1899 (2), pp.
121, 123; Leclercq, 1899, p. 128; Guiffrey, 1907, p. 96, note 1; Guif-
frey, 1908, p. 93, no. 238; Goncourt, 1909, p. 180; Pilon, 1909, pp. 47,
170; Furst, 1911, p. 133; Lespinasse, 1911, pp. 117, 318; Klingsor, 1924,
p. 83 (ill.); Museum cat., 1928, p. 183, no. 778; Pascal and Gaucheron,
1931, pp. 110-11; Ridder, 1932, pl. 66; Wildenstein, 1933, no. 253, fig.
35; Goldschmidt, 1945, fig. 21; Goldschmidt, 1947, fig. 25; Denvir,
1950, pl. 15; Strömborn, 1951, no. 64, p. 160 (Swedish ed., 1949, no.
64); Museum cat., 1958, p. 41, no. 778; *Du,* December 1960, p. 30;
Nemilova, 1961, pl. 3; Wildenstein, 1963-69, no. 172, pl. 24 (color);
Lazarev, 1966, pl. 40; Ochsé, 1972, pl. on p. 48; Snoep-Reitsma, 1973, p.
203 (the composition and the engraving); Carritt, 1974, p. 507, note 24.

Prints. An engraving in four colors was executed in 1742-43 by Jacques
Fabien Gauthier-Dagoty (1716-1785); it faces in the same direction as
the painting [cf. Bocher, 1876, pp. 42-43, no. 41; Hébert, Pognon and
Bruand, 1968, pp. 51-52, no. 27]. The *Mercure de France* for January
1743 (pp. 148-49) commented:
"Mr. *Gautier [sic],* the only engraver appointed by the King in mat-
ters of colored prints or printed paintings has just brought out four new
pieces, the third of which represents a young embroideress, a tapestry
worker, after M. *Chardin,* with its companion piece after the same
painter, representing a young draughtsman, seated on the floor, draw-
ing on a portfolio.... Mr. Gautier advances daily in the new art of print-
ing paintings. His works are much sought after and are extremely
marketable...."
From the May 1745 *Mercure de France* (p. 116) announcing the La
Roque sale, we learn that the Chardin paintings belonged to the collec-
tor who "gave them... to the author of printed paintings to be engraved
in colors," who did them in the same size as the original paintings.
Another version executed in reverse by E. Cécile Magimel seems to be
very rare [Bocher, 1876, p. 43, no. 41B]; Hédouin [1846, p. 229, no.
49; 1856, p. 207, no. 49, "E. Cécile Maginol"] was familiar with a ver-
sion entitled *L'Amusement (The Pastime).*

68

The most famous engraving is that of Jean-Jacques Flipart (1719-1782), dated 1757 (it was very probably exhibited that year at the Salon, no. 160, "Two Prints after M. Chardin") and frequently reproduced [Normand, 1901, p. 68; Snoep-Reitsma, 1973, fig. 55]. Obviously, this engraving does not reproduce the Stockholm painting, which at that time was already in Sweden [cf. Bocher, 1876, pp. 41-42, no. 40; Pognon and Bruand, 1962, p. 217, no. 25]; most likely it reproduces the version of the 1759 Salon (see *Related Works*).

Prints by J. J. Flipart.

Related Works. The Embroiderer and its companion piece, *Young Student Drawing,* are among Chardin compositions posing the greatest number of problems. We shall make an effort here to solve them.

On two occasions Chardin exhibited two pairs of paintings dealing with related subjects: the paintings which are surely today in Stockholm (Salon of 1738) and those of the 1759 Salon (no. 39, "A Young Draughtsman... a girl working on a piece of tapistry"). They belonged to the engraver Laurent Cars (1699-1771) and measured one *pied* high (32.5 cm.) by seven *pouces* wide (19 cm.). Whether they were on wood or on canvas is not specified. Included in the Salon of 1738 was a painting of a "young woman working on a piece of tapistry" (no. 21) that has long been thought to be a version of the Stockholm painting. Carritt (1974) has demonstrated appropriately that the 1738 painting must, in fact, have been a much larger composition, the companion piece of *The Young Draftsman* in the Louvre [76].

Two pairs of engravings after these Chardin compositions are known: those made by Gauthier-Dagoty (and their imitations), which copy the Stockholm paintings, and those of Jean-Jacques Flipart, dated from 1757. The paintings which Flipart's engravings reproduce show a goodly number of variations in comparison with the Swedish paintings. It must be understood from the start that these engravings were sold *"chez M. Cars,"* owner of the paintings in the 1759 Salon *[Mercure de France, December 1757]*.

Wildenstein lists no fewer than *six* versions of *The Embroiderer* and *eight* versions of the *Young Student Drawing.* Two versions of the former and three of the latter, all very close in composition to the Stockholm paintings, belonged to the Henry de Rothschild collection (all reproduced in 1929 by Quintin and all destroyed during World War II).

We know through a photograph only a single copy of *The Embroiderer,* of very high quality, which was sold at Christie's of London on 19 November 1920 (photograph at the Courtauld Institute in London). As for the *Young Student Drawing,* in addition to the painting

mentioned by Bürger (Thoré) in his review of the 1857 Manchester exhibition [1865, p. 340], we know through a photograph only the paintings in the collection of Montesquiou-Fezensac (27-28 May 1928, no. 12, with ill.) and La Beraudière (sold in Amsterdam on 15 November 1938, no. 19). We have seen the one exhibited at the Heim Gallery in 1959 (no. 17), which Wildenstein rightly criticized [1960, p. 2 "very poor copy"]. Its quality notwithstanding, it does have the great merit of being the *only* known version of the composition engraved by Flipart.

The references in early sales relating to one or the other of the two engraved compositions are as follows:

Two paintings: 23 February 1778 sale (by Nogaret et al.), no. 34, wood, each seven *pouces* by six *pouces* wide (18.9 × 16.2 cm.), "known through the prints"; 10 August 1778, Lemoyne sale, no. 25, canvas, six *pouces* six *lignes* by six *pouces* wide (17.5 × 16.2 cm.), "engraved"; 15 March 1779, sale of the Prince de Conti, no. 90, canvas, each seven *pouces* by six *pouces* wide (18.9 × 16.2 cm.), sketched by Saint-Aubin [see Dacier, 1919, X, facsimile, p. 31]; 19 March 1781, Boscry sale, no. 19, wood, 13 *pouces* by 6 *pouces* wide (35.1 × 16.2 cm.); 3 December 1787, sale of Mme la Présidente de Bandeville, no. 51, wood, 7 *pouces* by 6 *pouces* wide (18.9 × 16.2 cm.); 21 February 1811, Jean-François Coupry-Dupré sale, no. 12, wood, 7 *pouces* by 6 *pouces* wide (18.9 × 16.2 cm.) [the author specifies that it is one of the pictures from the Bandeville sale]; 28 February-25 March 1811, Sylvestre sale, no. 14, wood, 9 *pouces* 6 *lignes* by 7 *pouces* wide (25.7 × 18.9 cm.) [the author specifies that the "compositions are known through the two prints by Jac. Flipart"]; 19 May 1828, P. H. Lemoyne sale, no. 60, wood, height 6-1/2 *pouces* by 5 *pouces* 9 *lignes* (17.6 × 15.5 cm.) each. The draftsman is signed "on the upper right," the embroiderer "on the front left" (see the Lemoyne sale of 1778).

The Young Draftsman: 15-22 November 1779, anonymous sale [Ghent], no. 15, *"l'élève dessinateur copiant une figure académique,"* canvas 6 *pouces* by 5 *pouces* wide (16.2 × 13.5 cm.); 23 June 1783, Dandré-Bardon sale, no. 8, *"Un jeune homme assis et dessinant,"* wood, height 6 *pouces* 3 *lignes,* width 5 *pouces* (16.9 × 13.5 cm.); 18 November 1803, M. sale, no. 7, *"L'intérieur d'un atelier de peinture; on y voit un élève qui copie un dessin; une étude de fontaine et deux de fleurs."*

What conclusions can be drawn from this information? First of all, unlike Wildenstein, we believe that the paintings at the 1759 Salon were those engraved by Flipart two years before. Of course, the author of the Sylvestre sale catalog does say that the two paintings in that sale are "known through the prints of Flipart." And the fact that the paintings at the 1759 Salon were appreciably larger than Sylvestre's paintings ought to disprove our hypothesis. But we do not think it necessary to take literally the indications in this catalog, especially since it speaks of "compositions." On the other hand, one does have to keep in mind first that Laurent Cars, who sold Flipart's prints in 1757, two years later was the owner of the paintings exhibited at the Salon, and second—and this is most important—that the author of the *Lettre critique à un ami sur les ouvrages... exposés au Salon du Louvre en 1759* wrote regarding the two paintings exhibited: "M. Flipart has engraved them with all possible care." If our hypothesis is correct, it would confirm our belief that the Salon paintings were chosen for engraving. One might perhaps suggest that, in fact, Chardin invented only *two* types of compositions which he repeated a number of times. However, at the present time we do not know how many copies of these two versions there were originally. Nor do we know their respective dates of execution.

See [69] for discussion.

69 *Young Student Drawing*

(Un jeune écolier qui dessine)

Wood (oak), 19.5 × 17.5 cm. (enlarged at an early date, judging by Dagoty's engraving, on the right and along the bottom by a centimeter and a half). Signed at the upper right: *Chardin.*
Stockholm, Nationalmuseum*

Provenance. See [68].

Exhibitions. 1738, Salon, no. 27 (p. 15, reprint of the cat.: "a young student who draws"); 1929, Paris, no. 3.

Bibliography. Clément de Ris, 1874, p. 497; Bocher, 1876, p. 92, no. 779; Dussieux, 1876, p. 604; Sander, 1876, p. 164, no. 2; Goncourt, 1880, p. 122; Dilke, 1899, pp. 335 (ill.), 340; Dilke, 1899 (2), pp. 121, 123; Leclercq, 1899, p. 128; Guiffrey, 1907, p. 96, note 1; Guiffrey, 1908, p. 93, no. 239; Goncourt, 1909, p. 180; Pilon, 1909, pp. 47, 170; Furst, 1911, p. 133; Lespinasse, 1911, pp. 117, 317; Klingsor, 1924, p. 87 (ill.); Réau, 1925, pl. 36; Museum cat., 1928, pp. 183-84, no. 779 (with pl.); Pascal and Gaucheron, 1931, pp. 110-11, 130; Ridder, 1932, pl. 68; Wildenstein, 1933, no. 217, fig. 36; Brinckmann, 1940, pl. 377; Goldschmidt, 1945, fig. 22 and pl. 2 (color); Goldschmidt, 1947, fig. 23; Lazarev, 1947, fig. 24; Denvir, 1950, pl. 11; Strömborn, 1951, no. 65, p. 162 (Swedish ed., 1949, no. 65); Museum cat., 1958, p. 41, no. 779; *Du,* December 1960, p. 31 (repr.); Zolotov, 1962, pl. 10; Garas, 1963, pl. 24; Rosenberg, 1963, pp. 10, 45, 50, 51 (repr.); Wildenstein, 1963–69, no. 176, pl. 25 (color); Lazarev, 1966, pl. 43 (color); Valcanover, 1966, fig. 1; Snoep-Reitsma, 1973, p. 203 (engravings and composition); Carritt, 1974, p. 507, note 24; Kuroe, 1975, pl. 13 (color); Fried, 1975–76, pp. 146, 168; *Chefs-d'oeuvre de l'Art. Grands Peintres,* 1978, fig. 1.

Prints. See [68]. The color engraving by Gauthier-Dagoty is listed by Bocher [1876, p. 19] as no. 15A [Hébert, Pognon and Bruand, 1968, p. 52, no. 28]; that of E. Cécile Magimel as no. 15B [according to Hédouin, its title was *Le Principe des Arts*]. And that of Flipart, dated 1757, which very likely reproduces the painting in the 1759 Salon, is no. 14 [Pognon and Bruand, 1962, p. 216, no. 24].
 Bocher calls attention to a lithograph by Louis-Emmanuel Soulange-Teissier (1814-1898) after the engraving of Gauthier-Dagoty.

Related Works. See [68].

The history of the two Stockholm paintings is well known. Beginning as the property of the Chevalier de La Roque probably as early as 1738 and in any case by 1743, when they were engraved in four colors by Gauthier-Dagoty, they were purchased two years later for the heir to the Swedish throne at the estate sale of La Roque, Watteau's friend, through the intermediary of Gersaint. A letter from Gersaint to Count Tessin, now in the National Archives in Stockholm and dated 17 June 1745, informs us that he has just bought fifteen paintings and that the cases containing them "were loaded onto a boat yesterday to be transported to Rouen." Gersaint lists these paintings as follows: "three Wouwermans, one Berchem, a magnificent Teniers of the artist's best period, a Tilborch, three Ostades, two small military scenes by Parrocel, which M. de La Roque had purchased at the sale of M. Rigaud, painter to the king," and "two small and two large Chardins." (These last are, of course, our two paintings and *The Washerwoman* [55] and *Woman Drawing Water from a Water Urn* [56]; quotations are taken from the

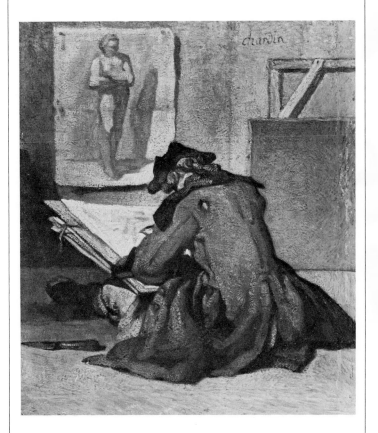

69

copy of the letter appearing in Tessin's *Journal*, Royal Library of Stockholm, *Akerödagboken*, L 82.1: 23, pp. 1159, 1160, supplied by Mlle Eva Andersson).

The two paintings were exhibited at the 1738 Salon along with seven other works by Chardin (five of which are included in this exhibition). They elicited little comment. Yet the frequently cited and remarkable text of the Chevalier de Neufville de Brunaubois-Montador applies more to the Stockholm paintings than to the other seven [*Lettre à madame la marquise de S.P.R.*, 1 September 1738]: "It seems that he bears down on his brushstrokes and yet his figures are strikingly authentic; the singularity of his manner only gives them greater character and soul."

The small format of these works and the fact that, contrary to his usual practice, Chardin here made use of wood as the support, probably explains the rich, soft stroke, the delightful technique so particular and so original, as the chevalier had noted. But do the two paintings date from 1738? Let us recall that Chardin exhibited appreciably earlier works, such as *Lady Sealing a Letter* (1733), at the 1738 Salon. We would be tempted, therefore, to push back the date by two or three years and to associate the Stockholm paintings, in view of their technique, with *Soap Bubbles* and *The Game of Knucklebones*.

In the first painting we see a young woman, wearing a bonnet and full white apron, seated in an unpainted chair with her work on her lap. She is selecting a ball of blue wool from a workbasket. Resting against a table with red covering and on which is placed a pincushion, an ell (a measure for cloth) specifies the kind of work the woman is doing.

In the second painting, seated on the floor with his legs spread far apart, his back turned to the viewer, and a three-cornered hat covering his head, a draftsman leans over a portfolio; he is copying an academy study in red chalk which is pinned to the wall. On the bare floor lies the knife used to sharpen the pencil; against the wall in the background rests two canvases, one not yet used, the other turned so that one sees only the stretcher. The coat of the young man is torn at the shoulder, revealing the red of his suit. Nothing could seem more simple than these two small compositions without a precise subject. But behind that simplicity is hidden great knowledge: in the color schemes — the white skirt contrasting with the brown coat, touches of red and blue cleverly distributed — in "the harmony of lights," and in the composition, once again pyramidal. Chair, table, ell, portfolio, stretcher, and knife all enable the artist to balance perfectly the masses of the two models. The unbroken surface on which the draftsman is seated contrasts with the large paving-stones of the floor seen in *The Embroiderer* and which is not unlike those seen in *The Washerwoman* and *Woman Drawing Water from a Water Urn*. If a curious mixture of weariness and indolence is visible on the face of the woman, the concentration, care, and attentiveness of the young draftsman are rendered all the more palpably by not making his face visible.

70 *The Schoolmistress*

("*La maîtresse d'école*")

Canvas, 61.5 × 66.5 cm. Signed at the right: *Chardin*.
London, The Trustees of the National Gallery*

Provenance. For the pre-1850 provenance, see *Related Works*. Collection of James Stuart, Scottish political refugee in France at the beginning of the nineteenth century and great aboriculturist (his sale of 9-11 February 1829 included no. 7, by Chardin, "Woman peeling onions, sketch" [information supplied by D. Carritt]); estate sale of James Stuart (Boyne Terrace, Notting Hill), London, Christie's 18-19 April 1850, no. 185, "A girl teaching a child to read. Very elegant," 10 *livres*. Acquired by Fuller. John Webb collection. Given in 1925 to the National Gallery in London by Mrs. Edith Cragg (of Wrotham) in memory of her father John Webb.

Exhibitions. 1740, Salon, no. 62 (?); 1968, London, no. 137, fig. 191.

Bibliography. Holmes, 1925, pp. 33-34, pl. B; Pascal and Gaucheron, 1931, p. 132; Wildenstein, 1933, no. 169, fig. 26; Museum cat., 1937, p. 53 (ill.); Museum cat. (Davies), 1946, no. 4077; De la Mare, 1948, pl. 7 (and color cover); Museum cat., 1950, pl. 12; Denvir, 1950, pl. 12; Wallis, 1954, p. 111 (ill.); Museum cat. (Davies), 1957, pp. 28-29, no. 4077; Garas, 1963, fig. 25; Wildenstein, 1963-69, no. 80, pl. 7 (color); Museum cat., 1973, p. 118 (with ill.); Snoep-Reitsma, 1973, pp. 192, 219 (concerns the theme); Wright, 1976, p. 37; Kemp, 1978, p. 23.

Prints. There exists a very fine engraving of this composition by François-Bernard Lépicié *père* (1698-1755) dated 1740 [Bocher, 1876, pp. 34-35, no. 34, who lists three states of it; Sjöberg, 1977, p. 401, no. 55]. The engraving was publicized in the *Mercure de France* of October 1740 (p. 2282). The capiton, humorously tinged with anti-feminity, is signed by Lépicié:

If this charming child takes on so well
The serious air and imposing manner of a schoolmistress,
May one not think that dissimulation and ruse
At the latest come to the Fair Sex at birth.

The engraving was often reproduced [see, among others, Normand, 1901, p. 51]. Simon Duflos (mentioned in Lyons in 1727 and in Paris in 1752) made of it "a bad duplicate copy" [cf. Bocher, 1876; Roux and Pognon, 1955, p. 135, no. 13]. The December 1861 issue of *Le Magasin pittoresque*, p. 408, offered a duplicate reproduction on wood of the original print *(Gauchardc; Dessin d'Hadamard d'après Chardin)*; an anonymous text entitled *La Soeur aînée* (pp. 407-8) accompanies this reproduction.

Related Works. The provenance of the known copies of this composition is especially difficult to determine, and we do not claim to have solved the problem. Chardin exhibited a *"petite maîtresse d'école"* (no. 62) at the 1740 Salon. We may presume that the Lépicié engraving, dated 1740 (see *Prints* above) and whose format is nearly square, is a very faithful reproduction.

We have found four sale references in the eighteenth century describing a *Maîtresse d'école*. Each time, this composition is paired with a version of *Soap Bubbles* (see, for more details, [61], *Related Works*): (1) sale of Baché, et al., 22 April 1776, no. 8 (56.5 × 73 cm.); (2) sale of Rohan-Chabot, Wâtelet, et al., 23 May 1780, no. 26 (58 × 73 cm.); (3) Wâtelet sale, 12 June 1786, no. 10 (65 × 81 cm.); and (4) sale of Dulac, et al., 6 April 1801, no. 19, with no indication of dimensions. D. Carritt has also called our attention to a sale in London on 9 May 1789 (Sir Robert Bernard collection, "collection formed by Sir Francis St. John," no. 107), which included "a domestic scene of mother and daughter."

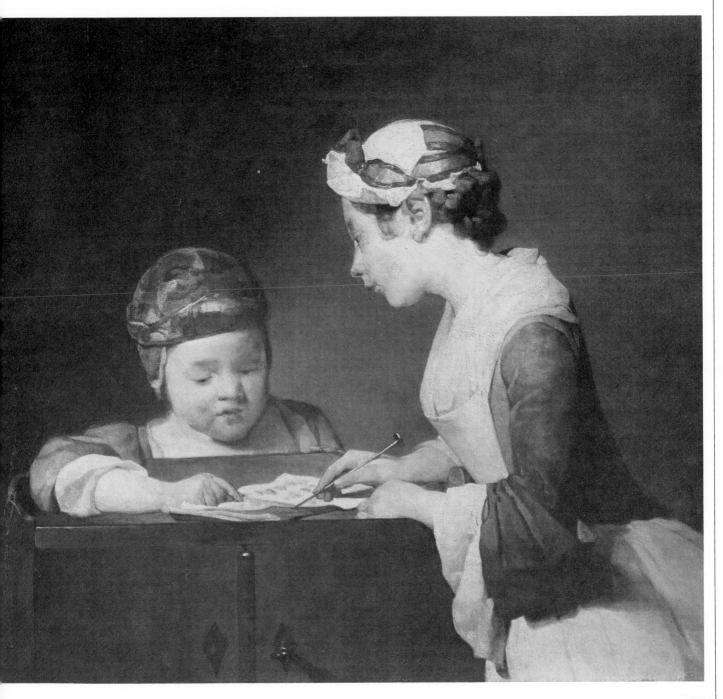

Four versions of the work are known today—the finest, unquestionably the one in the National Gallery, London (61.5 × 66.5 cm.). The other three include one in Washington (58.5 × 74 cm.), which comes from the collections of the Marquis de Cypierre (sale in 1845) and the Viscount de Curel (sale in 1918); one in Dublin [Wildenstein, 1963-69, no. 79, fig. 37; 62 × 73 cm.]; and a third, more vertical version on wood, clearly mediocre in quality [cf. Gimpel, 1963, p. 399], in the Henry de Rothschild collection destroyed during World War II [Wildenstein, 1933, no. 172; wood 25 × 20 cm.; a copy, also on wood, at the Helbing Gallery, Frankfurt, 3 April 1932, no. 71]. We should add that Wildenstein [1963, p. 151] tried to identify the Dublin painting with the one comprising no. 190 of the 1745 La Roque sale. The sales entry reads in part: "The second painting represents a mother instructing her child and correcting his mistakes. It is a copy altered in several places by M. Chardin." The catalog adds: "It has also been engraved by *L'Epicier* [sic] under the inscription *La Gouvernante*." This addition destroys Wildenstein's hypothesis.

There are several nineteenth-century sale references worthy of note: sale [Didot], 27-28 December 1819, no. 25, 54 × 46 cm. ("It is unfortunate that this painter who has been surnamed *The Inimitable* has made paintings only for foreign courts"); Magnan de la Roquette sale (Aix), 22 November 1841, no. 116; Aguado sale, 18 April 1843, no. 7, no dimensions; Cypierre sale, 10 March 1845, no. 24, no dimensions (this is the version in Washington). In 1850 at the latest, the London version is in Great Britain. Anonymous sale, 5 March 1852, no dimensions: the catalog specifies "grisaille"; Devère sale, 17 March 1855, no. 8, "serious subject" with no indication of size, cited by the Goncourts [1864, p. 151], and possibly the painting in the Cypierre collection; Signol sale, 1-3 April 1878, no. 44, "graceful composition which has been engraved," 57 × 63 cm.

Chardin(?), Washington, National Gallery of Art.

Chardin(?), Dublin, National Gallery of Ireland.

The Washington version of this composition did a great deal to advance Chardin's reputation. At the sale of the Marquis de Cypierre in 1845 it created a sensation. Reverberations from this sale are noted both by Hèdouin (1846)—Chardin's first biographer—who identifies the work with that of the 1740 Salon, and by Ch. Blanc (1862). The Goncourts considered it "the original." Clément de Ris [1848, p. 194], for his part, specifies that this painting and the *Top* (the Sao Paulo version, see [75]) "attracted to him [Chardin] the attention of collectors." For a time the Dublin painting passed for the finest of the lot, but it has suffered much over the years and now looks like a pastel.

The London version, by far the best and the only one whose attribution cannot be disputed, is most likely the painting figuring at the 1740 Salon and engraved by Lépicié that same year. It is not known for whom it was painted, by whom it was first owned, or how it got to Great Britain in the middle of the nineteenth century (if not sooner). We have brought together under *Related Works* all that we know of the various versions formerly put up for sale; no one knows, however, when the London painting was made. Attempts to date Chardin's paintings by referring to the ages of his own children—Jean Pierre born in 1731 and Marguerite Agnès born in 1733—have proven useless; even if his children did provide him with inspiration, it was never really Chardin's intention to paint like a scrupulous portrait painter. (For an hypothesis which would tend to prove that this painting represents the children of M. Le Noir, see [71].) Wildenstein places this painting around 1731-1732. D. Sutton—compiler of the catalog for the 1968 Royal Academy of London exhibition at which the painting was an enormous success (even though it had long been exhibited at the National Gallery)—believes it was completed shortly before 1739-1740. Kemp (1978) is undecided and wonders whether it really could have been painted before 1735. As for us, we would like to call attention to the fact that a version of the painting was associated in the eighteenth century with a copy of *Soap Bubbles*, one of Chardin's earliest figural works, if Mariette is to be believed. By its style, moreover, this painting clearly shows an evolution with respect to

works that are much more thickly painted, such as *The Game of Knucklebones* [60], or are less well composed, such as the *Portrait of the Painter Joseph Aved* [62]. The beauty of the paint recalls that of Glasgow's *Lady Taking Tea*, completed in February 1735. The simplicity of the composition and the perfect arrangement of every detail suggest the date 1735, perhaps 1736.

The critics had little to say about this painting and the four others which Chardin sent to the 1740 Salon (*The Monkey as Painter* and *The Monkey as Antiquarian* [see 66, 67], as well as *Saying Grace* [86] and *The Diligent Mother* [84], both given to Louis XV). They praise, as usual, the "ingenuousness" of their author—what we would call today his simplicity and naturalness. Only Abbé Desfontaines [*Observations sur les écrits modernes*, 31 August 1740, p. 283] speaks of the painting: "Monsieur Chardin has succeeded in keeping the good graces of the public with three little paintings which have pleased it very much: *The Diligent Mother, The Little Schoolmistress*, and *Saying Grace*. What elegance, what spontaneity, what truth! The viewer feels more than he can say."

Seldom did Chardin place each detail so perfectly. Our attention is drawn to the center of the composition by the large needle with which the elder sister points to the letters of the alphabet. We also note that Chardin has omitted the architectural elements that decorated the background of his previous compositions; he has replaced them here with the cabinet on which the two children are leaning. And the splashes of color on the two headpieces—one ornamented with ribbons—contrast with the delicate harmony of the whites, blues, and yellows of the clothing.

The most exceptional aspect of the London painting, the only large-figured one (along with the painting in Berlin) in which Chardin has brought together two personages, is the manner in which the artist has been able to communicate a sense of close relationship between the two children. The sulky, self-assured concentration of the younger, the combination of attention and distraction, affection and mocking superiority of the older—already such a coquette—simultaneously present, yet far away, are masterfully caught by careful attention to the poses more than by the meticulous rendering of facial features. Chardin has succeeded in making this ordinary scene, repeated daily in thousands of homes, an image of eternal truth; it concerns and touches each of us.

71 The House of Cards (also called The Son of M. Le Noir Amusing Himself by Making a House of Cards)

(*Le château de cartes, dit encore "Le Fils de M. Le Noir s'amusant à faire un château de cartes"*)
Canvas, 60 × 72 cm. Signed at the right center: *chardin* (with, as is often the case, a lowercase *c*).
London, The Trustees of the National Gallery*

Provenance. Probably the painting of the 1741 Salon, no. 72. In England by 1762? (see *Prints*). Collection of John Webb (as was the *Schoolmistress* of the same museum!). Given in 1925 to the National Gallery of London by Mrs. Edith Cragg (of Wrotham). Webb's daughter. It had been claimed that the painting came, like *The Schoolmistress* [70], from the James Stuart sale of 18 April 1850, no. 107. But Davies (1957) points out that this painting was sold under the name of Greuze and also that it does not carry Christie's markings on its stretcher. We are, nevertheless, amazed at the number of coincidences which relate these two works to each other. Without going into detail here, might one not think that the two paintings had a common fate during the eighteenth century? Could they not both represent the Le Noir children?

Exhibition. 1741, Salon, no. 72 ("The Son of M. Le Noir amusing himself by making a house of cards").

Bibliography. Bodkin, 1925, pp. 93-94; Holmes, 1925, pp. 33-34, pl.A; Wildenstein, 1933, no. 145, fig. 25; Museum cat., 1937, ill. p. 53; De la Mare, 1948, p. 18 and pl. 8 (color); Museum cat. (Davies), 1946, pl. 16, no. 4078; Museum cat., 1950, pl. 13; Denvir, 1950, pl. 26; Museum cat. (Davies), 1957, p. 29, no. 4078; Russell-Smith, 1957, pp. 37 (fig. 6), 38; Wildenstein, 1963-69, no. 208, fig. 96; Lazarev, 1966, pl. 52; Museum cat., 1973, ill. p. 118; Wright, 1976, p. 37; Kemp, 1978, p. 23.

Prints. An engraving was executed by François-Bernard Lépicié (1698-1755) in 1743 [cf. Bocher, 1876, pp. 16-17, no. 11; Sjöberg, 1977, pp. 105-6, no. 64]. There also exists a "poor duplicate copy" signed Simon Duflos [Roux and Pognon, 1955, p. 135, no. 12]. The undated Lépicié engraving was publicized in the *Mercure de France* of September 1743, p. 2061 (the text of the caption will be given at a later point). Lady Dilke [1899, p. 391, note 2] was the first to point out that the Lépicié engraving had been distributed free of charge to those purchasing the January 1762 issue of *British Magazine*. This issue contains a long anonymous commentary (p. 32) on the engraving from the Chardin painting which it judged "as ingenious in the design as happy in the execution." The commentary stresses especially the significance of the work as a symbol of "the vanity of human pursuits." This text is as fascinating a document on the reputation of Chardin in Great Britain during his own lifetime as it is a revealing analysis of the interpretation given to his works by his contemporaries.

Related Works. There are no known copies of the London painting. For the various *House of Cards* paintings, their variations, sales references, etc., see [65].

Chardin exhibited only two paintings at the Salon of 1741: *The Morning Toilet*, now in Stockholm [88], very well received by the critics, and *The House of Cards* or, more precisely, *The Son of M. Le Noir Amusing Himself by Making a House of Cards*. The Oc-

tober 1741 *Mercure de France* mentions the latter very briefly: "The second painting, representing a young man enjoying himself by making a card castle, has also met with some approval." Abbé Desfontaines [*Observations sur les écrits modernes*, 9 September 1741, pp. 333-34] gives only the painting's title.

Jean-Jacques Le Noir, "merchant, resident of Paris, rue Mauconseil, parish of Saint-Eustache," furniture dealer and cabinetmaker, was one of Chardin's friends. He was the witness for Françoise-Marguerite Pouget at Chardin's second marriage in November 1744, and we know that the artist was already closely associated with him, since Chardin had exhibited a *"Portrait de Mme Le Noir tenant une brochure"* (no. 57) at the Salon of the preceding year. This portrait, which we know only through mediocre copies, is one of the most important Chardin compositions. The 1747 engraving by Surugue entitled *L'Instant de la méditation* is all that we have to remind us of the original painting.

Little is known about Le Noir. He was still alive in 1751 [Archives Nationales, Minutier Central, étude XIII, liasse 293]. His wife, Marie-Joseph Rigo, also still alive in 1751, was born in the diocese of Liège (étude X, liasse 497), and had obtained her naturalization papers in March 1730 [Archives de la Seine, Dc 66, fol, 256, recto]. This is very probably the same Le Noir who, in 1744, was in possession of Boucher's *Vue des environs de Beauvais* (The Hermitage) engraved that same year by Le Bas [Ananoff, 1976, I, no. 220]. In any case, Le Noir was certainly one of Chardin's closest friends. We have proof of this in the engraving by the same Le Bas of the *Seconde vue de Beauvais* after Boucher which is "dedicated to Monsieur Chardin, advisor to the Académie Royale de Peinture et Sculpture. By his very humble servant and friend Le Noir." We might perhaps go so far as to propose that *The Schoolmistress*, exhibited at the 1740 Salon and now at the National Gallery, London, shows us other children of M. Le Noir.

The work was exhibited at the Salon of 1741. But was it painted that year, or perhaps earlier? At first sight, comparison of this piece with *The Diligent Mother* or *Saying Grace*, both shown at the Salon of 1740, would tend to eliminate such a late date. Certainly the comparison with *The Morning Toilet* which figured at the same 1741 Salon seems more convincing. But its relationship with the *Little Girl with Shuttlecock* of 1737 and especially with *The Schoolmistress* would seem to require placing the painting around 1736-1737. This is particularly called for when one takes into account the difference in scale of the figures, on the one hand, and, above all, the state of preservation to which Ch. Holmes (1925) and M. Davies (1957) refer. The London painting has suffered from wear, abrasion from too-vigorous cleaning, and especially from a relining, done about the middle of the nineteenth century, that flattened the surface texture. For all that, however, the painting is still considered one of the finest Chardins, with its simultaneously enameled and creamy appearance and the impassive silhouette of the charming adolescent with elegant buttons on his sleeve [cf. Russell-Smith, 1957] who stands out against a smooth background.

As has been said earlier in the discussion of the Louvre version, the *House of Cards* is a new illustration of the extremely popular *vanitas* theme. Its association with cards goes back a long way. It was treated in the eighteenth century by Ch. A. Coypel [Snoep-Reitsma, 1973, fig. 59] and Boucher [Jean-Richard, 1978, no. 1400, with ill.], among others. At the 1783 Salon in Lille, Mlle X... exhibited, nos. 106 and 107: a *jeune garçon s'amusant à faire un château de cartes* ("A young boy amusing himself by making a house of cards") as companion piece to *une jeune fille faisant des boules de savon* ("A young girl making soap bubbles") [information supplied by François Pupil]. Chardin made a speciality of the theme. The captions accompanying the engraving—very faithful to the paintings they copy—are in this respect very revealing. The one accompanying the Filloeul engraving reads as follows:

You are wrong to make fun of this adolescent
And his vain construction
Ready to fall at the first puff of air
Graybeards, even at the age of wisdom
There often comes from our brains
More ludicrous castles in Spain.

The one composed, as was his habit, by Lépicié *père* himself (and copied by Aveline!) is just as clear:

Charming child, pursuing your pleasure,
We smile at your fragile endeavors:
But confidentially, which is more solid—
Our projects or your house?

There are other equally obvious allusions to *vanitas*: the young man holding an ace of hearts in his hand, the king of spades, the queen of hearts protruding from a drawer, and so forth. In any case, Chardin is far from being an "inventor" in the domain of iconography and there is no need, very plainly, to seek out a sophisticated philosophical explanation for his works. His originality is of another kind. In the four compositions treating the same theme, Chardin works with a very limited number of objects and forms: a young adolescent with brown hair, seen at half-length, building a house of cards on a gaming table. The differences from one composition to another are to be found in the way the hair is arranged, in the three-cornered hat, and the partly open drawer.

Chardin appears to have arranged with meticulous care—as in his still lifes—his model and surrounding objects before beginning to paint. This silent, motionless world immediately suggests another "series," that of Cézanne's *Joueurs de cartes*, created in Aix around 1890-92. But Cézanne's players, always adults, are arranged in couples or in groups (except, of course, in the preparatory studies). And although certain preoccupations are shared by the two artists (Cézanne will bear witness to this himself with regard to the *Autoportrait à la visière* [see 136]), and although both figures are withdrawn, the Parisian differs from the Aixois in many ways. While Chardin is also interested in composition and the solidity of forms, and in the "synthetic truth of gesture," he preserves a kindly affection for his models.

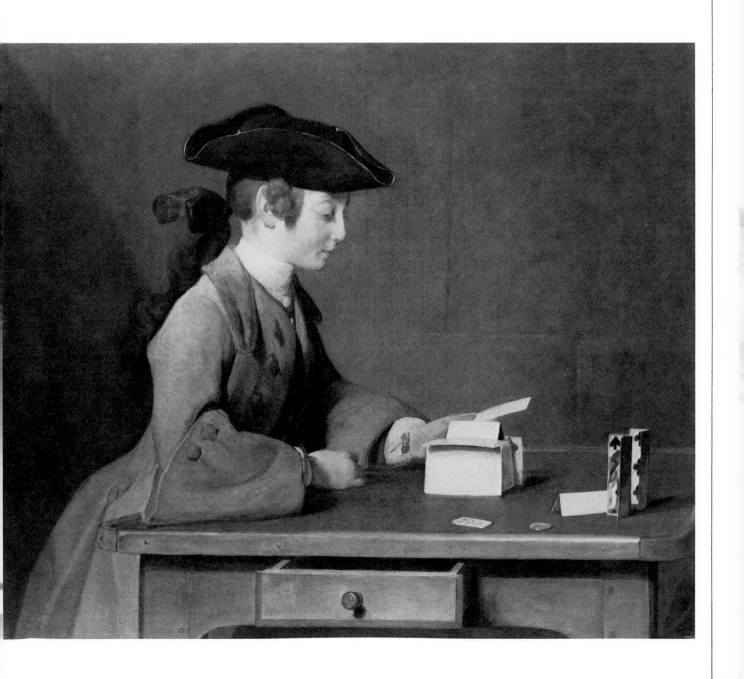

71

72 *Little Girl with Shuttlecock*

("Une petite fille jouant au volant," dit La Fillette au volant)

Canvas, 81 × 65 cm. Signed and dated at the left center on two lines: *Chardin 1737* (?)
Paris, Private Collection

Provenance. Collection of Catherine II of Russia as of 177(4?). Supposedly sold at auction by Czar Nicholas I in 1854 [Ernst, 1935]. Collection of [Count] L. J. [de] Lazareff, or Count Lazare, of St. Petersburg (?) [the Goncourts, 1880, p. 121, call this collector "Comte Lazare"; Guiffrey, p. 43, "Collection of M. le Marquis d'A [bzac] coming from the estate of M. le Comte de L... of St. Petersburg"]. Collection of the Marquis d'Abzac (in 1874); Abzac sale, 29 January 1875, no. 4 (5,000 francs). Ernest Cronier collection, then Cronier sale, 4-5 December 1905, no. 1 (reproduced; 140,000 francs). Acquired at this sale by Baron Henry de Rothschild; remains in the family of this great collector.

Exhibitions. 1737, Salon, (p. 21, reprint of the cat.); 1874, Paris, no. 54 (d'Abzac collection); 1907, Paris, no. 49; 1910, Berlin, no. 302 (no. 19 with ill. in large-size edition of cat.); 1926, Amsterdam, no. 7; 1929, Paris, no. 16; 1932, London, no. 233, pl. 38 (no. 152 of the commemorative cat.); 1937, Paris, no. 138; 1946, Paris, no. 11; 1949, Paris, no. 50; 1951, Geneva, no. 8, pl. 1; 1955, Zurich, no. 61; 1956, Paris, no. 18 (ill.); 1957, Paris, no. 12 (ill.); 1958, Stockholm, no. 74, pl. 26; 1961, Paris, no. 4; 1966, Paris, no. 35 (ill.).

Bibliography. Hermitage cat. (Minich), 177(4?), no. 407; P.[aul] L.[acroix], in *Revue Universelle des Arts*, 1861, XIII, p. 178, no. 407; Bocher, 1876, p. 31, no. 29 (Hermitage); Goncourt, 1880, p. 121; Courboin, 1897, pp. 267-68 (does not know the painting itself); Schéfer, 1904, p. 55 (cites the composition); Alexandre, 1905, pp. 4, 6, 8, pl. on pp. 9, 10; Morice, 1906, p. 236; Dayot and Vaillat, 1907, pl. 8; Guiffrey, 1907, p. 96; Nolhac, 1907, p. 40; Tourneux, 1907, p. 97; Guiffrey, 1908, p. 85, no. 186 (repr. between pp. 60 and 61); Goncourt, 1909, p. 178; Leprieur, 1909, p. 143; Pilon, 1909, pp. 73, 91, 167; Meier Graefe, 1910, p. 270; Furst, 1911, p. 128; Quintin, 1929, unnumbered photograph; Ganz, 1930, p. 161 (ill.); Pascal and Gaucheron, 1931, pp. 63, 117, 124, 125, pl. 66; Bazin, 1932, pp. 17, 22 (fig. 62); Ridder, 1932, p. 11, pl. 36; Wildenstein, 1932, p. 70 (ill.); Wildenstein, 1933, no. 160, fig. 46; Wildenstein, 1933 (2), p. 371; Ernst, 1935, pp. 135-36, pl. on p. 139; Pilon, 1941, (cover ill.); Goldschmidt, 1945, fig. 6; Florisoone, *Pro Arte*, 1946, p. 233; Goldschmidt, 1947, fig. 7; Lazarev, 1947, fig. 26; Bouret, 1949, p. 4; Jourdain, 1949, p. 32; Gide, 1955, p. 187; *La Revue Française*, June 1957, no. 90 (ill.); *Illustrated London News*, 8 June 1957, p. 945 (ill.); Seckel, *Kunsthandel*, 1959, p. 15; Adhémar, 1960, p. 455; *Du*, December 1960, p. 34 (repr.); Zolotov, 1962, fig. 13; Garas, 1963, pl. 20; Rosenberg, 1963, p. 11; Wildenstein, 1963-69, no. 206, pl. 32 (color) and jacket; Donat de Chapeaurouge, 1969, p. 53 (discusses the theme; reproduces the version of the Uffizi); Snoep-Reitsma, 1973, pp. 211-12, 230 (discusses the theme; reproduces the engraving); Kuroe, 1975, pl. 19 (color); Rosenberg in exh. cat., Florence, 1977 pp. 184-85, no. 131.

Print. An engraving was made by François-Bernard Lépicié *père* (1698-1755). Bocher cataloged four states and an etched proof without any lettering [Bocher, 1876, p. 31, no. 29; Sjöberg, 1977, p. 105, no. 63; on the engraving, also see Goncourt, 1863, p. 526]. The caption for the engraving reads:
Without care, without sorrow, tranquil in my desires;
A racquet and a shuttlecock form all my pleasures.
The engraving was frequently reproduced [Couboin, 1897, p. 268; Normand, 1901, p. 55; Snoep-Reitsma, 1973, fig. 67].

Related Works. There exists in the Uffizi, Florence, a version not listed by Wildenstein that is identical in every respect but signed at the bottom right [on this work, see Rosenberg, Florence exh. cat., 1977, no. 131, pp. 184-85, color pl. on cover]. It is appreciably inferior in quality to the version exhibited here, but it does seem to us an autograph copy. Nothing is known of its early provenance. The reader will note, however, that it is associated with a copy of *The House of Cards* today in Washington.

The origin of this work remains a mystery. It is not mentioned in any Parisian collection in the eighteenth century and appears in an extremely rare catalog of Russian imperial collections dating from 1774 [reprinted in 1861 in the *Revue Universelle des Arts*, XIII, p. 178; in the opinion of Ernst, 1935, this catalog had been compiled by Ernst Minich between 1777 and 1785]: "no. 407 Sébastien Chardin: *Une jeune fille jouant au volant* ('A young girl playing with shuttlecock')." The number immediately following, no. 408, *Un jeune garçon faisant des maisons de cartes* ("A young boy making a house of cards") refers indisputably to the painting now in Washington [73]. The painting was sold by Czar Nicholas I in 1854 (in 1876, Bocher thought it was still at The Hermitage). In 1874 it was lent by the Marquis d'Abzac to an exhibition for the "benefit of the natives of Alsace-Lorraine in Algeria"; the following year it was put up for public sale. It disappeared until 1905 when it was purchased at the Ernest Cronier sale by the father of the present owner. The sale created quite a stir (for another painting figuring in that sale, see [60]). But André Gide was not impressed. He wrote in his

Chardin(?), Florence, Uffizi.

diary [*Journal,* 1955, p. 187]: "That whole collection smacks a little of its millionaire owner. After all that we were led to expect, I find the Fragonards and the Chardins disappointing...."

The reading of the date on the left of the painting, as often happens with Chardin, has always posed a problem. At the time of the 1875 sale catalog it was interpreted as *1751,* a reading which has persisted until the present. Wildenstein, however, read it as *1741* in 1933. If one accepts this reading, one would also be obliged to believe that the painting is not the one Chardin had presented at the Salon of 1737. After careful examination under the best lighting possible and after a slight cleaning of the work, we think that the date reads *1737.* Such a dating would permit us to consider *Little Girl with Shuttlecock* as the work which figured at the 1737 Salon, slightly antedating *The Young Draftsman* of the Louvre, which is dated 1737, even though it was exhibited in 1738.

At this 1737 Salon, the first to be held since 1704, Chardin exhibited eight paintings, certain of them completed some time before. *Woman Drawing Water from a Water Urn* and *The Washerwoman* [55, 56] probably date from 1733, *The Philosopher* [62], from 1734. *The Little Girl with Shuttlecock* was at that time one of his few recent creations. There was at the same Salon a *Young Man Amusing Himself with Cards* which we find later on, like the *Little Girl with Shuttlecock,* in 177(4?), at The Hermitage, and which today is in Washington. It now seems certain that these two works were companion pieces. Not only do they share a common history for a long time but we also have the good and probably autograph replicas of both in the Uffizi [see exh. cat. Florence, 1977, no. 131] to prove that the two were a pair from the beginning.

Commentaries on this Salon are rare. We read in the September 1737 *Mercure de France* (p. 2020): "The figures seen on this occasion in all his works [those of Chardin] have been much applauded by the most demanding connoisseurs." The *Mercure* also states that Chardin's "paintings held their own next to those of the greatest masters." The Commissaire Dubuisson, writing to the Marquis de Caumont on 20 November 1737 [*Lettres du commissaire Dubuisson,* ed. A. Rouxel, 1882, pp. 404-5] observed: "I was delighted by some little whimsies by a M. Chardin. It was a *little girl playing shuttlecock....* When one speaks of truth in painting, that is where one would have to look for it to be sure of finding it." He added — and the text is revealing in that it shows the weight given to the hierarchy of genres in the judgment of contemporaries and the importance attached to the subject — "I am aware of the distinction one ought to make between such limited subjects and others which require much greater imagination but also I claim only to be telling you what I enjoyed the most...."

Donat de Chapeaurouge (1969) sees more in the work than the portrait of a child; he sees an "allegory." The racquet and shuttlecock, in his view, are symbols of all that is transitory and superfluous, of useless distractions that contrast with the scissors and pincushion — clearly visible but neglected by the little girl. Snoep-Reitsma (1963) stresses the interest in children, very new at the time (who "are content," writes Fénelon in *De l'éducation des*

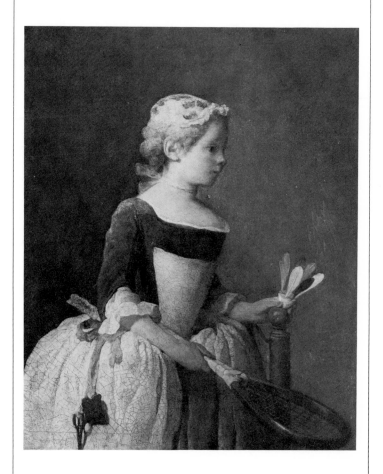

72

See Color Plate VIII.

filles, "provided they can frequently move about: a shuttlecock or a ball is all they need."; and again, "I have played at shuttlecock and a thousand little games," wrote Mme de Sévigné).

The painting is one of the most delightful images created by Chardin: a doll-like little girl with a rather vague look and an up-turned nose. One hand—again, the hand of a little girl, without long nails—rests on a chair, about to use the shuttlecock with its multicolored feathers; her other hand holds the racquet. She wears a flowered bonnet which hides her powdered hair, a silken ribbon around her neck and a gold earring in her ear (and not, as has been often said because of confusion with Vermeer, a pearl!). Near her arm, a long blue ribbon holds a pair of scissors and a pincushion. Her bodiced apron is attached to her dress with pins. The work is certainly more than a portrait, and Chardin's concern is certainly not the physical resemblance. But is it therefore an allegorical composition? Although he gives priority, even in a work like this, to the rendering of masses (in this case, the white mass of the full dress), and although he has rarely used colors as bright and milky, he nevertheless has not overlooked "feeling," which to him was most basic.

73 The House of Cards

(Le château de cartes)

Canvas, 82 × 66 cm. Signed (?) at the bottom toward enter: *J Chardin*. Washington, National Gallery of Art (Andrew Mellon Collection, 1937)

Provenance. Collection of Catherine II of Russia in 177(4?) (sometimes said to have come from a Paillet sale of 15 December 1777, no. 211; in [65] we presented reasons for finding this identification most unlikely). Sold by The Hermitage in 1932. Andrew W. Mellon collection; entered the National Gallery in Washington at its inception in 1937.

Exhibition. 1737, Salon (p. 15, reprint of the cat.; "a young man amuses himself with cards").

Bibliography. Hermitage cat. (Minich), 1774 or 1777-85, no. 408; P.[aul] L[acroix], in *Revue Universelle des Arts*, 1861, XIII, p. 178, no. 408; Bocher, 1876, p. 92, no. 1515; Clément de Ris, 1880, p. 270; Goncourt, 1880, p. 120; Mantz, 1883, p. 188; Dilke, 1899, p. 181; Dilke, 1899 (2), p. 114; Normand, 1901, p. 68; Cat. Samov (Hermitage), 1903, no. 1515; Dayot, 1907, p. 122 (ill.); Dayot and Vaillat, 1907, pl. 13; Guiffrey, 1908, p. 91, no. 233; Goncourt, 1909, p. 177; Pilon, 1909, pl. between pp. 96 and 97, 170; Wrangell, 1909, p. XXV, p. 230; Furst, 1911, p. 133; Réau, 1912, p. 396; Hermitage cat., 1923, p. 301 (ill.); Bodkin, 1925, p. 93; Réau, 1928, p. 180, no. 33; Ridder, 1932, pl. 76; Grappe, 1933, p. 490; Wildenstein, 1933, no. 141, fig. 23; Ernst, 1935, pp. 135–36, ill. p. 137; Museum cat. (Washington), 1941, pp. 38–39, no. 90; Goldschmidt, 1945, fig. 28 (Louvre); Goldschmidt, 1947, fig. 5 (Louvre); Lazarev, 1947, fig. 27; Jourdain, 1949, fig. 27; Museum cat. (Mellon coll.), 1949, p. 104 (ill.); Einstein, 1956, p. 233 and fig. 18; Einstein, 1958, pp. 19 (fig. 15), 21 (fig. 18), and color cover; Wildenstein, 1960, p. 2; Museum cat. (Walker), 1963, p. 316 (ill.); Mittelstädt (ed.), 1963, p. 32, pl. on p. 33 (color); Wildenstein, 1963-69, no. 207, pl. 33 (color); Museum cat., 1968, p. 19 (ill.); Museum cat., 1975, p. 75 (color pl.); *The Barnes Foundation Journal of the Art Depatment,* Spring 1976, pl. 12; Florence exh. cat., 1977, pp. 184-85.

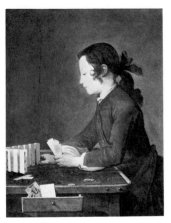

Chardin(?), Florence, Uffizi.

Print. An engraving was executed after 1743 by Pierre Aveline (1702?-1760?) [Bocher, 1876, pp. 15-16, no. 10; Roux, 1931, no. 67]. The caption for this engraving is the same as on the Lépicié engraving of the composition today in London [71].

Related Works. There is in the Uffizi, Florence, a replica of this painting [see Florence exh. cat., 1977, no. 132, with ill.]. For various *House of Cards* paintings, see [65]. For the companion piece of the Washington painting, *Little Girl with Shuttlecock,* see [72].

We have already enumerated (see [65]) the various Chardin *House of Cards* paintings known to us, together with the reasons which lead us to believe the Washington composition is the one from the 1737 Salon. At that same Salon there was exhibited a *Little Girl with Shuttlecock,* which is, in our opinion, the version we show here [72].

The Washington painting is traditionally dated 1741 (Wildenstein) or 1751 (Ernst). It is clear that if it is the pendant to the *Little Girl with Shuttlecock* of the 1737 Salon, it must also date from 1737 at the latest. From the point of view of the execution, this date is perfectly acceptable. At any rate, it has seemed useful to bring together these two works which have been separated since the mid-nineteeth century and which, in our opinion, had shared a common (but unknown) fate between 1737 and the time of their purchase by Catherine II of Russia.

Of the three versions of the *House of Cards* exhibited here, the Washington painting best summarizes the goals of Chardin: the composition is masterful in simplicity and already very like Cézanne in the absence of superfluities, which nevertheless betrays no effort or will to systematize. Chardin conceals the pains he takes behind an apparent ease and a typically eighteenth-century elegance, which thus permits certain particularly ingenuous serendipities, such as, for example, the partly open drawer with the two playing cards. But it is also Chardin's desire to be the poet of childhood. The adolescent in this painting, who has left work for play (he is still wearing his large apron), is absorbed in his game, detached from the world about him. He seems to have been painted not by an objective and indifferent observer, but by one who is warmly empathetic.

A passage from *Bend Sinister* by V. Nabokov (1947, ed. 1974, p. 34) applies equally to the versions of *The House of Cards* in Washington, London, or the Louvre: "The only pure thing in the room was a copy of Chardin's *House of Cards* which she once placed over the mantelpiece (to organize your dreadful lair, she had said), the conspicuous cards, the flushed faces, the lovely brown background."

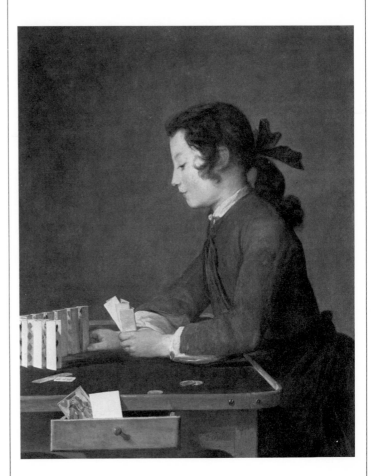

73

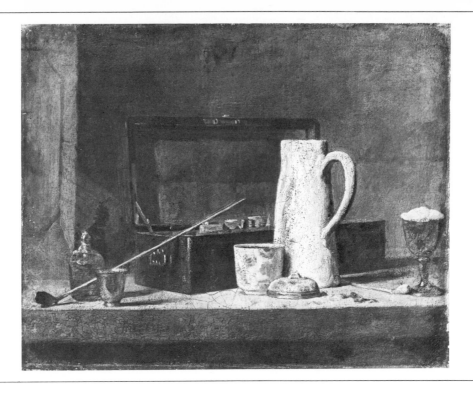

See Color Plate

74 *The Smoker's Kit (*also called *Pipes and Drinking Vessel)*

(La Tabagie, dit Pipes et vase à boire)

Canvas, 32.5 × 40 cm. Signed at the bottom left on the edge of the table: *Chardin.*
Paris, Musée du Louvre, M. I. 721

Provenance. Probably the sale of M. de Castilhon, 21 January 1853, no. 15 (and not no. 115): "A pitcher, some glasses, a cup, and a lighted pipe compose this charming painting" (François de Castilhon [1778-1852] was *"inspecteur du musée, Montpellier").* Laurent Laperlier collection; acquired by the Louvre at the Laperlier sale of 13 April 1867, no. 24 (1,700 francs; *"Le Buffet").*

Exhibitions. 1935, Copenhagen, no. 29; 1946, Paris, no. 98; 1952, Paris, no. 78; 1961, Paris, no. 118, color pl. on p. 54; 1966, The Hague, no. 36 (repr.); 1966, Paris, no. 37 (repr.).

Bibliography. La Chronique des Arts et de la Curiosité, 21 April 1867, p. 122; Museum cat. (Tauzia), 1878, no. 726; Goncourt, 1880, p. 128; Chennevières, 1888, p. 61; Normand, 1901, pp. 38-39, 106; Dayot and Guiffrey, 1907, pl. on p. 51; Guiffrey, 1908, p. 70, no. 80; Goncourt, 1909, p. 189; Pilon, 1909, p. 165; Furst, 1911, p. 122, no. 101 and pl. 31; Faure, 1921, pl. on p. 221; Museum cat. (Brière), 1924, no. 101; Klingsor, 1924, pl. on p. 111; Pascal and Gaucheron, 1931, pl. between pp. 136 and 137; Fry, 1932, p. 66, pl. 13A; Ridder, 1932, pl. 25; Wildenstein, 1933, no. 1099, fig. 162; Huyghe, 1935, p. 3 (ill.); Pouthas, *La Renaissance,* 1936, pp. 10 (ill.), 11; Florisoone, 1938, pl. 3 (color); Brinckmann, 1940, pl. 386; Furst, 1940, p. 17; Pilon, 1941, p. 5 (ill.); Goldschmidt, 1945, fig. 50; Jakovsky, *Les Arts de France,* 1946, no. 4, pp. 24–25 (ill.); Chamson, *Du,* September 1947, p. 14; Goldschmidt, 1947, fig. 45; Lazarev, 1947, fig. 15; Florisoone, 1948, pl. 70; Jourdain, 1949, pl. 1; *L'Art Sacré,* September-October 1951, p. 27 (ill.); Sterling, 1952, pl. 74; Francastel, 1955, p. 130 (ill.); Wildenstein, 1959, p. 104, fig. 9, p. 105; Adhémar, 1960, p. 457, pl. 241; *Sele Arte,* 1960, no. 46, p. 85, p. 59; Bazin, 1962, p. 296 (ill.); Rambures, 1962, unpaginated (ill.); Zolotov, 1962, pls. 23, 24 (detail); Garas, 1963, pl. 27 (color); Mittelstädt (ed.), 1963, color cover; Rosenberg, 1963, pp. 6, 84 (color pl. detail), 85, 88, 94 (color pl.); Wildenstein, 1963-69, no. 305, pl. 45 (color); Thuillier and Châtelet, 1964, p. 206; Huyghe, 1965, p. 9 (color pl.); Lazarev, 1966, pl. 25; Valcanover, 1966, pl. 13 (color); Stuffmann, 1971, pl. 51 (color); Rosenberg, Reynaud, Compin, 1974, no. 141 (ill.); Kuroe, 1975, pl. 24 (color); Faré, 1976, p. 162; Faré, 1977, pl. 120 (color); *Chefs-d'oeuvre de l'Art. Grands peintres,* 1978, pl. 13.

Today one of Chardin's most popular works, this painting has not always enjoyed such popularity. Acquired by Frédéric Reiset at the first Laurent Laperlier sale in 1867, where it brought a rather high price, it was not even mentioned by Bocher in 1876. The Goncourt brothers omitted the name of the buyer in their comments on the Laperlier sale, and Philippe Burty did not include it in his long list of Chardins owned by Laperlier when he wrote his biography [1867 and 1879] of this enthusiastic, though not always discriminating, collector.

Originally called *The Buffet*, then *Corner of a Table* [Guiffrey], it seems to have been given its present title by Edmond Pilon in 1909. Although *Pipes and Drinking Vessel* sounds good, is it really appropriate? In 1959 Wildenstein pointed out that the inventory of the estate of Chardin's first wife, taken shortly after her death in 1737, included "a smoking kit of rosewood with key lock and steel handle, lined in blue satin, containing a silver set of two small goblets, small funnel, small candleholder with extinguisher, four small pipe stems and two small palettes, two crystal flasks with silver cap and chain, and two colored porcelain pots — the entire kit appraised as a precious object at twenty-five *livres*." This, no doubt, is the smoker's kit which Chardin painted. However, some of the objects set out on the stone table by the artist are rather difficult to identify. The two white clay pipes, the footed goblet, and the flask are easily reconizable; but what about the object to the right, and what did it contain? Could it be one of the silver goblets mentioned in the 1737 inventory? And what was the function of the faience pitcher and of the little pot mounted in silver whose creamy whites immediately catch the viewer's eye?

The dating of this work seems to have posed a problem. Only Wildenstein ventured a guess — 1760-63, too late, in our opinion. The execution is indeed unlike that of any other known Chardin still life. The "pasty, crumbly texture" [Sterling, exh. cat., 1952] of the paint as well as the delicate harmony of blues and whites can be found in only one other canvas, *Little Girl with Shuttlecock*, painted, we think, in 1737. This also is the date we propose for *The Smoker's Kit* of the Louvre. Compare the little girl's headdress with the small white pot in the foreground with its pink and blue splashes of color. The miniscule touch of red at the end of the glowing pipe with its blackened bowl from which a few spirals of smoke escape, the faded roses on the little pot and its cover, the silvery glints of the goblet and the handles on the kit accent the exquisite harmony of the blues and the porous whites, "buttery" — to use La Caze's favorite expression.

This work, "perhaps the most beautiful of his still lifes" (Sterling), is not in a perfect state of preservation. But it is one of Chardin's most masterfully organized compositions. How can we not admire the line of the long pipe stem resting on the case, the long shadows stretching out against the stone, and "the confident grouping of objects whose subtle cohesion does not disturb the sense of a natural order"?

"In these objects," Sterling goes on to say, "Chardin finds and expresses one of those systems of balance that seem to be buried in the chaos of the everyday spectacle and seem only to await their painter." Speaking of Cézanne, Sterling concludes, "He makes you aware of his effort; he does not overwhelm us with a sense of ease as does Chardin's serious yet smiling gift of discovery."

75 *Portrait of the Son of M. Godefroy, Jeweller, Watching a Top Spin* (also called *Child with a Top* or *Portrait of Auguste-Gabriel Godefroy [1728-1813]*)

(*"Le Portrait du fils de M. Godefroy, joaillier, appliqué à voir tourner un toton,"* dit *L'Enfant au toton,* dit encore *Portrait d'Auguste-Gabriel Godefroy [1728-1813]*)

Canvas, 67 × 76 cm. Signed and dated at the bottom left: *Chardin 17..* (the date is illegible).
Paris, Musée du Louvre, R. F. 1705*

Provenance. See [63].

Exhibitions. 1738, Salon, no. 116; 1867, Versailles, no. 101 ("Portrait of a child playing with a top"); 1897, Paris, no. 26 ("G. de Villanèuse [child with a top]"); 1907, Paris, no. 64; 1946, Paris, no. 94; 1957–58, Paris, no. 14, pl. 12; 1966, Vienna, no. 10, pl. 37.

Bibliography. Burty, *La Liberté,* 16 September 1867 (cites only one painting); Saint-Priest, 1867, p. 235; Michel, 10 May 1897, p. 3; Moreau-Vauthier, n.d. (around 1897) p. 248; Tourneux, 1897, p. 452; Normand, 1901, pp. 51 (note), 93; Schéfer, 1904, pp. 56, 69 (composition cited); *The Burlington Magazine,* August 1907, p. 335; October 1907, pp. 57–58, pl. on p. 46; Dayot, 1907, p. 129 (pl.); Dayot and Guiffrey, 1907, pl. on p. 23; Dayot and Vaillat, 1907, pl. 6A; Guiffrey, 1907, pp. 97-99, 100 (pl.), 101; *L'Illustration,* 15 and 22 June 1907 (with ill.); *Musées and Monuments de France,* 1907, pp. 88, 121; Nolhac, 1907, pp. 42, 45 (ill.); Tourneux, 1907, pp. 94–95; Guiffrey, 1908, p. 66, no. 64; Desazars, 1908, pp. 407-16; Leprieur, 1909, pp. 135-56 (repr. from the engraving, p. 140); Pilon, 1909, pp. 51, 73, 91, repr. between pp. 112 and 113, 165; Furst, 1911, p. 121, no. 64 and pl. 12; Champreux, 1913, pp. 33–35; Museum cat. (Brière), 1924, no. 90A; Raffaelli, 1913, p. 52; Réau, 1924, p. 497 (ill.); Gillet, 1929, pp. 66, 77 (repr.); Osborn, 1929, pl. 185; Ridder, 1932, pl. 8; Wildenstein, 1933, no. 623, fig. 34; Jamot, 1934, p. 138 (repr.); Grappe, 1938, p. 27 (ill.); Hourticq, 1939, p. 101 (ill.); Brinckmann, 1940, fig. 379; Pilon, 1941, p. 47; Goldschmidt, 1945, fig. 26; Goldschmidt, 1947, fig. 27; Lazarev, 1947, fig. 28; Jourdain, 1949, fig. 33; Denvir, 1950, pl. 22; Dacier, 1951, fig. 137; *Le Figaro (Grand concours d'erreurs),* 4 and 11 February 1952; Francastel, 1955, p. 133; Golzio, 1955, p. 916 (ill.); Pigler, 1956, II, p. 526; Adhémar, 1960, p. 455; *Du,* December 1960, p. 37; Zolotov, 1962, pl. 82; Garas, 1963, pl. 19; Ponge, 1963, pp. 263, 264 (color details); Rosenberg, 1963, pp. 10, 49 (repr. in color), 50; Mittelstädt (ed.), 1963, p. 34, pl. on p. 35 (color); Wildenstein, 1963-69, no. 166, pl. 23; Lazarev, 1966, pl. 51; Valcanover, 1966, pl. 9 (color); Leymarie, 1967, p. 8 (repr.); Zolotov, 1968, p. 71 (ill.); Demoris, 1969, pl. between pp. 368 and 369; *Die Kunst und das schöne Heim,* November 1969, p. 498 (ill.); Donat de Chapeaurouge, 1969, pp. 51-52, fig. 272; Snoep-Reitsma, 1973, pp. 205-7; Lazarev, 1974, fig. 197; Rosenberg, Reynaud, Compin, 1974, no. 131 (ill.); *Dictionnaire Robert,* 1975, I, p. 489 (ill.); Kuroe, 1975, pl. 12 (color); *Chefs-d'oeuvre de l'Art. Grands Peintres,* 1978, pl. 9 (color); Anonymous, *Les peintres illustres,* coll. directed by Henry Roujon, n.d., pl. 3 (color).

Print. An engraving entitled *Le Toton,* by François-Bernard Lépicié (1698-1755), appeared in 1742. Bocher [1876, p. 52, no. 50] lists two states [see also Sjöberg, 1977, p. 105, no. 62]. The engraving, often reproduced [Normand, 1901, p. 49; Schéfer, 1904, p. 34; Snoep-

Reitsma, 1973, fig. 58], was publicized in the November 1742 *Mercure de France*. Here is its caption:
In the hands of caprice, to which he abandons himself
Man is truly a Top endlessly spinning;
His fate often depends on the movement,
Which fortune gives to his turning.
There exists a more vertical, counterfeit copy with the caption in French and German; it is unsigned, but bears the mark of Joh. Jac. Haid. The chalcography of the Louvre possesses a copperplate by Eugène Décisy (1866-1936) after this painting [*Catalogue de la chalcographie*, 1968, p. 170, no. 6713].

Related Works. Three versions of this composition are mentioned in the eighteenth century: (1) sale of the Chevalier de La Roque, May 1745, no. 173: *Un tableau peint sur toile par M. Chardin représentant un*

Chardin(?), Sao Paulo Museum.

jeune écolier qui joue au toton; il porte vingt cinq pouces de haut sur vingt sept et demi de large ("A painting on canvas by M. Chardin of a young schoolboy playing with a top; 25 by 27-1/2 *pouces*" [67.5 ×74 cm.]); (2) estate inventory of Chardin of 18 December 1779, *un jeune homme qui joue au toton; prisé 24 livres* ("A young man playing with a top, valued at 24 *livres*"); (3) Geminiani sale, London, 1743, no. 151: "Chardin... A boy playing with a Totum" (6 *livres* 6). Probably the painting which sold at the 1748-49 sale of the architect William Kent (1684-1748), no. 151: "A boy playing with a totum" [information furnished by D. Carritt].
One version known today passes for an autograph replica. It has belonged to the collections of the Marquis de Cypierre (sale in 1845) [see Champfleury, 1845, p. 8], the Marquis de Montesquiou (as of 1860) [see the exchange of letters in the *Intermédiaire des Chercheurs et des Curieux* of 20 March 1896, p. 324, and 10 June 1896, p. 663], and Camille Groult. It is today in the museum of Sao Paulo (67 × 73 cm., signed and dated *Chardin 1741*) [Wildenstein, 1963-69, no. 204, fig. 95], and had been carefully compared in 1907 with the painting in the Louvre [and sometimes harshly judged; see Guiffrey, 1907, p. 101; Leprieur, 1909, p. 142, note]. Mention must also be made of the copy at the Marius Paulme sale of 22 November 1923 (no. 22, repr. in the cat.) and the vertical one in The Ashmolean Museum at Oxford which shows only the right-hand portion of the composition [museum cat., 1961, no. A907].

Of the two *Godefroy Children* paintings, which today are among the most popular works in the Louvre, only the dated (1741) version of the *Child with a Top,* now in the Sao Paulo museum, was known at first. Both the price it brought at the Marquis de Cypierre sale in

1845 and the enthusiastic comments of the press and critics — Bürger (Thoré), the Goncourts, et al. — in 1860, in the wake of its presentation at the Galerie Martinet, contributed greatly to the rediscovery of Chardin.
The two paintings were shown in 1867 at a modest exhibition held in Versailles where they nevertheless caught the attention of Philippe Burty (1830-1890) and Saint-Priest ("a portrait of a child playing with a *"toutou"* [sic] which indeed has some of the qualities of Chardin, to whom it has been attributed"). In 1897 they were pointed out by André Michel ("little masterpieces") following their presentation at an exhibition of *Portraits de femmes et d'enfants*. Daily they were becoming more and more famous when, in 1907, they were exhibited at the Galerie Georges Petit, rue de Sèze, beside the version of the *Child with a Top*. Word spread rapidly that the Louvre, whose only large-figured painting of Chardin at the time was *The House of Cards* in the La Caze collection [65], wanted to acquire them. A controversy was aroused by a group attempting to prove that the best version was not the one the museum wanted to buy. Criticism of the projected purchase was organized by Dr. Richard Liebreich, an ophthalmologist first living in Paris, then in London, at the turn of the century, and conducted in the press by what the Louvre curator of paintings, Paul Leprieur, designated — in a style that is still with us — a "coalition of jealousies and very base self-interest" (see the amusing though violently anti-German article in *The Burlington Magazine* of August 1907, p. 335, and also the 15 June 1907 issue of *L'Illustration*). Most happily, however, nothing prevented Leprieur from concluding the transaction. He published both works two years later in what remains the basic study on them. Although the signature and the date are scarcely visible any more, the *Child with a Top* is clearly the *portrait du fils de M. Godefroy, joaillier, appliqué à voir tourner un toton* ("Portrait of the son of M. Godefroy, jeweller, watching a top spin") shown at the Salon of 1738 (no. 116). At that same Salon Chardin also exhibited *The Young Draftsman* [76] now in the Louvre, the *Lady Sealing a Letter* [54], and other works — among them, one of the most important Chardin paintings that is lost, the *Portrait d'une petite fille de M. Mahon, marchand, s'amusant avec sa poupée*. Contemporary criticism had little to say about the Louvre painting except to cite it [*Mercure de France,* October 1738, and the Chevalier de Brunaubois-Montador].
Four years later, Lépicié engraved a *Child with a Top*. It is very difficult to determine whether he was using the version in the Louvre or the one, as is generally assumed, in Sao Paulo (see *Related Works*). Let us remember that it was the habit of engravers to reproduce works exhibited at the Salon and frequently, to do so several years after the exhibition. In addition, if we want to identify the Sao Paulo painting with the one at the La Roque sale of 1745 (see *Related Works),* it is amazing that the catalog editor did not mention its having been engraved by Lépicié.
Who was "this son of M. Godefroy, jeweller" of whom the Salon catalog speaks? The research conducted by Leprieur is once again of vital importance. Auguste-Gabriel, son of Charles Godefroy, a

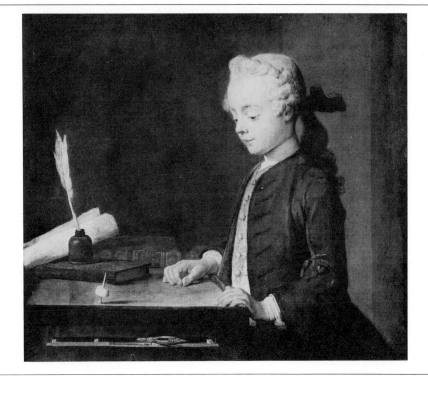

banker and jeweller who died in 1748 (the two Chardin still lifes now in Williamstown, Massachusetts, figured at the 1748 estate sale), was ten years younger than his brother Charles [63]. Born in 1728, he became an *écuyer* and controller-general of the Navy. He was very fond of painting, and bought many of the works in his father's collection, which were sold after the latter's death (the sale catalog had been compiled by Gersaint). In 1782 he acquired the *La Finette* and the *l'Indifférent* of Watteau (both in the Louvre) at the Marquis de Ménars sale (Marigny). His name figures among the purchasers at the principal sales held in the eighteenth century. He sold his collection in 1785 before undertaking a five-year trip to Italy. At his death in 1813 a second sale was held which reveals the clear evolution in his taste toward "neoclassicism." Naturally, the family portraits, among them his own and that of his brother, done by Chardin, were not included in these sales. They were bequeathed instead to rather distant relatives. It is quite easy to trace them throughout the nineteenth century (see [63], *Provenance)* up to their purchase by the Louvre in 1907.

A laboratory examination conducted by the Louvre has enabled us to see that at an early stage Chardin positioned the books, top, and inkwell closer to the left of the composition: the radiograph distinctly shows two quill pens. Then Chardin brought them closer to the little boy.

The work has sparked a great deal of comment. For many critics it represents the image of innocent childhood: "masterpiece of freshness and innocence," exclaimed Nolhac in 1907. If we are to believe Lépicié's engraving and the 1738 Salon catalog, Auguste-Gabriel Godefroy is playing with a teetotum, a small disk of bone or ivory pierced through the center with a pivot (a match, for example), whose sides are marked with letters or numbers—not distinguishable on Chardin's painting. Is it really a teetotum, or is it perhaps some other form of top? The chalk-holder (the one we see in *The Young Draftsman),* which has been placed in the partly open drawer of a chiffonier, the goose feather, and the piece of paper have been abandoned for the sake of the distraction: the game. The symbolism of the work is easily interpreted.

Exceptional are the arrangement of the painting (centered on the surface of the table and the half-open drawer), the alternating red and green bands of color in the background, the touch of white created by the teetotum—the only moving element in the work—and the elegant costume of the boy with his light-colored vest and his wide cuffs. But the most striking feature in the painting is the relaxed calm and reflective silence of the model.

Chardin gives evidence of an unlimited sympathy for childhood and its games. It would seem that the artist wanted to paint for children, from their point of view. He has succeeded in representing their world, a world from which adults are excluded but for which they preserve a feeling of nostalgia.

76 *The Young Draftsman*

(Le jeune dessinateur)

Canvas, 80 × 65 cm. Signed and dated at the left above the chalk-holder on two lines: *Chardin / 1737.*
Paris, Musée du Louvre, R. F. 1944-4

Provenance. Very probably brought into England before 1740 by Francesco Geminiani (ca. 1680-1762), a musician, merchant, and art lover (see *Print); put up for sale the first time in 1741, no. 19, "A boy at his drawing," then again in 1743, no. 105 (rather than no. 22; see Carritt, 1974). Collection of Roger Harenc (or Harene); his estate sale at Langford and Sons, 1-3 March 1764, no. 57, "A boy drawing" (4 *livres* 14.6). William Fauquier collection, London; sale at Christie's on 30 January 1789, no. 86, "A boy drawing" (sold for 6 *livres* 6.). Collection of Thomas Fauquier, son of William; sales of Thomas Fauquier at Christie's on 23 January 1819, no. 47, "Portrait of the son of Chardin drawing" (bought back), and on 17 January 1820, no. 77, "Chardin. A portrait of his son" (bought back). Upon the death of Thomas, his son William probably tried again to sell the work on 25 November 1826 at Christie's (no. 83 perhaps?), then on 16 February 1828 (no. 109?). May have been acquired in England in 1832 by Auguste Casimir Victor Casimir-Périer (1811-1878), son of Louis-Philippe's minister and great collector of paintings, while he was secretary at the French embassy.

Given to the Louvre with life interest reserved in 1944 by Mme Edme Sommier (1881-1968), *née* Germaine Casimir-Périer, daughter of the President of the Republic (1894-1895), from whom she had inherited the painting, and granddaughter of the presumed buyer in 1832 (committee, 1 July 1943; board of trustees, 7 July; settled on 7 March 1944). Entered the Louvre in 1968.

Exhibitions. 1738, Salon, no. 117; 1907, Paris, no. 31; 1935, Copenhagen, no. 34; 1937, Paris, no. 136; 1945, Paris, no. 74; 1947, Paris, no. 52; 1973, Saint-Paul-de-Vence, no. 768 (repr. in color).

Bibliography. Guiffrey, 1907, p. 101; Tourneux, 1907, p. 96; Guiffrey, 1908, pp. 84-85, no. 181; Leprieur, 1909, p. 141; Pilon, 1909, pp. 92 (note), 167; Furst, 1911, p. 128; Wildenstein, 1933, no. 216, fig. 48; Goldschmidt, 1945, fig. 24; Huyghe, 1946, p. 21; *Apollo,* December 1946, p. 141, pl. on p. 142 (Watt); Goldschmidt, 1947, fig. 44; Florisoone, 1948, p. 63; Wildenstein, 1963-69, no. 161, pl. 19 (color); Béguin, 1969, pp. 121, and pl. on p. 122 (color); Rosenberg, 1969, pp. 201-3 (ill.); *La Chronique des Arts,* supplement to *Gazette des Beaux-Arts,* February 1970, p. 13, no. 65 (repr.); Wagner, 1970, P. 141, fig. 3; Snoep-Reitsma, 1973, pp. 200-205, fig. 50; Carritt, 1974, pp. 502, 507-9; Rosenberg, Reynaud, Compin, 1974, no. 130 (ill.).

Prints. A mezzotint was executed in 1740 in London by John Faber, Jr. [Bocher, pp. 30-31, no. 28]. Faber specifies both the date of the painting and the date of his mezzotint. The caption, composed by the poet John Lockman, friend of Hogarth, reads:
The happy youth whom strength of genius fires;
Who, smit with science to fair Fame aspires,
Thro' all her windings, Nature must pursue;
Nor quit the Nymph till he obtain the clue.
The engraving by Peter Halm [see Seidel, 1900] was made shortly before 1900 from the copy in Berlin.

Related Works. We know, in addition to the Berlin version [77], three copies: one in pastel attributed to Reynolds but more likely the work of John Russell, slightly earlier than 1779, presumably purchased by John Frederick, third duke of Dorset, for fifty pounds and now in the collection of Lord John Sackville at Knole [see Carritt, 1974, p. 509]. The second copy, also in pastel, was put up for sale in Berlin (at Henrici's?):

Meyer sale, 2 September 1934, no. 56 (ill. in the cat., *Französische Schule, 18. Jh.).* K. Roberts called attention to the third copy in *The Burlington Magazine* of July 1968 (p. 421(: "a version on glass of Chardin's *Young Draftsman* of 1737... made after Faber's print."

The two paintings of the Louvre and Berlin [77], both signed and dated 1737, are among the best documented works of Chardin today. The latter was very probably acquired in Paris for Frederick the Great by Count Friedrich-Rudolf of Rothenburg (1710-1751). The origin of the former, until very recently, was more obscure. It entered the Louvre in 1968 as the gift of Mme Edme Sommier, in memory of her father Auguste Casimir Victor Casimir-Périer (1847-1907), President of the Republic at the end of the last century. The differences between the two versions, especially on the right in the position of the wooden pegs of the table, made it possible to affirm that the Louvre painting was the one engraved by John Faber in 1740, at which time it was presumably already in England. The point has been demonstrated, thanks to the research of David Carritt (1974), and the provenance has thus been established with great precision. As was the case with many of Chardin's genre scenes, the work passed through several English collections in the eighteenth century before being bought and returned to France by the grandfather of the donor.

Carritt's research has proven a second, no less important, point: at its first sale in England in 1741 the Louvre painting had a companion piece with which it was to remain until the Harenc (or Harene) sale in 1764. The companion piece was sometimes entitled "a girl musing," occasionally "a girl with needle work." Which painting might this have been? Chardin exhibited nine paintings at the 1738 Salon (five of which are exhibited here). Among those nine paintings there figured, in addition to the *dessinateur taillant son crayon* ("draftsman sharpening his pencil"), two pairs of paintings: no. 19, *un garçon cabaretier qui nettoye un broc* ("tavern-keeper's boy scrubbing a jug"), was paired with no. 23, a *récureuse* ("scullery maid"); and no. 26, an *ouvrière en tapisserie qui choisit de la laine dans son panier* ("embroiderer choosing wool from her basket"), was hung with no. 27, *un jeune écolier qui dessine* ("young student drawing"). Among the three paintings we have not mentioned were *une jeune ouvrière en tapisserie* ("a young embroiderer"), which all the Chardin biographers assumed a little hastily was a repetition of the first *Embroiderer.* Yet it is most unlikely that Chardin exhibited two identical paintings, with similar but not identical titles, at the same Salon. Therefore Carritt has concluded — rightly, in our view — that the "young embroiderer" (no. 21) was the companion piece of the "young draftsman" and that the new work, lost from sight from the time of its entry into several English sales of the eighteenth century, is to be added to the short list of figural compositions by Chardin.

At the Salon of 1738 *The Young Draftsman* now in the Louvre drew little comment. Only the Chevalier de Neufville de Brunaubois-Montador — whose text on Chardin's technique (one of the first) is often cited — mentions the painting; but he makes no further observation. Yet the work is one of Chardin's most perfect.

The Goncourts [1863, p. 533], who were familiar only with the engraving, already admired the draftsman: "tall and slender, elegant, with his three-cornered hat firmly planted on his head, the flow of a large wig rippling down his back, indolently sharpening his pencil."

Rarely has Chardin been able to subordinate so skillfully the force of a perfectly balanced composition, mathematically arranged in the manner of a Cubist, to the most delicate psychological analysis. The neutral color of the background brings out the elegance of the figure gracefully bent over the table with its subtle, alternating areas of shadow and light. What artist was more sensitive than Chardin to the world of childhood? He has captured the dreamy concentration, the poised gesture, and tranquility of the scene. Its warm, discreet harmony is punctuated by a few touches of color—the red ribbon of the portfolio and the blue of the apron attached by one button (the one we see in the *House of Cards* paintings of Nuneham and Washington). The young artist has just completed a sketch: the slightly caricatured head of an old man (or of a "satyr"; see the text of Diderot cited in the entry for the Berlin painting). These accomplishments have no equivalent in the whole of eighteenth-century painting.

77 *The Young Draftsman*

(Le jeune dessinateur)

Canvas, 81 × 67 cm. Signed at the left above the chalk-holder on two lines: *Chardin / 1737.*
Berlin, Staatliche Museen Preussischer Kulturbesitz, Gemäldegalerie*

Provenance. Probably acquired in 1747 by Count Friedrich-Rudolf of Rothenburg (1710-1751) for Frederick the Great of Prussia (an invoice dated 25 July which we have been unable to locate [see Seidel, 1900] mentions the work and the price paid for it (600 *livres);* the Count of Rothenburg should not be confused with his cousin, Conrad-Alexandre. After fighting in France, he had gone into the service of Frederick the Great in 1740; he stayed in Paris on numerous occasions between 1744 and 1748 [see Börsch-Supan, 1968]. Mentioned in 1779 in the Unter den Linden Castle, property of Prince Henry, brother of Frederick the Great. In the nineteenth century, at the palace in Potsdam, then at the New Palace. Still the property of the reigning Prussian family in 1926. Acquired by the Kaiser-Friedrich Museum of Berlin in 1931.

Exhibitions. 1883, Berlin, no. 43; 1900, Paris, no. 1 (with engraving by Peter Halm after the painting); 1907, Paris, no. 8; 1910, Berlin, no. 304 (no. 21 with ill., large-size edition of the cat.); 1948, Washington; 1950, Amsterdam, no. 18, pl. 120; 1950, Brussels, no. 18; 1951, Wiesbaden, no. 4; 1951, Paris, no. 51, pl. on p. 63; 1951-52, Berlin, no. 16; 1953, Berlin, no. 10; 1962, Berlin, no 8; 1963, Paris, no. 3 (ill.).

Bibliography. Nicolai, 1779, p. 688; Dohme, 1883, pp. 255-56; Ephrussi, 1884, p. 104; Dilke, 1899, p. 186 and pl. on p. 183 (the engraving by Faber); Dilke, 1899 (2), pp. 117-18; Museum cat. (Seidel), 1900, p. 85, no. 22 (with engraving by Peter Halm); Fourcaud, 1900, pp. 273, 274 (ill.); Lafenestre, 1900, pp. 557-58; Merson, 1900, p. 306, note; Seidel, 1900, p. 32, no. 1 (ill.); Dorbec, 1904, p. 342; Dayot and Vaillat, 1907, pl. 9; Guiffrey, 1907, p. 101; Tourneux, 1907, pp. 89, 96;

Frantz, 1908, p. 25 (ill.); Guiffrey, 1908, p. 56, no. 2 (pl. between pp. 48 and 49); Leprieur, 1909, no. 141; Pilon, 1909, pp. 92 (note), 169; Furst, 1911, p. 131; Bouyer, 1919, pp. 433-34; Foerster, 1923, p. 61; Klingsor, 1924, p. 41 (ill.); Osborn, 1929, pl. 189 (ill.); Museum cat. 1931, pp. 91-92, no. 2076 (ill. 1935, p. 91); Friedländer, 1931, pp. 34-36 (ill. p. 35); Ridder, 1932, pl. 50; Wildenstein, 1933, no. 215; Brinckmann, 1940, pl. 378; Pilon, 1941, p. 46; Bride, *National Geographic Magazine,* December 1948, p. 726; Jourdain, 1949, cover; St.-Gaudens, *Carnegie Magazine,* February 1949, p. 222; Gillet-Rolland, 1949, p. 84 (a letter from Louis Gillet to Romain Rolland of 17 September 1900 mentions the work with praise); *Arts,* 2 February 1951 (ill.); Museum cat. 1960, p. 20; 1963, p. 28, pl. 80; Garas, 1963, pl. 4; Rosenberg, 1963, pp. 10, 44 (color ill.), 45, 50; Wildenstein, 1963-69, no. 160, fig. 72; Thuillier and Châtelet, 1964, p. 205 (color ill., p. 206); Lazarev, 1966, pl. 49; Rosenberg, 1969, p. 203, fig. 2; *Les Grands Musées,* June 1970, no. 20 (color pl.); Carritt, 1974, p. 509; Kuroe, 1975, pl. 11 (color); Museum cat. 1975, pp. 97-98, no. 2076 (ill.); English edition, 1978, p. 101, no. 2076 (ill.); *Weltkunst,* 14 December 1977, p. 2583 (ill.); Riederer, 1977-78, p. 31 (with detailed photographs showing old damage).

Prints and *Related Works.* See [76].

Refer to the Louvre version [76] for information concerning the copies of this composition. The Berlin and Louvre paintings, both from 1737, were compared at the 1907 Chardin-Fragonard exhibition in Paris. But the comparison provoked very few comments. We find only Guiffrey (1907) commenting in connection with the Louvre painting which was at that time in the Casimir-Périer collection, "an excellent replica in a better state of repair than the original."

The Berlin version was not acquired until 1931. It was published by the great Max J. Friedländer for whom Chardin was *der gröste französische Maler des XVIII. Jahrhunderts* ("the greatest French painter of the eighteenth century") [1931, p. 36]. As we have already said, the differences between the two works are slight. The only distinction that deserves mention is the different placement of the wooden pegs in the table. The two works are also similar in quality. We know today that the Louvre painting is the one which was included in the 1738 Salon. It is also probably the first version to be completed, because of the visible signs of modification on the right arm, for example. The Berlin painting is far from being intact. Even in the nineteenth century Dohme (1883) and Dilke (1899) complained that the background of the work had been repainted. An excellent restoration has just been finished [for photographs of the bare canvas, see Riederer, 1977-78, and *Weltkunst,* 1977]. The restoration has permitted us to see that with the exception of one serious deficiency, making it necessary to redo the tip of the three-cornered hat but without touching the face, the work was in better condition than one might think after reading the earliest commentators. It remains nonetheless true, we think, that the Berlin version is harsher and less subtle than the one in the Louvre. Examination of the restored version itself will enable us to decide. The seriousness of the model, the solemn expression on his face in the Louvre version are sacrificed in the Berlin painting to a more smiling and extroverted youthfulness. Dohme in 1883 criticized the latter painting for its "lack of psychological depth."

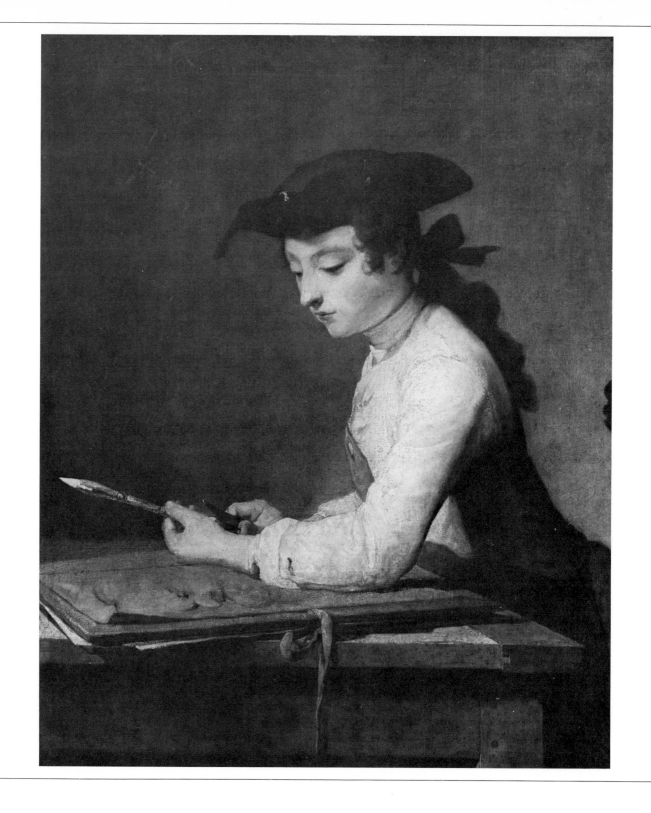

76

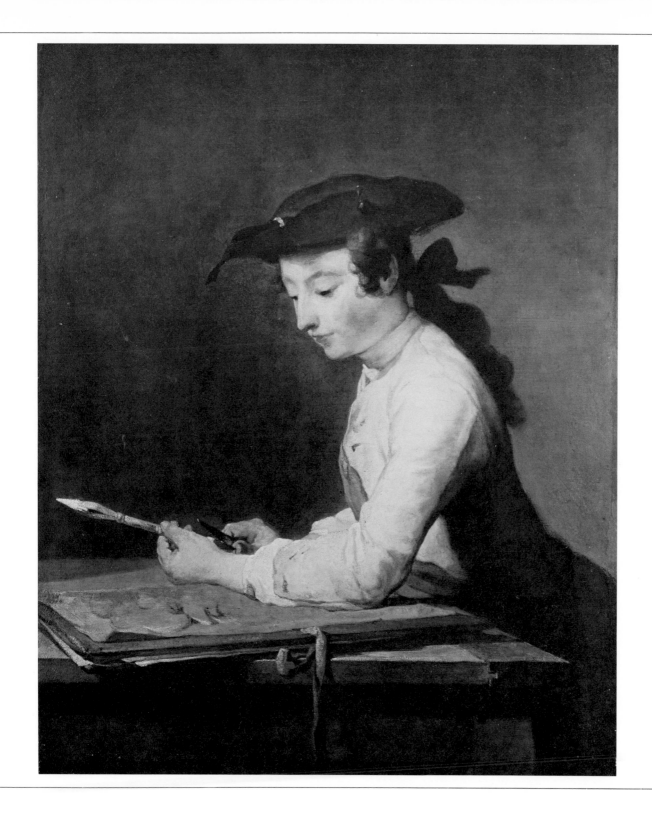

77

The theme of the young draftsman is an old one, and once again Chardin is hardly an innovator. He was to treat this theme on a number of occasions (two examples, [69] and [94], are included in the present exhibition); he owes its origin, or at least its popularity, to the Northern painters. W. Vaillant, who worked in Paris during the seventeenth century, made a kind of personal specialty of this subject. Chardin's originality, however, lies in the way he approaches the theme, giving priority to the composition, which is always perfectly controlled. Some see in the work a criticism by Chardin of academic draftsmanship as a teaching method in opposition to the faithful imitation of "nature" [Snoep-Reitsma, 1973, and the recent Berlin catalogs]. We prefer to conclude this entry by citing the famous text of Diderot in his *Salon* of 1765 [Seznec and Adhémar, 1960, p. 58]:

"Chardin seemed to doubt that there could be any education longer and more painful than that of a painter, not even that of a doctor, a lawyer, or Sorbonne professor.

"'At the age of seven or eight,' he said, 'they put a chalk-holder in our hand. We begin to draw, after engravings, eyes, mouths, noses, and ears, then feet, hands. Our back has been bent over the sketchbook for a long time when we finally come face to face with a statue of the *Hercules* or with the *Torso* [Belvedere], and little do you know of the tears shed on account of some satyr or gladiator, of the *Medici Venus*, or the *Antinoüs*. Rest assured that the Greek masterpieces would no longer elicit the envy of art teachers, if the latter were exposed to their pupil's scorn. After spending days without end and lamplit nights before immobile and inanimate nature, we are presented with the living reality, and suddenly the work of all the preceding years seems to come to nothing; we were no more at a loss the first time we took up our pencil. One has to teach the eye how to look at nature; and how many there are who have never seen it nor ever will! That is the agony of our life. They keep us five or six years in front of a model, then release us to our creative ability, if we have any. Whether or not one has talent is not decided in an instant.'"

78 Rabbit, Copper Pot, Quince, and Two Chestnuts

(Lapin mort avec chaudron de cuivre rouge, coing et deux châtaignes)

Canvas, 69 × 56 cm. Monogrammed near the bottom on the right: *cd*. Stockholm, Nationalmuseum*

Provenance. Collection of Count Carl Gustaf Tessin (1695-1770) in Paris; sent in August 1741 from Paris to Sweden (figures in the inventory taken in Paris, Quai des Théatins, before the ambassador's departure [Riksarkivet, Stockholm, E 5757, valued at 108 *livres;* see also Moselius, 1939, p. 131, and Åkeröarkivet, III, C. G. Tessin inventory, Kungl. Biblioteket, Stockholm L 82:2:3]). Sold to the Swedish royal family in 1749. Collection of Queen Luise Ulrike, sister of Frederick the Great, at Drottningholm Castle in 1760 (inventory of Duben). Is seen on a drawing by Fredenheim, curator of the royal collections, showing the arrangement of the paintings at Drottningholm around 1790 [preserved in the Archives of the Royal Palace; Nordenfalk, 1958, p. XXXI]. Stockholm Nationalmuseum since 1865.

Exhibitions. 1932, London, no. 261 (pl. 39); 1935, Copenhagen, no. 31.

Bibliography. Clément de Ris, 1874, p. 497; Bocher, 1876, p. 93, no. 785; Dussieux, 1876, p. 604; Sander, 1876, p. 164, no. 7; Sander, 1878, p. 55, no. 26; p. 84, no. 105; Goncourt, 1880, p. 129; Dilke, 1899, p. 336; Dilke, 1899 (2), p. 122; Leclercq, 1899, pp. 126–27; Dayot and Vaillat, 1907, pl. 55; Guiffrey, 1908, p. 94, no. 245; Goncourt, 1909, p. 191; Pilon, 1909, pl. between pp. 32 and 33, 170; Furst, 1911, p. 134; Lespinasse, 1911, pp. 117; 230, no. 105; 324, no. 26; Gaullin, 1923, pl. on p. 21; Museum cat. 1928, pp. 184–85, no. 785; Bazin, 1932, p. 22, fig. 61; Grappe, 1932, p. 18 (ill.); Ridder, 1932, pl. 29 (said to be in the Louvre!); Wildenstein, 1933, no. 715, fig. 78; Wildenstein, 1933 (2), p. 372, pl. 8; Huyghe, 1935, p. 3; Moselius, 1939, p. 131; Goldschmidt, 1945, fig. 35 and pl. 3 in color; Goldschmidt, 1947, figs. 33 and 34 (color detail); Lazarev, 1947, fig. 8; Denvir, 1950, pl. 33; Strömborn, 1951, p. 164, pl. 66 (Swedish ed., 1949); Sterling, 1952, p. 80, pl. 73; *Du,* April 1954, p. 6 (pl.); Museum cat. 1958, p. 41, no. 785 (ill., p. 43); Wildenstein, 1959, p. 98; Nemilova, 1961, pl. 13; de Batz, 1962, p. 272, fig. 2; Zolotov, 1962, pl. 18; Garas, 1963, pl. 7; Rosenberg, 1963, pp. 72-73, pl. on pp. 74 and 76 (detail, color); Wildenstein, 1963-69, no. 21, fig. 9; Lazarev, 1966, pl. 1; Lundberg, 1970, p. 125, pl. on p. 129 (color); Talbot, 1970, pp. 157, 158, fig. 10, 159, note 15; Oppermann, 1972 [1977], I, pp. 121-22, note 3; II, fig. 286; Lazarev, 1974, pl. 180; Kuroe, 1975, pl. 2 (color).

Related Works. At the La Roque sale of May 1745 there figured (no. 191) *un autre tableau peint sur toile par M. Chardin représentant un lapin et une marmite; il est sans bordure et porte vingt cinq pouces de haut sur vingt-un de large* ("Another work painted on canvas by M. Chardin representing a rabbit and a pot; it is unframed and measures 25 *pouces* high by 21 *pouces* wide" [67.5 ×56.7 cm.]). This painting sold for 6 *livres* to the expert Rémy.

Ever since its departure from Paris in August 1741, the Stockholm painting has not been seen in France. It is incontestably one of the finest still lifes by Chardin. The *Rabbit, Copper Pot,...* became the property of Tessin in Paris in 1741, then was sold by the former Swedish ambassador to the royal family of his own country in 1749. It entered the Nationalmuseum of Stockholm in 1865.

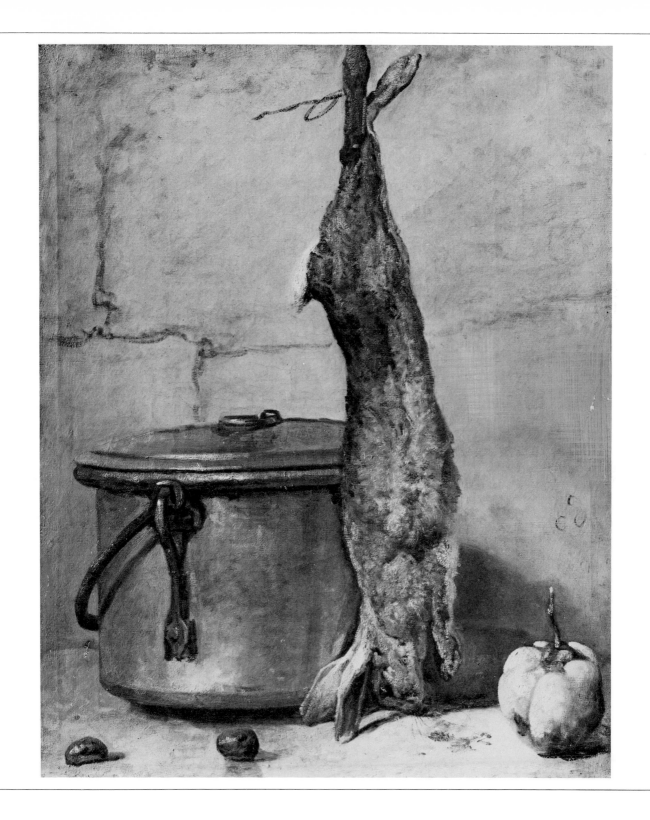

78

The first problem concerning this work is its date. We reject immediately the hypothesis of Denvir which places the painting around 1760. Wildenstein places it around 1726-1728 and considers it the companion piece to the *Basket of White and Red Grapes...* [8] belonging to the Louvre. This opinion contradicts his other comment that it was commissioned by Tessin for Queen Luise Ulrike, wife of the king of Sweden and sister of Frederick the Great. Carritt [in a letter of 1976] would also date this as an early work of Chardin, contemporaneous with the *Green-Neck Duck...* [17] in the Musée de la Chasse; both of these paintings would then be the first hunting still lifes by Chardin to which Mariette alludes. Pilon (1909), Talbot (1970), and Opperman (1972-77) prefer to date the painting around 1735, if not later.

Obviously, the work is a perplexing one. The large rabbit filling the entire canvas, with its muzzle brushing the surface below, and the disproportionate pot resemble nothing we have encountered up to this point. For that reason, we would be tempted to isolate the painting and consider it one of the rare still lifes done by Chardin between 1735 and 1739. Of all the paintings of this kind on exhibition here, the Stockholm painting comes closest to the *Tufted Lapwing...* [26], dated 1732. The scumbled stone background, the solidly vertical arrangement, the counterpoint of the quince placed to the right of the composition, all belong to a repertory of forms perfected by Chardin. Yet there are other details which prevent us from accepting the *Rabbit, Copper Pot,...* as exactly contemporaneous and which argue instead for a date several years later: monumentality that is unhampered by detail, lack of restraint in the composition, and refinement of the colors — the gray background lightly tinged with pink, the ochred warm brown of the pot, the gray of the rabbit's fur.

An aspect of this painting which distinguishes it from the earlier still lifes with rabbits and hares, in which Chardin had specialized at the beginning of his career, is the presence of the few drops of blood near the acid-yellow quince. Never before had Chardin succeeded in painting with such perfection, and with such modest gravity. It is when he eliminates unnecessary detail and paints only what is essential that he succeeds in moving us. Calculating constructor of space, Chardin is here the painter of contained emotion.

79 *The Scullery Maid*

(L'écureuse, dit aussi La récureuse)

Canvas, 45.5 × 37 cm. signed and dated at the left center: *Chardin / 1738*.
Glasgow, Hunterian Art Gallery, University of Glasgow*

Provenance. Collection of Dr. William Hunter (1718-1783; on the extremely varied collection of this great physician, see the 1957 article by J. Russell and the catalog of the London exhibition of 1973). Given by Hunter to the University of Glasgow (when and from whom Hunter bought the painting [we know he was in Paris in 1748] are not known).

Exhibitions. 1907, London, no. 112; 1913, London, no. 38; 1914, Glasgow, no. 216; 1926, Amsterdam, no. 11; 1937, Paris, no. 140; 1952, London, no. 3; 1954-55, London, no. 220, pl. 17; 1973, London, no. 13, pl. 9.

Bibliography. Laskey, 1813, p. 87, no. 17; Guiffrey, 1907, p. 95, note 1; *The Burlington Magazine,* 1907, p. 96, and frontispiece of May issue, p. 64; Guiffrey, 1908, p. 61, no. 25, p. 86; Furst, 1911, p. 132, pl. 11; Pascal and Gaucheron, 1931, p. 128; Ridder, 1932, pl. 57; Wildenstein, 1933, no. 15, fig. 9; Florisoone, 1938, pl. 2; Hourticq, 1939, p. 89 (ill.); Furst, 1940, p. 15 (ill.); Goldschmidt, 1945, fig. 4; Goldschmidt, 1947, fig. 2; De la Mare, 1948, pls. 4 and 10 (color, detail); Denvir, 1950, pl. 10; *The Scottish Art Review,* 1950, III, no. 2, pp. 20, 21 (ill.), 24 (detail); *Apollo,* January 1951, color cover, p. 10; Museum cat. (MacLaren Young), 1952, pl. p. 7; Russell, 1957, pp. 12, 13 (pl.), 14, 17, 19; Goncourt, 1959, p. 158 (ill.); Adhémar, 1960, p. 455; Garas, 1963, color cover; Rosenberg, 1963, pp. 10, 45, 50, 53 (color pl.), 55 (color detail); Seznec and Adhémar, 1963, p. 26, fig. 29; Wildenstein, 1963-69, no. 185, pl. 27 (color); Lazarev, 1966, pl. 33; Valcanover, 1966, pl. 5 (color); Wagner, 1970, p. 139, fig. 1; Snoep-Reitsma, 1973, pp. 180, 181, fig. 21, p. 180; Haskell, 1976, pl. 156; Kemp, 1976, pp. 228-31, fig. 52; Wright, 1976, p. 37; *Chefs-d'oeuvre de l'Art. Grands peintres,* 1978, pl. 5; Kemp, 1978, p. 25.

Prints. In 1740 Charles-Nicolas Cochin *père* (1688-1754) engraved a version similar to this painting [Bocher, 1876, p. 20, no. 16; Roux, 1940, pp. 642-43, no. 265] which, in our view, was the one in the Salons of 1738 and 1757 and which was destroyed during World War II with a part of the Henry de Rothschild collection (see *Related Works*). On 24 September 1740, Cochin gave to the Academy [Procès-Verbaux, V, p. 282] two proofs of this engraving, which he had exhibited at the Salon of 1740 [p. 27, reprint of the cat.] and of which Bocher lists three states. There is also a plate in reverse of this engraving signed H. Zanelli [Bocher, p. 20, no. 16B], a fine copy not described by Bocher [Edmond de Rothschild collection, Musée de Louvre, no. 6085LR], and a small etching made by Charles Jacque (1813-1894) [Bocher, p. 21, no. 16C]. The 5 February 1848 issue of *L'Illustration* (p. 561) shows a line engraving of the painting. Finally, Charles Courtry engraved the Marcille painting [G. Duplessis, March 1876, and catalog of the Marcille sale,

H. de Rothschild Collection;
destroyed during World War II.

6-7 March 1876; engraving reproduced by Normand, p. 39] — the same one, in our view, which Cochin had already reproduced.

Related Works. On two occasions Chardin exhibited a painting dealing with this subject: at the Salon of 1738 *(une Récureuse* ["a Scullery Maid"], no. 23) and the Salon of 1757 *(une femme qui écure* ["a woman scouring pans"], no. 34). The third state of Cochin's engraving dating from 1740 (see *Prints*) mentions that the painting is taken "from the collection of M. le Comte de Vence," The 1757 Salon version also came from that collection. At the sale of the Comte de Vence (24 November 1760, but actually 9-17 February 1761, no. 138), the painting was acquired by Peters. It later belonged to the Marquise de Pompadour, whose brother, the Marquis de Ménars, inherited it from her [Cordey, 1939, p. 88] in 1764. The painting then passed through the sales of Ménars (18 March -6 April 1782, no. 30), Haudry (1794), Autroche, and in the collections of François Marcille (before 1846) [cited by Hédouin, p. 224, no. 11, and p. 225, no. 54], Camille Marcille (sale of 6-7 March 1876), Stéphane Bourgeois, and Henry de Rothschild. It was destroyed during World War II [Wildenstein, 1963-69, no. 187, fig. 85, and no. 265]. None of the other versions known to us through either the original painting or a photograph can claim to pass for the work of Chardin; these are: (1) Johnson collection in Philadelphia; (2) the former Doisteau collection (exhibited in Brussels in 1904, no. 13) then to New York in 1971; (3) Corcoran Gallery of Art in Washington; (4) former Rothschild collection, also destroyed during World War II; (5) the Baron Stumm collection in Holzhausen, shown in Berlin in 1910 (no. 24 with ill. in the large edition of the catalog), then Ritter of Munich, sold in Cologne, 30 January 1952 (with 1909 certificate of Bode and 1949 certificate of Voss) [see also Meier Grafe, 1910, p. 270, "the most delightful of all these paintings... like a diminutive version of a vision of Rembrandt"].

A *Retour du marché (Return from Market)* and a *Récureuse (Scullery Maid)* in a format very similar to that of the Glasgow painting figured at the Sylvestre sale (no. 13) of 28 February-25 March 1811.

At the 1743 Geminiani sale in London, no. 67 was "Chardin... A Woman, with a Frying Pan, a Sketch" [information from D. Carritt].

The University of Glasgow also has the companion piece to the painting exhibited here, which, unfortunately, we were not able to borrow [see, most recently, Kemp, 1976].

Painting no. 19 of the 1738 Salon, entitled *un garçon cabaretier qui nettoye un broc* ("Boy cleaning a large jug"), also engraved by Cochin in 1740 *(le garçon cabaretier* ["The tavern-keeper boy"], p. 27, reprint of the cat), but which was not shown at the 1757 Salon, appeared at the same sales as the Rothschild *Scullery Maid* until 1876. In 1908 (according to Guiffrey), it belonged to the Brugmann collection in Brussels. But since that time it has not been seen by any Chardin expert.

A third copy exists in a large collection — "a superlative version" [Carritt, letter of 1976] — which we do not know even through a photograph, but which seems to be an original, judging by the reactions of the few individuals who have had the privilege of seeing it (Sir Anthony Blunt; B. de La Beaumelle). Can this painting be the one we have just described?

We point out, finally, a copy of the *Tavern-Keeper Boy* valued at 15 *livres* in the estate inventory of Claude-Nicolas Rollin, dated 16 January 1749 [see Wildenstein, 1967, p. 158].

At the 1738 Salon Chardin exhibited, along with eight other paintings (five of which are in the present exhibition), a *Scullery Maid*. Was it the painting now in Glasgow or was it another version, undoubtedly an original (it is difficult to know with certainty, if it also was dated from 1738), that was destroyed during World War II after having belonged to some of the greatest admirers of Chardin (the Comte de Vence, the Marquise de Pompadour, her brother the Marquis de Ménars, François Marcille and then Camille Marcille, and Henry de Rothschild)? Differences between the two paintings (a flat earthenware dish replaced the casserole we see here; a spoon [?] was placed beside it) confirm that the painting engraved by Cochin in 1740 was the one Chardin exhibited at the 1757 Salon. It is well known that eighteenth-century engravers preferred to copy works exhibited at the Salon. That is the only argument we have for supposing that the 1738 Salon painting is the same as the one destroyed, which would, consequently, have been exhibited twice in the eighteenth century.

The Salon painting, although cited by the *Mercure de France* (October 1738) and by the Chevalier de Neufville de Brunaubois-Montador (1738), was not the object of any special notice. The most enthusiastic comment on the painting came somewhat later, from Diderot, in his comparison of Bachelier with Chardin [*Salon of 1765*, Seznec and Adhémar, 1963, pp. 17-8]. "Yes, no doubt Chardin is permitted to show a kitchen," he wrote in a rarely cited text, "with a servant girl bent over her washtub rinsing her dishes. If sublimity of technique were not what is involved, Chardin's ideal would be a wretched one."

The painting was known to Hédouin in 1846 [p. 224, no. 11, and p. 225, no. 54], who wrote that "during the period of David's Greco-Roman school, Watteau and Chardin had no commercial value whatsoever." In 1848 it was shown on the Boulevard Bonne-Nouvelle at the benefit exhibition organized for the Société des Artistes relief fund. It played an important part in the rediscovery of Chardin in the nineteenth century.

The Scullery Maid met with some reservations on the part of the critic for *L'Illustration* (A. J. D.), which published a print of it in the 5 February 1848 issue (p. 561). He referred to Chardin as a "brutal realist." About the painting, he added, "the technique applying thick layers of paint is uniform to the point of monotony; it gives a grainy appearance which suggests the effects obtained by grazing the surface of the canvas with the flat of a brush loaded with pigment thickened with copal. These paintings have an appearance of clarity, simplicity and tranquility which pleases the viewer at first sight." Regarding the companion piece, *The Tavern-Keeper Boy*, A. J. D. wrote: "If his partiality [that of Chardin] shows, it is in favor of the jug rather than the face of the tavern-keeper boy"!

On the other hand, Clément de Ris [*L'Artiste,* 30 January 1848, p. 194] commended "the solidity of tone, [the] vigor, [the] intelligent and graceful skill in the use of the pigment." We find the same enthusiasm, in 1862, in the observations of Charles Blanc (p. 8): "What truth, what sense of illusion; if you stand ten minutes in front of this small frame, you will see the woman, so gracefully natural in her humble duties, grow before your eyes: it will seem to you that her hands really move, that she is alive, that she hears you, and that one word from you will cause her to turn momentarily from her work. Never did Chardin paint more thickly, never was he more simple, more harmonious, more vigorous without exaggeration, more real without vulgarity." Blanc stresses these words in

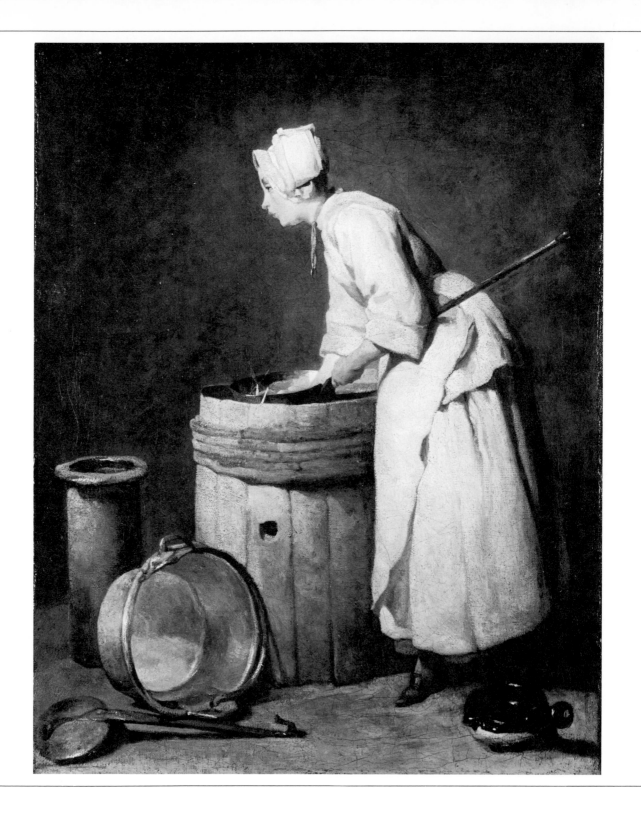

7*

which he sees the clue to the difference between Chardin and the Northern painters.

Two years later the Goncourts (p. 148) outdid even that: "On top of undertones of yellow, blue, and pink, that seem to have been hatched with chalk, the cotton bonnet, blouse, and apron of unbleached linen, play on the three notes of pure white, gray white, and rusty white, a triumphant symphony of warm whiteness." And in the words of Decamps, "the whites of Chardin!... I cannot get them."

All these commentaries, however, do not refer to the Glasgow version which became known only much later, after its appearance at the 1907 Whitechapel exhibition, where it had created a "sensation." The anonymous editor of *The Burlington Magazine,* which reproduced it, very intelligently compared it with the works of Velásquez and Millet, analogous in subject and especially in spirit: "He [Chardin] looks on the world with a calm gaze, Millet with an eye that is impassioned, perhaps even indignant."

The Glasgow painting also has for its companion piece a magnificent *Tavern-Keeper Boy,* which we regret being unable to exhibit. It is our opinion, we repeat, that the 1738 Salon version, the one engraved by Cochin in 1740, is the painting whose history we follow up to the Camille Marcille sale in 1876 but which we have lost track of since the turn of the century. The Glasgow painting has just been radiographed and subjected to a close study by Martin Kemp (1976). While the x-radiograph of *The Scullery Maid* has produced little information, that of *The Tavern-Keeper Boy* [Kemp, 1976, fig. 55] — the date of which ends in a 5 or a 6 (as is often the case with Chardin, the figure is difficult to read) — shows that at an early stage the young man was holding in his uplifted hand a glass, probably full of wine, and was getting ready to pour wine through the large funnel from the vat into a bottle. These appreciable modifications encourage Kemp to think (with some hesitation, since he cannot explain the absence of modifications in *The Scullery Maid)* that the pair of paintings in Glasgow is earlier

The Tavern-Keeper Boy.
Glasgow, Hunterian Art Gallery.

than the pair belonging to the Comte de Vence (and therefore, in our opinion, the pair at the 1738 Salon). We withhold judgment on this point, however, until the Marcille painting has been rediscovered. We are convinced, in any case, that *The Tavern-Keeper Boy* was painted before *The Scullery Maid.*

Critics have often emphasized the elements shared by the two works: the full vat on which the boy is resting his jug is very similar to the one used by the scullery maid, although inverted in the latter painting. The medallion attached to a blue ribbon hung round *The Scullery Maid*'s neck (which will reappear in *The Return from Market)* corresponds to the key hanging from the innkeeper's waist. Is it possible to find a connection between the two works with regard to their significance and find in them a common moral meaning? Snoep-Reitsma thinks not, and Kemp approaches the question with caution. It seems more reasonable to us, since we know little of Chardin's theoretical ideas, not even to attempt an interpretation.

A question less often pondered is why Chardin exhibited *The Scullery Maid* again in 1757, some twenty years later. The *Journal encyclopédique* of October 1757 (p. 105) judged the painting rather harshly as being "a little yellow in tone and revealing effort," though it was "however, a very fine piece." But Renou, secretary of the Academy and the probable author of *Lettres* on this Salon [*Obsevations sur la physique et les Arts,* Deloynes Collection, VII, 83, pp. 73-94] ventured a fascinating parallel between Greuze, whose paintings had created a great stir at the 1755 Salon, and Chardin:

"They have put the works of both on the same line [i.e., on the same wall at the Salon], as if to facilitate the comparison of this painter with M. Greuze. They gain and they lose by turns. If color is the issue, M. Chardin is superior. His paintings are vigorous, all his objects are reflected in one another, and there results from this a transparency of color which brings to life all that his brush touches.... If we consider these two masters from the point of view of talent, M. Greuze seems to have more fire, a greater inclination toward the grand manner, proving to us that 'the least noble style still has its nobility'; but he does not always have M. Chardin's ingenuity. Generally speaking, his draughtsmanship is more assured and he has more expression, which is a considerable advantage: happy is he if he can join to that the magic of Chardin's tones! for he must still consider him as his master in this respect!"

Greuze had not only received great acclaim at the Salon by treating subjects similar to those of Chardin but he had also just shown a drawing (now in the Albertina, Vienna) entitled *The Scullery Maid,* which Beauvarlet (1731-1797) [cf. Brookner, 1972, pl. 21] was preparing to engrave and which fashionable minds of that time could, of course, admire and compare with the painting by Chardin.

In his *Scullery Maid* Chardin successfully brings together the kitchen items he had painted separately a few years before — copper pot, skimmer, earthenware casserole, and long-handled frying pan, wooden vat, and a "large clay vase" (?) — with a female figure

seen in profile, coifed with a white bonnet, and very elegantly dress-ed for such chores. As usual, Chardin emphasizes the convex and concave forms and the objects, both in their coloration and tex-ture. But he devotes his attention above all to his feminine model, who seems to be posing with a detached air. *The Scullery Maid* is motionless, silent; her face is without expression. She seems to be performing the same everyday task and yet appears removed from time.

Was there not a little malice on the part of Chardin, a whole generation older than Greuze, in showing again at the 1757 Salon a work so obviously the opposite of the anecdotal and literary pieces, rich in picturesque details, which had assured a triumph for Greuze two years earlier?

80 *The Return from Market*

(La pourvoyeuse)

Canvas, 46 × 37 cm. Signed and dated at the left center near the model's elbow: *Chardin/1738.*
Berlin, Staatliche Schlösser und Gärten, Schloss Charlottenburg*

Provenance. La Roque sale, May 1745, no. 190 (?) Acquired in Paris, according to a receipt known to Seidel (1900), by the agent of Count Friedrich-Rudolf of Rothenburg (1710-1751) [see [77] and Börsch-Supan, 1968] for 450 *écus* for Frederick II or Prussia, along with a ver-sion of *Woman Scraping Vegetables (see [82]).* This receipt, of which we can find no trace, is generally dated 1746. In 1760 the painting was recovered in the park of Charlottenburg after the looting of the palace by Austrian troops. It was exhibited at Potsdam from 1773, and since the end of World War II has once again graced Charlottenburg Palace. See also [81], *Related Works.*

Exhibitions. 1883, Berlin, no. 39; 1900, Paris, no. 2; 1907, Paris, no. 9; 1929, Paris, no. 4; 1947, Wiesbaden, no. 15; 1951, Wiesbaden, no. 3; 1953, Berlin, no. 12; 1962, Berlin, no. 7; 1963, Paris, no. 4 (color pl.).

Bibliography. Oesterreich, 1768, p. 35, no. 13; Nicolai, 1769, p. 481; Oesterreich, 1773, p. 127, no. 570; Nicolai, 1779, p. 687; Nicolai, 1786, III, p. 1014; Rumpf, 1794, p. 262; Rumpf, 1823, II, p. 227; Bocher, 1876, p. 90, no. 573; Dussieux, 1876, p. 221; Goncourt, 1880, p. 122 ("perhaps doubtful"); Dohme, 1883, p. 256; Ephrussi, 1883, p. 104; Seidel, 1894, p. 49; Dilke, 1899, pp. 186, 188; Dilke, 1899, (2), p. 118; Berlin cat. (Seidel), 1900, no. 99; Fourcaud, 1900, p. 273; Lafanestre, 1900, p. 557; Merson, 1900, p. 306, note; Seidel, 1900, pp. 20-21, no. 23; Dayot and Vaillat, 1907, pl. 30; Guiffrey, 1907, p. 95; Tourneux, 1907, p. 89; Frantz, 1908, pp. 26 (ill.), 30; Guiffrey, 1908, pp. 56-57, no. 3; Pilon, 1909, pp. 89, 169; Furst, 1911, p. 131, pl. 15; Bouyer, 1919, p. 434; Foerster, 1923, p. 61; Hildenbrandt, 1924, p. 169, fig. 216; Pascal and Gaucheron, 1931, p. 131; Wildenstein, 1933, no. 40 fig. 15; Kühn, 1937, p. 5; Furst, 1940, p. 19 (ill.); Goldschmidt, 1945, fig. 5; Goldschmidt, 1947, fig. 3; Jourdain, 1949, pl. 19 (detail); Museum cat., 1956, p. 13; 1960, p. 20; 1963, p. 28; Wildenstein, 1963-69, no. 188, fig. 86; Lazarev, 1966, pl. 37; Börsch-Supan, 1968, p. 83; Schloss Charlottenburg cat., 1969, p. 60.

Prints and *Related Works.* See [81].

See [81] for discussion.

81 *The Return from Market*

(La pourvoyeuse)

Canvas, 47 × 38 cm. Signed and dated on two lines to the right of the model's right elbow: *Chardin/1739.*
Paris, Musée du Louvre, M.I. 1020

Provenance. Very possibly the picture from the sale "of an amateur," 27 January 1777, no. 11 (26 × 13 *pouces* [70.2 × 35.1 cm.], "The picture has been engraved by Lépicié"). It then appeared at the following sales: [Benoit], 10 April 1786, no. 38 (16 *pouces* 6 *lignes* × 13 *pouces* [44.5 × 35 cm.], "This picture is one of the most beautiful by this master for its truth and freedom of execution. It has been engraved by l'Epicié"); Nanteuil sale, 1 March 1792, no. 11 (16 × 13 *pouces* [43.2 × 35.1 cm.], "The works of this painter always offer great truth to nature"). Sale of Dr. Maury, "nephew of the former archbishop of Paris," 13-14 February, 1835, no. 5 (no. dimensions, but see 1860 Paris exh. cat., no. 99). Sale of 13-14 March 1835, no. 14, no dimensions (?). Sale of A. Giroux (*père*), 10 February 1851, no. 38. Collection of Laurent Laperlier (1805-1878) from 1860; Laurent Laperlier sale, 11-13 April 1867, no. 7. Acquired by the Louvre at the Laperlier sale for 4,050 francs with two other Chardin pictures [74, 130]. See also *Related Works.*

Exhibitions. 1860, Paris, no. 99; 1928, Paris, no. 31; 1934-35, Lyon (in exchange for works loaned by Lyon for *The Painters of Reality,* a 1934 Paris exh.); 1945, Paris, no. 5; 1946, Paris, no. 95; 1965, Moscow-Leningrad, p. 46; 1966, The Hague, no. 34 (ill.); 1966, Paris, no. 34 (with pl.).

Bibliography. Bürger (Thoré), 1860, pp. 333, 334, 337; Gautier, 1860, p. 1065; Gautier, 1864, p. 75; Goncourt, 1864, pp. 148-49; *La Chroni-que des Arts et de la Curiosité,* 21 April 1867, p. 122; Burty, 1867, p. V; Marcy, 1867, pp. 111-13 (describes the picture soon after it entered the Louvre); Bocher, 1876, p. 45, no. 45, and p. 85; Museum cat. (Tauzia), 1878, no. 724; Burty, 1879, p. 148; Goncourt, 1880, p. 180; Chennevières, 1888, pp. 58, 61; Dilke, 1899, p. 188 and note 1; Dilke, 1899 (2), p. 118; Normand, 1901, pp. 56, note 4, 64; Schéfer, 1904, pp. 45 (repr.), 59, 68; Dayot and Guiffrey, 1907, pl. between pp. 92 and 95; Guiffrey, 1908, p. 68, no. 69; Goncourt, 1909, pp. 127-28, 180; Pilon, 1909, pp. 51, 89, 165, pl. between pp. 104 and 105; Furst, 1911, p. 121, no. 99; Raffaelli, 1913, p. 51 (ill.); Faure, 1921, p. 223 (ill.); Museum cat. (Brière), 1924, no. 99; Schneider, 1926, fig. 81, p. 129; Gillet, 1929, pp. 64, 71 (repr.); Pascal and Gaucheron, 1931, p. 131; Ridder, 1932, pls. 12, 48 (detail); Wildenstein, 1933, no. 41; Florisoone, 1938, pl. 4 (color); Hourticq, 1939, p. 95; Pilon, 1941, p. 2 (repr.); Pilon, 1941 (2), p. 19 (ill.); Lazarev, 1947, fig. 19; Florisoone, 1948, p. 63; Jourdain, 1949, fig. 18; Dacier, 1951, p. 135 (repr.); Malraux, 1951, pp. 293, 294, color detail between pp. 294 and 295; Golzio, 1955, p. 917 (repr.); Barrelet, 1959, p. 308; Goncourt, 1959, p. 156 (repr.); Bazin, 1960, p. 224 (color pl. on p. 225); Saisselin, 1961, pp. 154, 155, fig. 7; Zolotov, 1962, pl. 3; Garas, 1963, pl. 5 (color); Gimpel, 1963, p. 408; Rosenberg, 1963, pp. 10, 50, 56 (color pl.), 57 (detail), 59 (detail), 60; Wildenstein, 1963-69, no. 189, pl. 28 (color); Huyghe, 1965, p. 10 (repr.); Gaillard, 1966, p. 94; Valcanover, Martin, 1967, ill. (un-paginated); Laclotte, 1970, p. 37 (color pl.); Wagner, 1970, p. 142, fig. 5; Proust, 1971, p. 373; Rosenberg, 1971, pp. 19, fig. 8 (detail), 20; Ochsé, 1972, pls. 46, 47 (detail); Rosenberg, Reynaud, Compin, 1974, no. 133 (ill.); Kuroe, 1975, pl. 16 (color); Haskell, 1976, p. 102, pl. 230; *Chefs-d'oeuvre de L'Art. Grands peintres,* 1978, ill. (unpaginated); *Les peintres illustres,* directed by Henry Roujon, pl. 8 (color).

Prints. The engraving by François-Bernard Lépicié *père* (1698-1755) was among the most important in popularizing Chardin [Bocher, 1876, pp. 45-46, no. 45, and Sjöberg, 1977, pp. 404-5, no. 61]. It is dated 1742 which confirms a notice in the *Mercure de France* of November 1742 which described it as "a cook who comes into her kitchen from the market carrying bread and meat."

In 1860 (and 1864) Théophile Gautier wrote ironically of the quatrain (perhaps also by Lépicié) which accompanied the engraving:

From your appearance I note and conclude
That you, dear child, take without scheme
Above the household expense
What you need to be properly dressed.

This engraving has been reproduced in numerous publications, from the article by Virgile Josz, written in 1899 to commemorate the bicentennial of Chardin's birth, to Snoep-Reitsma [1973, p. 182, fig. 25]. Bocher catalogs nine different prints (one ca. 1750 by Jean Lemoine), one with a new caption:

Engraving by Lépicié.

We spend all our toil keeping food in our mouths
While our spirits cry out and our hearts are in pain;
They too have their needs,
We recognize that; why must they be denied?

Another has the caption in French and German. (The reasons for believing that the Lépicié engraving was done after the Louvre picture are given below.) An engraving by Henri Guérard (1846-1897), which illustrates the article by Chennevières [1888, p. 58], and one by Boilot [Normand, 1901, p. 64] are both after the Louvre picture. The print by Peter Halm is after the Berlin picture [Seidel, 1900]. Finally, there is the copper engraving in the Louvre collection by Fernand Desmoulin (1853-1914) [*Catalogue de la chalcographie*, 1968, p. 124, no. 6056], and a very rare etching by Charles Jacque (1813-1894).

Related Works. Chardin exhibited in the Salon a *Return to Market* on two occasions: in 1739 [p. 14, reprint of the cat.] and in 1769, no. 32, "A woman who is returning from market. This picture, a repetition with changes, belongs to M. Silvestre, drawing master to the royal children."

Let us first settle the matter of the latter picture. Everything indicates that the "repetition" which belonged to Sylvestre in 1769 was one of a pair sold in the Sylvestre sale, 28 February-25 March, 1811, no. 13, "The Return from Market and The Scullery Maid, [both] pictures 16 *pouces*, 9 *lignes* high by 13 *pouces*, 6 *lignes* wide" (45 × 36 cm). While

The Scullery Maid seems to be lost (see [79]), *The Return from Market* would appear to be the canvas destroyed during World War II along with part of Henry de Rothschild's collection [Wildenstein, 1963-69, no. 356, fig. 162]. There are two drawings by Gabriel de Saint-Aubin after the version in the 1769 Salon [Salon cat., now in the Cabinet des Estampes, Bibliothèque Nationale; Dacier, 1909, II, p. 10 of the facsimile], and a water color showing a wall of the same Salon, now in a private collection in Paris. The drawing done after *The Return from Market* which is now at the Art Institute of Chicago (46.383) is a copy of the first (1738) version of the canvas, and its attribution to Saint-Aubin is questionable. These drawings do not serve to identify the Sylvestre painting as the destroyed Rothschild picture, but a single word from Diderot's commentary resolves the question. In his description of this "repetition" [Seznec and Adhémar, 1967, p. 83], Diderot mentions a *"réchaud à l'esprit de vin"*; this alcohol stove appears in the Rothschild picture, as it does in *Saying Grace* [86], but is absent both from the first versions of *The Return from Market* and from the Lépicié engraving of

Saint-Aubin, drawing after the painting exhibited at the 1769 Salon.

1742. This element, therefore, constitutes one of the *"changements"* referred to in the Salon catalog of 1769.

There are three autograph versions of *The Return from Market*: the one in Berlin, of 1738 [80], which seems to have left France in 1746 along with a *Woman Scraping Vegetables,* now lost (see [82]); another one, also of 1738, which, along with *The Governess* [83], is now in Ottawa (these paintings, along with a version of *Woman Scraping Vegetables* — see [82] — were in the collection of the Princes of Liechtenstein between 1741 and about 1950); and the version of 1739 acquired by the Louvre in 1867, which we think is the picture that appeared in the following sales: *"d'un amateur"* of 1777, Benoit of 1786, and Nanteuil of 1792.

Which one of these three canvases was exhibited at the Salon of 1739 and which was engraved by Lépicié in 1742 (see *Prints*)? Is it the same one which appeared in the 1745 La Roque sale, no. 190, described in the catalog as "Two pictures on canvas, one representing a cook returning from market; it is an original by M. Chardin and has been engraved by M. Lépicié with the title La Pourvoyeuse. The second picture is of a mother who is lecturing her child on the errors into which he has fallen. The latter is a copy retouched in several places by M. Chardin.... (bought for 16 *livres* by 'Colins')"?

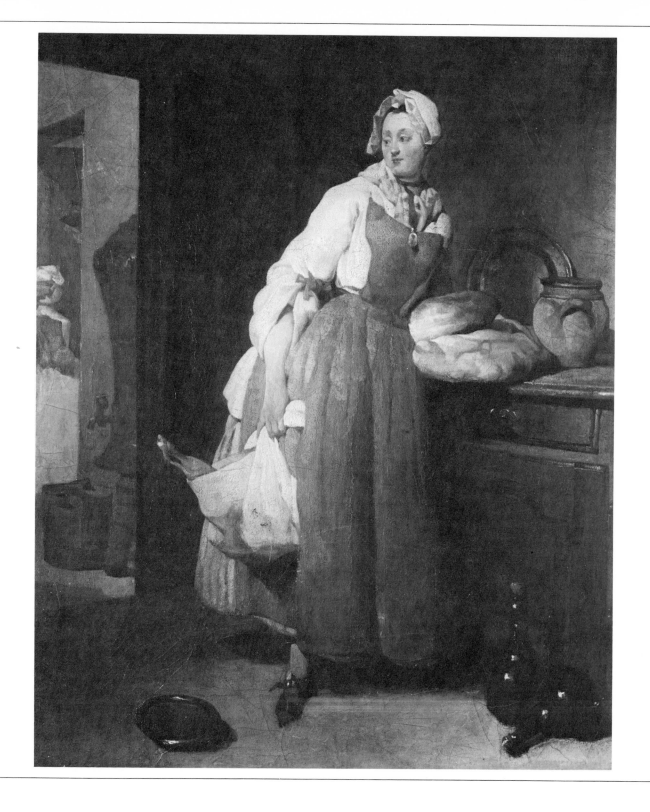

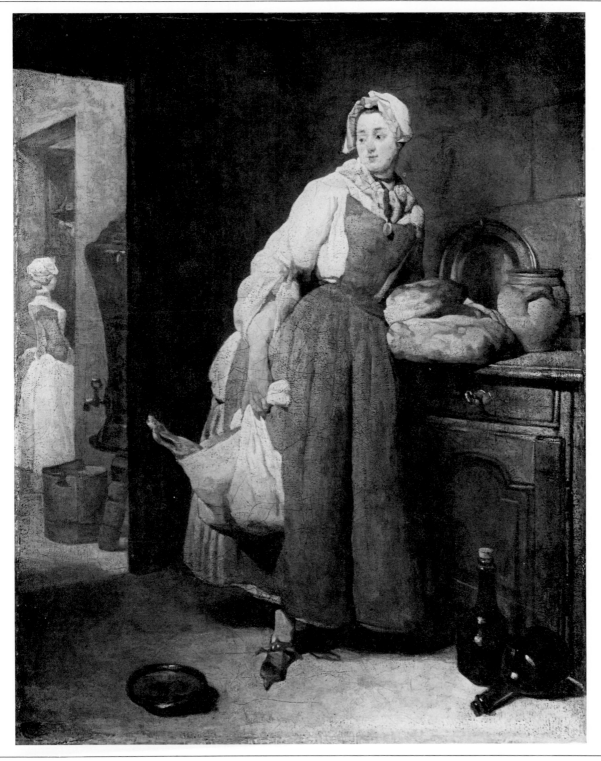

81

See Color Plate X.

These questions are very difficult to resolve because the variations among the three pictures, on the one hand, and between the pictures and the print, on the other, are very slight (let us add that the old sources, whether they speak of one or the other version, regularly specify that it was engraved, but never that it had been in the Salon, nor who owned the picture in the 1738 Salon).

After close study of the old references, the pictures, and the print, we would like to propose with greatest caution these points. (1) The picture that was engraved is the one in the Louvre. The background formed by stone blocks quite visible in the print shows clearly in the Louvre picture, less clearly in the Ottawa one, and not at all in the Berlin version. The other differences among the pictures all appear to confirm this hypothesis. (2) The Salon picture is the one in Ottawa: it is dated 1738, as are the two other Liechtenstein canvases which could have been bought as a group at the Salon by Prince Joseph Wenzel of Liechtenstein. (3) The La Roque picture could have been acquired (shortly after the 1745 sale to "Colins") by Rothenburg for Frederick the Great of Prussia.

Comparing two of the three versions will either prove or disprove our thesis. Regrettably, the third version in Ottawa, still on its original canvas, could not be loaned to this exhibition.

Separate entries for the Berlin and Louvre pictures seem unnecessary. The provenance of both pictures, as well as the Ottawa version, has been discussed above. Let us say first that the Berlin and Ottawa pictures are dated 1738, the Louvre one, 1739. They are very close in quality, but the Berlin version has suffered a little from cleaning, in our opinion, which reduces its resonance. Dohme noted this in 1883, and Guiffrey in 1907 declared it "very worn and very much restored." It is known that the picture was found abandoned in the park of Charlottenburg after the sack of the palace in 1760 by Austrian troops.

At the Salon of 1739, the third at which Chardin exhibited figural compositions, it was, according to the few extant commentaries, *The Governess* which evoked the most praise of the six works shown. The Chevalier Neufville de Brunaubois-Montador [*Description raisonné*, 1739, p. 9] did not share that opinion:

Ottawa, The National Gallery of Canada.

"What seems to have preference this year is a cook returning from the butcher and the baker [*La Pourvoyeuse*]. It is certainly the most carefully observed characterization that I know." Thanks to the Lépicié engraving of 1742, the work did not fall into total oblivion. Astonishingly, it appears on the walls of the "Salon of Mme Geoffrin in 1755", a painting done at the height of neo-classicism in 1812 by the Rouen artist Anicet-Charles-Gabriel Lemonnier (1743-1824), among the pictures which were supposed to have been part of the collection of that celebrated writer, who, it is said, possessed a version of *The Bird-Song Organ* (see[93]). The Lemonnier picture is at Malmaison; a sketch is in the Rouen museum; and a preparatory drawing is in the Musée Borély, Marseille, under a Boucher attribution [cf. Schommer, 1959].

More natural is the influence of the picture on the work of François Bonvin (1817-1887) [see G. Weisberg, 1970]. Bonvin was a personal friend of Laurent Laperlier and left a warm, personal tribute to him which we are publishing in another connection. Laperlier was a great collector of Chardin's works, and owned the Louvre's *Return from Market* from 1860. It should not be surprising that Fantin-Latour (1836-1904) copied the picture, possibly soon after its entry into the Louvre [exh. cat. *Fantin-Latour*, Grenoble, 1936, no. 189]. Raoul Larche (1860-1912) was inspired by the figure in *The Return from Market* for his monument to Chardin in which the girl holds bunches of flowers instead of a loaf of bread and a leg of mutton [plaster reproduced in *Gazette des Beaux-Arts*, July 1920, p. 20].

Of the various versions of *The Return from Market*, the one from the Laperlier collection was the first to become famous — thanks to the 1960 exhibition at the Galerie Martinet, organized by Philippe Burty and which had well-known repercussions. Seven years later it was bought by the Louvre. Thoré's (Bürger's) commentary reveals his thorough knowledge of Dutch painting [1860, p. 337]:

"The Diligent Mother and *Saying Grace,* both at the Louvre, are masterpieces. So too is *The Return from Market* for those artists who are passionately fond of its bravura and the quality of its color. The brushwork is less meticulous, less delicately worked; rather, it is broad, full, and loose. Between the Louvre pictures and that of our exhibition there is almost the same difference as between a Metsu and a Pieter de Hooch or (I would like to say this if the painter of *The Milkmaid* in the Six van Hillegom collection were better known in France) a van der Meer of Delft. But it is the work of Nicholaas Maes that this rich and luminous picture most resembles." Théophile Gautier [1860, p. 1065; 1864, p. 75] also cited the name of Pieter de Hooch: "There is no way to make much of a case for aesthetics with this picture, but it is a true painting."

In 1860 the Goncourts admired in Vienna the four Liechtenstein Chardins [*Journal*, 1860; 1956 ed., I, p. 817]; *The Return from Market* surprised them by its "colors placed side by side, giving the painting the appearance of a tapestry in *gros point,*" as did the Laperlier canvas with its "rough and grainy texture." "Light tones, soft and cheerful, dappled everywhere, and endlessly reappearing, even in the white of the blouse, rise like a web of daylight, a dove-

colored mist, like motes of dust, a floating haze that envelops the woman, her clothing, the side-board, the loaves, the wall, and the distant background." [1864, pp. 148-49]

Henry de Chennevières (1888), who considered *The Return from Market* as the "the principal piece" of the Louvre, gives us a more descriptive analysis: "How to render in words the milky whites of the woman's dress, the exceptional appearance of the faded blues in her apron! The belly of the bread bin [in fact, according to D. Alcouffe, a low buffet of very good quality], the crust of the bread, floury and golden. The two bottles on the floor, the red seal of one echoing the blue ribbon at her sleeve! The yellow-orange dress of the waiting-maid, answering the colors of the bin! And the silhouette of the urn!"

André Malraux (1951) reproduces a detail of the picture, appropriately focused on that urn (which, we should remember, Chardin had made the subject of another picture [53], and which occupies the place of honor in *Woman Drawing Water from a Water Urn* [55, 57]), and writes, "*The Return from Market* is a genial Braque, barely dressed enough to fool the viewer.... Chardin is not simply a little master of the eighteenth century who is more refined than his rivals; he is, like Corot, a gently imperious simplifier. His quiet mastery overthrew the baroque still life of Holland and made mere decorators of his contemporaries; in France nothing was able to compete with him from the death of Watteau to the Revolution...."

Indeed, one must admire that perfect pyramidal composition and the play of half-opened doors which alternately plunges details into shadow or floods them with light. Through the opening one can see a minute corner of sky and the group at the threshold of the house mentioned by Yann Gaillard [1966, p. 94]. "The woman leans on the sideboard, resting her arm. Near the loaves, a pewter plate gleams. Her other arm, with a rosy knot at the sleeve, carries a joint of meat, the shank sticking out of the linen. Through an open door in the rear wall we see another woman, her back to the light. The woman in the foreground wears a gray apron, and at her feet lie two bottles glossy as shells. The other woman, in pink, turns toward the dark rectangle of another doorway."

Yet how can we be satisfied by these perfect descriptions which touch upon the formal beauty of the picture but do not explain at all the kind of "fascination" that the work has never ceased to exert. Let us not again be witty about the Lépicié poem which accompanies the print (see above) and which demands that a subject be given to the picture, that it should be read as an amusing anecdote chiding the dishonest servant. The work is not devoid of such meaning, but its less immediate and less literary aspects require a new analysis. René Demoris (1969) recently proposed one which will serve as the basis for the present interpretation, although Chardin himself would doubtless have been astonished by it. The shopper has returned from market, the knuckle of a leg of lamb is sticking out of the butcher's bag, and she has put the round loaves of bread on the low sideboard: "The activities [that Chardin] chooses belong to the repetitive, daily world of the household. Marketing and washing do not evoke much feeling, and the faces are therefore without expression." The shopper, who seems to be recovering her breath, is "caught in a timeless moment [which puts her] in an attitude of repose. Chardin [thus] gives the feeling of an indefinite time, showing us persons involved in an activity and at the same time detached from it."

These few quotations do not explain everything: they stress a profoundly new attitude with which Chardin treated subjects consciously chosen for their banality. Such originality, put in the service of a technique both surprising and personal, is for many the greatness of Chardin.

82 Woman Scraping Vegetables

(La ratisseuse)

Canvas, 45.5 × 36.5 cm. Signed at the lower right: *Chardin*. Munich, Bayerische Staatsgemäldesammlungen

Provenance. Galerie of Prince Karl-August of Zweibrücken, apparently purchased between 1775 and 1793 by the conservator of the collection, Johann Christian Mannlich (1741-1822), who had been a pupil of Boucher in Paris; collection transferred to Kaiserslautern (1793), then to Mannheim (1799), and finally to Munich (1805). Remained in the Palace of Schleissheim until 1881. At the Alte Pinakothek since 1881.

Exhibitions. 1948, Brussels, no. 144; 1948, Paris, no. 96, pl. 111; 1948, Amsterdam, no. 34; 1958, Munich, no. 38.

Bibliography (only those references pertinent to the Munich version of *Woman Scraping Vegetables* are cited; many of them came from the 1972 Munich catalog). Mannlich, 1805, p. 4, no. 12; *Notice*, 1818, p. 9, no. 12; Dillis, 1831, p. 100, no. 594; Schleissheim cat., 1850, p. 34, no. 976; 1870, p. 26, no. 587; Parthey, 1863, p. 278, no. 4; Bocher, 1876, pp. 48, 49, 92; Museum cat., 1884, p. 268, no. 1376; Hirth and Muther, 1888, p. 205, pl. on p. 204; Dilke, 1899, p. 186, note 4; Dilke, 1899 (2), p. 118, note 2; Normand, 1901, pp. 60, 108; Schéfer, 1904, pl. between pp. 48 and 49; Guiffrey, 1908, pp. 57, 58, nos. 11 and 68; Museum cat., 1908, p. 288, no. 1376; 1911, pp. 28-29, no. 1376; Voll, 1908, pp. 255-56, pl. on p. 254; Pilon, 1909, p. 169; Kanoldt, 1910, p. 165, no. 1376; Ansel and Frapié, 1911, p. 165, no. 1376; Furst, 1911, pp. 119, 131; Museum cat., 1920, p. 28; 1936, p. 47, pl. on p. 194; Henriot, 1925, p. 2; Henriot, 1926, p. 47; *Chardin* exh. cat., 1929, p. 12; Wildenstein, 1933, no. 47; *Arts*, 17 December 1948 (ill.); Guldener, 1948, p. 156; Denvir, 1950, pl. 14; Museum cat., 1953, p. 14; 1957, p. 24, pl. on p. 264; *Le Figaro Littéraire*, 27 March 1954 (ill. in article by Marcel Proust); Weber, 1954, p. 17 (with ill.); Buchner, 1957, p. 56, pl. 98; Goncourt, 1959, p. 157 (ill.); Poensgen, 1959, pp. 117, 124, pl. 27; Schönberger and Soehner, 1960, pp. 87, 356, pl. 244; Martin, 1961, p. 5; Martin, 1962, pp. 30-31, pl. 32; Mittelstädt, ed., 1963, p. 22, pl. on p. 23; Weber, 1963, p. 12; Wildenstein, 1963-69, no. 171, fig. 78; Guilly, 1964, p. 724 (color pl.); Photiades, 1964, p. 16; Jedlicka, 1965, p. 181; Bauer, 1966, p. 95, pl. onp. 96; Lazarev, 1966, pl. 34 (color); Soehner, 1967, p. 16, pl. on p. 86; Martin, 1968, p. 95, no. 44 (with color pl.); *Le Monde des Grands Musées*, May 1969, p. 64, no. 92 (color pl.); Pfeiffer-Belli, 1060, pp. 191-92, pl. 113; Museum cat. (Hohenzollern and Söehner), 1972, pp. 25-26, pl. 18; Museum cat., 1974, p. 68 (ill.); Eisler, 1977, pp. 311-13.

Prints. An engraving by François-Bernard Lépicié (1698-1755) is dated 1742 [Bocher, 1876, p. 48, no. 46, and Sjöberg, 1977, p. 404, no. 60]. Announced by the *Mercure de France* of January 1743 (pp. 148-149), this engraving was accompanied by a quatrain very "ecological" in tone:

> When our Forebears took from nature's hands
> These vegetables, proof of their simple way,
> The art of turning our food to poison
> Had not yet seen the light of day.

Bocher catalogs five states of this engraving (there is also a copy of about 1750 by Jean Lemoine).

There is a lithograph of the Munich picture by Joseph Anton Selb (1784-1832), after a drawing by Ferdinand Wolfgang Flachenecker (1792-1847), published by Piloty in 1831 in a volume devoted to the Schlessheim pictures. A small reproduction of the same picture, dated 1832, attributed to Achille Réveil, accompanied by one of the rare commentaries on Chardin written during the period in which the artist was almost forgotten, appeared in *Musée de peinture et de sculpture, ou Recueil des principaux tableaux...des collections publiques et particulières de l'Europe* (1832, XIII, pp. 899-900; see passage quoted below).

Finally, Ch. Giroux engraved the Munich picture for an illustration in a work on Chardin by Charles Normand (1901, p. 60).

Related Works. Une ratisseuse de navets ("Woman peeling turnips") appeared in the Salon of 1739. The Lépicié engraving of that subject dates from 1742. Is it the Salon picture reproduced in the engraving? Is it after the version that is today in Washington, or the one in Berlin, or of a third composition of the same subject?

The Washington picture [cf. C. Eisler, 1977] is signed and dated 1738. It was most probably acquired by Prince Joseph Wenzel of Liechtenstein, while ambassador in Paris between 1737 and 1741, in the same manner as *The Return from Market* (see [80]) and *The Governess* [83], both now in Ottawa.

The Berlin canvas [Wildenstein, 1963-69, no. 169, fig. 76] was bought in Paris, most probably in 1746 by Count Friedrich-Rudolf of Rothenburg for Frederick II of Prussia with *The Return from Market* exhibited here [80]. Contrary to what is always repeated, the picture is no longer in Berlin; it disappeared in 1918. Our attempts to locate it in one of the collections of the descendants of the Prussian imperial family have been fruitless. Nevertheless, we can state definitely that the work had suffered considerably [cf. Dohme, 1883] and that it had been cut at the bottom and on the right.

Nothing is known of the Munich canvas before its transfer from the gallery at Zweibrücken to Munich at the end of the eighteenth century.

The fourth *Ratisseuse* that is generally attributed to Chardin [cf. Wildenstein, 1963-69, no. 170, fig. 77] and comes from the collections of Sir Hugh Lane and David David-Weill (and is today in the prefecture of Groningue), is known to us only by photograph, but it does not seem to be an authentic Chardin.

There are many very important English sale references communicated to us by David Carritt: London, sale of Peter Le Mastre (sometimes Le Maistre) of Broxburn, near Hoddesdon Herts, 20 February 1755, no. 57, "A woman paring turnips," sold for 9 *livres;* Edinburgh, sale of James Stuart, 9-11 February 1829, no. 7, "Woman peeling onions, sketch"; London, anonymous sale, 28 April 1848, no. 63, "A girl peeling parsnips."

For reasons given in the discussion of [80], which we know are not conclusive, we think that the version shown at the Salon is the one now in Washington but that the engraving could well be after the Munich canvas.

There are a few copies of the picture (see the 1972 list by Hohenzollern which completes that of Wildenstein); none of those known to us through photographs deserve mention.

Washington, National Gallery of Art.

A sketchbook page in the Art Institute of Chicago (46.383) attributed to Gabriel de Saint-Aubin (1724-1780) shows, hanging on the wall of the Salon next to the Louvre's *Jupiter et Antiope* by Watteau, a *Woman Scraping Vegetables.* But is this drawing really by Saint-Aubin?

Today there are three original versions of this picture and a good studio copy (see above). Only the Washington canvas is dated (1738); it is also signed, like the versions formerly in Berlin and Groningen, in the center slightly to the left of the block and cleaver. The Munich picture is signed at the lower right. The *Woman Scraping Vegetables* shown at the Salon of 1739 seems to have pleased less than *The Return from Market,* and especially *The Governess.* Only the Abbé Desfontaines (1685-1745) [for this interesting figure, see Zmijewska, 1970, pp. 30-33] makes mention of it: "Each of his works exhibited this year deserves particular praise, especially the *Gouvernante* and the *Ratisseuse*" [*Observations sur les écrits modernes,* 3 October 1739, p. 116].

The picture is hardly noted in the eighteenth century. Bocher (1876), however, uncovered a very curious text devoted to the painting in Munich, written by J. Duchesne the Elder in 1832 — when Chardin appeared totally forgotten. It was illustrated with an engraving by Réveil, curator in the print department of the Royal Library. Donat de Chapeaurouge drew attention to this text in 1953 [see *Prints* above; *Musée de peinture et de sculpture...*]:

"When during the eighteenth century all the painters of the French School seemed to forget nature and move away from it, Chardin alone was a faithful admirer, whether representing inanimate objects, or putting household scenes on canvas. It is strange that Hogarth, who lived at the same time, never mentioned Chardin in any way in his observations on painting and that he said the French School did not have even a mediocre colorist."

The origin of the subject and composition of *Woman Scraping Vegetables* is certainly to be found in Northern seventeenth-century painting. Furst in 1911 made a comparison with G. Netscher's *La couseuse* ("The Seamstress") in Dresden. Seymour (1961) mentions the name of Pieter de Hooch. Snoep-Reitsma (1973) cites Teniers and reproduces (p. 183, fig. 25) an engraving by W. Vaillant of a woman peeling a pear, very close in composition to the Chardin picture. Colin Eisler, in his distinguished 1977 entry for the Washington picture, mentions *L'éplucheuse* ("The Woman Peeling") by N. Maes in the National Gallery, London.

The composition, in colors unusually vivid for Chardin, combines kitchen objects — the earthenware bowl of water with turnips, the cauldron, the pan leaning against the butcher block spotted with blood in which a cleaver is driven — and vegetables chosen for their forms — pumpkin, cucumbers, and turnips. The woman, with a fixed and vacant stare, has stopped her work. Once again Chardin's intention is not a portrait, even less to tell a story. Snoep-Reitsma (1973) correctly notes that eighteenth-century followers of Chardin dealing with the same subject would add a few *détails piquants,* such as a little child alluding to a "mistake" made by the servant.

There is no social criticism, as some would have it. Chardin has given us a solid image, devoid of unnecessary details, of a slightly stooped servant who untiringly repeats the same motion; it is a timeless image, fixed forever.

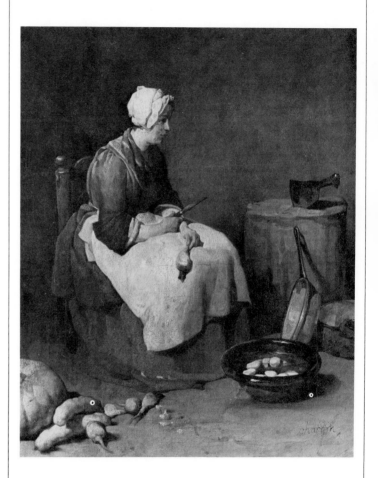

82

83 The Governess

(La gouvernante)

Canvas, 46.5 × 37.5 cm. Signed and dated at the left center: *Chardin 1738* (not 1739 as often cited).
Ottawa, The National Gallery of Canada

Provenance. It seems the picture was destined for Jean de Jullienne (1686-1766) according to the text by Mariette cited later in this entry. Jullienne, however, seems not to have owned a Chardin [on Jullienne, see Dacier and Vuaflart, 1929]. It was, in fact, acquired by the "banker Despuechs" who still owned it when Lépicié finished a print of it at the end of 1739 (he owned the *Jeu de l' oie* ["Game of Goose"] and the *Tours de cartes* ["Card Tricks"] engraved by Surugue *fils,* and if "Despuechs" is the "Delpèche" in the margin of the La Roque sale catalog in 1745, he acquired two small still-life pictures of kitchen utensils; he might have been a member of the Delpuech de la Loubière family, which we have not been able to identify). According to Mariette, "Despuechs" sold the picture before December 1739 [see *Mercure de France,* December 1739, p. 3112] to Prince Joseph Wenzel of Liechtenstein, ambassador to Paris between 1737 and 1741. The collections of the Grand Duchy of Liechtenstein preserve two portraits of this ostentatious character by Rigaud done in 1741 [see J. von Falke, *Geschichte des fürstlichen Hauses Liechtenstein,* 1882, pp. 163-69]. The picture was in Vienna during the entire eighteenth century at the Liechtenstein Palace, Herrengasse, but in a private gallery (which explains why it was not included in the Liechtenstein catalogs of 1762 and 1780); it was there that the Goncourts saw it 25 September 1860. Acquired along with *The Return from Market* (see [80]) by the National Gallery of Canada in 1956.

Exhibitions. 1739, Salon (p. 14, reprint of the cat.); 1907, Paris, no. 24; 1910, Berlin, no. 313 (with pl.; in large-size edition of cat., no. 26); 1948, Lucerne, no. 6; Between 1951 and 1955, National Gallery, London; 1956, Art Gallery of Ontario, Toronto; 1962, Seattle, no. 35, pl. 1; 1968, London, no. 134, pl. 1 (color); 1975-76, Toledo, Chicago, Ottawa, no. 14, pl. 56 (and color pl.).

Bibliography. Goncourt, 1860, cf. Goncourt, 1956; Parthey, 1863, p. 278, no. 5 or 6; Goncourt, 1864, p. 154; Waagen, 1866, p. 289 ("ein reizendes Bild!"); Bocher, 1876, pp. 28, 91; Dilke, 1899, pp. 333, 334; Dilke, 1899 (2), p. 120; Schéfer, 1904, pl. on p. 41 and p. 70; Dayot and Guiffrey, 1907, pl. between pp. 6 and 7; Dayot and Vaillat, 1907, pl. between pp. 25 and 26; Guiffrey, 1907, p. 96; Michel, 1907, pl. 1; Tourneux, 1907, p. 91; Guiffrey, 1908, pp. 59-60, no. 18; Goncourt, 1909, p. 129; Pilon, 1909, p. 170, pl. between pp. 136 and 137; Alfassa, 1910, p. 294; Meier Graefe, 1910, p. 270; Furst, 1911, p. 119, pl. 14; Klingsor, 1924, pl. between pp. 59 and 60; Museum cat. (Liechtenstein), 1927, p. 80, no. 371 ("signed and dated 1735"); Osborn, 1929, pl. on p. 186; Museum cat. (Liechtenstein), 1931, pp. 83-84, no. 371 (ill.); Pascal and Gaucheron, 1931, pp. 29, 32, 110; Wilenski, 1931, pl. 4 (color); Ridder, 1932, pls. 70, 73 (detail); Babelon, 1933, p. 1 (ill.); Wildenstein, 1933, no. 87, fig. 19; Hourticq, 1939, pl. on p. 97; Brinckmann, 1940, pl. 381; Pilon, 1941, p. 18 (ill.); Museum cat. (Liechtenstein), 1943, p. 95 (pl. 3, color); Goldschmidt, 1945, fig. 7; Goldschmidt, 1947, fig. 4; Lazarev, 1947, fig. 20; Florisoone, 1948, pl. 68; Jourdain, 1949, pls. 20, 21 (detail); Denvir, 1950, pl. 8; Fosca, 1952, pl. on p. 59 (color); Goncourt (1860), 1956 ed., I, p. 817; *Illustrated London News,* 7 April 1956, p. 255 (ill.); *Arts,* May 1956, p. 15 (ill.); *Art Quarterly,* 1956, pl. on pp. 212-13; Hubbard, 1956, pp. 142, 152, pl. 60; Museum cat. (Ottawa), 1957, p. 97 (with pl.); *Canadian Art,* Winter 1957, p. 47, pl. 49; *Art News,* January 1957, pp. 5, 32 (color cover); *Art News Annual,* 1959, pl. on p. 56; *Vie des Arts,*

Christmas 1959, p. 15, pl. 2; Adhémar, 1960, p. 445; *The Museum Journal,* April 1960, p. 5, pl. on p. 3; Nemilova, 1961, pl. 9; Antal, 1962, p. 48, pl. 85b; *Connoisseur,* April 1962, pl. on p. 277; Zolotov, 1962, pl. 14; Wildenstein, 1963-69, no. 191, pl. 29 (color); Garas, 1963, pl. 13; Thuillier and Châtelet, 1964, p. 207 (color pl.); Lazarev, 1966, pl. 39; *Agnew's 1817-1967,* pl. (unpaginated); *Apollo,* February 1968, p. 135, pl. 3 (color pl.); Demoris, 1969, pl. between pp. 368 and 369, p. 384; Wagner, 1970, p. 143, fig. 6; Boggs, 1971, p. 100, pl. on p. 101 (color); Levey, 1972, pl. 144; Kuroe, 1975, pl. 15 (color); Eisler, 1977, p. 372, fig. 102; *Les Peintres illustres,* coll. directed by H. Roujon, n.d. (pl. 5, color).

Prints. An engraving was made in 1739 by François-Bernard Lépicié, *père* (1698-1755) under the title *La Gouvernante* [see Bocher, 1876, pp. 26-28, no. 24, and Sjöberg, 1977, pp. 399-400, no. 53]. The quatrain accompanying the engraving is also by Lépicié:

His pretty face dissembles well,
Obedience in all but name,
But I will bet his thoughts do dwell
On when he can resume his game.

The print was announced by the *Mercure de France,* December 1739 (p. 3112), and has been reproduced frequently [Normand, 1901, p. 91, Snoep-Reitsma, 1973, fig. 31]. On 30 January 1740 Lépicié offered two proofs to the Academy [*Procès-Verbaux,* V, p. 267]. Bocher catalogs six states. There is also a copy of it by Jean Lemoine published around 1750.

Charles Blanc [1862, p. 5] reproduced the print (drawn by Paquier and engraved by Carbonneau) and Charles Jacque made a very rare etching of it (not in the catalog of the Bibliothèque Nationale). Bocher reports a small woodcut reproduction which adorns a work by Paul Lacroix (Bibliophile Jacob), *XVIIIe siècle. Institutions, Usages et Costumes* [1875, p. 261, fig. 144].

Related Works. Today only one version of *The Governess* directly linked to Chardin is known: the one exhibited here. It seems, however, that there existed at least one other by the hand of the artist. Here, organized by date, are the references related to this composition that we know: (1) Chevalier Antoine de La Roque sale, May 1745, no. 190. Gersaint, the catalog author, after describing *The Return from Market* (the version now in Berlin, [80]?) writes, "The second picture represents a mother giving a lesson to her child, reminding him of his misdeeds. The latter is a copy, retouched in several places by M. Chardin; it has been engraved by M. L'Epicier...." Remember that the two pictures were acquired by "Colins" for 164 *livres.* (2) Estate inventory of Claude-Nicolas Rollin, 16 January 1749 "two (!) pictures painted on canvas, copies of Chardin, representing L'Ecolier and the other Gouvernante" 36 *livres* [D. Wildenstein, 1967, p. 158; Archives Nationales, Minutier Central, étude LIII, liasse 235]. (3) Estate inventory of Chardin, 18 December 1779 "a child and his governess priced at 80 *livres,*" and estate sale 6 March 1780, no. 14 (with pendant, "The Diligent Mother"), sold for 30 *livres.* (4) Estate sale of the Marquis de Livois (in Angers) catalog by P. Sentout, 1791, no. 219, "a schoolboy come from class, scolded by his governess, who brushes his hat" (47.2 × 20.2 cm.) [see also Planchenault, 1933, p. 226].

We know through photographs three examples of the picture which deserve to be cited. One of more than respectable quality is at Tatton Park, National Trust, formerly in the collection of Lord Egerton (Cheshire) [see, most recently, Wright, 1976, p. 37; exhibited at Manchester, 1960, no. 127]. It could well be a "retouched copy."

A second one in the collection of Count de Vogüe in Dijon (reported by Bocher in 1876), exhibited at the Musée des Beaux-Arts of Geneva, appears to be the picture in the Didot sale of 6-8 May 1828, no. 17, and the Boittelle sale of 1-2 April 1874, no. 8 (see [93], *Provenance).*

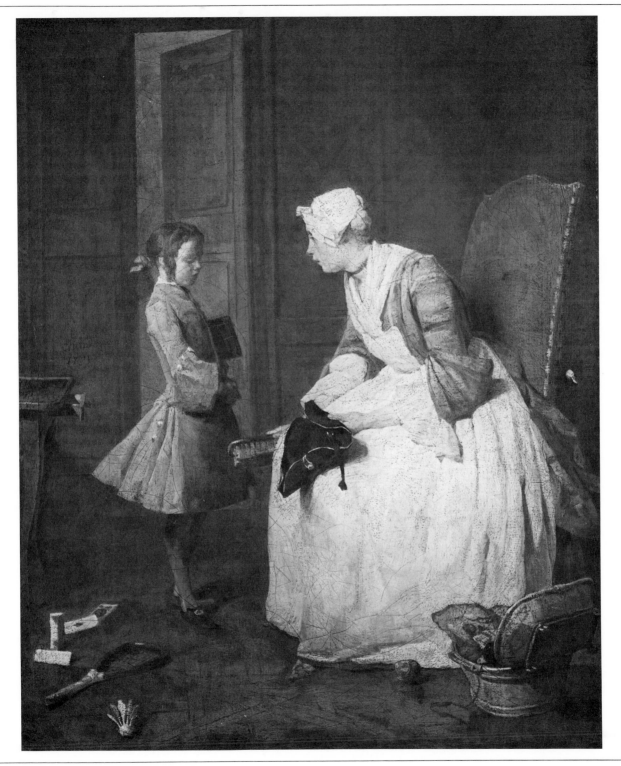

83

See Color Plate XI.

A third picture in the Dryden sale, New York, 16 February 1939, no. 33 (ill.; pendant to a *Return from Market)* came from the collection of the Shah of Iran and the King of Württemberg!

Finally, let us call attention to the curious pen drawing exhibited in London in 1968, no. 145, which is difficult to attribute to Chardin, given the present state of our knowledge of the painter's graphic work.

Presented at the Salon of 1739, *The Governess* enjoyed an extremely favorable reception. The Abbé Desfontaines (1685-1745), whose *Observations sur les écrits modernes* [3 October 1739, p. 116] we noted in relation to *Woman Scraping Vegetables,* put the two works on the same level. "The inimitable Chardin always makes us admire the simple and true which rule his works and which attracts everyone because his perfect imitation of nature strikes every eye. Rival of Rembrandt and Teniers, his reputation increases every day and everything he does deserves more and more public regard." Simon-Henri Dubuisson, commissioner of the Châtelet, wrote, "We have had an exhibition of pictures at the Louvre. It was smaller than before, but it offered beautiful things. [One of] the more pleasing pieces was a little child whose governess scolds him while brushing his hat, by Chardin" [*Lettres...au marquis de Caumont, 1735-40,* 1882, p. 580-1; cf. Zmijewska, 1970, p. 143].

The Chevalier de Neufville Brunaubois-Montador (1707-about 1770), whose opinions we have already quoted many times, adds in his letter to Madame la Marquise S.P.R. of 9 September 1739 [p. 9, see Zmijewska, 1970, pp. 27-29]: "A governess who lectures a little boy while she dusts his hat to send him to class is astonishingly natural and always painted in the same taste, that is to say, in a crumpled style, nevertheless resulting in a marvelous ensemble."

The *Mercure de France* [September 1739, p. 2217, was it La Roque who wrote it?] summarized quite well the general opinion: "If we should report here all the praises heaped upon the works of this seductive painter, this article would take up more space than any other. The yound student scolded by his governess for having dirtied his hat is the piece which has attracted the most votes." A few months later the *Mercure de France* [December 1739, p. 3112] announced the publication of the Lépicié engraving in highly flattering terms: "It brings equal honor to the rare talent of M. Chardin, painter of the Academy, and to M. Lépicié, also of the Academy, who has engraved it with extreme care after one of his best pictures which had been shown at the last Salon and which won all the votes." The editor of the *Mercure* adds, "The picture, according to the print, belongs to the collection of le Chevalier Despuech [the inscription on the print reads Despuechs], but we have just learned that it is no longer there and that a nobleman of the Emperor's court bought it to take to Vienna." Mariette, writing ten years later, gives his version of the story:

"What quite made his reputation was the picture of The Governess. He thought he was painting it for M. de Jullienne—who had appeared to want it—but it was [actually] acquired by a banker named Despuechs and was later purchased for 1800 *livres* by M. le Prince de Liechtenstein during his ambassadorship in France."

The work is hardly mentioned for over a century. It was the Goncourts who rediscovered it on 25 September 1860 during their visit to Vienna: "The Governess, hung very high. Child, violet coat, red chair, background in reddish brown and chalky tones; the woman, a harmony in white, cap, fichu, and apron; greenish dress; very warm in color." Hung still too high when Lady Dilke saw it in 1899, the work did not leave Europe for Ottawa until 1956.

One need not dwell on the skill of composition, on this room with its far wall opening to the outside through a half-opened door which silhouettes the schoolboy, on the creamy cap and skirt of the governess, on the red of the high chair-back, and the many other chromatic accomplishments.

Rather, let us look at what is inventive about the work. Charles-Nicolas Cochin *fils* remarked about it (and was quoted later nearly word for word by Haillet de Couronne): "His subjects are now more elevated by his choice of more refined persons. Such are the pictures *The Governess* and *Lady Varying Her Amusements."*

On a beautiful French parquet floor, a little boy dressed with care, books under his arm, listens to his governess. She has a work basket at her feet and is dressed with no less elegance (which has led some to say she is, in fact, the young boy's mother). She holds in her hand one of the three-cornered hats Chardin particularly liked to paint and which she prepares to brush. The racquet, shuttlecock (also seen in [72]), cards and gaming table (seen in numerous *House of Cards* pictures) all evoke the pleasure that the child regretfully leaves behind. Chardin no longer shows us laborers and tavern boys, scullions or kitchen maids, but representatives of the bougeoisie (in which the Goncourts saw the future heroes of the Revolution) into which Chardin seems to have moved, thanks to his first successes at painting.

The other innovation in the picture is the introduction of a second figure into the composition which allows dialog and permits a much easier reading of the subject. Guiffrey (1907) noted this and pointed out "the deep emotion that [Chardin] successfully expressed. With what tender regard the young woman, while scolding him a bit for having soiled his hat, gazes at the young schoolboy about to leave for a nearby school, with his books already under arm, leaving behind his cards, racquet, and shuttlecock. His respectful and slightly ashamed look with lowered eyes is charming. It is a little intimate drama in which the two actors have been taken from life." In December 1739 the *Mercure de France* had already pointed out to its readers "the graciousness, sweetness, and restraint that the governess maintains in her discipline of the young man about his dirtiness, disorder, and neglect; his attention, shame, and even remorse; all are expressed with great simplicity."

Chardin always preferred to represent women rather than men, children rather than adults. What he wanted to say was said less by the expression he gave to faces (very often the same), or by the look of his models (an indescribable mixture of attention and distraction), than by the posture and position of their bodies which are always perfectly still. Chardin, avoiding sentimentality and anecdote, expresses in paint better than any other painter that tender and modest dialogue between adult and child.

84 *The Diligent Mother*

(La Mère laborieuse)

Canvas, 49 × 39 cm.
Paris, Musée du Louvre, Inv. 3201*

Provenance. "On Sunday the 27th of November [1740] M. Chardin of the royal academy of painting and sculpture was presented to the king by the Controller General with two of his own pictures which His Majesty received most favorably. These two works were already known, having been exhibited at the Salon du Louvre last August. We have already spoken of them in the *Mercure* of the following October under the title *La Mère laborieuse* and *Le Bénédicité*" [*Mercure de France*, November 1740, p. 2513]. Mentioned at the Hôtel de la Surintendance at Versailles in 1760 [inventory of Jeaurat, Archives Nationales] and in 1784 [inventory of L. J. Durameau, Archives du Louvre]: under the drawing of an armoire is written, "There are in this armoire two little pictures by Chardin, one showing *La Mère laborieuse*, the other a *Bénédicité.*" At the Petit Trianon in 1810. Sent to Paris 16 July 1816. In storage in 1818. Between 1830 and 1832 on deposit, along with its pendant, *Le Bénédicité*, at the Légion d'Honneur at Saint-Denis. Returned to the Louvre in 1832 but apparently not exhibited until 1845 [see *Bulletin des Arts*, 10 July 1845, p. 5, and Champfleury, 1845, p. 8].

Exhibitions. 1740, Salon, no. 60 ("La Mere laborieuse"); 1945, Cahors, no. cat.; 1946, Paris, no. 96; 1960, Paris, no. 566; 1978, Moscow and Leningrad, no. 112 (ill.).

Bibliography. Bulletin des Arts, 10 July 1845, p. 5; Champfleury, 1845, p. 8; Hédouin, 1846, p. 224, no. 26; Clément de Riz [*sic*], 1848, p. 111; Hédouin, 1856, p. 182, no. 26; Bürger (Thoré), 1860, p. 334; Blanc, 1862, p. 15; Goncourt, 1863, p. 520, note; 1864, p. 149; Lacroix, 1875, p. 71; Bocher, 1876, p. 84, no. 98; Goncourt, 1880, p. 122; Chennevières, 1888, p. 58; Dilke, 1899, pp. 334, 391; Dilke, 1899 (2), pp. 120, 125 (note); Fourcaud, 1899, pp. 407, 408, pl. between pp. 400 and 401 (the caption for the print states that the picture is in the Louvre); Fourcaud, 1900, pp. 25, 26 (repr. of print); Merson, 1900, p. 306; Engerand, 1901, p. 80; Normand, 1901, pp. 54, 101; Schéfer, 1904, pp. 57 (ill.), 59, 69; Dayot and Guiffrey, 1907, color frontispiece; Guiffrey, 1907, p. 96; Tourneux, 1907, p. 91; Guiffrey, 1908, p. 67, no. 66; Goncourt, 1909, pp. 128, 179; Pilon, 1909, p. 165 and pl. between pp. 72 and 73; Furst, 1911, p. 121, no. 91 and pl. 17; Raffaelli, 1913, p. 55 (ill.); Museum cat. (Brière), 1924, no. 91; Klingsor, 1924, pl. on p. 63; *Le Figaro artistique,* 7 January 1926, p. 207 (ill.); Gillet, 1929, pp. 62-64, 70 (ill. pl. 72); Pascal and Gaucheron, 1931, pp. 29, 73 107; Ridder, 1932, pls. 14, 47 (detail); Wildenstein, 1933, no. 95, fig. 16; Hourticq, 1939, pl. on p. 98; Pilon, 1941, p. 21 (ill.); Goldschmidt, 1945, fig. 29; Goldschmidt, 1947, fig. 9; Lazarev, 1947, fig. 18; Jourdain, 1949, pl. 15; Denvir, 1950, pl. 1; Dacier, 1951, p. 133 (ill.); Proust, 1954, p. 42 (ill.); *Médecine de France,* 1957, no. 80 (ill. detail); Goncourt, 1959, p. 104; Adhémar, 1960, p. 456; Nemilova, 1961, pl. 10; Zolotov, 1962, pl. 11; Garas, 1963, pl. 12; Rosenberg, 1963, p. 10; Wildenstein, 1963-69, no. 194, pl. 30 (color); Quenot, 1964, pp. 17-18; Gaillard, 1966, p. 94; Lazarev, 1966, pl. 42; Proust, 1971, pp. 373, 376; Lacambre, 1973, p. 47; Snoep-Reitsma, 1973, pp. 188-190; Rosenberg, Reynaud, Compin, 1974, no. 136 (ill.); Lazarev, 1974, pl. 194; Anonymous, *Les peintres illustres*, series directed by Henry Roujon, n.d., color pl. 6.

Prints. The picture was engraved by François-Bernard Lépicié (1698-1755) in 1740 [Bocher, 1876, pp. 35-37, no. 35; Sjöberg, 1977, p. 403, no. 58]. The print, which confirms that "the original picture is in the collection of the King" was accompanied by a little poem by Lépicié:

A trifle distracts you my child:
This leaf work you did yesterday,
By each stitch I can see
How your mind often drifted away.
Believe me, that sloth you must shirk
To discover this truth, as you should:
That steadiness, prudence and work
Are more valued than beauty and goods.

The print which exists in two states [see Bocher and Sjöberg], announced by the *Mercure de France,* December 1740 (p. 2709), was exhibited at the Salon of 1741. On 7 January 1741 Lépicié [and not the elder Cochin, as stated by Wildenstein] offered two proofs of his print to the Academy [Procès-Verbaux, V, p. 290]. Bocher catalogs many copies, one of which (missing from the collection of the Bibliothèque Nationale) is attributed to Jean Lemoine (Paris, about 1750). There is also a rare etching by Charles Jacque and the one which illustrates p. 71 of *Institutions, usages et costumes* by Paul Lacroix [Bibliophile Jacob, 1875].

Related Works. Chardin exhibited a *Diligent Mother* only once, at the Salon of 1740 (no. 60). It was surely the Louvre picture here cataloged. There are two other known versions of the picture: the one in the museum in Stockholm (50 × 39.5 cm.) cataloged by Wildenstein [1963-69, no. 196, fig. 89] with only mention of its pendant, a copy of *Saying Grace* (see [86]). It remains on its original canvas which bears the following inscription on the back (perhaps in the hand of Chardin himself?): *D'après Le tableau//original du cabinet//du Roy/de chardin//1741.* This picture, whose history is well known since 1741 when it was sent by Count Tessin to Sweden, is only a hard copy which, nevertheless, has immense interest; it serves as proof that even during Chardin's lifetime there existed a flourishing business (Tessin valued the picture at 180 *livres*) in "reproductions" of works by the painter. (Another example was a *Mère montrant à broder la tapisserie à sa fille...d'après Chardin* ["Mother showing her daughter how to embroider"] in a sale of 6 January 1974, no. 82.)

Another version was formerly in the Rockefeller collection in New York (50 × 39 cm.); we have only recently seen it [Wildenstein, 1963-69, no. 195, fig. 88]. Its history is equally well known. It appeared at the Major sale in London in 1758 (no. 38) with a version of *Saying Grace* (see [86]) and was acquired by Lord Egremont for 24 *livres* 3. It remained in the Egremont collection at Petworth until 1927, when it went to the United States [St. John Gore, *Apollo,* May 1977, p. 348]. The picture is qualitatively better than the one in Stockholm. But can one go so far as to call it an original from the hand of Chardin, or is it one of those good copies, retouched by Chardin, that appeared in eighteenth-century sales?

A third version, probably autograph, was in the Chardin sale (it is difficult to identify in the estate inventory), of 6 March 1780, no. 14 (with a *Governess*—see [80]—as its pendant). Its probable trail can be followed in various sales cataloged by Wildenstein [1963-69, no. 193, to which probably should be added the sale of 27-28 January 1834, no. 66]. This picture disappeared in 1877.

There is also the copy attributed to Manet by Mathey [1963, II, p. 22 and fig. 96].

The history and reception of this painting is discussed with that of its pendant — *Saying Grace* — under [86]. The picture, exhibited at the Salon of 1740, was offered by Chardin on 27 November 1740 to Louis XV. Quickly forgotten, it was "rediscovered" when presented in the new galleries of the Louvre devoted to French painting, reinstalled by Fréderic Villot (1809-1875). But it always took second place to *Saying Grace* — wrongly, in our opinion, especially since its recent restoration has revived all its brilliance.

The work is probably earlier in date than *Saying Grace.* The technique of *The Diligent Mother,* with its creamy and granular paint, is close to that of *The Governess* [83] and *The Return from Market* [81]. The fact that Lépicié had engraved the picture well before *Saying Grace,* which is much more polished, tends to confirm this.

A young mother, her scissors hanging by a ribbon, is seated on a chair on whose back hangs a work bag. On her feet are bedroom slippers of rose and faded blue, and on her head is the bonnet that Chardin models are seldom without. She is examining some embroidery with her daughter; in front of them is a yarn-winder with its skein of wool. At its foot are balls of wool in many colors. A bobbin lies on the tiled floor. Standing out against the hem of the large white apron is a box serving as a pin cushion. In front of it lies a pug dog, as compact as a block [cf. Quenot, 1964], the same as the one in *The Blind Man from the Quinze-Vingts* of the Salon of 1753. At the right, a teapot and a cup upside down in its saucer sit on the mantelpiece, which is decorated with candelabra; the hearth is hidden by a screen which provides a touch of red. A tall, folding screen in the background blocks the daylight from the half-opened door.

Chardin approaches once again his favorite theme of mother and daughter. A "professor of the Duplessis college" wrote a long poem dedicated to Chardin and devoted to *Saying Grace* and *The Diligent Mother* [Mercure de France, December 1747, p. 2710], of which we have excerpted a portion here:

Friend of innocence, in painting this age
Your most lively beauties glowed;
Chardin, it is to lovable childhood
Most praise for your art is owed.

One could linger over the expressive details of the faces fixed on the embroidery. Between that mother "with eyes full of the past…knowing, calculating, and foreseeing" and her daughter "with inexperienced eyes," there is established a dialogue that Chardin knows how to capture by observing attitude, by the position of the wrist and the hand, "which are no less significant" than the faces (Proust). This dialogue is modest and tender, reserved and warm, and has no need to express itself in words.

After Chardin, Stockholm, Nationalmuseum.

Inscription on the back of the Stockholm picture.

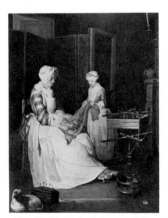

Chardin(?), United States, Private Collection.

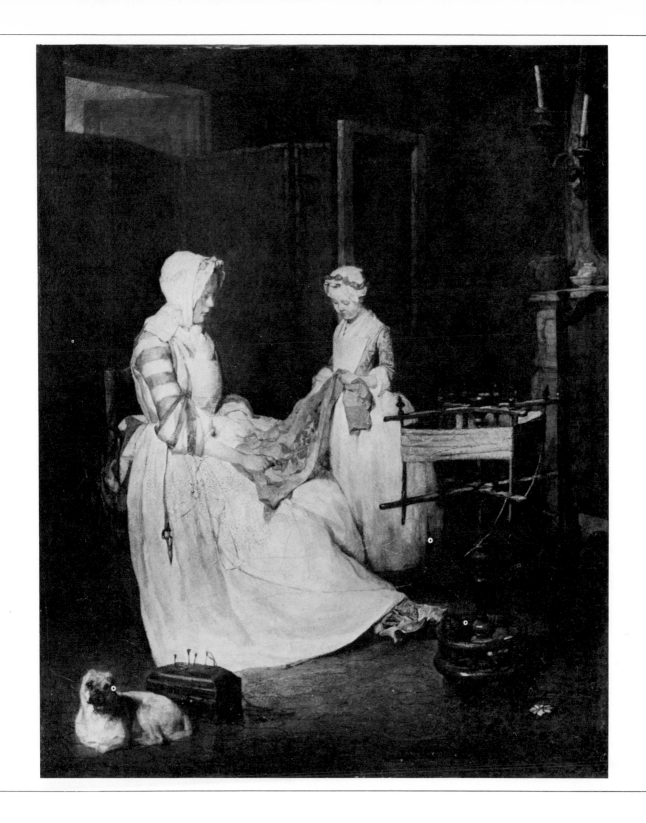

84

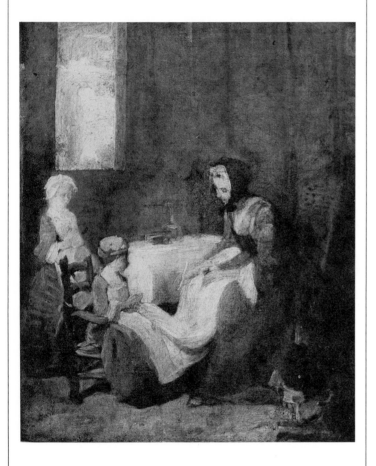

85

85 *Saying Grace* (sketch)

(Le Bénédicité)

Canvas, 46.5 × 38 cm.
Paris, Private Collection

Provenance. Very probably the sale of Antoine-Joseph Dezallier d'Argenville (1860-1765), 18 January 1779, no. 481, "Study for a *bénédicité,* oil sketch by Simon [*sic*] Chardin." (The rapid sketch of Gabriel Saint-Aubin in the margin of his copy of that sale catalog, preserved at the Petit Palais, is not legible enough to prove or disprove identification of the picture exhibited here with the one in this sale; Dezallier d'Argenville was the father of the art historian, who probably organized the sale. François Marcille sale, 12 January 1857, no. 20, "sketch." Anonymous sale, 22 January 1867, no. 12, "sketch." Sale B., 22 February 1875, no. 565, "sketch." Sale Baron de Beurnonville, 21-22 March 1883, no. 8, "sketch." Collection of E. Borthon, Dijon, catalog by H. Chabeuf, 1890, no. 16. Collection of Raoul d'Hotelans, Novillars, in 1906. Collection of Arthur Veil-Picard.

Exhibitions. 1906, Besançon, no. 18; 1928, Paris, no. 34; 1929, Paris, no. 12; 1949, Paris, no. 51; 1959, Paris, no. 9, pl. 3; 1968, London, no. 135, fig. 196.

Bibliography. Hédouin, 1846, p. 227, no. 100 ("esquisse"); Hédouin, 1856, p. 201, no. 100 ("esquisse"); Blanc, 1862, pp. 6-7; Boucher, 1928, p. 198; Wildenstein, 1933, no. 80; *Le Figaro Littéraire,* 27 March 1954 (ill. in the article by Marcel Proust); Goncourt, 1959, p. 160 (ill.); Wildenstein, 1963-69, no. 197, fig. 90; Huyghe, 1965, p. 11 (ill.); Rosenberg, 1969, p. 99.

Prints and *Related Works.* See [86].

Did Chardin paint sketches? At first one tends to answer in the negative, so much does the unfinished seem contrary to his artistic conceptions. Nevertheless, examination compels us to admit that the artist left unfinished pictures and that they were more numerous than one would think.

First of all, in his estate inventory there were "twelve rough sketches valued at 24 *livres*" and "two children, life-size, rough sketches, valued at 6 *livres.*" On the other hand, during the artist's lifetime, in the collection of "Monsieur Guignon" (sold 21 March 1774, no. 1), there was a "Sketch. By Chardin"; and the picture exhibited here has every chance of coming from the collection of Dezallier d'Argenville, dispersed in 1779, a few months before the death of the painter.

Today there are two other sketches generally attributed to Chardin: one for *Meal for a Convalescent* [92] in Washington, now on the New York art market [Wildenstein, 1963-69, no. 217, fig. 103, and pl. 61 in English edition], and the one for *The Housekeeper* [91]. Both show important differences from the finished pictures but fewer, however, than in this sketch for *Saying Grace.* Only the attitude of the child who joins his hands is found in the Louvre picture. The other child stands in front of a window which allows a glimpse of sky—rare in Chardin. The mother—whose attitude recalls *The Governess* and, even more (though reversed), *The Diligent Mother*—is seated and seems to hold in her hand an egg

cup and a spoon. In the right foreground is a child's toy, a wooden horse.

From the point of view of technique, the three sketches are very similar. The execution is fluid, leaving long visible brushstrokes: we know that Chardin scarcely drew at all. Mariette (1749) wrote, shortly after the execution of paintings like *Saying Grace,* of his working method: "M. Chardin has to have continually before his eyes the object [Mariette had earlier written 'the model'] that he sets out to copy, from the first study until the last brushstroke; it takes a long time and is capable of disheartening all others but him."

Is this one of those "rough sketches" abandoned for some unknown reason, which, according to Charles Blanc (1862; one of the first scholars to understand the importance of the work), "testifies to the hesitations and doubts of the painter"? We would very willingly think so.

86 *Saying Grace*

(Le Bénédicité)

Canvas, 49.5 × 38.5 cm.
Paris, Musée du Louvre, Inv, 3202

Provenance. See [84], *Provenance.* Chardin offered *Saying Grace* to Louis XV at Versailles on 27 November 1740, and it has never left the national collections.

Exhibitions. 1740, Salon, no. 61 ("Le Bénédicité"); 1928, Paris, no. 32; 1939, New York, no. 37 (the photograph shows the La Caze picture, which in our opinion had been sent in place of the Louis XV picture, the reverse of what the catalog says); 1939-40, San Francisco, no. 91; 1946, Paris, no. 97; 1965, Saint-Etienne (also Dijon, Chambéry, and Avignon) no. 6; 1966, Vienna, no. 9; 1968, Portland, no. 1 (ill.); 1973-74, Paris, no. 16; 1974, Paris, no. 102 (color pl. on p. 127).

Bibliography. Bulletin des Arts (Alliance des Arts), 10 July 1845, p. 5; Champfleury, 1845, p. 8; Hédouin, 1846, p. 224, no. 27; Clément de Riz [sic], 1848, p. 111; *Le Magasin Pittoresque,* May 1848, XVI, pp. 161-62; Hédouin, 1856, p. 192, no. 27; Bürger (Thoré), 1860, pp. 334, 338; Blanc, 1862, pp. 6, 15; Goncourt, 1863, p. 520, note; 1864, p. 149; Bocher, 1876, pp. 10, 841, no. 99; Goncourt, 1880, p. 119;Chennevières, 1888, p. 58; 1889, p. 121; Dilke, 1899, p. 334; Dilke, 1899 (2), p. 120; Fourcaud, 1899, pp. 407-409 (ill. of the engraving between pp. 404 and 405; but it states that the picture is in the Louvre); Fourcaud, 1900, pp. 25, 26 (engraving ill. on p. 22); Merson, 1900, p. 306; Engerand, 1901, p. 80; Normand, 1901, pp. 54 (note), 55 (note), 65 (ill. of the engraving between pp. 54 and 55, but it states that the picture is in the Louvre); Schéfer, 1904, p. 59; Dayot and Guiffrey, 1907, pl. between pp. 64 and 65; Dayot and Vaillat, 1907, p. V; Guiffrey, 1907, p. 96; Tourneux, 1907, p. 91; Guiffrey, 1908, pp. 67-68, no. 67; Goncourt, 1909, pp. 128, 176; Pilon, 1909, pp. 43, pl. between pp. 48 and 49, 165; Furst, 1911, p. 121, no. 92; Raffaelli, 1913, p. 53 (ill.); Museum cat. (Brière), 1924, no. 92; Hildebrandt, 1924, p. 163, fig. 210; Klingsor, 1924, p. 69 (repr.); Dacier, 1925, p. 68; Gillet, 1929, p. 63; Osborn, 1929, pl. 187; Pascal and Gaucheron, 1931, pp. 29, 73, 107; Fry, 1932, p. 66, pl. 136; Wildenstein, 1933, no. 74, fig. 17; Rostrup, 1935, p. 269 (ill.); Florisoone, 1938, pl. 1 (color, detail); Grappe, 1938, p. 26 (ill.);

Christoffel, 1939, p. 133 (ill.); *Magazine of Art,* May 1939, p. 279; Brinckmann, 1940, pl. 382; Pilon, 1941, p. 43 (ill.); Goldschmidt, 1945, fig. 30; Hautecoeur, 1945, p. 51(ill.); Huyghe, 1946, no. 8, p. 39 (ill.); Goldschmidt, 1947, fig. 10; De la Mare, 1948, pl. 2 (color); Jourdain, 1949, pls. 22, 23 (detail); Dacier, 1951, fig. 132; *Art News,* November 1953, p. 19 (ill.); Proust, 1954, p. 42 (ill.); Golzio, 1955, p. 918 (ill.); Seznec and Adhémar, 1957, p. 89; Courthion, 1959, p. 51 (color pl.); Adhémar, 1960, p. 456, pl. 238; Schwarz, 1961, pl. on p. 23; Antal, 1962, pl. 62b; Zolotov, 1962, pl. 15; Garas, 1963, pls. 14 (detail), 15; Gimpel, 1963, p. 407; Rosenberg, 1963, pp. 10, 45, 46 (color pl.), 49; Wildenstein, 1963-69, no. 198, pl. 31 (color); Thuillier and Châtelet, 1964, pp. 204, 206, 229; Gaillard, 1966, p. 94; Proust, 1971, pp. 373, 379-80; Levey, 1972, pl. 145; Duncan, 1973, pp. 570-72 and fig. 2 on p. 571; Lacambre, 1973, p. 47; Snoep-Reistma, 1973, pp. 188-90; Rosenberg, Reynaud, Compin, 1974, no. 137 (ill.); Kuroe, 1975, pl. 17 (color); Anonymous, *Les Peintres illustres,* series directed by Henri Roujon, n.d., color pl. 5 and cover; C. Lucien-Huard, *Les Musées chez soi,* n.d., III, pp. 350-51.

Prints. An engraving was executed by François-Bernard Lépicié (1698-1755) in·1744 with the title *Le Bénédicité* [Bocher, 1876, pp. 10-12, no. 5, only one state cataloged; Sjöberg, 1977, pp. 408-9, no. 70]. The quatrain accompanying the print (which was announced in the *Mercure de France* [December 1744, p. 137] and exhibited at the Salon of 1745) is also by Lépicié:

The sister on the sly laughs at her little brother
Who stammers out his grace.
He hurries through his prayer without a hint of bother,
His appetite full reason for his haste.

The print's caption and the announcement in *Mercure de France* state that "the original picture is in the collection of the King." Renée-Elisabeth Marlié Lépicié (Lépicié's wife), and Gilles-Edme Petit, reproduced and copied the engraving. L. (or Jean) Simon copied it in mezotint with the title in English, *The Grace.* Bocher catalogs: a lithograph by Bouchot; a copper engraving by Ed. Budischovsky which appeared in *L'Artiste,* 1855 (XV); the very rare etching by Charles Jacque; and the woodcut by Ch. Jardin after E. Bocourt in the section on the life of Chardin in *l'Histoire des Peintres* by Charles Blanc [1862, p. 13]. There is also the woodcut (L. Marvy del., J. Gauchard sc.) which illustrates an article on *Saying Grace* that appeared in *Le Magasin Pittoresque* [1848, XVI, p. 161; also reused by Lucien-Huard, *Les Musées chez soi,* n.d., III, p. 352]. In addition, there is the woodcut by Courboin in *L'Art* [1889, XLVI, p. 149] and the Gaujean engraving which illustrates the article by Chennevières on the Chardins in the Louvre [1889, between pp. 122 and 123; see also the anecdote reported on p. 122 where we learn that Ch. Chaplin wanted to make an etching of the picture]. There is an engraving by Joh. Klaus after the Stockholm picture, and one done by Kreuzberger illustrating the work of Olivier Merson [1900, p. 305]. Finally, in the collection of the Louvre is the copper one by Eugène Décisy (1866-1936) after *Saying Grace* from the royal collections [*Catalogue·de la chalcongraphie,* 1968, p. 130, no. 6132].

Related Works. Chardin exhibited a *Saying Grace* three times at Salons—in 1740, 1746, and 1761. The first of these three pictures is certainly the one in the Louvre (Inv. 3202). At the Salon of 1761, no. 42 was "Saying Grace, repetition with changes of the picture in the collection of the King. It belongs to M. Fortier, Notary." We know the composition (horizontal, not vertical) from the Gabriel de Saint-Aubin drawing in the margin of his copy of the Salon catalog [Cabinet des Estampes, Bibliothèque Nationale; cf. Stryienski, 1903, p. 65; see also the drawing in the album said to be by Saint-Aubin in Chicago, 46.383]; we also know its dimensions (51.5 × 67.5 cm.), thanks to the catalogs of the Fortier sale (2 April 1770, no. 43) and the Choiseul-Praslin sale (18 February 1793, no. 164). The Marquis de Livois owned

a copy of it in pastel "as beautiful as the original" (cat. 1791, no. 302; 19 × 25 *pouces*). The 1746 Salon picture, no. 71, "replica of Saying Grace with an addition to make it a pendant to a Teniers in the collection of M. ..." is commonly assumed to be lost, as is the picture of 1761.

Exhibited here are four versions of this compositions, all upright: (1) the version from the Salon of 1740, offered to Louis XV, and today in the Louvre; (2) the picture from the La Caze collection thought to be the one Chardin had kept in his studio (see [87], *Provenance*); (3) the Hermitage picture, dated 1744 [89], whose circumstances of leaving France for the collection of Catherine II are not known; and (4) a sketch [85] once in the collections of Dezallier d'Argenville and François Marcille.

In addition, we would like to draw attention to others. The copy now in Stockholm (49 × 39 cm.) was sent to Sweden by Tessin in 1741, valued by him at 180 *livres* and bears on its reverse, on the original canvas, the inscription: *d'après le tableau orinal* [*sic*]// *du cabinet du Roy* // *de chardin* // *1741* ("after the original in the king's collection by Chardin, 1741").

Next is the picture in the collection of the Earl of Wemyss, Gosford House, Scotland (51 × 40.5 cm.), which came from the Major sale, London, 1758, no. 39, "Figures saying grace" (24 *livres*); it was pendant to a *Diligent Mother* (see [84]). It was acquired by "Chartres," that is, Charteris, 7th Earl of Wemyss (1723-1808) and direct ancestor of the present owner. The picture, which we know through a photograph, seems to be a good studio replica [see the review by D. Carritt of the 1957 Edinburgh exhibition of paintings from Gosford House, organized by Colin Thompson, in *The Burlington Magazine*, 1957, p. 344.]

Another picture in the Museum Boymans-van Beuningen, Rotterdam (50.5 × 66.5 cm.) [Wildenstein, 1963-69, no. 216, fig. 102], came from

Saint-Aubin, drawing after the painting exhibited at the Salon of 1761.

the Marcille collection and was the subject of frequent comment in the nineteenth century—sometimes enthusiastic [Chennevières, 1889, pp. 122-23, "Chardin of the first importance"]—sometimes not [Thoré (Bürger), 1860, p. 338, "surely not all by him (Chardin)"]. Although one may want to identify the Rotterdam painting as the one exhibited at the Salon of 1761, one must note that the differences between this picture and the Saint-Aubin are far from negligible. Differences in the drawing cannot be denied: the boy on the left carries a plate and the mantelpiece has been omitted. However, one cannot always have absolute confidence in the accuracy of Saint-Aubin, especially since, in practice, his drawing was done in black chalk in front of the painting and then redone later in the studio in pen and ink wash. We believe that the Rotterdam painting reflects the version exhibited at the Salon of 1761, although we doubt that it is the original.

Diderot, in his review of the 1761 Salon, certainly had serious reservations about the quality of this later version. "It has been a long time since the painter finished anything himself; he no longer takes the trouble to do the feet and hands" [Seznec and Adhémar, 1957, p. 125]. After *The Bird-Song Organ* [93] of the Salon of 1751, we know that Chardin turned out few genre scenes. These reservations, however, are not sufficient, in our opinion (no more than the condition of the work—overcleaned and missing both its glazes and that incomparable rough substance of original Chardins), to allow this canvas to be identified as the one exhibited at the 1761 Salon.

There remains the fate of the 1746 Salon picture. We have said that the Hermitage picture is dated 1744 and shows "an adition," although of limited importance compared to the Louvre versions. It is said (since Hédouin, 1846) to have belonged to La Live de Jully (1725-1779), but it is mentioned neither in the 1764 catalog nor in the 1770 sale of the collection of that great art lover. Is it impossible that the owner, whoever he was, disposed of it, and that the Salon picture of 1746 might be the one in The Hermitage?

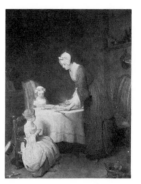

After Chardin, Stockholm, Nationalmuseum.

Inscription on the back of the Stockholm picture.

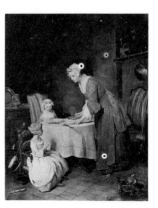

Chardin(?), England, Private Collection.

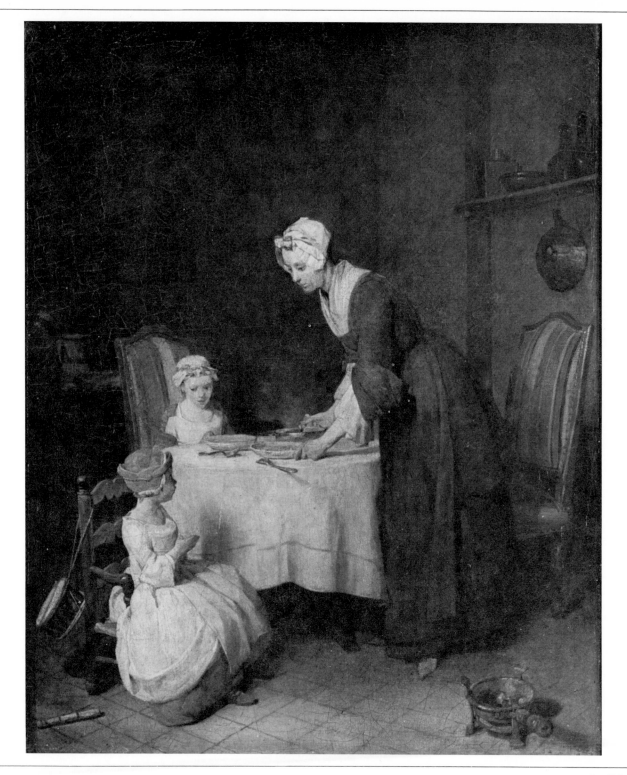

86

See Color Plate XII.

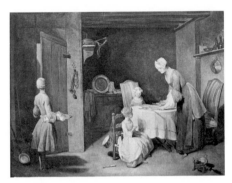

After Chardin(?), Rotterdam,
Boymans-van Beuningen Museum.

Saying Grace (from the Latin *benedicite* — bless; the first word of grace before meals) was, and perhaps still is, the most popular picture by Chardin. This was not always so. At the Salon of 1740, where Chardin showed five pictures, the anonymous editor (La Roque?) of the *Mercure de France* [October 1740, p. 2274] noted *Saying Grace, The Diligent Mother*, the two monkey pictures (see [66, 67]), and *The Schoolmistress* [70]. "This painter's pictures have a reputation of always pleasing the public, everyone from scholars to the ignorant, people of all ages and classes. In the works of this skillful artist, nature is followed with such accuracy and simplicity that some connoisseurs say he has found by his own diligence the means of taking nature as it is and stealthily carrying off what is most simple and stimulating."

Desfontaines [*Observations sur les écrits modernes*, 31 August 1740, p. 283] mentions only the three genre scenes: "M. Chardin has maintained his popularity with three little pictures which have pleased many: *The Diligent Mother, The Little Schoolmistress*, and *Saying Grace*. How elegant, natural, and true! The viewer feels more than he can put into words."

On 27 November 1740, Philibert Orry (1689-1747), who was minister of culture responsible for the restoration of the regular Salon (he was, above all, comptroller-general of finances) presented Chardin to Louis XV at Versailles. It was the only official meeting between the king and the greatest painter (other than Boucher) of his reign. The artist offered the king *Saying Grace* and *The Diligent Mother*, as reported by the *Mercure de France*, November 1740 (see [84]). Mariette wrote, on the other hand, "The king wanted for his gallery two of his pictures, *Saying Grace* and *The Diligent Mother*." In December 1740 the *Mercure de France* (p. 2711) published a long poem by a "professor of the Duplessis college...on the two pictures made for the king." After comparing Chardin with Le Brun and Mignard, he concluded: "Amid the authors of *Andromache* and *Horace*/sits La Fontaine on the summit of Parnassus/ enjoying immortality with them." The parallel between La Fontaine and Chardin was frequent in the eighteenth century. Finally, in 1744 Lépicié engraved *Saying Grace* (four years after *The Diligent Mother*), specifying that it was in the king's collection.

Had Chardin really *given* his picture to the king? This sort of gift usually merited a reward for the donor, but there is no record of one in the royal accounts.

Saying Grace and *The Diligent Mother* must not have pleased for long. In 1784 they were in an armoire at the Hôtel de la Surintendance at Versailles. It was not until 1845, when new rooms dedicated to French eighteenth-century painting were opened at the Louvre, that they were once again shown to the public, thanks to Frédéric Villot (1809-1875). Champfleury, the biographer of the Le Nains, wrote, "We have been given two little Chardins, which are not only pretty but positively delightful." Prints, commentaries, and interpretations then multiplied. *Saying Grace* was among the most popular works in the Louvre up to World War I. *Le Grand Larousse* [1867, II, pp. 532-33] devoted an entire entry

to it. Nothing sums up better the reason for such enthusiasm than an anonymous text which appeared in Volume XVI (May 1848) of *Le Magasin Pittoresque:*

"It is a part of the century of Louis XV which would remain almost unknown to us without the brush of Chardin. Born into the working middle class (his father was a cabinetmaker), educated by it, living in the midst of it, he took pleasure in recalling simple everyday life, scenes of order and calm, the sweet but serious and honest manners of a class completely separate from the dazzling, shallow court, whose weaknesses and faults have been revealed to us only too accurately. Chardin has authored in his language of paint and poetry, with his soft colors and conscientious verisimilitude, a whole other story about what passed before his own eyes, what delighted him, a veritable story of the country, not just of degenerate nobility.

"Here we enter with Chardin into a modest bourgeois home. It is noon; the young mother has served the meal just prepared; leaning on the table, she teaches grace to her two children. Do not the cap correctly worn, the handkerchief tastefully placed, the long cuffs of muslin and the rose-colored shoes reveal the character of this young wife? Is not the dignified and modest order of her life shown in the neatness of her clothes? In her house she maintains the traditional honor, piety, and sacredness of family. Of higher luxuries she has but one — good taste. She is one of the thousands of women to whom virtuous, honest men commit their honor and happiness, their name and children, and whose presence is a blessing for the soul. Chardin delights in showing these modest but praiseworthy virtues and fixing them forever beneath a radiant light. His overflowing spirit ceaselessly reproduced that smiling life of duty. The silks of marchionesses, duchesses, and countesses gleam before him in vain. Feathers wave, fans flutter, and graceful necks arch, all to no avail. If it should ever happen that he had to cross that gilded wave of coquettish manners, gallant repartee and delicate, flattering wit, it would be to return to the realm of dignified households with a new joy and respect for gentle movements, peaceful faces, and spotless linen dresses.

"For Watteau, there are the luncheons on the grass, the moonlit strolls, the capricious beauty of the day with the elegant soldier of her choice, the dances of titled shepherds and shepherdesses under the trees, but Chardin chose the modest and peaceful interior — the mother brushing the coat of her son before sending him off to school or teaching her little brood to stammer out the name of God. He imitated calm with calm, joy with joy, dignity with dignity. It seems that a century could not contain two such different histories, but they existed side by side. Each had its own historian, both men of genius. The brilliant shimmer of Watteau has too often eclipsed the sweet clarity of Chardin. Dazzled by the provocative coquetry of a marchioness, one hardly pauses before the humble bourgeoisie. Yet what is more profound, more sweetly mysterious than that mild painting comprising the true treasures of human life: honor, order, and economy!"

Saying Grace would be brandished (even by the Goncourts!) to condemn, in the name of bourgeois virtue, the debauchery, profligacy, and wickedness of the reign of Louis XV, as it was then imagined. But the picture is more than an anecdotal genre scene. Ch. Blanc (1862) insisted on its intrinsic qualities as a "model of spirit without affectation and charm without pretension." He admired the solicitude of the mother, her "patient good humor... to see her poor little one stammer out his prayer, one eye on his soup."

Marcel Proust, in a text written in 1895 but not published until 1954 in *Figaro Littéraire* [English text from *Marcel Proust on Art and Literature, 1896-1919* (New York: Meridian, 1958), p. 333], insisted, above all, that "Friendship exists...between the stooping body, the happy hands, of the woman who is laying the table and the old tablecloth and the still unchipped plates, whose gentle tenacity she has felt for so many years always holding its own in her careful grasp, between the tablecloth and the sunlight, which as a keepsake of their daily encounters has given it the smoothness of cream or of a linen lawn, between the sunlight and the whole of this room that it fondles, where it falls asleep, where now it loiters, now frisks into when least expected — exists with all with the tenderness of years between warmth and materials, between beings and things, between past and present, between light and shade."

The theme is not new: the Dutch used it often (among others, see the Maes or Breckelenkam of the Louvre, the Maes in Amsterdam, the Jan Steen in London), approaching it like a biblical story or a genre scene. Abraham Bosse made it the subject of one of his most popular prints, and Le Brun's *The Holy Family* (at the Louvre), primarily religious in inspiration, was very early called *Saying Grace.* Chardin approaches the composition as a daily scene rather than as a religious picture. Work in *The Diligent Mother* follows prayer and a meal.

In the last fifty years *Saying Grace* has lost its prestige to other less-anecdotal daily scenes, and especially to the still lifes. With the triumph of pure painting, the delicate recipe of Chardin was less interesting. Indeed, the painter remained faithful to a formula at which he was a past master — the pyramidal composition displayed in an interior, employing the same group of objects but increasing the number of figures and aiming for a picture whose subject was immediately legible and which lent itself easily to commentary. Were not the Goncourts right when they wrote more than a century ago [1864, p. 149], "The finishing touches seem to have grown cold in Chardin's hand...the painting lacks fire; it is a little flat and dull. It has lost its liveliness by being overworked"?

The picture suffered when its immense fame hindered a fresh view. Chardin, however, never mixed with so much skill his tenderness for the world of childhood and an extraordinary sense of arrested time, immortalizing the scene and its actors.

87 *Saying Grace*

(Le Bénédicité)

Canvas, 49.5 × 41 cm.
Paris, Musée du Louvre, M.I. 1031*

Provenance. Possibly the painting in the 18 December 1779 Chardin estate inventory referred to as *Le Bénédicité prisé quarante huit livres* ("Saying Grace, valued at 48 *livres*"); mentioned again in the (unpublished) estate inventory of Chardin's widow, 6 June 1791, as *Un tableau peint sur toile représentant le Bénédicité dans sa bordure de bois doré prisé le tout ensemble trente livres* ("A painting done on canvas representing saying grace in its frame of gilded wood, painting and frame together valued at 30 *livres*") [Archives Nationales, Minutier Central, étude XCIX, liasse 730]. Vivant Denon sale, 1 May 1826, no. 145: *Ce tableau est peint dans une harmonie généralement claire, parfaitement dégradée, 18 × 15 pouces* ("The picture is painted in a color harmony which is generally bright and perfectly graduated [48.6 × 40.5 cm.]). (Denon [1747-1825] was the former director of the Musée Napoléon.) Sale of Daniel Saint (1778-1847, the painter of miniatures) "for reasons of health," 4 May 1846, no. 48: *charmant tableau du maître* ("charming painting by the master"). A copy of the sale catalog (now at the Bibliohèque d'Art et d'Archéologie, Paris) was illustrated with sketches by Jules Boilly [cf. J[oubin], 1925, who reproduces the page listing *Saying Grace* and *Les apprêts d'un déjeuner rustique* ("Preparations for a rustic luncheon"), also now in the Louvre, which Saint and La Caze (who acquired it) both believed to be by Chardin, but which Hédouin (1865, p. 202) rightly attributed to Roland de La Porte]. Acquired at the Saint sale by La Caze (for 501 francs ["Chardin has gone up a good deal in price," *Bulletin des Arts,* 1846]). La Caze bequest to the Louvre in 1869.

Exhibitions. 1929, Paris, no. 7 (with, by mistake, the photograph of the work acquired by Louis XV); 1934, San Francisco, no 23; 1934, Los Angeles, no. 1 (ill.); 1935, Baltimore, no. 4 (ill.); 1935, Copenhagen, no. 28 (with pl.); 1935, New York, no. 6; 1935-36, New York, no. 22 (with pl.); 1939, New York, no. 37 (the photograph shows the La Caze painting, the one sent, in our opinion, although the catalog entry specifies that the composition lent to the exhibition was the one acquired by Louis XV); 1939-40, San Francisco, no. 91 (see [86]; 1941, Cincinnati; 1949, Copenhagen (exh. on laboratory techniques); 1951, Pittsburgh, no. 84 (ill.); 1952-53, Hamburg and Munich, no. 9 (with pl.); 1953, Brussels, no. 17; 1953-54, New Orleans and New York, no. 34, repr. on p. 71; 1958, Bordeaux, no. 8, pl. 23 (reproduced, by mistake, the version acquired by the king); 1959, Paris, no. 10, pl. 4; 1960, Paris, Louvre, no. 568; 1969, Paris, La Caze collection, p. 10 (122); 1973-74, Paris, no. 17; 1978, Moscow and Leningrad, no. 113.

Bibliography. Bulletin des Arts, 10 May 1846, IX, pp. 369-70; *Annuaire des Artistes et des Amateurs,* 1861, p. 119; Mantz, 1870, p. 17; Museum cat. (La Caze), 1871, no. 170; Bocher, 1876, pp. 10, 85, no. 170; Clément de Ris, 1877, p. 445; Goncourt, 1880, p. 119; Chennevières, 1889, pp. 122-23; Dilke, 1899, p. 341, note; Dilke, 1899 (2), p. 24, note; Fourcaud, 1899, p. 17; Merson, 1900, p. 306; Normand, 1901, pp. 55 (note), 65; Schéfer, 1904, pl. on p. 53; Dayot, 1907, p. 126 (reproduced the Louvre painting, indicating it belonged to The Hermitage); Dayot and Vaillat, 1907, pl. 25 (reproduction believed to be the painting from The Hermitage); Guiffrey, 1908, p. 68, no. 68; Goncourt, 1909, p. 176; Pilon, 1909, p. 166; Furst, 1911, p. 121, no. 93, pl. 27; Museum cat. (Brière), 1924, no. 93; A. J[oubin], Dacier and Vuaflart, 1929, p. 49; Ridder, 1932, pl. 13; Wildenstein, 1933, no. 75; Huyghe, 1934, p. 362; Huyghe, 1935, p. 3; Anonymous, *Les Beaux-Arts,* 1935, p. 1, no. 153; *Art Digest,* 1 June 1939, p. 34 (ill.); *Bulletin of the Cincinnati Art Museum,* January 1941, pl. on p. 12; Sterling, *The Metropolitan Museum of Art Bulletin,* June 1944, pl. on p. 279; *Formes et couleurs,* 1946, no. 1, p. 86 (ill.); Ver[onesi], 1959, p. 226; Rosenberg, 1963, p. 49; Wildenstein, 1963-69, no. 199, fig. 91; Huyghe, 1965, p. 7 (detail); Rosenberg, Reynaud, Compin, 1974, no. 138 (ill.).

Prints and *Related Works.* See [86].

The differences between the two Louvre paintings are worth noting. On the version given by Chardin to Louis XV, the floor is tiled and the whole composition appears as if brought closer to the viewer. On the La Caze version, the one which Chardin appears to have kept in his own collection and his widow kept until her death in 1791, certain faces — that of the little girl, for instance — seem expressionless, and the mother's hands and the folds of the napkin are more weakly rendered. In a word, although the second painting is indisputably by Chardin himself, its quality is inferior.

The objects Chardin chose to put in both paintings are the same. The viewer will notice in particular the drum, and the drumstick which has fallen to the floor, the large pewter dish, the pitcher and the loaf of bread lying on the low cupboard (the same piece of furniture we see in *The Return from Market*), the spirits-of-wine chafing dish and the *siamoise* covering the two high-backed chairs — a material made of linen and cotton (originally of silk and cotton, introduced into France by the famous Siamese ambassadors to the court of Louis XIV) which became popular around 1740. On the table are two plates, a spoon, a fork, and a steaming, silver-plated soup bowl. The older child joins her hands while the little boy, his hands tightly clasped (one of the finest passages of painting in the entire corpus of Chardin), watches his mother and the table. By means of the triangle of glances Chardin involves us in this scene of everyday life, brimming with human warmth, delicacy, modesty, and tenderness.

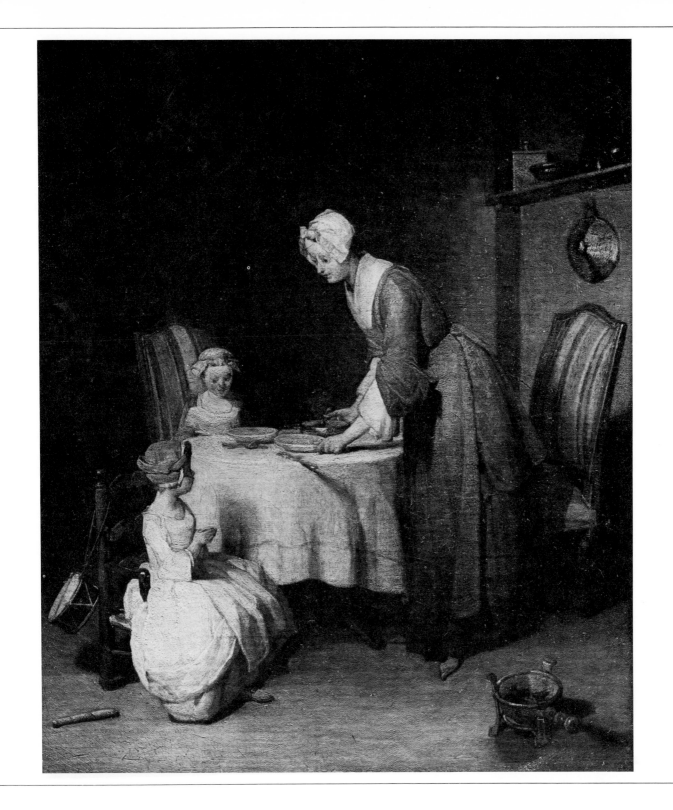

87

88 *The Morning Toilet*

(*La Toilette du matin, dit aussi Le Négligé*)

Cnavas, 49 × 39 cm.
Stockholm, Nationalmuseum

Provenance. Comissioned by Count Carl Gustaf Tessin (1695-1770) while he was in Paris; completed in 1741. Through a letter of 6 October 1745 (made available by J. Heidner) from Tessin to Scheffer, Tessin's successor in Paris, we know that the Swedish ambassador had paid 600 *livres* for the picture. Sent by him from Paris to Stockholm by way of Rouen in 1741 (valued at 600 *livres*). Sold by Tessin to King Fredrik I in 1749 to be given to Princess Luise Ulrike (1720-1782) of Sweden. Appears in the inventory made by Duben of Drottningholm Castle in 1760. Transferred from Drottningholm to the Nationalmuseum of Stockholm in 1865.

Exhibitions. 1741, Salon, no. 71 ("Le Négligé, or Morning Toilet, belonging to M. Tessin"); 1929, Paris, no. 1 (with pl.); 1932, London, no. 237, pl. 38 (and 150 of the commemorative cat.); 1935, Copenhagen, no. 32; 1954-55, London, no. 213.

Bibliography. Blanc, 1862, p. 14 (the composition); Goncourt, 1864, p. 138 (the composition); Clément de Ris, 1874, p. 497; Bocher, 1876, p. 93, no. 782; Dussieux, 1876, p. 604; Sander, 1876, p. 164, no. 9; 1878, p. 61, no. 122; p. 79, no. 75; Goncourt, 1880, p. 122; Dilke, 1899, pp. 185, 334, 336-38, 340; Dilke, 1899 (2), pp. 117, 120-122, 124; Fourcaud, 1899, p. 397 (repr. of the engraving); Leclercq, 1899, pp. 125 (ill.), 127-28; Fourcaud, 1900, p. 15 (repr. of the engraving); Normand, 1901, p. 54, notes 2, 93; Schéfer, 1904, pp. 60, 70; Dayot and Vaillat, 1907, pl. 49; Guiffrey, 1908, pp. 93-94, no. 242; Goncourt, 1909, pp. 138 (the composition), 180; Pilon, 1909, pp. 73-74, pl. between pp. 120 and 121, 170; Furst, 1911, p. 134, pl. 28; Lespinasse, 1911, pp. 117, 331, nos. 122; 1912, pp. 217-18 (no. 75); Klingsor, 1924, pl. on p. 49; Museum cat., 1928, p. 184, no. 782; Alexandre, 1929, p. 522 (ill.); Jamot, 1931, p. 306, pl. 20; Pascal and Gaucheron, 1931, p. 73 (mentioned); Ridder, 1932, pl. 67; Fry, 1932, p. 69, pl. 14a; Grappe, 1932, p. 23; Wildenstein, 1933, no. 100, fig. 18; *L'Amour de l'Art*, July 1935, p. 240 (ill.); *L'Art et les Artistes*, October 1935, no. 160, p. 33 (ill. of the engraving); Huyghe, 1935, p. 3; Brinckmann, 1940, pl. 383; Goldschmidt, 1945, fig. 32; Goldschmidt, 1947, fig. 29; Lazarev, 1947, fig. 21; Denvir, 1950, pl. 24; Godfrey, *Studio*, 1955, p. 84; Museum cat. (Nordenfalk) 1958, p. 41, no. 782; Goncourt, 1959, p. 161 (ill.); Adhémar, 1960, p. 456; *Du*, December 1960, p. 33 (ill.); Nemilova, 1961, pl. 11; Garas, 1963, pl. 16; Rosenberg, 1963, pp. 11, 47 (color pl.), 49, 82; Wildenstein, 1963-69, no. 200, pl. 34 (color); Lazarev, 1966, p. 41; Wagner, 1970, p. 140, fig. 2; Snoep-Reitsma, 1973, p. 191 (reproduction of the engraving on p. 190, fig. 36); Lazarev, 1974, fig. 195; Kuroe, 1975, p. 82 (ill.).

Prints. An engraving was executed by Jacques-Philppe Le Bas (1707-1783) in 1741 [Bocher, 1876, pp. 39-40, no. 38; Sjöberg and Gardey, 1974, p. 144, no. 29]. Abbé Desfontaines [*Observations sur les écrits modernes*, 21 October 1741, p. 144] and the *Mercure de France* [December 1741, p. 2697] announced the publication of the engraving, which specified that the painting belonged to Count Tessin. The Le Bas engraving was accompanied by verses written by Pesselier (for this poet, see [66, 67], *Prints*):

> Before the age of reason dawns,
> She follows her mirror's seductive counsel.
> In the will to please and the art of pleasing,
> The fair ones, I see, are never children.

Bocher lists two states of this engraving together with an etching and a mezzotint, the work of an unidentified engraver. He also mentions the engraving by J. Buford accompanying the work by P. Lacroix (Bibliophile Jacob) in *Institutions, usages et costumes* [1875, p. 489], and the etching by Charles Jacque. Lespinasse points out a print by R. Haglund (Stockholm, 1877). Lastly, E. Gaujean made an engraving of the picture to illustrate Lady Dilke's article [1899, between pp. 392 and 393].

Related Works. The few mediocre copies that we know are recent and go back to the engraving by Le Bas.

Chardin exhibited only two paintings at the Salon of 1741: the *House of Cards* [71] now in London and *The Morning Toilet*. The latter painting belonged to Count Tessin, Swedish ambassador to Paris, "whose exquisite taste and generous opulence have been making use of and rewarding the talents of our excellent artists for several years now," in the words of Abbé Desfontaines, one of the Salon's commentators [*Observations sur les écrits modernes*, 9 September 1741, pp. 333-34].

The *Morning Toilet* seems to have met with more success than *The House of Cards*. We read in the October 1741 *Mercure de France* the following laudatory observations: "Nothing in fact is more simple or more felicitously captured than the action of an attentive mother arranging a pin in her daughter's hair. What is even more appealing is the childish emotion which the skillful painter found a way to express through a glance in a mirror by the little girl, as if on the sly, to satisfy her little girl's vanity and see for herself whether the ministrations of her dear mother have indeed made her more beautiful."

The most interesting commentary, however, is the often-cited anonymous [see Zmijewska, 1970, pp. 29-30] *Lettre à Monsieur de Poiresson-Chamarande...au sujet des tableaux exposés au Salon de 1741* (pp. 33-34):

"In this same section there is one of M. *Chardin's* little subjects, in which he has painted a *Mother* arranging *her little daughter's hair*. It is once again the *Bourgeoisie* whom he calls into play.... There isn't a Woman of the Third Estate who, looking at the picture, doesn't fancy that she's seeing an image of herself, her home life, her straightforward ways, her bearing, her daily occupations, her morals, the moods of her children, her furniture, her wardrobe...."

Le Bas's print also came out in 1741. (We recall that the prolific and needy engraver owned two Chardins [see 20], also that through his pupil, Rehn, the Swede, who had been Tessin's protege in Paris, he tried unsuccessfully to sell the *Surgeon's Signboard* in Sweden in 1745 [*Archives de l'Art Français*, 1854, V, pp. 118-23].) We read on the Le Bas engraving a quatrain by Charles-Etienne Pesselier (1712?-1763?), who seems to have specialized in making up poems to accompany Chardin's compositions. Pesselier published some rather insipid verse in the December 1741 *Mercure de France* (p. 2698) in which he vaunted the talent and "naivete"—the word used most frequently in the eighteenth century to describe Chardin—and flattered Tessin (with some success, if one may judge

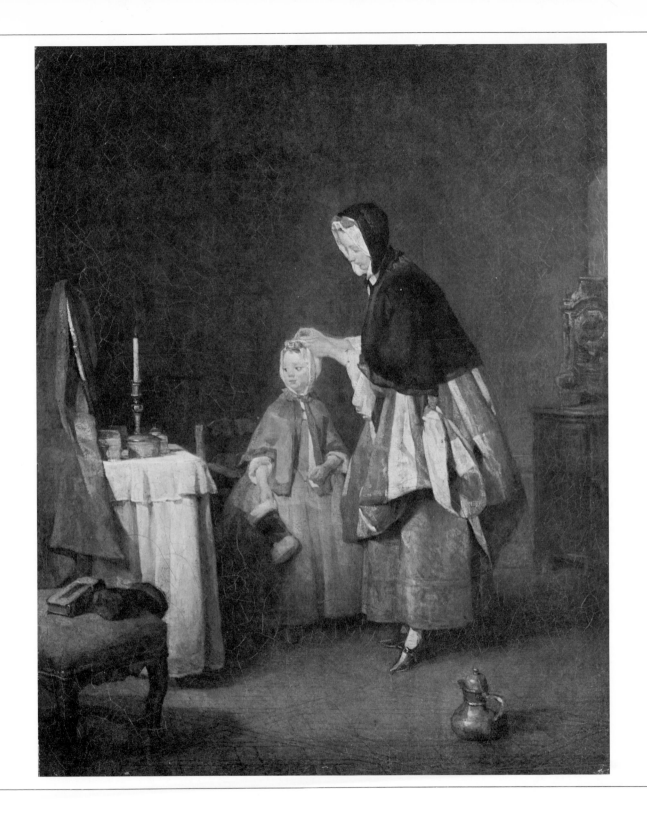

275

from the letter he sent to his wife on 8-19 January 1742: "Why should I be ashamed of my love for the arts?").

The Morning Toilet is one of Chardin's most polished works. On a stool covered with red cloth we see the mother's missal and muff. A marabout—a little pewter (or silver) hot-water jug—sits on the inlaid floor. The handsome piece of furniture in the corner is surmounted by a marquetry clock in the Boulle style. (Might this clock be the one figuring in various Chardin inventories—the 1737 estate inventory of Marguerite Saintard, for example ["a clock with an enameled copper face in its marquetry frame, decorated in bronze, made in Paris by Fiacre Clément"]?) The clock reads a few minutes before seven, the hour for mass. In front of the woman we see a mirror and, reflecting in the mirror, a toilet service of silver or silver-plated metal consisting of a candlestick, a powder puff, two square boxes, and a powder box. Chardin has given the greatest attention, however, to the rendering of the clothing: the mother's black cape and hood raised on the head, the red and white striped dress tucked up in such a way that we can see her beige underskirt; the little girl's pink dress, blue cape, and collarette.

There is little to say about the significance of the subject. From the eighteenth century on, commentators have stressed the nascent coquetry of the little girl stealing a glance in the mirror and have interpreted the work as a kind of warning against vanity and an allegory of Vanity [the painting as allegory has recently been analyzed very carefully by Snoep-Reitsma]. Is not the smoke from the candle which has just been extinguished there to remind us of this? (But then, too, Chardin liked to paint such things. Recall the steaming soup of *Saying Grace* and the steaming tea of the Glasgow *Lady Taking Tea*.)

The merit of the painting, however, lies in the way Chardin has rendered the texture of the clothing and the glitter of the metals. Rarely has he worked with such care. Rarely has the pictorial material—creamy, less polished than in the works of the 1735 period—given as much pleasure in the savoring. And never before have the color harmonies, the blues and the pinks, the reds and the browns, been as refined.

But there is more. The Goncourts' description of this painting concludes with this often-cited phrase: "Sunday, the whole of the bourgeois Sunday, is contained in this picture." The phrase echoes, in a way, the remark of the critic of the 1741 Salon to the effect that the "bourgeois women" of the time recognized themselves in this painting. Chardin has succeeded in rendering, more by the bodily attitudes than by the expressions on the model's faces, their inner dispositions, dispositions which affect us, both because they concern us and because we have also experienced them.

89 *Saying Grace*

(Le Bénédicité)

Canvas, 49.5 × 38.5 cm. Signed in the background at the left in a scarcely legible manner: *Chardin 1744;* at the bottom left in red: *1835.* The inscription *Chardin* at the bottom left was added later. Leningrad, The Hermitage*

Provenance. Possibly the painting at the Salon of 1746, said to have been painted (most likely an error) for La Live de Jully (1725-1779) (see]86], *Related Works,* for the *Saying Grace* in the collection of Louis XV). Acquired for The Hermitage by Catherine II between 1763 and 1774. (See also [86], *Provenance.*)

Exhibitions. 1746, Salon, no. 71 ("repetition of the *Bénédicité* with one addition") (?); 1955-56, Moscow and Leningrad, p. 61; 1972, Dresden, no. 9, pl. 27; 1977, Tokyo, no. 34.

Bibliography. Revue Universelle des Arts, 1861, XIV, p. 178, no. 428 (reprint of cat. of 177(4?); Goncourt, 1864, p. 154; Waagen, 1864, p. 305; Bocher, 1876, p. 92, no. 1513; Dussieux, 1876, p. 578; Clément de Ris, 1880, p. 270; Goncourt, 1880, p. 119; Mantz, 1883, pp. 187-88; Museum cat., 1887, p. 57, no. 1513; Dilke, 1899, p. 341, note; Dilke, 1899 (2), p. 124, note; Fourcaud, 1899, p. 417; Normand, 1901, pp. 65, 66, 108; Museum cat. 1903, no. 1513; Dayot, 1907, p. 126 (with ill., but the work reproduced is that of the La Caze collection in the Louvre); Dayot and Vaillat, 1907, pl. 25 (but reproduces the La Caze work in the Louvre); Guiffrey, 1908, pp. 91-92, no. 235; Goncourt, 1909, p. 176; Pilon, 1909, pp. 43, 170; Furst, 1911, p. 133, pl. 16; Réau, 1912, p. 396; Museum cat., 1916, no. 1513; Réau, 1928, p. 180, no. 31; Wildenstein, 1933, no. 78, fig. 52; Lazarev, 1947, fig. 22; Sterling, 1957, pp. 43, 217, note 67; Chastel, 1958, p. 42; Museum cat., 1958, I, p. 355, no. 1193, fig. 280; Nemilova, 1961, pls. 6 (color), 7 (detail, and detail on cover); Museum cat. (Lewinson-Lessing), 1963 (German ed.), pl. 78 (color); Museum cat. 1963, pl. 41 (color); Mittelstädt (ed.), 1963, p. 36, pl. 37; Wildenstein, 1963-69, no. 214, fig. 101; Lazarev, 1966, pl. 44; Wagner, 1970, fig. 1; Watson, 1970, p. 538; Lazarev, 1974, fig. 193 (color); Museum cat., 1976, no. 1193.

Prints and *Related Works.* See [86].

The Hermitage painting is the only version of *Saying Grace* to be signed and dated (on the background wall, at the left), *1744,* the year of Chardin's second marriage. The only variation between the painting Chardin gave to Louis XV [86] and the painting now in Russia is the addition at the bottom right of a long-handled copper frying pan containing two eggs beside the chafing dish. But is this addition significant enough to allow identification of the Hermitage painting with the one at the 1746 Salon, "coming from the collection of M...." and painted "to form a companion piece for a Teniers," a "repetition of *Saying Grace* with an addition"? We have attempted to prove that this was so in our discussion of the Louvre's *Saying Grace* [86]. Catherine the Great, to whom this painting belonged, displayed an interest in the work of Chardin, particularly in his domestic interiors. When the painter died, a number of biographers mentioned paintings of his which had gone to Russia (in addition to *The Washerwoman* [58] and the *Attributes of the Arts* [125], see also the entries for *Little Girl with Shuttlecock* [72] and *The House of Cards* [73]). Renou, for instance, had this to say

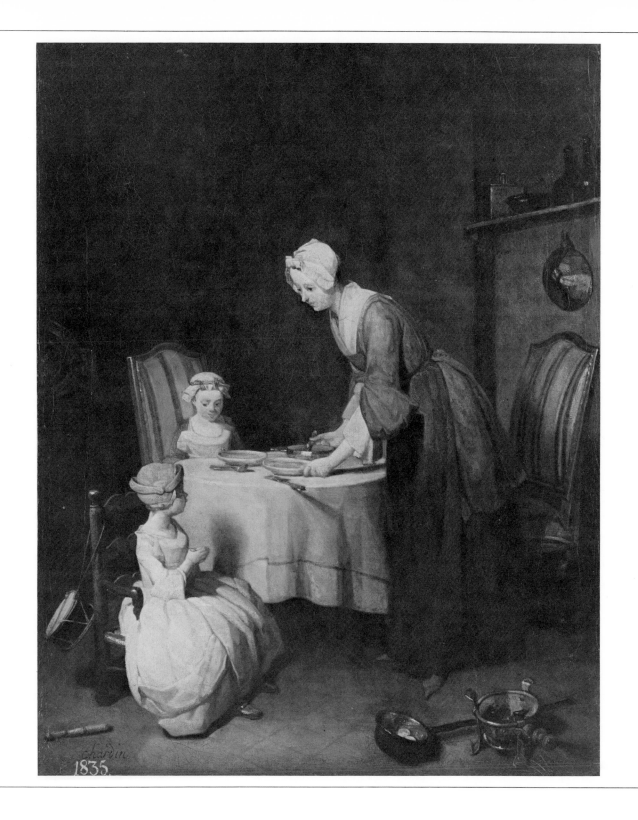

89

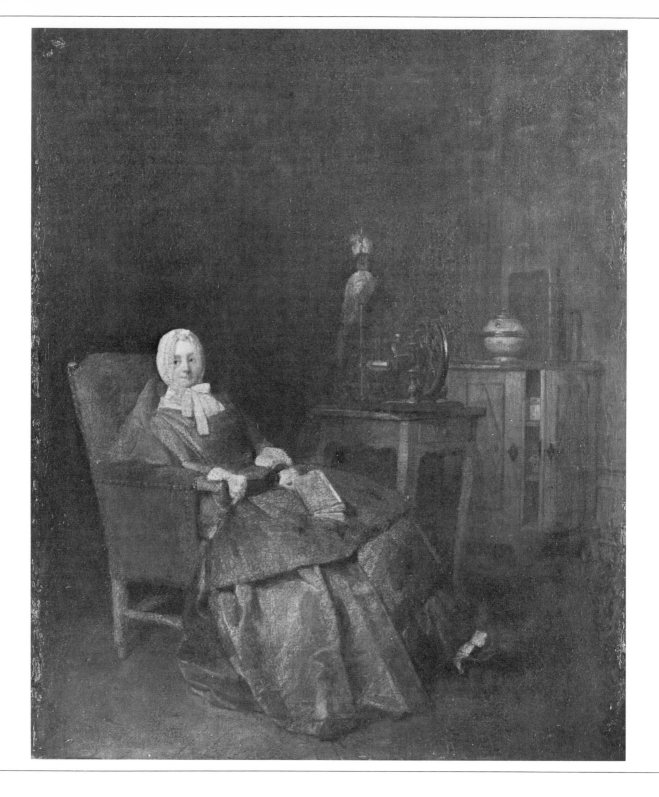

[Bibliothèque Nationale, Fonds Deloynes, Ms.]: "Most of the subjects from domestic life which he treated are known through the engravings; several are...in the collection...of the Russian Empress." Confirmation is provided by the author of the *Nécrologe des Artistes et des Curieux* [Paris, 1780, pp. 185-86]: "Catherine II...has shown eagerness in obtaining his works."

Until now it has been impossible to compare the three major versions of *Saying Grace*. This exhibition will not only enable us to judge the qualities they have in common but will also make it possible to study the painter's stylistic evolution at a time when his production of genre scenes was slowing down.

90 *Domestic Pleasures*

("Les Amusements de la vie privée")

Canvas, 42.5 ×35 cm.
Stockholm, Nationalmuseum*

Provenance. For details of the history of this composition, see [90], text. Commissioned from Chardin in 1745 by Luise Ulrike of Sweden (1720-1782) through her agents Tessin and Scheffer. Delivered in February 1747. At Drottningholm Castle by 1760 (cf. inventory by Duben). A sketch, done around 1790 by Fredenheim, curator of the royal collections, shows where the painting was hung in the major collection room, where the council formerly met at Drottningholm. Remained at Drottningholm until 1865, when it was transferred to the Nationalmuseum in Stockholm.

Exhibition. 1746, Salon, no. 72 ("Amusements de la vie privée").

Bibliography. Blanc, 1862, p. 15; Goncourt, 1864, pp. 147, 154, 156 (only through engraving); Clément de Ris, 1874, p. 497; Bocher, 1876, p. 93, no. 786; Dussieux, 1876, p. 604; Sander, 1876, p. 164, no. 4; 1878, p. 79, no. 73; Goncourt, 1880, p. 119; Dilke, 1899, pp. 338-40, 392; Dilke, 1899 (2), pp. 122-24, 126; Leclercq, 1899, p. 128; Dorbec, 1903, p. 41; Guiffrey, 1908, p. 94, no. 243; Goncourt, 1909, pp. 125,126,138,141 (only through engraving), 175, 176; Pilon, 1909, pp. 39, 41, 77, 81, 170; Furst, 1911, p. 134; Lespinasse, 112, pp. 216, 217, no. 73; Klingsor, 1924, pl. on p. 91; Museum cat. 1928, p. 185, no. 786; Ridder, 1932, pl. 69; Wildenstein, 1933, no. 243, fig. 199; Goldschmidt, 1945, fig. 33; Goldschmidt, 1947, fig. 30; Denvir, 1950, pl. 19; Turner, 1957, p. 304; Museum cat. (Nordenfalk), 1958, p. 41, no. 786; Wildenstein, 1959, p. 104; Adhémar, 1960, p. 456; Wildenstein, 1963-69, no. 221, fig. 105.

Prints. An engraving by Louis Surugue *père* (1686-1762) was done in 1747. The print, entitled *Les Amusements de la vie privée* ("Domestic Pleasures") was dedicated to "Madame la comtesse de Tessin, sénatrice de Suède." Beneath the engraving, which bears the Tessin coat of arms, we read: "The original painting is in the Gallery of Brotningholm [*sic*] in Sweden, forming the companion piece of another [work] by the same Author representing a Lady going over the accounts of domestic expenditures, painted in 1747" [cf. Bocher, 1876, p. 3, no. 1].
The engraving figured at the Salon of 1747 (p. 30 of the catalog) and has often been reproduced (Schéfer, Normand, Fourcaud, Furst, Snoep-Reitsma, et al.). It exists as a proof engraving and in two states. We cited above the letter accompanying the first state, with the name of the castle spelled incorrectly. Scheffer, Swedish ambassador to Paris, quickly became aware of the error. He wrote to Tessin on 9 June 1947:

"Your Excellency will find that instead of Drotningholm, it has been made Brotningholm, but I have corrected that error which has slipped into only a very small number of proofs." It was announced by the *Mercure de France* [June 1747, p. 131], which concluded: "It is troublesome that pictures by M. Chardin such as *La Fontaine, La Blanchisseuse,* and *La Toilette du Matin* go to foreign countries and are lost to us."

Related Works. We know of no copies of this picture of sufficient quality to deserve mention.

There would be no point in relating in detail the history (the anecdotal history) of Luise Ulrike's purchase of this painting and its companion piece *(The Housekeeper,* now totally ruined and unfit for showing — both pieces are in Stockholm), were it not a source of precious information about the work habits of Chardin. We know that Carl Gustaf Tessin, Swedish ambassador to France (1739-1742), had purchased four Chardins (all exhibited here) at the La Roque sale of 1745 with immediate delivery. During his ambassadorship, he had commissioned from Chardin *The Morning Toilet* [88] and had brought back to Sweden, in addition to copies of *Saying Grace, The Diligent Mother,* and the *Rabbit, Copper Pot...* [78], one of Chardin's finest still lifes. It is not surprising, then, to find the following sentence in a letter addressed by Count Tessin to his successor in Paris, Carl Fredrik Scheffer (1715-1786), on 6 October 1745 (made available, along with whatever concerns Chardin in the still-unpublished correspondence between the two men, by Jan Heidner): "The Princess Royal Luise Ulrike is equally desirous of having, 'in addition to paintings by Boucher,' two works as large as the one [*The Morning Toilet*] he [Chardin] made for me...."

Luise Ulrike, sister of Frederick the Great of Prussia, had married Adolf Fredrik, the future king of Sweden (he acceded to the throne in 1751).

Not long after the communication between Tessin and Scheffer (17-27 October 1745), Berch, secretary to the embassy in Paris, wrote to Tessin: "The matter of the paintings is encountering a little difficulty from M. Chardin who candidly admits he could only provide the two pieces a year from now. His slowness and the pains he takes must, he said, already be known to Your Excellency. The price of 25 *louis d'or* is modest for one who has the misfortune to work so slowly.... A painting he is working on now will take him another two months to complete. He never works on more than one thing at a time; Boucher is faster...." [publ. by Ph. de Chennevières, 1856, p. 56].

On 8 November 1745 Tessin pressed the issue: "Whoever says 'Princess' says 'Impatient Woman.'" From another letter of Tessin dated 20 April 1746 we learn the titles of the two works: "I know how slow he is, and if one didn't keep after him he'd never finish. We're asking of him two paintings, to wit, *The Gentle Upbringing* and *The Strict Upbringing."* Luise Ulrike confirms these titles in a letter of 31 May addressed to her mother [Arnheim, 1909, I, p. 283]: "I have given the first [Boucher] the subject of the four times of day and the other *The Strict Upbringing* and *The Gentle, Subtle Upbringing."* Both Luise Ulrike and Tessin brought pressure on

Scheffer. "Not a day passes," Tessin wrote to Scheffer on 13 May, "that the Royale Madame does not bring up the subject with me." By the beginning of June, Scheffer appears at the end of his tether: "[I] have no other justification to give you but the libertinism of Boucher, which you'd have to see to believe, and the slowness of Chardin, the admission of which you'd have to hear from his own lips in order not to believe it an exaggeration." On 9 September Scheffer sent Tessin the Salon catalog proving that one of the two Chardins was finished. On 7 October the count received from Scheffer a letter written to him by Chardin (one of the rare autograph letters we know to exist). Scheffer states that "the painting which is finished [Domestic Pleasures] has elicited admiration from all the connoisseurs." Chardin's letter, also unpublished, is of the greatest interest:

"I would like to be able to satisfy the eagerness of Monsieur le comte de Tessin to have at once the two paintings he wants of me. You could, sir, have at your disposal the first one, which has been exhibited at the Louvre. As for its companion piece, although it is well advanced, I cannot promise to give it to you before Christmas. I am not hurrying, because I have developed a habit of keeping at my works until, in my view, I see in them nothing more to be desired, and I shall be stricter than ever on this point in order to merit the good opinion with which Monsieur le comte de Tessin honors me. Furthermore, since France will be losing these two paintings and since one owes something to one's own nation, I would hope that the count will allow me enough time to have them engraved, which would bring us to spring. I would find this favor all the more fitting as I owe the public in some way an account of my labors in gratitude for the welcome it has given my works."

On 27 June 1747 Chardin gave the two paintings (Domestic Pleasures and The Housekeeper, see [91]) to Scheffer, who sent them on to Sweden. "The Chardin paintings are such that one feels like getting down on one's knees in front of them," wrote Tessin on 6 June. Luise Ulrike informed her mother on 14 July 1747, not without some pride, "I have them in my collection."

These letters are interesting from more than one point of view. They provide an enlightening glimpse of the two greatest painters of their generation, Boucher—who was to deliver only le Matin ("Morning"; also called La Marchande de modes [The Woman Selling Millinery], presently in the Stockholm museum [Ananoff, 1976, no. 197; to compare with Chardin's Morning Toilet of 1741, see [88]) — and Chardin, who himself recognized his slowness (often called laziness by others).

Luise Ulrike had, in fact, commissioned two paintings from Chardin on subjects she had chosen. Her choice of subjects—The Gentle, Subtle Upbringing and The Strict Upbringing—was probably inspired by the two well-known compositions by Charles-Antoine Coypel (1694-1752) which she must have known through the Desplaces engravings of 1738. We do not know why Chardin changed subjects, why he avoided these themes which would have enabled him to paint once again the delicate ties uniting a mother to her children.

We ought to note, also, that Chardin was very anxious to have his painting engraved before its departure for Sweden. This concern was, in part, monetary, since in the eighteenth century engravings after original oils were an important source of revenue for painters. But it was also connected—and we detect a touch of patriotism here—with a desire to preserve in France the memory of a painting which greatly satisfied Chardin.

Chardin exhibited four paintings at the Salon of 1746. In addition to Domestic Pleasures, he showed a replica of Saying Grace (see [89]) and, for the first time, two portraits: the Portrait de M. ... ayant ses mains dans son manchon ("Portrait of M. ... with his hands in his muff"; certainly not the Washington picture; Wildenstein, 193-69, no. 212, fig. 99; Michaud, 1813, pp. 75-76, thought it represented "one of his friends" and not a woman) and the Portrait de M. Levret, de l'Academie royale de chirurgie ("Portrait of M. Levret of the Royal Academy of Surgery"), now lost but known to us through the engraving [Wildenstein, 1963-69, no. 213, fig. 100]. Although the portraits do not seem to have been popular, the diffident commentary of the Stockholm painting published by Lafont de Saint-Yenne, the first great art critic of the eighteenth century and defender of historical painting, in his famous Réflexions sur quelques causes de l'état présent de la peinture en France [1747, pp. 109-11] is worth repeating:

"I should have mentioned Chardin among the ranks of the painters who are original composers. One admires in him the ability to render, with a truth and simplicity all his own, certain moments in life which are in no way interesting, which by themselves do not merit any attention, and some of which are unworthy both of the author's choice and the beauties we admire in them: yet they have made for him a reputation which extends into foreign countries. As the author paints only for his own amusement and consequently very little, the public, eager to have his paintings, has enthusiastically sought out, by way of compensation, the prints that have been engraved after his works.... He produced this year [a piece which] represents a pleasant-looking idler in the form of a woman stylishly and carelessly dressed, with a rather piquant face, enveloped in a white headdress tied under the chin and which hides the sides of her face. One arm lies in her lap; the other languidly holds a booklet. Beside her and a little to the rear is a spinning wheel on a small table. One admires the truth of the imitation, the finesse of its brushstrokes, both in the figure and in the ingenious piece of work represented by the wheel and the furniture in the room."

Two years later, the author of the Observations sur les Arts et sur quelques morceaux de peinture... exposés au Louvre en 1748 [1748, pp. 89-90] was far less reserved:

"Has there ever been anything more pleasant than a small painting exhibited at the Salon of 1746...entitled amusements de la vie paisible [pleasures of the peaceful life]? It depicts a woman comfortably seated in an armchair, holding in one hand, which lies in her lap, a booklet. Judging by a kind of languor dominating her gaze, which is fixed on a corner of the painting, we guess that she has been reading a novel and that the novel's effect on her emotions causes her to daydream about someone whom she'd like to see come

keep her company! Has there ever been anything more charming than this little picture which could stand comparison with the best works of the Flemish school and which would be an ornament in the collections of the most discriminating art lovers."

The Stockholm painting has seldom been reproduced. Although it has not been totally ruined like its companion piece *(The Housekeeper* (see [91]), it nevertheless has suffered over the years. Still, its recent restoration has brought back to it a consistent quality.

On 26 November 1744 Chardin remarried. One wonders if we have here the portrait of François-Marguerite Pouget (1707-1791), who provided a moderate degree of financial security for Chardin (as Lafont de Saint-Yenne has already noted, not without malice). The model in the painting looks at the viewer—something unusual for Chardin. Her gaze is vague, the gaze of someone who has just interrupted a reading which still claims her thoughts. It is that gaze which establishes the climate of the work, more aptly entitled *Serenity* in the opinion of the Goncourts. The interior Chardin paints is not very different from those he painted before his second marriage. We have already seen the corner cupboard with its partly opened door, the serving table, and the inlaid floor, not to mention the white bonnet with its strings fastened beneath the model's chin. The new pieces include: the large, red easy-chair, the porcelain jar rimmed in silver and placed beside two books, and most particularly the spinning wheel and its distaff, abandoned by the reader. And therein lies the theme of the painting whose focus is the blue and pink splash of the book: reading. For the painting portrays, as if seen from within, the peace that reading can bring. The tranquility of the model echoes that of the objects surrounding her as she remains absorbed in the world of her book.

Who could have suspected that eight years after *The Return from Market* Chardin would paint works of such gentleness, such calm, such interiority? And how can we not regret that the artist so quickly abandoned such painting to concentrate on still life, trompe l'oeil, and pastel?

91 *The Housekeeper* (sketch)

(L'Econome [esquisse])

Canvas, 46 × 38 cm.
Paris, Private Collection

Provenance. One of the twelve "sketches" remaining in Chardin's studio at the time of his death and listed in his estate inventory (see [85], text) (?). Collection of the painter Sébastian Rouillard (1789-1852) [see Florence exh. cat. 1977, p. 207]; Rouillard sale, 21 February 1853, no. 113 (and not 114, which is probably the sketch for *Meal for a Convalescent* [92]; handwritten notes in the copy of the cat. at the Musée de Chartres indicate "Vente Rouillard, no. 113, 220 francs, 1853"; the picture was certainly (?) in that sale—something denied by Wildenstein, 1960), *Une jeune femme, assise près d'une table, ecrit la depénse de son ménage. Esquisse* ("Young woman, seated near a table, writes up the household expenses. Sketch"). Acquired by François-Martial Marcille (1790-1856) for 220 francs; François Marcille sale, 2-3 March 1857, no. 43, *La Cuisinière* ("The Cook"); acquired at this sale by Eudoxe Marcille (1814-1890), son of François (inscriptions written by Eudoxe Marcille appear on the verso of the stretcher). Has remained in the family since that time.

Exhibitions. 1885, Paris, no. 56; 1959, Paris, no. 12, pl. 5; 1961, Paris, no. 6.

Bibliography. Horsin-Déon, 1862, p. 137; Goncourt, 1864, p. 149; Bocher, 1876, pp. 41, 99; Goncourt, 1880, p. 122; Chennevières, 1890, p. 303; Dilke, 1899, p. 338 (note); Dilke, 1899 (2), p. 122 (note); Guiffrey, 1908, pp. 78, no. 134, 94; Goncourt, 1909, pp. 128, 180; Furst, 1911, p. 125; Wildenstein, 1933, no. 245, fig. 31; Ratouis de Limay, 1938, p. 312; Huisman, 1959, p. 75 (ill.); Wildenstein, 1960, p. 2; Wildenstein, 1963-69, no. 219, fig. 104.

Print. Jacques-Philippe Le Bas (1707-1783) engraved this composition in 1754 [Bocher, 1876, pp. 40-41, no. 39; Sjöberg and Gardey, 1974, p. 145, no. 130]. His print is not reversed, but follows the painting and is accompanied by these lines:

Wonder of wonders! A woman taking time
For household matters from cares more pleasant by far
We see in this picture of olden days
The way things should be, not the way they are.

The picture, Le Bas adds, "belongs to the collection of the King of Sweden, [and has been] drawn by Rehn after the Original Painting." Le Bas exhibited his print at the Salon of 1755 (part of no. 70). Wildenstein has proposed that Le Bas's engraving, for which Bocher gives two states, was made after the sketch exhibited here rather than after the definitive version of the work now in Stockholm. But all the facts, and especially the allusion to Rehn in the engraving's caption, militate against such an interpretation. The Swedish engraver Jean Eric Rehn (1717-1793) had received his training from Le Bas in Paris between 1740 and 1745. After Rehn's departure the two artists remained in contact with each other through an exchange of letters (now preserved at Kragenholm Castle in Sweden). In a well-known letter sent to Rehn by Le Bas on 10 January 1746, the Frenchman asked his student to try to sell his *Surgeon's Signboard* in Sweden [published in *Archives de l'Art Français*, 1854, p. 120]. There is nothing surprising, therefore, about Le Bas's request in 1754 that Rehn send him a sketch of the painting then at the Swedish court.

91

Stockholm, Nationalmuseum.

Related Works. The definitive version of the painting, now seriously damaged, belongs to the Stockholm museum (no. 787). Its state of deterioration is so far advanced that there would be no point in including it in the present exhibition [Wildenstein, 1963-69, no. 220, fig. 106].

A preparatory sketch for *The Housekeeper* is preserved, with its companion piece, *Domestic Pleasures* [90], in the Stockholm Nationalmuseum. The finished painting, now in such poor condition it cannot be shown in the present exhibition, is one of the rare figure compositions of Chardin which did not appear at a Salon. Luise Ulrike of Sweden, who had commissioned it, was too impatient to wait that long. Scheffer, Tessin's successor as Swedish ambassador to France, was too anxious to please the princess to allow the artist to delay sending the work to Stockholm, as he would have preferred [see the unpublished letters exchanged between Tessin and Scheffer in [90], text, and the Salon catalogs of 1747 and 1748, which allude to the two paintings "recently sent on their way to the Swedish Court"]. Chardin did not even have enough time to have his painting engraved. In 1754 Jacques-Philippe Le Bas, an old friend of Chardin, had to ask Jean Eric Rehn to send him a drawing of the painting then at the Swedish court so that he could make an engraving of it.

As the Tessin-Scheffer correspondence published in the preceding entry proves, the picture was executed after *Domestic Pleasures,* during the autumn of 1746 and the early months of 1747. The composition of the sketch is very similar to that of the definitive painting, and its execution is highly reminiscent of *Saying Grace* [85] and *Meal for a Convalescent* [92] The free workmanship does not prevent us from distinguishing in the foreground the sugar-loaf and package of candles on the left and the basket and bottles of wine on the right. "The painting...although barely map-

ped out, has at a distance the appearance of a finished piece," wrote Horsin-Déon in 1862. The fine passage written on this work by the Goncourts [1864, p. 149] also deserves repeating:

"I remember a first draft of *The Housekeeper,* a woman seated near a window hung with a green drape. On a brown background where the brush has left its rough imprint, the paint brush loaded and soaked with white, following the curve of the folds in the garment, turning and flattening at the elbow and the cuffs of the sleeves, leaving behind, on the fully lighted areas, trails of dry paint, had produced on the canvas the work of a rough outline. Nothing but white and dirty gray; no more than a hint of pink on the face and hands, a hint of violet on a ribbon, a speck of red on the trim of the skirt; and yet, there is a face, a dress, a woman, and already the entire harmony of the painting in the dawn of its color."

Snoep-Reitsma [1973, pp. 222-23] has observed that the subject of *The Housekeeper* had been very rarely treated in painting. She knows of no example in seventeenth-century Northern painting. Why did Chardin choose it? Why did he want to treat this theme symbolizing domestic virtues as a companion piece to *Domestic Pleasures,* which vaunts the charms of reading? Why did he want the expense accounts to correspond to the novel? Beyond the tension between idleness and work, what significance did Chardin have in mind? We cannot say.

It would surely be tempting to see in the work a kind of tribute to Chardin's new spouse (the painter had remarried in 1744), but nothing of what we know of Chardin's life and artistic habits allows us such an interpretation. Let us content ourselves with admiring once again the presence of this woman's form, simultaneously alert and dreamy, whose occupation is summed up by a few strokes of the brush.

92 *Meal for a Convalescent* (also called *The Attentive Nurse*)

("Les Aliments de la convalescence," dit aussi "La Garde attentive")

Canvas, 46 × 37 cm. Signed or inscribed at the lower right: *Chardin* (the painter's name is preceded by initials which are hard to read). Washington, National Gallery of Art, Samuel H. Kress Collection

Provenance. Painted for Prince Joseph Wenzel of Liechtenstein (1696-1777), Austrian ambassador to Paris between 1737 and 1741 [see J. v. Falke, 1882, and [83], text]. Not listed in the catalogs of 1762 and 1780, since at that time it was in the private gallery of the princes of Liechtenstein in Vienna. Remained in the Liechtenstein collections until 1950. Samuel H. Kress Collection, New York, in 1950. Given in 1951 to the National Gallery in Washington.

Exhibitions. 1747, Salon, no. 60 ("La Garde attentive ou les aliments de la Convalescence"); 1907, Paris, no. 25; 1910, Berlin, no. 298 (no. 22 with pl. in large-size edition of cat.); 1948, Lucerne, no. 5.

Bibliography. Goncourt, 1860, see 1956 ed., p. 817; Blanc, 1862, p. 15; Goncourt, 1863, p. 531; 1864, pp. 149, 154, note; *La Chronique des Arts et de la Curiosité,* 21 April 1867, p. 122; Liechtenstein Cat., 1873, no. 559 (1885 ed., no. 379); Bocher, 1876, p. 91; Goncourt, 1880, p. 123; Dilke, 1899, p. 334; Dilke, 1899 (2), p. 120; Fourcaud, 1899, p. 406; Fourcaud, 1900, p. 24; Schéfer, 1904, pp. 70, 71, 75, pl. on p. 77; Dayot and Vaillat, 1907, pl. 24; Dayot and Guiffrey, pl. between pp. 24 and 25; Guiffrey, 1907, pp. 94, 95; Frantz, 1908, p. 30; Guiffrey, 1908, p. 59, no. 17; Goncourt, 1909, pp. 116, 129 (note), 182; Pilon, 1909, pp. 45, pl. between pp. 52 and 53, 170; Alfassa, 1910, p. 294; Furst, 1911, pp. 42, 119, pl. 21; Liechtenstein Cat., 1927, no. 379; 1931, pp. 65-66, no. 379; Osborn, 1929, pl. 7 (color); Pascal and Gaucheron, 1931, p. 82 (cites the Salon reference); Ridder, 1932, pls. 72, 74 (detail); Wildenstein, 1933, no. 1, pl. 1; Pilon, 1941, p. 19 (ill.); Lazarev, 1947, pl. 23; Jourdain, 1949, pl. 24; Denvir, 1950, pl. 18; *Art News,* April 1951, p. 5 and pl. on p. 63 (also the cover); Museum cat. (Suida), 1951, no. 101, p. 226, pl. on p. 227; Einstein, 1956, p. 234; Goncourt, 1956, p. 817; Einstein, 1958, p. 22; Museum cat., 1959, p. 355, no. 1116 (pl.); Wildenstein, 1959, p. 104; Adhémar, 1960, p. 456; Garas, 1963, pl. 17; Wildenstein, 1963-69, no. 218, pl. 35 (color); Walker, 1964, p. 212, pl. on p. 213 (color); Snoep-Reitsma, 1973, pp. 224, fig. 84, 225; Museum cat., 1975, pp. 66, pl. on p. 67, 80 (ill.); Kuroe, 1975, pl. 19 (color);

Jules de Goncourt, engraving after the sketch for *Meal for a Convalescent.*

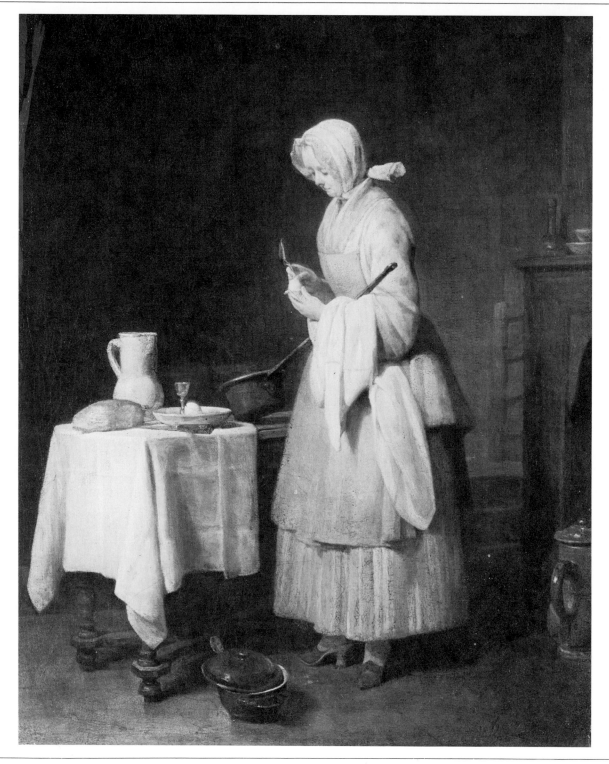

9

See Color Plate X

Walker, 1975, p. 322, pl. on p. 323 (color); Eisler, 1977, pp. 313-14, fig. 279.

Related Works. A sketch for this painting is on the New York market [Wildenstein, 1963-69, no. 217, fig. 103, and pl. 61 of the English ed.], with significant differences. It very probably comes from the Rouillard sale (like the sketch for *The Housekeeper* [91]), 21 February 1853, no. 114, and the François Marcille sale of 2-3 March 1857 (no. 33), and most certainly from the sales of Laperlier (11-13 April 1867, no. 9, and 17-18 February 1879, no. 4), Beurnonville (9-16 May 1881, no. 29), and L. Michel-Lévy (17-18 June 1925, no. 124). It appeared at the great exhibition of 1860 (no. 353) and the Salon of 1863 and was engraved by Jules de Goncourt (1830-1870) to illustrate the 1864 study on Chardin done by the two brothers [cf. Bocher, 1876, pp. 25-26, no. 23; Burty, 1876, no. 59; and Adhémar-Lethève, 1955].

There is no engraving for *Meal for a Convalescent,* also called *The Attentive Nurse* (to use the titles given for the work at the 1747 Salon), which is exceptional for figural painting by Chardin. In the Salon catalog we read: "This painting forms the companion piece to another by the same artist which is in the collection of the prince of Leichtenstein [*sic*] and which he [Chardin] could not borrow along with two others that left a short time ago for the Swedish Court." This intriguing sentence has sometimes led art historians astray. Through the intermediary of the catalog editor, Chardin wanted first and foremost to apologize to the Salon visitor for having sent only one painting to the exhibition. The two paintings "on their way to the Swedish Court" were, of course, *Domestic Pleasures* (which had figured in the preceding Salon!) and *The Housekeeper* (see [90, 91]), which had left Paris for Stockholm in February of 1747. But what might be "the other painting," the companion piece to *The Attentive Nurse* in the Liechtenstein collection?

We know that during his ambassadorship in Paris the prince had acquired a *Woman Scraping Vegetables* (now in Washington), *The Governess,* and *The Return from Market* (both in Ottawa; see [83]). Of these three pictures, dated 1783, only *The Return from Market* could pass for the companion piece to *Meal for a Convalescent.* Some have therefore concluded [Walker, Eisler] that *Meal for a Convalescent* also dates from around 1738. Such a conclusion is absolutely impossible from the point of view of style. Very obviously, *Meal for a Convalescent* was painted between February 1747 and the opening of the Salon. The painting was then sent to Vienna before Chardin had time to have it engraved. Our search for archival documents concerning this purchase has, however, proven fruitless, and we do not know why the prince, several years after his stay in Paris, wanted to "complete" his Chardin series.

The picture remained practically unknown until the Goncourts passed through Vienna and visited the Liechtenstein Gallery on 25 September 1860. At the Salon of 1747, only Abbé Le Blanc (1707-1782), the future guide of Marigny (along with Cochin and Soufflot) during the journey of the Pompadour's brother to Italy, had anything to say about it [in *Lettre sur l'exposition des ouvrages de peinture...de l'anée 1747*]; his text is very run-of-the-mill:

"Another French painter in a completely different genre has also discovered the art of treating domestic subjects without being common. M. Chardin is the artist I have in mind. He has developed for himself a manner all his own, a manner abounding in truth. Equally to be admired are the care with which he studies nature and the particular talent he has for rendering it."

The Washington painting offers us a series of familiar objects skillfully arranged. As is frequent with Chardin, a pot sits on the floor near a table with turned legs whose outdated style comes perhaps from the closing years of the seventeenth century. The handle of a ladle projects from the pot. Near a chair and in front of the fireplace (whose mantel displays a carafe and a cup and saucer) we see a large pitcher. On the table, half-covered by a white tablecloth, are a loaf of bread, a faience water pitcher, a knife, and, on a plate, an egg cup and an egg. The nurse, a napkin thrown over her left arm and a spoon in her hand, is peeling a hard-boiled egg; pieces of eggshell have fallen on the floor. The long handle of a steaming saucepan rests on her forearm. Chardin emphasized, however, the delicate color harmony of the elegant oufit the young woman is wearing. A whole scale of pinks, soft violets, and whites confers on the painting, whose focus is the white splash of the egg, its own peculiar climate—even, one would like to say, wintry.

The nurse appears to be distracted, melancholy, dreamy. Are her thoughts with her patient, or with her suitor? We may be sure that the engraver would have provided enlightening verses with his print. One wonders whether Chardin wanted such an explanation or whether he was very much aware that the beauty of his painting lay in this uncertainty—in the mystery of this tall, feminine form, absorbed in her work and yet absent.

93 *The Bird-Song Organ* (also called *Lady Varying Her Amusements*)

(La Serinette, dit aussi "Dame variant ses amusements")

Canvas, 50 × 43.5 cm.
Paris, Private Collection*

Provenance. Commissioned from Chardin by Le Normant de Tournehem, director of royal construction, in 1751, through Charles-Antoine Coypel (1694-1752), first painter to the king, [see the note preserved at the Institut Néerlandais, Paris; 1964 exh. cat., no. 367A, p. 57]. Paid for on 3 January 1752, 1500 *livres* [Engerand, 1901, pp. 79-81; the note at the Institut Néerlandais shows that the invoice presented to Vandières, Tournehem's successor, on 18 January, was not paid until 8 February]. Collection of the Marquis de Vandières (1721-1781) by 6 August 1753, at which time Vandières acceded to the request of Lépicié (*not* Cochin) that the engraving be dedicated to him and that it carry the words "this painting is from my collection"; sale of Vandières, younger brother of the Pompadour (from whom he had obtained *L'ecureuse* [The Scullery Maid] and *Le Garcon cabaretier* [The Innkeeper-Boy], no. 30 in that same sale), 18 March-6 April 1782, no. 29. Acquired by M. de Tolozan (does not figure at the Tolozan sale of 1802). Richard de Lédan sale, 3-18 December 1816, no. 41; the catalog specifies that the painting is from the collection of the Marquis de Ménars. The copy of this catalog at the Frick Art Library in New York indicates in a handwritten note the name of the person who acquired the picture: "Didot" [Frick cat., 1968, p. 47]. Sale [Didot], 27-28 December 1819, no. 22; sale of A. [Didot; could this be Ambroise-Firmin, 1790-1876 ?], 6-8 May 1828, no. 16: "This painting, which possesses the beauties and the harmony of a Metzu or a Terborch, is not the same as the one at the Denon sale. The latter is a repetition from two years later, showing, by way of modification, a green workbag. In ours, which is in perfect condition, the bag is red." (See general discussion below.) Collection of Lord Pembroke according to the Pauper and Boittelle catalogs; Mme Pauper sale, 12-15 March 1873, no. 3 (acquired by Haro); sale of B[oittelle], a former senator, 1-2 April 1874, no. 7 (appears to have been bought back).

Exhibitions. 1751, Salon, no. 44 ("A painting measuring 18 *pouces* high by 15 *pouces* wide; a lady varying her amusements") (?); 1959, Paris, no. 14, pl. 6.

New York, The Frick Collection.

Muncie (Ind.), Ball State University.

Bibliography. Wildenstein, 1933, no. 264A (among paintings unknown to the author or else rejected by him); Wildenstein, 1960, p. 2 (rejects the painting); Frick cat., New York, 1968, pp. 45, 47, note 20.

Print. The painting of the 1751 Salon was engraved by Laurent Cars (1699-1771). Cars's frequently reproduced engraving is dedicated to the Marquis de Vandières, to whom the painting belonged. It was publicized by the *Mercure de France* in November 1753 [p. 160; see also Bocher, 1876, pp. 50-51, no. 47; Roux, 1934, pp. 494-96, no. 123]. It does not differ from the painting exhibited here.

Related Works. The following references to early sales might relate to the painting in The Frick Collection, New York, or to the one exhibited here, or to a third version in Muncie, Indiana: (1) Nicolas sale, 3 November 1806, no. 4 (no dimensions); (2) X sale, 13 March 1827, no. 20 (sale mentioned in the 1959 catalog, but unverifiable); (3) Sale of Baron V. Denon, former director of the Musée Napoléon, 1 May 1826, no. 144 (Denon also owned the La Caze *Saying Grace* now in the Louvre).

Bocher [1876, p. 50], on the other hand, has this to say: "M. Clément de Ris, in one of the very charming letters he sent me on the subject of Chardin, tells me he had seen in Tours in 1854 a replica very superior to the one in the Morny sale [the Frick painting]. 'They offered to sell it to me at the time for 500 francs,' he said, 'and I very much regret not having been foolish enough to buy it'; I should say so."

(4) Houdetot sale, 12-14 December 1859, no. 19; (5) Duc de Morny sale, 31 May-12 June 1865, no. 93.

There are three versions of this painting [none is listed by Guiffrey, 1908, and Wildenstein accepts only the two American versions]. First, there is the one on exhibit here, for which we are proposing —hesitantly—a new pedigree (see *Provenance*). Another version belongs to Ball State University in Muncie [Wildenstein, 1963-69, no. 228, fig. 110; we have never seen this version for which Wildenstein proposes a Choiseul provenance and which, therefore, we have been unable to check; he associates this painting with the one listed by Bocher]. Finally, there is the justifiably famous one in The Frick Collection in New York (whose provenance is surely Houdetot and Morny) [see the 1957 article by Turner and the 1968 Frick catalog; as is well known, the policy of this museum prohibits loans] that is generally thought to be the picture of the 1751 Salon, then in the Vandières collection [Wildenstein, 1963-69, no. 227, fig. 109] The reasons which make us doubt this identification will be given shortly.

It is particularly difficult to set forth clearly the problem of the provenance of the various known versions of *The Bird-Song Organ*. However, the tentative proposal we offer here seems logical to us. Until now the position has always been that the Frick painting is the one at the Salon of 1751, which, therefore, had been commissioned by the king and which had entered, in 1753, the collection of the Marquis de Vandières (the future Marquis de Marigny and Marquis de Ménars), who was the director of royal construction and the brother of the Pompadour. There are two reasons, in our view, for rejecting this position.

In the first place, the catalogs for the 1819 Richard de Lédan sale specifies that *The Bird-Song Organ* in that sale is from the Ménars collection. Furthermore, the copy of this catalog in the Frick Art Library in New York contains a handwritten note giving the name of the person acquiring the painting—"Didot." But at the second Didot sale (1828), the painting is described as follows: the workbag hung on the embroidery frame is *red* (as it is on the painting ex-

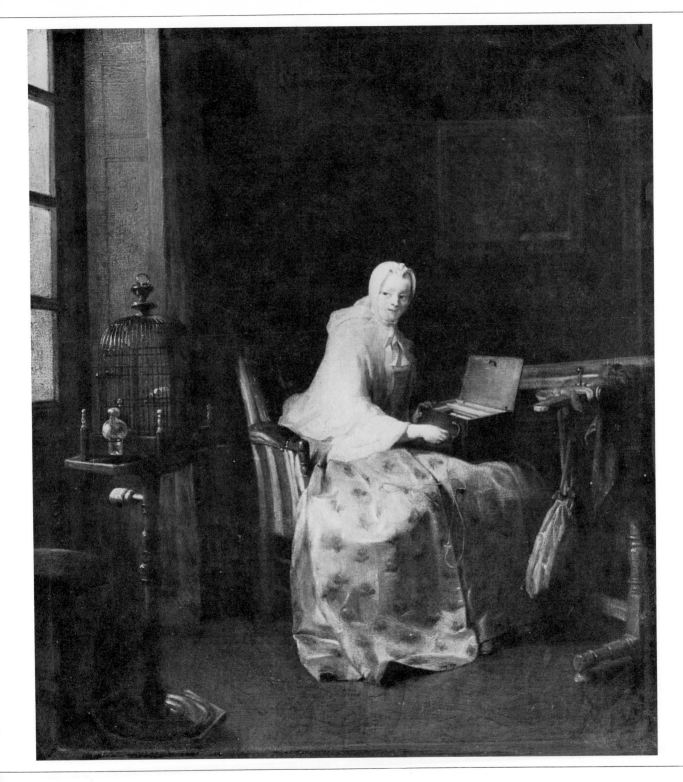

93

X-radiograph of the Frick painting.

thermore, it seems to us that the author of the 1828 Didot catalog was not entirely wrong when he wrote that the Denon painting (i.e., the Frick picture) was a "replica dating from two years later" (than the Vandières version).

Study of the sale catalogs dating from the beginning of the nineteenth century prompts a second remark. At the Didot sale of 1819 (at which there were four paintings by Chardin) it is clearly stated, with respect to *The Bird-Song Organ*, that "what makes it even more interesting is the fact that the figure passes for the portrait of Madame Geoffrin. This painting and the following three have belonged to her." At the 1826 Denon sale the painting represented "the presumed portrait of Madame Geoffrin." And in the catalog for the second Didot sale (at which there appeared a *Governess* which turned up again in the Pauper and Boittelle sales!), two years later, the title of the work was scarcely changed: *Une dame qui passe pour être Mme Geoffrin* ("A lady thought to be Mme Geoffrin").

Nothing is known of the Chardin paintings which Mme Geoffrin (1699-1777) is said to have owned. The painting by Anicet-Gabriel Lemonnier at Malmaison—*Le Salon de Mme Geoffrin* ("Mme Geoffrin's Drawing Room"; Salon of 1814, sketch in Rouen, draw-

hibited here), while the bag in the Denon version (1826 sale) is *green* (like those in the Muncie and New York versions).

The second point is just as significant. The paintings at the Frick and in Paris are not appreciably different, except for some extremely minor details due to the clumsy intervention of someone doing restoration. The only *noteworthy* difference involves the *strings* of the workbag. On the Frick composition, the workbag has been *strung* on the cross-piece of the frame; on the Paris version, it is *tied* to the cross-piece with a knot. This detail is important, for the engraving by Laurent Cars (1753), which certainly reproduces the Vandières-Ménars painting, shows this knot.

The Frick picture has sometimes drawn harsh criticism (even the recent 1968 catalog of the museum expresses some reservations, most particularly about its condition). In 1860, for instance, Bürger (Thoré) wrote (pp. 335-38), while the work was in the possession of the Duc de Morny: "This exquisite painting, probably too energetically cleaned, now resembles some insignificant product of the imitators of M. Meissonier in certain areas. The head and hand of the young woman turning the wheel are no longer by Chardin...his crystalline paint has been rubbed, scraped, and flattened...until it recalls the glossy paint of a Willem Mieris."

The Goncourts [1880, p. 123] pronounced the painting "cleaned and repainted in the manner of a miniature and having absolutely nothing to do with a Chardin," and Bocher (1876) spoke of a "copy."

We are in no way proposing that the Frick painting is not by Chardin. The x-radiograph published by Turner in 1957 [p. 307, fig. 6] revealed significant changes made by the artist in the course of its execution (for example, in the upper part of the painting there is a woman in half-length, upside down in relation to the finished picture), as well as the evident quality of the painting. Fur-

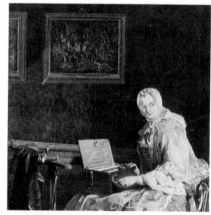

L. Cars, detail of the engraving showing in the background the Lépicié prints after pictures by Ch. A. Coypel.

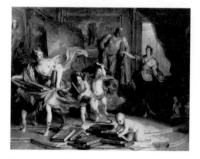

Coypel, Norfolk (Va.), Chrysler Museum.

Engraving by Lépicié.

ing in the Musée Borély in Marseille under the name of Bocher), in which we discern a *Return from Market*—is pure invention. It is generally agreed, on the other hand, that *The Bird-Song Organ* is definitely not a portrait of the famous writer. If we must find in the painting a resemblance to someone, that person would more likely be the second Mme Chardin, Marguerite-Françoise Pouget, although Chardin certainly had no intention of producing a portrait here.

The Bird-Song Organ represents Chardin's first royal commission. This has always been seen as surprising. Why did Tournehem ask the artist for a painting eleven years after Chardin had given the king *Saying Grace* and *The Diligent Mother?* Why did the painting enter the collection of Tournehem's successor as director of royal construction—Vandières—rather than the collections of the king? Why, in 1752, did Vandières commission a companion piece from Chardin for the first painting (still at this date in the royal collections), leaving to him the choice of a subject? And why didn't Chardin do this second painting?

We may have the beginnings of an explanation in the engravings decorating the background wall of the room in which *The Bird-Song Organ* scene takes place. Both these engravings were made after compositions by Charles-Antoine Coypel (1694-1752), first painter to the king and director of the Academy. The first, engraved by Lépicié in 1733, represents *Thalia Pursued by Painting,* an allusion to Coypel's double vocation of painting and theater [see Schnapper, 1968; the picture has just entered the Chrysler Museum at Norfolk]. The second, only a fragment off which can be seen, is also after a composition by Coypel and is entitled *Children's Games.* It, too, was engraved by Lépicié. By associating with his painting the king's first painter (Coypel, who was not to live much longer; a man well liked by all his colleagues at the Academy and admired throughout all Europe) and the all-powerful secretary of the Academy (and frequent engraver of Chardin, François-Bernard Lépicié [1698-1755]), Chardin may have wanted to show to whom he owed the favor of this very-well-rewarded commission. One has to wonder if it is by accident that Chardin received a royal pension, the first of his career, of 500 *livres* on 1 September 1752.

At the Salon of 1751, where *The Bird-Song Organ* was Chardin's only entry, the painting was the object of just one commentary. The text, *Jugements sur les principaux ouvrages exposés au Louvre* [1751, pp. 20-22] is unsigned and has been erroneously attributed to Ch. A. Coypel [Zmijewska, 1970, p. 53]. It deserves mention since, although it heaps praise upon Chardin, it does not avoid expressing certain criticisms and reproaching Chardin for his laziness:

"If one may compare small things with great, I would say that no one sees nature better than M. *Chardin* or possesses like him the Art of *catching it in the act.* His little painting on the training of a canary is charming; the woman whose head when seen up close does not have enough relief, is well placed and perfectly draped. All the surrounding accessories are rendered, and placed, in a very intelligent way. Perfect harmony reigns in this painting; one could

ask neither for a draughtsmanship more correct nor a better color tint. After all this praise dictated by the truth, I may be allowed to tell him that Nature, in overwhelming him with her favors, *has put herself out for an ingrate;* the Public is annoyed at never seeing more than one painting by a hand so skilled. I've been told that he was working at the present time on another, the subject of which struck me by it strangeness. In it, he is painting himself with a picture mounted on an easel in front of him; a little genie representing Nature is bringing him some brushes and he is taking them; but at the same time fortune is taking some of them away from him, and while he watches Laziness smile at him with an indolent air, the other falls from his hands. Given the talent M. Chardin has, how pleased the collectors would be if he were as industrious and as productive as Mr. *Oudry!*"

The lines written by Abbé Raynal in the November 1753 *Mercure de France* (p. 160) on the subject of the Laurent Cars engraving, which had just been published, are no less interesting:

"The painter's compositions, although simple and in keeping with the ways of the times, make no pretension to the heroic style. But the appropriateness of the choice and charm of the images offer a strong criticism of the Flemish painters in general. The fact of the matter is that smokers' kits, fist fights, the needs of the body—in short, Nature captured at her most abject—are the subjects most frequently treated by the Brauwers, the Ostades, the Ténières [*sic*], etc. M. Chardin has always avoided these images humiliating for humanity."

Haillet de Couronne pays *The Bird-Song Organ* a somewhat similar compliment, using it to take the same "nationalistic" stand, when he writes, upon the death of Chardin, that the "subjects [of Chardin] were dignified by a loftier choice of personages" (he is also speaking of *The Governess).*

A young woman is seated in an easy chair upholsered in *siamoise* (see [89]). She wears a cap and a hooded tippet over a dress embroidered with flowers. On her lap she holds a bird-song organ (a kind of small cylindrical organ used to teach canaries to sing). [From the *Avant-coureur* of 7 August 1769, pp. 500-1, we learn that M. Joubert "has for sale some of these bird-song organs to which he has adapted the newest, most prominent tunes.... All one has to worry about is turning the handle with a smooth motion.... He also makes some which one can use to spin silk by means of a little wheel which the handle turns when one plays the tunes" (see also, Mirimonde, 1977, pp. 58-60)]. In front of the woman is an embroidery frame on which is hung a large workbag; on the left, the bird cage sits on a stand equipped with a cross-piece which would make it possible to attach a screen in order to protect the canary from the light [cf. Roubo, III, III, 1774, pl. 328].

As we already noted concerning *Domestic Pleasures,* Chardin's manner of handling his interior scenes is evolving. We no longer have the tall forms of servant women filling the entire painting; these have been replaced by the elegant figures of bourgeois women posed in the middle of elegantly furnished rooms. The execution has also changed, becoming more polished, more detailed, more

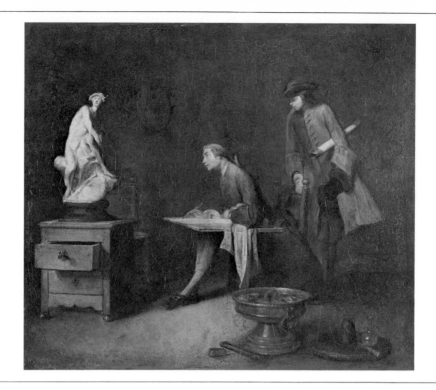

porcelain-like, sacrificing for the sake of a rather cold elegance its vigor and early roughness. The colors likewise have lost some of their boldness to softer pastel tints; the sheen of the dress embroidered with pink and green flowers, for example, is painted with a virtuosity that prepares us for Boilly.

Can we see in this evolution the increasing influence of Dutch painting? Whatever the case may be, never has Chardin been so close to Metsu, Netscher, Ter Borch, Mieris, and even G. Dou, without, however, abandoning that note of poetry and reverie which constitutes his originality.

94 *The Drawing Lesson*

(L'étude du dessin)

Canvas, 41 × 47 cm.
Sweden, Wanås Collection*

Provenance. All the evidence points to the conclusion that *The Drawing Lesson* and its companion piece, *The Right Education,* sent to Luise Ulrike of Sweden by Chardin in 1749, are the paintings subsequently owned by Count Sparre (1746-1794) and now at Wanås Castle in Sweden. (Later, we shall discuss the reasons which may call this identification into question.) When Sparre died in 1794 the two paintings were in Kulla-Gunnardstorp, a country estate belonging to the count; inherited in 1837 by Count C. de Geer and transferred to Wanås; in 1855 passed into the hands of Elisabeth Wachtmeister, niece of the count. The paintings have remained in this family since that time.

Exhibitions. 1748, Salon, no. 53 ("A painting representing the Serious Student to serve as companion piece to those which left last year for the Swedish Court"); *or* 1753, Salon, no. 59 ("Two paintings, companion pieces, under the same number. One represents a Draughtsman Copying Pigalle's Mercury and the other a Girl Reciting a Passage from the Gospels. These two paintings, from the collection of M. de La Live, are copied after the originals in the Collection of the King of Sweden. The draughtsman is exhibited for the second time with some changes"); 1926, Stockholm, no. 56; 1958, Stockholm, no. 75 (pl. 27).

Bibliography. Sander, 1878, p. 80, no. 79 (does not know the present whereabouts); Granberg, 1886, p. 293, no. 24; Cat. Wanås (Göthe), 1895, p. 12, no. 6; Dilke, 1899, p. 334, note 5, pp. 340-341; Dilke, 1899 (2), pp. 123, 124; Guiffrey, 1908, p. 95, no. 252; Pilon, 1909, p. 170; Furst, 1911, p. 134; Granberg, 1911, 1, p. 110, no. 489, pl. 66; Lespinasse, 1912, p. 220, no. 79; Wildenstein, 1933, no. 227; Goldschmidt, 1945, fig. 23; Florisoone, 1948, p. 57; Wildenstein, 1963-69, no. 222, pl. 37 (color); Hasselgren, 1974, pp. 57, 124, pl. on p. 165 (G.6).

For *Prints, Related Works,* and discussion, see [95].

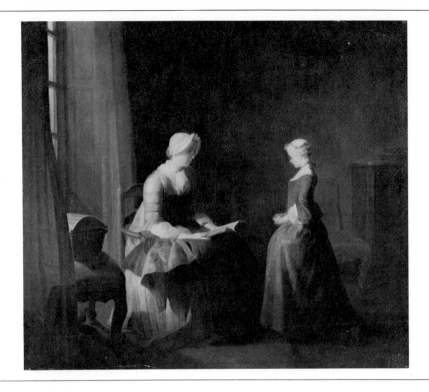

Engravings by Le Bas.

95 *The Right Education*

(La bonne éducation)

Canvas, 41 × 47 cm.
Sweden, Wanås Collection*

Provenance. See [94].

Exhibitions. 1753, Salon, no. 59 (?) (the catalog text has been cited in the preceding entry); 1926, Stockholm, no. 27; 1958, Stockholm, no. 74.

Bibliography. Sander, 1878, p. 80, no. 78 (does not know the present whereabouts); Granberg, 1886, p. 293, no. 25; Cat. Wanås (Göthe), 1895, p. 13, no. 7; Dilke, 1899, p. 334, note 5, pp. 340-341; Dilke, 1899 (2), pp. 123-124; Guiffrey, 1908, p. 95, no. 251; Pilon, 1909, p. 170; Furst, 1911, pp. 95, 134; Granberg, 1911, II, pp. 2-3, no. 6, pl. 9; Lespinasse, 1912, p. 219, no. 78; Wildenstein, 1933, no. 84; Goldschmidt, 1945, fig. 31; Florisoone, 1948, p. 57; Wildenstein, 1963-69, no. 223, pl. 36 (color); Hasselgren, 1974, pp. 57, 124, pl. on p. 165 (G.7).

Print. The frequently reproduced engraving of *The Drawing Lesson* [Normand, 1901, p. 68; Dacier, 1925, pl. 32; Snoep-Reitsma, 1973, p. 204, fig. 57; Fried, 1975-76, fig. 3] by Jacques-Philippe Le Bas (1707-1783) is oriented the same as the Wanås painting. But beyond that, it differs in some respects: the pair of fire-tongs is arranged another way; the piece of coal and the grinding stone next to it have been eliminated; and a chair which can be seen behind Pigalle's *Mercure* has also been removed. The caption for the engraving gives the

date of the painting as 1749. And the engraving is dedicated to the Queen of Sweden: "The painting is in Her Majesty's Collection." Bocher [1876, pp. 22-22, no. 18] and Sjöberg [1977, pp. 145-146, no. 132] list two states of the picture exhibited at the Salon of 1757 (no. 155).

The engraving after *The Right Education*, also done by Le Bas, bears the same date and dedication. It also shows Sweden's coat of arms [Bocher, 1876, pp. 13-14, no. 7; Sjöberg, 1977, p. 145, no. 131]. The engraving reverses the painting; otherwise, the engraving is more faithful to its original than its pendant. (It does, however, show more of the buffet.)

From the *Mercure de France* for August 1760 (p. 195) we learn that "the queen of Sweden…appreciative of the respectful care the author has taken to dedicate to her the engraving of two of her paintings chosen from several in Her Majesty's collection, has honored him with a magnificent medal bearing the imprint of her portrait."

There is a small reproduction engraved on wood of *The Right Education* in the work by Paul Lacroix (Bibliophile Jacob), *Institutions, usages et costumes* [1875, p. 269, fig. 149].

Related Works. We do not know whether the two paintings now in Wanås are the ones Chardin sent to Sweden in 1749 or the ones he exhibited at the 1753 Salon, whose whereabouts have been unknown since the La Live de Jully sale of 5 March (2-14 May) 1770. We point out that on 10 May 1844 a piece entitled "The student, the engraved picture" was put up for sale at Christie's of London, no. 40 of a Rochard sale (the Rochard brothers were art dealers and collectors). It is evident, however, that a version of *The Drawing Lesson* and one of *The Right Education* have disappeared.

Luise Ulrike (sister of Frederick the Great of Prussia and wife of Adolf Fredrik, future king of Sweden, 1710-1771), we recall, had received *The Morning Toilet* and *The Housekeeper* from Chardin at the beginning of 1747. Because the princess liked the two paintings, she wanted to acquire others. On 29 September 1747 the Swedish ambassador to Paris, Carl Fredrik Scheffer (1715-1786), wrote to his predecessor, Count Tessin [the unpublished letters of the two ambassadors have been very graciously made available by Jan Heidner]: "M. Chardin promises within a year the two paintings Your Excellency desires of him. But he has sworn to me that he is unable to finish them any sooner." Chardin asked for "one hundred *pistoles* per painting." On October 30 Tessin informed Scheffer that "the two paintings by Chardin, Luise Ulrike wants them whatever they cost." In a letter of 12 December 1747 to her mother [Arnheim, 1910, II, p. 88] Luise Ulrike wrote: "I am waiting daily for two paintings by Chardin." On 8 November 1749 Scheffer informed Tessin that "Monsieur Chardin who, slow as he may be, still finishes what he has begun, has just delivered to me the second of his two paintings commissioned two years ago at 1000 *livres* each." We know that the paintings had arrived in Stockholm on 25 November 1748 through a letter from the queen to her sister Amelia [Arnheim, 1910, II, p. 140]. Although listed in the 1760 inventory of Drottningholm [see Sander, 1878, and Lespinasse, 1912], the paintings were not mentioned in 1774.

It is generally held that the princess, who became queen in 1751, had given them to Count Gustaf Adolf Sparre (1746-1794). This hypothesis seems the most logical; we accept it, pending further information, although we do wish to make the following remarks:

(1) Judging from the captions on the Le Bas prints, the queen of Sweden's paintings were the ones he engraved. But if, in fact, the print of *The Right Education* is faithful to the painting, the print of *The Drawing Lesson* offers important variants with respect to the Wanås painting. As we have already pointed out, there is in the painting a chair behind Pigalle's *Mercury*, the pair of fire-tongs on the right foreground is differently arranged, the copper brazier is of another type, and, in particular, a piece of coal and a stone for grinding colors have been added. However, a second pair of paintings exist that are similar to the one sent to Sweden by Chardin. It belonged to La Live de Jully (1725-1779) at the time of the 1753 Salon and is described in the 1766 *Catalogue historique* (p. 20) of this avid collector. It passed through his sale of 5 March 1770 (actually, 2-14 May 1770, no. 97), and was acquired for 720 *livres* by Langlier for Boileau.

(2) The catalog for the 1753 Salon specifies clearly that *The Drawing Lesson* involves "changes" with respect to the painting on the same subject belonging to the queen of Sweden. These changes, which we have listed above, are to be found on the Wanås painting.

(3) We do not know why or exactly when Queen Luise Ulrike might have given her two Chardins to Sparre; in any case, two paintings on these subjects were in his possession when he died in 1794. But Sparre [cf. Hasselgren, 1974] was in Paris at the time of the La Live de Jully sale in 1770. He purchased at this sale one of the best-known pictures in the collection: *The Washerwoman* by Greuze (with Langlier acting as his agent), still in Wanås today. What is more, La Live de Jully wrote in the preface to the 1764 catalog of his collection (p. VIII): "I have put the name of the author on each piece, because it is very possible to know all there is to know about the Arts and still be unaware of the artist's name." So the frame of the La Live Greuze has the same identification sticker on its upper part, with the name of the artist, as the two Chardins!

Much ado about little, one may be tempted to say. Not so. Study of the reviews for the Salons of 1748 and 1753, which were favorable but often punctuated with negative implications, makes it easier to understand why Chardin was about to abandon painting figural compositions. In 1748 he exhibited only *The Draftsman;* he had not yet completed *The Right Education,* as Mariette, writing in 1749, makes clear: "At present he is making one for the Royal Prince of Sweden which shows a mother or a governess making a little girl recite a portion of the Gospel to form a pair with another painting exhibited at the last Salon and whose subject is a young student copying the Mercury of M. Pigalle."

The fact that he had sent only one picture to the Salon was the critics' first complaint against Chardin. Abbé Gougenot (1719-1767), for example [and not Baillet de Saint-Julien; see Zmijewska, 1970, p. 62], criticized him "for not giving enough relief to the flesh" [*Lettre sur la peinture...* , 1748, pp. 108-10]. (In another connection, the Abbé wrote, and his advice was to be heeded: "His talent for rendering so well certain moments of domestic life ought not cause him to abandon his talent for painting fruits and animals... "). The author of the *Observations sur les Arts et sur*

quelques morceaux de peinture... exposés au Louvre en 1748 wrote (but is he sincere?): "Far be it from us to think like some enlightened critics who have been claiming these last few years M. Chardin has lost his touch. One finds, on the contrary, that from time to time he enobles his genre, which we might describe as the *'genre marotique'* [i.e., the archaistic genre] in painting."

Chardin exhibited nine paintings at the 1753 Salon, although most of them had been painted some time before, and some were even dated early in the painter's career *(The Philosopher* [62], for instance, and the Musée de la Chasse *Hare* [22]). The reviews were far more numerous than in 1748. Abbé Le Blanc (1707-1782) was highly laudatory, and Jacques Lacombe (1724-1801) wrote: "It is the kind of thing which produces its total effect only at a certain distance; at close range the painting represents only a kind of haze which seems to envelop all the objects." But others criticized the "wretched attic" in which the scene takes place, the "figures whose legs are too long" [*Estève, Lettre à un ami,* 1753], the "lighting [which is] too washed out, too little colored," "a mist which does not dissipate, whether you stand close or farther away," "the heads... ambiguous and not well defined." The author of this last criticism, Abbé Garrigues de Froment [*Sentiments d'un amateur sur l'exposition des tableaux du Louvre,* 1753, p. 34], compares the two La Live paintings with *The Philosopher* of 1734: "He labors over his work, he polishes it nowadays. Is this change in manner and way of proceeding to our advantage? Informed connoisseurs claim that it is not."

For, in fact, Chardin has changed. The first thing we note is that he has abandoned the taller format for a wider one. His figures are arranged in a larger space, and yet they are not any better able to breathe. To be sure, the two paintings, *The Drawing Lesson* especially, are in far-from-perfect condition; some modifications by Chardin have become visible to the naked eye. The result is that the drawing sometimes appears unclear. Certain objects can be identified only through study of the engravings. But even when allowance has been made for deterioration, the paintings are still vulnerable to criticism. Although one can recognize without difficulty the rush workbasket on the left in *The Right Education,* illumined by the window light, it is not so easy to distinguish the ball of yarn and the spool lying in front of it, the buffet, and the two chairs of gilded wood along the wall. The two figures—mother and child—seem enveloped in that "mist" which one critic singled out for blame. The same is true of *The Drawing Lesson:* it is equally hard to pick out the palette hung near the chair on the background wall or the black muff which the young man wearing a three-cornered hat is holding in his left hand.

By putting Pigalle's *Mercury* in a prominent place on a small chest of drawers, Chardin's primary intention was to pay tribute to a friend. Pigalle (1714-1785) had executed the terra-cotta sculpture of his *Mercury Attaching His Heel-Wing* in Rome between 1736 and 1740. In 1742, as he was completing a large marble group for Frederick I of Prussia, the well-disposed critics of the Salon were identifying him and Chardin as two of the greatest living French artists. But the Pigalle-Chardin relationship was also more personal. Chardin owned a version of the *Mercury* (it is listed in his estate inventory of 1779, valued at six *livres!)* which he was to include on a number of occasions in his paintings [cf. Le Corbeiller, 1963]. Pigalle, for his part, admired Chardin; he owned six of his paintings: two hunting scenes, a trophy honoring the arts (see [125]), a still life with fruit, a luncheon scene, and a pastel portrait of Chardin.

Chardin had another reason for introducing the *Mercury* for the first time into one of his paintings: he wanted to take a stand. Abbé Gougenot [*Lettre sur la peinture,* 1748, p. 109] was well aware of this when he wrote: "The figure being copied is M. Pigalle's Mercury. By means of this choice, the author is letting it be known that our own School can furnish drawing with the purest models of correctness." He was indicating clearly that the young draftsman no longer had any need to look to Antiquity; he would find comparable masterpieces from now on in the modern French school.

The two Wanås paintings mark a distinct change in Chardin's technique. His touch is becoming more blended, more filmy, lighter. The extremely delicate coloring is becoming softer, more subdued, the tones reminiscent of pastel. In addition, while the observation of each gesture—for example, the joined hands of the little girl, or the strained faces of the draftsman and the companion watching him, or the position of the neck of each of the four protagonists—remains admirably correct, the themes chosen, the scenes fixed on canvas are less compelling, and therefore difficult to remember. The artist seems to have lost some of the strength of his technique as well as inspiration. Was he aware of this? Had the critics touched him to the quick? Why did he abandon this genre and return to the still life? We may indulge in all sorts of speculation, but no one knows the answer.

VI *Chardin's Return to Still-Life Painting*

At the Salon of 1748 Chardin showed only one genre scene: *The Drawing Lesson* [94]. His *Pear, Partridge, and Snare on a Stone Ledge* [96] dates from the same year. During the following twenty years, Chardin presented fewer and fewer genre scenes at the Salons; his still lifes, on the other hand, multiplied. In 1751, he showed *The Bird-Song Organ* [93], painted for the king; in 1753 he exhibited the *Portrait of the Painter Joseph Aved* [62] that he had painted twenty years before, along with the small *Blind Man of Quinze-Vingts* and replicas of both *The Drawing Lesson* [94] and *Good Education* [95]. In the last five Salons at which he entered genre scenes (1757, 1759, 1761, 1769, and 1773), he showed either older works or repetitions with changes of compositions he had "invented" between 1733 and 1740.

Had Chardin's creative springs dried up? It seems likely, but so far no entirely convincing explanation has been given for this exhaustion of a genre that had brought the artist such great success, nor for the new change of direction in his career. For while the artist's repertory of genre scenes was decreasing, his still lifes were increasing. He exhibited five of them in 1753, one in 1755 along with a trompe l'oeil, four in 1757, seven in 1759, and at least as many two years later, in 1761. The Salon of 1769 was the last to include his still-life paintings.

During this period Chardin's life, too, underwent considerable change. His second marriage in 1744 to Françoise-Marguerite Pouget brought him financial security. In 1752 he received the first of several pensions granted by the king. Five years later he obtained lodgings at the Louvre, a privilege he keenly appreciated. He also devoted more and more time to the Academy in various capacities, becoming treasurer in 1755 and, in the same year, beginning to take charge of picture-hanging and organizing the Salons — responsibilities recognized by official appointments in 1761.

Before examining Chardin's still lifes of this period, we must warn that he continued, just as he had done with his genre scenes, to exhibit at the Salons not only his recent work but also canvases he had painted more than twenty years earlier. To identify an existing picture with one that appeared at a certain Salon does not signify that it had actually been painted for that particular exhibition. To cite only one example: A "still life of game, belonging to M. Aved" at the Salon of 1753 is unquestionably *Hare with Gun, Game Bag, and Powder Flask* [22] now at the Musée de la Chasse et

de la Nature, painted about a quarter of a century earlier. This habit of Chardin has greatly vexed art historians concerned with the problem of his chronology and stylistic evolution.

The thirty or so still lifes from this period in the exhibition represent a striking variety of objects and themes: dead game [96, 98, 99, 101]; flowers [100]; ordinary fruits (peaches [130], plums [108, 121], and grapes [120]) as well as more unusual ones (pomegranates [117], melons [111], wild strawberries [115]); jars [114], various glasses, and tureens [103, 104]; coffeepots [116], and so on.

Yet one can hardly confuse these later still lifes with those of the period between 1725 and 1735. First, let us compare one of the dead rabbits from the earlier group with one painted a quarter of a century later. In the earlier pictures where the rabbit occupies much of the canvas, Chardin was concerned with the precise rendering of details, for example, the hairs and coloring of the pelt. Later, by contrast, the artist is concerned with masses and volumes; the composition itself has both a rigorous discipline and classic simplicity; the shifting instability of the earlier works is no longer evident. Instead of freshly shot game we now see dead animals painted with compassion and tenderness. A similar transformation applies to the silver goblets. Compared to the earlier ones [9, 10], the execution of the one in the Louvre picture [128] — done shortly before 1769 — has become smooth and fluid, with none of the thick impasto characteristic of the earlier works. Chardin now lends more presence to the object by letting the reflections of light bring out its very essence: no longer is it *a* silver goblet; it has become *the* silver goblet.

Second, there is definitely a stylistic development in Chardin's art over more than twenty years. Earlier, Chardin painted with bold brushstrokes, placed side by side without merging, in an almost pointillist technique that is particularly striking in the *Bouquet of Carnations, Tuberoses, and Sweet Peas* [100]. For a few years (ca. 1755-57) he multiplied the number of objects in his pictures and placed them at further distances, thus diminishing their scale in order to allow for more and more ambitious compositions. In the end, he concentrated increasingly on the effects of reflected light, on transparencies, on merged brushstrokes, and on thinned pigments. Becoming more and more concerned with the overall effect, he created a vision in which objects and fruits emerge, timeless and permanent, from a mysterious half-light.

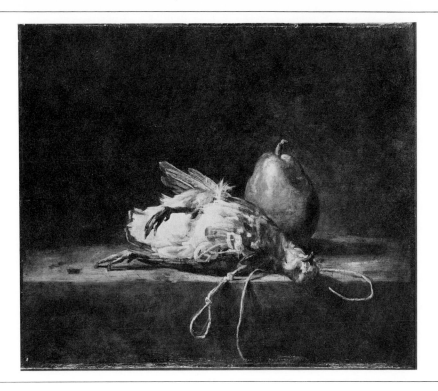

96 *Pear, Partridge, and Snare on a Stone Table*

(Perdrix morte, poire et collet sur une table de pierre)

Canvas, 39 × 45.5 cm. Signed and dated at the lower left: *Chardin 1748.*
Frankfurt, Städelsches Kunstinstitut*

Provenance. Ch. de Boissière sale, 19 February 1883, no. 12. Baron de Beurnonville sale, 3 June 1884, no. 364. X sale in Versailles (Palais des Congrès), 13 May 1970, no. 77 (color pl.); removed from the sale [see *Connaissance des Arts,* 1970]. Acquired by the Frankfurt museum in 1973.

Exhibitions. Never shown.

Bibliography. Wildenstein, 1933, no. 748 ("doubtful or inauthentic, or which we have not seen"); *Connaissance des Arts,* September 1970, p. 29 (F.D.R.); *La Chronique des Arts,* Supplement to *Gazette des Beaux-Arts,* February 1974, p. 58, no. 184 (ill.); Lenz, 1975, p. 299 (ill.).

This handsome still life with game, recently acquired by the Frankfurt museum, has the very great merit of being dated—very probably 1748. The theme must have inspired Chardin on several occasions. He exhibited a *Partridge and Fruit* belonging to "M. Germain" at the Salon of 1753, and a painting on the same subject figured at the Prince de Conti sale in 1777. The work was painted between *Meal for a Convalescent* [92], shown at the Salon of 1747, and *The Bird-Song Organ* of 1751, at a time when Chardin's activity was slowing down appreciably and the Salon critics were taking him to task for exhibiting too little.

Had Chardin never stopped painting still lifes? Or is the Frankfurt still life one of the first he did after a long interruption? In any case, there are no known paintings of this kind dating between 1736 and 1748.

The red partridge lies on its side on a stone table beside the snare and a large butter pear. The red and gray belly of the partridge and the bright red of the pear splashed with green stand out against the scumbled background of the canvas painted in a warm harmony of browns. The execution is rapid and sure, without the finish and polish of the figural paintings done at the same time. The composition is extremely simple: the horizontal axis formed by the table and the dead bird is broken by the stem of the fruit and the snare. The slip-knot of the snare draws attention to the little drama Chardin has succeeded in conjuring up with his usual restraint.

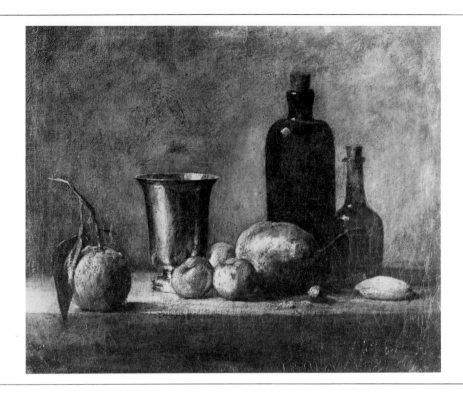

97 *Seville Orange, Silver Goblet, Lady-Apples, Pear, and Two Bottles*

(Bigarade, gobelet d'argent, pommes d'api, poire et deux bouteilles)

Canvas, 38 × 46 cm. Signed and dated at the lower right, on two lines: *Chardin/175*(?); the last digits have been read in turn as 38, 50, and 56. Paris, Private Collection

Provenance. Acquired with [106] in this catalog by François Marcille (1790-1856) at the estate sale of Gabriel d'Arjuzon (1761-1851), 2-4 March 1852, no. 2, "still life" (or no. 3, companion piece of no. 2), for 368 francs 55 (memorandum of sale with the name of Marcille as acquirer pasted to the verso of the painting). Collection of Eudoxe Marcille (1814-1890); has remained in this family.

Exhibitions. 1860, Paris, no. 110 ("1750"); 1878, Paris, no. 33 ("1750"); 1959, Paris, no. 13 ("1750 or 1756"); 1961, Paris, no. 9.

Bibliography. Bürger (Thoré), 1860, p. 235; Horsin-Déon, 1862, p. 137; Bocher, 1876, p. 100 ("1738"); Goncourt, 1880, p. 130 ("1738"); Chennevières, 1890, p. 302; Guiffrey, 1908, p. 80, no. 146 ("1738"); Goncourt, 1909, p. 191; Furst, 1911, p. 126; Wildenstein, 1933, no. 787, fig. 99 ("1756"); Lazarev, 1947, fig. 9; Barrelet, 1959, p. 308 ("1756"); Faré, 1962, p. 164; Wildenstein, 1963-69, no. 245, pl. 39 (color) ("1756"); Lazarev, 1966, pl. 14; Faré, 1976, p. 161; Arjuzon, 1978, p. 58.

Related Works. Supposedly, a replica of this painting is in a private collection in New York; we know it only through the photograph in Faré [Faré, 1976, p. 159, fig. 244]. For the "companion piece," see [106].

Although this painting was certainly paired with the *White Teapot...* [106] in the collection of Count d'Arjuzon (before 1852, therefore), we are not sure that the two paintings are companion pieces or even works executed at the same time. [G. de Lastic does not seem convinced that they are either; see exh. cat. Paris, 1959, no. 13.] This still life presents an arrangement, on a stone table, of a Seville orange with its stem and a green leaf, a stemmed silver goblet, three lady-apples, a pear, a hazelnut, a macaroon (or a marzipan biscuit) and two bottles—a half-empty green one containing a red liquid and a smaller one of clearer glass filled with a yellow liquid.

The composition has been balanced with a rigor not present in the still lifes of the 1730s. The position of each fruit and each object has been meticulously calculated with an eye to its color, luminosity, material, and proportions. However, the cold light entering from the left differentiates them more than it envelopes them (contrary to Chardin's approach from 1758 on); it illuminates the fruits, the silver, and the glass more than it bathes them in itself; it attracts reflections more than it gives them off. Given this unusual quality, we think the Marcille painting is a transitional work and, like the Frankfurt *Pear, Partridge and Snare...* of 1748, is one of the first examples of Chardin's authoritative return to still life after an almost uninterrupted hiatus of more than ten years. Therefore, we rally to the side of Philippe Burty who did not hesitate, when drawing up the catalog for the 1860 exhibition at the Galerie Martinet, to date the painting 1750.

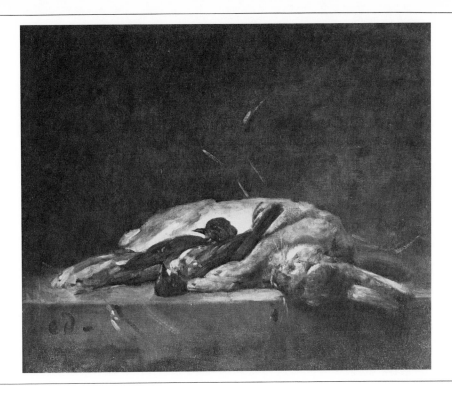

98

See Color Plate XIV.

98 *A Rabbit, Two Thrushes, and Some Straw on a Stone Table*

(Un lapin, deux grives mortes et quelques brins de paille sur une table de pierre)

Canvas, 38 × 45 cm. Monogram at the lower left: *c d* (as on the Stockholm *Rabbit* [78]).
Paris, Musée de la Chasse et de la Nature

Provenance. Estate sale of the sculptor Jean-Baptiste Lemoyne (1704-1778), 10 August 1779, no. 29 (not no. 28, as Wildenstein has it): *Un lapin et deux oiseaux, 14 × 16 pouces* ("A rabbit and two birds," 38 × 43 cm.). Sale of the collection of Madame de La Fresnaye, 4 March 1782, no. 24, *Un lapin et deux oiseaux morts sur une table de pierre, 1 pied 6 pouces × 1 pied 10 pouces* ("A rabbit and two dead birds on a stone table," 48 × 59.5 cm.) (?). Could be the picture now in the Musée de la Chasse, but only if these dimensions include the frame. Inheritance sale of Mme de M[andrin], Paris, Galerie Charpentier, 10 December 1935, Letter A. Private collection in the United States in 1962 [de Batz, who says it belonged to "M. de Mondrol"]. Sale, Sotheby's of London, 8 December 1965, no. 66 (plate in the cat.).

Exhibitions. Never shown.

Bibliography. Wildenstein, 1933, no. 724 (whereabouts unknown) (and 726?, La Fresnaye sale); de Batz, 1962, p. 272 (ill.); Wildenstein, 1963-69, no. 38 ("disappeared"; "around 1727") (and 31? "disappeared"; "around 1726-1728," La Fresnaye sale).

Of the four works by Chardin in the Musée de la Chasse, this one is the latest. It must have been painted a few years after the Frankfurt *Pear, Partridge, and Snare...* (1748), close in time to the *Rabbits* of the Amiens museum [101], whose companion piece it may originally have been.

A wild rabbit and two thrushes lie on a stone entablature, as if abandoned. Chardin had taken on this theme more than once some twenty years earlier. Here, however, he treats it in an entirely new way. In the first place, the rabbit and birds take up far less room on the canvas. The dead animals are subordinated to a large empty space, with the result that the scene breathes more freely. The color scale is also much more restrained, consisting of muted tones—a whole range of harmonizing grays with only a white splash of the dead rabbit's belly in the center of the composition and a touch of red on the breast of one of the birds. The execution, finally, which aims primarily to render volume by means of masses and no longer through the application of rough brushstrokes, is very new. Chardin is stressing the total effect and attempting to render the weight of what he shows us more than its surface and appearance. Whereas in earlier still lifes he depicted freshly killed game, he now paints dead animals and birds with tenderness and compassion.

299

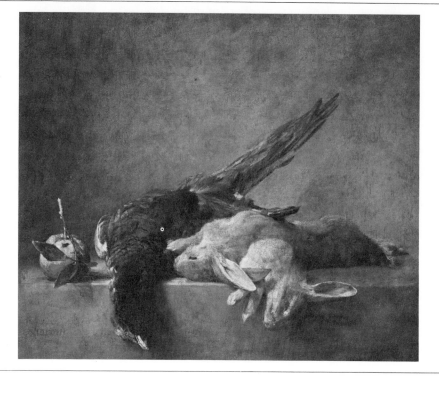

See Color Plate

99 *Two Rabbits, A Pheasant, and Seville Orange on a Stone Ledge*

(Deux lapins, un faisan morts et une bigarade sur une table de pierre)

Canvas, 49.5 × 59.5 cm. Signed at the lower left: *Chardin* (the date is illegible).
Washington, National Gallery of Art, Samuel H. Kress Collection

Provenance. David David-Weill Collection in Paris in 1926 (the painting appears in a canvas (ca. 1928) by Vuillard representing the collector. Collection of Samuel H. Kress in 1946. Given to the National Gallery in Washington in 1952.

Exhibitions. 1937, New York, no. 5; 1939, New York, no. 18 (pl.).

Bibliography. Henriot, 1926, p. 43, pl. on p. 45; Wildenstein, 1933, no. 714, fig. 83; Jourdain, 1949, pl. 52; Museum cat. (Suida), 1951, p. 228, no. 102, pl. on p. 229; Einstein, 1956, p. 234, fig. 16 on p. 230; Einstein, 1956, p. 22, fig. 16 on p. 18; Museum cat., 1959, p. 353, no. 1115 (pl.); Rosenberg, 1963, pp. 72-73 (color pl.), 80 (color detail); Wildenstein, 1963-69, no. 30, pl. 1 (color); Museum cat., 1975, p. 66, pl. on p. 67; Museum cat., 1975, p. 80 (ill.); Kuroe, 1975, pl. 1 (color); Walker, 1975, p. 325, no. 432 (color pl.); Faré, 1976, p. 151, fig. 232; Eisler, 1977, pp. 314-15, fig. 277.

The early history of this splendid painting is unknown to us. It belonged to the David David-Weill collection before World War II and entered the National Gallery of Washington in 1952 with the Kress collection.

Wildenstein is alone in proposing a date from the beginning of Chardin's career: 1726 to 1728. In our view, it cannot be earlier than 1750. The date proposed in 1977 by Colin Eisler—shortly before 1760—seems entirely reasonable after comparing the work with the Louvre's *Jar of Olives* [114] on which we see the same Seville orange. The two works have in common the same neutral brown background (very different from the stone niches of Chardin's early works), the same rather powdery light bathing an extremely simple composition. Chardin adds to the wild rabbits of the Musée de la Chasse and the Amiens museum, which have been tossed pell-mell on a stone ledte, a Seville orange (a type of bitter orange used in eighteenth-century pastries). The artist has attempted to paint the skin of the fruit, the plumage of the bird, and the fur of the little rabbits as economically as possible. He is concerned less with details than with solidity, volume, mass, the weight of things. In this painting Chardin had in mind rather than a sumptuous hunting scene glorifying the marksman, a discreet and modest tribute to the victims.

100 Bouquet of Carnations, Tuberoses, and Sweet Peas in a White Porcelain Vase with Blue Decoration

(Bouquet d'oeillets, de tubéreuses et de pois de senteur dans un vase de porcelaine blanche à motifs bleus)

Canvas, 44 × 36 cm.
Edinburgh, National Gallery of Scotland*

Provenance. Very probably the painting in the collection of the painter Aved, Chardin's faithful friend (estate sale of 24 November 1766, no. 136; see *Related Works*). Collection of François-Martial Marcille (1790-1856) as of 1846 [see Hédouin], then of his son Camille Marcille (1816-1875). In a letter dated 1863 written to the Goncourts and accompanied by a sketch showing the canvas, Camille Marcille wrote: "It was bought by my father toward the end of his life from a collector whose name I do not know" [see Adhémar, 1968; Huisman (1959) said it had been purchased from a "demolition contractor"]. Marcille sale, 6-7 March 1876, no. 18. Acquired by the Marquis de Charly [Guiffrey, 1908]. Edmond Borthon collection, Dijon, in 1890. Raoul d'Hotelans collection, Novillars. David David-Weill collection aroud 1922-1923 (it can be seen with two other Chardins from the same collection in a painting depicting the collector, done around 1928, by Vuillard. Purchased by the National Gallery of Scotland in 1937 from the Cowan Smith Fund.

Exhibitions. 1858, Chartres, no. 60; 1869, Chartres, no. 19; 1929, Paris, no. 9; 1932, London, no. 204 (in commemorative cat., no. 157, pl. 64; 1952, Paris, no. 79, pl. 32; 1954, Rotterdam, no. 50, pl. 31; 1966, The Hague, no. 35 (ill.); 1966, Paris, no. 36 (pl.); 1968, London, no. 138, fig. 189.

Bibliography. Hédouin, 1846, p. 226, no. 69; Hédouin, 1856, p. 197, no. 69; Goncourt, 1864 (fascicule), p. 9, note 1; Bocher, 1876, p. 97; Saint-Victor, intr. to cat. for Marcille sale, 1876, p. V; Goncourt, 1880, p. 128; Cat. Edmond Borthon coll., 1890, no. 17; Guiffrey, 1908, p. 43; Goncourt, 1909, pp. 107, 189; Henriot, 1925, p. 2, pl. 4; Henriot, 1926, p. 53, pl. on p. 55; Alexandre, 1929, p. 525 (ill.); Bazin, 1932, p. 22, fig. 63; Wildenstein, 1932, p. 55 (ill.); Wildenstein, 1933 (2), p. 373, fig. 9; Wildenstein, 1933, no. 1102, fig. 94; *Beaux-Arts*, 4 June 1937, no. 231, p. 1 (ill.); *Apollo*, XXVII, 1938, pp. 176 (color repr.), 226; De la Mare, 1948, pl. 6 (color); Jourdain, 1949, fig. 48; Sterling, 1952, p. 80, pl. 72 (color); *Scottish Art Review*, 1953, no. 4, p. 8 (ill.); *Emporium*, February 1955, p. 91 (ill.); Museum cat., 1957, p. 46, no. 1883 (ill., 1965, p. 16 C); Huisman, 1959, p. 81 (repr.); Wildenstein, 1959, p. 105; *Du*, December 1960, p. 35 (ill.); Nemilova, 1961, pl. 14; Garas, 1963, pl. 37; Rosenberg, 1963, pp. 70 (color pl.), 75, 85; Wildenstein, 1963, no. 313, pl. 17 (color); Thuillier and Châtelet, 1964, p. 206; Lazarev, 1966, pl 27 (color); Valcanover, 1966, pl. 17 (color) and color cover; Adhémar, 1968, p. 232; Demoris, 1969, p. 366; Museum cat., 1970, p. 13; Museum cat. (Baxandall), 1971, p. 76, color pl. on p. 77; Thompson, 1972, p. 106, fig. 98; Kuroe, 1975, pl. 25 (color); Faré, 1976, pp. 162, 165, fig. 253; *Le Larousse des grands peintres*, 1976, directed by M. Laclotte, p. 62 (color pl.); Wright, 1976, p. 37; Faré, 1977, p. 182 (ill.); *Chefs-d'oeuvre de l'Art. Grands Peintres*, 1978, pl. 17 and color cover.

Related Works. This is a list of contemporary references to Chardin which might relate to this painting:

(1) Salon of 1761. No critics allude to a painting of flowers by Chardin, but a sketch made by Saint-Aubin on the margin of his copy of the catalog (p. 13), preserved today in the Cabinet des Estampes, Bibliothèque Nationale, informs us that Chardin did exhibit a painting on this subject [cf. Stryienski, 1903, p. 65, and Dacier, 1911]. It was probably one of the "other paintings" included in catalog entry no. 46. Saint-Aubin's sketch shows an oval painting. To the extent that one may trust his sketch, the vase had a narrower neck.

(2) Salon of 1763, no. 59: "The Bouquet" belonged to Count Saint-Florentin, along with a companion piece. It is sometimes identified with the painting in the Louvre [118].

(3) Estate inventory of the painter and friend of Chardin, Joseph Aved (1702-1766), 16 June 1766, no. 66: *Des fleurs dans un vase de porcelaine, tableau de M. Chardin prisé 15 livres* ("Flowers in a porcelain vase, painting by M. Chardin valued at 15 *livres*"); Aved sale,

Saint-Aubin, drawing after the picture exhibited at the Salon of 1761.

24 November 1766, no. 136: *Des fleurs dans un vase de porcelaine blanche à fleurs bleues posé dur une tablette* ("Flowers in a white porcelain vase with blue flowers on a small table," 17 × 14 *pouces* [46 × 38 cm.]; sold for 12 *livres* to Rémy). Generally identified with the Edinburgh painting.

(4) Inventory of the collection drawn up in 1744 by the draftsman Thomas-Aignan Desfriches (1715-1800), friend of Chardin: *Fleurs, esquisse 48 livres* ("Flowers, sketch, 48 *livres*") [valued at 42 *livres* and entitled "pot of flowers" in another undated inventory; see Ratouis de Limay, 1916, p. 268]. This painting was not in the Desfriches sale of 1834.

(5) Estate inventory of Chardin, 18 December 1779: *Un tableau de fruits et de fleurs ou est un concombre prisé six livres* ("Painting of fruits and flowers with a cucumber, valued at 6 *livres*") and *Un pot à l'eau et des fruits prisé six livres* ("Water pot and fruit, valued at 6 *livres*"). These two paintings were not in the Chardin sale of 1780.

When the Goncourts' first article on Chardin appeared in the 1863 *Gazette des Beaux-Arts*, Camille Marcille wrote to the authors, congratulating them and giving them some precise details about the Chardins he owned. Thus we learn that the *Vase of Flowers* that he sketched in the margin of his letter had come to him from his father, who had acquired it shortly before his death in 1856 or, at

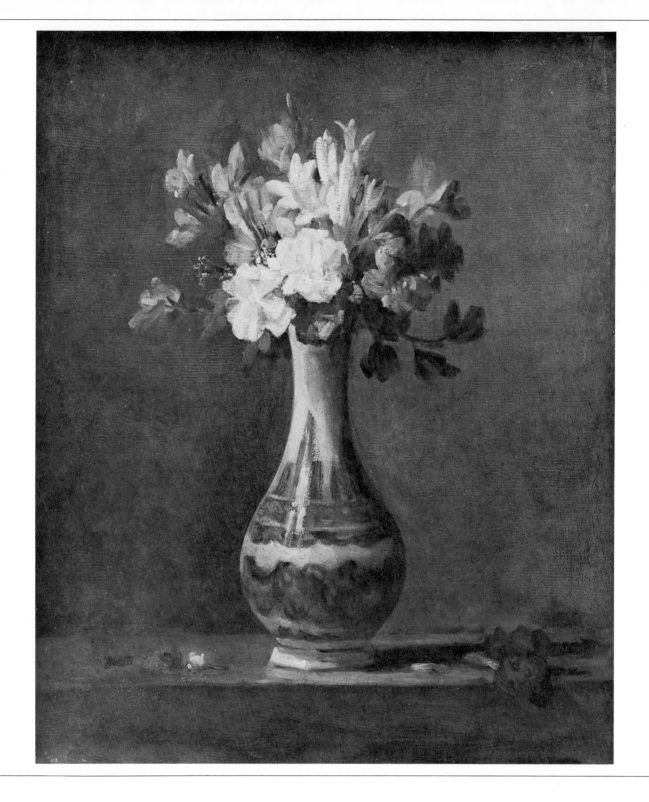

the latest, in 1846 [Hédouin]. The Goncourts republished their *Chardin* in 1864 in fascicule. They added to the passage on *Basket of Wild Strawberries* [115] (which they called *carnations,* and which belonged to Eudoxe Marcille, the brother of Camille), the following note: "These carnations... can only compare with the marvelous bouquet of tuberoses and sweet peas in a Japanese vase belonging to M. Camille Marcille."

Whether the painting shows a "Japanese" vase or one from Delft is most uncertain. Our colleagues at the Sèvres museum, M. Fourest and Mme Hallé, hesitate between an oriental porcelain and a German faience. Whatever the case may be, this long-necked vase — too tall for the flowers it contains — is to be found in no other Chardin painting.

Chardin flower paintings are, moreover, very rare (we have given a list of them above). The artist seems to have painted them all rather late. The one now in Edinburgh, the only one to survive, very probably comes from the collection of Chardin's faithful friend, the painter Aved. The date generally proposed — 1760 to 1763 — seems to us quite convincing. The painting's broad brush-strokes neatly placed on the canvas without any blending relates this piece technically to the *Pheasant* in Washington [99], which we prefer to date approximately 1754. But the Edinburgh painting's uniqueness weakens any hypothesis one might formulate.

The painting depicts white carnations, tuberoses, sweet peas, and, on a small table, a few petals and one red carnation. Since World War II it has been one of the most frequently reproduced Chardin paintings. It appears, for example, on the cover of the popular Italian collection *I Maestri del Colore.* This popularity is richly deserved. "The simplification of form and relief, thee classic calm of the composition," writes Sterling [exh. cat. Paris, 1952], "make of this painting... the immediate precursor of Cézanne's." Sterling insists that the "spirit of synthesis" is more modern than evething painted by Delacroix, Millet, Courbet, Degas, and the Impressionists. Still commenting on this exceptional painting, Sterling adds [1952, p. 80]: "It is impossible to imagine anything more "advanced" in composition and pictorial treatment.... Only with Cézanne... can one imagine such strength in as much simplici-ty. Before Chardin, only with Vermeer (from whom one vainly waits for a still life) could such serenity have been born of a few har-monies in white and blue seen in a milky light."

101 *Two Rabbits with Game Bag and Powder Flask*

(Deux lapins avec une gibecière et une poire à poudre)

Canvas, 50 × 56.5 cm. (enlarged at the top and bottom by 18 mm. and on the right by 22 mm.).
Amiens, Musée de Picardie

Provenance. Most likely, estate sale of the sculptor Jean-Baptiste Le-moyne (1704-1778) (as also [98]), 10 August 1778, no. 28, *Un tableau représentant deux lapins posés sur une gibecière, 15 × 20 pouces* ("Painting representing two rabbits lying on a game bag," 40.5 × 54 cm.). Sale [Didot], 27-28 December 1819, no. 24, *Deux lapereaux et quelques accessoires de chasse sont posés sur un appui en pierre, 19 × 21 pouces* ("Two young rabbits and some hunting equipment are placed on a stone ledge," 51.5 × 56.5 cm.); the catalog of this collection claims that the painting, along with three other Chardins (see [93]), comes from the collection of Mme Geoffrin. X sale, 18 March 1829, p. 7, no. 8, *Deux lapereaux morts et étendus auprès d'une carnassière et d'une poire à poudre. Etude d'apres nature de la plus grande verité* ("Two dead young rabbits laid out near a game bag and powder flask. Study from nature of the greatest truth"). In the Paris collection of the brothers Ernest and Olympe Lavalard as of 1862; given to the Amiens museum in 1890.

Exhibitions. 1883-1884, Paris, no. 25; 1931, Paris, no. 5; 1951, Paris, Salon de la Chasse et de la Venerie (no cat.); 1959, Paris, no. 24; 1966, Vienna, no. 12; 1975, Brussels, no. 87 (ill. on p. 131).

Bibliography. Horsin-Déon, 1862, p. 145; Bocher, 1876, p. 95; Gonse, 1900, p. 15; Guiffrey, 1908, p. 62, no. 33; Museum cat., 1911, p. 131, no. 137; Furst, 1911, p. 119; Courthion, 1932, p. 537 (ill.); Wildenstein, 1933, no. 704, fig. 88 (and 723?, Lemoine sale, 1778); Denvir, 1950, pl. 35; Wildenstein, 1960, p. 2; Vergnet-Ruiz and Laclotte, 1962, pp. 84 (ill.), 93, 230, and fig. 103; Rosenberg, 1963, pp. 72 (color pl.), 84; Wildenstein, 1963-69, no. 32, fig. 15 ("around 1726-1728" (and 37 ? "disappeared," Lemoine sale, 1778); Valcanover, 1966, pl. 12 (color); Foucart *père*, 1977, pp. 25-30, 43, 50; *Chefs-d'oeuvre de l'Art. Grands Peintres*, 1978, pl. 12 (color).

This somewhat worn painting that has been enlarged on three sides probably comes — like *A Rabbit...* of the Musée de la Chasse [98] (whose companion piece it may be) — from the estate sale of the sculptor Jean-Baptiste Lemoyne. Lemoyne owned a fine collection of Chardin paintings (several of which were put up for sale after the death of his son, the architect Pierre-Hippolyte Lemoyne, on 19 May 1828). In addition to the *Monkeys* of the Chartres museum [66, 67], the sculptor's collection included a *Still Life with Fruit,* an *Embroiderer,* and a *Young Draftsman.*

The composition is very simple: the horizontal line, formed by the bodies of the young rabbits lying on the stone ledge is alleviated by the head of one and by the ribbon of the dangling powder flask. Only the brief blue of the ribbon and touch of straw-yellow made by the game bag interrupt the muted color scheme of grays and browns. Chardin eliminates all detail, seeking the effect of the ensemble. One must step back in order to grasp the painting as a whole, to better interpret the subject. But Chardin is after more. He is not indifferent to the scene he shows us: this attentive and sympathetic observer renews a subject that is the height of banality,

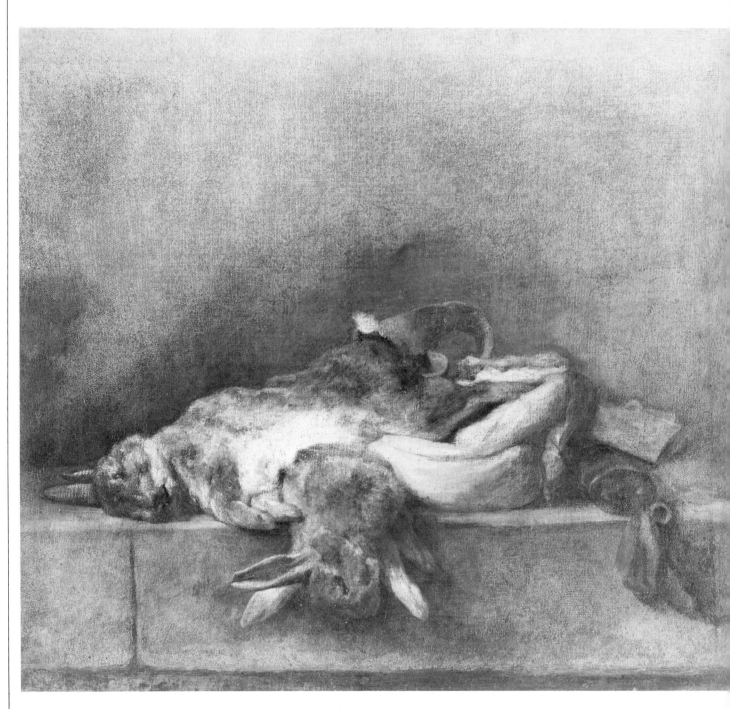

101

repeated by generations of still-life painters, and brings to it a note of restrained emotion that is very personal. Few painters have been able to evoke death with such discretion.

102 Kitchen Table (also called Preparation for a Meal with Chicken, Loin of Mutton, Copper Pot, Faience Pitcher and Other Utensils)

(La table de cuisine, dit aussi Préparatifs du repas avec poulet, carré de mouton, marmite de cuivre, pot de faience et autres ustensiles)

Canvas, 39 × 47 cm. Signed and dated at the bottom right on two lines: *Chardin/1755* (the last two digits, which are very faint, have often been read as 33).
Boston, Museum of Fine Arts

Provenance. Collection of Ange-Laurent La Live de Jully (1725-1779) at the time of the 1757 Salon; does not appear in the catalog of that collection (1764), nor in the 1770 sale. Sale of P[eters] (Johann Anton de Peters, 1725-1795), 9 March 1779, no. 104 (probably bought back through the intermediary of Basan for 130 *livres*): "A kitchen and pantry; in one we see a chicken, loin of mutton, copper pot, faience pitcher, and other necessary utensils; in the other, a pâté, some fruit, a tureen, an oil and vinegar cruet, etc. These two paintings, admirable for brushwork and color, are on canvas; each measures 13 *pouces* 6 *lignes* high by 16 *pouces* 6 *lignes* wide [36.5 × 44.5 cm.]." Estate sale of Mme de Peters, 5 November 1787, no. 165: "A kitchen where one sees a chicken, a loin of mutton, copper pot, faience pitcher, and other necessary utensils.... It comes from the collection of the late M. La Live" (14 × 17 *pouces* [38 × 46 cm.]; probably bought back for 98 *livres* by Rémy). Sale of M. du C[harteaux et Salavet] (by Rémy and Le Brun), 30 April-2 May 1791, no. 146: "Tables on which are a pâté, a tureen, an oil and vinegar cruet, a loin of mutton, a fowl, and kitchen and pantry utensils; these two richly composed paintings are beautifully painted; they were made with care for M. de Juli de La Live [*sic*], patron of the Arts." Gift of Mrs. Peter Chardon-Brooks to the Boston museum in 1880.

Exhibitions. 1757, Salon, no. 33 ("Two paintings, one of which depicts preparations for some food on a kitchen table; and the other, some dessert on a pantry table. They are from the French collection of M. La Live de July"); 1783, Salon de Correspondance, no. 80 ("Kitchen utensils with meat, belonging to M. de Peters, Painter"); 1931, Cambridge, no. cat.; 1935, Toronto, no. 6, repr. p. 14; 1938, Cambridge, no. cat.; 1956, Cincinnati and Milwaukee, no. 13.

Bibliography. Downes, *Atlantic Monthly*, October 1888, p. 501; Furst, 1911, p. 134 ("1735"); Museum cat., 1921, p. 79, no. 190; Museum cat., 1932, pl. (unpaginated); Wildenstein, 1933, no. 949, fig. 163 (and no. 948A); Gammell, 1946, pl. 45; Denvir, 1950, pl. 5; Museum cat., 1955, p. 11; Fussiner, 1956, pp. 303 (fig. 1), 304, 310; Faré, 1962, p. 163; Wildenstein, 1963-69, no. 120, fig. 53 ("1733") (and no. 239 "disappeared"; perhaps identical in the English edition with either the Boston painting or the one in Cherbourg [105]); Faré, 1976, p. 158; Fried, 1977, p. 97 (repr.).

See [103] for discussion.

103 Butler's-Pantry Table (also called Dessert with Pâté, Fruits, Tureen, Oil and Vinegar Cruets)

(La table d'office, dit aussi Partie de dessert avec pâté, fruits, pot à oille, huilier)

Canvas, 38 × 46 cm. Signed and dated at the right on two lines: *Chardin / 1756*.
Carcassonne, Musée des Beaux-Arts

Provenance. See [102]. This painting was not included in the Salon de la Correspondance of 1783 nor, contrary to what Wildenstein has written, at the second Peters sale in 1787. Collection of Augustin-Jean Seraine (1782-1865), retired army captain; gift to the Carcassonne museum in 1846.

Exhibitions. 1757, Salon, no. 33 (for the text of the cat., see preceding entry); 1935, Copenhagen, no. 30; 1938, Carcassonne, no. 24; 1949, Geneva, no. 66; 1975, Brussels, no. 92, pl. 3 (color).

Bibliography. Museum cat., 1864, p. 10, no. 17; Goncourt, 1864, p. 150, note; Museum cat., 1894, p. 8, no. 19; Guiffrey, 1908, p. 63, no. 43; Furst, 1911, p. 120; Guiffrey, 1913, pp. 540-41; Wildenstein, 1933, no. 1059, fig. 160 (and no. 982); Huyghe, 1935, p. 3; Museum cat., 1949, pp. 31-32; Barrelet, 1959, p. 310; Wildenstein, 1959, p. 105; Adhémar, 1960, p. 457; Museum cat., 1960, p. 32 (repr.); Faré, 1962, p. 163; Vergnet-Ruiz and Laclotte, 1962, pp. 84, 93, 230, fig. 104; Wildenstein, 1963-69, no. 258, fig. 122 (and no. 240, "lost"); Faré, 1972, pp. 160-61.

Related Works. For the Louvre replica, see [104].

Ange-Laurent La Live de Jully (1725-1779) [see B. Scott, 1973], the owner of many Chardins and "introducer of ambassadors," was an "honorary member of the Académie de Peintre," a friend of all the artists of his day, a draftsman, and a talented engraver. He had lent some replicas of *The Drawing Lesson* and *The Right Education,* possibly the paintings now in Wanås [94, 95], to the 1753 Salon. In 1757 he exhibited two still lifes, for which the catalog gave only titles: *l'une représente... quelques mets sur une table de cuisine et l'autre une partie de dessert sur une table d'office* ("one represents some dishes on a kitchen table and the other a dessert course on a butler's-pantry table"). Fortunately, various eighteenth-century sales catalogs (see [102], *Provenance*) provide us with exact descriptions. Two sales were held of the collection of the Cologne painter Johan Anton de Peters (1725-1795) [on this painter-engraver, see the excellent study of Hella Robels, 1972]. Because of these two sales, we can be certain (as D. Carritt proposed in a 1977 conversation) that the Boston and Carcassonne paintings are indeed the ones lent by La Live de Jully in 1757 (only the Boston painting was in the second sale, and the La Live provenance is given only in the catalog of this second sale). To be sure, it is not clear why only the Boston painting appeared at the second Peters sale (1787), why it alone had been lent by Peters to the Salon de la Correspondance of 1783, and how it had rejoined its companion piece at the sale of M. du C. in 1791. Granted, the drawings of Gabriel de Saint-Aubin (1724-1780) in the margin of his copy of the catalog for the first

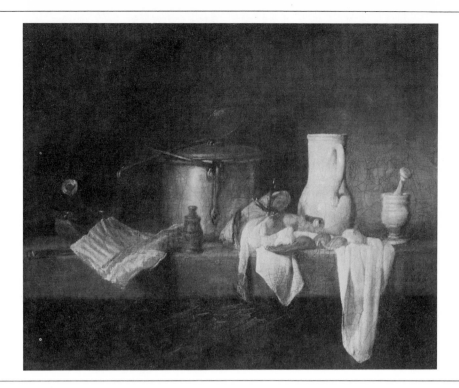

Peters sale (1779), reproduced by Dacier [1919 (IX), p. 31 and note 3; p. 32 of the fascimile], are too vague to definitely confirm our hypothesis. Granted, the 1755 date on the Boston painting is scarcely legible. But each of the objects mentioned in the sales catalog descriptions is to be found in both paintings. On the one we have the *kitchen* table, the chicken, the loin of mutton, the copper pot, the faience pitcher. Not mentioned are the frying pan, the knife, the skimmer, the pepper box, the mortar and pestle; however, these are designated as a group by the term "kitchen utensils." On the other painting, we find the *pantry* table with the pâté, the fruits, tureen, and the oil and vinegar cruets (we shall refer to these again later). In addition, the two works "complement" each other very well, the scale of the objects is similar, and the objects make a perfect match for one another.

At the 1757 Salon most of Chardin's seven pictures had been completed several years earlier—the *Hare* of the Musée de la Chasse [22], for instance, or the 1738 Salon version of *The Scullery Maid* (see [79]), still lifes as well as genre scenes, and even a portrait now lost but known to us through the engraving ("the oval one of M. Louis, professor and royal inspector of surgery"). The two paintings now in Boston and Carcassonne were hardly noticed. Nothing was said about them specifically, even though criticism to Chardin's entries was, generally speaking, favorable.

These two paintings, however, are the most important and sure evidence of Chardin's return to still life after an interval of almost twenty years. As we have said, Chardin exhibited only *The Bird-Song Organ* in 1751. Certain of the still lifes he exhibited at the Salon of 1753 were not new, and we know very little about some of the others, such as *Fruits from the Collection of M. Chasse.* Two years later Chardin submitted "an animal painting," which has yet to be identified. Aside from the still lifes of Frankfurt ([96], 1748) and Cherbourg (]105], 1756 in all likelihood), we know of no clearly dated work from this long period devoted mostly to genre scenes and portraits, and only rarely have we dated a particular still life to this twenty-year period.

The Carcassonne painting has recently been restored (perhaps a little too enthusiastically), and the Boston painting appears a little worn. Both, however, reveal to the naked eye important modifications. The tray beneath the tureen which Chardin presented in front view, for example, originally was wider, and the mortar and the tablecloth seem to have been placed farther to the left. Another point is that the objects in the Boston painting are familiar to us and were represented by Chardin in almost all of his still lifes of the 1730s; the same is not true for the Carcassonne painting. Certainly, the liqueur table with its open drawer, its cups, and sugar bowl of Oriental porcelain, which Chardin has placed on the right in front of the marble-topped, semi-circular pantry table, is not new, but

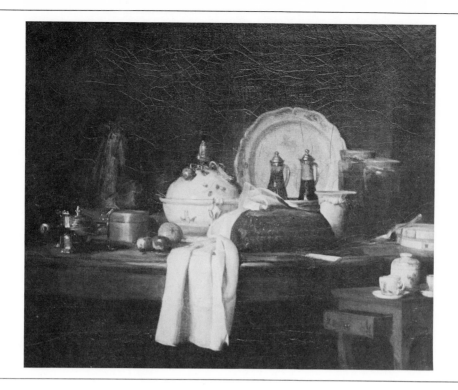

this is the first time that the elegant oil and vinegar cruets with their silver stoppers and the alcohol chafing dish with a small silver pot inside are depicted. The tureen (*pot à oille*), with its multicolored flower decoration, merits some explanation: *pot à oille* derives from the Spanish term for a type of soup pot, *olla*. Originally fashioned of silver (see [20]) or gilded silver, this kind of soup tureen was common in the eighteenth century. It was made either of porcelain or, as here, of faience.

It would seem that Chardin wanted to allude, in the Boston painting, to his early works—the kitchen interiors which had established his reputation—and that he used the Carcassonne painting, which he was to repeat (the Louvre version is much more famous than this first one he painted), to show the more precious objects which he now had.

Another innovation is the scale. Using a greater number of objects than before, the artist makes them seem smaller than life—"miniaturized." He loads his composition, accentuates the impression of horizonality, multiplies the accents of color and forms—oval, cylindrical, and conical. Playing on the contrast between the pantry's richness and the austerity of the kitchen, multiplying, perhaps excessively, his focal points, Chardin took pleasure in balancing these relationships.

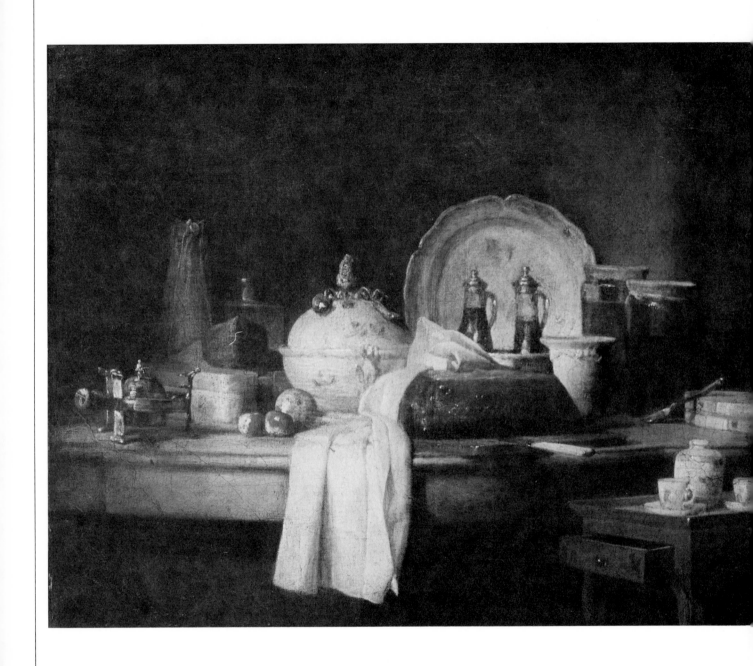

104 *Butler's-Pantry Table* (also called *Dessert with Pâté, Fruits, Tureen, and Oil and Vinegar Cruets*)

(La table d'office, dit aussi Partie de dessert avec pâté, fruits, pot à oille et huilier)

Canvas, 38 × 46 cm. Signed and dated at the middle right: *Chardin 17(63?)*.
Paris, Musée du Louvre, M. I. 1040*

Provenance. Collection of Dr. Louis La Caze (1798-1869) before 1860; bequest of La Caze to the Louvre in 1869.

Exhibitions. 1860, Paris, no. 361 ("1776"); 1945, Paris, no. 85; 1946, Paris, no. 99; 1955, London, no. 214; 1956, Besançon, no. 48; 1958, Munich, no. 40, fig. 60; 1960, Louvre, no. 572; 1966, Vienna, no. 16; 1969, Vienna, no. 16; 1969, Paris, La Caze collection, p. 10 (122); 1976, Paris, no. 4.

Bibliography. Blanc, 1862, pp. 3, 11, and note 1 (print repr.); Goncourt, 1863, p. 521; Museum cat. (Carcassonne), 1864, p. 10 ("a Parisian collector has a painting like this one"); Louvre cat., La Caze, 1871, no. 179 ("17.."); Bocher, 1876, pp. 9, 87, no. 179; Goncourt, 1880, p. 129 ("17.."); Chennevières, 1889, p. 128; Normand, 1901, p. 107; Guiffrey, 1908, p. 70, no. 81; Goncourt, 1909, pp. 105, 190; Pilon, 1909, pl. between pp. 56 and 57, pp. 105, 166; Furst, 1911, p. 122, no. 111; Museum cat. (Brière), 1924, no. 111; Hildebrandt, 1924, p. 170, fig. 218; Larguier, 1927, pl. on p. 16; Gillet, 1929, pp. 61-62, 69, pl. 71; Ridder, 1932, pl. 18; Wildenstein, 1933, no. 1060, fig. 89; Goldschmidt, 1945, fig. 49; Goldschmidt, 1947, fig. 42; Jourdain, 1949, pl. 9; Seznec and Adhémar, 1957, p. 171; Barrelet, 1959, p. 310; Wildenstein, 1959, pp. 102, 105, fig. 7; Adhémar, 1960, p. 457; Schönberger and Soehner, 1960, pp. 90, 357, pl. 40; Faré, 1962, p. 164 (and pl. 366 in Vol. II); Garas, 1963, pl. 34; Ponge, 1963, p. 258 (detail); Rosenberg, 1963, pp. 63 (color pl.), 69 (color detail); Wildenstein, 1963-69, no. 327, pl. 50 (color); McCoubrey, 1964, p. 44 and fig. 5; Rosenberg, Reynaud, Compin, 1974, no. 144 (ill. and color detail on jacket); Kuroe, 1975, pl. 27 in color; Faré, 1976, pp. 164, 166, fig. 256; Anonymous, *Les Peintres illustres*, coll. directed by Henry Roujon, n.d., pl. 1 (color).

Prints. Emile Deschamps engraved this painting while it was in the possession of La Caze, using a drawing by E. Bocourt to illustrate the section devoted to Chardin in Charles Blanc's *Histoire des Peintres* [1862, p. 11; see Bocher, 1876, p. 9, no. 3].

Related Works. For the version signed and dated 1756 in the Carcassonne museum, see [103].

Although the Louvre painting is more famous than the one in Carcassonne, much of its history still remains a mystery. Let us recall that the Carcassonne painting (see [103] for its objects, etc.), signed and dated 1756, appeared at the Salon of 1757 when La Live de Jully was its owner. In 1908 Jean Guiffrey identified the Louvre painting with the second of the paintings lent to the 1763 Salon [61] by the draftsman-engraver and great collector of Chardin's works, Jacques-Augustin de Sylvestre (1719-1809): "Two other paintings, one representing fruits and the other the remnants of a luncheon." This title and Guiffrey's identification have since prevailed, though in a highly debatable fashion.

Nineteenth-century authors hesitated over the composition's subject, which they designated sometimes as *ustensiles divers* (various utensils), sometimes as *les apprêts d'un déjeuner* (preparations for a luncheon). The painting has been correctly entitled "Butler's Pantry" by Philippe Burty (catalog for the 1860 exhibition) and the Goncourts. Indeed it does represent, as the 1757 Salon catalog entry proves, a semi-circular butler's-pantry table lavishly furnished; it does not represent, as we ourselves erroneously wrote in 1974, the "remnants of a luncheon." The pâté, with an ivory-handled knife slipped beneath it, sits on a small cutting board. Among the sugar loaf wrapped in blue paper and the various other packages and fruits, the box of yellow and blue candy (?), the jars, and the faience pot of preserves, there is nothing to suggest "remnants."

At any rate, if the Louvre painting had belonged to Sylvestre, it should have turned up again at the artist's sale in 1811. An attempt has been made to identify it with no. 17 of the 1811 sale catalog, but the two paintings comprising this lot were put up for sale again in 1824 (Gounod, 23 February, no. 3), and the 1824 catalog descriptions make an identification with the Sylvestre work impossible.

As for the date on the painting, it is extremely difficult to decipher; generally, it has been read as 1763. If this is correct, the painting might be one of the "other paintings" sent by Chardin to the Salon whose titles are not specified in the catalog. Commentators on the Salon, highly complimentary about Chardin, do not describe the artist's paintings precisely enough to identify them with certainty. Only a few very vague sentences by Diderot, who concentrated exclusively on the *Jar of Olives* [114] might apply to the Louvre's *Pantry Table* [Seznec-Adhémar, 1957, p. 222]. "There are," wrote Diderot, "several small paintings by Chardin at the Salon: almost all of them represent fruits with the accessories of a meal. It is nature itself; the objects free themselves from the canvas and are deceptively true to life."

There are no significant differences between the Louvre painting and the one in Carcassonne. Both have the same dimensions, color schemes, and objects. Thus, their comparison in this exhibition (photographs cannot do them justice) promises to be extremely interesting. Is the Louvre painting identical in every respect? Is it harsher, less spontaneous than the first version? Are the two works of the same quality? Only direct comparison of the paintings will provide answers to these questions.

105 *Kitchen Table with Plucked Chicken on a Cloth, Cooking Pot, Copper Kettle, and Other Kitchen Utensils*

(Table de cuisine avec un poulet plumé posé sur une nappe, chaudron, marmite de cuivre et autres ustensiles de cuisine)

Canvas, 31.5 ×40.5 cm. Signed and dated on the edge of the table at the left: *Chardin 175(6?)*; the last two digits have sometimes been read as *52* [Clément des Ris, Bocher, Guiffrey, and Wildenstein], and sometimes as *46* [letter of Françoise Guéroult, curator of the Musée Thomas-Henry, 1978).
Cherbourg, Musée Thomas-Henry

Provenance. Collection of the painting-expert and art dealer Thomas Henry (1767-1836); given to Cherbourg in 1835.

Exhibition. 1954, Paris, no. 31.

Bibliography. Museum cat., 1835, p. 35, no. 99; Goncourt, 1864, p. 150; Museum cat., 1870, p. 30, no. 99; Clément de Ris, 1872, p. 125 ("1752"); Bocher, 1876, p. 89 ("1752"); Goncourt, 1880, p. 129; Guiffrey, 1908, p. 63, no. 47 ("1752"); Goncourt, 1909, p. 190; Pilon, 1909, p. 168; Furst, 1911, p. 120; Museum cat., 1912, p. 25, no. 99; Ridder, 1932, pl. 41; Wildenstein, 1933, no. 950, fig. 165; Museum cat., 1949, p. 18, no. 99; Vergnet-Ruiz and Laclotte, 1962, pp. 84, 230; Wildenstein, 1963-69, no. 229, fig. 111 ("1752"); Faré, 1976, p. 160.

The date of the Cherbourg painting is debatable. We think it is 1756, which seems to match perfectly with the style of the work. The painting is, in fact, very close stylistically to the 1755 *Kitchen Table* in Boston [102]. Copper kettle, pepper box, knife, white cloth — all these items are common to both compositions. Only the carafe and the glass of wine, the bottle-green pitcher, the cooking pot, the cucumbers, and the eggs do not appear in the Boston painting. In both, the objects are represented as if from a distance — "miniaturized." The kitchen utensils, accentuated by a neutral background, have been chosen for their ellipsoidal, oval, and circular shapes. The horizontal axis of the kitchen table is interrupted by the white cloth on which the head and neck of the chicken show up clearly. As usual, Chardin has put together and arranged his painting with care, meticulously placing each object. What differentiates the Cherbourg painting from those of the same kind created twenty years before is not so much the execution — which details less sharply each object — as the rhythm of the composition as a whole. The juxtaposition of forms in the first still lifes has been replaced by a more general vision of the work, conceived as a whole, in which colors and masses are intimately related.

106 *White Teapot with White and Red Grapes, Apple, Chestnuts, Knife, and Bottle*

(Théière blanche avec raisin blanc et noir, pomme, châtaignes, couteau et bouteille)

Canvas, 37.5 × 46 cm. Signed at the bottom left: *Chardin.*
Paris, Private Collection

Provenance. For the "pendant," see [97]. Collection of the draftsman Sylvestre between 1759 and 1811 (?); Sylvestre sale, 28 February-25 March 1811, part of lot no. 16(?) (see below for our arguments in favor of this hypothesis). Sale of Count d'Arjuzon, 2-4 March 1852, no. 2 (or no. 3). Collection of François Marcille (1790-1856), then of his son Eudoxe Marcille (1814-1890); still in the same family.

Exhibitions. 1759, Salon no. 38 ("two other paintings of fruit") (?); 1860, Paris, no. 109; 1878, Paris, no. 34; 1937, Paris, no. 139; 1959, Paris, no. 20, pl. 10; 1961, Paris, no. 8.

Bibliography. Bocher, 1876, p. 100; Goncourt, 1880, p. 130; Chennevières, 1890, p. 302; Guiffrey, 1908, p. 80, no. 145; Goncourt, 1909, p. 191; Furst, 1911, p. 126; Wildenstein, 1933, no. 872, fig. 101; *L'Amour de l'Art*, 23 May 1937, p. 23, fig. 46; Barrelet, 1959, p. 308; Huisman, 1959, p. 75 (ill.); Faré, 1962, p. 164 (pl. 367, II, "Wildenstein collection," but seems to reproduce the Marcille painting as the reference to Faré in Wildenstein, 1969, proves); Wildenstein, 1963-69, no. 246, fig. 117; Huyghe, 1965, pp. 3, 4 (two details); Lazarev, 1966,

pl. 12; Faré, 1976, p. 161, fig. 248 ("Wildenstein collection," but seems to reproduce the Marcille painting); d'Arjuzon, 1978, p. 58.

Related Works. For the Boston and Algiers replicas with variants, see [119]. For the Wildenstein replica, see Faré, 1962 and 1976. For the "pendant," see [97].

This painting passes for the companion piece of *Seville Orange, Silver Goblet...* [97] with which, it is true, it was paired in the d'Arjuzon sale of 1852. Because the date for *Seville Orange, Silver Goblet...* has generally been read as 1756 (in our opinion, however, it dates from 1750), the same date of 1756 has been given to *White Teapot...* . The 1750 dating makes more sense, as we shall see.

Both Philippe Burty, in the catalog for the 1860 exhibition, and (more emphatically) the editor of the 1878 catalog link the *White Teapot...* with the paintings exhibited at the Salon of 1759. Such a connection might pertain only to one of the "other paintings of fruits," which measured 1½ *pieds* wide by 13 *pouces* high (approximately 48.5 × 35 cm.). These two paintings belonged to the "king's drawing master," Jacques-Augustin de Sylvestre (1719-1809). At the Sylvestre estate sale of 28 February-25 March 1811 (no. 16) there were two paintings, measuring approximately 36 by 45 cm., described together as: *Deux tableaux. On y voit des prunes, des pêches, du raisin, une poire, des noix, une théière et une bouteille de liqueur* ("Two paintings. In them are plums, peaches,

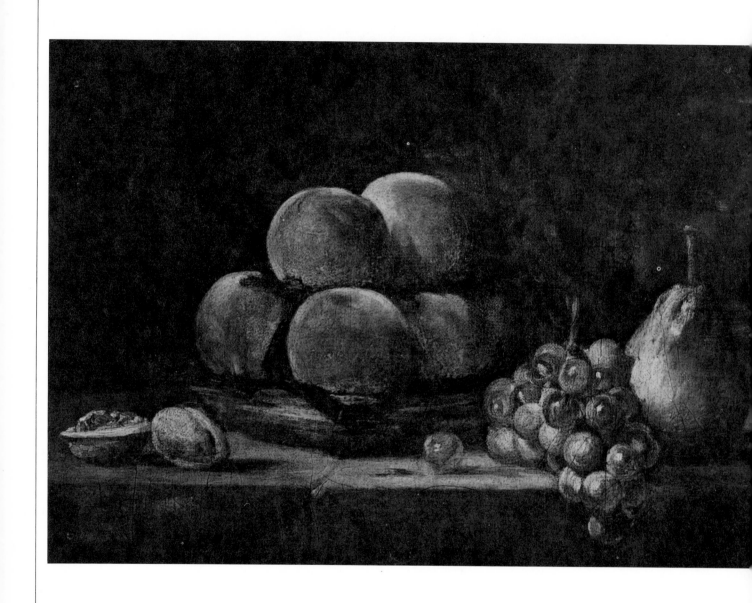

grapes, a pear, nuts, a teapot, and a bottle of liqueur"). One of these paintings could be the work we are exhibiting. We are fully aware of the weakness of this hypothesis and would not have proposed it, without being encouraged by the opinions of the authors of the 1860 and the 1878 catalogs.

A date slightly earlier than 1759 would fit the painting perfectly from the stylistic point of view. In comparison with the "companion piece" [97], the composition has lost its stiffness and seems more natural; the fruits have a velvety texture. In addition, the teapot (possibly an English faience, according to our colleagues at Sèvres) emerges in the half-light and illumines the fruit and the table. This evolution in Chardin's style will be more noticeable when we compare the Marcille painting with the one in Boston [119]. By the end of the 1750s Chardin had perfected the formula which for another ten years would enable him to create a new series of still lifes, all variations on a limited number of objects and fruits—and all masterpieces.

107 *Basket of Peaches with White Grapes, Pear, and Walnuts*

(Corbeille de pêches avec raisin blanc, poire et noix)

Canvas, 32.5 ×41 cm. (slightly enlarged on the sides).
France, Private Collection*

Provenance. Collection of Eudoxe Marcille (1814-1890) as of 1862; in all probability from the collection of his father François; has remained in the family since that time.

Exhibitions. Never exhibited.

Bibliography. Horsin-Déon, 1862, p. 137; Bocher, 1876, p. 100; Chennevières, 1888, p. 61; Chennevières, 1890, p. 302; Guiffrey, 1908, p. 80, no. 144; Wildenstein, 1933, no. 801, fig. 104; Wildenstein, 1963-69, no. 334, fig. 150 ("around 1764/65; we have been unable to re-inspect this picture"); Cat. of Reinhart (Koella) collection, 1975, p. 104.

Related Works. There is a slightly larger (38 × 46 cm.) painting, identical in all other respects, in the Oskar Reinhart collection, Winterthur, Switzerland [Wildenstein, 1963-69, no. 270, color, pl. 40; this foundation is forbidden, by regulation, to lend]. The Reinhart painting comes from the Laperlier collection and was exhibited in 1860 at the Galerie Martinet. It is signed and dated, almost illegibly, 1758.

This painting is not well known. That is to say, it is far less familiar than the slightly larger but otherwise identical painting of the Reinhart Foundation in Winterthur. The Reinhart painting, which comes from the Laperlier collection, is signed and dated 1758. The two pictures are probably from the same year. Is *Basket of Peaches...* one of the Chardins lent by Marcille *père* to educate and train Laperlier's eye, as Bonvin tells it? "My device met with marvelous success," Bonvin adds. "From that time forward, the revelation was complete. M. Laperlier became more adept than any other art collector..." [Burty, 1879, p. 150]. We do not know if this story is true, just as we do not know whether the picture had been "picked up on the quays," as the Goncourts [1909, p. 105] report. They wrote that François Marcille "had bought most of

Winterthur (Switzerland), Reinhart Collection.

these still lifes for 12 to 20 francs and had never spent more than a *louis...."*

Chardin was to paint baskets of peaches on a number of occasions; in fact, his very last painting of fruit [130] used this theme. In the composition here six peaches lie on green leaves in a wicker basket surrounded by two walnuts—one of which is opened—a bunch of white grapes, and a pear. Like the series of similar works which were to occupy Chardin for the next ten years, this picture calls to mind a passage from the painter J. F. Raffaelli's *Promenade au musée du Louvre* [1913, pp. 51-52]:

"When you pick a fruit—a peach, a plum, a bunch of grapes—you see on it what we call the bloom, a kind of silvery down. If you put this fruit on a table, the illumination and the play of the reflected light on the objects surrounding it add a variety of gray tones to its own color. Finally, the atmosphere, whose color is a blue-gray, envelops everything. The result is that the brightest colors in nature are bathed in lilac-tinted grays. But only subtle colorists alone see these grays on everything around us, and it is precisely by this gray quality that we recognize the good colorist. A colorist is not one who puts many garish colors on his paintings; he is one who perceives and catches in his paintings all these colored grays. Chardin is one of our greatest colorists because—of all the masters—he is the one who perceived most sensitively and rendered most successfully the reflections, the delicate grays produced by light, and atmospheric depth."

108 *Basket of Plums with a Glass of Water, Two Cherries, a Pit, and Three Green Almonds*

(Panier de prunes avec un verre d'eau à demi plein, deux cerises, un noyau et trois amandes vertes)

Canvas, 38 × 47 cm. signed at the bottom left: *Chardin.*
Rennes, Musée des Beaux-Arts

Provenance. Collection of the Abbé Trublet (1697-1770) in 1759 (?). Bequeathed by Dr. Adolphe Toulmouche (1797-1876), professor at the Ecole de Médecine in Rennes and archeologist, to his niece Mme Paul Lemonnier, *née* Marie Toulmouche. Given to the Rennes museum in 1913 by Mme Lemonnier.

Exhibitions. 1759, Salon, no. 37 (?); 1953, Rennes, no. 5; 1954, Saint-Etienne, no. 54; 1955, Bourg-en-Bresse cat., p. 17, no. V2; 1960-61, Le Mans, Rennes, Angers, no. 45, pl. 7; 1968, Rochester, no cat.

Bibliography. Vergnet-Ruiz and Laclotte, 1962, pp. 84, 230; B. S. in Brussels exh. cat., 1975, p. 137; Faré, 1976, p. 164, fig. 250.

Related Works. There is another version of this painting, very similar in size, signed and dated 1759, in the Oskar Reinhart collection, Winterthur [Wildenstein, 1963-69, no. 277, color pl. 41].

See [109] for discussion.

109 *Basket of Peaches and Red and White Grapes with Wine Cooler and Stemmed Glass*

(Panier de pêches et raisin blanc et noir avec rafraîchissoir et verre à pied)

Canvas, 38 × 47 cm. signed at the lower right: *Chardin.*
Rennes, Musée des Beaux-Arts

Provenance. See [108].

Exhibitions. 1759, Salon, no. 37 (?); 1953, Rennes, no. 6 (pl. VII); 1954, Saint-Etienne, no. 55; 1955, Bourg-en-Bresse, p. 17, no. V3; 1968, Rochester, no cat.; 1975, Brussels, no. 93, pl. on p. 135.

Bibliography. Paris exh. cat. (G. de Lastic), 1959, under no. 16; Vergnet-Ruiz and Laclotte, 1962, pp. 84, 230; Faré, 1976, p. 164, fig. 251.

Related Works. There are two other versions of this painting, both signed and similar in every respect to the one exhibited here. The first is the companion piece to the *Basket of Plums* and belongs to the Oskar Reinhart Foundation, Winterthur, Switzerland [Wildenstein, 1963-69, no. 276, fig. 131]. The second was once part of the Marcille collection and still belongs to the Marcille family [Wildenstein, 1963-69, no. 278, fig. 132].

Although the Wildenstein monograph does not include these two Rennes paintings, they can only be the work of Chardin. Another pair of these paintings is now in the Reinhart collection in Winterthur (the *Basket of Plums...* is dated 1759), along with a third version of the *Basket of Peaches...* that was formerly part of the Marcille collection. On 4 June 1759 the *Feuille Nécessaire*, published by the bookseller Jacques Lacombe (1724-1801), printed the following notice (pp. 260-61):

"M. *Chardin*, Professor of the Académie Royale de Peinture, has just completed two paintings of fruit, 18 *pouces* wide and approximately 15 *pouces* high (48.6 × 40.2 cm.). One of these paintings represents a basket of plums on a table; next to the basket there is a goblet half filled with water which creates two kinds of transparencies, perfectly rendered. On the front part of the table are two cher-

Winterthur (Switzerland), Reinhart Collection.

Paris, Private Collection.

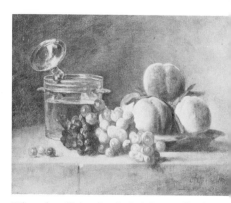

Winterthur (Switzerland), Reinhart Collection.

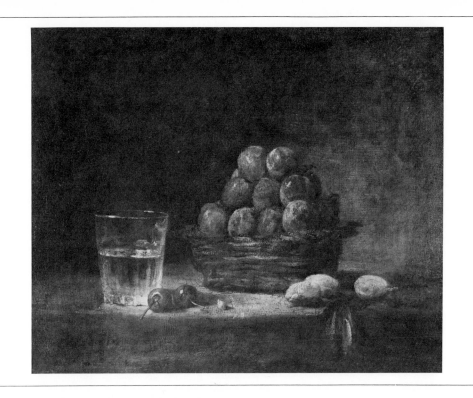

108

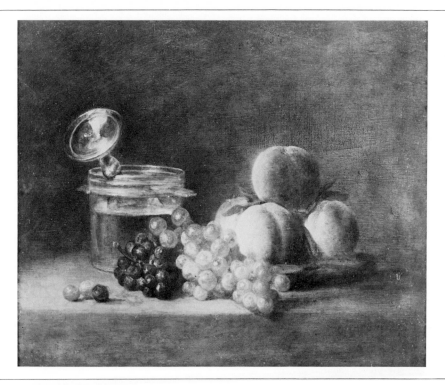

109

ries, a cherry pit, and two almonds in the shell. The companion piece is a basket of peaches with red and white muscat grapes; a crystal bucket full of water, and a glass inverted in this bucket, offer light effects which deceive the eye. These two paintings, which are of the greatest truth, are presently in the collection of M. l'Abbé Trublet; his taste for the Arts and his urbanity will no doubt lead him to let Art-lovers see them."

The Abbé Trublet's paintings were exhibited at the Salon of 1759 and mentioned by Diderot [Seznec-Adhémar, 1957, p. 66]: "The peaches and grapes wake one's appetite and invite one's touch. I would much prefer they were in your collection [Diderot is writing to Grimm] than in the collection of that wretch Trublet to whom they belong."

There is also a reference to these works in the correspondence between the Margravine of Baden, Karoline Luise, and her advisor, Fleischmann [G. Kircher, 1933; also see [18]]. On 19 October 1759 the Margravine wanted to know how much Abbé Trublet had paid for the two paintings. On 27 October Fleischmann answered: "M. Chardin... has kept them at home. As this clever painter has been a friend of mine for more than ten years, you may count on having replicas, Madame, which will hardly cost you more than the Abbé paid for his, although he asked me not to press him about the price he paid for them. The times are hard for everyone, especially for artists." The transaction was not concluded, but this letter is one of the rare contemporary accounts of Chardin's work habits and of his replicas.

We do not know, however, whether the Reinhart or the Rennes pair were in the Salon of 1759. The fact that *Basket of Plums...* is dated 1759 suggests that it was done first. It may also be interesting to note that Abbé Nicolas-Charles Joseph Trublet (1697-1770), so ill-treated by Voltaire, was from Saint-Malo, and that the Rennes paintings have an early Breton origin.

As he had done in 1757, Chardin exhibited many of his paintings in 1759 — both old and recent — genre scenes (such as the replicas of *The Young Draftsman* and *The Embroiderer* — see [94] and [95]) and still lifes with game or fruit. At first glance, the Abbé Trublet's paintings seem to be nothing out of the ordinary. In *Basket of Plums...* Chardin's intention is to render the bloom of the fruits, the reflected light of the water, the transparency of the glass, and the light on the almonds and the reed basket. The only original note in *Basket of Peaches...* is a fern-ash glass immersed in an elegant wine cooler with handles [Barrelet, 1959, p. 311]. But if we compare the two Rennes paintings with the Carcassonne and Boston compositions exhibited at the preceding Salon, we notice that Chardin's manner has changed considerably. The organization is extremely simple and the objects seem closer to the viewer. Most important, the artist seems to be concentrating specifically on the light coming from the left — modifying, subtly varying the colors of objects and fruits, and giving unity to the atmosphere pervading the composition. This new preoccupation with infinite nuances of light, this desire to capture the intangible, will become more pronounced in Chardin's still lifes of the ten years to come.

110 *Jar of Apricots*

(Le bocal d'abricots)

Oval canvas, 57 × 51 cm. Signed and dated at the bottom center on two lines: *Chardin / 1758* (for a long time read as 1760: sometimes as 1756).
Toronto, Art Gallery of Ontario

Provenance. Collection of Jacques Roettiers (1707-1784), goldsmith to the king in 1761 (was not in the Roettiers sale of 19 January 1778 which included a still life with fruit by Chardin formerly in the collection of L. J. Le Lorrain; sale, 20 March 1758, no. 39). Montaleau sale, 19 July 1802, no. 25: *Deux tableaux de forme ovale faisant pendant et offrant des sujets de genre, tels que pêches, poires, prunes, biscuits, bocal à liqueurs et autres ustensiles de ménage* ("Two oval-shaped companion pictures depicting genre subjects, such as peaches, pears, plums, biscuits, liqueur jar, and other household items"; 56 × 50 cm.). Collection of François Marcille (1790-1856), then of his son Camille (1816-1875), who writes in a letter to the Goncourts in 1863: it was "bought by my father from a descendant of Chardin, who was living behind the Porte Saint-Denis or the Porte Saint-Martin; I would decide rather in favor of the latter" [see Adhémar, 1968; on this descendant of Chardin, see also the letter of Laperlier cited in [130]]. Marcille sale, 6-7 March 1876, no. 17. Acquired by the merchant, Stéphane Bourgeois, from Cologne. Collection of Baron Henry de Rothschild, then James de Rothschild until 1951. Leigh Block collection in Chicago. Acquired by the Art Gallery of Toronto in 1962.

Exhibitions. 1761, Salon, no. 45 ("Two oval-shaped paintings belonging to M. Roettiers, goldsmith to the King"); 1869, Chartres, no. 21; 1929, Paris, no. 33; 1932, London, no. 175 (no. 154 in the commemorative cat.); 1949, Paris, no. 6; 1951, Geneva, no. 9; 1954, Fort Worth, no. 10; 1955, Chicago, no. 6 (with pl.); 1965, Columbus, no. 8; 1968, London, no. 142, fig. 187.

Bibliography. Bocher, 1876, p. 97; Saint-Victor, preface of the cat. for the Marcille sale, 1876, p. V; Goncourt, 1880, p. 128; Guiffrey, 1908, pp. 43, 88, no. 203; Goncourt, 1909, p. 189; Pilon, 1909, p. 68; Dacier, 1911, p. 58; Furst, 1911, p. 129; Quintin, 1929, n.p., pl.; Pascal and Gaucheron, 1931, pp. 137-38; Wildenstein, 1933, no. 767, fig. 92; *Arts,* 27 May 1949, p. 1; Barrelet, 1959, p. 309; *The Art Quarterly,* 1962, p. 170 (ill.); Faré, 1962, p. 164; *La Chronique des Arts,* supplement to the *Gazette des Beaux-Arts,* February 1963, p. 14, fig. 65; Wildenstein, 1963-69, no. 299, pl. 42 (color) (and no. 301?); Adhémar, 1968, p. 232; Museum cat., 1974, p. 14 (color pl.); Kuroe, 1975, pl. 22 (color).

See [111] for discussion.

111 *The Cut Melon*

(Le melon entamé)

Oval canvas, 57 × 52 cm. Signed and dated in the center: *Chardin 1760.*
Paris, Private Collection

Provenance. See [110]. Marcille sale, 1876, no. 16; acquired by Stéphane Bourgeois of Cologne. Has remained in the collection of a descendant of Baron Henry de Rothschild.

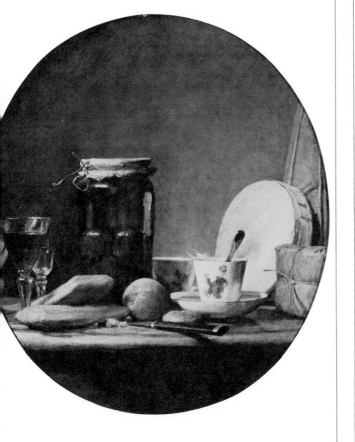

110

See Color Plate XVI.

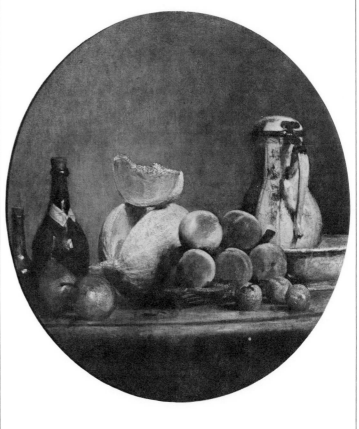

111

See Color Plate XVII.

Exhibitions. 1761, Salon, no. 45; 1869, Chartres, no. 20; 1907, Paris, no. 43; 1929, Paris, no. 34; 1932, London, no. 179, ill. on p. 39 (no. 155 in the commemorative cat.); 1951, Paris, no. 32 (repr. in the foreword); 1954, Rotterdam, no. 46, pl. 26.

Bibliography. Bocher, 1876, p. 97; Saint-Victor, preface of the cat. for the Marcille sale, 1876, p. V; Goncourt, 1880, p. 128; Chennevières, 1889, p. 125; Guiffrey, 1908, pp. 43, 88, no. 204; Goncourt, 1909, p. 189; Pilon, 1909, p. 68; Dacier, 1911, p. 58; Furst, 1911, p. 129; Quintin, 1929, n.p., pl.; Pascal and Gaucheron, 1931, p. 138; Wildenstein, 1933, no. 777, fig. 91; *Arts,* 27 May 1949, p. 1; Jourdain, 1949, fig. 53 (actually reproduces the Louvre version); Roger-Marx, *Le Figaro,* 22 December 1951, p. 9 (ill.); Barrelet, 1959, p. 308; Faré, 1962, p. 164; Wildenstein, 1963-69, no. 298, pl. 43 (color) (and no. 300?); Vienna exh. cat., 1966, p. 27; Adhémar, 1968, p. 232.

Related Works. There is an identical painting, signed but not dated, in the Louvre (M.I. 1034) [Wildenstein, 1963-69, no. 302, fog. 187; Rosenberg, Reynaud, Compin, 1974, no. 142, ill.] It comes from the collection of La Caze who owned it by 1860. Its recent restoration has made it possible to see that its author had left unfinished an area of from one to two centimeters along the periphery. The quality of the

Chardin(?), Paris, Louvre.

Louvre painting is far inferior to that of the painting exhibited here. We hesitate to attribute it to Chardin.

Are these two paintings the ones at the 1761 Salon, at that time in the possession of the celebrated goldsmith Jacques Roettiers (1707-1784)? Wildenstein refutes this claim on the basis of the sketches done by Gabriel de Saint-Aubin (1724-1780) on the margin of his copy of the Salon catalog [Stryienski, 1903, p. 67; Dacier, 1911, p. 14 of the facsimile] now in the Cabinet des Estampes, Bibliothèque Nationale (see also pen and ink sketch in the sketchbook said to be by Saint-Aubin in Chicago). These rapid, black chalk sketches gone over in ink are certainly different from the paintings in Toron-

to and Paris. It was Saint-Aubin's custom to try to give an idea of the whole of the composition rather than its details (he specifies, by the way, that the two paintings were "framed by a branch and a chain of gold," a type of frame quite common at the time). We

Saint-Aubin, drawings after the pictures exhibited at the Salon of 1761.

ought not be unduly disturbed by the fact that Camille Marcille wrote to the Goncourts (in a letter cited under *Provenance*) that his father, the first great collector of Chardin's works in the nineteenth century, had obtained the two works "from a descendant of Chardin" (see [130]). Roettiers no longer owned them in 1778; he could have sold them to one of Chardin's parents. The existence of a replica of *The Cut Melon* that is now in the Louvre and was formerly in the collection of Dr. La Caze, friend and rival of the Marcilles, does nothing to favor either theory. None of the critics of the Salon (at which La Tour exhibited the pastel *Portrait* of Chardin now in the Louvre) commented on the two paintings. They were interested above all, in the replica of *Saying Grace* (see [96]), often for the sake of judging it harshly. Here is another proof that the eighteenth century as a whole was much more interested in figural paintings, including genre scenes, than in still lifes.

The two paintings are among the finest of this period of Chardin's career. Certain of the objects had already been depicted in the *Butler's-Pantry Table* [103] exhibited at the Salon of 1757: the jar; the odd yellow box encircled with blue, sometimes referred to as a box of candy and sometimes as a box of sugared almonds; the sugar loaf wrapped in blue paper; and the brown package tied with string. Others, such as the water pitcher (Vincennes?) with its silver-gilt rim, would be used again a few years later.

Oval paintings are a rarity in Chardin's works; however, the few paintings of this shape (see]122]) are among his finest. In *The Cut Melon* we see two pears, three plums, some peaches in a reed basket, a melon that has been cut open, two bottles of liqueurs, a water pitcher and its bowl. In the Toronto painting [110] we see biscuits, a macaroon, a lemon, stemmed glassware, and a steaming cup of coffee—a more "elegant" and less rustic grouping than the

fruits in the first painting. The string which seals the jar in [111], the play of oblique lines created by the spoon in the cup and the knife on the table in [110] and the stems of the two pears and the balanced slice on the open melon all demonstrate how skillfully the artist composed his work. His genius lies in the subtlety of this clever arrangement and the creation of an impression of perfect spontaneity. The same refinement is to be found in the color highlights: the blue of the sugar-loaf paper complements the red on the bottle corks; the warm tones of the wine and the liqueur in the jar contrast with the fresh, sharp colors of the melon. Colors and forms are linked by the light, whose role in this painting is essential. It strikes the open melon, the cover of the box, and the oiled-paper cover of the jar, conferring on each object its mass, its consistency, its individuality, and its "truth"—a word most frequently used by eighteenth-century critics in an attempt to account for the "magic" of Chardin's brush.

112 *Pheasant and Game Bag*

(Faisan mort et gibecière)

Canvas, 72 × 58 cm. Signed and dated on the right near the bottom, on two lines: *Chardin f./1760.*
Berlin, Staatliche Museen Preussischer Kulturbesitz, Gëmaldegalerie

Provenance. This painting is mentioned in the inventory of his collection drawn up in 1760 by Chardin's friend, Thomas-Aignan Desfriches (1715-1800), a draftsman living and working in Orléans; inventory published in part by Ratouis de Limay [1907, p. 31]: *Un faisan et une gibecière* ("Pheasant and game bag"). Desfriches appears to have paid 48 *livres* for the work, but he valued it at 72. In the 1774 inventory [Ratouis de Limay, 1916, p. 268], the painting and its companion piece (see [113]), *Un lièvre et un faisan* ("Hare and phesant") are valued at 200 *livres*. Desfriches sale after the death of his daughter Mme de Limay, 6-7 May 1834, no. 55, *Lièvre mort et vase de fleurs à côté; faisan et attributs de chasse* ("Dead hare and vase of flowers beside it; pheasant and attributes of hunting"). Collection of Becq de Fouquières before 1925; Mme Becq de Fouquières estate sale, 8 May 1925, no. 18 (with plate). Acquired by Yves Perdoux. Given to the Berlin museum by Thomas Agnew and Sons in 1925.

Exhibitions. 1929, Paris, no. 6; 1948-49, Washington and other cities in the United States; 1958, Munich, no. 39.

Bibliography. Museum cat., 1931, p. 91, no. 1944 (pl. 90 of 1933 ed.); Wildenstein, 1933, no. 700, fig. 143; Museum cat., 1956, p. 13; 1960, p. 20; 1963, p. 28; Wildenstein, 1959, p. 177 ("very early"); Wildenstein, 1963-69, no. 284, fig. 134; Stuffmann, 1971, pl. 372a; Museum cat., 1975, p. 97 (ill.); 1978, p. 101 (ill.).

See [113] for discussion.

113 *Hare with Pot of Gillyflowers and Onions*

(Lièvre mort avec pot de giroflées et oignons)

Canvas, 73 × 60 cm. Signed at the bottom left: *Chardin.*
Detroit, The Detroit Institute of Arts

Provenance. See [112]. Only the Berlin painting [112] appears in the first inventory (1760) made by Thomas-Aignan Desfriches (1715-1800) of his collection. In 1774 and in the 1834 sale the two works are reunited. In the (unpublished) 1786 inventory, it correctly states that the picture shows a "pot of gillyflowers," not a pot of hyacinths! No. 17 of the 1925 Becq de Fouquières sale. M. Shermatieff collection, Paris. Acquired by the Detroit museum in 1926.

Exhibitions. 1926, Detroit, no. 10; 1947, New York, no. 12; 1950, Montreal, no. 18; 1964, Detroit, no. cat.

Bibliography. Le Figaro Artistique, 28 May 1925, p. 523 (ill.); Roger-Milès, *Revue de l'Art Ancien et Moderne*, May 1925, no. 718, p. 175 (repr.); W[alther], 1927, pp. 43-45 (ill. p. 44); Wildenstein, 1933, no. 717, fig. 144; Museum cat., 1944, p. 24, no. 30; *Allen Memorial Art Museum Bulletin*, Oberlin, March 1945, pp. 11, 12 (repr.); *Art News*, November 1947, p. 39 (ill.); *Art Digest*, 1 November 1947, p. 12 (ill.); Wildenstein, 1959, p. 177 ("very early"); Wildenstein, 1963-69, no. 283, fig. 133; Scott, 1973, p. 41, fig. 10; Banks, 1977, p. 86.

The friendship of Chardin and the draftsman-collector Thomas-Aignan Desfriches seems to have been of long standing. Ratouis de Limay published (1907) the letters Chardin sent to Desfriches, signed by Chardin but usually written by his second wife. Desfriches owned a number of Chardin paintings; unfortunately, collation of the inventories of 1760 (Ratouis de Limay, 1907), 1774 (Ratouis de Limay, 1916), 1778, 1786 (unpublished), and the sale of the draftsman's daughter, Mme Ratouis de Limay, in 1834, do not enable us to know exactly how many he owned nor the precise subjects. The Berlin painting dated 1760, however, is mentioned—alone—in the inventory of 1760 (purchased for 48 *livres;* valued at 72!). In 1774 its companion piece, now in Detroit, rejoined it (the pair was valued at 200 *livres*). The two paintings were sold in 1834, but "made" only 84 francs! They appeared again, still together, in a 1925 sale, and immediately thereafter one entered the Berlin museum, the other the museum in Detroit. This exhibition makes it possible to bring them together again, temporarily.

The Berlin painting depicts a hen-pheasant hanging by one leg on a string, its beak almost touching a stone ledge. On the left lies a game bag. The piece is very stiffly arranged. The half-circles formed by the wings accent the compact appearance of the bird and, at the same time, soften the rigor of the composition. The unattached, projecting leg of the pheasant gives depth to the painting.

The Detroit *Hare,* which we have not seen since its recent restoration, is more surprising. The hare, too, is hung by a leg to a nail. Part of it lies on a stone ledge on which we see three onions and a faience pot (from Nevers or Saint-Cloud?) containing a branch of gillyflowers in bloom. A few drops of blood have oozed out of the hare's head. It is unclear whether Chardin painted this picture

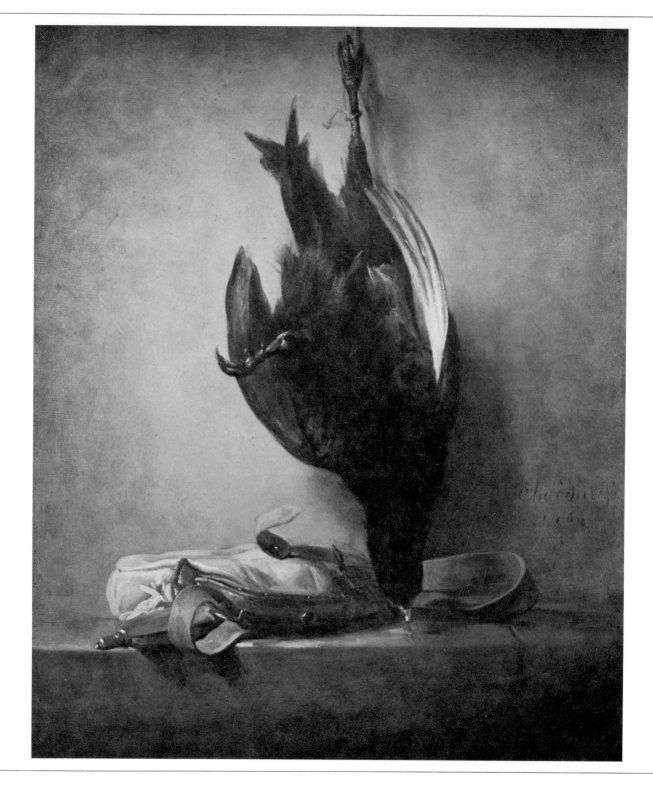

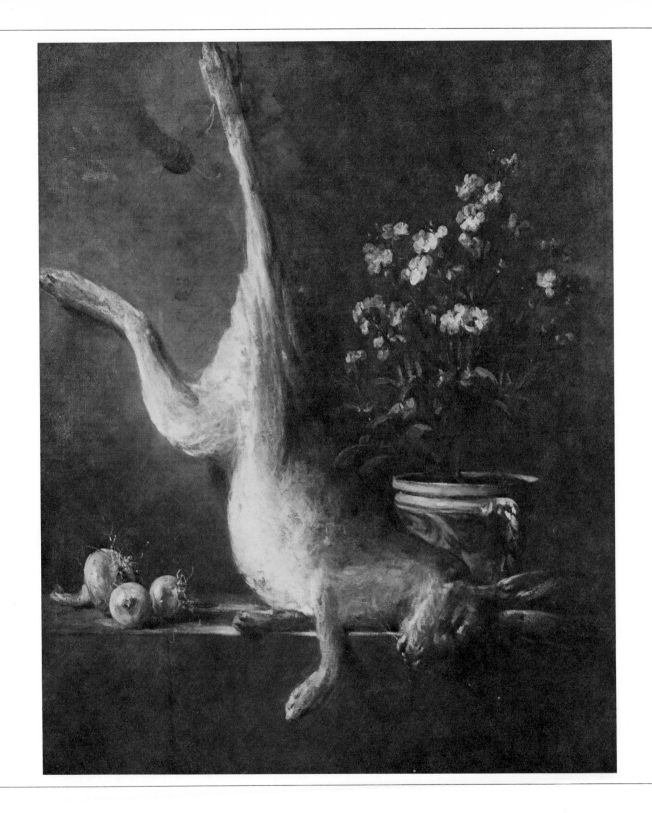

shortly after the one now in Berlin or whether he sent it to Orléans only some years later. In any case, its execution is less careful and not entirely successful.

Chardin has here undertaken the bold composition of his first hunting compositions, which also were vertical, but he has not succeeded in retaining their force and daring. The beauty of the Berlin painting, similar in composition to certain of the partridges done in the 1730s, lies above all in the utilization of light and air surrounding the pheasant's body to make it stand out sharply against a neutral, unevenly lighted background.

One senses a certain exhaustion of inspiration in these two paintings, the last Chardin devoted to dead game. Was it their relative failure (was Chardin aware of it?) that explains the artist's decision around 1760 to abandon this type of work in order to concentrate on fruits and to create, in this new genre, some of his purest masterpieces?

114 *Jar of Olives*

(Le bocal d'olives)

Canvas, 71 × 98 cm. Signed and dated at the bottom right, on two lines: *Chardin/1760*.
Paris, Musée du Louvre, M. I. 1036*

Provenance. Collection of Abbé Pommyer "conseiller en Parlement," in 1763 (?) (see discussion below concerning the arguments in favor of this provenance). La Caze collection by 1860. Bequest of Dr. Louis La Caze (1798-1869) to the Louvre in 1869.

Exhibitions. 1763, Salon, no. 60 ("Another picture of fruit belonging to Abbé Pommyer, conseiller en Parlement") (?); 1860, Paris, no. 105; 1958, Bordeaux, no. 6; 1960, Paris, no. 569; 1969, Paris, La Caze collection, p. 10 (122); 1978, Bordeaux, no. 97 (ill.).

Bibliography. Bürger (Thoré), 1860, pp. 334, 335, 339; Gautier, 1860, p. 1237; *Annuaire des Artistes et des Amateurs*, 1861, II, p. 119; Gautier, 1864, p. 75; Mantz, 1870, p. 17; Museum cat. (La Caze), 1871, no. 175; Bocher, 1876, p. 86, no. 175; Goncourt, 1880, p. 129; Chennevières, 1889, pp. 125-26; Normand, 1901, pp. 34, 106; Guiffrey, 1908, p. 71, no. 82; Goncourt, 1909, p. 190; Pilon, 1909, pp. 58, 101, 166; Furst, 1911, p. 122, no. 107; Klingsor, 1924, pl. on p. 97; Ridder, 1932, pl. 17; Wildenstein, 1933, no. 786, fig. 117; Goldschmidt, 1945, fig. 8; Goldschmidt, 1947, fig. 11; Jourdain, 1949, fig. 4; Seznec, 1951, pl. 6b; Seznec and Adhémar, 1957, p. 171, fig. 79; Barrelet, 1959, p. 309; Adhémar, 1960, p. 457; Faré, 1962, p. 164; Rosenberg, 1963, pp. 13, 14, 62 (color pl.), 64 (color detail); Wildenstein, 1963-69, no. 307, pl. 44 (color); Thuillier and Châtelet, 1964, p. 206; Lazarev, 1966, pl. 19; Valcanover, 1966, pl. 11 (color); Seznec, 1967, p. 139 (ill.); Seznec, 1967 (2), p. 10, fig. 4; *Vuillard-Roussel* exh. cat., Paris, 1968, p. 119; Demoris, 1969, pp. 368-69; Rosenberg, Reynaud, Compin, 1974, no. 143 (ill.); Faré, 1976, p. 162; *Chefs-d'oeuvre de l'art. Grands Peintres*, 1978, pl. 11 (color).

Related Works. None of the copies that we know of this picture merits mention. Let us single out, however, the painting by Vuillard dated 1921 and entitled *The La Caze Room;* in this painting — now in the Bauer collection in Switzerland [exh. cat. *Vuillard-Roussel*, Paris, 1968, no. 156, with ill.], along with the paintings by Largillierre, Watteau, and Fragonard donated by La Caze — we see the *Jar of Olives.*

The 1763 Salon catalog does not specify the subjects of the six Chardin still lifes with fruit and "other paintings" exhibited under the same number. However, we know that the *Jar of Olives*, signed and dated 1760 and now in the Louvre, thanks to the La Caze bequest (1869), was included in Chardin's entry: indeed we have Diderot's long and famous desciption of it. But which one was it: one of the two paintings belonging in 1770 to the Count of Saint-Florentin, Duke de La Vrillière (1705-1777), *(Fruits* and *Bouquet);* the *Fruits* in the possession of Abbé Pommyer, who was to become an *associé libre* of the Academy of Paintings in 1767; the *Fruits* that was companion piece to the *Remains of a Luncheon* in the collection of Jacques-Augustin de Sylvestre (1719-1809), "drawing master to His Majesty"; the "small painting" belonging to the sculptor Jean-Baptiste Lemoyne (1704-1778), whose name we have encountered several times already among the owners of Chardin paintings; or, finally, one of the "other paintings" exhibited at the same time by Chardin?

Wildenstein identified only two of Chardin's entries in the 1763 Salon with paintings that still exist: the composition owned by Lemoyne, which he assumes to be the *Basket of Peaches with Silver Goblet* in the Masson collection [Wildenstein, 1963-69, no. 321, fig. 149; we know this work only through a photograph], and one of the two Sylvestre paintings, which he thinks might be the *Butler's-Pantry Table* now in the Louvre (see [104]). If the Lemoyne work did depict a *Basket of Peaches*, it measured 37 × 45 cm. (and not 34 × 42) and was signed and dated 1761, and therefore is probably not the Masson painting (Lemoyne sales of 10 August 1778, no. 26, and 19 May 1828, no. 62). Wildenstein thinks, on the other hand, that one of the two Sylvestre pictures could be the *Butler's-Pantry Table* in the Louvre (see [104]). As for the Sylvestre painting, as we have already said, the hypothesis that the Sylvestre work was the *Jar of Olives* has very little chance of proving correct. The Sylvestre pictures "passed through" the Sylvestre sale of 1811 (no. 17) and the Gounod sale of 1824 (part of no. 3). They represented *un panier de prunes, une corbeille de raisins et d'autres fruits sur des appuis* ("a basket of plums, an open basket of grapes, and other fruits on ledges") and measured 30.5 × 39 cm. (The *Butler's-Pantry Table* of the Louvre measures 38 × 46 cm.!)

By process of elimination — although we recognize how weak our argument is — we would like to propose that the Saint-Florentin paintings are the Louvre's *Brioche* and *Grapes and Pomegranates* [117, 118], dated 1763 (a hypothesis advanced by Seznec and Adhémar in 1957), and that the Abbé Pommyer's *Fruits* is the *Jar of Olives* shown here.

In the *Jar of Olives*, we see a pâté on a stone ledge "prominently displayed against one of those typical Chardin backgrounds — a wall whose color varies from a somber gray to a faded blackish-brown" [H. de Chennevières, 1889]. The pâté is lying on a small cutting board, the blade of a black-handled knife slid beneath it. We also see a Seville orange, two half-full glasses of *"forigère"* wine, a dish containing three pears and an apple, a lady-apple lying in front of the dish, two macaroons and a biscuit, the large jar of olives

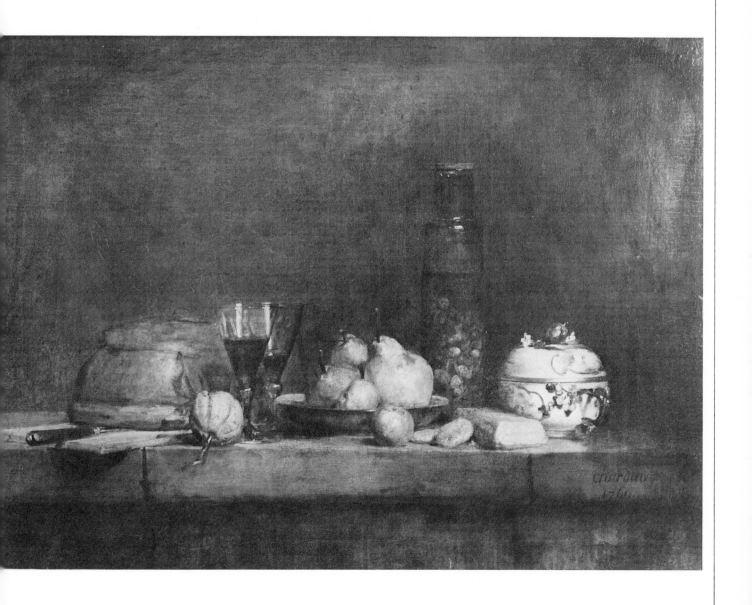

114

and, finally, a handsome Meissen bowl. Certain of the changes Chardin made while working on the painting are visible to the naked eye.

We will not insist here, like Chennevières and so many others, on the "theory of correspondences and reflections" presented so perfectly in this painting: the essential role of light; the soft, powdery air enveloping the composition and imparting to it such perfect equilibrium; and its sense of calmness and stillness. Instead, we will quote Diderot, who discovered for himself the genius of Chardin that very year [Seznec and Adhémar, 1957, pp. 222-23]:

"That [painting] one sees in mounting the stairs is especially worthy of attention. The artist has placed on a table an old porcelain vase, two biscuits, a jar filled with olives, a basket of fruit, two glasses half full of wine, a Seville orange, and a pâté.

"To look at the paintings of others, it seems that I need different eyes; to look at those of Chardin, I need only to make good use of those nature has given me.

"If I were to destine my child for a career in painting, that is the painting I would buy. 'Copy that for me,' I would tell him, 'copy that for me again.' But perhaps nature is no more difficult to copy.

"This porcelain vase is of porcelain; these olives are really separated from the eye by the water in which they float; all you have to do is take these biscuits and eat them, open this Seville orange and squeeze it, pick up the glass of wine and drink it, take these fruits and peel them, put your hand on this pâté and slice it.

"Here is one who understands the harmony of colors and reflected light. O Chardin! It's not white, red, or black pigment that you crush on your palette: it's the very substance of the objects, it's air and light that you take up with the tip of your brush and fix onto the canvas....

"This magic defies understanding. It is thick layers of color applied one on top of the other and beneath which an effect breathes out. At other times, one would say, it is a vapor that has been breathed onto the canvas; elsewhere, a delicate foam that has descended upon it. Rubens, Berghem, Greuze, Loutherbourg would explain to you what is involved here better than I; all of them will make your eyes sensitive to the effect. Approach the painting, and everything comes together in a jumble, flattens out, and vanishes; move away, and everything creates itself and reappears.

"I have been told that Greuze, walking upstairs to the Salon and noticing the piece by Chardin which I have just described, looked at it and went on, heaving a deep sigh. That praise is briefer and better than mine.

"Who will pay for Chardin's paintings when this unique man is no more? You should also know that this artist has a clear judgment and speaks marvelously well about his art.

"Ah! my friend, spit on the drapery of Apelles and the grapes of Zeuxis. An impatient artist is easily fooled, and animals make poor judges of painting. Have we not seen the birds in the King's garden smashing their heads against the most wretched of perspectives? But it is you and I that Chardin will fool, whenever he pleases."

115 *Basket of Wild Strawberries*

(Le panier de fraises des bois)

Canvas, 38 × 46 cm. Signed at the bottom left: *Chardin.*
Paris, Private Collection

Provenance. Collection of Eudoxe Marcille (1814-1890) by 1862; has remained in that family since then.

Exhibitions. 1761, Salon, part of no. 46 ("Other paintings, of the same type, under the same number"); 1937, Paris, no. 141, pl. 66; 1959, Paris, no. 19, pl. 9; 1961, Paris, no. 10.

Bibliography. Blanc, 1862, p. 2; Goncourt, 1863, pp. 521-22; Bocher, 1876, p. 101; Goncourt, 1880, p. 130; Dilke, 1899, p. 190, note 1; Dilke, 1899 (2), p. 119, note; Guiffrey, 1908, p. 80, no. 143; Goncourt, 1909, pp. 107, 191; Pilon, 1909, p. 167; Dacier, 1911, VI, p. 58, note 2; Furst, 1911, p. 126; Wildenstein, 1933, no. 774, fig. 100; Florisoone, 1948, pl. 71; Seznec and Adhémar, 1957, p. 89; Barrelet, 1959, p. 309; Ver[onesi], 1959, p. 264 (ill.); *Du*, December 1960, p. 32 (ill.); Wildenstein, 1963-69, no. 297, pl. 46 (color); Thuillier and Châtelet, 1964, pp. 203 (color ill.), 206; Lazarev, 1966, pl. 24 (color).

This unusual painting was surely in the Salon of 1761: Gabriel de Saint-Aubin copied it, in a quick sketch done in black chalk and gone over in ink, at the top of page 14 of his copy of the Salon catalog (preserved today in the Cabinet des Estampes, Bibliothèque Nationale) [reproduced by Stryienski, 1903, and Dacier, 1911]. No critic of the Salon, not even Diderot, mentioned the painting. No eighteenth-century biographer of Chardin pointed it out. Nor is it known when and where Eudoxe Marcille (or his father François) purchased it. It is mentioned in 1862, apparently for the first time, by Charles Blanc: "A basket of strawberries, a crystal glass half full of water shimmering with the rosy reflection of a fine peach placed near two white carnations and some cherries... that is all he needed to make an exquisite piece." A few months later the text of the Goncourts appeared, which undoubtedly refers to this painting even though it describes only the carnations:

"These two carnations: they are nothing but a fragmentation of blues and whites, a kind of mosaic of silvered enamellings in relief; step back a little, the flowers rise up from the canvas as you move away, the leafy pattern of the carnation, its heart, its soft shadow, its crinkled, shredded aspect—everything coalesces and blossoms.

Saint-Aubin, drawing after the picture exhibited at the Salon of 1761.

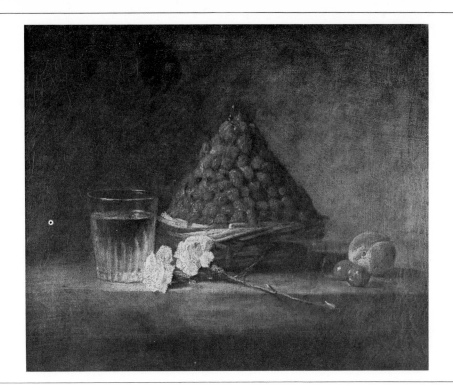

115

See Color Plate XVIII.

Such is the miracle of Chardin's art: modelled in the mass and the surroundings of their outlines, drawn with their own light, made, so to speak, of the essence of their colors, they seem to detach themselves from the canvas and come alive, by means of a marvelous working of optics in the space between painting and spectator."

The pyramid of wild strawberries arranged in a wicker basket is flanked by a faceted glass, three-quarters full of water, two carnations which have long given the painting its title, two cherries, and a peach. Wild strawberries are as rare in Chardin as the carnations; generally speaking, the artist rarely painted flowers.

Once again, the extreme simplicity of the composition, which eliminates all detail and achieves perfect balance, and the boldness of the execution are admirable. The straight, horizontal line formed by the stone ledge is alleviated by the green stem of one carnation, and the water's transparency contrasts with that of the glass tinted by the two touches of red reflected by the strawberries. In this painting Chardin has surpassed himself: the freedom of the white and red harmony, simultaneously bold and elegant, renders the work unforgettable. By avoiding showy brilliance, with an ease and assurance unequalled in his own time, Chardin has created, with a disconcerting and apparent ease, one of his most beautiful still lifes.

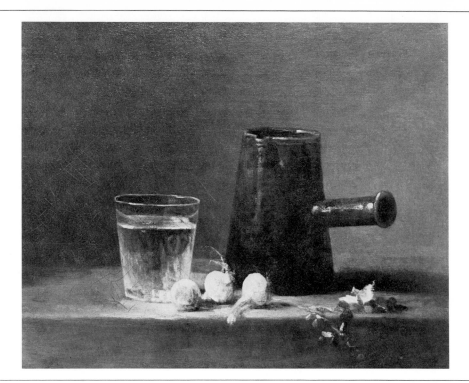

116 *Glass of Water and Coffeepot*

(Verre d'eau et cafetière)

Canvas, 32.5 × 41 cm. Signed at the bottom left (scarcely legible): *Chardin.*
Pittsburgh, Museum of Art, Carnegie Institute

Provenance. Collection of Philippe Burty (1830-1890), very likely as of 1874; Burty sale, 2-3 March 1891, no. 30. Charles Haviland sale, 14-15 December 1922, no. 42 (ill.). George Haviland sale, 2-3 June 1932, no. 105 (ill.). A. M. Schwenk collection. Acquired by Pittsubrgh in 1966 (collection of Howard A. Noble).

Exhibitions. 1874, Paris, no. 748 (supplementary cat., "Still life. Collection of M. Ph. Burty") (?); 1880, Paris, no. 43; 1973, New York, unnumbered; 1974, Atlanta, unnumbered (ill.); 1977, Cincinnati, unnumbered (color pl.).

Bibliography. Mantz, 1879, p. 114; Goncourt, 1880, p. 131; Mantz, 1891, preface of cat. for Burty sale, p. 11; Goncourt, 1909, p. 192; Pilon, 1909, p. 54; Catroux, 1922, p. 280, pl. on p. 283; Hildebrandt, 1924, p. 171, fig. 219 (as at the Louvre!); *Beaux-Arts,* 25 June 1932, p. 7 (ill.); Wildenstein, 1933, no. 1007, fig. 158; Barrelet, 1959, p. 309; Wildenstein, 1963-69, no. 94, fig. 40; Myers, *Carnegie Magazine,* December 1966, pp. 339-43 (color cover); *La Chronique des Arts,* supplement to the *Gazette des Beaux-Arts,* February 1967, p. 87, fig. 312; Museum cat., 1973, pp. 37-38, pl. 21 (color).

This beautiful painting, recently acquired by Pittsburgh, belonged to Philippe Burty (1830-1890). The role of this critic in reviving an interest in Chardin is well known. He was also responsible for compiling the catalog of the exhibition held at the Galerie Martinet in 1860, the first of the nineteenth century in which Chardin was strongly represented.

Burty's friends, the Goncourts (for whom Burty cataloged the engravings by Jules), were very familiar with his picture: in 1880 they described it as "three little white onions, a branch of fennel, a brown clay pitcher, a glass three-quarters full. A marvel, this little picture, in which the insignificance of the composition sets off to best advantage the artistic wisdom of the best still-life painter of all the schools."

According to Dr. Frederick H. Utech of the Botany Department of Pittsburgh's Carnegie Museum of Natural History, the "onions" are actually cloves of garlic and the "fennel," the leaves and lower part of the garlic plants. As for the "clay pitcher," it is not a *bouillotte,* as is generally proposed, but a coffeepot [information supplied by M. Alcouffe; see plates of the *Encyclopédie,* 1765, IV, "Fayencerie"].

Wildenstein dates the painting about 1728-1731. We think thirty years later is more realistic, and would date the painting at about the same time as *Basket of Wild Strawberries* [115]. The way in which Chardin treats the limpid water and the transparency of the

glass is identical in both works. The brown mass of the coffeepot, the ray of light clinging to its handle and its rim, the silvered coloring of the glass of water, the white and green splashes of color created by the garlic heads and the stems of the plant place the Pittsburgh painting among the finest done by Chardin.

117 Grapes and Pomegranates

(Raisins et grenades)

Canvas, 47 × 57 cm. Signed and dated at the bottom left: *Chardin 1763*.
Paris, Musée du Louvre, M. I. 1035

Provenance. In 1763 in the collection of the Count of Saint-Florentin (1705-1777), Duke de La Vrillière in 1770 (?). Collection of Pierre-Louis Eveillard, Marquis de Livois (1736-1790), in Angers. Catalog of that collection by Pierre Sentout, painter (Angers, 1791, no. 222, also shared with the following): *Deux tableaux faisant pendant, l'un représente un banc de pierres. On y voit dessus des raisins blancs et noirs, un pot à eau de fayence, deux grenades, deux verres à pied avec du vin dedans, une poire, deux pommes et un couteau à manche d'ivoire, le tout représenté d'après nature et faisant illusion* ("Two paintings forming companion pieces, one represents a bench made of stones. We see on it white and black grapes, a faience water pitcher, two pomegranates, two stemmed glasses holding wine, a pear, two apples, and an ivory-handled knife, all depicted from nature and creating an illusion"). Confiscated during the Revolution, but part of the Livois collection was returned to the "republican heirs" [see Planchenault, 1933]. Probably that share of the inheritance received by the children of Mme Mathieu de Scépeaux-Boisguignot, *née* Marie-Louise de Greffin [according to Planchenault, 1934, p. 256]. Gamba sale, 17 December 1811, no. 55: *Deux sujets de genre, représentant des déjeuners de fruits, brioches, etc.* ('Two genre subjects, representing luncheons consisting of fruits, brioches, etc.'). A piece displaying amazing virtuosity. Livois collection. "Acquired for 79 *livres* by "Bligni." Collection of Louis La Caze (1798-1869); bequeathed to the Louvre in 1869.

Exhibitions. 1763, Salon, no. 58 ("A painting of fruit") (?); 1936, Paris, no. 19; 1949, San Francisco, no. 7 (ill.); 1968, London, no. 143, fig. 12; 1969, Paris, La Caze collection, p. 10 (122).

Bibliography. Museum cat. (La Caze), 1871, no. 174; Bocher, 1876, p. 86, no. 174; Goncourt, 1880, p. 129; Chennevières, 1889, pp. 126-27; Normand, 1901, p. 106; Schéfer, 1904, pl. on p. 97; Guiffrey, 1908, p. 71, no. 86 (and pl. on p. 5); Goncourt, 1909, p. 190; Pilon, 1909, p. 166 and pl. between pp. 152 and 153; Furst, 1911, p. 122, no. 106, pl. 29; Museum cat. (Brière), 1924, no. 106; Klingsor, pl. on p. 101; Ridder, 1932, pl. 19; Planchenault, 1933, p. 226; Wildenstein, 1933, no. 865, fig. 115; Pilon, 1941, pl. on p. 49; Jourdain, 1949, fig. 8; Dacier, 1951, pl. 140; Seznec and Adhémar, 1957, p. 171; Barrelet, 1959, pp. 306, 311, fig. 11 (detail); Wildenstein, 1959, p. 105; Adhémar, 1960, p. 457; Faré, 1962, p. 164; Wildenstein, 1963-69, no. 322, pl. 48 (color); Lazarev, 1966, pl. 20 (color); Rosenberg, 1969, p. 99; Rosenberg, Reynaud, Compin, 1974, no. 145 (ill.).

Related Works. Numerous copies of this painting are known, most of them from the nineteenth century (for example, Joseph Bail, private collection; A. Boulard, Dorotheum sale, Vienna, December 1968, no. 9).

See [118] for discussion.

118 The Brioche

(La brioche)

Canvas, 47 × 56 cm. Signed and dated at the bottom left on two lines: *Chardin /1763*.
Paris, Musée du Louvre, M. I. 1038

Provenance. See [117]. Collection of the Count of Saint-Florentin in 1763 (?). Collection of the Marquis de Livois (1736-1790) in Angers; catalog of the collection by P. Sentout (1791, no. 222 as the companion piece): *L'autre représente une table avec un déjeuner dessus: on y voit une brioche sur une assiette de fayence, un sucrier, deux pêches, un biscuit, massepains, cerises et une petite carafe de cristal avec un bouchon doré...* ("The other represents a table with luncheon preparations: we see a brioche on a faience plate, a sugar bowl, two peaches, a biscuit, marzipan biscuits, cherries, and a small crystal carafe with a gilded stopper... "). Confiscated during the Revolution, but included in that portion returned to the "republican heirs" of the Marquis [Planchenault, 1933 and 1934]. Gamba sale, 17 December 1811, no. 55 (see [117], *Provenance*). Acquired by "Bligni" for 79 *livres*. Collection of Louis La Caze (1798-1869); bequeathed to the Louvre in 1869.

Exhibitions. 1763, Salon, no. 59 ("another representing the Bouquet") (?);1946, Paris, no. 100; 1965, Paris, no. 289; 1966, Vienna, no. 14; 1967, Montreal, French Pavilion (no cat.); 1969, Paris, La Caze collection, p. 10 (122); 1975-76, Toledo, Chicago, Ottawa, no. 15, pl. 99; 1976, Paris, no. 3.

Bibliography. Mantz, 1870, p. 17; Museum cat. (La Caze), 1871, no. 177; Bocher, 1876, p. 86, no. 177; Goncourt, 1880, p. 129; Chennevières, 1889, p. 127; Guiffrey, 1908, p. 72, no. 89; Goncourt, 1909, p. 190; Pilon, 1909, p. 166; Furst, 1911, p. 122, no. 109; Faure, 1921, pl. on p. 221; Museum cat. (Brière), 1924, no. 109; Osborn, 1929, fig. 190; Ridder, 1932, pl. 20; Planchenault, 1933, p. 226; Wildenstein, 1933, no. 1090, fig. 161; Brinckmann, 1940, fig. 387; Goldschmidt, 1945, fig. 40; Roger-Marx, *Formes et Couleurs*, 1946, p. 68 (ill.); Jourdain, 1949, fig. 54; Seznec and Adhémar, 1957, p. 171; Barrelet, 1959, pp. 310, 312, 313, fig. 14 (detail); Wildenstein, 1959, pp. 103 (fig. 8), 105; *Du*, December 1960, p. 36 (ill.); Faré, 1962, p. 164 (and pl. 365 in Vol. II); Garas, 1963, pl. 29; Rosenberg, 1963, pp. 4 (color detail), 14, 38 (color), 75; Wildenstein, 1963-69, no. 323, pl. 49 (color); Thuillier and Châtelet, 1964, p. 305; Lazarev, 1966, pl. 21 (color); Valcanover, 1966, pl. 10 (color); Brookner, 1971, fig. 5; Pizon, 1972, p. 13 (ill.); Lazarev, 1974, pl. 187; Rosenberg, Reynaud, Compin, 1974, no. 146 (ill.); Kuroe, 1975, pl. 26 (color); Faré, 1976, pp. 164, 167, fig. 257; Faré, 1977, p. 172; *Chefs-d'oeuvre de l'art. Grands peintres*, 1978, pl. 10 (color).

Related Works. We know of a number of copies of this painting, although none are of outstanding quality. One attributed to Roland de La Porte, in which other objects and fruits have been added, was at the Drouot sale of 7 June 1974 (no. 30, ill.) and 8 December 1975 (no. 139, ill.).

Because both Louvre paintings are dated 1763, one is naturally tempted to identify them with certain of the works Chardin sent to the Salon that year. We have accepted, with some hesitation (see the entry for *Jar of Olives* [114], the hypothesis proposed by Jean Seznec and Jean Adhémar 1957) that suggests the two Louvre paintings are those once belonging to the Count of Saint-Florentin (1705-1777), Louis XV's powerful minister [see A. Doria, 1933], and described as representing *Fruits* and a *Bouquet*. Granted,

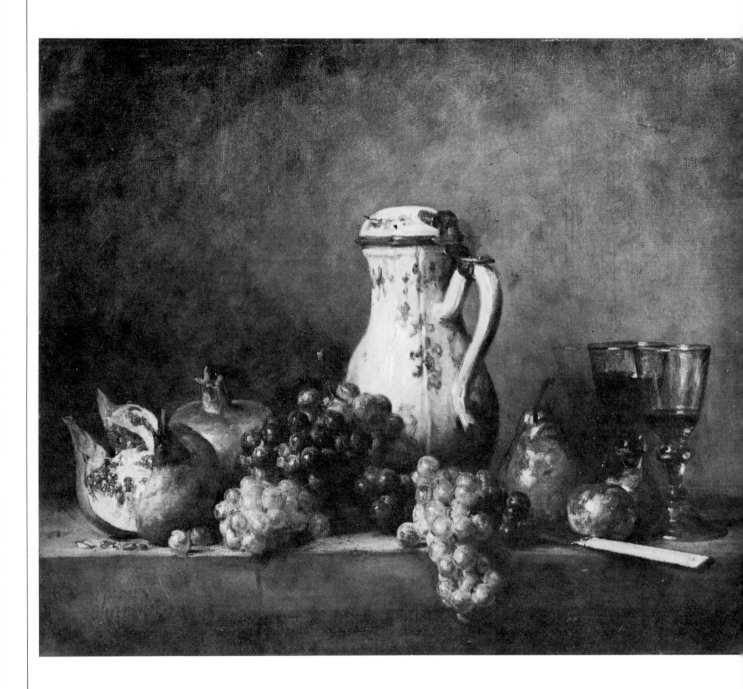

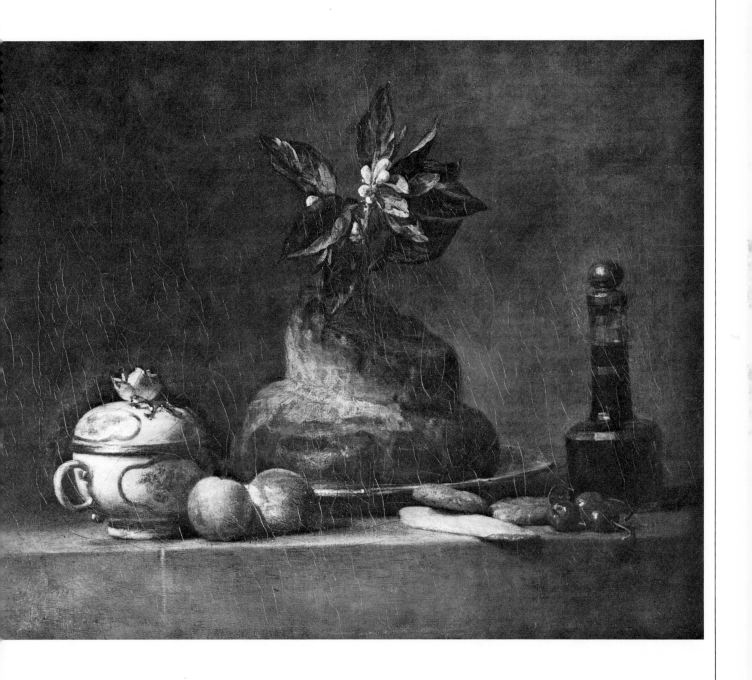

118

See Color Plate XIX.

these titles hardly correspond to the subjects depicted in the two works owned by the Louvre; but it is well known that the Salon catalogs are generally vague when it comes to titles. If there is some doubt, however, about the Saint-Florentin connection, there is none about the fact that the two pictures next belonged to the Marquis de Livois (1736-1790) in Angers.

There are some unusual objects depicted in these paintings. The water pitcher, for instance, with its polychrome decoration and silver-gilt rim, had already appeared in *The Cut Melon* dated 1760 [111]. The Meissen bowl does not seem to be the same as the one in the Louvre's *Jar of Olives* nor in the *Duck* of Springfield [122]. As for the small liqueur carafe of cut glass with its flattened sides "in the Bohemian style" and its gilded stopper [see Barrelet, 1959], this is the only time it appears in a work of Chardin. Also unique are the splendid pomegranates and the blossoming branch of an orange tree crowning the brioche.

Critics of the 1763 Salon acclaimed on Chardin. The magnificent Diderot text, which discusses in some detail the *Jar of Olives*, has already been quoted (see [114]). Other critics spoke of the painter's work in general terms without, unfortunately, providing any details on his entries. "The paintings he has exhibited this year are the most beautiful we have ever seen from him," wrote Fréron in the *Année littéraire* [1763, VI, p. 153]. Fréron went on to admire the "forcefulness and truth with which he renders nature," as well as his amazing understanding of color and the effects of direct and reflected light."

The Abbé de La Garde, editor of the *Mercure de France,* wrote in a special issue for September (p. 37): "This illustrious artist seems... to have totally renewed the strength of his talent." Only C. J. Mathon de la Cour, reviewing a Salon for the first time, had some reservations. Although he also was highly laudatory, his comments clearly reveal his preference for the "hierarchy of genres": "I would rather... that he [Chardin] had applied himself to making his paintings interesting by using handsome figures, like those he has given us in the past. Men like to find themselves everywhere; this secret yearning is the germ of sociability. Music which imitates the sound of a clock or the noise of thunder does not please us as much as music expressive of human feeling. Landscapes, fruits, and even animals call forth admiration; but they will never be as interesting as a well-painted head" [*Lettres à Madame XX sur les peintures... exposées au Salon du Louvre en 1763,* p. 38].

These paintings bear witness to Chardin's customary care in organizing his compositions; in skillfully arranging and interrelating the objects represented; in rendering the texture appropriate to each of them, from the dew-covered grapes to the clouded glasses; in playing on the contrasts between colors and forms. Never before had Chardin given such attention to the reflections of light and the color changes that light produces. Yet it would be insulting to the artist to limit his talent only to extraordinary skill in reproduction. The orange blossom, the grapes, and the pomegranates affect the viewer with a kind of blissful and mysterious fascination, both silent and poetic, which induces contemplation and revery.

119 *White Teapot with Two Chestnuts, White Grapes, and Pear*

(Théière blanche, avec deux châtaignes, raisin blanc et poire)

Canvas, 32 × 40 cm. Signed and dated at the bottom left on two lines: *Chardin / 17(64 ?).*
Boston, Museum of Fine Arts

Provenance. Signol sale, 1-3 April 1878, no. 45: *Attribué à Chardin: Une théière, une grappe de raisin blanc et une poire posées sur une table* ("Attributed to Chardin: A teapot, a bunch of white grapes, and a pear on a table"; 31 × 40 cm.) (?). Collection of the Baron de Beurnonville; Beurnonville sale, 21-22 May 1883, no. 7. Acquired by Martin Brimmer, who gave it in the same year to the Boston museum.

Exhibitions. 1935-36, New York, no. 23 (ill.); 1947, New York, no. 11.

Bibliography. Eudel, 1884, p. 334; Downes, *Atlantic Monthly,* October 1888, p. 501; Guiffrey, 1908, p. 46; Furst, 1911, p. 134; Guiffrey, 1913, p. 541; Museum cat., 1921, p. 79, no. 191; Museum cat., 1932, ill. (unpaginated); Wildenstein, 1933, no. 870 (and 873?); *Beaux-Arts,* 1935, no. 153, p. 1; Paris exh. cat., 1937, p. 73; *The Art Digest,* 1 November 1947, p. 12; Museum cat., 1955, p. 11; Paris exh. cat., 1959, under no. 20; Faré, 1962, p. 164; Wildenstein, 1963-69, no. 335, fig. 116 (and not fig. 151, the Algiers painting! See *Related Works*); Museum cat., 1964, p. 255 (ill.).

Related Works. There is a close replica of this Boston painting, with variations of detail in the fruits, now in the museum of Algiers [Wildenstein, 1963-69, no. 247, fig. 151, and not 116, which is, in fact, the

Algiers, Musée National des Beaux-Arts d'Alger.

Boston painting.]. The painting's pendant is a picture in the Averill Harriman collection recently given to the National Gallery, Washington [Wildenstein, 1963-69, no. 248, fig. 118]: *Quatre pommes, une poire, un couteau et pot de faïence blanche* ("Four apples, a pear, a knife and white faience pitcher"). Despite the rather sizeable difference in dimensions (31.5 × 33.5 cm., as compared with the 33 × 41 cm. of the paintings in Boston and Algiers), this painting probably comes from the sale of the Baron de S[ain]t [Julien] of 20 June 1784, no. 69. For the Marcille painting, which differs appreciably from the Boston and Algiers compositions, see [106].

The date of the Boston painting, which has always been read as 1764, is very hard to decipher. It does seem accurate, however, when compared with the Angers museum's *Basket of Grapes* [120], clearly dated 1764. We are convinced of this by the very similar way in which the grapes are treated in both these works, with particular attention given to the highlights on each grape; by the fact that both paintings depict a green and a red pear; and also by the artist's signature underlined with a stroke of the brush.

While it is almost identical to the Algiers painting, the Boston work differs substantially from the Marcille canvas [106]. Only the teapot (of English faience, according to M. Fourest and Mme Hallé of the Sèvres museum), with its four-angled spout, is the same in both works (though in the Boston painting it appears closer to the viewer).

Chardin has again simplified his composition, reducing it to a few fruits placed at random on a table. The teapot, accentuated by the painting's brown background, lights the entire composition and gives it unity. To achieve the creamy whiteness of the faience, Chardin uses blue, green, brown, and yellow. To render its value, he plays with tinted shadows and reflections of light. Once again, he amazes us with the originality of his craftsmanship: every object he treats is freed of its anecdotal and temporal aspect and is transformed into a work of art, impressive in its stillness and—for whoever contemplates it—a source of calm delight.

120 Basket of Grapes with Three Lady-Apples, a Pear, and Two Marzipan Biscuits

(Corbeille de raisins avec trois pommes d'api, une poire et deux massepains)

Canvas, 32 × 40 cm. Signed at the bottom on two lines: *Chardin / 1764.*
Angers, Musée des Beaux-Arts

Provenance. Collection of Pierre-Louis Eveillard (1736-1790), Marquis de Livois, in Angers; cataloged after his death by Pierre Sentout, painter, Angers, 1791, no. 22 (the number already given to *Grapes and Pomegranates* and *The Brioche*): *Sur une table on y voit une corbeille, des raisins noitié pourris, trois pommes d'apis [sic], une poire et un masse-pain [sic], le tout naturellement représenté* ("On a table one sees a basket, some half-spoiled grapes, three lady-apples, a pear and a marzipan biscuit, all naturally represented"). Considered as belonging to the share of the Livois heirs either absent or emigrated at the time of the Revolution, and therefore confiscated. Exhibited at the Logis Barrault in Angers beginning in 1800 [see Planchenault, 1933 and 1934]. See also [120], *Related Works*.

Exhibitions. 1765, Salon, no. 49 ("Several paintings under the same number, one of which represents a basket of grapes") (cf. [120], *Related Works;* could also be the Amiens version); 1954-55 London, no. 225; 1961-62 Montreal, Quebec, Ottawa, Toronto, no. 14, pl. on p. 84; 1978, Moscow, Leningrad, no. 114.

Bibliography. Museum cat., 1800, p. 15, no. 17; Clément de Ris, 1859, pp. 245, 250; Goncourt, 1864, p. 150; Clément de Ris, 1872, p. 31; Bocher, 1876, p. 89, no. 17; Goncourt, 1880, p. 129; Museum cat. (Jouin), 1881, pp. 9-10, no. 32; Museum cat., 1885, p. 17; Gonse, 1900, p. 37; Guiffrey, 1908, p. 62, no. 37; Goncourt, 1909, p. 190; Pilon, 1909, p. 168; Furst, 1911, p. 120; Planchenault, 1933, p. 226; Wildenstein, 1933, no. 866, fig. 97; Planchenault, 1934, p. 264; Seznec and Adhémar, 1960, p. 26 and fig. 28; Faré, 1962, p. 164; Vergnet-Ruiz and Laclotte, 1962, p. 230; Rosenberg, 1963, pp. 14, 71 (color); Wildenstein, 1963-69, no. 336, fig. 153; McCoubrey, 1964, p. 47, fig. 10; Faré, 1976, pp. 165, 166, fig. 255.

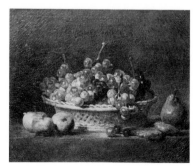

Amiens, Musée de Picardie.

Related Works. A second version of this painting is not very different, except for the arrangement of the grapes and the color of their stems in the upper right portion of the work. It is dated *1765* [Wildenstein, 1963-69, no. 338, fig. 154] and comes, like the other three Chardins now in Amiens [41, 43, 101], from the collection of the brothers Ernest and Olympe Lavallard. We do not know whether it was this version or the Angers version which was in the Salon of 1765. For the companion piece, of which there is also a replica, see [121]. One might conceivably try to identify the Angers painting and its companion piece (or the second pair) with no. 17 of the Sylvestre sale (28 February-25 March 1811: *Deux autres tableaux dans lesquels sont un panier de prunes, une corbeille de raisins et d'autres fruits* ["Two other paintings in which there are a basket of plums, another of grapes and other fruits"]) and no. 3 of the Gounod sale (23 February 1824: *Un panier de prunes, une corbeille de raisins et d'autres fruits sur des appuis* ["A basket of plums, another of grapes and other fruits on ledges"]). Both the dimensions (30.5 × 39 cm.) and the descriptions agree quite well. But in our opinion the pair of paintings from the Gounod sale [117, 118] are the ones lent by Sylvestre to the Salon of 1763 (no. 61).

The Marquis de Livois (1736-1790) owned seven paintings by Chardin, as well as several pastels (see [134]). After lengthy negotiations described in detail by Planchenault (1933 and 1934), only one part of his collection entered the Angers museum to become and to remain the core of the Angers collection. Of the seven oils by Chardin, three are now at Angers (*Peaches and Plums* and *Still Life with Goblet and Bottle* [Wildenstein, 1963-69, no. 255, fig. 119, and no.

256, fig. 120] —two exquisite little paintings, 19 × 34 cm., —which were too small to include in the present exhibition) and two are in the Louvre [117, 118]. Earlier (see [83]) we called attention to *The Governess* of the Livois collection. As for the seventh and last painting, "one of the finest in this genre which the master has painted," which seems to have been overlooked by the biographers of Chardin, here is its description:

Sur un banc de pierre on y remarque un saladier rempli de pêches avec des feuilles de vigne: à côté, des raisins blancs et noirs et un morceau de sucre; sur le devant, une tasse à café avec sa soucoupe et un [sic] cuiller, une carafe de cristal, une bouteille carrée de verre vert, deux pêches et une prune sur une feuille de vigne; de plus une boîte de fer blanc remplie de café brûlé ("On a stone bench one sees a salad bowl filled with peaches and vine leaves; beside it, white and black grapes and a lump of sugar; in front, a coffee cup with its saucer and a spoon, a crystal carafe, a square, green-glass bottle, two peaches, and a plum lying on a vine leaf; in addition, a tin box filled with roasted coffee"; P. Sentout catalog, Angers, 1791, no. 221; the painting measured 54 × 65 cm.). The Marquis de Livois seems not to have obtained these paintings directly from Chardin. Research presently in progress ought to enable us to determine the origin of each work and the precise role played in the establishment of the Livois collection by Jean-Jacques Lenoir, *écuyer*, subsequently controller-general of the Maison du Roi (from which Livois purchased a block of seventy-five paintings in 1781).

Again, because of the description given by Diderot [Seznec and Adhémar, 1960, p. 114], it seems certain that it was either the Angers *Basket of Grapes* or its replica in Amiens, dated 1765, that was shown in the 1765 Salon at which Chardin was strongly represented: "Scatter around the basket a few separate grapes, a macaroon, a pear and two or three lady-apples; you will agree that individual grapes, a macaroon, a few isolated lady-apples are not much paint with regard to either form or colors; yet, have a look at the painting of Chardin."

Chardin put his entire understanding of reflected light in this simple reed basket filled with white and black grapes: the satiny finish of each individual grape picks up and reflects the light. It is fitting to cite Diderot again, at the beginning of his commentary of the Chardins of the 1765 Salon: "You come just in time, Chardin, to restore my eyesight which your colleague Challe had mortally wounded. So there you are again, you great magician, with your silent arrangements! How eloquently they speak to the artist! How much they tell him about the imitation of nature, the science of color, and harmony! How freely the air circulates around these objects."

121 *Basket of Plums with Walnuts, Currants, and Cherries*

(Panier de prunes, avec noix, groseilles et cerises)

Canvas, 32 × 40.5 cm. Signed at the bottom left on the edge of the stone ledge: *Chardin*.
Paris, Private Collection

Provenance. Collection of Eudoxe Marcille (1814-1890) by 1860; has remained in this family. (For a hypothetical early provenance of this painting and its companion piece, the *Basket of Grapes...*, see [120], *Related Works*.) There was a "basket of plums," without any indication of dimensions, at the Benoist sale, of 30 March 1857, no. 17.

Exhibitions. 1765, Salon, no. 49 ("Several paintings under the same number, one which represents a basket of grapes"); 1860, Paris, no. 108.

Bibliography. Gautier, 1860, p. 1065; Horsin-Déon, 1862, p. 137; Gautier, 1864, p. 76; Bocher, 1876, p. 101; Goncourt, 1880, p. 130; Chennevières, 1889, p. 129; Schéfer, 1904, pp. 64, 67; Guiffrey, 1908, pp. 79-80, no. 142; Goncourt, 1909, p. 191; Furst, 1911, p. 126; Wildenstein, 1933, no. 850, fig. 111; Copenhagen exh. cat., 1935, p. 10,

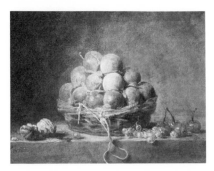

Norfolk (Va.), Chrysler Museum.

under no. 33; Paris exh. cat., 1937, p. 76, under no. 144; Lazarev, 1947, pl. 14; Seznec and Adhémar, 1960, p. 26; Zolotov, 1962, pl. 22; Wildenstein, 1963-69, no. 333, fig. 152; McCoubrey, 1964, p. 46, fig. 9; Faré, 1976, p. 166; Museum cat. (Chrysler Museum at Norfolk), Nashville, 1977, no. 21.

Related Works. Another version of this painting is now at the Chrysler Museum at Norfolk, Virginia. The Chrysler painting was exhibited in 1935 in Copenhagen and in 1937 in Paris at the Masterpieces of French Art exhibition. It has been frequently reproduced [Florisoone, 1938, in color; Hourticq, 1939; Garas, 1963; Lazarev, 1966; et al.] and lent by Chrylser on numerous occasions to other institutions (Chicago, 1940; Philadelphia, 1941; Portland, 1956; Princeton, 1958; New York, 1963 and 1965; Norfolk, 1976; Nashville, 1977, etc.). It presents several variations in detail in the arrangement of the fruits (on the left, for example, there is an additional red currant) and especially in the position of Chardin's signature, which is much farther to the left in this painting. For the companion piece, a *Basket of Grapes...*, see the preceding entry; for the highly problematical identification of [120] and [121] with those included at the Sylvestre sale of 1811 and the Gounod sale of 1824, see [120], *Related Works*.

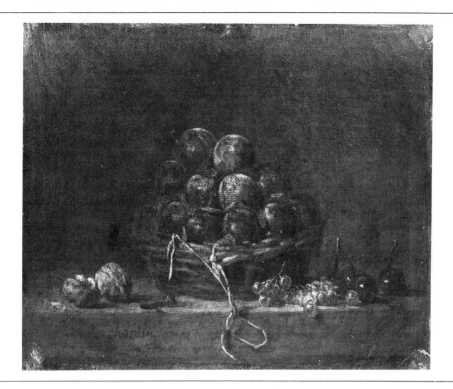

Thanks to the description given by Diderot [Seznec and Adhémar, 1960, p. 114], we can confirm positively that one of the "paintings" mentioned in the catalog of the 1765 Salon, without any specification of subject, is the picture exhibited here (or, if need be, its replica in the Chrysler Museum at Norfolk; see *Related Works* above). "Put on a stone bench," Diderot writes, "a wicker basket full of plums, for which a paltry string serves as a handle, and scatter around it some walnuts, two or three cherries, and a few small bunches of grapes" [the "bunches of grapes" are actually white currants].

Although this painting has rarely been exhibited, it has still been greatly admired. In comparing the Marcille *Plums* (they are *prunes de monsieur,* as the Goncourts have noted) with the Laperlier *Peaches* now in the Louvre [130], Henry de Chennevières wrote [1889, p. 128]: "The similarity in the way the nuances are produced is at the very least remarkable. And that is saying a good deal in favor of our painting, for M. La Caze was in the habit of repeating to M. Marcille, as they stood in front of his *Plums:* 'My dear fellow, whatever you do, don't ever get rid of this pearl; it's a unique Chardin.'" Gaston Schéfer, in his little-known book on Chardin, made no effort to conceal his enthusiasm:

"At a distance, their lovely violet coloring, their satiny skin, the bloomy down on their surface, are a joy to see: not one brushstroke clashes with another or mars their transparency. When one examines them closely, one by one, one discovers they are made of the green reflected from the leaves surrounding them, the white of the light, red, blue, the whole range of similar colors. And from this ensemble, so very odd and disparate, there emerges an astonishing masterpiece of truth."

In comparison with the Rennes painting on the same subject, the same deliberately frontal perspective is retained here; but Chardin simplifies the composition even more, centering it on the basket and the ingenious bit of the string used to carry it. The knot of that string stands out against the edge of the table and softens whatever excessive rigidity the composition might have. The string, like the basket in this picture's companion piece, is also there to remind one of arrested time, of a human presence which Chardin rarely eliminates completely — even from the most austere of his still lifes. The plums are there to be eaten as well as admired. They are not only a decorative element but also have a function that is part of their beauty.

122 *Duck Hung by One Leg, Pâté, Bowl, and Jar of Olives*

(Canard mort pendu par la patte avec pâté, écuelle et bocal d'olives)

Oval canvas, 152.5 × 96.5 cm. Signed and dated at the bottom left: *Chardin 1764.*
Springfield (Massachusetts), Museum of Fine Arts (The James Philip Gray Collection)

Provenance. Collection of Gustave Rothan (1802-1890), diplomat and historian, as of 1876 (included in neither the Rothan sale of 1890 nor the article on this collection published by Mantz in 1873). A. Lévy collection in 1899-1900 [Fourcaud]. Jacques Doucet collection in 1907; Doucet sale, 6 June 1912, no. 137 (ill.). Collection of Mrs. John W. Simpson, New York (who gave to Washington the *Soap Bubbles* in the present exhibition, [59]). Acquired by Springfield in 1946.

Exhibitions. 1765, Salon, no. 48 ("Three paintings under the same number, one of them oval in shape and representing refreshments, fruits, and animals"); 1878, Paris, no. 38; 1945, Baltimore, no. 5, pl. on p. 6; 1947, Cambridge (no cat.). 1965, Indianapolis, no. 4 (color pl.).

Bibliography. Bocher, 1876, p. 102; Goncourt, 1880, p. 130; Fourcaud, 1899, p. 393 (pl.); Fourcaud, 1900, pl. between pp. 10 and 11; Guiffrey, 1908, pp. 44, 76, no. 117; Goncourt, 1909, p. 192; Furst, 1911, p. 124; Dacier, 1912, p. 337; Fénéon, 1921, p. 314 (ill.); Wildenstein, 1933, no. 697, fig. 90; *Bulletin of the Allen Memorial Art Museum*, Oberlin, March 1945, pp. 12-13; *Art News*, April 1946, no. 2, p. 47 (ill.); *The Art Quarterly*, Winter 1946, pp. 82-84 (ill.); *The Art Digest*, 1 June 1946, p. 11 (ill.); *Bulletin*, Museum of Fine Arts, Springfield, April-May 1946, no. 4 (ill.); Born, 1947, p. 94, pl. 10; Museum cat., 1948, pl. on p. 25; *Art News*, February 1949, p. 27; Denvir, 1950, pl. 29; *Life* (Robinson), 2 May 1955, p. 125 (color pl.); *Art News*, September 1958, p. 28, pl. 5 (color); Museum cat., 1958, p. 37 (color pl.); Barrelet, 1959, p. 309; Seznec and Adhémar, 1960, p. 26; Wildenstein, 1963-69, no. 337, pl. 51 (color); *Indianapolis Star Magazine*, 21 February 1965 (ill.); *Springfield Sunday Republican*, 9 June 1968 (ill.); Faré, 1976, p. 165.

Chardin exhibited at the Salon of 1765 a few still lifes with fruit, including [120, 121], the three Choisy overdoors (see [123, 124]), and "three paintings, under the same number, representing refreshments, fruits, and animals." The Salon catalog specifies that the "oval" painting is five *pieds* high (162.5 cm.) and that two other paintings measure 4 *pieds* 6 *pouces* wide by 3 *pieds* 6 *pouces* high (146 × 113.5 cm.). Thanks to Diderot, who devoted to Chardin some of his best-known pages [Seznec and Adhémar, 1960, p. 113], we are positive that the Springfield painting is the one in the 1765 Salon:

"If it is true that a connoisseur cannot dispense with having at least one Chardin, let him get hold of this one. The artist is beginning to grow old. He has sometimes done as well; never better. Hang a river bird by the leg. On a buffet beneath it, imagine a few biscuits both whole and broken, a jar stopped with cork and filled with olives, a painted and covered porcelain bowl, a lemon, a napkin unfolded and thrown down carelessly, a pâté on a round wooden board, with a glass half full of wine. Here one sees that

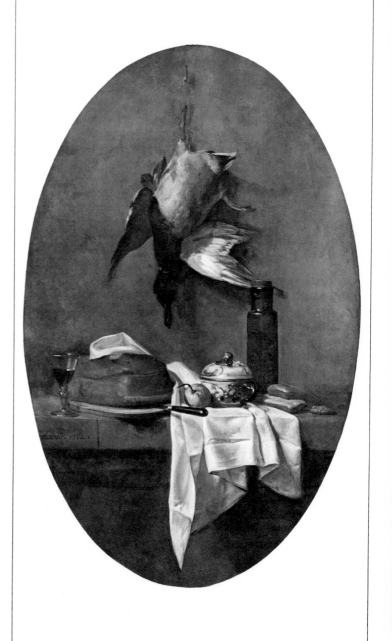

122

See Color Plate XXIV.

there are no intractable objects in nature, and that the point is simply to render them. The biscuits are yellow, the jar is green, the napkin white, the wine red; and this yellow, green, white, and red contrast with one another in a way that pleases the eye with the most perfect harmony. And don't think that this harmony is the result of a weak, soft, and over-polished style. Not at all; everywhere we find the most vigorous touch. It is true that these objects do not change beneath the eyes of the artist. As he has seen them one day, so he finds them again the next. That is not the case with animate nature. Constancy is the attribute only of stone."

Saint-Aubin, water color of the picture
exhibited at the Salon of 1765.
See also p. 343.

Diderot also describes two paintings accompanying the *Duck* (which cannot be those of the [Duquesne] sale of 19 December 1771, since these latter measured 22 *pouces* by 17 *pouces* 6 *lignes* (59.4 × 47.3 cm.) [cf. Wildenstein, 1963-69, nos. 324 and 325]. These two large paintings (whose first owner is as unknown to us as that of the first owner of the Springfield work) are among the most important lost Chardins. We reprint here Diderot's text as well as the reproduction of the water color by Gabriel de Saint-Aubin (Louvre), showing a wall of the Salon of 1765, in the hope of relocating them:

"Fruits and animals. Imagine a square construction of grayish stone, a kind of window with its ledge and cornice. Toss over it with all the nobility and elegance you can muster, a garland of grapes extending the length of the cornice and falling down both sides. Inside the window place a glass full of wine, a bottle, a loaf of bread that has been cut open, other carafes cooling in a faience bucket, a small clay jug, some radishes, fresh eggs, a saltcellar, two cofee cups filled and steaming, and you will see the picture painted by Chardin. This construction of smooth, wide stone with the garland of grapes decorating it is consummately beautiful. It is a model for the facade of a temple to Bacchus."

Here also is the description of the companion piece: "The same stone construction; around it, a garland of plump white muscat grapes; inside, peaches, plums, carafes of lemonade in a tin bucket painted green, a lemon peeled and cut in half, a basket full of *échaudés* [a kind of cake], a Masulipatan [fine cotton] handkerchief hanging outside, a carafe of orgeat, with a glass half full of the syrup. How many things! What diversity of forms and colors! And yet what harmony! What restfulness! The handkerchief is astonishingly soft."

In the Springfield picture Chardin has once again painted objects and fruits with which we are very familiar: the knife, whose blade has been slid beneath the pâté on the cutting board, the stemmed glass half full of red wine, the Seville orange, the Meissen bowl, the jar of olives stopped with cork, the marzipan biscuits; even the wild duck reminiscent of the *Green-Neck Duck*... belonging to the Musée de la Chasse [17], painted more than thirty years before.

Whereas until now Chardin had accustomed us to expect smaller works, he sent to the 1765 Salon six large paintings. To be sure, we are dealing here with a commission to decorate a dining room, in all likelihood, though at present nothing is known about it. The surprise comes from the ease with which Chardin adapts to these new dimensions and to this oval form that is considered so difficult to "furnish." It comes too from the way he solves the problems inherent in this kind of commission, at the same time avoiding the pitfalls of decorative art. The touch of red provided by the Seville orange, accentuated by the large white mass of the napkin and the carmine legs of the duck with its whitish belly of soft down against the gray-green background, immediately attracts attention. The general harmony, the masterful simplicity of the arrangement, its perfect rhythm, the balance of the masses that have been organized with no apparent effort make the Springfield painting one of Chardin's masterpieces. Never has the transformation, the maturation of Chardin's style been so evident. Every superfluous detail has been eliminated. Now Chardin is creating works of increasing rigor whose classical character is becoming obvious.

VII *Large Decorative Compositions and Trompe l'Oeil in Grisaille*

At the Salon of 1765 Chardin exhibited three overdoors that had been commissioned for the Château de Choisy [123, 124]. He also showed three other large compositions, of which only one has survived [122]; the two lost ones are known to us through a description by Diderot and a water-color drawing by Gabriel de Saint-Aubin. In 1766 he completed his *Attributes of the Arts* [125] for the Russian Academy of the Fine Arts in St. Petersburg and exhibited a second version (now lost) three years later. Finally, at the Salon of 1767, he showed to the public two overdoors on musical subjects which he had painted for the Château de Bellevue [126, 127].

These six works, painted within the short span of three years, are of a large format that seems unusual for Chardin. In addition, some are oval or arched, obliging Chardin to find new solutions to problems of composition. The subjects themselves are not new: musical instruments and the attributes of the arts and sciences had occupied Chardin in 1730 and 1731. But what a difference there is between the pictures for Rothenbourg [27, 28] and those destined for the royal castles which had been commissioned from Chardin by his friend Cochin. Gone are the sumptuous, somewhat-chaotic richness and uncontrolled lyricism of the early pair, replaced by a cubist severity, a sense of harmony, and a perfect mastery of interrelationships.

Yet the greatness of Chardin is that he never surrendered to the restrictions imposed upon him by the place where his works were to be hung. He never slipped into the merely decorative; in fact, Chardin was never more painterly than in these commissioned works. Chardin did not renounce still lifes immediately. He showed several at the Salons of 1765 and 1769. One of the very last was *Basket of Peaches with Walnuts, Knife, and Glass of Wine* [130] acquired by the Louvre at the Laurent Laperlier sale in 1857, whose pendant was the *Basket of Grapes* in the Henry de Rothschild collection (destroyed in World War II with so many important Chardins). In its simplicity and spareness, its gentle coloring, delicacy of light, and the sensitivity and modesty of its creator, it is probably the most perfect of Chardin's still lifes.

The Salon of 1769 brought a new surprise: Chardin entered two grisaille paintings [131, 132] after two bas-reliefs by Van Obstal in the royal collections. He repeated this specialty at the Salons of 1771 [133] and 1776 [138], both times with copies after Bouchardon. Bouchardon and Pigalle were the only contemporary sculptors whose

works he was to copy (see [123, 94]). By rendering homage to them, Chardin certainly meant to imply that masterpieces of modern art were as worthy of being copied as the classical art of antiquity.

Grisaille painting was not a new discovery for Chardin. His copy of a bas-relief by Duquesnoy (see [33]) had already caused a sensation at the Exposition de la Jeunesse of 1732. His return to a practice of his early years proves once again how he not only refused to be imprisoned in any rigid formula but also strove to explore fresh avenues and to renew his art constantly in subject matter as well as execution.

123 *Attributes of the Arts*

(Les Attributs des Arts)

Canvas, 91 × 145 cm. (rounded at the corners; for the original dimensions, see discussion below; restored to original dimensions for this exhibition). Signed and dated at the right on two lines: *Chardin /1765*. Paris, Musée du Louvre, Inv. 3199*

Provenance. One of the three overdoors commissioned from Chardin in 1764 for the "drawing room adjacent to the game room," also called the visitors' drawing room, in the Château de Choisy. On 14 October 1764 Charles-Nicolas Cochin (1715-1790), the all-powerful secretary of the Academy at the time (and friend of Chardin), submitted to Marigny, director of royal construction, the plan for the decoration of the château that he had been asked to draw up. The heart of Cochin's plan involved historical paintings to be commissioned from Carle Vanloo, Boucher, Vien, and Deshays. But, he added [Engerand, 1901, pp. 226-27], "in another drawing room adjacent to the game room, there are three overdoors; one could put there the principal arts, such as Architecture, Painting, and Music." Cochin did not mention the name of Chardin in his plan, but he did bring it up on 25 October [Archives Nationales, 0¹1910, 1764, vol. 3; see also *Nouvelles Archives de l'Art Français*, 1904, p. 334]:

"I respectfully propose to you that the other [room] be entrusted to M. Chardin. You know how much realism and beauty he imparts to the imitation of things which he undertakes and which he is able to do from nature. We could, then, find a place for his talents by asking him to do two or three of these paintings. In one he would bring together various attributes of the sciences, such as globes, an air pump, microscopes, telescopes, graphometers, etc. In another, he would depict the attributes of the arts: compass, square, ruler, rolls of drawings and prints, palette and brushes, the many and diverse tools of the sculptor. If it were to be in the room needing three paintings, in the third, one might put the *attributes of music*, the different string and wind instruments.

"I believe these paintings would give a good deal of pleasure by that truth that charms everyone and that art of rendering which has resulted in M. Chardin's being considered by artists as the greatest painter in this genre there has ever been. Besides, these paintings would cost only 800 *livres* apiece."

The order of the king is dated 17 November 1764 [0¹ 1378, 1764, p. 201, verso]. The three works were exhibited at the Salon of 1765 where they were very well received. Bailly informed Marigny on 22 October 1765 that he had "installed the paintings" at Choisy [0¹ 1911, 1765, vol. 1, 81]. On 12 November of that same year Cochin wrote to Marigny [0¹ 1911, 1765, vol 1, 94]: "The paintings by M. Chardin are most beautiful and create exactly the right effect in their place at Choisy, where I saw them, and I think that to have paid only 800 *livres* for each is a bargain."

In 1768 Chardin's bill was submitted for Marigny's approval by Cochin and Gabriel [0¹ 1921, 83], but the artist was not paid until 28 November 1772. He did receive 3,000 *livres*, however; part of it was in cash and part in "contracts at four per cent on the 'aides' and 'gabelles' [taxes levied by the State]". Cochin, now in disfavor and officially replaced by the new first painter, Pierre, added to Chardin's bill the following note [Archives Nationales, 0¹ 1921ᴮ]: "I have always secretly regretted having set too low a value, when I was charged with the administration of the arts, on the five paintings by M. Chardin mentioned here [he was referring, in addition to the three pictures for Choisy, to two paintings at Bellevue; see [126, 127]]; a man of his merit ought to have been treated more generously. Would there be a way to persuade the Director General to make reparation for my failure by granting M. Chardin some kind of bonus, given the delay he has met with and the method of payment to which he consents?"

Unlike the paintings by Carle Vanloo, Vien, Hallé, and Lagrenée (who had substituted for Boucher and Deshays), which Louis XV had ordered moved immediately, Chardin's compositions remained in place until the Revolution. All three were inventoried at Choisy-le-Roy on 30 May 1792 [*Inventaire général des richesses d'art de la France*, 1886, II (Plon), p. 12]. They were transferred in Year II for storage at the Petits-Augustins [Archives nationale F¹⁷, 24¹, fol. 13, verso], where they were again listed in 1795 [*Inventaire*, 1886, p. 262, no. 355; see also *Revue Universelle des Arts*, XXI, 1865, p. 145, no. 583, which publishes the 1794 inventory made by Alexandre Lenoir]. Two of the Chardins were handed over to Naigeon, curator of the storage facility on the rue de Beaune, by the Jury on the Arts on 9 Novôse Year VI [*Inventaire...* , p. 344, nos. 180 and 110], following a deliberation of 21 Messidor Year V [Archives Nationales F¹⁷, 1192 D, dossier 58], no. 269: *deux tableaux, l'un par Chardin et l'autre dans le genre de Rembrandt... ad jugés pour vingt livres et un sol* ("two paintings, one by Chardin and the other in the style of Rembrandt... sold for twenty *livres* one *sol*"). The two remaining paintings were sent to Fontainebleau in 1806 [Archives, Louvre, p. 12], where they were shown in the François I gallery, in the royal dining room, etc. By 1835 the curators of the Louvre wanted these two paintings returned to Paris. *Attributes of the Arts* was brought back in 1836, but it required a report made out by Frédéric Reiset, curator of paintings, to get back the *Attributes of Music* [8 June 1868, Archives, Louvre, I BB 17, p. 52; see also the 1888 text of Chennevières which is included in [124]]: "M. Reiset cites the overdoor made by Chardin for the Château de Choisy which is now at Fontainebleau where, for five years, it has been hidden by a drape and from where we have been unable to remove it, despite all our attempts to do so." That painting was not exhibited at the Louvre until August 1872.

Although it is generally agreed that the *Attributes of the Sciences* "disappeared from Fontainebleau between 1810 and 1851," more than likely, it was sold by the Revolutionary administration. What became of it remains a mystery. But there might be some benefit in republishing Diderot's description from his critique of the 1765 Salon [Seznec and Adhémar, 1960, p. 112]:

"The *Attributes of the Sciences*. We see, on a table covered with a reddish carpet, going, I think, from right to left, some books standing on end, a microscope, a small bell, a globe half-hidden by a curtain of green taffeta, a thermometer, a concave mirror on its stand, a pair of opera glasses with its case, some maps done up in a roll, the end of a telescope. It is nature itself, in truth of color and forms; the objects move apart one from the other, advance and recede, as if they were real; nothing could be more harmonious; and there is no confusion, in spite of the many objects and the small space."

Exhibitions. 1765, Salon, no. 46 ("Another [painting] representing those [Attributes] of the Arts"); 1936, Paris, no. 1105; 1960, Louvre, no. 571; 1963, Paris, no. 318; 1966, Vienna, no. 449.

Bibliography. Museum cat. (Villot), 1855, no. 104; Blanc, 1862, p. 15; Goncourt, 1863, p. 520; Bocher, 1876, p. 85; Goncourt, 1880, p. 124; Chennevières, 1888, pp. 58-59; Engerand, 1896, p. 163; Dilke, 1899, p. 190, note 4; Dilke, 1899 (2), p. 119; Fourcaud, 1899, pp. 398-401; Furcy-Raynaud, 1899, p. 241; Fourcaud, 1900, pp. 16-19; Engerand, 1901, pp. 81-83; Normand, 1901, pp. 36-37; Schéfer, 1904, pp. 87-89; Guiffrey, 1908, pp. 68-69, no. 72; Goncourt, 1909, p. 183; Pilon, 1909, pp. 69, 165; Vitry, 1910, pp. 20-21; Furst, 1911, p. 121, no. 98; Museum cat. (Brière), 1924, no. 98; Pascal and Gaucheron, 1931, p. 95; Ridder, 1932, pl. 23; Wildenstein, 1933, no. 1133, fig. 181; Jourdain, 1949, fig. 11; Denvir, 1950, pl. 36 (color); Barotte, *Jardin des Arts*, 1956, no. 18, p. 330 (ill.); Adhémar, 1960, p. 457; Seznec and Adhémar, 1960, p. 26, fig. 21; Faré, 1962, p. 164; Garas, 1963, pl. 33; Rosenberg, 1963, p. 14; Wildenstein, 1963-69, no. 339, fig. 155; Lazarev, 1966, pl. 30; Mesuret, 1972, p. 197; Rosenberg, Reynaud, Compin, 1974, no. 147 (ill.); Faré, 1976, pp. 164-65, pl. 258 (color).

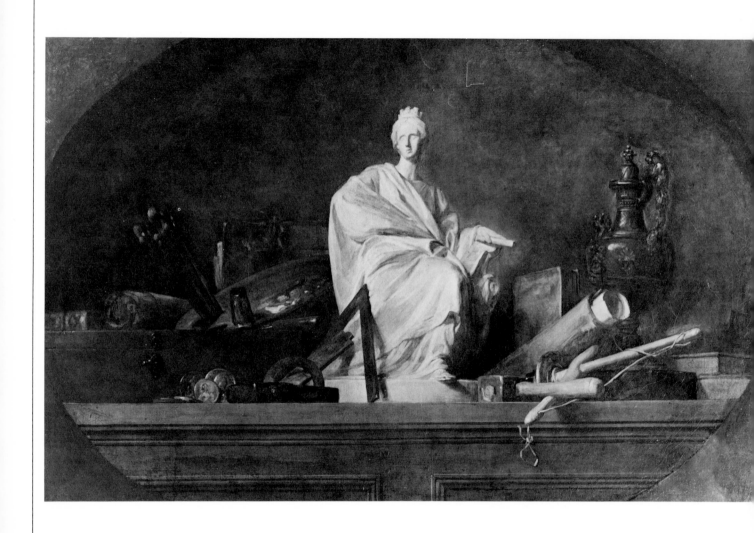

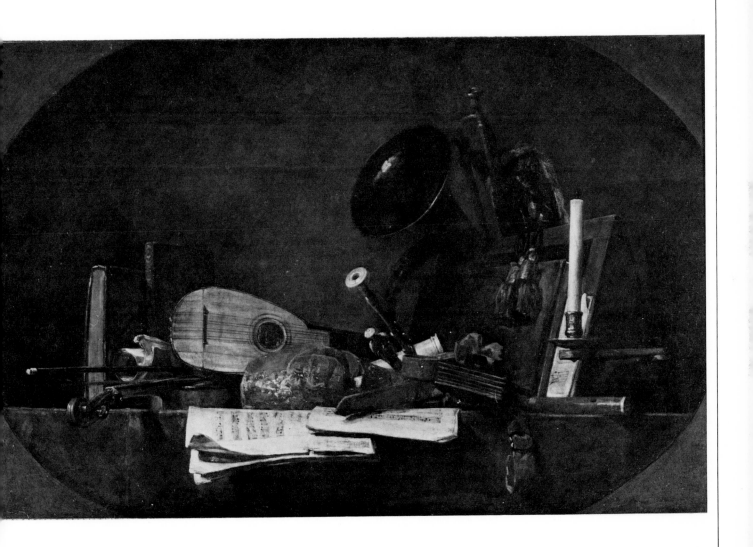

124

See Color Plate XXI.

Related Works. The museum of Beaune has an anonymous copy of the *Attributes of the Arts* dating from the end of the nineteenth century [Schaettel cat., 1971, no. 49]. At the Salon of Toulouse in 1769 there were exhibited (nos. 9 and 10) "A painting of musical instruments by Chardin" and "Mathematical instruments by the same." R. Mesuret [1972, p. 197, nos. 1812 and 1813] connects these compositions with the Choisy paintings. As we have said earlier, it has long been thought that the *Attributes of the Sciences* disappeared from Fontainebleau at the beginning of the nineteenth century. We had hoped to pick up a trace of the painting in several sales held at that time which included a "firescreen coming from the palace of Fontainebleau. Chardin [signed]": 29 November 1873, no. 8; see also 28 April 1873, no. 13; 28 February 1874, no. 8; and 17 December 1879, no. 182, (unverified) [cf. Wildenstein, 1933, no. 1044]. We have also found a reference to a painting depicting an admittedly rather different subject, but which also came from Fontainebleau (the Marquis H. de V. sale, in London, 5 June 1871, no. 170): "A fireboard, painted with Louis XVI andirons and a log of wood. From the palace of Fontainebleau." But the fact that the *Attributes of the Sciences* was sold during the Revolution, without, it seems, passing through Fontainebleau, renders this hypothesis extremely fragile.

See [124] for discussion.

124 *Attributes of Music*

(Les Attributs de la Musique)

Canvas, 91 × 145 cm. (rounded at the corners; for the original dimensions, see discussion below; restored to original dimensions for this exhibition). Signed and dated at the upper right: *Chardin 1765.*
Paris, Musée du Louvre, Inv. 3200

Provenance. See [123].

Exhibitions. 1765, Salon, no. 47 ("Another [painting], in which one sees those [attributes] of Music; 3 *pieds* 10 *pouces* wide by 3 *pieds* 10 *pouces* high"); 1934, Paris, no. 607; 1954, Saint-Etienne, no. 53, fig. 28; 1959, Paris, no. 21, pl. 11; 1960, Ottawa, no 5, pl. on p. 17; 1960, Paris, no. 570; 1964, Paris, no. 494; 1965, Lisbon, no. 326; 1966, Vienna, no. 15.

Bibliography. Bocher, 1876, p. 85; Museum cat. (Tauzia), 1878, no. 725; Goncourt, 1880, p. 124; Chennevières, 1888, pp. 58-59; Engerand, 1896, p. 163; Dilke, 1899, p. 190, note 4; Dilke, 1899 (2), p. 119; Fourcaud, 1899, pp. 398-401; Furcy-Raynaud, 1899, p. 241; Fourcaud, 1900, pp. 16-19; Engerand, 1901, pp. 81-83; Normand, 1901, pp. 36-37; Schéfer, 1904, pp. 87-89; Guiffrey, 1908, p. 69, no. 73; Goncourt, 1909, p. 183; Pilon, 1909, pp. 50, 165; Furst, 1911, p. 122, no. 100; Museum cat. (Brière), 1924, no. 100; Klingsor, 1924, p. 121 (ill.); Pascal and Gaucheron, 1931, p. 95; Ridder, 1932, pl. 22; Wildenstein, 1933, no. 1112, fig. 182; Goldschmidt, 1947, fig. 38; Jourdain, 1949, fig. 10; Golzio, 1955, p. 915 (ill.); Ver[onesi], 1959, p. 263 (ill.); Adhémar, 1960, p. 457, fig. 237; Seznec and Adhémar, 1960, p. 26; Nemilova, 1961, pl. 19; Faré, 1962, p. 164 (pl. 362 in vol. II); Garas, 1963, pl. 32; Gimpel, 1963, p. 408; Ponge, 1963, p. 254 (color detail); Rosenberg, 1963, pp. 6, 14, 102 (color detail), 105, 109 (color detail); Wildenstein, 1963-69, no. 340, pl. 52 (color); Mirimonde, 1965, pp. 115 (fig. 9), 116, 117; Weber, *Connoisseur,* August 1965, p. 238 (ill.); Lazarev, 1966, pl. 32; Mesuret, 1972, p. 197; Rosenberg, Reynaud, Compin, 1974, no. 148 (ill.); Kuroe, 1975, pl. 28 (color); Faré, 1976, pp. 164-65, fig. 259; Mirimonde, 1977, pp. 14-15, pl. 4, fig. 7; Weisberg, 1978, p. 294, fig. 22.

Related Works. See [123].

The *Attributes of the Arts* and the *Attributes of Music* are among those paintings by Chardin most frequently reproduced. Yet actually their fame is recent and their entry into the Louvre was not without obstacles. Through his friend Charles-Nicolas Cochin (1715-1790), Chardin had obtained a commission for three overdoors to decorate a room in the Château de Choisy, the drawing room adjacent to the game room. This commission was part of a broader plan for decorating the palace which benefitted the best historical painters of the time—Carle Vanloo, Vien, Hallé, and Lagrenée the Elder, as well as Bachelier and Vernet [Engerand, 1901, pp. 224-28]. It is well known that these large historical paintings, based on the theme "the generous and humanitarian deeds of kings make their people happy," were not to Louis XV's liking—the king was not receptive to such gross flattery—and it was necessary to remove them rather quickly. The paintings done by Chardin, however, remained in place until the Revolution, when one of his works, *Attributes of the Sciences,* was probably sold (see *Provenance* above); it has since disappeared. The other two paintings were sent to Fontainebleau. The *Attributes of the Arts* returned to Paris in 1836, but it required a major effort on the part of Frédéric Reiset (1815-1891) to obtain the *Attributes of Music* for the Louvre. We have already cited a passage from his report showing the disdainful way in which that particular painting was treated. Here is the version of Henry de Chennevières (1888), which we have every reason to believe is true:

"The *Music* painting was still at Fontainebleau in June of 1870. It took an act of quasi-vandalism to have it permanently removed. In the spring of 1868, M. Reiset was amazed to learn the fate meted out to this work by a sacrilegious architect. He hurries to Fontainebleau and brings back, for the edification of the curator of the Louvre, the following news:

'The painting in question has been for a long time above a door in the palace, in the François I salon along with two others by Rouget. When this room was restored about five years ago, an early tapestry wall hanging was added, and, as the three overdoors were no longer in harmony with the new decor, they were *covered over* by three other paintings representing a salamander with the monogram of François I. As a result, our paintings were *left in their places* and since that time have been sequestered, so to speak, under the new paintings which cover them—in spite of all the efforts to have them removed.'

"Two years later, a formal order was finally issued to bring the architect to his senses."

As we said earlier, the catalog for the 1765 Salon and various archival documents clearly indicate that these works originally measured "3 *pieds* 10 *pouces* wide by 3 *pieds* 10 *pouces* high," that is, approximately 1 meter 25 cm. square. But at the present time, the two Louvre paintings measure 91 × 145 cm. While we are quite certain that the two paintings have been narrowed considerably at the top and bottom, we do not understand how they could have been enlarged at the sides. At any rate, the examinations conducted by the Louvre laboratory prove that the paintings were not

oval originally but very definitely were rounded at the corners, and also reveal the large number of modifications made by the artist in the course of the execution, but do not show any signs of enlargement.

Another document exists which can throw light on the early form of the paintings: the magnificent water color by Gabriel de Saint-Aubin [Louvre, Cabinet des Dessins, Inv. 32749], showing the principal wall of the 1765 Salon on which the Chardin paintings had been grouped together. Clearly distinguishable in the upper row is the Springfield *Duck* [122], flanked by two rectangular compositions that have since disappeared. In the row below is *Attributes of the Arts* on the left and, on the right, *Attributes of the Sciences* (Saint-Aubin's drawing thus completes Diderot's description of the now-lost painting; see [123], *Provenance.)* Finally, in the middle of the bottom row we see the *Attributes of Music.* These sketches, whose exactness is admittedly relative, show that the paintings were enclosed in almost-square frames which must have concealed a part of the painted surface.

We have already commented on three of the paintings included among Chardin's many works at the 1765 Salon. His three *Attributes* were objects of unanimous admiration. In Diderot's account of the Salon, which begins with praise of Chardin and which makes us even more aware of the presence of the painter at the elbow of the critic, we read the following: "They are all equally perfect. Remember what Chardin told us at the Salon: 'Gentlemen, gentlemen, have a heart. Among all the pictures here, seek out the worst and know that two thousand hapless artists broke their brushes between their teeth, despairing to paint anything as bad.'"

Saint-Aubin, water color of the Chardins exhibited at the Salon of 1765.

The only reservation expressed by the critics—of which Mathon de la Cour is the perfect example—is the reproach that Chardin is only a skillful "imitator of nature" incapable of "invention," incapable of painting anything but what he has before him [*Lettres à Monsieur xx... sur les peintures... exposées au Salon du Louvre en 1765*, p. 25]: "It is always a perfect imitation of nature, an art that renders admirably the transparency of bodies and the softness of feathers. M. Chardin has excelled *in this genre* [italics added]. The paintings often create an illusion of reality; although this is not the greatest merit in painting, it is nevertheless very great."

The *Attributes of the Arts* allude as much to painting as to drawing, as much to the goldsmith's craft as to architecture, as much to engraving as to the casting of medals. Each craft is symbolized by its attributes: brushes and palette, square, the sculptor's hammer, drill, etc. Nevertheless, Chardin wanted to draw attention to two objects in particular: the ewer (an "antique vase," according to Diderot) on the right, and the plaster sculpture of the City of Paris in the center of the painting.

The ewer had already been depicted in a painting executed more than thirty years before: the Rothenbourg *Attributes of Music* [27, 28]. Chardin was to paint it once again in the *Attributes of the Arts and Their Rewards* [125] now in Leningrad. Similarities have been noted by Daniel Alcouffe between the piece seen in the Chardin paintings and the gilded silver ewer (with its odd, apparently tiger-shaped handle) done by Nicolas Delaunay (1697) and now part of the treasure of the cathedral in Poitiers.

The plaster sculpture by Edme Bouchardon (1698-1762), however, is the pivotal object in this painting. One might even go so far as to say it takes on the value of a manifesto. The sculptor Bouchardon had just died at the height of his glory. The two artists seem to have been on friendly terms since Bouchardon's return from Italy in 1732, and we know that Bouchardon owned a still life by Chardin [34]. By placing the plaster statue of the rue de Grenelle fountain—"Bouchardon's masterpiece" in the judgment of Diderot—so conspicuously in his painting, Chardin surely had in mind more than a gesture of homage to the great sculptor. He also wanted to reaffirm that contemporary works of art deserve the same admiration as those bequeathed to us by Antiquity. It is equally apparent that by selecting Bouchardon's allegorical figure of Paris (there were a number of versions of it; the version now in Dijon was shown at the Vienna exhibition of 1966 next to the Louvre painting), Chardin wished to symbolize the position of the city as the universally recognized capital of the art world.

The musical instruments in the second painting have been identified by A. P. de Mirimonde. They include: on the left, in front of the two books, a violin with its ivory-buttoned bow; a *mandore* (according to Diderot—or soprano lute or even a mandolin); a court bagpipe with its bag of cerise velvet embroidered in gold lying on some sheets of music, its two pipes, its drone-box and its bellows; a German flute made of wood; a horn; a trumpet (only the upper part is visible) with its "rich flag and two splended tassels." The white stripe of the candle, which has often been reproduced and

commented upon (by Francis Ponge, for example), is placed in front of the music stand which the artist positioned at an angle.

These paintings call for two observations. First of all, what is involved is an official commission, the first one Chardin had received (if exception is made for the *Bird-Song Organ*). The austere style of Chardin's still lifes made them seem somewhat out of place in the interior-decorating schemes of the royal residences. By asking the artist to produce some overdoors, Cochin was cleverly reconciling official needs with the speciality of Chardin, who was little accustomed to undertaking works of such a format. Compositions involving such subjects were not new to the painter, however. He had already done the *Attributes of the Sciences* for Rothenbourg more than thirty years before (see [29]), at about the same time he had also completed two or three large pictures depicting musical instruments [27, 28] for this same patron. Two years after painting the Choisy overdoors, Chardin produced two new masterpieces on the theme of music, destined this time for the Château de Bellevue. The subject of the *Attributes of the Arts* was also familiar to him [30]; and thus the Choisy painting was not the only time Chardin was to treat it [125].

One is impressed, when comparing the 1731 paintings with those done in 1765, by how many details these works have in common and by the very similar conception of their organization. For instance, the splash of white produced by the Bouchardon plaster in the Choisy painting echoes the white of the antique bust in the *Attributes of the Arts*. It would not be difficult to cite numerous other examples. What has changed considerably, however, is the rigor of the organization: in the later paintings it is perfectly controlled. The place of each instrument, of each object, has been painstakingly studied with an eye to the material of which it is made, its color, and its mass. Gone is the "epic" note, the unreal quality of the early paintings. In their place there is perfection and a profound sense of the balancing of masses, which explains why the Cubists admired the Choisy compositions so much. Chardin was successful in adapting to an official commission for a room decoration without lapsing into mere ornamentation.

Rarely has the extremely harsh judgment on Oudry, expressed by Thoré (Bürger), seemed more precise [1860, p. 339]: "Between the talent of Chardin and that of Oudry there is this difference — every decoration produced by Chardin is strong and true painting; every painting produced by Oudry is clever decoration."

125 *Attributes of the Arts and Their Rewards*

("Les Attributs des Arts et les récompenses qui leur sont accordées")

Canvas, 112 × 140.5 cm. ("This rectangular painting was subsequently changed into an irregularly shaped overdoor"; the restoration carried out in 1926 "returned it to its original shape" [note by I. Nemilova, curator at The Hermitage; see also Notthafft, 1936]. Signed at the lower left: *Chardin 1766*.
Leningrad, The Hermitage

Provenance. Commissioned by Catherine II (1729-1796) for the conference room at the Fine Arts Academy of St. Petersburg in 1766, but very likely kept by the empress. Brought to Russia in 1766 by the sculptor Falconet (1716-1791) [Nemilova, 1975]. Placed in storage during the reign of Nicholas I and sold at auction in 1854 (like the *Little Girl with Shuttlecock* [72] [see Dussieux, 1852 and 1876; Guiffrey, 1907; and Wrangell, 1913]). In the Greuch collection at the end of the nineteenth century and beginning of the twentieth. H. van der Pale collection, near Oranienbaum. Acquired by The Hermitage in 1926.

Exhibitions. 1937, Paris, no. 142 (pl. 52, repr. of the Moscow painting instead of The Hermitage painting described in the cat.); 1955-56, Moscow, Leningrad, p. 61; 1972, Dresden, no. 10, pl. 26; 1975-76, Washington, New York, Detroit, Los Angeles, Houston, Mexico, Canada, no. 12 (color pl.).

Bibliography. Hermitage cat., 177 (4?, according to P. L[acroix], *Revue Universelle des Arts*, 1861, XIII, p. 117), no. 378; Dussieux, 1852, p. 132; Blanc, 1862, p. 16; Dussieux, 1876, p. 553; Normand, 1901, pp. 37, 105; Guiffrey, 1908, pp. 77, 91; Pilon, 1909, p. 170; Wrangell, 1913, pp. 63, 89-90; Réau, 1928, p. 180, no. 34; Wildenstein, 1933, no. 1131; Notthafft, 1936, pp. 15-17; Sterling, 1957, p. 43, pl. 35; Museum cat., 1958, I, p. 355, no. 5627 (pl. 279 on p. 353); Descargues, 1961, pp. 63, 172-73 (ill.); Nemilova, 1961, pls. 16 (detail), 17 (color); Faré, 1962, p. 164; Prokofiev, 1962, no. 54 (ill.); Zolotov, 1962, pl. 26; Le Corbeiller, 1963, p. 25; Lewinson-Lessing, 1963, no. 79 (with pl.); Mittelstädt (ed.), 1963, p. 42, pl. on p. 43 (color); Wildenstein, 1963-69, no. 343, fig. 157; Lazarev, 1966, pl. 31 (color); Kuznetsov, 1967, no. 76 (color pl.); Seznec and Adhémar, 1967, p. 23; Charmet, 1970, pp. 9 and 20; Watson, 1970, p. 538; Museum cat. (Minneapolis), 1971, no. 90; Lazarev, 1974, pl. 189; Nemilova, 1975, p. 434, fig. 8 on p. 431; Faré, 1976, p. 168; Museum cat., 1976, p. 233, no. 5627, fig. 146.

Related Works. A painting very similar to the one belonging to The Hermitage is in the Minneapolis Institute of Arts [Wildenstein, 1963-69, no. 344, color pl. 53]; it is also signed and dated 1766. Its provenance is the sale of the widow Mme Devisme, *née* Pigalle, of 17 March 1888, no. 37 [see also Eudel, 1889, pp. 147, 149-50] and the Groult collection. The painting is said to be the one Chardin exhibited at the Salon of 1769, no. 31: *"Les Attributs des Arts et les Récompenses qui leur sont accordées* ('The Attributes of the Arts and the Rewards Accorded Them'). This painting, a replica differing slightly from the one made for the Empress of the Russias, belongs to the Abbé Pommyer, judge of the Grande Chambre du Parlement, honarary fellow of the Academy. It measures about 5 *pieds* wide by 4 *pieds* high." There are a number of reasons, some of them already proposed by D. Carritt, for rejecting this identification which, until now, we had accepted [exh. cat. Toledo, Chicago, Ottawa, 1975-76, no. 16, pl. 103; see, however, the French edition of the catalog]: (1) There are no noteworthy "changes" on the Minneapolis version from the painting in Russia; (2) there are some changes on the two drawings after the painting of the Salon of 1769

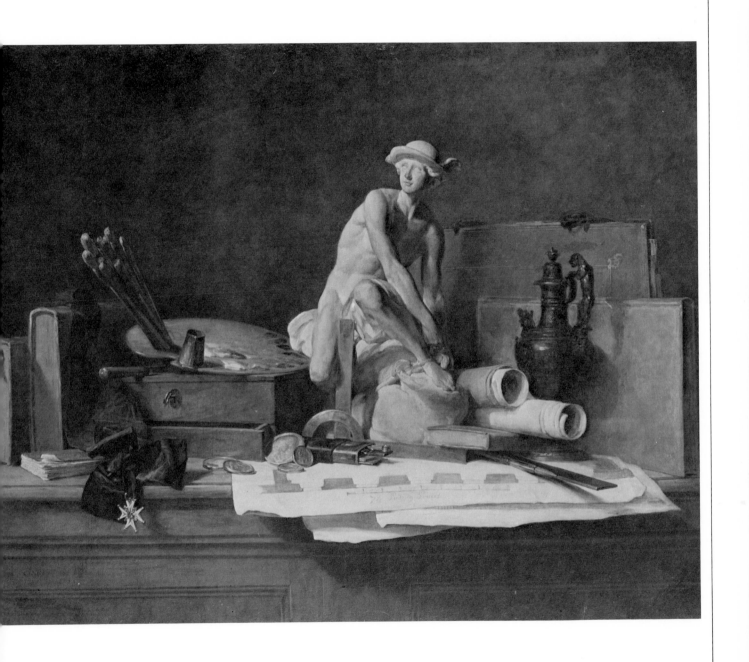

125

Minneapolis Institute of Arts.

Saint-Aubin, drawings after the painting
exhibited at the Salon of 1769.

done by Gabriel de Saint-Aubin on the margin of his copy of the catalog
[p. 11; Cabinet des Estampes, Bibliothèque Nationale; see Dacier, 1909,
II, p. 75]—insofar as one can trust this artist who frequently took liber-
ties with the paintings he copied; and (3) as we have already noted, the
Minneapolis painting comes from the family of Pigalle (1714-1785). The
one at the Salon belonged to Abbé Pommyer in 1769 (see [114]) and
probably was the one which turned up later at the W[ille] sale of 6
December 1784, no. 64. However, and this point is essential, Pigalle did
own a Chardin painting on this subject. Among the *six* Chardins listed
in his estate inventory of 29 August 1785 [published *in part* by Guiffrey,
1886, pp. 169-78, and in a more complete fashion by Rocheblave, 1919,
pp. 364-65; see, however, Archives Nationales, étude LVII, liasse 574],
there were, in addition to two hunting scenes, an overdoor representing
fruit, another overdoor representing a luncheon, a self-portrait of Char-
din done in pastel, as well as "another painting of average size painted
on canvas depicting a trophy glorifying the arts by Chardin, in their
gilded frames, valued at 200 *livres."* It seems certain today that the Min-
neapolis painting is indeed from the collection of Pigalle, to whom
Chardin had very likely given it, and that the work at the Salon of 1769,
belonging to Pommyer and then to Wille, remains to be found.

One should be careful not to confuse the Leningrad picture with the
one in Moscow (once also in Leningrad) representing the *Attributs des
arts avec une tête de Mercure en plâtre* "Attributes of the arts with a
plaster head of Mercury") [Wildenstein, 1963-69, no. 237, pl. 38], and
unfortunately not included in the present exhibition. The Moscow
painting, measuring 52 × 112 cm., shows a Mercury, to be sure. But
the Mercury is *a bust* and has no connection with Pigalle; it is the studio
cast of a famous sculpture of Antiquity. The Moscow composition might
be identical to a painting at the Laperlier sale of 11-13 April 1867, no.
28 (attributed to Chardin's son) and then at the London sale of Sir John
Murray Scott of 27 June 1913, no. 119. (Laperlier makes numerous allu-
sions to this painting, which he says was signed by Chardin *fils,* in his
letters to Bonvin and the Goncourts, among others. He owned yet
another "Attributes of the Arts"; same sale, no. 20, 63 × 92 cm.: "A
palette laden with brushes, some rolled-up drawings, some books, a
sculpted mask, and a sculptor's hammer."

See also the sale of 29 December 1766, no. 70: "A Mercury on a table
and various attributes of the Arts," 21.5 × 24.5 cm. [Wildenstein, 1933,
nos. 1140, 1142, 1147, 1152 and p. 58, no. 5]. Mention should also be
made of the painting attributed to Chardin *fils* in the Lemoyne sale of
10 August 1778, no. 135: "Instruments of study grouped with a plaster
cast of Pigalle's Mercury; Height 8 *pouces,* Width 6 *pouces."* In conclu-
sion we cite this curious passage from the Goncourts [1909, p. 105, note
2]:

"The son of an art lover related this anecdote to me. Aubourg, a
second-hand dealer in paintings on the Place Pigalle, had bought a still
life in the following way. He had noticed at the street stall of a cobbler a
torn picture which the cobbler was using to protect his feet from the
cold. 'A plank would do you more good,' Aubourg said to him; 'but I'd
need to have a piece a wood,' replied the cobbler. And the bargain was
struck for a piece of wood and a liter of wine. The painting represented
a map of the world and various instruments of art and mathematics ar-
ranged around a Mercury by Pigalle."

The Leningrad *Attributes of the Arts...,* signed and dated 1766,
brings the name of Chardin into association with those of Catherine
II of Russia, Falconet, Pigalle and, in all probability, Diderot.
Catherine II liked Chardin: she owned no fewer than five of his
paintings, all of which are in this exhibition. In addition to the
three paintings at The Hermitage [58, 89, 125], the Washington
House of Cards [73] and *Little Girl with Shuttlecock* [72] were also

hers. When the *Attributes of the Arts...* arrived in St. Petersburg, she "diverted" the painting from its destination, the Academy of Fine Arts, in order to place it in her personal collection.

In all likelihood, it was Falconet who was charged with taking the painting to Russia. Although we do not know the detailed contents of the twenty-five packing cases he took with him when he sailed from Rouen in September 1766 aboard the *Aventurier* to sculpt the monument to Peter the Great, we do know that in the sculptor's baggage was Boucher's large *Pygmalion and His Statue,* donated by Boucher to the Fine Arts Academy of St. Petersburg [Ananoff, 1976, I, no. 240, with ill.].

We have already called attention to the presence of the *Mercury* by Pigalle in a considerably earlier work by Chardin: the plaster cast — a version of which Chardin had in his collection (see his estate inventory) — is being copied by the young draftsman in the Wanås painting (see [94]). Here, Pigalle's work (remember that the plaster cast had been exhibited at the 1742 Salon) occupies an even more prominent place and dominates the other arts: painting, symbolized by the palette, knife and brushes; architecture; medal-making; drawing; engraving; and goldsmithing, evoked by the curious ewer which appeared in the *Attributes of the Arts* painted in 1765 for Choisy (on the ewer, which Chardin himself may conceivably have owned, see [123]). Another object included in the painting seems to be a second allusion to Pigalle: the black ribbon with the cross of the Order of St. Michael. In 1765 Louis XV had gone to inspect the monument erected in his honor by the city of Rheims. In the words of Dezallier d'Argenville [*Vies des fameux sculpteurs...,* II, 1787, pp. 397-98]: The king "charged the Dauphin to see to it that [Pigalle] was given the ribbon of Saint-Michael. Pigalle thanked the prince but declined the honor, justifying his refusal by the fact that Bouchardon and Lemoyne, his elders, had not yet received it. Upon the death of the former, Lemoyne preferred to this mark of distinction a pension which would be more useful to his children; only then did Pigalle accept it."

The story is not to be taken literally, since Bouchardon had died in 1762 [in his book on *Pigalle,* published in 1859, Tardé does not know anything about Bouchardon; he mentions Coustou, who received the ribbon only posthumously]. It makes no difference. On 8 May 1759 Pigalle became the first sculptor to receive the Order of St. Michael, a fact which Chardin's painting in its allusion to the "rewards" accorded to artists suggested. The two men certainly knew one another; writers in the eighteenth century and later frequently compared the painter and the sculptor. We cite, as proof of their friendship, the fact that when the Academy decided on 29 May 1762 to send two of its members to the bedside of Pigalle, who was "dangerously ill," Coustou and Chardin were chosen. We further add that Chardin had made a replica of his painting, which he had given to Pigalle (it is mentioned in the estate inventory). It is entirely possible that the painting now in Minneapolis is this replica (see *Related Works*).

The role which Diderot might have played in all this is less clear. The relationship between Diderot and Catherine II of Russia and

his contribution to the development of the empress's collections of paintings are well known. So, too, are his friendship and admiration for Chardin. A remark written by the critic may suggest that he was no stranger to this prestigious commission. In 1769 Chardin exhibited a "replica with a few changes" of the painting he had made three years before for the "Empress of the Russias." The critics were, as usual, enthusiastic. Diderot was no less enthusiastic: "This painting of the *attributes of the arts* is the replica of the one he executed for the Empress of Russia, which is better." This preference inclines us to think the writer had something to do with the commission.

The picture was conceived as an overdoor. The composition's perfect balance derives from the counterpoint between the masses and the colors. But let us turn once again to Diderot, as we consider this painting, and some passages from his commentary on the work at the 1769 Salon, whose present whereabouts, unfortunately, are not known (he found the *Mercury* "somewhat slight" and "too dominant over the rest") [*Salon* of 1769, see Seznec and Adhémar, 1967, pp. 82-83]:

"While looking at his *Attributes of the Arts,* the eye, refreshed, remains satisfied and at rest. When one has looked at this piece for a long time, the others appear cold, carved out, commonplace, crude, and unharmonious. Chardin is between nature and art; he relegates the other imitations to the third rank. There is in him nothing suggestive of the palette. It is a harmony beyond which one does not hope for more; it winds its way imperceptibly into his composition, totally present in each individual part of the expanse of his canvas.... Chardin is an old magician from whom age has not yet taken his magic wand."

126 *Attributes of Civilian Music*

(Les Attributs de la musique civile)

Canvas, oval, 112 × 144.5 cm. (originally rounded at the corners; judging from the Salon catalog, the work originaly measured 97.5 × 146 cm.). Signed and dated: *Chardin 1767.*
Paris, Private Collection

Provenance. In 1766 Louis XV decided to renovate the Château de Bellevue as a residence for his daughters. Just as he had done two years before in the case of Choisy, Marigny charged Charles-Nicolas Cochin to submit a plan. Lagrenée, Taraval, Durameau, Fragonard, Restout *fils,* and Jollain were asked to participate. On 15 July 1766 [Archives Nationales, O[1] 1931 and *Nouvelles Archives de l'Art Français,* 1905, pp. 50-54], Cochin wrote to Marigny: "The music room would seem to me to require something related to its purpose. That is why I would think it would be appropriate to decorate it with two overdoors by M. Chardin. This artist attains a degree of perfection unique in his genre." Cochin's proposal was accepted. In 1767 Chardin presented his two paintings at the Salon. That same year the artist submitted his account in the amount of 2000 *livres* [Achives Nationales, O[1] 1931]. It was not paid until 1772, the same time as the account for the three Choisy overdoors (see [123, 124]). At this point we lose track of the paintings. They do not seem to have been confiscated during the Revolution but, as is well

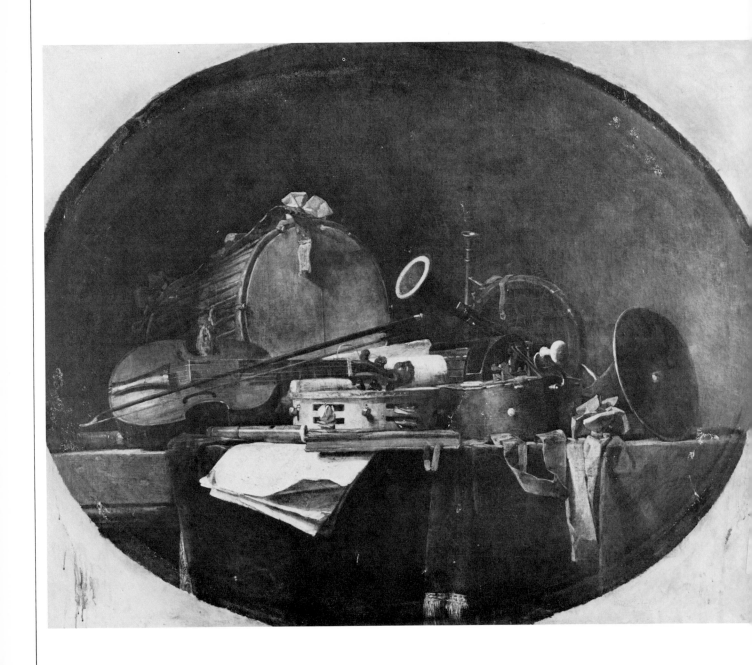

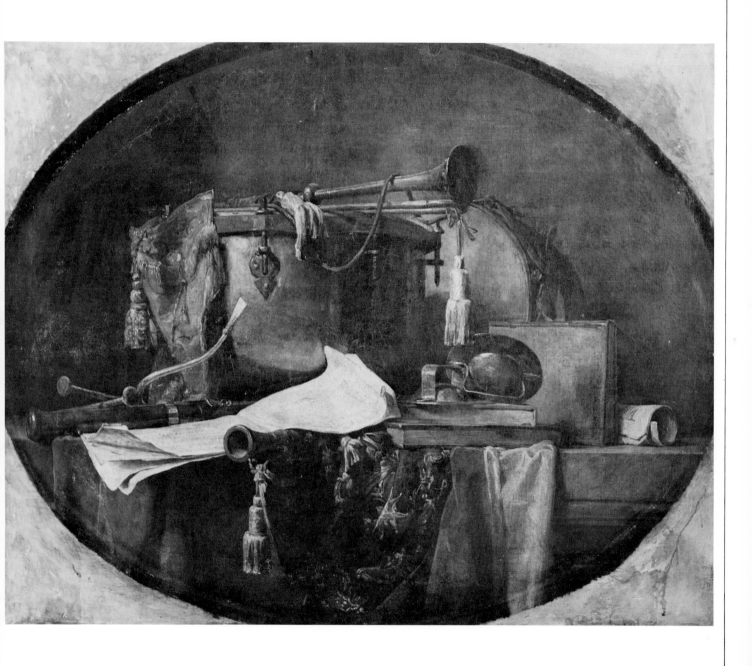

127

See Color Plate XX.

known, the contents of Bellevue were auctioned off, beginning on 23 Germinal Year III [Archives de Seine-et-Oise, II Q.74]. On 27 Messidor Year III there were included, under number 5535, "Three overdoor paintings nos. 2192 and 4540... valued at 802 *livres* to Huard." Could these be the Chardins?

The two paintings reappear at the estate sale of the painter Sébastien Rouillard (1789-1852) [see exh. cat. Florence, 1977, p. 207], whom we have mentioned with regard to the sketch for *The Housekeeper* [91], on 21 February 1853, no. 115: "Chardin [signed]. Two large paintings of still lifes. Oval shape." Henry de Chennevières [1888, p. 59] describes this sale as follows: "The first group [the paintings exhibited here], acquired in 1853 at the sale of the painter Rouillard, for the price of 1,650 francs for both, is characeized by an incredible symphony of tones. M. Eudoxe Marcille took the place of his father, then in Italy, at this auction, and he still recalls with emotion this proud conquest. It was a time when one deserved to be committed for spending 800 francs for a Chardin."

When the collection of François Marcille (1790-1856) was divided, his eldest son Eudoxe (1814-1890) received the two paintings. They have remained in that family ever since.

Exhibitions. 1767, Salon, no. 38: ("Two paintings under the same number representing various musical instruments. These curved paintings, approximately 4 *pieds* 6 *pouces* wide by 3 *pieds* high belong to the King and are destined for the apartments of Bellevue"); 1858, Chartres, no. 64; 1874, Paris, no. 55; 1880, Paris, no. 34; 1887, Paris, no. 15; 1900, Paris, no. 58; 1907, Paris, no. 28.

Bibliography. Blanc, 1862, p. 16; Horsin-Déon, 1862, p. 137; Goncourt, 1864, p. 158; Bocher, 1876, p. 99, no. 2; Goncourt, 1880, pp. 124-25; Hamel, 1887, p. 154; Chennevières, 1888, p. 59; Chennevières, 1890, p. 303; Engerand, 1896, pp. 163-64; Dilke, 1899, pp. 188-90, note 4; Dilke, 1899 (2), p. 119; Furcy-Raynaud, 1899, p. 241; Engerand, 1901, pp. 82-83, 247-48; Normand, 1901, p. 37; Furcy-Raynaud, 1904, pp. 50-54; Schéfer, 1904, pp. 88-89; Guiffrey, 1907, p. 102; Guiffrey, 1908, pp. 78-79, no. 135; Goncourt, 1909, pp. 144, 183-84; Pilon, 1909, pp. 70, 145 (ill.), 167; Furst, 1911, p. 125; Pascal and Gaucheron, 1931, p. 96; Biver, 1933, pp. 168-69; Wildenstein, 1933, no. 1113, fig. 178; Notthafft, 1936, p. 16; Paris exh. cat., 1959, under no. 21; Adhémar, 1960, p. 457; Faré, 1962, p. 164; Seznec and Adhémar, 1963, p. 23; Wildenstein, 1963-69, no. 346, pl. 55 (color); Faré, 1976, p. 166; Mirimonde, 1977, p. 15.

See [127] for discussion.

127 *Attributes of Military Music*

(Les Atrributs de la musique guerrière)

Canvas, oval, 112 × 144.5 cm. (originally rounded at the corners).
Signed and dated at the lower right: *S. Chardin 1767.*
Paris, Private Collection

Provenance. See [126].

Exhibitions. 1767, Salon, no. 38 (see [126]); 1858, Chartres, no. 64; 1874, Paris, no. 56; 1880, Paris, no. 35; 1887, Paris, no. 16; 1900, Paris, no. 58; 1907, Paris, no. 29; 1937, Paris, no. 143 (pl. 52 of the album).

Bibliography. Blanc, 1862, p. 16; Horsin-Déon, 1862, p. 137; Goncourt, 1864, p. 158; Bocher, 1876, p. 99, no. 61; Goncourt, 1880, pp. 124-25; Hamel, 1887, p. 254; Chennevières, 1888, p. 59; Chennevières,

1890, p. 303; Engerand, 1896, pp. 163-64; Furcy-Raynaud, 1899, p. 241; Dilke, 1899, pp. 188-90, note 4; Dilke, 1899 (2), 119; Normand, 1901, p. 37; Engerand, 1901, pp. 83, 247-48; Furcy-Raynaud, 1904, pp. 50-54; Schéfer, 1904, pp. 88-89, 113 (ill.); Guiffrey, 1907, p. 102; Guiffrey, 1908, p. 79, no. 136; Goncourt, 1909, pp. 144, 183-84; Pilon, 1909, pp. 70, 133 (ill.), 167; Furst, 1911, p. 125; Pascal and Gaucheron, 1931, p. 96; Biver, 1933, pp. 168-69; Wildenstein, 1933, no. 1114, fig. 176; Notthafft, 1936, p. 16; Goulinat, *Le Dessin,* October 1937, p. 171; November 1937, p. 245; Paris exh. cat., 1959, under no. 21; Adhémar, 1960, p. 457; Faré, 1962, p. 164; Seznec and Adhémar, 1963, p. 23, fig. 20; Wildenstein, 1963-69, no. 345, pl. 54 (color); Faré, 1976, p. 166; Mirimonde, 1977, p. 15.

Print. An engraving by Henri Guérard (1846-1897) after the Marcille painting illustrates the 1890 article by Henry de Chennevières (betwen pp. 302 and 303).

Chardin exhibited only two pictures at the Salon of 1767, the two works commissioned by Marigny the preceding year upon the suggestion of Cochin to decorate the music-room overdoors in the Château de Bellevue, intended by Louis XV for his daughters. The theme of musical instruments was not new to the painter. He had already treated it more than thirty years before in the two Rothenbourg overdoors [27, 28]; in those ovedoors he had added various other objects to the musical instruments: a basket of fruit, a parrot, a ewer, etc. Here, however, there is nothing that does not relate directly to the subject.

In the *Attributes of Civilian Music,* Chardin skillfully groups a Geman flute, a violin with its bow (the head of which is shaped like a pike), a snare drum, a tambourine with bells, a hurdy-gurdy with a wheel, a clarinet, and a hunting horn on a broad red rug. Its companion piece, the *Attributes of Military Music,* displays an arrangement put together "with an art superlatively understood": a trumpet, two kettledrums with their sticks, a bass drum, cymbals, an oboe, and a bassoon with its brass mouthpiece. As in the other painting, the generous touches of soft pink tinged with green or blue produced by the fabric and the reflection of light on the metals confer on the work its general tonality "in a magnificent opulence of tones."

These two paintings were admired by everyone commenting on the 1767 Salon. We cannot refrain from the temptation to cite long passages from the commentary by Diderot [Seznec and Adhémar, 1963, pp. 128-29]. This critic, more than anyone else, knew how to speak about these works and to grasp their magnificent and sumptuous arrangement:

"These two paintings are very well organized. The instruments depicted on them are tastefully arranged. There is, in this seeming disorder, a kind of vitality. The overall results are delightful. Everything reflects the greatest truth, in both form and color. It's there that one learns how to unite vigor and harmony. I prefer the one depicting kettledrums, perhaps because these objects provide larger masses and their arrangement is more stimulating. The other one could stand as a masterpiece by itself.

"I am certain that when time has dulled the somewhat hard and crude brilliance of the fresh paint, those who now think Chardin did better work in the past will change their minds. Let them go

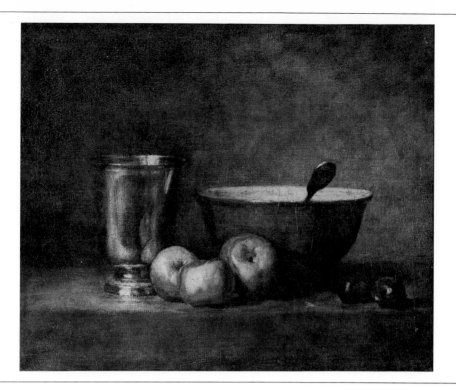

128

take another look at these works when time will have mellowed them....

"I am unaware that Chardin's models, the inanimate objects he imitates, do not change place, color, or form; and that, all things being equal, a portrait by La Tour has more merit than a genre piece by Chardin. In a flap of time's wing there will be nothing left to justify the reputation of the former. The precious dust will rise from the canvas, partly scattered to the winds, partly clinging to the long feathers of the god Saturn. Men will speak of La Tour, but they will see Chardin....

"It is said of Chardin that he has a technique all his own, and that he makes as much use of his thumb as of his paintbrush. I don't know how much truth there is in this. What is certain is that I have never known anyone who has seen him at work. Whatever the case may be, his compositions appeal both to the uninformed and the connoisseur. It is a vigor of incredible coloring, an overall harmony, a piquant effect, beautiful masses, a magical workmanship that leaves one in despair, a mixture of variety and order. Step back, come close; it is the same illusion, with neither confusion nor symmetry, and absolutely no dazzle; the eye is always refreshed, because there is always calm and repose. One pauses instinctively before a Chardin, as a traveler weary of the journey sits down, almost without realizing it, in a grassy place offering him silence, water, shade, and cooling breezes."

128 Three Lady-Apples, Two Chestnuts, Bowl, and Silver Goblet (also called The Silver Goblet)

(Trois pommes d'api, deux châtaignes, une écuelle et un gobelet d'argent, dit Le gobelet d'argent)

Canvas, 33 × 41 cm. Signed at the lower left: *Chardin*.
Paris, Musée du Louvre, M. I. 1042

Provenance. Entered the collection of Dr. Louis La Caze (1798-1869) at an unknown date (sale of 17 April 1862, no. 19: "pears and walnuts on a table," and no. 20: "companion piece of the preceding"?). La Caze bequest to the Louvre in 1869.

Exhibitions. 1954, Rotterdam, no. 48, fig. 30; 1960, Louvre, no. 576; 1966, Vienna, no. 11, pl. 34; 1969, Paris, La Caze collection, p. 10 (122 and fig. 4 on p. 119); 1977, Paris, p. 77 (unnumbered).

Bibliography. Museum cat. (La Caze), 1871, no. 181; Bocher, 1876, p. 87, no. 181; Goncourt, 1880, p. 129; Chennevières, 1889, p. 128; Normand, 1901, p. 108; Guiffrey, 1908, pp. 71, 88, no. 88; Goncourt, 1909, p. 190; Pilon, 1909, pp. 100, 166; Schéfer, 1909, pp. 114, 115; Furst, 1911, p. 122, no. 113 and pl. 34; Museum cat. (Brière), 1924, no. 113; Hildebrandt, 1924, p. 170, fig. 217; Paris exh. cat., 1929, p. 22, under no. 38; Pascal and Gaucheron, 1931, p. 140; Ridder, 1932, pl. 21; George, *The Studio*, 1932, p. 15 (ill.); Wildenstein, 1933, no. 834, fig. 154; Hirsch, *Le Dessin*, December 1938, p. 317 (ill.); Hourticq, 1939, p.

351

92 (ill.); Jourdain, 1949, fig. 3; Denvir, 1950, pl. 31 (color); Garas, 1963, fig. 36; Ponge, 1963, p. 261 (color pl. detail); Rosenberg, 1963, p. 42 (color pl.); Mittelstädt (ed.), 1963, p. 38, pl. on p. 39 (color); Wildenstein, 1963-69, no. 291, fig. 140; Huyghe, 1965, p. 9 (color pl.); Lazarev, 1966, pl. 17 (color); Valcanover, 1966, pl. 14 (color); Ochsé, 1972, pp. 50-51 (ill.); Lazarev, 1974, fig. 186; Rosenberg, Reynaud, Compin, 1974, no. 151 (ill.); Kuroe, 1975, pl. 23 (color); *Chefs-d'oeuvre de l'Art. Grands Peintres,* 1978, pl. 14 (color).

Related Works. A slightly larger version of this painting (36 × 45 cm.) was in the Henry de Rothschild collection, but it was destroyed during World War II [Wildenstein, 1933, no. 835, fig. 109; 1963-69, no. 293, fig. 142]. This painting has to be the same as the one previously in the Jules Burat collection, sale of 28-29 April 1885, no. 34 [Wildenstein, 1933, no. 844; see also *Annuaire des Artistes et des Amateurs,* 1861, II, p. 130]. Burat had gotten it from the François Marcille collection, sale of 12 January 1857, no. 23 [Eudel, V, 1886, p. 365; Chennevières, 1889, p. 128; Wildenstein, 1933, under no. 849]. A replica, not very old, in our opinion, belonged to René Gimpel [*Les Arts,* n.d., pl. II) before World War II.

See [129] for discussion.

Painting in the H. de Rothschild Collection; destroyed in World War II.

129 *Three Pears, Walnuts, Glass of Wine, and Knife*

(Trois poires, des noix, un verre de vin et un couteau)

Canvas, 33 × 41 cm. Signed at the lower left: *Chardin.*
Paris, Musée du Louvre, M. I. 1041

Provenance. See [128].

Exhibitions. 1954, Rotterdam, no. 47; 1960, Paris, no. 575; 1969, Paris, La Caze collection, p. 10 (122).

Bibliography. Museum cat. (La Caze), 1871, no. 180; Bocher, 1876, p. 87, no. 180; Goncourt, 1880, p. 129; Chennevières, 1889, p. 128; Normand, 1901, p. 107; Guiffrey, 1908, p. 71, no. 85; Goncourt, 1909, p. 190; Pilon, 1909, p. 166; Furst, 1911, p. 122, no. 112, pl. 36; Museum cat. (Brière), 1924, no. 112; Ridder, 1932, pl. 24; Wildenstein, 1933, no. 828, fig. 153; Larguier, *Formes et couleurs,* 1946, no. 1, p. 43 (ill.); Jourdain, 1949, fig. 5; Barrelet, 1959, p. 309; Wildenstein, 1963-69, no. 292, fig. 141; Lazarev, 1966, pl. 22; Rosenberg, Reynaud, Compin, 1974, no. 150 (ill.).

When and where La Caze (1798-1869) acquired these two paintings is not known. Neither is anything known precisely about the early history of these works. Entries in the Salon catalogs, sale catalogs, and inventories dating from the eighteenth century are too vague to permit our affirming that such and such "a painting of fruit" from such and such a collection is the same as a particular still life belonging to La Caze. We have very little information, furthermore, concerning the details of the purchases made by the "good doctor," in other respects a very secretive man. If he kept a diary or an account book, they have not been found, and descriptions of his collection during his lifetime are rare. Sylvie Béguin [1969, p. 116] sketches this portrait of him: "The search for paintings completely absorbed all his time: he had divided Paris into sectors which he would methodically and patiently explore every day, taking care not to omit the least second-hand dealer. He was seen regularly at the Hôtel Drouot: people nicknamed him and his friend François Marcille the 'Castor and Pollux' of the Hôtel des Ventes. La Caze made it a point of honor to buy cheaply, and he developed a complicated strategy for getting what he had picked out at first glance. He never sold his paintings."

Philippe de Chennevières (1820-1899), who had known him well [1888, p. 122], stresses that La Caze pursued his painting activities even after he had given up the practice of medicine around 1850: "Still lifes by Chardin abounded in his collection, and not without cause: they served his private education. I remember that when I visited for the first time, on the rue des Mathurins, that large building so happily situated in a cheerful garden and where the paintings of M. Lacaze [*sic*] were already accumulating in a gallery, where I was most astounded not to find a single chair, he partly opened the door of a study that was completely filled—crammed—with paintings, and in a corner of which there stood a broken-down bed, a student's bed; the cot of the man who dined for 40 *sous* on a sausage with garlic and a cup of black coffee so that

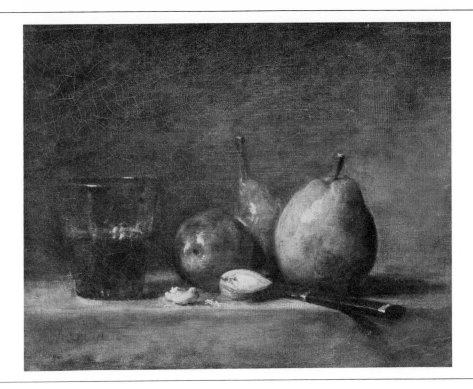

he could swell his hoard of paintings; and at the end of the gallery he had us step for a moment into a kind of kitchen, in which there were stacked, one on top of the other, pictures of a certain size, depicting still-life subjects. These were his pastimes, his own works, and they were not too badly done; he did not take an empty pride in having passed through the studio of Girodet in his youth."

Here is the portrait of La Caze drawn by Philippe Burty (1830-1890) [1879, p. 147]: "Tomorrow, who will remember the bearing and the comments of this La Caze, so intelligent and so quick, buttoned into his frock-coat and his arch coldness, poking you with his elbow as you stand before one of his Chardins and saying: 'Isn't that easy?' or, breaking a long silence as he stands in front of Ingres's *La Source* exhibited at the Galerie Martinet to say: 'The poor child is scrofulous. If I were to lance her, I'd get out that pus. Let's go see Greuze....'"

There is general agreement that the two paintings are late works clearly conceived as a pair (notice, for instance, the identical role played by the knife and the silver spoon in both compositions). Wildenstein suggests "around 1760," relating it to the *Jar of Olives* [114], in which the fruit is bathed in this same misty atmosphere. His hypothesis is entirely sound. And yet comparison of the two paintings with the Laperlier *Basket of Peaches* (also in the Louvre at the present time), which is dated 1768, suggests that the three compositions are very close together in Chardin's career. Never

before has the artist reduced his arrangements to such a minimum. Never before has he given so much importance to the bright areas and reflected light, reflections of the apples on the silver-stemmed goblet (perhaps the one stolen from Chardin in 1759) and the wide-mouthed bowl, and of the light in the glass of red wine. Never before has the artist mingled light and shadow, air and color to such an extent as to render more than just a faithful resemblance. Indeed, Chardin has captured the very essence of the forms and the fruits.

We cite again the text on the 1757 Salon that was probably written by the painter Antoine Renou (1731-1806) but has often been attributed to Gauthier-Dagoty [see Zmijewska, 1970, p. 100], in *Observations sur la physique et les Arts*, 1757, p. 15: "His paintings are silvery and strong, all the objects are reflected in one another and from this comes a transparency of color which gives life to everything touched by his paintbrush."

130 *Basket of Peaches with Walnuts, Knife, and Glass of Wine*

(Corbeille de pêches, avec noix, couteau et verre de vin)

Canvas, 32.5 × 39.5 cm. Signed and dated at the bottom right on two lines: *Chardin /1768.*
Paris, Musée du Louvre, M.I. 722*

Provenance. Collection of Laurent Laperlier (1805-1878). According to Bocher (1876), he supposedly acquired the painting "for twenty francs from a washerwoman at the head of the rue des Martyrs," but in an unpublished letter of 19 January 1864 from Algiers [in the Bibliothèque Nationale, Département des Manuscrits], Laperlier gave the Goncourts a version that we have every reason to believe is exact:

"Through M. Carrier, who had visited the individual several times, I learned about a relative of Chardin who was something like 95 years old, living in squalor in a little room of a house on the sordid street which circles the Théâtre de la Porte Saint-Martin, right in front of the opening where they slide in the scenery, and who owned some pictures by the artist, his relative. One fine day I learned — how I don't know — that the good gentleman having died, arrangements were being made for the sale of his few possessions. I was on a mission in Strasbourg... but I charged M. Bonvin, an artist-painter who thought very highly of Chardin, to stand in for me, which he did, much to my advantage, for since I had for rivals only the lowliest second-hand dealers, I acquired at very reasonable prices four excellent paintings (the *Basket of Grapes,* the *Peaches,* a pastel *Portrait of the Old Man* [a large portrait] and the *Pastel, replica of the museum's portrait)...* . "This worthy man had exercised the profession of architect, but by reason of his great age, he had freed himself from every care except that of preserving his old slippers, for which he had such veneration, it seems, that his room was literally jammed with them... ." (Was this "architect" A. J. Frary, of 92 rue de Bondy, who died in 1854 at the age of 74?)

Laperlier sale, 11-13 April 1867, no. 17; acquired by the Louvre for 1380 francs (at that same sale the Louvre bought *The Smoker's Kit* [74] and *The Return from Market* [81]).

Exhibitions. 1769, Salon, no. 35 ("Two paintings of fruit under the same number") (?); 1860, Paris, no. 112; 1946, Paris, no. 101; 1966, Vienna, no. 17.

Bibliography. La Chronique des Arts et de la Curiosité, 21 April 1867, p. 122; Burty, preface of Laperlier sale cat., 1867, p. V (also in *La Liberté,* March 1867); Bocher, 1876, p. 85; Museum cat. (Tauzia), 1878, no. 727; Burty, 1879, p. 148; Goncourt, 1880, pp. 128-29; Chennevières, 1888, p. 61; 1889, p. 128; Normand, 1901, pp. 39-40; Guiffrey, 1908, p. 71, no. 83; Goncourt, 1909, pp. 189, 190: Pilon, 1909, p. 165 and pl. between pp. 64 and 65; Furst, 1911, p. 122, no. 102; Museum cat. (Brière), 1924, no. 102; Wildenstein, 1933, no. 795, fig. 105; Goldschmidt, 1945, fig. 46; Goldschmidt, 1947, fig. 41; Jourdain, 1949, fig. 12; Faré, 1962, p. 164; Gimpel, 1963, pp. 406, 407; Mathey, 1963, p. 22, 36; Mathey, 1963 (2), p. 95; Wildenstein, 1963-69, no. 352, pl. 56 (color); Lazarev, 1966, pl. 28; Rosenberg, Reynaud, Compin, 1974, no. 149 (ill.); Anonymous, *Les peintres illustres,* coll. directed by Henry Roujon, n.d., pl. 7 (color).

Related Works. A copy of this painting has been attributed to Manet by Jacques Mathey, who has published it on several occasions — twice in 1963. According to Mathey, Manet supposedly saw the Chardin in 1860 at the Galerie Martinet [1963, p. 36, no. 97, ill.]. It was put up for sale several times, most recently in Aix-en-Provence, 25 June 1973, no. 266 (color plate in cat.). For the companion piece of the Louvre painting — the *Basket of Grapes,* formerly in the Henry de Rothschild collection — see [130].

Basket of Peaches... was acquired by the Louvre's cuartor, Frédéric Reiset, at the Laperlier sale of 1867, two years before the La Caze collection entered the museum. We learn from an important unpublished letter of Laurent Laperlier to the Goncourts in 1864, following the appearance of their first article in the *Gazette des Beaux-Arts,* that Laperlier had bought the painting, together with

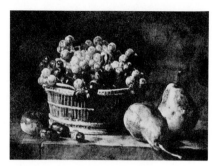

Painting in the H. de Rothschild Collection; destroyed in World War II.

its companion piece, the *Basket of Grapes,* at the estate sale of an architect descended from Chardin. Camille Marcille had already made known the existence of this descendant of the painter living near the Porte Saint-Martin; François Marcille, his father, had bought from the man himself *The Cut Melon* [111] and *Jar of Apricots* [110], [see also Adhémar, 1968]. Laperlier's letter is also interesting because it conjures up the image of his friend, the painter François Bonvin (1817-1887), a fervent admirer of Chardin. Shortly after Laperlier died, Bonvin wrote Philippe Burty a long letter (which Burty published [1879, pp. 149-50], in which he gives a charming portrait of this enthusiastic collector. Bonvin's letter also establishes with certainty that the *Basket of Grapes* in the Henry de Rothschild collection — destroyed during World War II — was signed and dated 1768, like the *Basket of Peaches...,* and is truly the companion piece of the Louvre painting (and that, consequently, its provenance is not the Sylvestre and Gounod sales [see Wildenstein, 1963-69, no. 351, fig. 161]. We have every reason to believe, furthermore, that the two paintings were exhibited at the Salon of 1769 (no. 35).

Of all the Chardin paintings of fruit known today, *Basket of Peaches...* is the last to have been executed. The artist enjoyed painting this fruit — accompanied here by a glass of red wine, a knife with a black handle, and two walnuts — but never before had he depicted it from so close a vantage point. The peaches lie in a woven basket, separated from one another by green leaves, reflecting the light and appearing to be illumined from within. Looming out of the half-light, these few fruits "seem to detach themselves from the canvas and take on a life of their own, through I know not what marvelous optical interaction in the space between the painting and the spectator" [Goncourt, 1863, pp. 521-22]. And, in the words of Renou, one of Chardin's first biographers (1780): "No one understood better than he the magic of chiaroscuro."

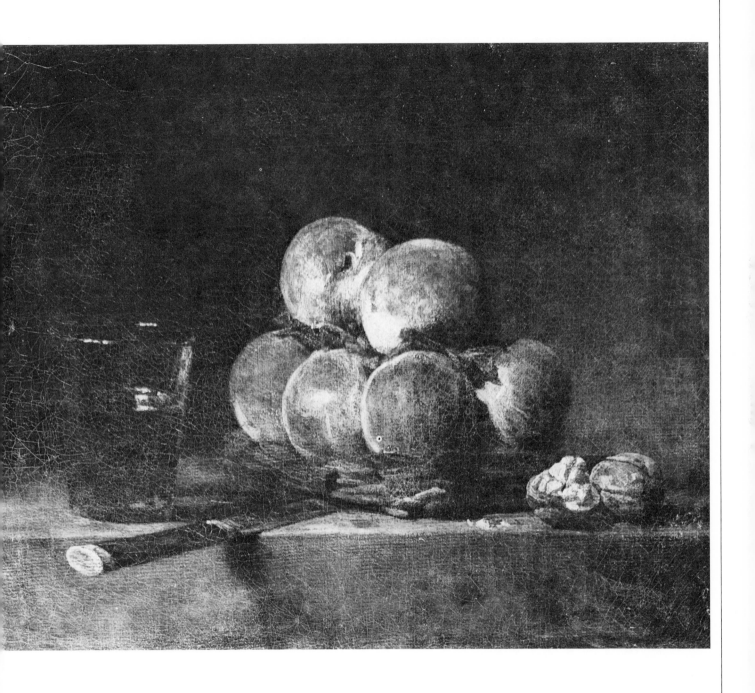

130

131 *Nude Woman Milking a Goat Held by a Child*

("Une femme nue occupée à traire une chèvre que retient un enfant")

Canvas, 53 × 91 cm. Signed near the upper right on two lines: *Chardin /1769.*
Private Collection*

Provenance. Randon de Boisset sale, 27 February 1777, no. 234 (the cat. describes it in detail, even to the point of specifying the date). Sale of the engraver Jean-Baptiste Tilliard (1740-1813), 30-31 December 1813, no. 3: "two representations of Bacchanalia, painted in grisaille, in imitation of the bas-reliefs" (?). E. Tondu sale, 10-15 April 1865, no. 40. Collection of Armand Queyroi, curator of the museum of Moulins (Allier), in 1876; Armand Queyroi sale, 2-26 February 1907, no. 181 (cat. illustrated with an etching by Armand Queyroi). Collection of Dr. Tuffier in 1907. Acquired from M. François Daulte of Lausanne by its present owner in 1953.

Exhibitions. 1769, Salon, no. 34 ("Two paintings under the same number representing bas-reliefs"); 1907, Paris, no. 66; 1955, Zurich, no. 63.

Bibliography. Bocher, 1876, p. 102; Goncourt, 1880, p. 125; Dayot and Vaillat, 1907, pl. 36; Guiffrey, 1908, p. 90, no. 219; Goncourt, 1909, p. 185; Furst, 1911, p. 130; Wildenstein, 1933, no. 1207, fig. 173 (reproduces the etching by Armand Queyroi); Wildenstein, 1963-69, no. 359, pl. 60 (color); Seznec and Adhémar, 1967, p. 24; Faré, 1976, p. 168.

See [132] for discussion.

132 *Satyr Holding a Goat Suckled by a Little Satyr*

("Un satyre tenant une chèvre que tête un petit satyre")

Canvas, 53 × 91 cm. Signed and dated at the upper right: *Chardin. 1769.*
Private Collection*

Provenance. See [131]. Tondu sale, 1865, no. 39. Queyroi sale, 1907, no. 181 (with the etching by Armand Queyroi). Acquired by the present owner in 1953.

Exhibitions. 1769, Salon, no. 34 (for cat. text, see [131]);1907, Paris, no. 65; 1955, Zurich, no. 62.

Saint-Aubin, drawings after the pictures of 1769.

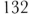

132

Bibliography. Bocher, 1876, p. 102; Goncourt, 1880, p. 125; Dayot and Vaillat, 1907, pl. 34; Guiffrey, 1908, pp. 89-90, no. 218; Goncourt, 1909, p. 185; Furst, 1911, p. 130 and pl. 38; Wildenstein, 1933, no. 1206, fig. 171 (reproduces the etching by Armand Queyroi); Wildenstein, 1963-69, no. 358, fig. 163; Seznec and Adhémar, 1967, p. 24; Cailleux, 1969, pp. VI (fig. 9), and VIII; Faré, 1976, p. 168.

Prints. The catalog for the 1907 Queyroi sale reproduces two etchings by Armand Queyroi after the paintings belonging to him.

Related Works. We would like to connect these two paintings with two compositions from the estate of Charles-Nicolas Cochin (1715-1790); he still owned a small round painting by Chardin "representing some books and papers on a table"), sale, 21 June 1790, no. 4: "Two charming overdoors painted by Chardin in grisaille imitating the bas-relief superlatively well and depicting children at play with a satyr, a goat... ." The dimensions, however, vary appreciably (40.5 × 90.5 cm.); furthermore, it seems unlikely that Cochin would have bought two paintings by his friend Chardin at the estate sale of Randon de Boisset in 1777.

"These two little bas-relief subjects are poor choices; they are mediocre sculptures," wrote Diderot in his criticism of the 1769 Salon in which these two works were exhibited. Was he unaware of who had made them? Thanks to the research conducted by Mme G. Bresc, we can be certain that he was. The sculptor was Gérard Van Opstal (1605-1668) [see, most recently, Bué-Akar, 1976, pp. 137-46], an artist who worked in the style of François Duquesnoy (whom Chardin had frequently copied; see [33]) and Jacques Sar-

razin. The two marble reliefs entered the royal collections upon the death of the sculptor and were eventually confiscated during the Revolution. A "nude woman milking a goat held by a child," listed in the 1824 Louvre inventory (MR sup. 78; 22 × 34 cm.), is no longer in the Louvre. But a "Satyr holding a goat suckled by a little satyr" (MR sup. 89; 24 × 45.5 cm.) is still exhibited in the museum's galleries. Chardin could easily have copied both in the royal collections, and would not have been the first to do so. Desportes had made use of the bas-relief with the satyr in a painting dated 1741 [Faré, 1976, p. 93, fig. 143].

If proof is needed that these two Chardins are indeed those at the Salon of 1769, we have it in the sketches made by Saint-Aubin on the margins of his copy of the catalog [now in the Cabinet des Estampes, Bibliothèque Nationale; Dacier, 1909, II, p. 75]. It seems probable—though we have no evidence to show for it—that they belonged at the time to Randon de Boisset, the brilliant *receveur général des finances* and great collector of contemporary French and Flemish painting.

The two works at the Salon of 1769 were favorably received. They were the first grisailles exhibited by Chardin since the Salon of 1755 (see [33]). (The four he was to show before he died in 1779 are all included in the present exhibition, [131, 132, 133, 138].) The author of *Sentiments sur les tableaux exposés au Louvre* [1769, pp. 9-10] found them "admirable." The *Année littéraire* (pp.

296-97) wrote: "It is not only the degree of illusion he has achieved which makes these pictures worthy of the highest esteem; it is also the manner—spirited, bold, and broad—in which they have been painted." Diderot, after he had criticized the marble sculptures of Van Opstal, went on to say [Seznec and Adhémar, 1967, p. 84]:

"It is mediocre sculpture, but these paintings fill me with admiration. They show how one can bring both harmony and color even to objects which least require them. They are white, and yet there is neither black nor white; nor two tints alike, and yet the harmony could not be more perfect. Chardin had been so very right in saying to one of his colleagues, a run-of-the-mill painter: Does one paint with colors?—With what else, then?—With what else? With feeling... . It is feeling that perceives light rippling and reflecting on surfaces; it is sensibility that captures those reflections and renders, I know not how, their impenetrable confusion."

One further point is why Chardin decided to do trompe-l'oeil paintings (which are more cream-colored than grisaille). The artist may have had several reasons for taking this new direction. Chardin could paint admirably, but he was not, as we have said, an "inventor" of compositions. By copying these marbles, he was once again side-stepping the issue. A more personal reason might also have been involved. We know that Chardin was having trouble with his eyes and that he was soon to give up painting with oils and take up pastels, since the binders and the colored pigments he used were making his eyes hurt. Might it be that the restricted color scale he had to use in painting these imitations of bas-reliefs reduced his discomfort?

Ought we not also take into account the evolution of taste? When Carle Vanloo died (1765), Boucher, a contemporary of Chardin, and successor to Vanloo as head of the Academy, became first painter to the king and maintained for a few more years the style which had assured French painting first place in Europe. But younger artists were turning to an art which accorded greater importance to line and a polished execution instead of color, and to Antiquity instead of genre. Even as he chose "pleasant subjects," Chardin may have been attempting to adapt to this evolution in the very year when Fragonard dated certain of his *Figures de fantaisie* and Greuze was exhibiting at the Salon his ambitious *Septime Sévère*.

133 *Autumn*

(L'Automne)

Canvas, 51 × 82.5 cm. Signed and dated at the lower right: *Chardin. 1770.*
Moscow, State Pushkin Museum of the Fine Arts*

Provenance. May be the "painting showing a plaster-cast child and other attributes," no. 47, of the Hazé sale of 4 May 1779 (but it may also relate to [138] of this cat.). May be one of the "two grisailles imitating perfectly some bas-reliefs" dated 1770, from the [Barbier] sale, 10-11 February 1837, no. 91. Collection of Dimitri Tchoukine (1855-1932). Entered The Hermitage in 1924; transferred to the Pushkin museum in 1927.

Exhibitions: 1771, Salon, no. 38 ("a painting showing a Bas-Relief"); 1955, Moscow, p. 61.

Bibliography. Réau, 1918, p. 233, no. 452; Wildenstein, 1933, nos. 1208, 1208A; Museum cat., 1948, p. 86, no. 1139; Paris exh. cat., 1959, under no. 23; Museum cat., 1961, p. 195, no. 1139; Zolotov, 1962, pl. 9; Wildenstein, 1963-69, no. 362 (not repr.); Seznec and Adhémar, 1967, p. 135.

The fountain by Edme Bouchardon (1698-1762) on the rue de Grenelle provided Chardin with inspiration on several occasions. He had depicted the plaster cast representing the City of Paris in the center of the Choisy *Attributes of the Arts* [123], to cite another example. Here he is copying one of the plaster casts for the reliefs on the *Seasons* located beneath the statues at the sides. These plaster casts, which Bouchardon had presented at the Salon of 1741, remained very popular, as we see from two late eighteenth-century sales (1784 and 1789). The cast in question here is the *Allegory of Autumn:* children playing with a he-goat and eating grapes.

Although we have no sketch by Saint-Aubin to prove it, we are certain that the Moscow painting, which is clearly dated 1770 (and has been very rarely reproduced), is indeed the "Bas-Relief" of the Salon of 1771. Even though none of the *salonniers* refers directly to Bouchardon's *Autumn,* their commentaries, as laudatory as they are vague, confirm this association. This example, written in verse, was by an anonymous critic of the *Muse Errante au Salon* [1771, p. 16]:

Chardin, whose imitations charm in profusion,
Here fascinates our eyes with this illusion;
One thinks one sees a relief and it's only a painting.
Art is fully revealed in this picture so striking.

As a matter of fact, the critics were less surprised by the trompe l'oeil (the artist was following a long and primarily Northern tradition in illustrating this genre) than by Chardin's three pastels, the first he showed to the Salon public. It is mainly the pastels, as we shall see, that captured the attention of the commentators.

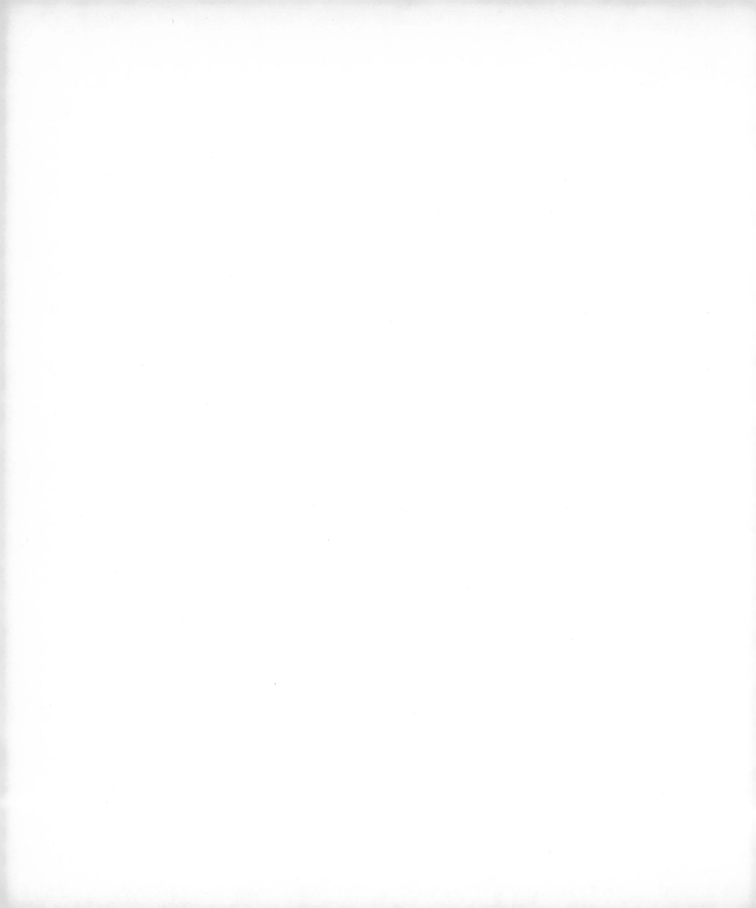

VIII *Chardin's Pastels*

The Salon of 1771 held a new surprise for the critics when Chardin exhibited portraits in pastel; he was to show more of them at his last four Salons.

During Chardin's last years he suffered cruelly from kidney stones until his death from dropsy, December 6, 1779. He also suffered disappointments in his professional career. He lost his office as treasurer in 1774, and in the same year the responsibility for arranging Salon displays was given to Vien. These changes were the direct consequence of Marigny's replacement by Angiviller as head of the royal buildings, and particularly of the growing power wielded by Pierre, the new first painter to the king, defender of the "grand genre" and the sworn enemy of Chardin's friend Cochin, whom he had discharged from his posts at the Academy.

It has often been assumed that the pastel portraits brought Chardin his last satisfaction. The assumption is based on a passage in the *Année littéraire* of 1771: "It is a genre which we have not seen him undertake previously and in which his first attempts succeed to the highest degree." It is further based on the fact that, at the Salon of 1779, one of Louis XV's daughters paid homage to the painter by presenting him with a golden box.

The truth may be more subtle. It is debatable whether the critics admired the artist, or rather the prowess of the "tireless old man," this "picturesque phenomenon," who continued to exhibit despite his advanced years. The praise seems tinged with reserve; for Chardin had become an old-fashioned painter with the dawning of a triumphant neoclassicism. Jacques-Louis David's *Funeral of Patrocles* dates from the year of Chardin's death, and the new age would show no mercy for Chardin.

Because of the fragility of pastel, the Paris showing of this exhibition includes only the pastels from the Louvre [134, 135, 136, 139] and the showings at Cleveland and Boston only the *Portrait of Madame Chardin* from The Art Institute of Chicago [137]. The image of Chardin as pastellist is therefore somewhat distorted. A number of the pastels which are missing—either because they are presently on the market or because their loan was impossible—prove that Chardin not only portrayed himself and his second spouse but also made portraits of children and of old people, expressive head studies, and a copy after Rembrandt (once again attesting to his affinity for Northern painting).

The Louvre pastels are, however, his finest and most poignant. When Chardin resigned his official posts, he gave to the Academy a pastel portrait of himself, done by Maurice Quentin de La Tour in 1760. Chardin must have been familiar with the specific problems of this medium, but it is nonetheless astonishing with what audacity and assurance he approached this technique. And even the genre itself required his courage, if we recall the lukewarm reception of his earlier oil portraits exhibited at the Salons of 1746 and 1757 (see Section V).

His self-portraits confirm the extreme care he took throughout his entire career not to leave the smallest detail to chance in composing his pictures and planning their structure. Before reaching for the crayons he must have studied himself attentively and adjusted his attire, which looked "as outlandish as that of an elderly English tourist." The portraits offer a psychological analysis as well as a superb lesson in painting. Chardin had always made it his rule to hide any show of emotion behind an elegant appearance—a characteristic of his century, which insisted on decorum and abhorred emotional states. Only in his last self-portrait [139], painted very shortly before his death, would he allow emotion to assert itself and let us see the lean features of an old man, worn out by a life devoted to painting—an old man who, in his art, had found that rare synthesis of theoretical research, technical perfection, excellence, and human warmth.

134 *Self-Portrait* (also called *Portrait of Chardin Wearing Spectacles)*

(Autoportrait, dit Portrait de Chardin aux besicles)

Pastel, 46 × 37.5 cm. Signed and dated at the lower right on two lines: *Chardin / 1771.*
Paris, Musée du Louvre, Cabinet des Dessins, Inv. 25206*

Provenance. Collection of Jacques-Augustin de Sylvestre (1719-1809); Sylvestre estate sale, 28 February-25 March 1811, part of no. 11: "The Portrait of Chardin shown in a night cap, and dressing gown, and with glasses on his nose; and the portrait of Franç. Marg. Pouget, Chardin's wife. Done in pastel, by Chardin, one in 1771, the other in 1775. H. 16 *p.* 4 *l.;* W. 13 *p.* 6 *l.*" (For the *Portrait of Madame Chardin,* see [135].) Estate sale of the painter and pastellist François-Louis Gounod (1758 — 1823), father of the composer, 23 February 1824, part of no. 2: "Chardin shown in a dressing gown, and with glasses on his nose; and the wife of the painter. Two portraits done in pastel. H. 16 *p.;* L. 13 *p.* 6 *l.*" *(For the Portrait of Madame Chardin,* see [135].) Bruzard estate sale, 23-24 April 1839, no. 57: "Portrait of Chardin painted by himself in pastel in 1771. This portrait has been engraved by Chevillot." Acquired by the Louvre for 72 francs. The head appraiser of the Royal Museums, George, wrote to the assistant director of the Louvre, Alexandre de Cailleux (1787-1876) on 25 April 1839 [Archives, Louvre, D.6]: "With very few exceptions, I have taken care of all you wanted done at the Bruzard sale and have been fortunate enough to get most of the items at prices very much lower than I had anticipated paying for them, which is probably due to the sale's being badly managed," (George had estimated that the *Self-Portrait* would sell for 150 francs!)

Exhibitions. 1771, Salon, part of no. 39 ("Study of three heads, in pastel, under the same number"); 1949, Paris, no. 21; 1957-58, Paris, no. 16.

Bibliography. Hédouin, 1846, p. 227, no. 94; Chennevières, 1856, p. 55; Hédouin, 1856, p. 200, no. 94; Blanc. 1862, p. 14; Goncourt, 1863, pp. 515-16; 1864, pp. 158-59; Museum cat. (Reiset), 1869, no. 678; Bocher, 1876, pp. 4, 15, 45, 88, no. 678; Goncourt, 1880, p. 117; Chennevières, 1888, p. 59; Dilke, 1899, p. 394; Dilke, 1899 (2), pp. 127-28; Normand, 1901, pp. 70, 74, 75, 76, 85, 86, 108; Schéfer, 1904, pp. 119, 120, pl. on p. 121; Dayot and Guiffrey, 1907, pl. on p. 108; Guiffrey, 1908, p. 65, no. 60; Goncourt, 1909, pp. 145-46, 173; MacFall, 1909, repr. pl. 6 (opp. p. 42); Pilon, 1909, pp. 49, 148, 166; Furst, 1911, p. 135, pl. 39; Raffaelli, 1913, p. 55; Klingsor, 1924, cover ill.; Ratouis de Limay, 1925, p. 39, pl. 40; Réau, 1925, pl. 37 (1); Schneider, 1926, fig. 80; Dacier and Ratouis de Limay, 1927, p. 101, no. 98, pl. 69; Bouchot-Saupique, 1930, no. 10; Ridder, 1932, pp. 19-20, pl. 85; Wildenstein, 1933, no. 646, fig. 53; Leroy, 1934, p. 199, fig. 13; Roux, 1940, p. 357, no. 38; Goldschmidt, 1945, fig. 1; Ratouis de Limay, 1946, pp. 63-64, pl. 25; Sweet, *Bulletin of The Art Institute of Chicago,* April 1945, p. 52 (repr.); Lazarev, 1947, pl. 30; Florisoone, 1948, pl. 64; Jourdain, 1949, fig. 39; Loisy, *Art et Industrie,* May 1949, no. 15, p. 41 (ill.); Denvir, 1950, pl. 37; *Le Figaro Littéraire,* 27 March 1954 (ill.); Proust, 1954, p. 39 (ill.); Golzio, 1955, p. 914 (ill.); Sérullaz, *Revue des Arts,* 1957, p. 287 (ill.); Adhémar, 1960, p. 457, pl. 240; Garas, 1963, frontispiece (detail); Rosenberg, 1963, pp. 15, 19, 75, 83, 104, 107, and color pl. on p. 18; Mittelstädt (ed.), 1963, p. 46, color pl. on p. 47; Wildenstein, 1963-69, no. 366, pl. 57 (color) (and part of 362A, French ed., 1963);Thuillier and Châtelet, 1964, p. 208 (color pl.); Huyghe, 1965, p. 8 (ill. detail); Lazarev, 1966, pl. 54; Seznec and Adhémar, 1967, p. 134, fig. 78; Watson, 1970, p. 537; Proust, 1971, pp. 376-77 (and 601?); Monnier, 1972, no. 42 (ill. and color pl.); Ochsé, 1972, color pl. on p. 49; Lazarev, 1974, fig. 198; Kuroe, 1975, pl. 30 (color); Faré, 1976, p. 148, fig. 228.

Prints. The Louvre portrait was engraved before 1780 (the year when Haillet de Couronne listed the engraving by Juste Chevillet (1729-1802). Bocher gives two states of it [1876, pp. 3-4, no. 2 and p. 15, no. 9; see also Dayot and Vaillat, 1907, pl. 64; Roux, 1940, p. 357, no. 38]

In the background of the *Full-Length Portrait of Marguerite Siméone Pouget,* niece (?) of Chardin, engraved by Chevillet in 1777 [Bocher, 1876, p. 45, no. 44], we see above the fireplace in an oval frame a version of the Chardin portrait which is identical to the pastel in the Louvre.

Bocher illustrated the frontispiece of his 1876 work with an engraving in an oval medallion done by Ch. Courtry.

An engraving by Géry Bichard illustrated the work by Normand [1901, p. 75].

An engraving after a drawing by Dété appears in Dayot, *L'Art et les Artistes,* special issue, 1907, p. 123.

Related Works. One might think that the study of Chardin's pastels offers few difficulties. Nothing could be less true. We know that the artist exhibited pastels at the Salons of 1771 (three), 1773 (one), 1775 (three), 1777 (three), and 1779 ("several"). The catalog descriptions are very sketchy, and the critics are not much more explicit. And we know that Saint-Aubin illustrated only the catalog for the 1777 Salon (at least it is the only one located to date). Therefore, we shall restrict ourselves here to calling attention, in chronological order, to the early references to pastels depicting either Mme Chardin or the painter himself. Three of the five pastels in this exhibition represent the artist; the other two depict his second wife. Because of their fragility, we have been unable to obtain the loan of the few other pastels known to us, eleven of which are signed and dated:

1. Chardin's estate inventory: "The portrait with glasses, replica, valued at 72 *livres*" (not included in the 1780 Chardin sale; neither were the other pastels listed in the inventory).

2. Estate inventory (unpublished) of Mme Chardin, 6 June 1791: "Three paintings done in pastel, two of which show M. and Mme Chardin and the third, Mlle Daché (sister of Mme Chardin), all three under glass and in their gilt wood frames; no value has been set on them; they have been included only for record." Could the pastels of the Chardins be those now in the Louvre? As for Mlle [*sic*] Daché, she is very obviously Mme Dachet, a sister of the second Mme Chardin [Wildenstein, 1933, p. 78, 150], who had married a stockbroker. This is the first mention of the existence of this pastel. (See also the estate inventory [unpublished] of Juste Chardin, 25 Thermidor Year II, which lists "ten paintings, one of which is under glass".)

3. Estate inventory of the sculptor Pigalle, 29 August 1785: "the pastel portrait of M. Chardin painted by himself in its frame, valued at 48 *livres.*"

4. Catalog of the collection of the Marquis de Livois drawn up by Sentout (Angers, 1791, no. 300 in the list of pastels): "His portrait painted by himself in a night cap and wearing glasses. This portrait's touch is masterful, its color fresh and its verity astounding. Height 16 *pouces;* Width 13 *pouces.*" Planchenault [1934, p. 262] writes: "This pastel of Chardin... corresponds in description and dimensions to the one in the Louvre, but there are several replicas of it, and the portrait which once belonged to Livois seems to us to be the one bought in Angers around 1890 and shown to us by a collector living in Paris." One wonders whether Planchenault is referring to the Rothschild pastel now in the Louvre.

5. Sylvestre sale, 1811: two pastels, the *Self-Portrait* of 1771 and the *Portrait of Madame Chardin* of 1775, both now in the Louvre [134, 135].

6. Gounod sale, 1824: *idem.*

7. Bruzard sale, 1839: The Louvre purchased three Chardin pastels, two which appeared at the Sylvestre and Gounod sales, and a third [136] which the catalog erroneously says was dated 1779.

8. Laperlier sale of 11-13 April 1867, no. 59: "Portrait of Chardin. Glasses on his nose, a scarf around his neck and on his head a kind of cap tied on with a blue ribbon. This portrait, 45 × 38 cm., which is the replica of the one in the Louvre, had been done by Chardin for his nephew." We have previously cited in [130] the letter of 19 January 1864 from Laperlier to the Goncourts, in which the collector declares he has bought four works by the painter through Bonvin, at the sale of an architect related to Chardin: "The basket of grapes, the peaches a pastel portrait of an old man, large portrait [undoubtedly the pastel signed and dated 1771, which is now on the market; see exh. cat. Paris, 1971, no. 1 with pl.] and the pastel, replica of the museum's portrait." Cailleux [1971, p. V] has advanced the plausible hypothesis that this last pastel might be the one in the Henry de Rothschild collection which entered the Louvre in 1966. [See, on the Laperlier pastel, Bocher, 1876, p. 116; Goncourt, 1880, p. 117, and 1909, p. 173; Dayot and Vaillat, 1907, under no. 64].

9. Jean-Louis David (1792-1868) sale 18-19 March 1868, no. 12: "a portrait of an old woman (pastel), signed, "which is generally identified with the *Portrait of Madame Chardin* in Chicago [137], but which could just as easily be the *Portrait of an Old Woman* which copies in part the *Portrait Said to Be of the Mother of Rembrandt* of The Hermitage [Foucart-Lecaldano, 1971, no. 328] and is now in the museum of Besançon, signed and dated 1776 [Cailleux, 1975, fig. 192].

10. In a letter of 10 June 1890 addressed most likely to Kaempfen, the director of the Louvre, Eudoxe Marcille wrote: "A young man came to me from Messrs Lafenestre and Chennevières. This young man is asking 20,000 francs for a pastel portrait of Chardin by Chardin. When you think that my father could have bought the portraits of Chardin and his wife for four hundred francs! How times have changed."

11. As of 1899 [Dilke, 1899, p. 394; see also Guiffrey, 1908, no. 128], Camille Groult had in his possession a replica of the 1775 *Self-Portrait*. It was included in the Groult sale at the Galerie Charpentier on 21 March 1952, no. 64, pl. 30 of the catalog. On the back of this pastel, according to the catalog, was written the following inscription: *Porteret de Jan-Siméon Chardin apartien à Juste Chardin, rue Faubourg Saint-Germain à Paris.*

12. A replica of the 1771 *Self-Portrait* (the one listed here) but signed and dated 1773 was listed at a sale held at the Galerie Georges Petit, on 22 May 1919 (no. 99 with ill.). The catalog, which specifies that the work is from the collection of the Viscount of Rochebouët, proposes that this "pastel was given to Mlle de la Marsaulaye, student of Chardin, by her instructor."

13. We add to the sales references: 30 March 1857 (no. 114), 9 April 1869 (no. 17), 1 and 2 December 1875 ("Chardin 1765 his portrait [with glasses] pastel"), 16 December 1880 (no. 81), and 29-31 May 1910 (no. 5; sale in Joigny) already brought to our attention by Wildenstein [1933, nos. 654 and 655], the following indications: The painter Ph. Rousseau seems to have owned a copy of one of the Louvre self-portraits [Eudel, 1888, p. 369]; the *Nouvelles de la République des Lettres et des Arts* of 20 July 1779 (p. 181) points out "a portrait of M. Chardin, Painter to the King, painted in oil after the pastel picture done by this clever artist himself, same size, by M. Graincourt [1748-1823]," which bears witness to the notoriety the work received even during Chardin's lifetime.

The *Self-Portrait with Spectacles* appears on the painting by Philippe Rousseau (1816-1887), *Picture of an Interior,* shown at the 1867 Salon and known through the engraving and a sketch engraved in *Album autographe, L'art à Paris en 1867,* 4th installment.

In 1939 Giacometti copied on the same sheet of paper the Louvre's self-portrait of Chardin, the portrait of his wife, and the self-portrait of David; this drawing (67.40) is now at The Art Institute of Chicago.

When he was seventy-two, Chardin, who had done very little drawing up until then, exhibited three "pastel studies of heads" at the Salon of 1771. The three pastels created a sensation. The *Muse Errante* published a poem on them (and also on the bas-relief shown at the same Salon and now in Moscow [133]). The *Année littéraire* [1771, V, p. 294] observed: "This is a genre in which we had not yet seen him working, and which, in his first attempts, he carries to the highest degree [of perfection]." Diderot [Seznec and Adhémar, 1967, p. 178] is less eloquent than usual but he does not stint his praise: "It's still the same bold, assured hand and the same eyes accustomed to seeing nature, but really seeing it and discerning the magic of its effects."

We find confirmation in the *Plaintes de M. Badigeon, marchand de couleurs, ou les critiques du Salon de 1771* [1771, pp. 10-11] that the Louvre pastel dated from 1771 is indeed one of those exhibited at the Salon: "The admirable Chardin has put out several pastels, among others *his portrait* [italics added], as true as everything he does; bas-relief, etc., etc. He is the father of the effects which the younger generation must consult often."

We know of only one other pastel bearing the 1771 date, a *Portrait of an Old Man* [exh. cat. Paris, 1971, no. 1 with ill.; Cailleux, 1971, p. IV, fig. 2] purchased by Laurent Laperlier at the sale of a descendant of Chardin (see *Related Works,* where we attempt to straighten out the problem of the provenance of the different pastel self-portraits by Chardin).

Why did the aging Chardin, from 1771 on, devote himself primarily to the pastel, as Degas was to do a century later? Answers abound: illness; infirmity; strain on the eyes, which the mixture of binders and pigments irritated. In 1778 Chardin himself wrote to d'Angiviller, Marigny's successor: "My infirmities have prevented me from continuing to paint with oils; I have jumped into pastel." There are very probably other reasons. Was it not the artist's desire to prove that he was not just the greatest painter of still lifes of his day, as the commentators on the Salons indefatigably repeated over and over again? We recall that he had exhibited "a portrait of M. with his Hands in his Muff" at the Salon of 1746, along with the portrait of the surgeon André Levret. Eleven years later he showed the portrait of another surgeon, Antoine Louis, which the critics received coolly. (Both of these surgeon portraits have been lost; we know them only through engravings.) In 1760 Maurice Quentin de La Tour (1704-1788) did the portrait of the artist, his friend; Chardin gave this portrait to the Academy in 1774, when he resigned form the office of treasurer, and the painting is now in the Louvre [Monnier, 1972, no. 75 with ill.]. Seven years later, Chardin sat for Ducreux [Lyon, 1958, p. 165] and had the opportunity to reassess the difficulties of this new technique. By taking on the portrait once again, although this time in pastel, and by devoting himself essentially to the representation of his own features and those of his wife, Chardin was trying to climb a rung on the ladder, universally accepted at the time, of the "hierarchy of genres."

When Chardin died, his faithful friend (and his portraitist on two occasions, 1755 and 1776), Charles-Nicolas Cochin wrote a let-

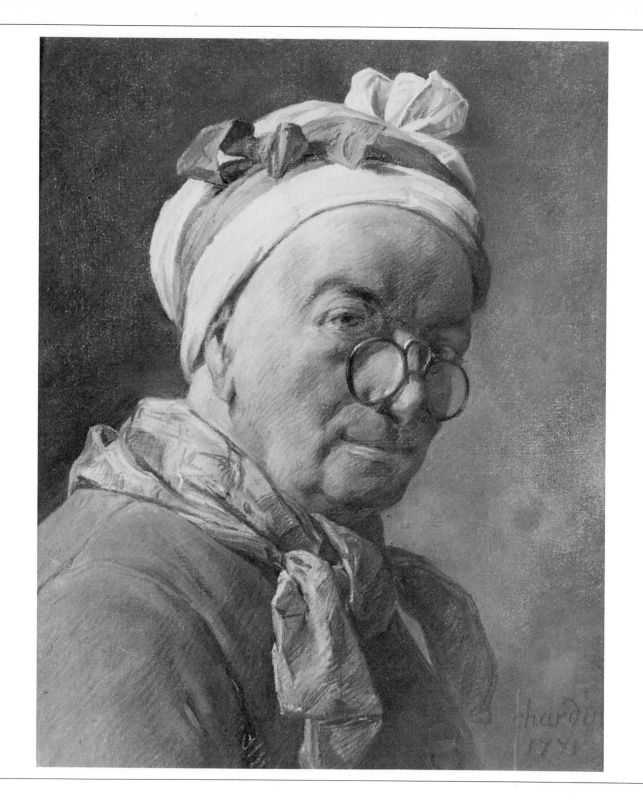

134

ter to Haillet de Couronne comparing him with Caravaggio (who was enjoying a revival of interest at the time). His letter [manuscript in the Bibliothèque Municipale, Rouen] is extremely enlightening in this regard:

"Several years before he died, he was attacked by many infirmities which caused him to abandon or at least to exercise more infrequently his talent for painting with oils. It was then that he tried to make use of the pastel, a kind of painting which he had never thought of pursuing before. He did not use it for his usual genres; but he did make use of it to treat studies of heads, of life-size. He made several of these depicting various characters, young persons, old people and others. He succeeded in this extraordinarily well through his ability and his bold, easy manner, easy at least in appearance, for it was the fruit of much reflection, and he was hard to satisfy. These pieces let it be known to what extent he had a feeling for what is noble, and what he might have accomplished in the history genre if he had put his mind to it; and I don't believe it's possible to deny that, if he had looked at it from the same angle as it was treated by Michelangelo da Caravaggio, he would have excelled in it."

One should note in passing that this 1771 date is contemporary with great changes in the artistic life of the times. When Boucher died in 1770, he was suceeded as first painter and director of the Academy by J. B. M. Pierre (1714-1789), a man whose hatred of and scorn for Cochin and Chardin was returned. Marigny no longer enjoyed the favor of an aging Louis XV. Beaufort (1721-1784), an artist of the second rank, exhibited a *Serment des Horaces (Oath of the Horatios)* at the 1771 Salon; its very title epitomizes these transformations. Chardin, in his own fashion, did not want to be left behind.

It is not that the Louvre pastel is so different from his earlier works. Chardin looks out at us over his steel spectacles. A white cloth forming a cap is held in place on his head with a blue ribbon. A pink scarf with blue stripes lies loosely about his neck. He is wearing a light brown garment. We have here, as in the still lifes, the same concern for careful construction, the same monumentality. Marcel Proust wrote on the subject, about 1895, [English text from *Marcel Proust on Art and Literature, 1896-1919* (New York: Meridian, 1958), pp. 329-30]:

"Go to the Pastel Room, and look at the self-portraits Chrdin painted in his seventieth year. Above an enormous pair of eyeglasses, that has slipped down to the tip of his nose and compresses it between two brand new lenses, his hard-worn pupils are screwed high up in his dulled eyes with a look of having seen a great deal, found much to laugh at, much to love, and of saying, with a sort of wistful brag, 'Yes, I'm an old man sure enough.' Beneath the dimmed gentleness that age has strewn on them, they sparkle still; but the eyelids, grown slack as a clasp that has been too long in use, are red-rimmed. His skin, too, like the old coat he is wrapped in, has stiffened and faded. Like the material, it has kept and almost brightened its shades of pink, and in places a sort of golden opalescence glazes it. And at every turn the wear and tear of the one

recalls the worn tints of the other, being, like the tints of all things nearing their end, whether dying embers, rotting leaves, sinking suns, garments wearing out or men growing old, extremely delicate, rich, and soft. It is astonishing to see how exactly the fold of the lips is determined by the raised eyelids, which the wrinkles on the nose also comply with. Character, life, mood of the moment, the three component factors, are faithfully, fastidiously translated by the slightest pucker of the skin, the least emergence of a vein. I hope that from now on, whether in the street or in your own home, you will stoop with respectful interest over these worn inscriptions which, if you know how to decipher them, will tell you infinitely more things, and more arresting, and more vital, than the venerablest manuscripts could."

135 *Portrait of Madame Chardin, née Françoise-Marguerite Pouget (1707-1791)*

(Portrait de Madame Chardin, née Françoise-Marguerite Pouget [1707-1791])
Pastel, 46 × 38.5 cm. Signed and dated at the lower right on two lines: *Chardin /1775.*
Paris, Musée du Louvre, Cabinet des Dessins, Inv. 25208*

Provenance. Like [134], from the estate sale of Sylvestre, 28 February-25 March 1811, no 11. Thereafter, at the sale of Gounod (father of the composer), 23 February 1824, no. 2. Sale of M. Bruzard, 24 April 1839, no. 58: "Another portrait by the same artist painted in 1779 [*sic*]. Portrait of the wife of Chardin. Two pastels" (The catalog specifies that the two pastels will be sold with no. 59—attributed to Chardin—*"Bohémien et Diseuse de bonne aventure* ['Bohemian woman and fortune-teller'] Two gouaches." This was apparently not what happened, however.) Acquired by the Louvre, through the efforts of the assistant director Cailleux (1787-1876), for 146 francs (the expert George had valued them at "300 francs, possibly much less. Yet they are three very handsome works by this painter and undoubtedly authentic" [Archives, Louvre, D6]). See also [134], *Related Works.*

Exhibitions. 1775, Salon, part of no. 29 ("Three Pastel Studies of Heads, under the same number"); 1927, Paris, no. 10; 1935, Paris, no. 24; 1946, Paris, no. 103; 1949, Paris, no. 23; 1957-58, Paris, no. 18, pl. 29; 1965, Paris, no. 29.

Bibliography. Hédouin, 1846, pp. 186, 227, no. 95; Chennevières, 1856, p. 55; Hédouin, 1956, pp. 177, 200, no. 95; Blanc, 1862, p. 14; Goncourt, 1863, pp. 515-16; 1864, pp. 159-60; Museum cat. (Reiset), 1869, no. 680; Bocher, 1876, p. 88, no. 680; Goncourt, 1880, p. 118; Chennevières, 1888, p. 59; Dilke, 1899, p. 395; Dilke, 1899 (2), p. 128; Fourcaud, 1899, pp. 391, 416; Fourcaud, 1900, p. 9; Normand, 1901, pp. 17 (note 2), 70, 76-78, 86, 108; Schéfer, 1904, pp. 72, 117, 120 (ill.); Dayot and Vaillat, 1907, pl. 42; Dayot and Guiffrey, 1907, pl. between pp. 72 and 73; Guiffrey, 1908, pp. 65-66, no. 62; Goncourt, 1909, pp. 146, 147, 174; MacFall, 1909, facing p. 100 (ill.); Pilon, 1909, pp. 49, 149, 166, and pl. between pp. 148 and 149; Furst, 1911, p. 135, pl. 41; Raffaelli, 1913, p. 55; Klingsor, 1924, p. 127 (ill.); Réau, 1924, pl. on p. 498; Ratouis de Limay, 1925, p. 40, pl. 42; Dacier and Ratouis de Limay, 1927, p. 101, no. 99, pl. 70; Réau, 1929, pl. 37 (2); Bouchot-

Saupique, 1930, no. 12, pl. 4; Pascal and Gaucheron, 1931, p. 102; Ridder, 1932, pp. 10, 19, 88, pl. 86; Wildenstein, 1933, no. 665 (not ill.); Hourticq, 1939, p. 101, pl. on p. 105; Pilon, 1941, p. 59 (ill.); Goldschmidt, 1945, fig. 2; Ratouis de Limay, 1946, p. 64, pl. 26; Lazarev, 1947, pl. 31; Jourdain, 1949, fig. 43; Denvir, 1950, pl. 38; Turner, 1957, p. 303; Adhémar, 1960, p. 457; Zolotov, 1962, pl. 28; Garas, 1963, pl. 39; Rosenberg, 1963, pp. 16, 83, 97; Mittelstädt (ed.), 1963, p. 44, pl. on p. 45 (color); Wildenstein, 1963-69, no. 373, pl. 58 (color); Lazarev, 1966, pl. 55 (color); Seznec and Adhémar, 1967, p. 246, fig. 102; Zolotov, 1968, p. 72 (repr.); Watson, 1970, p. 537; Proust, 1971, p. 601; Monnier, 1972, no. 44 (with pl.); Kuroe, 1975, pl. 31 (color).

Prints. The second article by the Goncourt brothers in the *Gazette des Beaux-Arts* (1864) is illustrated by an engraving by F. La Guillermie after this painting [Bocher, 1876, p. 6, no. 7]. This engraving was used again by Fourcaud [1899, p. 386; 1900, p. 4] and Normand [1901, p. 77] to illustrate their works (Normand attributes it to Léopold Flameng, under whose direction La Guillermie executed it). There is also an engraving by Abel Lugat [Guiffrey, 1908].

Related Works. For the Chicago version, signed and dated 1776, see [137]. For the 1939 drawing by Giacometti (now in Chicago) which copies the Louvre painting, see [134]. For early references to pastels depicting Madame Chardin, see [134], *Related Works.* In 1755 Laurent Cars made an engraving after a drawing by Charles-Nicolas Cochin which represented Madame Chardin.

We will not attempt to retrace here the life of Françoise-Marguerite Pouget (1707-1791), Chardin's second wife. The widow of Charles de Malnoé, she married Chardin on 26 November 1744. She has been seen as the model for many of Chardin's genre paintings, particularly *Domestic Pleasures* [90] and *The Bird-Song Organ* [93]. The truth is, we know nothing about her personality, her tastes in art, or her true role as the helpmate of her husband. She seems to have sheltered the artist from need and to have helped him with the delicate management of the Academy's accounts and the writing of his correspondence (see especially the charming correspondence between Chardin and Desfriches published by Ratouis de Limay in 1907). When the painter died, she was obliged to leave the lodging at the Louvre which she had occupied since 1757; she then went to live with a member of her family, Paul-Laurent Adger, a stockbroker. Two letters from Cochin to Decamps and Desfriches help us to see what the last years of her life were like: quite difficult, it would seem. Her unpublished estate inventory informs us, however, that she had kept several of her husband's paintings, among them a *Saying Grace* and three pastels (her portrait, that of the painter, and that of her sister, the widow of another stockbroker, Dachet, the uncle of M. Adger).

At the Salon of 1775 Chardin exhibited three studies of heads. He had presented only one such study in 1773, possibly the fine portrait of a man presumed to be the painter Bachelier (1724-1806) [Wildenstein, 1963-69, no. 370, fig. 169] now at the Fogg Art Museum in Cambridge. However, we pointed out earlier that a replica of the 1771 portrait, also dated 1773, was listed in a 1919 sale. Bachaumont confirms that the Louvre portrait did indeed appear at the 1775 Salon when he writes in his *Mémoires secrets* [1775, XIII, p. 211]: "M. Chardin... took pleasure in painting himself *with his wife.*"

In *L'Opinion* of 28 February 1920 we find these comments: "We have asked a certain number of artists, writers, and lovers of art the following questions: 'The Louvre Museum has just dedicated a gallery to a few masterpieces of Italian painting. Don't you think that one might imagine a mate to this gallery? It would be devoted to French art. Would you make up a list of eight French paintings, selected from the paintings owned by the Louvre, without limiting yourself to any particular period, which could in your opinion find a place in this ideal gallery?' The response of Marcel Proust [ed. 1971, p. 601] deserves mention: '*Portrait of Chardin* by himself; *Portrait of Mme Chardin* by Chardin; *Still Life* by Chardin; *Spring* by Millet; *Olympia* by Manet; a Renoir or *The Bark of Dante,* or *The Cathedral of Chartres* by Corot; *The Indifferent* or *Embarkation for Cythera* by Watteau.''

Cambridge (Mass.), Fogg Art Museum.

We would not be forgiven if we failed to include here the admirable passage devoted to this painting by the Goncourts [1864, pp. 159-160]. They have just compared the two self-portraits of the Louvre with those of Rembrandt:

"And yet that is not yet his masterpiece: it is in the portrait of his wife that he reveals all his ardor, all the power of his spirit, the force and the fever of his inspired execution. Never did his hand display more genius, more audacity, more felicity, more brilliance, than in this pastel. With what an impetuous touch, full and dense, Chardin attacks the paper, frays it, thrusts into it his chalk, with what wild, impulsive strokes, not least assured when most accidental and freed from the hatchings that had hitherto dulled his sparkle and bound his shadows. How triumphantly he brings to life the face of the elderly Marguerite Pouget, enveloped up to the eyes in this almost monastic headdress, so often worn by his figures! There is nothing lacking in this prodigious study of an old woman, not a line

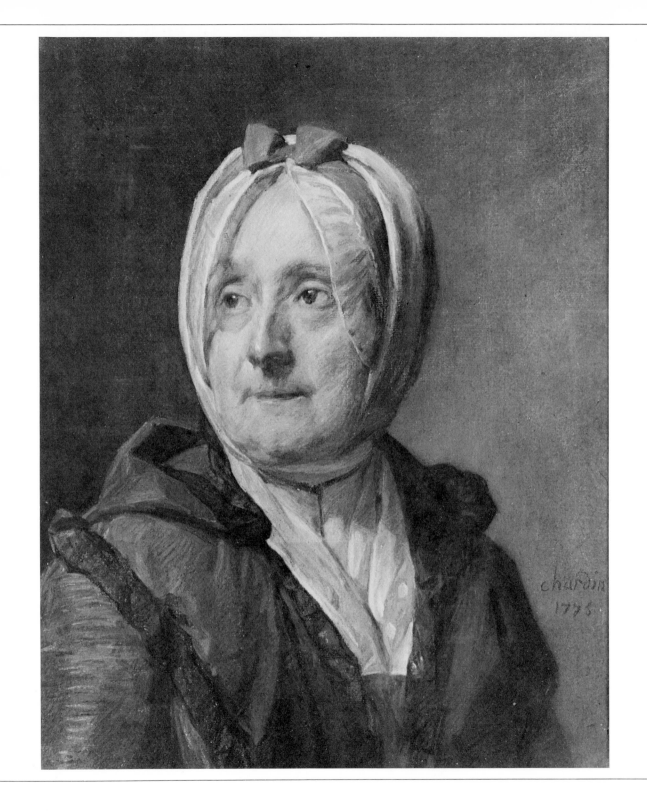

nor a tone. The ivory pallor of the brow, the chilled glance whose smile has flown away, the wrinkles around the eyes, the emaciated nose, the receding, half-closed mouth, the complexion like a fruit exposed to winter; Chardin gives us all these signs of old age; he gives us a feeling of them almost of their nearness with his inimitable, elusive workmanship which in some mysterious way puts the sitter's breath upon the lips of the portrait, the flicker of daylight upon the drawing of the face. And how can we capture the secret, define the substance of that toothless mouth which moves, wrinkles, draws back, breathes, which has all the infinite subtleties of nature's lines, curves, and inflexions? It is only a few loitering strokes of yellow and a few streaks of blue. What are the shadow cast by the cap, the light on the temples filtered through the linen, this transparency trembling near the eye? Brushstrokes of pure reddish brown, broken by a few strokes of blue. The white cap, absolutely white, is made of blue, and only blue. The whiteness of the face is achieved with pure yellow, not a touch of white; there are only three touches of white chalk in the whole head, the highlight at the end of the nose, and in the eyes. To have painted everything in its true color, without painting anything in its own hue, this is the *tour de force*, the miracle to which the colorist has risen."

136 Self-Portrait (also called Portrait of Chardin Wearing an Eyeshade)

(Autoportrait, dit Portrait de Chardin à l'abat-jour)

Pastel, 46 × 38 cm. Signed and dated at the lower right on two lines: *Chardin / 1775.*
Paris, Musée du Louvre, Cabinet des Dessins, Inv. 25207*

Provenance. Does not appear in the catalogs of the Sylvestre (1811) and Gounod (1824) sales, contrary to what is generally said. Bruzard sale of 24 April 1839, no. 58, with *Portrait of Madame Chardin* [135]. Acquired by the Louvre at this sale for 146 francs. See [134] *Related Works.*

Exhibitions. 1775, Salon, part of no. 29 ("Pastel studies of three heads, under the same number"); 1946, Paris, no. 102; 1949, Paris, no. 22 (pl. on cover); 1957-58, Paris, no. 17, pl. 28; 1965, Paris, no. 28.

Bibliography. Chennevières, 1856, p. 55; Goncourt, 1864, pp. 158-59; Museum cat. (Reiset), 1869, no. 679; Bocher, 1876, p. 88, no. 679; Goncourt, 1880, p. 118; Chennevières, 1888, p. 59; Dilke, 1899, p. 394 and note 5; Dilke, 1899 (2), p. 128; Fourcaud, 1899, pp. 391, 416; Fourcaud, 1900, p. 9; Normand, 1901, pp. 70, 74-76, 86, 108; Schéfer, 1904, pp. 9 (ill.), 119-20; Dayot, 1907, p. 140 (ill.); Dayot and Guiffrey, 1907, pl. on p. 2; Guiffrey, 1908, p. 65, no. 61; Goncourt, 1909, pp. 145, 146, 147; MacFall, 1909, pl. 34 facing p. 186; Pilon, 1909, pp. 49, 148, 166, pl. between pp. 8 and 9; Furst, 1911, p. 135, pl. 40; Raffaelli, 1913, p. 55; Benesch, 1924, pl. 24 between pp. 166 and 167; Hildebrandt, 1924, p. 172, fig. 221; Klingsor, 1924, pl. opp. the title; Réau, 1924, pl. on p. 498; Ratouis de Limay, 1925, p. 39, pl. 41; Gasquet, 1926, p. 203; Gillet, 1929, pp. 64, 73, pl. 75; Osborn, 1929, pl. on p. 183; Bouchot-Saupique, 1930, no. 11, pl. 4; Pascal and Gaucheron, 1931, p. 102; Ridder, 1932, pl. 84; *Miroir du Monde*, 7 November 1931,

no. 88 (ill.); Wildenstein, 1933, no. 651, fig. 61; Jamot, 1934, p. 135 (ill.); Cézanne (ed. Rewald), 1937, p. 263; Florisoone, 1938, pl. 5 (color); Grappe, 1938, p. 24 (ill.); Hourticq, 1939, p. 101, ill. on p. 104; Furst, 1940, p. 13 (ill.); Pilon, 1941, p. 58 (ill.); Pilon, 1941 (2), p. 18 (ill.); Goldschmidt, 1945 (cover ill.); Florisoone, 1946, p. 104 (repr.); Ratouis de Limay, 1946, p. 64; Goldschmidt, 1947 (cover ill.); Lazarev, 1947, pl. 1; Florisoone, 1948, pl. 64 (color); Jourdain, 1949, fig. 42; *Attractions*, 1954, no. 1, repr. on cover; Adhémar, 1960, p. 457; *Du*, December 1960, p. 38 (ill.); Nemilova, 1961, pl. 1; Bazin, 1962, p. 296 (ill.); Zolotov, 1962, pl. 27; Garas, 1963, pl. 38 (color); Mittelstädt (ed.), 1963, p. 46, pl. on p. 47 (color); Rosenberg, 1963, pp. 6, 16, 19, 75, 83, 97, 104, 106, 107, color pl. on p. 92; Wildenstein, 1963, no. 372, pl. 59 (color); Guilly, *Kindler's Lexikon*, 1964, p. 728 (color pl.); *Goya*, September-October 1965, p. 128 (ill.); Huyghe, 1965, p. 8 (ill. detail); Valcanover, 1966, pl. 16; Seznec and Adhémar, 1967, p. 246, fig. 101; Zolotov, 1968, pl. on p. 73; Watson, 1970, p. 537; Kojina, 1971, pp. 69 (color pl.), 74, no. 38; Proust, 1971, pp. 377-79 (and 601 ?); Stuffmann, 1971, pl. 50 (color); Levey, 1972, no. 43 (with pl.) *Encyclopedia Britannica*, 1974, p. 43 (ill.); Lazarev, 1974, pl. 179; Tufts, 1974, pp. 2 (pl. 6), 3; Kuroe, 1975, pl. 32 (color); *Chefs-d'oeuvre de l'Art. Grands Peintres*, 1978, pl. 16 (color).

Prints. Bocher (1876) lists Baulant's wood engraving after the drawing by Baucour to illustrate the *Vie de Chardin* in Ch. Blanc's *Histoire des Peintres* [1862, p. 5, no. 4]. (The Baulant engraving was repeated, although reversed, in *Le Magasin Pittoresque* of June 1850, p. 172, no. 5.) He also lists the engraving (no. 7) executed under the direction of Léopold Flameng by F. La Guillermie (three states) to illustrate the second article by the Goncourt brothers on Chardin published in the *Gazette des Beaux-Arts* of 1864 [repeated by Chennevières, 1889, p. 121, and Fourcaud, 1899, p. 385; 1900, p. 3]. We also point out the 15-franc stamp designed by P. P. Lemagny and engraved by Hetenberger that was issued on 11 June 1956 and withdrawn on 24 November 1956. On the first-day cover of this stamp, there is, in addition to the *Self-Portrait*, a detail of the *Child with a Top* [75].

Related Works. For the replica, which aroused the admiration of Dilke [1899, p. 394], and which was once in the Camille Groult collection, and for the early references to Chardin self-portraits in pastel, see [134], *Related Works.*

"Do you remember the splendid pastel of Chardin, equipped with a pair of spectacles, a visor forming a shade? He's an artful one, that painter. Haven't you noticed that by letting a plane of light ride across his nose at an angle, the values are better established for the eye? Verify this fact, and tell me if I am wrong." So wrote Cézanne to Emile Bernard on 27 June 1904 with regard to the Louvre pastel which had been exhibited with the portrait of Madame Chardin at the Salon of 1775. Ten years earlier Proust had contemplated publishing a long commentary on the work (ed. 1958, pp. 330-31):

"In the other pastel self-portrait we have of him, it is a match for the ludicrous eccentricity of some elderly English tourist. From the eye-shade shoved down over his forehead to the Madras neckerchief knotted under the chin, everything about it makes one want to smile, to smile without a thought of concealment, in the face of this old oddity who is patently so intelligent, so crazy, so amiably prepared to be taken as a joke—above all, so much of an artist. For every detail of this startlingly casual get-up, all equipped for going to bed, is as much an index of discimination as it is a flout to convention. If that pink Madras neckerchief is so old, it is because a

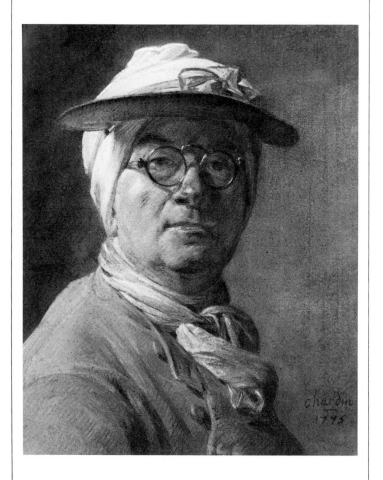

faded pink is softer. Looking at those pink and yellow crumples which seem to have left their reflection on the sallowed and rosied skin, seeing the dull glitter of the steel spectacles confirmed by the blue lining of the eye-shade, the first astonishment provoked by the old man's extraordinary attire melts into serene delight — and into the aristocratic pleasure, too, of finding the stately hierarchy of precious colours, the ordered laws of beauty, in the seeming disorder of an old commoner dressed at his ease.

"But looking more closely at Chardin's face in this pastel you will think again, and feel perplexed, not daring to smile, nor justify yourself, nor shed tears before the ambiguity of his expression. It is what often happens to a young man confronted with an old man, and never if he is with a man of his own age — to be baffled, I mean, by that language we call the play of physiognomy, which is representational as a picture, but swift, direct, and disconcerting as a retort. Does Chardin here look at us with the bravado of an old man who makes light of himself, exaggerating the vaunt of his unabated good health, of his unquenched love of mischief, in order to entertain us or to show he is not really taken in by them: 'Aha! So you believe you young ones know everything?' Or has our youth wounded him in his impotence; does he hit back with a passionate defiance, useless, and grievous to see? One could almost believe it, there is so much stern intent in the alertness of the eyes and the quiver of the lips. How many among us have been thus at a loss over the meaning and purpose of something an old man has said, above all over some glance of his, some twitch of the nose, some compression of the lips. We sometimes smile at the aged as if they were charming old madmen. But sometimes too we tremble at them as though they were madmen."

What can we add to these commentaries that has not already been said? Let us observe only that Chardin has arranged a costume for himself with the same care, the same attention that he brought to the placement of the objects forming his still lifes. The visor, which protects the artist's eyes, and its ochreous pink ribbon, the scarf knotted around the head and neck — each detail has been maturely considered. Chardin attains perfection through this workmanship so vigorous and yet so right. His aim is to give his work a sense of the commonplace without the appearance of any underlying effort.

136

See Color Plate XXII.

137 *Portrait of Madame Chardin, née Françoise-Marguerite Pouget (1707-1791)*

(Portrait de Madame Chardin, née Françoise-Marguerite Pouget [1707-1791])

Pastel, 46 ✕ 38 cm. Signed and dated at the lower right on two lines: *Chardin /1776*.
Chicago, The Art Institute of Chicago, The Helen Regenstein Collection

Provenance. Sale of the artist Jean-Louis David (1792-1868), painter-draftsman to the emperor, 18-19 March 1868, no. 12 (?): *Portrait de vieille femme* [pastel], *signé* ("Portrait of an old woman, signed") [could refer just as well to the Besançon museum's pastel, *Head of a Woman*, after Rembrandt, also signed and dated 1776; Cailleux, 1975, fig. 192]. Collection of Loriol in Geneva. Marquis de Biron, Paris (?). Collection of Forsyth Wickes by 1933 in Paris and Newport, Rhode Island. Acquired for The Art Institute of Chicago by Mrs. Joseph Regenstein in 1962. For the early provenance of the work, see [134], *Related Works*.

Exhibitions. 1926, New York, no. 2 (ill.); 1927, Chicago, no. 2; 1935, Copenhagen, no. 267; 1935-36, New York, no. 26 (pl.); 1951, Pittsburgh, no. 86 (ill.); 1951, Providence, no. 43; 1954, Baltimore, no. 84, pl. on p. 35; 1956, New Haven, no. 194 (ill.); 1961, Richmond, p. 68; 1963, New York, no. 46 (pl. 23); 1974, Chicago, no. 29 (color pl.); 1976, Chicago, no. 38 (ill.); 1978, Chicago, no. 27 (ill.).

Bibliography. Wildenstein, 1933, no. 666, fig. 62; *Beaux-Arts*, 1935, no. 138, pp. 1 (no. 153), 3; Grappe, *L'Amour de l'Art*, July 1935, p. 241, fig. 24; Furst, 1940, p. 17 (ill.); Paris exh. cat., 1957-58, under no. 18; Joachim, *The Art Institute of Chicago Quarterly*, Winter 1962-63 (Vol. 56, No. 4) p. 63 and cover ill.; Wildenstein, 1963-69, no. 374, fig. 172; Vallery-Radot, 1965, pp. 68 (ill.), 130; Monnier, 1972, under no. 44.

Related Works. For the Louvre version, signed and dated 1775, see [135], and for the early references to pastels showing Madame Chardin, see [136], *Related Works*.

Although the Chicago pastel was executed a year later than the Louvre version, the two works do not seem to differ in any appreciable fashion. The reader is asked to see [135] concerning the second Madame Chardin, the reception accorded the work at the Salon of 1775, and the admirable description of the Louvre pastel made by the Goncourts in 1864.

We add that in 1776 Chardin signed a second pastel, *Head of an Old Woman* (now in the Besançon museum), copied from Rembrandt's portrait (now in The Hermitage) of a woman said to be his mother. Chardin's contemporaries often compared him with the great Dutch painter — as early as the *Portrait of the Painter Joseph Aved* of 1734 [62]. But the comparison was never more justified than when it came to the pastels of the final years, where psychological analysis is fundamental. The Frenchman was never to relinquish his own modesty, reserve, nobility, and dignity.

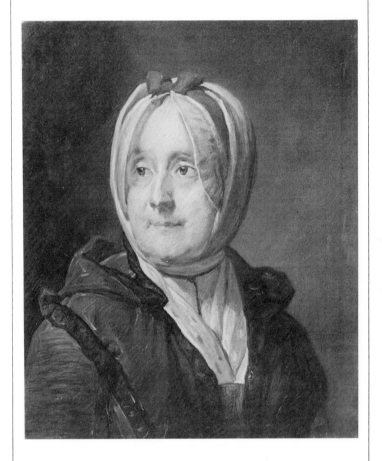

137

See Color Plate XXIII.

138 Winter

(L'Hiver)

Canvas, 54.5 × 87.5 cm. Signed and dated at the lower left: *Chardin pinx 1776.*
France, Private Collection*

Provenance. Possibly the painting at the "Chardin sale (1790) imitating Bouchardon's bas-relief of Winter... bought back at 72 *livres,"* pointed out by the Goncourts [1880, p. 125; however, we have been unable to locate this sale]. First François Marcille sale, 16-17 January 1857, no. 424, "Attributed to Chardin. Bas-relief after Bouchardon" (in this same sale there were two other grisailles attributed to Chardin, no. 19, "Pigalle's Mercury," and no. 28, "Vespasian"). Second Marcille sale, 2-3 March 1857, no. 37, "Children, grisaille." Collection of Eudoxe Marcille (1814-1890); has remained in this family since that time.

Exhibitions. 1777, Salon, no. 49 ("a painting imitating the bas-relief");1849, Paris, no. 7 ("a bas-relief [grisaille]") (?).

Bibliography. Chennevières, 1890, p. 302; Wildenstein, 1933, no. 1211; Paris exh. cat., 1959, under no. 23; Wildenstein, 1963-69, no. 382, fig. 174; Faré, 1976, p. 168.

This work is little known. Although dated 1776, it is nevertheless the latest of Chardin's oil paintings to come down to us. *Winter* is the fourth trompe l'oeil exhibited by the artist since his "return to grisaille," after his entries of 1769 [131, 132] and 1771 [133]. Like *Autumn* in the Salon of 1771, which had approximately the same dimensions, *Winter* copies a plaster cast for Bouchardon's *Seasons* on the fountain of the rue de Grenelle.

We are sure that this work is the one at the 1777 Salon because we have Saint-Aubin's sketch of it on the margin of his copy of the catalog [Cabinet des Estampes, Bibliothèque Nationale; see Dacier, 1910, IV, p. 45]. Critics once again made use of the same terms to describe the painting: "firm and grand manner," "total illusion" [Bachaumont, *Mémoires secrets*, XI, 1777, p. 40]; "one is tempted to reach out and touch it" [*L'Année littéraire*, 1777, VI, p. 342]; "a touch [that is] bold, able and full of effect" [*Mercure de France,* October 1777, p. 172). They admired the painter's longevity and his fidelity to the Salon (in comparison with Fragonard,

Besançon, Musée des Beaux-Arts.

Saint-Aubin, sketch on a page of the 1777 Salon catalog.

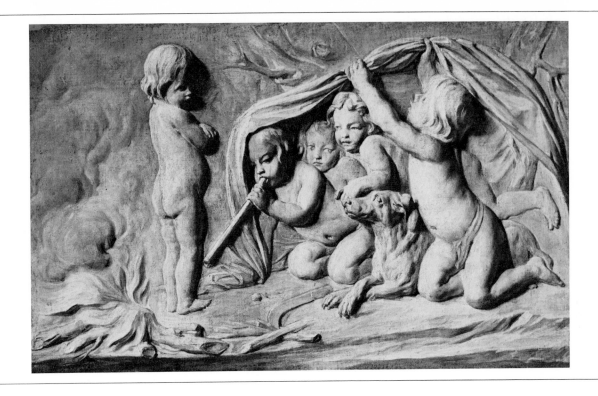

138

mentioned by name, who refused to exhibit): "M. Chardin reminds me of those athletes who, staggering about after a fierce combat, gather all their remaining strength to go die in the arena," wrote *La Prêtresse ou Novelles Manières de prédire ce qui est arrivé* [1777, p. 13].

The painting, however, is not entirely free from certain awkward touches, and it has lost the virtuosity of the 1771 Salon painting. One senses that the hand of the artist is faltering. We would like to say Chardin consciously chose to copy *Winter* in the evening of his life, but we have no proof.

Diderot alone [Seznec and Adhémar, 1967, p. 178] noticed, once again, those aspects of this grisaille which were exceptional and different with respect to the two paintings exhibited in 1769. He seems to have remembered well how those earlier paintings imitated the marble and its reflections, instead of, as here, the matte quality of the plaster:

"One recognizes the great man every time. M. Chardin employs here a different magic; this piece is much less finished than his earlier works, and yet it has as much effect and truth as anything from his brush; its illusion is extremely strong, and I have seen more than one person deceived by it. It seems one could say of M. Chardin and M. de Buffon that Nature has taken them into her confidence."

139 *Self-Portrait* (also called *Portrait of Chardin at His Easel*)

(*Autoportrait, dit aussi Portrait de Chardin au chevalet*)

Pastel, 40.5 × 32.5 cm.
Paris, Musée du Louvre, Cabinet des Dessins, R. F. 31770*

Provenance. The source of this pastel in the nineteenth century is unclear. Could it be the pastel of the 1867 Laperlier sale (no. 59) measuring, according to the catalog, 45 × 38 cm. and coming from the collection of a descendant of Chardin? We have assembled all the information we could find in the entry for the 1771 *Self-Portrait* (see [134], *Related Works*), whose composition is very similar to that of the painting listed here. Collection of Léon Michel-Lévy by 1885; sale, 17-18 June 1925, no. 44 (ill.) ("acquired from a descendant of Chardin's family along with the spectacles the artist wears on his nose"). Collection of Baron Henry de Rothschild, then of Baron James de Rothschild. Sale, Palais Galliéra, 1 December 1966, no. 113 (color ill.) [the spectacles, no. 114 of the same sale, are reproduced in *Abc décor*, November 1966, p. 80; see, in regard to them, the 1909 article by Roujon]; preempted by the Louvre at this sale.

Exhibitions. 1885, Paris, no. 6; 1907, Paris, no. 80; 1908, Paris, no. 7; 1927, Paris, no. 9, pl. 3; 1929, Paris, no. 28; 1932, London, no. 192, (pl. 37 of the ill. vol.) (in commemorative cat., no. 156); 1950, Paris, no. 101, pl. 27; 1951, Geneva, no. 6; 1956, Paris, no. 17; 1959, Paris, no. 25, pl. 13; 1967-68, Paris, no. 455 (with repr.).

Bibliography. Dayot and Vaillat, 1907, pl. 1A; Fourcaud, 1908, pp. 15 (ill.), 18; Guiffrey, 1908, p. 82, no. 163; Roger-Milès, 1908, p. 5 (ill.); Roujon, 1909, pp. 121-25; Pilon, 1909, pp. 150-51, 167; Furst, 1911, p. 136; Dacier and Ratouis de Limay, 1927, no. 98, pl. 69; Alexandre, 1929, p. 527 (ill.); Quintin, 1929, pl. (unnumbered); Pascal and Gaucheron, 1931, pp. 119, 121, 136 (with repr.); George, *L'Amour de l'Art*, October 1932, p. 269, fig. 19; Ridder, 1932, p. 20; Wildenstein, 1933, no. 650, frontispiece; Wildenstein, 1933 (2), p. 367 (pl.); Pilon, 1941, frontispiece; Ver[onesi], 1959, p. 140; Wildenstein, 1963-69, no. 375, fig. 171; Lazarev, 1966, pl. 56; Duret-Robert, *Connaissance des Arts*, February 1967, p. 42; Huisman, 1970, pp. 391-92 (nineteenth-century copy); Cailleux, 1971, p. V; Monnier, 1972, no. 45 (ill.); *Revue de Louvre et des Musées de France*, 1974, p. 78 (ill.); Kuroe, 1975, p. 92.

Related Works. See [134], *Related Works.*

The Louvre's purchase of this pastel in 1966 stirred up some controversy in the press—for instance, in *Connaissance des Arts* (February 1967), *Le Figaro Littéraire* (24 April 1967), and Huisman, 1970; also see Chantelou, *Le Monde* (23 December 1966). And as so often happens, it was quite unjustified. The claim was made that the Léon Michel-Lévy/Rothschild pastel was a useless repetition of the 1771 *Self-Portrait* already in the Louvre. A rapid comparison of the two works, however, proves the inaccuracy of this. Here the old artist has positioned himself in front of an easel that supports a frame covered with a sheet of blue-tinted paper. He holds in his hand a stick of red pastel. He has grown thin, his features are sunken, he seems more bent, and his gaze has lost some of its irony.

What might the date of this pastel be? In 1777 Chardin exhibited three pastels. Gabriel de Saint-Aubin's drawing on the margin of his copy of the catalog [Cabinet des Estampes, Bibliothèque Nationale: Dacier, 1910, IV, pp. 45-46] makes it easy to identify two of the three pastels: the *Jeune homme au chapeau* ("Young man wearing a hat") and the *Fillette* ("Little Girl"), formerly in the collections of Princess Mathilde and Foulon de Vaux and now in a private collection in the United States [Wildenstein, 1969, no. 376, fig. 173 and pl. 63; no. 377, pl. 62]. The third pastel is harder to recognize since Saint-Aubin's sketch is very faint. Attempts have sometimes been made to see in it the Rothschild *Self-Portrait* exhibited here. But one could more easily take it for another self-portrait in which the artist presented himself in profile, turned toward the right. There are two versions of this work: one is dated 1775; the other, known only through a photograph, was in a private collection in New Orleans before being sold [?] in Dublin, 9 November 1960, no. 56 (ill.), and then at Sotheby's, London, 21 July 1966, no. 124.

At the Salon of 1779, the last of a long series of Salons at which Chardin exhibited, the artist presented (no. 52) "Several pastel studies of heads under the same number." The critics stressed the painter's longevity and praised his "bold and intelligent coloring" that was "fresh and brilliant," his "profound understanding of harmony," and the "vigor" of his entries. But only *La Bonne Lunette* [1779, p. 40] gives any details about Chardin entries: "two heads of old men and a *Jacquet*." Was one of these heads the new *Self-Portrait* of the Louvre? Whatever the case may be, this piece is surely one of Chardin's last creations.

The *Jacquet* [a kind of servant or lackey] obtained for Chardin one of the last gratifications of his self-esteem. All the Salon commentators relate the anecdote; here is the version published shortly after Chardin's death by the *Nécrologe des Hommes Célèbres* [XV, 1780, pp. 187-188]: "There has been much talk of the high quality of the last Salon. The queen and the whole royal family wanted to see it, and showed that they liked it. One of the pieces most enjoyed by Mme Victoire, whose enlightened opinion it is the aim of the best artists to obtain, was a small painting by M. Chardin representing a little *Jacquet*. She was so struck by the truth of this figure that the very next day this princess sent M. le comte d'Affry to the painter with a gold box, as proof of the esteem in which she held his ability." We have previously noted that Mme Victoire was very familiar with Chardin's work. The Château de Bellevue, where the daughters of Louis XV resided, was decorated with *Attributes of Civilian Music* [126] and *Attributes of Military Music* [127].

With his head hooded in a white cap held in place by an elegantly tied blue ribbon and his brown coat unbuttoned so that we can see his scarf, Chardin rests his hand on his easel and stares at us with a weary gaze. A strong light falls on the blues of the ribbon and the edge of the easel, accentuating the bright red pastel crayon—as if Chardin had wanted to call attention to his new medium and to put his own face in shadow. The artist has lost the bluff assurance that was still evident in the 1771 version of the work. How can we not be moved by this last image of the painter, the greatest poet of silence! On 6 December 1779, at nine o'clock in the morning, Chardin died in the Louvre.

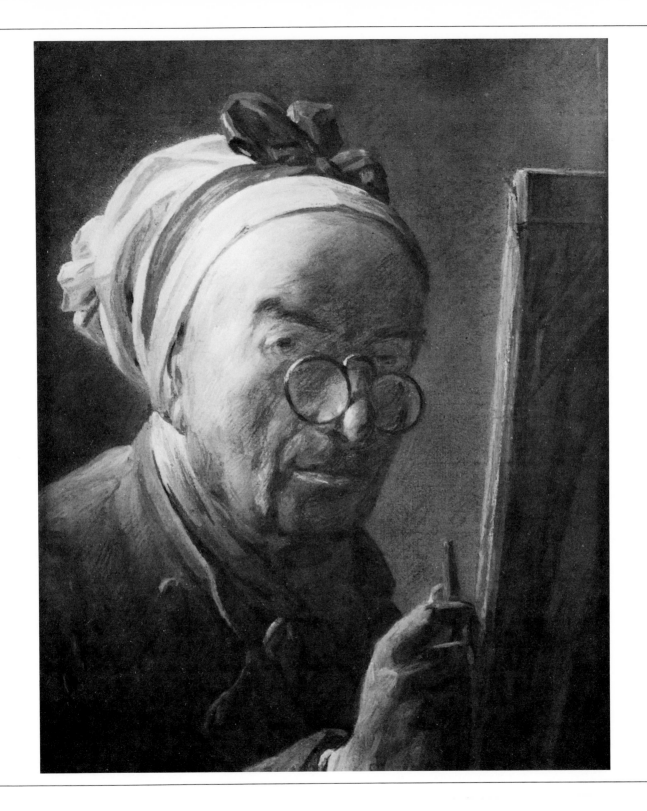

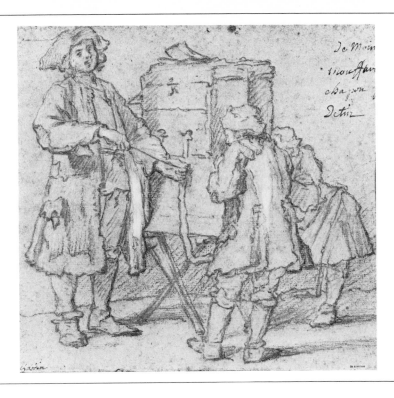

CHARDIN (?)

140 *Curiosity*

(La curiosité)

Red chalk and traces of black chalk on yellowish paper, 198 × 213 mm. At the lower left in ink: *Chardin.* On the right is the stamp of the Goncourt brothers' collection (Lugt, 1921, I, no. 1089). At the upper right in ink, in an early hand (the hand of Chardin, in the opinion of the Goncourts): *De Main/ Mouffard/ Chapon/Detin.*
France, Private Collection*

Provenance. Du C[hartreux] sale, 2 May 1791, no. 482: *Une pastorale à la mine plomb sur velin aussi de Natoire; la Curiosité et un autre dessin de Chardin et un Evêque par Vassé* ("A pastoral scene in black lead on parchment also by *Natoire;* Curiosity and another drawing by *Chardin;* and a Bishop by Vassé"). Collection of the brothers Edmond (1822-1896) and Jules (1830-1870) de Goncourt about 1863 (engraved at that time by Edmond de Goncourt). Goncourt sale, 15-17 February 1897, no. 40 ("attributed to Chardin"). Collection of Dr. F. Gaillard. Palais Galliéra sale, 27 March 1965, no. 3, pl. 2 ("Chardin?").

Exhibition. 1933, Paris, no. 305 (photograph of the drawing).

Bibliography. Goncourt, 1864, p. 166 (note); Goncourt, 1880, p. 109; Goncourt, 1881, p. 60 (ed. n.d., I, pp. 55-56); Goncourt, 1909, p. 162; Mathey, 1933, p. 82; Mathey, 1964, pp. 18, 20 (fig. 4), 27, no. 4; Ananoff, 1967, pp. 60, pl. 3 (color), 61.

Prints. An engraving (two states) by Edmond de Goncourt "around 1863" [Adhémar and Lethève, 1955, p. 247, no. 9,"Man Showing Pictures"].

The Goncourts thought they owned "three pure archetypes of Chardin drawings" (1864): the *Man in a Three-Cornered Hat,* now in the Louvre [142]; *Portrait of an Old Woman Holding a Cat,* unanimously rejected today (the painting for which it served as a preliminary study—once in the collection of the Baronne de Conantre and now on the market in Paris—is attributed to Ducreux) [see Mathey, 1964, p. 29, figs. 13 and 14]; and the work exhibited here, which represents, according to the Goncourts, "A man showing a magic lantern to children." At the Goncourt estate sale, for which Féral *père* and *fils* acted as appraisers, only the first of these drawings was sold as being by Chardin himself; the other two, along with a *Jacquet,* were only "attributed" to Chardin.

The drawing shown here was recently reattributed to Chardin by J. Mathey and A. Ananoff, correctly, in our view. It offers clear similarities with both *The Vinegar-Barrow* [1] and the *Manservant Pouring a Drink for a Player* [2] of Stockholm: the same hesitancy, the same kinds of retouchings in black chalk, the same manner of placing the figures on the ground. But there is more. The Goncourts hardly mention a fourth drawing in their possession, a *Jacquet* "drawn on the same paper as *Curiosity* and mounted in the same old frame" (and coming from the same Du Chartreux sale of 1791)

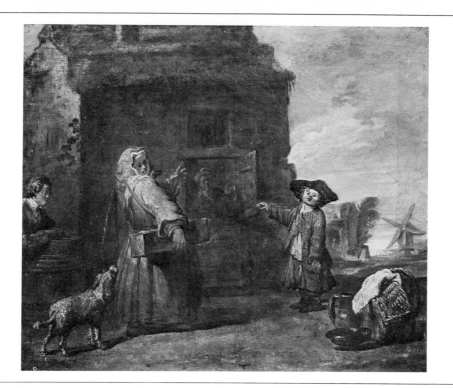

[Goncourt, 1881, p. 60; sale 15-17 February 1897, no. 41]. The present whereabouts of this drawing is unknown, but we do have an idea of it from the engraving by Edmond de Goncourt [Adhémar and Lethève, 1955, p. 247, no. 10]. This engraving proves conclusively that *Jacquet* and *Curiosity* are by the same hand. Surely this *Jacquet* is a preliminary study for a figure in the little *Unidentified Genre Scene* now in a private collection in Sweden [141]. But does this painting go back to Chardin? One point seems assured: the picture in Sweden and *Curiosity* are by the same hand.

CHARDIN (?)

141 *Unidentified Genre Scene*

(Scène de genre non identifiée)

Canvas, 37.5 × 45.5 cm. (enlarged by a few centimeters on the upper portion). Signed and dated at the lower center on two lines: *Chardin / 1730* (?)
Sweden, Private Collection*

Provenance. Comes from England. In Sweden before 1938 in the Gösta Stenman collection.

Exhibitions. 1938, Stockholm, no. 9, pl. 3; 1941, Stockholm, no. 299; 1958, Stockholm, no. 77 ("unknown artist").

Bibliography. Stenman, 1938, pp. 6-7; Goldschmidt, 1945, pp. 66-71, fig. 16; Goldschmidt, 1947, fig. 17.

This painting poses a number of difficult problems. The subject of the picture commonly called the *Boîte du prestidigitateur* ("The Conjurer's Box") escapes us. Why is the young woman who holds a long box under her arm surprised by the appearance of a man who is smoking, revealed to us by a little boy wearing a wide hat and greatcoat who has just opened the upper part of a Dutch door? We do not know. Could this be the illustration of an episode in some popular novel?

Engraving by Edmond de Goncourt.

On what grounds has this picture been attributed to Chardin? There are a number of them. Goldschmidt, who was the first to draw attention to this picture and to stress its importance (1945 and 1947), observed that the spaniel we see on the left of the painting is identical to the one in the painting of *The Water Spaniel* in the Wildenstein collection, New York [Wildenstein, 1963-69, no. 68, fig. 32]. We have also pointed out (in [140]) that the Goncourts owned a drawing known as the *Jacquet,* attributed to Chardin by 1791, which is now lost but known to us through an engraving by Edmond de Goncourt. This *Jacquet* is plainly a preliminary study for the little boy in the center of the painting. Furthermore, the pitcher, the basket, and the bowl on the ground to the right of the composition are close to certain still-life objects painted by Chardin.

We have yet to explain the 1730 date, the same as the one on the *Spaniel,* admittedly surprising at first glance. If this date were to be correct, it would prove that Chardin did not completely abandon genre scenes around 1725-1726 and that the painter's "conversion," around 1733 (see [54] and later works), to the representation of the human figure of the human figure had been preceded by several trial efforts.

The painting exhibited here is not without some weakness, particularly in the landscape on the right with its curious mill. Could this be one of Chardin's experiments in the manner of Gillot? There is one further reason for this point of view: the unique technique, with its juicy impasto, that we see in *The Water Urn* [55], *The Washerwoman* [56], and *The Game of Knucklebones* [60].

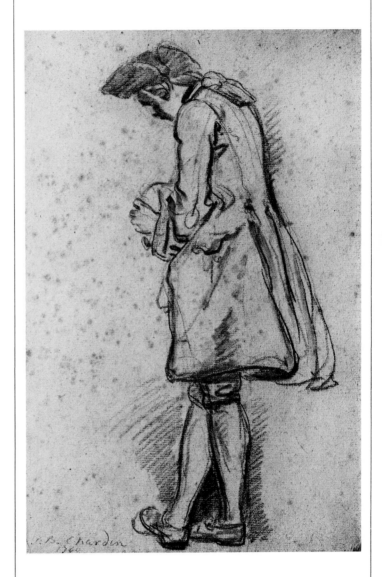

142

CHARDIN (?)

142 *Man in a Three-Cornered Hat*

(L'homme au tricorne)

Slightly blurred red chalk, 349 × 227 mm. At the lower right there is an early inscription in red chalk: *J. B. Chardin 17(?)0.*
Paris, Musée du Louvre, Cabinet des Dessins, Inv. R. F. 2055*

Provenance. Acquired before 1860 (engraved by Jules de Goncourt at that time); Goncourt sale, 15-17 February 1897, no. 39 (does not have the stamp of that collection). Acquired at this sale for 2,200 francs by the Louvre.

Exhibitions. 1879, Paris, no. 497; 1933, Paris, no. 183; 1935, Copenhagen, no. 332; 1937, Paris, no. 519 (and pl. 94); 1946, Paris, no. 353; 1954, Paris, no. 6; 1958, Paris, no. 25 (xeroxed cat.), ill. in *Elle,* 7 April 1958.

Bibliography. Goncourt, 1864, pp. 165-66, note 1 (engraving by Jules de Goncourt; illustrates the study on Chardin by the two brothers in 1864); Bocher, 1876, p. 22, no. 19; Burty, 1876, pp. 5, 15, no. 67; Chennevières, 1879, p. 200 (ill. on p. 201) (p. 104 of the offprint, ill. on p. 105); Goncourt, 1880, p. 109; Goncourt, 1881, p. 59 (ed. not dated, I, p. 55); Chennevières, 1888, p. 61; Normand, 1901, repr. in red-chalk style, between pp. 92 and 93; Dayot, 1907, p. 130 (ill.); Guiffrey, 1908, pp. 72-73, no. 95, pl. between pp. 66 and 67; Goncourt, 1909, p. 162; Guiffrey and Marcel, 1909, III, p. 59, no. 2219 (repr.); Furst, 1911, p. 135, pl. 43; Ridder, 1932, pl. 87; Mathey, 1933, p. 82; Pilon, 1941, p. 53 (ill.); Lavallée, 1948, p. 73, pl. 36; Jourdain, 1949, pl. 59; Boucher and Jaccottet, 1952, pl. 45 and p. 174; Bauer, 1962, p. 302; Garas, 1963, p. 25 (ill.); Mathey, 1964, pp. 18-20, 21, 27, and fig. 5; Vallery-Radot, 1965, p. 87 (ill.); Valcanover, 1966, fig. 2.

This sanguine drawing in a beautiful rosy red was etched by Jules de Goncourt in 1860 [see Burty, 1876]. For a long time it was accepted as the only drawing unquestionably done by Chardin. Chennevières, for instance, considered it in 1879 as the "only true drawing known to be an authentic Chardin." More recently, P. Lavallée saw in it the "masterpiece" drawn by Chardin. He discerned in it, like the Goncourts — who obtained this piece from a source unknown to us — "a boy standing in profile, leaning against a wall and getting ready to throw a ball."

However, the Louvre drawing presents a whole series of problems. Its subject is unclear, and the inscription on its lower left is accompanied by a date generally read as *1760* [sometimes as *1764;* cf. exh. cat., 1937]. The third numeral of this date is, in our view, impossible to read; it could just as easily be a *2* or a *3.*

This drawing bears little resemblance to the three in Stockholm. The model here is wearing a three-cornered hat, like the models in two of the Stockholm drawings and of certain *House of Cards* paintings, and his legs are crossed in a way that makes him seem even more unsteady than the models in the Stockholm drawings. However, the execution and technique are very different here. The artist seems to have been primarily concerned with rendering the mass and the outline of the boy. The model does indeed appear to be one of those Chardin was fond of depicting; his face is hidden and his hair is tied back. Therefore, the attribution of this drawing to Chardin seems to us to be based more on a general impression, a "climate," than on specific reasons. We have included it here primarily out of respect for the Goncourts and so that it can be compared with the few rare and indisputable drawings by Chardin.

Biography

Before recounting the life of Jean Siméon Chardin, I would like to comment on the methodology used in preparing this biography. I have drawn heavily on several previous accounts of the life of Chardin: in the eighteenth century, the biographies or eulogies by Mariette, Cochin *fils,* Haillet de Couronne, and A. Renou (1780); in the nineteenth century, those by P. Hédouin, the Goncourts, J. Guiffrey, and A. Jal; and more recently, the indispensable biographies by Pascal and Gaucheron (1931) and G. Wildenstein (1933), as well as the Wildenstein article of 1959.

I initially attempted to return to primary sources, making use of original archival documents (cited here without modernized spelling). However, this was not always possible, since most of the original public records pertaining to Chardin were destroyed in the 1871 fire of the Hôtel de Ville in Paris, during the Commune. We are acquainted with them only through publications by Jules and Edmond de Goncourt in 1863 to 1864. In the case of other missing or transferred archival documents, we have had to rely on "second-hand" records published by Ph. de Chennevières, the Goncourts, J. Guiffrey, M. Furcy-Raynaud, and others in the latter part of the nineteenth or beginning of the twentieth century.

I have not included events which were of only indirect significance to the artist and his family, nor those events which concerned only Chardin's painting—such as reviews of the Salons in which he regularly exhibited his pictures. I have, however, included titles of Chardin's works exhibited at the Salons, as well as titles of dated works appearing in this exhibition [cited with the catalog number in parentheses rather than in brackets, as in other parts of this catalog] or those known to us through old documents or photographs. Mention of these works is not intended to constitute a complete account of all of Chardin's oeuvre.

I thought it important to include the various payments of royal pensions to the artist and the accounts for which Chardin was responsible as Treasurer of the Royal Academy of Paintings and Sculpture. Also, in connection with the Academy, I had intended to provide maximum information from the long and detailed record of Chardin's attendance at the Academy, drawn from the Procès-Verbaux [minutes]; however, the quantity of material was so enormous that it could not be done.

Abbreviated reference sources are A.N. (for Archives Nationales), M.C. (for Minutier Central), and P. V. (for Procès-Verbaux).

I sincerely thank Mme Nicole Munich, who searched long and patiently in archives to provide material for this biography; I have made full use of her material. In addition, the recent research (1975) of Mlle Geneviève Génisson, the unpublished communications of Mlle Mireille Rambaud, and the energetic help of Mlle Elisabeth Walter have been of inestimable value in compiling this biography.

—Sylvie Savina, Paris

Editor's note: Because the importance of this account of Chardin's life lies chiefly in the direct quotations from French archival documents, the biography has been left in the original French.

1699

2 novembre: **Naissance de Jean Siméon Chardin à Paris,** rue de Seine (voir ci-dessous). De son vivant, comme après sa mort, beaucoup d'auteurs ont pu donner à notre peintre les prénoms de Jean-Baptiste-Siméon. Il convient désormais de le prénommer Jean Siméon; voir 4 mars 1780.

3 novembre: Acte de naissance: «Paroisse de Saint Sulpice, 1699. Ledit jour troisième novembre, a été baptisé Jean Siméon, né le jour précédent, fils de Jean Chardin, maître menuisier, et de Jeanne-Françoise David, sa femme, demeurant rue de Seine, maison du sieur Jean Chardin; le parrain Siméon Simonet, aussi menuisier, la marraine, Anne Bourgine, femme de Jacques le Riche, menuisier, laquelle a déclaré ne sçavoir signer.» (Extrait des registres des baptêmes de l'église paroissiale de Saint-Sulpice de Paris. Archives de l'Hôtel de Ville, détruites le 24 mai 1871. Publié pour la première fois par Edmond et Jules de Goncourt, 1863, p. 516, note 1, où ils remercient M. Désauigers de ses recherches.)

Jean Chardin, menuisier du Roi et menuisier de Paris, était fils de Françoise Brossart et d'Étienne Chardin, menuisier (décédé avant 1678) et frère d'Étienne Chardin, également menuisier. Il avait épousé en premières noces, le 25 septembre 1678 (Archives nationales, Minutier central, Étude C, liasse 337), Agnès Dargonne, fille de Catherine Chaumont et de Claude Dargonne, maître parcheminier à Paris (est-ce le frère d'Agnès, Nicolas Dargonne qui épousera Marthe, la sœur de Jean Chardin?). Agnès Dargonne meurt le 17 octobre 1693 (Inventaire après décès du 14 août 1694, A.N., M.C., Étude CVI, liasse 101), laissant cinq enfants: Jean Chardin (né le 21 août 1679), Marie-Agnès (née le 14 septembre 1681), Pierre (1693 - avant 1706), Agnès Suzanne (née en 1690) et Marie Nicole (1692 - avant 1706).

Le 8 juin 1695 (A.N., M.C., Étude XXIX, liasse 262), Jean Chardin épouse en secondes noces Jeanne Françoise David, veuve avec un enfant de Jean Roussel, sergent à verge au Châtelet. C'était la fille de Nicole Cottin et de Noël David «maître paulmier raquetier» (fabricant de raquettes pour le jeu de paume), mariés le 1er novembre 1665 (A.N., M.C., Étude XVI, liasse 310). Le père de Noël David était marchand à Mouchy-le-Château en Picardie, et celui de Nicole Cottin, «maître paulmier raquetier» à Paris. Elle avait une sœur, mariée à Charles Hébert, et deux frères dont l'un était maître de musique ou joueur de basse de viole. La seconde femme de Chardin avait trois frères et sœurs: Jean François David, «maître paulmier raquetier»; Marie Louise l'aînée, qui épousera le 19 juin 1692 Jean Charles Hezette, tabletier (A.N., M.C., Étude XXIX, liasse 225); Marie Louise la cadette, qui épousera le 17 janvier 1694 François Charpentier, boulanger (A.N., M.C., Étude XXIX, liasse 259).

Jean Chardin († 1731) et Jeanne Françoise David († 1743) qui devaient avoir quatre enfants: Jean Siméon Chardin (1699-1779), Juste Chardin (1702-24 thermidor an II), Noël Sébastien (né le 11 septembre 1697 d'après Jal (1867); ceci nous paraît impossible puisque Noël Sébastien est encore mineur en 1731; on ne lui rendra ses comptes de tutelle qu'en 1739) et Marie Claude, (née en 1704).

1706

29 septembre: Jean Chardin rend leurs comptes de tutelle à ses enfants. A cette date, Pierre et Marie Nicole sont morts (A.N., M.C., Étude CXIX, liasse 99).

1720

20 avril: La sœur de Chardin, Marie Claude, épouse à Saint-Sulpice Claude Michel Bulté, marchand de soie, fils de Pierre Bulté, marchand joaillier.
Parmi les témoins figure le peintre Noël Nicolas Coypel. On apprend aussi que les parents de Chardin n'habitent plus rue de Seine, mais 21 rue du Four, au coin de la rue Princesse (Pascal et Gaucheron, 1931, p. 59).

1723

6 mai: **Premier contrat de mariage,** entre Jean Siméon Chardin et Marguerite Saintard, née en 1697, fille du *Sieur Simon Louis Saintard marchand bourgeois de Paris Dem[t] rue Ste Margueritte paroisse Saint Sulpice, et de Françoise Pantouflet sa femme.* Celle-ci, à cette date, n'est pas morte contrairement à ce que dit G. Wildenstein, 1959, p. 176, puisqu'elle signe au bas de ce contrat (A.N., M.C., Étude CVI, liasse 215).
La fiancée a une dot importante (3 000 livres d'argent comptant) et Chardin possède quelques meubles et 2 000 livres, sur lesquels il doit payer sa réception à la maîtrise de l'Académie de Saint-Luc. Les témoins des deux parties viennent de milieux différents. Pour Chardin, ce sont ses oncles et tantes, les David (paulmiers raquetiers), ses parents, les Chardin (menuisiers), ses frères et sœurs (Dargonne, Roussel...), son beau-frère Bulté, marchand de soie... La fiancée a pour témoins ses cousins, avocats au Parlement, Procureurs au Parlement et à la Cour (Jean David de Saintard, Louis Lemoyne, Relier), des amis (Joncquet, Tuillier, secrétaire du cardinal de Bussy, le baron de Bosserue, lieutenant-colonel d'infanterie).

1724

3 février: Jean Siméon Chardin reçoit ses lettres de maîtrise de l'Académie de Saint-Luc (date donnée dans son acte de renonciation à la maîtrise le 5 février 1729, voir ci-après).

1726

Date figurant sur la gravure (datant de 1743) de Pierre Louis Surugue fils (1716-1772) d'après le *Singe peintre* de Chardin.

1727

27 décembre: Contrat de mariage entre Louis Barère, maître peintre et Henriette Suzanne Silvestre, fille de Louis Silvestre, peintre ordinaire du Roi. Jean Siméon Chardin, maître peintre, ami, y assiste comme témoin (Rambaud, 1964, p. 201).

1728

27 mai: Chardin expose Place Dauphine: «une raie, un chat, des poissons» (n° 7) «et différents tableaux» (sans catalogue, cf. Dorbec, 1905 et Guiffrey, 1908).
25 septembre: **Réception de Jean Siméon Chardin à l'Académie royale de peinture et sculpture:** «Siméon Chardin, Peintre dans le talent des animaux et des fruits, a présenté plusieurs tableaux dans ce genre, desquels l'Académie a été si satisfaite qu'ayant pris de même les voix par les fèves, Elle a agréé sa présentation et l'a reçu en même tems en qualité d'Académicien, retenant deux de ces tableaux, auxquels il mètra des bordures, représentant l'un un Buffet et l'autre une Cuisine, pour son tableau de réception, et a modéré son présent pécuniaire à cent livres, et il a prêté le serment de même.» (P.V., V, 1883, p. 47-48).
30 octobre, 31 décembre: Chardin est présent à l'Académie (P.V., V, p. 49, 53).
1728: Tableaux datés: le *Buffet* (n° 14), *Deux lapins morts* (Karlsruhe), le *Larron de bonne fortune* (collection Edmond de Rothschild).

1729

5 février: Renonciation de Chardin à la maîtrise de l'Académie de Saint-Luc:
«Le Sieur Jean Siméon Chardin, maître peintre, sculpteur, graveur et enlumineur à Paris; et peintre de l'Académye Royalle, demeurant à Paris rue Princesse paroisse Saint Sulpice, lequel (...) a déclaré qu'il renonce à la maîtrise de Peintre Sculpteur graveur et enlumineur à Paris, (...) des lettres de maîtrise, qui lui cy ont esté données le troisième février mil sept cent vingt quatre...» (A.N., M.C., Étude XXVII, liasse 172).
27 août: Chardin est présent à l'Académie (P.V., V, 1883, p. 62).
5 décembre: «Troisième feste. Grand feu et illumination dans la cour des ministres à Versailles le 5 décembre 1729 à l'occasion de la naissance de M. le Dauphin.»
Participent à ce feu d'artifice, «la veuve Morel, artificière» qui reçoit 3 017 livres 14 sols, «le sieur Bonnart, peintre», qui reçoit «7 548 livres pour luy que pour tous les autres peintres qui ont travaillé tant à Paris qu'a Versailles pour la décoration du grand feu d'artifice et illumination qui ont été exécuté audit Versailles le 5 décembre 1729 à l'occasion de la naissance de Monseigneur le dauphin ainsy qu'il est cy après détaillé.
Deux cent cinquante livres dix sols au Sr Chardin autre peintre pour six journées à 8 h et vingt deux journées et demie à raison de 9 h par jour cy... 250 l. 10 s.» (A.N., O¹ 2858).
La participation de Chardin au décor de ce feu d'artifice, sur les dessins de J.A. Meissonnier (1675-1750), avait été signalée par Chennevières (1888, p. 57) et jamais mentionnée depuis.
1729: L'*Almanach Royal* donne pour la première fois l'adresse de Chardin parmi les membres de l'Académie: «Chardin, rue Princesse, chez M. Chardin, menuisier du Roi».

1730

15 février: Chardin reçoit six livres de Conrad Alexandre de Rothenbourg: «La somme de six livres pour les *fruits* fournis au S. *Chardin* Peintre qui a peint des dessus de porte de la salle à manger... 6 livres» (Registre: arrêté de comptes: Frédéric Rodolphe de Rottembourg et Pierre Lardeguive le notaire. Séquestre de la succession de Conrad Alexandre de Rottembourg le 28 février 1736. A.N., M.C., Étude XXIII, liasse 490; inédit).

1730

6 mai, 29 juillet: Chardin est présent à l'Académie (P.V., V, 1883, p. 72-75).
31 octobre: Chardin reçoit 360 livres «pour des *tableaux originaux* de *trois dessus de porte* du *salon* du

perron du premier appartement représentant de la *musique* et des *instruments* de 120 livres chaque... 360 livres » (Registre : arrêté de comptes : Frédéric Rodolphe de Rottembourg et Pierre Lardeguive le notaire. Séquestre de la succession de Conrad Alexandre de Rottembourg le 28 février 1736. A.N., M.C., Étude XXIII, liasse 490 ; inédit) (n°s 27, 28).

1730 : Tableaux datés : *Nature morte au gigot* (n° 34), *Nature morte au carré de viande* (n° 35), le *Chien barbet* (collection privée, New York).

1731

17 janvier : « Le Sieur Jean Simon Chardin et damoiselle Margueritte Saintard fille se sont desistez du contrat de mariage cy endroit et en ont consenty la nullité par acte passé par devant les Notaires soussignez ce jourd'huy dix sept janvier mil sept cent trente un. » Ce document figure en marge du contrat du 6 mai 1723.

26 janvier : **Deuxième contrat de mariage** entre Jean Siméon Chardin et Marguerite Saintard (A.N., M.C., Étude CXVII, liasse 377). La dot de la fiancée n'est plus que de 1 000 livres. Chardin apporte à la communauté 2 500 livres et du mobilier.

1er février : **Mariage de Jean Siméon Chardin avec Marguerite Saintard.** « Paroisse Saint Sulpice. Le 1er janvier 1731 a été célébré le mariage de Jean Siméon Chardin, peintre de l'Académie royale, âgé de trente et un ans, fils Jean Chardin, maître menuisier, et Jeanne Françoise David, présents et consentants, de cette paroisse depuis plusieurs années, y demeurant rue Princesse, avec Marguerite Saintar, âgée de vingt-deux ans, fille des défunts Simon-Louis Saintar, marchand, et de Françoise Pantouflet, assistée de Pierre Perant, marchand de son, demeurant rue de la Verrerie, paroisse de Saint-Mery, créé tuteur de l'épouse par acte passé devant M. le lieutenant civil en datte du vingt-sept novembre mil sept cent trente, y demeurant rue Férou, de droit de celle de Saint-Mery sans opposition, fiançailles faites hier présents et Pierre Naudin, arquebusier des menus plaisirs du roy, demeurant rue de la Pelleterie, paroisse Saint-Jacques-la-Boucherie, cousin de l'époux ; Juste Chardin, menuisier des Menus plaisirs du roy, rue Princesse, frère de l'époux ; Claude Saintar, bourgeois de Paris, demeurant rue Saint-Denis, paroisse de Saint-Jacques-la-Boucherie, oncle de l'épouse ; Pierre Saintar, négociant, demeurant rue Neuve et paroisse Saint-Mery, cousin de l'épouse, qui nous ont certifié le domicile des parties ci-dessus et leur liberté pour le présent mariage soussigné. » (Acte d'état civil ; disparu. Recopié par Edmond et Jules de Goncourt, 1864, p. 152, note 2, avec une erreur de date).

Entre 1723, date du premier contrat, et son mariage, il semble que la fiancée ait eu à subir des revers de fortune, dont nous ne savons pas les causes. On a souvent pensé à la banqueroute de Law, mais celle-ci se situe dix ans avant les événements nous concernant.

Charles Nicolas Cochin dans son *Essai sur la vie de Chardin* (1780) rapporte la rencontre des jeunes gens : « Vers ce temps-là », le temps de la *Raie*, donc 1728, « M. Chardin, ayant par hasard été conduit dans un petit bal d'honnête bourgeoisie, y fit la connaissance d'une demoiselle fort estimable à qui il s'attacha. Ils ne tardèrent pas à être accordés ; mais comme l'état de M. Chardin n'était pas encore bien consolidé, le mariage fut remis à autre temps, et par diverses circonstances a été retardé de plusieurs années. Dans cet intervalle les affaires du père de la demoiselle s'étant dérangées il se trouva qu'au lieu d'une fortune honnête, qu'elle avait été fondée à espérer, elle n'avait plus rien. M. Chardin se piqua

de constance et l'épousa malgré ce revers. Cependant, cette position, jointe à la délicatesse de la santé de son épouse, qui à quelques instants de là mourut de la poitrine, le tint longtemps dans une détresse qu'il sut cacher avec courage, mais qui le força à faire un usage peu satisfaisant de ses talents. »

2 avril : **Mort de Jean Chardin, père du peintre** (Génisson, 1975, p. 1).

26 avril, 31 juin : Chardin est présent à l'Académie (P.V., V, 1883, p. 88-89).

24 juillet : Partage de la succession de Jean Chardin (A.N., M.C., Étude CXVII, liasse 381). Cet acte nous apprend la situation des différents frères et sœurs.

De son premier mariage, restent en vie Marie Agnès, lingère, demeurant chez sa belle-mère Jeanne Françoise David (contrat d'apprentissage du 17 décembre 1696, A.N., M.C., Étude XVI, liasse 608) et Sœur Agnès Suzanne, demeurant à Crécy-en-Brie dans la Communauté des Filles Charitables. Des enfants du second mariage, sont majeurs Jean Siméon Chardin, peintre de l'Académie Royale de peinture et sculpture, Juste Chardin, maître menuisier à Paris, et Marie Claude Chardin *épouse séparée quant aux biens* du Sieur Claude Michel Bulté, marchand bourgeois de Paris (d'après Jal, C.M. Bulté était allé s'établir à Amsterdam où il mourut le 22 mars 1748). Jean Baptiste Bellanger, bourgeois de Paris est nommé tuteur de Noël Sébastien Chardin.

8 août : Chardin reçoit 300 livres de Conrad Alexandre de Rothenbourg : « Au S. *Chardin* Peintre de l'Académie Royale de Peinture la somme de trois sent livres suivant quittance sur *deux tableaux* représentant des arts posés sur les armoires de la bibliothèque de son excellence au premier appartement de son hotel... 300 » (Registre : arrêté de comptes : Frédéric Rodolphe de Rottembourg et Pierre Lardeguive le notaire. Séquestre de la succession de Conrad Alexandre de Rottembourg le 28 février 1736. A.N., M.C., Étude XXIII, liasse 490 ; inédit) (n°s 29 et 30).

18 novembre : **Baptême Jean Pierre Chardin, fils du peintre** et de Marguerite Saintard (Jal. 1867).

1731 : Travaux de restauration de la Galerie François Ier à Fontainebleau, sous la direction de J.B. Vanloo.
La participation de Chardin à ces travaux est attestée par des biographes anciens, tel son ami Cochin (en 1780) : M. *Jean Baptiste Vanloo fut chargé de restaurer une galerie du château de Fontainebleau. Il emmena avec lui quelques-uns des meilleurs élèves de l'Académie : M. Chardin fut du nombre.* Nous n'avons rien retrouvé concernant ce fait dans les cartons O¹ 1925^A-B (cote incomplète donnée par Herbet, 1937, p. 188-189, et Pressouyre, 1972, p. 33 et note 43, p. 43) aux Archives nationales. Et nos recherches dans les Comptes des Bâtiments du Roi sont restées vaines.

1731 : Tableaux datés : les *Attributs des Sciences* (n° 29), les *Attributs des Arts* (n° 30), *Nature morte à la raie et au panier d'oignons* (n° 36), le *Menu de maigre* (n° 37), le *Menu de gras* (n° 38). 173(1 ?) *Deux lapins, une perdrix brune avec gibecière et poire à poudre* (n° 25).

1732

5 janvier, 26 janvier : Chardin est présent à l'Académie (P.V., V, p. 98, 100).

12 juin : Chardin expose Place Dauphine : « On étoit dans l'habitude d'exposer tous les ans à l'occasion des processions de la Fête-Dieu dans la Place Dauphine, et à l'entrée de cette place, du côté du Pont Neuf quantité de tableaux de peintres anciens et modernes, qui attiraient beaucoup les specta-

teurs... Quelques jeunes peintres qui y ont exposé cette année plusieurs de leurs tableaux qu'on a vus avec beaucoup de plaisir, principalement ceux du Sr Chardin, de l'Académie Royale qui sont peints avec un soin et une vérité à ne rien laisser désirer. Deux de ces tableaux, qui ont été faits pour le comte de Rottembourg, ambassadeur de France à la cour de Madrid, représentent différents animaux, des instruments et trophées de musique » (n°s 27 et 28) « et plusieurs autres petits tableaux d'ustensiles... Mais ce qui lui a fait le plus d'honneur, c'est un bas-relief peint d'après un bas-relief de bronze de François Flamand » (n° 33). (Mercure de France, juillet 1732, p. 1612.)

30 août : Chardin est présent à l'Académie (P.V., V, 1883, p. 108).

1732 : Tableaux datés : *Nature morte avec un quartier de côtelettes* (n° 39), *Nature morte à la raie et au panier d'oignons* (collection Jules Strauss. Passé en vente chez Parke Bernett, 14 mars 1951, n° 58. (1732 ?) *Vanneau huppé, perdrix rouge et bigarade* (n° 26).

1733

5 janvier : Jeanne Françoise David, veuve de Jean Chardin, se désiste du bail d'une boutique et d'une pièce (à l'angle de la rue du Four et de la rue Princesse) qui avait été consenti à Claude Pousse, maître tapissier, le 14 mars 1731. Les mêmes locaux sont loués à Jean Coignard marchand mercier, pour 450 livres par an (A.N., M.C., Étude XCI, liasse 739).

10 janvier, 31 janvier, 25 avril, 30 mai, 4 juillet : Chardin est présent à l'Académie (P.V., V, 1883, p. 113, 114, 119, 121, 123).

3 août : **Baptême de Marguerite Agnès, fille du peintre** (Jal, 1867) ; d'après Pascal et Gaucheron, 1931, p. 62, « l'enfant meurt en bas âge en 1735 ».

31 décembre : Chardin est présent à l'Académie (P.V., V, 1883, p. 134).

1733 : Tableaux datés : « *Une femme occupée à cacheter une lettre* » (n° 54). 173(3 plutôt que 5) « *Une femme tirant de l'eau à une fontaine* » (n° 55).

1734

9 janvier : Chardin est présent à l'Académie (P.V., V, 1833, p. 136).

24 juin : Chardin expose Place Dauphine : « On en voyait seize du sieur Chardin ; le plus grand représente une jeune personne qui attend avec impatience qu'on lui donne de la lumière pour cacheter une lettre. Les figures sont grandes comme nature » (n° 54). « Les autres tableaux du même auteur sont des jeux d'enfants fort bien caractérisés, des trophées de musique, des animaux morts et vivants, et autres sujets dans le goût de Téniers où l'on trouve une grande vérité. » (Mercure de France, juin 1734, p. 1405.)

26 juin : Chardin est présent à l'Académie (P.V., V, 1883, p. 141).

3 août : Testament de Jeanne Françoise David, mère de Chardin (A.N., M.C., Étude CXVII, liasse 398).

28 août, 2 octobre : Chardin est présent à l'Académie (P.V., V., 1883, p. 144, 146).

30 octobre : Chardin est présent à l'Académie : « La Compagnie aïant apris que M. Hallé est indisposé, elle a nommé Mrs Coustou et Christophe pour l'aller visiter de sa part ; Mrs Bousseau et Dumont iront de même chez M. Coypel qui est malade, et Mrs Chardin et Drouais visiteront pareillement M. Geuslain, qui est dangereusement malade » (P.V., V, 1883, p. 146).

27 novembre : Chardin est présent à la réception à l'Académie de son ami Aved (1702-1766) (P.V., V, 1883, p. 148).

4 décembre : Date figurant près de la signature du *Souffleur* (n° 62), portrait par Chardin de son ami Aved.

31 décembre : Dans le « compte de la dépense générale de la maison de son Exc. » (le comte Conrad Alexandre de Rothenbourg) « faite par le sieur Petit » (son secrétaire) « pendant l'année entière 1734 », on trouve à ce jour la mention suivante : « Au S. Chardin le prix de 6 tableaux de ses œuvres, 4 petits et 2 grands » (n°ˢ 27 à 34 et 62) « livrés à son Exc. 480 l. » (A.N., M.C., Étude XXIII, liasse 490 ; inédit). Ce même jour, Chardin est présent à l'Académie (P.V., V, 1883, p. 150).

1734 : D'après Jal (1867), Juste Chardin, frère du peintre, avait épousé « Marie Geneviève Barbier, qui de 1734 à 1749 lui donna neuf enfants, dont six filles et trois garçons ».

1734 : Tableaux datés : *Portrait du peintre Joseph Aved* (n° 62), *Table de cuisine* (collection Wanås, Suède).

1735

8 janvier, 26 mars : Chardin est présent à l'Académie (P.V., V, 1883, p. 152, 157).

13 avril : **Mort de Marguerite Saintard** (d'après l'inventaire après décès du 18 novembre 1737, et non 14 avril 1735, d'après Jal, 1867).

15 avril : Convoi et enterrement de Marguerite Saintard, femme de Jean Siméon Chardin.

« Le quinze avril 1735 a été fait le convoi et enterrement de Marguerite Sainctard, femme de Jean-Siméon Chardin, peintre ordinaire du roy, morte hier en sa maison, rue Princesse, âgée d'environ vingt-six ans, et y ont assisté Claude Sainctard, oncle, Justin Chardin, beau-frère, Noël Sébastien Chardin, aussi beau-frère de la ditte défunte, qui ont signé. » (Archives de l'Hôtel de Ville, détruites le 24 mai 1871. Publiées par Edmond et Jules de Goncourt, 1864, p. 153, note 2).

Les frères Goncourt ont-ils fait une erreur en recopiant cet acte ? Marguerite Saintard serait née en 1709, fiancée en 1723 à l'âge de 14 ans, et mariée à 22 ans en 1731. Jal est-il plus crédible en la disant morte à l'âge de 38 ans, donc née en 1697 ?

30 avril, 25 juin : Chardin est présent à l'Académie (P.V., V, 1883, p. 158, 160).

2 juillet : Chardin est présent à l'Académie (P.V., V, 1883, p. 160).

Le *Mercure de France* de juin 1735 (p. 1383-1386) nous apprend qu'en vue d'une élection d'officiers à l'Académie, les prétendants apporteraient des ouvrages *faits ou finis dans la présente année.* Chardin postulait donc au poste d'officier puisqu'il *exposa quatre petits morceaux excellents représentant de petites femmes occupées dans leur ménage et un jeune garçon s'amusant avec des cartes* (n°ˢ 55, 56 et cf. aussi n° 65).

30 juillet, 20 août, 27 août : Chardin est présent à l'Académie (P.V., V, 1883, p. 162-164).

3 octobre : Chardin reprend « *le philosophe* » (n° 62), à la succession de Conrad Alexandre de Rothenbourg, qui ne lui avait sans doute jamais été payé : « En présence des notaires au chatelet de Paris soussigné *S. Jean Siméon Chardin* peintre du Roy demeurant à Paris rue du Four quartier St. Germain paroisse St. Sulpice a reconnu avoir reçu de la succession de Messire Conrad Alexandre Comte de Rottembourg par les mains de M. Lardeguive ledit notaire à ce reçu qui en déduction des sommes à luy déposées appartenant à ladite succession en la présence du consentement et à la réquisition de sieur Mathieu François Petit secrétaire des commande-

ments de son altesse sérinissime Monseigneur le Comte de Rottembourg demeurant à Paris... héritier général et spécial du défunt comte de Rottembourg... a payé au dit *Chardin* en louis d'or et louis d'argent et monnoie ayant cours compté et réellement délivré à la vue des notaires soussignés la somme de *deux cent livres* à laquelle il a été convenu avec ledit Chardin par l'indemnité d'un tableau représentant une philosophe qui luy avait esté commandé pour le feu Sr. comte de Rottembourg et qui a esté rendu audit *Chardin* ainsi qu'il le reconnaît pour en disposer ainsi qu'il le jugera à propos de laquelle somme de deux cent livres ledit Chardin quitte et décharge la succession... » (A.N., M.C., Étude XXIII, liasse 488 ; inédit).

29 octobre, 31 décembre : Chardin est présent à l'Académie (P.V., V, 1883, p. 166, 168).

173(5?) : Tableaux datés : *« Une dame qui prend du thé »* (n° 64).

1736

28 avril, 30 juin, 28 juillet, 23 août, 28 septembre : Chardin est présent à l'Académie (P.V., V, 1883, p. 177, 178, 180, 181, 183).

1736/1737 : Décès de Marguerite Agnès, fille de Chardin (mentionné dans l'inventaire après décès de sa mère, 18 novembre 1737).

1736 : Tableaux datés : *Lapin avec gibecière et poire à poudre* (collection privée, New York).

1737

4 mai, 6 juillet, 3 août : Chardin est présent à l'Académie (P.V., V, 1883, p. 203, 210, 211).

18 août-5 septembre : Chardin expose au Salon du Louvre, qui ouvre ses portes après plusieurs années d'interruption : « une *fille tirant de l'eau à une fontaine* » (n° 55) ; « une *petite femme s'occupant à savonner* » (n° 56) ; « un *jeune homme s'amusant avec des cartes* » (n° 73) ; « un *chimiste dans son laboratoire* » (n° 62) ; « un *petit enfant avec les attributs de l'enfance ; une petite fille assise, s'amusant avec son déjeuner ; une petite fille jouant au volant* » (n° 72).

14 septembre : Chardin est présent à l'Académie ((P.V., V, 1883, p. 215).

14 novembre : Chardin est reconnu tuteur de son fils, *Jean-Pierre Chardin âgé de six ans ou environ fils unique de Jean Siméon Chardin peintre du roy, ... et de la défunte damoiselle Marguerite Saintard son épouse.* Claude Saintard, oncle maternel est le subrogé-tuteur. (Renseignement fourni par l'inventaire après décès de Marguerite Saintard du 18 novembre 1737.)

18 novembre : **Inventaire après décès de Marguerite Saintard, épouse Chardin** (A.N., M.C., Étude CXVII, liasse 417, publié intégralement par Pascal et Gaucheron, 1931, p. 62-70). Cet inventaire dressé par Aved, clos le 2 décembre 1737, est une des pièces d'archives les plus intéressantes parmi celles qui jalonnent la vie de Chardin. L'énumération du mobilier permet de reconnaître les objets usuels et les meubles que l'on retrouve dans les tableaux de Chardin, tels la fontaine de cuivre avec son *robinet de potin*, le gril, l'écumoire, etc., ainsi que la table en cabaret ou la tabagie de palissandre. L'inventaire décrit le contenu de quatre pièces, une cuisine au troisième étage avec un atelier sur le même palier donnant sur le Four, puis un cabinet de plain-pied ayant vue sur la rue du Four et une chambre à coucher sur la rue Princesse.

23 novembre : Chardin est présent à l'Académie (P.V., V, 1883, p. 219-220).

1737 : Tableaux datés : le *Jeune dessinateur* (n° 76), le *Jeune dessinateur* (n° 77), le *Château de cartes* (d'après

une composition de Chardin, collection Henry de Rothschild). 173(7?) la *Fillette au volant* (n° 72), *Nature morte à la raie...* (vente, 14 mai 1912, n° 143).

1738

Mai : Le *Mercure de France* (p. 955) annonce la première gravure d'après un tableau de Chardin, *Dame cachetant la lettre* par Étienne Fessard (1714-1777) (n° 54).

21 juin : Chardin est présent à l'Académie (P.V., V, 1883, p. 232).

Juillet : Le *Mercure de France* (p. 1603) annonce la mise en vente du *Jeune soldat* et de la *Petite fille aux cerises* gravée par Cochin père (1688-1754) d'après les tableaux de Chardin du Salon de 1737. Nous ferons attention à de pas confondre Cochin père, graveur, avec Cochin fils (1715-1790), secrétaire de l'Académie et biographe de Chardin.

18 août-19 septembre : Chardin expose au Salon du Louvre : « n° 19 : un petit tableau représentant un *Garçon cabaretier qui nettoye son broc* » (cf. n° 79) ; « n° 21 : un tableau représentant une *Jeune ouvrière en tapisserie* » ; « n° 23 : un tableau représentant une *Récureuse* » (cf. n° 79) ; « n° 26 : un tableau représentant une *Jeune ouvrière en tapisserie, qui choisit de la laine dans son panier* » (n° 68) ; « n° 27 : son pendant, un *Jeune écolier qui dessine* » (n° 69) ; « n° 34 : un tableau de quatre pieds au carré, représentant une *Femme occupée à cacheter une lettre* » (n° 54) ; « n° 116 : un petit tableau représentant le *Portrait du fils de M. Godefroy, joaillier, appliqué à voir tourner un toton* » (n° 75) ; « n° 117 : autre représentant un *Jeune dessinateur taillant son crayon* » (n° 76) ; « n° 149 : *le portrait d'une petite fille de M. Mahon, marchand, s'amusant avec sa poupée.* »

1738 : Vente Andrew Hay à Londres. C'est, à notre connaissance, la première vente publique où figure un Chardin (*A girl with cherries*, petite fille aux cerises).

1738 : Tableaux datés : l'*Écureuse* (n° 79), la *Pourvoyeuse* (n° 80), la *Gouvernante* (n° 83), l'*Écureuse* (collection Henry de Rothschild ; détruit), la *Ratisseuse* (Washington), le *Garçon cabaretier* (ancienne collection Marcille), la *Pourvoyeuse* (Ottawa).

1739

5 février : Jeanne Françoise David, veuve de Jean Chardin, rend ses comptes de tutelle à Noël Sébastien Chardin, frère cadet du peintre (Pascal et Gaucheron, 1931, p. 72).

2 mars : L'Assemblée de l'Académie se réunit comme à l'ordinaire : « Il a été résolu que, le samedi 21, Mrs les Directeurs, Recteurs, Adjoints à Recteur, Professeur en exercice et, à tour de rôle, dans les anciens Professeurs M. Coypel, dans les Professeurs M. Dumont le Romain, dans les Adjoints M. Adam, dans les Conseillers Mrs Duchange et Parrocel, dans les Académiciens Mr Chardin et le Secrétaire, s'assembleront à huit heures précises du matin, pour régler la répartition de la capitation de la présente année 1739 et examiner et arrêter les comptes de 1738. » (P.V., V, 1883, p. 248).

21 mars : Chardin est présent à l'Académie (P.V., V, 1883, p. 250).

Juin : Le *Mercure de France* (p. 1367) annonce la mise en vente de deux estampes d'après Chardin, la *Fontaine* (cf. n° 55) et la *Blanchisseuse* (cf. n° 56), gravées par C. N. Cochin.

27 juin : A l'Assemblée de l'Académie, « M. Cochin a présenté... huit épreuves de quatre planches qu'il a gravées d'après M. Chardin, Académicien, dont deux ont pour titre la *Blanchisseuse*, et la *Fontaine*, et les deux autres représentent des enfants. La Com-

pagnie, après les avoir examinées, les a jugé dignes de paroître au jour sous sa protection, pour faire jouir l'exposant des privilèges accordés à l'Académie, par l'Arrest du Conseil d'État du 28 juin 1714» (P.V., V, 1883, p. 253).

4 juillet: Chardin est présent à l'Académie (P.V., V, 1883, p. 255).

19 août: Pierre Jean Chardin, fils du peintre, âgé de huit ans, est parrain à Saint-Sulpice d'un de ses cousins germains, Jean Juste Chardin, fils de Juste Chardin et de Geneviève Barbiez (Jal, 1867).

6 septembre-30 septembre: Chardin expose au Salon du Louvre: «un petit tableau représentant une *Dame qui prend du thé*» (n° 64); «un petit tableau représentant *l'Amusement frivole d'un jeune homme faisant des bouteilles de savon*» (cf. n° 59); «un petit tableau en hauteur représentant la *Gouvernante*» (n° 83); «autre, représentant la *Pourvoyeuse*» (cf. n° 80); «autre, représentant des *Tours de cartes; la Ratisseuse de navets*» (cf. n° 82).

19 septembre: Chardin est présent à l'Académie (P.V., V, 1883, p. 259).

Décembre: Le *Mercure de France* (p. 2883) annonce la mise en vente de trois estampes: les *Bulles de savon* exposé au Salon de 1739, la *Joueuse d'osselets* par Filloeul, et la *Gouvernante* par Lépicié (exposé au même Salon), n°s 59, 60, 83.

1739: Tableaux datés: la *Pourvoyeuse* (n° 81), *Nature morte au carré de viande* (Oberlin).

1739 ou 1741

Inventaire de l'hôtel, quai des Théatins, de Carl Gustaf Tessin (1695-1770), ambassadeur en France de la future reine de Suède, Louise Ulrique, de 1739 à 1741.
Y figurent deux gravures d'après la *Gouvernante*, dans deux pièces différentes, une gravure d'après Chardin dont le sujet n'est pas mentionné, et un *Lapin*, tableau dont l'estimation correspond à peu près à celle d'un tableau de Desportes, mais représente le quart du prix d'un Vanloo ou d'un Boucher. (Carl-Gustav Tessins Generalinventarium. Riksarkivet. Stockholm, E 5757).

1740

30 janvier: Assemblée de l'Académie: «Le Secrétaire a présenté à la Compagnie deux épreuves d'une planche qu'il a gravée d'après un tableau de M. Chardin, Académicien, aïant pour titre la *Gouvernante*. La Compagnie, après l'avoir examiné, l'a approuvée pour faire jouir l'exposant des privilèges accordés à l'Académie par l'Arrest du Conseil d'État du 28 juin 1714.» (P.V., V, 1883, p. 267.)
A cette date, le Secrétaire de l'Académie est F.B. Lépicié (1698-1755), graveur de Chardin, qui exerce cette fonction depuis le 16 avril 1737, et l'occupera jusqu'à sa mort. Il ne faut pas le confondre avec son fils Nicolas-Bernard Lépicié (1735-1784), peintre d'histoire et de genre.

12 février: Lettre de Tessin à Carle Harlemann: «De vous dire mes autres follies iroit à l'infini. Telles sont: une Tabatière peinte par Massé avec le portrait de la petite Charlotte. Un autre portrait d'Oudry du gros Pähr. Un tableau de Boucher. *Un autre de Chardin*. Un dito de Charles Van Loo. Plusieurs dessins de Bouchardon et de Lancret. Tirons le rideau sur le reste, je vois déjà que vous me regardez en pitié.» (Archives du château d'Ericsberg, Suède; cf. Wildenstein, 1933, p. 69-70).

22 août-15 septembre: Chardin expose au Salon: «n° 58: un tableau représentant le *Singe qui peint*» (cf. n° 66); «n° 59: autre le *Singe de la philosophie*» (cf.

n° 67) (en marge de l'exemplaire du livret de ce Salon dans la collection Deloynes au Cabinet des Estampes de la Bibliothèque nationale, une note manuscrite indique *ou plutôt le singe médailliste et antiquaire*); «n° 60: autre la *Mère laborieuse*» (n° 84); «n° 61: autre le *Bénédicité*» (n° 86); «n° 62: autre la *Petite maîtresse d'école*» (n° 70).

A ce même Salon, sont exposées deux estampes d'après Chardin, exécutées par C.N. Cochin: le *Garçon cabaretier* qui avait été exposé au Salon de 1738, sous le n° 19, et l'*Écureuse* (cf. n° 79), son pendant, exposé au Salon la même année sous le n° 23.

3 septembre, 29 octobre: Chardin est présent à l'Académie (P.V., V, 1883, p. 280-281, 283).

Dimanche 27 novembre: Le *Mercure de France* (p. 2513) relate la **présentation de Chardin au Roi** par M.P. Orry (1689-1747), surintendant des Bâtiments: «Le dimanche 27 novembre 1740, M. Chardin de l'Académie royale de peinture et sculpture, fut présenté au roi par M. le contrôleur général avec deux tableaux de sa composition que Sa Majesté reçut très favorablement; ces deux morceaux sont déjà connus, ayant été exposés au Salon du Louvre au mois d'août dernier. Nous en avons parlé, dans le Mercure d'octobre, sous le titre: la *Mère laborieuse* et le *Bénédicité*» (n°s 84, 86).

Décembre: Le *Mercure de France* (p. 2709-2710) annonce la mise en vente de la gravure de Lépicié d'après la *Mère laborieuse*, le *Bénédicité* devant être gravé un peu plus tard (cf. décembre 1744). A cette occasion le *Mercure* publie les vers d'un professeur au collège Du Plessis (c'est-à-dire Louis le Grand), *à M. Chardin, peintre de l'Académie Royale de Peinture sur les deux tableaux qu'il a faits pour le Roi* (n°s 84, 86).

1740: J. Faber (1684-1756), graveur anglais, publie à Londres une estampe «à la manière noire» du *Jeune Dessinateur taillant son crayon*, exposé au Salon de 1738 sous le numéro 117 (n° 76).

1741

7 janvier: Chardin est présent à l'Assemblée de l'Académie et Lépicié présente à la Compagnie sa planche d'après la *Mère laborieuse*, annoncée dans le *Mercure de France* de décembre 1740: «Le Secrétaire a présenté à la Compagnie deux épreuves d'une planche qu'il a gravée d'après M. Chardin, aïant pour titre la *Mère laborieuse*; l'examen fait, l'Académie a aprouvé ladite planche, pour faire jouir l'exposant des privilèges accordez à l'Académie par l'Arrest du Conseil d'État du 28 juin 1714» (P.V., V, 1883, p. 290).

28 janvier: Chardin est présent à l'Académie (P.V., V, 1883, p. 292).

1er-23 septembre: Chardin expose au Salon du Louvre: «n° 71: un tableau représentant le *Négligé ou la Toilette du matin* appartenant à M. le Comte de Tessin» (n° 88); «n° 72: autre, représentant *Le fils de M. Lenoir s'amusant à faire un château de cartes*» (n° 71).

Décembre: Le *Mercure de France* (p. 2697) annonce la mise en vente de l'estampe de Le Bas (1707-1783) d'après la *Toilette du Matin*, exposé au Salon de septembre sous le n° 71 (n° 88):
«Le Négligé ou Toilette du matin, estampe en hauteur, gravée par M. Le Bas, chés lequel elle se vend, rue de La Harpe, d'après le tableau original de M. Chardin, exposé dans le dernier Salon, lequel tableau a été généralement applaudi. On en peut voir la description dans le Mercure d'Octobre, à l'article du Salon du Louvre. L'intelligent graveur est parfaitement entré dans l'esprit du sujet qui y est traité, et le débit rapide de cette estampe prouve bien qu'elle est du gré du public. Pour l'intelligence des vers de M. Pesselier, qu'on lit au bas de cette es-

tampe, il faut remarquer que le principal personnage est une mère attentive qui raccommode la cornette de sa fille, tandis que la jeune personne observe dans le miroir les soins que prend sa mère pour l'embellir.»

Comme pour la gravure de la *Mère laborieuse* en décembre 1740, le *Mercure* publie à la suite de l'annonce un poème dédié à Chardin, par Pesselier.

Décembre: Visite de l'atelier de Chardin par Mehemet Effendi:
Mehemet Effendi, nommé aussi Saïd Pacha, Berglierbey de Roumely, ambassadeur extraordinaire du Sultan, arriva à Paris en 1741. La *lettre au Sujet du portrait de S. Exc. Saïd Pacha*, 1742 (Bibliothèque nationale, Cabinet des Estampes, fonds Deloynes, t. 47, n° 1219, p. 13) relate sa visite chez Massé et aussi à l'atelier de Chardin: «M. l'Ambassadeur s'est aussi transporté chez M. Chardin, connu par cette admirable simplicité qui le rend si fidèle Imitateur de la Nature, et qui fera dire un jour, qu'il était dans son art, ce que notre incomparable La Fontaine était dans le sien, c'est-à-dire inimitable. Ne penserez-vous pas avec moi, Monsieur, qu'en voyant ces chefs d'œuvres reconnus pour tels, S. E. aura senti tout le prix de ce simple et de ce vrai si rares, si difficiles à saisir dans un siècle où l'art en tout genre est si voisin de la manière et de l'affectation.»

1741: Tableaux datés: l'*Enfant au toton* (São Paulo).

1742

5 janvier: Chardin, malade, n'est pas présent à l'Académie:
«L'Académie a nommé M. Cochin et M. Jouvenet pour aller visiter M. Chardin, qui est malade.»
A. de Montaiglon met en note que Surugue y alla à la place de Jouvenet, un des fils ou neveux du grand Jouvenet mort en 1717 (P.V., V, 1883, p. 312).

8-9 janvier: Tessin dans une lettre adressée à son épouse, conservée à Stockholm (Riksarkivet), parle des vers de Pesselier pour son tableau, la *Toilette du matin:* «Quelle folie a moy d'y joindre d'autres [vers] tirés du Mercure du mois passé et que Pesselier (auteur de la jolie comédie d'Ésope au Parnasse) a composé sur mon tableau de Chardin. C'est une vanité que je me donne, et qui n'est bonne qu'avec vous.»

30 juin: Chardin est de nouveau présent à l'Académie: «Mr Coustou a remercié la Compagnie de la visite qu'Elle lui a fait faire au sujet de sa maladie; M. de Tournierre et M. Chardin en ont fait de même» (P.V., V, 1883, p. 322).

7 juillet: Chardin est présent à l'Académie (P.V., V, 1883, p. 324).

25 août-21 septembre: Chardin n'expose pas au Salon du Louvre. Il est probable que ce soit à cause de sa maladie qui dura de janvier (le 5 janvier, malade, il est absent de l'Académie) à juin.

Novembre: Le *Mercure de France* (p. 2506) annonce la vente de deux estampes d'après Chardin: la *Pourvoyeuse* (cf. n° 80) et l'*Enfant au toton* (n° 75).

1742: Lépicié grave la *Fillette au volant* (n° 72).

1743

Janvier: Le *Mercure de France* (p. 149) annonce la mise en vente de l'estampe de Lépicié d'après la *Ratisseuse* de Chardin, exposé au Salon de 1739 (cf. n° 82).

Le même mois, deux estampes en couleur par Jacques Fabien Gautier D'Agoty (1716-1785) représentant l'*Ouvrière en tapisserie* (n° 68) et le *Jeune dessi-*

nateur (n° 69), d'après les deux tableaux exposés au Salon de 1738, sont annoncés p. 149 du *Mercure*.

19 avril: Dans l'inventaire après décès du graveur Antoine Aveline (1691-1743) on trouve deux estampes d'après Chardin, dont les sujets ne sont pas décrits (Rambaud, 1971, p. 197 et 914).

4 mai, 25 mai, 8 juin, 28 juin, 6 juillet: Chardin est présent à l'Académie (P.V., V, 1883, p. 343-346).

5 août-25 août: Chardin expose au Salon du Louvre: «n° 57: un tableau représentant le *Portrait de Madame Le...* tenant une brochure; n° 58: autre petit tableau représentant *des enfants qui s'amusent au jeu de l'oie;* n° 59: autre faisant pendant, où sont aussi *des enfants qui font des tours de cartes.*»

Au même Salon, le graveur P.L. Surugue (1710-1772) expose trois estampes d'après Chardin: l'*Antiquaire* (cf. n° 67), le *Peintre* (cf. n° 66) et l'*Inclination de l'âge* (le *Portrait d'une petite fille de M. Mahon, marchand, s'amusant avec sa poupée*), d'après le tableau disparu exposé au Salon de 1738, sous le n° 149.

6-8 août: Inventaire après décès du sculpteur Robert Le Lorrain (1666-1743; Archives de Mᵉ Vienot; M.E. Sainte-Beuve, 1929): on y trouve deux Chardin: «Item, deux petits tableaux peints sur toile par Chardin, dans leur bordure de bois doré, prisé trente deux livres.»

28 septembre: **Chardin est élu Conseiller à l'Académie:**

«Aujourd'hui, samedi 28ᵉ Septembre, l'Académie s'est assemblée, par convocation générale, pour la lecture des délibérations du quartier et pour remplir les places de Professeur et de Conseiller, vacantes par la démission volontaire de M. De Troy et par la mort de M. Lancret, mort le 14 septembre, à deux heures après minuit, âgé d'environ 52 ans. (...) M. de La Datte, Académicien, a remplacé M. Oudry dans le grade d'Adjoint à Professeur, et M. Chardin, aussi Académicien, a monté au rang de Conseiller.» (P.V., V, 1883, p. 351.)

Dans un livret sur l'*Académie Royale de Peinture et de Sculpture*, paru chez Collombat en 1751, page 16, l'auteur note:

1743. M. CHARDIN, P. au bout de la rüe Princesse, à gauche en entrant par la rue du Four, fauxbourg S. Germain. Académicien en 1728.

Septembre: Le *Mercure de France* (p. 2061) annonce la mise en vente de l'estampe de Lépicié d'après le *Château de cartes* de Chardin (n° 71).

26 octobre: Chardin est présent à l'Académie: «L'Académie a nommé Mrs Duchange et Chardin, Conseillers, pour aller visiter de sa part M. Gobert, qui est malade.» (P.V., V, 1883, p. 353.)

7 novembre: **Décès de Jeanne Françoise David, mère de Chardin,** douze ans après son époux (date donnée par l'acte de partage de sa succession; cf. ici 14 juillet 1744).

12 novembre: «Inventaire des meubles, effets, titres et papiers de Jeanne Françoise David», mère du peintre. D'après cet inventaire, les meubles furent vendus, sauf les effets qui revinrent à sa fille Marie Claude Chardin, épouse séparée de M. Bulté. (Renseignements donnés par l'acte de partage de sa succession; cf. ici 14 juillet 1744.)

29 novembre: Chardin est présent à l'Académie: «Mrs Duchange et Chardin, nommés, dans la délibération du 26 octobre dernier, pour aller visiter M. Gobert, ont rapporté à l'assemblée qu'ils l'avoient trouvé beaucoup mieux et fort sensible à l'attention de la Compagnie.» (P.V., V, 1883, p. 356.)

31 décembre: Chardin est présent à l'Académie (P.V., V, 1883, p. 358.)

1744

31 janvier, 29 février, 28 mars: Chardin est présent à l'Académie (P.V., V, 1883, p. 360-365).

Avril: Le *Mercure de France* (p. 780) annonce la mise en vente d'une gravure de Surugue d'après Chardin:

«*Les tours de cartes,* estampe gravée par P.L. Surugue le fils, d'après le tableau original de M. Chardin, conseiller de l'Académie royale de peinture, du cabinet de M. Despuechs. Elle se vend chez L. Surugue, graveur du Roi, rue des Noyers, vis-à-vis Saint-Yves.»

14 juillet: Partage de la succession de Jeanne Françoise David, mère de Chardin, décédée le 7 novembre 1743.

Au bas de toutes les pages de ce document sont apposées les initiales des quatre enfants Chardin: *J S C,* «Jean Siméon Chardin, peintre du Roy et conseiller de l'Académie royale de peinture, demeurant à Paris rue du Four», *J C,* «Juste Chardin, maître menuisier à Paris habitant au même endroit», *N C S,* «Noël Sébastien Chardin, bourgeois de Paris, demeurant rue des Arcis, paroisse Saint Merry» et *M C C,* Marie Claude Chardin.

Les trois frères se partagent la succession, c'est-à-dire le produit de la vente faite après l'inventaire des biens de la défunte le 12 novembre 1743. Marie-Claude Chardin, épouse Bulté, reçoit *habits, linges et hardes,* et quelque argent pour payer les frais causés par la maladie de sa mère et les messes basses ordonnées au prêtre de Saint-Sulpice.

Les deux filles du premier lit de son époux, Marie-Agnès, lingère, qui habitait chez sa belle-mère, et Sœur Agnès Suzanne reçoivent leur part du douaire qui avait été prévu depuis la mort de leur père pour Madame Chardin mère.

La part de J.S. Chardin est de 3 816 livres 6 sols 8 deniers, celle de Juste de 3 222 livres 10 sols et celle de Noël Sébastien, 4 710 livres (puisque, n'étant pas encore marié, il a moins besoin d'être doté). Ils ont quelques rentes en commun, tels que les profits de la maison de la rue du Four (A.N., M.C., Étude LXXXII, liasse 263).

30 juillet, 29 août: Chardin est présent à l'Académie (P.V., V, 1883, p. 368, 370-372).

1ᵉʳ novembre: **Contrat de mariage** entre Jean Siméon Chardin et dame Françoise Marguerite Pouget (A.N., M.C., Étude LXXXII, liasse 265). Il épouse, neuf ans après la mort de Marguerite Saintard sa première femme, Françoise Marguerite Pouget, *veuve sans enfants de Sr Charles de Malnoé, bourgeois de Paris et ancien mousquetaire du Roy.*

Françoise Marguerite Pouget née en 1707 (elle a 37 ans en 1744) vivait rue de la Verrerie, paroisse Saint-Méderic (A.N., Y 326 - fol. 227; non vérifié; cf. Pascal et Gaucheron, 1931, p. 77) lorsqu'elle épousa Charles de Malnoé, veuf de Marie de Laperlier, en 1729 (contrat de mariage du 24 août 1729; cf. Pascal et Gaucheron, 1931, p. 77). Sans enfants, elle devait hériter de tous les biens de son mari, en vertu de la donation au dernier vivant qu'ils s'étaient faite le 5 octobre 1729. La veuve jouissait d'un certain nombre de rentes, dont les rapports de l'immeuble où elle habitait, 13 rue Princesse.

A ce contrat, agréé par Messire Jérôme D'Argouge *chevalier seigneur de Fleury, conseiller du Roy,...* etc., sont témoins les deux frères de Chardin — Juste et Noël Sébastien — *et Jean-Jacques Lenoir négociant à Paris et dame Marie-Joseph Rigo son épouse, amis communs des parties.*

Rappelons que dès 1741, Chardin expose au Salon (n° 72) le *Portrait du fils de M. Lenoir s'amusant à faire un château de cartes* (n° 71). Et qu'en 1743, il expose sous le n° 57, un *Portrait de Mme Lenoir tenant une brochure* connu par la gravure de Surugue de 1747 sous le titre l'*Instant de la méditation,* avec la dédicace «Dédié à M. Lenoir par son très humble et très obéissant serviteur et amy, JBS Chardin».

23 novembre: Les bans sont publiés à Saint-Sulpice (date donnée par l'acte de mariage ci-dessous.)

25 novembre: Fiançailles de Chardin avec Françoise Marguerite Pouget (date donnée dans l'acte de mariage ci-dessous).

26 novembre: **Second mariage de Chardin:** «Paroisse Saint-Sulpice, 1744. Le jeudi vingt-six novembre a été célébré le mariage de Jean-Siméon Chardin, âgé de quarante-quatre ans, peintre du roy, veuf de Marguerite Saintar, avec Françoise-Marguerite Pouget, âgée de trente-sept ans, veufve de Charles de Malnoé. Les deux parties de cette paroisse y étant paroissiens et demeurants depuis plusieurs années, rue Princesse, un ban publié en cette église sans opposition, de deux bans obtenue de Mgr l'archevêque de Paris en date du vingt-trois du présent mois, insinué et controllé le même jour, fiançailles faites hier, présents et témoins Jean Daché, agent de change et banquier, rue et paroisse Saint Sauveur; Jean-Jacques Lenoir, négociant, bourgeois de Paris, rue Mauconseil, paroisse Saint-Eustache, amis de l'épouse; Juste Chardin, menuisier-ébéniste du roy, rue Princesse, frère de l'époux; Jacques-André-Joseph Aved, peintre du roy, conseiller en son Académie royale de peinture et sculpture, rue de Bourbon, amy de l'époux, qui nous ont tous certifié le domicile des parties ci-dessus, leur liberté pour le présent mariage, et ont signé.» (Archives de l'Hôtel de Ville, détruites le 24 mai 1871. Publié par J. et E. de Goncourt, 1864, p. 155-156, note 2.)

22 décembre: Chardin signe au bas du contrat de mariage du 1ᵉʳ novembre 1744 (A.N., M.C., Étude LXXXII, liasse 265) une reconnaissance des biens apportés par sa femme dans la communauté.

Décembre: Le *Mercure de France* (p. 137) annonce la mise en vente de l'estampe de Lépicié d'après le *Bénédicité* (n° 86), appartenant au Roi, qui avait été exposé au Salon de 1740 sous le n° 61, en pendant à la *Mère laborieuse* (n° 84).

1744: Tableaux datés: le *Bénédicité* (n° 89).

1745

Janvier: Le *Mercure de France* (p. 152) annonce la sortie de l'estampe de Lépicié d'après le *Souffleur,* tableau signé et daté du 4 décembre 1734 (n° 62), exposé au Salon de 1737.

27 février: Chardin est présent à l'Académie (P.V., V, 1888, p. 4).

Août: Chardin n'expose pas au Salon, mais les gravures de Lépicié d'après le *Souffleur* et le *Bénédicité* y figurent, ainsi que les *Tours de cartes* de Surugue d'après le tableau du Salon de 1739.

28 août: Chardin est présent à l'Académie (P.V., VI, 1885, p. 15).

6 octobre: Lettre de C. G. Tessin (1695-1770) adressée à Scheffer (1715-1786) de Stockholm: «... On [la princesse royale Louise Ulrique] désireroit aussi fort deux tableaux de Chardin, de la grandeur de celuy qu'il a fait pour moy et qui m'a couté 600. francs. On luy laisse le choix de sujets; mais comme il réusit parfaitement en gouvernantes et en enfants, on luy propose, l'Éducation douce et l'éducation sévère. A ajouter Deux cent livres pour les bordures.» (Correspondance (inédite) Scheffer-Tessin; communiqué par Jan Heidner.)

17/27 octobre: M. Berch, secrétaire d'ambassade sous le comte Tessin, écrit de Paris cette lettre maintes fois publiée (Chennevières, 1856; Dussieux, 1876, p. 595-596; Goncourt, 1864; Guiffrey, 1908; Pascal et Gaucheron, 1931; Wildenstein, 1933): «Monseigneur, l'affaire des tableaux rencontre un peu de difficultés du côté de M. Chardin, qui avoue naturellement qu'il ne pourroit pas donner les deux pièces que dans un an d'icy. Sa lenteur et la peine qu'il se donne doivent, dit-il, déjà être connus à V.E. Le prix de 25 louis d'or par tableau est modique pour

lui, qui a le malheur de travailler si lentement; mais en considération des bontés que V.E. a eues pour lui, il passera encore ce marché, et laissera à la volonté de cet ami de V.E., s'il veut y ajouter quelque chose quand l'entreprise sera achevée. De toute façon, V.E. a encore du temps pour se déterminer, si Elle veut qu'il travaille. Un tableau qu'il a chez lui l'occupera probablement encore un couple de mois. Jamais chez lui plus d'un entrepris à la fois. »

21 octobre : Naissance et baptême d'Angélique Françoise, fille de J.S. Chardin et F.M. Pouget (Jal, 1867). C'est la seule mention connue par nous d'un descendant de Chardin par son second mariage.

30 octobre : Chardin est présent à l'Académie (P.V., VI, 1885, p. 18).

8 novembre : Lettre de Tessin adressée à Scheffer : « Je ne sai, mon cher Baron, si vous n'avés pas reçu une lettre, par laquelle Madame Royale vous demandoit par moy, un deshabillé d'accouchée et quelques tableaux de Boucher et de Chardin. Qui dit Princesse, dit impatiente, et Elle demande a tout moment si je n'ai point de reponse... » (Correspondance (inédite) Scheffer-Tessin).

1745 : Vente de la collection d'Antoine de La Roque (1672-1744). Pour la première fois en France, des tableaux de Chardin figurent dans une vente publique. Ce sont l'*Ouvrière en tapisserie* (n° 68), le *Dessinateur* (n° 69), la *Pourvoyeuse* (cf. n° 80), la *Gouvernante* (n° 83), des *Ustensiles de cuisine*, la *Fontaine* (n° 55), la *Blanchisseuse* (n° 56), l'*Enfant au toton*, et *Lapin et marmite*.

1745 : Liste des meilleurs peintres, sculpteurs et graveurs de l'Académie Royale de Peinture et Sculpture de Paris, année 1745 :
Chardin figure entre Oudry et Charles Parrocel dans la catégorie des *Peintres a talens : Chardin, rue du Four au coin de la rue Princesse faubourg Saint Germain il excelle aussy aux animaux, aux choses naturelles et aux petits sujets naïfs.* Cette adresse prouve bien que Chardin n'avait pas à cette date quitté son domicile pour aller habiter chez sa femme, 13 rue Princesse — ce dont nous n'avons trouvé aucune preuve — comme le disent Herbet (1899), Pascal et Gaucheron (1931) et les auteurs à leur suite.

1746

10 janvier : Lettre de J.Ph. Lebas (1707-1783) adressée à J.E. Rehn (1717-1793) : « Vous assureray monsieur le Comte de mes respect. Et s'il veut bien me rendre le service de parlé de ce plafond de M. Chardin, il me fera plaisirs. C'est à vous que je recommande cette affaire étant sur qu'el est entre bonne main » (Suède, archives du Château de Krageholm).

29 janvier : Chardin est présent à l'Académie (P.V., VI, 1885, p. 23).

22 mars : Tessin adresse une lettre à Scheffer où il est question de Chardin : « ... Vous ne me dites rien de Chardin, cependant l'on compte fort sur deux tableaux de sa façon... » (Correspondance (inédite) Scheffer-Tessin).

26 mars : Chardin est présent à l'Académie (P.V., VI, 1885, p. 27).

20 avril : Lettre de Tessin à Scheffer : « ... A propos de tableaux ! Comment vont ceux de Boucher ? Madame Royale espère fort qu'ils seront prêts à partir par le vaisseau de Paulsen. Vous ne me parlés pas de Chardin ; Aiés s'il vous plait, la bonté de le presser, je connois ses lenteurs, et a ne luy dire mot, il n'auroit jamais fait. Ce sont deux tableaux, savoir l'Education douce, et l'Éducation sévère, qu'on luy demande... » (Correspondance (inédite) Scheffer-Tessin).

30 avril : Chardin est présent à l'Académie (P.V., VI, 1886, p. 28).

13 mai : Lettre de Tessin à Scheffer, d'Ulriksdal : « ... Je supose Paulsen en chemin, et j'attens son arrivée avec toutte l'impatience possible : la nouvelle Gallerie à Drotningholm sera, vers le tems de son arrivée, en état de recevoir les tableaux de Boucher et de Chardin, et il ne se passe point de jour sans que Madame Royale ne m'en parle. Ah, mon cher Baron, que voulés vous que je dise pour votre justification et pour la mienne, si par hazard ces éternels tableaux ne venoient pas?... » (Correspondance (inédite) Scheffer-Tessin).

Début juin : Lettre de Scheffer à Tessin, de Paris : « Monseigneur,
La lettre dont Votre Excellence m'a honoré le 2/13 du mois passé, me jette dans la plus grande confusion par l'attente que j'y trouve de voir Paulsen porteur des tableaux de Boucher et de Chardin. Rien ne sera si aisé pour vous, Monseigneur, que de vous justifier, vous avés donné vos ordres, et j'ai assés avoué que je les ai reçus, mais comment ferai-je moi, qui n'ai d'autres pièces justificatives à produire que le libertinage de Boucher dont il faut etre temoin pour le croire, et la lenteur de Chardin dont il faut entendre l'aveu de sa bouche pour ne la pas croire exagerée ? Je n'ai cependant que cela à dire, M. Berch ne me dedira pas, et je me flatte que sa déposition contribuera à ma decharge, puisqu'avant son depart je me fiois bien plus à lui qu'à moi meme pour l'execution des ordres de Vre Excellce sur les ouvrages de ce genre, son goût, sa connaissance avec les ouvriers et la confiance meme de Vre Excellce me portant à le croire plus propre que moi à les bien executer. J'attends à present votre resultat, Monseigneur, par rapport à Chardin, et je presse tous les jours Boucher d'en donner un à ses tableaux, qui vont lentement à cause des ordres de M. Tournehem, auxquels ces tableaux cedent souvent, puisque Boucher ne cede jamais ni aux uns ni aux autres ses plaisirs. » (Correspondance (inédite) Scheffer-Tessin).

10 juin : Tessin écrit à Scheffer, d'Ulriksdal : « ... J'ai demandé à Madme Royale si Elle desiroit les répétitions que vous me proposés pour elle, mais Elle aime mieux attendre et avoir des pièces originales et uniques ; Elle vous prie d'en prendre soin, et dit, qu'il y a loin d'ici à l'automne. S.A.R. desireroit aussi une douzaine de boules de Mars, c'est le seul remede dont son estomac, qui est fort derangé, s'accomode ; Comme ce n'est pas Chardin qui les fait elles pourront venir par la première occasion (sic!)... » (Correspondance (inédite) Scheffer-Tessin).

25 juin : Chardin est présent à l'Académie (P.V., VI, 1886, p. 31).

7 juillet : Lettre de Tessin à Scheffer, d'Ulriksdal : « ... J'ose encore vous recommander de talonner Boucher et Chardin : A mesure que la Gallerie s'avance a Drotningholm, la vive impatience de Madame Royale augmente, et Elle m'en parle a toute heure... » (Correspondance (inédite) Scheffer-Tessin).

15 juillet : Lettre de Tessin à Scheffer, d'Ulriksdal : « ... Madame Royale, ..., vient de m'ordonner de presser tout de nouveau les tableaux de Boucher et de Chardin, pour sa Gallerie a Drotningholm, a laquelle il ne manquera bientôt que la decoration interieure... » (Correspondance (inédite) Scheffer-Tessin).

12 août : Réponse de Scheffer à Tessin, de Paris : « ... Je me flatte de parler plus a propos en assurant Votre Excellence que les tableaux de Chardin avancent fort, et que Boucher promet les siens avant l'automne infailliblement... » (inédite) Scheffer-Tessin).

25 août-25 septembre : Chardin expose au Salon : « n° 71 : un tableau, répétition du *Bénédicité*, avec une addition pour faire pendant a un Teniers placé dans le cabinet de M*** » (cf. n° 89) ; « n° 72 : autre, *Amusements de la vie privée* » (n° 90) ; « n° 73 : *Le portrait de M***, ayant les mains dans son manchon* ; n° 74 : *Le portrait de M. Levret*, de l'Académie royale de Chirurgie ».

A ce même Salon est exposée la gravure de Surugue représentant le *Jeu de l'Oye* d'après le tableau de Chardin exposé au Salon de 1743 sous le n° 58.

27 août : Chardin est présent à l'Académie (P.V., VI, 1885, p. 34).

2 septembre : Lettre de Tessin à Scheffer, de Stockholm : « ... Quant avec tout cela, nous aurons ces tableaux, si longtemps desirés, et jusqu'ici si vainement attendus, de Boucher et de Chardin, nous ne vous demanderons plus rien de l'année. » (Correspondance (inédite) Scheffer-Tessin).

9 septembre : Lettre adressée à Tessin par Scheffer de Paris : « ... L'exposition des tableaux au Louvre est fort nombreuse cette année. Vre Excellce en trouvera l'explication icy jointe. Elle y vérifiera la paresse de Boucher et la lenteur de Chardin, tous deux me promettent cependant leurs ouvrages pour les premiers vaisseaux. » (Correspondance (inédite) Scheffer-Tessin).

24 septembre : Chardin est présent à l'Académie (P.V., VI, 1885, p. 36).

7 octobre : Lettre adressée à Tessin par Scheffer, de Paris : « ... D'un autre côté Chardin vient de m'écrire une lettre, que je prends la liberté de faire passer à Votre Excellence, et par laquelle Elle aura la bonté de voir où nous en sommes avec lui. Le tableau qui est achevé a fait l'admiration de tous les connoisseurs à la dernière exposition au Louvre. C'est celui qui est marqué dans le catalogue sous le titre d'amusemens de la vie privée. Il est actuellement chés le Graveur et il sera dedié à Made la Comtesse de Tessin. » (Correspondance (inédite) Scheffer-Tessin).

Le tableau dont il est question est bien sûr les *Amusements de la vie privée* (n° 90), n° 72 du livret du Salon de 1746.

La lettre de Chardin, jointe à ce billet, datée du 5 octobre, est conservée à Stockholm (Riksarkivet, dépôt du château d'Ericsberg). La voici :
« Monsieur
Je voudrois pouvoir répondre a l'Empressement qu'a Monsieur le Conte de Tessin de recevoir incessament les deux tableaux qu'il desire avoir de moi. Vous pouriez Monsieur disposer du premier qui a Etez Exposé au Louvre, quand à son Pendant, quoi qu'il soit avancé je ne puis m'Engager a vous Le Remettre avant noel. Je prend du tens parce que je me suis fait une habitude de ne quitter mes ouvrages que quand, à mes yeux, je n'y vois plus rien a desirer, Et je me ferai sur ce point plus Rigoureux que jamais pour pouvoir Renplir l'opinion avantageuse dont Monsieur le Conte de Tessin M'honore, de plus comme ses deux tableaux seront perdus pour la France Et que L'on doit quelle que Chose a sa nation Je souhaiterois que Monsieur le Conte me Laissa Le tems de Les faires graver ce qui meneroit jusqu'au Printemps. cette grace me seroit d'autant plus agréable que je doit En quelle que façon un Compte au public de mes occupations par Reconnoissance de L'accueil qu'il fait a mes ouvrages. Je suis Monsieur avec respect votre tres humble Serviteur. Chardin. ce 5 octobre 1746. »

28 (?) octobre : Lettre de Scheffer à Tessin, de Fontainebleau : « ... Aussitôt que je serai de retour à Paris, j'executerai les ordres de Vre Excellce par rapport aux tableaux de la dernière exposition dont S.A.R. desire de savoir le prix. Ceux de M. Parocel ont été faits pour le Roi de France, et celui de Chardin est precisement un des deux qui sont destinés pour Drotningholm. » (Correspondance (inédite) Scheffer-Tessin).

26 novembre : Chardin est présent à l'Académie (P.V., VI, 1885, p. 39).

31 décembre : Chardin fait partie de la députation chargée d'aller le 1er de l'an, saluer M. le Protecteur (M. Orry) et M. le Directeur Général des Bâtiments (M. de Tournehem) (P.V., VI, 1885, p. 40).

1747

27 février : Lettre de Scheffer à Tessin, de Paris : «...Chardin à la fin m'a tenu parole, et m'a remis les deux tableaux dont il s'étoit chargé, batisés *Les amusemens de la vie privé*, et *La femme oeconome*. Le premier est gravé, le second n'a point pû l'etre, il sort des mains du Peintre et je n'aurais pû le faire passer de trois mois encore, si j'avais voulu le faire passer entre ceux (*sic!*) du Graveur...» (Correspondance (inédite) Scheffer-Tessin).

2 mars : Jean Siméon Chardin et Françoise Marguerite Pouget *demeurans rue Princesse paroisse St Sulpice en la maison y après déclarée,* reconnaissent être propriétaires d'une maison rue Princesse, et d'une loge à la foire Saint-Germain-des-Prés, rue de la lingerie, bâtiments qui appartenaient à la famille Malnoé et que Mme Chardin possédait en tant qu'héritière de son premier mari. (A.N., S 2842 ; non vérifié).

Le couple Chardin avait donc déménagé entre 1745, date à laquelle Chardin habite encore *rue du Four au coin de la rue Princesse,* **et 1747** où il habite dans un immeuble appartenant à sa femme à quelques numéros de son ancien logis (au 13 de la rue Princesse).

4 mars : Chardin est présent à l'Académie : «Ensuite la Compagnie a résolu que le vendredi, 24 du présent mois, à cause de la fête de l'Annonciation qui tombe sur le samedi, Mrs les Directeurs, Recteurs, Adjoints à Recteurs, Professeur en exercice et, à tour de rôle, dans les anciens Professeur, M. d'Ulin ; dans les Professeurs, M. Le Moine le fils, dans les Adjoints, M. Pigalle ; dans les Conseillers, Mrs *Chardin,* Duchange et le Secrétaire, et, dans les Académiciens, M. Francisque Millet, s'assembleront, à huit heures précises du matin, pour régler la répartition de la capitation de la présente année 1747, et examiner et arrêter les comptes de 1746.» (P.V., VI, 1885, p. 48-49).

24 mars, 29 avril, 3 juin : Chardin est présent à l'Académie (P.V., VI, 1885, p. 50-51, 56).

6 juin : Lettre de Tessin à Scheffer, de Stockholm : «...Les tableaux de Chardin sont a se mettre a genoux devant, et de désir en désir, on est venu a en désirer encore deux, mais chaqu'un a deux figures ; je sai bien que c'est l'affaire d'une année, mais nous pesterons et nous prendrons patience.» (Correspondance (inédite) Scheffer-Tessin). Les deux tableaux *à se mettre a genoux devant* sont le n° 90 et l'*Économe* dont nous exposons l'esquisse (n° 91). Les deux autres qu'*on est venu a... désirer* sont vraisemblablement les n°s 94 et 95.

9 juin : Lettre de Scheffer à Tessin de Paris : «...En attendant qu'il se présente à Rouen quelqu'occasion par laquelle je pourrai envoyer avec d'autres estampes celle que Chardin a fait graver et dedier à Made la Comtesse de Tessin, et dont il m'a remis une epreuve bien enquadrée, j'ai l'honneur de joindre icy aujourd'huy la lettre qu'il a écrite à Vre Excellce à ce sujet, aussi bien qu'une autre epreuve que je me suis fait donner de cette estampe par le Graveur lui meme. Vre Excellce trouvera qu'au lieu de Drotningholm on a mis Brotningholm, mais j'ai fait corriger cette erreur, qui ne s'est glissée que dans un trés petit nombre d'epreuves.» (Correspondance (inédite) Scheffer-Tessin).
Il s'agit du tableau n° 90. L'épreuve de la gravure de Surugue avec un *B* au lieu d'un *D* existe au Cabinet Edmond de Rothschild, musée du Louvre.

Juin : Le *Mercure de France* (p. 131) annonce la mise en vente de l'estampe des *Amusements de la vie privée,* gravée par Surugue (n° 90).

1er juillet : Chardin est présent à l'Assemblée de l'Académie (P.V., VI, 1885, p. 60).

21 juillet : Lettre de Tessin à Scheffer, de Stockholm. Il charge Scheffer de remettre une lettre à Chardin : «...Vous permettés bien que je vous charge de l'incluse pour Chardin le Peintre.» (Correspondance (inédite) Scheffer-Tessin). Nous n'avons pas retrouvé cette lettre.

29 juillet : Chardin est présent à l'Académie (P.V., VI, 1885, p. 62).

3 août : Vente de la maison de la rue Princesse à Juste Chardin, frère du peintre (A.N., M.C., Étude LXXXII, liasse 281). Messire Simon Louis Brulart, chevalier, marquis de Brulard, seigneur de Beaubourg et autres lieux, vend à *Juste Chardin maître menuisier à Paris et des Menus Plaisirs du Roy* et à *Damoiselle Marie-Geneviève Barbier son épouse,* la maison rue Princesse au coin de la rue du Four (un plan est joint à cet acte), que la famille Chardin habitait dès avant 1720.

5 août : Chardin est présent à l'Académie. A la même réunion, «M. Surugue le père a présenté à l'assemblée six épreuves de trois planches qu'il a gravées, dont deux d'après M. Coypel, dont les sujets représentent la Folie qui pare la Decrépitude des agissemens de la jeunesse et une Dame en habit de bal, la troisième d'après M. Chardin, Conseiller, ayant pour titre : «Les amusemens de la vie privée». L'examen fait, la Compagnie a aprouvé lesdites planches pour faire jouir l'exposant des privilèges accordés à l'Académie par l'Arrest du Conseil d'Etat du 28 juin 1714.» (P.V., VI, 1885, p. 63).

25 août-25 septembre : Chardin expose au Salon du Louvre : «n° 60 : un tableau représentant *la garde attentive ou les Aliments de la convalescence.* Ce tableau fait pendant à un autre du même auteur, qui est dans le Cabinet du Prince de Leichtenstein et dont il n'a pu disposer, ainsi que de deux autres qui sont partis depuis peu pour la Cour de Suède.» (n° 92).

26 août, 2 septembre : Chardin est présent à l'Académie (P.V., VI, 1885, p. 65, 67).

29 septembre : Lettre de Scheffer à Tessin, de Fontainebleau : «...M. Chardin promet dans le courant d'un an les deux tableaux que Vre Excellce souhaite de lui, mais il m'a juré qu'il lui étoit impossible de les finir en moins de tems. Partant de là il m'a protesté aussi qu'il ne peut absolument point les donner au même prix que les derniers, et qu'à moins de Cent pistoles par tableau il ne sauroit se charger de cet ouvrage sans s'exposer à mourir de faim. Je lui ai dit que je demanderois sur cela des ordres, en attendant il a déjà commencé à travailler, parce qu'il y a un Conseiller au Parlement qui lui demande aussi un tableau à deux figures, de sorte que si le prix ne convient point à Vre Excellce il ne sera pas embarrassé d'un autre marchand. Il a au reste été extremement flatté de la lettre que Vre Excellce lui a fait la grace de lui écrire, et il m'a prié d'assurer Vre Excellce que la nécessité seule l'oblige à marchander avec Elle, dans le temps que l'honneur de travailler pour un Juge si eclairé lui tiendroit lieu de recompense, s'il etoit dans une situation plus aidée...» (Correspondance (inédite) Scheffer-Tessin).

30 septembre, 27 octobre : Chardin est présent à l'Académie (P.V., VI, 1885, p. 71, 73).

30 octobre : Lettre de Tessin à Scheffer, de Stockholm : «...La gazette de Clément n'a pas eu le bonheur de plaire, en effet il faut connoitre Paris pour y prendre plaisir, mais les deux Tableaux de Chardin a deux figures, on en veut a quelque prix que ce soit...» Le *on* concerne, bien sûr, Louise Ulrique de Suède. (Correspondance (inédite) Scheffer-Tessin).

Octobre : Le *Mercure de France* (p. 138) annonce la sortie de l'estampe de Surugue l'*Instant de la Méditation,* d'après le tableau de Chardin exposé au Salon de 1743 sous le n° 57, représentant Mme Lenoir tenant une brochure. La gravure est dédiée à M. Lenoir.

25 novembre : Chardin est présent à l'Académie (P.V., VI, 1885, p. 77).

1748

5 janvier, 3 février, 24 février : Chardin est présent à l'Académie (P.V., VI, 1885, p. 86, 90, 92).

20 mars : Lettre de Tessin à Scheffer de Stockholm : «...Je vous prie de tirer de l'oreille a Boucher et a Chardin ; j'en porte toutte la peine puisque Made Royale crie après moi tous les jours de la vie.» (Correspondance (inédite) Scheffer-Tessin).

22 mars : Le beau-frère de Chardin, Claude Michel Bulté meurt à Amsterdam (Jal, 1867). Rappelons que Marie Claude Chardin s'était mariée en 1720 (voir 20 avril de cette année), et était séparée de biens au moment du partage de la succession de son père, le 24 juillet 1731. Il paraît donc compréhensible qu'elle «donna peu de temps aux larmes ; au bout de deux mois et demi elle jeta aux orties les coiffes et les robes de deuil» (Jal, 1867).

30 mars, 31 mai, 8 juin : Chardin est présent à l'Académie (P.V., VI, 1885, p. 95, 113, 116).

13 juin : Marie Claude Chardin, habitant rue de la Calandre, épouse Jean Baptiste Mopinot (né le 21 février 1690, fils d'un marchand de vin), marchand, à Saint-Germain-le-Vieil. Le marié habite rue des Arcis, paroisse Saint-Merry. Les témoins sont : Jean Charles Frontier (1701-1763), peintre ordinaire du Roi, demeurant rue Petit Lion, paroisse Saint-Sulpice, Jean Siméon Chardin et Juste Chardin (Jal, 1867).

28 juin, 6 juillet, 27 juillet : Chardin est présent à l'Académie (P.V., VI, 1885, p. 122, 124, 126-127).

3 août : Chardin fait partie de la commission chargée d'examiner les ouvrages exposés au prochain Salon :
«Officiers nommés pour l'examen des ouvrages du Salon. Il a été réglé que, le lundi 19e Aoust, conformément aux ordres du Roy, à la lettre de M. de Tournehem, en date du 6 May dernier, et à la délibération du 21e Aoust 1745, il y auroit une assemblée particulière, pour examiner les ouvrages qui seront exposés au Salon, et en conséquence on a nommé, par la voie du scrutin, — indépendamment de M. le Directeur, de Mrs les Anciens Recteurs, Recteurs et Adjoints à Recteurs, qui sont de tous les jugemens, — M. Le Clerc, Ancien Professeur, Mrs Vanloo, Boucher, Nattoire, De Vermont, Oudry, Bouchardon, Professeurs ; Mrs Pigalle, Nattier, Slodtz, Adjoints à Professeurs, et Mrs Massé et Chardin, conseillers.» (P.V., VI, 1885, p. 127-128).

18 août : Chardin est présent à l'Académie pour l'examen des tableaux du Salon (P.V., VI, 1885, p. 131).

23 août : Chardin est présent à l'Académie (P.V., VI, 1885, p. 132).

25 août-septembre : Chardin expose au Salon du Louvre : «n° 53 : un tableau représentant l'*Élève studieux* pour servir de pendant à ceux qui sont partis l'année dernière pour la Cour de Suède» (cf. n° 94).

31 août, 7 septembre : Chardin est présent à l'Académie (P.V., VI, 1885, p. 134-136).

8 septembre : Lettre de Scheffer à Tessin, de Paris : «...Le Sr Chardin, qui quoique lent finit cependt cet ce qu'il commence, vient de me livrer le second des deux tableaux qui furent commandés il y a deux ans à 1 000 livres pièce. Comme il a déjà reçu 500 livres sur ce dernier qui vient d'etre fini, je n'ai eu aujourd'hui que 500 livres à payer, avec 35 livres pour la bordure dont j'ai l'honneur de joindre icy la quittance du Sr Chardin qui a été payé au moyen d'une lettre de change que je viens de tirer sur Vre Exce

pour le compte de S.A.R.» (cf. n° 95). (Correspondance (inédite) Scheffer-Tessin).

18 novembre: Lettre de Tessin à Scheffer, de Paris: «...A mes importunités infinies j'ajoute encore celle de vous prier, de faire dorenavant dresser des nottes a part sur les envois qui ne sont pas pour moy, comme actuellement le tableau de Chardin, qui est pour Madame Royale, sans quoi je me verrai toujours dans la nécessité d'en payer les fraix, le port, les droits du Sond &c, m'etant du tout impossible d'en faire la separation ou de le porter en compte, faute de verifications.» Il s'agit toujours du n° 95. (Correspondance (inédite) Scheffer-Tessin).

29 novembre, 7 décembre, 31 décembre: Chardin est présent à l'Académie (P.V., VI, 1885, p. 142-146).

1748: Tableaux datés: *Perdrix morte, poire et collet sur une table de pierre* (n° 96).

1749

16 janvier: Dans l'inventaire après décès de Claude Nicolas Rollin, figurent «Deux (!) tableaux peints sur toile copies de Chardin représentant l'Ecolier et l'autre la Gouvernante» (A.N., M.C., Étude LIII, liasse 235).

29 mars: Chardin, présent à l'Académie, est nommé avec Frontier (1701-1763) — le peintre qui avait été témoin au mariage de sa sœur le 22 mars 1748 — pour aller visiter Aved: «M. Aved, Conseiller, qui avoit été nommé pour se trouver à la reddition des comptes, ayant eu la jambe cassée, la Compagnie a député, pour aller le visiter, M. Chardin et M. Frontier.» (P.V., VI, 1885, p. 160).

12 avril: Chardin est présent à l'Académie (P.V., VI, 1885, p. 163).

30 mai: Inventaire après décès de Claude le Besgue de Majainville, prêtre, docteur de Sorbonne, abbé commendataire de l'abbaye de Morigny, conseiller au parlement, dressé à son domicile, rue d'Enfer:
«Estampes... La Galerie des Chartreux, le Cabinet des Beaux-Arts, plusieurs portraits, quelques Chardin, n° 27... 10 l.» (Rambaud, 1971, p. 943-944).

7 juin: Chardin est présent à l'Académie (P.V., VI, 1885, p. 167).

7 septembre: Lettre de Daniel Wray à Philip Yorke, plus tard lord Hardwicke: «France has produced several good sculptors. Bouchardon, who is, I think, at the head of them at present, was a student, in the French Academy of Design at Rome in my time, of great hopes. I have since seen many Prints after him very good; and have heard his Fountains and, I think, his Tomb of Cardinal Fleury commended. Look at all these with no transient eye. Call in too at Chardins, who paints little pieces of common-life; and upon Liotard (but he is the Colonels painter), admirable in Crayons. All one praise we allow these artists; but we believe, when you have heard their Prices you will be able to convince people that Oram and Scot and Pond are not extravagantly paid.» (Londres, British Museum. Add. Manuscrit 35401. fol. 121 verso).

8 novembre: Chardin est présent à l'Académie (P.V., VI, 1885, p. 182).

1750

4 avril, 3 octobre, 31 décembre: Chardin est présent à l'Académie (P.V., VI, 1885, p. 204, 233, 246).

1751

27 mars: Chardin est présent à l'Académie (P.V., VI, 1885, p. 266).

24 avril: Chardin est présent à l'Académie: «La Compagnie a nommé M. Chardin et M. Tocqué pour aller visiter M. Massé, qui est malade.» (P.V., VI, 1885, p. 270).

26 juin, 7 août: Chardin est présent à l'Académie (P.V., VI, 1885, p. 277, 281).

25 août: Chardin expose au Salon du Louvre: «n° 44: un tableau de 18 pouces sur 15 de large. Ce tableau représente une *Dame variant ses amusements*» (cf. n° 93).
Un mémoire manuscrit de la main de Chardin portant la date *année 1751* nous apprend que *le tableau qui m'a été demandé par Monsieur Coypel et que j'ay fait porte 18 pouces de haut sur 15 de large. Il represente une Dame variant ses amusements. Chardin.* (Ce manuscrit passé dans la vente Camille Marcille, 8-9 mars 1876, n° 118, p. 88; appartient aujourd'hui à l'Institut Néerlandais de Paris.)

28 août, 25 septembre: Chardin est présent à l'Académie (P.V., VI, 1885, p. 283-286).

30 octobre: Chardin est présent à l'Académie: «Ensuite M. Le Moyne ayant présenté un Aspirant Peintre dans le genre des fleurs, l'Académie a nommé pour en examiner les ouvrages, et en faire le rapport à la prochaine assemblée, M. Galloche, Recteur, M. Restout, Adjoint, M. Oudry, Professeur, et M. Chardin, Conseiller. — Nª: Il n'y a point eu de rapport, attendu la foiblesse du Sujet.» (P.V., VI, 1885, p. 290).

6 novembre: Chardin est présent à l'Assemblée de l'Académie (P.V., VI, 1885, p. 292).

18 novembre: Au bas du billet de Chardin conservé par l'Institut Néerlandais (voir ici à 25 août 1751), Coypel note: *Je soussigné Premier Peintre du Roi certifie à M. de Tournehem, Directeur et Ordonnateur Général des Batimens que le tableau mentionné dans ce memoire — c'est-à-dire la Serinette (n° 93) — a été fait et fort approuvé, à Paris ce 18 9ᵇʳᵉ 1751.*

27 novembre: Chardin est présent à l'Académie (P.V., VI, 1885, p. 294).

1751: On peut lire sur l'exercice pour l'année 1751: *au sieur Chardin.*
Mémoire au tableau representant une Dame assise dans un fauteuil et jouant de la Serinette auprès d'un serin qu'il a fait pour le service du Roi pendant l'année 1751 Estimé 1 500 l. (n° 93) (A.N. O¹ 1921ᴮ).

1752

8 janvier: Chardin est présent à l'Académie (P.V., VI, 1885, p. 302).

18 janvier: Une note manuscrite figure en haut du billet autographe de Chardin (appartenant à l'Institut Néerlandais, Paris, dont nous avons donné le texte à la date du 25 août 1751) concernant la *Serinette* (n° 93): *Ce mémoire a été présenté à M. de Vandières le 18 janvier 1752 et arrêté à 1 500 l.*

29 janvier: Chardin est présent à l'Académie (P.V., VI, 1885, p. 303).

3 février (et non 3 janvier ou 8 janvier): En marge de l'exercice pour l'année 1751 (A.N. O¹ 1921ᴮ), à propos de la *Serinette* (n° 93) dont nous avons donné le texte au 25 août 1751, figure la mention suivante: *Payement 1752 3 fev. 1500 l.*

24 mars, 10 mai, 27 mai: Chardin est présent à l'Académie (P.V., VI, 1885, p. 311, 320, 322).

2 juin: Lettre de l'abbé Joly (1715-1805) adressée au sieur Maurissaut, sculpteur sur bois et encadreur, à propos du cadre qu'il doit exécuter pour la *Serinette* (n° 93). D'après le texte qui suit, il ne semble pas — comme il a été écrit — que ce tableau fasse partie du Cabinet du Luxembourg: «M. Coypel croit qu'il faudroit lui faire fournir le mémoire détaillé desdites bordures faites pour le cabinet du Luxembourg qui doit être de 56, savoir 32 ayant pour couronnement une fleur de lys, pour autant de tableaux, et 24, sans aucun ornement, pour contenir des dessins, ledit mémoire réglé par M. de Lépée selon son dire et suivant l'intention de M. Coypel. Voilà le mémoire que M. Coypel croit devoir certifier, comme il certifiera aussi, après le règlement fait par M. de Lépée, six autres bordures ordonnées par lui, savoir: trois bordures pour la suite des tableaux en petit de la reine de Pologne, peints par lui; une bordure pour le portrait de Mme la Dauphine, peint par M. Nattier; une bordure pour le portrait de M. Tournehem, peint par M. Tocqué et donné à l'Académie royale de peinture, et la sixième pour un tableau de M. Chardin, représentant une dame jouant de la serinette auprès de son serin...» (Furcy-Raynaud, 1904, p. 8-9).

3 juin, 23 juin, 1ᵉʳ juillet: Chardin est présent à l'Académie (P.V., VI, 1885, p. 323, 325, 326).

10 juillet: Etats des papiers a effets qui se sont trouvés sous les scéllés de la succession de feu M. Coypel, Premier Peintre du Roy concernant l'Académie et les Arts.
Commencé cet inventaire le 10 juillet 1752. Mémoires payés en entier: ...Une Dame variant ses amusements (n° 93).
Plus un mémoire de M. Chardin montant de 1 500 l. payé en entier le 8 février 1752. Il s'agit d'une copie du mémoire du 3 février, avec une erreur de date (A.N. O¹ 1934ᴮ, dossier n° 12.).

25 juillet: Lettre de Lépicié adressée à Vandières (1727-1781). Le marquis de Vandières, frère de madame de Pompadour, futur marquis de Marigny et de Ménars, Directeur des Bâtiments de 1751 à 1773 était un grand amateur de Chardin (cf. n° 93 et aussi 79). Lépicié donne la liste des Académiciens pensionnés par le Roi et fait quelques propositions de noms pour de nouvelles pensions: «Sans vous nommer, Monsieur, tous ceux qui n'ont pas encore reçu des bienfaits du Roy, je crois que voici ceux qui méritent le plus... M. Chardin, recommandable aussi par ses talens et par sa probité, se trouve dans le même cas.» (A.N. O¹ 1907ᴮ, 1752, volume 21, n° 104).

29 juillet, 5 août, 26 août: Chardin est présent à l'Académie (P.V., VI, 1885, p. 327, 329, 331).

1ᵉʳ septembre: Note émanant de la Direction Générale des Bâtiments: *Académie de Peinture. Pensions vacantes* (celles de de Troy, Parrocel et Coypel). *Je propose à votre Majesté d'en faire la distribution ainsy que cy après... au Sieur Chardin 500.*
Ce manuscrit porte le *bon* du Roi, daté du 1ᵉʳ septembre 1752 (A.N., O¹ 1073; inédit).

2 septembre: Chardin est présent à l'Académie (P.V., VI, 1885, p. 333).

7 septembre: **Lettre de M. de Vandières à Chardin:**
«M. Chardin. A Paris le 7.7ᵇʳᵉ 1752.
Sur le rapport que j'ay fait au Roy Monsieur de vos talents et de vos Lumières, **Sa Majesté vous accorde dans la distribution de ses graces pour les arts, une pension de 500 livres,** je vous en informe avec d'autant plus de plaisir, que vous me trouverés toujours très disposé à vous obliger, dans les ocasions qui pourront se présenter et qui dépendront de moy à l'avenir. Je suis, M.V.V.» (A.N., O¹ 1752, volume 21).
A la même date figure sur le Registre des Renvois et décisions (A.N., O¹ 1195, 1752, fol. 212 verso), la copie de la lettre de Vandières adressée au Roi (voir ici à 1ᵉʳ septembre) et la mention en marge *bon du Roi* et sa date.

30 septembre, 7 octobre, 4 novembre, 2 décembre, 30 décembre: Chardin est présent à l'Académie (P.V., VI, 1885, p. 334, 336, 338, 339, 341).

1752: Liste des Officiers de l'Académie Royale de Peinture et de Sculpture et Etat des Pensions accordées à quelques uns jusques en l'année 1752: ...Conseillers... Chardin (1743). (A.N., O¹ 1925ᴬ; inédit).

1753

15 janvier : «État Général des Ouvrages de peinture et de Sculpture qui ne sont que commencez, et qui ont été distribuez à MM. les Artistes ci après, tant sous les Directions de Monsieur Orry, celle de Monsieur de Tournehem que celle de Monsieur de Vandières. Avec une estimation desdits Ouvrages, et les acomptes donnez jusqu'au 30 décembre 1752... Au sieur Chardin. Un tableau pour faire pendant à celui connu sous le titre d'une Dame variant ses amusemens. Estimé 1500 ; Nota. Il y travaille» (A.N. O¹ 1921ᴬ).

23 février, 31 mars, 7 avril, 26 mai, 2 juin, 28 juillet : Chardin est présent à l'Académie (P.V., VI, 1885, p. 345, 347, 348, 351, 352, 357).

2 août : Lettre de B. Lépicié à M. de Vandières : «... Permettez moi, Monsieur de vous demander une grace au nom du Sr Chardin. Il souhaiterait fort que vous lui accordassiez celle, de vous dédier l'estampe que l'on grave d'après son tableau représentant une Dame qui s'amuse avec une Serinette et de pouvoir marquer que le dit tableau est tiré de votre Cabinet.» En marge, de la main de Vandières : *J'y consens* (nº 93) (A.N. O¹ 1908 - 1753, volume 1).

4 août : Chardin est présent à l'Académie (P.V., VI, 1885, p. 359).

6 août : Lettre de M. de Vandières adressée à B. Lépicié, de Compiègne : «... à l'Egard de la demande du Sr Chardin, je consens qu'il me dédie l'estampe qu'il fait graver d'après son tableau de la femme à la serinette, et qu'il marque au bas de l'Estampe ce tableau est tiré de mon Cabinet. Je suis, Monsieur, votre très humble et très obéissant serviteur.»

25 août-25 septembre : Chardin expose au Salon : «nº 59 : deux tableaux pendants sous le même numéro. L'un représente un *Dessinateur d'après le Mercure de M. Pigalle,* et l'autre *une Jeune fille qui récite son évangile.* Ces deux tableaux tirés du Cabinet de M. de La Live, sont répétés d'après les originaux placés dans le cabinet du Roi de Suède. Le dessinateur est exposé pour la deuxième fois avec des changements» (cf. nᵒˢ 94 et 95) ; «nº 60 : un tableau représentant un *Philosophe occupé de sa lecture.* Ce tableau appartient à M. Boscry, architecte» (nº 62) ; «nº 61 : un petit tableau représentant un *Aveugle* ; nº 62 : autre, représentant un *Chien, un singe et un chat,* peints d'après nature. Ces deux tableaux tirés du cabinet de M. de Bombarde ; nº 63 : un tableau représentant une *Perdrix et des fruits,* appartenant à M. Germain ; nº 64 : deux tableaux pendants sous le même numéro, représentant des *Fruits,* tirés du cabinet de M. de Chasse ; nº 65 : un tableau représentant du *Gibier,* appartenant à M. Aved» (nº 22).

28 septembre, 6 octobre : Chardin est présent à l'Académie (P.V., VI, 1885, p. 366, 367).

Novembre : Le *Mercure de France* (p. 160) annonce la mise en vente de la gravure de Laurent Cars (1699-1771) d'après la *Serinette* de Chardin.

1ᵉʳ décembre : Chardin est présent à l'Académie (P.V., VI, 1885, p. 372-373).

29 décembre : Chardin est présent à l'Académie. Son fils reçoit la 3ᵉ médaille des Prix de Quartiers (P.V., VI, 1885, p. 375).

1753 : Baillet de Saint Julien (1715-?) écrit une *Lettre à M. Ch[ardin] sur les caractères en peinture* (Genève).

1754

2 mars : Chardin fait partie des Commissaires nommés pour la reddition des Comptes de l'Académie de 1753 : «Ensuite il a été résolu que, le samedi 30 du présent, Mrs les Directeurs, Anciens Recteurs, Recteurs, Adjoints à Recteurs, Professeur en exer-

cice et, à tour de rôle : dans les Anciens Professeurs, M. Le Clerc ; dans les Professeurs, M. Jeaurat ; dans les Adjoints, M. Hallé ; dans les Conseillers, M. Chardin et le Secrétaire et, dans les Académiciens, M. Chastelain, s'assembleront à neuf heures précises du matin, pour régler le rôle de la Capitation de 1754, ainsi que pour l'examen et l'arrêté du Compte de 1753» (P.V., VI, 1885, p. 381).

6 avril : Chardin est présent à l'Académie. Son **fils Jean Pierre Chardin est admis à concourir pour le Grand Prix :** «Jugement des épreuves pour les grands-prix. — L'Académie, après avoir vu les épreuves faites par les Etudians pour concourir aux Grands-Prix, n'a jugé de capable à y être admis que les nommés St Aubin, Chardin, Celoni, Jolain, et Du Rameau, pour la Peinture, et les nommés Bridan, Berruer, Le Comte et Sigis pour la Sculpture» (P.V., VI, 1885, p. 384).

1ᵉʳ juin, 6 juillet, 27 juillet, 3 août, 22 août : Chardin est présent à l'Académie (P.V., VI, 1885, p. 388, 391-393).

31 août : **Jean Pierre Chardin, fils de notre peintre, remporte le Premier Prix de l'Académie :** «Aujourd'hui, samedi 31ᵉ Aoust, l'Académie s'est assemblée, par convocation générale, pour juger les Grands Prix faits par les Elèves sur les sujets tirés de l'Ancien et du Nouveau Testament, dont l'un représente Mathatias, l'autre le Massacre des innocents. ...Le Sieur Chardin, qui a fait le tableau marqué D, s'est trouvé mériter le premier Prix de Peinture ; ...» (P.V., VI, 1885, p. 394-395).

7 septembre : Chardin est présent à l'Académie (P.V., VI, 1885, p. 397).

22 septembre : Jean Pierre Chardin, fils du peintre, entre à l'École Royale des élèves protégés (Courajod, *L'École Royale des élèves protégés,* 1874, p. 177).

28 septembre, 5 octobre, 29 novembre, 31 décembre : Chardin est présent à l'Académie (P.V., VI, 1885, p. 398, 401, 404).

1754 : Chardin a des élèves : Jèze, l'auteur présumé du *Journal du Citoyen,* La Haye, 1754, fait «mention des Maîtres particuliers en peinture (donnant des leçons chez eux) : Boucher, Vanloo, Favanne, Restout, Balin, Natoire, Oudry, Nattier, *Chardin,* Toqué, Aved, Lajoue, Delobel, etc.».

1754 : La pension de Chardin sur l'exercice de 1754 est de 500 livres (A.N. O¹ 1934ᴬ, dossier 12).

1755

4 janvier, 25 janvier, 1ᵉʳ février, 1ᵉʳ mars : Chardin est présent à l'Académie (P.V., VI, 1885, p. 405-407, 410).

22 mars : **Chardin devient trésorier de l'Académie :** «Extrait des registres de l'Académie Royale de Peinture et de sculpture du 22 mars 1755. L'Académie a jugé à propos d'établir un Trésorier conformément à l'article XIX des statuts ordonnés par le Roi le 24 décembre 1663. M. Chardin, conseiller, a été élû d'une voix unanime pour remplir cette place, et l'a accepté aux termes portez dans l'article susdit des statuts» (A.N. O¹ 1925ᴬ). Cet extrait est une copie certifiée *véritable et conforme à l'original,* par Cochin fils (nouvellement secrétaire et historiographe de l'Académie, depuis la mort de F.B. Lépicié, le 28 avril 1755. Il s'agit de Charles-Nicolas Cochin fils (1715-1790), que l'on ne doit pas confondre avec Charles-Nicolas Cochin père (1688-1754), fréquent graveur de Chardin.

5 avril : Chardin est présent à l'Académie (P.V., VI, 1885, p. 412-413).

12 avril : Jean Pierre Chardin reçoit une gratification de 75 livres (A.N. O¹ 1928, dossier 9).

13 avril : Le duc de Luynes dans ses *Mémoires sur la Cour de Louis XV (1735-1758)* (t. 14, 1864, p. 133-134) rapporte que M. de Marigny présenta au Roi les ouvrages des jeunes élèves de l'Académie. Jean

Pierre Chardin, fils du peintre, expose donc à Versailles *Alexandre s'endormant avec une boule d'or dans sa main, afin de s'éveiller au bruit qu'elle fera en tombant,* et le tableau avec lequel il avait eu son Premier Prix en 1754, *Mathatias tuant un juif qui avait sacrifié aux idoles et le ministre Antiochus qui l'y avait forcé.*

17 avril : Lettre de Cochin à Marigny (M. de Vandières étant devenu marquis de Marigny depuis septembre 1754) : «Nous avons fait M. Chardin, dont l'intégrité est connue, notre trésorier, afin que nos deniers soient en sûreté à l'avenir, et ce rétablissement est conforme à nos statuts auxquels nous avions mal à propos fait ce changement. Nous espérons, avec le petit profit du livre, payer les dettes les plus pressantes, telles que ce qui est dû aux modèles, qui ne sont pas en état d'attendre. L'Académie n'est pas riche et elle n'est pas en état de rien négliger, encore moins de rien perdre.» (Furcy-Raynaud, 1904, p. 85-86).

26 avril, 3 mai : Chardin est présent à l'Académie (P.V., VI, 1885, p. 414, 415).

12 mai : **Chardin prend ses fonctions de trésorier de l'Académie** (voir lettre du 28 juin 1778).

31 mai, 7 juin, 28 juin : Chardin est présent à l'Académie (P.V., VI, 1885, p. 417-419).

Juin : Le *Mercure de France* annonce la mise en vente de l'estampe d'après le portrait de Chardin, dessiné par Cochin et gravé par L. Cars (1699-1771) :

«La ressemblance y est heureusement saisie. Cette naïveté qui forme son caractère et qui règne dans ses ouvrages frappe d'abord les regards ; on y reconnaît le La Fontaine de la gravure. Voici des vers faits pour être inscrits au bas de cette estampe. Un artiste d'un talent si vrai mérite bien cette distinction et ne peut-être, selon moi, trop dignement célébré par tous les arts réunis ensemble.

«De quoi pourrait ici s'étonner la nature ?
C'est le portrait naïf de l'un de ses rivaux.
Il respire en cette gravure,
Elle parle dans ses tableaux.»

5 juillet : Chardin est présent à l'Académie (P.V., VI, 1885, p. 420).

8 juillet : Chardin fils reçoit une gratification de 75 livres (A.N. O¹ 1928, dossier 9).

26 juillet : Chardin est présent à l'Académie (P.V., VI, 1885, p. 421).

1ᵉʳ août : Payement au sieur Chardin d'une ordonnance sur l'exercice de 1754 de l'Académie : «Pour les neuf derniers mois de l'année 1754 des dépenses de l'Académie royale de peinture à raison de 4 000 l. par an... 3 000 l.» (A.N. O¹ 1921ᴮ ; inédit).

2 août : Chardin est présent à l'Académie (P.V., VI, 1885, p. 421).

16 août : Lettre de Cochin à Marigny : «Monsieur, — l'Académie, assemblée en Comité, a fait aujourd'hui, selon l'usage, le choix des tableaux qui doivent être exposés au Salon du Louvre ; vous m'avez ordonné, Monsieur, de vous en informer aussitôt, afin que vous donnassiez vos Ordres à M. Portail. La Compagnie, ayant appris l'Accident qui lui est arrivé et qui le met hors d'État de vacquer à cet Arrangement, en a été fort touché, et plusieurs de ses membres se sont offerts à faire ce service pour lui. C'est pourquoi, Monsieur, si cela est conforme à vos intentions, M. Chardin, aidé des officiers en exercice, suppléera à son Absence. Je suis, etc.» (A.N. O¹ 1923ᴮ, registre, p. 10).

23 août : Chardin est présent à l'Académie. **M. Chardin** [est] **nommé pour présider à l'arrangement des tableaux au Salon.** — Ensuitte, le Secrétaire a fait lecture du Résultat de l'assemblée tenue par Committé le 16 du présent mois, par laquelle M. Chardin, Trésorier, a été chargé, selon l'ancien usage, de présider à l'arrangement des ta-

bleaux exposés au Salon, M. Portail, chargé de cet employ par Monsieur le Directeur Général des Bâtiments du Roy, n'ayant pu faire ce service pour cause de maladie.» (P.V., VI, 1885, p. 422).

25 août: Réponse de Marigny à Cochin: «J'ai reçu, Monsieur, votre lettre du 16 de ce mois dans laquelle vous me rendés compte du choix que l'Académie a fait cette année, aidé des officiers en exercice, à l'arrangement des tableaux du Salon. L'accident arrivé à M. Portail ne luy permettant pas d'aller faire cet arrangement suivant l'usage, je ne puis qu'approuver dans cette circonstance la délibération de l'Académie, sans que néanmoins elle puisse tirer à conséquence pour l'avenir. Je suis, etc.» (A.N., O^1 1908) (la copie de cette réponse se trouve aussi en marge du registre O^1 1923B, p. 10, face à la lettre du 23 août).

28 août-septembre: Chardin expose au Salon: «n° 46: des *Enfants se jouant avec une chèvre*. Imitation d'un bas-relief en bronze» (cf. n° 33); «n° 47: un tableau d'*Animaux*».
A ce même Salon, Lebas (1707-1783) expose *L'Œconome*, d'après le tableau de Chardin exposé au Salon de 1747 et tiré du Cabinet du Roi de Suède, dessiné par J.E. Rehn d'après l'original (cf. n° 91).

30 août: Chardin est présent à l'Académie (P.V., VI, 1885, p. 423).

6 septembre: Chardin est présent à l'Académie: «M. le Directeur (c'est-à-dire Louis de Sylvestre, 1675-1760) a remercié, au nom de la Compagnie, M. Chardin des soins qu'il a bien voulu se donner pour l'arrangement des tableaux du Salon» (P.V., VI, 1885, p. 424).

7 septembre: «Payement au Sieur Chardin d'une ordonnance pour le 1er quartier des dépenses de l'Académie pendant l'année 1754 à raison de 4 000 livres par an... 1 000 l.» (A.N., O^1 1921B; inédit).
«Payement au sieur Chardin d'une ordonnance pour les médailles qui seront distribuées aux élèves de l'Académie qui auront remporté les prix pendant l'année 1755 de 1330 livres (A.N., O^1 1921B; inédit).

10 septembre: Remise par Marigny des récompenses des Grands Prix de 1754; rappelons que Jean Pierre Chardin avait eu le Premier Prix, cette année-là (P.V., VI, 1885, p. 425).

28 septembre, 4 octobre, 25 octobre, 8 novembre, 29 novembre: Chardin est présent à l'Académie (P.V., VI, 1885, p. 427, 428, 430).

24 décembre: Jean Pierre Chardin reçoit une gratification de 75 livres au titre d'élève royal protégé (A.N., O^1 1928, dossier 8).

31 décembre: Chardin est présent à l'Académie (P.V., VI, 1885, p. 433).

1755: La pension de Chardin est toujours de 500 livres.
Direction générale des Bâtimens du Roi: «Sommes proposées sur les fonds de l'exercice 1755 destinées au payement des pensions..., ladite année... J.B. Chardin cinq cent livres» (A.N., O^1 1934, dossier 13).
Sur l'exercice de 1755 est noté: «au Sieur Chardin. Un tableau dont le sujet sera à son choix pour faire pendant à celui qu'il a livré, et qui est connu sous le titre d'une *Dame variant ses amusemens*. Estimé 1500 livres. Il y travaille» (A.N., O^1 1921B).

1755: Tableaux datés: la *Table de cuisine* (n° 102).

1756

10 janvier: Chardin est présent à l'Académie (P.V., VII, 1886, p. 2).

12 janvier: Chardin fils reçoit une gratification de 75 livres (A.N., O^1 1928, dossier 9).

31 janvier: Chardin est présent à l'Académie (P.V., VII, 1886, p. 3).

3 février: Ordre est donné par la Direction générale des Bâtiments du Roi de payer les pensions sur l'exercice 1754; Chardin reçoit 500 livres (A.N., O^1 1934A, dossier 12).

28 février, 6 mars: Chardin est présent à l'Académie (P.V., VII, 1886, p. 4-5).

27 mars: Chardin est présent à l'Académie: «Rapport du compte rendu par M. le Trésorier; répartition de la capitation. — Ensuite, le Secrétaire a rapporté à la Compagnie que M. le Directeur, Mrs les Anciens Recteurs, Recteurs, Adjoints à Recteurs et Officiers, nommés par la précédente délibération pour établir le rôle de l'imposition et de la répartition de la Capitation de la présente année 1756, se sont assemblés dans l'Académie, le matin de ce même jour 27 Mars. Le rôle a été dressé, arrêté et signé par lesdits Officiers, Commissaires à cet effet, et déposé dans les Archives de l'Académie; il en a été délivré copie à M. le Trésorier, pour être par lui pourvu au recouvrement des sommes y imposées, et à leur employ à l'acquit des droits dûs au Roy et autres dépenses nécessaires à l'entretien de l'Académie. Après lequel arrêté, il a été encore procédé, par les mêmes Commissaires, à l'examen et à l'arrêté du compte de l'exercice de M. Chardin, Trésorier, pendant l'année 1755, sur le rapport qui a été fait du tout auxdits Commissaires, et l'Académie a approuvé et confirmé les rôles et l'arrêté du Compte» (P.V., VII, 1886, p. 5).

3 avril, 24 avril: Chardin est présent à l'Académie (P.V., VII, 1886, p. 8).

3 mai: Chardin fils reçoit une gratification de 75 livres (A.N., O^1 1928, dossier 11).

8 mai, 29 mai, 5 juin, 26 juin: Chardin est présent à l'Académie (P.V., VII, 1886, p. 9, 11, 12, 13).

2 juillet: Chardin fils reçoit une gratification de 75 livres (A.N., O^1 1928, dossier 11).

24 juillet, 7 août, 21 août: Chardin est présent à l'Académie (P.V., VII, 1886, p. 17-19).

22 août: Ordre émanant de la Direction générale des Bâtiments du Roi: au «S. Chardin, peintre du Roi, conseiller de son académie royale de peinture et de sculpture, élu par délibération d'icelle du 22 mars 1755 conformément à l'article XIX des statuts à la place de trésorier pour toucher les revenus de ladite académie et en payer les dépenses... En conséquence est proposé lui faire toucher la somme de treize cent trente livres pour le fonds des dépenses des Batimens de sa Majesté... pour les médailles à distribuer aux Elèves de la susdite académie qui y ont remporté les prix... mil livres pour le premier quart de la présent année des menues dépenses et entretiens de ladite académie... cy 2330 livres» (A.N., O^1 1934A, dossier 14).
Cet ordre est confirmé par deux mémoires, l'un pour le paiement du premier quartier, l'autre pour les médailles (A.N., O^1 1921B).

28 août, 25 septembre: Chardin est présent à l'Académie (P.V., VII, 1886, p. 21, 23).

12 octobre: Chardin fils reçoit une gratification de 75 livres (A.N., O^1 1928, dossier 11).

30 octobre, 6 novembre, 27 novembre, 31 décembre: Chardin est présent à l'Académie (P.V., VII, 1886, p. 25-27).
La pension de Chardin s'élevant à 500 livres lui est payée le 31 décembre sur l'exercice de 1755 (A.N., O^1 1934A, dossier 13).

1756: Tableaux datés: la *Table d'office* (n° 103). 175(6?) *Table de cuisine avec un poulet*... (n° 105).

1757

4 janvier: Chardin fils reçoit une gratification de 75 livres (A.N., O^1 1928, dossier 11).

8 janvier, 29 janvier, 5 février: Chardin est présent à l'Académie (P.V., VII, 1886, p. 31-33).

8 février: Payement *au Sieur Chardin* d'une *Ordonnance pour les neuf derniers mois des dépenses de l'Académie Royale de Peinture pendant l'année 1755, à raison de 4 000 par an, de 3 000 livres.* (A.N., O^1 1921B; inédit).

26 février: Chardin est présent à l'Académie (P.V., VII, 1886, p. 33).

1er mars: Payement *au Sieur Chardin* d'une *Ordonnance pour les neuf derniers mois des dépenses de l'Académie Royale de Peinture pendant l'année 1756, à raison de 4 000 livres par an, de 3 000 livres* (A.N., O^1 1921B; inédit).

5 mars: Chardin est présent à l'Académie (P.V., VII, 1886, p. 34).

8 mars: Lettre de Chardin à Marigny: «Les bontés dont vous mavés honoré, autorisent la liberté que je prends de me recommander aujourd'hui à votre protection. Il vaque un logement aux Galleries du Louvre par la mort du sieur Marteau. Si j'étais assés heureux pour l'obtenir, je vous devrois, Monsieur, le seul bien auquel j'aspire: ma reconnaissance seroit infinie, et ne pourra être égalée que par le profond respect avec lequel je seray toute ma vie Monsieur, votre très humble et très obéissant serviteur. à Paris, ce 8 mars 1757» (A.N., O^1 1069, 218; inédit).

13 mars: **Lettre de Marigny à Chardin:** « Je vous apprends avec plaisir, Monsieur, que le **Roy vous accorde le logement vacant aux Galleries du Louvre** par le décès de S. Marteau, vos talents vous avaient mis à portée d'espérer cette grace du Roy, je suis bien aise d'avoir pu contribuer à la faire verser sur vous. Je suis, Monsieur, Votre très humble et très obéissant serviteur» (A.N., O^1 1909, 1757, volume 1, folio 33).
A cette même date, Marigny écrit à Cochin: «Je vous préviens, Monsieur, que le roy accorde au Sieur Chardin, Le logement vacant aux Galleries du Louvre, par le décès du S. Marteau. Je l'en informe par ce Courrier de même que M. Soufflot. Je suis, Monsieur, votre très humble et très obéissant serviteur» (A.N., O^1 1909, 1757, volume 1).

26 mars: Chardin est présent à l'Académie (P.V., VII, 1886, p. 34).

2 avril: Chardin est présent à l'Académie: «M. Chardin, Conseiller, Trésorier de l'Académie, a fait part à la Compagnie de la grâce honorable que le Roy lui accordant en lui accordant un logement aux Galeries du Louvre. La Compagnie lui a témoigné l'intérêt qu'Elle prend à tous les avantages que son mérite et ses talents lui procurent» (P.V., VII, 1886, p. 35).

30 avril: Chardin est présent pour la réddition des comptes et répartition de la capitation de l'Académie (P.V., VII, 1886, p. 36).

15 mai: Cette date figure au bas d'une lettre adressée au Roy, émanant des Galeries du Louvre: «Je supplie très humblement votre Majesté de vouloir bien confirmer par un Bon, la concession qu'Elle a faite au Sieur Chardin de la maison vacante aux Galleries du Louvre, par le décès du Sr Martaut» (A.N., O^1 1069 - 218; inédit).

25 mai: Date figurant en haut de la lettre de Chardin du 8 mars 1757, et sur la lettre du 15 mai 1757. Il semble que ce soit la date du *Bon du Roi* accordant à Chardin son logement, confirmé le 27 mai par le document ci-après.

27 mai: (et non 22 mai) **Brevet de don d'un logement aux Galleries du Louvre pour le Sieur Chardin:** «Aujourd'hui vingt sept may mil sept cent cinquante sept le Roy étant à Versailles voulant gratifier et traiter favorablement le S. Jean Baptiste Chardin, l'un des Peintres de son académie de Peinture et Sculpture, Sa Majesté luy a accordé et fait don du logement vacant aux Galleries du Louvre

par le décès du S. Marteau, Pour par le dit S. Chardin en jouir pendant sa vie, a condition de ne le louer ni ceder a personne sous quelque pretexte que ce soit: Mande Sa majesté au Marquis de Marigny, Commandeur de ses Ordres, Directeur Général de ses batiments de faire jouir le dit Sieur Chardin du contenu au present Brevet que pour assurance de sa volonté Elle a signé de sa main et fait contresigner par moy Conseiller Secrétaire d'Etat et de ses commandements et finances. »

4 juin, 25 juin: Chardin est présent à l'Académie (P.V., VII, 1886, p. 38, 39).

17 juillet: Dans un mémoire présenté à Marigny, Carle Vanloo, Directeur de l'Ecole royale des élèves protégés, propose *le Sieur Pierre Jean Baptiste Chardin de Paris, Peintre âgé de 25 ans qui a remporté le premier prix de Peinture le 31 aoust 1754... élève de M. son père,* pour le voyage d'Italie (A.N., O¹ 1927, dossier 7).

30 juillet, 6 août: Chardin est présent à l'Académie (P.V., VII, 1886, p. 42, 43).

11 août: **Comptes de tutelle rendu par Chardin à son fils. Jean Pierre Chardin renonce à l'héritage.** Ce document mentionne les contrats précédents et confirme la date de la mort de Marguerite Saintard (13 avril 1735). Jean Pierre Chardin est reconnu comme héritier, pour la moitié, de ce que possédait sa mère, et seul héritier de sa sœur Marguerite Agnès, morte en bas âge. Il nous paraît utile de citer quelques extraits des comptes: «Et, en conséquence, ledit sieur Chardin fils fait audit sieur son père, ce acceptant, tous délaissement, cession et abbandonnement nécessaires à titre et compte de communauté, liquidation et partage de succession dud. surplus d'effets restans libres de ceux contenus audit inventaire pour en jouir, faire et disposer en toute propriété par ledit sieur Chardin père comme luy appartenant, au moyen des présentes. Attendu l'insuffisance des biens de lad. communauté, sur laquelle seulle led. Chardin père exerce ses droits, les six mille vingt livres sept sols quatre deniers qui luy restent encore du montant de sesd. reprises de propres fictifs, préciput et autres cy dessus énoncés, tombent en pure perte sur luy, comme il en demeure d'accord...

...led. sieur Chardin fils reconnaît qu'il ne peut prétendre ny demander aucune chose aud. sieur son père à titre de partage de communauté, à laquelle, nonobstant qu'elle luy soit onéreuse et que, par conséquent, il eût eu depuis sa majorité la liberté d'y renoncer, pour, au cas de renonciation de lad. défunte Dᴵᵉ sa mère, demander aud. sieur son père la restitution entière des mille livres de dot par elle apportées aud. mariage sans aucune charge des dettes de ladite communauté. Il n'a point voulu exercer cette faculté qui l'auroit jetté dans des frais d'une renonciation à lad. communauté en pure perte pour luy...

...A l'égard de toutes les dépenses et débours que led. sieur Chardin père a été indispensablement obligé de faire pour led. sieur son fils, pendant le cours de lad. tutelle jusqu'à présent par ses pensions et entretien, frais d'étude, de collège, de dessein et de peinture, et généralement tout ce qui peut concerner l'éducation et mettre un jeune homme à portée de prendre un état honnête et convenable à sa famille, ledit sieur Chardin fils reconnoît que tout ce qui a été consommé pendant vingt-deux ans et demie ou environ qu'a duré la tutelle excede beaucoup tout ce qui pourroit luy revenir et appartenir dans lesdites succession et communauté, quand bien même il s'en seroit tenu à la restitution totale de la dot de mille livres et intérêt...» (A.N., M.C., Étude LXXXII, liasse 366).

12 août: **Jean Pierre Chardin proteste contre la renonciation à la succession de sa mère et de sa sœur que son père lui a fait signer la veille.** Il dépose devant le commissaire Bricogne: «Ce

jourd'hui, 12 août 1757, huit heures du matin, par devant nous Nicolas Barthelemi Bricogne, etc., est comparu sieur Jean-Pierre Chardin, élève protégé du roi dans la peinture, fils majeur de sieur Jean-Siméon Chardin, conseiller et trésorier de l'Académie royale de peinture, demeurant à l'Hôtel royal des pensionnaires de Sa Majesté au Louvre. Lequel nous a dit qu'après la mort de la dame Saintard, sa mère, il a été fait un inventaire; que lui comparant étant sur le point de partir pour Rome pour la continuation de ses études, ledit sieur Chardin, son père, marié en secondes noces, lui a fait entendre que son éducation lui avoit coûté considérablement et qu'il étoit par là dans le cas de renoncer à la succession de la dame sa mère; que lui comparant, comptant sur la bonne foi de son père, a été, du présent mois, avec lui, sur les onze heures du matin, chez M. Desmeures, notaire, où ledit sieur Chardin lui a fait entendre qu'il avoit un acte essentiel à signer; que lui comparant a d'abord hésité à donner cette signature qui lui étoit demandée avec beaucoup d'instance; qu'il a même totalement refusé de la donner; mais, sur les reproches dudit sieur son père qui lui faisoit entendre que c'étoit lui manquer de respect en doutant de sa bonne foi et que d'ailleurs il le contraindroit judiciairement, il s'est déterminé et a signé un acte qui, par la lecture qui lui en a été faite, lui a donné à entendre que c'étoit une renonciation pure et simple à la succession de la dame sa mère; en sorte que, étant sorti de chez ledit Mᵉ Desmeures, lui comparant, a été prendre conseil sur la signature qu'il avoit donné aussi légèrement, et il lui a été conseillé de venir par devers nous à l'effet de protester, comme il fait par ces présentes contre la signature qu'il a donné, etc.» (J.J. Guiffrey, *Courrier de l'Art,* 9 août 1883, nº 32, p. 386-387).

20 août: Chardin est présent à l'Académie (P.V., VII, 1886, p. 44).

25 août-septembre: Chardin expose au Salon: «nº 32: un tableau d'environ 6 pieds représentant des *Fruits et des animaux;* nº 33: deux tableaux, dont l'un représente les *Préparatifs de quelques mets sur une table de cuisine,* et l'autre une *Partie de dessert sur une table d'office.* Ils sont tirés du cabinet de l'École Française de M. de La Live de July» (nᵒˢ 102-103); «nº 34: une *Femme qui écure.* Tableau tiré du cabinet de M. le Comte de Vence» (cf. nº 79); «nº 35: le *Portrait en médaillon de M. Louis,* professeur et censeur royal de chirurgie; nº 36: un tableau d'une *Pièce de gibier avec une gibecière et une poire à poudre.* Tiré du cabinet de M. Damery».

A ce même Salon, J.Ph. Lebas (1707-1783) expose deux estampes *La Bonne Éducation, L'Étude du dessin* (nᵒˢ 94 et 95) d'après les tableaux exposés au Salon de 1753.

27 août, 3 septembre: Chardin est présent à l'Académie (P.V., VII, 1886, p. 45).

9 septembre: Jean Pierre Chardin obtient une gratification de 300 livres afin de partir pour Rome (A.N., O¹ 1921ᴮ). A la même date, Cochin certifie que Jean Pierre a bien remporté le premier prix de l'Académie en 1754 (A.N., O¹ 1927, dossier 7).

13 septembre: **Jean Pierre Chardin reçoit son brevet de pensionnaire à Rome** (*Correspondance des Directeurs,* t. XI, 1901, p. 196).

24 septembre, 1ᵉʳ octobre, 22 octobre, 29 octobre, 5 novembre, 26 novembre: Chardin est présent à l'Académie (P.V., VII, 1886, p. 47-52).

13 décembre: Jean Pierre Chardin est à Rome (*Correspondance des Directeurs,* t. XI, 1901, p. 196).

24 décembre: «Relevé des Sommes ordonnées par Monsieur le Directeur Général le 24 Xᵇʳᵉ 1757 sur les fonds des exercices 1756 et 1757 savoir: Pensions... Chardin conseiller 500.» (A.N., O¹ 1934ᴬ, dossier 14).

31 décembre: Chardin est présent à l'Académie (P.V., VII, 1886, p. 54).

Décembre: Le *Mercure de France* (p. 171) annonce la mise en vente des estampes de J.J. Flipart (1719-1782) d'après la *Dévideuse* et le *Dessinateur* de Chardin (cf. nᵒˢ 68 et 69).

1758

7 janvier, 28 janvier, 4 février, 25 février, 4 mars: Chardin est présent à l'Académie (P.V., VII, 1886, p. 55-59).

18 mars: Chardin est présent à l'Académie, pour l'arrêté du compte de l'exercice de l'année 1757, et le règlement du rôle de la capitation de l'année 1758 (P.V., VII, 1886, p. 60).

20 mars: A la vente Louis Joseph Le Lorrain (1715-1759) organisée par l'artiste au moment de son départ pour la Russie figurent quatre Chardin: des «lapins morts» (nº 5), un grand «héron mort, une *(sic)* caniche et autres attributs de chasse» en largeur, un «déjeuner de café» et un «panier de prunes» (cf. P. Rosenberg, «Louis Joseph Le Lorrain (1715-1759)», in *Revue de l'Art,* 1978, nº 40-41, p. 173-202).

1ᵉʳ avril, 29 avril, 6 mai, 3 juin, 23 juin: Chardin est présent à l'Académie (P.V., VII, 1886, p. 62-66).

27 juin: (et non 31 mai): La souscription pour les gravures d'après des ports de France de J. Vernet (1714-1789) par Lebas et Cochin, est ouverte chez Chardin: «Programme concernant la gravure des Vües Perspectives des ports de france d'après les tableaux appartenant au Roy, peints par M. Vernet... On souscrira chez M. Chardin Trésorier de l'Académie Royale de Peinture et de Sculpture, demeurant aux galeries du Louvre, qui a bien voulû être dépositaire des deniers provenans des souscripteurs. On pourra aussi souscrire chez M. Cochin, aux galeries du Louvre, et chez M. Lebas Rüe de la harpe à la Rose Blanche» (A.N., O¹ 1909, 1758, volume 2, nº 43).

29 juillet, 5 août: Chardin est présent à l'Académie (P.V., VII, 1886, p. 68, 69).

17 août: Chardin témoigne de la folie d'André Rouquet, peintre émailleur du Roi, qui voulait mettre le feu aux logements du Louvre. A la suite de sa déposition, ainsi que de celles de Cochin, Sylvestre, Restout, Germain et La Tour, Rouquet sera conduit à l'hospice de Charenton (Guiffrey, 1885, p. 254-267).

23 août, 26 août, 2 septembre, 30 septembre: Chardin est présent à l'Académie (P.V., VII, 1886, p. 69, 70, 73).

1ᵉʳ octobre: Sur la liste alphabétique de messieurs les élèves de l'Académie Royale de Peinture et de Sculpture commencée le 1ᵉʳ octobre 1758, on trouve page 5:
Chardin, S.: protégé par Chardin son oncle, demeure chez son père, ébéniste, rue Princesse...
Il s'agit de Sébastien Chardin, sculpteur, fils de Juste Chardin et de Geneviève Barbiez.

21 décembre: Chardin est témoin au contrat de mariage d'Edme Dumont (1722-1775) avec Marie Françoise Berthault (*Nouvelles Archives de l'Art Français,* 1877, p. 248-258).

30 décembre: Chardin est présent à l'Académie (P.V., VII, 1886, p. 79).

1758: Sur l'exercice 1758 destinés au payement des Pensions des Peintres de l'Académie Royale de Peinture, la pension de Chardin s'élève toujours à 500 livres (A.N., O¹ 1934ᴬ, dossier 16).

1758: Parution d'une estampe gravée par Antoine Schlechter, d'après le *Portrait d'Andréas Levret* de Chardin, exposé au Salon de 1746 sous le numéro 74 (tableau disparu).

1758: Tableaux datés: le *Bocal d'abricots* (nº 110), la *Corbeille de pêches* (collection Reinhart).

14 janvier, 27 janvier, 3 février, 17 février, 3 mars : Chardin est présent à l'Académie (P.V., VII, 1886, p. 81-84).

18 mars : Le gobelet d'argent de Chardin lui est dérobé dans son logement au Louvre : «Monsieur François Renaud, âgé de cinquante six ans, natif de Villepinte près Gonesse, domestique sans condition depuis un an qu'il est revenu de Toulon où il avait été dix ans au service de M. de Chastenay, capitaine de vaisseaux», est l'auteur de ce méfait. Les procès-verbaux et dépositions relatifs à ce vol, datant du 25 mars, 27 mars, 1er avril, 8 avril, conservés à Paris (Bibliothèque de l'Arsenal, Archives de la Bastille, carton 12051, p. 92-102), donnent quelques renseignements sur la vie de l'artiste. Son logement aux Galeries du Louvre était situé vis-à-vis de l'église Saint-Thomas (détruite). Le ménage avait alors à son service une domestique nommée Jeanne Berthier. Le voleur déclare qu'ayant trouvé la porte de l'appartement ouverte et personne à l'intérieur, il avait dérobé un *Goblet à pied gaudronné sur le bord duquel sont les lettres J.C.*, posé dans une cuvette en faïence, et avait couru le revendre au Pont-Neuf à une bouquetière pour 30 livres (la valeur du gobelet d'argent représente 6 % de la pension annuelle de l'artiste).

31 mars : Chardin est présent à l'Académie pour la répartition de la capitation et la reddition des comptes (P.V., VII, 1886, p. 83-84).

7 avril, 28 avril, 5 mai, 26 mai, 2 juin : Chardin est présent à l'Académie (P.V., VII, 1886, p. 86, 89, 90, 92).

4 juin : Le journal intitulé *La Feuille Nécessaire* (p. 260-261) annonce que l'on peut voir chez l'abbé Trublet (1697-1770) deux tableaux de Chardin représentant des natures mortes (cf. nos 108 et 109).

30 juin, 7 juillet, 28 juillet, 23 août : Chardin est présent à l'Académie (P.V., VII, 1886, p. 94, 97, 99, 100).

25 août : Chardin expose au Salon du Louvre : «no 35 : un tableau d'environ 7 pieds de haut sur 4 pieds de large, représentant un *Retour de chasse*. Il appartient à M. le Comte Du Luc ; no 36 : deux tableaux de 2 pieds 1/2 sur 2 pieds de large, représentant des *Pièces de gibier avec un fourniment et une gibecière*. Ils appartiennent à M. Trouard, architecte ; no 37 : deux tableaux de *Fruits* de 1 pied 1/2 de large sur 13 pouces de haut. Ils appartiennent à M. l'abbé Trublet (nos 108 et 109) ; «no 38 : deux autres tableaux de *Fruits*, de même grandeur que les précédents, du cabinet de M. Silvestre, maître à dessiner du Roi» (no 106) ; «no 39 : deux petits tableaux de 1 pied de haut sur 7 pouces de large ; l'un représente un *Jeune dessinateur*, l'autre une *Fille qui travaille en tapisserie*. Ils appartiennent à M. Cars, graveur du Roi».

27 août : La *Feuille Nécessaire* (p. 457) publie la suite du catalogue des Estampes de M. Lebas, Graveur du Roi :
«De M. Chardin, Peintre du Roi :
Le Négligé, ou la Toilette du Matin 1 livre 10 sols
L'Œconome 1 livre 10 sols
La Bonne Éducation 1 livre 10 sols
Étude du Dessein 1 livre 10 sols
Il y a chez M. *Le Bas* un Tableau de ce même Peintre, qui mérite l'attention des Curieux : on assure que l'Auteur n'en a fait aucun où il y ait un aussi grand nombre de Figures. Il étoit destiné à servir de plafond à la demeure d'un Chirurgien. On y voit une bagarre de gens qui se battent à l'épée, un jeune homme blessé que le Chirurgien panse, et qu'un prêtre exhorte à la mort, le Commissaire, le Guet, la populace, et des gens aux fenêtres. Tant de personnes en action, rendent ce Tableau extrêmement

animé. L'expression y est partout très variée. Il est d'un bon ton de couleur. Les Talens de l'auteur sont assez connus, et sa modestie ne fait qu'en rehausser l'éclat.»
Il s'agit de l'*Enseigne du chirurgien*, œuvre de jeunesse de Chardin, dont le souvenir nous est conservé par la gravure de Jules de Goncourt d'après l'esquisse, disparue avec l'incendie de l'Hôtel de Ville en 1871. C'est ce tableau que J.Ph. Lebas mentionnait au graveur Rehn (1717-1793 ; voir ici à la date du 10 janvier 1746).

1er septembre, 7 septembre : Chardin est présent à l'Académie (P.V., VII, 1886, p. 103-104).

19 septembre : Lettre de Natoire, directeur de l'Académie de France à Rome, à Marigny au sujet de l'obstination du fils Chardin à vouloir une certaine chambre à coucher, au Palais Mancini (*Correspondance des Directeurs*, t. XI, 1901, p. 307-308).

28 septembre, 6 octobre : Chardin est présent à l'Académie (P.V., VII, 1886, p. 105).

19 octobre : Lettre de Caroline Louise, Margravine de Bade, au conseiller Fleischmann, résidant à Paris : «Puisque vous êtes lié, Mons. avec l'Abbé Trublet, je serais charmée d'apprendre par vous ce qu'il a payé à Mr Chardin de deux petits tabl. dont l'un représente un verre d'eau, des cerises, et dont je sais quelques autres fruits encore. Vous serez surpris Monsieur que j'ai connaissance de ces peintures, c'est que j'en ai vu l'éloge dans une petite brochure périodique où l'on parle des beaux arts ; ne voilà-t-il pas abuser de votre complaisance, Mr ? — je sais que vous me le pardonnez et que vous ne cessez d'être persuadé de cette estime... etc.» (Kircher, 1933, p. 107-108 ; nos 108-109 du présent catalogue ; pour les Chardin de Caroline Louise de Bade, voir le no 18).

27 octobre : Réponse du conseiller Fleischmann à la Margravine Caroline Louise : «Les tableaux que Chardin a faits pour l'Abbé Troublet sont point actuellement chez ce dernier. On les avait montrés à l'exposition des tableaux du Louvre et depuis Chardin les en a retirés et les a gardés chez lui. Cet habile peintre étant de mes amis depuis plus de dix ans vous pouvez Madame compter avoir des répétitions de lui, qui ne vous coûteront guères plus que l'abbé n'en a payé pour les siens, quoiqu'il m'ait prié de le dispenser de m'en accuser le prix qu'il en a donné. Les temps sont mauvais pour tous les gens et singulièrement pour les artistes. On quitte aujourd'hui l'agréable pour s'en tenir à l'utile, même pour se réduire au nécessaire. Pour peu donc que V.A.S. soit d'humeur de se donner de ces petits morceaux curieux, je me fais fort de les lui procurer au meilleur marché possible» (Kircher, 1933, p. 108). Caroline Louise répond à cette lettre (sans date) : «Je vous suis très obligée Monsieur d'être entré en détail sur les deux tableaux du Sr. Chardin, j'apprends avec plaisir que vous êtes de ses amis, tâchez de tirer de lui par manière de discours ce qu'il demanderait d'un petit tableau» (en marge de la lettre, «d'une ou deux figures») «mais fini. Je vous l'avouerai tout unaniment Mrs, que je viens d'acheter en entier un bien bon cabinet de tableaux que les calamités de la guerre ont fait vendre ; et cela m'a mené à une dépense très considérable, ainsi que je me vois encore forcée de me refuser encore pour un temps tout ce qui serait fort cher, cependant si je pouvais avoir quelque ouvrage de Chardin je serais au comble de ma joie. Votre liaison Mons. avec le Sr. Chardin m'a fait naître cette idée, mais pour peu que vous trouverez des difficultés ne craignez point de me le dire. Je ne connais point le prix de cet artiste, on me l'a fort loué, mais en même temps on me l'a dit d'une cherté épouvantable. Vous n'oseriez donc pas me nommer dans tout ceci Mons. Vous connaissez vos français ils sont d'une facilité et d'une politesse

que l'on est embarqué avec eux lorsqu'on le pense le moins, il ne conviendrait alors plus pour moi de reculer et cela m'engagerait dans une dépense qu'actuellement je dois éviter ; mais ayant vu de ses ouvrages et sachant leurs prix je pourrai alors prendre mes arrangements là-dessus» (Kircher, 1933, p. 108).
Ce même jour Chardin est présent à l'Académie (P.V., VII, 1886, p. 107).

10 novembre, 24 novembre : Chardin est présent à l'Académie (P.V., VII, 1886, p. 108-109).

1er décembre : Chardin est présent à l'Académie : «Le Secrétaire a déclaré à la Compagnie que M. le Comte de Caylus, Honoraire Amateur, a remis à M. Chardin, Trésorier de l'Académie, la somme de deux cent livres, destiné au Prix proposé pour l'Étude d'une teste d'expression, lequel Prix sera de cent livres ; le reste de cette somme sera employée aux frais du Modèle et autres nécessaires à cet objet. L'Académie a marqué à M. le Comte de Caylus la plus vive reconnaissance d'une générosité si digne de lui, qui ouvre aux Élèves de nouvelles sources d'émulation dans une étude si importante, qui, jusqu'à ce jour, n'avoit été excitée dans aucune Académie par des moyens si efficaces» (P.V., VII, 1886, p. 109).

28 décembre : Lettre de Caroline Louise, Margravine de Bade, à l'architecte La Guêpière (1715?-1773) : «...Je viens maintenant aux tableaux ; ils arrivèrent mercredi au soir, j'en suis extrêmement contente, et je ne saurais assez vous témoigner ma reconnaissance.
Les Bacheliers sont beaux, mais les *deux Chardins* l'emportent, ils sont admirables. Vous en aurez reçu les comptes, je vous prie Mons. de me les renvoyer ainsi que les ports de lettre et autres frais. Vous me direz aussi si vous voulez que j'en fasse faire le payement à Paris p. Mr. Kornmann ou comment. Je ne vois l'heure que de vous les montrer et de vous assurer de bouche de ces sentiments de reconnaissance, d'estime et de considération avec lesquels je ne cesserai de vous honorer...» (Kircher, 1933, p. 110. Il s'agit du no 18 du présent catalogue et de son pendant).

31 décembre : Chardin est présent à l'Académie (P.V., VII, 1886, p. 113).

1759 : «Sommes proposées sur les fonds de l'exercice 1759 destinées au payement des Pensions accordées aux Peintres... Conseillers *J.B. Chardin 500*» (A.N., O1 1934A, dossier 17, 1759, document 11).
«Sommes proposées sur les fonds de l'exercice 1759 destinées au payement des honoraires de l'Académie royale de peinture et sculpture, savoir... *S. Chardin*, Peintre du Roi en son Académie, chargé des Recettes et Dépenses de lad. Académie quatre mille livres po. l'année entière 1759, des menues dépenses et entretien d'icelle, cy 4000» (A.N., O1 1934A, dossier 17, 1759, document 16).

1759 : «Somme proposée sur les fonds de l'exercice 1759 destinée au service de l'Académie Royale... *S. Chardin*, peintre du Roi et conseiller de son académie, Trésorier par Délibération d'icelle, treize cent trente livres pour les fonds fait dans l'État des dépenses des batiments de sa Majesté de l'année 1759. destiné pour les médailles distribuées aux Élèves peintres et sculpteurs, qui ont remporté les prix cy... 1330» (A.N., O1 1934A, dossier 17, 1759, document 17).

1759 : Dans l'édition avec supplément de son *Dictionnaire portatif des Beaux-Arts*, Lacombe (1724-1801) note aux pages 3 et 4 de son supplément : *CAZES Pierre Jacques... le célèbre Le Moine a été un des Élèves de M. Cazes, ainsi que M. Chardin, dont les talens sont si aimables et si estimés.*

5 janvier : Chardin fait partie du Comité chargé de régler les arrangements à prendre en ce qui concerne le Prix accordé par M. le Comte de Caylus pour l'expression des passions (P.V., VII, 1886, p. 114).

16 janvier : «Payement au sieur Chardin d'une ordonnance pour les médailles qui ont été distribuées aux Élèves de l'Académie Royale de Peinture pendant l'année 1757... de 1330 livres» (A.N., O[1] 1921[B]).

26 janvier, 9 février, 23 février, 1er mars : Chardin est présent à l'Académie (P.V., VII, 1886, p. 118, 124-125).

29 mars : Chardin est présent à l'Académie pour la reddition des comptes et la répartition de la capitation, qui cette année-là est doublée (P.V., VII, 1886, p. 125-126).

12 avril, 26 avril, 3 mai, 31 mai, 7 juin : Chardin est présent à l'Académie (P.V., p. 129-136).

21 juin : Chardin assiste chez le comte de Caylus à la signature du contrat par lequel le comte fait don à l'Académie royale de peinture et sculpture d'un prix pour les figures d'expression. Il reçoit 113 livres 10 sols 8 deniers (Monnot, 1880-1881, p. 210-219).

28 juin, 5 juillet, 26 juillet : Chardin est présent à l'Académie (P.V., VII, 1886, p. 137-139).

31 juillet : Chardin reconnaît avoir reçu du comte de Caylus la somme de 86 livres, 13 sols, 4 deniers (Monnot, 1880-1881, p. 210-219).

2 août : Chardin est présent à l'Académie (P.V., VII, 1886, p. 140).

10 août : Lettre de Vien (1716-1809) adressée à Desfriches (1715-1800) : «Monsieur, j'ai appris par M. Chardin, vostre ami et le mien, que don prieur de Bonne Nouvelle n'estoit point content du Christ qui est dans mon tableau, ou du moins qu'il desirait qu'il fût vêtu... » (Ratouis de Limay, 1907).

14 août : Le graveur J.G. Wille (1715-1808) note dans son *Journal* à cette date : «J'ai acheté deux petits tableaux de M. Chardin, sur l'un il y a un chaudron renversé, des oignons et autres ; sur l'autre un chaudron et un poêlon et autres, très bien faits, trente six livres ; c'est bon marché, aussi me les a-t-on cédés par amitié» (n° 50).

23 août, 30 août : Chardin est présent à l'Académie (P.V., VII, 1886, p. 142-143).

Août : Le *Mercure de France* (p. 195) annonce que Chardin reçoit une médaille de la Reine de Suède, Louise Ulrique, en remerciements des estampes d'après l'*Étude du Dessin* et la *Bonne Éducation* (n[os] 94-95), qu'il lui a dédiées.

6 septembre, 27 septembre, 4 octobre, 25 octobre, 27 octobre, 8 novembre, 6 décembre, 31 décembre : Chardin est présent à l'Académie (P.V., VII, 1886, p. 144-147, 149-152).

1760 : «État Général et alphabétique des ouvrages de Peinture, Sculpture et Dépenses relatives à ces Arts ; avec une colonne des Estimations, acomptes et debets desdits ouvrages tant terminez et livrez que commencez... ju:qués et compris les six premiers mois de l'Année 1760.
Direction M. de Marigny — Artiste Chardin — Un tableau dont le sujet est au choix de l'auteur qu'il lui ordonné en 1755 pour faire pendant à celui qu'il a fait pour le service du Roi gravé sous le titre d'une Dame variant ses amusements. Estimé... 1 500 livres. L'auteur travaille à ce morceau» (O[1] 1921 ; inédit).

1760 : Cette année-là, La Tour exécute un *Portrait de Chardin* au pastel (Paris, musée du Louvre, Cabinet des Dessins) et l'expose au Salon de 1761, «n° 47 Plusieurs tableaux en pastel sous le même numéro».

1760 : Tableaux datés : le *Melon entamé* (n° 111), *Faisan mort avec gibecière* (n° 112), le *Bocal d'olives* (n° 114).

10 janvier : Chardin est présent à l'Académie (P.V., VII, 1886, p. 155).

14 janvier : La pension de Chardin sur l'exercice de 1754 est enfin payée (A.N., O[1] 1934[B], dossier n° 14).

31 janvier, 7 février, 28 février, 7 mars : Chardin est présent à l'Académie (P.V., VII, 1886, p. 156-158).

28 mars : Chardin est présent à l'Académie pour l'examen et l'arrêt des comptes de son exercice pendant l'année 1760.
À cette même séance, «M. Surugues le fils, Graveur, Académicien, a présenté une estampe qu'il a gravée d'après M. Chardin, représentant l'*Aveugle*, pour jouir du privilège accordé à l'Académie par l'Arrest du Conseil du· 28 juin 1714» (P.V., VII, 1886, p. 160). Il s'agit du tableau exposé au Salon de 1753 sous le n° 61.

4 avril, 25 avril, 2 mai, 30 mai, 6 juin : Chardin est présent à l'Académie (P.V., VII, 1886, p. 161, 164-167).

19 juin : Chardin signe une pétition, avec ses camarades Cochin, Desportes, La Tour, Restout, Bailly, adressée à Marigny : «Les artistes des galleries du Louvre, suplient, Monsieur, de bien vouloir faire attention à la justice de leur demande énoncée dans le mémoire cy-joint. La communauté des maîtres peintres de Saint-Luc attaquent leurs privilèges accordés de temps immémorial, autorisés par le Roy Louis Quatorze ; Ils joignent icy tant copie des lettres enregistrées en parlement que dans les autres Cours ; Ils se flattet, monsieur, que vous voudrez bien les honorer avec votre protection, et comme leur supérieur né, intervenir en cette cause» (A.N., O[1] 1909, 1761, volume 5).

27 juin, 4 juillet : Chardin est présent à l'Académie (P.V., VII, 1886, p. 168-169).

13 juillet : Lettre de Cochin adressée à Marigny :
Chardin s'occupera désormais, officiellement, de l'arrangement du Salon :
«Par une note de votre main en réponse à une lettre que j'eus l'honneur de vous écrire, en novembre 1759, à l'occasion de la mort de M. Portail, vous me fites l'honneur de me marquer que vous régleriés l'affaire de l'arrangement du Salon ainsi que j'avois l'honneur de vous le proposer. Je vous représentois que je croyois que si vous vouliés bien régler à cette mutation, que ce seroit dorénavant le trésorier de l'Académie (présentement M. Chardin) qui seroit chargé de ce soin ; le Salon pourroit être mieux arrangé et plus à la satisfaction de l'Académie, parce qu'il seroit plus à portée d'y vacquer par sa demeure à Paris ; et par son rang dans l'Académie, de concilier les esprits en leur conservant les droits d'ancienneté dont les artistes sont jaloux, sans préjudicier à l'agrément du coup d'œil. J'ajoutois qu'il me paraissoit que ce n'étoit point diminuer les droits de la place de garde des tableaux qui ne compte comme un avantage, et qui n'est plutost qu'un déplacement onéreux, attendu sa permanence nécessitée à Versailles.
Il est vray que nous ignorions alors si ce seroit un homme de l'Académie qui en seroit pourvu, et qu'ayant depuis été accordée à M. Jeaurat, estimé dans la compagnie, cela ôterait l'inquiétude qu'on pouvoit avoir d'être sous la loy d'un étranger à ce corps ; mais, outre que M. Jeaurat, à qui j'ay fait part de ce que vous avez décidé sur ce sujet, m'a paru acquiescer à cet arrangement, je persiste à penser qu'il est mieux pour l'Académie que ce soin soit donné à un membre qui, nécessairement, est un des principaux officiers de son corps, qu'attaché à une place qui dans d'autres temps pourroit être donné, à des personnes qui lui seroient absolument étrangères.

Si donc, Monsieur, vous confirmés ce que vous arrangeates alors, je vous supplie de vouloir bien donner vos ordres à M. Chardin sur ce sujet.» (A.N., O[1] 1925[B], dossier 7, 1761).
En haut de cette lettre figure une note de Marigny : «Je décide que dorénavant ce sera le Trésorier de l'Académie qui sera chargé du détail qui était confié à feu M. Portail concernant l'exposition susdite».

19 juillet : Lettre de Marigny adressée, de Versailles, à Cochin : «L'intention du Roi, est, étant qu'il y ait exposition de tableaux et de modèles cette année au Sallon du Louvre, dans le tems accoutumé : vous aurez agréable d'en informer de ma part, Mrs de l'Académie, afin qu'ils fassent en committé le choix des ouvrages qu'ils jugent dignes d'y être placés et dont j'ai décidé que l'arrangement serait fait à l'avenir par le Trésorier de l'Académie qui sera désormais chargé de ce Détail, qui avait été confié à feu M. Portail» (A.N., O[1] 1925[B], dossier n° 7 ; inédit).

24 juillet : Cochin lit la lettre de Marigny du 19 juillet à la séance de l'Académie (P.V., VII, 1886, p. 170).

1er août : Chardin est présent à l'Académie (P.V., VII, 1886, p. 173).

19 août : Jean Pierre Chardin ne participe pas aux envois d'œuvres que les artistes se devaient de faire de Rome (*Correspondance des Directeurs*, t. XI, 1901, p. 392).

22 août : Chardin est présent à l'Académie (P.V., VII, 1886, p. 173).

24 août : Paiement à Chardin de 1 330 livres pour les médailles d'or et d'argent distribuées aux élèves qui ont remporté les prix de l'année 1758 ; Ordre de paiement de la pension de Chardin sur l'exercice de 1758 (A.N., O[1] 1934[A], dossier 16).

25 août : Chardin expose au Salon du Louvre : «n°42 : le *Bénédicité*. Répétition du tableau qui est au Cabinet du Roi, mais avec des changements. Il appartient à M. Fortier, notaire ; n° 43 : plusieurs tableaux d'*Animaux*. Il appartiennent à M. Aved, conseiller de l'Académie ; n° 44 : un tableau représentant des *Vanneaux*. Il appartient à M. Silvestre, maître à dessiner du Roi ; n° 45 : deux tableaux de forme ovale. Ils appartiennent à M. Roettiers, orfèvre du Roi» (n[os] 110 et 111) ; «n° 46 : autres tableaux du même genre sous le même numéro» (n° 115).
À ce même Salon, Surugue expose sa gravure de l'*Aveugle* d'après Chardin, qu'il avait présentée à l'Académie le 28 mars.

29 août : Chardin est présent à l'Académie (P.V., VII, 1886, p. 175).

5 septembre : Chardin est présent à l'Académie. On y lit une lettre insultante d'Oudry adressée à Chardin. Il s'agit de Jacques Charles Oudry fils (1720-1778), et non du grand Oudry (qui meurt en 1755), comme on a pu l'écrire (Wildenstein, 1963, préface, p. 32) : «Le Secrétaire a fait lecture d'une lettre adressée par M. Oudry, Académicien, à M. Chardin, Conseiller, chargé par le Roy de l'arrangement des tableaux au Salon, laquelle le Sieur Oudry se plaint du jugement des Commissaires de l'Académie en termes insultans et pour Elle et pour M. Chardin. Cette lecture ouïe, l'Académie a ordonné à son Secrétaire d'écrire de sa part au Sr Oudry, pour lui déclarer qu'Elle lui interdit l'entrée de ses assemblées, jusques à ce que, par de justes réparations, il ait satisfait tant à l'Académie qu'à M. Chardin ; préalablement, Elle a ordonné que les deux tableaux de lui qui sont au Salon en seront ôtés» (P.V., VII, 1886, p. 176).

13 septembre : Lettre de Chardin adressée à Marigny : «Je viens d'apprendre par M. Cochin, qui saisit avec empressement les occasions de m'obliger, qu'il se trouvera dans la pension de Rome une vacance de six mois. Mr Cochin plus au fait que moi,

aura l'honneur de vous instruire de ce qui y donne lieu.

Serais-je assez heureux, Monsieur, pour que dans ce cas, vous daigniassiez m'accorder la grace de faire tourné ce tems dont ce tems dont l'un des Élèves ne pourra jouir, au profit de mon fils dont la pension va expirer. C'est sur les preuves de bontés dont vous m'avez déjà honoré, que j'ose hazarder de vous faire cette prière. Je suis avec respect, Monsieur...» (Paris, Institut Néerlandais, 1977-A-44 ; inédit).

16 septembre : Jean Pierre Chardin copie une œuvre du Dominiquin à l'église Saint-Silvestre, à Rome (*Correspondance des Directeurs*, t. XI, 1901, p. 395).

25 septembre : Jean Pierre Chardin, malgré la demande de son père du 13 septembre, ne bénéficie pas d'un prolongement de son séjour à Rome (*Correspondance des Directeurs*, t. XI, 1901, p. 396).

26 septembre : Chardin est présent à l'Académie pour la lecture de la lettre d'excuses d'Oudry fils : «Le Secrétaire a fait lecture d'une lettre de M. Oudry, Peintre, Académicien, par laquelle il s'excuse des termes, peu mesurés à l'égard de l'Académie, qui lui étoient échappés dans sa lettre à M. Chardin. La Compagnie, informée en même temps qu'il avoit pareillement satisfait à M. Chardin, l'a rétabli dans le droit d'assister à ses assemblées dont elle l'avoit interdit à l'assemblée précédente» (P.V., VII, 1886, p. 177).

3 octobre, 31 octobre, 7 novembre : Chardin est présent à l'Académie (P.V., VII, 1886, p. 179, 181, 182).

11 novembre : Jean Pierre Chardin travaille toujours à l'église Saint-Silvestre, à Rome. Natoire se plaint à Marigny de sa lenteur et de son manque d'habileté (*Correspondance des Directeurs*, t. XI, 1901, p. 403).

28 novembre, 5 décembre : Chardin est présent à l'Académie (P.V., VII, 1886, p. 183, 184).

22 décembre : L'ordre de paiement des pensions sur l'exercice 1758, qui avait été donné le 24 août, est suspendu (A.N., O¹ 1934ᴬ, dossier 16).

31 décembre : Chardin est présent à l'Académie (P.V., VII, 1886, p. 185).

1761 : Tableaux datés: *«Pêches, raisins, etc., sur une table»* (vente P.H. Lemoyne, 19 mai 1828, n° 62 ; à ne pas confondre avec le n° 321 du Wildenstein 1963-1969).

1762

9 janvier, 30 janvier : Chardin est présent à l'Académie (P.V., VII, 1886, p. 187).

Janvier : La gravure de Lépicié d'après le *Château de cartes* de Chardin (n° 71) est reproduite dans le *British Magazine* de ce mois (n° 32), accompagnée d'un texte la commentant et l'interprétant comme l'illustration du thème de la vanité des entreprises humaines. Il est signalé que cette gravure sera donnée gratuitement à tous les abonnés du *British Magazine*.

6 février : Chardin est présent à l'Académie (P.V., VII, 1886, p. 188).

10 février : Une lettre de Natoire à Marigny nous apprend que Jean Pierre Chardin est encore à Rome et attend la fin de la mauvaise saison pour revenir à Paris (*Correspondance des Directeurs*, t. XI, 1901, p. 412).

27 février, 6 mars : Chardin est présent à l'Académie (P.V., VII, 1886, p. 189).

17 mars : Chardin reçoit 1 330 livres de la Direction générale des Bâtiments du Roi, en paiement des dépenses de l'exercice 1759 destinées aux *médailles distribuées aux peintres et sculpteurs qui ont remporté les prix.* Cet ordre (A.N., O¹ 1934ᴬ, dossier 17) est doublé d'une ordonnance de remboursement (A.N., O¹ 1921ᴮ).

27 mars : Chardin est présent à l'Académie pour l'examen et l'arrêté des comptes de son exercice pendant l'année 1761 (P.V., VII, 1886, p. 190).

3 avril : Chardin est présent à l'Académie (P.V., VII, 1886, p. 191).

6 avril : Chardin reçoit sa pension de 500 livres sur les fonds de l'exercice 1759, ainsi que 4 000 livres pour les menues dépenses et l'entretien de l'Académie pour l'année 1759 (A.N., O¹ 1934ᴬ, dossier 17).

24 avril, 8 mai : Chardin est présent à l'Académie (P.V., VII, 1886, p. 192, 193).

29 mai : Chardin est présent à l'Académie. L'Assemblée le charge, ainsi que G. Coustou (1716-1777), d'aller visiter M. Pigalle, dangereusement malade. L'Académie ne pouvait choisir meilleur représentant, quand on sait les liens d'amitié qui unissaient Chardin à Pigalle (P.V., VII, 1886, p. 193).

5 juin, 26 juin, 3 juillet : Chardin est présent à l'Académie (P.V., VII, 1886, p. 196, 197).

21 juillet : Une lettre de Natoire adressée de Rome à Marigny nous apprend que **Jean Pierre Chardin a été enlevé par des corsaires près de Gênes, alors qu'il revenait en France.**

«Le Sr Chardin, s'étant embarqué issy pour s'en retourner en France, a eu le malheur d'être pris, luy et l'équipage, près de Gênes, par les corsaires anglois. On nous apprend que le consul françois de cette République fait son possible pour donner du secour à ces pauvres infortunés, et fait le procès audit corsaire, disant que la prise n'est pas bonne, attendu que cette capture s'est faite presque au port de Gênes» (*Correspondance des Directeurs*, t. XI, 1901, p. 429).

30 juillet, 7 août : Chardin est présent à l'Académie (P.V., VII, 1886, p. 198-199).

8 août : Marigny répond à la lettre de Natoire du 21 juillet : «L'aventure du Sr Chardin est très fâcheuse ; il est à désirer que M. Regny, consul de France à Gênes, puisse faire décider que la prise n'est pas bonne, afin qu'il recouvre sa liberté» (*Correspondance des Directeurs*, t. XI, 1901, p. 439).

21 août, 28 août, 4 septembre, 25 septembre, 2 octobre : Chardin est présent à l'Académie (P.V., VII, 1886, p. 200, 201, 202, 204, 205).

7 octobre : Ordre est donné par la Direction générale des Bâtiments du Roi de verser 1 330 livres à Chardin :
«Au Sieur Chardin, une ordonnance en datte du 7 8ᵇʳᵉ 1762... pour les médailles qu'il a fournies pour les Elèves de l'Académie qui ont remporté les prix en l'année 1760» (A.N., O¹ 1921ᴮ).

9 octobre : Lettre de Marigny adressée, de Fontainebleau, à Cochin : «M. Chardin, Monsieur, recevra par ce même courrier une ampliation d'ordonnance de 1 330 livres, expédiée en son nom ; vous en préleverés 831 liv. 2s. 9d. pour le payement à M. de Cotte des médailles fournies le 11 7ᵇʳᵉ dernier, et que je lui ay promis sous peu de jours. Je suis, etc.» (A.N., O¹ 1910, volume 1, document 142).

15 octobre : L'abbé Pommyer, grand amateur de Chardin, demande, dans une lettre à La Tour, de dire «mille choses à M. et Mme Chardin» (Desmaze, 1874, p. 9).

30 octobre, 6 novembre, 27 novembre, 4 décembre, 31 décembre : Chardin est présent à l'Académie (P.V., VII, 1886, p. 205-207, 208, 209, 210, 211).

1763

8 janvier, 29 janvier : Chardin est présent à l'Académie (P.V., VII, 1886, p. 213).

4 février : Cochin demande à Marigny de bien vouloir partager la pension de Vanloo (de 1 000 livres) entre Vien d'une part, et Chardin d'autre part, pour le dédommager du travail qu'il fournit au moment de l'accrochage du Salon :

«Je profiteray de cette occasion pour vous mettre sous les yeux une chose qui me sembleroit avoir quelque justice. L'Académie souhaittoit que l'arrangement du Salon fût confié à quelqu'un de son corps qui pût être présent à Paris. Vous avés eu la bonté d'accorder que ce seroit M. Chardin. Il en a été charmé lui-même, regardant cette confiance comme une marque de l'Estime dont vous voulés bien l'honorer. Je croyois lorsque j'eus l'honneur de vous la demander pour lui, qu'il y avoit quelque honoraire ou gratification attaché à ce service ; mais jusques alors il avoit été regardé comme un des devoirs d'une place (la place de garde des plans et tableaux, qu'occupoit M. Portail), assés bien récompensée d'ailleurs pour supporter cette sujétion. M. Chardin ne forme aucune idée à ce sujet, il Remplit ce devoir avec autant de plaisir que s'il y avoit quelque récompense attachée. Il paroit même singulièrement sensible et inquiet même jusqu'à l'excès à chaque fois de sçavoir si vous avés été satisfait, mais je crois devoir y penser pour lui, et devoir vous faire cet exposé à son insçu, d'autant plus que je vois que cela lui dérobe beaucoup plus de temps qu'il n'en coûtot à M. Portail, qui après avoir employé quelques jours nécessaires pour l'arrangement général étoit à l'abry de toute persécution en se réfugiant à Versailles, au lieu que M. Chardin est obligé d'être continuellement occupé de cette affaire pendant tout le temps que dure le Salon.

Je pense que (sans rien déranger à l'ordre ordinaire des choses ni créer aucuns nouveaux honoraires) s'il vous plaisoit joindre à la pension dont il jouit déjà, une de ces deux pensions dont vous allés disposer, ce seroit un moyen de le dédommager du temps qu'il sacrifie, qui ne paroistroit point déplacé parce que c'est un des anciens de l'Académie» (Furcy-Raynaud, 1904, p. 255-256 ; copie, A.N., O¹ 1910, 1763, volume 2).

6 février, 26 février : Chardin est présent à l'Académie (P.V., VII, 1886, p. 214).

28 février : Cochin dans une lettre à Marigny réitère sa demande de pension pour Chardin, ne demandant cette fois que 250 livres, au lieu de 500 le 4 février : «Je crois toujours que M. Chardin, faisant le service du Salon qui lui prend du temps, il seroit juste qu'il en fût récompensé par une augmentation de pension. Quand elle seroit de 500 liv., comme j'avois d'abord eû l'honneur de vous le proposer, personne ne la trouveroit mal placée. Cependant, comme jusqu'à présent ce service n'a été que tous les deux ans, il pourroit être suffisamment dédommagé en lui accordant une augmentation de 250 liv.» (Furcy-Raynaud, 1904, p. 260 ; copie de cette lettre en date du 8 mai 1763, avec en marge le *Bon* du Roy, A.N., O¹ 1923ᴮ 164 verso et 165).

5 mars : Chardin est présent à l'Académie (P.V., VII, 1886, p. 215).

26 mars : Chardin est présent à l'Académie pour l'examen et l'arrêté de son exercice pendant l'année 1762 (P.V., VII, 1886, p. 216).

9 avril, 30 avril : Chardin est présent à l'Académie (P.V., VII, 1886, p. 217, 218).

5 mai : Marigny annonce à Cochin que le Roi accorde 200 livres par an à Chardin (Furcy-Raynaud, 1904, p. 265).

A cette même date, **Marigny écrit à Chardin** pour le lui annoncer : «**J'ai obtenu du Roy, pour vous, Monsieur, 200 livres par an en considération des soins et peines que vous prené lors de l'Exposition des tableaux au Louvre,** Regardé ce petit avantage comme un témoignage du désir que j'ay de vous obliger» (Copie ; A.N., O¹ 1110, 1763, p. 219).

7 mai, 4 juin, 25 juin : Chardin est présent à l'Académie (P.V., VII, 1886, p. 219, 221, 223).

29 juin : Paiement à Chardin d'une ordonnance de 1 330 livres pour les médailles des Elèves de

l'Académie qui ont remporté les prix en l'année 1761 (A.N., O[1] 1921[B]).

2 juillet, 30 juillet, 6 août: Chardin est présent à l'Académie (P.V., VII, 1886, p. 223-225).

15 août: Chardin expose au Salon du Louvre: «n° 58: un tableau de *Fruits*» (n° 117); «n° 59: un autre représentant le *Bouquet*» (n° 118?). «Ces deux tableaux appartiennent à M. le Comte Saint Florentin; n° 60: autre tableau de *Fruits* appartenant à M. l'abbé Pommyer, Conseiller au Parlement» (n° 114); «n° 61: deux autres tableaux représentant, l'un des *Fruits*, l'autre le *Débri d'un déjeuner*. Ces deux tableaux sont du Cabinet de M. Silvestre, de l'Académie Royale de Peinture, et maître à dessiner de S.M.; n° 62: autre petit tableau, appartenant à M. Lemoyne, Sculpteur du Roi. Autre tableau sous le même numéro.»

20 août, 27 août, 3 septembre, 24 septembre, 10 octobre, 29 octobre, 5 novembre, 25 novembre, 26 novembre, 3 décembre, 31 décembre: Chardin est présent à l'Académie (P.V., VII, 1886, p. 227, 228, 230, 232, 233, 235, 236, 239).

1763: Tableaux datés: *Raisins et grenades* (n° 117), la *Brioche* (n° 118).

1764

7 janvier, 28 janvier, 4 février: Chardin est présent à l'Académie (P.V., VII, 1886, p. 241-242).

24 février: Chardin est présent à l'Académie. Il est chargé par l'assemblée d'aller visiter M. Dandré-Bardon, malade (P.V., VII, 1886, p. 243). Dandré-Bardon possédait des Chardin (n° 21).

3 mars: Chardin est présent à l'Académie (P.V., VII, 1886, p. 245).

31 mars: Chardin est présent à l'Académie pour la répartition de la capitation et pour l'examen et l'arrêté de son exercice pendant l'année 1763 (P.V., VII, 1886, p. 246).

7 avril, 28 avril: Chardin est présent à l'Académie (P.V., VII, 1886, p. 248, 250).

1er mai: Cochin nous apprend, dans une lettre adressée à Marigny, que l'Académie va rétablir les cours d'anatomie suspendus depuis quinze ans faute de moyens pour payer un professeur, grâce aux économies faites par Chardin: «Nous avons pris connaissance des petits fonds provenant du don que vous avez fait à l'Académie, en lui accordant le livret du Salon, et qui ont été très sagement économisés depuis que M. Chardin est notre trésorier. Nous nous trouvons en état de faire les frais préliminaires qui doivent être la base d'une étude suivie de l'anatomie.» Cette décision est bien sûr liée à celle de l'Académie de Saint-Luc, rivale de l'Académie Royale qui venait de faire annoncer dans la presse un cours gratuit d'anatomie (Furcy-Raynaud, 1904, p. 307-308).

5 mai: Chardin est présent à l'Académie (P.V., VII, 1886, p. 250).

26 mai: Cochin et Chardin, présents à l'Académie, sont chargés d'aller remercier M. Massé de son geste envers l'Académie. Grâce aux 2000 livres données, un fonds est créé en faveur des veuves et des orphelins d'artistes (P.V., VII, 1886, p. 253).

2 juin: Chardin, présent à l'Académie, déclare devant l'Assemblée avoir reçu 2000 livres de M. Massé (P.V., VII, 1886, p. 254).

30 juin, 7 juillet, 28 juillet, 4 août, 23 août, 31 août, 1er septembre, 28 septembre, 6 octobre: Chardin est présent à l'Académie (P.V., VII, 1886, p. 256, 257, 258, 260, 261, 263, 271, 273).

25 octobre: Cochin, secrétaire de l'Académie, sollicite une nouvelle faveur auprès de Marigny pour son grand ami Chardin: «Monsieur, — les secondes idées sont quelquefois les meilleures. En laissant

subsister le Projet des quatre dessus de porte en sujets d'histoire dans le salon des Jeux au château de Choisy. Je reviens sur les idées que j'ay eû l'honneur de vous proposer pour les cinq dessus de porte des deux pièces qui précèdent ce salon.

Je persiste toujours dans l'Idée d'en avoir quelques uns de M. Vernet, dans l'une des deux pièces: mais j'ai l'honneur de vous proposer de confier l'autre à M. Chardin. Vous sçavés à quel degré d'Illusion et de Beauté, il porte l'imitation des choses qu'il entreprend et qu'il peut faire d'après nature. On pourroit donc placer ses talens en lui proposant de faire deux ou trois de ces tableaux. Dans l'un, il grouperoit divers attributs des sciences, comme globes, machine pneumatique, microscopes, téléscopes, graphomètres, etc. Dans l'autre, il réuniroit les attributs des arts, le compas, l'Equerre, la règle, des rouleaux de desseins et d'estampes, la Palette et les Pinceaux, le maillet et les divers outils du statuaire, etc. Si c'étoit dans la pièce où il est besoin de trois tableaux, on mettroit dans le troisième les attributs de la musique, divers instruments à corde et à vent, des livres notés, etc.

Je crois que ces tableaux plairoient beaucoup par cette véritri séduit tout le monde, et cet art de la rendre qui fait que M. Chardin est considéré des artistes comme le plus grand peintre dans ce genre qu'on ait jamais connu. Au reste, ces tableaux ne seroient que de 800 liv. chacun.

Je suis, avec un profond respect...» (A.N., O[1] 1910, 1764, volume 3, document 120).

27 octobre: Chardin est présent à l'Académie (P.V., VII, 1886, p. 275).

28 octobre: **Chardin reçoit le Bon du Roi pour peindre les trois dessus-de-porte de Choisy** (n° 123-124). Cette date est portée en marge de la copie du mémoire de Marigny adressé au Roi, copie datant du 17 novembre 1764 (A.N., O[1] 1378, 1764, p. 201-202), lui exposant le programme pour Choisy: *Le Roy a mis de sa main au bas du mémoire cy à côté Bon le 28 octobre 1764.*

10 novembre: Chardin, présent à l'Académie, reçoit de l'assemblée procuration pour toucher une rente de M. de Julienne: «Ensuitte, il a annoncé à la Compagnie que M. de Jullienne, Honoraire Amateur, lui a fait remettre un contrat de constitution de la rente de sept cent cinquante livres, au principal de quinze mille livres, laquelle rente sera employée, conformément au projet de M. de Jullienne, accepté par l'Académie le 1er septembre dernier, et registré le 10 du même mois. Ce contrat, constitué par la Compagnie des Indes au profit de l'Académie, a été passé chez Mtre Bouron, notaire, en date du 15 septembre de la présente année, sous le numéro 869, M. Chardin, Trésorier, sera autorisé, par une procuration, à l'effet de recevoir ces revenus, et ladite procuration sera signée à l'assemblée prochaine» (P.V., VII, 1886, p. 275-276).

20 novembre: Un acte notarié publié par Lhuillier (1872), conservé dans les minutes des notaires de Crécy-en-Brie (Étude Demassue), nous donne un certain nombre d'informations concernant la famille du peintre, notamment sur les deux demi-sœurs de Chardin qui demeuraient à Crécy-en-Brie.

L'une, Agnès Suzanne, entrée très tôt en religion, était devenue mère des novices de la communauté. L'autre, Marie Agnès, lingère, avait dû se retirer auprès de sa sœur, comme simple pensionnaire, après la mort de sa belle-mère, Jeanne Françoise David, le 7 novembre 1743, chez qui elle vivait encore après la mort de son père.

Marie Agnès Chardin «ouvrière en linge, demeurant ordinairement à Crécy, dans la maison séculière des dames pieuses et charitables, où elle est pensionnaire» distribue 61 livres de rente perpétuelle à ses neveux et nièces.

Tout d'abord à «Pierre Chardin, pensionnaire du roi, son neveu, fils de son frère Jean Siméon Chardin». On apprend ainsi que le jeune homme n'habite plus chez son père, mais rue du Battoir, paroisse Saint-André-des-Arts, à Paris. Viennent ensuite les noms des différents enfants de Juste Chardin (1703-1794) «menuisier des menus plaisirs», habitant rue Princesse, frère de notre peintre, qui, selon Jal (1867, p. 363), s'était marié à Marie Geneviève Barbiez; elle lui avait donné six filles et trois garçons de 1734 à 1749. D'après cet acte, il ne reste plus à Juste, en 1764, que quatre enfants: Marie Jeanne Chardin, Just Sébastien, sculpteur, Marie Angélique et Marie Agnès Just. Marie Agnès Chardin n'oublie pas sa sœur Agnès Suzanne à qui elle donne 40 livres de rente viagère.

24 novembre, 1er décembre, 12 décembre: Chardin est présent à l'Académie (P.V., VII, 1886, p. 277, 280, 283).

26 décembre: Chardin reçoit une ordonnance de paiement de 173 livres, 8 sols, 10 deniers, en *supplément à la pension de 500 livres à lui accordée, à compter du 8 février 1763 jusqu'au dernier décembre suivant, à raison de 200 livres par an* (A.N., O[1] 1921[B]).
La pension ne lui a, en fait, été accordée qu'à partir de mai 1763.

1764: A cette même date sur les *Sommes proposées sur les fonds de l'exercice 1763 au payement des pensions assignées sur les Batiments du Roi*, Chardin reçoit 673 livres 8 sols, 10 deniers, soit le montant de l'ordonnance précédente et sa pension annuelle.

1764: Tableaux datés: *Corbeille de raisins avec trois pommes d'api, une poire et deux massepains* (n° 120), *Canard mort pendu par la patte...* (n° 122). 176(4?) la *Théière blanche* (n° 119).

1765

5 janvier: Chardin est présent à l'Académie (P.V., VII, 1886, p. 987).

13 janvier (et non 10 janvier): Chardin pose sa candidature à l'Académie des Sciences, Belles-Lettres et Arts de Rouen:
«Messieurs,
Le plus beau droit des talens est de prétendre à l'association des personnes respectables qui les chérissent. Vous êtes depuis longtemps en possession de ce titre, je désire il y a longtems de partager le sort de mes confrères qui ont le bonheur de vous appartenir: Permettez, Messieurs, que je saisisse la circonstance favorable à mes vûes. Votre illustre Compagnie jugeroit elle a propos de le seconder. J'ai l'honneur d'être avec respect, Messieurs, Votre très humble et très obéissant serviteur. Paris le 13 janvier 1765» (Rouen, bibliothèque municipale. Archives de l'Académie des Sciences, Belles-Lettres et Arts).
Ses amis Descamps et Cochin le poussèrent sans doute à effectuer cette démarche. Rappelons aussi que sa seconde femme était originaire de Rouen.

16 janvier: Les Registres de l'Académie de Rouen font état de la demande de Chardin: *M. Chardin trésorier de l'académie royale de Peinture de Paris a demander une place d'associé.*
Chardin n'est d'ailleurs pas le seul à solliciter cette faveur dans la classe des arts, déjà surchargée. Il passe en second après Jean-Rodolphe Perronet (1708-1794), chevalier de l'ordre du Roi, Inspecteur Général des Ponts et Chaussées. Le registre ajoute que leur élection sera mise au scrutin à la séance prochaine (Rouen, bibliothèque municipale. Archives de l'Académie des Sciences, Belles-Lettres et Arts. Registre des délibérations de l'Académie, volume 2, p. 25).

23 janvier: Chardin est élu à l'unanimité membre de l'Académie de Rouen en remplacement du sculpteur Michel-Ange Slotz (1705-1764) (Rouen, bi-

bliothèque municipale. Archives de l'Académie des Sciences, Belles-Lettres et Arts. Registre des délibérations de l'Académie, volume 2, p. 26).

26 janvier : Chardin est présent à l'Académie (P.V., VII, 1886, p. 288).

30 janvier : **Chardin est reçu à l'unanimité à la place d'associé de l'Académie de Rouen** (Rouen, bibliothèque municipale. Archives de l'Académie des Sciences, Belles-Lettres et Arts. Registre des délibérations de l'Académie, volume 2, p. 26).

Janvier : Le *Mercure de France* annonce la mise en vente des estampes de Cochin et Lebas d'après les *Ports de France* de Joseph Vernet. La souscription pour ces estampes avait été ouverte dès le 27 juin 1758, tant chez Chardin que chez les deux graveurs. C'est à propos de cette série que Chardin écrit à Desfriches : «Je viens de faire remetre au caroce d'Orléans une caisse qui contien les Quatorze suittes des Ports du Royaume pour lesquels J'ay reçu le montant, Les quatre aux-fortes et les quatre seconde suites sont les huit premières suittes qui vous ont été choisie, j'espère que vous en seré aussi contemps que j'ay de satisfaction a vous assurer du parfait attachement avec lequel j'ay l'honneur D'être Monsieur Vostre très humble et très obéissant serviteur. Chardin.
Mon épouse et moy avons l'honneur dassurer Madame et votre aimable famille de Nos très humble sivilité.
Port de la caisse . 1.5
emballage aussi toile cirée 5
 ‾‾‾‾
 6.5
9 livres par souscription» (Ratouis de Limay, 1907, p. 54).

1er février : Chardin est présent à l'Académie (P.V., VII, 1886, p. 290).

5 février : Lettre de remerciments de Chardin adressée à l'Académie de Rouen : «Messieurs, être admis au rang de vos associés, y occuper la place d'un de nos artistes célèbres, obtenir ce bonheur par une grace particulière, sont de ces bienfaits uniques dont on ne peut dignement s'acquitter que par les sentiments de la plus vive reconnaissance. Telle est, Messieurs, celle dont mon cœur est pénétré ; Daignez en recevoir icy les témoignages sincères, et me permettre d'y joindre les assurances du respect avec lequel j'ai l'honneur d'être ; Messieurs...»
A la même date, Chardin adresse à M. Maillet du Boulay la lettre suivante (Un *Singe peintre* de Chardin passera à la vente Maillet du Boulay, du 22 janvier 1770, n° 5) : «Je sens tout le prix de l'honneur que l'Académie de Roüen vient de me faire ; les termes distingués et obligeans dans lesquels vous avez la bonté de m'en annoncer la nouvelle ajoûte un mérite particulier au bienfait ; Si j'ai jamais senti, Monsieur, le bonheur d'avoir acquis quelque talent, c'est lorsque ce talent me procure l'avantage d'appartenir au Corps respectable dont vous être le digne organe...» (Rouen, bibliothèque municipale. Archives de l'Académie des Sciences, Belles-Lettres et Arts ; inédit).

12 février : J.G. Wille, dans son *Journal*, nous apprend qu'à cette date Chardin dîne chez MM. Papetier et Eberts, associés, marchands d'estampes, «où il y avait MM. Flipart et Choffard, graveurs, et MM... Roslin, Vien, peintres avec plusieurs autres personnes. Nous y avons fort bien passé notre temps».

13 février : L'académie de Rouen assemblée à cette date lit «une lettre de remerciement de Mr Chardin sur son association aussi bien que celle qu'il a adressée particulièrement à Mr du Boullay» (Rouen, bibliothèque municipale. Archives de l'Académie des Sciences, Belles-Lettres et Arts. Registre des délibérations, volume 2, p. 27).

23 février, 2 mars : Chardin est présent à l'Académie (P.V., VII, 1886, p. 291, 293).

30 mars : Chardin est présent à l'Académie pour l'examen et l'arrêté des comptes de son exercice pendant l'année 1764 (P.V., VII, 1886, p. 294).

13 avril : Chardin est présent à l'Académie. Il est chargé par l'assemblée, d'aller, avec son ami Cochin, visiter le graveur Cars, «dangereusement malade» (P.V., VII, 1886, p. 296).

27 avril, 4 mai : Chardin est présent à l'Académie (P.V., VII, 1886, p. 296, 297).

25 mai : Chardin est présent à l'Académie ; il donne son avis sur le *carmin* du Sieur Visquenel : «Le Secrétaire a fait lecture d'un Mémoire, présenté par le Sr Visquenel, par lequel il déclare qu'ayant eût l'honneur de présenter à MM. de l'Académie Royale des Sciences un carmin de sa composition, auquel ces Mrs, après différentes épreuves et l'examen le plus exact, ont accordé leur approbation, il désireroit joindre à ce suffrage celui de l'Académie Royale de Peinture et de Sculpture. Lecture faite ensuitte de l'extrait des Registres de l'Académie Royale des Sciences, du 15 may 1765, dans lequel les Commissaires, nommés dans cette Académie, ont dit : «Qu'en conséquence, de différentes épreuves et comparaisons», ils croyent «que le carmin présenté par le Sr Visquenel n'est inférieur à aucun autre ni en bonté ni en beauté», ayant d'ailleurs annoncé, dans le cours du Rapport, que les épreuves et comparaisons ont même été à son avantage, et il leur a paru avoir encore même plus d'éclat, lorsqu'il est en poudre, que les «plus beaux qu'ils ayents vus,» enfin, qu'ils ne voyent «aucun reproche à lui faire». Sur cet exposé, et, après avoir ouï le rapport de M. Boucher, de M. Vien, de M. Chardin et de M. Vernet, qui ont fait l'essay de ce carmin et l'ont déclaré très beau, l'Académie a acquiescé à la demande du Sr Viquesnel et lui a accordé son approbation» (P.V., VII, 1886, p. 298).

1er juin : Chardin est présent à l'Académie (P.V., VII, 1886, p. 299).

28 juin : Chardin est présent à l'Académie. Son neveu, Sébastien Chardin, fils de Juste, obtient la troisième médaille, comme sculpteur pour «les Prix accordés tous les trois mois sur les académies des Élèves» (P.V., VII, 1886, p. 300).

6 juillet : Chardin est présent à l'Académie (P.V., VII, 1886, p. 301).

23 juillet : Lettre de Marigny adressée, de Compiègne, à Cochin : «Ayéz agréable, Monsieur, de prévenir de ma part Messieurs les Académiciens que, le Roy voulant qu'il y ait exposition de tableaux et de modèles dans la présente année 1765 au Sallon du Louvre et dans le tems accoutumé, ils se disposent à tenir leur comité pour choisir les ouvrages qu'ils jugeront devoir y être placés, et dont l'arrangement dans le Sallon doit être fait par M. Chardin, Trésorier de l'Académie, et vous m'enverrez le résultat de leur Comité. Je suis, etc.» (A.N., O¹ 1925ᴮ, 1765, dossier 8, et O¹ 1923ᴮ, 1765 ; copies datées du 4 août).

27 juillet, 3 août, 23 août : Chardin est présent à l'Académie (P.V., VII, 1886, p. 302, 303, 305).

25 août : Chardin expose au Salon du Louvre : «n° 45 : un tableau représentant les *Attributs des Sciences* ; n° 46 : un autre représentant ceux des *Arts* » (n° 124) ; «n° 47 : autre, où l'on voit ceux de la *Musique*» (n° 123). «Ces tableaux de 3 pieds 10 pouces de large sur 3 pieds 10 pouces de haut, sont destinés pour les appartemens de Choisy ; n° 48 : trois tableaux, sous le même numéro, celui ovale, représentant des *Rafraîchissements*, des *Fruits* et des *Animaux*» (n° 122). «Ces tableaux de 4 pieds 6 pouces de largeur sur 3 pieds 6 pouces de haut, celui ovale a 6 pieds de haut ; n° 49 : plusieurs tableaux sous le même numéro, dont un représentant une *Corbeille de raisins*» (n° 120 et 121).

31 août, 7 septembre, 28 septembre, 5 octobre : Chardin est présent à l'Académie (P.V., VII, 1886, p. 306-307, 309-310).

22 octobre : Lettre de J.S. Bailly, garde des tableaux des Maisons Royales de 1754 à 1792, à Marigny concernant les tableaux de Choisy (n°ˢ 123-124), «pour rendre compte au Roy» : «J'ay l'honneur de vous donner avis que j'ai mis en place quatorze tableaux au château de Choisy que j'ai fait conduire en bon état dont voici le détail... trois dessus de porte représentant des attributs des arts par M. Chardin» (A.N., O¹ 1911, 1765, volume 1).

26 octobre, 9 novembre : Chardin est présent à l'Académie (P.V., VII, 1886, p. 311, 312).

12 novembre : Lettre de Cochin à Marigny à propos du prix des tableaux de Choisy (n°ˢ 123-124) : «Les Tableaux de M. Chardin sont de la plus grande Beauté et font parfaitement leur Effet en place à Choisy, où je les ay vûs, et j'estime que c'est les avoir à bon marché que de ne les payer que 800 livres chacun. Quant aux deux dessus de porte de fleurs par M. Bachelier, il paroist qu'ils seront payés à 600 livres pour chacun.
Ainsi ce seroit :
Pour les deux dessus de porte
de M. de Lagrenée 2 000 liv.
Pour les 4 de M. Vernet 4 800 liv.
Pour les 3 de M. Chardin 2 400 liv.
Et pour les 2 de M. Bachelier 1 200 liv.»
(A.N., O¹ 1911, 1765, volume 1, document 94).

29 novembre : Chardin est présent à l'Académie (P.V., VII, 1886, p. 313).

7 décembre : Chardin est présent à l'Académie. Celle-ci l'autorise à placer les 2 000 livres dont M. Massé avait fait don à l'Académie le 26 mai 1764 : «L'Académie a arrêté la somme de deux mille livres données par M. Massé, Conseiller, ainsi qu'il est expliqué dans la délibération du samedy 26 may 1764, ensemble la somme mille quatre cent livres des deniers appartenans à l'Académie, et étant entre les mains de M. Chardin, Trésorier, seront employées à acquérir deux cent livres de rente, à 4 pour 100, sur les Aides et Gabelles de l'Edit d'Avril 1758, pour être les arrérages de ladite rente employés, jusqu'à concurrence du produit des dits deux mille livres, conformément au désir de M. Massé, ainsi qu'il est énoncé dans la ditte délibération du 26 may 1764, et à cet effet M. Chardin düement autorisé à faire le dit employ, et les frais de contract et autres relatifs à la ditte acquisition» (P.V., VII, 1886, p. 315).

31 décembre : Chardin est présent à l'Académie (P.V., VII, 1886, p. 318).

Sans date : Chardin rédige un mémoire ; il est *prêt à remettre, pour trois tableaux, cy... 2400 livres.* En face de cette colonne on peut lire : *Donner à Mr Chardin... 1200 livres pour acompte sur lesdits tableaux* (A.N., O¹ 1921, 1765).

1765 : Tableaux datés : les *Attributs des Arts* (n° 123), les *Attributs de la Musique* (n° 124), les *Attributs des Sciences* (disparu ; cf. n° 123), la *Corbeille de raisins* (Amiens).

1766

4 janvier : Chardin est présent à l'Académie (P.V., VII, 1886, p. 320).

9 janvier : En haut de la lettre adressée par Bailly à Marigny concernant les dessus-de-porte de Choisy (n°ˢ 123-124), le 22 octobre 1766, est noté : «Le Roy a donné ordre qu'on retirat les tableaux et qu'on remit les choses dans le premier État. 9 janvier 1766. Lettre a M.[Hajan] en conséquence». Cet ordre ne concerne vraisemblablement que les tableaux d'histoire (A.N., O¹ 1911, 1765, volume 1).

25 janvier, 1er février, 22 février : Chardin est présent à l'Académie (P.V., VII, 1886, p. 321-322).

22 mars : Chardin est présent à l'Académie. L'Académie apprend par Cochin qu'Aved le fidèle ami de Chardin est mort le 4 mars (P.V., VII, 1886, p. 324).

5 avril : Chardin est présent à l'Académie pour l'examen et l'arrêté du compte de son exercice pendant l'année 1765.

26 avril, 3 mai, 31 mai, 7 juin, 28 juin : Chardin est présent à l'Académie (P.V., VII, 1886, p. 330-333).

5 juillet : **Cochin** dans une lettre à Marigny **propose de nouveau Chardin pour exécuter deux dessus-de-porte, cette fois pour le château Bellevue** (nᵒˢ 126-127) : «La salle de musique me paroistroit demander quelque chose de relatif à sa destination. C'est pourquoi je penserois qu'elle seroit convenablement décorée avec deux dessus de porte de M. Chardin. Cet artiste atteint à un degré de perfection unique dans son genre» (Furcy-Raynaud, 1905, p. 50-51). Cette lettre est accompagnée d'un mémoire des tableaux destinés aux appartements du château de Bellevue :
«Salle de Musique.
M. Chardin, faits et placés.
Deux dessus de porte :
Deux groupes d'Instrumens de musique, en deux tableaux» (A.N., O¹ 1911, 1766, volume 2).

26 juillet, 2 août, 23 août, 30 août : Chardin est présent à l'Académie (P.V., VII, 1886, p. 335-337).

6 septembre : Chardin est présent à l'Académie (P.V., VII, 1886, p. 339). La présentation par Chardin du peintre Loutherbourg (1740-1812) à l'Académie, fait l'objet de controverses. Cochin s'en explique dans une lettre à Marigny : outre que Loutherbourg avait fait un mariage «honteux», il était accusé d'avoir détourné des diamants et d'avoir voulu occuper un atelier aux Tuileries destiné à Bachelier. «M. Chardin, qui étoit son présentateur, lui parla avec franchise et lui dévoila qu'on étoit inquiet du succès du procès criminel qui lui avoit été intenté, et qu'un corps qui désire se maintenir avec honneur ne peut rien souffrir de louche dans ses membres» (Furcy-Raynaud, 1905, p. 66, 68).

27 septembre : Chardin est présent à l'Académie (P.V., VII, 1886, p. 340).

Septembre : Diderot écrit au sculpteur Falconet à propos des jugements de Chardin fils sur Rubens : «...je vous dirai qu'un jour le fils de Chardin et quelques élèves en peinture considéroient ensemble un tableau de Rubens. L'un disoit : Mais voyez donc comme ce bras est contourné. Un autre : Appelez vous cela des doigts ? — Celui cy : Et d'où vient cette jambe ? — Celui-là : Comme ce col est emmanché ! — Mais toi, Chardin, tu ne dis rien ? — Pardonnez moi ; je dis qu'il faut être f...» (le mot est biffé dans l'un des manuscrits. Dans l'autre se lit l'abréviation «fᵐᵉⁿᵗ») «bête pour s'amuser à relever des guenilles dans des chef d'œuvre où il y a des endroits incompréhensibles, à dégoûter à jamais de la palette et des pinceaux.» (Diderot, *Correspondance*, t. VI, 1961, p. 303.)

4 octobre : Chardin est présent à l'Académie (P.V., VII, 1886, p. 341).

25 octobre : Chardin, présent à l'Assemblée, est député par l'Assemblée, avec Vanloo et Bachelier, pour aller remercier M. de Sartines, lieutenant général de la Police, de l'Établissement d'une École élémentaire de dessin «en faveur des métiers relatifs aux Arts» et des cent jetons d'argent qui donneront aux élèves «une idée de ceux que l'on (leur) distribue pour constater leur assiduité» (P.V., VII, 1886, p. 341-342).

8 novembre, 29 novembre, 6 décembre, 15 décembre, 31 décembre : Chardin est présent à l'Académie (P.V., VII, 1886, p. 346, 347, 348, 350).

1766 : Catherine II (1729-1796) commande à Chardin les *Attributs des Arts...*, (nᵒ 125), pour la salle de conférence de l'Académie des Beaux-Arts de Saint-Pétersbourg.

1766 : Parution d'une estampe de Miger, d'après le *Portrait en médaillon de M. Louis*, professeur et censeur royal de chirurgie, par Chardin, exposé au Salon de 1757, sous le nᵒ 35.

1766 : Tableaux datés : «Les Attributs des Arts et les récompenses qui leur sont accordées» (nᵒ 125), «Les Attributs des Arts et les récompenses qui leur sont accordées» (Minneapolis).

1767

10 janvier, 31 janvier, 28 février, 7 mars, 28 mars, 4 avril, 25 avril, 2 mai, 30 mai, 6 juin : Chardin est présent à l'Académie (P.V., VII, 1886, p. 351-359).

26 juin : **Jean Pierre Chardin, fils de notre peintre, arrive à Venise.** Il accompagne le marquis de Paulmy, ambassadeur de France à Venise (Cochin, 1780). Celui-ci repartira pour la France le 1er octobre 1768. **On ne sait rien sur Jean Pierre Chardin postérieurement au 26 juin.** Le lieu et les circonstances de sa mort sont très controversés. L'auteur du *Nécrologe* (1780) et les Goncourt le font mourir à Paris peu après son retour de Rome. Cochin (1780) et avec lui Haillet de Couronne, thèse reprise par Schéfer (1904), pensent que Jean Pierre Chardin se suicida en se jetant dans un canal. Nos recherches pour éclairer ce point sont restées à ce jour vaines.

27 juin, 4 juillet, 24 juillet, 1er août, 22 août : Chardin est présent à l'Académie (P.V., VII, 1886, p. 360-364).

25 août : Chardin expose au Salon du Louvre : «nᵒ 38 : deux tableaux sous le même numéro représentant divers *Instruments de musique*. Ces tableaux cintrés, d'environ 4 pieds 6 pouces de large sur 3 pieds de haut, sont au Roi et destinés pour les appartements de Bellevue» (nᵒˢ 126 et 127).

29 août, 5 septembre, 19 septembre, 3 octobre : Chardin est présent à l'Académie (P.V., VII, 1886, p. 365, 366, 368, 369).

27 octobre : Une lettre de l'abbé Pommyer adressée à La Tour, nous apprend que ce dernier, Chardin et Cochin soutiennent la candidature de l'abbé à la place d'associé libre à l'Académie (Desmaze, 1874, p. 26).

31 octobre : Chardin, présent à l'Académie, est chargé par l'assemblée d'aller annoncer à l'abbé Pommyer (qui, rappelons-le, possédait des tableaux de Chardin ; nᵒ 114) sa nomination d'*associé libre* à l'Académie : «Ensuitte, le Secrétaire a proposé de remplir des deux Places d'Associés libres, vacantes, l'une par le décès de M. Gougenot, et l'autre par la mutation de M. Mariette, ce que l'Académie ayant jugé convenable, ces deux Places ont été remplies par la voye du scrutin, l'une par M. l'Abbé Pommyer, Conseiller en la Grande Chambre du Parlement, Doyen et Chanoine de l'Église de Reims, et l'autre par M. Blondel d'Azaincourt, Lieutenant colonel d'Infanterie, Chevalier de l'Ordre militaire de St Louis... M. Boucher, Directeur, et M. Bergeret, Associé libre, ont bien voulu se charger de faire part à M. d'Azaincourt de sa nomination à la Place d'Associé libre, M. Chardin et M. De la Tour, Conseillers, se sont pareillement chargés d'en faire part à M. l'Abbé Pommyer» (P.V., VII, 1886, p. 370-371).

7 novembre, 28 novembre, 5 décembre : Chardin est présent à l'Académie (P.V., VII, 1886, p. 372-375).

31 décembre : Chardin présent à l'Académie est chargé par ses confrères d'aller visiter M. Restout, dangereusement malade, avec J.B. Lemoyne et G. Coustou (P.V., VII, 1886, p. 376).

1767 : Chardin présente un mémoire (A.N., O¹ 1921ᴮ) à Marigny par l'intermédiaire de Cochin pour les deux tableaux faits pour le Roi pendant l'année 1767. Il s'agit des *Instruments de la musique civile*, et des *Instruments de la musique militaire* (nᵒˢ 126 et 127) présentés au Salon cette même année et destinés au salon de la musique du château de Bellevue. Ce document porte deux prix d'estimation l'un au-dessus de l'autre, 2000 et 1600, pour les deux tableaux. Les nombreuses copies conformes de ce document (A.N., O¹ 1921ᴮ) portent l'un et l'autre prix. Dans les sommes à payer par la Direction des Bâtiments sur les fonds de l'exercice 1767, destinées au Département des Dépenses particulières (A.N., O¹ 1934ᴮ, 8ᵉ dossier), nous trouvons, dans les dépenses estimatives, la mention des deux grandes commandes décoratives : les trois *Attributs* de Choisy (estimés 3000 livres) et les deux *Attributs* de Bellevue (estimés 2000 livres). Sur les 5000 livres dues au peintre, 1200 lui ont été payées le 19 septembre 1766. La Direction des Bâtiments lui doit encore 3800 livres.

1767 : Tableaux datés : les *Attributs de la musique civile* (nᵒ 126), les *Attributs de la musique guerrière* (nᵒ 127).

1768

6 janvier : Cochin intercède auprès de Marigny pour un parent de M. La Roche qui vient de mourir, habitant aux Galeries du Louvre dans le logement de ce dernier et dont Greuze veut l'expulser : «C'est un usage établi de tous les temps que ceux qui ont à vuider ces logements ont au moins de délay le quartier qui suit celui où est mort le possesseur parce qu'il n'est pas à présumer qu'ils puissent trouver sur le champ un logement... Tous ceux qui cy-devant ont obtenu des logemens aux galeries ont observé ce procédé décent et humain. M. Chardin ne fut pas même voir son logement pendant tout l'intervalle du quartier, de crainte d'affliger ceux qui étoient forcés de s'en aller» (A.N., O¹ 1911, 1768, volume 5, document 10).

9 janvier : Chardin est présent à l'Académie (P.V., VII, 1886, p. 378).

15 janvier : Lettre de Cochin adressée à Desfriches : «Au demeurant, je souhaite que votre santé et celle de toute votre chère famille se soutiennent mieux que jusqu'à présent n'a fait Mme Desfriches. Dieu vous sauve de la grippe ! Quantité de gens icy payent ce malheureux tribut. Madame *Chardin* en est violemment malade. Il y a cependant du mieux...» (Ratouis de Limay, 1907, p. 69).

30 janvier, 6 février, 27 février : Chardin est présent à l'Académie (P.V., VII, 1886, p. 379, 382, 384).

3 mars : François Vernet paie à Chardin 625 livres «pour quinze mois de loyer de la maison qu'occupe mon frère» (il s'agit du peintre Joseph Vernet), «rue Princesse, faubourg Saint-Germain». C'est la maison du 13 de la rue Princesse appartenant à Madame Chardin (Pascal et Gaucheron, 1931, p. 98).

5 mars, 26 mars : Chardin est présent à l'Académie (P.V., VII, 1886, p. 385-386).

29 mars : Lettre de M. de Marigny adressée à Chardin : «La mort de M. Restout, Monsieur, faisant vaquer la pension dont il jouissait, Sa Majesté a bien voulu vous accorder 300 livres en augmentation de celle dont vous jouissez déjà. Vous ne devés point douter de la satisfaction que je goûte en vous annonçant cette nouvelle marque des bontés du Roy. Je suis Monsieur...» (A.N., O¹ 1117, 1768, fol. 432).

3 avril : Lettre de Madame Chardin adressée à Desfriches à Orléans :
«monsieur et ami, nous avons recûe hier samedi un patée sans lettre d'avis, ce qui ne ma pas empêché

de le reconnoitre pour estre de votre part, et dont nous vous fesons nos tres humble remerciments, comment vont vos santé après un hiver aussy rude. Mr Chardin la assez bien soutenüe pour moy j'ay eu a peut de choses près une fluction de poitrine, j'espère que le beau tems me remettra tout à fait, il y a eû bien des malades, vous scavez sans doute que Mr Restout est mort le premier jour de l'an, vous scavez peut être aussy qu'il avait 1 200 livres de pension. Le roy vien d'en acordée 600 à la veuve, et le logement au fils, comme je scait linterrés que vous prenez à ce qui nous regarde, je vous fait part Monsieur, que des autre 600 livres de cette pension le roy en a acordé 300 à Mr Chardin et même somme a Mr Dumont, qui avait sollicité. Mes Mr Chardin n'en avoit rien fait, nous avons reconnüe à cette occasion le cœur et l'amitiés de notre bon ami Mr Cochin, qui saisie les moments de rendre service. Lors que Mr Chardin a été remercier Mr le marquis de Marigny il en a été recüe on ne peut pas mieux avec toutes les marques et les assurence d'une parfaite estime. C'est un des bonheurs de la vie que d'avoir celle de ces supérieur et l'amitiés des honetes gens, conservez nous la votre, monsieur, et me croyes avec la plus parfaite considération Votre très humble servante femme Chardin. Nous assurons madame et m^elle de nos très humble compliments » (Ratouis de Limay, 1907, p. 54-55).

9 avril : Chardin est présent à l'Académie (P.V., VII, 1886, p. 387). De ce jour date une lettre adressée par Cochin à Marigny : «Je ne puis vous exprimer les sentiments qu'y ont excités les termes affectueux dont vous avés bien voulu vous servir et les marques de bonté que vous y donnés à l'Académie ; il n'est pas possible d'éprouver une reconnoissance plus vive. A cela se sont joints les exposés qu'ont fait M. Dumont et M. Chardin des nouvelles grâces dont vous les avés honorés ; j'y ay ajouté celles dont je jouis récemment par vos bontés, et ça a été un concert de louanges » (Furcy-Raynaud, 1905, p. 144).

30 avril, 7 mai : Chardin est présent à l'Académie (P.V., VII, 1886, p. 388-389).

25 mai : En marge du mémoire présenté par Chardin à Marigny pour les deux tableaux de Bellevue, n^os 126 et 127 (A.N., O^1 1921^B), Cochin a noté à cette date : «Je soussigné, secrétaire perpétuel de l'Académie Royale de Peinture et Sculpture, certifie a Monsieur le marquis de Marigny, Directeur et Ordonnateur général des Bâtiments du Roi, en vertu du pouvoir qu'il m'a donné, que les ouvrages mentionnés au présent mémoire ont été faits pour le service du Roy. a Paris le 25 may 1768. Cochin.»

28 mai, 4 juin : Chardin est présent à l'Académie (P.V., VII, 1886, p. 389-391).

23 juin : Le mémoire présenté par Chardin pour les tableaux de Bellevue (n^os 126 et 127), visé par Cochin, est «remis au bureau » de la Direction Générale des Bâtiments du Roi (A.N., O^1 1921^B), portant l'estimation de 1 600 livres pour les deux œuvres.

25 juin : Chardin est présent à l'Académie. Son neveu, Sébastien Chardin, fils de son frère Juste, reçoit la seconde médaille du Prix accordé tous les trois mois sur les académies des élèves (P.V., VII, 1886, p. 391).

2 juillet : Chardin est présent à l'Académie pour l'examen de l'arrêté du compte de son exercice pendant l'année 1767 (P.V., VII, 1886, p. 393).

22 juillet : Ange Jacques Gabriel, Premier architecte du roi, inspecteur général des Bâtiments, accuse réception des deux tableaux de Chardin pour Bellevue (n^os 126, 127) dans la lettre date sur le mémoire que Chardin avait fait en 1767, visé par Cochin le 25 mai 1768, et remis à la Direction générale des Bâtiments le 23 juin de cette même année (A.N., O^1 1921^B). Les tableaux doivent être payés

1 600 livres au total. A cette même date, Gabriel arrête l'estimation des trois tableaux de Choisy (n^os 123 et 124) à 2 400 livres (A.N., O^1 1921^B).

30 juillet, 6 août, 20 août, 27 août, 3 septembre, 24 septembre, 1^er octobre, 5 novembre, 26 novembre, 3 décembre : Chardin est présent à l'Académie (P.V., VII, 1886, p. 395-413).

1768 : Tableaux datés : *Corbeille de pêches, avec noix, couteau et verre de vin* (n° 130), *Corbeille de raisins* (collection Henry de Rothschild ; détruit).

1769

7 janvier, 28 janvier : Chardin est présent à l'Académie (P.V., VIII, 1888, p. 2-3).

4 février : Chardin est présent à l'Académie (P.V., VIII, 1888, p. 3-4).

5 février : Chardin reçoit 1 330 livres de la Direction générale des Bâtiments du Roi en paiement des médailles qu'il a fournies pendant l'année 1764 aux *Élèves qui ont remporté les prix* (A.N., O^1 1934^B, 5^e dossier).

25 février, 4 mars, 18 mars, 1^er avril, 29 avril, 6 mai : Chardin est présent à l'Académie (P.V., VIII, 1888, p. 4-11).

27 mai : Chardin est présent à l'Académie pour l'examen et l'arrêté du compte de son exercice de trésorier pendant l'année 1768 (P.V., VIII, 1888, p. 12).

3 juin, 1^er juillet, 29 juillet : Chardin est présent à l'Académie (P.V., VIII, 1888, p. 13-17).

25 août : Chardin expose au Salon du Louvre : «n° 31 : les *Attributs des arts et les récompenses qui leur sont accordées.* Ce tableau, répétition avec quelques changemens de celui fait pour l'Impératrice de Russie, appartient à l'abbé Pommyer, Conseiller en la grande chambre du Parlement, Honoraire associé libre de l'Académie. Il a environ 5 pieds de large sur 4 pieds de haut ; n° 32 : une *Femme qui revient du marché.* Ce tableau, aussi répétition avec changemens, appartient à M. Silvestre, Maître à dessiner des Enfants de France ; n° 33 : une *Hure de sanglier.* Ce tableau a 3 pieds de large, sur 2 pieds 6 pouces de haut, est tiré du Cabinet de Monseigneur le Chancelier» (il s'agit de Maupeou) ; «n° 34 : deux tableaux sous le même numéro représentant des *Bas-reliefs* » (n^os 131 et 132) ; «n° 35 : deux tableaux de *Fruits*, sous le même numéro» (n° 130) ; «n° 36 : deux tableaux de *Gibier* sous le même numéro.»

26 août : Chardin est présent à l'Académie (P.V., VIII, 1888, p. 21).

Ce même jour, aux époux Chardin reçoivent 2 000 livres de rente viagère annuelle (exempte d'impôts) constituée par «M. Jean Alexandre Lenoir Delamotte, conseiller du Roy, receveur ancien alternatif des tailles de l'élection de Bauget, tant en son nom qu'en ceux de D^e Thérèze Françoise Pioger de Pantigné, son épouse, et de Jean Jacques Lenoir, son frère, écuyer, controleur des guerres à la suite de la maison du Roy...». Rappelons qu'un Jean Jacques Lenoir avait été témoin au mariage de Chardin le 26 novembre 1744. De même, un certain Lenoir de Baugé vend 75 tableaux à Pierre Louis Eveillard, marquis de Livois, qui possédait des Chardin (n° 120). Les liens entre la famille Lenoir et Chardin sont encore obscurs. (Renseignements fournis par l'inventaire après décès de Chardin du 18 décembre 1779.)

2 septembre, 30 septembre : Chardin est présent à l'Académie (P.V., VIII, 1888, p. 23-24).

7 octobre : Chardin est présent à l'Académie (P.V., VIII, 1888, p. 26).
De ce même jour date une lettre de Mme Chardin, adressée à Desfriches : «Monsieur et ami j'ay envoyer hier vendredy après midy au carrosse d'Orléans rüe contrescarpe la quais qui renferme le

portrait de mademoiselle votre fille a votre adresse. Il vous arrivera surement a bon port. la santé de Mr Chardin est encore un peut chancelente cependant il y a bien du mieux, nous assurons madame et mademoiselle de nos très humbles respects en vous embrasson de tout notre cœur vous assurand de la parfaite estime et considération monsieur et ami Votre très humble servante Chardin ce 7 octobre 1769» (Ratouis de Limay, 1907, p. 55). La lettre fait allusion au portrait de Mlle Desfriches par Perronneau (1715-1783), dont celui-ci parle à Desfriches dans une lettre du 2 janvier 1770 (Ratouis de Limay, 1923, p. 126). Chardin était chargé de la réexpédition des ouvrages après le Salon.

27 octobre, 30 décembre : Chardin est présent à l'Académie (P.V., VIII, 1888, p. 27, 31).

1769 : [Roze de Chantoiseau] dans son *Essai sur l'almanach général d'indication d'adresse personnelle...* nous donne les adresses des deux frères de Chardin : celle de Juste, rue Princesse — que nous connaissions déjà —, *menuisier de la ville et fauxbourgs de Paris... ancien syndic,* et celle de Noël Sébastien, rue de la Barillerie, parmi les marchands merciers.

1769 : Tableaux datés : *« Une femme nue occupée à traire une chèvre que retient un enfant »* (n° 131), *« Un satyre tenant une chèvre que tête un petit satyre »* (n° 132).

1770

27 janvier, 3 février, 23 février, 3 mars, 31 mars, 7 avril, 28 avril, 5 mai : Chardin est présent à l'Académie (P.V., VIII, 1888, p. 34-41).

29 mai : Chardin est présent à l'Académie pour l'examen et l'arrêté du compte de son exercice pendant l'année 1769 (P.V., VIII, 1888, p. 41).

2 juin : Chardin est présent à l'Académie (P.V., VIII, 1888, p. 43).

6 juin : **Lettre de Cochin à Marigny.** Ce fidèle ami propose à nouveau Chardin **pour une augmentation de pension :** «...Vous m'avés permis d'achever de vous proposer les objets relatifs au décès de M. Boucher. Il reste la distribution de la pension académique dont il jouissoit ; elle étoit de douze cent livres. Je n'étois pas d'abord assés instruit ; mais depuis j'ay eû les renseignements nécessaires. J'ay dont l'honneur de vous proposer de la diviser en trois parts inégales : celle à M. Vernet, dont le nom seul annonce la célébrité, et à M. Roslin, de qui les talens vous sont connus, chacun une pension de 500 livres, et les 200 livres restantes en augmentation à M. Chardin. Il est plus que septuagénaire, et, à cet âge il est consolant d'être secouru par les supérieurs, surtout lorsqu'on soutient la force de ses talents au degré où on le voit la maintenir. C'est à peu près la dernière faveur que je vous demanderay relativement aux artistes mes confrères et mes amis» (A.N., O^1 1912, 1770, volume 1).
C'est en effet une des dernières faveurs qu'il demandera, puisqu'en 1771, Cochin sera déchargé par Marigny du «détail des Arts».

30 juin, 7 juillet : Chardin est présent à l'Académie (P.V., VIII, 1888, p. 45-47).

26 juillet : Chardin reçoit une lettre de M. de Marigny augmentant sa pension de 400 livres : «La mort de M. Boucher faisant, M., vacquer une Pension dans les Arts, **le Roy vient de vous accorder une augmentation de 400 livres** à celle dont vous jouissez deja. C'est avec plaisir que je vous donne la nouvelle de cette grace de Sa Majesté...» (A.N., O^1 1121, 1770, folio 437-438).
Ce même jour Marigny adresse une lettre à J.B.M. Pierre (1714-1789), Premier peintre du roi : «Je vous fais part, Monsieur, des diverses dispositions relatives aux Arts, que S.M. a faites dans son dernier travail sur les Bâtimens. Elle a disposé, en faveur du

Sr Hallé, de la place de surinspecteur de la manufacture des Gobelins. M. Boucher jouissoit d'une pension de 1 200 livres que S.M. a répartie en augmentations : de 400 livres celle de 800 dont jouissoit M. Chardin ; les 800 restantes, elle le a accordées à M. Roslin. Enfin, S.M. a bien voulu accorder 1 200 livres de pension à Mme Boucher, en considération des services et des talens de feu M. Boucher. L'intention de S.M. est, au surplus, que vous jouissiez de son logement en entier ; mais il n'est pas possible que vous rentriez en possession de ce logement, vu qu'il y a un ouvrage à faire dans l'attique au dessus, et qui consiste à jeter un plancher de séparation entre cet attique et le premier étage pour y former des dépôts. Néanmoins, l'intérêt que M. le Contrôleur général paroit prendre à cet ouvrage me donne lieu de croire qu'il ne traînera pas en longueur » (A.N., O¹ 1912, 1770, volume 1).
Ce même jour, Cochin dans une lettre à Marigny précise que, le 28 juillet, Mlle Vallayer (Coster) présentera à l'Académie ses *tableaux dans le genre de M. Chardin* (A.N., O¹ 1925ᴮ).
27 juillet : Lettre de remerciements de Chardin adressée à Marigny (cette lettre dut être écrite par Mme Chardin, car l'écriture est la même que celle des lettres adressées par Mme Chardin à Desfriches les 3 avril 1768 et 7 octobre 1769) : « Monsieur, je suis pénétré des nouvelles Bontés dont vous venée de m'honorer, retenu à la maison par les infirmités dont je suis accablé, je suis privé de la satisfaction d'aller vous en faire mes très humbles remerciemens, j'espere saisir quelque moment de suspension pour remplir ce devoir, et vous supplie monsieur de vouloir bien recevoir mes excuses dans les circonstances présentes et d'agreer les sentimens du plus profond respect avec lequel jay l'honneur d'estre Monsieur votre très humble et tres obeissant serviteur » (A.N., O¹ 1912, 1770, volume 1, folio 98).
28 juillet, 4 août, 1ᵉʳ septembre, 28 septembre, 6 octobre, 31 décembre : Chardin est présent à l'Académie (P.V., VIII, 1888, p. 49, 50, 52, 54, 60).
1770 : Le nom de Chardin figure en bonne place sur la liste des « Sommes proposées à payer sur les fonds de l'exercice 1770 destinés au Département des Pensions » : « S. Chardin pour sa pension pendant l'année 1770 en sa qualité de Peintre du Roi... 800 livres... Luy deux cent livres pour l'augmentation de sa pension pendant les six premiers mois 1770 et à raison de 400 livres d'augmentation a datter du premier juillet 1770... 200 livres... Luy pour les soins qu'il prend lors de l'exposition des tableaux... 200 livres... Total 1 200 livres » (A.N., O¹ 1934ᴮ, dossier nº 11, 1770).
1770 : Tableaux datés : *L'automne* (nº 133).

1771

5 janvier, 23 février, 2 mars, 23 mars, 6 avril, 27 avril : Chardin est présent à l'Académie (P.V., VIII, 1888, p. 61, 64-66, 68, 70).
4 mai : Chardin est présent à l'Académie. A cette séance, Cochin, le fidèle ami de Chardin, est « déchargé du détail des Arts ». J.B.M. Pierre, Premier peintre et directeur occupe désormais cette charge. Cochin n'est donc plus que le modeste secrétaire de l'Académie et perd tout son pouvoir. Il reçoit cependant une pension de 1 000 livres, modeste consolation : « M. Cochin, Secrétaire de l'Académie, a été honoré d'une pension de 1 000 livres comme récompense de ses services, pendant le temps qu'il a été chargé du détail des Arts. L'Académie a vu avec le plus sensible plaisir cette distribution des bienfaits du Roy en faveur de ses Membres, et M. Pierre, Premier Peintre du Roy et Directeur, a reçu les remerciemens dus à la part qu'il

a eue à cette judicieuse dispensation » (P.V., VIII, 1888, p. 74).
25 mai : Chardin est présent à l'Académie pour l'examen et l'arrêté des comptes de son exercice pour l'année 1770 (P.V., VIII, 1888, p. 75-76).
1ᵉʳ juillet : Paiement des mémoires pour les tableaux effectués par Chardin, pour Choisy (nᵒˢ 123 et 124) et Bellevue (nᵒˢ 126 et 127). Il reçoit 460 livres comptant et 3 340 livres en contrats à 4 % sur les aides et gabelles (Engerand, 1901, p. 82-83).
10 juillet : Chardin signe (avec plusieurs de ses collègues) un certificat assurant que les ocres de la Verie, paroisse de Challans, au bord du marais poitevin, sont aussi belles que celles d'Italie : « Nous soussignés, peintres du Roy et membres de son Académie de peinture et de sculpture, après avoir fait l'épreuve des ocres présentées par M. le Baron de Lézardière, et découvertes dans ses terres, nous avons trouvé qu'elles égalaient les terres d'Italie et dépassaient de beaucoup celles dont on se sert communément en France, et donnent d'ailleurs l'espérance de la plus grande perfection. En foi de quoi nous avons donné le présent certificat pour servir et valoir ce que de raison. A Paris le 10 juillet 1771 » (B. Fillon, *Lettres écrites de la Vendée à M. Anatole de Montaiglon,* Paris, 1861, p. 74).
11 juillet : Chardin délivre un certificat au baron de Lézardière : « Je soussigné, membre de l'Académie de peinture, certifie avoir fait essay de l'ocre jaune et de l'ocre rouge-brun de la Vérie, en Bas-Poitou, et avoir été très satisfait tant de la qualité que de la force de la couleur, meilleure que celle mise en pratique pour l'ordinaire par les peintres. Chardin » (Fillon, 1861, p. 74).
27 juillet, 3 août : Chardin est présent à l'Académie (P.V., VIII, 1888, p. 80-81).
23 août : Chardin est présent à l'Académie. A cette assemblée sont présentées les ocres des terres du baron de Lézardière : « Plusieurs Membres de l'Académie, MM. Pierre, Du Mont le Rom., Hallé, Vien, Chardin, Vernet, Roslin et Le Prince, qui en ont fait l'épreuve, ont certifié à la Compagnie qu'elles égaloient en beauté les terres d'Italie on surpassoient de beaucoup celles dont on se sert communément en France, et que, d'ailleurs, elles donnent l'espérance d'une plus grande perfection encore. En conséquence, l'Académie a accordé son approbation » (P.V., VIII, 1888, p. 82).
25 août : Chardin expose au Salon du Louvre : « nº 38 : un tableau représentant un *Bas-relief* » (nº 133) ; « nº 39 : trois *Têtes d'étude au pastel,* sous le même numéro » (nº 134).
31 août, 7 septembre, 28 septembre, 26 octobre, 23 novembre, 31 décembre : Chardin est présent à l'Académie (P.V., VIII, 1888, p. 84-88, 91).
1771 : Tableaux datés : *Autoportrait aux besicles* (pastel ; nº 134).

1772

25 janvier : Chardin est présent à l'Académie (P.V., VIII, 1888, p. 93).
7 février : Par une lettre de Descamps adressée de Rouen à Desfriches, nous apprenons que **Chardin est malade :** « J'ai reçu depuis 4 jours, une lettre de notre ami M. Cochin ; il me marque que notre ami Chardin souffre toujours. Voilà toujours la foiblesse humaine qui expose notre âme à souffrir du malaise de notre chétive machine que l'on dit, par habitude un chef-d'œuvre de perfection ; n'en croyez rien, ce créateur a bien voulu que cela fut ainsi pour nous punir » (Ratouis de Limay, 1907, p. 92). Il semble que Chardin souffrait de la maladie de la pierre, c'est-à-dire de coliques néphrétiques.

29 février, 7 mars, 28 mars, 4 avril, 25 avril, 2 mai : Chardin est présent à l'Académie (P.V., VIII, 1888, p. 95-100).
30 mai : Chardin est présent à l'Académie pour l'examen et l'arrêté des comptes de son exercice pendant l'année 1771 (P.V., VIII, 1888, p. 100).
27 juin : Chardin est présent à l'Académie (P.V., VIII, 1888, p. 102).
Juin : Chardin doit recevoir 700 livres de la Direction générale des Bâtiments du Roi pour les six premiers mois de sa pension annuelle de 1772, soit 600 livres, et 100 livres sur les 200 livres pour les soins qu'il accordent à l'exposition au Salon du Louvre (A.N., O¹ 1934ᴮ ; dossier 13).
4 juillet : Chardin est présent à l'Académie (P.V., VIII, 1888, p. 103).
20 juillet : Note adressée à la Direction générale des Bâtiments du Roi : « M. Chardin commence à être inquiète. Monsieur le Marquis de Marigny peut-être sûr que l'Ecole ne fermera pas mais il est supplié d'accélérer les secours — en calculant les ressources extraordinaires on trouve six chevaux dans l'académie de peinture à vendre / dont deux poussifs / cinq voitures assés en desordre. Ce qui produira même ressource — on convient que l'entretien de ces trois voitures peut faire une somme par an » (A.N., O¹ 1925ᴮ 1772).
24 juillet, 1ᵉʳ août, 22 août, 29 août, 5 septembre : Chardin est présent à l'Académie (P.V., VIII, 1888, p. 104-108).
15 septembre : Dans une lettre à Pierre, Marigny autorise *Juste Sébastien Chardin, sculpteur neveu de M. Chardin,* à occuper une chambre à l'Académie de Rome, vacante depuis le départ du Sieur Florentin (et non Valentin) (A.N., O¹ 1123, 1772, folio 383).
26 septembre, 3 octobre : Chardin est présent à l'Académie (P.V., VIII, 1888, p. 109).
15 octobre : Paul Laurent Atger, agent de change, cousin de Chardin — sa femme, Louise Victoire Nicole Pouget, était la cousine de Madame Chardin —, s'engage à payer aux époux Chardin 300 livres de rente viagère annuelle. (Renseignements fournis par l'inventaire après décès de Chardin du 18 décembre 1779).
31 octobre, 7 novembre : Chardin est présent à l'Académie (P.V., VIII, 1888, p. 110-111).
15 novembre : Un document nous révèle l'état des pensions dues à Chardin par la Direction des Bâtiments du Roi.
En retranchant les différentes avances que lui a fait l'Académie en temps que trésorier pour le paiement des médailles des Grands Prix, et en comptant les augmentations de pensions dues par suite des décès de Restout et de Boucher, le total des sommes dues s'élève à 6 030 livres. S'ajoute à cela ce qui reste à payer au peintre des tableaux pour Choisy (nᵒˢ 123 et 124) et Bellevue (nᵒˢ 127 et 127), soit 2 800 livres : *Il est dû en tout 8 830 livres* (à Chardin).
A la suite de cette note, Cochin ajoute : « J'ay toujours eu un remord secret d'avoir prisé trop sévèrement, dans le temps que j'étois chargé du détail des Arts, les cinq tableaux de M. Chardin ci-mentionnés ; un homme de son mérite auroit dû être traité plus largement. Y auroit-il moyen d'obtenir que M. le Directeur Général voulût bien réparer ma faute ? Qu'il voulût bien accorder à M. Chardin quelque gratification, vu le retard qu'il a essuyé et la nature des effets avec lesquels il consent d'être payé. Il me semble qu'il seroit possible de porter le contract de 8 830 L. jusqu'à 10 000 L., prix ordinaire des dessus de porte de chés le Roy. M. Cuvilliers est prié de vouloir bien soumettre cette demande à M. le Directeur général » (A.N., O¹ 1921ᴮ).
Ce texte porte la mention *Approuvé la notte 15 9ᵇʳᵉ 1772 a fontainebleau :* « En conséquence de la décision les mémoires de M. Chardin ont été arrêtés le 28 9ᵇʳᵉ

1772, le premier à 300 livres et le second à 2 000 livres. »

28 novembre: Chardin est présent à l'Académie (P.V., VIII, 1888, p. 111).

Ce jour-là les mémoires pour les tableaux de Choisy (n^os 123 et 124) et Bellevue (n^os 126 et 127) sont arrêtés. Chardin reçoit donc 3 800 livres pour les cinq tableaux (soit 1 000 livres par tableau — au lieu de 800 livres — moins l'acompte de 1 200 livres que la Direction lui avait déjà versé) (A.N., O¹ 1934^B, 8^e dossier; copies conformes dans O¹ 1921^B).

30 décembre: Chardin reçoit *400 livres de rente au principal de 10,000 livres* (voir 1^er juillet 1771). Cette mention se trouve dans le «mémoire des honoraires et déboursés dûs par Sa Majesté à M. Picquais, notaire de ses Batimens pour depôt de la grosse d'un contrat de 1.000.000 livres sur les aydes et gabelles à 4 pour 100 de l'édit de février 1770, ci après énoncé, donné en paiement à différens particuliers pour objets qui leur étoient dûs par le Roi, et déclarations sur lesquelles ont été passées sur le prête-nom des Batimens de portions de rente à prendre dans ledit contrat» (A.N., O¹ 2769, cahier 7. Mémoires des batimens du Roy. n° 1220).

31 décembre: Chardin est présent à l'Académie (P.V., VIII, 1888, p. 113).

1773

9 janvier: Chardin est présent à l'Académie (P.V., VIII, 1888, p. 115).

13 janvier: Lettre de Marigny à Natoire, directeur de l'Académie de France à Rome: «M. Chardin, peintre du Roi, m'ayant demandé pour un neveu qu'il a à Rome la permission d'occuper une chambre à l'Académie, je la lui ai accordée. Ainsi, vous lui en donnerez une, ce que je présume facile, vû le nombre de jeunes artistes qui en sont sortis cette année» (*Correspondance des Directeurs*, XII, 1902, p. 408).

6 février: Chardin est présent à l'Académie (P.V., VIII, 1888, p. 116).

9 février: Le sculpteur Sébastien Chardin, neveu de notre peintre, est installé à Rome dans la chambre qu'on lui avait promise le 15 septembre 1772 (lettre de Natoire à Marigny, *Correspondance des Directeurs*, XII, 1902, p. 415).

27 février: Chardin est présent à l'Académie (P.V., VIII, 1888. p. 117).

1^er mars: Lettre de Pierre à Chardin. Il lui confie un nouveau modèle pour l'Académie afin que Chardin prenne avec celui-ci les arrangements nécessaires. Il s'agit d'un modèle italien dont Pierre parlera à Marigny dans une lettre du 13 juillet 1773 (Paris, bibliothèque de l'École des Beaux-Arts, manuscrit n° 593; inédit).

6 mars, 27 mars, 3 avril: Chardin est présent à l'Académie (P.V., VIII, 1888, p. 118-120).

6 avril: Lettre de Pierre à Chardin à propos du paiement du modèle qu'il lui avait présenté le 1^er mars, afin qu'il soit payé pour deux mois et non six semaines (on voit que Chardin tenait les cordons de la bourse de l'Académie aussi solidement que Mme Chardin le faisait pour leur ménage) malgré un arrêt au mois de janvier (Paris, bibliothèque de l'École des Beaux-Arts, manuscrit n° 593).

30 avril, 8 mai: Chardin est présent à l'Académie (P.V., VIII, 1888, p. 121, 122).

29 mai: Chardin est présent à l'Académie pour l'examen et la reddition des comptes de son exercice pendant l'année 1772 (P.V., VIII, 1888, p. 123).

5 juin, 26 juin, 3 juillet: Chardin est présent à l'Académie (P.V., VIII, 1888, p. 124-126).

3 juillet: Lettre de Pierre à Marigny à propos du modèle de l'Académie: «L'Académie éprouve une perte réelle par la mort du nommé Deschamps, an-

cien modèle, servant depuis environ cinquante ans avec un zèle et un sentiment peu communs dans la classe des hommes qui n'ont d'autre but que le pain. La circonstance du Salon le fera désirer, quoique le second modèle, nommé Dauriac, paroisse assés intelligent et de très bonne volonté.

Il y a quatre ou cinq mois que l'on avoit admis à l'épreuve, quant à la conduite, un Italien qui avoit servi quelques années à l'Académie de France à Rome; très beau modèle, il paroît sage, et son premier métier de maçon fait aujourd'huy une ressource dans l'arrangement de l'exposition, qui exige souvent de la hardiesse. Malgré cela, M. Chardin et moy n'en serons pas moins inquiets; le bon Deschamps n'est plus, et la confiance dans les deux autres n'est pas encore établie; mais aussi les précautions seront multipliées» (Furcy-Raynaud, 1905, p. 276-277).

31 juillet, 7 août, 23 août: Chardin est présent à l'Académie (P.V., VIII, 1888, p. 128-130).

25 août: Chardin expose au Salon du Louvre: «n° 36: une *Femme qui tire de l'eau à une fontaine*. Ce tableau appartient à M. Silvestre, maître à dessiner des Enfans de France. C'est la répétition d'un tableau appartenant à la reine douairière de Suède» (cf. n° 55); «n° 37: une *Tête d'étude au pastel*».

28 août, 25 septembre, 2 octobre, 30 octobre, 6 novembre: Chardin est présent à l'Académie (P.V., VIII, 1888, p. 136-137).

25 novembre: **Les Chardin vendent en viager leur maison rue Princesse**, maison qui, rappelons-le, appartenait à la femme du peintre par héritage de son premier mari, Charles de Malnoé. Les acquéreurs sont un certain *Gilles Petit, maître menuisier à Paris*, et sa femme *dame Marie Jeanne Autin*. Ils s'engagent à verser quinze cents livres de rente annuelle en quatre termes (A.N., M.C., Étude XVII, liasse 760; insinuation de cet acte: A.N., S 2842, 1773).

27 novembre, 4 décembre, 31 décembre: Chardin est présent à l'Académie (P.V., VIII, 1888, p. 137-140).

1773: Chardin présente un *mémoire des dépenses faites pour l'Exposition des tableaux dans le Salon du Louvre*, ordonné par l'abbé Terray, directeur et ordonnateur général des *Bâtiments du Roi* (dès juillet 1773, l'abbé Terray remplace Marigny dans sa charge de surintendant, et ce, jusqu'à sa disgrâce en mai 1774). Chardin a dépensé pour l'arrangement de ce salon 806 livres 4 sols, tant en *aunes de toile verte*, qu'en *plumeaux balets, ficelles, tringles, chandelles*, et en paiement des journées des Suisses ou couturières. Ce mémoire ne sera réglé qu'en mars 1779, quelques mois avant la mort de notre peintre.

1773: Tableaux datés: *Portrait de Bachelier* (pastel; Cambridge, Fogg Art Museum), *Autoportrait aux besicles* (pastel; réplique; vente à la galerie Georges Petit, 22 mai 1919, n° 99).

1774

8 janvier, 29 janvier: Chardin est présent à l'Académie (P.V., VIII, 1888, p. 142).

Janvier: Chardin signe avec d'autres artistes logés au Louvre une requête afin que Nicolas Desportes, cousin de Claude-François Desportes, malade, puisse bénéficier de son logement après la mort de celui-ci (*Nouvelles Archives de l'Art Français*, 1873, p. 181).

5 février, 26 février, 26 mars, 9 avril, 30 avril, 7 mai: Chardin est présent à l'Académie (P.V., VIII, 1888, p. 143-144, 147-149).

28 mai: Chardin est présent à l'Académie pour l'examen et la reddition des comptes de son exercice pendant l'année 1773. Ce même jour, «l'Académie,

instruite que M. Desportes, Conseiller, est malade, a prié M. Le Moyne et M. Chardin de lui vouloir bien faire visite au nom de la Compagnie» (P.V., VIII, 1888, p. 150).

Le graveur Wille (1715-1808) note à cette date dans son *Journal* (p. 571): «Je fus obligé d'assister à la reddition des comptes de notre Académie royale. M. Pierre, premier peintre du roy, les recteurs, directeurs, professeurs du mois, MM. Chardin, trésorier, et Cochin, secrétaire y assistèrent. Cela dura depuis neuf heures et demie jusqu'à près de deux heures. Après cela nous allâmes tous à un repas splendide, chez M. Cochin. Au sortir de là, vers les six heures, nous allâmes à l'Assemblée de l'Académie qui se tint ce jour-là. »

4 juin, 25 juin, 2 juillet: Chardin est présent à l'Académie (P.V., VIII, 1888,.p. 151-154).

30 juillet: **Chardin démissionne de sa charge de trésorier de l'Académie.** Est-ce à cause de son âge et de ses infirmités (il souffrait de la pierre), ou sous la pression de Pierre et de d'Angiviller, le nouveau surintendant?:

«Ensuitte, le Secrétaire a fait lecture d'une lettre de M. Chardin, Conseiller, Trésorier de l'Académie, adressée à la Compagnie, où il lui expose qu'il y a vingt ans que l'Académie lui a fait l'honneur de le nommer son Trésorier; que, depuis la mort de M. Portail, M. le Marquis de Marigny ayant décidé que le Trésorier soit chargé de la décoration du Salon toute son ambition avoit été de s'acquitter de cette double fonction d'une manière qui pût être agréable à l'Académie, mais que son âge et ses infirmités le forcent à regret à suplier l'Académie de vouloir bien agréer sa démission; qu'il continuera cependant à s'acquitter de cet employ jusqu'à ce que la Compagnie ait fait choix de son successeur, et qu'il se fera un plaisir de lui donner les lumières qui pourront dépendre de lui. Le Secrétaire a ajouté que M. Chardin seroit flatté si l'Académie avoit agréable de lui permettre de placer dans l'Académie son portrait peint en pastel par M. de La Tour.

Visite à M. Chardin. — L'Académie a témoigné à M. Chardin le regret de sa retraite et la plus vive reconnoissance des soins, du zèle et de l'ordre qu'il a apportés dans cette gestion, dont Elle éprouve les avantages. Elle a reçu le don de son portrait avec action de grâces, et Elle a prié M. Le Moyne, ancien Directeur, et M. Cochin, Secrétaire, d'aller chés M. Chardin, de la part de la Compagnie, lui réitérer ses remerciements.

L'Académie a remis, à remplir cette place de Trésorier, à ce qu'Elle ait connu quelles sont les personnes de son Corps qui pourroient accepter de s'en charger» (P.V., VIII, 1888, p. 155-156).

6 août: Chardin est présent à l'Académie lors de la nomination de Guillaume Coustou comme successeur à la place de trésorier. La charge de l'arrangement du Salon est dissociée de celle de trésorier (la pension qui couvrait cette fonction est supprimée) et Vien en est chargé pour l'année suivante (P.V., VIII, 1888, p. 157).

16 août: Lettre émanant de la Direction générale des Bâtiments du Roi à Pierre: «M. Chardin ayant désiré remettre la trésorerie de l'Académie et le soin de l'arrangement des tableaux lors de leur exposition, personne ne pourroit mieux le remplacer pour le premier objet que M. Coustou, et M. Vien pour le second; ainsi j'approuve fort ce que l'Académie a statué à cet égard dans son assemblée du 6 de ce mois; cela ne me paroît que tendre au mieux pour le présent et pour l'avenir» (A.N., O¹ 1125, 1774, fol. 213-214).

20 août, 27 août, 3 septembre, 24 septembre, 1^er octobre, 28 octobre, 5 novembre, 28 novembre, 3 décembre: Chardin est présent à l'Académie (P.V., VIII, 1888, p. 159-170).

25 décembre: Chardin rend ses comptes à l'Académie, qui prouvent une gestion honnête, intelligente et saine (Paris, bibliothèque de l'École des Beaux-Arts, manuscrit n° 594).

30 décembre: Chardin est présent à l'Académie (P.V., VIII, 1888, p. 171).

1775

7 janvier: Chardin est présent à l'Académie. Son portrait au pastel par La Tour est accroché dans la salle (P.V., VIII, 1888, p. 175).

28 janvier, 4 février, 25 février, 4 mars, 31 mars: Chardin est présent à l'Académie (P.V., VIII, 1888, p. 179-183).

8 avril: Cochin lit à l'Assemblée de l'Académie une lettre de d'Angiviller, Directeur et ordonnateur des Bâtiments du Roi (depuis 1774), concernant l'École des Élèves, datant de deux jours plus tôt. A cette séance un certain nombre de commissaires sont nommés, dont Chardin pour approfondir les causes d'un «relâchement qui présente une perspective si fâcheuse pour les arts, afin d'y remédier» (P.V., VIII, 1888, p. 184).

29 avril: Chardin présente à l'Académie «le sieur Jean-Baptiste Weiler, Peintre en émail et miniature, né à Strasbourg, âgé de 28 ans, présenté à la Compagnie par M. Chardin, Conseiller, ayant présenté de ses ouvrages, l'Académie a agréé sa présentation. M. le Directeur lui ordonnera ce qu'il doit faire pour sa réception» (P.V., VIII, 1888, p. 187).

2 mai: Chardin écrit à d'Angiviller afin d'obtenir une gratification pour compenser la perte qu'il a subie en étant payé pour les tableaux de Choisy et Bellevue par une rente à 4 % sur les Aides et Gabelles (voir 1er juillet 1771):
«Monsieur,
J'ay plusieurs fois cherché l'occasion d'avoir l'honneur de vous rendre mes devoirs, sans avoir pu jusqu'à présent rencontrer le moment favorable de satisfaire mon empressement. J'ose n'être pas moins assuré, Monsieur, que vous daignez me conserver l'amitié dont vous avez toujours bien voulu m'honorer, et c'est dans cette circonstance que je prends la liberté de mettre icy sous vos yeux quelques observations qui me sont personnelles. La peinture m'a été plus onéreuse que lucrative, l'âge et les infirmités m'ont oté depuis longtemps la peine de l'exercer et viennent encore m'obliger à renoncer à la place de trésorier de l'Académie et à la décoration du Salon, après avoir rempli ces doubles fonctions pendant vingt ans avec tout le zèle et le bon ordre qu'a pu m'inspirer le désir de servir utilement l'Académie qui en a paru contente. D'après cet exposé, Monsieur, si ma position et mes services vous paraissent mériter quelques égards, et me donner une sorte de titre pour oser espérer des bontés du Roy et des vôtres quelque témoignage de satisfaction, je remets mes intérêts entre vos mains. Qu'il me soit cependant permis, Monsieur de vous avouer ingénuement qu'une gratification dans ce moment est l'unique bienfait où se bornent mes vœux; elle serviroit en même tems à me dédommager de l'obligation ou j'ai été de recevoir en contrats le payement des derniers ouvrages j'ay eu l'honneur de faire pour Sa Majesté tant à Bellevue qu'à Choisy. J'ose être persuadé, Monsieur, que vous daignerez, si cela se peut, favoriser mon attente et me faire éprouver les effets de cette bienveillance particulière que vous accordez aux Arts si dignement confiés à vos soins et dont vous fûtes l'ami longtems avant d'en être le ministre.
Monsieur, votre très humble et très obéissant serviteur» (Pascal et Gaucheron, 1931, p. 40).

4 mai: Note en marge de la lettre ci-dessus: «M. Cuvillier, 4 may 1775. Observation: M. le Di-

recteur général connaît le mérite du sujet, ainsi il n'y a à s'expliquer que sur le fonds de sa demande qu'il détermine dans la fin de sa lettre à une gratification momentanée. Sa pension proprement ditte est de 1.200 l. et courre sur ce pied à compter de 1771; elle n'avoît été que de 500 l. jusques et compris 1767, et fut portée à 800 l. en 1768. Ces gradations usitées dans les pensions des peintres naissent par des extinctions dont on profite pour augmenter en proportion du mérite des sujets survivants. M. Chardin a joui, en outre, de 200 l. à raison du soin qu'il avoit de préparer les Salons; son âge ne lui permet plus et cet émolument passera à celui qui fera le service» (Pascal et Gaucheron, 1931, p. 41).

6 mai: Chardin est présent à l'Académie (P.V., VIII, 1888, p. 91).

9 mai: La lettre de demande de Chardin à d'Angiviller porte en marge à cette date: *Bon pour 600 livres de gratification sauf à la renouveller, s'il y a lieu.*

22 mai: Lettre de d'Angiviller à Chardin lui annonçant son accord pour une gratification de 600 livres: «Quelque soit, Monsieur, la difficulté des tems et surtout mon administration, je cède volontiers aux différentes considérations qui se réunissent pour vous mériter ces égards particuliers. Ainsi j'ai arrêté en votre faveur une gratification de 600 l. dont je compte vous faire passer l'ordonnance incessamment. Nous verrons par succession de tems s'il se présentera quelque moyen de vous donner des témoignages plus essentiels des bontés du Roy, et en cherchant à les faire naître j'irai à la façon de penser de l'administrateur le sentiment particulier d'estime et d'amitié que je vous porte depuis longtemps. J'ay l'honneur d'être Monsieur, etc.» (Pascal et Gaucheron, 1931, p. 42).

27 mai: Chardin, présent à l'Académie, est chargé par la Compagnie d'aller féliciter M. Vien, «qui a été dangereusement malade», de sa convalescence (P.V., VIII, 1888, p. 191).
Ce même jour, Chardin présente l'«inventaire général des Tableaux, Sculptures tant en marbre que moulées en plâtre, Dessins, Planches gravées, Estampes, Livres, Meubles, Ustensiles et effets quelconques, et contrats (...) appartenant à l'Académie Royale de Peinture et Sculpture... au comité du 27 may 1775.» On apprend ainsi que la *Raie* (n° 7) est exposée dans la salle d'assemblée: *Tableau représentant une Raye et plusieurs autres poissons, avec différents ustensiles de cuisine...* (Paris, bibliothèque de l'École des Beaux-Arts, manuscrit n° 39).

3 juin: Chardin est présent à l'Académie: «M. Le Moyne, et M. Chardin ont rapporté à la Compagnie qu'ils ont fait visite de sa part à M. Vien, qui a été extrêmement sensible à cette attention de la Compagnie» (P.V., VIII, 1888, p. 192).

30 juin, 8 juillet, 29 juillet, 5 août, 23 août: Chardin est présent à l'Académie (P.V., VIII, 1888, p. 192-197).

25 août: Chardin expose au Salon du Louvre: «n° 29: trois *Têtes d'étude au pastel*, sous le même numéro» (n°s 135 et 136).

28 août, 2 septembre, 30 septembre, 7 octobre, 27 octobre, 4 novembre, 25 novembre, 2 décembre, 30 décembre: Chardin est présent à l'Académie (P.V., VIII, 1888, p. 198-206).

1775: Tableaux datés: *Autoportrait à l'abat-jour* (pastel; n° 136), *Portrait de Madame Chardin* (pastel; n° 135).

1776

27 janvier, 24 février: Chardin est présent à l'Académie (P.V., VIII, 1888, p. 209-210).

2 mars: Chardin, présent à l'Académie, rend compte de sa visite à M. Vernet, dont la Compagnie l'avait chargé (P.V., VIII, 1888, p. 212).

30 mars, 13 avril, 27 avril, 4 mai, 25 mai, 1er juin, 28 juin, 6 juillet, 27 juillet, 3 août, 23 août, 31 août, 7 septembre, 20 septembre, 28 septembre, 5 octobre, 26 octobre, 9 novembre: Chardin est présent à l'Académie (P.V., VIII, 1888, p. 212-248).

29 novembre: Chardin est présent à l'Académie et fait partie des «Commissaires nommés pour l'examen de l'ouvrage de M. Pigage» (P.V., VIII, 1888, p. 251).

28 décembre: Chardin est présent à l'Académie (P.V., VIII, 1888, p. 254).

1776: Chardin figure dans l'*Almanach historique et raisonné des architectes, peintres, sculpteurs, graveurs et cizeleurs* (Paris, 1776, p. 74) sur la liste des Conseillers de l'Académie: «M. Chardin, peintre, ancien trésorier, de l'Académie des Sciences, Belles-Lettres et Arts de Rouen, aux Galeries du Louvre».

1776: Tableaux datés: *Portrait de Madame Chardin* (pastel; n° 137), *L'hiver* (n° 138), *Portrait de vieille femme* (pastel; Besançon).

1777

2 janvier: Lettre de Madame Chardin à Desfriches: «J'ay recue monsieur votre obligente lettre et votre excelent patée, dont nous vous fesons nos très humbles remerciments, j'espere que notre bon ami Mr Cochin en mengera sa part et que nous boirons ensemble a votre santé. vous nous fachee monsieur en disant que vous ne scavoi pas quand vous vienderay a Paris, je me flate du moins pour le tems du salon que nous aurons le plaisir de vous embrasser et de vous assurer de vive voix du plus sincère attachement et de toute la reconnaissance possible. monsieur et madame votres humble servante Chardin. M. Chardin et moi vous fesons toutes sortes de bons souhaits et parfaite santé vous demandant a tous deux la continuation de vos amitiés, tous mes voisins de la Galeries vous font mil remerciments et compliments» (collection privée; inédit).

4 janvier, 25 janvier, 1er février, 22 février: Chardin est présent à l'Académie (P.V., VIII, 1888, p. 256-258).

29 février: Cochin, secrétaire de l'Académie Royale, grand ami de Chardin, est reçu associé libre de l'Académie des Sciences, Belles-Lettres et Arts de Rouen, rejoignant dans cette classe son ami qui avait été élu quelques années auparavant (Correspondance de Cochin avec Descamps et avec l'Académie, conservée à Rouen, bibliothèque municipale, Archives de l'Académie des Sciences, Belles-Lettres et Arts).

8 mars: Chardin est présent à l'Académie (P.V., VIII, 1888, p. 259).

21 mars: Chardin écrit une lettre de protestation à d'Angiviller. Il convient de la publier en son entier, afin de montrer l'amitié de Chardin pour Cochin, sa loyauté et sa reconnaissance pour celui qui facilita sa carrière. Cochin qui venait de démissionner de sa place de secrétaire avait été placé par Pierre à la fin de la classe des conseillers de l'Académie, de façon autoritaire et arbitraire (selon Chardin) et sans consultation de la Compagnie:
«Monsieur le comte,
La Bienveillance dont vous m'avés honoré depuis longtems m'inspire une confiance sans bornes pour vous ouvrir mon âme toute entière sur une affaire dans laquelle je me crois blessé. Je crois devoir la soumettre à votre jugement; si je me suis trompé, mes intentions sont droites et louables et votre équité mettra dans la balance les torts et les raisons. Je me crois d'autant mieux fondé à prendre cette liberté que je n'ai jamais vû un Directeur Général traiter les artistes avec plus d'aménité, les encourager davan-

tage, et combler l'Académie d'autant de Bienfaits. Puissent ceux qui vous sont subordonnés vous prendre pour exemple!

Mais aussi ce que je n'avois point encore vu quoiqu'ancien, ce sont des procédés semblables à ceux de M. Pierre, c'est qu'un Directeur de l'Académie (au mérite duquel d'ailleurs nous rendons tous justice) apporte une délibération toute faite et la dicte à notre jeune Secrétaire pour la faire enregistrer despotiquement, sans souffrir que l'Académie aille aux voix. Il était question dans cette délibération de donner à M. Cochin le titre de Conseiller. Je me suis levé au nom de tous mes confrères qui en étoient prévenus, j'ai plaidé la cause de l'honnêteté, j'ai demandé que l'on tînt compte à M. Cochin du tems qu'il a exercé le Secrétariat et qu'il dattat de sa nomination à cette place pour prendre rang parmi les Conseillers. J'étois d'autant mieux fondé en raisons que M. Cochin eût été Conseiller depuis nombre d'années par ses talens supérieurs, s'il n'eût pas été Secrétaire. J'ajouterai un fait, que peut-être M. Pierre a ignoré. Il y a environ quinze ans que dans un de ces momens où l'on interprétoit les statuts pour le bien de l'Ecole, un nombre d'officiers pensèrent à M. Cochin pour le faire Adjoint à Professeur, mais quoiqu'il n'en pût qu'être très flatté, sa modestie et la crainte que cet exemple ne pût ouvrir la porte à des abus, le lui firent refuser.

Cette demande que je faisois de le mettre au rang indiqué par son ancienneté vient si juste à l'Académie qu'elle a été reçue avec une sorte d'acclamation; cependant M. Pierre s'est levé contre, et m'a demandé si j'avois les certificats de MM. les Conseillers de leur acquiescement à cet arrangement; il a ajouté qu'il sçavoit le contraire, et faisant usage de ce qu'il n'étoit pas possible de leur demander leurs voix en ce moment, puisque les billets de convocation n'ayant pas fait mention de cette proposition intéressante, MM. les Conseillers étoient presque tous absens, on a décidé la chose sans vérifier ce fait, et sous qu'on pourroit dire après que M. le Directeur a en quelque manière pris l'Académie au dépourvu; et quoique les oppositions qu'on apportoit fussent couvertes du prétexte de se conformer aux statuts, nous les connoissons et nous sommes assurés qu'on n'y trouvera jamais une loi contre les circonstances où se trouvoit M. Cochin.

Pour moi, Monsieur, le bon sens me dicte que lorsque après vingt ans de service on met un Officier à la queue de sa Compagnie, lorsqu'on dit que c'est par récompense, et qu'on le fait inscrire ainsi, on commet une inconséquence: et je crois pouvoir ajouter que M. le Directeur a manqué lui-même aux statuts, en empêchant de délibérer. Cette affaire a été terminée, M. Cochin a témoigné être satisfait de la place qu'on lui a accordée, c'est à dire qu'il a tenu le langage qu'il lui convenoit de tenir; mais de savoir si l'Académie a fait ce qu'il convenoit qu'elle fît, c'est une autre question; au moins a-t-elle été instruite de la bonne volonté de l'Académie.

Mais un autre objet m'a blessé parce qu'il sembloit tenir au mépris; ce n'est pas parce qu'il dit que je suis cabale, si être honnête et juste s'appelle faire cabale, j'en fais gloire; mais il a ajouté en parlant à M. d'Azincourt, à voix basse à la vérité, mais assez haut pour que je l'entendisse, *Que c'étoient ceux à qui M. Cochin avoit fait avoir des bienfaits du Roi qui levoient ce lièvre-là; on ne peut blâmer la reconnaissance,* lui a répondu M. d'Azincourt. *On donnoit alors,* dit encore M. Pierre, *des pensions à tout le monde.*

Je ne puis me faire l'application de ce discours sans en être blessé. Croit-il que M. Cochin a surpris pour moi la religion des supérieurs? J'ai osé parler de mes bienfaits à mes services et au peu de talent que Dieu m'a donné: il est dur de molester un vieillard à qui le Roi a accordé les Invalides.

Après avoir formé dans le tems le projet de mettre sous vos yeux ces faits, j'en ai d'abord été détourné par ceux-mêmes qui auroient dû m'y encourager, j'ai donc balancé plus d'une fois, et enfin je m'y suis déterminé quoique un peu tard, incité par d'autres qui ont crû que je me devois cette satisfaction, et encore par ce qui s'est passé dans une de nos dernières assemblées. Ce que j'ai l'honneur de vous dire, Monsieur, n'est point positivement une plainte, je la crois si peu telle que j'en envoye une copie à M. Pierre lui-même: regardez la plutôt comme un épanchement de mes sentimens que la bienveillance que vous m'avés marquée en toute occasion a pour ainsi dire arraché de mon cœur: à quoi j'ajouterai pour second motif que si quelqu'une de nos légères contestations parviennent jusqu'à vous, il est très important pour moi que vous ne preniez aucune opinion défavorable à mon égard.

J'ai l'honneur d'être, avec un profond respect, Monsieur le comte, votre très humble et très obéissant serviteur» (A.N., O^1 1925B, 1777).

22 mars: Chardin est présent à l'Académie (P.V., VIII, 1888, p. 261).

2 avril: Réponse d'Angiviller à la lettre de Chardin du 21 mars: «Comme personne, Monsieur, ne désire autant que moi de voir régner entre des artistes, membres d'un même corps et qui font honneur à la Nation, la concorde et l'amitié, j'ai été peiné en recevant la lettre par laquelle vous me faites part de vos plaintes sur ce qui s'est passé à l'Académie, dans la séance où M. Cochin, se démettant du Secrétariat, a été admis au nombre des Conseillers; l'estime particulière que j'ai toujours eue pour vos talens et votre honnêteté a beaucoup ajouté à ce sentiment, c'est dans cet esprit que, puisque vous désirez connoitre mon sentiment sur cette affaire, je vais vous le marquer.

Rien n'est plus louable que le motif qui vous a guidé dans la proposition que vous avez faite, d'accorder en interprétant les statuts, à M. Cochin une place plus avancée dans la classe des Conseillers, où sa démission de la place de Secrétaire le faisoit entrer: je reconnois même tout ce que cette proposition recevoit de faveur des circonstances particulières: sçavoir des talens distingués de M. Cochin et des services qu'il a rendu aux arts et à l'Académie; mais il étoit question de donner aux statuts qui la régissent une extension ou une interprétation, et je pense à cet égard que l'Académie ne pouvoit point prendre cela sur elle. Je n'ignore pas que guidée uniquement par l'amour du bien, elle s'est crûe quelquefois autorisée à donner à des articles de ses statuts des modifications, votre lettre même l'annonce. Mais dans ce cas elle a outrepassé ce qu'elle pouvoit faire, par ce que ces interprétations ou modifications une fois admises, il pouvoit arriver que l'Académie ayant à sa tête, des personnes moins zélées pour son avantage, elle donnoit chez elle entrée à mille abus, M. Cochin l'a lui-même senti dans la circonstance que vous me rapportez et s'est donné comme en celle-ci, une marque de son désintéressement, sentiment par lequel il est aussi connu que son talent élevé. Il n'appartient enfin qu'à celui de qui émane le règlement de l'étendre, l'interpréter ou le modifier, et je suis si pénétré de cette idée que dans le cas où quelque article des statuts de l'une des deux Académies confiées à mes soins auroit besoin de quelque interprétation, je ne prendrois point sur moi de prononcer, mais je mettrois les circonstances et la difficulté sous les yeux du Roy, afin qu'il prononçât lui-même, telle est ma manière de penser sur la proposition que vous aviez faite et sur laquelle il n'a pas été délibéré par l'opposition qu'y a mise M. Pierre, il suffisoit que cette proposition présentât quelque chose qui n'étoit pas dans la lettre du règlement, pour que le Directeur, dont l'un des devoirs est d'en maintenir

l'observation fut autorisé à empêcher la délibération jusqu'ici seulement; quant à l'autre objet de votre lettre, vous avez à l'estime de tous les artistes des droits tels que vous aurez tort de vous faire l'application du discours dont vous vous plaignez; rien n'est aussi plus contre l'idée de M. Pierre qui ne m'a jamais témoigné pour vos talens et votre personne que des sentimens incompatibles avec une pareille application, ainsi je crois que vous devez oublier tout ce qui s'est passé dans cette occasion, et jouir tranquillement de l'honneur et de l'estime que vous vous êtes acquis dans la carrière que vous avez courue, personne ne désire plus que moi de vous donner des marques de la justice que je vous rens à tous égards, et c'est avec ces sentimens que je suis, Monsieur, etc.» (A.N., O^1 1925, 1777).

D'Angiviller ne tint donc aucun compte de la lettre de Chardin.

5 avril: Chardin est présent à l'Académie (P.V., VIII, 1888, p. 262).

16 avril: Lettre de Chardin adressée à d'Angiviller. Notre artiste est obligé de s'incliner devant le Directeur général des Bâtiments:
«Monsieur le Comte,
Je suis rempli des sentimens de la plus vive reconnoissance en recevant les marques d'estime et d'affection dont vous m'honorez dans votre lettre.
Je ne me flattois point que vous voulussiez employer des momens qui vous sont précieux à me donner cette consolation; mais, moins je l'ai espéré, plus j'y suis sensible.
Depuis que je suis de l'Académie, j'y ai toujours vécu dans la paix et dans l'union, et c'est la première fois que j'ai eu lieu de former quelque plainte, si toutefois cette ouverture en est une.
Au reste, ces légères altercations n'ont d'autre suite que de tenir plus attentif de part et d'autre à ne donner aucune prise sur soi.
Si cette affaire, Monsieur, m'a causé quelque peine et quelques mécontentemens, dès cet instant je les oublie et je vous en fais le sacrifice, heureux si vous voulez bien le regarder comme une foible marque de la reconnoissance qu'excitent en moi vos bontés.
Je suis avec un profond respect,
Monsieur le Comte,
Votre très humble et très obéissant serviteur,...» (Darcel, 1885, p. 71).

26 avril, 3 mai, 31 mai, 7 juin, 28 juin, 5 juillet, 26 juillet, 2 août: Chardin est présent à l'Académie (P.V., VIII, 1888, p. 263-276).

25 août-29 septembre: Chardin expose au Salon du Louvre: «n° 49: un tableau imitant le *Bas-relief*» (n° 138) et «n° 50: trois *Têtes d'étude au pastel*, sous le même numéro».

30 août, 20 septembre: Chardin est présent à l'Académie (P.V., VIII, 1888, p. 279-281).

27 septembre: Chardin est présent à l'Académie et demande à la Compagnie s'il est normal qu'il soit présent à tous les jugements et les comités: «M. Chardin, Conseiller et Ancien Trésorier, ayant fait part à l'Académie de quelques doutes sur son droit de présence à tous les Comités et jugemens, dont il a joui jusqu'à présent, l'Académie, confirmant ce droit par acclamation, lui a prouvé l'estime qu'Elle a pour ses talens, et sa reconnaissance pour un service de plus de vingt ans dans la Charge de Trésorier.» (P.V., VIII, 1888, p. 303-304).

Les *Procès-Verbaux*, par leur forme même, ne permettent pas d'être au fait du détail des querelles des divers clans qui divisent l'Académie; cependant, depuis la «disgrâce» de Cochin — la correspondance de Chardin avec d'Angiviller plus haut en fait foi, et ici encore les «quelques doutes» de notre artiste —, on imagine aisément le climat tendu que l'autoritarisme de Pierre faisait régner sur l'Académie.

29 septembre: Lettre de Pierre adressée à d'Angiviller.

Il lui explique que le secrétaire d'une Académie ne doit avoir aucune prépondérance, et que les directeurs ne doivent pas passer pour des *décorations* (il n'était pas question pour Pierre de laisser le champ libre à un nouveau Cochin!). En rendant compte de la séance tenue à l'Académie le 27 septembre, Pierre écrit: «Le P. Peintre... a fait confirmer par le vœu unanime le vœu de M. Chardin, tous les droits dont il jouissoit depuis 12 ans, par considération pour ses talens, par reconnaissance pour ses services, et par l'amitié de la Compagnie, comme il n'y avoit rien de constaté tous les doutes seront détruit. M. Chardin a remercié» (A.N., O¹ 1925ᴮ, dossier 1777, nᵒ 11).

4 octobre, 31 octobre: Chardin est présent à l'Académie (P.V., VIII, 1888, p. 307-308).

30 décembre: Chardin fait partie du comité chargé de «l'examen des tableaux et modèles des Élèves de Rome remis à un Comité fixé au 4 janvier (1778)» (P.V., VIII, 1888, p. 314-315).

1777: Chardin figure parmi les conseillers de l'Académie dans l'*Almanach historique et raisonné des architectes, peintres, sculpteurs graveurs et cizeleurs*, p. 57: «M. Chardin, peintre de Portraits et differens genres, ancien Trésorier, de l'Académie des Sciences, Belles-Lettres, et Arts de Rouen, aux Galleries du Louvre.»

1777: Parution de l'estampe gravée par Juste Chevillet (1729-1790) représentant le *Portrait de Marguerite-Siméone Pouget*, en pied, devant une cheminée au-dessus de laquelle est accroché un autoportrait de Chardin.

1777: Tableaux datés: *Jeune homme au chapeau, Jeune fille*, pastels (collection privée, New York).

1778

10 janvier: Chardin est présent à l'Académie. Il a signé, le 4 janvier, le rapport des commissaires sur les envois des élèves de l'Académie de France à Rome, c'est-à-dire Suvée, Jombert, Le Monnier, David, Bonvoisin, etc. (P.V., VIII, 1888, p. 319-321).

4 février: Chardin est présent à l'Académie (P.V., VIII, 1888, p. 325).

4 avril: Chardin, présent à l'Académie, est chargé de l'arrangement de la Bibliothèque de cette institution avec Dandré-Bardon, Hallé et Renou (P.V., VIII, 1888, p. 331).

25 avril, 2 mai: Chardin est présent à l'Académie (P.V., VIII, 1888, p. 333-334).

30 mai: Chardin est présent à l'Académie et fait cadeau à la Compagnie de «la collection des estampes gravées d'après ses ouvrages reliés en un volume *in folio*. La Compagnie a témoigné à M. Chardin sa reconnaissance et a ordonné que le volume soit déposé dans la bibliothèque» (P.V., VIII, 1888, p. 335-337).

10 juin: Un document d'archives nous apprend que Chardin recevra pour 1778 une pension de 1400 livres (A.N., O¹ 1925ᴮ, 1778).

27 juin: Chardin est présent à l'Académie (P.V., VIII, 1888, p. 340).

28 juin (et non 21 juin): Chardin demande au comte d'Angiviller à toucher les honoraires qu'il recevait comme trésorier, *ce qu'on appelle une retraitte:* «Les bienfaits que répand votre administration sur les Arts et en particulier sur l'Académie royale de peinture et de sculpture, me donnent la confiance que vous voudrez bien vous occuper un instant de l'exposé que je vais prendre la liberté de mettre sous vos yeux.

En 1755, l'Académie, à la mort d'un sieur Reydellet, son Concierge et Receveur, qu'elle avoit chargé du soin de ses finances, les trouva dans le plus grand désordre. Elle reconnût qu'Elle avoit été trompée

dans la confiance qu'Elle avoit cru pouvoir lui donner, tant sur l'expérience qu'elle avoit de son intelligence, que sur les bons témoignages qui avoient été rendus de lui. Elle sentit alors la nécessité indispensable de faire revivre la charge de Trésorier qui autrefois étoit exercée par un de ses membres. Après s'être bien consultée, elle jugea devoir m'honorer de sa confiance pour cette place, avec l'ancien honoraire de 300 l. qui y avoit été attaché dès l'établissement de l'Académie, et j'eus l'honneur d'être élu tout d'une voix.

Ce furent alors beaucoup moins ces honoraires que la satisfaction d'être utile à ma Compagnie, et l'empressement de répondre à sa confiance qui me déterminèrent à accepter.

J'ai commencé à exercer cette place le 12 may 1755. A cette époque non seulement l'Académie n'avoit aucuns fonds, il ne lui étoit rien dû sur ceux accordés par le Roy pour son entretien, mais encore elle se trouvoit endettée d'environ 4.000 l. Au contraire, lorsque je me suis démis de cette place à la fin de 1774, toutes dettes acquittées et nonobstant beaucoup de dépenses extraordinaires et considérables que l'Académie s'étoit trouvée en différens tems obligée de faire, j'ai laissé, soit en caisse, soit en sommes libres à recouvrir, une trentaine de mille livres. Je n'ai eu à cet égard, je l'avoue, d'autre mérite que celui de l'exactitude et de l'attention avec laquelle j'ai rempli les devoirs de ma place, mais je n'en ai pas moins eu, je le dire, une vraye satisfaction de voir l'ordre rétabli dans nos finances. Tous mes confrères m'en firent eux-mêmes des compliments distingués; M. Pierre, surtout, me dit de choses obligeantes à ce sujet, et me demanda même, pour lui personnellement, une copie du tableau que je remettois à l'Académie, de toute ma petite administration. Je viens tout récemment de remettre au Trésorier actuel un inventaire de tous les tableaux, sculptures, et effets quelconques appartenant à l'Académie, que j'ai cru aussi du devoir de ma place de présenter, et qui a été vérifié et approuvé par le dernier comité» (voir 27 mai 1775).

«Il est assez ordinaire, Monsieur le comte, qu'une personne qui a exercé un emploi avec honneur pendant 20 ans, dans un Corps quelconque, ait une continuation d'honoraires, ce qu'on appelle une retraite.

En 1775, lorsque j'eûs quitté ma place, vous eûtes à la vérité, Monsieur le Comte, la bonté de me faire participer aux bienfaits de Sa Majesté, en me fesant donner une gratification *malgré la difficulté des tems*. Par la raison même de cette difficulté, je dus être content, mais vous voulûtes bien me faire espérer *de me donner des témoignages plus essentiels des bontés du Roy, s'il s'en présentoit quelque moyen*. Comme j'ai eu pour principe toute ma vie d'observer dans mes démarches, j'ai cru que je n'aurois point a rougir de vous en proposer un qui ne pourroit causer aucun dérangement dans les récompenses attribuées à mes confrères.

Ce moyen seroit, Monsieur le comte, de me faire jouir de la continuation de mes honoraires, en les prenant sur la surabondance des fonds libres de l'Académie. Lors de ma retraite, j'aurois craint qu'il n'y eût de l'indiscrétion à faire une pareille demande, ignorant jusqu'à quelles sortes de dépenses pouvoient entraîner les nouveaux établissemens projetés dans l'Académie; Aujourd'huy que les tems sont changés pour elle, que j'y vois avec nouveaux bienfaits, ses fondemens sont assurés sur une base plus solide, qui a permis même d'augmenter les honoraires de tous les Officiers, je crois donc oser revenir sur mes pas. Le droit qui m'a été conservé d'assister à tous les comités particuliers, et notamment à ceux relatifs à la reddition des comptes me met assez à portée d'être instruit de la situation des finances de

l'Académie, en connoissance de cause, qu'elles peuvent sans la moindre gêne supporter cette continuation d'honoraires dont mon revenu se trouve diminué précisément dans un âge ou les besoins sont plus multipliés. Je me flatte que l'Académie, vû l'amitié et l'estime qu'elle m'a fait paroître dans tous les tems, ne verroit qu'avec plaisir cette faveur accordée à l'un de ses plus anciens membres.

C'est au surplus, Monsieur le Comte, encore la médiocrité de ma fortune, qui m'inspire cette démarche, que l'honneur qui résulte de ces sortes de retraites accordées à des services rendus; c'est, si je ne me fait point illusion, la justice de la chose ellemême; mais c'est uniquement à vous, Monsieur le Comte, qu'il appartient d'en juger, ce n'est qu'à vous, à votre équité, que je puis devoir cette faveur, et quoi qu'il en puisse arriver, ce sera la dernière grâce que je puisse jamais obtenir, vû mon âge et mes infirmités.

Si j'osais, en finissant, Monsieur le Comte, après avoir parlé des Intérêts de Trésorier, stipuler aussi ceux du Peintre, je prendrois la liberté d'observer au Protecteur des Arts que cette faveur rejailliroit en même tems sur un artiste qui se plaît à convenir à la vérité que dans le courant de ses travaux, les bienfaits de sa Majesté l'ont aidé à soutenir la peinture avec honneur, mais qui a malheureusement éprouvé que les études longues et opiniâtre qu'exige la nature, ne conduisoient pas à la fortune. Si cette capricieuse m'a refusé ses faveurs, Elle n'a pû me décourager, ni m'enlever l'agrément du travail. Mes infirmités m'ont empêché de continuer de peindre à l'huile, je me suis rejeté sur le pastel qui m'a fait recueillir encore quelques fleurs, si j'ose m'en rapporter à l'indulgence du public. Vous même, Monsieur le Comte, avez paru m'accorder votre suffrage aux précédens Salons, avant que vous en fussiez le premier ordonnateur et vous m'avez encouragé dans cette carrière dans laquelle je me suis montré plus de 40 années.

J'ai peut-être, Monsieur le Comte, trop abusé de vos momens, mais j'ose espérer que vous voudrez bien excuser ma prolixité, si vous daignez attribuer tous les détails dans lesquels j'ai cru devoir entrer, et au désir que j'ai eu d'éclairer votre bienfaisance, en même tems que je l'invoquois, et à la confiance que ne cesseront de m'inspirer vos anciennes bontés.

Je suis avec un profond respect, Monsieur le comte, votre très humble et très obéissant serviteur.
Paris, le 21 juin 1778

P.-S. — hélas! vous n'en êtes pas encore quitte, Monsieur le Comte, ma femme qui veut être de moitié en tout avec moi, prétend qu'il ne suffit pas de lui avoir communiqué ma lettre, elle veut aussi parler pour son compte, et vous allez l'entendre:

«Vous n'auriez, me dit-elle, rien gâté à votre requête, si vous aviez exposé les peines et les soins que j'ai pris pour votre administration, et je ne me contente pas de compliments stériles que toute l'Académie m'a fait dans le tems: s'il y a une récompense à obtenir, la Trésorière y a des droits, et la seule à laquelle elle aspireroit, ce seroit d'être munie d'un *bon* vis à vis du nouveau Trésorier pour le sommer de s'acquitter depuis 1755.»

Cent fois pardon, Monsieur le Comte, de vous avoir encore arrêté, je ne vous ai concédé à mettre sous vos yeux cette réflexion de ma femme que comme une occasion de lui rendre la justice que je lui dois en convenant que, sans ses secours, j'aurois été souvent fort embarrassé de bien des détails de cette place, très étrangers aux Arts» (A.N., O¹ 1925ᴮ, 1778).

4 juillet: Chardin est présent à l'Académie (P.V., VIII, 1888, p. 342).

21 juillet: D'Angiviller répond à Chardin. Sa demande du 28 juin de «continuation d'honoraires» est rejetée: «J'ai reçu, Mr, la lettre que vous avez

pris la peine de m'écrire pour m'exposer les services que vous avez rendus à l'Académie royale de peinture, dans le tems que vous en avez exercé la Trésorerie, et par laquelle vous me présentez un moyen d'y avoir égard, en vous accordant sur les fonds de l'Académie la continuation des honoraires que vous aviez en qualité de Trésorier, je vais répondre avec quelques détails à cette lettre.

Personne ne fait plus de cas que moi de votre talent et ne rend plus de justice à la manière dont vous avez gardé les fonctions dont l'Académie vous avoit chargé. Je ne puis cependant ne vous pas marquer quelque surprise de la demande que vous m'adressez aujourd'hui. J'ai crû devoir me faire à cette occasion représenter les grâces que vous avez successivement obtenues et j'ai trouvé que vous jouissiez depuis fort longtems d'un logement et d'une pension qui a été assez rapidement portée à 1.400 l. (indépendamment des 200 l. accordé depuis pour l'arrangement des tableaux), tandis que les premiers officiers de l'Académie n'avoient que 5, 6, ou 800 livres, je n'ai pu m'empêcher d'y reconnoître une récompense comme anticipée des services que vous rendiez alors comme Trésorier; car si vos ouvrages prouvent les soins qui vous ont acquis une réputation méritée dans le genre qui a fait l'objet de vos travaux, vous reconnaissez sans doute que l'on doit la même justice à vos confrères qui ont suivi des genres qui sont également difficiles, ou qui le sont même davantage. Je regarderois donc comme un double employ l'augmentation de traitement que vous sollicitez aujourd'hui en considération de vos soins; ces sortes de soins dans les compagnies doivent d'ailleurs avoir pour principale récompense le plaisir d'être utile à ses confrères, d'autant plus qu'ils ne prennent pas un travail bien fatiguant ni bien assujettissant et qu'il n'est presque question que d'ordre et d'exactitude.

J'ajouterai que vous me proposez un moyen qui prouve que vous n'êtes pas instruit des intentions du Roy sur l'emploi de l'augmentation des fonds provenant des nouveaux bienfaits accordés à son Académie, il seroit déplacé d'en intervertir la destination qui n'a jamais été d'en former des pensions, pour lesquelles il y a des fonds établis, mais de payer les honoraires d'un travail actuel, et les autres dépenses de l'instruction dont l'Académie est chargée. La place de Trésorier n'a à cet égard pas plus de droit que les autres places de l'Académie.

Si avant 1755 l'Académie avoit chargé des détails de la trésorerie le Sr Reydellet qui l'administra très infidèlement, je ne puis trop m'en étonner, et je ne puis trop reprocher une conduite que comme un oubli de toute règle, puisque les statuts nomment pour cette place de confiance un des membres de l'Académie, mais on auroit tort d'inférer de là que l'Académie doive une reconnaissance particulière à celui de ses confrères qui veut bien s'en charger, parce que c'est un devoir de corps, et que celui de ses membres qui, désigné par la Compagnie pour cette place, refuseroit, sans des motifs légitimes, de la remplir, seroit assurément blâmable.

Telles sont, Monsieur, mes réflexions sur la demande contenue dans votre lettre du 20 du mois dernier, que j'ai vue, je vous l'avouerai, avec quelque peine, étant plus instruit aujourd'hui de l'état des choses, que je ne l'étois au commencement de 1775, où je vous laissois entrevoir la possibilité d'une augmentation à votre pension; la juste distribution des grâces est, vous le sçavez, un des premiers encouragements des talens, et quoique votre talent et vos services justifient ce qui a été fait pour vous, je pense qu'un grand nombre de vos confrères ne pourroient le voir porter plus haut sans mécontentement.
Je suis, Monsieur, etc.» (A.N., O¹ 1925ᴮ).
Pierre avait donné à d'Angiviller un projet de réponse dont le ton blessant prouve que le Premier

peintre n'avait pas oublié la lettre de Chardin en faveur de Cochin:
«J'ai vu avec peine, Monsieur, l'exposé de vos demandes, parce qu'outre qu'elles me paroissent pas fondées, vous me proposez des moyens qui me prouvent que vous n'estes pas instruit des intentions du Roy sur l'employ de l'augmentation des bienfaits. La place que vous avez occupé, ainsi que toutes celles de l'Académie, avoient des honoraires proportionnés aux faibles revenus que la Compagnie possédoit. Vous estes donc de pair avec les autres officiers, et la Trésorerie n'étoit pas un office distinctif pour obtenir des grâces particulières et séparées de celles que Sa Majesté accorde aux artistes vous distinguent par le talent. Vous n'avés point à vous plaindre du traitement qui vous a été fait successivement lorsque l'administration s'est occupée de vous dans cette dernière partie. Vous jouissiez depuis longtemps d'un logement et de la pension la plus forte qu'il y ait dans l'Académie, lorsque Sa Majesté me confia au moment des bastimens. Je ne m'étois pas encore fait représenter l'état des pensions, lors de la gratification que je vous accordai à votre relvaille, joint à cela que vous me la demandates avec un empressement qui me fit craindre un besoin d'argent, et tel que je me crus obligé de vous faire pressentir de nouveaux secours. Je me suis mis à portée de comparer votre traitement avec celuy des autres officiers les plus anciens et les plus élevés en grade. La plupart ne jouissoient que de 5, 6 et 800 l. de pension, tandis que la vôtre avoit été portée très rapidement jusqu'à 1.400 l. Si vos ouvrages prouvent les soins qui vous ont mérité une réputation dans un genre, vous devés sentir que l'on doit la même justice à vos confrères, et **vous devés convenir qu'à travail égal vos études n'ont jamais comporté des frais aussi dispendieux ny des pertes de tems aussi considérables que celles de MM. vos confrères qui ont suivi les grands genres.** L'on peut même leur savoir gré du désintéressement que je me suis déterminé à mettre plus de proportion dans la distribution des grâces, et c'est par justice que je me suis occupé des retraites accordées aux recteurs. Je n'ai point ignoré la façon de penser de votre Compagnie sur le zèle et l'exactitude dont vous estiés capable, mais vous m'étonnés en m'apprenant que l'Académie avoit nommé un subalterne pour remplir une place de confiance, lorsque les statuts nommoient un membre académicien. Comment avoit-on pu risquer d'être trompé et comment ne surveilloit-on pas un mercenaire, puisqu'excepté les dépenses fixes et courantes, le trésorier même n'a pas le droit de faire des dépenses extraordinaires sans l'aveu général de la Compagnie, ou au moins sans le concours des principaux officiers qui la représentent?
Epargnés-moy le désagrément de vous refusée par la suite. Vos dernières demandes ne sont pas justes et peuvent tendre à des abus que je dois non seulement arrêter, mais même prévenir. Il seroit déplacé d'intervertir la destination des fonds qui pourroient rester en caisse et qui ont un employ, puisque la bienfaisance du Roy en a accordé de particuliers pour les pensions et que, de toutes les Académies, celle de peinture et sculpture est la plus favorisée» (Pascal et Gaucheron, 1931, p. 54-56).

25 juillet, 1ᵉʳ août, 24 août, 29 août, 5 septembre, 26 septembre, 31 octobre: Chardin est présent à l'Académie (P.V., VIII, 1888, p. 342-352).

15 novembre: Lettre de Cochin à Desfriches: «A propos, il ne faut pas que j'oublie (car je serais battu) que M. et Mme Chardin vous font mille compliments. J'ai lâché devant eux que j'allais vous écrire ce soir: aussitôt ils me sont tombés sur le corps. Bien

nos compliments, bien nos compliments. etc., et puis l'on a dit je ne sais combien de choses de vous: *C'est un brave garçon comme ceci, un galant homme comme cela.* Vous jugez bien que je ne me suis pas avisé de les contredire; les oreilles ont dû vous tinter» (Ratouis de Limay, 1907, p. 73).
28 novembre: Chardin est présent à l'Académie (P.V., VIII, 1888, p. 140).
31 décembre: «État général des Pensions dûes au 31 Xᵇʳᵉ 1778 savoir à la Peinture. Messieurs... Chardin. Dû quatre années depuis 1775 à 1778 à raison de 1400. cy 5600» (A.N., O¹ 1915, 1770, volume 1).
1778: Le graveur Dupin présente à M. Louis, secrétaire de l'Académie royale de chirurgie, une réduction de son portrait par Chardin, gravé par Miger en 1766. Le tableau avait été exposé au Salon de 1757, sous le n° 35.

1779

25 janvier: «Relevé des sommes dues aux artistes. Chardin — Peintre — 5000 acompte 1200. Reste 3800 cy 3800» (A.N., O¹ 1934ᴮ, registre 1775-1779, folio 28).
30 janvier, 6 février, 27 février: Chardin est présent à l'Académie (P.V., VIII, 1888, p. 365, 367, 369).
27 mars: Chardin, absent à cette séance, est désigné pour faire partie du comité qui examinera les envois des élèves de l'Académie de France à Rome (P.V., VIII, 1888, p. 373).
10 avril: Chardin est présent à l'Académie. On y lit le rapport sur les envois de Rome, signé le 5 avril du même mois, où sont signalés les progrès du peintre David (P.V., VIII, 1888, p. 377-378).
24 avril: Chardin est présent à l'Académie. A cette séance, le comte d'Affry (qui offrira à Chardin une boîte en or de la part de Mme Victoire (ou Mme Adélaïde) lors du prochain Salon) est nommé Honoraire-Associé libre à la place du grand amateur La Live de Jully, décédé. (Pour les Chardin ayant appartenu à La Live de Jully, nᵒˢ 102 et 103 et cf. nᵒˢ 94-95) (P.V., VIII, 1888, p. 378-379).
1ᵉʳ mai, 29 mai, 27 juin: Chardin est présent à l'Académie (P.V., VIII, 1888, p. 380-382, 384, 389).
25 août: Chardin expose au Salon du Louvre: «n° 55: plusieurs *Têtes d'étude au pastel*, sous le même numéro».
A ce Salon (voir le *Nécrologe*, et Haillet de Couronne, 1780), la fille de Louis XV, Mme Victoire — qui connaissait déjà Chardin par les deux dessus-de-porte qu'il avait exécuté pour Bellevue (demeure de Mesdames, filles de Louis XV) —, séduite par un de ces pastels (le *Jacquet*) en demande le prix. Vraisemblablement, Chardin le lui offre et reçoit en cadeau une boîte en or (tabatière) par l'intermédiaire du comte d'Affry.
25 septembre: Un protégé de Chardin — le peintre sur émail Weiler — qu'il avait présenté le 29 avril 1775, est reçu à l'Académie (avec un portrait en émail d'Angiviller) (P.V., VIII, 1888, p. 398).
2 octobre: Chardin, malade, ne peut aller à la séance de l'Académie: «M. Cochin, Secrétaire, a présenté à la Compagnie, au lieu et place de M. Chardin, absent par maladie, le Sieur Henry François de Cort, Peintre en païsage, né à Anvers, âgé de 34 ans, qui a fait aporter de ses ouvrages. Les voix prises à l'ordinaire, l'Académie, ayant reconnu sa capacité, a agréé sa présentation. M. le Directeur lui dira ce qu'il doit faire pour sa réception» (P.V., VIII, 1888, p. 400).
Octobre: Pierre dans un rapport à d'Angiviller note «M. Chardin n'est pas absolument bien, mais sans cependant donner sujet à être inquiet». En marge de cette phrase, une note: «Depuis cela a fort changé» (A.N., O¹ 1925ᴮ, 1779, dossier 12).

6 novembre : Chardin est absent de l'Académie : «La Compagnie, informée que M. Chardin, Conseiller, étoit dangereusement malade, a nommé MM. La Grenée l'aîné et Cochin pour le visiter de sa part» (P.V., VIII, 1888, p. 403).

16 novembre : Lettre de G.F. Doyen à Desfriches : «Monsieur, je suis chargé de la part de Madame Chardin de vous faire bien des excuses de ce qu'elle n'a pas eu l'honneur de vous remercier et de vous faire part de sa situation qui est bien douloureuse. M. Chardin a reçu le bon Dieu, il est dans un état d'affessement qui donne les plus grandes inquiétudes ; il a toute sa tête, l'amflure des jambes a passé dans différantes parties du corps ; on ne sait ce que cela deviendra. Vous devés juger de sa situation et de celle de ses amis. Elle vous fait bien des complimens. Je vous renouvelle mes remerciements très humbles. J'ay l'honneur d'être parfaitement Monsieur, votre très humble et très obéissant serviteur» (Ratouis de Limay, 1907, p. 101-102).

27 novembre : Cochin rapporte à l'Académie que Chardin avait été très sensible à l'intérêt que la Compagnie portait à sa santé (P.V., VIII, 1888, p. 405).

1779 : **6 décembre (lundi) : Chardin meurt à 9 heures du matin, âgé de 80 ans, dans son logement des Galeries du Louvre,** vraisemblablement d'hydropisie.

Haillet de Couronne dans son *Éloge* (1780) dira de lui : «...j'observerai qu'il était de petite stature, mais fort et musclé. Il avoit de l'esprit, un grand fond de bon sens et un excellent jugement.»

7 décembre : Inhumation de Chardin.
«Du mardy 7ᵉ (decembre 1779) M. Jean-Baptiste-Siméon Chardin, peintre du Roy et de son Académie Roÿale de Peinture et Sculpture, ancien trezorier de ladite Academie, de l'Academie Roÿale des sciences, belles lettres et arts de Roûen, âgé de quatre vingt ans passés, veuf en premières nopces de Margueritte Saintard et époux de deˡ Françoise Margueritte Pouget, décédé hier à neuf heures du matin aux galleries du Louvre, a été inhumé en cette église en présence de Srˡ Juste Chardin, ancien entrepreneur des Batiments du Roy, et du Srˡ Noël-Sebastien Chardin, mᵈ mercier, ses frères, qui ont signé la minutte» (Archives de l'Hôtel de Ville, détruites le 24 mai 1871 ; copie de l'original : A.N., M.C., Étude LVI, liasse 248).

Ce même jour, J.J. Caffiéri (1725-1792), sculpteur du Roi, adresse une lettre à la Direction des Bâtiments : «Monsieur. C'est avec regret que nous voyons finir la carrière de *M. Chardin.* Cette mort laisse un logement et une pension vacante ; je ne vous réitère point ce que j'ay eu l'honneur de vous écrire plusieurs fois. Vous me permettrés, Monsieur, de vous prier de vous ressouvenir de moi, comme vous avés eu la bonté de me le permettre. Je suis avec respect...» (Guiffrey, *Les Caffiéri,* Paris, 1877, p. 265).

9 décembre : Lettre de Pierre à d'Angiviller : «La perte de M. Chardin laisse plusieurs grâces à partager. Son logement aux galleries. M. Chardin jouissoit de 1400 livres en pension, sur quoy il est bon d'observer qu'il n'y a véritablement que 1 200 livres de pension. Les 200 livres, qui complettent la somme de 1 400 livres, n'étant reportées qu'une gratification particulière accordée à feu M. Chardin, sous le prétexte de décorateur du sallon. En sorte, Monsieur le Comte, qu'il paroitroit Convenable d'affecter les dites 200 livres, à celuy qui sera chargé successivement du soin d'arranger, par nos ordres, le Sallon, et qu'elles fussent attribuées qu'au décorateur du Moment, afin de ne pas retomber dans l'abus, que des égards non fondés ont laissé subsister... Les 1 200 livres doivent être partagées entre Vernet, Van Loo et Brenet» (A.N., O¹ 1915, 1779, volume 3, document 280).

1779 : **18 décembre : «Inventaire après décès du sieur Jean Baptiste Siméon Chardin»,** à la requête de «Dame françoise marguerite Pouget, veuve de en premières noces de Charles de Malnoé, écuyer ancien mousquetaire du Roy,» de Juste Chardin, «menuisiers des menus-plaisirs du Roy,

10 décembre : Lettre de Mme Chardin adressée à d'Angiviller :
«Monsieur
Les marques de bonté et d'affection dont vous avez dans tous les temps honoré feu M. Chardin, mon Epoux, semblent établir en ma faveur l'Espoir d'obtenir quelque grâce de ces mêmes bontés. Déjà avancée en âge, je me trouve privée des secours que l'estime accordée à ses talens et à ses services luy avoit mérités.
S'il étoit possible, Monsieur, que vous voulûssiez bien m'accorder quelque partie de la pension dont il avoit été gratifié, ce seroit un bienfait digne de votre humanité et de l'affection dont vous honorez les artistes qui ont obtenu quelque distinction dans leur art. Je n'aurois point osé espérer cette grâce si je n'y avois été encouragée par l'exemple de grâces semblables accordées à quelques veuves qui béniront jusques à la fin de leurs jours la main généreuse qui les a secourues.
Je suis, avec le plus profond respect, Monsieur, Votre très humble servante» (A.N., O¹ 1915, 1779, volume 3, document 296).

12 décembre : La pension de Chardin est redistribuée. D'Angiviller demande au Roi son *Bon* pour la redistribution entre Vernet pour 300 livres, Amedée Vanloo pour 300 livres, et Brenet pour 600 livres (A.N., O¹ 1073, 317).

13 décembre : Pierre est informé par d'Angiviller de la répartition de la pension de Chardin entre Vernet, Vanloo et Brenet (A.N., O¹ 1915, 1779, volume 3).

18 décembre : Avant de répondre à Mme Chardin, d'Angiviller avait demandé un éclaircissement sur les pensions accordées aux veuves d'artistes :
«Il y a à la vérité quelques exemples de Veuves ou filles d'Artistes de l'Académie qui ont obtenu des pensions après la mort de leur mari ou de leur père, mais... ça été presque à titre de charité. Mad. Chardin est fort loin de cette extrémité. Il est certain qu'elle et son mari, gens toujours très ménagers et même resserrés, jouissaient de 5 à 6 000 livres de rentes. Ce serait un exemple qui entrainerait loin d'accorder des pensions a des veuves d'artistes de l'academie, qui n'avaient point été spécialement au service des Batiments» (A.N., O¹ 1915, 1779, volume 3).

Après lecture de cette note, d'Angiviller répond à Madame Chardin en ces termes :
«J'ai reçu, madᵐᵉ, la lettre que vous m'avez fait l'honneur de m'écrire, et par laquelle vous me demandez, en considération des talens de feu M. Chardin, quelque marque des bontés du roy. Je souhaiterois, vu l'estime que je faisois de la personne de M. Chardin et de ses talens, pouvoir accéder à cette demande. Mais quoiqu'il y ait eu, en effet, quelques exemples de veuves d'artistes qui ont obtenu des pensions après la mort de leurs maris, je trouve que c'étoient ou des veuves d'artistes qui étoient morts spécialement au service du roy, ou quelques-unes qui, par suite de la mort de leur mari, restoient dans un état de détresse tel que l'honneur des arts de l'Académie exigeoit en quelque sorte que l'on vint à leur secours. Mad. Chardin s'est fait une réputation méritée et dans le public et dans l'Académie, mais n'a pas eu le premier avantage, parce que la nature de son talent, quoique éminent, ne le comportoit pas. Je suis assuré que le second cas ne vous est pas applicable, et votre délicatesse refuseroit sûrement un bienfait du roi à ce titre.
J'ai l'honneur d'être, etc.» (A.N., O¹ 1915, 1779, volume 3, document 295).

demeurant à Paris rue princesse, fauxbourg St Germain, paroisse Saint Sulpice» et de Noël Sébastien Chardin, «ancien marchand mercier à Paris, y demeurant rue basse des Ursins paroisse Saint Landry» (A.N., M.C., Étude LXI, liasse 246).

Cet inventaire nous permet de savoir exactement le nombre de pièces habitées par Chardin aux Galeries du Louvre, c'est-à-dire : 4 chambres — la chambre de la cuisinière, 2 chambres, l'une au second, l'autre au troisième donnant sur la rue des Orties, et une chambre à coucher ayant vue sur la galerie — une salle à manger, une cuisine, plus un corridor, une cave et une souente sous l'escalier.

La prisée des tableaux fut faite par Joseph Vernet et Cochin.

Depuis l'inventaire après décès de sa première femme en novembre 1737, le décor de la vie de Chardin n'avait guère changé, quelques objets ainsi que la garde-robe sont peut-être plus luxueux.

Mais l'inventaire des «papiers» de l'artiste et de sa femme nous révèle combien le ménage Chardin était financièrement à l'aise par l'énumération des divers contrats de rente. La veuve Chardin n'était pas dans le besoin.

26 décembre : Décharge de Chardin au Mont-de-Piété.
Ce document en partie détruit par le feu ne nous permet aucune interprétation (A.N., M.C., Étude LVI, liasse 246).

28 décembre : Séance de l'Académie : «En ouvrant la séance, le Secrétaire a notifié la mort de M. Jean Baptiste Siméon Chardin, Peintre ordinaire du Roy, Conseiller et ancien Trésorier de cette Académie et Membre de celle des Sciences, Belles-Lettres et Arts de Rouen, décédé en cette ville aux Galeries du Louvre le 6 de ce mois, dans le 81ᵉ de son âge.
...La lecture des délibérations du Quartier a été remise à la prochaine assemblée, qui est fixée au samedi 8 de Janvier prochain, dans laquelle on procédera à remplir la Place de Conseiller, vacante par la mort de M. Chardin» (P.V., VIII, 1888, p. 407-408).

1780

8 janvier : Séance de l'Académie royale : «En ouvrant la séance, en conséquence de la délibération précédente, on a procédé à remplir la place de Conseiller, vacante par la mort de M. Chardin. Les voix prises à l'ordinaire, M. Duplessis, Académicien, a été nommé Conseiller» (P.V., IX, 1889, p. 1).

29 janvier : Renonciation de la dame veuve Chardin à la communauté d'entre elle et son mari.
Le document en partie détruit par le feu ne nous apporte aucun éclaircissement sur les causes de cette renonciation (A.N., M.C., Étude LVI, liasse 246).
Ce même jour, acte est passé de la transmission et du partage entre la dame veuve Chardin et les héritiers de son mari, c'est-à-dire les deux frères Juste et Noël Sébastien. Ce document est en partie détruit par le feu (A.N., M.C., Étude LVI, liasse 246).

5 février : Séance de l'Académie royale : «En ouvrant la séance, le Secrétaire a fait lecture d'une lettre écrite de Versailles, en datte du 31 janvier dernier, à M. Pierre, Directeur, par M. le Comte d'Angiviller, Directeur et ordonnateur général des Bâtimens du Roy, dans laquelle il annonce qu'il a informé Sa Majesté des deux délibérations de l'Académie, l'une par laquelle Elle a fait choix de M. Duplessis pour remplir la place de Conseiller, vacante par la mort de M. Chardin, et l'autre par laquelle Elle a admis M. Suvée, déjà Agréé, en qualité d'Académicien, et il annonce que le Roy a confirmé lesdites élections» (P.V., IX, 1889, p. 4).

4 mars : **Notoriété en rectification des noms de Jean Siméon Chardin :** «Le Sieur Jean Char-

les Rousseau, bourgeois de Paris, y demeurant rue St Honoré, paroisse St Eustache et le Sieur Joseph Gombaux, bourgeois de Paris demeurant rue [...], paroisse St Germain l'Auxerrois lesquels ont certifié et attesté que... *Jean Siméon Chardin*, en son vivant Peintre ordinaire du Roy, conseiller et ancien Trésorier de l'Académie de peinture et sculpture, membre de l'Académie des Sciences, Belles Lettres et Arts de Rouen, décédé à Paris le six décembre dernier. Et que **c'est par erreur et inadvertence si dans divers actes titres et pièces, et notamment dans son extrait mortuaire, il a été nommé de nom de bapteme Jean Baptiste Siméon,** Jean Bpte Simon, ou autrement **au lieu de Jean Siméon...**» (A.N., M.C., Étude LVI, liasse 248 ; inédit).

6 mars : **Vente Chardin** à l'Hôtel d'Aligre, rue Saint-Honoré.

19 juillet : Dans le registre des délibérations de l'Académie de Rouen (conservé à la bibliothèque municipale de Rouen) figure à cette date la mention suivante : « M. de Couronne a lu l'éloge de M. Chardin peintre » (volume II, p. 320).

Haillet de Couronne écrivit un *Éloge* de Chardin grâce à une biographie de Chardin rédigée par Cochin. Cet *Éloge* était destiné à être lu devant les membres de l'Académie de Rouen dont Cochin faisait partie. La bibliothèque de Rouen conserve la correspondance Cochin-Haillet de Couronne, publiée pour la première fois en 1875-1876 par Beaurepaire.

Cochin dans une lettre du 1er juillet 1780, envoie un canevas à Haillet, lui demandant d'insister sur quelques points : « il aura d'abord à ajouter les époques et les circonstances de l'admission de M. Chardin à l'Académie de Roüen, toutes choses dont je ne scavois pas un mot, ... *ce sont ses affaires* », ou au contraire de modérer ses propos : « vous trouverés vers la fin quelques mots de certains desagremens, que cependant on explique pas. M. Pierre ne se les appliquera-t-il ? ne s'en formalisera-t-il point ? par ma foy sil s'y formalise, *ce seront ses affaires* ». Cochin demande aussi à Haillet de Couronne de ne pas évoquer l'épisode où Chardin jeta au bas d'un escalier un laquais du baron Crozat, afin de ne pas nuire à la mémoire de leur ami commun.

24 décembre : Lettre de Cochin à Descamps : « ... Mme Chardin demeure maintenant rue du Renard Saint Sauveur, chés M. Adger, agent de change. M. Dachet, oncle de M. Adger, avoit épousé une sœur de Mme Chardin. Ils ont toujours été liés d'amitié ; M. Dachet est mort ; M. Adger a offert à Mme Chardin de la recevoir chés lui, où elle couleroit la vie douce, n'ayant plus le souci de rien que de sa santé ; Mme Chardin a accepté, et s'y trouve très heureuse. Ils ont une maison de campagne où ils vont passer la plus grande partie de l'été, au moyen de quoy elle jouit d'un doux repos, d'un bon air, et fait de l'exercice sans fatigue. Elle a cependant essuyé une violente maladie l'automne dernier, mais il n'y paroist plus et elle est à présent en très bonne santé. Si vous lui faites des excuses de ne lui avoir pas écrit, vous jetterés la faute sur moy comme de raison, car j'aurois dû vous écrire plutost ; elle me grondera, et nous n'en serons pas moins bons amis tous. Je la vois de temps en temps, et dine quelquefois chez M. Adger » (*Archives de l'Art Français*, 1857-1858, p. 219-220).

1781

1er avril : Lettre de Cochin à Desfriches : « Vous me demandés des nouvelles et l'adresse de notre amie Madame Chardin. Elle a essuyé une maladie violente il y a six ou sept mois, mais elle en est parfaitement revenue. Je ne puis vous dissimuler qu'elle éprouve à présent un cruel chagrin. Après

avoir quitté notre galerie, elle s'est retirée chés M. Adger, agent de change, son allié ; c'étoit une très bonne maison, elle avoit la satisfaction d'y être chérie et d'y jouir de la plus parfaite tranquillité, mais lorsqu'on vit avec des amis on est forcé de participer aux chagrins qu'ils éprouvent. Ce M. Adger vient d'être forcé de faire une faillitte de 1,500,000 livres ; on ne reproche rien à M. Adger, ni faste, ni défaut de conduite, on n'a à se plaindre que de son trop de confiance en des gens qui depuis ont manqué ; aussi ses créanciers ont ils agi avec lui avec toute la douceur, la politesse et la confiance possibles, mais vous sentés qu'il n'est pas présens vray que toute cette maison est dans la désolation et que Madame Chardin en a sa bonne part.

J'ay été la voir, mais comme M. et Mme Adger ont toujours été présens à notre conversation, je n'ay pû m'informer si Madame Chardin ne perd rien dans cette affaire et si elle ne leur a pas confié quelques parties de son bien, ce que je n'ay que trop lieu de craindre ; je tacheray de m'éclaircir la dessus. Son adresse est : à Mme Chardin, chés M. Adger, agent de change. rue du Renard St Sauveur. Si vous lui écrivés, ne touchés point cette corde ou touchés la avec tant de délicatesse que cela n'augmente pas sa peine. Bien des respects, etc. » (Ratouis de Limay, 1907, p. 79-80).

M. Paul Laurent Atger, agent de change, banque et finance à Paris, et sa femme Louise Victoire Pouget (cousine de Mme Chardin) avaient fait aux époux Chardin une rente viagère annuelle de 300 livres (qui se prolongeait au décès d'un des conjoints), en octobre 1772.

1783

Liste, émanant de la Direction générale des Bâtiments, des sommes dues aux Peintres au 1er janvier 1783 : « Chardin Peintre 4606 livres » sur l'exercice 1779 (A.N., O¹ 1934ᴮ).

1784

8 janvier : Testament de Marguerite Pouget.
Ses légataires universelles sont *Delle Marie Jeanne Pouget*, sa sœur et *Dame Louise Victoire Nicole Pouget*, femme de Paul-Laurent Atger. Elle charge Jean Louis Atger, agent de change, du soin de ses funérailles (A.N., M.C., Étude XCIX, liasse 680, inédit).

1790

13 mars : L'inventaire après décès de Mme de La Salle nous apprend que la nièce de Chardin, Marie Agnès Justine, fille de Juste Chardin, veuve de Claude Frary, ancien distillateur de la Compagnie des Indes, habite à Paris rue d'Enfer, paroisse Saint-Jacques-du-Haut-Pas. Elle a deux enfants mineurs : Agnès Justine Frary et Alexandre Juste Frary (probablement le futur architecte, 1779-1854 ; A.N., M.C., Étude II, liasse 747).

7 mai : Inventaire après décès de l'abbé Charles André Berthelot, décédé le 5 mai.
Cet abbé était l'oncle maternel de la femme d'un certain *Juste Henry Chardin, négociant à Paris, y demeurant rue St Denis,* avec sa femme *Dame Marie Louis Jordrin* (A.N., M.C., Étude X, liasse 786).
Ce Chardin ne semble pas faire partie de la descendance directe de Juste que nous pensons connaître par les divers actes mentionnés ci-dessus. Il pourrait cependant s'agir d'un petit-fils du frère cadet de Chardin, Noël Sébastien, marchand mercier. En ef-

fet le nom de Juste Henry revient très souvent dans les actes notariés de 1789 à 1806, accompagné de la mention *marchand mercier* ou *négociant*. Son adresse exacte est donnée dans un acte du 19 fructidor an 10 (août 1801) (A.N., M.C., Étude X, liasse 847) : 105 rue Saint-Denis à Paris.

Est-ce de ce neveu, Juste Henry, habitant rue Saint-Denis, ou de l'autre neveu, Alexandre Juste Frary, dont parlent Laperlier et Camille Marcille dans leurs lettres aux Goncourt comme du descendant de Chardin, architecte, habitant près de la porte Saint-Denis ou Saint-Martin (voir les notices nᵒˢ 110-111).

1791

13 avril : Mme Chardin reçoit diverses sommes en remboursements sur les arrérages de rentes (A.N., M.C., Étude XCIX, liasse 728).

15 mai : **Mort de Mme Chardin,** dans « l'appartement qu'elle occupait au second étage d'une maison sise à Paris rue du Renard Saint-Sauveur appartenant à M. Atger » (voir un inventaire après décès à la date du 6 juin) « Anne-Françoise Marguerite Pouget, veuve en premières noces de Ch. de-Malnoé, écuyer, et en deuxièmes noces de Jean-Siméon Chardin, Peintre du roi et ancien trésorier de l'Académie de peinture, décédée, rue du Renard Saint Sauveur, le 15 mai 1791, âgée de quatre-vingt-quatre ans, en présence de Joseph Heublet, peintre et doreur, son cousin » (Archives de la Seine. Enregistrement. Table des décès. Reg. D 20 Q 8 ; cf. Wildenstein, 1933, p. 151).

16 mai : Inhumation à Saint-Sauveur de Françoise Marguerite Pouget âgée de 84 ans (Goncourt, 1864, p. 164, note 2).

6 juin : **Inventaire après décès de Françoise Marguerite Pouget** (A.N., M.C., Étude XCIX, liasse 730 ; inédit) rédigé à la demande de sa sœur, Marie Jeanne Pouget, fille majeure.
L'inventaire est fait sous les yeux de la femme de chambre Henriette Horey, femme d'André Rivolette, qui confirmera que rien (objets, meubles, etc.) n'a été distrait. On y retrouve, à peu de choses près, les mêmes objets que dans l'inventaire après décès de Chardin du 18 décembre 1779.

18 juin : Succession de Mme Chardin : sa sœur et légataire universelle, Marie Jeanne Pouget, habite à Crécy-en-Brie dans la Communauté des Dames Charitables (rappelons qu'une des demi-sœurs de Chardin, Agnès Suzanne, en était la Supérieure et que l'autre sœur, Marie Agnès, lingère, s'y était retirée). Sa cousine, « la Dame Atger », est aussi légataire universelle, habite toujours rue du Renard Saint-Sauveur mais est « séparé quant aux Biens » de Paul Laurent Atger, son époux. Les deux femmes se partagent les rentes de la défunte (A.N., M.C., Étude XCIX, liasse 730).

1794

11 août (24 Thermidor) : Juste Chardin, frère de Jean Siméon Chardin, habitant au 185 de la rue Révolutionnaire (ancienne rue Princesse) meurt (voir 12 août).

12 août (25 Thermidor) : Scellés apposés après le décès de Juste Chardin (Archives de la Seine D 11 U¹ 4 ; inédit) :
« Nous Joachim Ceyran, juge de Paix de la section Mucius Scevola, ayant été requis, nous sommes transporté, assisté de notre secrétaire greffier, rue Révolutionnaire, nᵒ 185 dans une maison appartenant au sieur Chardin. » Sont présents « les citoyens : *Sébastien-Juste Chardin*, sculpteur, demeurant à Paris,

rue de la Liberté, nº 111, section de Marat» (il mourra le 28 juillet 1808, à 72 ans, rue des Noyers, laissant une veuve, Anne Victoire Bouzoni et un neveu, Jean-Baptiste Richier (*Intermédiaire des Chercheurs et des Curieux*, 10 août 1885, XVIII, nº 414, p. 475-476);

«*Marie-Jeanne Chardin*, fille majeure demeurant 185 rue du Four,

Simon François Vatinelle, routier, demeurant à Paris rue des Fossoyeurs, nº 1045, section Mucius Scevola, au nom et comme mari maître des droits en action nobiliaire en possession de *Marie Angélique Chardin* son épouse,

nous avons déclaré que le citoyen *Juste Chardin*, leur père et beau père, décédé dans le logement où nous sommes le 24 de ce mois à 6 heures du matin âgé de 91 ans de la maladie dont il était alité...»

Ces scellés révèlent un intérieur assez riche; y figurent *dix tableaux dont un sous verre, deux estampes en sous verre, un tableau dessus-de-porte*. En cours de procédure comparait la citoyenne *Marie Agnès Justine Chardin*, veuve du citoyen Claude Frary, distillateur, demeurant 144 rue des Noiret (?) section de l'Observatoire.

Les quatre enfants de Juste sont bien ceux dont les noms étaient portés sur le testament de leur tante Marie Agnès Chardin, le 20 novembre 1764.

L'héritage est partagé en cinq: les quatre enfants et la «citoyenne Geneviève Agnès Chardin veuve de Jean Simon [...illisible à cet endroit] ancien entrepreneur de menuiserie, demeurant à Paris rue des Mathurins, nº 8». Cette dernière personne, l'énigmatique «veuve de Jean Simon», est peut-être la femme de Juste, qui, d'après Jal (1867), s'appelait Geneviève Barbier.

ERRATA

Page 382, column 2
6 mai 1723, line 2:
delete "née en 1697,"

Page 384, column 1
31 dec 1734, line 7:
for "nos. 27 à 34"
read "nos. 27 à 30"

Page 387, column 1
Last line under 1745:
add before period
"A.N., O^1 1921^A"

Page 388, column 1
2 mars 1747, line 8:
delete "; non vérifié."

Page 389, column 3
7 sept 1752, line 11:
for "A. N., O^1 1752"
read "A. N., O^1 1907^B, 1752"

Page 397, column 3
31 dec 1765, line 7:
for "1921, 1765"
read "1921^A, 1765"

Page 401, column 2
25 nov 1773, line 8:
for "Étude XVII"
read "Étude XCII,"
line 9:
for "A. N., S 2842,"
read, A. N., O^1 1921^B, S 2842,"

Exhibitions

Only those exhibitions which were accompanied by a catalog and which included works in the present exhibition are listed here. The various Salons of the eighteenth century—Exposition de la Jeunesse, Salon du Louvre, and the Salon de la Correspondance of 1783—have not been included; individual catalog entries provide this information under Exhibitions where applicable.

We have cited catalog numbers for works in the present exhibition only when two or more exhibitions were held in the same year and city.

The most important exhibitions are noted with an asterisk.

1849, Paris. *Explication des ouvrages de peinture exposés à la Galerie Bonne-Nouvelle*, Association des Artistes, Galerie Bonne-Nouvelle.

1852, Paris. *Explication des ouvrages de peinture, dessin et sculpture exposés aux Galeries Bonne-Nouvelle*, Association dès Artistes, Galerie Bonne-Nouvelle.

1858, Chartres. *Exposition archéologique et d'objets d'arts*, Société Archéologique d'Eure-et-Loir.

*1860, Paris. *Tableaux et dessins de l'école française, principalement du XVIIIe siècle, tirés de collections d'amateurs* (cat. with two supplements), Galerie Martinet.

1866, Amiens. *Exposition rétrospective*, Musée Napoléon.

1867, Versailles. *Exposition rétrospective*, Société des Amis des Arts du Département de Seine-et-Oise.

1869, Chartres. *Exposition départementale*, Société Archéologique d'Eure-et-Loir.

1873, Tours. *Exposition rétrospective d'objets d'art*.

*1874, Paris. *Objets d'art exposés dans le palais de la Présidence du corps législatif au profit des Alsaciens-Lorrains en Algérie* (cat. with supplement), Palais Bourbon.

1878, Paris. *Tableaux anciens et modernes exposés au profit du musée des Arts décoratifs*, Musée des Arts Décoratifs.

1879, Paris. *Dessins de maîtres anciens*, Ecole des Beaux-Arts.

*1880, Paris. *Exposition de tableaux anciens de décoration et d'ornement*, Musée des Arts Décoratifs.

1883, Berlin. *Ausstellung von Gemälden älterer Meister im Berliner Privatbesitz*, Königlichen Akademie der Künste.

1883-1884, Paris. *L'Art du XVIIIe siècle*, Galerie Georges Petit.

1885, Paris. *Exposition de tableaux ... au profit de l'oeuvre des orphelins d'Alsace-Lorraine*, Musée du Louvre.

1887, Paris. *Exposition de tableaux de maîtres anciens au profit des inondés du Midi*, Musée des Arts Décoratifs.

1892, Paris. *Cent Chefs-d'oeuvre des écoles françaises et étrangères*, Galerie Georges Petit.

1896, Chartres. *Exposition rétrospective*, Société Archéologique d'Eure-et-Loir.

1897, Paris. *Exposition de portraits de femmes et d'enfants*, Ecole des Beaux-Arts.

1900, Paris. *Exposition rétrospective de l'art français des origines à 1800*, Exposition Universelle. [62]

1900, Paris. *Exposition rétrospective de la ville de Paris*, Exposition Universelle. [126, 127]

1900, Paris. *Les Collections d'art de Frédéric le Grand*, Exposition Universelle. [77, 80]

1904, Brussels. *L'Art français au XVIIIe siècle*, Palais des Beaux-Arts.

1906, Besançon (France). *Exposition rétrospective des arts en Franche-Comté*, Musée des Beaux-Arts.

1907, London. *Spring Exhibition*, Whitechapel Art Gallery.

*1907, Paris. *Exposition Chardin et Fragonard*, Galerie Georges Petit.

1908, Paris. *Exposition de cent pastels*, Galerie Georges Petit.

1910, Berlin. *Ausstellung von Werken französischer Kunst des 18. Jahrhunderts* (with a large-size edition), Königliche Akademie der Künste.

1913, London. *Collection of Pictures, Drawings ... of the French School of the 18th Century*, Burlington Fine Arts Club.

1914, Glasgow. *Fifty-Third Annual Exhibition*, Royal Glasgow Institute.

1920, New York. *Old Masters*, Knoedler & Co.

1922, Stockholm. *Carl Gustaf Tessin's franska handtechningar*, Nationalmuseum.

1925, Norwich. *Loan Collection of Pictures Illustrative of the Evolution of Painting from the 17th Century to the Present Day*, Castle Museum.

1926, Amsterdam. *Exposition rétrospective d'art français*, Musée de l'Etat.

1926, Detroit. *Loan Exhibition of French Paintings*, The Detroit Institute of Arts.

*1926, New York. *J.B.S. Chardin*, Wildenstein & Co.

1926, Stockholm. *Liljevalchs, Fransk Konst i svensk privat ägo*, Nationalmuseum.

1927, Chicago. *Paintings by Chardin*, The Art Institute of Chicago.

1927, Paris. *Pastels français des XVIIe et XVIIIe siècles*, Hôtel Charpentier.

1928, Paris. *La Vie parisienne au XVIIIe siècle*, Musée Carnavalet.

*1929, Paris. *Exposition des oeuvres de J.B.S. Chardin*, Galerie Pigalle.

1930, Berlin. *Meisterwerke aus den Preussischen Schlössern*, Preussische Akademie der Künste.

1930, Paris. *Les Artistes du Salon de 1737*, Grand Palais.

1931, Paris. *Cadres français et étrangers du XVe au XVIe siècle*, Galerie Georges Petit. [16]

1931, Paris. *Chefs-d'oeuvre des musées de province*, Musée de l'Orangerie.

1932, London. *Exhibition of French Art 1200-1900 — Commemorative Catalogue of the Exhibition of French Art 1200-1900*, Royal Academy of Arts.

1932, Paris. *Exposition rétrospective du décor de la table et de la salle à manger*, Salon des Arts Ménagers, Grand Palais.

1933, Amsterdam. *Het Stilleven*, Kunsthandel J. Goudstikker.

1933, London. *Three French Reigns*, Royal Northern Hospital.

1933, Paris. *Exposition Goncourt*, Gazette des Beaux-Arts.

1933, Springfield (Massachusetts). *Opening Exhibition*, Museum of Fine Arts.

1933, Stockholm. *Selected Drawings from the 15th to the 18th Centuries*, Nationalmuseum.

1934, Chicago. *A Century of Progress, Exhibition of Paintings and Sculpture*, The Art Institute of Chicago.

1934, London. *The Collection of "A Collector,"* Wildenstein & Co.

1934, Los Angeles. *Exhibition of Eleven Canvases*, Los Angeles County Museum of Art.

1934, Paris. *Le Siècle de Louis XV*, Gazette des Beaux-Arts. [57]

1934, Paris. *Musique française*, Bibliothèque Nationale. [63, 124]

1934, San Francisco. *French Painting from the 16th Century to the Present Day*, California Palace of the Legion of Honor.

1935, Baltimore. *A Survey of French Painting*, The Baltimore Museum of Art.

1935, Brussels. *Cinq Siècles d'art*, Vol. I, Exposition Universelle et Internationale.

1935, Copenhagen. *French Art of the 18th Century*.

1935, Paris. *Le Dessin français dans les collections du XVIIIe siècle*, Gazette des Beaux-Arts. [1, 2, 4]

1935, Paris. *Portraits et figures de femmes*, Musée de l'Orangerie. [135]

1935, Toronto. *Loan Exhibition of Painting Celebrating the Opening of the Margaret Eaton Gallery and the East Gallery*, Art Gallery of Ontario.

1935-1936, New York. *French Painting and Sculpture of the 18th Century*, The Metropolitan Museum of Art.

1936, Cleveland. *The Twentieth-Anniversary Exhibition of The Cleveland Museum of Art*.

1936, New York. Chardin and the Modern Still Life, Marie Harriman Gallery.

1936, Paris. *Exposition rétrospective de la vigne et le vin dans l'art*, Musée des Arts Décoratifs. [14, 117, 118]

1936, Paris. *Instruments et outils d'autrefois*, Musée des Arts Décoratifs. [123, 124]

1937, New York. *Pictures from the David-Weill Collection*, Wildenstein & Co.

1937, Paris. *Chefs-d'oeuvre de l'art français*, Palais National des Arts.

1938, Carcassonne (France). *Exposition des chefs-d'oeuvre du musée de Carcassonne*, Musée Municipal.

1938, Stockholm. *Svensk-Franska Konstgalleriet, Fransk konst i svensk ägo*.

1939, Boston. *The Sources of Modern Painting*, Museum of Fine Arts.

1939, New York. *Masterpieces of Art*, New York World's Fair. [21, 59, 86, 87]

1939, New York. *The Great Tradition of French Painting*, Wildenstein & Co. [99]

1939-1940, San Francisco. *Seven Centuries of Painting*, California Palace of the Legion of Honor.

1940, Chicago. *Origins of Modern Art*, Arts Club of Chicago.

1941, Philadelphia. *Chrysler Collection*, The Philadelphia Museum of Art.

1941, Stockholm. *Frankrike genom konstnärsögon*, Nationalmuseum.

1941, Washington. *The Functions of Color in Painting*, The Phillips Collection.

1945, Baltimore. *Still-Life and Flower Paintings*, The Baltimore Museum of Art.

1945, Paris. *Chefs-d'oeuvre de la peinture*, Musée du Louvre. [81, 104]

1945, Paris. *Nouvelles Acquisitions*, Musées Nationaux. [76]

1945, Paris. *Peintures de la réalité au XVIIIe siècle*, Galerie Cailleux. [16]

1946, Paris. *Chefs-d'oeuvre de la peinture française du Louvre des primitifs à Manet*, Musée du Petit Palais. [7, 74, 75, 81, 84, 86, 104, 118, 130, 135, 136]

1946, Paris. *Les Chefs-d'oeuvre des collections privées françaises retrouvés en Allemagne*, Musée de l'Orangerie. [61, 72]

1946, Paris. *Les Goncourt et leur temps*, Musée des Arts Décoratifs. [63, 142]

1947, New York. *French Still Life from Chardin to Cézanne*, Seligmann-Helft Gallery.

1947, Paris. *Cinquantenaire des Amis du Louvre, 1897-1947*, Musée de l'Orangerie.

1947, Wiesbaden. *Malerei des 18. Jahrhunderts*, Landesmuseum.

1948, Amsterdam. See 1948, Paris.

1948, Brussels. *Chefs-d'oeuvre de la Pinacothèque de Munich*, Palais des Beaux-Arts.

1948, London. See 1948, Paris.

1948, Lucerne. *Sammlung Liechtenstein*, Kunstmuseum.

1948, Montclair (New Jersey). *History of Still Life and Flower Painting*, Art Museum.

1948, Paris. *Chefs-d'oeuvre de la Pinacothèque de Munich*, Musée du Petit Palais.

1948, Washington and other cities. *Masterpieces from the Berlin Museums*, National Gallery of Art.

1949, Copenhagen. *Scientific Method of the Louvre Laboratory*.

1949, Geneva. *Trois Siècles de peinture française*, Musée Rath.

1949, Paris. *L'Enfance*, Galerie Charpentier. [72, 85]

1949, Paris. *Les Magiciens de la peinture*, Galerie Bernheim-Jeune. [110]

1949, Paris. *Pastels français*, Musée de l'Orangerie. [134, 135, 136]

1949, San Francisco. *Rococo Masterpieces of 18th-Century French Art from the Museums of France*, California Palace of the Legion of Honor.

1950, Amsterdam. *120 Beroemde Schilderijen mit het Kaiser-Friedrich-Museum te Berlijn*, Rijksmuseum.

1950, Brussels. *Chefs-d'oeuvre des musées de Berlin*, Palais des Beaux-Arts.

1950, Montreal. *The Eighteenth-Century Art of France and England; L'Art en France et en Angleterre au XVIIIe siècle*, Museum of Fine Arts; Musée des Beaux-Arts.

1950, Paris. *Chefs-d'oeuvre des collections parisiennes*, Musée Carnavalet. [46, 139]

1950, Paris. *Le Dessin français de Fouquet à Cézanne*, Musée de l'Orangerie. [1]

1950, Philadelphia. *Diamond Jubilee Exhibition*, Philadelphia Museum of Art.

1950, Vienna. *Meisterwerke aus Frankreichs Museen*, Albertina.

1951, Geneva. *De Watteau à Cézanne*, Musée d'Art et d'Histoire.

1951, Paris. *Chefs-d'oeuvre des musées de Berlin*, Musée du Petit Palais. [77]

1951, Paris. *Natures mortes françaises du XVIIe siècle à nos jours*, Galerie Charpentier. [52, 111]

1951, Pittsburgh. *French Painting 1100-1900*, Museum of Art, Carnegie Institute.

1951, Providence (Rhode Island). *Unfamiliar Treasures from Rhode Island Collections*, Museum of Art, Rhode Island School of Design.

1951, Wiesbaden. *Französische Kunst aus 5. Jahrhunderten*, Landesmuseum.

1951-1952, Berlin. *Meisterwerke aus den Berliner Museen, Europäische Malerei des 17. und 18. Jahrhunderts*, Berliner Museen.

1952, London. *French Drawings from Fouquet to Gauguin*, Arts Council Gallery. [1]

1952, London. *The Hunterian Collection, An 18th-Century Gentleman's Cabinet*, Kenwood. [64, 79]

1952, New York. *Gastronomy in Fine Arts*, Cultural Division of the French Embassy.

*1952, Paris. *La Nature morte de l'Antiquité à nos jours*, Musée de l'Orangerie.

1952, Syracuse (New York). *100 Years of Painting*, Museum of Fine Arts.

1952-1953, Hamburg, Munich. *Meisterwerke der französischen Malerei von Poussin bis Ingres*.

1953, Berlin. *Meisterwerke aus den Berliner Museen und Schlössern, Gemälde alter Meister, Gemälde des 19. Jahrhunderts*, Museum Dahlem.

1953, Brussels. *La Femme dans l'art français*, Palais des Beaux-Arts.

1953, Rennes (France). *Natures mortes anciennes et modernes*, Musée de Rennes.

1953-1954, New Orleans. *Masterpieces of French Painting Through Five Centuries, 1400-1900*, New Orleans Museum of Art.

1954, Baltimore. *Man and His Years*, The Baltimore Museum of Art.

1954, Fort Worth. *Inaugural Exhibition*, Fort Worth Art Center.

1954, Paris. *Le Pain et le vin*, Galerie Charpentier. [105]

1954, Paris. *Choix de dessins et de miniatures du XVIIIe siècle*, Musée du Louvre, Cabinet des Dessins. [142]

1954, Rotterdam. *Vier Eeuwen Stilleven in Frankrijk*, Museum Boymans-van Beuningen.

1954, Saint-Etienne. *Natures mortes de l'Antiquité au XVIIIe siècle*, Musée d'art et d'Industrie.

1954, Saarbrücken (Germany), Rouen (France). *Unbekannte Meisterwerke; Chefs-d'oeuvre oubliés ou peu connus*.

1954-1955, London. *European Masters of the 18th Century*, Royal Academy of Arts.

1954-1955, Tokyo, Fukuoka, Kyoto. *Exhibition of French Art in Japan* (cat. in Japanese).

1955, Bourg-en-Bresse (France). *Art et gastronomie*, Musée de l'Ain.

1955, Chicago. *Great French Paintings*, The Art Institute of Chicago.

1955, Paris. *Trente Tableaux de maîtres anciens*, Galerie Heim.

1955, Zurich. *Schönheit des 18. Jahrhunderts*, Kunsthaus.

1955-1956, Moscow, Leningrad. *French Art from the Fifteenth to the Twentieth Century*.

1955-1956, New York. *Treasures of Musée Jacquemart-André*, Wildenstein & Co.

1956, Besançon. *Natures mortes d'hier et d'aujourd'hui*, Musée des Beaux-Arts.

1956, Cincinnati, Milwaukee. *Still-Life Paintings Since 1470*.

1956, New Haven. *Pictures Collected by Yale Alumni*, Yale University Art Gallery.

*1956, Paris. *De Watteau à Prud'hon*, Gazette des Beaux-Arts.

1956, Portland (Oregon). *Paintings from the Collection of Walter P. Chrysler, Jr.*, Museum of Art.

1957, Besançon. *Concerts et musiciens*, Musée des Beaux-Arts.

1957, Paris. *Cent Chefs-d'oeuvre de l'art français*, Galerie Charpentier.

*1957-1958, Paris. *Portraits français de Watteau à David*, Musée de l'Orangerie.

1958, Bordeaux. *Paris et les ateliers provinciaux au XVIIIe siècle*, Musée des Beaux-Arts.

1958, Des Moines. *Current Painting Styles and Their Sources*, Des Moines Art Center.

1958, Munich. *Europäisches Rokoko*, Residenz.

1958, New York. *Fifty Masterworks from the City Art Museum of St. Louis*, Wildenstein & Co.

1958, Paris. *Portraits dans le dessin français du XVIIIe siècle*, Cabinet des Dessins, Musée du Louvre.

1958, Provincetown (Massachusetts). *Chrysler Art Museum of Provincetown, Inaugural Exhibition*.

1958, Stockholm. *Fem sekler Fransk Konst*, Nationalmuseum.

1959, Albi (France). *Chefs-d'oeuvre du musée Jacquemart-André, XVe siècle au XVIIIe siècle*, Musée Toulouse-Lautrec.

*1959, Paris. *Hommage à Chardin*, Galerie Heim.

1960, Copenhagen. *French Portraiture from Largillierre to Manet*, Ny Carlsberg Glyptotek.

1960, Ottawa. *Masterpieces of European Painting 1490-1840*, National Gallery of Canada.

1960, Paris. *700 Tableaux de toutes les écoles antérieurs à 1800, tirés des réserves du Département des Peintures*, Musée du Louvre.

1960-1961, Le Mans, Rennes, Angers (France). *Peintures et dessins du XVIIIe siècle*.

1961, Los Angeles. *French Masters, Rococo to Romanticism*, UCLA Art Galleries.

1961, Paris. *Chefs-d'oeuvre des collections particulières*, Musée Jacquemart-André. [10, 11, 24, 57, 72, 91, 97, 106, 115]

1961, Paris. *Le Tabac dans l'art, l'histoire et la vie*, Musée des Arts Décoratifs. [74]

1961, Richmond (Virginia). *Treasures in America*, Virginia Museum of Fine Arts.

1961-1962, Montreal, Quebec, Ottawa, Toronto. *Héritage de France; French Paintings 1610-1760*.

1962, Berlin. *Meisterwerke aus den Schlössern Friedrichs des Grossen*, Schloss Charlottenburg.

1962, London. *Primitives to Picasso*, Royal Academy of Arts.

1962, Paris. *Cailleux 1912-1962*, Galerie Cailleux.

1962, San Francisco. *The Henry P. McIlhenny Collection*, California Palace of the Legion of Honor.

1962, Seattle. *Masterpieces of Art*, Seattle Art Museum, Modern Art Pavilion.

1963, New York. *French Masters of the Eighteenth Century*, Finch College Museum of Art. [36]

1963, New York. *Master Drawings from The Art Institute of Chicago*, Wildenstein & Co.

1963, Paris. *Cinq Siècles de cartes à jouer, en France*, Bibliothèque Nationale. [65]

1963, Paris. *Diderot*, Bibliothèque Nationale. [123, 124]

1963, Paris. *La Peinture française au XVIIIe siècle à la cour de Frédéric II*, Musée du Louvre. [54, 77, 80]

1963, Raleigh. *Tercentenary Exhibition*, North Carolina Museum of Art.

1963, Winston-Salem. *Collectors' Opportunity*, Gallery of the Public Library.

1964, Dublin. *1864-1964: Centennial Exhibition*, National Gallery of Ireland.

1964, Paris. *Le Dessin français de Claude à Cézanne dans les collections hollandaises*, Institut Néerlandais.

1964, Paris. *J. Ph. Rameau, 1683-1764*, Bibliothèque Nationale. [124]

1964-1965, Rennes, Dijon, Chambéry, Saint-Etienne, Avignon. *Peintures françaises du XVIIIe siècle au musée du Louvre*.

1965, Bordeaux. *La Peinture française dans les musées de l'Ermitage et de Moscou*, Musée des Beaux-Arts.

*1965, Columbus (Ohio). *Chardin: His Paintings and His Engravers*, Columbus Gallery of Fine Arts.

1965, Indianapolis. *The Romantic Era, Birth and Flowering, 1750-1850*, Indianapolis Museum of Art.

1965, Lisbon. *J. Ph. Rameau*, Palacio Foz.

1965, Moscow, Leningrad. *Exhibition of European Paintings from the Louvre, Bordeaux, and Other Museums of France* (in Russian edition).

1965, New York. *Still-Life Painters*, Finch College Museum of Art.

1965, Paris. *Marcel Proust*, Bibliothèque Nationale. [118]

1965, Paris. *Pastels et miniatures, XVIIe-XVIIIe siècles*, Musée du Louvre, Cabinet des Dessins. [135, 136]

1965-1966, Bordeaux, Paris. *Chefs-d'oeuvre de la peinture française dans les musées de Léningrad et de Moscou* (two editions).

1966, The Hague. *In the Light of Vermeer*, Mauritshuis.

1966, Paris. *Dans la lumière de Vermeer*, Musée de l'Orangerie.

1966, Vienna. *Kunst und Geist Frankreichs im 18. Jahrhundert*, Oberes Belvedere.

1967, Bordeaux. *La Peinture française en Suède*, Musée des Beaux-Arts.

1967-1968, Paris. *Vingt Ans d'acquisitions au musée du Louvre, 1947-1967*, Musée de l'Orangerie.

1967-1968, San Diego, San Francisco, Sacramento, Santa Barbara, New Orleans, San Antonio. *French Paintings from French Museums, 17th-18th Centuries.*

1968, Atlanta. *The Taste of Paris from Poussin to Picasso*, The High Museum of Art.

1968, Göteborg. *100 Malningar och Teckninger fran Eremitaget*, Konstmuseum.

*1968, London. *France in the 18th Century*, Royal Academy of Arts. [2, 4, 10, 25, 39, 60, 68, 70, 83, 85, 100, 110, 117]

1968, London. *French Paintings and Sculpture of the 18th Century*, Heim Gallery. [3]

1968, Paris. *Watteau et sa génération*, Galerie Cailleux.

1968, Portland (Oregon). *75 Masterworks*, Museum of Art.

1969, Bordeaux. *L'Art et la musique*, Galerie des Beaux-Arts.

1969, New York, Boston, Chicago. *Drawings from Stockholm.*

1969, Paris. *Présentation de la collection La Caze*, Musée du Louvre.

1969, Tokyo. *French Art of the 18th Century*, National Museum of Occidental Art.

1969-1970, Paris, Bordeaux. *Peintures du XVIIIe siècle au musée des Beaux-Arts de Bordeaux* (Paris, Galerie Cailleux).

1970, Detroit. *The Robert Hudson Tannahill Bequest to The Detroit Institute of Arts.*

1970, Raleigh. *Exhibition Number One from the Permanent Collection*, North Carolina Museum of Art.

1970-1971, Amsterdam. See 1970-1971, Paris.

1970-1971, Brussels. See 1970-1971, Paris.

1970-1971, Nagoya, Kamakura, Osaka, Fukuoka. *Exhibition of Masterpieces from the Bordeaux Museum of Fine Arts.*

1970-1971, Paris. *Dessins de Stockholm*, Cabinet des Dessins, Musée du Louvre. [2, 4]

1970-1971, Paris. *Le Siècle de Rembrandt*, Musée du Petit Palais.

1971, Paris. *Trente Pastels, gouaches et aquarelles du XVIIIe siècle*, Galerie Cailleux.

1972, Dresden. *Meisterwerke aus der Ermitage Leningrad und aus dem Puschkin-Museum Moskau*, Gemäldegalerie.

1973, London. *A Selection of Paintings, Drawings, Prints, and Other Works from the Hunterian Museum, University of Glasgow*, Colnaghi and Co.

1973, New York. *Twelve Years of Collecting*, Wildenstein & Co.

1973, Saint-Paul-de-Vence (France). *André Malraux*, Fondation Maeght.

1973, Troyes, Nancy, Rouen. *La Scène de genre et le portrait dans la peinture française du XVIIIe siècle—Tableaux du Louvre.*

1973-1974, Paris. *Copies, répliques, pastiches*, Musée du Louvre.

1974, Atlanta. *A French Way of Seeing: An Exhibition of Paintings from the Museum of Art, Carnegie Institute, Pittsburgh*, The High Museum of Art.

1974, Chicago. *The Helen Regenstein Collection of European Drawings*, The Art Institute of Chicago.

1974, San Francisco. *Three Centuries of French Art*, California Palace of the Legion of Honor.

1974, Paris. *Louis XV, un moment de perfection de l'art français*, Hôtel de la Monnaie.

1974, Tokyo. *Master Paintings from The Hermitage, Leningrad.*

1975, Brussels. *De Watteau à David*, Palais des Beaux-Arts.

1975, Cleveland. *The Year in Review*, The Cleveland Museum of Art.

1975-1976, Toledo, Chicago, Ottawa. *The Age of Louis XV: French Paintings 1710-1774.*

1975-1976, Washington, New York, Detroit, Los Angeles, Houston, Mexico, Canada. *Master Paintings from The Hermitage and the State Russian Museum, Leningrad.*

1976, Chicago. *Selected Works of 18th-Century French Art in the Collections of The Art Institute of Chicago.*

1976, Norfolk (Virginia). *Homage to the Louvre*, Chrysler Museum.

1976, Paris. *Hommage à Louis Gillet (1876-1943)*, Musée Jacquemart-André.

1977, Allentown (Pennsylvania). *French Masterpieces of the 19th Century from the Henry McIlhenny Collections*, Allentown Art Museum.

1977, Cincinnati. *The Best of Fifty*, The Taft Museum.

1977, Nashville. *Treasures from the Chrysler Museum at Norfolk and Walter P. Chrysler, Jr.*

1977, Omaha. *The Chosen Objects, European and American Still Life*, Joslyn Art Museum.

1977, Paris. *Francis Ponge*, Centre Georges Pompidou.

1977, Tokyo. *French Master Draftsmen of the 18th Century*, Wildenstein Gallery.

1978, Bordeaux. *La Nature morte de Brueghel à Soutine*, Galerie des Beaux-Arts.

1978, Chicago. *European Portraits 1600-1900 in The Art Institute of Chicago.*

1978, Moscow, Leningrad. *Le XVIIIe Siècle français—Tableaux des collections publiques françaises.*

Bibliography

This bibliography, compiled with the assistance of Mlle Marie-Paule Durand, does not purport to be exhaustive: it contains only those works which were consulted while writing this catalog. For example, eighteenth-century Salon catalogs and journals or periodicals are not cited here; rather, they are included in the discussions of relevant catalog entries. Translated from the French edition, this list contains few, if any, revisions; nor have we attempted to make it conform to standard American bibliographical style in every instance. Titles of the most important books or articles on Chardin are preceded by an asterisk, thus providing the reader with a convenient guide to Chardin.

ADHEMAR, H. "Une nature morte de M. H. Bounieu, autrefois attribuée à Chardin," *Bulletin du Laboratoire du musée du Louvre*, 1956, pp. 63-66.
———."Chardin," in *Encyclopedia of World Art*, Vol. III, 1958.
ADHEMAR, J. "Lettres adressées aux Goncourts concernant les Beaux-Arts conservées à la Bibliothèque nationale," *Gazette des Beaux-Arts*, Vol. LXXII, November 1968, pp. 227-36.
ADHEMAR, J. and LETHEVE, J. *Inventaire du fonds français après 1800* (Bibliothèque nationale), Paris, 1955, Vol. IX.
AGNEW. *Geoffrey Agnew's 1817-1967*, London, 1967.
A. J. D. "Exposition des ouvrages de peinture au profit de la caisse de secours de la Société des Artistes," *L'Illustration*, 5 February 1848, pp. 359-62.
ALEXANDRE, A. "La collection E. Cronier," *Les Arts*, November 1905, No. 47, pp. 2-32.
———. "A la gloire de Chardin," *La Renaissance*, November 1929, pp. 521-28.
ALFASSA, P. "Exposition d'art français du XVIIIe siècle à Berlin," *Revue de l'Art ancien et moderne*, April 1910, pp. 161-78.
ANANOFF, A. "Chardin. Il reste sûrement plus de quatre dessins," *Connaissance des Arts*, February 1967, No. 153, pp. 60-63.
ANSEL, F. J. and FRAPIE, F. R. *The Art of the Munich Galleries*, London, 1911.
ANTAL, F. *Hogarth and His Place in European Art*, London, 1962.
ANTONOVA, I. *Le musée de Moscou*, Paris, 1963.
ARJUZON, J. d'. *Notice et généalogie de la famille d'Arjuzon* (typewritten), Paris, 1978.
ARNHEIM, F. *Luise Ulrike, die schwedische Schwester Friedrichs des Grossen. Ungedruckte Briefe an Mitglieder des preussischen Königshauses*, Vol. I: 1729-1746, Gotha, 1909; Vol. II: 1747-1758, Gotha, 1910.
AVENEL, G. "Les riches depuis sept cents ans. Honoraires des artistes peintres et sculpteurs," *Revue des Deux-Mondes*, 5th Series, Vol. 37, 1907, pp. 573-603.

BABELON, J. "A propos d'un livre nouveau, J.B.S. Chardin," *Beaux-Arts*, 15 December 1933, No. 50, pp. 1, 8.
BACHAUMONT, L. de. *Mémoires secrets pour servir à l'histoire de la République des Lettres en France, depuis 1762, jusqu'à nos jours, ou Journal d'un observateur...*, 36 vols., London, 1777-1789.
BAILLET de SAINT-JULIEN, L. G. *Lettre à M. Ch[ardin] sur les caractères en peinture*, Geneva, 1753.
———. *La Peinture* (poem), Paris, 1753 (2nd ed. 1755; 3rd ed. 1757).
BANKS, O. T. *Watteau and the North: Studies in the Dutch and Flemish Baroque Influences on French Rococo Painting*, New York, 1977.
BARCELO, L.-J. "La nature morte et la table," *Vie des Arts*, 1960, No. 21, pp. 39-43.
*BARRELET, J. "Chardin du point de vue de la verrerie," *Gazette des Beaux-Arts*, Vol. LIII, May-June 1959, pp. 305-13.
BATZ, G. de. "Masterpieces and the Artist: Four Paintings Compared," *The Connoisseur*, Vol. CXLIX, April 1962, pp. 272-74.
BAUER, G. *Dessins français du XVIIIe siècle —La figure humaine*, Paris, 1959.
BAUER, H. *Die Alte Pinakothek in München*, Munich, 1966.
BAZIN, G. "Le XVIIIe siècle," *L'Amour de l'Art*, January 1932, pp. 17, 19, 22.
———. *Les Trésors de la peinture du musée du Louvre*, Paris, 1957 (2nd ed. 1960; 3rd ed. 1962).
BEAUREPAIRE, Ch. de. See COCHIN.
BEGUIN, S. "Exposition Hommage à Louis La Caze (1798-1869)," *Revue du Louvre et des musées de France*, 1969, No. 2, pp. 115-20.
———. "Le Louvre, Département des peintures," *Les Muses*, 29 October 1969, pp. 121-22.
BELLIER de LA CHAVIGNERIE, E. "Notes pour servir à l'histoire de l'exposition de la jeunesse. Les artistes français du XVIIIe siècle oubliés ou dédaignés," *Revue universelle des Arts*, Vol. XIX, 1864, pp. 38-67.

BELLIER de LA CHAVIGNERIE, E. and AUVRAY, L. *Dictionnaire général des artistes de l'école française*, 2 vols., Paris, 1882, Vol. I, pp. 229-30.

BENESCH, E. *Otto Benesch: Collected Writings*, 4 vols., London, 1970-1971; Vol. I: *Rembrandt*, pp. 73-75; Vol. II: *Drawings*, pp. 372-74.

BENESCH, O. "Rembrandts Vermächtnis," *Belvedere*, August 1924, pp. 148-75.

————. "Rembrandt's Artistic Heritage: From Rembrandt to Goya," *Gazette des Beaux-Arts*, Vol. XXXIII, May 1948, pp. 281-300.

BENOIT, A.N. *Histoire de la peinture*, St. Petersburg, 1912, Vol. IV, pp. 312-20.

BIVER, P. *Histoire du château de Bellevue*, Paris, 1933.

BJURSTRÖM, P. "Letter to the Editors," *Master Drawings*, Vol. VII, 1969, pp. 58-61.

————. "François-Jérôme Chantereau, dessinateur," *Revue de l'Art*, 1971, No. 14, pp. 80-85.

BLANC, Ch. *Histoire des peintres de toutes les écoles depuis la Renaissance jusqu'à nos jours*, Vol. II: *Ecole française*, Paris 1865; Vol. II: *Ecole hollandaise* (Egbert van der Poel), Paris, 1883.

*BOCHER, E. *Jean-Baptiste Siméon Chardin*, Les gravures françaises du XVIIIe siècle, 3rd fasc., Paris, 1876.

BODKIN, Th. "Chardin in the London and Dublin National Galleries." *The Burlington Magazine*, Vol. XLVII, August 1925, pp. 93-94.

BOGGS, J. S. *The National Gallery of Canada*, Toronto, 1971.

BOILLY, J. "Billet de Ch. N. Cochin à Belle le fils," *Archives de l'Art français*, 1852-1853, p. 128.

BOIS, Y. A., BONNE, J.-CI., BONNEFOI, Ch., DAMISCH, H. and LEBENSZTEYN, J.-CI. "La Raie," *Critique*, August-September 1973, pp. 679-80.

BORN, W. *Still-Life Painting in America*, New York, 1947.

BÖRSCH-SUPAN, H. "Friedrich Rudolf, comte de Rothenbourg," *L'Oeil*, December 1968, pp. 12-19.

————. "Art Collections in Berlin and Potsdam in the Eighteenth Century," *Apollo*, August 1977, pp. 126-33.

BOUCHER, Fr. "L'exposition de la vie parisienne au XVIIIe siècle au musée Carnavalet," *Gazette des Beaux-Arts*, Vol. XVII, April 1928, pp. 193-212.

BOUCHER, Fr. and JACCOTTET, Ph. *Le dessin français au XVIIIe siècle*, Lausanne, 1952.

BOUCHOT-SAUPIQUE, J. *Catalogue des pastels (musée du Louvre)*, Paris, 1930.

BOUILLON, J. P. See GONCOURT, J. and Ed., 1967.

BOURCARD, G. *Guide manuel de l'amateur d'estampes du XVIIIe siècle. Ecole française*, Paris, 1885.

BOURET, J. "L'ènfance à la galerie Charpentier," *Les Arts*, 17 June 1949, pp. 1,4.

BOUYER, T. "La question des oeuvres d'art et les tableaux français du Roi de Prusse," *Le Cousin Pons*, 1 February 1919, No. 55.

BRIERE, G. *Catalogue des collections nouvelles formées par les musées nationaux de 1914 à 1919 et qui sont exposées temporairement dans la salle La Caze depuis le 10 février 1919*, Paris, 1918-1919.

————. *Les accroissements des musées nationaux français, le musée du Louvre depuis 1914; dons, legs et acquisitions*, Paris, 1919.

BRINCKMANN, A. E. *Die Kunst des Rokoko*, Berlin, 1940.

BRINTON, S. "The Late Sir Hugh Lane's Collection," *The Connoisseur*, Vol. XLIV, February 1916, pp. 68-70.

BROOKNER, A. *The Genius of the Future*, New York, 1971.

————. *Greuze: The Rise and Fall of an Eighteenth-Century Phenomenon*, London, 1972.

BUCHNER, E. *Die Alte Pinakothek*, Munich, 1957.

BUE-AKAR, G. "Eléments nouveaux concernant la vie et l'oeuvre de G. Van Opstal, sculpteur ordinaire du Roi," *Bulletin de la Société de l'histoire de l'Art français (1975)*, 1976, pp. 137-46.

BULLOCK, B. C. *"Vous revoilà donc, grand magicien...": A Study of Chardin and Diderot* (typewritten), New York, Columbia University, 1976.

BURCKHARDT, J. *Burckhardt und die Karlsruher Galerie. Briefe und Gutachten*, Karlsruhe, 1941.

*BÜRGER, W. (THORE). "Exposition de tableaux de l'école française, tirés de collections d'amateurs," *Gazette des Beaux-Arts*, Vol. VII, 1860, pp. 257-77, 330-40; Vol. VIII, pp. 228-40.

————. "Petit guide des artistes en voyage—Allemagne Rhénane," *Annuaire des amateurs et des artistes*, Vol. III, 1862, pp. 287-308.

————. *Trésors d'art en Angleterre*, 3rd ed., Paris, 1865.

BURROLET, Th. *Le musée Cognacq-Jay*, Paris, 1973.

*BURTY, Ph. *Catalogue de tableaux et dessins de l'école française, principalement du XVIIIe siècle, tirés de collections d'amateurs* (with 2 supplements), Paris, 1860.

————. *La collection Laperlier*, preface of sale catalog, Paris, 11-13 April 1867.

————. *Eaux-fortes de Jules de Goncourt*, Paris, 1876.

————. "Profils d'amateurs. I. Laurent Laperlier," *L'Art*, Vol. XVI, 1879, pp. 147-52.

Cabinet de l'amateur et de l'antiquaire: "Catalogue général des ouvrages exposés au Salon du Louvre depuis 1699 jusqu'en 1789," 1844, Vol. III, pp. 120-24.

CAILLEUX, J. "Themes and Revivals in Connection with Two Still-Life Paintings by Fr. Desportes," *The Burlington Magazine*, September 1969, Suppl. No. 24, pp. I-VII.

————. "Three Portraits in Pastel and Their History," *The Burlington Magazine*, November 1971, Suppl. No. 27, pp. II-VI.

————. "Les artistes français du XVIIIe siècle et Rembrandt," *Etude d'Art français offertes à Ch. Sterling*, Paris, 1975.

CAIN, J. *Musée Jacquemart-André*, Paris, 1967.

CAMBURAT, M. de. *Exposition des tableaux du Louvre faite en l'année 1769*, Geneva, 1769.

CAMPARDON, E. *Madame de Pompadour et la Cour de Louis XV*, Paris, 1867.

————. *J. B. Massé, peintre de Louis XV*, Paris, 1880.

CARRITT, D. "Pictures from Gosford House," *The Burlington Magazine*, Vol. XCIX, October 1957, pp. 343-44.

*————. "Mr. Fauquier's Chardins," *The Burlington Magazine*, Vol. CXVI, September 1974, pp. 502-9.

CASANOVA, M. L. "La mostra del rittrato francese," *Capitolium*, Vol. XXXVII, 1962, pp. 388-92.

CATROUX, R. Cl. "La collection Charles Haviland," *Revue de l'Art ancien et moderne*, November 1922, pp. 279-86.

CEZANNE, P. *Correspondance*, collected by J. Rewald, Paris, 1937.

[CHABEUF, H.] *Catalogue des tableaux et objets d'art de la collection E. Borthon*, Dijon, 1860.

CHAMPFLEURY, J. "Les nouveaux tableaux du musée," *L'Artiste*, 15 July 1845, pp. 8-9.

————. *Le Réalisme*, essays selected and introduced by G. and J. LACAMBRE, Paris, 1973.

CHAMPREUX d'ALTENBOURG. "Un portrait de Capitoul au musée du Louvre," *Bulletin de la Société archéologique du Midi de la France* (session of February 1910), 1913, No. 40, pp. 33-35.

CHAPPUIS, A. *Les dessins de Paul Cézanne du Cabinet des Estampes du musée de Bâle*, Olten and Lausanne, 1962.

CHARMET, R. *La peinture française dans les musées russes*, Paris, 1970; English ed. New York, 1970.

CHASTEL, A. "La peinture française en Russie, *Médecine de France*, 1958, No. 91, pp. 41-42.

*CHENNEVIERES, H. de. "Chardin au musée du Louvre," *Gazette des Beaux-Arts*, Vol. XXXVIII, 1880, pp. 54-64; Vol. I, 1889, pp. 121-30.

———. "Silhouettes de collectionneurs. M. Eudoxe Marcille," *Gazette des Beaux-Arts*, Vol. IV, 1890, pp. 217-35, 296-310.

CHENNEVIERES, Ph. de. *J.B.S. Chardin, Portraits inédits d'artistes français*, 3rd livraison, April 1856.

———. *Les dessins des maîtres anciens exposés à l'Ecole des Beaux-Arts en 1879*, Paris, 1880.

———. *Souvenirs d'un directeur des Beaux-Arts*, 5 vols., Paris, 1883-1889, Vol. I: pp. 50, 102; Vol. IV: pp. 67, 121-22, 126-41; Vol. V: pp. 18-65.

———. "Le comte L. Clément de Ris," *Mémoires de l'Academie de Bellesme*, Vol. I, 1873, pp. 1-27.

CHOUILLET, J. *La formation des idées esthétiques de Diderot*, Paris, 1973.

CHRISTOFFEL, U. "Vom Stilleben Zurbarán und Chardin," *Eberhard Hanfstaengl zum 75. Geburtstag*, Munich, 1961, pp. 52-58.

CLARK, C. C. "Jean-Baptiste Siméon Chardin: Still Life with Herring," *The Bulletin of The Cleveland Museum of Art*, Vol. LXI, November 1974, pp. 309-14.

CLEMENT, Ch. "La collection Camille Marcille," *Journal des débats*, 5 March 1876.

CLEMENT de RIS, L. "Troisième exposition de l'Association des artistes," *L'Artiste*, 23 January 1848, pp. 177-80; 30 January 1848, pp. 193-96.

———. "Nouvelle galerie française du Louvre," *L'Artiste*, 1 December 1848, pp. 110-12.

———. *Les musées de Province, Histoire et description*, 2 vols., Paris, 1859-1861 (2nd ed. 1972).

———. "Musée national de Stockholm. Ecole française," *Gazette des Beaux-Arts*, Vol. X, 1 November 1874, pp. 493-98.

———. *Les amateurs d'autrefois*, Paris, 1877.

———. "Le Musée impérial de l'Ermitage à Saint-Pétersbourg. Ecole française," *Gazette des Beaux-Arts*, Vol. XXI, 1880, pp. 262-73.

COCHIN, Ch. N. "Essai sur la vie de Chardin (1780)," published by BEAUREPAIRE in *Précis analytique des travaux de l'Academie des Sciences, Belle-Lettres et Arts de Rouen*, Vol. LXXVIII, 1875-1876, pp. 417-41.

COHEN, G. and P. *"Les Vestales." A Missing Work by Jean-Baptiste Siméon Chardin* (typewritten), Evanston, Illinois, 1973.

CONISBEE, P. "Art and Society in 18th-Century France," *The Burlington Magazine*, Vol. CXVIII, June 1976, pp. 417-18.

CONSTABLE, W. G. *The Painter's Workshop*, Oxford, 1956.

CORDEY, J. *Inventaire des biens de Madame de Pompadour rédigé après son décès*, Paris, 1939.

CORNU, P. See THIEME-BECKER, 1912.

Corrrespondance des directeurs de l'Academie de France à Rome, published by Montaiglon and Guiffrey, Paris, 1901, Vol. XI; Vol. XII, 1902; Vol. XIII, 1904.

COURAJOD, L. See DUVAUX.

———. *L'Ecole royale des élèves protégés*, Paris, 1874.

COURBOIN, Fr. "Le retour de l'école," *Revue de l'Art ancien et moderne*, Vol. II, 1897, pp. 267-68.

COURCY MAY, H. de. "The Spirit of the 18th Century," *Art News*, Vol. XLI, December 1942, pp. 9-19.

COURTHION, P. "Les peintres et la table," *L'Art Vivant*, 1 November 1932, No. 166, p. 526.

———. *Paris d'autrefois de Fouquet à Daumier*, Paris, 1957.

COX, T. "A First View of the French Exhibition," *The Connoisseur*, January 1932, pp. 3-10.

———. "The National Gallery of Canada," *The Museums Journal*, Vol. LX, April 1960, pp. 2-5.

CROMBIE, T. "The Thyssen Pictures and the National Gallery," *Connoisseur Year Book*, 1962, pp. 97-103.

CUMMINGS, F. and ELAM, Ch. *The Detroit Institute of Arts*, Detroit, 1971.

DACIER, E. *Catalogues de ventes et livrets de Salons illustrés par Gabriel de Saint-Aubin*, Paris, 1909-1921, 6 vols. with facsimile.

———. "La collection Jacques Doucet," *Revue de l'Art ancien et moderne*, March 1912, pp. 321-38.

———. "L'Art français." *Musée Jacquemart-André*, Paris, 1913, pp. 57-72.

———. *L'oeuvre gravé de Gabriel de Saint-Aubin*, Paris, 1914.

———. *La gravure en France au XVIIIe siècle—La gravure de genre ou de moeurs*, Paris, 1925.

——— *L'Art au XVIIIe siècle en France, 1715-1760*, Paris, 1951.

DACIER, E. and RATOUIS de LIMAY, P. *Pastels français des XVIIe et XVIIIe siècles*, Paris, 1927.

DACIER, E. and VUAFLART, A. *Jean de Jullienne et les gravures de Watteau. I. Notices et documents biographiques*, Paris, 1929.

DARCEL, A. "Une lettre de Chardin," *Revue de l'Art ancien et moderne*, Vol. I, 5 May 1885, p. 71.

DARGENTY. G. "Chardin," *L'Art*, Vol. XXXIII, 1883, pp. 3-6.

DAVIES, M. *National Gallery Catalogues. French School*, London, 1947.

———. "Catalogue of the D. G. Van Beuningen Collection," *The Burlington Magazine*, Vol. XCIII, July 1951, pp. 242-43.

DAYOT, A. *Chardin-Fragonard*, special number of *L'Art et les Artistes*, 1907, No. 27.

DAYOT, A. and GUIFFREY, J. *J. B. S. Chardin*, Paris, 1907.

DAYOT, A. and VAILLAT, L. *L'oeuvre de J. B. S. Chardin et J. H. Fragonard*, Paris, 1907.

DECORDE. "Quelques lettres inédites de Cochin (1757-1790)," *Précis analytique des travaux de l'Académie des Sciences, Belle-Lettres et Arts de Rouen*, 1868-1869, pp. 171-228.

DE LA MARE, W. *Chardin (1699-1779)*, New York, 1948.

DELZANT, A. *Les Goncourt*, Paris, 1889.

DEMONTS, L. "Dessins français des cabinets d'Allemagne," *Bulletin de la Société de l'histoire de l'Art français*, 1909, pp. 259-80.

DEMORIS, R. "La nature morte chez Chardin," *Revue d'Esthétique*, Vol. XXII, 1969, pp. 363-85.

DENIS, M. "Cézanne," *L'Occident*, September 1907, No. 70, pp. 118-32.

DENVIR, B. *Chardin*, Paris, 1950.

DESAZARS. "Le capitoul Godefroy," *Revue des Pyrénées*, Vol. XXI, 1909, pp. 407-16.

DESCARGUES, P. *Le musée de l'Ermitage*, Paris, 1961.

DESMAZE, Ch. *Le reliquaire de M. Quentin de La Tour, peintre de Roi Louis XV, sa correspondance et son oeuvre*, Paris, 1874.

DEVILLE, E. *Index du Mercure de France*, Paris, 1910.

DEZALLIER d'ARGENVILLE, A. N. *Voyage pittoresque de Paris*, 2nd ed., Paris, 1752.

DIDEROT, D. *Correspondance*, 16 vols., Paris, 1961.

———. *Oeuvres esthétiques*, Paris, 1966.

———. See SEZNEC, J. and ADHEMAR, J.

DILKE, E. F. S. "L'art français au Guidhall de Londres en 1898," *Gazette des Beaux-Arts*, Vol. XX, 1898, p. 334.

*——— . (1) "Chardin et ses oeuvres à Potsdam et à Stockholm," *Gazete des Beaux-Arts*, Vol. XXII, 1899, pp. 177-90, 333-42, 390-96.

———. (2) *French Painters of the 18th Century*, London, 1899.

DILLIS, G. V. *Verzeichnis der Gemälde in der königlich-bayrischen Galerie zu Schleissheim*, Munich, 1831.

DIMIER, L. *Les peintres français du XVIIIe siècle*, 2 vols., Paris and Brussels, 1928-1930.

DOHME, R. "Die Austellung von Gemälden älterer Meister: Französische Schule," *Jahrbuch der königlich-preussischen Kunstsammlungen*, Berlin, 1882, Vol. 4.

DONAT de CHAPEAUROUGE, C. *Untersuchungen zur Kunst Chardins* (inaugural dissertation), Bonn, 1953.

———. *Die Stilleben Chardins in der Karlsruher Galerie*, Karlsruhe, 1955.

*———. "Chardins Kinderbilder und die Emblematik," *Actes du 22e Congrès international d'Histoire de l'art (Budapest 1969)*, Budapest, 1972, Vol. II, pp. 51-56.

DORBEC, P. "Un portrait de la seconde femme de Chardin au Musée Carnavalet," *Gazette des Beaux-Arts*, Vol. XXIX, 1903, pp. 37-41.

―――. "Le portraitiste Aved et Chardin portraitiste," *Gazette des Beaux-Arts,* Vol. XXXII, 1904, pp. 89-100, 215-24, 341-52.

―――. "L'Exposition de la Jeunesse au XVIIIe siècle," *Gazette des Beaux-Arts,* Vol. I, 1905, pp. 456-70; Vol. II, pp. 77-86.

DORIA, A. *Le comte de Saint-Florentin, son peintre et son gravure d'après des documents inédits,* Paris, 1933.

DÜBEN, C. W. von. *General-Forteckning på alla Hennes Kongl. Majit Drottningen (Lovisa Ulrika) vid Kongl. Lustslottet Drottningholm tillhorige Taflor or Schilderier 1760,* reprinted in SANDER, *National Museum Bidrag,* Vol. I, 1872.

DUBOS, Ch. *Extraits d'un journal, 1908-1928,* 2nd ed., Paris, 1931.

DUMONT-WILDEN, L. "L'exposition de l'art français au XVIIIe siècle," *Revue de l'Art ancien et moderne,* Vol. XV, March 1904, pp. 229-34.

DUNCAN, C. "Happy Mothers and Other New Ideas in French Art," *Art Bulletin,* December 1973, No. 4, pp. 570-83.

DU PAYS, A. J. "Exposition de tableaux et dessins de l'école française," *L'Illustration,* 29 September 1860.

DUPLESSIS, G. See WILLE.

―――. "La Collection de M. Camille Marcille," *Gazette des Beaux-Arts,* Vol. XIII, 1876, pp. 419-39.

―――. *Catalogue de la collection de pièces sur les Beaux-Arts imprimées et manuscrites recueillie par P. J. Mariette, Ch. Nic. Cochin et M. Deloynes...,* Paris, 1881.

DUSAULCHOY. *Mosaïque historique, littéraire et politique, ou Glanage instructif et divertissant d'anecdotes,* Paris, 1818, Vol. II, pp. 156-57.

DUSSIEUX, L. *Les Artistes français à l'étranger,* Paris, 1852 (2nd ed. 1856; 3rd ed. 1876).

DUVAUX, L. *Livre-Journal (de),* 2 vols., Paris, 1873.

EICHHOLZ, A. "Affenliebe zur Malerei; Possen mit tierischem Ernst," *Die Kunst,* Vol. LX, August 1962, pp. 460-63.

EINSTEIN, L. "Looking at French 18th-Century Pictures of the National Gallery, Washington," *Gazette des Beaux-Arts,* Vol. XLVII, 1956, pp. 213-50 (book by same title published in Paris, 1958).

EISLER, C. "A Chardin in the Grand Manner," *Bulletin of The Metropolitan Museum of Art,* February 1960, pp. 203-12.

* ―――. *Complete catalogue of the Samuel H. Kress Collection: European Paintings, Excluding Italian,* Oxford, 1977.

ENGERAND, F. "Les commandes officielles de tableaux au XVIIIe siècle. Jean-Baptiste Siméon Chardin," *La Chronique des Arts et de la Curiosité,* 4 April 1896, pp. 128-30; 2 May 1896, pp. 163-64.

―――. *Inventaire des collections de la couronne: Inventaire des tableaux commandés et achetés par la Direction des Bâtiments du Roi, 1709-1792,* Paris, 1901.

EPHRUSSI, Ch. "Exposition de maîtres anciens tirés des collections privées de Berlin en 1883," *Gazette des Beaux-Arts,* Vol. XXX, July 1884, pp. 97-104.

ERNST, S. "Notes sur des tableaux français de l'Ermitage," *Revue de l'Art ancien et moderne,* December 1935, pp. 135-44.

EUDEL, P. *L'Hôtel Drouot et la Curiosité en 1883,* Paris, 1884.

―――. *L'Hôtel Drouot et la Curiosité en 1884-1885,* Paris, 1886.

―――. *L'Hôtel Drouot et la Curiosité en 1885-1886,* Paris, 1887.

―――. *L'Hôtel Drouot et la Curiosité en 1886-1887,* Paris, 1888.

―――. *L'Hôtel Drouot et la Curiosité en 1887-1888,* Paris, 1889.

FALKE, J. von. *Geschichte des fürstlichen Hauses Liechtenstein,* Vienna, 1882.

FANTIN-LATOUR, Madame. *Catalogue de l'oeuvre de Fantin-Latour,* Paris, 1911.

FARE, M. *La nature morte en France, son histoire et son evolution du XVIIe siècle au XXe siècle,* 2 vols., Geneva, 1962.

FARE, M. and F. "Le trompe-l'oeil dans la peinture français du XVIIIe siècle," *L'Oeil,* 1976, No. 257, pp. 2-7.

―――. *La vie silencieuse en France. La nature morte au XVIIIe siècle,* Fribourg, 1976.

―――. *Natura in posa. La grande stagione della natura morta europea,* Milan, 1977.

―――. "Saveurs de la vie silencieuse du XIXe siècle," *L'Oeil,* July-August 1978, No. 276-77, pp. 10-19.

FARRENC, H. "Le musée Jacquemart-André," *L'Art et les Artistes,* Vol. XVI, 1928, No. 88, pp. 289-98.

FAURE, E. *Histoire de l'Art,* 5 vols., *Art moderne,* Paris, 1921, Vol. IV.

FENEON, F. "Les grands collectionneurs. IX. M. Jacques Doucet," *Bulletin de la vie ártistique,* 1 June 1921, No. 11, pp. 313-18.

FIERENS, P. "La vie et l'oeuvre de Chardin," *Journal des débats,* 2 October 1934.

FLORISOONE, M. *Chardin,* Les trésors de la peinture française au XVIIIe siècle, Geneva, 1938.

―――. *Le XVIIIe siècle,* Paris, 1948.

FOERSTER, Ch. F. *Das Neue Palais bei Potsdam,* Berlin, 1923.

FONTAINE, A. *Les collections de l'Académie royale de peinture et de sculpture,* Paris, 1910 (2nd ed. 1930).

FOSCA, Fr. *Candide,* 8 May 1930.

―――. *The Eighteenth Century. Watteau to Tiepolo,* Geneva, 1952.

FOUCART, J. *(père). Les Lavalard* (typewritten), Amiens, 1977.

FOUCART, J. and LECALDANO, P. *Rembrandt,* Les classiques de l'Art, Paris, 1971.

*FOURCAUD, M. de. "Jean-Baptiste Siméon Chardin," *Revue de l'Art ancien et moderne,* Vol. II, 1899, pp. 383-418.

―――. *J. B. S. Chardin,* Paris, 1900.

―――. "Potsdam à Paris," *Revue de l'Art ancien et moderne,* October 1900, pp. 269-76.

―――. "Le pastel et les pastellistes français au XVIIIe siècle," *Revue de l'Art ancien et moderne,* 1908, pp. 5-20, 109-26, 221-32, 273-92.

F. P. "Il secolo del Rococo," *Emporium,* Vol. CXXVIII, 1958, pp. 259-69.

FRANCASTEL, P. *Histoire de la peinture française,* Paris and Brussels, 1955, Vol. I.

FRANCIS, E. C. "Chardin and His Engravers," *The Print Collector's Quarterly,* July 1934, pp. 229-49.

FRANKFURTER, A. M. "Prophetic Rhythms," *Mademoiselle,* April-May 1949, p. 93.

FRANSOLET, M. *François Du Quesnoy sculpteur d'Urbain VIII, 1597-1643,* Brussels, 1942.

FRANTZ, H. "The Chardin-Fragonard Exhibition in Paris," *The Studio,* Vol. 42, 1908, pp. 25-30.

*FRIED, M. "Absorption: A Master Theme in French Painting," *Eighteenth-Century Studies,* Winter 1975-76, No. 2, pp. 139-77.

―――. "Anthony Caro's Table Sculptures," *Arts Magazine,* March 1977, No. 7, pp. 94-97.

FRIEDLÄNDER, J. "Der Zeichner von Chardin," *Berliner Museen,* 1931, pp. 34-36.

FRY, R. *Characteristics of French Art,* London, 1932.

FURCY-RAYNAUD, M. "Chardin et la Direction générale des Bâtiments du Roy," *La Chronique des Arts et de la Curiosité,* 29 July 1899, p. 241; 12 August 1899, pp. 232-33.

―――. *Chardin et M. d'Angiviller. Correspondance inédite* (including a funeral oration by RENOU), Paris, 1900.

―――. "Correspondance de M. de Marigny avec Coypel, Lépicié et Cochin," *Nouvelles Archives de l'Art français (1903),* Vol. XIX, 1904.

*FURST, H. *Chardin,* London, 1911.

―――. *The Art of Still-Life Painting,* New York, 1927.

―――. "Chardin Yesterday and Today," *The Connoisseur,* July 1940, pp. 13-18.

FUSSINER, H. "Organic Integration in Cézanne's Painting," *College Art Journal,* Summer 1956, No. 4, pp. 302-12.

GAILLARD, Y. *Collection particulière. Essai en forme de tableaux,* Paris, 1966.

GALLET, M. *Stately Mansions: 18th-Century Paris Architecture,* New York and Washington, 1972.

———. "L. Fr. Trouard et l'architecture religieuse dans la région de Versailles au temps de Louis XV," *Gazette des Beaux-Arts*, Vol. LXXXVIII, December 1976, pp. 201-18.

GAMMELL, I. *Twilight of Painting*, New York, 1946.

GANZ, H. "Jean-Baptiste Chardin zum 150. Todestag," *Kunst und Künstler*, January 1930, pp. 159-62.

*GARAS, K. *Chardin*, Budapest, 1963.

GASQUET, J. *Cézanne*, 2nd ed. Paris, 1926.

GAUFFIN, A. *Konstwerk och Människor. Essayer och Kritiker*, Stockholm, 1915.

———. *Franska Mälningar urval och text*, Stockholm, 1923.

GAULT de SAINT-GERMAIN, P. M. *Les trois siècles de la peinture en France*, Paris, 1908.

GAUTHIER-DAGOTY, J. F. *Observations sur la peinture et sur les tableaux anciens et modernes*, Paris, 1753, Vol. I.

GAUTIER, Th. "Exposition du Boulevard des Italiens," *Le Moniteur universel*, 24 October 1860, pp. 1261-62.

———. "Chardin et Greuze," *L'Artiste*, 15 October 1861, pp. 174-76.

———. "Les coloristes français: Chardin," *L'Artiste*, 15 February 1864, pp. 73-76.

Gazette de l'Hôtel Drouot: "La cote des peintres," 2 May 1971.

GEISEN, J. "Spielende Kinder in der Kunst," *Die Kunst*, Vol. LXXXI, 1969, pp. 497-502.

GENISSON, G. *Quelques notes sur la famille du peintre Jean Siméon Chardin* (typewritten), Paris, 1975.

GERDTS, W. H. and BURKE, R. *American Still-Life Painting*, New York, 1971.

*GERSON, H. *Ausbreitung und Nachwirkung der Holländischen Malerei des 17. Jahrhunderts. De expansie der 17e Eeuwsche Hollandsche Schilderkunst*, Haarlem, 1942.

GETREAU-ABONDANCE, FL. *Catalogue raisonné des peintures et dessins de l'école française, musée Jacquemart-André*, Paris, 1976.

GIDE, A. *Journal. 1889-1939*, Dijon, 1955.

GILLET, L. "La peinture au musée du Louvre. Ecole française, XVIIIe siècle," *L'Illustration*, 1929.

GILLET, L. and ROLLAND, R. *Correspondance. Choix de lettres*, Paris, 1949.

GIMPEL, R. *Journal d'un collectionneur marchand de tableaux*, Paris, 1963.

GIROD de L'AIN, G. *Les Thellusson—Histoire d'une famille*, Paris, 1977.

GOBILLOT, R. *Le musée de Chartres*, supplement to *La Revue française*, December 1957, No. 96.

GODFREY, F. M. "European Masters of the 18th Century," *The Studio*, March 1955, No. 744, pp. 80-84.

*GOLDSCHMIDT, E. *Jean-Baptiste Siméon Chardin*, Stockholm, 1945 (Swedish ed.); Copenhagen, 1947 (Danish ed.).

GOLZIO, V. *Il Seicento e il Settecento*, in *Storia Universale dell'Arte*, Turin, 1955, Vol. II.

GONCOURT, Ed. de. *La maison d'un artiste*, Paris, 1881.

———. "Le grenier," *Gazette des Beaux-Arts*, Vol. XV, March 1896, pp. 185-94.

*GONCOURT, J. and Ed. de. "Chardin," *Gazette des Beaux-Arts*, Vol. XV, December 1863, pp. 514-33; Vol. XVI, February 1864, pp. 144-67.

———. *L'art due XVIIIe siècle*, 12 fascs., Paris, 1859-1875, "Chardin," fasc. II, 1864; "Notules," fasc. XII, 1875; also Paris, 1880-1884, 2 vols.; 3rd ed. 1909, Vol. I.

———. *Miroirs de l'Art* (series), intro. by BOUILLON, Paris, 1967.

———. "Chardin, peintre de la vie bourgeoise," *Jardin des Arts*, January 1959, No. 51, pp. 157-62.

GONSE, L. *Les chefs-d'oeuvre des musées de province*, Paris, 1900.

GOULINAT, J. "Chefs-d'oeuvre de l'art français. La peinture au XVIIe, XVIIIe, XIXe siècles," *Le Dessin*, November 1937, pp. 245-67.

GRANBERG, O. *Catalogue raisonné des tableaux anciens inconnus jusqu'ici dans les collections privées de Suède*, Stockholm, 1886.

———. *Inventaire général des trésors d'art en Suède*, Stockholm, Vol. I, 1911; Vol. II, 1913; Vol. III, 1914.

GRAPPE, G. "Le XVIIIe siècle," *L'Art Vivant*, January 1932, No. 156, pp. 16-22.

———. "L'enfant dans le peinture," *L'Art Vivant*, 1933, pp. 490-92.

———. "La réhabilitation du sujet," *L'Art Vivant*, December 1934, No. 191.

———. "Chardin et l'Intimisme," *La Belle France*, July 1938, pp. 23-27.

GRAUTOFF, O. "Jean-Baptiste Siméon Chardin," *Kunst und Künstler*, Vol. VI, 1908, pp. 496-508.

GRAVES, A. *A Century of Loan Exhibitions (1813-1912)*, 5 vols., London, 1913-1915; reprint, 3 vols., Bath, 1970.

GRISEBACH, L. *Willem Kalf*, Berlin, 1974.

GROOS, R. "Le XVIIIe siècle," *Visages du Monde*, 1937, No. 48, pp. 182-85.

GUIFFREY, J. "Exposition Chardin-Fragonard," *Revue de l'Art ancien et moderne*, 10 August 1907, pp. 93-106.

*———. *Jean-Baptiste Siméon Chardin. Catalogue complet d l'oeuvre du maître*, Paris, 1908.

———. "Tableaux français conservés au musée de Boston et dans quelques collections de cette ville," *Archives de l'Art français*, Vol. VII, 1913, pp. 533-52.

GUIFFREY, J. and MARCEL, P. *Inventaire général des dessins du musée du Louvre et du musée de Versailles. Ecole française*, Paris, 1909, Vol. III.

GUIFFREY, J. J. *Notes et documents inédits sur les expositions du XVIIIe siècle*, Paris, 1873.

———. *Les Caffiéri, sculpteurs et fondeurs-ciseleurs*, Paris, 1877.

———. "Scellés et inventaires d'artistes français du XVIIe et XVIIIe siècles," *Nouvelles Archives de l'Art français*, 2nd Series, Vol. V, 1884; Vol. VI, 1885.

———. "Correspondance de Joseph Vernet avec le directeur des Bâtiments sur le collection des ports de France," *Nouvelles Archives de l'Art français*, 3rd Series, Vol. IX, 1893, pp. 1-99.

———. "Les expositions de l'Académie de Saint-Luc et leurs critiques (1751-1774)," *Bulletin de la Société de l'histoire de l'Art français*, 1910, pp. 77-124.

GUILLY, R. *Kindler's Malerei Lexikon*, 1964, Vol. I.

GULDENER, H. von. "De Zeventiende en achtiende Eeuw," *Phoenix, Maandschrift voor Beeldende Kunst*, 1948, No. 5, p. 156.

*HAILLET de COURONNE. "Eloge de M. Chardin," *Mémoires inédits*, published by DUSSIEUX, SOULIE, et al., Paris, 1854, Vol. II, pp. 428-41.

HAMEL, M. "Exposition de tableaux de maîtres anciens au profit des inondés du Midi," *Gazette des Beaux-Arts*, Vol. XXXV, March 1887, pp. 245-56.

*HASKELL, F. *Rediscoveries in Art: Some Aspects of Taste, Fashion and Collecting in England and France*, London, 1976.

HASSELGREN, I. *Konstsamlaren Gustav Adolf Sparre 1746-1794. Hans studieresa våning och konstsamling i Göteborg*, Göteborg, 1974.

HAUSMANN, F. *Repertorium der diplomatischen Vertreter aller Länder seit dem Westfälischen Frieden 1648*, Zurich, 1950, Vol. II (1716-1763).

HAUTECOEUR, L. *Les peintres de la vie familiale. Evolution d'un thème*, Paris, 1945.

HEBERT, M., POGNON, Ed. and BRUAND, Y. *Inventaire du fonds français. Graveurs du XVIIIe siècle* (Bibliothèque nationale), Paris, 1968, Vol. X.

*HEDOUIN P. "Chardin," *Bulletin des Arts*, 10 November 1846, pp. 185-91; 10 December 1846, pp. 222-29.

———. *Mosaïques. Peintres. Musiciens. Littérateurs. Artistes dramatiques à partir du XVe siècle jusqu'à nos jours*, Paris, 1856.

HELD, J. and POSNER, D. *17th- and 18th-Century Art*, New York, 1971.

HENRIOT, G. "La collection David-Weill," *L'Amour de l'Art*, January 1925, pp. 1-23.

———. *Collection David-Weill. Vol. I: Peintures*, Paris, 1926.

HERAND. "Tableaux et Curiosités," *L'Artiste*, Vol. XI, 1 February 1861, p. 67.

HERBET, F. "Les demeures de Chardin," *Bulletin de la Société historique du VIe arrondissement de Paris*, Vol. II, 1899, pp. 142-47.

———. *Fontainebleau*, Paris, 1937, pp. 188-89.

HERDING, K. *Pierre Puget. Das bildnerische Werk*, Berlin, 1970.

HEYWOOD, F.B.A. *The Important Pictures of the Louvre*, Paris, 1912 (2nd ed. 1923).

HILDEBRANDT, E. *Die Malerei und Plastik des 18. Jahrhunderts in Frankreich*, Berlin, 1924.

HILLAIRET, J. *Les deux cents cimetières de Paris*, Paris, 1958.

HIRSCH, E. S. "Painting by Chardin in the Jacobs Collection: *Les Osselets*," *Baltimore Museum News*, Vol. XIV, February 1951, pp. 1-4.

HIRTH, G. and MUTTER, R. *Der Cicerone in der Königlischen älten Pinakothek zu München*, Munich, 1888.

HOLMES, Ch. "New Pictures at the National Gallery," *The Burlington Magazine*, Vol. XLVII, July 1925, pp. 33-34.

HORSIN-DEON, S. "Le cabinet de M. le comte de Morny," *Annuaire des Amateurs et des Artistes*, Paris, 1862, Vol. III.

———. "Cabinet de M. Eudoxe Marcille," *Annuaire des Amateurs et des Artistes*, Paris, 1862, Vol. III.

HOURTICQ, L. *La peinture française au XVIIIe siècle*, Paris, 1939.

HOUSSAYE, A. "Point de vue sur l'école française," *Annuaire des Amateurs et des Artistes*, 1860, pp. 206-12.

———. "A propos d'un portrait de Chardin," *L'Artiste*, 1862, pp. 149-51.

HUBBARD, R.H. *European Paintings in Canadian Collections: Earlier Schools*, Toronto, 1956.

HUISMAN, Ph. "La collection Marcille: 5000 tableaux méconnus," *Connaissance des Arts*, June 1959, No. 88, pp. 74-81.

———. "Les nouvelles salles du Louvre," *Revue des Deux Mondes*, 1 February 1970, pp. 389-94.

HULTON, P. "France in the Eighteenth Century," *Master Drawings*, Vol. VI, No. 2, 1968.

HUYGHE, R. "Exposition d'art français à San Francisco," *L'Art Vivant*, September 1934, p. 362.

———. "Le XVIIIe siècle français à Copenhague," *Les Beaux-Arts*, 23 August 1935, No. 138, pp. 1, 3.

———. "L'Art de la bourgeoisie," *Les Arts de France*, July 1946, No. 8.

———. "Département des peintures," *Bulletin des musées de France*, March 1946, No. 1, pp. 17-24.

———. "Chardin," *Jardin des Arts*, April 1965, No. 125, pp. 2-13.

ISARLOV, G. *La peinture française à l'exposition de Londres 1932*, Paris, 1932.

JAL, A. *Dictionnaire critique de biographie et d'histoire*, Paris, 1867.

JAMOT, P. "French Painting," *The Burlington Magazine*, Vol. LIX, December 1931, pp. 257-314; Vol. LX, January 1932, pp. 3-68.

———. *La peinture en France*, Paris, 1934.

JANSON, H. W. *Apes and Ape Lore*, London, 1952.

JEAN-RICHARD, P. *Inventaire général des gravures. Ecole française. Vol. I: L'oeuvre gravé de François Boucher dans la collection Edmond de Rothschild*, Paris, 1978.

JEDLICKA, G. "J. B. S. Chardin (1699-1779). Die Rübenputzerin," *Kunst der Welt*, 1965, No. 5, p. 181.

JOSZ, V. "Le centenaire de Chardin," *Mercure de France*, July-September 1899, pp. 5-17.

———. "A propos de Chardin," *Revue des Beaux-Arts et des Lettres*, 1 October 1899, pp. 447-51.

J[OUBIN], A. "Un catalogue de vente illustré par Jules Boilly," *Les Beaux-Arts*, 15 December 1925, pp. 336-37.

JOURDAIN, F. *Chardin*, Les Maîtres, Paris, 1949.

KANOLDT, J. *Guide Through the Old Pinakothek*, Munich, 1910.

KEMP, M. "The Hunterian Chardin X-Rayed," *The Burlington Magazine*, Vol. CXVIII, April 1976, pp. 228-31.

———. "A Date for Chardin's *Lady Taking Tea*," *The Burlington Magazine*, Vol. CXX, January 1978, pp. 22-25.

KEMPF, R. *Diderot et le roman ou le démon de la présence*, Paris, 1964 (2nd ed. 1976).

KIRCHER, G. "Chardin Doppelgänger Roland de La Porte," *Der Cicerone*, Vol. XX, 1928, pp. 95-101.

KLINGSOR, F. *Chardin*, Les Maîtres anciens et modernes, Paris, 1924.

KOECKLIN, R. *La donation de la famille Rothschild*, Lecture to the Assemblée générale annuelle de la Société des Amis du Louvre, Paris, 1909.

KOJINA, H. *Iskousstvo Fransii XVIII Vekd* (in Russian), Leningrad, 1971.

KÜHN, M. *Schloss Charlottenburg*, Berlin, 1937.

KUNSTLER, Ch. "La France régnait sur l'Europe au XVIIIe siècle," *Les Arts*, 1-7 May 1963, p. 20.

*KUROE, M. *Chardin* (in Japanese), Tokyo, 1975.

KUZNETSOV, I. *West European Painting in the Museums of the U.S.S.R.* (in Russian and in English), Leningrad, 1967.

LACAMBRE, G. and J. *Champfleury. Le Réalisme*, Paris, 1973.

LACHAISE, Dr. *Manuel pratique et raisonné de l'amateur de tableaux*, Paris, 1866.

LACLOTTE, M. *Musée du Louvre. Peintures*, Paris, 1970.

LACROIX, P. "Le nécrologe des artistes et des curieux. Chardin," *Revue universelle des Arts*, Vol. XIII, 1861, pp. 45-48.

———. *Le XVIIIe siècle—Institutions, usages et costumes—France 1700-1789*, Paris, 1875.

LAFENESTRE, G. "Les arts à l'Exposition universelle de 1900—La peinture ancienne: ecole française," *Gazette des Beaux-Arts*, Vol. XXIV, December 1900, pp. 537-62.

———. "La peinture, le musée Jacquemart-André," *Gazette des Beaux-Arts*, Vol. XI, February 1914, pp. 101-16.

LAGRANGE, L. "La galerie du duc de Morny," *Gazette des Beaux-Arts*, Vol. XIV, April 1863, pp. 385-401.

LARGUIER, L. *En compagnie de vieux peintres*, Paris, 1927.

LARIONOVA, E. "Truth and Beauty According to Chardin" (in Russian), *L'Artiste*, 1974, No. 12, pp. 53-56.

LAROUSSE, "Chardin," *Dictionnaire Universel*, Paris, 1867, Vol. III.

LA SIZERANNE, R. de. "Le double miroir du XVIIIe siècle. Chardin-Fragonard," *Revue des Deux-Mondes*, Vol. XL, 1 July 1907, pp. 171-91.

LASKEY, J. *A General Account of the Hunterian Museum*, Glasgow, 1813.

LASSAIGNE, J. "La peinture française," *Les Arts*, 14 June 1946, pp. 1, 8.

LASTIC, G. de. "Desportes et Oudry, peintres de chasses royales," *The Connoisseur*, December 1977, No. 790, pp. 290-99.

LAUTS, J. *Meisterwerke der Staatlichen Kunsthalle*, Karlsruhe, 1955.

———. *Karlsruhe, Alte Meister bis 1800*, Staatliche Kunsthalle, Karlsruhe, 1966.

———. *Stilleben alter Meister. II. Franzosen*, Staatliche Kunsthalle, Karlsruhe, 1970.

LAVALLEE, P. *Le dessin français*, Paris, 1948.

*LAZAREV, V. N. *Chardin*, Moscow, 1947 (in Russian); Dresden, 1966 (in German).

———. *Chardin. Old European Masters* (in Russian), Moscow, 1974.

LE CARPENTIER, C. *Galerie des peintres célèbres*, 2 vols., Paris, 1821, Vol. II, pp. 234-37.

LECLERQ, J. "L'école française du XVIIIe siècle, au National Museum de Stockholm," *Revue de l'Art ancien et moderne*, Vol. V, 1899, pp. 121-32.

LE CORBEILLER, C. "Mercury, Messenger of Taste," *Bulletin of The Metropolitan Museum of Art*, Vol. XXII, Summer 1963, p. 25.

LENZ, Ch. "Neuerwerbungen der Frankfurter Museen," *Städel-Jahrbuch*, 1975, p. 299.

LEPORINI, H. "Eine Austellung in Wien von Gemälden aus Preussischer Schlössern," *Pantheon*, 1942, pp. 68-69.

*LEPRIEUR, P. "Récentes acquisitions du département des peintures au musée du Louvre 1907-1908—Les portraits de Chardin," *Gazette des Beaux-Arts,* Vol. I, 1909, pp. 135-56.

LEROY, A. *La peinture française au XVIIIe siècle,* Paris, 1934.

*LESPINASSE, P. "L'Art français et la Suède de 1688 à 1816," *Bulletin de la Société de l'histoire de l'Art français,* 1911, pp. 54-293, 305-37; 1912, pp. 207-45.

LEVEY, M. and KALNEIN, W. *Art and Architecture of the 18th Century in France,* Baltimore, 1972.

LEVINSON-LESSING, V. F. *Catalog of Seventeenth- and Eighteenth-Century Painters in The Hermitage,* Leningrad, 1958 (in Russian); Prague, 1963 (in German); Prague, 1965 (in French).

LE WINTER, R. *Diderot ou les mots de l'absence,* Paris, 1976.

LEYMARIE, J. *L'esprit de la lettre dans la peinture,* Geneva, 1967.

LHUILLIER, Th. "Noms d'artistes français des XVIe, XVIIe, and XVIIIe siècles relevés sur des documents inédits dans les Archives de la Brie," *Revue des Sociétés savantes,* November-December 1872, pp. 489-516.

LUCIEN-HUARD, C. *Les musées chez soi,* Sceaux, n.d.

LUGT, F. *Les marques de collections de dessins et d'estampes ... avec des notices historiques sur les collectionneurs, les collections, les ventes, les marchands et les éditeurs,* 2 vols., Amsterdam and The Hague, 1921-1956.

LUNDGERG, G. "Tessin: ses succès," *Connaissance des Arts,* November 1970, pp. 122-29.

MAC FALL, H. *The French Pastellists of the 18th Century,* London, 1909.

Magasin pittoresque (Le): "Le jeu d'oie," Vol. XIII, December 1845, pp. 393-94; "Le Bénédicité," Vol. XVI, May 1848, pp. 161-62; "La Blanchisseuse de Chardin," Vol. XVIII, June 1850, pp. 171-73.

MALRAUX, A. *Les voix du silence,* Paris, 1951.

MANNLICH, Ch. von. *Beschreibung der Kgl.-Bayerischen Gemäldesammlungen,* Munich, 1805.

MANTZ, P. "La collection La Caze au musée du Louvre," *Gazette des Beaux-Arts,* Vol. IV, July 1870, pp. 5-25.

———. "La galerie de M. Rothan," *Gazette des Beaux-Arts,* Vol. VII, April 1873, pp. 273-94; Vol. VII, May 1973, pp. 429-49.

———. "Exposition en faveur de l'oeuvre des Alsaciens-Lorrains," *Gazette des Beaux-Arts,* Vol. X, 1874, pp. 97-114, 193-215, 289-309.

———. *Le musée de l'Ermitage à Saint-Pétersbourg,* Paris, [1883].

———. *La collection de feu de M. Jules Burat,* preface of sale catalog, Paris, 28-29 April 1885.

———. *La collection Philippe Burty,* preface of sale catalog, Paris, 2-3 March 1891.

MARCY, P. *Guide populaire dans les musées du Louvre,* Paris, 1867.

*MARIETTE, P.-J. "Chardin," *Abécédario,* published by Chennevières and Montaiglon, *Archives de L'Art français,* 1853-1862.

MARTIN, K. See BURCKHARDT.

———. "Notes on a Still Life by Chardin," *Allen Memorial Art Museum Bulletin,* Vol. IX, Autumn 1951, pp. 17-23.

———. "Bemerkungen zu zwei kopien nach Stilleben von J. B. S. Chardin," *Festschrift Kurt Bauch,* 1957, pp. 238-44.

———. *Alte Pinakothek München,* Munich, 1961 (2nd ed. 1962; 3rd ed. 1968, in French).

MARTIN-MERY, G. "Le musée des Beaux-Arts de Bordeaux," *Les monuments historiques de la France,* 1972, No. 2, p. 49.

———. "Les enrichissements du musée des Beaux-Arts de Bordeaux," *L'Oeil,* May 1976, No. 250, p. 20.

MATHEY, J. "Jeaurat, Cochin, Durameau et les dessins de Chardin," *Bulletin de la Société de l'histoire de l'Art français,* Vol. I, 1933, pp. 82-86.

———. *Le graphisme de Manet II, peintures réapparues,* Paris, 1963.

———. "Manet as a Pupil of Chardin," *The Connoisseur,* October 1963, pp. 92-97.

———. "Les dessins de Chardin," *Albertina-Studien,* 1964, Nos. 1/2, pp. 17-31.

MAUGIS, M. T. "La gourmandise inspire les artistes," *Jardin des Arts,* December 1958, No. 50, pp. 70-77.

MAY, G. "Chardin vu par Diderot et par Proust," *Publication of the Modern Language Association,* Vol. LXXII, June 1957, pp. 403-18.

*McCOUBREY, J. W. "The Revival of Chardin in French Still-Life Painting—1850-1870," *Art Bulletin,* Vol. XLVI, March 1964, pp. 39-53.

MEIER-GRAEFE, J. "Correspondance d'Allemagne—L'Exposition d'art français du XVIIIe siècle à Berlin," *Gazette des Beaux-Arts,* Vol. III, March 1910, pp. 262-72.

MENARD, R. "La collection Laurent-Richard," *Gazette des Beaux-Arts,* Vol. VII, 1873, pp. 177-96.

MERSON, L. O. *La peinture française au XVIIe siècle et au XVIIIe siècle,* 2nd ed., Paris, 1900.

MESURET, R. *Les expositions de l'Académie royale de Toulouse de 1751 à 1791,* Paris and Toulouse, 1972.

M. G. "Zwölf Werke von Jean-Baptiste Siméon Chardin 1699-1779," *Du,* 1960, No. 238, pp. 26-38.

MICHAUD. *Biographie universelle ancienne et moderne,* Paris, 1813, Vol. VIII, pp. 75-76; 1844, Vol. VII (2nd ed.), p. 507.

MICHEL, A. "Portraits de femmes," *Journal des débats,* 10 May 1897, p. 3.

———. "L'Exposition Chardin et Fragonard," *Journal des débats,* 14 June 1907, p. 3.

———. "De Chardin à Carrière," *Journal des débats,* 18 June 1907, p. 1.

MIRIMONDE, A. P. de. "De Chardin à Potke Verhaghen," *Revue des Arts,* 1955, No. 3, pp. 185-87.

———. "Les oeuvres françaises à sujets de musique au musée du Louvre. II. Nature mortes des XVIIIe et XIXe siècles," *Revue du Louvre et des musées de France,* 1965, No. 3, pp. 111-24.

———. "Musiciens isolés et portraits de l'Ecole française du XVIIIe siècle dans les collections nationales. I. Fin Louis XIV, Régence, Louis XV," *Revue du Louvre et des musées de France,* 1966, No. 3, pp. 141-56.

———. *L'iconographie musicale sous les rois Bourbons. La musique dans les arts plastiques XVIIe-XVIIIe siècles,* Paris, 1977.

MITTELSTÄDT, K. *Jean-Baptiste Siméon Chardin,* Welt der Kunst, Berlin, 1963 (2nd ed. 1968).

MOLINIER, E., MARX, R., and MARCOU, Fr. *L'art français des origines à la fin du XIXe siècle,* Paris, 1900.

MONGAN, A. "Chardin and French 18th-Century Painting," *Bulletin of the Minneapolis Institute of Arts,* Vol. XLVII, October 1954, pp. 52-55.

MONNIER, G. *Pastels des XVIIe et XVIIIe siècles,* Paris, 1972.

MONNOT. "Donation du comte de Caylus à l'Académie de peinture," *Nouvelles Archives de l'Art français,* 2nd Series, Vol. II, 1880-1881, pp. 210-19.

MOREAU-NELATON, E. *Bonvin raconté par lui-même,* Paris, 1927.

MOREAU-VAUTHIER, Ch. *Les portraits de l'enfant,* Paris, [1897].

MORICE, Ch. "La collection Henri de Rothschild," *L'Art et les Artistes,* September 1906, pp. 225-36.

MORISETTE, G. "Héritage de France," *Vie des Arts.* 1961, No. 24, pp. 27-31.

MORSE, J. D. *Old Masters in America,* Chicago, 1955.

MOSBY, D. F. *Alexandre-Gabriel Decamps* (thesis submitted to Harvard, 1973), New York, London, 1977.

MOSELIUS, C. D. "Gustav III och konsten," *Nationalmusei Årshok,* 1939, pp. 82-154.

MOUTON, J. *Suite à la peinture,* Paris, 1932.

MRAS, G. P. "A Game Piece by Eugène Delacroix," *Record of the Art Museum, Princeton University,* Vol. XVIII, 1959, pp. 65-75.

Nécrologe des Hommes célèbres de France (Le): "Eloge historique de M. Chardin," Paris, 1780, Vol. XV (1779).

NEMILOVA, I. *Chardin and His Paintings at The Hermitage* (in Russian), Leningrad, 1961.

————. "Contemporary French Art in 18th-Century Russia," *Apollo*, June 1975, pp. 428-42.

NEUFVILLE DE BRUNAUBOIS-MONT-ADOR. *Description raisonnée des tableaux exposés au Louvre*, Paris, 1738.

NEUGASS, Fr. "Chardin: *Der Junge mit der Seifenblase*," *Weltkunst*, 1951, No. 6, p. 2.

————. "Chardin-Stilleben mit silberner Suppenterrine," *Weltkunst*, 1960, No. 7, p. 1.

NICOLAI, F. *Beschreibung der Königlichen Residenzstädte Berlin und Potsdam*, Berlin, 1779 (3rd ed. 1786).

NICOLLE, M. "Les peintres français au XVIIIe siècle," *Revue de l'Art ancien et moderne*, February 1900, pp. 149-57.

NOLHAC, P. de. "Fragonard et Chardin," *Les Arts*, July 1907, pp. 37-46.

NORDENFALK, L. *Äldre Utländska Målningar och skulpturer*, preface, Stockholm, 1958.

*NORMAND, Ch. *J. B. Siméon Chardin*, Les Artistes célèbres, Paris, 1901.

Notice des tableaux de la Galerie royale de Munich, Munich, 1818.

"Notice historique sur M. Chardin, peintre ordinaire du Roi, conseiller et ancien trésorier de l'Académie royale de peinture et de sculpture, mort à Paris le 6 décembre 1779," *Journal de Littérature, des Sciences et des Arts*, Vol. I, 1780, pp. 59-69.

NOTTHAFFT, H. "*Les Attributs des Arts* de Chardin au musée de l'Ermitage," *Annuaire du musée de l'Ermitage*, Art de l'Europe occidentale, Vol. I, 2nd fasc., 1936, pp. 1-17.

OBSER, K. "Lettres sur les Salons de 1773, 1777, 1779 adressées par Du Pont de Nemours à la Margrave Caroline-Louise de Bade," *Archives de l'Art français*, 1908, pp. 1-123.

OCHSE, M. "Chardin (1699-1779). La couleur au service de la vie," *Jardin des Arts*, June 1972, No. 211, pp. 46-53.

OESTERREICH, M. *Beschreibung aller Seltenheiten der Kunst und übrigen Alterthümer, besonders an Statuen in dem Königl. Lustschlosse Charlottenburg bey der Residenz Stadt Berlin*, Berlin, 1768.

————. *Description de tout l'intérieur des deux Palais de Sans-Souci, de ceux de Potsdam et de Charlottenbourg*, Potsdam, 1773.

OPPERMAN, H. N. *Jean-Baptiste Oudry* (dissertation submitted to Chicago, 1972), 2 vols., New York, 1977.

OSBORN, M. *Die Kunst der Rokoko*, Berlin, 1929.

PAHIN de LA BLANCHERIE. *Catalogue de Salon de la Correspondance de 1783*, Paris, 1783.

PANOFSKY, D. "Gilles or Pierrot? Iconographic Notes on Watteau," *Gazette des Beaux-Arts*, Vol. XXXIX, 1952, pp. 319-40.

PARTHEY, G. *Deutscher Bildersaal*, Berlin, 1863, Vol. I.

*PASCAL, A. and GAUCHERON, R. *Documents sur la vie et l'oeuvre de Chardin*, Paris, 1931.

PAULSON, R. *Emblem and Expression: Meaning in English Art of the Eighteenth Century*, Cambridge, 1975.

PETRUCCI, R. "The French Exhibition in Brussels," *The Burlington Magazine*, Vol. IV, March 1904, pp. 217-18.

PFEIFFER-BELLI, E. *Rundgang durch die Alte Pinakothek*, Munich, 1969.

PHILLIPS, D. "A Survey of French Painting from Chardin to Derain," *Bulletin of the Phillips Collection*, February-May 1928, pp. 11-23.

————. "Catalogue and Notes of Interpretation Relating to a Tri-Unit Exhibition of Paintings and Sculptures," *Bulletin of the Phillips Collection*, 1928.

————. *The Artist Sees Differently: Essays Based Upon the Philosophy of a Collection in the Making*, Washington, 1931.

————. "Personality in Arts," *The American Magazine of Art*, April 1935, No. 4, pp. 214-22.

PHOTIADES, V. *Die Malerei im 18. Jahrhundert*, Gütersloh, 1964.

PICON, G., and ORIENTE, S. *Cézanne* Les Classiques de l'Art, Paris, 1975.

PIGLER, A. *Barokthemen, Eine Auswahl von Verzeichnissen sur Ikonographie des 17. und 18. Jahrhunderts*, 2 vols., Budapest, 1956.

PIGNATTI, T. *Longhi*, Venice, 1968.

*PILON, Ed. *Chardin*, Les Maîtres de l'Art, Paris, 1909.

————. (1) *Chardin*, Paris, 1941.

————. (2) "Chardin rue Princesse et aux Galeries du Louvre," *Visages du Monde*, July 1941, No. 74, pp. 18-20.

PINDER, W. "Jean-Baptiste Siméon Chardin," *Museum*, Vol. XI, 1909, pp. 41-44.

————. *Gesammelte Aufsätze aus den Jahren 1907-1935*, Leipzig, 1938.

PIOT, E. *Etat civil de quelques artistes français extrait des registres des paroisses des anciennes archives de la ville de Paris*, Paris, 1873.

PIZON, R. "Sur la composition des natures mortes de Chardin," *Le Peintre*, April 1972, pp. 10-14.

PLANCHENAULT, R. "La collection du marquis de Livois," *Gazette des Beaux-Arts*, Vol. X, July 1933, pp. 14-30; Vol. X, October 1933, pp. 220-37.

————. "La dispersion de la collection du marquis de Livois," *Revue d'Anjou*, 1934, pp. 249-65.

POENSGEN, G. "Die Ausstellung Ausklang des Barock, Kunst and Künstler des 18. Jahrhunderts in der Pfalz," *Ruperto Carola*, Vol. XXVI, 1959, pp. 107-26.

POGNON, E. and BRUAND, Y. *Inventaire du fonds français. Graveurs du XVIIIe siècle* (Bibliothèque nationale), Paris, 1962, Vol. IX.

PONGE, F. "De la nature morte et de Chardin," *Art de France*, 1963, pp. 255-64.

————. *Nouveau Recueil*, Paris, 1967.

PRESSOUYRE, S. "La galerie François Ier au château de Fountainebleau. II. Les Restaurations," *Revue de l'Art*, 1972, No. 16/17, pp. 25-44.

Procès-Verbaux de l'Académie royale de peinture et de sculpture, 1648-1792, 10 vols., Paris, 1875-1892: Vol. V, 1882; Vol. VI, 1885; Vol. VII, 1886; Vol. VIII, 1888; Vol. IX, 1889.

PROKOFIEV, V. *French Painting in U. S. S. R. Museums*, Moscow, 1962.

PROUST, M. "Chardin, the Essence of Things," *Art News*, Vol. LII, 1954, pp. 39-42.

————. "Chardin ou le coeur des choses," *Le Figaro Littéraire*, 27 March 1954.

————. "Chardin," in *Marcel Proust on Art and Literature, 1896-1919*, trans. by S. T. Warner, New York, 1958.

————. *Contre Sainte-Beuve*, in *Essais et articles*, Paris, 1971.

QUENOT, M. J. *Contribution à l'histoire du chien de compagnie d'après les peintures du Louvre*, Alfort, 1964.

QUINTIN, D. *Les Chardin de la collection H. de Rothschild*, Paris, 1929.

RAFFAELLI, J. F. *Mes promenades au musée du Louvre*, 2nd ed., Paris, 1913.

RAMBAUD, M. *Documents du Minutier central concernant l'histoire de l'art, 1700-1750*, Paris, 1964, Vol. I; 1971, Vol. II.

RAMBURES, J. L. "A la recherche des secrets du tabac," *Connaissance des Arts*, January 1962, pp. 105-8.

RATHERY, E. J. B. *Journal et Mémoires du Marquis d'Argenson*, 9 vols., Paris, 1868.

RATOUIS de LIMAY, P. *Aignan-Thomas Desfriches, 1715-1800*, Paris, 1907.

————. "Un inventaire de la collection de l'amateur orléannais Aignan-Thomas Desfriches," *Archives de l'Art français*, Vol. VIII, 1916, pp. 261-70.

————. *Les pastels du XVIIe et XVIIIe siècles*, Paris, 1925.

————. "Trois collectionneurs du XIXe siècle," *Le Dessin*, May 1938, No. 1, pp. 304-15.

————. *Le pastel en France au XVIIIe siècle*, Paris, 1946.

———. *J. B. Perronneau, sa vie et son oeuvre*, Paris and Brussels, 1953.

REAU, L. "La galerie de tableaux de l'Ermitage et la collection Semenov," *Gazette des Beaux-Arts*, Vol. VIII, November 1912, pp. 379-96.

———. *L'Art en Europe au XVIIIe siècle*, in MICHEL, A., *Histoire de l'Art*, Paris, 1924, Vol. VII.

———. *La Peinture française au XVIIIe siècle*, 2 vols., Paris, 1925, Vol. I, pp. 45-51.

———. "Catalogue de l'art français dans les musées russes," *Bulletin de la Société de l'histoire de l'Art français*, 1928, fasc. I, pp. 167-314.

REFF, Th. "Copyists in the Louvre, 1850-1870," *Art Bulletin*, Vol. XLVI, December 1964, pp. 552-59.

———. "Puget's Fortunes in France," in *Essays in the History of Art Presented to Rudolf Wittkower*, London, 1967.

REVERDY, P. "La nature aux abois," *Verve*, Vol. II, 1940, No. 8, p. 54.

Revue universelle des Arts: "Eloge de Chardin. Nécrologe des artistes et des curieux," Vol. XIII, 1861, pp. 45-48; "Le musée du Palais et l'Ermitage sous le règne de Catherine II," Vol. XIII, 1861, pp. 164-79; "Chroniques, documents, faits divers," Vol. XVII, 1863, pp. 213-14, and Vol. XXI, 1865, p. 120.

RICHARDSON, E. P. "Recent Important Acquisitions of American Collections," *Art Quarterly*, Vol. V, 1942, pp. 348-49.

*RIDDER, A. de. *J. B. S. Chardin*, Paris, 1932.

RIEDERER, J. *Kunst und Chemie. Das unersetzliche Bewahren*, Berlin, Staatliche Museen, 1977-1978.

ROBB, D. M. *The Harper History of Painting*, New York, 1951.

ROBELS, H. "Neues über das Leben und die Werke Johann Anton de Peters," *Wallraf-Richartz Jahrbuch*, Vol. XXXIV, 1972, pp. 263-306.

ROBERTS, W. *Morality and Social Class in 18th-Century French Literature and Painting*, Toronto, 1974.

ROBIN. See MICHAUD.

ROBIQUET, J. "Notice sur les 'brouettes,' 'roulettes,' ou 'vinaigrettes'—A propos d'un dessin de Chardin au Musée national de Stockholm," *Nationalmusei Årsbok*, Vol. VIII, 1938. pp. 130-32.

ROCHEBLAVE, S. *Jean-Baptiste Pigalle*, Paris, 1919.

———. *L'Art et le goût en France de 1600 à 1900*, Paris, 1923.

———. *Charles-Nicolas Cochin, graveur et dessinateur*, Paris and Brussels, 1927.

ROGER-MILES, L. *Maîtres du XVIIIe. Cent pastels*, Paris, 1908.

R[OGERS], M. R. "The Silver Goblet by J. B. S. Chardin," *Bulletin of the City Art Museum of Saint Louis*, 1935, pp. 52-55.

ROLAND-MICHEL, M. "Observations on Madame Lancret's Sale," *The Burlington Magazine*, Vol. CXI, October 1969 (supplement), pp. II-VI.

———. "A Basket of Plums," *The Bulletin of The Cleveland Museum of Art*, Vol. LX, 1973, pp. 52-59.

RORIMER, J. J. *Le Metropolitan de Giotto à Renoir*, Paris, 1961.

ROSENBERG, P. *Chardin*, Le Goût de notre Temps, Geneva, 1963 (also in English and in German).

———. "Une nature morte de Chardin au musée de Douai," *Revue du Louvre et des musées de France*, 1966, No. 4-5, pp. 209-10.

———. "Le legs Sommier—I. Le jeune dessinateur taillant son crayon par Chardin," *Revue du Louvre et des musées de France*, 1969, No. 3, pp. 201-3.

———. "Le XVIIIe siècle français à la Royal Academy," *Revue de l'Art*, 1969, No. 3, pp. 98-100.

———. "Jean-Baptiste Siméon Chardin," *Bulletin de la Société des Amis du musée de Dijon*, 1970-1972, pp. 66-69.

———. "La femme à la puce de G. M. Crespi," *Revue du Louvre et des musées de France*, 1971, No. 1, pp. 13-20.

———. "Chardin, Jean Baptiste-Siméon," in *Encyclopedia Britannica*, 1974, pp. 42-44.

———. "Chardin," in *Le Larousse des Grands Peintres*, edited by M. LACLOTTE, Paris, 1976, pp. 61-62.

———. "Louis-Joseph Le Lorrain," *Revue de l'Art*, 1978, No. 40-41, pp. 173-202.

ROSENBERG, P. and CAMESASCA, E. *Watteau*, Les classiques de l'Art, Paris, 1970.

ROSENBERG, P., REYNAUD, N. and COMPIN, I. *La peinture au musée du Louvre. Ecole française XVIIe et XVIIIe siècles*, 2 vols., Paris, 1974.

ROSEROT, A. "Les collections de Bouchardon," *Chronique des Arts et de la Curiosité*, 24 April 1897, No. 17, pp. 156-58; 1 May 1897, No. 18, pp. 167-68.

ROSTRUP, H. "Fra Chardin til Greuze," *Tilskueren*, Vol. I, 1935, pp. 267-85.

ROUART, D. and ORIENTI, S. *Edouard Manet*, Les Classiques de l'Art, Paris, 1970.

ROUARD, D. and WILDENSTEIN, D. *Manet*, 2 vols., Paris, 1975.

ROUBO, A. J. *L'Art du menuisier*, Paris, 1769-1775, Vol. III.

ROUJON, H. "Les bésicles du Père Chardin," in *En marge du temps*, 2nd ed., Paris, 1909, pp. 121-25.

ROUSSEAU, Th. *A Boy Blowing Bubbles* by Chardin," *Bulletin of The Metropolitan Museum of Art*, April 1950, pp. 221-27.

———. "Guide to the Picture Gallery," *Bulletin of The Metropolitan Museum of Art*, January 1954, p. 2.

ROUX, M. *Inventaire du fonds français. Graveurs du XVIIIe siècle* (Bibliothèque nationale), Paris, 1931, Vol. I; 1934, Vol. II; 1940, Vol. IV.

ROUX, M. and POGNON, E. *Inventaire du fonds français—Graveurs de XVIIIe siècle* (Bibliothèque nationale), Paris, 1955, Vol. VIII.

ROUXEL, A. *Mémoires secrets du XVIIIe siècle. Lettres du commissaire Dubuisson au Mis de Caumont, 1735-1741*, Paris, 1882.

R. S. D. "Institute Purchases a Great Still Life by Chardin," *Bulletin of the Minneapolis Institute of Arts*, Vol. XLIII, October 1954, pp. 50-51.

RUMPF, J. D. F. *Beschreibung der äusseren und inneren Merkwürdigkheiten der königlichen Schlösser in Berlin, Charlottenburg, Schönhausen in und bey Potsdam*, Berlin, 1794, Vol. I; 1823, Vol. II.

RUSSELL, J. "Un médecin collectionneur au XVIIIe siècle," *L'Oeil*, Summer 1957, No. 31-32, pp. 12-19.

RUSSELL-SMITH, F. "Sleeve Buttons of the 17th and 18th Century," *The Connoisseur*, February 1957, No. 139, p. 37.

SAINT-PRIEST, Fr. E. "Exposition de la Société des Amis des Arts," *La Chronique des Arts et de la Curiosité*, 20 September 1867, No. 195, pp. 234-36.

SAINT-VICTOR, P. de. *La collection Marcille*, preface of sale catalog, Paris, 6-7 March 1876.

SAINTE-BEUVE, Ch. A. "Les frères Le Nain, peintres sous Louis XIII," *Le Constitutionnel*, 5 January 1863. Reprinted in *Les Nouveaux Lundis*, Paris, 1865, Vol. IV, pp. 116-139.

SAINTE-BEUVE, M. E. "Inventaire après décès du sculpteur Robert Le Lorrain," *Bulletin de la Société de l'histoire de l'Art français*, fasc. I, 1929, pp. 138-46.

SAISSELIN, R. G. "Ut pictura poesis: Du Bos to Diderot," *Journal of Aesthetics and Art Criticism*, Vol. XX, Winter 1961, pp. 145-56.

SANDER, F. *Nationalmuseum Bidrag till Taflegalleriets historia*, Stockholm, 1872-1876, Vols. I-IV.

SCHAETTEL, Ch. *Catalogue des Peintures du musée des Beaux-Arts de Beaune* (typewritten), Faculté des sciences humaines, Dijon, 1971, No. 49.

*SCHEFER, G. *Chardin*, Les Grands Artistes, Paris, 1904.

———. *Les peintres de la bourgeoisie et du peuple*, in MICHEL, A., *L'art et les meurs en France*, Paris, 1909.

SCHMID, F. "The Painter's Implements in Eighteenth-Century Art," *The Burlington Magazine*, Vol. CVIII, October 1966, p. 519.

SCHNAPPER, A. "A propos de deux nouvelles acquisitions: 'Le chef-d'oeuvre d'un muet' ou la tentative de Charles Coypel," *Revue du Louvre et des musées de France*, 1968, No. 4-5, pp. 253-64.

SCHNEIDER, R. *L'Art français—Le XVIIIe siècle*, Paris, 1926.

SCHOMMER, P. "Un portrait de l'impératrice Joséphine et un tableau de sa collection," *Revue des Arts*, 1959, No. 3, pp. 113-19.

SCHÖNBERGER, A. and SOEHNER, H. *Die Welt des Rokoko*, Munich, 1959 (French ed. 1960).

SCHÖNBRUNNER, J. and MEDER, J. *Handzeichnungen alter Meister aus der Albertina und anderen Sammlungen*, 12 vols. Vienna, 1895-1908.

SCHWARZ, M. *The Age of Rococo*, London, 1971.

SCOTT, B. "Aignan-Thomas Desfriches," *Apollo*, January 1973, No. 131, pp. 36-41; "La Live de Jully, Pioneer of Neo-Classicism," pp. 72-77.

SECKEL, C. "Chardin: Mädchen mit Federball," *Kunsthandel*, 1959, No. 9, p. 15.

SEIDEL, P. "Friedrich der Grosse als Sammler von Gemälden un Sculpturen," *Jahrbuch der königlich preussichen Kunstsammlungen*, Vol. XV, 1894, pp. 48-57.

——. *Les collections d'oeuvres d'art français du XVIIIe siècle appartenant à sa majesté l'Empereur d'Allemagne, roi de Prusse*, Berlin and Leipzig, 1900 (also in German).

SEURIERE, M. "Comment les peintres voient la mère et l'enfant," *Jardin des Arts*, 1958, No. 50, pp. 90-96.

SEYMOUR, Ch. *Art Treasures for America. Samuel H. Kress Collection*, London, 1961.

SEYMOUR de RICCI, J. "Le musée Jacquemart-André," *Les Arts*, 1914, No. 146, pp. 2-32.

SEZNEC, J. "Les Salons de Diderot," *Harvard Library Bulletin*, Vol. V, 1951.

——. "Diderot and the Pictures in Edinburgh," *Scottish Art Review*, Vol. VIII, 1962.

——. *Diderot. Sur l'Art et les artistes*, Paris, 1967.

——. "Diderot, critique d'art," *Information d'histoire de l'Art*, January-February 1967, No. 1, pp. 5-15.

*SEZNEC, J. and ADHEMAR, J. *Diderot. Salons*, Oxford, 1957, Vol. I: 1759-1761-1763: Oxford, 1960, Vol. II: 1765; Oxford, 1963, Vol. III: 1767; Oxford, 1967, Vol. IV: 1769-1771-1775-1781.

SIGUIE, P. "Les tribulations d'un portrait célèbre: Madame Crozat par Aved au musée de Montpellier," *Actes du 86e Congrès national des Sociétés Savantes*, Montpellier, 1961, pp. 351-55.

SIEMER, L. "Zwei Stilleben von Jean-Baptiste Siméon Chardin," *Kunsthandel*, 1955, No. 3, pp. 10-11.

SJÖBERG, Y. and GARDEY, F. *Inventaire du fonds français. Graveurs du XVIIIe siècle* (Bibliothèque nationale), Paris, 1974, Vol. XIII; 1977, Vol. XIV.

*SNOEP-REITSMA, E. "Chardin and the Bourgeois Ideals of His Time," *Nederlands Kunsthistorisch Jaarboek*, 1973, No. 24, pp. 147-243. Appears in *Verschuivende Betekenissen*, The Hague, 1975.

SOEHNER, H. *Antica Pinacoteca de Munique*, Madrid, 1967.

STECHOW, W. "Notes on an Exhibition of Still-Life Paintings from the 17th to the 19th Century," *Bulletin of the Allen Memorial Art Museum*, Vol. II, March 1945, pp. 3-13.

STENMAN, G. *Stenmans 1913-1938*, Stockholm, 1938.

*STERLING, Ch. *La nature morte de l'Antiquité à nos jours*, Paris, 1952.

——. *A Catalogue of French Painting, Metropolitan Museum of Art*, Cambridge, 1955.

——. *Le musée de l'Ermitage. La peinture française de Poussin à nos jours*, Paris, 1957.

STRÖMBORN, S. *Masterpieces of the Swedish National Museum*, Stockholm, 1951 (Swedish ed. 1949).

STRYIENSKI, C. "Le Salon de 1761 d'après le catalogue illustré par Gabriel de Saint-Aubin," *Gazette des Beaux-Arts*, Vol. XXIX, 1903, pp. 279-98; Vol. XXX, pp. 64-76, 209-22.

STUFFMANN, M. "Les tableaux de la collection de Pierre Crozat. Historique et destinée d'un ensemble célèbre établis en partant d'un inventaire après décès inédit (1740)," *Gazette des Beaux-Arts*, Vol. LXXII, 1968, pp. 11-139.

STUFFMANN, M. in KELLER, H. *Die Kunst des 18. Jahrhunderts*, Berlin, 1971.

SUTTON, D. *French Drawings of the 18th Century*, London, 1949.

TALBOT, W. S. "Jean-Baptiste Oudry: Hare and Leg of Lamb," *The Bulletin of The Cleveland Museum of Art*, Vol. LVII, May 1970, pp. 149-58.

TARBE, P. *La vie et les oeuvres de Jean-Baptiste Pigalle, sculpteur*, Paris, 1859.

Telegraf, "Chardin, De Fransche Vermeer," 5 June 1938.

THIEME and BECKER. *Allgemeines Lexikon der bildenden Künstler von der Antike bis zur Gegenwart*, Leipzig, 1907-1950; 1912, Vol. VI. See CORNU.

THIERY. *Guide des amateurs et voyageurs*, Paris, 1787, Vol. I, p. 369.

THOMPSON, C. *The National Gallery of Scotland and Its Collection: A Study of the Changing Attitude to Painting Since the 1820's*, Edinburgh, 1972.

THUILLIER, J. and CHATELET, A. *La peinture française—De Le Nain à Fragonard*, Geneva, 1964.

Thyssen-Bornemisza Collection (The), 2 vols., Castagnola, 1971.

TOMPKINS, A. "A Still Life by Chardin," *Bulletin of the Art Association of Indianapolis, Indiana, John Herron Art Institute*, Vol. XXIII, September 1936, pp. 36-40.

TOURNEUX, M. "Un portrait apocryphe de Madame Geoffrin faussement attribué à Chardin," *Gazette des Beaux-Arts*, Vol. XV, 1896, pp. 471-76.

——. "L'exposition des portraits de femmes et d'enfants à l'Ecole des Beaux-Arts," *Gazette des Beaux-Arts*, Vol. I, June 1897, pp. 445-60.

——. "Diderot et le musée de l'Ermitage," *Gazette des Beaux-Arts*, Vol. XIX, April 1898, pp. 333-43.

——. "Philippe Burty," *Gazette des Beaux-Arts*, Vol. XXXVII, 1907, pp. 388-402.

——. "L'exposition Chardin-Fragonard," *Gazette des Beaux-Arts*, Vol. XXXVIII, 1907, pp. 89-102.

TRONCHIN, H. *Le conseiller François Tronchin et ses amis*, Paris, 1895.

TUFTS, E. M. "A Second Melendez Self-Portrait: The Artist as Still Life," *Art Bulletin*, Vol. LVI, March 1974, pp. 1-3.

TURNER, E. "*La serinette* by Jean-Baptiste Chardin: A Study in Patronage and Technique," *Gazette des Beaux-Arts*, Vol. LXIX, May-June 1957, pp. 299-310.

*VALCANOVER, F. *Jean Siméon Chardin, Maestri del Colore*, No. 124, Milan, 1966. Reprinted in the series *Chefs-d'oeuvre de l'art. Grands peintres*, Milan, 1978.

VALCANOVER, F. and MARTIN, R. *Jean Siméon Chardin*, Milan, 1967 (French ed.).

VALLERY-RADOT, J. *Les plus beaux dessins français du XVe à Géricault*, Paris, 1965.

VAN GOGH, V. *Correspondance complète* (intro. and notes by Georges Charensol), 3 vols., Paris, 1960.

VAUDOYER, J. L. "Exposition d'oeuvres de l'art français au XVIIIe siècle à l'Academie royale des Arts (Berlin)," *Les Arts*, July 1910, No. 103, pp. 3-30.

VERGNET-RUIZ, J. and LACLOTTE, M. *Petits et grands musées de France*, Paris, 1962.

VER[ONESI], G. "Capolavori delle raccolte parigine," *Emporium*, Vol. CXIII, March 1951, pp. 131-41; "Omaggio a Chardin," December, 1959, pp. 264-66.

VIARDOT, L. *Les musées d'Allemagne et de Russie*, 2nd ed., Paris, 1864.

VILLEBOEUF, A. "Un soir en Bourgogne," *Formes et couleurs*, 1946, No. 1, pp. 73-83.

VITRY, P. "Edme Bouchardon," *L'art et les artistes*, Vol. XI, April-September 1910, pp. 16-23.

VOLL, K. *Fürer durch die Alte Pinakothek*, Munich, 1908.

WAAGEN, F. *Die Gemäldesammlung in der Kaiserlichen Ermitage zu Sankt Petersburg*, Munich, 1864.

———. *Die vorhehmsten Kunstdenkmäler in Wien*, Vienna, 1866, Vol. I.

WAGNER, A. "Chardin als Genremaler," *Die Kunst und das schöne Heim*, Vol. LXXXII, March 1970, pp. 139-43.

WALKER, J. *National Gallery of Art, Washington*, London, 1964; New York, 1975.

WALLIS, N. "Chardin, the Superlative Craftsman," *The Connoisseur*, Vol. CXXXIII, 1954, p. 111.

WALTHER, J. "A Still Life by Jean Baptiste Chardin," *Bulletin of The Detroit Institute of Arts*, Vol. 8, January 1927.

WARNOD, A. "A la galerie Charpentier. Natures mortes françaises du XVIIIe siècle à nos jours," *Le Figaro*, 18 December 1951.

[WATSON, Fr.]. "The Taste of Angels," *Times Literary Supplement*, 1 July 1960.

*———. "18th-Century Masters of Cuisines. Chardin Stands at the Beginning of Modern Painting," *Times Literary Supplement*, 14 May 1970.

WEBER, W. "Die Galerie auf Schloss Karlsberg," *Die Kulturgemeinde*, Vol. 4, 1954.

———. "Kulturschätze von Europäischen Rand," *Stimme der Pfalz*, Vol. 14, 1963.

WEINER, P. P. *Les chefs-d'oeuvre de la galerie de tableaux de l'Ermitage à Pétrograd*, Munich, 1923.

WEISBERG, G. "François Bonvin and an Interest in Several Painters of the 17th and 18th Centuries," *Gazette des Beaux-Arts*, Vol. LXXXVI, December 1970, pp. 359-66.

———. "The Works of François Bonvin in the Burrell Collection," *The Scottish Art Review*, Vol. XIII, 1972, pp. 10-12, 31.

———. "The Traditional Realism of François Bonvin," *The Bulletin of The Cleveland Museum of Art*, November 1978, Vol. LXV, pp. 280-98.

WESCHER, P. "Les maîtres français du XVIIIe siècle au Cabinet des Dessins de Berlin," *Gazette des Beaux-Arts*, Vol. XI, June 1934, pp. 351-69.

WHITE, J. "Sir Hugh Lane as a Collector," *Apollo*, February 1974, No. 144, pp. 112-25.

WHITLEY, W. T. *Artists and Their Friends in England 1700-99*, 1928, Vol. I.

WILDENSTEIN, D. *Documents inédits sur les artistes français du XVIIIe siècle*, Paris, 1966.

———. *Inventaires après décès d'artistes et de collectionneurs français du XVIIIe siècle*, Paris, 1967.

WILDENSTEIN, G. *Le peintre Aved*, 2 vols., Paris, 1922.

———. *Le Salon de 1725*, Paris, 1924.

———. "L'Exposition de l'art français à Londres," *Gazette des Beaux-Arts*, Vol. VII, January 1932, pp. 54-76.

*———. (1) *Chardin*, Paris, 1933.

———. (2) "Le caractère de Chardin et sa vie," *Gazette des Beaux-Arts*, Vol. X, December 1933, pp. 365-80.

———. "A propos de la jeunesse et des débuts de Chardin," *Archives de l'Art Français*, Vol. XXII, 1959, pp. 175-78.

———. Le décor de la vie de Chardin d'après ses tableaux," *Gazette des Beaux-Arts*, Vol. LIII, February 1959, pp. 98-106.

———. "De l'utilisation des sources dans la rédaction des catalogues d'exposition," *La Chronique des Arts et de la Curiosité*, May 1960, No. 1096, pp. 1-2.

*———. *Chardin*, Zurich, 1963; English ed. revised and expanded by D. WILDENSTEIN, Oxford, Glasgow, and Zurich, 1969.

WILENSKI, R. H. *French Painting*, London, 1931.

WILHELM, J. "Peinture et publicité," *L'Oeil*, January 1958, No. 37, pp. 48-54.

*———. *"La partie de billard*: est-elle une oeuvre de jeunesse de Chardin?" *Bulletin du musée Carnavalet*, June 1969, pp. 7-13.

WILLE, J. G. *Mémoires et Journal de J. G. Wille* (preface by Ed. and J. de GONCOURT), published by DUPLESSIS, G., Paris, 1857.

WILSON, A. *Diderot*, New York, 1972.

WRANGELL, N. *Les chefs-d'oeuvre de la galerie de tableaux de l'Ermitage impérial à Saint-Pétersbourg*, London, 1909.

———. "Emperor Nicholas I and the Arts" (in Russian), *Starye gody*, Vol. III, 1913, pp. 53-90.

WRIGHT, Ch. *Old Master Paintings in Britain*, London, 1976.

YOUNG, E. "'Nature morte de Brueghal à Soutine' at Bordeaux," *The Burlington Magazine*, Vol. CXX, October 1978, pp. 700-701.

ZAMYATINA, A. N. "Chardin" (in Russian), *Le jeune artiste*, 1940, No. 8, pp. 13-18.

ZMIJEWSKA, H. "La critique des Salons en France avant Diderot," *Gazette des Beaux-Arts*, Vol. LXXVI, July-August 1970, pp. 1-144.

ZOLOTOV, Y. K. *Jean-Baptiste Siméon Chardin*, Moscow, 1955.

———. *Jean-Baptiste Siméon Chardin* (in Russian), Moscow, 1962.

———. *French Portraiture of the 18th Century* (in Russian), Moscow, 1968.

ERRATA

Introduction

Page 58. Paragraph 2, line 6: *for* placed *read* place.

Page 59. Paragraph 2, line 5: *for* ecstacy *read* ecstasy.

Principal Collectors of Chardin

Page 77. Column 1, next to last line: *for* exhibtion *read* exhibition.

Critical Evaluation of Chardin

Page 83. Column 2, last line: *for* pp. 426-28, 434 *read* pp. 426-28, 433-34.

Page 84. Column 2, line 13: for *littérature* read *littéraire*.

Catalog

[4] Page 106, line 4 below titles: *for* Nationlmuseum *read* Nationalmuseum.

[6] Page 113, line 24 below titles: *for* capitol *read* capital.

[7] Page 116, column 1, last line of small type: *for* no. 33] *read* (either) no. 22 (or) no. 23].

[10] Page 120, in English title: for *Apples* read *Apple*.

[14] Page 126, line 11 below titles: *for* 8 July 1861 *read* 8 July 1851.

[19] Page 134, in English and French titles: for *Bowl of Plums, a Peach, and Water Pitcher (Jatte de prunes, une pêche et un pot à eau)* read *Bowl of Plums with a Cherry, a Peach, and a Water Pitcher (Jatte de prunes avec une cerise, une pêche et un pot à eau).*

[30] Page 151, column 1, next to last line: *for* taffetas *read* taffeta.

[31] Page 152, in French title: for *de peintre* read *du peintre;* line 13 below titles, *for* 136, New York *read* 1936, New York; line 14, *for* 947, New York *read* 1947, New York.

[32] Page 153, line 11 below titles: *for* Guiffrey, 1907 *read* Guiffrey, 1908.

[41] Page 170, column 1, line 18 of small type: *for* Godegroy *read* Godefroy.

[42] Page 170, lines 14 and 19 below titles: *reverse* nos. 53 and 116.

[43] Page 172, in English title: for *Beets* read *Swiss Chard*.

[47] Page 176, last line of column 2: *for* compostions *read* compositions.

[48] Page 178, in French title: for *faience* read *faïence;* line 1 below titles, *for* Cnavas *read* Canvas; line 21, *for* Alexis Vallon *read* Alexis Vollon.

[49] Page 179, in French title: for *faience* read *faïence;* page 180, column 1, line 14, *for* with a problems *read* with problems.

[54] Page 195, column 1, line 6: *for* that it later *read* that it is later.

[55] Page 198, column 1, line 22: *for* the Sylvestre of *read* the Sylvestre sale of; line 28, *for* Cook collection in Richmond, Virginia *read* Cook collection in Richmond, Surrey.

[56] Page 198, column 2, line 14 of *Related Works:* for Cook collection in Richmond, Virginia *read* Cook collection in Richmond, Surrey.

[57] Page 200: *reverse* columns 1 and 2; line 1 below titles, *for* 11 x 5 cm. *read* 11.5 cm.; line 3 below small type section, *for* 11 x 5 cm. *read* 11.5 cm.; column 1, line 16, *for* workd *read* word.

[59] Page 205, line 7 of *Bibliography:* for *L'intermediaire* read *L'intermédiaire.*

[64] Page 216, line 3 below titles: for *a été fair* read *a été fait.*

[65] Page 220, column 2, line 6, below small type section: *for* undated version *read* undated version engraved by.

[67] Page 224, column 1, line 31, and column 2, line 3: for *La Peintre* read *La Peinture.*

[68] Page 226, column 1, lines 7 and 11 of *Related Works:* for tapistry *read* tapestry; column 2, line 4, *for* La Beraudière *read* La Béraudière.

[70] Page 228, line 5 below titles: *for* aboriculturist *read* arborculturist; line 5 of *Prints,* for capiton *read* caption; line 16 of *Prints,* for *Gauchardc* read *Gauchard sc.*

[75] Page 239, line 6 below titles: *for* Villetanèuse *read* Villetaneuse.

[82] Page 258, column 1, line 14: *for* Schlessheim *read* Schleissheim; line 25 of *Related Works,* for Groningue *read* Groningen.

[83] Page 262, column 1, paragraph 3 below small type section, line 5: *for* yound *read* young.

[84] Page 263, column 1, line 1 of *Exhibitions:* for Mere read Mère.

[88] Page 274, line 1 below titles: *for* Cnavas *read* Canvas.

[90] Page 279, column 1, last line: *for* 1947 *read* 1747.

[99] Page 300, column 2, line 15: *for* stone ledte *read* stone ledge.

[100] Page 301, column 2, line 19 of *Related Works:* for *dur une tablette* read *sur une tablette;* page 303, column 1, line 29, *for* thee *read* the.

[101] Page 303, column 2, line 12 of *Provenance:* for d'apres read d'après; line 2 of *Exhibitions,* for Venerie read Vénerie.

[102] Page 305, in French title: for *faience* read *faïence.*

[103] Page 305, line 3 below small type section: for *Peintre* read *Peinture.*

[112] Page 319, line 3 below titles: *for* Gëmaldegalerie *read* Gemäldegalerie.

[125] Page 344, line 11 of *Related Works:* for honarary *read* honorary.

Library of Congress Cataloging in Publication Data

Rosenberg, Pierre.
 Chardin, 1699-1779 : a special exhibition organized by the Réunion des Musées Nationaux, Paris, the Cleveland Museum of Art, and Museum of Fine Arts, Boston.

 Held at Grand Palais, Paris, Jan. 29-Apr. 30, 1979; the Cleveland Museum of Art, June 6-Aug. 12, 1979; Museum of Fine Arts, Boston, Sept. 11-Nov. 19, 1979.
 Bibliography: pp. 413-23.
 1. Chardin, Jean Baptiste Siméon, 1699-1779—Exhibitions. I. Chardin, Jean Baptiste Siméon, 1699-1779. II. Goodfellow, Sally W. III. Réunion des musées nationaux, Paris. IV. Paris. Grand Palais. V. Cleveland Museum of Art. VI. Boston, Museum of Fine Arts. VII. Title.
ND553.C4A413 1979 759.4 78-74107
ISBN 0-910386-48-X
ISBN 0-910386-49-8 pbk.